D1452396

THE PHILOSOPHY OF
GEORG HENRIK VON WRIGHT

THE LIBRARY OF LIVING PHILOSOPHERS

Lewis Edwin Hahn and Paul Arthur Schilpp, Editors

Already Published:

THE PHILOSOPHY OF JOHN DEWEY (1939)
THE PHILOSOPHY OF GEORGE SANTAYANA (1940)
THE PHILOSOPHY OF ALFRED NORTH WHITEHEAD (1941)*
THE PHILOSOPHY OF G. E. MOORE (1942)
THE PHILOSOPHY OF BERTRAND RUSSELL (1944)
THE PHILOSOPHY OF ERNST CASSIRER (1949)
ALBERT EINSTEIN: PHILOSOPHER-SCIENTIST (1949)
THE PHILOSOPHY OF SARVEPALLI RADHAKRISHNAN (1952)*
THE PHILOSOPHY OF KARL JASPERS (1957; aug. ed., 1981)
THE PHILOSOPHY OF C. D. BROAD (1959)
THE PHILOSOPHY OF RUDOLF CARNAP (1963)
THE PHILOSOPHY OF MARTIN BUBER (1967)
THE PHILOSOPHY OF C. I. LEWIS (1968)
THE PHILOSOPHY OF KARL POPPER (1974)
THE PHILOSOPHY OF BRAND BLANSHARD (1980)
THE PHILOSOPHY OF JEAN-PAUL SARTRE (1981)
THE PHILOSOPHY OF GABRIEL MARCEL (1984)
THE PHILOSOPHY OF W. V. QUINE (1986)
THE PHILOSOPHY OF GEORG HENRIK von WRIGHT (1989)

In Preparation:

THE PHILOSOPHY OF CHARLES HARTSHORNE
THE PHILOSOPHY OF A. J. AYER
THE PHILOSOPHY OF PAUL RICOEUR

*Temporarily out of print and available only from University Microfilms International.

Georg Henrik von Wright

THE LIBRARY OF LIVING PHILOSOPHERS
VOLUME XIX

THE PHILOSOPHY OF
GEORG HENRIK VON WRIGHT

EDITED BY

PAUL ARTHUR SCHILPP

AND

LEWIS EDWIN HAHN

SOUTHERN ILLINOIS UNIVERSITY—CARBONDALE

LA SALLE, ILLINOIS • OPEN COURT • ESTABLISHED 1887

 THE PHILOSOPHY OF GEORG HENRIK VON WRIGHT

OPEN COURT and the above logo are registered in the U.S. Patent and Trademark Office.

Library of Congress Cataloging-in-Publication Data

The Philosophy of Georg Henrik von Wright / edited by Paul Arthur Schilpp and Lewis Edwin Hahn.
 p. cm.—(The Library of living philosphers ; v. 19)
 Includes bibliographical references.
 ISBN 0-87548-372-0
 1. Wright, G. H. von (Georg Henrik), 1916– I. Schilpp, Paul Arthur, 1897–
II. Hahn, Lewis Edwin, 1908– III. Series.
B4715 W74P45 1989
198′ .8—dc20 89-29349
 CIP

The Library of Living Philosophers is published under the sponsorship of Southern Illinois University—Carbondale.

GENERAL INTRODUCTION*
TO
THE LIBRARY OF LIVING PHILOSOPHERS

According to the late F. C. S. Schiller, the greatest obstacle to fruitful discussion in philosophy is "the curious etiquette which apparently taboos the asking of questions about a philosopher's meaning while he is alive." The "interminable controversies which fill the histories of philosophy", he goes on to say, "could have been ended at once by asking the living philosophers a few searching questions."

The confident optimism of this last remark undoubtedly goes too far. Living thinkers have often been asked "a few searching questions", but their answers have not stopped "interminable controversies" about their real meaning. It is nonetheless true that there would be far greater clarity of understanding than is now often the case if more such searching questions had been directed to great thinkers while they were still alive.

This, at any rate, is the basic thought behind the present undertaking. The volumes of the Library of Living Philosophers can in no sense take the place of the major writings of great and original thinkers. Students who would know the philosophies of such men as John Dewey, George Santayana, Alfred North Whitehead, G. E. Moore, Bertrand Russell, Ernst Cassirer, Karl Jaspers, Rudolf Carnap, Martin Buber, et al., will still need to read the writings of these men. There is no substitute for first-hand contact with the original thought of the philosopher himself. Least of all does this Library pretend to be such a substitute. The Library in fact will spare neither effort nor expense in offering to the student the best possible guide to the published writings of a given thinker. We shall attempt to meet this aim by providing at the end of each volume in our series as nearly complete a bibliography of the published work of the philosopher in question as possible. Nor should one overlook the fact that essays in each volume cannot but finally lead to this same goal. The interpretative and critical discussions of the various phases of a great thinker's work

*This General Introduction, setting forth the underlying conception of this Library, is purposely reprinted in each volume (with only very minor changes).

and, most of all, the reply of the thinker himself, are bound to lead the reader to the works of the philosopher himself.

At the same time, there is no denying that different experts find different ideas in the writings of the same philosopher. This is as true of the appreciative interpreter and grateful disciple as it is of the critical opponent. Nor can it be denied that such differences of reading and of interpretation on the part of other experts often leave the neophyte aghast before the whole maze of widely varying and even opposing interpretations. Who is right and whose interpretation shall he accept? When the doctors disagree among themselves, what is the poor student to do? If, in desperation, he decides that all of the interpreters are probably wrong and that the only thing for him to do is to go back to the original writings of the philosopher himself and then make his own decision— uninfluenced (as if this were possible) by the interpretation of anyone else— the result is not that he has actually come to the meaning of the original philosopher himself, but rather that he has set up one more interpretation, which may differ to a greater or lesser degree from the interpretations already existing. It is clear that in this direction lies chaos, just the kind of chaos which Schiller has so graphically and inimitably described.[1]

It is curious that until now no way of escaping this difficulty has been seriously considered. It has not occurred to students of philosophy that one effective way of meeting the problem at least partially is to put these varying interpretations and critiques before the philosopher while he is still alive and to ask him to act at one and the same time as both defendant and judge. If the world's great living philosophers can be induced to cooperate in an enterprise whereby their own work can, at least to some extent, be saved from becoming merely "desiccated lecture-fodder", which on the one hand "provides innocuous sustenance for ruminant professors", and on the other hand gives an opportunity to such ruminants and their understudies to "speculate safely, endlessly, and fruitlessly, about what a philosopher must have meant" (Schiller), they will have taken a long step toward making their intentions more clearly comprehensible.

With this in mind, the Library of Living Philosophers expects to publish at more or less regular intervals a volume on each of the greater among the world's living philosophers. In each case it will be the purpose of the editor of the Library to bring together in the volume the interpretations and criticisms of a wide range of that particular thinker's scholarly contemporaries, each of whom will be given a free hand to discuss the specific phase of the thinker's work that has been assigned to him. All contributed essays will finally be sub-

1. In his essay 'Must Philosophers Disagree?' in the volume of the same title (London: Macmillan, 1934), from which the above quotations were taken.

mitted to the philosopher with whose work and thought they are concerned, for his careful perusal and reply. And, although it would be expecting too much to imagine that the philosopher's reply will be able to stop all differences of interpretation and of critique, this should at least serve the purpose of stopping certain of the grosser and more general kinds of misinterpretation. If no further gain than this were to come from the present and projected volumes of this Library, it would seem to be fully justified.

In carrying out this principal purpose of the Library, the editor announces that (as far as is humanly possible) each volume will contain the following elements:

First, an intellectual autobiography of the thinker whenever this can be secured; in any case an authoritative and authorized biography;
Second, a series of expository and critical articles written by the leading exponents and opponents of the philosopher's thought;
Third, the reply to the critics and commentators by the philosopher himself; and
Fourth, a bibliography of writings of the philosopher to provide a ready instrument to give access to his writings and thought.

The editors have deemed it desirable to secure the services of an Advisory Board of philosophers to aid them in the selection of the subjects of future volumes. The names of ten prominent American philosophers who have consented to serve appear on the next page. To each of them the editors are most grateful.

Future volumes in this series will appear in as rapid succession as is feasible in view of the scholarly nature of this Library. The next volume in this series will be devoted to the philosophy of Charles Hartshorne.

Throughout its years, the Library of Living Philosophers has, because of its scholarly nature, never been self-supporting. The generosity of the Edward C. Hegeler Foundation has made possible the publication of many of the volumes, but for the support of future volumes additional funds are needed. On February 20, 1979, the Board of Trustees of Southern Illinois University contractually assumed all responsibility for the Library, which is therefore no longer separately incorporated. Gifts specifically designated for the Library may be made through the University, and inasmuch as the University is a tax-exempt institution, all such gifts are tax-deductible.

P.A.S.
L.E.H.
Editors

DEPARTMENT OF PHILOSOPHY
SOUTHERN ILLINOIS UNIVERSITY–CARBONDALE

ADVISORY BOARD

ACKNOWLEDGMENTS

The editors hereby gratefully acknowledge their obligation and sincere gratitude to all the publishers of Georg Henrik von Wright's books and publications for their kind and uniform courtesy in permitting us to quote—sometimes at some length—from Professor von Wright's writings.

PAUL A. SCHILPP
LEWIS E. HAHN

*Deceased.
#Added to Board after the subject of this volume was chosen.

TABLE OF CONTENTS

 VON WRIGHT 889

INDEX BY GEORG HENRIK VON WRIGHT 925

 INDEX OF NAMES 925

 SUBJECT INDEX 934

PREFACE

A volume on von Wright's philosophy in this series needs no justification. For several decades already he has been moving into the focus of interest of philosophers around the world. Although he began his philosophical career and writing with a major interest first in logic and second in the philosophy of science, in his later years he has also become increasingly interested in ethics and the humanities. But he tells this story himself in his fascinating and informative 'Intellectual Autobiography'.

The editor desires to express his appreciation and gratitude, first, of course, to Professor von Wright himself for his uniform and always unstintingly given co-operation and helpfulness. But the contributors to this volume deserve no less praise, especially in view of the fact that—by no fault of either the publisher or the editor—the publication of this volume had to suffer unusual and frustrating delays.

Gratitude is due also to our publishers, the Open Court Publishing Company, who are doing all in their power to produce these volumes in the shortest possible time, yet without impairing either the accuracy or the appearance of the books.

The editor also wishes to call attention to the fact that, since February 20, 1979, Southern Illinois University–Carbondale has contractually become the owner of this series. This gives the undersigned a most welcome opportunity to express his gratitude and sincere appreciation to the administration of the University for their never-wavering support for these now past fifteen years.

PAUL ARTHUR SCHILPP

SOUTHERN ILLINOIS UNIVERSITY–CARBONDALE
CARBONDALE, ILLINOIS
JULY 9, 1980

SUPPLEMENT TO THE PREFACE

The unusual length and complexity of this manuscript have occasioned numerous problems and protracted delay in its publication. Except for the fact that several contributors graciously shortened greatly their original essays the manuscript would have been even longer. My special thanks to them.

Even so, the cost of publishing so long a manuscript with its many technical symbols constituted a formidable problem; and for good reasons some of the apparently obvious solutions would not do. For example, the general high quality of the essays precluded simply dropping enough of them to arrive at a manuscript of suitable length; and shortening it by publishing some of the essays elsewhere would have been a grievous loss for our Library of Living Philosophers project. Accordingly, I am most grateful to the administration of Southern Illinois University, particularly to President John C. Guyon and Vice President for Academic Affairs and Research Benjamin A. Shepherd, for arranging for a subvention to cut the costs to our publisher to manageable dimensions and make possible publication of this manuscript in its present form in one large volume rather than in two.

For some years we thought in terms of doing it in two volumes as we did with *The Philosophy of Karl Popper* (1974), and the present ordering of the critical essays and replies stems from the one planned for the two volumes. For this project the first volume would have contained Professor von Wright's 'Intellectual Autobiography'; the first 21 critical essays with his replies; and a bibliography of his writings. The criticisms and responses were grouped under four headings: 1. Induction and Probability, 2. Ethics and the General Theory of Norms and Values, 3. Action, Intentionality, and Practical Reasoning, and 4. Causality, Teleology, and Scientific Explanation. These critical essays contribute significantly to the topics treated while performing their main function of shedding light on some distinctive aspects of von Wright's philosophy, both in terms of their penetrating criticism and the opportunity afforded him to re-

state his views in light of his later research and reflection and to supplement and revise his earlier writings while putting his current views in appropriate context. The last ten critical essays and replies were to have been in a separate volume on Philosophical Logic, a topic of immense importance for von Wright's philosophy. This fifth group treats a diverse and impressive array of his contributions to modal logic and such offshoots as deontic logic, preference logic, and tense logic. The critical essays both illuminate von Wright's philosophical logic and make substantial contributions of their own to the topics treated.

I regret to report that one of our contributors did not live to see his essay and Professor von Wright's reply to it in print. Professor J. L. Mackie died on 12 December 1981. I am also saddened to note that four members of the Advisory Board that recommended a volume on von Wright are no longer with us. To the names of Cornelius Krusé, Herbert W. Schneider, and Richard P. McKeon now must be added that of Eugene Freeman, who passed away on 7 May 1986.

Patience, understanding, and hearty co-operation on the part of Professor von Wright and our contributors have made a difficult task go much better, and I am most grateful to them.

In readying the von Wright manuscript for publication Professor Schilpp's advice and counsel have been most helpful. I am grateful also for the help I have received in many ways and on numerous points from Dawn Kelly, Loretta Smith, and the Philosophy Department secretariat and from my colleagues, especially Matthew J. Kelly and David S. Clarke, Jr.

In addition my thanks are due to the staff of the Morris Library and especially to Alan M. Cohn and his associates for aid in running down references.

Finally, I offer special thanks to Marjorie L. Trotter, Ruth A. Cook, and Vernis Shownes for retyping many pages and making numerous others more presentable and for helping keep track of the multitude of items crucial for this manuscript.

LEWIS EDWIN HAHN
EDITOR

DEPARTMENT OF PHILOSOPHY
SOUTHERN ILLINOIS UNIVERSITY–CARBONDALE
JANUARY 1988

Postscript

I sadly report that yet another of our contributors did not live to see the publication of his essay and Professor von Wright's reply to it. Max Black died 27 August 1988. I note with sorrow, moreover, that two other members of the

Advisory Board that recommended a volume on von Wright have also passed away. Herbert Feigl died 1 June 1988 and Victor Lowe 16 November 1988.

My special thanks are due to Sharon R. Langrand for her assistance with the manuscript and proofs.

L. E. H.

17 MAY 1989

Second Postscript

I have just received word of the death of yet another of our distinguished contributors and, accordingly, sadly report that Stefan Nowak passed away 6 September 1989 after a long illness.

L. E. H.

19 OCTOBER 1989

PART ONE

INTELLECTUAL AUTOBIOGRAPHY OF

Georg Henrik von Wright

He seemed furious. Then he left the room without waiting for an apology or explanation. I was hurt and shocked. My first impulse was to give up efforts to approach this strange man. But I also wanted a straightforward answer as to whether I could come to his lectures or not. So I wrote him a letter — thinking that it would probably remain without answer. I was therefore much surprised when a few days later I got a friendly reply from the man I had so much angered. He was not going to let me come to his lectures, he said, but he was willing to explain to me <u>why</u>, if I came to tea with him at an appointed time. I went, and we had a friendly conversation — mainly, as I recall it, about architecture and about Norway. I told him what I was doing in Cambridge, and he explained to me why he had not liked my presence in his class. Term was approaching its end and he would not allow me to come to his lectures immediately; but I could come next term. He promised to look me up in the Easter Vacation and discuss philosophy with me. This he did, and when the Easter Term started I was one of the "recognized" pupils in his class.

The lectures Wittgenstein was then giving were on the foundations of mathematics. They have been recorded in at least two sets of good notes and they also exist in print in a pirated edition. I never took notes of Wittgenstein's lectures, but concentrated on trying to follow the thread of his thought. In retrospect I think it right to say that I understood next to nothing of what was going on, although I found Wittgenstein most impressive and

> *All deep, earnest thinking is*
> *but the intrepid effort of the*
> *soul to keep the open*
> *independence of her sea.*
> Herman Melville, *Moby-Dick*

The following notes fall into three parts.* The first part is an account of the external events which I consider relevant to my intellectual development. It also mentions a few facts of more general biographical interest. The second part narrates the origin of my various philosophical writings: how I became interested in the problems and how ideas for their solution came to me. I also evaluate some of these ideas and give hints of further developments. Finally, in the third part I try to express some thoughts on a question which has always engaged me and which I have never been able to answer to my satisfaction. It concerns the nature of philosophy and the goal of the philosopher's pursuits.

I

People often ask me about my name. An explanation may therefore be in place here. Around the year 1650, the earliest known members of my family had to leave Scotland because, it is said, they had sided with King Charles against Cromwell. They settled in Narva in Estonia, which was then a province under Swedish rule. Georg(e) Wright there begat Henrik Wright, who fought in the armies of Charles XII and after a long and eventful life died in his home in Finland, another part of the old Swedish realm. Henrik Wright's son Georg Henrik was, together with his three other sons, raised to noble rank after the royal coup d'état of 1772. This was how the odd combination of *'von'* and *'Wright'* originated.

Soon after, Sweden lost Finland and my country became an autonomous grand duchy under Russia. I was born in Helsinki 14 June 1916, in the last full year of the reign of the unfortunate Czar Nicholas II. I have lived the greater part of my life in Helsinki and feel rooted there. As a member of the Swedish-speaking minority in Finland, I prefer to call the city by its original Swedish name of Helsingfors.

My earliest consecutive memories are from my third and fourth years, when the family lived in Brooklyn, N.Y. I remember my childhood as on the whole

*This intellectual autobiography was written in the years 1972 and 1973. Its third section, on my view of philosophy, was revised in 1976. To the second section, dealing with the history of my philosophic research, I added a brief postscript in 1980.

happy, but I also remember frequent and long periods of illness, particularly during my early years at school. When I was twelve, the doctors advised my parents to take me to the well-known health resort of Meran(o) in Tirol, formerly Austria. Here I stayed with my mother, my grandmother, and my two sisters for a whole year. It was in Meran that my 'intellectual awakening' took place. It happened through my acquaintance with the elements of geometry in the spring of 1929. This gave me a tremendous thrill—and sleepless nights of thinking about triangles and circles, cones and spheres, and the mysterious number π, whose value it was impossible to tell 'exactly'.

In Meran I had a local tutor, who taught me German. Learning German was of formative importance to my future intellectual development. It gave me early access to the literature in which, to this day, I feel spiritually most at home: the poetry and prose of Goethe and Schiller, Schopenhauer and Nietzsche, Kafka and Musil, and many others. It was only much later, when I was a mature man, that I became familiar with a literature which perhaps has impressed me even more deeply, viz., Russian. But in the beginning I knew it only in translation.

After the year in Meran my health became more stable and I could go to school regularly. In Helsingfors I attended a school for boys in which the main emphasis was on the study of Latin; in the last three forms I also read Greek. The subjects which interested me most, however, were mathematics and history, and I was more attracted by the natural sciences, particularly physics, than by either the modern or the classical languages. On the whole I enjoyed my later school years very much. I was also fortunate in establishing many friendships which may now safely be pronounced lifelong.

My interest in philosophy did not develop gradually but came all of a sudden. I remember this very clearly. It happened at Christmas in the year 1929. At school we had been introduced to the elements of astronomy and the teacher had mentioned the hypothesis about the origin of the planetary system put forward by Kant and by Laplace. Kant was a philosopher, we were told. Philosophy was not astronomy or physics or mathematics. So what was it? My father, who had himself studied philosophy with Edward Westermarck, gave me some helpful answers and some books to read for further information. I found at once that philosophy was "my subject" and my determination to become a philosopher was firmly fixed from that moment.

Among the books my father had suggested to me there were two which I read and reread and digested very thoroughly. They were *Einleitung in die Philosophie* by Wilhelm Jerusalem and a textbook on psychology by the Swedish philosopher and fine essayist Hans Larsson. It was chiefly from these books that I learnt the elements of philosophy. As was perhaps natural for a youngster in early puberty, I was fascinated first and foremost by the mind-body problem and by the metaphysical theories on the nature of reality. My early philosoph-

ical beliefs, if they deserve that name, were an identity-theory or neutral monism in the spirit of Mach and Avenarius. Strangely enough, this is an area in which, as an active philosopher, I have (so far) done no work at all.

In May 1934 I graduated from school and in September that same year I was enrolled as a student at Helsingfors University. I devoted myself wholeheartedly to my studies and kept somewhat aloof from students' activities and nonacademic pursuits—though not from the company of my friends. After three years I graduated, having taken major examinations in (theoretical) philosophy, world history, and political science, and a minor examination in mathematics.

In those years Eino Kaila was professor of philosophy in Helsingfors and at the height of his powers. He was widely admired as one of the intellectual leaders of the country. His charisma was enhanced by the fact that he was also exceedingly good-looking. In the years immediately preceding my matriculation, Kaila had paid long visits to Vienna, and while I was at the university he was championing in Finland and Scandinavia the 'new philosophy' of Russell, Wittgenstein, and the Vienna Circle.

Through his wife, who was a cousin of my mother's, Kaila had heard about my interest in philosophy, and before my first term began he received me privately to discuss my studies. In the course of our conversation he asked whether I was more interested in philosophy of the 'logical' or of the 'psychological' type. (Psychology was still considered as a part of philosophy in Helsingfors, and Kaila was outstanding in both disciplines.) I found the question bewildering. After some groping efforts to reply, which Kaila dismissed as being beside the point, I thought I had better make up my mind on the spot and said: logic. This was probably the most consequential answer I ever gave to a question. Kaila then proceeded to assign to me some books to read outside the prescribed curriculum. Among them were Carnap's *Abriss der Logistik,* Dubislav's *Die Definition,* and, I think, Carnap's *Aufbau.* Carnap's *Syntax* had just appeared, but this, Kaila said, was too difficult for me; I could read it later. Kaila also advised me to concentrate from the beginning on philosophy and to leave the other subjects, except mathematics, for a later stage in my studies for the degree.

The readings which Kaila had suggested opened a new world to me. Until then I had read only an elementary text on traditional logic. The 'new' logic, to begin with, gave me many headaches. I found it quite difficult, I remember, to grasp the theory of the truth-functions, the notions of free and apparent variables, and the idea of formal proof from axioms. Only towards the middle or end of my first term—I also attended Kaila's lectures on logic—did I definitely feel that I was firmly on the track and that logic had become for me the gateway to serious philosophizing. My five-year period of philosophic puberty had come to an end.

In the course of the year Kaila put in my hands Philipp Frank's *Das Kausalgesetz und seine Grenzen* and asked me to prepare a paper on it for his seminar. He also directed my attention to the area of induction and probability. When the school year ended in May, he advised me to devote myself definitely to philosophy and gave me a number of books to study during the summer. One of the books was Keynes's *Treatise on Probability*. At that time I knew no English. The little I had learnt as a child in Brooklyn had long since been forgotten, and at school I had no instruction in that language. When I confessed my ignorance to Kaila, he said with characteristic directness that this was not the right way to reply to his suggestion and that after reading Keynes's book I would know some English. Thus Keynes's *Treatise* literally became my English 'primer'. (But I did not learn to speak and write English until one year later when I spent the summer in England and attended a language institute in London.)

My second year of university studies was also devoted to philosophy. I was writing my thesis *pro gradu* and reading for the final examination. The thesis was inspired chiefly by Popper's *Logik der Forschung,* which had just been published (1935) and which I read and reread with great enthusiasm. The theme of the thesis was what Popper had called the *Abgrenzungsproblem,* or the question of how to characterize the realm of empirical knowledge and demarcate it on the one hand from mathematics and logic and on the other hand from metaphysical speculation. A notorious difficulty was presented by probability statements, which, under the limiting frequency interpretation (then much in fashion) are neither verifiable nor falsifiable. A considerable portion of the thesis was therefore devoted to a discussion of probability. In addition to Keynes and Popper, I studied with particular care the writings of Reichenbach, von Mises, and Hempel. For the final examination I read Wittgenstein's *Tractatus,* Carnap's *Aufbau,* and, as far as I can remember, Carnap's *Syntax,* and a number of articles—by Carnap, Neurath, Schlick, Waismann, and others—in *Erkenntnis.* After the examination Kaila told me that I had helped him to understand *Tractatus* better. But the fact is that my own understanding of Wittgenstein's work, which I much admired, was at that time almost nil.

I have listed here my early readings in philosophy with a minuteness which some readers may think excessive. These readings did perhaps not contribute very much to the formation of the particular views which I later expressed in writings of my own. They nevertheless left a deeper imprint on my intellectual development than most of the systematic reading I did later.

If ever I held a philosophic 'creed' in any strong sense of the term, it was in those formative years of my university studies in Helsingfors. And this creed was logical positivism, or, as my teacher Kaila preferred to call it, logical empiricism. It was a position which came closest to the one held by Carnap in *Syntax.* It was perhaps not so much a 'positivism' as a kind of 'conventional-

ism' in the spirit of the Carnapian *Toleranzprinzip*. Maybe one could also describe it as a view according to which there were no *fundamental* problems left in philosophy. What remained to be done was merely to elaborate the consequences of adopted basic postulates or to carry out in detail various sketched 'programs'. Such programs were, for example, to show exactly how physical-object statements had to be analyzed in terms of sense-data statements, or how statements about sensations and other states of consciousness could be analyzed in terms of neural statements. 'Philosophically' both possibilities seemed indubitable and equally sound.

I still vividly recall the impression I had that a revolution had occurred in philosophy and put an end to disagreement about fundamentals. The new philosophy seemed incontestable, yet I refused in my heart to believe that it would not one day be contested. Only I could not see *how*—and this blindness is, I think, a characteristic of a genuine *Weltanschauung:* it delimits the thinkable.

In the remaining period of my studies for my degree I read history and political science. In those subjects I attended a minimum of lectures and had little contact with my teachers and fellow students. I read thousands of pages in a relatively short time and developed for myself a technique of quick reading (from sixty to eighty printed pages an hour) which I have also found useful later in life. My experience is that quick reading is an advantage to learning and also to retaining the material. Yet I dislike this way of reading and resort to it only under the pressure of time-shortage or some other necessity. Its great drawback is superficiality. Normal reading, when attentive, also involves reading between the lines, and this accompanying reflective process is eliminated in quick reading. I think this is something educators should remember—and I mention it here because reading has always been a 'problem' for me: what to read, how to read it, and how to compromise between time given to reading and time given to independent thinking.

In history I specialized in Renaissance studies and wrote a paper on Machiavelli's political philosophy. After passing the final examination in the early spring of 1937, I travelled for three months in Italy with a friend, Göran Schildt, art historian and writer. It was *the* journey of my life, animated by the enthusiasm of youth and an immature overestimation of my intellectual capabilities and aesthetic sensitivity. No fact of history should fail to be stored in my memory and assigned its proper place in the complete picture of mankind's past which I was going to build up for myself; no work of art should fail to be evaluated for its beauty and significance. These fancies were, of course, not part of a program for my professional work. But they were characteristic of the *Stimmung* in which I then viewed life.

Here a comment on my early attitudes to life may be in place. The attitudes have changed and the *Stimmung* referred to above has faded; but I think both have left lasting traces in me. Their formative sources were largely my friend-

ship with Schildt and the influence of our much admired teacher Kaila. A writer must also be mentioned here: Jakob Burckhardt. My first acquaintance with him was through *Kultur der Renaissance in Italien* and *Cicerone*. In these works there is an implicit 'humanism,' which is more explicitly professed in the *Weltgeschichtliche Betrachtungen*. This humanism, or something closely akin to it, stamped my attitude to life during the early years of my intellectual development.

A characteristic of this attitude is a view of history as a sort of *tableau vivant,* to be looked at in awe and contemplated like a work of art.[1] In the details of history one should try to discern the typical, the 'morphological similarities', the recurrent patterns. The great changes, the crises and revolutions of history, are like earthquakes and other catastrophes in nature. They cannot be judged under the moral categories of justice or rightness. But they may, like life as a whole, be seen in the light of 'tragedy'.

Being myself a philosopher and more inclined than Burckhardt to speculate about history, it is understandable that Spengler too should have strongly fascinated me in my youth. Later, in the early 1950s, my reading of Spengler resulted in a series of essays. (See Bibliography, items 126–132 and 147; hereafter cited with the prefix B.) I still think that Spengler is a great, though neglected and widely misunderstood, source of inspiration for thinking about history.

Another feature of the Burckhardtian humanist attitude is the admiration of *greatness*—greatness of achievement but also of personality (Goethe, Leonardo). Greatness is an unpredictable chance element in history; it is largely through greatness that the typical and recurrent gets its individuality.

A humanism such as Burckhardt's is apt to lead to a devaluation of the present, the not-yet-historical. This in turn encourages conservatism and a certain indifference or coolness to existing evils and injustices. Neither Naziism nor the Spanish civil war moved me very much. I remember the deep revulsion I felt at the news of Nazi atrocities, for example, the 'crystal night' in November 1938—but this revulsion was only sentimental and had no relation to my reflective views.

Perhaps one could call the attitudes to life and to history which I have described an 'aesthetic humanism'. Its program is 'dem Geist der Menschheit erkennend nachzugehen' and its delight a contemplative understanding of what has been. A tendency to take refuge in this disengaged position is still strong in me.

The overwhelming impressions of Italy and the strain of the journey so exhausted me that in the autumn of 1937 I passed through a nervous crisis. This interfered with my work and, I think, aggravated a certain hypochondriac disposition in me which apparently is inherited and which I can recognize in retrospect also when thinking back on the longish periods of illness in my childhood.

As a consequence of these troubles I broke off the studies which I had already commenced for a major examination in mathematics. I think the fact that I never had a 'full' education in that discipline left its stamp on the work I later did in logic. Knowing more mathematics might have helped me to avoid errors and would have spared me the time which I have sometimes spent on reinventing for myself segments of what I later learnt were but standard mathematics. (But the time thus spent I do not regard as entirely a waste.)

Though my training in mathematics remained incomplete, two men in the subject contributed to the formation of my intellectual character. One was Rolf Nevanlinna, who was also a close associate of Kaila's circle. As a graduate student I attended his course on the foundations of geometry—legendary in the annals of university teaching in Helsingfors for its brilliance and depth. As an undergraduate I had attended his lectures on probability. The other was Ernst Lindelöf, then the much-venerated Nestor of Finnish mathematicians. Lindelöf, who was a relative on my mother's side and in whose home I took piano lessons from his sister, showed a fatherly interest in my studies generally, even before I entered the university. His *great* quality as a teacher was the example he set of uncompromising honesty and precision in the mathematical craft.

Immediately after my graduation I began to look around for a topic for a doctor's dissertation. Kaila had several interesting suggestions. The one which attracted me most was semihistorical and concerned the contrast between the Aristotelian and the Galilean traditions in the philosophy of science. The 'point' of the thesis would have been to show how the Galilean conception had, in modern times, come to invade and transform psychology and the (non-historical) human and social sciences generally. As Kaila saw it, Galileanism stood for 'progress', Aristotelianism for the atavistic remains of primitive thinking in philosophy and science. Behind Galileo and the scientific revolution of the seventeenth century loomed the figure of Plato. With the full passion of his artistic and philosophic temperament Kaila sided with Plato against Aristotle. It was most engaging to hear him talk of these giants in the history of thought. At the time I wholeheartedly shared his vision—so very different from the perspective which I came to entertain later in life and which I have sketched in the first chapter of *Explanation and Understanding*.

I spent most of the first half of 1938 reading Galileo's dialogues and other literature relating to the two traditions in the history and philosophy of science. But in the end I shifted back to pursuits in which I had already been engaged during my undergraduate years. I proposed to Kaila a plan, of which he thoroughly approved, for a thesis on the justification of induction. The second half of the year was spent in reading the relevant writers: of the classics chiefly Bacon, Hume, Mill, and Jevons; of the moderns Keynes, Nicod, Ramsey, Broad, von Mises, and Reichenbach.

It had of old been customary that a Finnish postgraduate student working on his thesis spend some time in a foreign university. Considering the educa-

tion I had had in Helsingfors, the natural place for me to go was Vienna. Thither had gone my friend and fellow student Max Söderman, who graduated two years before me.[2] On my way to Italy in 1937 I visited him there, and he introduced me to Gödel and to Viktor Kraft. The 'circle', however, was then rapidly dispersing. One year later came the *Anschluss,* which put an end to my dreams of studying in Vienna. My prewar impressions of that city were of a dying cosmopolitanism in the melancholy twilight of 'old Europe'. My postwar impressions have been of an arid parochialism, of a place where not even memories are any longer alive. I spent a fairly long time in Austria in 1952. Kraft was then about to retire. I attended a couple of his postgraduate seminars *(Privatissima),* which, as he himself remarked at our final meeting on 27 June, had been the last link at the university level with the former *Wiener Kreis.* Now it was all finished.

My readings in induction and probability had taught me that Cambridge was a place with an impressive living tradition in inductive logic. So, *faute de mieux,* I decided to go there to work on my thesis. A stipend from Helsingfors University and another from my student fraternity, or 'nation', provided the necessary financial backing. Early in March 1939 I arrived at the place which was to become a second intellectual home for me. I had had no previous contacts with people there and knew only of R. B. Braithwaite and C. D. Broad. I called on Braithwaite first. He told me that Wittgenstein was in Cambridge. This was complete news to me. My ignorance of the fact reflects, I think, how undeveloped was the network of communication among scholars and centers of study in prewar Europe compared to what it is nowadays.

From Broad, who was chairman of the Faculty of Moral Sciences, I got permission to attend lectures and seminars. I decided to hear G. E. Moore and Wittgenstein. After having been to Moore's class twice I gave up. Moore's way of discussing philosophy did not then in the least appeal to me. Later in the spring I heard him read his paper on certainty to the Moral Sciences Club and attended the famous discussion of it at his 'at home' in the presence of Wittgenstein. Shortly before returning to Finland in the summer we had a discussion which I found exciting. But my *great* appreciation of Moore, the philosopher and the man, I did not acquire until much later.

My first encounter with Wittgenstein was rather dramatic. I went to his lecture in a room in King's College, introduced myself when he entered, and said that I had the chairman's permission to attend lectures in the faculty. Wittgenstein muttered something in reply which I did not understand, and I seated myself among the audience. He started to lecture and I became at once deeply fascinated. ''The strongest impression any man ever made on me'', I wrote in my diary that same day—and the statement remains true. At the end of the lecture, however, Wittgenstein expressed his great annoyance at the presence of 'visitors' in his class. He seemed furious. Then he left the room without

waiting for an apology or explanation. I was hurt and shocked. My first impulse was to give up efforts to approach this strange man. But I also wanted a straightforward answer as to whether I could come to his lectures or not. So I wrote him a letter—thinking that it would probably remain without answer. I was therefore much surprised when a few days later I got a friendly reply from the man whom I had so angered. He was not going to let me come to his lectures, he said, but he was willing to explain *why* if I came to tea with him at an appointed time. I went, and we had a friendly conversation—mainly, as I recall it, about architecture and about Norway. I told him what I was doing in Cambridge, and he explained to me why he had not liked my presence in his class. Term was approaching its end and he would not allow me to come to his lectures immediately; but I could come next term. He promised to look me up in the Easter vacation and discuss philosophy with me. This he did, and when the Easter term started I was one of the 'recognized' pupils in his class.

The lectures Wittgenstein was then giving were on the foundations of mathematics. They have later been reconstructed and published (1976) from the notes taken by four of the people attending the class. I never took notes of Wittgenstein's lectures, but concentrated on trying to follow his train of thought. In retrospect I think it right to say that I understood next to nothing of what was going on, although I found Wittgenstein most impressive and stimulating. The same holds true of the conversations we had in 1939 and which continued until I returned to Finland in the middle of the summer. What Wittgenstein did was to completely 'shake me up'. The position in philosophy which I had come to hold during my studies with Kaila was being called into question, the basic problems of philosophy, which I had considered settled, revived. I felt that I had to start again from scratch in philosophy. But in order to reach 'scratch' I had to crawl back quite a way—and this I could not accomplish quickly. It happened during the war years in Finland. I then wrote a book (B28), the Swedish title of which would translate in English as "Logical Empiricism". It can in some ways, I think, be compared to Ayer's *Language, Truth, and Logic,* though lacking the brilliance and persuasiveness of Ayer's masterpiece. It was for many years used as an elementary text in several Scandinavian universities. Although it gives an objective but not critical account of the type of philosophy in which I had myself been reared, its subjective role in my intellectual development was essentially that of a farewell to the philosophy of my student years.[3]

Among the people who attended Wittgenstein's lectures in 1939 were Casimir Lewy, Norman Malcolm, Rush Rhees, Yorrick Smythies (in whose rooms the classes were held), and Alan M. Turing. I did not, however, associate much with them. My thesis kept me busy. Its plan and main ideas had taken shape before I went to Cambridge. My chief concern was to take a stand on what others had said bearing on my problem. To this end I read a great amount

of the relevant literature in English, French, and German and made excerpts. (I still had the illusion that through reading one could acquire *complete* mastery of a subject.) Those fruits of my labors which were not immediately needed for my arguments I stuffed into the big section of notes after the main text in *The Logical Problem of Induction*. This was the title which, notwithstanding Nicod, I finally chose for my book.

The greater part of my days at Cambridge in 1939 I spent in the university library. This was the only period of my life when I worked regularly in a library. I distinctly dislike this type of environment for my work. I prefer to work in close contact with nature, whenever possible out of doors, seated in the sun. My best working periods have been on the island in the Gulf of Finland where my parents built a cottage and where, ever since I was a child, I have spent the greater part of most summers, usually from early June to late August.

The clearly noticeable approach of the war made me ill at ease at Cambridge. After the German invasion of Czechoslovakia I was on the brink of returning home; it was only on the calming advice of my father, who was then in England, that I decided to stay on. I returned home in July. With the Russo-German pact the gloom definitely fell. The outbreak of the war was a matter of course, and barely one month after the invasion of Poland disaster threatened the Baltic area and Finland.

I had been exempted from military service because of my asthmatic disposition. During Finland's Winter War, 1939–1940, I served in a voluntary organization for propaganda on the home front. After the armistice I was called up for regular military service and spent some months doing work for which I was better qualified in a bureau for ballistic calculations. Then I was again a civilian for some months and was able to finish my dissertation and see it through the press. I received my degree on the same day, 31 May 1941, when I married my fiancée, Maria Elisabeth, *née* von Troil. Our two children were born during the later war years.

When we were on our honeymoon, Finland was again dragged into the war, this time as an ally of Germany. I was summoned to the State Information Department, where I worked until the Finnish army was demobilized in December 1944. I was soon assigned the special job of writing a daily bulletin for foreign newspaper correspondents, summarizing the editorials and opinions of the Finnish press. This I did regularly for three years. Never before or after have I benefited so much from my 'quick reading'. I soon learnt to accomplish the day's job in a few morning hours. The rest of the time I was free to pursue my own interests. I was also very fortunate in being located in Helsingfors and allowed to live with my wife in our newly established home.

The war meant the almost total isolation of Finland from the community of scholars at large. Kaila had, somehow, gotten hold of a copy of Quine's *Math-*

ematical Logic. We discussed it in the informal colloquium, or 'circle', which Kaila had kept going since the mid-1930s. Then followed some years of complete silence. I recall the excitement with which we received, towards the end of the war, Carnap's *Introduction to Semantics* and *Formalization of Logic,* the latter as a private loan from Sweden. There is perhaps some significance to be attached to the fact that the shift of center of gravity in philosophical logic from syntax to semantics was retarded in Finland because of the war. Tarski's *Wahrheitsbegriff* had immediately been noted and debated in the Kaila circle. But the full implications of the semantic approach we could not work out on our own. Logical semantics, therefore, did not really get started in Finland until Jaakko Hintikka had appeared on our philosophical stage.

My thesis for the doctorate, the book on logical empiricism, and a few minor pieces of research (including a study on Lichtenberg, B14), qualified me for the position of *Docent* in Helsingfors University. A chair in philosophy with Swedish as its language of instruction had already been instituted before the war but was vacant. After my appointment as *Docent* in 1943 I was asked to fill it temporarily, and three years later I became holder of the professorship.

During the war years university instruction was irregular and classes were very small. As soon as the war was over, the picture changed completely. Students streamed back from the army, entering the open gates of the university, eager to learn and on the average much more mature intellectually than 'freshmen' generally. I think my first postwar years as university teacher, from 1945 to 1948, were overall my most exciting and happiest teaching experience. A good number of people who have since become prominent in academic or public life in Finland attended my lectures and seminars. In 1947 a student of singular brilliance appeared. He was Jaakko Hintikka. For a couple of years he came regularly to my lectures in Helsingfors, and he also visited me in Cambridge when I was a professor there. I think I have contributed to his becoming a philosopher. I have often thought that to have reared *one* such pupil is reward enough for a whole career as an academic teacher.

On the whole I like lecturing. I can testify, most emphatically, to the truth of the saying *docendo discimus*. I am quite sure that the work I have produced would have been *much* inferior had it not been for the frequent urge to present my thoughts to an audience with the maximum degree of clarity and precision of which I am capable. I have learnt much from the criticism and the questions of those before whom I have lectured. But I think I have learnt even more from 'listening' to my own presentation and spotting in it the things which have not carried the full weight of conviction and truthfulness. I am grateful for having been invited to give special lecture courses such as the Gifford, Tarner, or Woodbridge lectures. Most of my books are, in fact, based on lectures which I have been invited to give. Perhaps I have used these lecturing opportunities somewhat egotistically, to clarify my own mind rather than to enlighten the

minds of my audience. But I hope I have sometimes succeeded in conveying an impression of a philosophic brain *unsparingly* at work—and that this impression has not been without pedagogic value.

I am too slow and perhaps not co-operative enough to be much good in debate or group discussion. I used to fear the meetings of the Cambridge Moral Sciences Club during the years when I was its chairman, and I am often ill at ease when I attend or conduct seminars. But I have received immense stimulus from tête-à-tête discussions with colleagues and pupils. Such discussions tend to exhaust me far more than lecturing does and therefore I am perhaps more reluctant than I ought to be to engage in them.

In the summer of 1946 C. D. Broad visited Finland. He stayed three weeks with me and my family, most of the time in a country house which we had rented. It was a great delight to see him again, little changed by the war years, and to continue discussions with him on induction and probability. Thanks to his kind interest in me and my research he sponsored an invitation to me to give a series of lectures on inductive logic at Cambridge in the Easter term of the following year. I was also asked to lecture in London and at Oxford. But my 'headquarters' were at Cambridge, where I stayed until the middle of the summer.

At Cambridge I met Wittgenstein again and went to his lectures. The course, on the philosophy of psychology, was the last he gave before he retired. On this occasion I also got to know well some of the other people who were in the class or otherwise associated with Wittgenstein. Elizabeth Anscombe, Peter Geach, and Norman Malcolm—whose return to Cambridge happily coincided with mine—became my friends for life.

I saw a great deal of Wittgenstein and the impression he made on me was even deeper than that of eight years earlier. Each conversation with Wittgenstein was like living through the day of judgment. It was terrible. Everything had constantly to be dug up anew, questioned and subjected to the tests of truthfulness. This concerned not only philosophy but the whole of life. I now began to understand Wittgenstein better. In this I was helped by reading the then-existing version of the *Untersuchungen*. In our private talks Wittgenstein also mentioned to me his plans for giving up his chair and said that he would like to see me as his successor. This naturally flattered me, but at the same time I was frightened by the prospect.

When Wittgenstein had resigned his chair as from the beginning of 1948, I decided to apply. My decision was influenced by the darkening of the political prospects for the countries between East and West brought on by the outbreak of the Cold War. But I felt very torn, and when the crisis which Finland experienced in its relations with the Soviet Union was over, I withdrew my application. My surprise was total when, some weeks later, I received a cable

from Cambridge asking me to accept the assembled electoral committee's invitation to the professorship. I was overwhelmed, and surrendered.

The three and a half years during which I held the Cambridge chair were not an altogether happy time. I felt remorse at having deserted the place where I was most deeply rooted and which had the strongest claims on my loyalties. I was not yet mature enough to be the holder of a professorship in which my immediate predecessors had been Wittgenstein and Moore; I felt the immense burden of the Cambridge tradition too heavily on my shoulders. Also, I did not like the prospect of my children, then five and four years old, being reared in England and possibly becoming alienated from the culture and traditions of their family. After Wittgenstein's death in 1951 I decided to submit my resignation, and from the beginning of the following year I resumed duties in my former professorship in Helsingfors. I never regretted the decision, but I fully realized that I was giving up opportunities both as a teacher and as a research worker which I was not easily going to regain in Finland.

In my intellectual development the years as professor at Cambridge were quite important. It was then that my interest in modal logic awoke and deontic logic was invented. A careful study of Aristotle's logical writings broadened my horizon in the philosophy of logic, and the preparation of a series of public lectures (1949) on the place of Descartes in the history of scientific ideas (B116) did the same for my knowledge of the history and philosophy of science. I benefited much from supervising a number of good research students and particularly from discussions and work with Peter Geach, Alan Anderson, and Knut Erik Tranøy.

During these years Wittgenstein came to Cambridge on several occasions. Then he usually stayed with us in the big house we had rented in Lady Margaret Road. It was here that his fatal illness was discovered after his return from the United States early in November 1949. For six weeks he lay sick in our home. His last stay was in June 1950. When Wittgenstein was with us, he and I had daily talks, sometimes on things he was working on then, sometimes on the logical topics which were mine at the time, but most often on literature and music, on religion, and on what could perhaps best be termed the philosophy of history and civilization. Wittgenstein sometimes read to me from his favorite authors, for example, from Grimm's *Märchen* or Gottfried Keller's *Züricher Novellen*. The recollection of his voice and facial expression when, seated in a chair in his sickroom, he read aloud Goethe's *Hermann und Dorothea* is for me unforgettable.

Soon after my arrival in Cambridge as professor, Moore suggested that we get together and have regular discussions. I used to go to his house for a talk, on the average, every second Thursday during term time, and we continued to have conversations after my resignation whenever I revisited Cambridge in the

mid-1950s. The topics of our talks were usually selected from philosophical logic—a favorite theme being the nature of propositions. These were hard fights. I cannot say that we made much headway towards results. Nor did Moore 'shake one up' as did Wittgenstein. But he 'kept one at it' through the example he set of painstaking rigor and scrupulous honesty of argumentation and of incessant willingness to be puzzled, over and over again, by the same problems of philosophy. Moore exemplified a rare combination of deep-rooted, almost 'dogmatic', philosophic convictions and living doubt about any argument to defend them or to prove them correct. At the time I shared many of those convictions myself, and they implicitly stamped my own philosophic work for a long sequence of years beginning in the late 1940s. But I think they have by now gradually faded away.

My return from Cambridge at Christmas 1951 may be said to mark the end of my *Lehr- und Wanderjahre* in philosophy. After that I had to stand on my own feet. Kaila, Wittgenstein, and Moore were the three men who had had a formative influence on me as a philosopher. Besides great intelligence and creative originality they exemplified complete devotion and faithfulness to their calling. Kaila had 'put me on the track' and taught me the use of the tools (formal logic) which I have always carried with me, even when shifting interests have made me move into new areas of philosophy. Perhaps I could say that I learnt my 'method' from him; or that if as a philosopher I carry the label 'philosophical logician' it was Kaila who made me one. But as far as the 'content' of my philosophic thoughts goes, I think I learnt and continue to learn most from Wittgenstein. He molded my conception of what philosophy is. He made me realize that one cannot hope for 'final solutions' in that subject. Many things which philosophers say, naively simplifying matters, I could never say, having learnt from Wittgenstein to appreciate the conceptual multiplicity of the situations with which the philosopher has to cope. The insights which I acquired from him were thus essentially 'negative'. I am still struggling to transform them into something 'positive' as he successfully did himself. But my way will have to be different.

The same year I had gone to Cambridge as professor, Kaila became a member of the newly-instituted Academy of Finland and had to give up his university chair. Some other chairs in philosophy being vacant too, there followed an *interregnum* in Finnish philosophy. Kaila eventually got a successor in Oiva Ketonen. He was one of several promising mathematicians whom Kaila had attracted to logic and philosophy. Another was Erik Stenius, who first became professor in the Swedish university at Turku (Åbo Academy) and later succeeded me as professor in Helsingfors. Hintikka too found his way to philosophy from mathematics. The alliance between the two subjects is a noteworthy factor in the creation of the tradition which has given Finnish philosophy its characteristic profile for the past half-century.

Kaila's years as academician were spent in passionate but inconclusive efforts to integrate his views of physics, biology, and psychology into a *Naturphilosophie* as he, alluding to the Romantic tradition, used to call it. His work remained a torso. He died unexpectedly in August 1958. Like Wittgenstein and Moore he was occupied with philosophy to the very last. But he had become an isolated figure both in his own subject and in intellectual life generally in Finland. The touch of arrogance coupled with a dashing brilliance characteristic of him at the height of his powers had made him many enemies among petty characters, whose actions, inspired by envy and revenge, contributed to the alienation and pessimism of his later years.

Shortly after my return to Helsingfors from Cambridge, the professorship in moral, or, as we call it, practical, philosophy fell vacant because of the death of its holder, Erik Ahlman. I had already been acting in that chair before I moved to Cambridge and was now asked to act in it again. During the greater part of my total time as professor in Helsingfors University I was in fact acting in one or another chair besides my own. (For some time I also acted in Kaila's vacant chair and in the chair at Åbo Academy.) This made my teaching load relatively heavy. On the other hand it enlarged the circle of students whom I reached in my teaching. My own chair, in philosophy, was in the faculty of humanities and its language of instruction was Swedish. The chair in practical philosophy was in the faculty of political science and its language was Finnish. I also had to select the topics for my teaching from a broader area than would otherwise have been the case. This fact, in turn, contributed to a gradual shift in the center of gravity of my interests and research.

Kaila had been professor of theoretical philosophy and as a student of his I had had no training in value-theory or moral or legal or political philosophy. My own work had so far been mainly in inductive and modal logic, with one casual digression into the new province of deontic logic. My enlarged teaching duties committed me to a study of the classical and relevant modern texts in those other fields of philosophy, particularly ethics. My own ideas matured and took shape in the course of a constant confrontation with the thoughts laid down in the great ethical writings of Aristotle, Kant, and Moore. One author, whom I also found very stimulating to read, was Max Scheler. Another external impetus which pushed my research in a new direction was the invitation to give the Gifford Lectures at St. Andrews in 1959 and 1960.

A side interest which engaged me much in the years after the war until the end of the 1950s should also be mentioned here. It was an interest in the philosophy of a more visionary nature implicit in the work of Dostoevsky and Tolstoy, in Milton's *Paradise Lost* and Goethe's *Faust,* to mention only a few examples. I used to write essays in which I tried to clarify my own impressions from reading the authors concerned and to explain their relevance, as I saw it, to a reading public with roughly the same cultural and educational background

as my own. Many of the essays were also published in a book (B147) dedicated, "To My Friends". The nonprofessional nature of these writings and the fact that the essays were written in my own native language (Swedish) has kept me from making them available to a larger public. (Many of them have been published in Finnish translation, however.) I consider this restraint justified.

I think that one motive behind my essay-writing activities was a feeling of the discrepancy between the narrowly restricted relevance and scope of my professional work and the drive which I always felt to make philosophy relevant to my life and my understanding of the world. Perhaps *one* reason why I gradually abandoned these activities was that this rift in my philosophical personality—though still there to this day—has begun to heal. A perceptive reader of *The Varieties of Goodness* and *Explanation and Understanding* will, I think, see what I mean.

I mentioned above the aesthetic ('Burckhardtian') humanism which had been characteristic of my attitudes as a young student in the 1930s. In the second half of the 1940s these attitudes began to change. This change came with an awakening interest in moral and religious problems, or perhaps one should say in 'the problems of life'. I doubt whether the war had much to do with this. My appointment to act in the chair of practical philosophy was probably a more important factor. Discussions with Brazilian writer and non-professional philosopher Mario Vieira de Mello, who was stationed as a diplomat in Helsingfors and later in Oslo, meant a great deal to me. Through de Mello I was led to study the three volumes of Werner Jaeger's *Paideia,* which deeply impressed me.

These new attitudes were decidedly self-centered and individualistic. The problems of life were for me the problems of *'hiin Enkelte',* to use Kierkegaard's expression. The goodness and badness of social and political conditions and institutions mirrored the individual human agents' moral qualities. A 'revolution' in the external conditions of life could be of 'deeper' interest and significance only if it sprang from the inner conversion of men to a better life. Following Jaeger, I read Plato's *Republic* in the spirit of such an individual-centered humanism. Since then my views have changed a good deal, and both the 'aesthetic' and the 'ethical' humanism of my earlier years now seem to me immature and insufficient.

In 1961 I was appointed to the Academy of Finland and ceased to be a university professor. This meant a great change in my working conditions. As a member of the academy I had no teaching duties and, except during the two years when I was the academy's president, no regular administrative duties. But I retained the right to teach in my former university. Of this right I have availed myself regularly, except when I have been absent abroad. During some terms I have lectured—but my main contribution to instruction has been the conducting of research seminars, the instituting of interdisciplinary and inter-

university colloquia, and the organizing of small-scale international symposia. By engaging in activities to promote international contacts in general and those between Finland and the 'outer world' in particular, I have tried to repay a small part of the great debt of gratitude I feel for the hospitality and kindness shown to me in connection with my travels and visits to centers of learning in nearly all parts of the world.

Although Helsingfors University was always generous in granting me leave, my appointment to the academy greatly increased my possibilities for travel and long absences abroad. In 1954 I had already been visiting professor to Cornell for one semester. This visit laid the foundation for a long alliance which was further cemented by my election, in 1965, as Andrew D. White Professor-at-Large at that university. Some of my most stimulating teaching experiences are from lectures and seminars at Cornell. Most exciting of all was perhaps the seminar course on Wittgenstein's *Tractatus* which I gave on the occasion of my first visit. Rogers Albritton, Max Black, Stuart Brown, Norman Malcolm, and Jack Rawls attended regularly, and among the several good graduate students three stood out from the rest: Keith Donnellan, Carl Ginet, and Sydney Shoemaker. What a brilliant constellation of philosophers! The intense atmosphere of discussion and exchange of thought characteristic of the philosophy department at Cornell is perhaps the finest example I have seen of collective devotion to a subject. After Helsingfors and Cambridge, Cornell has become my third intellectual home.

My frequent and regular visits to the United States have contributed significantly to the changes in attitudes which I have undergone in the last ten to fifteen years. To begin with, I became more rationalistic and optimistic than before. Though in my youth I had been a positivist of a sort, I had never shared the belief in 'progress' through the advancement of science and diffusion of knowledge which has been the ethos of the positivist tradition. My humanist attitudes had been connected with a pessimistic view of reform and a sceptical view of the implications of science and technology for society. This was perhaps a natural attitude for a European intellectual of the mid-century. But the science-centered rationalism of many of my American colleagues, not only philosophers but also mathematicians and behavioral scientists, was contagious. I received a particularly strong impetus in this direction during my stay as Flint Visiting Professor at UCLA in 1963. My own research was then centered on the formal logic of actions, norms, and valuations (preferences). (The year 1963 saw the publication of *The Varieties of Goodness, Norm and Action,* and *The Logic of Preference*.) I began to take an interest in cybernetics and mathematical behavioral science. I thought I was witnessing a breakthrough of exact methods and thinking in the study of man comparable to the revolution in the sciences of nature which had taken place during the late Renaissance and Baroque periods. A segment of reality, viz., the world of man and society, which

had hitherto been veiled in relative obscurity, was becoming illuminated by the light of reason. Did this not signalize a hope that the attitudes of men to their fellow humans and their co-operation on the societal level would also assume a more rational, and thereby more humane, character? This vision determined my intellectual mood through the first half of the 1960s; and I gave it expression in a number of essays, papers, and talks (mostly in Swedish; B183, 196, 206, 207).

What had so far been missing from my thinking about the condition of *man* was a serious interest in the conditions of *society*. My rationalist humanism too, if I may use that name for it, had been individual-centered. Its hopes for a *regnum hominis* were vested in the effects of scientific and technological progress on the enlightenment and well-being of the individual. It ignored the fabric of institutionalized human interrelationships through which these effects had to be channelled. What made me reflect on the human condition in the light of societal forces and institutions can be condensed in one word: Vietnam. My engagement began when I joined in the protests of my American colleagues and other intellectuals against the atrocities of a war void of any justification and involving a massive deception of public opinion. But it soon developed into a critical review of my own past and relations to the world and in the end effected not inconsiderable changes in my attitudes and viewpoints.

I grew up in a bourgeois family in a country with a tradition of parliamentary democracy and with an economy based on free enterprise, in short, a country molded on the current 'Western' pattern. Thanks to my education and professional activities, contact with other countries and cultural traditions within this Western sphere became an integral part of my life. I am ineradicably a Westerner, or rather, a latter-day member of a European community which once existed. This is nothing I regret and it would be wanton to try to change it.

In the process of becoming what I am, I came to accept, to take for granted, a great number of standards for judging things and valuations implicit in the societies in which I had been living—in Finland, in England, in the United States. Such norms and valuations constitute a kind of *Weltbild,* or frame of reference, of which one is only dimly conscious and which one does not ordinarily analyze or try to revise critically. What was true of me in this regard is true, I think, of all men with the exception perhaps of a few of a very cosmopolitan or mixed cultural background.

I was, of course, well aware of the fact that there existed countries in this Western orbit which conformed very badly to the avowed Western standards, such as Germany in the 1930s or Portugal and Greece at the time (1973) when I was writing this intellectual autobiography. But they were exceptions, to be accounted for in the terms of unfortunate circumstances or peculiar traditions. There was always hope that, given time, they would return to normal, if not

by themselves, then after the shake-up of an armed conflict like the 1939–1945 war. It did not occur to me that these cases might be symptomatic of something inherent in the Western standards themselves. At the time I implicitly accepted the Cold War ideology and the notion that the defense of 'freedom' justified the suppression of any popular movement which ventured to overthrow an existing regime in the name of a socialist revolution.

It was these implicit beliefs that the Vietnam war challenged. The challenge had to be followed up by extensive reading, not only in contemporary history and current affairs, but also in social and political theory. I came to realize that the interpretation of events was not nearly as univocal as I had been used to thinking. In a different frame of ideas the world looked rather different.

Challenging what one has taken for granted, exposing to the light of consciousness the presuppositions of one's own thinking and judging, is the characteristic role of the intellectual as a critic of his times. Since these presuppositions are not the beliefs and prejudices of individual men but something engrained in the institutions and traditions of the community, their examination is inevitably a scrutiny of the foundations of society as the frame of life of the individual. For this reason, a critical concern for the condition of man is perhaps best termed 'social humanism'.

It is premature to say what implications these changes in my attitudes will have for my work in philosophy. They have in any case broadened my interests and extended them also to traditions in philosophy of which I had little knowledge and no understanding earlier. I now know that I can learn something from Hegel and even more from Marx and from some writers in an undogmatic and unorthodox Marxist tradition. The still tentative tracing of new paths in my philosophy can be noticed in the beginning and concluding chapters of *Explanation and Understanding*.

II

My early research, roughly from 1938 to 1947, had its center in inductive logic. It was Kaila's advice rather than my own spontaneous interests which had put me on that track. This had happened in my first undergraduate year (1935). When some years later I chose the 'problem of Hume' as a topic for my dissertation, I felt that I was continuing Kaila's work, in some of his early writings, on the problems of induction and probability. The approach was from the angle of epistemology rather than formal logic. I think it is fair to say that the 1941 version of *The Logical Problem of Induction* adds little which is new or original to the ideas which I have 'inherited' from Kaila or which were otherwise current among the logical empiricists of the day. I still consider these ideas basically sound. But I think there are other, perhaps more rewarding,

ways of dealing with the problem of justifying induction. Max Black has indicated some such ways in several of his writings. Hints in a new direction are also given in an added section to the revised edition of *The Logical Problem*, which appeared in 1957.

When in what follows I call ideas which I have had 'new' or 'original', I do not exclude the possibility that the same, or very similar, thoughts have been entertained and also publicized by others before me. In giving them those epithets, however, I claim them as *my own* in the sense that I have not antecedently found these ideas in the literature or heard others suggest them. (But I have sometimes subsequently discovered them in the work of other writers.) The thoughts have seldom, if ever, come to me as the (immediate) fruits of reading. Sometimes they have come in the course of writing about the topic to which they belong. But quite often they have been by-products of work in an area *different* from their own. They have usually 'dawned upon me' unexpectedly, and their birth was often connected with a concrete episode such as a solitary walk or a conversation with a friend.

The first philosophic idea which I can claim as my own in the sense just explained occurred to me during Finland's Winter War in the early months of 1940. I put it on paper as soon as the war was over, sent my essay to Broad, and had the good fortune of getting it published in *Mind* that same year (B5). The essay is entitled 'On Probability'. It is, I believe, the only writing of mine in which any stylistic influence of Wittgenstein or rather of the jargon of Wittgensteinians is discernible. This must be understood against the background of my period at Cambridge shortly before. I cannot remember, however, ever discussing probability with Wittgenstein.

The main topic of the paper is the notion of a random distribution of a characteristic in a potentially infinite extensional sequence, e.g., the distribution of heads in a sequence of tosses of a coin. This notion of randomness, as I still see it, is *epistemic*. Calling a distribution random reflects the lack of reasons for thinking that the frequency of the characteristic is different in any specified potentially infinite subsequence from what it is in the main sequence. A hypothetical frequency of a characteristic in a sequence is a probability measure only on condition that the characteristic is distributed randomly in the sequence, where randomness is being understood in this epistemic sense.

There is a close analogy between, on the one hand, *irregularity,* or random distribution of a characteristic as a condition of adequacy of a frequency definition of probability, and, on the other hand, traditional ideas about the *equipossibility* of alternatives as a condition of adequacy of a logical (Laplacian, *Spielraum*-type) definition of probability. Randomness as an adequacy condition is also related to the demand of *rationality,* which figures in the traditional views associating probabilities with degrees of belief. Thus the three classical types of theory of probability are intertwined in their roots. This, I think, is a

valuable insight. It was far from clear to me when I wrote the paper 'On Probability'. Nor have I been able to express it quite to my satisfaction in later publications. But I should like to return to the topic again.

What prompted me to continue research on induction and probability after I had got my doctorate in 1941 was dissatisfaction with the formal parts of *The Logical Problem of Induction*. The title of the book is in a sense a misnomer since my original interest in the area was predominantly epistemological. After the dissertation my interest gradually shifted to inductive *logic*. My first target was to make clearer the logic of sufficient and necessary conditions and its application to the study of induction by elimination. The idea of dealing with eliminative induction in terms of conditions instead of using the traditional terminology of 'causes' and 'effects' I probably got from Nicod. I must have noticed Broad's paper 'The Principles of Demonstrative Induction I' (*Mind*, 1930) but, curiously enough, it did not influence my own work. It was not until I read Broad's review articles on my thesis in *Mind* (1944) that I came to realize that my logic of conditions and analysis of the canons of induction had been anticipated by Broad to a much larger extent than by Nicod.

The logic of conditions and the theory of induction by elimination embodied in *A Treatise on Induction and Probability* was first sketched in a paper in Swedish in 1942 (B15) and worked out in detail in connection with lectures in Helsingfors in the academic year 1945–1946. For a long time I used to think of this work as well-nigh exhaustive of everything of interest to *logic* in the traditional study of inductive methods. But in recent years I have come to change my view. First, I think that the logic of conditions itself can be more profitably studied as a fragment of modal logic than—as was the case in my earlier work—as a fragment of predicate logic. Secondly, I have found that the logic of inductive methods has important connections with the logic of action concepts. Not until these connections have been studied in detail will one be able to give a satisfactory account of the logic of the specific mode of action we call experiment. As I see things now, the whole field of inductive logic in the tradition of Bacon and Mill will once again have to be dug up completely and investigated with the tools of logic. (A small beginning in this direction is made in the chapter on causation in *Explanation and Understanding*.)

Dissatisfaction with the formal treatment of probability in my thesis made me embark, in 1943, on the research which resulted in the longish essay, *Über Wahrscheinlichkeit* (1945[B46]). It too is far from satisfactory, but shows much progress in comparison with the thesis. It also contains an expanded and improved version of my views in the 1940 paper on the problem of randomness. But it mainly embodies three new ideas.

The first concerns a minor formal point. It is the observation that the Addition Principle, which in most axiomatic systems of probability figures as an axiom, can be proved on the basis of the weaker Complementarity Principle

$P(a/h) + P(\sim a/h) = 1$ with the aid of the Multiplication Principle. Noticing this was quite exciting.

The second is a detailed presentation of the steps involved in the derivation of the theorem of Bayes from the axioms of the calculus. By Bayes's Theorem I do not mean the simple formula of inverse probability often referred to by that name. I mean the principle which allows us, under given conditions, to regard the relative frequency of a characteristic in a sample as the most probable value of its probability. I think that my derivation of the theorem has novel features and that it helps to clarify one of the notoriously obscure corners of applied probability, including the controversial Laplacian Rule of Succession. The tendency in recent years, it seems to me, has again been towards a somewhat uncritical use of inverse probability methods. This holds true both of confirmation theory in the tradition of Carnap and of the neo-Bayesianism advocated by supporters of personalist or subjectivist probability theory. I feel critical about both these trends—and I sometimes doubt whether the amount of energy and ingenuity which continues to be spent on confirmation-theoretic research serves a worthy purpose.

Thirdly, and finally, *Über Wahrscheinlichkeit* proves from the axioms, and interprets in a frequency model, some theorems concerning the way in which confirming instances of a generalization affect its probability. The value of this interpretation seems to me to lie in the fact that it establishes a link (analogy, 'isomorphy') between probabilistic Confirmation Theory (in the somewhat restricted sense, in which I prefer to use the term[4]) and the logic of induction by elimination in the tradition of Bacon and Mill. The discovery of this connection, anticipated in the work of Keynes, excited me very much at the time and still seems to me to be of great interest. To put its main point in a nutshell: the increase in probability of a hypothesis effected by confirmation can be viewed as a measure of the eliminative effect which the confirmation exerts on concurrent hypotheses. Somewhat to my surprise and disappointment, nobody who has since written about induction and probability has, as far as I know, tried to explore in further detail these formal connections between the two main branches of inductive logic. A reason has perhaps been that this study transcends the possibilities of first order logic and requires quantification over predicates.[5] I am sure there will be a time when inductive logicians and philosophers of science overcome their fear of second and higher order symbolic languages. Then brighter prospects will open for a Confirmation Theory worthy of the name.

The ideas embodied in *Über Wahrscheinlichkeit*, with the exception of those on random distribution, were incorporated in an improved form in *A Treatise on Induction and Probability*. The *Treatise* is essentially the synthesis of the research in inductive *logic* proper which I had been doing in the six or seven years after the publication of my dissertation. The encouragement to write up in a monograph the results of the minor publications on the logic of

conditions (B15), on elimination theory (B107), and on probability (B46 and 105) came from C. D. Broad, to whom the book is dedicated. The work was finished in 1948, but did not appear until three years later. In the mid 1950s I was urged by an English publisher to prepare a new edition of my dissertation, which had long been out of print. In this I replaced the weak sections dealing with the formal logic of the subject by a summary exposition of the corresponding parts of the *Treatise*. But in essence the revised edition remains a discussion of the epistemological problem of the justification of induction. The inspiration to deal with this problem I had got from Kaila—and it was fitting that the maturest expressions of my thoughts on it should be dedicated to "my first master in philosophy, as a token of gratitude for what he has taught me and of admiration for what he has done to encourage serious study in logic and philosophy in my country."

Although the completion of my work on the *Treatise* closed a period in my philosophic activities, I have later from time to time been stirred to take up topics in induction and probability for renewed consideration. One such urge came in 1954, when I wrote articles under those headings for the *Encyclopaedia Britannica*. In the course of this work I arrived at a position in the philosophy of probability to which I still substantially adhere. It can be summarized with some oversimplification as follows:

Numerical probabilities are hypothetical magnitudes associated with the occurrence of events under recurrent or reproducible conditions. Such probabilities are, primarily, used for making (statistical) predictions in mass-experiments. This fact accords to the so-called 'laws of great numbers' a peculiar role, the clarification of which involves a discussion of the notions of ('practical') certainty, of randomness (independence), and of reasons for belief.

I was never able to give to my new views a well-articulated and convincing expression. In the mid-1950s I tried to do this in a long typescript entitled 'An Essay on Probability', but could not bring myself to finish it for publication. Three shorter papers, however, present aspects of my later thoughts on the 'meaning of probability'. One (B180) is a critical examination of personalist or subjectivist probability written for a symposium (with Savage and Good) at the international congress for logic at Stanford in 1960. (Work on this paper also, incidentally, became a starting point for my subsequent study of the logic of preferences.) The second (B232) is an examination of Wittgenstein's views on probability. It seems to me that the position Wittgenstein took in some of his writings of the early 1930s is very close to the one I have myself held from the time, roughly, of the *Encyclopaedia Britannica* probability article. I therefore felt that an account of what I took to be Wittgenstein's views at the same time served to clarify my own position.

One of Wittgenstein's tenets had been that the probability of a hypothesis (induction) must be distinguished from the probability of an event and that it is only the latter that can be associated with a numerical measure. This view I

consider important, and I have tried to substantiate it in a paper (B238) on confirmation theory and the concept of evidence. If I am right, the use of probability as a 'measure' of the support which a hypothesis gets from evidence is, in a characteristic sense, 'parasitic' on the primary use of probability for predicting frequencies.

I have not yet abandoned the hope of being able to give to these scattered views of mine on probability a better and more convincing statement. My views appear to be at odds with most of what is nowadays written on the philosophy of this controversial concept.

A special issue of inductive logic to which I have returned from time to time concerns the paradoxes of confirmation. My proposed solution of the puzzles here still seems to me superior to others I know. It consists, briefly, in showing that confirmation through 'paradoxical' instances cannot increase (affect) the probability of an inductive hypothesis—and that this formal result mirrors the fact that such instances *cannot* contribute to the elimination of competing hypotheses about the phenomena involved. I first presented the solution in *Wahrscheinlichkeit* and then, in an improved form, in *Treatise*. The proof, however, contained a formal error. This was pointed out by W. H. Baumer in a paper in 1963. Baumer's criticism stirred me to take up the problem once more and to correct the error, which did not affect the substance of what I had to say. Work on this kept me busy for quite a time and also led to some new ideas concerning the notion of a 'range of relevance' of a generalization. A final statement of my views is embodied in the paper 'The Paradoxes of Confirmation' published in 1966 (B202(a)). (But it should be read in conjunction with what I had said in earlier writings on the paradoxes and elimination.)

Not counting a minor piece of historical research—on Lichtenberg as philosopher (B14)—which I had done during the war years, it was not until after my second visit to Cambridge in 1947 that my creative work began to extend beyond the orbit of induction and probability. I was preparing an elementary course of lectures on logic for my class in Helsingfors and was struggling with the problem of giving an acceptable account of logical truth in the predicate calculus. Could not the notion of a truth-functional tautology be applied to quantified expressions also when the quantifiers ranged over a potentially infinite domain of individuals? After much experimenting with formulas of the monadic calculus, I discovered the following: if instead of pulling out the quantifiers to form a 'prefix' of an expression of the truth-functional type one pushed them as far as possible inside, one could exhibit the entire formula as a truth-functional compound of quantified units of a uniform structure. These units are either identical with one another or independent of one another. One could then test in a truth table whether the compound is a tautology in the

terms of those units, or existence-constituents as I called them later, and thus decide whether the formula is a truth of logic or not.

This seemed to me a most promising discovery,[6] and I at once proceeded to extend its basic idea to relational expressions. It was not very difficult to see that any fully quantified expression of the traditional predicate calculus can be transformed into a truth-functional compound of uniformly built existence-constituents—and thus given a normal form analogous to the normal forms of expressions in the propositional calculus. Hintikka was a freshman in the class for which I had prepared the lectures. His interest in the problem was aroused, and the theory of distributive normal forms—the name was invented by my colleague Ketonen—became the topic of his doctoral dissertation a few years later (1953).

Unlike the case in the monadic calculus, the constituents of quantified relational expressions are not logically independent. The problem then became one of unravelling the logical dependencies among the constituents. A solution to this problem would give us general principles of the distribution of the truth-values over the existence-constituents in a ('mutilated') truth table and thus a method for deciding the logical truth of the formulas.

Work on this problem became almost an obsession with me and kept me busy for some three or four years. I decided to attack it in stages, beginning with binary relations. But the approach through relation logic was not well-suited to my aims with regard to logical truths. In the most nearly final statement (B134) of the results of my endeavors I shifted to an approach through what I called double quantification. This was in 1951. For some years after that I was tempted to proceed with the case of triple quantification, but in the end my energies failed me. I hope someone will some day take up this study again: a theory of triple quantification may shed interesting light on the reasons why there can be no decision method for the whole of quantification theory.

In my inaugural lecture as professor at Cambridge I tried to assess the relevance to the philosophy of logic of the research I was doing on the concepts of tautology and logical truth (B104). I am afraid I did not succeed, then or later, in making this clear. Also, the very nature of my problem remained obscure. One way of describing what I was after would be to say that I wanted to give a completely 'finitist' characterization of truths of logic as tautologies. This characterization, moreover, would have to be independent of truths about numbers (arithmetic). I was anxious to separate logic from mathematics—perhaps influenced in this by Wittgenstein. A remark by Hermann Weyl had much impressed me: "Mathematics is the logic of the infinite." I still think that in this remark is hidden a *deep* truth, which remains to be dug up.

The immediate results of my struggles with the problem of logical truth had been the discovery of the distributive normal forms and the theories of simple and double quantification. This may seem meager in proportion to the energies

spent. But in a less immediate way these preoccupations turned out to be extremely fruitful for my research.

One day early in 1949, when I was walking along the bank of the Cam, the following analogy struck me: in the same manner as the quantifiers 'some', 'no', and 'all' are related to one another, so also are the modalities 'possible', 'impossible', and 'necessary' related. A moment's reflection sufficed to make it clear that the two groups of concepts also shared their distributive features with regard to conjunction and disjunction. Thus it ought to be possible to build a logic for the modal concepts *in analogy* with the logic of the quantifiers.

At that time I had read no modal logic and barely knew of the existence of the subject. I associated it in my thoughts with many-valued logic, and so I found my way first to Łukasiewicz's papers and only later to the *Symbolic Logic* of C. I. Lewis and C. H. Langford. I found all the earlier treatments of the topic very uncongenial and set out to build my own 'system' independently. In the meantime the discovery of some new analogies broadened my perspective of the entire field. One of these new analogies was between the modalities on the one hand and the notions of *'ought to'*, *'may'*, and *'must not'* on the other hand. A fourth triple of concepts which seemed to exhibit the same structural pattern were the notions of *'verified'*, *'undecided'*, and *'falsified'*. These observations grew into a vision of a general theory of modality which had at least four separate branches, viz., the study of the existential, the alethic, the deontic, and the epistemic modalities, as I called them, or the modes of existence, of truth, of obligation, and of knowledge, respectively.

The term 'deontic' was suggested to me by Broad. The birth of deontic logic can be dated, very definitely, to a discussion in my home at Cambridge around Christmas 1949 with Theodore Redpath and Knut Erik Tranøy. (Tranøy was then a research student at Cambridge and lived in the house which I rented in Lady Margaret Road.) We must have been discussing some topic in moral philosophy. I realized what a stroke of luck I had had and immediately set myself to writing a paper on the new logic. I sent the paper to *Mind* where it appeared in the first issue for 1951 (B123). I think I can safely say that nothing I have written has cost me so little effort and been so widely noted. I always felt there was something paradoxical in this.

The appropriateness, as such, of regarding quantification theory as a branch of the study of modality may be questioned. But the 'general theory' point of view had several fruitful consequences. One was the conception of modal logic as a superstructure, or 'second story', to be erected—like quantification theory—on the basis of the logic of propositions. Both Łukasiewicz and C. I. Lewis had regarded modal logic rather as an *alternative* to ('Russellian') propositional logic. This latter conception seems to me to place modal logic in a false perspective. The same criticism holds, in my opinion, of the conception of intuitionistic logic as an alternative to 'classical' logic. The view of modal

logic as superstructure seems to me decidedly the best one and appears now-adays to have become more or less universal. (I later learnt that the idea was not entirely novel. It can be traced back to a short paper by Gödel from the early 1930s and to a paper by Feys from 1937.)

Another consequence of the 'two-story' approach was the transfer to modal logic of the techniques of truth tables and distributive normal forms which were then being developed for quantification theory.

At the congress of philosophy in Amsterdam in 1948 I had been invited to contribute a volume to the then-started series 'Studies in Logic and the Foundations of Mathematics'. At first I declined, thinking that I had nothing suitable to offer. But when modal logic had 'dawned on me', I thought I had found a good subject for a small book and wrote, essentially in the winter and spring of 1950, *An Essay in Modal Logic*. I wrote it in a somewhat nervous hurry, feeling that I was only sidetracking from my main topic of research, which was then logical truth and quantification theory. The peculiar techniques I use in the *Essay* are clumsy and make reading unduly heavy. They were inspired not only by my fondness for distributive normal forms and truth tables but also by a distrust which, at the time, I had of formalized axiomatics. This distrust was, I think, an unwarranted by-product of an essentially sound craving for a criterion of logical truth in the theory of modality. I wanted to treat true propositions of modal logic as tautologies, subject to certain restrictions on the 'turning and twisting' of the combinations of truth-values in the components. A truth table constructed in accordance with such restrictive rules is a kind of semantic model of formulas in a modal system. Later a freer and technically much more manageable and powerful approach to the semantics of modal logic had its breakthrough in the investigations of Hintikka, Kripke, and Kanger. I for my part reverted to the more old-fashioned syntactic methods of formal axiomatization.[7]

If I had to name the most important development in philosophical logic since the Second World War, I should without hesitation mention the revival of the study of modal logic and its broadening into a general theory of the 'varieties of modality'. Epistemic and deontic logic were from the beginning within the orbit of this generalized modal logic. Somewhat later the enormously fertile field of tense-logic was opened up by Arthur Prior. (See below p. 37.) It, in turn, is closely related to the theory of the causal modalities, which was to become in the early 1970s a chief research interest of mine.

My preoccupation with the problem of logical truth roughly coincided with my time as professor at Cambridge. My return to Helsingfors also marks the inauguration, at the beginning of 1952, of a new period in my research. My plan was to deal successively with special topics in philosophical logic, one after the other, over the years. This would gradually, I thought, take me into

the foundations of mathematics (number and set theory). I never reached these farther landmarks. But in the course of the approximately ten years when I was pursuing this line, I produced papers on the problems of conditionals, entailment, negation, and the antinomies of logic. I worked on each of the topics for several years, and most of the essays were the end products of a great number of preliminary versions, often presented as papers for discussion to various audiences. In the case of several of the papers I was greatly indebted to comments and criticism by my friend Peter Geach. During my Cambridge years Geach and I had been doing joint work on a peculiar type of relation logic and on modal syllogisms. The first resulted in a longish paper (B133), but the second we did not finish then to our satisfaction.

The papers of this period on entailment (in B153) and on negation (B165) I consider unsatisfactory. But I think myself that the essay on the heterological paradox (B177) and the one on the Liar (B194) are among the best ones I have written. My position as regards the antinomies could perhaps be condensed in the statement that they represent 'singular points' in a network of concepts and arguments. They are not symptomatic of any 'disease' in our logic, and their existence should not be thought of as 'harmful'. One can deal with them as one deals with division by 0 in arithmetic, viz., 'encapsulate' them when they are discovered.

In the paper on negation (1959) I distinguished between two kinds of negation, *strong* and *weak*. (Later, in *Norm and Action,* I shifted to the terms *internal* and *external* negation.) 'Classical' negation is weak (or external) negation. When we say of a house which has no windows that it is windowless or *lacks* windows or of an agent who intentionally does not do a certain action that he *forbears* from doing it, then we are in the strong sense negating what we are affirming when we say that a certain house has windows or that an agent performs a certain action. I think this distinction between the two kinds of negation important and useful. Their logics should not be regarded as alternatives—any more than one should regard the logic of strict implication (modal logic) as an alternative to the logic of material implication (classical propositional logic). It seems to me, moreover, that one cannot do full justice to the logical intuitions behind Brouwer's intuitionism if one does not incorporate both negations within one system of logic.

The attempt to formulate rules for strong negation in the 1959 paper I regard as definitely unsuccessful, however. I came to realize this in connection with some research on action-logic which I was doing in 1971 and which was in its turn motivated by research on the logic of causation. I believe the new insights which I then had to be consequential, and at the time of writing this (1972) I am engaged in working out their implications for the theory of predication and of truth.[8]

The idea that with *An Essay in Modal Logic* I had written myself 'free' of that intriguing subject soon turned out to be an illusion. In 1952 I published a

paper (B136) in which I tried to argue for the extension of modal logic also to the formal study of axiological, or value, concepts. The attempt, however, was not successful. I soon came to realize that the general logical pattern to which value concepts conform is characteristically different from the patterns of logical relationship which are common to the different families (alethic, deontic, doxastic, epistemic, existential) of modal concepts. In the terminology of the 1952 paper, one could also say that the contrariety of axiological opposites, such as the good and the evil, is a different kind of contrariety from that of modal opposites—the necessary and the impossible or the obligatory and the forbidden, for example. The 'middle' between axiological opposites is the value-neutral. It has a different logical nature from the 'middle' between modal opposites, e.g., the contingent or the facultative. From time to time in the following years my thoughts returned to this topic. (I used to think about it when attending boring committee meetings.) Strangely enough, I did not notice that Halldén in his pioneer work 'The Logic of "Better"' (1957) had already got hold of the rope's end for which I was searching. Perhaps this oversight was due to the fact that I focused my interest on the notion of *preference* and preferential choice, which, in the first instance, I did not link with the notion of betterness. I can no longer recall exactly when the idea of a logic of preference or prohairetic logic took shape with me. I first presented it in connection with lectures on 'Ethics and Logic' at Edinburgh in 1962. The subject has since been more deeply studied—but still remains little cultivated in comparison with its modal logical counterpart, viz., deontic logic. It has also turned out to be far more controversial and tricky than I would initially have anticipated. It has continued to vex me ever since. In 1971 I wrote what I consider to be an improved version of basically the same ideas which I had propounded in *The Logic of Preference*. This piece of research (B254) I am eager to continue and to connect, if possible, with ideas on measurable value in utility- and personalistic probability-theory.

Another effort to extend modal logic, the fruitfulness of which I still doubt to this day, was the creation of a theory of *dyadic* or *relative* modalities. In the course of a conversation with Hintikka in 1952 I was struck by the following analogy: the probability of a conjunction (of two propositions) is not simply the product of the probability of the conjuncts, nor is the possibility of a conjunction (of two propositions) equivalent with the conjunction of the proposition that the first conjunct is possible. But could one not introduce into modal logic a formula $M(p\&q) \leftrightarrow Mp\&M(q/p)$ in analogy with the multiplication formula of probability theory $P(p\&q) = Pp \times P(q/p)$? Of old, probability and possibility had been regarded as related ideas. What is the probability of a proposition, on given evidence, but the *degree* to which this proposition, on that evidence, is possible? This being so, it was tempting to look for a formal similarity of structure also between modal logic and probability theory. Whatever the correct solution in this matter may be, it is possible to construct a

formal system of dyadic modal logic which has the following interesting prop-
erties:

1. Monadic modal logic of the traditional type can be viewed as a limiting
(or 'degenerate') case of this dyadic logic, viz., as a logic of possibility relative
to tautologous evidence.

2. Dyadic modal logic can be given an axiomatic presentation which is
strikingly similar to an axiomatic presentation of the probability calculus.

The logic of probability can thus be viewed as a numerical modal logic.
The analogy between the two logics holds independently of any particular inter-
pretation of the notions of probability and possibility respectively. Several
interpretations of probability are known. But the question of an interpretation
or a semantics for the dyadic modal calculus I have never been able to answer
to my satisfaction.

The deontic modalities seem inherently more 'relativistic' than the alethic
ones. What is obligatory or permitted has this deontic status, often, perhaps
usually, within a certain code (order, system) of norms or for a certain person
or category of persons. Moreover, something is often not obligatory or permit-
ted *simpliciter* but under given circumstances only. It is inviting to regard at
least this second type of relativity as a dyadic relationship between the obliga-
tory or permitted actions or states of affairs on the one hand and some hypo-
thetically prevailing circumstances on the other hand. In a note for *Mind* for
1956 (B151) I sketched a dyadic deontic logic on the same lines as the dyadic
modal logic which I had been studying earlier. A characteristic of this logic is
a deontic analogue to the probabilistic multiplication principle.

In *Norm and Action* I used dyadic deontic notions when discussing hypo-
thetical norms. Later in the 1960s I resumed the formal study of dyadic deontic
logic, partly inspired by work which had in the meantime been done by
Rescher. But this was, as I now see it, a rather different sort of venture from
my earlier (1956) sketch. Eventually (1967, 1968; B215 and 219) this led to
the evolution of a systematic variety of dyadic deontic systems. The basic idea
was to correlate members of two sets of 'possible worlds' in a deontic relation-
ship: *some* member of the one with *some* of the other, *every* member of the
one with *some* of the other, etc. The idea seems to me to be a sensible one.
But I have not succeeded so far in giving to it a formally satisfactory exposition
and treatment.

The research which most absorbed me during the ten years after my return
from Cambridge (in 1951) was not, however, philosophical logic. It was ethics
and the general theory of norms and values. This came to be so partly because
of the influence which my incidental plunge into deontic logic had had on my
general interests and partly because of my duties as acting professor in the chair
of 'practical' philosophy in Helsingfors during the greater part of that period.

From 1953 on I was projecting a work on norms and values. Additional stimulus came from the invitation to give the Gifford Lectures. The final result of these pursuits were the two books *Norm and Action* and *The Varieties of Goodness*. The year of their publication, 1963, closed another period in the development and direction of my research.

The basic problem behind *Norm and Action* was an ontological rather than a logical one. But it sprang directly from my position in the paper 'Deontic Logic'. There I had, unreflectingly, treated norms as true or false propositions. This, to say the least, is a debatable procedure. There existed an influential tradition in moral and legal philosophy according to which norms have no truth-value and therefore cannot stand in (genuine) logical relations, such as contradiction and entailment, to one another. This tradition was particularly strong in Scandinavia and I may be said to have been 'brought up' in it myself. I accepted the first of its tenets but wanted to deny the second. My problem then became how to *justify* deontic logic in the face of the 'atheoretical' nature of norms. What *are* norms? What is it for a norm to *exist* and to be *valid?* And what is the difference, if any, between a norm's existence and its validity?

My mind has never come to rest in the struggle with these questions. In *Norm and Action* I defended a version of what is known as the 'will-theory' of norms. An obliging or prohibiting norm, I argued, expresses the will of a norm-authority to make norm-subjects do or forbear doing certain actions. A permissive norm is a declaration of toleration which may, or may not, be coupled with a prohibition to a third party from interfering with the permission-holder's 'right'. The principles of a logic of norms are standards of consistency and rationality of willing with regard to the conduct of (other) people. The unity of a normative order or system is the self-consistency of a sovereign will.

It seems to me certain that there are important logical relations between norms and deontic modalities on the one hand and various optative and volitive ideas on the other. But I was not able to make these connections clear in *Norm and Action*. Later on, my thinking about the ontological status of norms turned in a different direction. Instead of viewing the obligatory as that which is required *by somebody*, I tried to view it as that which is required *for something*, i.e., as a necessary condition of something else. This indeed is another time-honored view of which there are several variants. Common to them all is that they try to link the sphere of the Ought with the sphere of the Is by means of the notions of efficacy (of a normative order) or of sanction (for breach of the rules). On the formal level this leads to a 'reduction' of deontic modal logic to alethic modal logic, as was first shown by Alan Anderson in an important note for *Mind* for 1958. The 'realism' of some of the variants of this view seems much too crude to be acceptable. But there is also something basically sound about this approach to norms. By introducing into discussion the ideas of immunity from and liability to punishment I tried to mitigate the crudeness of the

realist conception of the notion of obligation while at the same time safeguarding the possibility of incorporating deontic logic into the logic of (sufficient and necessary) conditions, which in its turn I would view as a part of ('ordinary') modal logic. I tried to show how this was to be done in two papers on the ontology of norms (1968/1969; B221 and 230) and in the paper 'Deontic Logic and the Theory of Conditions' (1969/1971; B222). Much remains to be done in this area. A task of supreme importance, as I see it, is to try to connect the 'realist' and the 'voluntarist' points of view in the philosophy of norms. It seems to me most unlikely that any *one* theory of the nature of norms could have an exclusive claim to truth in the matter.

None of my writings has cost me so much labor as *Norm and Action*. I do not find the result very satisfying. The successive changes which my positions continue to undergo might have earned for me the reputation of a chameleon of deontic logic. This is not pleasant. But perhaps it is the toll I had to pay later for my effortless entrance into this virgin area of research.

Very different is the story of *The Varieties of Goodness*. I had given the first series of Gifford Lectures, on norms, in April and May 1959. Soon after my return to Finland in June I began to prepare the second series, on values, which was to be delivered in January–March of the following year. I started practically from scratch. My first task was to make an inventory of all familiar uses of the word 'good' which I could think of. The plan and structure of the work and its leading ideas came to me during a few weeks of intense work in the first half of the summer of 1959. In July I started writing down the first typescript. It was finished by Christmas. In the autumn term I tried out the forthcoming Gifford Lectures on my class in Helsingfors. No lecture course I ever gave was as exciting to myself as this one. The typescript was rewritten and profoundly revised during the eight weeks at St. Andrews in the winter. I rewrote it for a third time in the course of the following academic year. Norman Malcolm was then in Finland and I had the great privilege of discussing with him every page of the work.

Varieties is the only book of mine of which I could say that writing it was easy and enjoyable. The work took almost exactly two years. This is, of course, a very short time for so big a subject. I should like to think of the book, however, as the fruit of reading and thinking which had engaged me for a much longer period. Of all my scholarly works it is the most personal and—if I may say so myself—the best argued.

It is therefore with mild surprise, but without bitterness, that I must note that this book has left hardly any trace in subsequent ethical and value-theoretic discussion. Its spirit seems to be very much at odds with contemporary ethical thinking—at least within the analytic tradition where this work belongs.

The aim of ethical inquiry, as I see it, is 'practical', i.e., is to direct our lives. But philosophical ethics is not 'moralizing'. Its task is not to say which

actions and patterns of conduct are good or evil, right or wrong, but to knit the conceptual web which constitutes our 'moral point of view'. Thus it shapes the standards whereby we 'moralize,' i.e., judge things morally. When I say "we judge" I do not mean 'we,' as a matter of fact, 'judge'. Ethics is not sociology of morals. Nor do I mean 'should judge'. For ethics cannot assume moral authority over men. It can only help men to reflect upon and see more clearly *what* they do when, in fact, they make moral judgments. Such reflection may change, or it may fortify, their moral attitudes and thereby also their view of how moral judgments *should* be made. I think that those who believe in a 'detached', not-normative and value-free, metaethics will have little understanding of this view of philosophical ethics.

A study of the 'varieties of goodness' will show, I think, that one cannot single out a concept of *moral* goodness or rightness to be studied in (relative) isolation from concepts which refer to *man as a whole*. Three eminently important concepts of this category are welfare, health, and happiness. The first can also be called, somewhat solemnly, the good of man. The things which promote it are called beneficial, those which detract from it harmful. All things inclusive of their consequences which a man treasures for their own sake are parts of the whole which is his good or welfare. (Health, one could say, is the basis of welfare and happiness its crown or flower.) The morality of conduct is a function of how the conduct of an individual affects the welfare of his fellow humans. In this regard morality is necessarily a social idea.

The good of man (welfare) is thus the pivotal notion of ethics. This notion, as it figures in *Varieties,* is the good of the human individual. Is there also a notion of the good of society which is not, somehow, logically reducible to the welfare of individuals? When writing *Varieties* I could not think of such a notion. It was this which led me to the fiction of 'man in a state of nature' and which guided my efforts to show how men's self-interested pursuit of a common good may make just action a practical necessity within the community. The moral will I could then define as a 'disinterested and impartial will to justice', i.e., as a will to treat your neighbor as though his welfare were yours and your welfare his. In this conception of morality I thought I recognized the true meaning of the Christian commandment to love one's neighbor as oneself.

I was also struck by the similarity between my efforts to 'derive' morality from the self-interested pursuits by individual men of their good and the efforts of some seventeenth- and eighteenth-century moral and political philosophers. The idea of the rough equality of men in a state of nature may seem very old-fashioned indeed. As a hypothesis of history it is perhaps absurd. But conceptually or logically it is still of interest. Whether it is philosophically satisfying is another matter. To find a plausible alternative to it, however, would require a complete change of point of view as compared with the position taken in *Varieties*. One would then have to make independent sense of the notion of the

good of society. This can be done only if one abandons the fiction of man in a state of nature and bases the considerations of morality and justice on the existence of societies as concrete historical facts. This is the point of view which Hegel and Marx may be said to have adopted. A difficulty for me is to reconcile their position with the demands of conceptual perspicuity which good philosophy must satisfy.

Both *Norm and Action* and *The Varieties of Goodness* contained seeds for further development. It was only natural that the first work, as the less satisfying of the two, should turn out to be the more fertile in this respect. I have already mentioned the urge which it gave me to think further about the logic and ontology of norms. This was a continuation of old themes in my thinking. Inspiration to essentially novel work stemmed from the parts of the book which dealt with action.

In my first sketch of a deontic logic I had dealt with the symbols for actions as one treats symbols for states of affairs. But actions are more like changes or events than like states. This made it seem doubtful whether one could represent adequately the structure of actions with the tools of ('classical') propositional logic alone. The logical study of action belonged to a study of a changing, not of a static, world.

A logic of action and a logic of change were part of the program of *Norm and Action*. Some of the basic ideas which were introduced in the book I think are sound—for example, the algebra of action resulting from the fourfold division of changes and not-changes and the corresponding eightfold division of 'elementary' modes of action and forbearance. The distinction between the external and internal negation of action statements and the comments[9] on the intensional nature of expressions for action as contrasted with the extensional nature of expressions for changes is also sound. But the calculus with the operators d and f (signifying doing and forbearing respectively) is not only clumsy but also, as I have come to see later, formally deficient.

The formal deficiencies in question do not, as far as I know, pertain to the new logic of action, the fullest presentation of which is given in *An Essay in Deontic Logic and the General Theory of Action* from the year 1968. This publication grew out of various research projects which I started as visiting professor to Pittsburgh in 1966. I then tried to connect them, not very successfully I am afraid, into a whole for lectures which I gave at Cracow in 1967 and repeated in Buenos Aires the year after. The new theory was more general than the old one, since it applied also to the strings of temporally successive actions which constitute the biography or life history of an agent. But in one regard the treatment in *An Essay* represented a retrograde step as compared with the earlier efforts. By allowing the vacuous introduction of new variables into the action descriptions, it did not preserve the intensional character of a logic of

action. A few years later, when working on something quite different, I had a new idea of how this intensionality could be safeguarded. This became the starting point for work on 'intensional logics', which has since occupied me and which may be regarded as a continuation of my earlier, less successful, efforts to cope with the problems of negation.

In the early 1950s I had been playing with the idea of a logic of change, being a theory of transformations among states of affairs. But the first written presentation of this idea was in *Norm and Action*. At the time I wrote it, I was only dimly aware of the work which Arthur Prior had initiated under the name 'tense-logic'. My state of ignorance, which deserves to be called shameful, continued until I met Prior at Pittsburgh in 1966. Then the center of gravity of my interest had already shifted from change to time; I had developed and published my calculus for the binary connective *and next* (1965; B201) and was working on the theory for *and then* (B208). The fact that my calculi are but fragments of Priorian tense-logic does not make me feel that my work had been a waste of time. First of all, it was fun to discover these things entirely on my own. And secondly, I believe that the peculiar course I had chosen—starting with a binary operation on states of affairs and introducing the temporal quantifiers *post hoc*—was worth pursuing to the end. The calculus T of discrete successions in time seems to me interesting in its very primitiveness and simplicity. For one thing, it allows for a nontrivial extension from states to histories of the notion of a truth-functional tautology. It can furthermore, be interpreted as a modal logic of a 'rationalist' universe, in which there is no room for contingent truths and falsehoods. And finally, it can, under this particular interpretation, be interestingly used for relating the ideas of time and necessity.

I am resolved to continue, for what it is worth, this independent route of mine into the logic of time. (I greatly prefer the name 'logic of time' to the name 'tense-logic' with its grammatical associations.) I should particularly like to explore some avenues which, to the best of my knowledge, have not yet been approached from this direction. The tense-logic I know is a study of temporal *succession*. It must, I think, be supplemented by a study of temporal *division*. This, in turn, leads to problems of infinite divisibility and continuity in nature—and thereby into the well-known conceptual jungle which someone called a paradise. I am under no particular illusions about the possibilities of finding my way through it. But I am eager to make the voyage.

When working on *Varieties* I had to take a stand on the problem of practical reasoning (argument, inference). This, in its most general form, can be said to concern the relation of thought to action, of *theoria* to *praxis*. I had met the problem in Plato and Aristotle and I had been much impressed by the revival of it in the work of Elizabeth Anscombe. This problem-sphere must be separated from those of deontic logic and of action logic. The logic of practical reasoning seems not to be formal logic at all but to be 'logic' in some different

and perhaps looser sense. What this means and what implications it has is difficult to tell, however.

Practical reasoning, moreover, presents a multitude of aspects, and the one which has mainly interested me is not exactly the same as the ones studied by Aristotle or by Anscombe. My interest has focused on the question of how a man's intentions (his wants, his will) and his opinions about how to make them effective can 'prompt him' to action. That there are *conceptual* (and thus in a sense *logical*) connections between intentions and epistemic attitudes on the one hand and actions on the other seems to me certain. But to lay bare these connections is anything but easy. What was said about the problem in *Varieties* is only a sketch and the fuller treatment in a paper of the same year (1963; B195) soon ceased to satisfy me. I already have the same feeling of dissatisfaction with my renewed treatment of the problem in *Explanation and Understanding* and in the separate paper which I published in 1972 (B248(a)). But I think I have made some progress.

For at least two different, though related, reasons I consider the topic of practical reasoning to be philosophically very important. The first is that its study reveals interesting conceptual differences between reasoning about one's own conduct (the 'first person case') and reasoning about the actions of others (the 'third person case'). These differences are an aspect of a deep-cutting general contrast between the subjective and the objective in the fields of knowledge, understanding, and truth.

The second reason why practical inference seems to me philosophically important is its relation to explanation. A practical argument from considerations about ends and means to the necessity of certain actions is the prospective of a forward-looking version of that which in retrospect becomes the explanation or the justification of actions actually performed. A practical argument is thus a teleological explanation 'reversed'. Considering the prominent role which explanation of action, and behavior generally, plays in the human and social and life sciences, the problems of practical inference turn out to be closely linked with the controversial questions of the place of teleology in those fields of investigation.

It had been my preoccupation, in the late 1950s, with questions of ethics—rather than with action—that awakened my interest in practical reasoning. At the time I had no idea that this study was eventually going to take me to the central problems of the philosophy of science. The turn of my thinking in this direction began in 1965. It was stimulated in part by some happy accidents. Elizabeth Anscombe had sent me a copy of Charles Taylor's *Explanation of Behavior*. The book would probably have remained unread, at least for some time, had it not been for the fact that I was just then (the summer of 1965) preparing a paper with the same title for a Scandinavian congress of psychol-

ogy. Taylor's book impressed me deeply. Its spirit struck me as congenial; but partly because of the obscurity of many of its arguments it spurred me to try to penetrate the same problem-region independently. Soon after, I received an external stimulus to pursue this course of research from an invitation by Trinity College, Cambridge, to give the Tarner Lectures. The lectures were given in the autumn of 1969 under the title 'Problems of Explanation in the Sciences of Nature and the Sciences of Man' and repeated the following spring at Cornell in a version which was practically identical with the text of *Explanation and Understanding*.

Thinking about teleology inevitably challenges thinking about causality, for one thing, because of the question whether teleological explanations can be 'reduced' to causal ones. A condition for this reduction would be that a teleological explanation could be shown to connect logically independent factors (the *explanandum* and the *explanans*) under a contingently true 'covering law'. Some forms of so-called teleology perhaps satisfy this demand. But it is my conviction that explanations of action in the terms of intentions, motives, reasons, and suchlike factors neither presuppose covering laws nor answer to the requirement of strict logical independence. I am not anxious to call such explanations 'teleological' nor to refuse the name 'cause' to intentions, motives, etc. But I would insist upon the *sui generis* character of action explanation in conformity with patterns of practical inference and contrast it with explanations which rely on lawlike connections.

Action explanation is prominent in the scientific study of man and society. Failure to recognize its distinct logical nature has, I think, been detrimental to the development of the human and social sciences. It has fostered a tendency to look for methodological ideals in a direction, viz., natural science, where they should not be sought. It lends support, moreover, to a 'reified' conception of men and social institutions as objects of nature governed by universal 'cast-iron' laws. In this view expert knowledge of the laws might be used for steering human behavior just as knowledge of the laws of nature can be used for engineering natural processes and resources to serve the interests of those who have the power and skill. This conception of man is implicit in an age which is witnessing great social changes due to industrialization and is imbued with faith in 'progress' through science and technology.

There was a time—roughly the first half of the 1960s—when I myself believed in the possibility of a science of man answering to this conception of his nature. This was the brief period of optimistic rationalism or 'scientism' which I mentioned earlier. I also indicated the events in the world which contributed to a change in my views. There is thus a certain parallelism in the development of my philosophic thought and my attitudes to political and social questions. It is possible that the two developments have reinforced one another. But it would be wrong to try to 'derive' the one from the other.

One day in the spring 1969 I was struck, all of a sudden, by an observation which seemed to me very consequential and the implications of which still direct my work. I had been thinking about causation, trying to combine a logic of sufficient and necessary conditions with a logic of changes or events. It occurred to me that conceptual features of those peculiar changes we call actions might be held responsible for the distinction we make between accidental and lawlike (nomic) uniformities and thereby also responsible for the idea of 'natural necessity' which we associate with causal connections.

Scientific methodology and inductive logic have of old accorded an important role to experiment. Experiment is a mode of action. Like all action it is interference with a 'natural' course of events. The 'logic of experiment', therefore, is a facet of the logic of action. But this insight could not have a fertilizing influence on the study of induction and the theory of causal relations as long as action had not been studied under a formal logical point of view.

The way I see the relations between action and causation makes the second conceptually dependent on the first. The idea that our causal notions are somehow derivative from notions of agency and action is familiar from the history of thought. It seems to me to reflect a fundamental truth. One difficulty is to state clearly wherein this truth consists—and what its implications are, e.g., for the questions of freedom and determinism. I don't think I have yet mastered the difficulty here. The attempt made in *Explanation and Understanding* did not yield an entirely satisfactory result. But it cleared the ground from which a further penetration into the problems could start. An external impetus in the same direction came from the invitation to give the Woodbridge Lectures at Columbia University in 1972. Their title was 'Causality and Determinism'. But they covered only a part of the entire ground which I hope eventually to survey here.

At the time of writing (1972–1973) my main occupation is research on causation, determinism, and freedom. After that comes work on some new ideas I have concerning an intensional logic which can be assigned a place between propositional logic as its substructure and quantification logic and its analogues (modal logic, deontic logic, etc.) as superstructure. Thus, after the detour which originated from my study of practical reasoning and led to the preoccupation with intentionality and teleology in *Explanation and Understanding*, I am back in the mainstream of my previous thinking: philosophical logic.

But not with the intention of remaining there for good. Too late to leave an imprint on *Explanation and Understanding* came the strong influence of Wittgenstein's last writings, those published under the title 'Über Gewissheit' ('On Certainty'). I had, of course, known them for a long time, like the rest of the 'later' Wittgenstein. What I refer to as influence had been latently there ever since my first acquaintance, in 1947, with the thoughts of the *Philosophische Untersuchungen* and had been gradually built up during the twenty years and

more of my work as one of the editors of Wittgenstein's posthumous works. But it seems that not until I had worked my way independently to the neighborhood of Wittgenstein's thinking could I be aware of and consciously try to exploit this influence. The Wittgensteinian mood of the so-called ordinary language philosophy of the 1950s left me completely cool. My neo-Wittgensteinianism, if it can be called by that name, is related to changes which my thinking as a whole has undergone since the mid-1960s: to my awakening interest in Hegel and Marx, to my questioning of the political and social *Weltbild* with which I had been brought up and lived, and to my search for a new humanist orientation.

What will this mean to my future development as a philosopher? This I can only state in terms of some questions which I am anxious to investigate, not in terms of anticipated answers to the questions.

My philosophizing about the explanation and understanding of action, and my logic of action, has so far been narrowly confined to the sphere of individual agents. It has been a kind of Robinson Crusoe philosophy of action. This means neglect of two things. First, it abstracts from the societal background of individual action. It tends to ignore the fact that the conceptualization of behavior *as* (intentional) *action* presupposes a community of institutions and practices in which agents are reared to participate. Under the impact of Wittgenstein, the problem of a 'private language' has been discussed almost *ad nauseam*. Not much attention has been paid to the equally problematic, related notion of 'private action'. A philosophy of action, as I now see it, must inevitably, i.e., under the compulsion of the craving for conceptual clarity, terminate in a philosophy of society.

Secondly, my individualistic approach neglected the study of collective action and the ways in which individuals interfere with one another in acting. (This neglect, though, was not complete; there is some casual discussion of the topics both in *Norm and Action* and in *Varieties* and also in later writings.) A philosophy of action must expand into a philosophy of labor and of the relations of agents in working. This leads to the problem of 'alienation,' which, talking in positive terms, is merely the problem of the 'meaning of life'.

Have the tools of formal logic any application to these questions? Perhaps they have an application to *some* of them and in *some* degree. But my intuitive feeling is that the appropriate techniques for dealing with the problems under consideration are essentially different from the techniques of philosophical logic. Is this perhaps so because formal techniques have a conceptually 'atomistic' character which makes them inherently inapplicable to the 'global' or 'holistic' structures with which a social philosophy has to cope? I do not know the answer. My ignorance is related to a question which has vexed me throughout my philosophic career. It is the question of *what,* as a philosopher, I am doing.

III

Die Philosophie darf den tatsächlichen Gebrauch der Sprache in keiner Weise antasten, sie kann ihn am Ende also nur beschreiben.

Die Philosophie stellt eben alles bloss hin, und erklärt und folgert nichts.

Sie lässt alles wie es ist.

Wittgenstein, *Philosophische Untersuchungen* 124a, 126a, 124c.

Die Philosophen haben die Welt nur verschieden *interpretiert;* es kommt darauf an, sie zu *verändern.*

Marx, *Deutsche Ideologie,* Thesen über Feuerbach, 11.

In order to be a good philosopher it is hardly necessary to have reflected on the nature of philosophy. To the question of what a philosopher does one could answer that he is thinking about philosophical problems and then mention some examples: the existence of the material world, the interaction of body and mind, the freedom of the will. What is ultimate reality? What can we know? What ought we to do?

This enumeration of questions, however, is not very illuminating unless we also know something about the answers which philosophers have given to them. To some, at least, of the above questions answers can be given which we should all agree are completely nonphilosophical—and yet may be good answers. This indicates that the philosopher's concern with those questions is peculiar, is a 'philosopher's concern'.

What is this? It cannot be taken for granted that the question has a univocal answer. Philosophy has a long history, and the concept itself has undergone changes as a consequence both of the internal development of the subject and of external changes in institutions and ways of life. One age perhaps sees the task of philosophy very differently from another age. I remember Wittgenstein asking: "Why should philosophy in the age of airplanes and automobiles be the same (thing) as in the age when people travelled by coach or on foot?" Yet he thought of his own activity as a legitimate heir to the search for truth which, since the days of the ancient Greeks, had been cultivated under the name 'philosophy'.

When a tradition or trend in philosophy continues unbroken and is not challenged, there is little need to reflect on the nature of the subject. In an age when there is a marked break with tradition, however, such reflection becomes natural and may even be an important aspect of the break itself.

My own preoccupation with the question of what philosophy is, is certainly connected with the fact that my undergraduate years coincided with the forceful

impact of logical positivism on philosophy. Few movements in philosophy, I should think, have had an equally strong revolutionary ethos. In Finland, Kaila transmitted to his pupils a feeling that we were witnessing a revolution of thought and the birth of a completely new future for philosophy. Perhaps the first postwar generation of students of philosophy at Oxford had a similar experience.

Later, however, the situation changed. In the Scandinavian and the Anglo-Saxon world the climate of 'analytic philosophy', heir to the movements started in Vienna and at Cambridge, prevailed for a long time. Students reared in this climate of opinion in the late 1950s and in the 1960s hardly thought of it as a revolutionary storm sweeping the stage of philosophy. One heard about other types of philosophy—Marxism, phenomenology, existentialism—being dominant in other parts of the world. But one tended to register this with the same dispassionate curiosity one adopts towards facts of cultural anthropology generally—not infrequently with a condescending feeling of one's own intellectual superiority. The same seems to hold true, *mutatis mutandis,* for the members of the other tribes of philosophers. This attitude always annoyed me deeply.

Some years ago, however, connected perhaps with the general unrest which then overtook the world, signs appeared that philosophy was again getting 'on the move'. Old ties of allegiance were loosened, and new connections were in the process of being established. Within the Marxist camp interesting splits could be noted. Consequent upon them an orientation towards phenomenology and related currents made its appearance in this quarter, but also an orientation toward the 'exact' and 'scientific' philosophy of the analytic mainstream. Furthermore, it became increasingly plain that there existed affinities between the later Wittgenstein and the philosophy inspired by him on the one hand and phenomenology and several of its offshoots on the other. As I see it, the world stage in philosophy has from then on presented an increasingly confused picture—with potentialities both of stiffening sectarianism and fertilizing contacts.

The logical positivists claimed that they had revolted against an old conception of philosophy. Wherein then did their new conception of philosophy consist? To give the answer may have seemed easy at the time, but does not do so in retrospect. This much was agreed upon: logic was very central to philosophy—as Russell had already said in *Our Knowledge of the External World* (1914). Logical investigations, moreover, were of a different nature from empirical, experiential investigations. The former were concerned with the *meaning* of statements, the latter rather with their *truth*. (In those days one did not often speak of logical investigations as 'conceptual'.)

Views roughly like these were given a persuasive expression in Moritz Schlick's paper 'Die Wende der Philosophie', which opened the first issue of the neopositivists' periodical, *Erkenntnis*. I read this paper again and again,

identifying my own views of the matter with those it contained. I used to quote its famous concluding sentence, which prophesied a future when there was no longer need for discussing 'philosophical questions' because people had learnt to speak about all questions 'philosophically', that is, clearly and meaningfully.

But the seeming unanimity contained seeds of divergent views. Schlick's inspiration had stemmed mainly from Wittgenstein, who had said in the *Tractatus* that philosophy is not a doctrine but an activity. The result of this activity was supposed to be not propositions (theses) but the fact that propositions become clear. The philosophic achievement would thus be a characteristic effect on the understanding of the philosophizing subject. Could such effects really have the permanence which Schlick's prophecy envisaged? Wittgenstein, of course, thought that the philosopher's job had to be done over and over again by anybody who cared about philosophy. This made the job appear too much like a Sisyphean task to be palatable to a great many philosophers—including those of the revolutionary school.

The philosophy of the Vienna Circle and its 'allies' in other parts of Europe was strongly science-oriented. It is significant that the program publication by which the Circle announced its existence to the world carried the title *Wissenschaftliche Weltauffassung*. To attain for philosophy "den sicheren Gang einer Wissenschaft" was the supreme ambition of the logical positivists. Philosophy had in the past occupied itself mainly with meaningless questions and remained a fruitless endeavor. Now, at long last, a platform had been laid and tools created for the erection of a solid fabric of objective and scientifically respectable philosophic insights.

This attitude stood surely in sharp contrast to Wittgenstein's view in the *Tractatus* and later. Philosophy is not on a level with the sciences, Wittgenstein had said, but something above or below science. If, however, philosophy is a science among others, then philosophy should also be able to accumulate truth in a doctrinal body of at least relative permanence. How shall this body be characterized? The best characterization at the time seemed to me the one given by Carnap who said that philosophy is the logical syntax of the language of science.

The rules of syntax define the meaningful expressions of a language. But how are we to know whether the rules we have given are the correct ones? The very question seems dubious. Rules set a standard of consistency or correct following. The rules themselves are not 'correct' or 'incorrect'. This insight is reflected in Carnap's famous statement in *Logische Syntax der Sprache* that in logic there are no morals. We are free to build the logic of our language as we please. The choice of rules is not a matter of truth but rather one of convenience. Only within a given logical (syntactic) framework can disputes of truth be meaningfully settled.

Thus the one view of philosophy, the Wittgensteinian one, seemed to lead to a subjectivist quietism; the other, Carnap's, to a relativistic conventionalism.

In my early enthusiasm for the 'new philosophy' I did not see clearly the difference between the two views. Nor did I appreciate the problematic character of both of them. Later I came to see problems here. But I did not abandon my initial conviction that philosophy is not one of the sciences, that its method is logical analysis, and that its primary concern is to clarify meaning. However, what all this *meant* became a problem for me.

The view that philosophy is the logic of language need not commit us to conventionalism. If one regards language, or fragments of language, as something which is there with its logic 'in it', so to speak, then the task of philosophy could be to expose this logic to our reflective understanding.

Such a view of philosophy might, moreover, be further articulated in several different ways. Using modern terminology, one could distinguish between a philosophic interest predominantly in the surface structure and predominantly in the deep structure of language. If one's interest is in the first, the task is to describe what is there visibly before one's eyes, so to speak, though so familiar perhaps that it ordinarily escapes notice. If one's interest is of the second type, one should try to 'dig up' or 'lay bare' a structure underlying our usage of language but veiled by misleading grammatical forms.

One can say that the surface point of view answered, by and large, to a conception implicit in the movement known as linguistic philosophy or ordinary language philosophy. This movement had received its inspiration from the later Wittgenstein, i.e., from the philosophy embodied first in Wittgenstein's teaching at Cambridge and in the dictations known as the Blue and Brown Books, later also in the *Philosophical Investigations* and other posthumous publications. Oxford of the 1950s became the Mecca of linguistic philosophy in much the same sense in which Vienna around 1930 had been the Mecca of logical positivism. In J. L. Austin this way of doing philosophy found its most forceful and genuine representative. Austin thought that much of what had traditionally been cultivated under the name of philosophy was destined to become what he called 'linguistic phenomenology'. Exactly how he conceived of its nature is not clear from his fragmentary and sketchy remarks. Perhaps one could characterize it as an empirical study of conceptual features of linguistic usage. Austin himself had a rare talent for it. So had Wittgenstein— although his gifts in this regard seem less subtle than Austin's. And the conception of philosophy as linguistic phenomenology is certainly a far cry from Wittgenstein's, even if the *seeds* of this conception can be found in his later writings.

The typical 'Oxford philosophy' never strongly appealed to me. One thing which tended to make me dissatisfied or impatient with it was that I could not always discern an acceptable motive force behind the investigations. Why is the logic of language interesting, a worthy object of concern for the philosopher? One could answer that *language* is, as a phenomenon, important enough

to motivate interest in its logic. This, I should say, is a satisfying reply to one whose interest is linguistic phenomenology—but hardly to one whose interest is philosophy. Linguistic phenomenology is something in its own right, just as logic is. When we have separated it out from philosophy, philosophy is still there in *its* own right.

How then would *I* have characterized a *philosopher's* urge to study the logic of language? Perhaps by saying that the urge has to be some paradox or puzzlement or contradiction arising from what *seems* a correct use of language. The difficulty is dissolved when it has been shown that some words are used ambiguously or with an unclear meaning or outside their normal range of application. Once the logical structure of the language fragment is clearly exposed, no contradiction or puzzlement remains. This description of the motive force for doing philosophy, incidentally, would probably have been acceptable also to many representatives of linguistic or ordinary language philosophy—at least to those who had in the 1930s been under the personal influence of Wittgenstein's teaching at Cambridge.

It seemed to me that my own endeavors in my dissertation had been philosophy in this spirit. The problem there was the justification of induction. My aim was to show that the craving for justification was a self-contradictory demand, a crying for the moon. If induction is the anticipation of things not yet known and if its justification is to be a proof of some kind, given in advance of experience, that we are right in our anticipations, then 'justification of induction' is a concealed *contradictio in adjecto*. But in order to make this plain one has to show, through a minute scrutiny, that this basic contradiction actually vitiates all known attempts at solving the problem: that the conventionalist conception of laws as analytic truths, and the presentation of inductive arguments in demonstrative form according to some 'canons of induction', and the reliance on 'laws of great numbers' for long-run predictions, etc., all suffer from it.

Here the *end* of the philosophic inquiry was to silence a felt disquietude of the mind by making us realize that there was nothing to be uneasy about. The *means* to this end consisted in displaying clearly certain obscure logical structures. The result of the displaying or laying bare of structures was a piece of logic: a logic of demonstrative induction, a logic of probability, etc. This result was something *enduring,* independently of whether it effected the end for which it had been created. Even if the end had been the motive force behind the constructions, the latter also possessed an interest in themselves. They were apt to give rise to new problems and also to stimulate further study. But these problems and this study belonged to *logic* and not, by themselves, to *philosophy*.

The above is a slightly rationalized account of the view of philosophy and its relation to logic which I adopted in my early work on induction and proba-

bility. I think one can say that this view was inspired mainly by Wittgenstein—although I had a higher regard for the independent value of logical constructivism than he himself seemed to have at the time I got to know him. A piece of writing which had also influenced my view of philosophy was the Introduction to Heinrich Hertz's *Die Prinzipien der Mechanik*. This influence, as far as I can remember, was independent of my association with Wittgenstein.

It was from Hertz, if from any specifiable source, that I got the view that philosophical problems reflected a craving after something implicitly contradictory and that the making explicit of the contradictions would resolve the problems and silence our craving for truths which were not there to be found. I now think that this is sometimes a true description of a problem situation in philosophy. Both the traditional problem of justifying induction which Hume had bequeathed to philosophy and the more special problem of random distribution which occupied me at the time seem to me good cases in point. And these were the problems with which, as a philosopher, I had first become seriously concerned.

The constructivist aspect of Hertz's work also strongly appealed to me. Had not he in the *Prinzipien* accomplished something similar to what I was attempting in *Logical Problem*, viz., to lay bare the logical structure of a fragment of our conceptual thinking? Reflecting on what I was doing in the light of this analogy, I was gradually led to a further modified view of the philosophic enterprise. I came to lay more emphasis on the means—the exposition of conceptual structures—than on what originally I saw as the end: the dissolution of a puzzlement. This developed into a view of philosophy as 'logical (or 'rational') reconstruction'. I even articulated it in a paper, not intended for publication, which I was bold enough to present to audiences at Cambridge and Oxford on the occasion of my first visit to England after the war.

Another work besides that of Hertz which had some influence on these developments in my thought was Felix Kaufmann's *Logik der Sozialwissenschaften*.[10] I studied it on Kaila's recommendation when I was appointed, in 1946, to act in the chair of 'practical' philosophy in Helsingfors. It was my first serious introduction to this branch of philosophy.

The foundation work done by Hertz in mechanics parallelled the work done antecedently by Cauchy and Weierstrass in analysis, by Dedekind in number theory, and subsequently by Hilbert in geometry. It is not inappropriate to call the work of these great men 'logical reconstruction'. For what they had done was not so much to break new ground in mathematics and physics as to scrutinize in detail the structure of ground already familiar. In the seventeenth and eighteenth centuries exact science had been predominantly a conquest of new regions. In the nineteenth century a demand for rigor arose; and this meant digging into foundations, reconstructing the steps of reasoning underlying the bold jumps of previous 'intuitions'. Foundation research in this sense can be

said to lay bare the logical 'deep structure' of arguments, the grammatical 'surface structure' of which does not clearly betray a warrant of their correctness nor the scope of their validity.

I used to think of the work I was doing after my dissertation in the theory of induction and probability and a few years later in modal logic with its numerous ramifications, as philosophy in this reconstructive spirit. (My preoccupations with logical truth were less easy to fit into this mold.) I think there was some truth in this conception of my activities and of their background in a certain intellectual tradition, as hinted at above. But the conception of philosophy as rational reconstruction is not only unduly narrow. It is also superficial.

In the conception of the philosopher's task as logical *re*-construction, it seems to be presupposed that there *is* something to be reconstructed. In the material with which the philosopher is working, there must be a 'hidden' structure to be laid bare. For if this were not the case, what would show whether the philosopher had performed his reconstructive task correctly? What was thought of as reconstructive discovery would then in fact be constructive invention on the part of the philosopher.

Let us think of modal logic or of some of its ramifications, for example, deontic logic. Was deontic logic a discovery or an invention? No doubt there was an element of genuine discovery connected with its origination. This was the observation that the words of ordinary language *'obligatory'*, *'permitted'*, *'forbidden'* are, often at least, used in accordance with rules which lay down certain logical properties of and relations between the concepts denoted by those words. These rules, in the philosopher-logician's formulation, showed a striking similarity to the rules in accordance with which the words *'necessary'*, *'possible'*, and *'impossible'* are ordinarily used. To observe that a use accords with certain rules was to note a *regularity of usage*. But the *rules* were the logician's invention. In the origination of deontic logic the elements of discovery and invention were thus intertwined.

We might, of course, have conceived of a set of rules and found that there was no corresponding regularity at all in the usage. Then we should not have succeeded in reconstructing the logic inherent in a fragment of language either. Or we might, upon closer scrutiny, have found that the rules conflicted with established usage. Then we should have had to drop the idea altogether as misconceived.

Is usage, then, the criterion of reconstructive success? It cannot be that every member of the language community always uses words in accordance with the rules we have invented. Some members sometimes use words *incorrectly*. And there may exist several accepted usages—or usage may vacillate.

Shall we say then that the philosopher (logician) aims at reconstructing the *correct* usage(s)? But what determines correctness? The rules themselves, it seems. We are facing a dilemma here.

I think that the dilemma should be dealt with along the following lines:

To the concepts in which the philosopher takes an interest there normally answer words in ordinary language. The philosopher experiences their use as somehow unclear or in need of systematization, for example, with a view to connecting usages within a *field* of concepts. Seldom, if ever, does a philosophic investigation concern just one concept in isolation, even if only one may be in the focus of interest. This means that what the philosopher does in relation to language could, with due caution, be described as filling out gaps, or lacunas, in existing usage. This he cannot do by consulting usage—since there is none to be consulted. If he can be said to consult anything at all, this would be his own 'intuitions' about the concepts under discussion, i.e., about the rules according to which he thinks they should be employed. Therefore I should wish to say that the philosopher's enterprise is not so much a *reconstruction of the logic of language*—either in the deep or in the surface structure—as an *explication of conceptual intuitions*.

In this view of philosophy as a 'filling of gaps in (linguistic) usage' it is easy to understand why neither factual nor correct usage can serve as touchstones of success. In the area where the philosopher moves these touchstones are simply lacking. But there exists a 'negative test'. This is afforded by what the language community, by and large, accepts or regards as correct usage. This the philosopher has no right to change. It defines, so to say, the borders of the gap which he tries to fill. Thereby it determines his very problem. The violation of usage would mean a distortion of the conceptual situation and be a sign that the philosopher, not language, has gone wrong. This is how I would understand Wittgenstein's words in the *Investigations* that "philosophy may in no way interfere with the actual use of language" and "that it cannot give it any foundation either."

Thus from having viewed philosophy as reconstruction of logical structures I gradually came to view it as explication of conceptual intuitions. The shift can be described, with caution, as one from emphasis on discovery to one with emphasis on invention (creation).

What is the position of logic in this picture of philosophy? Is modal logic or tense-logic 'philosophy'? Was Gödel's proof a 'philosophic' achievement? I do not think questions such as the last two call for a clear-cut yes or no answer. But I think it may be helpful to review them in the light of the following distinction.

One can distinguish between *conceiving* a logical system, a set of rules for a set of concepts, and studying a system *as given*. So-called meta-logical inquiries about consistency, completeness, and decidability or about the independence of axioms are aspects of the study of given systems. Proofs within a system (calculus) would also count as belonging to this type of study. It has its peculiar techniques and standards of truth and falsehood, for example, for de-

ciding whether a proof is correct or not. As long as these techniques and standards are employed without being questioned, we are engaged in logic, not philosophy. Logic, thus done, is best classified as belonging within the broader field of mathematics.

But logic is also linked with philosophy in ways which make the two inseparable. It is linked with philosophy at its base by the fact that the rules which constitute the systems (calculi) are at the same time attempts to explicate certain conceptual intuitions. And it is also linked with philosophy by virtue of its repercussions on these intuitions themselves. The occurrence of various 'paradoxes' or puzzles within a formal system is often symptomatic of an inadequacy of a proposed explication. Illuminating cases are the so-called paradoxes of material and strict implication and of confirmation. They are *philosophically* important because they constitute an urge for more satisfying explications than those provided by the current logical systems of such notions as, for example, entailment or evidence. The urge may be met by the construction of new systems—and therewith of new objects for the (pure) *logician's* inquiries.

Philosophical logic I would describe as an activity which constructs formal systems with a view to explicating our conceptual intuitions in some realm of discourse. I think that developments, not least in the last quarter of a century, testify that constructing such systems can be rewardingly carried out in practically *any* realm in the exploration of which philosophers traditionally have taken an interest. The systems can be termed 'logics' of the conceptual realms concerned, for example, the logic of time, of causation, of acts, of norms, or of preference. Some writers take exception to this extended use of the term 'logic'. They would like to reserve it for the formal study of concepts of a very high degree of universality, such as the sentential connectives or the quantifiers or, perhaps, the modal operators, i.e., for concepts which are involved in all, or nearly all, reasoning. I do not think myself that this is a sensible restriction. Some 'logics' admittedly are more basic than others, and therefore, I think, also more deserving of the *logician's* but not necessarily the *philosopher's* interest than are the more peripheral logical systems. But between the center and the periphery there is no rigid border separating 'pure' logic from its 'applications'.

Philosophical logic or, rather, logic for purposes of conceptual clarification thus has no limitations as far as the 'content' of its material is concerned. But from this important fact I would not conclude that all explication of conceptual intuitions has to take the form of logical systems construction. I would not, in other words, identify philosophy with philosophical logic. As a 'method' in philosophy, philosophical logic may even have serious limitations. This is a question about which I simply am not clear, although it has much occupied my thoughts. I therefore cannot answer it; at most I may have some suggestions of relevance to offer.

In the introductory chapter to *The Varieties of Goodness* I discussed the purpose of conceptual investigations in the field of ethics. The words characteristic of moral discourse, I said, are words "in search of a meaning" (and in search of connections of meaning). Their usage calls for a clarification of their criteria of application. The philosopher, who is pressed by problems of ethics, is anxious to know on which grounds he is going to censure people as worthy of praise or blame, as virtuous or vicious, and their actions as good or evil, right or wrong, etc. Our moral judgments determine in their turn our attitudes towards people, and they guide our actions in manifold ways. Therefore by shaping our moral notions, i.e., by explicating our conceptual intuitions in moral matters, we shape the way in which we react to the conduct of our fellow humans.

Something similar, I think, applies to political and social philosophy. Concepts like democracy and social justice, legitimacy and sovereignty are as much 'in search of a meaning' as the fundamental notions of ethics. To shape their meaning is to get to understand better our social situation and to develop standards for assessing the purposefulness of existing social institutions. As a consequence of a deepened understanding of the 'meaning' of society, our life in relation to its existing forms may be one of acquiescence and conformism *or* one of dissent and revolt.

It is not, however, the business of the philosopher, *as* a philosopher, to censure people or society. His task is to reflect on the conceptual standards used in moral censuring and social criticism. But this is likely to have practical implications for his life and, to the extent that his thoughts are influential, for the lives of others as well. In this way a philosopher may contribute not only to our understanding of the world—in the light of clarified concepts—but also, indirectly, to changing the world—in consequence of changed practical attitudes. This is how *I* would interpret Marx's well-known dictum about the philosopher's task.

In connection with my work on the antinomies of logic I was struck by the following feature of conceptual analysis:

What makes the study of the antinomies of logic—the Liar in particular—so profoundly important is that it touches on the very foundation of our thinking, challenges the very concepts of 'concept' or 'inference' or 'truth'. Any proposed solution will accept as basic and unquestioned something which another solution will challenge. To this game I can see no end other than the end of philosophy itself.

The clarification of concepts is necessarily in the terms of other concepts. The explication of conceptual intuitions which, for one reason or other, are thought to be in need of explication takes place within a conceptual frame which the philosopher does not question. What a philosopher accepts as basic

and ultimate is conditioned to some extent by tradition and culture (including language) and to some extent by his individual intellectual character.

Implicit acceptance of a conceptual framework can also be called a philosopher's *presuppositions*. What these are can, I think, often be seen only in retrospect, 'in the light of history'. Such insight can make us understand why a problem has become obsolete or why it needs fresh treatment. But it does not help us to any 'solutions'. This should give a hint why I cannot share the 'historistic' view of philosophy of a Croce or Collingwood. I would rather favor a view which could, with due qualifications, be called 'existentialist'.

For might it not be the case that some of the great controversies in philosophy, those which have constituted *Leitmotive* of human thinking for centuries if not for millennia, go back to ultimate alternatives for the choice of basic concepts? A choice which can no longer be *argued* but simply has to be *made*? It has occurred to me, particularly in the course of the investigations into the problems of action and causation which have been my main occupation in the last ten years, that the controversies between 'mechanism' and 'teleology', between 'determinism' and 'freedom', are ultimately of this character.[11] But then we should stress the word 'ultimately'. For it is only through a thorough analysis of the key concepts of both of two opposed positions that one can stand safely on the ground which one no longer undermines but makes the foundation of one's edifice.

Any argument for a basic position about, say, determinism, will have to overcome or transcend the arguments of a conflicting view. The overcoming seldom means only refutation; it will usually also involve partial acceptance of the opposed position. A well-argued contribution to philosophy is an element in a dialogue which the next contributor cannot by-pass if he is to be *au niveau* with developments. (Here *'au niveau'* does *not* mean 'well-informed' as opposed to 'ignorant'.) Thanks to this fact one can speak of *progress* in philosophy, even though there is no way of *settling* the basic disagreements.

How then shall we judge of the positivists' dream that philosophy attain "den sicheren Gang einer Wissenschaft", to use Kant's well-known phrase? In the face of this question one should raise a counter-question: how secure, after all, is the path along which science progresses compared with that of philosophy?

In science, too, there is conceptual change—and the *great,* or 'revolutionary', advances in science are often significantly connected with it. Achievement in science is therefore not always essentially unlike achievement in philosophy, although science is connected with experiment and observation in a way philosophy is not. In the social sciences, moreover, theory seems virtually indistinguishable from philosophy. But then many people would probably wish to question whether the social sciences, with some exceptions, can be said to have attained for themselves "den sicheren Gang der Wissenschaften".

In research many activities are intertwined. I think it is possible and also important to distinguish the peculiar activity of a philosopher from that of a logician or mathematician and also from that of a natural or social scientist. But not only is what research workers under any one of these labels do often relevant to work done under some other label. The very activity in which an individual researcher engages may have features falling under several of the labels. If one does not recognize this, one can understand neither philosophy nor science for what they are: historical phenomena of great conceptual complexity.

To take this view of the relations between different research activities does not commit one to sympathy with the amateurish interest which scientists sometimes take in the activities of a philosopher. I find particularly distasteful the kind of 'holiday thinking' in which scientists—some of great stature in their professional fields—sometimes indulge in order to express their nonprofessional views on the 'big questions': on the nature of mind and matter, on the meaning of life, or on the divine hand in nature. At the risk of being accused of professional conceit, I should say that whereas there are good examples of successful amateurs in the sciences I cannot think of any in philosophy.[12]

To say that philosophy is explication of conceptual intuitions is a peculiar way of *seeing* philosophy. It is the way *I* see it. This means not only: see what I do myself as a philosopher, but also: see the historical phenomenon of philosophy. Other philosophers may have seen things differently—but only a few of them articulated their views on this question. If I had become a philosopher in a different spirit I should perhaps have understood better and been able to learn more from such men as, say, Plato or Spinoza or Hegel. But what these men did was not of an *altogether* different kind from what I am doing myself—though it was vastly richer in scope and much greater in depth.

Postscript 1980

Looking back on what I wrote seven years ago, I am struck by the fact that the wishes I then had for my future work still remain largely unfulfilled. I am struck by the futility of trying to anticipate the development of my thoughts and my work.

In the very year when I finished this intellectual autobiography I gave two papers which, as things then turned out, started two new lines along which my thoughts have been moving ever since. One was on the problem of future contingencies (B273), which Aristotle discusses in the famous ninth chapter of *De Interpretatione*. It inaugurated a series of investigations which can perhaps best be subsumed under the title 'Time, Truth, and Necessity', which was also the title of the Nellie Wallace Lectures I gave at Oxford in 1978. Although the immediate inspiration for those investigations came from problems in ancient

and medieval thinking, their ultimate aim was to clarify questions of philosophy emerging from my earlier work in modal and related branches of logic.

The other paper which signalled a new departure in my research was published in 1976. It is called 'Determinism and the Study of Man' (B281) and continues earlier work on the explanation of action. It supplements my treatment, in B242 and elsewhere, of intentionalist explanation patterns ('practical syllogisms') with accounts of explanation models in the terms of external determinants, such as various challenges and rules which influence the individual's conduct as a member of a community in the context of institutionalized human relationships. Further elaboration of these ideas has led to considerable modifications in my views of the relation between actions and their reasons and also of the differences between the human and the natural sciences. These new thoughts have their latest embodiment in *Freedom and Determination* (B315).

I have mentioned a rift in my philosophical personality between an awareness of the narrowly restricted relevance of my professional work and a craving for a more 'visionary' grasp of the totality of human existence. I still feel and I am often tormented by this split in me. The literary manifestations of my search for a *Weltanschauung* have remained 'essayistic' in form and their language, with a few exceptions such as my Lindley Lecture at the University of Kansas, 'What Is Humanism?' (B285(a)), and an article in Portuguese (B311), has been my mother tongue, Swedish. A main theme of these writings from later years has been technology, the man-nature relationship, and the future of our civilization.

NOTES

1. 'Die Geschichte ist mir noch immer grösstenteils Poesie, sie ist mir eine Reihe der schönsten malerischen Kompositionen.' Burckhardt, *Weltgeschichtliche Betrachtungen* (Stuttgart: Kröner, 1935).

2. Max Söderman (1914–1947) was next to Kaila the greatest personal influence on me during my years as a student. He was highly intelligent, had the most fabulous memory I have ever met with in any person, and great artistic sensibility. Everyone expected much from him. On Kaila's advice, he started work on a thesis on the logic of Bolzano. He spent the years immediately preceding the war in Prague, Vienna, and Münster. During the war his health was seriously impaired. He continued to be receptive and a most entertaining and stimulating conversationalist. But it was becoming increasingly doubtful whether he was capable of creative work. He was known to have written a great deal, but when I searched his papers after his death nothing was found. He evidently had destroyed it all. But from reading his letters I can still revive some of the thrill of night-long conversations with him on a limitless variety of subjects.

3. From time to time I have yielded to the need to 'write myself to clarity' about a situation in philosophy. In the mid-1950s I wrote a textbook survey, the English title of which would be 'Logic, Philosophy, and Language' (B154), of the analytic move-

ment and its background in the history of logic from Aristotle through Leibniz to Frege. Some revisions and added chapters still kept it up to date ten years later. Writing this book, moreover, contributed much to broadening my horizon *beyond* logic and analytic philosophy. The book also had an introduction on the situation in contemporary philosophy as a whole; this topic I reviewed once again in my 'Presidential Address to the Finnish Society of Sciences' in 1966 (B209).

4. Cf. *Logical Problem.*, 1957 ed., pp. 118, 215.

5. *Über Wahrscheinlichkeit*, pp. 45–60; see also *Treatise*, Ch. IX. The φ = sets of concurrent hypotheses or possible conditions are second order constructs, and the assumption that some hypothesis is true and the statement that some are eliminated involve quantification over predicates.

6. I soon found that it was not novel. Quine had expressed essentially the same idea in a paper on quantification in *The Journal of Symbolic Logic*, 1945. The idea of decomposing formulas by pushing the quantifiers inside can be traced back to a paper by Behmann published in the *Mathematische Annalen* in 1922.

7. In an introduction written especially for the Spanish translation of the *Essay* (1970) I have commented on the semantic and syntactic approaches to modal logic and on the motivations for the peculiar techniques I use in the book.

8. Later published as the papers 'Remarks on the Logic of Predication' (B264) and 'Truth as Modality' (B258)

9. *Norm and Action*, p. 67.

10. The English translation of Kaufmann's book, which became available a few years later, is unfortunately a much watered-down version of the German original.

11. See *Explanation and Understanding*, p. 32.

12. Cf. Burckhardt, *Weltgeschichtliche Betrachtungen*, p. 22 ff.

PART TWO

DESCRIPTIVE AND CRITICAL ESSAYS ON THE PHILOSOPHY OF GEORG HENRIK VON WRIGHT

1

Charles Hartshorne

VON WRIGHT AND HUME'S AXIOM

What is distinguishable is separable', or, 'There is no object which implies the existence of any other if we consider these objects in themselves'— this dictum, in the second of the above versions, is so reformulated by von Wright that it becomes a simple tautology.[1] (A. J. Ayer also takes the dictum, which I shall call Hume's Axiom, to be tautologous.[2]) Von Wright argues that for his purposes the reformulation begs no important questions. However this may be, for some significant philosophical purposes the formulation is unsatisfactory.

Von Wright interprets 'distinguishable' or 'other' to mean *mutually* independent. This is linguistically odd, if nothing else. Otherness, distinguishability, difference, do not normally imply complete independence. *This is a fox* is very different from *this is an animal,* but the first entails the second, though not vice versa. And (with reference to *The Logical Problem,* p. 16) this point is not 'psychological' but logical! I think Hume was using words normally; if we take him at his word, we shall discover interesting implications of his dictum which we should otherwise miss.

As it stands, Hume's Axiom is doubly ambiguous, and one of its apparent meanings is demonstrably false. The first ambiguity is that the words used do not decide the range of entities to which the axiom is to apply. Does it apply only to simples, or to complex entities as well? If the latter, the Axiom is ambiguous in another way: does 'separable' mean *mutually* independent, so that not only can X occur without Y but Y can occur without X? With that understanding the axiom is demonstrably false. Here is my counterexample. 'Distinguishable' (or 'other') = df. neither identical nor equivalent. Corollary: distinguishability or otherness is symmetrical. X is *separable* from Y = df. a situation could include X without including Y. Corollary: separability, unlike distinguishability, is nonsymmetrical. Instance: the letter a is distinguishable and separable from the letter pair $ab;$ yet the pair is not separable from a. Conclusion: if complexes as well as simples are taken as values of the vari-

ables, then 'X distinguishable from Y' is compatible with 'X logically insepar-
able from, dependent upon Y.' Otherness and separability have different logical
forms. I am agreeing with von Wright that mutual inseparability is the negation
of significant otherness or distinguishability, but I cannot agree with him in
apparently taking even asymmetrical logical dependence as incompatible with
otherness. (Note *The Logical Problem,* p. 16, middle paragraph. Here no dis-
tinction between mutual and one-way dependence is mentioned. Yet it is a
logician writing. Similarly paradoxical is Russell's usual treatment of internal
and external relations, a treatment which, like that of Bradley, systematically
neglects the asymmetrical case of logical dependence-independence.)

Where complexes as well as simples are allowed as values for variables, 'if
X and Y are distinguishable they are separable' is false if symmetrical separa-
bility is intended. We shall see that this asymmetry of one form of 'distinguish-
able and separable' opens the door to a reasoned rejection of the Humean idea,
which (I take it) is also, in the relevant respect, von Wright's idea of causation.
I say that it 'opens the door' to a reasoned rejection. I do not say that it requires
this rejection. For, as usual in philosophy, a mere formal truth, such as the
lack of symmetry just referred to, cannot of itself determine one's whole philo-
sophical position. Still, it is dangerous to neglect truths of this kind, as I be-
lieve von Wright will grant.[3]

Suppose we restrict the applicability of the Axiom to simples, or to entities
of which none is more complex than another. And suppose we justify this
restriction by holding that any entity is either a simple or a complex of simples,
and that the separability of complexes follows from that of the simples com-
posing them. Thus if n and m are separable (with simples this means symmet-
rically), and if both are separable from o and from p, then nm is separable from
op. It is clear that Hume was thinking along this line. It would not have oc-
curred to him to assert that a series of events is separable from the members of
the series. What he asserted was that the events taken singly are separable from
the series and from one another; likewise separable are two series of which the
first member of one series follows the last member of the other.

Russell, essentially Humean in his philosophy, once remarked that the only
example he could see of logical dependence or internal relatedness is the de-
pendence of a whole upon its parts.[4] If by 'part' one means a proper part, not
identical with the whole, then there must be a complexity in the whole that is
lacking in the part. The early Wittgenstein had similar ideas. Reality is viewed
as a complex of mutually independent simples.

We have now come close to the real issue about necessary connections.
The later Wittgenstein seems to have abandoned the doctrine of simples, as
many philosophers have done. But how can one fail to see that this rejection
reopens the supposedly settled issue of internal relations? It reopens it, how-
ever, not in the usual form ('Are relations internal to their terms?'), for that is

a symmetrical question. Rather the question is raised in the form, 'Are rela-tions, at least of one basic kind, internal in one direction and external in the other?' To include *nm* is to include *n;* but *n* can be included in a situation not including *nm*.

It may appear that all this is irrelevant to the question, 'Are events neces-sarily connected to other events?' For we rule out as trivial the fact that what happens within an hour in a certain place necessarily includes what happens there within part of the hour. To show a nontrivial application we must look more carefully at asymmetrical separability and events.

If proposition *p* strictly entails *q,* but not vice versa, then clearly the truth of *p* cannot be separated from that of *q,* though the truth of *q* is separable. If *p* is merely the conjunction of *q* with another proposition, we have the trivial case: r · q→q. Not all entailment is like this; nevertheless, there is a valid sense in which normal entailment (without equivalence, conditional but not biconditional) implies a greater complexity in the premise than in the conclu-sion. Something is omitted in the latter that was in the premise; otherwise there would be symmetrical entailment.

At last we know what the real question about necessary connections is: 'Are successive events equally simple, or is there a one-way increase in complex-ity?' Recall that our only model (here I agree with Russell) for strict logical necessity is one-way inclusion. (Two-way inclusion is equivalence, a special and, in a sense degenerate, case.)

The relation of entailment to inclusion is nicely modeled in the formula $p \rightarrow q \equiv (p \cdot q \equiv p)$. But although *p* thus somehow contains *q*, it is not (except in trivial cases) a mere conjunction of *q* and some second proposition. *This is a fox* entails *this is an animal,* yet one cannot think of fox-ness as simply animal-ness plus a second something. The second something presupposes ani-mality. The notion that everything is either a simple singular or a mere aggre-gate of such singulars will not do. Singulars there must be, but 'simple' sin-gulars are a will-o'-the-wisp. Or, if there are such, they are not the only ultimate constituents of reality.

To come closer to the central matter of events, let us consider *experiences* as events. In each experience there is at least the appearance of perception and memory. Both, taken naïvely, are exhibitions of real connections. I can remem-ber an earlier experience only because it happened; I can hear the sound of the steam whistle only because the whistle did blow. Only from a sophisticated point of view is there any doubt that the possibility of remembering depends logically upon the remembered, and the possibility of perceiving upon the per-ceived.

Of course philosophers are sophisticated. They keep thinking of cases where what was remembered did not happen or what was perceived was not there. In this sophistication I believe there is a trap into which most philoso-

phers have fallen. Let us label as proposition *A* the assertion that memory or perception can be wholly illusory. Now, either this proposition is subject to some qualification, or it holds absolutely. If the latter, then in principle solipsism of the present moment seems to follow as a genuine possibility. With most linguistic analysts, I take this possibility to be nongenuine, indeed not truly intelligible. But it follows that there is something not quite correct in proposition *A*. There must be some logical limitation upon the fallibility of memory and perception. But then Hume's doctrine is false. The occurrence of memory or perception somehow guarantees a real past and a real world. I do not believe there is any escape from this dilemma over and above accepting momentary solipsism as a possible truth, or rejecting Hume's Axiom. I submit that it is the Axiom which should be rejected. Here I am agreeing with two great logician-philosophers, Peirce and Whitehead, and with Bergson, W. P. Montague, and many others.

The required qualification upon proposition *A* is suggested by the distinctions of memory vs. recollection, prehension vs. apprehension, givenness vs. judgment. In the first tenth of a second one may perceive a musical tone and in the second tenth remember doing so. But one does not *re*collect the tone; rather one simply collects it, intuits it in combination with new data. Recollection is a more complex process of simple memory re-remembered, perhaps many times, with intervening lapses of any distinct reference to the item remembered. Similarly, it is one thing to feel a pain and another thing to think, 'I feel pain.' Obviously verbalization is additional to sheer memory or sheer perception. 'Obstinately verbal minds' miss this point. Now I submit that the famous 'mistakes of memory', or 'mistakes of perception', are entirely a matter of something additional to memory *simpliciter,* or prehension *simpliciter,* and always involve elements of judgment, usually with some degree of verbalization. The doctrine to be substituted for Hume's is that there is an aspect of necessary connection in perception and memory which may appropriately be termed *givenness,* and which is what is left when one abstracts from all aspects of inference or interpretation, i.e., of using the given as sign, or embedding it in a system of signs, especially verbal. This is exactly what Whitehead means by his 'answer to Hume'. It is also, though less clearly, the view of Peirce (in his doctrine of Secondness or Reaction) and, independently, of Bergson. Either Hume's Axiom is erroneous, or these philosophers were mistaken precisely where they were most sure of being right. I think I know where the real mistake lies.

I wish to guard against several misunderstandings. First, I give an example of a mistake of memory that illustrates what is meant by the distinction between sheer memory and interpreted memory. I once, at the University of Chicago, was in doubt as to whether I had or had not gone to the Faculty Mail Exchange that day. Then suddenly I recalled: I had been on the way to the place in

question and had, oddly enough, vividly pictured the array of mailboxes, but then a friend met me and something he said made me decide to alter my plan. So I had *not* gone to the Exchange, but I *had* had an experience of its visual appearance. Hence my uncertainty.

Two aspects of our experience are involved here: there is the *indistinctness* of givenness, whether mnemonic or perceptual, and the more or less irresistible tendency to *overinterpret* the given (a tendency so vividly characterized by Descartes), to guess what the data may signify. I hold that there is no such thing as absolute distinctness in any human experience. We see more or less distinctly, subject to the resolving power of the human eye and other limitations. In dim light this is obvious, or when things are seen from afar. But it is true in any light or at any distance. Equally pervasive is the tendency to eke out the possession of the given by interpretations, inferences, guesses—call them what you wish. When George IV claimed to have been at Waterloo, he doubtless was remembering, and genuinely remembering, experiences of imagining himself there, memories whose data were sufficiently indistinct to be interpretable as perceptions rather than as imaginings.

A second clarification concerns the temporal structure of perception. I do not know von Wright's view here; but with Whitehead, at least some Buddhists, and Peirce in some passages at least, I take the given in perception to be past events, not strictly contemporary or simultaneous ones. So understood, perception is as directly relevant as memory to Hume's problem of necessary connections between successive events. In both cases the past itself is in our possession, though (1) more or less indistinctly so and (2) extremely subject to misinterpretation. Yet intuitively we have the actual past, not a mere picture of that past. The difference between perception and memory is not essentially in temporal structure, but in content. In what we ordinarily call 'memory', the content is previous experiences in our personal sequence or stream of awareness; in what I call 'impersonal memory', or perception, the content is previous events other than our own experiences. In either case the events remembered or perceived can be viewed as causal conditions of the remembering or perceiving experiences. In perception the events temporally closest to the experience, and its most direct causal conditions, are bodily or neural. Here I am partly in agreement with the 'identity hypothesis', though with differences that perhaps will be obvious. The prehended data are neural, not (I hold) the prehending itself. And the latter is temporally subsequent (by a small fraction of a second) to the former.[5]

Perhaps it is necessary to guard against still another misinterpretation of the alternative to Hume which I am proposing. It might be taken as a mere matter of definition that in memory or perception the remembered or perceived must have really happened. If the events did not take place, we do not call the experience 'memory' or 'perception', but 'illusion' or 'imagination'. Thus the

doctrine becomes a trivial affair of how we use words. This is obviously not an interpretation that an opponent of Hume can accept. And I think it misses the point, which is that in every case experiencing has intuitive (but not necessarily judgmental, thoughtful, or verbalized) possession of what really happened, in such fashion that, had it not happened, the experiencing could not—logically could not—have occurred with the internal quality (call it what you will) which it actually has. In short, necessary connections are precisely what is asserted.

A fourth aspect of my doctrine (the doctrine of 'process philosophy') to be noted is that the strictly necessary connections run backward, not forward, in time. It is the later which logically requires the earlier, not conversely. The later is complicated by including the earlier asymmetrically. But now it may appear that we have not thrown light upon Hume's primary problem, which was how the later is knowable from the earlier, or how prediction is possible. I concede that we have not directly and obviously answered this question. But, I will now argue, we have taken an important step toward answering it.

I restate the position we have reached: experience is an effect which intuits its antecedent causal conditions (in a more than Humean sense of condition), this intuiting being what we call memory and perception insofar as we abstract from inference, interpretation, guessing, and the like, including all verbalization. These functions or actions additional to mere memory or perception (in their purely intuitive aspects) may be summed up as forms of thinking, sign-using, or imagining. The question now arises: Granted that we directly experience, feel, intuit, at least some past events, 'How is it that we can infer other past events, and also many truths about contemporary and future happenings?' What I wish to argue is that if past events which, for conscious introspection, are neither remembered nor perceived are regarded as, in some subconscious, faint, or not distinctly detected form, in fact remembered or perceived, it can then be deduced, given a reasonable framework of concepts, that in principle events are causally inferrible from their successors, and partially, but not wholly, inferrible from their predecessors.

That all past events are somehow experienced may seem monstrously implausible, and I cannot argue adequately for it in this essay; but I do think I can show that, *if* the past is completely involved as datum causally conditioning present experience, then the present and future must be partially, though not wholly, accessible to causal inference. In other words, while absolute determinism (a foolish and useless doctrine, in my view) is not justifiable from the available premises, a qualified determinism (all we really need, or all science and common sense really use) is justifiable.

There is at least one group of writers who can furnish the conceptual framework referred to above. These writers, sometimes called 'process philosophers', have held that becoming is both creative and cumulative—'creative'

meaning that the new in any moment of process was not wholly contained in or strictly implied or entailed by the previous moments, and conditions; and 'cumulative' meaning that these conditions are in some sense contained in or strictly implied by the new. Each instance of becoming is a 'creative synthesis' of the previous instances.[6] Causality, on this view, is one-way inclusion or entailment. Bergson's snowball image of duration neatly expresses the idea. The rolling ball acquires new layers while retaining the old ones. Or, to use a more literally applicable formula, an adult remembering (mostly not with distinct consciousness) his childhood experiences presupposes and somehow implies these childish experiences, though the child was in no comparable sense aware, or implicative, of the adult life of that individual. Also, according to physics, when we see an event in the distant stellar universe we are perceiving the past, often the remote past, whereas there is no comparable way to perceive the future.

It seems not to have been noticed that deductive logic can show how, from the creative-cumulative view, it is intelligible that, although exact and unqualified prediction of future events is in principle impossible, still much about the future is predictable. Partial though not complete predictability, I shall show, is an entailment of the creative-cumulative view. This is the logical structure (not made fully explicit by him) of Whitehead's 'answer to Hume', which I regard as the only answer that need have impressed Hume very much.[7]

Assume, as the meaning of cumulativeness *cum* creativity, that absolute knowledge of an event would necessarily include or entail absolute knowledge of its causal antecedents but not vice versa. Let K stand for absolute knowledge (partially explicable as the unattainable limit of better and better partial knowledge) of events preceding event E, and let K' stand for absolute knowledge of E itself. And suppose one had K but not K'. Then (because of creativity) K' could not be inferred; but still (because of cumulativeness) something about K' could be inferred, namely, it would have to entail K. This is significant for not any and every proposition, or state of knowledge, can entail a given proposition or state of knowledge. Moreover, since K is here logically very 'strong', being the absolute description or knowledge of certain concrete actualities, the limitations imposed upon K' are substantial.

It must be understood that K' is not a mere conjunction of K with additional propositions or bits of knowledge. Otherwise the point just made above would indeed be trivial. This trivial version is ruled out as an interpretation of process philosophy by its doctrine, found in all its representatives, that concrete reality consists of unit-events, each of which is genuinely singular, and not a mere conjunction of many events, though it intrinsically refers to many. Thus an experience in which various events of the past are remembered or perceived is not those past events plus some new features which themselves do not entail the events. Rather there is a felt qualitative unity such that the new quality

intrinsically refers to the old qualities. "The many become one and are increased by one" (Whitehead). This is the point of 'creative synthesis'. Peirce's theory of categories implies a similar doctrine.[8]

My suggestion now is: the causal limitations which a present situation imposes upon its future are nothing but those that are logically implied by the principle that every future situation must strictly entail the present situation as belonging to its past. *Predictability is cumulativeness read backward.* Thus my childhood, with its world, determined that either I, as adult, or else the world without me, would years later be the kind of person or the kind of world that could refer back to just that childhood and that previous world.

The key to this reverse inference is found in deductive logic. Suppose A says to B: 'I am thinking of a class of propositions, call them the p's, each of which entails, but is not entailed by, the proposition q^*, which is, "There is an animal in the room"—what can you infer from this about the p's?' B: 'I infer that the p's are all at least as specific or definite (logically strong) as q^*; indeed, since they are stipulated to be non-equivalent to q^*, they must be more definite, as in "There is a small animal in the room," or "There is a dog in the room." Also any p must have a subject matter closely related to that of q^*; it cannot compare to q^* as would "There is a plant (or a rose, or a pitcher of water) in the room." '

Suppose, instead of q^* we take a logically stronger proposition, e.g., 'There is a small terrier in the room'; or even, 'Our little terrier Fido is in the room.' In this case the p's must be much more narrowly limited than in the other case. Thus: 'Our little terrier Fido asleep (or scratching himself) is in the room.' Entailment without equivalence is always a matter of dropping, in conclusions, some part of the logical strength, the information, contained in premises. The one-way view of causal necessity is the limiting, most concrete case of this, with the description of the later situation, the outcome or effect, being the logically stronger premise, and the antecedent situation or cause the logically weaker conclusion. Becoming is enrichment of reality, adding definiteness but not subtracting any. The cause-effect relation is to be fully understood only from the standpoint of the effect, in which alone lies the complete determinateness.

The traditional view was very different. The cause was the superior entity, or if not, cause and effect were 'equal'. Effects were to be 'known in their causes'. And so, before an event existed to be known it was, nevertheless, completely defined and ready to be known. (Or else it existed before it happened.) This upside-down idea (if I may be allowed a historical *excursus*) was neatly embodied in the standard medieval theological view that God knows the world simply by knowing himself as its cause. But if the effect is contained in the cause, what is the point of causation? The only value which production can have is to enrich reality. The cause-with-the-effect must be superior to the

cause alone. Also, if causes do not annihilate themselves, effects-with-causes are the only effects there are. God does not annihilate himself in producing the world, and so the world with its divine cause is more than the cause alone. Either this effect is superior to God, or it is God as enriched by the world produced. Neither implication was acceptable to medieval thinkers.

Spinoza took the medieval scheme seriously and deduced the catastrophic consequence that the world must be in God, and in God taken merely as necessary and eternal cause; i.e., the world in all details must be as necessary as God. Therewith, as Wolfson rightly says, Spinoza destroyed (one chief aspect of) 'the medieval synthesis'. For two centuries and more philosophers and theologians hesitated to try the remaining theistic possibility, which is to admit that effects as such are more than their causes, and hence supreme Reality must be the universal or inclusive contingent effect, as well as the universal or primordial necessary cause. It must be influenced by, as well as influential upon, all things. To avoid contradiction one must admit (as Whitehead and others have done) a real distinction in God between the divine nature as primordial and the divine nature as consequent, or as influenced by the creation.

Returning from this theological excursus, I wish to point out that attention to the 'fallacy of affirming the consequent' (and deducing the antecedent) has been allowed to obscure the important truth that 'A certain proposition q is entailed by every member of the class C of propositions' tells us something about this class and, moreover, that the more definite or logically strong q is the more we thus learn about the class C. One group of such classes of propositions is what is meant by 'real possibilities' in the normal sense, i.e., possibilities for the future of some given present. Here q is very strong indeed. And this is one reason why the transition from cumulativeness to the possibility of implications for the future has been overlooked. Ordinarily, textbook cases of implication often involve very weak instances of q. Suppose q is, 'I see something moving'. Then 'I see our dog Fido moving' is one of a fantastically wide variety of possible p's entailing q. Causal prediction can start from an incomparably richer base than a mere visible moving something. So the reverse inference to the class of p's can be incomparably more definite.

A full account would have to consider the distinction between law-like statements and those specifying particular 'initial conditions'. It would also have to ask what, in 'inanimate' nature, corresponds to memory and perception. I personally believe further that the adequate understanding of law-like statements requires the idea of a cosmic lawgiver. But still, all this would come under K, the knowledge or description of the antecedent situation from which the result, the effect, is to come. Even God's lawgiving action must be antecedent to the effects it influences, not simultaneous with them (nor yet eternal). Thus the ultimate principle of 'cause' or 'condition' is univocal, even though there is also a 'difference in principle' between divine and other causation. God

as causal influence in every event will (in one aspect of his being) be *antecedent* to every event and, as influenced by every event, will be *subsequent* to every event. God alone is primordial and God alone is everlasting. That causes are logically independent of effects just as, in the normal cases of entailment, conclusions are independent of premises, will be universally true.

Obviously one source of confusion is the metaphor that conclusions 'follow' from premises. In our knowledge, drawing conclusions may temporally succeed the positing of premises. But this is the reverse of the ontological relations. Thus 'animal' follows logically from 'human', but animals were in the world long before human beings. Events in their concreteness are never, never, deduced from or known in antecedent events, whereas they are habitually known in subsequent ones (more or less directly) by either memory or perception. The past is cognitively derived from the present by abstracting from that in the present which is novel. To realize today what yesterday was like we must drop out part of what we know about today's experiences. The full logical strength is in the present; it was in no sense in the past. Thus have multitudes of philosophers been misled, partly at least, by a metaphor. Causal prediction is reading the deductive relations backward, from a conclusion to the class of premises capable of entailing it. We are asking, in Whitehead's metaphor, what sort of future could "house", accommodate, what is now going on as its past?

The chief mistake concerning causation has been acceptance of the false dilemma: either deductive logic cannot throw light upon the causal relations of events, or each new event is to be viewed as premise for new entailed conclusions. On the contrary, each event is primarily a new premise for old conclusions. Only in a weakened sense, and purely derivatively from this, is it a premise for new conclusions. This is not particularly paradoxical. Each new experience of a grown man is a new premise from which that man's birth and childhood logically follow. Or, after the death, say, of Washington, each new stage of the writing of American history is a new premise from which the one-time existence of Washington logically follows (assuming, as we all do, that Washington can be and is denoted). The reverse inference, from the life of Washington to subsequent historians and their writings about Washington, is a weaker one and merely gives us a class of possible or probable historians writing about him. And while the adult Washington presupposes the child Washington, the latter might have accidentally died before growing up. To assert the contrary is to leap into a 'dark' whose degree of darkness cannot be exaggerated.

It is true that the laws of physics, as now known, do not suffice to validate all aspects of the above scheme. But we should not forget, I think, that physics is the most abstract form of knowledge of nature. We know what it is like to be an animal, in a sense in which we can never know what it is like to be an atom (rather than a man experimenting with atoms). I cannot believe that physics goes as deeply into the nature of things as biology and psychology. It may

be more accurate and more comprehensive than they, but at the price of know-
ing less well what sort of things it is dealing with, apart from human experi-
ences of this subject matter. Do we know what radiant energy or electricity
are? We know some structural (mathematically expressible) truths about them,
and we are familiar with certain human experiences partly traceable to them as
causes, but this is all, so far as physics can tell us.

To the contention of some philosophers that the question, 'What is such
and such, beyond its structural-causal status?' has no meaning, I reply, 'It has
a clear but in some cases not very definitely answerable meaning, which is:
How does such-and-such differ from or resemble various aspects of our human
experiences, and this in qualitative as well as merely structural respects?' We
know what we are asking; but since qualities are not definitely knowable except
by intuition and our sharply definite intuitions are limited by the capacities of
our sense organs, there is much that we cannot know about the qualities of
reality.

Two mistakes in traditional reflections upon causality have been the arbi-
trary assumptions (1) that causal conditioning is symmetrical, or is biconditio-
ing (events equally definitely or indefinitely requiring their antecedent condi-
tions and their subsequent results) and (2) that the way to understand effects is
to consider what it means to be a cause. By (1) either creativity is wholly
excluded (determinism) or no strict cumulativeness is allowed (Mead). By (2)
one unwittingly tries, as it were, to understand deduction by asking how con-
clusions imply premises. It is not causes but effects which are the premises,
the logically stronger terms. We find the past in the present, not vice versa;
and only because the past is in the present is the future also—though only
partially—in the present, as that which, whatever else later becomes true of it,
must contain the present as its past. When we know what it is to be an effect,
then we can, by logical principles, derive what it is to be cause, for that is the
simpler case. A cause defines a set of possible effects, a set which, though it
may not yet have an actual member, is bound to acquire members.

As soon as we see that the key to causation is in the status of being an
effect of antecedent conditions, we are ready to see also that both memory and
perception are, by their very meaning, just such effects. And then we see what
Hume overlooked. He sought causal connections between things perceived and/
or remembered, rather than between perceivings or rememberings themselves
and their contents. Or more precisely, he sought connections between 'impres-
sions', taken either as not intrinsically referring to anything impressing itself
upon them, or else as things doing the impressing; while the results of this
action, the real impressions, are dismissed from consideration. It was a strange
error, repeated on a grandiose scale by Russell—and how many others!

That it was a significant error seems clear. If we do not know what it is to
perceive or remember, how shall we know that and what we perceive or re-
member? If perceiving and remembering are not indispensable ideas in episte-

mology, what could be such ideas? If we can know that we know anything, we must be able to know what it is to experience—that is, to perceive or remember. And the time to look for relations between entities perceived or remembered, but which perhaps at least apparently do not themselves perceive or remember, is after we have done real justice to the relational structures of perceiving and remembering as such. In this sense at least epistemology is prior to ontology.

Humean positivism misses the boat at this landing as neatly as boats can be missed. To employ a classical joke, the boat is missed by two, or rather three, jumps. (1) Humists look for, and announce their failure to find, a symmetrical causal necessity, a biconditioning, whereas we know from propositional logic that the biconditional (equivalence) is a derivative relation, not the basic meaning of implication. (2) They look for necessity in the wrong place, in mere objects taken as independent absolutes, rather than in experiences as essentially relative to what is experienced. (3) Insofar as they take causality as a one-way (rather than symmetrical or directionless) requirement, they take the inference to be primarily from cause to effect. (E.g., note line 20, p. 18, of *The Logical Problem*.) Thus, in nearly all possible ways they fail to deal with the causal theory common to the most characteristic constructive metaphysical systems of recent times—Bergson, Peirce, Whitehead, also Montague, Parker, Hartshorne, and others. And some idealistic critics of Humism, e.g., Ewing, make some of the same mistakes. This is indeed a comedy of errors, or of failure in communication. For the creative-cumulative view of becoming is clearly implicit in doctrines that were held long before Hume (e.g., by the Socinians). Lequier held such a doctrine a hundred years ago. It is much more widely held now. And partisans of Hume's view that causal relations are mere constant conjunctions have yet to tell us how they know that no such doctrine can be true.

Two admissions are in order. The process philosopher needs some solution of Kant's First Antinomy. He must either suppose a first moment of all becoming, or admit an infinite or indefinite number of past events. My own view is that an actual infinity of already elapsed events is a tenable idea, and that mathematical finitism taken to exclude this is not obligatory. The other admission concerns a perhaps even greater difficulty. Granted, some will say, that the past insofar as remembered or perceived is implied by the present: how far can this implication go, considering how much of the past—so far as we can empirically know—is neither remembered nor perceived? Here we confront the question of unconscious or faintly conscious memories and perceptions and the question of various levels of non-human memory and perception, including for some of us divine memory and perception. I hold that a theist is here, as in other fundamental questions, in an advantageous position, provided he avoids certain mistakes in the idea of God—for example the idea that God is universal

cause but not universal effect, or that God is in every sense immutable. I also hold that a psychicalist, for whom singular events (the momentary state of a stone is not one stony event but a vast number of molecular, atomic, or particulate events) all perceive in at least some minimal sense, has the advantage over a materialist or dualist.

I believe that the difficulties mentioned in the previous paragraph are to be taken seriously, but are not insuperable. In contrast, the difficulties of Hume's view, as well as those of materialism and also of 'absolute idealism' (holding either that every event implicates every other, past, contemporary, or future, or that events and temporal relations are not real), seem to me incurable and sufficient to justify the rejection of these views. Some version of process philosophy seems therefore the only hope of understanding causality. It alone can show *how* events require their antecedents, from which, as I have tried to show, it is deducible that they entail an important part of the natures of their successors. More than this is not needed for the purposes of life; indeed, the more than this which is affirmed by determinism is pragmatically meaningless. It is intrinsic to the meaning of prediction that it be less than absolute. It is the very point of foreknowledge that it be qualified to allow elements of choice between possible outcomes of present situations. Only the myth of the knower as mere spectator, outside the world of action and peering into it, as it were, through a metaphysical window, could ever have made determinism seem a sensible idea.

I seriously suggest that process philosophy is a definite theory of causality compared to which other doctrines are either glaringly unsuccessful attempts at a theory, or refusals to theorize on the subject at all.

Let us summarize the argument. If proposition q is true, then unless q has de facto maximal logical strength (is the perfect description of a concrete state of the world process), some logically stronger proposition p, itself maximal in strength, is also true. If q has de facto maximal strength, then, although no stronger proposition is as yet true, of the class C of possible logically related but still stronger propositions some one (it is not predesignated which) *will become* true.[9] The disjunction of such possible related but stronger propositions than any as yet true defines 'real possibilities'. Thus the world grows in content—the very meaning of 'creativity'. As partial illustration: let q be, 'I now feel in such-and-such a way'; then C may include, 'I remember in such-and-such a manner having previously felt in the way specified'. The description of the quality of my remembering will include and be logically stronger than the description of the feeling remembered. Thus becoming is *increase in richness of content;* although, because of the limitations of our conscious memories and perceptions, the increase is largely hidden from our distinct apprehension. The contrast between the apparent lack of increase—or at times the apparent net loss—and the required gain is one of the aspects of existence which suggest a

religious interpretation of the world. Apart from a real gain in content, becoming is, in ultimate perspective, essentially meaningless. This is one reason why merely secular philosophies leave us finally frustrated. It is also a reason why causality often seems so mysterious or irrational—as it did to Hume.

It will be obvious that I am agreeing with Hume and von Wright that no event (in its full concreteness) can be the necessary consequence of antecedent conditions. To admit that it could would contradict creativity and turn conditioning into mere biconditioning, a suspicious reduction to the degenerate case. (Would it not be odd if the logic of events were more symmetrical than the logic of ideas? As Plato saw, absolute symmetry or equality is only an ideal.) That "absolute idealists" have been guilty of this reduction to symmetry is their affair, for which process philosophers can accept no responsibility. The idea of creativity is the rejection of any unqualified notion of 'sufficient condition', if more is meant than that, granted the condition, what actually happened was thereby made possible. Conditions can be necessary, but even if all necessary conditions are present the event may not occur—unless by 'the event' one means an approximately defined kind of event, rather than a particular instance of the kind. 'An explosion' may be the necessary result of a situation, but never the precise explosion which takes place. It is not antecedent conditions which finally decide events, but those events themselves. This is the freedom or self-creation which process philosophers and existentialists unite in affirming. If or insofar as von Wright's 'deterministic postulate'[10] conflicts with this, I regard it as at best an allowable fiction, whose admissibility even as such renders questionable the present state of science, and indeed the state of knowledge as far back as Clerk Maxwell and Peirce.[11]

Von Wright (*Explanation and Understanding,* pp. 160ff) distinguishes between determinism of the predictability type and determinism of the intelligibility type, or predeterminism and postdeterminism. The second type explains events through intentions and is teleological. I miss here (perhaps I overlooked) the qualification that no intention or purpose can ever be as definite as concrete actions or events. In carrying out any purpose, which necessarily has aspects of generality or indeterminacy, creativity is required transcending any advance specifications.

A possible objection to the process view is that, at most, it only shows that *if* there is a future at all, it must be congruent with the past. But perhaps there will not be a future. Perhaps what is now happening is the last event that will ever happen. The question is, 'Does this make sense?' What would make an event the last of all? There seem to be two possibilities: some internal quality of the event constitutes its lastness, or something outside the event does so. The first seems, and I believe is, absurd. The second I take to be absurd also. 'After this, nothing.' But nothing is nothing; it has no positive functions and by itself can constitute no truth. I hold with those philosophers who deny that

there can be such a thing as a merely negative fact. No event can in itself be the last, and no nothingness 'following' it can make it to have been the last. Only a positive present can have a past. This is part of what Whitehead has in mind when he speaks of 'the creative ground' from which neither God nor creature can escape. Becoming is in principle endless. 'The many become one and are increased by one', thus forming a new many to become a still richer one. This is reality itself, and all talk not about this is about nothing and means nothing; that is to say, it does not mean, and is meaningless. So the necessity that the future adapt itself to the past is not hypothetical, conditional upon there being a future. There necessarily will be.

Nothing in the foregoing should be taken to imply that we can have definitive a priori insight into causal necessities (to the extent that these really obtain). Our prehensions being incurably indistinct, as Spinoza, Descartes, Leibniz, Peirce, and Whitehead agree that they are, only the normal testing procedures of inductive inquiry can tell us what generalizations, from which predictions can be derived, are worth trusting. The value of 'solving Hume's problem' (here I am in partial agreement with von Wright) is not to give an extra degree of certainty to predictions or to assertions of particular natural laws, but to give us the satisfaction of understanding *in principle* what it is in the world that makes it possible for the past to furnish evidence concerning the future, or concerning contemporary spatially remote events, or indeed for the near past to furnish evidence concerning the more remote past. There are values in understanding the way the world hangs together besides the mere confirmation this may give our animal faith, as extended by science, the possibility of foreknowledge (within limits set by our weaknesses and by the pervasive presence of creativity).

One wonders at the defensiveness of much current philosophizing, as though we needed philosophy only to dispel a degree of skepticism or erosion of animal faith, an erosion which itself is produced by philosophy, and which is either pretense or borders on mental illness. Curiosity, not fear that perhaps we cannot predict, or cannot know anything worth knowing, seems a healthier motive for philosophizing. (In these remarks I am not attacking von Wright, but certain others, who will, I suspect, occur to the reader.) Not *whether* we can predict but *why,* and subject to what limitations, is the question. We cannot 'know the future' with certainty for two reasons: we cannot know the past or present except partially, more or less indistinctly and inaccurately; and even if we knew it perfectly, future events would be only partly defined or implied by this knowledge. Nevertheless, that there are real necessary connections backward and approximate or probabilistic connections forward in time I take to be an a priori truth, for it expresses the nature of experience and becoming as such; and to this there is no alternative, for it is the principle of alternativeness itself, i.e., creativity.

I fear I have seemed to go far afield from von Wright's work. I apologize for this. But I do not know how one can put a really important question to a philosopher with rather different interests and beliefs without some indication of systematic background for the question.

There is one essay of von Wright's with which I wish to express hearty agreement. This is his Eddington Memorial Lecture *Time, Change and Contradiction*.[12] Here the distinguished logician gives an argument for the position adopted long, long ago by Buddhism, and recently by James and Whitehead: the view that actual becoming is not continuous but comes in least units, which James called 'drops' or 'buds'. Whitehead calls this the 'epochal theory' of time. It can also be termed an atomic or quantum theory. Von Wright's argument for this theory seems to me superior to Whitehead's own, which is a form of Zeno's argument.[13] Von Wright holds that the logical principle, 'no *S* can be *p* and not-*p* at the same time' is inapplicable if change is taken as continuous. For then, in any second, for any *S* and for some *p* there is both *p* and not-*p*, and the same with any other fraction of time. So (assuming continuous change) either we must take *S* at an instant (or in zero duration) or give up the principle of noncontradiction. With many other philosophers, von Wright rejects the notion that an actuality can have a definite character in zero time. The conclusion then follows: becoming cannot be continuous. I hope I have not miserably oversimplified or distorted the argument, which I regard as a welcome contribution to metaphysics.

There is a significant relation of temporal atomicity to the Humean problem. All talk about 'events' is incurably indefinite if becoming is taken as continuous. As Leibniz insisted, plurals imply singulars. Is a single event that which happens here (or there) in a second? A half-second? Or what? Clearly there are no objectively singular events, granted continuity. Partly because he is vague or ambiguous on this issue, Bergson is also vague or ambiguous in his dealing with the Humean problem. Even Peirce, with his 'infinitesimal present', seems evasive here. Thus it is no accident that Whitehead alone is perfectly clear and definite both about the quantum character of becoming and about the one-way dependence of experiences upon earlier events.[14] A definite theory of relations requires a definite theory of terms. Only those few who, like Whitehead and von Wright, see that continuity is but an idea or conceptual schema, or but an order among possibilities, not an order of actualities, can have a definite theory of temporal relations. If Hume himself had such a theory (definite, but incorrect), then he held a quantum theory of becoming. I believe that there are at least hints in this direction in his work.

I look forward to whatever comments von Wright is willing to make on this attempt to get him to reconsider his relations to Hume, and perhaps also to some philosophers who have really 'answered' Hume. How far, if at all, this would imply changes in his technical treatment of induction is a question

I am forced by my limitations to leave to him, or to others who, like him, are in command of the resources of contemporary logic.

DEPARTMENT OF PHILOSOPHY CHARLES HARTSHORNE
THE UNIVERSITY OF TEXAS AT AUSTIN
JUNE 1972

NOTES

1. Georg H. von Wright, *The Logical Problem of Induction*. 2d Rev. Ed. (Oxford: Blackwell, 1957), pp. 15–16.

2. Alfred J. Ayer, *The Problem of Knowledge* (London: Macmillan and Co., 1957), p. 27.

3. For a discussion of the general tendency to neglect asymmetrical relationships, see Ch. X of my *Creative Synthesis and Philosophic Method* (London and LaSalle, Ill.: SCM and Open Court, 1970). There is some discussion of asymmetry in causal relations in von Wright's *Explanation and Understanding* (London: Kegan Paul; Ithaca: Cornell University, 1971), pp. 41ff, 74–82, 191. In this book cause is so defined that effects can precede their causes. I think the evidence he cites does not refute the asymmetrical temporal view of causation that I defend. In a way his examples confirm the contention that it is the past which is necessitated by the present, not the future.

4. Richard Rorty in a letter has called my attention to a remark of Russell's made early in his career that might have led him to a non-Humean view. Russell notes that the cognitive relation is internal to the mental term and external to the physical term ('Meinong's Theory of Complexes and Assumptions', *Mind*, N.S., No. 52 (1904:509ff). Rorty found the reference in Joachim's *Nature of Truth*, and says, "Joachim, of course, goes on to expostulate on how the relation can't possibly be external to either term." Of course, indeed. Such was absolute idealism, blithely going to the opposite extreme from Hume's absolute atomism. Ironically it was an absolute idealist (Bosanquet) who spoke of the "meeting of extremes."

5. How, from intuitive awareness of bodily events, we are able to derive knowledge of extrabodily ones is illuminatingly treated by Abner Shimony in 'Symposium: Evolution and the Causal Theory of Perception''. *Journal of Philosophy* 68 (1971), No. 19: 571–97.

6. For the idea of creativity see Ch. I of *Creative Synthesis*. Also A. N. Whitehead, *Process and Reality* (New York: Macmillan Co., 1927, 1967), Ch. II, sec. II, 'Category of the Ultimate'; also (vi) Category of explanation.

7. For Whitehead on Hume see the former's *Symbolism: Its Meaning and Effect* (New York: Macmillan Co., 1927; Putnam's, 1959), Ch. II.

8. *The Collected Papers of Charles Sanders Peirce*, edited by Charles Hartshorne, Paul Weiss, and Arthur W. Burks. (Cambridge, Mass.: Harvard University Press, 1931, 1958), Vol. I, Bk. III; also pars. 7.528ff.

9. For a defense of the view that truths about particular events emerge with, or at some finite time prior to, the events, see my article, 'The meaning of "Is going to be" ', *Mind* 74 (Jan. 1965): 128–136. This view has been criticized, I think inconclusively, by Michael Clark in *Knowledge and Necessity*, edited by G.N.A. Vesey. Royal

Institute of Philosophy Lectures (Vol. 3, 1968–69). (London: Macmillan, 1970), pp. 170–180.

10. *A Treatise on Induction and Probability*. Paterson, N.J.: Littlefield, Adams, 1960. See Index, *deterministic postulate*. Certain qualifications on determinism seem implied by von Wright's discussion of action and closed systems in *Explanation and Understanding*, pp. 48f, 129ff, 160–167, 206. But the creativity of experience and becoming as such (an idea which Bergson, Peirce, and Whitehead have in common and which I accept) seems another matter, if I understand these subtle passages.

11. For Peirce's criticism of determinism see his essay, 'The Doctrine of Necessity Examined', in *Collected Papers*, 6.55ff. Also see 1.135ff. For Maxwell's view, see *The Life of James Clerk Maxwell* by Lewis Campbell and W. Garnett (London: Macmillan and Co., 1882), pp. 434, 438, 441, 444. Some of the complexities of the scientific problem are elucidated in the 'Symposium on Determinism' by John Earman, Clark Glynour, and Kurt Bendall in *Journal of Philosophy* 68 (1971), No. 21: 729–761.

12. Cambridge University Press, 1969.

13. For Whitehead's argument against the continuity of process see *Process and Reality*, Ch. III, sec. iii; also Index, *Zeno*. For the nearest Peirce came to the epochal view see *Collected Papers*, 7.352, 532, 536.

14. 'Whitehead' here means, as I interpret him. Some passages in *Process and Reality* do seem to imply symmetry.

2

Henry E. Kyburg, Jr.

VON WRIGHT ON THE LOGIC OF CONDITIONS AND INDUCTIVE LOGIC

There is an appealing simplicity about induction by elimination. It is akin to the appealing simplicity of a British detective novel, in which, once the spoiled younger son, the eccentric aunt, the careerist daughter, and the odd uncle who made his fortune in Australia are eliminated, the blame for the crime falls unerringly and conclusively on the one other person who had access to the elderberry wine, the butler. Although the appeal of eliminative induction has not gone unobserved (both Bacon and Mill regarded it as the best of all inductive methods), by far the most thorough analysis of the mechanism of induction by elimination is due to G. H. von Wright.

This analysis is carried out in the framework of a 'logic of conditions', that is, a logic of *sufficient, necessary,* and *necessary-and-sufficient* conditions. In *The Logical Problem of Induction* these conditions are interpreted extensionally: if the conditional

$$\bigwedge_{x} (Fx \rightarrow Gx)$$

is true, i.e., if there happens to be nothing that is both F and not G, then we say that F is a sufficient condition of G, and that G is a necessary condition of F. Similarly, if

$$\bigwedge_{x} (Fx \leftrightarrow Gx)$$

is true, we say that F is a necessary and sufficient condition of G.[1]

No detailed analysis of the logic of conditions and its relation to induction is provided in *The Logical Problem of Induction*. Von Wright says, "The really important task of a logic of induction is to analyse the logical mechanism of elimination so that it becomes clear what pure elimination alone can achieve, and exactly to formulate the content of the principles needed in order to extract inductive generalizations from the data of elimination."[2]

This is precisely the task von Wright set himself in his *Treatise on Induction and Probability*. In this work, the same extensional analysis of conditions is adopted, but with slightly different notation. "That (the property denoted by) *A* is a Sufficient Condition of (the property denoted by) *B* means that whenever *A* is present, then *B* is also present, or that $A \subset B$."[3] Despite the extensional form of condition statements, von Wright says, "A connexion of condition between properties may also be called a connexion of law, or nomic connexion," and, "the Logic of Conditions is thus the logic of nomic connexion."[4] Many philosophers would balk at the suggestion that a statement of condition is a statement of nomic connection. It is true (say) that the property of being a coin in my pocket is included in the property of being copper; but there is surely nothing here we would dignify with the adjective 'nomic'. On von Wright's view, this conditional is not even saved from being a *law of nature* by the fact that my pocket is not big enough to contain an infinite number of coins. The 'implication property' corresponding to the inclusion statement is universal, and "If the property in question is (denumerably) infinite, the theory is said to have the numerically unrestricted range of application which entitles it to the name of a law (law of nature)."[5]

Von Wright now feels[6] that the logic of conditions should be assimilated to modal logic, rather than merely to quantification theory. This would have the consequence that '*A* is a sufficient condition of *B*' would come to be interpreted as '*Necessarily* $A \subset B$.' Although this approach would eliminate the awkwardness of having to call certain trivial condition statements 'Laws' or 'statements of nomic connection,' such a change in framework would have relatively little bearing on the logic of eliminative induction. We shall show this by exhibiting (briefly) the eliminative mechanisms developed by von Wright, and then showing what modifications would be required by taking the conclusions of inductions to be intensional rather than extensional. We shall finally turn to the more basic question of where the premises for eliminative induction come from.

Properties are denoted by the capital letters, *A, B, C*, etc. Let ϕ_o be a set of properties. Let $B(\phi_o)$ be the Boolean algebra of properties based on ϕ_o, where the operations $\wedge, \vee, \bar{\ }, \rightarrow$, and \leftrightarrow are given their natural interpretation:

$A \vee B$ is just that property that something has when it has the property *A* or the property *B*.

$A \rightarrow B$ is just that property that something has when it has either the property \bar{A} or the property *B*.

\bar{A} is just that property that something has that lacks the property *A*.

$A \leftrightarrow B$ is just that property that something has when it either has the properties *A* and *B*, or lacks both properties.

$A \wedge B$ is just that property that something has when it has both the property *A* and the property *B*.

Two properties, A and B, are coextensive, $A \equiv B$, just in case everything that has the one property also has the other, i.e., just in case everything whatever has the property $A \leftrightarrow B$. Coextensive properties in $B(\phi_0)$ are regarded as identical—this is appropriate since the whole analysis is extensional.

We say that one property is included in another, $A \subset B$, just in case everything that has the one property also has the other, i.e., just in case everything whatever has the property $A \rightarrow B$.

We say that a set of properties ϕ_0 are *totally logically independent* just in case there is no property A in ϕ_0 and no non-zero and non-universal Boolean function F of the remaining properties in ϕ_0 such that either $A \subset F$ or $F \subset A$ is logically valid.[7]

Let ϕ_0 contain k properties. Then ϕ_0 is a set of logically totally independent properties just in case the assertion that $B(\phi_0)$ has cardinality less than 2^k is not logically valid.

Henceforth let ϕ_0 be a set of k logically totally independent properties.

Let us (following the von Wright of TIP) define conditions as follows:

(1) A is a necessary condition of B: $B \subset A$
A is a sufficient condition of B: $A \subset B$
A is a necessary-and-sufficient condition of B: $A \equiv B$

From these definitions, it follows that if A is a necessary condition of B, so is the property $A \lor C$; and if A is a sufficient condition of B, so is the property $A \land C$. It is clearly the greatest sufficient condition and smallest necessary condition of an event that are of most interest to us.

(2) A is a greatest sufficient condition of B just in case no member of $B(\phi_0)$ which includes but is not included in A is a sufficient condition of B.
A is a smallest necessary condition of B just in case no member of $B(\phi_0)$ which is included in, but does not include A, is a necessary condition of B.[8]

Finally, we wish to take account of the possible plurality of causes or conditions. For example, both A and B may be greatest sufficient conditions of C, and both G and H may be smallest necessary conditions of F.

(3) A is the total sufficient condition of B in ϕ_0 if and only if A is the sum of all the greatest sufficient conditions of B in ϕ_0
A is the total necessary condition of B in ϕ_0 if and only if A is the product of all the smallest necessary conditions of B in ϕ_0

As von Wright remarks, "It is of no interest to introduce the notions of Greatest, Smallest, and Total Necessary-and-Sufficient Conditions, since the Necessary-and-Sufficient Conditions of a property are all co-extensive."[9]

The actual mechanism of eliminative induction is extremely simple: The observation of an instance of A which is not an instance of B eliminates the hypothesis that A is a sufficient condition of B. The observation of an instance

of B which is not an instance of A eliminates the hypothesis that A is a necessary condition of B. And of course either observation eliminates the hypothesis that A is a necessary-and-sufficient condition of B. In order to arrive at positive results through elimination, however, two supplementary postulates are required: the Deterministic Postulate and the Selection Postulate.

We restrict our attention now to greatest sufficient conditions and smallest necessary conditions. The complexity of a condition is the number of members of ϕ_0 of which that condition is a presence function. More precisely, every sufficient condition is coextensive with a conjunction of m members of ϕ_0 and n complements of members of ϕ_0. Every necessary condition is coextensive with the disjunction of m members of ϕ_0 and n complements of members of ϕ_0. It suffices to consider only such conditions. The sum m plus n, is the complexity of the condition. The plurality of sufficient conditions is the number of disjunctions in the total sufficient condition; the plurality of necessary conditions is the number of conjunctions in the total necessary condition.

The Deterministic Postulate says, roughly, that for a given conditioned property, actual conditioning properties exist.

The Selection Postulate says that there is a set ϕ_0 of initially possible conditioning properties which includes the actual conditioning properties, and is such that "the state of analogy among any given number of things in respect to the initially possible conditioning properties, can be settled on the basis of an enumeration of the data of elimination."[10] In short, it states that we can tell of each instance and for every property in ϕ_0 whether that instance is a positive or a negative instance of that property.

In their most plausible form, these postulates may be combined as follows: "The conditioned property H has, among k initially possible conditioning properties, (at least) m (not-more-than-) n-complex conditions of a certain kind."[11]

As von Wright understands clearly, the combined postulates must be understood as a premise of demonstrative inductive inference. Given the postulate, given a set of instances, it is possible to conclude deductively that a certain condition is the Total Sufficient Condition for H (for example). Since the premise is admittedly a strong material statement (in effect, it states that one of a finite disjunction of universal statements is true), the result of this analysis must be construed as a reconstruction of a certain sort of inductive argument, rather than as anything having anything to do with the *justification* of induction.[12]

How would this analysis have to be changed to take account of a more plausible construal of condition statements as intensional in character rather than extensional? Extremely little—in part, because there are indications that von Wright had something like this in mind in the first place. The warning, "It is important not to confuse inclusion with implication and entailment, nor coextension with equivalence and identity",[13] suggests that properties are not to

be identified when their extensions are the same, and this is important only if an intensional analysis is to be offered.

A part of the analysis of the preceding section is simply unchanged. ϕ_0 is still taken to be a set of properties, $B(\phi_0)$ the Boolean algebra based on it. The operations have the same interpretations. As before, properties A and B are coextensive (still rendered $A \equiv B$) just in case everything that has the one also has the other, i.e., when every actual thing has the property $A \leftrightarrow B$.

We now, however, no longer regard coextensive properties as identical. Two properties, A and B, are identical just when they are coextensive in every logically possible world, i.e., when they are *necessarily* coextensive.

(4) $A = B$ if and only if $N (A \equiv B)$

Since in our Boolean algebra based on ϕ_0 we were concerned only with logically valid relationships among properties, this change leaves our Boolean algebra unaffected. Similarly, the conditions under which a set of properties ϕ_0 are logically totally independent remain unchanged.

The basic change concerns the definition of necessary, sufficient, and necessary-and-sufficient conditions. On the new analysis, to say that A is a necessary condition of B, is to say not merely that $B \subset A$ is true, but that it is *necessarily* true. On the other hand, we do not wish this necessity to be logical necessity or entailment.[14] Let us write N_e for this physical or empirical necessity, and take it to mean truth in every physically possible world. Then, paralleling (1), we have

(5) A is a sufficient condition of B just in case $N_e(A \subset B)$
 A is a necessary condition of B just in case $N_e(B \subset A)$
 A is a necessary-and-sufficient condition of B just in case $N_e(A \equiv B)$

With these definitions of conditions, it is still true that if A is a sufficient condition of B, so is $A \wedge B$ (since $N_e(A \wedge C \subset A)$), and if A is a necessary condition of B, so is $A \vee C$. Thus we still want to define greatest sufficient conditions and smallest necessary conditions as before in (2), and we will wish to take account of a possible plurality of conditions by speaking of total sufficient conditions and total necessary conditions, as in (3).

The mechanism of elimination works just as before. If we find an instance of A which is not an instance of B, that eliminates A as a possible sufficient condition of B, since $N_e(A \subset B)$ entails $A \subset B$ which entails that there is nothing exemplifying A which does not exemplify B. Finding an object of the latter sort clearly eliminates the hypothesis $N_e(A \subset B)$. Similarly, finding an instance of B which is not an instance of A eliminates the hypothesis that A is a necessary condition of B. Thus the whole mechanism of elimination developed and described by von Wright for extensional condition statements works perfectly well for our new intensional condition statements. Nothing central in the whole of chapter IV is changed.

We must reexamine the question of the supplementary premises for induction, however. The supplementary premise we required before was "The conditioned property H has, among k initially possible conditioning properties, (at least) m (not-more-than) n-complex conditions of a certain kind."[15] Unpacking this supplementary premise in terms of intensional condition statements, we find that it amounts to the assertion that a certain finite disjunction of statements of the form $N_e\phi$ is true. Since we can eliminate such statements by observing counterinstances, we can clearly construct an argument which will eliminate all but one candidate; and that one candidate thereupon will be the deductive consequence of the supplementary premise together with the data of elimination. Thus even the supplementary premise may retain the same form; but of course its content is considerably stronger.

This has one epistemologically interesting consequence. When we interpret condition statements extensionally, to say that A is a sufficient condition of B is just to say that every instance of A is an instance of B. If there are only a finite number of instances of A, the statement is in principle decidable—we may uncover its truth value by looking at all the instances of A. If there are a denumerable number of instances of A, we may nevertheless speak of being able to decide the truth of the statement 'in the limit'. If the statement is false, there is an instance of A that is not an instance of B; if there is an instance of A that is not an instance of B, there is a first such instance in our enumeration of the A's; and a finite number of examinations will reveal that instance (though, of course, we don't know how many—hence 'in the limit'). The situation is quite different when the condition statement is interpreted intensionally.

If there are only a finite number of instances of A, we can in principle examine them all; but even if we find that they *are* all instances of B, that will not tell us that $N_e(A \subset B)$ is true. This means that even if we go on to achieve that coveted state of perfect analogy, there is still no way in which we can tell whether $A \subset B$ is merely true in our particular world, or in every physically possible world, except from the strong premise. There is, in fact, no empirical evidence *possible* which will allow us to distinguish between $A \subset B$ and $N_e(A \subset B)$: we are in a position to sample from only one possible world. It thus becomes difficult to see where the strong supplementary premise can come from.

Von Wright suggests that the logic of conditions, or the logic of elimination, is the pervasive underlying mechanism of induction. He does not suggest that this provides a *justification* of induction, for he recognizes[16] that the premise required, even in its extensional form, is a falsifiable material premise. "It has been shown that our original definition of Laws of Nature as Universal Implications or Equivalences is, in fact, sufficiently general to embrace also Statistical Laws. This means that inductive inference leading to Statistical Laws is a sub-species of inductive inference of the second order, as previously de-

fined by us. Thus the logical study of induction, as undertaken in this book, is relevant not only to a narrow type of inductive conclusion, but is the study of the most general and comprehensive pattern of such inference."[17]

Let us first examine the question of whether, in point of fact, statistical laws can plausibly be regarded as universal implications, subject to the eliminative logic already described. Then let us see if it is plausible to construe statistical laws, as we may construe condition statements, in an intensional way.

A statistical law, as construed by von Wright, is a limiting frequency statement. Let H, R be the sequence of instances of H ordered by the rule R. The statistical law $F (A, H, R, p)$ is given the following interpretation: Either the instances of H are finite in number, and the proportion that have the property A is p; or the instances of H are denumerable, and, ordered by the rule R, the limit of the relative frequency of A's among H's is p. Let p_i be the proportion of A's among the first i H's, when the H's are ordered by R. Then $F (A, H, R, p)$ will hold just in case the limit of the p_i, as i increases without bound, is p. Formally, the statistical law will hold just in case

(1) $\qquad (\epsilon)(\exists m)(n)(0 < \epsilon \wedge m < n \rightarrow p - \epsilon < p_n < p + \epsilon)$

Since the values of p_n are bounded by 0 and 1, this is equivalent to

(2) $\quad (q)(\exists \epsilon)(\exists m)(n)(q \neq p \rightarrow 0 < \epsilon \wedge (m < n \rightarrow p_n \leq q - \epsilon \vee q + \epsilon \leq p_n))$

Statement (1) can be viewed as a universal implication asserting that every real number ϵ that has the property of being greater than 0 has the further property of being associated with some point m of convergence of the sequence p_n toward p. Statement (2) can be construed as a universal implication asserting that every value q which has the property of being different from p has the further property of being associated with some point m of divergence of the sequence from the value q. We can thus falsify the first assertion by finding a number ϵ that has the first property (i.e., is positive) but lacks the second property (i.e., fails to be associated with some point m of convergence); and we can falsify the second assertion by finding a number q that has the first property (i.e., is distinct from p) but fails to have the second property (i.e., fails to be associated with some point m of divergence).

The first point to be noted is that the 'properties' involved here are very different from such properties as being a crow or being black. It is one thing to go out and find a crow who isn't black; it is quite another matter to encounter a number that fails to be associated with a point m of convergence. To say that m is a point of convergence is to say

(3) $\qquad (n)(m < n \rightarrow p - \epsilon < p_n < p + \epsilon)$

But this is itself a universal implication whose scope is the whole set of natural numbers. We can go out and verify that a crow isn't black; we cannot go out

and verify that (3) is true. To establish (3) is already to establish a universal implication of the same character as 'all crows are black'.

Of course von Wright is concerned with the logic of the situation, and not with its epistemology; he is concerned with the mechanism of induction, and not with its justification. This is the ground for taking the logic of conditions (which, for deductive cogency, requires strong general premises) as the logic of induction in the first place. The patterns of inference in the statistical and in the non-statistical case are nevertheless significantly different. In the non-statistical case, the argument has the form E, therefore L, where E is a body of experimental evidence (a collection of instances) and L is a condition statement. The argument may be rendered deductive by the explicit inclusion of the appropriate general premise (e.g., actual conditioning properties exist in ϕ_0). The items in E are items that may be directly verified, and serve to eliminate (contradict) some of the condition statements logically possible relative to the general premise.

Let us keep the analogy as much intact as we can, and look at the pattern of inference that yields a statistical law. The law is that every real number ϵ that has the property of being greater than 0 has also the property of being associated with some point m of convergence of the sequence p_n towards p. Since we generally look for the conditioning property of a given conditioned property, this becomes a matter of looking for the necessary condition of a number ϵ being greater than 0, where this necessary condition has the form: Has the property of being associated with some point m of convergence of the sequence p_n towards p. Thus the family of possible conditioning properties with which we are concerned has (generally) the power of the continuum. The properties that qualify as possible necessary conditions for a number ϵ having the property of being positive have the form:

$$(\exists m)(n)(m < n \rightarrow p - \epsilon < p_n < p + \epsilon)$$

Since p may take any value between 0 and 1, there are uncountably many of such possible necessary conditions.

Of course we need not take this too seriously—we knew all along that the stipulation that ϕ_0 be finite was an unrealistic idealization.[18]

Now if this is to be the form of the possible necessary conditions we are looking for, then the falsifying instances must be of the form: ϵ fails to have the property $(\exists m)(n)(m < n \rightarrow p^* - \epsilon < p_n < p^* + \epsilon)$ despite the fact that it is positive. (Obviously a positive ϵ fails to have this property if and only if the law $F\ (A,\ H,\ R,\ p^*)$ is false.) In analogy with the nonstatistical case, the explicit premise E must therefore be 'ϵ^1 fails to have the property corresponding to p^1, ϵ^2 fails to have the property corresponding to p^2 . . . ϵ^k fails to have the property corresponding to p^k'. Since we have an infinite number of alternative hypotheses to consider, we cannot expect that a finite body of evidence

will lead to a single law—we cannot expect to achieve a perfect analogy. We might hope, however, that such a body of evidence might render it probable that some law of a certain family (say, the family corresponding to values of p lying between q_1 and q_2) is true. Even this hope is doomed to frustration, however: however finitely many real numbers you remove from the interval [0, 1], there will be uncountably many left between *any* two points. Or: However many of the possible necessary conditions are eliminated by the finite data, the remaining hypotheses will fill the whole space between 0 and 1.

One way out of this difficulty does not seem implausible. We are concerned with the frequency of A's in the sequence H, R. Our concern however may be relieved by approximate knowledge. Thus we may, not implausibly, only consider hypotheses representing the frequency to (say) only three decimal places. Then we have a finite number (1001) of alternative necessary conditions to be bothered with, and they have the form:

$$(\exists m)(n)(m - n \rightarrow .000 - \epsilon < p_n < .000 + \epsilon)$$
$$(\exists m)(n)(m < n \rightarrow .001 - \epsilon < p_n < .001 + \epsilon)$$
$$(\exists m)(n)(m < n \rightarrow .002 - \epsilon < p_n < .002 + \epsilon)$$

and so on.

We may also stipulate that the conditioned property is that of being a number greater than .001, although this will still not guarantee that a necessary condition exists in our list, since there may be *no* limit p_n to the sequence.

If we thus alter our set of initially possible conditioning properties we may in principle achieve a perfect analogy. There is nevertheless a remaining disanalogy. Suppose that ϵ is an instance of the conditioned property (ϵ is a real number greater than .001). In order that ϵ may falsify the second alternative in the list, we must observe it to lack the property

$$(\exists m)(n)(m < n \rightarrow .001 - \epsilon < p_n < .001 + \epsilon)$$

But this is just to say that we must observe it to *have* the property:

$$(m)(\exists n)(m < n \wedge (p_n < .001 - \epsilon \vee .001 + \epsilon < p_n))$$

and this already involves verifying an empirical generalization about an infinite number of natural numbers—assuming that H is infinite. In the non-statistical case, the evidence E was something more accessible to us than the law we were supposed to confirm. In order to explain the logic of how we could confirm a law L on the basis of accessible evidence E, we introduced the appropriate deterministic premise. In the statistical case, if we construe the law and the deterministic premise analogously, the evidence E' that we require is *not* accessible—it is no more accessible than the very law we want to confirm in the first place.

If condition statements can be construed intensionally, so, surely, should statistical statements. Indeed, in the case of statistical statements the need is even more pressing. '$A \subset B$' may be true, by accident, while '$Ne(A \subset B)$' is in fact false; it can never be the case that '$Ne(A \subset B)$' is true and '$A \subset B$' is false. In the case of a statistical statement the matter is otherwise. Suppose we wish to regard it as a law that a sixth of the tosses of a certain die yield twos. It is not only the case that we may toss the die six times and obtain a single two, or six million times, and obtain one million twos, but also that we may toss the die six times, and get three twos, or six hundred times and get two hundred twos, without rejecting the law. It is these considerations that have led some people (Popper and Hacking, for example[19]) to take 'propensity' rather than 'frequency' as the fundamental concept occurring in statistical laws. Thus a newly minted coin, tossed once and then destroyed, cannot exhibit a frequency of heads other than 0 and 1; yet we wish to say, and indeed, to say on good grounds, that its behavior is characterized by the number one-half; we may say that its propensity to land heads is a half. If we prefer to deal with frequencies, we will say that its long run frequency of heads *would* be one-half. Note the parallel to the problem of interpreting statements of conditions. To say that A is a sufficient condition of B may be taken to mean that A is necessarily included in B, i.e., $N_e(A \subset B)$. Or it may be taken to say that the bare extensional statement $A \subset B$ is true in all possible worlds, as well as true in this one. The dis-analogy is that we may say that A produces B with a propensity of a half, even when the frequency of B's among A's in this world (and indeed in many others) is different from a half.

Let us offer an intensional interpretation of statistical statements. Since there isn't more than a finite number of instances of any property in our world (or anyway we may, if necessary, truncate our world so that this is so) let us express frequency statements in the simple form $F (A, H, p)$, which we interpret, *extensionally*, as: the frequency of instances of the property A among instances of the property H is p. We obtained the logical form of a necessary condition by considering all logically possible worlds, and demanding that $A \subset B$ be true in all logically possible worlds. We obtained the physical concept of a necessary condition by considering all physically possible worlds, and demanding that $A \subset B$ be true in every physically possible world. We cannot do the same thing for statistical laws, writing them in the form $N_e(F, (A, H, p))$, because we know perfectly well that there are possible worlds (our own, for example, in which we sometimes destroy newly minted coins) in which $F (A, H, p)$ is false. (This is the dis-analogy referred to earlier.)

Suppose that $N_e(F (A, H, p))$ is true. Then, intuitively, the worlds in which $F (A, H, p)$ is true will be the worlds in which the maximum number of instances of H are to be found. Suppose there is no maximum number of instances of H (the number of instances may still be finite in each possible

world). Then $F (A, H, \sqrt{2} - 1)$, for example, may not be true in any world. But it may still be the case that as the number of instances of H gets larger and larger, the limit of $F (A, H, p)$—p being the ratio making $F (A, H, p)$ true in a particular world—will approach $F (A, H, \sqrt{2} - 1)$. Conversely, suppose that as we consider worlds with more and more instances of H, we either encounter a maximal world in which $F (A, H, p)$ is true, or, if we consider the sequence of true statistical statements $F (A, H, p_n)$, that sequence approaches $F (A, H, p)$ as a limit. It seems natural to me to take $N_e (F (A, H, p))$ to be true. To be sure, not all intuitions agree; there are those who think of necessity as requiring some underlying mechanism, and it might be the case that $F (A, H, p)$ was true in every possible H-maximal world, but only 'accidentally' so. But of course the same complaint would then have to be made regarding the interpretation of nomic conditionality as extensional truth in every physically possible world. In any event, I don't understand how something that holds in every physically *possible* world can be an 'accident' except in the sense that the 'laws of nature' are accidental, and might logically have been otherwise. I shall therefore take the limiting truth of $F (A, H, p)$ to be the defining condition of $N_e (F, A, H, p))$.

Let us formalize these intuitions. We suppose that we are speaking of a particular language L. Let S be a set of sentences of L—intuitively, the set of laws of nature we assume to hold, or have adequate grounds for accepting. A model of L consists of a finite set of objects D, together with a function f that assigns to each n-place predicate of L a subset of D^n, and to each term of L an object in D. (For the sake of simplicity—and following custom—we leave out of account operation expressions.) We define truth in a model in the usual way. The (physically) possible worlds, then, are those models in which every statement of S is true. Let H and A be one-place predicates of L. An H-sequence of possible worlds is a sequence of models (ordered by some ordinal α) such that if w_1 is prior to w_2, then the set assigned by f to H in w_1 is properly included in the set assigned by f to H in w_2, and there is no model not in the sequence which *could* extend the sequence, i.e., which is a possible world, relative to S. $F (A, H, p)$ is well defined in each model to which H is assigned a non-empty set, and it is true just in case p is the ratio of the cardinality of $f (H) \cap f (A)$ to that of $f (H)$. Let p_k be that rational number such that $F (A, H, p_k)$ is true in the k'th possible world of the H-sequence. We say that $F (A, H, p)$ is true in the H-sequence just in case

$$\lim_{k \to \infty} p_k = p.$$

(If the number of worlds in the H-sequence with increasing numbers of instances of H is finite, say of number n, then

$$\lim_{k \to \infty} p_k = p_n,$$

so finitude imposes no problems.) We now say that $N_e(F\ (A,\ H,\ p))$ is true, just in case $F\ (A,\ H,\ p)$ is true in every H-sequence.

Now let us suppose that $N_e(F\ (A,\ H,\ p))$, i.e., that $F\ (A,\ H,\ p)$, is true in every H-sequence of possible worlds. It may yet be that in our particular world (where we do not have as large a set of instances of H as 'possible') $F\ (A,\ H,\ q)$ is true, with q different from p. Indeed, this may be so simply *because* of the paucity of instances of H in our world. Clearly the eliminative approach to statistical inference will do us no good at all here: when we have used up the instances of H that we have in our world, we have used up all possible evidence. It would become absurd to say that, although eight out of ten of the tosses of coin C we performed before melting it down yielded heads, the law relating heads to tosses is $N_e(F\ (H,\ T,\ \frac{1}{2}))$. We may talk about the frequency of heads in some other world where we can toss the coin, if not as often as we choose, at least a very large number of times. But that world may not be accessible to us, just as the world in which the possible A that is not a B may not be accessible to us so that we cannot falsify, in our world and directly, the condition statement $Ne(A \subset B)$. Where von Wright requires that we be able to assert that for every positive epsilon there is an m such that for every n the frequency differs by no more than ϵ from the theoretical value, in our world we may very often simply be unable to achieve that m—even leaving aside the question, already raised, about how we can know that we have found it.

These considerations suggest that despite the fact that it is possible to provide a formal interpretation of statistical laws according to which they have the same structure (universal implication) as those laws to which von Wright devotes most of his attention, it may be an oversimplification to regard the confirmation of statistical laws as a subspecies of non-statistical inductive inference. In the following section we shall attempt to show (1) that statistical inference is basic, and eliminative inference, in a sense, is a derivative and secondary mode of inductive inference, and (2) that this approach provides a useful handle by means of which to get ahold of, and perhaps even solve, some of the deep epistemological problems concerning induction.

First we observe that, on some interpretations of probability, a finite amount of empirical evidence can render a statistical hypothesis probable. Interpret probability as follows, for example: Relative to a body of knowledge K, a statement has probability p just in case (1) that statement is equivalent to the statement that the object a has the property P; (2) a is a random member, relative to K, of a reference class R of possible objects; and (3) we know, in K, that a proportion p of R have the property P. The latter is just one of the statistical laws referred to in the previous section: $N_e(\text{F}\ (P,\ R,\ p))$. Some such statements are logically true, and hence belong in anybody's body of knowledge—even that of the Cartesian skeptic. For example, at least 99 percent of the 10,000 member subsets of a set S are representative in the sense that the

proportion of objects having P in the sample differs by no more than .01 from the proportion of objects in S that have P. And we may interpret the relation of being 'a random member of' in such a way that a is a random member, relative to K, of a reference class R, just in case there is nothing *known in K* about a which puts it in a special subclass of R about which we have conflicting statistical knowledge in K. Now suppose that K is the body of knowledge of the Cartesian skeptic, and we add to K the evidence report that 10,000 S's have been examined and found to have P. Relative to this very limited body of knowledge, it is clear that there can be no conflicting knowledge about a sub-class of the set of all 10,000 member subsets of S. (For example, let it happen to be the case that the sample has some odd property: say, of 'having been observed by C', or of 'being actual'. This indeed puts our sample into a special subclass of the set of all 10,000 member subsets of S but that will cut no ice because in our skeptical body of knowledge we most surely do not know that such samples are less (or more) frequently representative than those from R as a whole.) Then relative to the skeptical body of knowledge, the probability is at least 99 percent that at least 99 percent of the S's have the property P.

This is all a strictly logical matter: there is no inductive 'inference' at all, yet. Probability, defined in the way I have suggested, is a logical relation, holding between statements and sets of statements corresponding to bodies of knowledge. We introduce inference—statistical inference, inductive infer-ence—when we go on to the next step and say: incorporate statements that are probable enough into your body of knowledge. We note that we cannot say, 'if S is probable enough relative to K, incorporate S into K,' unless we demand that S have probability 1. But this is not the issue anyway: we want to be able to justify a statement by reference to a set of statements satisfying higher stan-dards. Thus if K is the set of statements which we accept only on the basis of very potent evidence, and we wish to justify accepting a statement S on the basis of less potent evidence, relative to K, we will say that S is accepted into K'. In short, let us index bodies of knowledge by the probability level required for acceptance: thus K_1 is the strict skeptic's body of knowledge—but even relative to this body of knowledge, some statements can be rendered proba-ble—for example $N_e(F\ (S,\ P,\ (.99,1.0)))$. $K_{.99}$ would be the set of statements whose probability, relative to some higher level body of knowledge, is at least .99; and in general, K_r will be the set of statements whose probability is at least r, relative to some body of knowledge whose index is greater than r.

Now we cannot take having a probability of so-and-so as being both a necessary and sufficient condition of acceptance. In particular, there may be a number of different statistical statements supported to the same degree by the same evidence. (For example, it is highly probable that the proportion of P's in the sample will be less than, or just a tiny bit more than, the proportion in the parent population S; and it is highly probable that the proportion of P's in

the sample will be more than, or just a tiny bit less than, the proportion in the parent population S; but we don't want to accept both (or, in fact, either) of these statements.) We thus add a condition, to the effect that of contrary statements having the same probability, we accept that one having the greatest information. In the simple inference case, that amounts to accepting that statement about the proportion of P in S which is most precise, i.e., which assigns the shortest interval to the parameter representing that proportion.[20]

Now let us suppose that we have an acceptance rule built along the lines suggested for statistical hypotheses. We observe that there is no eliminative mechanism underlying this rule. It is basically a probabilistic rule, and does not require any empirical premises of greater generality than evidence statements. How do we get from here to the eliminative mechanisms that are undoubtedly involved in many inductive inferences?

Let us first consider universal generalizations of the form all S's are P's. Suppose that relative to a body of knowledge K_r, $N_e(F\ (S,\ P,\ (t,\ 1.0)))$ is acceptable, and thus an item of the body of knowledge K_s. Suppose in addition that t is greater than s, and that there is no knowledge in K_s of anything that is an S and not a P. Relative to K_s, the probability of anything that is an S being also a P, is even greater than the probability level of that body of knowledge, and so will be accepted in any lower level body of knowledge. In other words, from 'a is an S', in the body of knowledge K_s, we may infer 'a is a P' in any lower level body of knowledge. We therefore get precisely the results we would get if we incorporated not $N_e(F\ (S,\ P,\ (t,\ 1.0)))$, but $N_e(\bigwedge_x (Sx \rightarrow Px))$

in the body of knowledge K_s. So let us take as our acceptance rule for universal generalizations:

If the probability of $N_e(F\ (S,\ P,\ (t,\ 1.0)))$ is greater than s, relative to a body of knowledge K_r, where r is greater than s, and t is greater than s, and there is no statement of the form '$a \in S$ and $\sim a \in P$' in the body of knowledge K_s, then accept $N_e(\bigwedge_x (Sx \rightarrow Px))$ in that body of knowledge.

Once we have universal generalizations in our body of knowledge (and note that this is a relatively sophisticated stage) then we are in a position to indulge in eliminative induction. When we have accepted:

$$\bigwedge_{x,y} [(Px \wedge Ry) \rightarrow (Qx \vee Qy)], \text{ or}$$

$$\bigwedge_{x,y} [(Px \wedge Ry) \rightarrow (Qx \wedge Qy)]$$

then we can apply von Wright's logic of conditions, and, finding an a that is P but not Q, can infer that R is a sufficient condition of Q:

$$\bigwedge_y (Ry \rightarrow Qy)$$

As an example, suppose that we have accumulated statistical data concerning the presence in large quantities of bacteria of type A and the presence in large quantities of bacteria of type B, and the presence of a certain constellation of symptoms, C. In particular let us suppose that it is very highly probable that very nearly one hundred percent of the pairs of instances, x,y, which are such that x reveals a large quantity of bacteria of type A and y reveals a large quantity of bacteria of type B, are such that both reveal the constellation of symptoms C. We then accept (at a certain level of pragmatic rigor) the statement

(1) $$N_e \bigwedge_{x,y} [(Ax \wedge By) \to (Cx \vee Cy)]$$

We now explore further—or, more plausibly, deliberately set up—an experiment designed to find an object a in which a large quantity of bacteria of type A are present, but in which the symptoms C are absent. If we succeed, we may accept

(2) $$Aa \wedge \sim Ca$$

Since (1) is equivalent to

(3) $$N_e[\bigwedge_x (Ax \to Cx) \vee \bigwedge_y (By \to Cy)]$$

we may infer,

(4) $$N_e \bigwedge_y (By \to Cy)$$

in accordance with the logic of sufficient conditions.

It is possible also to formalize more complicated inductive arguments that only with a certain amount of difficulty can be made to conform to the logic of conditions. Consider the very typical scientific argument: If any sample of substance S has property P, then all samples of S have P; a is a sample of substance S and has property P; therefore all samples of S have property P. In many cases P is a quantitative property, so that an analysis in terms of elimination must involve the elimination of all but one of a continuum of possible necessary conditions.

Suppose that we have the universal generalization:

(5) $$N_e(\bigwedge_x (Kx \to \bigvee_y \bigwedge_z (S(x,z) \to R(z,y))))$$

For example, we may become practically certain that practically all organic salts have exactly one melting point. To be sure, this may be construed as a second order induction, for we must first of all be practically certain that compound 1 has exactly one melting point, and then that compound 2 has exactly one melting point, and so on, and each of these requires that we accept the

generalization that practically all samples of compound 1 melt at just about such and such a temperature, etc. Nevertheless, each stage fits in perfectly well with the model given above, and we can come to accept (5) under the interpretation: Kx: x is an organic salt; $S(x,z)$: z is a sample of x; $R(z,y)$: z melts at standard conditions at y degrees centigrade.

We now synthesize a brand new organic compound a, and we test a sample of it, b, for melting point, and find that it melts at 73 degrees centigrade. We correctly and validly infer that all samples of a melt at 73 degrees—$N_e \bigwedge\limits_{x}(S(a,x) \to R(x,73))$—from (5) and

(6) $$S(a,b) \wedge R(b,73) \wedge Ka$$

In analyzing von Wright's logic of necessary and sufficient conditions, we found two main points that seemed arguable. First, it seemed that in order to capture the intent of condition statements that might plausibly be used in inductive arguments, those statements would have to receive some sort of intensional interpretation, as distinct from a merely truth-functional interpretation. Second, the treatment of statistical generalizations from the point of view of the logic of conditions seemed both strange and strained. Both of these difficulties are alleviated by reversing the priority of statistical and condition arguments (taking statistical arguments to be fundamental, and condition arguments to be derivative), and by interpreting statistical statements intensionally. Thus we interpret 'the proportion of A's that are B's is p' as meaning that in any large enough possible world the proportion is arbitrarily close to p. We give a rule of acceptance for statistical statements, and a secondary rule for universal generalizations. Since a universal generalization is acceptable only when a corresponding statistical statement of the form 'Practically all . . .' is acceptable (barring trivial cases), the universal generalizations that serve as premises as well as those (therefore) that appear as conclusions in condition arguments are themselves intensional: that is, we must accept that they (almost) hold in any large enough possible world. For '$F(A,B,1)$' to hold in any large enough possible world is for it to hold in every possible world, and thus to be 'necessary' in the traditional sense.[21] A by-product of this analysis is that the mechanism of inductive justification is revealed, as well as the mechanism of inductive argument. To substantiate this claim, however, requires an epistemological justification for the acceptance rule suggested, and that is another story.

DEPARTMENT OF PHILOSOPHY HENRY E. KYBURG, JR.
THE UNIVERSITY OF ROCHESTER
FEBRUARY 1973

NOTES

1. This extensional analysis of conditional statements follows from the remarks on pp. 61–62, together with the explanation of "→" given in footnote 1 of paragraph 2 of Chapter 1, of *The Logical Problem of Induction*, henceforth referred to as *LPI*.

2. *LPI*, p. 84.

3. *A Treatise on Induction and Probability*, henceforth *TIP*, p. 66.

4. *TIP*, p. 67.

5. *TIP*, p. 64.

6. 'Deontic Logic and the Theory of Conditions', in *Deontic Logic*, edited by Risto Hilpinen, (Dordrecht: D. Reidel, Synthese Library, 1971), pp. 105–120.

7. It should be noted in passing that von Wright's formulation of this condition is defective. The presence or absence of a property in a thing is called its presence value. "A property is called logically independent of another property, if, given the presence value of the second property in a thing, there is no rule determining the presence-value of the former in the same thing." Logically total independence is then defined in the natural way. But if in *fact* $A \leftrightarrow B$ is universal, then there is a rule (namely, 'A is present if and only if B is present') determining the presence value of B from the presence value of A. In fact under this interpretation of independence, a set of properties ϕ_o can be logically totally independent only if no property in the set has a necessary-and-sufficient condition in the set, which is clearly contrary to certain versions of the 'deterministic postulate' required for inductive inferences. Furthermore it also seems natural to construe logical independence in such a way that if $A \subset B$ is logically true, then A and B are not logically independent; but on von Wright's definition $\phi_o = \{A, B\}$ is a set of logically totally independent properties even when B is just the property $A \wedge C$.]

8. Von Wright's formulation of these definitions, p. 71 of *TIP*, is slightly defective. He defines a 'greatest sufficient condition' as follows: "That A is a Greatest sufficient condition of B in ϕ_o means that A is a sufficient condition of B in ϕ_o and that no member or conjunction of members of ϕ_o which includes (but is not included in) A is a Sufficient Condition of B." According to this definition, both $A_0 \wedge \overline{A}_1$ and $A_0 \wedge \overline{A}_1 \wedge \overline{A}_3$ may qualify as greatest sufficient conditions of B, provided A_0 is not a sufficient condition of B. $A_0 \wedge \overline{A}_1$ includes but is not included in $A_0 \wedge \overline{A}_1 \wedge \overline{A}_3$, but it is not a "member or conjunction of members of ϕ_o" and thus, clearly contrary to the intent of the definition, does not prevent $A_0 \wedge \overline{A}_1 \wedge \overline{A}_3$ from being a 'greatest' sufficient condition of B.

9. *TIP*, p. 71.

10. *TIP*, p. 130.

11. *TIP*, p. 139.

12. *TIP*, p. 131.

13. *TIP*, p. 44.

14. *TIP*, p. 41.

15. *TIP*, p. 139.

16. *TIP*, p. 139.

17. *TIP*, pp. 82–83.

18. This is seen already in the paradigm case of deductive induction: the evaluation of physical constants. The inductive argument there proceeds: every substance in a given phase and under given conditions of temperature and pressure has exactly one conductivity; one sample of X under these conditions has that conductivity, as measured experimentally; therefore every sample of X under these conditions will have that conduc-

tivity. Here also the antecedently possible hypotheses are uncountable in number. For a more detailed discussion of this case, see Kyburg, 'Demonstrative Induction', *Philosophy and Phenomenological Research* 21 (1960–61): pp. 80–92.

19. K. R. Popper, 'The Propensity Interpretation of the Calculus of Probability' in Körner, ed., *The Colston Papers*, Vol. IX (1957), pp. 65–70; Ian Hacking, *Logic of Statistical Inference* (Cambridge, 1965).

20. Isaac Levi, *Gambling with Truth,* New York, 1967; Keith Lehrer, 'Induction and Conceptual Change', *Synthese* 23 (1971): 206–25; H. Kyburg, *Probability and the Logic of Rational Belief* (Middletown, Conn., 1961).

21. In this summary I have left out of account, for the sake of simplicity, the epsilons and deltas required for accuracy.

3

Stefan Nowak

VON WRIGHT ON PROBABILITY AND RANDOMNESS

I

At the very beginning I would like to stress that this paper covers only a sub-area of Professor von Wright's writings on probability.[1]

1. Especially I would like to concentrate on his discussion of the problem of the *meaning of probability statements* and the notion of randomness as strictly related to it. Needless to say, these are the central philosophical problems of probability. Let me quote here the first paper by Professor von Wright:

> Vom philosophischen Standpunkt es ist auffalend, dass, obwohl der Empiriker mit der Wahrscheinlichkeit als einem geläufigen Begriff mit umfassender Anwendung operiert, der Erkenntnistheoretiker dagegen sich in der Ungewischeit darüber findet, was die Wahrscheinlichkeitsaussagen eigentlich bedeuten, was für einen Sinn und was für eine Gültigkeit ihnen zuzuschreiben sei.[2]

The problems connected with the meaning and validity of probability statements often return in von Wright's writings as a central philosophical problem of probability. Being a philosophical problem, it should be dealt with using philosophical rather than mathematical tools:

> Some of the epistemological controversies about probability are of particular interest, because they show how easily philosophers are misled by certain modes of thought modelled on the pattern of mathematical reasoning. The chief purpose of this paper ['On Probability'] is to settle one of these controversies by leading our thought out of the mathematical mazes in which it has apparently gone astray.[3]

2. Let me present at the beginning one quotation from the paper quoted above. After having discussed in 'On Probability' the three approaches to the interpretation of the meaning of probability statements—i.e., the frequency approach, the range approach, and the "subjective" view—von Wright writes:

With these brief remarks it has not been our intention to bring about any decision as to how probability "ought" to be defined. The whole question about *the* definition and *the* meaning of probability seems to us futile. We have rather wanted to show that the three mentioned ways of defining probability all have something to do with each other, that they are interconnected, and, so to speak, "check each other up."[4]

This statement defines the author's attitude toward the problem of this 'belongingness' to any of the 'schools' of philosophy of probability. Instead of declaring one of them as 'his own', von Wright prefers to analyze both the merits and weaknesses of all of them. This attitude is similar to Carnap's 'probability 1' and 'probability 2' position, except that here we have to deal also with 'probability 3', i.e., with the 'subjective' theory of probability. And, like Carnap, von Wright is 'slightly inclined' toward the range approach to probability, which will be discussed later.

The most important feature all three approaches have in common is that they all satisfy the postulates of the Abstract Calculus of Probability. With regard to the frequency and range models the author states:

It is a most important fact that the theories of probability which can be developed on the basis of the two models mentioned, though differing in their conception of the "meaning" of their fundamental notion, yet agree by and large in their logical structure. This fact suggests the possibility of creating an Abstract Calculus of Probability, i.e. a deductive theory which is "neutral" with regard to conflicting options about the meaning of probability and studies only the mathematical laws which this notion obeys. Within a theory of this abstract kind "probability" figures as an undefined term for which certain axioms are laid down. The axioms are sometimes said to constitute an *implicit definition* of probability.[5]

The same requirement is formulated for the notions of 'subjective probability'. In his discussion of Ramsey's approach to probability von Wright reminds us that the notion of probability understood as 'partial belief' satisfies the axioms of the abstract calculus.[6]

The abstract calculus of probability can be developed either in the language of additive set functions, as formulated by Kolmogorov, or as a logistic calculus in which the functor P characterizes the relations between sentences or sentence-like propositions. Von Wright prefers the Keynes and Reichenbach tradition in this area and develops several axiomatizations of the calculus of the logistic type. In his last axiomatization, he starts the presentation of the calculus with the three following axioms:[7]

A1. $P(a/h) + P(\sim a/h) = 1$.

A2. $P(a \And b/h) = P(a/h) \times P(b/h \And a)$.

A3. If h is self-consistent, then $P(h/h) = 1$.

I will not discuss the formal problems of the calculus here. What I would like to discuss is the problem of to what degree the axioms as presented above may be said to constitute an *implicit definition* of the concept of probability. It

seems to me that the postulates of the calculus constitute a *necessary defini-tional condition* of any concept of probability, *but not a necessary and suffi-cient one*.

At first one sees that, if there are three different concepts of probability, each of them satisfying these postulates, the postulates define only a *genus proximum* for them. One could argue with this by saying that the formal notion of probability as implicitly defined by the axioms is a more general class of probabilities when the specific interpretations of this concept in the context of the three theories (or approaches) mentioned above delimit some sub-areas from this more general concept, which nevertheless defines 'probability'. But I think that the concept of probability in any of the meanings is understood in such a way that it not only denotes certain relations between sets (or between sentences—in von Wright's axiomatizations) but also assumes that the events or properties which constitute these sets (to which these propositions refer) *are random. The notion of randomness* (or some of its equivalents, which will be discussed below), which cannot be defined implicitly by the axioms of the calculus—as they were formulated—*seems to be unavoidable for any concept of probability*.

This is postulated by the authors of some axiomatizations. If we take, for example, Kolmogorov's axiomatization of the calculus,[8] we see that he starts with two basic terms: 'probability' and 'random event'. One could say that the axioms of his theory give a clear implicit meaning to the notion of probabil-ity—whatever might be described in terms of additive set functions satisfies by the same concept of 'probability', but Kolmogorov made it clear that the op-erations on additive sets refer to probabilities only if these sets are composed of 'random events', which are undefined in his theory, constituting one of its basic terms.

It seems that the notion of randomness is involved in all three concepts of probability. It figures of course explicitly in the frequency theory, as it was formulated by von Mises, but it also exists, although in a somewhat disguised form, in the range theory in the form of the concept of 'equipossibility' of alternatives, and in the 'subjective' theory where it occurs in the form of un-predictability of the expected event rather than on the basis of its a priori or a posteriori established probability within the reference class.

Von Wright does not postulate the concept of randomness at the level of his formalization of the calculus. He says only that the sentences related by the functor *P* refer to certain events or properties, and not necessarily random ones. But in his comments on some approaches he comes pretty close to this position. In writing on the frequency theory he declares:

> The fields in which probability values are measured, *i.e.,* the probability-series, may therefore be defined as series with an infinite number of members, each one carrying a certain characteristic such that:

 A. The relative frequency with which each characteristic occurs in the series has
 a fixed limiting-value.

 B. The characteristics alternate in a random manner.[9]

In the same paper he relates the notion of 'equipossibility' of the range approach to the probabilistic series of the frequency approach and writes:

> But suppose that, with regard to two characteristics, it is said that the occurrence of each of them under certain circumstances is equally possible. Then if we formed probability-series, the members of which possessed these pecularities which made us say that the two characteristics above were equally possible, the limiting-frequencies of the two characteristics in the series must be the same.[10]

I would add here that not only their limiting-frequencies have to be the same but they also have to alternate in a random way, which seems to be implicitly included in the meaning of 'equipossibility'.

Finally, with regard to the notion of rational belief, typical of the subjective approach to probability, von Wright writes:

> The statement that the rational degree of belief in an event is, say, p implies the other statement that the limiting-frequency of the event in question in a certain probability-series is p. The probability field, we might also say, *defines* the *rationality* of the belief in the event.[11]

Here I should add that the randomness of the events in the probability-series has an equivalent in the subjective concept of probability. Due to it we are not making our predictions in terms of certainty but only in terms of a certain, possibly highest *degree* of expectation.

Thus we see that the three approaches to probability have more in common than simply the formal structure of the calculus—they all permit the applications of the calculus to the area limited additionally by direct or indirect reference to randomness. But if so, then it seems that the idea of randomness should be explicitly formulated at the level of axiomatizations in order to distinguish probabilistic interpretations of the calculus, e.g., from simple operations with relative frequencies.

In his *Treatise on Induction and Probability* von Wright seems to indicate the incompleteness of the implicit definition of the concept of probability in terms of only the axioms of the calculus: "We shall try to make precise a sense in which these three traditional views in their 'bare' forms, *i.e.*, without use of the additional ideas of random distribution, equipossibility, and rationality of belief, represent three different interpretations of axiomatic probability."[12] I think that these three 'bare' concepts of probability do not refer to any probability at all, and therefore this concept should not be used in any of these contexts without—as I wrote—direct or indirect reference to randomness, which is common to all of them.

3. The notion of randomness is a central idea in the frequency interpretation of probability. The analysis of the frequency approach and the discussion

of the concept of 'collective' receives much attention in von Wright's writing on probability. As we know, a collective is for Richard von Mises a series of events, infinite or "practically unlimited",[13] which satisfies two conditions: there is a fixed limit of relative frequency of the events in the series and the frequency of particular finite sub-series tends towards this value with increase of the number of cases in the series and there is no possibility (no rule) for changing the limiting-frequency value. The first property is equivalent to Bernouilli's Law of Great Numbers; the second defines the notion of randomness, for which von Mises used also the terms "insensitivity to place selection" or "impossibility of a gambling system".

It seems that both the insensitivity to place selection and the impossibility of a gambling system refer to the same property of a collective, which might be called *positional or relational randomness*. It means that we can change the limiting value neither by taking, e.g., each tenth member of the collective nor by taking the members which follow after certain particular series of events— the probability of a 'head' is the same after the series of tosses which were composed in half from 'heads' and in half from 'tails' as it is after the series of tosses which were completely uniform, composed of heads or tails only *(Nachwirkungsfreiheitsprinzip)*.

In discussing the concept of a collective, von Wright distinguishes *intensional* and *extensional* collectives. An intensional collective is a series which can be constructed by some mathematical rules. Extensional collectives are empirical series constructed by extrapolation of sequences of observed events. Von Wright analyses the problem of to what degree the notion of randomness is free from contradiction, i.e., to what degree the collectives may be said to exist. The answer is different for intensional and for extensional collectives.

The concept of limiting value has a clear meaning both for intensional and for extensional collectives. It is applicable to the constructed or observed series if the members of these series are enumerable. Therefore "The notion of a limiting-frequency must not be regarded as 'meaningless' or in any other way unsatisfactory. But it is important to observe that the notion makes sense only relative to a *way of ordering* the values of the variables which satisfy h. By re-ordering the sequence we may alter or even destroy the limiting value." And in a footnote to this paragraph we read: "This important point, it seems to us, has not received sufficient attention from von Mises or from Reichenbach, not to speak about earlier proponents of the frequency-theory of probability."[14]

The idea that the value of limiting frequency or even its existence depends upon the ordering of the events in the series is right if it is understood in a 'weak' sense, i.e., when it means that there is an infinite class of orderings which are 'admissible' for a collective with a given p as frequency-limit and that some infinite class of orderings is incompatible with the given p. But it seems to me that this idea was implicitly, although not explicitly, included in von Mises' concept of a collective as its basic property, i.e., randomness.

After having stated that the idea of a frequency-limit is free from contradictions with regard both to intensional and extensional collectives, von Wright asks another basic question: ''But what becomes then with the randomness which also ought to be a property of probability series?''[15] The idea of insensitivity to place selection is questioned with regard to constructed, i.e., to intensional probability-series. After discussing the attempts by Copeland and others to find the solution for a perfect a priori randomness von Wright states that the proposed solutions may be insensitive toward most but not toward all thinkable rules of selection:

> This means that *the randomness characterizing probability-series is a property which cannot be mathematically specified so as to make the construction of probability-series possible*. . . . But as the construction of probability-series was required in order to decide . . . whether the definition of probability in terms of limiting-frequencies was free from contradiction, it seems as if this question could not be settled. And as long as it remains unsettled the frequency-definition of probability remains problematic.[16]

4. The extensional, i.e., empirical collectives, are—as we remember—constructed by extrapolation of observed series. The notion of randomness means here, as von Wright states in many places, that *we don't know any rules* which might be used for the prediction of the next event otherwise than on the basis of its frequency in the whole series, or which might alter the value of frequency limit.

> Die Definition der regellosen Distribution besagt, dass wir keine Eigenschaft B kennen, von der wir glauben, die Wahrscheinlichkeit von Ax in Hx sei gegen Zerlegung von Hx durch Bx nicht unempfindlich.[17]

This understanding of collective introduces two essential modifications of von Mises' definition.

The first one refers to the nature of selection principles which might alter the probability or 'destroy' a collective. For von Mises they were positional characteristics of the elements in the series, either their positions in the enumerable sequence as a whole or their relations to an antecedent series of a specific kind. For von Wright this is only one class of the selection rules. The other equally important class of hypothetical modifiers of probability series are *physical properties* of the elements in the series, which might alter or destroy the probability or even transform it into certainty due to some natural laws of science.

Another modification strictly related to the first one is a special kind of 'subjectivization' of the concept of collective. *The collective exists when we don't know any modifiers of frequency-limit* when von Mises understands collective in an objective manner: it exists when the frequency limit is the same in all partial sequences of events, taken in any arbitrary manner from the initial series. In defining the nature of randomness, von Wright writes:

Randomness marks the limit of our knowledge about the way in which an event takes place. When we do not know anything more about the way in which an event occurs in a series than that it has such and such a limiting-frequency, we say that the event is distributed randomly. . . . That a characteristic is distributed randomly *means* that we do not know any law for its distribution. Of course, we *may* detect a law for the distribution, but we may also never do so, we simply *do not know*. . . . The randomness of those series . . . is a property of the way in which the series are *used*.[18]

When we discover such a property B which changes the probability of A in a series H, the concept of a collective has to be abandoned for the whole series H, and instead of this we must introduce a new collective of the type HB or two collectives: HB and $H\overline{B}$ with a new probability (or probabilities) of occurrence of A in the new series.

Let me question the last point. Suppose that a series of events H, B, A, is of such a kind that we have two different collectives: the probability of A when HB occurs (p_1) is not equal to the probability of A when $H\overline{B}$ occurs (p_2). Suppose additionally that the events B occur at random with respect to H, or in other terms, that HB makes another collective in the series H. As I have demonstrated in another paper,[19] the sequence of the type HA will then still satisfy the conditions of a collective with respect both to frequency limit and randomness of occurrence *as long as we do not introduce the property B as the principle of selection of the events H in the series*. If we assume for simplicity's sake that $P\ B/H\ =\ 0.5$ then the probability of A with respect to H will be equal to

$$\frac{p_1 + p_2}{2}$$

The collectives of the above type for which there is a gambling system, but for which the gambling system is *either unknown or not used for prediction*, satisfy all the definitional conditions of probability. In my paper, just referred to, dealing with the notion of collective I proposed to call them 'collectives in the weak sense' in order to distinguish them from the 'strong' collectives in von Mises' sense.

The 'subjective' definition given by von Wright admits the possibility of 'weak' collectives only for conditions when the modifiers of the overall probability of A in H are unknown. The admission of what I called 'weak' collectives was based on von Wright's criticism of von Mises' concept, which was too strong to deal with situations other than, e.g., the games of chance, and especially with such natural series of events as those described, e.g., by vital statistics. In his essay on C. D. Broad's account of probability and induction von Wright writes:

Von Mises' theory, which is sometimes called the *statistical* theory of probability, seems to be particularly ill-suited to deal with probabilities in statistics! . . . as a

consequence of this instability [of limiting frequencies] in the conditions determining the frequencies in such classes the notion of a frequency-limit, and therewith also von Mises' notion of a collectivity, threatens to become *inapplicable* to them.[20]

The idea of relativization of probabilities in a collective to some physical properties is developed in the *Treatise on Induction and Probability*. Suppose that we take a series of events A and H which make a collective, and moreover suppose that we know that some events of the class H may also have the property G which may be additionally identified. G then makes a selection principle in the series H. Suppose now that the relative frequency with respect to HG is different than with respect to H alone. Now G may be an element of a set of properties ϕ_0, which we decided to distinguish for some reasons, or it may not belong to the set ϕ_0. If it does not, we may define the concept of *randomness* relative to ϕ_0:

> The distribution of A in H . . . is called "random" relative to ϕ_0 if there is no property G, which belongs to ϕ_0, or if a presence-function of members of ϕ_0 and which is such that the relative frequency of A in H and G is different from the relative frequency of A in H. . . . If, in the above definition of relative randomness, we suppress all reference to ϕ_0, we get the following definition of absolute randomness: The distribution of A in H . . . is called random if there is no property G such that the relative frequency of A in H and G . . . is different from the relative frequency of A in H. . .[21]

The idea of absolute and relative randomness is in accordance with von Wright's other formulations quoted above, if we assume that ϕ_0 refers to some or all *known* properties which might occur jointly with H and modify P A/H. It means in a more formal way that we don't know any modifiers of the overall probability of A/H. But we could interpret ϕ_0 as denoting only *some* of the known properties when other properties which are known to alter P A/H are not included in ϕ_0. I would be very much in favor of the second solution. Von Wright, if we interpret the above formulation in the context of other publications, is definitely in favor of the first interpretation: "As soon as a series is shown to be *not* random [i.e., that there are some properties which alter the probability of the events predicted—S.N.], it is discarded as a probability-series."[22]

If we relate the notion of probability to its use in prediction, we might like to use it for different types of predictions. If we would like to predict whether A will occur in a particular situation, then of course we should use all possible information for that purpose. This implies that we should use as the basis of our prediction the frequency limit of A in a collective defined both by H and all *known* modifiers of P A/H which can be assessed as characteristics of the given H. The doctor's prediction of his patient's chance of survival makes a good example of this category of situations.

But in some cases our prediction refers to the expected—most probable—frequency of A's in a certain finite series of H's. It is obvious that in such situations the use of known modifiers of the frequency-limit of A/H is useless, assuming that they occur at random with respect to H. We know then that they will have no final impact upon the frequency of A in the expected series of H's. The overall probability of A/H (although it is equal to the 'weighted mean' of all probabilities conditional upon the occurrence of all randomly distributed and known modifiers of $P\ A/H$) may be in itself an interesting and valid object of assessment, and an important premise in predictions. To give an example, for an insurance company it may be much more important to know the overall probability of death among all those who apply for insurance in a given year than to predict possibly accurately these chances for each particular case.

If we take life statistics as an example of collectives, we know in advance that the probability of death is modified by an infinite number of biological, social, and situational conditions. We could give a priori a long list of conditions which increase or decrease the chances of death. But assuming that all these factors occur more or less at random, we still feel entitled to expect that their total effect will occur more or less at random, justifying our probabilistic expectations in the long run for the whole national population.

Therefore I think that we should accept the use of both the term 'probability' and the term 'randomness' for these situations, which correspond to the last category described above, i.e., when we consciously omit in our predictions some known modifiers of the overall probability in a collective.

5. One of the basic objections which von Wright raises against the frequency approach is connected with the problem of *verifiability* of frequency-limit. This problem looks different for extensional and for intensional collectives. In the case of intensional collectives we know the frequency limit of the given collective because it is clearly defined by the rules of construction of the given collective, but—as we remember—there are serious problems with the randomness of constructed probability series. The extensional collectives may be random. Also the notion of a frequency limit is, for them, free of contradictions; but the frequency-limit established by an extrapolation of the observed sequence of events is always more or less *hypothetical*—it can never be finally proven. We never know whether a frequency observed in a finite series taken from a collective represents its 'main trend'; i.e., whether it is relatively close to the frequency-limit of this collective or is rather a rare, very improbable but still theoretically possible subseries of events, the relative frequency of which differs markedly from the probability in the infinite collective and which we happened to observe due to chance.

> Haben wir nämlich eine Ereignisfolge von n Elementen in der m Elemente ein gewisses Merkmal besitzen, so sagt uns der Häufigkeitsbruch m/n niemals etwas über den Häufigkeitslimes des betreffenden Merkmals . . . ein hypothetisch auf-

genommener limes-Wert *p* vereinbar [ist] mit jeder beliebigen, in einer empirischen Folge beobachteten Häufigkeit *m/n*—auch mit der ''unwahrscheinlichsten''. Die limes-Aussagen sind also weder verifizierbar noch falsifizierbar.[23]

Mentioning the Bernouillian Theorem, which permits us to characterize certain frequencies for finite series as highly improbable for certain collectives, von Wright writes:

> Dabei muss jedoch genau betrachted werden, dass dieses ausserordentlich bedeutungsvolles Gesetz uns keineswegs zur strengen Nachprüfung einer limes-Aussage befähigt, denn dieses Gesetz—das ja nur eine tautologe Umformung der Ausgangsformeln, letzten Endes der Axiome der Wahrscheinlichkeitsrechnung ist—schliesst vom Grenzwert stark abweichende Häufigkeiten nich aus, sondern bezeichnet sie nur eben als unter gewissen Bedingungen ausserst unwahrscheinlich.[24]

And finally: ''inductive generalizations are unverifiable propositions in the sense that we can never verify more than a finite number of their instances. This unverifiability applied equally to Universal and to Statistical generalizations.''[25]

The arguments seem irrefutable, and I fully agree that we cannot verify the propositions about the frequency-limit of the given collective in the 'strong sense', i.e., with absolute certainty. But the question then arises whether we should disregard the possibilities of weaker, i.e., probabilistic verifications of frequency-limits in the given collective, if we accept these limits in our everyday research with quite satisfactory results. I have in mind here all the applications of the rules of statistical inference to the assessment of parameters in finite populations on the basis of the random samples drawn from these populations. As we know, the frequency of a characteristic in a finite population determines both the frequency-limit of this characteristic in an infinite (drawn with replacement) random sample and the probabilistic distribution of different finite samples. The infinite random sample drawn with replacement from this finite population makes, then, a perfect collective; each particular finite sample makes a series of cases from this collective. When making inferences from any finite random sample to the probability in the infinite series, and, indirectly, to the structure of population from which the sample was drawn, we know that we are doing it with a certain risk of error, but we accept it because we know that we have no other choice. *Within the limits of our knowledge our decisions are most rational.*

The same may be said with regard to natural collectives. *For a natural collective, any finite series of events* (either a series of consecutive events or a series chosen in any arbitrary way) *makes a natural random sample of the whole collective.* It means that by the same process the rules of statistical inference can be applied to the estimation of frequency-limits on the basis of observation of finite sub-series belonging to the infinite collective. By increasing the number of observed cases we may either increase the accuracy of our estimation of the frequency limit (confidence interval), or the degree of our

certainty in our estimations (significance level of our results), or both. We know also that our estimation may be wrong, because it may be based upon the observation of exceptionally rare series—as a pollster knows that his predictions of the results of an election, even when made with a high level of significance, may still be wrong. But again, our decision about the probable value of the frequency-limit seems to be rational. This is simply the best we can do, and we know that by doing so in most cases we will make approximately good estimations of the frequency-limits of any collective. Agreeing that the frequency-limit cannot be completely proven, I would rather put the stress on the fact that it may be estimated with very high probability (of the second order) and with almost deliberate accuracy if we can observe a sufficient number of members of the collective.

The above argument is valid, of course, only for the situations when we know, or feel entitled to assume, that the observed series of events is taken from any collective at all—otherwise the question about the frequency-limit is meaningless. It means that the natural randomness of the given kind of observations has to be assumed before we start our attempts to estimate the frequency-limits of these events. But here one should remember that when we are saying that a certain series is *random with an unknown frequency-limit* we assert less than when we say that a certain collective has a *given frequency-limit*. It may be easier to prove, or better, to assume with a high level of credibility, that the phenomena in question are random rather than to attribute a given frequency-limit to this randomness. Our conviction about the random character of the phenomena in question may be based upon our understanding of the situation in which these events occur, upon certain scientific knowledge about these phenomena, etc. Once we assume their random character, we may start our observations aimed toward estimating the numerical aspect of this randomness, i.e., the frequency-limit of our series.

I do not think that I am here in basic disagreement with Professor von Wright. It is rather a difference of stress upon the positive or negative aspects of verificational procedures of universal statistical laws. But since he puts such a stress upon what we *cannot* do with collectives, it seems to me relevant to underline the fact that we can still do a great deal, and with results which are very important both for our scientific knowledge and for our everyday practice. For these reasons I am—at least in terms of "emotional attitudes"—more positive toward the frequency theory of probability than is von Wright.

6. Raising serious objections toward the frequency approach to probability, von Wright seems to be much more in favour of the *range model,* i.e., contemporary continuations of classical theory of probability; but he stresses that the oldest approach to probability is the frequency approach, whose first formulations we find in Aristotle's works. In the classical theory probability was understood as the ratio of 'favourable' alternatives for the *given* event to all alter-

natives in a situation. This theory can be formulated either in terms of relations between properties (or events), or in terms of relations (truth-functions) between propositions. Von Wright chooses the second kind of language for the range theory, and following Wittgenstein's suggestions proposes a generalized model for a range theory.[26] This model, when compared with the formulations of the classical theory, does not assume a priori that the alternatives of the given range are equally possible specifications of the generalized range model:

> We consider some set σ of propositions such that *a* and *h* are truth-functions of some members of σ. We thereupon consider the disjunctive normal forms of *a* and *h* and of *h* in terms of all the members of σ. Let us assume that . . . the normal forms are disjunctions of *m* and of *n* conjunctions respectively. By the probability of *a* given *h* we now mean the ratio of *m:n* The conjunctions in the normal form we shall call *unit-alternatives*.
>
> The numbers *m* and *n* above are *measures* of the σ—ranges of the propositions *a* and *h* and of *h* respectively. These measures are obtained simply by counting the number of units in the ranges of the propositions.[27]

This definition satisfies, of course, the postulates of the calculus. The unit-alternatives may have either equal or unequal 'weight'.

> The answer given to this problem [of adequate choice of σ—S.N.] in the 'classical' theory of probability can in our terminology be stated as follows:
>
> The choice of σ ought to be such that each unit in the ranges can be given an *equal weight*. Or, popularly speaking, the data ought to be analyzable into a number of *equipossible* alternatives.
>
> When this condition is added to what we called above the 'classical' range-definition we get the following: the probability of *a* given *h* is the proportion of alternatives, which are favourable to *a* among a number of *equally possible* alternatives which fall under *h*.[28]

The range model can be understood in two ways. It may be understood as a strictly logical construction, and in this interpretation all its propositions are analytically true. But if its main purpose was to set up a theoretical framework for the possibility of a probabilistic prediction of real future events on the basis of an a priori-assessed structure of the alternatives, then the question arises, How can we know that all the members of a certain range have an equal weight, or, in other terms, that all the units of the given alternative are equipossible?

Von Wright quotes here the famous Principle of Insufficient Reason, called also the Principle of Indifference and states:

> It seems to us that a Principle of Indifference may be legitimately invoked as a ground for framing a *hypothesis* about the equality of certain initial probabilities, but that use of this principle can never amount to a *proof* of the equality in question.
>
> It is difficult to see how any assumptions about the a priori probabilities . . . could be anything but a hypothesis for the correction of which future experience about the case under consideration may constitute a reason.[29]

Such a solution nevertheless has one serious implication, namely that the frequency interpretation of the probability, and more specifically the observation of alternatives, is a check of the adequacy of choice of this range. Quoting Waismann as the author of this proposal von Wright is not completely satisfied with this solution: "To accept this answer is to let the frequency-interpretation function as a check on the *adequacy* of any particular range-interpretation of the concept of probability. This may be said to ignore the problem of adequacy for the frequency-interpretation."[30]

These objections are related to von Wright's criticism of frequency inter-pretation, presented and discussed in the previous sections of this paper. Con-sequent on what I wrote above, I would be rather inclined to accept Wais-mann's solution to this problem. If we agree that an a priori range defined on the basis of the Principle of Indifference is nothing else but a hypothesis which ought to be confirmed by future experience, then I don't see what else could constitute this experience than the observation of the collective (its certain finite sub-series) 'generated' by the situation described (hypothetically) in terms of the range of equipossible alternatives. As we have seen above, the propositions about the frequency-limit of the given collective, although not verifiable in the 'strong' sense of the term, are nevertheless verifiable in probabilistic terms in quite a satisfactory degree. The notion of a frequency limit is, moreover, suf-ficiently clear to be used as a definitional reference for defining in an empirical (operational) way the meaning attributed to the given range *if this range of equipossible alternatives is understood as a frequency-generating situation.*

If we understand the range approach in this way as proposed above, these two models—frequency and range model—although definitionally related in the above manner, are by no means identical. One refers to the structure of the situation in which the frequencies are generated, the other one to the frequen-cies themselves—i.e., to the structure of the sequence of events which were 'produced' by this situation. It means that we would then have not two alter-native interpretations of the probability calculus but two complementary models describing two aspects of reality to which the probabilistic thinking might ap-ply: one of them applying to the *'collective generating situations,'* the other to the *'collectives' themselves.* It then becomes obvious, and here I agree with von Wright's formulation quoted above, that the problem as to which of these constitutes *the* definition of probability is futile. They are obviously comple-mentary, and obviously related to each other.

The reason for developing range models of frequency-generating situations is exactly the same as the reason for construction of any theory which may be used for the prediction of future events. We know that the theory might be falsified or modified by future research, but we still construct our theories with certain predictive implications. The logic of the range theory of probability is extremely useful for developing such models of frequency-generating situ-

ations, and the fact that our theoretical assumptions may be changed by the observation of consecutive sequences of events (i.e., collectives themselves or rather their sub-series) does not diminish the value of this approach.

On the other hand, theoretical assumptions made in the language of the range theory might be used for the substantiation of propositions derived from the observation of collectives described in the language of frequency theory. Our extrapolations concerning the frequency-limit of the given collective are certainly more 'legitimate' when we can relate the observed sequence to a situation described in theoretical terms of equipossible alternatives, than in the case where we only know the sequence of events which *seems* to alternate randomly. Thus, in a way, both these models check up each other in exactly the same way as theory and empirical research check up and 'legitimize' each other.

If we accept the above complementary relation between the range model and the frequency model of probability, it becomes clear that the range model, if it describes only the *proportions* of certain alternatives of the given range, is *obviously incomplete*. The proportion of the given alternative to the whole range of alternatives in a frequency-generating situation may be accounted for by the proportion of the events of the given type in the whole consecutive collective under the frequency approach, but it cannot explain (account for) the basically irregular, i.e. random character, of this collective. *We seem to need a kind of 'randomness-generating device' as an additional assumption about the nature of conditions to which this range applies.* The existence of this 'randomness-producing device' is the empirical counter-part of the Principle of Indifference in these aspects of its meanings, when it refers to the unpredictability of simple events, i.e., to their random character. When a certain situation is described in terms of equipossible alternatives, these alternatives may occur in either a systematic or a random way. The description of the rotation of the earth makes day and night equally possible, but they alternate in a completely systematic way. The difference between this situation and characterized as 'tossing a perfect coin' illustrates the difference between systematic and random equipossibilities. Only the last one makes a model for the range theory of probability.

It would go beyond the aim of this paper to analyze in a more thorough manner the nature of these assumptions which are needed to account for the random character of a collective in a collective-generating situation. Nevertheless, if we want to have a kind of correspondence (or isomorphism) between these two aspects of probabilistic phenomena, it seems that we have to assume "either that a kind of disposition to a basically random occurrence of the events has been built 'into the collective generating situation', or that the collective generating situation has a causal structure with some of the causes being distributed (or occurring) randomly".[31]

7. When predicting future events on the basis of their known or assumed probabilities, we proceed rationally when we "adjust" the degree of our belief that the event a will occur with the probability $p\ a/h$, if $p\ a/h$ is the frequency-limit of our collective. If $p\ a/h$ is greater than p non-a/h, then we are entitled to believe rationally that a rather than non-a will occur, and on the basis of that we expect that in a certain series of events h the event a will prevail. We know, of course, that it is possible that in a certain series of $h's$ non-a may prevail over the occurrence of a, but we expect that 'in the long run' the 'chance series' will be cancelled out. Von Wright asks about the foundations of this belief: "If rationality in beliefs is to justify induction, then it must be possible to give some kind of 'guarantee' that the 'Cancelling-out of Chance' will take place for degrees of probability representing rational degrees of belief."[32]

In the context of this problem von Wright analyses the theorem of Bernouilli, which says that with the increase of the number of observed cases the probability that the frequency p_1 of the events will not differ by more than a certain ϵ from the limiting value of the p in the infinite series tends to 1.0, and reminds us:

> Actually it is an old idea that this theorem amounted to a proof that—although irregularities and chance events may upset our calculations when applied only to a narrow sector of the world—in the course of nature as a whole regularity, law and order prevail. It is therefore intelligible that the proof of the theorem was regarded as an intellectual achievement of the greatest philosophical significance.[33]

Von Wright demonstrates that this is only a philosophical illusion. Let us present his arguments briefly. As we know, there are two probabilities in Bernouilli's theorem: one of them states the probability of an event in an infinite series—equal to the frequency limit of that event—is equal to, say, p. This is the probability of the first order. Then we have the probability that the frequency in a finite series of n events will not differ from p by more than ϵ. This is the probability of the second order. Its value tends to 1 with increase of n and must be very close to 1 when n refers to a great number of cases. For such situations we say that it is *almost certain* that the frequency of our events on n occasion will not differ more than ϵ from its limiting value.

But if something is *almost certain*, it does not mean that even the most improbable series will not occur or that they will not occur relatively frequently within the area of our experience. And vice versa: whatever kind of empirical measurement is applied to the checking of proportions of our events in our finite probability series, it will tell us nothing about their (second order) probability within the Bernouilli realm.

> We have now arrived at the following general conclusion: In whatever way degrees of possibility may be measured, it is not possible with this measurement to exclude that a great possibility will, even in the long run, be realized extremely seldom and

a small possibility again very often, unless the grounds for measuring possibilities involve the assumption that a proposition will, on repetition, be true in the long run in a proportion of cases proportional to its degree of possibility.

With this we have shown that the theorem of Bernouilli provides a bridge from the realm of probabilities into the realm of empirical frequencies solely under the condition that the probability of the second order, involved in this theorem, is given an interpretation which implies that a proposition will, on repetition, be true in the long run, in a multitude of cases proportional to its probability. But this implication is nothing but that the Cancelling-out of Chance will take place. . . .The idea of the theorem of Bernouilli being a proof of the Cancelling-out of Chance is thus circular.[34]

I think that very little can be added to this penetrating analysis of the problem of the relation between the logical or mathematical consequences of a certain formal structure and the empirical interpretation of this structure and its implications for prediction. The theorem of Bernouilli is a tautological construction with analytical validity, and as such it can prove nothing about the real phenomena; it cannot prove the empirical validity of the Law of Great Numbers. In its strict tautological meaning it establishes the relations between one property of a perfect collective (probability of the first order) and its other property—probability of the second order with regard to the number of cases in a series. It cannot say anything about the empirical world because it is not a synthetical but an analytical construction.

But let me add here that like any formal, logically consistent way of reasoning, such an analytical construction as the Law of Great Numbers is an extremely useful tool for the construction of theoretical models for certain areas of empirical reality. It logically reveals to us necessary connections between different aspects of this reality—once they have some of them, they must (by definition) possess also the others. Assuming the empirical validity of some of these assumptions, we may derive from them many other properties, which are the logical consequences of these assumptions. When our observation reveals that these consequences do not occur, we reject the assumptions.

Thus, if we interpret the Law of Great Numbers as a definitional property (or a logical consequence) of a collective, and we additionally assume that the phenomena of our interest make a collective, we are entitled to use it in our prediction. This assumption is being made for some areas of empirical reality, and nevertheless the directors of insurance companies of Prince Rainier of Monaco still feel relatively secure about their future incomes. They validly assume that the levelling-out of chance works in the fields of their interest.

On the other hand, we can apply the fact of occurrence of very improbable series (under our assumption) to the falsification of these assumptions. This is of course not a complete (i.e., certain) but only a probabilistic kind of falsification, but still I would say that we are proceeding rationally when, on observing a series which seems to be probabilistically incompatible with our assumptions, we reject these assumptions with a given probabilistic confidence level.

In his paper on *Wahrscheinlichkeitsbegriff* von Wright writes:

Nur zwei Möglichkeiten der endgultigen Lösung dieser Frage scheinen vorzuliegen. Entweder ist "der Satz vom Ausgleich des Zufalls" synthetisch, eine empirische Aussage über die Struktur der Wirklichkeit. Diese Lösung entspricht wohl der Aufzufassung von Reichenbach. Oder aber ist die Sache so aufzufassen wie es von Waismann angedeutet, freilich jedoch nicht durchgeführt worden ist. Nach dieser Auffassung wurde "das Gesetz der Grossen Zahlen" ein tautologes Prinzip sein, eine logische Konsequenz daraus, dass es uns gelungen ist, gewisse Naturgesetze, All-satze zu Formulieren.[35]

I do not think that we are faced here by a disjunction, but rather by an alternative of complementary interpretations which are directly related to each other as any theory to its empirical interpretation. Moreover, coming to the empirical interpretation of probability statements as synthetical propositions, one should speak clearly about the area of the world to which they seem to apply rather than about the structure of reality as a whole.

8. The problems discussed above are strictly related to von Wright's discussion of the doctrine of Inverse Probability and the limits of legitimacy of applications of Bayes's Theorem. The problem may be loosely stated as follows: are we entitled to attribute a certain probability to a on the basis of observation of the relative frequency of a in an observed series of events? Following Keynes' proof of the Inverse Principle von Wright presents it as follows:

Let b refer to one set of conditions in which a may occur with a given a priori probability, with this probability being equal to $P(b/h)$. $P(a/h \cdot b)$ refers to the probability of a in the conditions b (called here the likelihood of h under b). Let finally $P(b/a \cdot h)$ refer to the a posteriori probability of the condition b. The simple formula for the Inverse Principle is as follows:

$$P(b/a \cdot h) = \frac{p(b/h) \times P(a/h \cdot b)}{P(b/h) \times P(a/h \cdot b) + P(\sim b/h) \times P(a/h \cdot \sim b)}$$

In this formula we have only two alternative conditions which may generate the series of a: s:b and non-b. If we admit more than two alternatives for b, we obtain a generalized formula for the Inverse Principle for the condition b_i belonging to b:

$$P(b_i/h \cdot a) = \frac{P(b_i/h) \times P(a/h \cdot b_i)}{\sum_{i=1}^{s} P(b_i/h) \times P(a/h \cdot b_i)}$$

If in this formula all a priori probabilities are equal, then the a posteriori probability $P(b/h \cdot a)$ has its maximum value for this condition b_i, for which the likelihood $P(a/h \cdot b_i)$ is the greatest.

From this formula one can pass to the Inverse Law of Maximum Probability and Great Numbers which permits us to estimate to which of the Bernouillian

Independence-Realms, b_1, b_2 . . . b_i . . . b_s, differing in their probability (likelihood) of the event a, our observed series of a's belongs. If the ratio of the event a on n occasions is $m:n$, we obtain the highest probability for this b_i, the likelihood of a for which (i.e., $P(a/h \cdot b_i)$) is closest to $m:n$.

This inverse form of Bernouilly's Theorem is also called Bayes's Theorem. One might think that the a posteriori probability in this Theorem could be understood as the second order probability of Bernouilly's Theorem, but von Wright rightly stresses that this is not the case:

> The calculated probability is the probability that the conditions, under which an occurrence of the event took place, were just the conditions b_i. The unknown of the problem, therefore, is *not a probability*. It is *the presence of certain conditions,* relative to which the event has a probability. The 'inverse problem' in all its variations can be described as a problem of *re-identification* of the conditions under which an event has occurred, these conditions constituting a 'field of measurement' (data, information) of the event's probability.[36]

I agree completely that what is being assessed or identified in the case of 'inverse reasoning' is not the first order probability of a, nor the second order probability of certain series of a's with the structure $m:n$, and that we come to the conclusion about the probability of a in the given independence-realm only indirectly. But I do not see any reason why $P(b_i/h \cdot a)$ should not be called 'probability' (what was underlined by the author in the above quotation) even if it is not identical with the other two probabilities. This, however, may be only a verbal problem because in another place von Wright writes: "The 'inverse problem' . . . consists in determining the probability that the conditions, under which an occurrence of a complex event a took place, were exactly the conditions b_i. It is thus a problem of 'identifying', with probability, an independence realm for E."[37]

Von Wright mentions here two serious problems which seem to limit the applicability of the Inverse Principle. One of them is related to the assumption that the alternative conditions b constitute independence-realms for a, or as I would prefer to put it, that they are collective-generating conditions with respect to a. Under this assumption we can legitimately use, e.g., Bayes's Theorem for the identification of one of several urns (with different but known a priori probabilities of black balls) from which our series of balls has been drawn (with replacement). This theorem cannot be applied to many natural situations to which the notion of independence-realms cannot be validly applied. "And from it follows at once that such uses of inverse probability as those of determining the probability that the sun will rise tomorrow or that the next raven to be observed will be black are illegitimate."[38]

Another equally serious objection is directed toward the second assumption of inverse probability, i.e., the assumption that the a priori probabilities of all alternative conditions b for the occurrence of a are equal. The equality of their

a priori probabilities is usually based upon the famous Principle of Insufficient Reasons or the Principle of Indifference, and this can be used only—as we have seen from the quotation in section 6 of this paper—for developing hypotheses about equipossibility but not for proving their validity.

Agreeing with this, I would like to go one step further. I think that for many situations assumption of the equal a priori probabilities of a set of alternative conditions b is simply meaningless. We can imagine repeating many times an experiment with drawing balls from a set of urns chosen 'intentionally at random' (assuming that we know the proportions of the black balls in each of these urns); and on comparing different series of the balls drawn with their probabilities in the different urns we come to the conclusion that the urns were chosen really at random, or in other terms that they had equal probability of being chosen in our experiment. But for many natural cases of inverse reasoning the idea of such repeatability of conditions does not make any sense at all, and by the same token the notion of their equal (or non-equal) probability does not seem to be applicable.

Fortunately enough, we have here at our disposal the second part of Bayes' Theorem, which tells us:

> that, practically independently of *a priori* probabilities, it becomes in the long run infinitely probable that the event's probability will equal its relative frequency. The danger of using this loose mode of speech is, among other things, that it leaves without mentioning the assumptions of independence needed in order to warrant the Bernouilian charter of the event's probability.[39]

Or, in other words, once we know (or assume) that we are dealing with a random collective, we may stop to speculate about all thinkable alternatives and about their a priori probabilities and to use the relative frequency in the sufficiently long series for estimating the probability of the events in question, as I tried to demonstrate in another section of this paper.

The analysis of Inverse Probability is strictly related to von Wright's penetrating analysis of the theory of confirmation and the problems of inductive probability, but I omit these problems here.

9. The third group of meanings of probability statements refer to the *degree of our belief* that a certain event will occur, or in other terms to the area of 'subjective probability'. Von Wright discusses the problems of subjective probability on many occasions, and especially in his "Remarks on the Epistemology of Subjective Probability".[40] He starts it with the analysis of Ramsey's views.

According to Ramsey, a person's degree of belief (i.e., his subjective probability attributed to an event) can be defined, or better, measured by his behavior in the choice situations, by his preferences or his indifferences in the cases of 'simple' and 'conditioned' options. We have the case of 'simple' option when one of the two or more goods can be chosen by a person without addi-

tional conditions; it is conditioned when he may get the chosen good if some additional events, the occurrence of which is not certain, will occur. The indifference in the simple option measures equal values. The indifference to equally valuable goods in conditioned options means their equal probability. By observing a person's preferences and relating them to equal values and equal probabilities established previously we may thus establish the whole structure of his value system and his probabilistic expectations with regard to the given alternative of 'goods'.

It can be shown that Ramsey's system of measuring degrees of belief satisfies the postulates of the calculus, and especially the addition and multiplication principle.[41] The basic ideas in Ramsey's thinking are the notions of indifference and preference. Von Wright writes, "Ramsey's procedure takes for granted that it is clear what it *is* to have an attitude of preference or of indifference in a conditioned option—i.e., that the formation of such attitudes does not present a problem which is relevant to the definition of degrees of belief. If we wish to criticize Ramsey's definition, we must raise doubts at this very point."[42]

Here the author proposes to distinguish between *reasoned* and *unreasoned* attitudes of indifference, i.e., ones in which the choosing person knows that the goods are equally valuable for him and therefore cannot make up his mind (the reasoned attitude), and ones in which the choosing person has no reasons at all for making his choice (unreasoned attitude).

> An unreasoned attitude of indifference cannot, in combination with assessment of value, be used to define probabilities. This is so, because we have then no guarantee that the probabilities thus defined will satisfy the requirement of uniqueness—even for the same subject at a given moment. If our man is just too ignorant or too stupid to form an opinion on the matter, his attitude of indifference may easily be invariant under changes in the values of the goods which, if we accept Ramsey's definition, affect the probabilities.[43]

The distinction between reasoned and unreasoned attitudes in options is important if we treat Ramsey's propositions as empirical laws predicting real human behavior. But von Wright quotes Ramsey, according to whom "any definite set of degrees of belief which broke them (*sc.,* the laws of probability) would be inconsistent in the sense that it violated the laws of preference between options, such as that preferability is a transitive asymmetrical relation. . . ." And he adds, "the laws of the calculus can be called 'laws of consistent (or coherent) partial beliefs.' . . . Laws of the calculus can be said to provide a standard of consistency in beliefs."[44]

It means that Ramsey (at least in this quotation) treats his propositions not as empirical laws but as *normative rules* for consistent rational thinking in uncertainty situations, shaping these rules according to the postulates of the calculus. In such situations only the so-called 'reasoned' indifferences or pref-

erences—and I would add, 'completely reasoned' ones—may satisfy this no-
tion, when *the unreasoned attitudes are here prohibited by definition*. It is an
open empirical question how many people and in what kind of situations will
possess reasoned or unreasoned attitudes; and Ramsey is entitled not to care
about this as long as he treats his definition only as a set of normative stan-
dards. The notion of 'reasonability' seems thus to be implicitly involved in
Ramsey's definition if it is understood as a system of postulates concerning the
problem of how people *should* shape their beliefs and preferences. On the other
hand, only if we can assume that thinking of all or some definite people is
completely rational (in a probabilistic sense) can we use Ramsey's definition
for empirical measurement of the degree of their belief, and in this respect—in
the application of Ramsey's notion for empirical assessment—von Wright's
supplement to this motion is necessary.

Von Wright also defines another aspect of what he proposes to call 'rea-
soned attitude in options':

> When a person has what is here called a reasoned attitude of indifference in a
> conditioned option, he expects that a repetition of the same choice on a number of
> occasions for making it would result in an *accumulation* of goods of roughly the
> same value to him as the accumulation which would result from an alternative
> choice. . . . The suggestion presupposes that the conditioned option which we are
> discussing can be repeated. This presupposition again is fulfilled if the proposition
> *p* which conditions the option is to the effect that some generic event *E* takes place
> on some type of occasion *O*. . . . The *most expected frequency* of the event on
> repeated occasions for its occurrence is the *probability* we assign to it on the single
> occasion of an option, in which we judge the alternatives presented for considera-
> tion equally good.[45]

I think that the last sentence of this quotation should read: 'The most ex-
pected frequency of the event on repeated occasions for its occurrence *should
be the probability* we assign to it.' Then we read, ''it is not possible, without
circularity, to *define* subjective probability in terms of values of goods and
attitudes in options.''[46]

It is true that for the normative sense of subjective probability, the postu-
lates of the calculus define the rules of consistency, and the frequencies in the
long run (or a priori probabilities) determine the values of initial probabilities
assigned to the events, or on the other hand, that the logical and empirical
structure of probabilistic phenomena is used for the development of standards
of correct probabilistic reasoning in the situations of uncertainty. But then we
have two different notions of probability in definiens and definiendum. On one
side of the definition we have either the frequency-limit or proportions of dif-
ferent alternatives; and on the other we have the normative standards defining
how strongly we should believe that a certain event will occur. The circularity
may then be only spurious, terminological, or verbal rather than essential. On

the other hand, if we treat this as a set of empirical propositions (which no one of the 'subjectivists' does in a consistent manner), then assuming that we can measure the values, we can attribute probabilities to the events on the basis of people's choice in conditioned options. But then we should not expect that most of the people will really base their expectations on the expected frequencies of events in the long run—they may not even ask the question about frequencies and base their subjective probabilities on the strength of their desires (wishful thinking) or fears. Nor can we expect that they will derive the far-going probabilistic implications from their initial probabilities according to the rules of the calculus unless they are professional game theoreticians working in their professional roles.

I think that such an interpretation is in accordance with von Wright's other formulations on the subject of subjective probability. In the *Treatise on Induction and Probability* we read:

> On the Psychological Interpretation the axioms and theorems of axiomatic probability would *not* express formal propositions but material propositions about the way in which people actually distribute their partial belief. They would be, so to speak, psychological laws of believing. The mere fact . . . that different persons (or even the same person at different times) may entertain different degrees of belief in the same property on the same evidence, is, as such, no proof that probability is 'subjective' also in the further sense that not all people distribute their beliefs in accordance with the axioms and theorems of the calculus. Nevertheless, probability *may* be 'subjective' in this further sense also; *i.e.,* the axioms and theorems as laws of believing *may* be false. There are, moreover, certain well known psychological phenomena . . . which seem to indicate that people do not without exception believe in conformity with the rules of the calculus of probability. . . .
>
> The Frequency and the Possibility Interpretations make the axioms and theorems of the Calculus deducible from a definition of probability in virtue of laws of logic and arithmetic. The Psychological Interpretation, on the other hand, would not make these axioms and theorems deducible from a definition of probability, but would make them psychological laws of believing, to be confirmed or refuted by experience.[47]

Or, in another place: ". . . The calculus of probability as a theory for the distribution of actual beliefs would presumably break down as being a false theory."[48]

So, agreeing in general with most of the statements quoted above, I would say that the notion of a 'reasoned attitude' is either involved (at least partially—i.e., the consistency rule) in Ramsey's notion of subjective probability, when this is interpreted in a normative sense, or introduces unnecessarily certain elements of Psychological Interpretation, criticized (justifiably) by von Wright on other occasions as having little in common with the rules of the Calculus.

Writing about normative or regulative functions of the Calculus for the distribution of our beliefs, von Wright asks the question as to what this postulate really means. He answers as follows:

> It is first to be observed that the standard of rationality cannot be defined as a *standard of consistency*. This is important. Not only does the calculus of probability not tell us how we actually believe but it does not even tell us that *if* our actual beliefs in certain simple cases are distributed in such and such a way, *then in order to be consistent* we ought to distribute our beliefs in certain other cases—compounded from those simple ones—in a determinate way. For actual degrees of beliefs are psychological facts and can, as actual facts, never *contradict* one another.[49]

Here I would like to disagree. If we interpret the theorems of the calculus as the normative standards, describing how people ought to think in order to be rational, then different beliefs may be logically contradictory even if they exist in the head of the same person, as any different opinions of the same person may be logically contradictory. Then the rules of the calculus should be used in order to avoid such contradictions, as we teach students elementary logic in order to eliminate inconsistencies in their thinking. So it means that the *formal side* of these standards is essential for they are the rules of correct derivations of conclusions from some initial probabilistic assumptions. The other aspect of rationality (the only one which is accepted by von Wright) is called *material*. "This material characteristic determining certain degrees of belief as *rational* is, evidently, the same as that referred to when we say that it is 'rational' to prefer the more probable to the less probable. . . ."[50]

The distinction of formal and material components of the notion of rationality seems to be important not only when we want to develop standards of rational thinking in uncertainty situations in order to teach people the correct rules of thinking. It also seems to be important on other occasions when we would like to use the axioms and theorems of the calculus for developing (hypothetical) theoretical models of real human thinking. As was mentioned above, their analytical truth does not make them empirically valid; they have to be confirmed by observation of real human behavior. If they are valid only for some people, then we should ask, for what kind of people and under what conditions these models of rational probabilistic thinking may be used for the explanation and prediction of their behavior. The other question is what factors are responsible for the deviations of human behavior from probabilistic models of rationality. Here the distinction of empirical validity and internal consistency of these models seems to be especially important. We can imagine people who assign the initial probabilities correctly, i.e., who accept the principle that subjective probability should be adjusted to the frequency of the event in the long run, but who are unable to make further derivations, because the more compli-

cated rules of the calculus are simply too difficult or unknown to them. On the other hand we can imagine persons who, due to their 'optimism' or 'pessimism' do not evaluate the initial probabilities correctly (or are unwilling to adjust them to the known frequency limits), but who, on the basis of these initial assumptions, make correctly (consistently) all further derivations. Consistency and empirical validity seem to be two important complementary aspects of the application of probabilistic models as explanatory laws of human behavior.

10. The degree of our expectation should be based upon our knowledge of the expected, most probable, frequency of the events. In some cases it is enough to have only one 'predictor' of the occurrence of future events; in others, different kinds of information may be relevant for the problem. The author clearly states that *we should use all relevant information in the case of prediction of future events.* "The probability of the predication, in other words, is the probability of the conjectured property on *all relevant information* about the thing as evidence".[51]

But then the question arises, *what makes the set of all information relevant for the given case?* I think that we can distinguish three different situations:

The first situation occurs when all we know about the event A, e.g., is that it is a member of a collective A, H, with unknown or nonexisting variables of the class G which, when characterizing the events of the class H, modify the frequency-limit of A. In von Wright's terminology we are making here our prediction in terms of *chance*.[52] The chance is *absolute* if the property G does not exist. It is *relative* with respect to some modifiers of this probability G, if such properties G exist, but are unknown to us. In such a case all the relevant information we have is the frequency-limit of A in H, and it defines the degree of our expectation that A will occur.

The situation is equally simple when we know that a certain G may be used as a selection principle for A in H with $P\ A/H \neq P\ A/HG$, and we don't know any other modifiers of this probability, because then the set GH defines all relevant knowledge for the prediction of A.

But this case, as I tried to demonstrate above, is one of the situations in which we may still use only H as containing all the relevant information for the prediction of the frequency of A in fairly long series of H, if this is the problem of our interest and if we assume that G occurs at random with respect to H. On the other hand, if we are interested in predicting the occurrence of A on the next particular case, we should use both G and H as our "predictors". But, since H in our case is the definitional property of our collective A,H, for, in other terms both A and G belong to H, then the occurrence of H cannot alter the probability of A when G occurs, and the probability of A under G is equal to $P\ (A/GH)$. It means that in the situation when the extension of the property G—which modifies the probability of A in w, the weak collective A, H—is

included in the extension of the property H, it is sufficient to the most rational prediction of the occurrence of an individual event A to base our prediction only upon the occurrence or nonoccurrence of G.

The situation becomes more complicated when the event A is a member of several random collectives, extensions of the antecedents of which *intersect,* because we are faced here by a well known problem of inductive inconsistency.[53] We know that the fact of the belongingness of A to different collectives is relevant for the prediction of its occurrence, but we do not know the rules according to which the derivations should be made in the situation of obvious inconsistency of probabilities relating A to its different antecedent conditions. I think that some rules can nevertheless be proposed.

The hardest problem which should be solved is the question as to whether the intersection of two probabilistic collectives (e.g., S, A and D, A) will make another probabilistic collective at all. Let us give an extreme illustration of this problem. Suppose that we know on the basis of previous observations of fairly long series of events of the types SA and DA that $P (A/S) = 0.01$ and the same is the value of $P (A/D)$. On the basis of that we might suspect that the intersection of S and D might constitute another collective with a fairly low (but probably slightly higher) probability of occurrence of A with respect to S and D jointly. But it may turn out that these two events together make a sufficient condition for A being a necessary component of this condition SD. In such situation $P (A/SD)$ is of course equal to 1.

Von Wright admits the possibility of randomness in the case of strictly deterministic relations, provided that the causes (sufficient conditions) will be excluded from the set of our "predictors."

> If A is a Determined Property, then it cannot in an absolute sense be said to be distributed in a random or irregular way over the members of any field of measurement H. . . . These facts, however, do not exclude a Determined Property from possessing a (not-extreme) chance for its occurrence in a given positive instance of another property, or from being randomly distributed over the positive instances of another property, *relative to some set of properties* ϕ_0.[54]

Let us see what the probability of the occurrence of A will be when one of its causes occurs under the assumption that S and D together make a sufficient condition for A and are randomly related with respect to each other. It is obvious that[55]

$$P(A/S) = P(D/S) \quad \text{and} \quad P(A/D) = P(S/D).$$

On the other hand, if the notion of randomness cannot be attributed to the relation between S and D (if, e.g., the occurrence of S with respect to D does not have an unambiguous frequency-limit and there will be no definite frequency-limit for the relation between A and D), then the events A and D do not make a collective at all and the notion of the probability of A with respect

to D is meaningless, as is then the idea of rational adjustment of our subjective probability that A will occur in the given instance of D.

Finally, even if the 'product' (intersection) of two collectives with respect to A will make a new random collective for the occurrence of A with a definite frequency-limit, we still don't know how we should predict this frequency-limit of A for SD occurring jointly unless we make some additional assumptions. Without proposing a universally valid algorithm I would like to discuss this problem for the situations where the antecedents of different collectives to which A belongs are causally related to A. By that I mean here that the experimental manipulation of the occurrence of either S or D can influence the frequency-limit of the occurrence of A in an empirical series, and we interpret the selection of certain cases of the type D and non-D (and so of the cases of the type A and non-A) as a substitute for experimental manipulation. Another assumption which we have to make refers to the kind of causal relations between S, D, and A. We have, that is to say, to decide whether S and D are *additive* or *interacting* causes of A. We shall speak about the interactive patterns of making a new collective on the intersection of the two older ones.

By the *additive pattern* of formation of a new collective from the two former ones I mean a situation in which the (dychotomic) variables S and D, being causally related to A, belong to two alternative sufficient conditions for A. To make it more clear let us assume that A in our population H may be "produced" (i.e., caused) either by the joint occurrence of DF or by the joint occurrence of SR. It means that, once DF occurs, the occurrence of S is irrelevant for the occurrence of A , and vice versa—once SR occurs, the occurrence of D is irrelevant for the occurrence of A. If we additionally assume that F occurs with respect to D not always but only with a certain probability, the conditional causal relation between D and A is reflected in a certain probabilistic relation between them. The same goes for the relation between S and R, which makes the conditional causal relation between S and A a probabilistic one.

Now let us assume for simplicity's sake that all four variables, D, F, S, R, are distributed randomly both with respect to the total field of measurement H and with respect to each other (both in pairs and in all possible combinations). In such a situation when disregarding F and R in our observations we shall have two collectives (in the weak sense of the term), namely, D-A and S-A, with certain overall probabilities of occurrence of A, namely, $P(A/D)$ and $P(A/S)$.

Under the assumption that the relations between S and A and correspondingly between D and A are causal, one might think that these values $P(A/D)$ and $P(A/S)$ "express" in probabilistic terms only the causal connections between D and A or S and A. But on closer examination it seems reasonable to distinguish two different components of any of these probabilistic relations: *its*

causal and spurious components. Let us look first at the collective *D-A*. In this collective only those *A*'s which follow the joint occurrence of *D* and *F* are caused by *D*, when the others occur after *D* due to the fact that *D* in the given instances occurred jointly with *S* and *R*, but was not "participating" in "producing" *A* in these instances. If we now say that the causal component of the probabilistic relation *P(A/D)* refers to this proportion of A's which were caused by *D*, it becomes obvious *that the causal component of this relation is equal to P(F/D)*, and under the assumption of the independence of all the variables involved, it is equal *P(F)* in the population *H*.

In exactly the same manner we define the causal component of the second probabilistic relation, i.e., *P(A/S)* as equal to *P(R/S)* or in our case to *P(S)*, and *all the rest of these two relations become spurious components of them.*

The formula for the overall probability of occurrence of *A* under the occurrence of *D* or *S* may be presented as follows:

$$P(A/D) = P(F/D) + P(SR/D) - P(RSF/D)$$
$$P(A/S) = P(R/S) + P(FD/S) - P(FDR/S)$$

And assuming the independence of all variables:

$$P(A/D) = P(F) + P(S) \times P(R) - P(S) \times P(R) \times P(F)$$
$$P(A/S) = P(R) + P(D) \times P(F) - P(D) \times P(F) \times P(R) .$$

In these formulas only their first components, i.e., *P(F)* and *P(R)* represent causal components of the corresponding partially causal and partially spurious probabilistic relations, *P(A/D)* and *P(A/S)*, or of the corresponding initial collectives. The numerical value of these components may be established very easily. For the collective *D-A* this value is equal to the probability of occurrence of *A* for its sub-collective when non-*S* occurs, or symbolically: to $P(A/D\bar{S})$; and for the other collective *S-A*, its causal component is equal to: $P(A/S\bar{D})$. Let us now call *F* the supplementary factor for *D* with respect to *A*, meaning that its addition makes *D* a sufficient condition for *A*. *R* is correspondingly the supplementary factor for *S* with respect to *A*. We may now say that in order to establish the probability of occurrence of an unknown supplementary factor for the given sufficient condition, we have to study the frequency of the effect under conditions of non-occurrence of all alternative sufficient conditions.

Let us now denote $P(F/D) = P(F)$, (which is equal, as we remember, to $P(A/D\bar{S})$, by p_1 and $P(R/S) := P(R)$ by p_2. Now the formula for the new collective, being the intersection of collectives *D-A* and *S-A*, *under the assumption of their additive character* looks as follows:

$$P(A/SD) = P(F) + P(R) - P(F) \times P(R) \quad or,$$
$$P(A/SD) = p_1 + p_2 - p_1 \times p_2.$$

The relations of the above kind are called *additive* due to the formula $p_1 + p_2$ being part of them, which means that they are based upon the sum of causal components of the corresponding alternative causal collectives. But, as we see, they are not 'completely additive' in the sense that the sum of the causal components must be diminished by the probability of the joint occurrence of the alternative supplementary factors F and R. We may say that the greater the number of alternative causal relations producing a new additive collective, the less strictly additive it will be. In the case of three initial collectives—e.g., with their causal components equal to p_1, p_2, and p_3—and the antecedents of these collectives denoted as C_1, C_2, and C_3,

$$P(A/C_1 \cdot C_2 \cdot C_3) = p_1 + p_2 + p_3 - p_1 \times p_2$$
$$- p_1 \times p_3 - p_2 \times p_3 - p_1 \times p_2 \times p_3.$$

We may generalize this in the following way. Let us assume that A is produced in the population H by a set of alternative known conditional causes C_1, C_2 . . . C_n, and that these conditional causes are distributed randomly both with respect to H and with respect to each other. Assume, moreover, that each of these causes produces A with a probability lower than 1 due to the fact that we don't know the supplementary factors F_1, F_2 . . . F_n also distributed randomly in the above manner and making with corresponding causes C_1, C_2 . . . C_n sufficient conditions for A. Let finally p_1, p_2 . . . p_n denote the probabilities of these supplementary factors and thus the causal components of the corresponding additive collectives $P(A/C_1)$, $P(A/C_2)$. . . $P(A/C_n)$.

The value of the causal component of any of these probabilistic relations can be established under the conditions when only one corresponding cause C occurs when others are absent, and is equal to the probability of A under occurrence of this cause and absence of other alternative causes. The probability of occurrence of A under the conditions that all alternative causes C occur jointly is here equal to the sum of the causal components of all alternative collectives diminished by the sum of probabilities of joint occurrences of all supplementary factors in all their combinations.

$$P(A/C_1, C_2 . . . C_n) = p_1 + p_2 . . . + p_n - p_1 \times p_2 - . . . p_1 \times p_n$$
$$- p_2 \times p_n - p_1 \times p_2 \times . . . p_n.$$

And, as was said above, this should be the level of our rational expectation that the event A will occur when all its alternative ''additive'' causes occur jointly, and under the additional assumptions formulated above, which are by no means obvious in every case of prediction of the event A.

By the *interactive* pattern of formation of the new collective *SD-A* from the two former ones namely *D-A* and *S-A* I mean situations in which the variables

S and D belong to the same sufficient condition for A, although they do not make a complete sufficient condition for A in the population H. The complete sufficient condition for A is composed of the events S, D, and F when occurring jointly, but the role of F is unknown to us. Suppose additionally that all these variables are distributed randomly both with respect to H and with respect to each other.

It is obvious that under these assumptions the sequences of events D-A and S-A will make two (conditional) collectives in the population H. Let us denote their (supposedly known) probabilities as follows:

$$P(A/D) = p_1, \qquad P(A/S) = p_2.$$

In these two collectives their probabilistic values are, reducible to their causal components; due to the absence of alternative causes of A in the population *H there are no spurious components in them.* Let us additionally denote the probabilities of occurrence of the antecedents of these collectives in H as follows:

$$P(D) = p_3, \qquad P(S) = p_4.$$

We don't know the probability of the unknown supplementary factor F, but we know that it is equal to $P(A/SD)$ or to the expected probabilistic value of the new collective being the product (intersection) of the two former ones, D-A and S-A, because:

$$P(A/SD) = P(F/SD) = P(F).$$

We may now easily compute the value of $P(A/SD)$ since we know that

$$P(A/D) = P(S) \times P(F)$$

and therefore

$$P(F) = \frac{P(A/D)}{P(S)} \qquad \text{or} \qquad \frac{p_1}{p_4}.$$

By the same,

$$P(A/SD) = \frac{p_1}{p_4}.$$

Or we may compute it from the probabilistic value of another collective S-A where:

$$P(A/SD) = \frac{P(A/S)}{P(D)} \qquad \text{or} \qquad \frac{p_2}{p_3}.$$

These values determine again both the frequency-limit of A in SD and the degree of our rational expectation that A will occur in a particular case, when we assess the occurrence of S and D jointly.

One might say in this case that the assumption that we don't know only one supplementary factor of the given interactive set of causes makes a rather strong assumption, but under the assumption of the independence of all the unknown supplementary factors we may treat F as the joint occurrence of all unknown supplementary factors F_1, F_2 . . . F_n. In such a situation all the above formulas are true for our F and the prediction for the new interactive collective may be formulated in exactly the same way as proposed above.

I would be glad to know Professor von Wright's reaction to this kind of interpretation of his notion of "all relevant information in the case of probabilistic prediction".

11. Let me quote to the end of this paper several points from the summary of Professor von Wright's unpublished 'Essay on Probability':

> Distinction between two kinds of probability: hypothetical and inductive. Hypothetical probabilities when used for predicting frequencies in experiments with reproducible occasions for the occurrence or non-occurrence of events are called Experimental Probabilities. . . . A hypothetical probability is a magnitude associated primarily with a generic event considered relative to a class of occasions for its occurrence or non-occurrence. Secondarily it may become associated primarily with a generic event considered relative to a class of occasions for its occurrence or non-occurrence. Secondarily it may become associated with propositions asserting the occurrence or non-occurrence of individual events. An inductive probability is an attribute of a proposition considered relative to (inductive) evidence for its truth.
> . . . The frequency—and range—view of probability characterized as unsuccessful attempts to account the nature of hypothetical probability. . . . Three main steps in the use of Experiment Probabilities, described as framing hypotheses, are concerned with the values of probabilities, the transformation of probabilities into practical certainties and the revision of hypotheses in the light of statistical evidence. . . . (p. 1).

I quote this because I have the feeling that the only essential differences between Professor von Wright's views and mine are related to the problem as to whether the nature of hypothetical probabilities can be successfully presented. I am here perhaps more optimistic than the author. If we admit that hypotheses are hypotheses, we require from them only two things: first, that they can be presented in a sufficiently clear manner, free from internal contradictions and, second, that they have observable consequences.

I think that the notion of a collective (with all its modifications which I tried to present above) is free from contradictions if we treat it as the hypothetical structure of random empirical series, and that it implies important observable consequences. Although we never can be sure that we are not dealing

with an exceptional series of events, the (hypothetical, random) distribution of different series in the collective permits us to assess the frequency-limits with (inductive) probability fairly close to certainty. Again, if we treat the range-approach as a set of formal tools which permit us to describe certain empirical 'collective generating situations' then again we can do that, and then we can modify the correctness of our assumptions on the basis of the observable series with certain degrees of inductive probability. And this is all we can require in any empirical science.

UNIVERSITY OF WARSAW STEFAN NOWAK
APRIL 1974

NOTES

1. This paper is based on the following publications by Professor G. H. von Wright: 'Der Wahrscheinlichkeitsbegriff in der modernen Erkenntnisphilosophie', *Theoria* 4 (1938); 'On Probability', *Mind* 49 (1940); *Über Wahrscheinlichkeit: Eine logische and Philosophische Untersuchung,* Acta Societatis Scientiarum Fennica, Nova Series A, Vol. 3, no. 11 (Helsinki, 1945); *A Treatise on Induction and Probability* (London, 1951); 'Carnap's Theory of Probability', *Philosophical Review* 60 (1951); *The Logical Problem of Induction,* (Oxford, 1957); 'Probability', *Encyclopaedia Britannica,* Vol. 12 (Chicago, 1959); 'Broad on Induction and Probability', in *Philosophy of C. D. Broad,* edited by P. A. Schilpp (New York, 1959); 'Remarks on the Epistemology of Subjective Probability ', in *Logic, Methodology and Philosophy of Science: Proceedings of the 1960 International Congress* (Stanford 1962); and 'Wittgenstein's View on Probability', *Revue International de Philosophie* 23 (1969). Moreover, I had an opportunity to read Professor von Wright's detailed outline of probability problems in his unpublished typescript entitled 'Essay on Probability'. Citations to these works appear in the following notes in shortened form.
2. 'Der Wahrscheinlichkeitsbegriff', pp. 3–4.
3. 'On Probability', p. 265.
4. Ibid., p. 282.
5. *Logical Problem of Induction,* pp. 90–91.
6. 'Essay on Probability', unpublished essay.
7. *Logical Problem of Induction,* p. 93.
8. A. N. Kolmogorov, *Grundbegriffe der Wahrscheinlichkeitsrechnung,* Ergebnisse der Mathmatik und ihrer Grenzgebiete (Berlin, 1933).
9. 'On Probability', p. 269.
10. Ibid., p. 282.
11. Ibid., p. 281.
12. *Treatise on Induction,* pp. 171–172.
13. Richard von Mises, 'Grundlagen der Wahrscheinlichkeitsrechnung', *Mathematische Zeitschrift* 5 (1919), and *Wahrscheinlichkeit, Statistik und Wahrheit,* 2d ed. (Vienna, 1936).
14. *Logical Problem of Induction,* pp. 99, 210.
15. 'On Probability', p. 275.

16. Ibid., pp. 273–74.
17. *Über Wahrscheinlichkeit*, p. 36.
18. 'On Probability', pp. 277–79.
19. S. Nowak, 'Inductive Inconsistencies and Conditional Laws of Science', *Synthese* 23 (1972), pp. 357–376.
20. 'Broad on Induction and Probability', p. 350.
21. *Treatise on Induction and Probability*, pp. 228–29.
22. 'On Probability', p. 277.
23. 'Der Wahrscheinlichkeitsbegriff', p. 10.
24. Ibid., p. 11.
25. *Logical Problem of Induction*, p. 6
26. See 'Wittgenstein's View on Probability'.
27. *Logical Problem of Induction*, pp. 100–01.
28. Ibid., p. 101.
29. Ibid., p. 116.
30. Ibid., p. 102.
31. See S. Nowak, 'Inductive Inconsistencies and Conditional Laws of Science'.
32. *Logical Problem of Induction*, p. 144.
33. Ibid., p. 145.
34. Ibid., pp. 148–49.
35. 'Der Wahrscheinlichkeitsbegriff', p. 114.
36. *Logical Problem of Induction*, p. 114.
37. Ibid., p. 114.
38. Ibid., p. 115.
39. Ibid., p. 109.
40. 'Remarks on the Epistemology of Subjective Probability', in *Logic, Methodology and Philosophy of Science*. (See note 1 above.)
41. Ibid., p. 333.
42. Ibid.
43. Ibid., p. 334.
44. Ibid., p. 333.
45. Ibid., pp. 334–35.
46. Ibid., p. 335.
47. *Treatise on Induction and Probability*, pp. 219–220.
48. *Logical Problem of Induction*, p. 140.
49. Ibid.
50. Ibid., p. 141.
51. *Treatise on Induction and Probability*, p. 228.
52. Ibid., pp. 225–236.
53. See S. Nowak, 'Inductive Inconsistencies and Conditonal Laws of Science' *Synthese* 23 (1972), pp. 357–376.
54. *Treatise on Induction and Probability*, pp. 235–36.
55. See: S. Nowak, 'Causal Interpretation of Statistical Relationships in Social Research, Philosophy of Science', vol. XXVII (1960), pp. 219–231. See also: S. Nowak, 'Conditional Causal Relations and their Approximations in the Social Sciences', in P. Suppes et al. (eds.), *Logic, Methodology and Philosophy of Science*, IV (Amsterdam and London: North Holland, 1973), pp. 765–787.

4

Risto Hilpinen

VON WRIGHT ON CONFIRMATION THEORY

I

G. H. von Wright's published writings on induction, probability, and confirmation include two books, *The Logical Problem of Induction* (abbreviated here *LPI*)[1] and *A Treatise on Induction and Probability* (abbreviated *TIP*),[2] a long essay *Über Wahrscheinlichkeit* (abbreviated *EW*),[3] and several shorter articles in various philosophical journals and books.[4] In *TIP* von Wright distinguishes between "three main problems of induction": (1) the mainly psychological problem of *discovery*, (2) the philosophical problem of the *justification* of induction, and (3) the logical problem of analyzing the inferential mechanism of induction or the problem of *inductive logic*.[5]

The main topic of *TIP* and *EW* is the logic of inductive inference, whereas *LPI* is primarily concerned with the problem of justification. It is clear, however, that this problem cannot be discussed without a logical analysis of inductive arguments, and long sections of *LPI* deal with purely logical questions.

In this essay I shall examine von Wright's contributions to a branch of inductive logic termed *confirmation theory*. Some authors, for instance Rudolf Carnap, have used the expressions 'inductive logic' and 'confirmation theory' synonymously. Von Wright uses the latter expression in a more restricted sense:

> By Confirmation-Theory we shall here understand the theory of how the probability of a given proposition is affected by evidence in the form of propositions which are logical consequences of it. A case of particular importance to this theory is when the given proposition is a generalization and the evidence for it is some of its instances. Verified instances *confirm* the generalization. It is the primary task of confirmation theory to evaluate, in terms of probability, the confirming effect of the instances on the generalization.[6]

The author is indebted to the University of Queensland and to the Finnish State Council for Humanities for support of research.

This essay will be concerned with confirmation theory in this restricted sense. The following discussion is based mainly on the three works mentioned above. Von Wright's more recent writings on probability and induction seem to have retained, in many respects, the basic philosophical outlook of these early works.

According to von Wright, the logic of induction can be divided into two parts, "depending on whether the question of the truth or falsehood of the conclusions alone enters the discussion, or whether there is the further question of the probability of the conclusion also."[7] The former part of inductive logic is termed the logic of *inductive truth,* the latter part the logic of *inductive probability.* Von Wright's logic of 'inductive truth' is essentially the logic of *elimination.* In his review of Carnap's *Logical Foundations of Probability,* von Wright criticizes Carnap's view that inductive logic is the same as probability logic on the ground that this view fails to do justice to the theory of elimination as an independent branch of inductive logic. Von Wright says that the theory of elimination can be regarded as "a branch of inductive logic complementary to the theory of confirmation".[8] The logical mechanism of elimination "rests on the fundamental, though trivial, fact that no confirming instance of a law is a verifying instance, but any disconfirming instance is a falsifying instance".[9]

In so far as 'elimination' means merely the *invalidation* or falsification of hypotheses, it is based on certain *deductive* patterns of inference which are systematized in von Wright's 'logic of conditions'.[10] However, eliminative induction does not only eliminate hypotheses inconsistent with observational evidence, but also "makes the conclusion of an inductive argument appear to stand out more and more, so to speak, among a number of initially 'concurrent' conclusions."[11]

This feature of eliminative induction cannot be explicated without using some probabilistic measure of the strength of evidence. If by 'inductive logic' (as opposed to deductive logic) we understand a logical theory of the essentially *non-demonstrative* aspects of inductive arguments, von Wright's criticism of Carnap seems unjustified. On the other hand, von Wright is obviously right in emphasizing the importance of the logic of conditions for the analysis of inductive inferences, and his reconstruction of the classical canons of eliminative induction in terms of the logic of conditions is an important contribution to the philosophy of induction.[12]

II

In the first chapter of *TIP* von Wright distinguishes between two types of inductive inference. The first type of inference, termed *induction of the first order,* is described as follows: "From the proposition that something has been

the case under certain conditions *and* that the conditions are repeated we *infer*, as we say, the proposition that the same thing will be the case again.''[13] The second type of inductive inference is characterized as follows: ''From the proposition that something has been the case under certain conditions we *infer*, as we say, the proposition that, *if* the same conditions are repeated, then the same thing will be the case again.''[14] An argument of this type is termed by von Wright *induction of the second order*. The conclusion of a second-order induction is a universal conditional or biconditional.[15] In the following I shall discuss only cases in which the conclusion of a second-order induction is a universal conditional (or universal implication).

Let us assume that A and C are two properties or 'conditions', and that C has been present in all observed (positive) instances of A. ('A' stands for 'antecedent', 'C' for 'consequent'.) Let $E_n = [a_1, a_2, \ldots, a_n]$ be a set of observed instances or *individuals*, let e_n be a singular statement which describes the results of these observations, and let a_{n+1} be an individual which does not belong to E_n. A first-order inductive argument can be expressed schematically in the form

$$(1) \qquad\qquad e_n, Aa_{n+1} \Rightarrow Ca_{n+1},$$

where the symbol '\Rightarrow' stands for the relationship between the premises and the conclusion of an inductive argument. Second-order inductions of the type described above have the form

$$(2) \qquad\qquad e_n \Rightarrow (x)(Ax \supset Cx).$$

Von Wright's distinction between first-order and second-order inductive arguments corresponds to W. E. Johnson's distinction between *eduction* and *induction*.[16] First-order inference may also be termed *singular* or predictive inference and second-order inference *universal inference*. Confirmation theory, in the sense understood here, is essentially a probabilistic theory of universal inference.

According to von Wright, a universal conditional $(x)(Ax \supset Cx)$ has three types of confirming instances: instances in which both the antecedent property A and the consequent property C are present, instances in which A is absent and C is present, and instances in which both A and C are absent.[17] According to this usage, all instances *compatible* with the generalization are 'confirming instances'. For reasons of clarity, I shall here call such instances *positive instances* of the generalization. All positive instances of a generalization are not necessarily confirming instances; the concept of confirming instance will be defined in section III.

In the following it will be assumed that the generalization $(x)(Ax \supset Cx)$ is a hypothesis about a denumerable universe U, and the class of observed individuals E_n contains the first n members of an ordered sequence $a_1, a_2, \ldots .$

of the individuals in U. The evidential statement e_n is an n-termed conjunction i_1 & i_2 & . . . & i_n, where each conjunct i_j implies that a_j is a positive instance of the generalization $(x)(Ax \supset Cx)$.

III

If inductive arguments are defined as a subtype of non-demonstrative arguments, all inductive arguments are, by definition, (deductively) inconclusive or invalid. Nevertheless it is usually assumed that some non-demonstrative arguments are 'legitimate' or 'acceptable'. In (1) and (2) this is expressed by the symbol '\Rightarrow'. In probabilistic confirmation theory this concept of 'inductive legitimacy' or 'inductive validity' is explicated in terms of probability: the 'validity' (or degree of validity) of an argument depends on the *probability* of the argument; that is, on the conditional probability of the conclusion relative to the premises. The probabilities associated with arguments are termed *inductive probabilities*.

If the relationship between the premises and the conclusion of an argument is characterized in terms of probability, it is possible to define several interesting concepts of 'inductive validity'. The following two notions are of main interest here:

(3) Let $P(h|e)$ be the inductive probability of h relative to e. If $P(h|e)$ is high (for instance, $P(h|e) \geqq 1 - \epsilon$, where ϵ is some small number), $e \Rightarrow h$ is a *probable argument*.

(4) Let k be some corpus of 'background information'. If $P(h|e \, \& \, k) > P(h|k)$, the argument $e \Rightarrow h$ is, relative to the information k, a *relevant argument*.

If $P(h|e \, \& \, k) > P(h|k)$, we say that e is *positively relevant* to h on k. Thus an argument is a relevant argument if and only if the conjunction of the premises is positively relevant to the conclusion. Let $P(h)$ be the inductive probability of h conditional on tautological or 'empty' evidence k. If $P(h|e) > P(h)$, we can say that $e \Rightarrow$ h is an a priori relevant argument. If h itself is a tautological statement, any argument with h as a conclusion (including an argument with no premises) is a probable argument. (3) and (4) are not the only philosophically interesting concepts of inductive validity or 'inducibility'.[18] In recent philosophical literature there has been a great deal of discussion of probable arguments satisfying certain *consistency requirements;* in particular, the condition

(5) For any evidence statement e, the set $\{h: e \Rightarrow h\}$ is consistent and closed under deduction.

It is easy to see that not all probable arguments satisfy condition (5). Arguments satisfying this condition may be termed *acceptance arguments*.[19]

An instance i of a generalization g is a *confirming* instance if and only if $i \Rightarrow g$ is a relevant argument (or i is positively relevant to g).[20] The concept of confirming instance is relative to certain background information in the same way as is the concept of relevance. In this article I shall use the expression 'confirming instance' only in this probabilistic meaning; this notion is logically distinct from the concept of positive instance defined in section II.

Von Wright's confirmation theory is primarily concerned with the following two questions: (a) Under what conditions is an argument of the form (2) a *relevant* argument, and (b) Under what conditions is (2) a *probable* argument? Let e_m be a conjunction $i_1 \& i_2 \& \ldots \& i_m$, where each i_j implies that a_j is a positive instance of g; let e_n^m be a conjunction $i_{m+1} \& i_{m+2} \& \ldots \& i_{m+n}$; and let $e_{m+n} = e_m \& e_n^m$. It is usually assumed that (1) if e_{m+n} includes only positive instances of g, e_n^m is positively relevant to g on e_m (for all $m \geqq 0$, $n \geqq 1$), and that (2) the argument $e_n \Rightarrow g$ can be made probable by increasing the number of positive instances. This hypothesis may be termed the *Confirmation Conjecture*. In *LPI* and *TIP* von Wright proves that the first part of the Confirmation Conjecture holds if e_n^m is a logical consequence of g, $P(g) > 0$, and if the 'eductive probability' $P(e_n^m | e_m) < 1$. The second part holds also if E_n exhausts the whole universe U when n grows without limit. This result is termed by von Wright the *Principal Theorem of Confirmation*.[21] Similar theorems have been proved earlier by C. D. Broad[22] and J. M. Keynes.[23]

IV

Probability can be regarded as an attribute of *statements* or as an attribute of *properties*. If inductive probabilities are used for characterizing the strength of arguments, they should clearly be attributed to statements (or to the propositions expressed by statements). In *TIP* von Wright says that probability is a magnitude attributed to *propositions*.[24] In the present context the distinction between statements and propositions is inessential.[25] However, in von Wright's formal theory of inductive probability the concept of probability is defined as a functor which takes *properties* or *attributes*, and not sentences or propositions, as its arguments. Probabilities of this type may be termed *attribute probabilities*. If F and G are properties, an elementary probability statement '$P(F|G) = p$' can be read 'The conditional probability of F given G is p'. In this paper I shall identify properties with their extensions (that is, with classes); thus the probability statement '$P(F|G) = p$' can also be read 'The probability that a member of G belongs to F is p'.

If probabilities are attributed to properties (or open sentences), how can they be applied to propositions (or closed sentences)? In certain special situations it seems reasonable to require that the probability of a hypothesis should be equal to a certain attribute probability. For instance, if '*a*' is an individual constant and we know nothing about the individual designated by '*a*' except that it belongs to a certain class *G*, it seems reasonable to take $P(F|G)$ as the probability of the *proposition* that *Fa* on the evidence that *Ga*.[26] A conditional probability $P(h|e)$ can be determined in this way only in cases in which both *h* and *e* are in subject-predicate form, and contain the same individual term. Von Wright says that "by the probability of something we shall understand the probability that a certain thing has a certain property," and "by the evidence for the probability that a certain thing has a certain property we shall understand a proposition to the effect that the *same* thing has a certain (other) property".[27] According to von Wright, the assignment of numerical probabilities to propositions is possible only if the propositions can be expressed in subject-predicate form. He calls the subject-predicate analysis of a proposition an *Aristotelian analysis*.[28] If we wish to express the strength of a universal inference such as (2) in terms of probability, it is necessary to present both the generalization *g* and the evidence statement e_n in subject-predicate form in such a way that they both contain the same subject-term.

Frege has pointed out that quantifiers can be regarded as second-level functors which take functional expressions (or predicates) as arguments.[29] For instance, a universal generalization *(x)Fx* can be viewed as an instance of a second-level predicate *(x)Xx*, where '*X*' indicates an empty argument-place. Von Wright's method of assigning probabilities to inductive generalizations is based on this Fregean idea.[30] The predicate *(x)Xx* designates the second-level property of being a universal property in the domain of quantification. In the following I shall express this property by 'Ω_U'. Thus $\Omega_U(F)$ expresses the same proposition as *(x)Fx*. For simplicity, I shall again identify properties and their extensions; thus Ω_U is the class of all universal (first-order) properties. According to von Wright, it is possible to assign a numerical value to the probability of $\Omega_U(F)$ on the evidence e_n only if the evidential proposition can also be expressed as a second-order statement about the property *F*. It is easy to see how this can be done. Individual terms can be interpreted in the same way as quantifiers and quantifier-phrases; they can also be viewed as second-level functors which take predicates as arguments. Instead of taking the expression 'John' in the sentence 'John is tall' as an argument of the functional expression 'is tall', we can regard 'John' as a functor which takes 'is tall' as its argument. The properties designated by such second-level predicates are termed *individual characters*. If Ω_j is the character of a_j, $\Omega_j(F)$ holds if and only if $F(a_j)$ is true. The character of an individual is the set of all properties possessed by the

individual. In general, any set of (first-order) properties will be termed below a *character*.[31]

An evidence statement $e_n = Fa_1 \ \& \ Fa_2 \ \& \ . \ . \ . \ \& \ Fa_n$ can thus be expressed in the form $\Omega_1(F) \ \& \ \Omega_2(F) \ \& \ . \ . \ . \ \& \ \Omega_n(F)$, where each Ω_j is the character of a_j. The *common character* of the individuals $a_1, a_2, . . ., a_n$ is the intersection of their individual characters. Thus e_n states that F belongs to the common character of the first n members of the sequence $a_1, a_2, a_3,$ This evidence statement has the form we have been looking for; it is a second-order statement about the property F. Let

$$(6) \qquad \qquad \Omega^n = \bigcap_{j=1}^{n} \Omega_j$$

be the common character of the members of E_n. The common character of all members of U or the *universal character* of U is the class

$$(7) \qquad \qquad \bigcap_{j=1}^{\infty} \Omega_j = \Omega_U.$$

In the context of a given inquiry we are usually not interested in the *total* character of the members of U, but only in a certain part of their character, that is, in the *subsets* of a certain class Ω_0 of 'relevant properties'. The a priori and the a posteriori probability of the generalization $(x)Fx$ can now be determined as follows:

$$(8) \qquad \qquad P((x)Fx) = P(\Omega_U|\Omega_0)$$

$$(9) \qquad \qquad P((x)Fx|e_n) = P(\Omega_U|\Omega^n).$$

The 'eductive probability' that the $n+1$th observed individual will be a positive instance of $(x)Fx$ on the evidence that the first n individuals are positive instances of the generalization is

$$(10) \qquad \qquad P(i_{n+1} |e_n) = P(\Omega_{n+1}|\Omega^n)$$
$$= P(\Omega^{n+1}|\Omega^n).$$

A universal conditional $g = (x)(Ax \supset Cx)$ expresses a relation or a 'nomic connexion' between two properties.[32] Thus we can regard it as an instance of a two-place predicate $\Omega_U(X, Y) = (x)(Xx \supset Yx)$, where '$X$' and '$Y$' indicate the empty argument-places. In this case we let the characters $\Omega_j (j = 1, 2,$. . .), Ω_U and Ω_0 be certain *relations* or sets of *ordered pairs* of properties: an ordered pair $<F, G>\epsilon\Omega_0$ belongs to Ω_j if and only if $Fa_j \supset Ga_j$ is true, and $<F, G> \epsilon \ \Omega_U$ if and only if $(x)(Fx \supset Gx)$ is true. The set Ω_0 contains all 'relevant' ordered pairs $<F, G>$ under consideration; Ω_U and all individual

characters Ω_j are subsets of Ω_0. The characters Ω^n ($n \geqq 1$) and the probabilities $P(g)$, $P(g|e_n)$, and $P(i_{n+1}|e_n)$ are determined in the same way as above.[33]

V

In *TIP* von Wright discusses three different interpretations of inductive probability: the *frequency* interpretation, the *possibility* interpretation (or logical interpretation), and the *psychological* interpretation. On the frequency interpretation, $P(\Omega_U|\Omega^n) = p$ means that the relative frequency of the property Ω_U among the members of Ω^n is p. If Ω^n is an infinite sequence, $P(\Omega_U|\Omega^n)$ is defined as the limit of the relative frequency of Ω_U among the members of Ω^n.[34] In *TIP* von Wright seems to regard the frequency interpretation as an adequate explication of the meaning of probability. The main purpose of von Wright's Aristotelian analysis of universal generalizations is to make the frequency interpretation intelligible in the case of generalizations. According to von Wright, the possibility of such an analysis supports a *monistic* view as to the nature of probability. The monistic view assumes that the difference between inductive and 'ordinary' (statistical) probability is not a difference in the interpretation of the calculus of probability.[35] However, the mere possibility of a frequency interpretation of inductive probability is hardly sufficient to justify the monistic conception of probability.[36] Moreover, in von Wright's system the traditional dualism between inductive and statistical probability recurs as a dualism between second-order and first-order probabilities; thus von Wright's system does not really support the monistic viewpoint.

One of the standard criticisms of the frequency theory is that it cannot explain the meaning of probabilities assigned to *single events* and *generalizations*.[37] Frequency theorists have usually dealt with the problem of the single case by assigning each individual event a to some reference class G, and by taking $P(F|G)$ as the probability that a is F. In general, the frequency theory explains the probability of a *proposition* (or of a complete sentence) by viewing the proposition as a member of a certain *class* of propositions (e.g., the instances of some propositional function), and by taking the relative truth-frequency of the members of this class as the probability of the proposition. Von Wright employs the same method in assigning probabilities to universal generalizations.

The frequency interpretation of the probability of a single case is subject to the well-known difficulty that any individual event belongs to a large number of different reference classes G, and the probability of the event can vary considerably between different reference classes. Which of the possible reference classes should be used for assigning a probability-value to the individual event? Von Wright's frequency interpretation of inductive probability is subject to the

same problem: The inductive probability of a generalization is a probability of a 'single case': $\Omega_U(A, C)$ is a statement about certain *individual properties,* not about arbitrary members of certain classes of properties. The generalization $(x)(Ax \supset Cx)$ itself does not contain explicit reference to any class Ω_0 of 'relevant' (pairs of) properties. This problem cannot be solved merely by saying that the probability of a generalization is relative to certain evidence, and the evidence statement fixes the reference class. The evidence statement e_n does not fix the reference class: e_n states that the observed individuals exemplify certain properties (or that certain properties belong to the characters of the observed individuals), but it does not specify how to choose the characters to be considered.[38]

The proponents of the frequency interpretation have presented various methodological rules for the choice of the reference class. For instance, Hans Reichenbach has proposed the somewhat vague rule that we should take as the reference class "the narrowest class for which reliable statistics can be compiled".[39] According to Wesley C. Salmon, we should choose "the *broadest homogeneous* reference class to which the single event belongs".[40] In *TIP* von Wright says that the probability of F on the evidence G is the probability of a *prediction* that a is F if a has in addition to G no property G' such that $P(F|G) \neq P(F|G \cap G')$.[41] This definition of the probability of a prediction is equivalent to Salmon's reference class rule. It is clear that rules of this kind do not always determine a unique preferred reference class.

Frequency theorists have emphasized that the problem of the single case is not a theoretical problem concerning the definition of probability, but rather a practical or methodological problem: the reference class rule is not a part of probability logic, but "a methodological rule for the application of probability knowledge to single events."[42] This view is based on the assumption that probabilities are, strictly speaking, attributable only to generic events or attributes, not to individual events or propositions. However, in confirmation theory we are primarily interested in the probabilities of statements or propositions, and in this area the reference class problem is a serious theoretical problem which concerns the very definition of inductive probability (as an attribute of statements). In *LPI, EW,* and *TIP* von Wright does not pay much attention to this problem, but in some of his later publications it is discussed in detail. In 'The Paradoxes of Confirmation,' for example, von Wright remarks that

The application of probabilities, which are primarily associated with characteristics, to individuals is connected with notorious difficulties. The application is sometimes even said to be meaningless. This, however, is an unnecessarily restricted view of the matter. If x is an individual in the range of significance of φ and ψ, and if it is true that $P(\varphi|\psi) = p$, then we may, in a *secondary sense,* say that, as a bearer of the characteristic ψ, the individual x has a probability p of being a bearer also of the characteristic φ.[43]

By this von Wright seems to mean that numerical individual probabilities are always *conditional* on certain assumed attribute probabilities.[44]

VI

If the a priori probability and the a posteriori probability of a generalization are determined by (8) and (9), respectively, the reference class Ω_0 should presumably be chosen according to Reichenbach's reference class rule or some other similar rule. Let us assume that $(x)(Ax \supset Cx)$ is the generalization 'All ravens are black'. In this case Reichenbach's rule does not determine a unique preferred reference class, but suggests several different ways of choosing Ω_0. $(x)(Ax \supset Cx)$ is a conditional whose consequent is Cx; thus we may restrict the membership of Ω_0 to pairs $<F, G>$ in which $G = C$. Let us denote the domain of Ω_0 by '$D(\Omega_0)$'. The members of $D(\Omega_0)$ are in this case a priori possible *sufficient conditions* of C. Moreover, we know a priori that ravens are a species of birds; consequently Reichenbach's rule can be taken to recommend the restriction of the membership of $D(\Omega_0)$ to various species of birds. Let Γ_0 be the class of all pairs $<F, C>$ in which F is some species of birds. The individual character of a_j is the set

(11) $\Gamma_j = [<F, C> : <F, C> \epsilon \Gamma_0 \ \& \ (Fa_j \supset Ca_j)].$

Let Γ^n be the common character of the members of E_n. The universal character Γ_U is the common character of all members of U. $D(\Gamma_U)$ contains all *actual* sufficient conditions of C. According to the present analysis, the probability of $(x)(Ax \supset Cx)$ is the relative frequency of the *actual* sufficient conditions of C among all (a priori or a posteriori) *possible* sufficient conditions of C. This method of determining the probability of a generalization is based on a *sufficient condition analysis* of the generalization.[45]

On the other hand, we also know that $(x)(Ax \supset Cx)$ is a conditional whose antecedent is Ax, and we can thus choose Ω_0 in such a way that $D(\Omega_0) = \{A\}$; the range of Ω_0 contains all a priori possible *necessary* conditions of A. Let Φ_0 be a reference class chosen in this way, and let $R(\Phi_0)$ be the range of Φ_0. Since A is known to be a species of birds, it seems natural to restrict the membership of $R(\Phi_0)$ to properties in terms of which birds are normally described. A set of properties whose members belong to the same general kind or modality is termed a *family* of properties; for instance, different colors constitute a family of properties.[46] If birds are characterized in terms of the families $\mathscr{F}_1, \mathscr{F}_2, \ldots, \mathscr{F}_k$, we let Φ_0 be the set of all pairs $<A, G>$ such that G belongs to some family $\mathscr{F}_h (h = 1, 2, \ldots, k)$. Each individual character Φ_j contains all pairs $<A, G> \epsilon \Phi_0$ such that $Aa_j \supset Ga_j$ is true. The common character of the first n observed individuals is denoted by 'Φ^n', and the universal

character Φ_U is again defined as the intersection of all individual characters. This method of determining the probability of a generalization is based on a *necessary condition analysis* of the generalization. In the sufficient condition analysis, the generalization $(x)(Ax \supset Cx)$ is viewed as an instance of the second-level predicate $(x)(Xx \supset Cx)$. The members of $D(\Gamma'')$ are termed the (possible) *conditioning* properties of C and C is termed the *conditioned* property. In the necessary condition analysis the generalization is viewed as an instance of the predicate $(x)(Ax \supset Xx)$; in this case A is the conditioned property and the members of $R(\Phi'')$ are possible conditioning properties of A.[47]

According to von Wright, the sufficient condition analysis and the necessary condition analysis are the two principal ways of effecting an Aristotelian analysis of the universal conditional $(x)(Ax \supset Cx)$.[48] They correspond to two 'natural' methods of choosing the reference class Ω_0, but it is clear that they are not the only methods of choosing Ω_0. For instance, we can combine these two methods and take as the reference class Ω_0 the set

(12) $\Psi_0 = [<F, G>: F \in D(\Gamma_0) \ \& \ G \in R(\Phi_0)].$

It is also possible to choose as Ω_0 some subset of Ψ_0 other than Γ_0 or Φ_0.

In *LPI* and *TIP* von Wright presents a proof of the Principal Theorem of Confirmation for the frequency interpretation of inductive probability.[49] In the case of the sufficient condition analysis of g, the proof can be presented briefly as follows: Consider the sequence $\Gamma_0, \Gamma^1, \Gamma^2, \ldots$. We assume that Γ_0 and consequently all sets Γ'' are finite sets. It is clear from the definition of the sets Γ'' that $\Gamma_0 \supseteq \Gamma^1 \supseteq \Gamma^2 \supseteq \ldots \supseteq \Gamma_U$. Thus, if $P(\Gamma_U|\Gamma_0) > 0$, $P(\Gamma_U|\Gamma'') > 0$ for every n, and

(13) $P(\Gamma_U|\Gamma^{n+1}) \geqq P(\Gamma_U|\Gamma'')$

holds for every n. The 'eductive probability' $P(\Gamma_{n+1}|\Gamma'') < 1$ if and only if Γ^{n+1} is a proper subset of Γ''; in this case $P(\Gamma_U|\Gamma^{n+1}) > P(\Gamma_U|\Gamma'')$, and i_{n+1} is a confirming instance of g. Moreover, since

(14) $\Gamma_U = \bigcap \Gamma'',$

the a posteriori probability of the generalization approaches 1 when the number of confirming instances grows without limit.[50] The proof of the Principal Theorem for the necessary condition analysis of g is essentially similar.[51]

VII

Von Wright's theory of confirmation is a probabilistic theory of *elimination*. As was observed above, a positive instance i_{n+1} of a generalization g is a confirming instance of g if and only if Ω^{n+1} is a proper subset of Ω''. In the

case of the sufficient condition analysis, i_{n+1} is a confirming instance of g if and only if it eliminates some property F from the set of a posteriori possible sufficient conditions of C, and in the necessary condition analysis i_{n+1} is a confirming instance of g if and only if it eliminates some property G from the set of a posteriori possible necessary conditions of A. The strength of an argument depends only on the *variety of evidence* and not at all on the number of observed individuals. The enumeration of instances has no effect on the probability of a generalization apart from the eliminative effects of new instances. This feature of von Wright's inductive logic is a consequence of the fact that in his system individuals are identified with their characters (or with certain subsets of their characters), that is, with sets of properties. If two individuals have the same character, they are mutually indistinguishable and count as the same 'individual'. We can also say that in von Wright's system universal inductions are inferences concerning *properties*, not inferences concerning individuals.

A pair of properties $<F, C>\epsilon\Gamma_0$ does *not* belong to Γ_j if and only if Fa_j & $\sim Ca_j$ is true. The observation of an individual a_j can eliminate a property F from the set of a posteriori possible sufficient conditions C, and confirm the generalization g, only if $\sim Ca_j$ is the case. Moreover, if i_j confirms the conditional g, F cannot be A (the antecedent property of the conditional). According to the sufficient condition analysis, the generalization 'All ravens are black' is confirmed only by things which are neither ravens nor black (e.g., by white swans). On the other hand, it is clear that an instance i_j can eliminate a property G from being a necessary condition of A only if A is present in i_j; and if i_j is a confirming (and not a disconfirming) instance of g, C must also be present in i_j. According to the necessary condition analysis, 'All ravens are black' can be confirmed only by black ravens. If the probability of $(x)(Ax \supset Cx)$ is determined in terms of the reference class Ψ_0 (cf. set (12)), all positive instances of the generalization can be confirming instances.

The result provided by the sufficient condition analysis of g—that $(x)(Ax \supset Cx)$ is confirmed only by individuals which are neither A nor C—may seem 'paradoxical'. Let us consider the raven hypothesis, and let the domain of Γ_0 be the set of different species of birds. The raven hypothesis is confirmed by white swans, red parrots, etc. In the sufficient condition analysis, the hypotheses 'All swans are black', 'All parrots are black', etc., are considered as *rivals* of the raven hypothesis. However, the generalizations 'All swans are black' and 'All parrots are black' do not seem to be rivals of the raven hypothesis in any straightforward sense; the truth of these hypotheses is perfectly compatible with the truth of the raven hypothesis. There seems to be no a priori reason why observations of white swans should confirm the raven hypothesis, if black ravens do not confirm it. The confirming effect of white swans on the raven hypothesis is due to certain empirical assumptions involved in the deter-

mination of the probabilities $P(\Gamma_U|\Gamma_0)$. According to the frequency interpretation of inductive probability, '$P(\Gamma_U|\Gamma_0) = p$' means that 100p percent of the members of $D(\Gamma_0)$ are sufficient conditions of C; that is, blackness is a *regular feature* of a definite proportion of various species of birds. If some species is found not to be regular with respect to blackness, then given the assumption mentioned above the probability that blackness will be a regular feature of the remaining species is, of course, increased.[52] In the case of the necessary condition analysis of 'All ravens are black', the corresponding empirical assumption is that a certain proportion of the members of $R(\Phi_0)$ are regular features of ravens. If the probability of the raven hypothesis is determined by the combined method (in terms of the reference class Ψ_0), the a priori probability of the generalization is the *average* proportion of necessary conditions of the members of $D(\Psi_0)$ among the members of $R(\Psi_0)$ (that is, among the attributes in the families $\mathscr{F}_1, \mathscr{F}_2, \ldots, \mathscr{F}_k$).

The empirical assumptions involved in various methods of determining the probability of a universal conditional are instances of two general postulates underlying eliminative induction. These postulates are termed by von Wright the *Deterministic Postulate* and the *Selection Postulate*.[53] Taken together, these two postulates can be here formulated as follows:

(15) The conditioned property F has, among s initially possible conditioning properties, (at least) m actual conditioning properties of a certain kind.[54]

In the sufficient condition analysis of a universal conditional g, the conditioned property is the consequent property C and the initially possible conditioning properties are the members of $D(\Gamma_0)$; in the necessary condition analysis the conditioned property is A and the conditioning properties are the members of $R(\Phi_0)$. In the case of the combined analysis, the postulate (15) must be expressed in a more complex form

(16) The properties $F \in D(\Psi_0)$ (jointly) have (at least) m necessary conditions among the s attributes $G \in (R(\Psi_0)$.

VIII

According to the frequency interpretation, statements of inductive probability are empirical hypotheses about certain sets of properties. If probabilities are interpreted in this way, they can be used for the evaluation of arguments only if they are known. A person whose degree of belief in the generalization 'All ravens are black' corresponds to the probability defined by the sufficient condition analysis of the generalization behaves as if he knew that blackness is a regular feature of a definite proportion of various species of birds. On the other

hand, a person whose degrees of belief correspond to the probabilities defined by the necessary condition analysis of g behaves as if he knew that a definite number of the attributes $G \in \mathcal{F}_h$ ($h = 1, 2, \ldots, k$) are regular features of ravens. The latter assumption is more plausible than the former assumption; we know that ravens constitute a 'natural kind', and natural kinds are regular with respect to a large number of different features. Not only ravens but other species of birds as well are natural kinds, and consequently the postulate underlying the combined method is also a plausible hypothesis. But black objects do not form a natural kind, and there is no a priori reason for assuming that blackness should be a regular feature of a definite number of different species of birds. This epistemic asymmetry between different ways of choosing Ω_0 explains why the necessary condition analysis and the combined analysis, in the case of the raven hypothesis, yield intuitively more natural results than the sufficient condition analysis.[55] The necessary condition analysis is also very natural from the linguistic viewpoint: in the sentence 'All ravens are black', the whole quantifier phrase 'All ravens' can be regarded as a functor which takes the predicate 'black' as an argument.[56]

The postulates of eliminative induction are very specific assumptions about the frequency of the conditioning relationships between different families of attributes.[57] The inductive procedures systematized by von Wright's logic of inductive probability are applicable only to situations in which such assumptions are part of our antecedent knowledge. In some knowledge situations it is perhaps possible to make vague a priori conjectures about the frequency of the conditioning relationships between certain families of attributes, but usually the probabilities $P(\Omega_U | \Omega^n)$ cannot be known. Even if the value of an attribute probability $P(\Omega_U | \Omega^n)$ is known, it can be used as a measure of the credibility (or probability) of a generalization g only if Ω^n is an epistemically homogeneous reference class or Ω_U.[58] If we have reason to believe that certain members of $D(\Omega^n)$ are more likely to be sufficient conditions of the attributes in $R(\Omega^n)$ than some other members of $D(\Omega^n)$, an attribute probability based on the reference class Ω^n cannot be used as a measure of the credibility of g. The probabilities $P(\Omega_U | \Omega^n)$ give only a rough description of the process of eliminative induction; in most cases they are not adequate credibility-measures (or measures of degree of confirmation) of hypotheses.[59]

According to von Wright's eliminative theory of induction, a generalization g is confirmed by an instance i_{n+1} if and only if this instance eliminates some 'rival hypothesis' g' from the set of possible generalizations. This means that a hypothesis is *disconfirmed* only if it becomes inconsistent with the data of observation. In many inductive situations possible generalizations cannot be eliminated in this straightforward way, but empirical data can nevertheless disconfirm certain generalizations—that is, make them appear very implausible (if the likelihood of the generalization is very small in comparison with the like-

lihoods of alternative generalizations). A theory of induction based exclusively on the eliminative patterns of inference is unable to cope with such situations.[60] (It might be argued that straight-forward elimination is not even a typical or an 'interesting' case of disconfirmation of a hypothesis.)

It is platitudinous to say that the probability of a proposition is a measure of rational degree of belief in the proposition, but it is not clear what this philosophical platitude really amounts to. In *TIP* von Wright says that

> Sometimes a *rational* belief is understood to mean a *true* belief. In the case of partial belief this means that the rational degree of belief is one which corresponds to the (true) probability of the conjectured event. Thus truth as a condition of rationality would mean that probability, on some definition of probability other than the psychological definition, is made the standard of rationality of our partial beliefs.[61]

This view may be termed the *correspondence theory of rational belief*. On this interpretation of 'rational belief', it is impossible to explain the rationality of partial beliefs in *propositions* or *hypotheses*. It is clear that a proposition (for instance, a general hypothesis) has in itself no "true probability" which could serve as a measure of rational degree of belief in the proposition, unless we take the probability to be 0 or 1, depending on the truth-value of the proposition. If we accept truth as the sole criterion of rationality, the conclusion that "the significance of numerical individual probabilities is bound to be purely subjective"[62] seems inescapable. But it is very implausible to identify *rational* belief with *true* belief; some of our beliefs can surely be 'true by accident' without possessing the slightest degree of 'rationality', and eminently rational beliefs may turn out to be false. Much of traditional epistemology has been concerned with the problem of distinguishing rational true belief from 'lucky guesses'. Rationality is primarily a property of *sets* or *systems* of beliefs, and if inductive probability is a measure of rational degree of belief, it is not reasonable to require that the meaning of isolated probability statements should be analyzable in terms of relative frequencies or (non-partial) beliefs concerning relative frequencies.[63]

DEPARTMENT OF PHILOSOPHY RISTO HILPINEN
UNIVERSITY OF TURKU, FINLAND
AUGUST 1973

NOTES

1. Acta Philosophica Fennica, Vol. 3 (Helsinki, 1941); 2d rev. ed. (Oxford: Basil Blackwell, 1957). The references below are to the second edition.
2. (Routledge and Kegan Paul: London, 1951).

3. *Über Wahrscheinlichkeit. Eine logische und philosophische Untersuchung,* Acta Societatis Scientiarum Fennicae, Nova Series A, Vol. 3, no. 11 (Helsingfors, 1945).

4. The problems of confirmation theory are discussed in the following articles: 'Carnap's Theory of Probability', *Philosophical Review* 60 (1951): 362–74; 'Induction', *Encyclopaedia Britannica,* Vol. 12 (Chicago, 1959), pp. 273–76; 'Probability', *ibid.,* Vol. 18 (Chicago, 1959), pp. 529–532; revised version *ibid.,* Vol. 18, (Chicago 1965), pp. 570–74; 'Broad on Induction and Probability', in *The Philosophy of C. D. Broad,* edited by P. A. Schilpp (New York: Tudor Publishing Company, 1959), pp. 313–352, reprinted in C. D. Broad, *Induction, Probability, and Causation,* (Dordrecht: D. Reidel Publishing Company, 1968), pp. 228–272; 'Remarks on the Epistemology of Subjective Probability', in *Logic, Methodology and Philosophy of Science: Proceedings of the 1960 International Congress,* edited by Ernest Nagel, Patrick Suppes, and Alfred Tarski (Stanford, Calif.: Stanford University Press, 1962), pp. 330–39; 'The Paradoxes of Confirmation', *Theoria* 31 (1965): pp. 255–274; 'The Paradoxes of Confirmation', in *Aspects of Inductive Logic,* edited by Jaakko Hintikka and Patrick Suppes (Amsterdam: North-Holland Publishing Company, 1966), pp. 208–18; 'Wittgenstein's Views on Probability', *Revue internationale de Philosophie* 23 (1969): pp. 259–279; 'A Note on Confirmation Theory and the Concept of Evidence', *Scientia* 105 (1970): pp. 595–606.

5. *TIP,* pp. 16–31.

6. *LPI,* pp. 117–18.

7. *TIP,* p. 31.

8. 'Carnap's Theory of Probability', p. 364.

9. *TIP,* p. 86.

10. The logic of conditions is discussed in *LPI,* pp. 64–73, and in TIP, pp. 66–77.

11. *TIP,* p. 86.

12. Von Wright's reconstruction of the classical canons of eliminative induction is presented in *LPI,* pp. 64–84, and in *TIP,* pp. 84–139.

13. *TIP,* p. 14.

14. Ibid., p. 15.

15. Ibid., p. 63.

16. See W. E. Johnson, *Logic,* Part III (Cambridge: Cambridge University Press, 1924), ch. 4.

17. *TIP,* p. 64.

18. This expression is due to Keith Lehrer; see his papers 'Theoretical Terms and Inductive Inference', *American Philosophical Quarterly Monograph Series,* Studies in the Philosophy of Science, Monograph 3 (1969), pp. 30–41, and 'Induction, Reason, and Consistency', *British Journal for the Philosophy of Science* 21 (1970): 103–114.

19. For a discussion of the philosophical problems concerning the concept of acceptance, see the articles in Marshall Swain's anthology *Induction, Acceptance, and Rational Belief,* (Dordrecht: D. Reidel Publishing Company, 1970).

20. Cf. G. H. von Wright, 'A Note on Confirmation Theory and the Concept of Evidence', p. 598.

21. In his proof of the Principal Theorem of Confirmation von Wright assumes that the evidence statement e_n is a logical consequence of the generalization $g,$ in other words, each i_j has the form $Aa_j \supset Ca_j$. It is perhaps more interesting to study a case in which we know not only that all observed individuals are positive instances of the generalization, but also what *kinds* of positive instances they are. Let us assume that $i_j = Aa_j \supset Ca_j$ $(j = 1, 2, \ldots)$, and let e_n be the conjunction $i_1 \ \& \ i_2 \ \& \ \ldots \ \& \ i_n$. Let

i_j' be an evidence statement which specifies the *kind* of the jth instance of g: (thus i_j is Aa_j & Ca_j or $\sim Aa_j$ & Ca_j or $\sim Aa_j$ & $\sim Ca_j$), and let e'_n be the conjunction of the first n instances i'_j. It is obvious that if $P(g|e_n)$ approaches 1 when n grows without limit, $P(g|e'_n)$ approaches 1 as well: e'_n implies e_n; thus

(i)
$$P(g|e_n) = \frac{P(g \ \& \ e'_n) + P(g \ \& \ e''_n)}{P(e'_n) + P(e''_n)},$$

where $e''_n = e_n \ \& \sim e'_n$. It is clear that (i) approaches 1 when n grows without limit only if $P(g \ \& \ e'_n)/P(e'_n) = P(g|e'_n)$ approaches 1.

An instance i'_{n+1} is positively relevant to g on e'_n if and only if

(ii)
$$\frac{P(i'_{n+1}|e'_n \ \& \ g)}{P(i'_{n+1}|e'_n)} > 1.$$

Let $i''_{n+1} = i_{n+1} \ \& \sim i'_{n+1}$. Thus

(iii)
$$P(i_{n+1}|e'_n) = P(i'_{n+1}|e'_n) + P(i''_{n+1}|e'_n),$$

and since $P(i_{n+1}|e'_n \ \& \ g) = 1$,

(iv)
$$P(i'_{n+1}|e'_n \ \& \ g) + P(i''_{n+1}|e'_n \ \& \ g) = 1.$$

(iii) and (iv) imply that if $P(i_{n+1}| \ e'_n) < 1$ and

(v)
$$\frac{P(i'_{n+1}|e'_n \ \& \ g)}{P(i'_{n+1}|e'_n)} = \frac{P(i''_{n+1}|e'_n \ \& \ g)}{P(i''_{n+1}|e'_n)},$$

then (ii) holds as well, and i'_{n+1} is a confirming instance of g (positively relevant to g on e'_n). Condition (v) is the condition of *differential irrelevance of g with respect to its positive instances*. If (v) holds for all instances i'_{n+1}, the generalization had no *differential* relevance with respect to its various positive instances; any positive instance of g is 'as good' as any other. If the confirmation of a generalization in a given instance is not maximally probable relative to previous confirming instances, and if the generalization has no differential relevance with respect to its positive instances, all *kinds* of positive instances confirm the generalization. Paul Berent has recently presented an example in which a generalization ('All men are less than 100 feet tall') can be *lowered* by a positive instance (discovery of a man 99 feet tall) ('Disconfirmation by Positive Instances', *Philosophy of Science* 39 (1972): p. 522). It is clear that Berent's example does not satisfy the condition of differential irrelevance.

22. C. D. Broad, 'The Relation Between Induction and Probability I', *Mind* 27 (1918): pp. 389–404 (the proof of the Principal Theorem is on pp. 400–02); reprinted in C. D. Broad, *Induction, Probability, and Causation* (Dordrecht: D. Reidel Publishing Company, 1969), pp. 1–16 (see pp. 13–14).

23. J. M. Keynes, *A Treatise on Induction and Probability* (London: MacMillan and Co., 1921), pp. 235–38.

24. *TIP*, pp. 172, 239.

25. In logical semantics propositions are usually represented by sets of models (the truth sets of propositions). If inductive probabilities are attributed to propositions, the theory of inductive probability can be expressed in the set-theoretical notation standard in other branches of probability theory. Cf. Rudolf Carnap, 'A Basic System of Induc-

tive Logic', in *Studies in Inductive Logic and Probability,* vol. 1, edited by Rudolf Carnap and Richard Jeffrey (Berkeley , Calif.: University of California Press, 1971), pp. 56–62.

26. According to Isaac Levi, "it seems reasonable to assume (and it is usually assumed by those who recognize the intelligibility of inductive probabilities) that the inductive probability of obtaining such an outcome on a specific trial will be equal to the statistical probability of obtaining an outcome of that type on an arbitrary trial, *provided that no relevant information is known about the specific trial to be made other than that it is a trial of an experiment of the type just described"* (*Gambling with Truth,* p. 209). Inductive inference based on statistical probabilities (or attribute probabilities) is termed *direct inference* (Carnap, *Logical Foundations of Probability* [Chicago: The University of Chicago Press, 1950], pp. 492–98); thus this rule may be termed the *Rule of Direct Inference.*

27. *TIP,* p. 172. In *TIP* von Wright is unclear about the distinction between attribute probabilities and probabilities assigned to propositions. It is also misleading to say that *Ga* is evidence for the *probability* that *a* is *F* (if the relationship between the premises and the conclusion of an inductive inference is expressed in terms of conditional probability); *Ga* is evidence for the hypothesis *Fa,* not for the probability of *Fa.*

28. *TIP,* pp. 37–38.

29. Gottlob Frege, 'Funktion und Begriff', in Frege, *Kleine Schriften,* edited by Ignacio Angelelli (Darmstadt: Wissenschaftliche Buchgesellschaft, 1967), pp. 125–142.

30. The following exposition of von Wright's system is based on a more general viewpoint than his own exposition in *LPI, EW,* and *TIP,* and the terminology used here also differs from that used by von Wright.

31. See David Lewis, 'General Semantics', *Synthese* 22 (1971): pp. 18–67. Lewis defines individual characters as "maximal compatible sets of properties" (p. 53). This analysis of singular terms resembles Leibniz's doctrine of individual concepts; see Benson Mates, 'Leibniz on possible worlds', in *Logic, Methodology, and Philosophy of Science III,* edited by B. van Rootselaar and J. F. Staal (Amsterdam: North-Holland Publishing Company, 1968), pp. 507–529.

32. *TIP,* pp. 66–67.

33. According to this analysis, e_n states only that $<A, C>$ belongs to the common character of the first n observed individuals, i.e., all members of E_n are positive instances of g. The question of the *differential* relevance of various *kinds* of positive instances of g cannot be discussed in the present analysis of g and e_n (cf. note 21 above).

34. *TIP,* pp. 167–71, 242. In the classical formulations of the frequency theory (Hans Reichenbach, *The Theory of Probability* (Berkeley, Calif.: University of California Press, 1949); Richard von Mises, *Probability, Statistics and Truth* (London: Allen and Unwin, 1957) probability is defined in terms of infinite sequences. However, in this paper I shall consider only the finite frequency interpretation of inductive probability, and assume that Ω_0 is always a finite set. Cf. note 51.

35. *TIP,* p. 238.

36. Any set of entities satisfying the axioms of the probability calculus can be regarded as an *interpretation* of probability calculus, but an interpretation in this sense need not have anything to do with the ordinary meaning of 'inductive probability'.

37. See e.g., John W. Lenz, 'The Frequency Theory of Probability', in *The Structure of Scientific Thought,* edited by Edward H. Madden (Boston: Houghton Mifflin Co., 1960), pp. 263–69.

38. According to D. H. Mellor ('Chance', *Proceedings of the Aristotelian Society,* Supplementary Volume 48 [1969]: 10–36; *The Matter of Chance* [Cambridge: Cam-

bridge University Press, 1971], pp. 50–62), the probability of the single case presents no problem for the propensity interpretation or the dispositional interpretation of probability, since propensities can be ascribed directly to individuals. (Cf. also Ronald N. Giere, 'Bayesian Statistics and Biased Procedures', *Synthese* 20 (1969): 371–387.) However, it is difficult to see how the propensity interpretation could be applied to the probabilities of generalizations, since it is not clear what in this case would constitute the 'chance set-up' to which probabilities are ascribed. In this context Wesley C. Salmon's claim that the propensity interpretation does not help solving the problem of the single case seems justified. Cf. Wesley C. Salmon, 'Statistical Explanation', in Wesley C. Salmon et al., *Statistical Explanation and Statistical Relevance* (Pittsburgh: University of Pittsburgh Press, 1971), pp. 39–40.

39. Hans Reichenbach, *The Theory of Probability* (Berkeley, Calif.: University of California Press, 1949), p. 374. A similar rule was put forward already by John Venn in his pioneering work *The Logic of Chance* (London: MacMillan and Co., 1888), pp. 233–34). See also J. M. Keynes, *A Treatise on Probability* (London: MacMillan and Co., 1921), pp. 103–04. For recent discussions of the reference class problem, see Carl G. Hempel, 'Maximal Specificity and Lawlikeness in Probabilistic Explanation', *Philosophy of Science* 35 (1968): pp. 116–133, and Henry E. Kyburg, 'More on Maximal Specificity', ibid. 37 (1970): pp. 295–300.

40. Salmon, 'Statistical Explanation', p. 43. According to Salmon, a reference class G is homogeneous with respect to F if and only if there is no attribute G' (distinct from F) such that $P(F|G) \neq P(F|G \cap G')$, that is, if no attribute G' is statistically relevant to F within G. The possible reference classes to which Salmon's rule is applied must be restricted to classes defined by certain 'appropriate' reference predicates G (cf. Kyburg, "More on Maximal Specificity", p. 298). I shall assume here that all characters Ω^n are 'appropriate' reference classes. A reference class G is *epistemically homogeneous* if "we have strong reasons to believe that our reference class is not homogeneous, but we do not know what property will effect a statistically relevant partition of G" (Salmon, 'Statistical Explanation', p. 44). If we choose a reference class Ω_0 for Ω_U by considerations of homogeneity, it is clear that these considerations pertain to the epistemic homogeneity, not to the actual homogeneity of Ω_0. No reference class Ω_0 (distinct from Ω_U) is actually homogeneous with respect to Ω_U (cf. note 51).

41. *TIP*, pp. 227–28.

42. Salmon, 'Statistical Explanation', op. cit., p. 44.

43. *Aspects of Inductive Logic*, p. 212.

44. In his paper 'Remarks on the Epistemology of Subjective Probability', von Wright rejects the frequency interpretation and says that a numerical probability is a "hypothetical magnitude". A probability statement is not "anything which either an objective state of nature—such as the approximation of a relative frequency towards a limit—or some facts of logic—say about ratios of measures of ranges—would, if known, make true or false" (pp. 335–36). Probabilities cannot be *defined* in terms of relative frequencies, but they can be justified (accepted) or rejected on the basis of frequency data by virtue of James Bernoulli's 'Principle of practical certainty' (p. 336). A similar "partial frequency interpretation" of probability statements has been presented by Harald Cramer in *Mathematical Methods of Statistics* (Princeton, N.J.: Princeton University Press, 1946), pp. 148–150. This viewpoint is still very close to the classical frequency theory; for instance, von Wright emphasizes that probabilities can be assigned in a non-arbitrary way only to attributes or 'generic events' (pp. 335, 339).

45. *TIP*, pp. 239–240.

46. For the notation of a family of attributes, see Rudolf Carnap, 'A Basic System of Inductive Logic', pp. 43–44.

47. *TIP*, p. 87.

48. *Ibid.*, p. 239.

49. *LPI*, pp. 127–131; *TIP*, pp. 249–254.

50. This follows from the 'Axiom of Continuity'; see *LPI*, pp. 121–22.

51. The frequency interpretation of the Principal Theorem of Confirmation implies that no reference class Ω^n distinct from Ω_U is actually homogeneous with respect to Ω_U (cf. note 40). Every $\Omega^n \neq \Omega_U$ has subsets Ω^{n+m} such that $P(\Omega_U|\Omega^{n+m}) > P(\Omega_U|\Omega^n)$. Consequently Ω_0 can be only epistemically homogeneous, but not actually homogeneous with respect to Ω_U. The only actually homogeneous reference class for Ω_U is Ω_U itself. According to the frequency theory of confirmation, making observations of the individuals in U is a method by which an investigator attempts to define probabilistically (or inductively) relevant partitions of the original reference class Ω_0, and approach towards the actually homogeneous class Ω_U.

52. Note that this holds only if Γ_0 is a finite set. In general, the elimination of a (finite) number of pairs of properties from Ω^n can increase the probability of Ω_U only if Ω^n is a finite set.

53. *TIP*, pp. 129–31.

54. *Ibid.*, p. 139. In *TIP* von Wright considers conditions of various degrees of "complexity", and formulates this postulate for conditions of a given degree of complexity. In this essay I have considered only "simple" properties.

55. It is, of course, possible that in some other cases the sufficient condition analysis is "more natural" than the necessary condition analysis.

56. Cf. Lewis, 'General Semantics', pp. 49–51.

57. In *TIP* von Wright notes that "the premises of eliminative induction are not the same from case to case: their exact content essentially depends upon the individual nature of the case to which they are applied" (p. 131).

58. Cf. Salmon, 'Statistical Explanation', pp. 43–45.

59. According to the frequency interpretation, the 'eductive probability' $P(\Omega_{n+1}|\Omega^n)$ depends on the *actual* similarity between a_{n+1} and previously observed individuals. However, if probabilities are regarded as measures of rational degree of belief, eductive probabilities should depend on the *expected* degree of similarity between individuals, and this need not be (and in many cases is not) the same as the actual degree of similarity.

60. Certain simple situations of this kind are discussed (within the framework of parametric confirmation theory) in Jaakko Hintikka, 'Induction by Enumeration and Induction by Elimination', in The *Problem of Inductive Logic*, edited by Imre Lakatos (Amsterdam: North-Holland Publishing Company, 1968), pp. 191–216, and in Risto Hilpinen, 'Relational Hypotheses and Inductive Inference', *Synthese* 23 (1971): pp. 266–286 (see especially the example on pp. 272–281).

61. *TIP*, p. 234.

62. 'Remarks on the Epistemology of Subjective Probability', p. 339. Cf. also von Wright's paper 'A Note on Confirmation Theory and the Concept of Evidence', p. 606.

63. This conception of rational belief may be termed the *coherence theory of rational belief*. In *TIP* von Wright notes that the traditional subjectivist theories of probability "were intended, not to define probability in terms of belief, but rational belief in terms of probability" (p. 234, footnote 1). This formulation suggests that we should be able to *define* (subjective or personal) probability as something other than rational degree of confidence (cf. also the reference indicated above by note 61). This view, based on the correspondence theory of rationality, is mistaken; the interpretation of probability as rational degree of belief means merely that the axioms of probability are regarded as conditions of coherence for partial beliefs.

5

William H. Baumer

VON WRIGHT ON THE PARADOXES
OF CONFIRMATION

The paradoxes of confirmation may appear to be intrinsically a minor issue in confirmation theory. They are, however, one of those minor issues that can become so serious as to discredit an entire confirmation theory unless they are resolved. Professor von Wright has addressed them in several contexts, including his books *A Treatise on Induction and Probability* and *The Logical Problem of Induction* and three essays: 'The Paradoxes of Confirmation' (1965), 'The Paradoxes of Confirmation' (1966), and 'A Note on Confirmation Theory and on the Concept of Evidence' (1970).[1] The following discussion includes a restatement of the paradoxes, consideration of the earlier approach to them proposed by von Wright, consideration of the modifications incorporated in the three subsequent short essays dealing either directly or in large part with the paradoxes, and the sketch of another and more satisfactory response to the paradoxes that is an extension of von Wright's general approach to confirmation.

1. THE PARADOXES

The paradoxes of confirmation are the incoherent result of three theses regarding confirmation of an hypothesis by evidence instances. Each of these theses has of itself a certain appeal and initial obviousness. Unfortunately the conjunction of them generates a considerable amount of confusion and contradiction. One of these theses is a seemingly clear-cut, common-sense view of what can serve to confirm an hypothesis: hypotheses are confirmed by those instances that are straightforwardly instantiations of them. The second thesis may seem intuitively obvious only to those with some knowledge of formal logic, but in any event is easily justified: what confirms an hypothesis must simulta-

neously and equally confirm any logically equivalent hypothesis. The third thesis is again what may be called a more common-sense—though perhaps now a somewhat reflective common-sense—view: there must be instances, and for most 'low-level' hypotheses many instances, that are simply irrelevant to any given hypothesis; the instances that confirm an hypothesis must be members of a select class.

The first of these three theses is frequently labelled the Nicod criterion after one of its proponents.[2] It can be expressed more formally this way. Take as the basic form of an hypothesis:

(1) $(x) \cdot Fx \supset Gx$

On the standard analysis, this has four instantiations:

(2) $FGa, \sim FGb, F \sim Gc, \sim F \sim Gd$

Of these, the third, or 'c'-type instance is disconfirming; it falsifies the hypothesis. But only 'a'-type instances can be confirming on the Nicod criterion, since only these are direct instantiations of the hypothesis.

Difficulties with this appear, however, as soon as one turns to equivalent formulae in respect to (1). Consider:

(3) $(x) \cdot \sim Gx \supset \sim Fx$
(4) $(x) \cdot \sim Fx \lor Gx$

Obviously each is equivalent to (1) and to the other. Less obviously, but importantly, any conclusion derivable from a set of premises including any one of these formulae can be equally validly derived from that set of premises modified by the replacement of the formula first included by either of its equivalent formulae. Such derivation would require at most a modest number of intermediate and trivial inferences. But if (1) has been confirmed by a number of 'a'-type instances while these have confirmed neither (3) nor (4), the substitution of either of the latter for (1) in a set of premises is the substitution of an unconfirmed or differently confirmed, presuming Nicod criterion support of (3) or (4), premiss for a confirmed premiss.

On the other hand, suppose that it is held that whatever confirms (1) or (3) or (4) confirms either directly or indirectly the other two equivalent formulae. On the Nicod criterion, 'd'-type instances are (direct) confirmations for (3); 'b'-type instances are (direct) confirmations for (4). These may, then, be considered indirect confirmations of (1) and (4) or (1) and (3) respectively. While this may serve to meet the equivalence criterion as well as the Nicod criterion, it results in there being no irrelevant instances whatever for any of the three hypothesis versions under consideration. Instead, every possible instantiation is either confirming or disconfirming. After all, the four types of instances exhibited in (2) are not only mutually exclusive; they are also conjointly exhaustive.[3]

2. VON WRIGHT'S EARLIER PROPOSAL

Von Wright, in process of developing a formalized version of eliminative in-
duction, recognized the necessity of responding to this set of problems. He
thus attempted to provide a resolution of the confirmation paradoxes by means
of certain developments that rest upon his formal confirmation theory, but are
not integral to it. He also accepted the view that any formalization of confir-
mation must include a definition of 'confirming instance'. In this section, von
Wright's earlier proposal is summarized, some of its difficulties noted, and a
possible variant on the earlier proposal is also considered. The consideration of
the difficulties involved in attempting a definition of 'confirming instance' are
set aside, and are taken up in a subsequent section.

Von Wright's earlier approach to the confirmation paradoxes involves his
version of a formal confirmation theory. This has as a principal component the
derivation of a version of Bayes's Theorem in a standard probability calculus,
the denomination of that as the 'Principal Theorem of Confirmation' (hereafter
'PT'), and the interpretation of that by means of eliminative induction patterns
highly similar to those proposed by John Stuart Mill.[4] The PT, when com-
pletely formalized (it is not so in von Wright's presentation), is:

(5) $P(g,e) > O.P\ (i_{y+1},\ e.I_n) < 1: \supset .P(g,e.I_{n+1}) > P(g,e.I_n)$

which can be read as follows: If the probability of a generalization g relative
to some evidence e is greater than 0 and the probability of the $n + 1$ instance
i relative to e and the conjunction of the previous n instances I_n is less than 1,
then the probability of that generalization relative to that evidence and the con-
junction of the $n + 1$ instances I_{n+1} is greater than the probability of that
generalization relative to the evidence and the conjunction of the n instances
(See *LPI*, p. 119).

The interpretation of this in terms of eliminative induction may be summa-
rized along these lines. Take a generalization such as (1) and consider it to be
a statement to the effect that one characteristic is a condition of the other, i.e.,
that F is a sufficient condition of G or that G is a necessary condition of F.
Postulate that every occurrence of any property has a sufficient or necessary
condition, as the hypothesis may require. Postulate further that one knows all
of the possible conditioning characteristics of the conditioned characteristics in
question. In the present example, that means to postulate that one knows all of
the possible sufficient conditions of G or all of the possible necessary condi-
tions of F. Eliminative induction then requires that the evidence be instances
which serve to eliminate one or more previously uneliminated possible condi-
tioning characteristics. When all the possible conditioning characteristics save
that in the hypothesis at issue are eliminated, the hypothesis can be considered
maximally confirmed—again, given the two postulates underlying the proce-

dure. If the generalization in question is understood as a statement of a necessary condition, the elimination can only occur in those cases in which the antecedent of the generalization (when it is written as a conditional) is present. Characteristics not concurrently present in an instance with that antecedent characteristic—here F—are eliminated as necessary conditions of that conditioned characteristic. On the other hand, if the generalization is read as a statement of a sufficient condition—that F is a sufficient condition of G—then elimination can take place only by means of instances in which the conditioned characteristic G is absent.

The PT is then interpreted in the following way. Let the generalization be an hypothesis such as (1) understood as a statement of a necessary or of a sufficient condition. Let the initial evidence e be a set of possibly conditioning characteristics, e.g., possible necessary conditions of F. If this set is not empty, then it may be said that the generalization has some initial probability. Let the next instance—i_{n+1}—be one in which some possible conditioning characteristic included in the initial evidence and not eliminated in any of the previously attained confirming instances—I_n—is not present although the conditioned characteristic is present. This suffices to give that next confirming instance a probability of less than 1. It then follows that the probability of the generalization relative to the initial evidence and the $n + 1$ confirming instances will be greater than the probability of the generalization relative to the initial evidence and the first n instances confirming the generalization. (See *LPI*, pp. 126–131 and 76–81.)

Utilization of the eliminative inductive interpretation of the PT provides, on von Wright's earlier view, a basis for resolving the confirmation paradoxes. The first step in this resolution is to recognize that no new instance can provide confirming evidence for a generalization—i.e., increase its probability—if that instance is maximally probable relative to the initial evidence and any previously observed confirming instances. The next step is to recognize that what is incorporated in the evidence (relative to which the probability of the next potentially confirming instance will be determined) is very important. Von Wright maintains that if this evidence includes the information that this next instance is either $\sim F$ or G, the next instance is maximally probable relative to that evidence. In such a case, the instance cannot increase the probability of the generalization. From this von Wright concludes that the paradoxical confirmations are 'harmless'; they do not add to the probability of a generalization that they might be supposed to 'confirm'. Further, von Wright supposes that the solution to the confirmation paradoxes thus provided can be expressed in the following language:

> Whether the fact that a thing which is both A and B is a genuine or a paradoxical confirmation of the law that all A are B depends upon *the way in which this fact*

becomes known to us (LPI, p. 125). . . . 'genuinely confirmed', one might say, means the same as 'saved from falsification after having stood the risk' (*LPI*, p. 126).

This approach to dealing with the paradoxes has attractive features. One of these is the introduction of the notion that genuine confirmations must somehow involve a risk that the hypothesis might not be confirmed but rather be falsified. A further advantage of this particular approach is that it maintains the equivalence criterion. If formula (1) is read as a necessary condition statement, i.e., *G* is a necessary condition of *F,* then (3) says that $\sim G$ is a sufficient condition of $\sim F$. Given this, the same sorts of instances that provide eliminative inductive support of (1) provide eliminative inductive support of (3). Such instances will be those in which *F* and *G* are both present, in which *F* is observed present before *G* is, and in which some other initially possible but not previously eliminated necessary condition of *F* is eliminated. Confirming instances for formula (3) read as a sufficient condition statement will be instances in which $\sim F$ is absent, i.e., *F* is present, and will also be instances in which $\sim G$ is absent, i.e., *G* is present, and in which some initially possible but previously uneliminated sufficient condition of the absence of *F* will be eliminated. Another way of saying this is that precisely the same instances that confirm (1) as a necessary condition statement will—at least relative to the same initial evidence and postulates—confirm (3) as the equivalent sufficient condition statement. Entirely parallel relationships obtain between formula (1) read as a sufficient condition statement, formula (3) read as a necessary condition statement, and the instances that can provide eliminative inductive support of these two equivalent generalizations. Equally appropriate parallels presumably hold in relation to formula (4), though von Wright does not address these.

Unfortunately, these advantages and achievements are not only accompanied but also outweighed by disadvantages and failures. Appeal to the order of our knowledge has the unhappy result of ruling out what are otherwise entirely satisfactory, adequate, and acceptable eliminative inductive evidence instances. Consider, for example, instances brought to provide support of an hypothesis such as (1) read as a necessary condition statement. Suppose that in the next instance we find the characteristics *F* and *G* present, but that another characteristic, say *H,* is absent. Suppose further that *H* was a characteristic included in the set of initially possible necessary conditions of *F,* and that *H* has not previously been eliminated in any other known supporting instance. Thus far, it would seem that this instance does indeed provide eliminative inductive support of the generalization that *F* has *G* as a necessary condition. But now add one further component: in observing this instance, we noted that it was *G* and $\sim H$ before we noted that it was *F.* That suffices to rule it out; the order of our

knowledge is improper and no inductive support of the generalization is provided. Yet 'intuitively' this kind of instance is precisely what constitutes the eliminative inductive support of a generalization. It is as 'intuitively acceptable' as is the Nicod criterion. Thus, a proposed solution of the paradoxes designed to maintain our intuitive views on one count results in denying our intuitive views on another.

It may be suggested, of course, that the only response required to the difficulty just sketched is the use of more caution in developing eliminative inductive instances. But this advice to be more cautious is, to say the least, inadequate. Appeal to the 'order of our knowledge' is not a feasible solution or component of a solution to the paradoxes. First, consider the case where we have the kind of instance described in the preceding paragraph, but two persons observing. One of these persons observes the instance in the proper order, while the other observes it in the order described above. Is the instance a genuine confirming instance, or is it not? Are we to say that whether or not an instance is a genuine confirmation depends upon who is doing the observing, and thus make confirmation subjective in a significant way? If so, it would seem that a major concern involved in the development of a formal confirmation calculus—the development of objective criteria for the evaluation of inductive inferences—has been most seriously undercut.

Consider a further problem. If we are to appeal to the order of our knowledge, at what point does that order enter when we deal with recorded data: when the data are recorded, or when the recordings are consulted? Consider as well this situation: suppose not only that (1) be read as a necessary condition statement (i.e., G is a necessary condition of F) but that G be also viewed as a necessary causal conditon of F (i.e., G is the cause or a necessary part of any cause of F). Suppose further that causation as here understood involves temporal succession, i.e., the cause must occur in its entirety immediately before or at the same time as the effect. If this be so, it will be impossible to meet the requirement set by the appeal to the order of our knowledge: it will be impossible to observe that F is present prior to observing that G is present.

Given the foregoing problems, it may next be suggested that what is required is some reformulation of this 'order of knowledge' solution of the paradoxes. For example, it might be thought that the requirement that an instance be known to be F before being known to be G or known to be $\sim G$ before being known to be $\sim F$ can be changed by inserting 'or at the same time as'. The requirement then reads: a genuine confirming instance must be known to be F before or at the same time as it is known to be G, etc. Even on this approach, there are invalidating difficulties. With regard to necessary causal conditions, problems remain wherever the hypothesized necessary condition is a part of a complete cause and cannot be the last causal condition introduced into the situation. That is, F is here the effect; G is a necessary causal condition

that must be introduced prior to the appearance of the effect, and the instance will thus be known to be G prior to being known to be F.

As may be expected, the situation regarding sufficient condition hypothesis confirmation has entirely parallel difficulties. The original version of the 'order of knowledge' requirement makes confirmation of these by eliminative induction problematic. Otherwise entirely satisfactory eliminative inductive instances supporting an hypothesis can be rendered invalid by mere incorrect orders of observation. Observations of the same instance by two persons, one of whom does so in the 'proper' order while the other does so in an 'improper' order, are entirely possible, again introducing a subjective component that is entirely inappropriate. Amendment of the requirement fails to remove the difficulties. An example supporting all of this can be provided as follows: suppose the eliminative confirming instance at hand is $\sim F \sim GH$, where H is a not previously eliminated initially possible sufficient condition of G. If the absence of F and presence of H are observed prior to noting the absence of G, the instance is 'improper'. This may with care be avoidable in instances where the hypothesis is purely a sufficient condition statement. It is, however, unavoidable if the hypothesis is a causal statement, i.e., a statement of a sufficient condition temporally preceding the conditioned characteristic in order of occurrence. An instance of the sort just suggested is a paradigm of what would constitute an eliminative confirmation of (1) as a sufficient condition or 'sufficient condition in time' statement. The amended version of the 'order of knowledge' requirement does not alleviate the problems at all. (These problems have been developed at length in the writer's 'Von Wright's Paradoxes'.[5])

3. VON WRIGHT'S REVISED APPROACH

In response to the problems posed for his earlier approach, von Wright has advanced a revised approach to the paradoxes. This is presented in his 'The Paradoxes of Confirmation' (1965), 'The Paradoxes of Confirmation' (1966), and 'A Note on Confirmation Theory and on the Concept of Evidence' (1970). Central to this revised approach is the introduction of the concept of the range of relevance of a generalization. This introduction is to provide a means for ruling out as inappropriate the paradoxical kinds of confirming instances. In this section, that proposal is summarized and certain difficulties involved in its relationship to the formal confirmation theory developed by von Wright are specified. In addition, an alternative application of the range of relevance proposal to non-eliminative confirmation theories is discussed.

The introduction of the concept of a range of relevance of a generalization has a certain initial and—if the term be not found pejorative—intuitive attraction. In essence, this approach proposes to restrict possible confirming in-

stances of a generalization to instances falling within a range of relevance of the hypothesis in question. The suggestion that this restriction be introduced is perhaps more obviously appealing if the confirmation paradoxes are considered not in terms of symbolized examples but rather in terms of sample generalizations. One frequently used example—so frequent that it was the source of "the raven paradoxes" as an alternative label for these paradoxes—is provided by the generalization 'all ravens are black'. It appears that black ravens and only black ravens can confirm this generalization. Yet, 'all ravens are black' is logically equivalent to 'everything is either not a raven or else is black' and also to 'all non-black things are non-ravens'. The 'obvious' confirming instances for these, the instances that fit the Nicod criterion, are respectively things which are not ravens but are black, and things which are neither black nor ravens. But this would seem to indicate that any black pair of shoes, any white piece of paper, any red rug, and so on—for however long a list of things one pleases to construct—would equally serve to 'confirm' the original generalization that all ravens are black. The confirmation of ornithological theories from the comfort of one's fireside may be appealing in that it saves going out in the rain, but it is certainly not appealing in that it fits any of our 'intuitive' notions of what confirmation ought to be.

Introduction of the notion of a range of relevance, however, would seem to eliminate these difficulties. It would seem, that is, to suggest that somehow only those instances that are within that range of relevance are appropriate confirmations of the generalizations. But there is a problem: what, precisely, is the range of relevance of a generalization? If the generalization is 'all ravens are black', that would appear to be easily answered: the range of relevance is ravens. Alternatively, we might suppose the range of relevance to be somewhat larger, e.g., the class of birds. We should, at any rate, suppose that shoes, sealing wax, and a thousand other things are not included within this range of relevance, and thus that the paradoxical confirmations are effectively eliminated. At any rate, this is clearly what von Wright intends by this proposal.

The actual outcomes of the proposal, however, are somewhat different from those intended. The proposal can be viewed as offered within the formalized confirmation theory advanced by von Wright. This system includes one significant postulate so far as the range of relevance proposal is concerned, and that postulate in conjunction with the range of relevance proposal generates certain difficulties. The postulate in question is called by von Wright the 'completely known instances' postulate. This, once more, is the assumption that in any given confirmation situation one knows all of the possible conditioning characteristics of a conditioned characteristic involved in an hypothesis to be confirmed. This postulate thus restricts the characteristics to be considered in any confirmation situation. It thereby also restricts the possible confirming instances for the hypothesis at issue. The addition of the range of relevance requirement

is, as a result, either redundant or inconsistently restrictive. This range of relevance proposal also, it must be said, does not serve to resolve the paradoxes independently of its conflict or overlap with the 'completely known instances' postulate. In the following paragraphs, these difficulties are elaborated.

The problem of redundancy or incoherence of the proposed range of relevance requirement and the postulate of completely known instances (hereafter 'RR' and 'CKI', respectively) is the equally unsatisfactory outcomes of two major alternatives. To recognize these, it is necessary to recognize that the RR is in effect a requirement of a specification for any hypothesis at issue of a set of possible confirming instances and possible conditioning characteristics. On the basis of the RR, these possible conditioning characteristics are those to be considered in the application of the eliminative inductive patterns. What must simultaneously be recognized, but is apparently not recognized by von Wright, is that the CKI serves to require the specification of precisely the same kinds of sets of instances and of possible conditioning characteristics.

The RR and CKI requirements of specifications of possible confirming instances, in turn, can have one of two possible outcomes. Either the specifications provided are the same sets of instances and characteristics, or they are not. Suppose first that the specified sets are the same. If that be so, one of the two requirements—the RR or the CKI—is redundant. Suppose, on the other alternative, that these result in the specification of different sets (such that there is at least one characteristic which is a member of one but not of the other). Then two relationships between these sets are possible. On the one, the set resulting from the CKI is more inclusive than that resulting from the RR. On the other relationship that is possible if the two sets are not identical, the converse holds. It is, it should be further noted, possible that both of these relationships hold simultaneously, i.e., that at least one characteristic specified as a possible conditioning characteristic on the basis of the CKI is not so specified on the basis of the RR and conversely. On any of these alternatives, however, at least one characteristic is a possible conditioning characteristic on the basis of one of the two criteria, but is not such a characteristic on the basis of the other. Thus, the RR and the CKI are on this alternative inconsistent.

There is, obviously, only one way to remove the possible inconsistency between the RR and CKI: insure that they result in the specification of the same sets of possible conditioning characteristics on the basis of whatever initial evidence may be (simultaneously) offered under either for the determination of this set in relation to any hypothesis proposed for confirmation. But this is to make one of the two redundant and superfluous. Since the CKI is already built into von Wright's confirmation calculus, it would seem the appropriate one to maintain; the RR would seem the one to delete.

The immediate question remaining is whether or not the confirmation paradoxes are removed by the introduction of the range of relevance requirement.

So far as eliminative confirmation as formulated by von Wright is concerned, the answer is that they are not so removed. This requirement functions precisely as does the postulate of completely known instances. That the paradoxes are a problem within von Wright's original confirmation calculus is sufficient substantiation of the failure of the apparently new requirement so far as that version of a confirmation calculus is concerned.

There is, however, another approach to confirmation calculi for which the range of relevance requirement may seem more promising. This approach utilizes an instantial rather than an eliminative structure, and attempts to develop an explication of degrees of confirmation on that basis. The principal idea is that an hypothesis is confirmed in proportion to the confirming instances of it that are known. This basic idea can apparently be given more structure and strength by using an instantial rather than eliminative interpretation of the PT. Suppose formula (5) above is broken into three parts and thus interpreted. Specifically, suppose:

(5a) $$P(g,e) > 0$$

is interpreted to mean that the ratio of the set of instances represented by the hypothesis g in relation to the set of initial evidence instances e is greater than 0 and also less than 1. Then:

(5b) $$P(i_{n+1}, e.I_n) < 1$$

is taken as another ratio such that the reference class of instances $e.I_n$ does not make the new instance i_{n+1} certain, i.e., does not give it a probability of 1. From these two it follows that:

(5c) $$P(g, e.I_{n+1}) > P(g, e.I_n)$$

The formula here is interpreted as stating that the ratio of instances represented by g in relation to instances represented by $e.I_n$ is less than the ratio of 'g' instances to '$e.I_{n+1}$' instances.

What this interpretation of the PT requires is noteworthy on two counts. First, it requires that the hypothesis involved be taken as equivalent to a conjunction of its instances. Secondly, it requires that there be a definition of what is an instance and thus a confirming instance of the hypothesis. The first assumption is more than passingly problematic. The second can supposedly be addressed by using a combination of the Nicod and equivalence criteria, thus removing the problem of instances directly fitting equivalent versions of an hypothesis but not confirming it.

This definition of 'confirming instance' seems to leave the problem of massive confirmation by massive sets of d instances, to say nothing of large sets of b instances as well. But, it is held, that is easily handled. Since the degree of confirmation of the hypothesis is a ratio of instances to instances, one need

only recognize what is involved in supposing d instances to be genuinely confirming. The reference class of evidence instances $e.I_n$ or $e.I_{n+1}$ is then very, very large. Adding one or many more d instances as 'evidence' does not significantly change the size of this class in relation to that of the 'g' instances set. It thus does not change the degree of confirmation of the hypothesis at issue. Indeed, it may be argued that admission of d or b instances here at all as possible confirming instances and thus members of e effectively makes the reference class infinite, so that the initial degree of confirmation of the hypothesis is effectively nil. If so, no confirmation of the hypothesis is then possible; hence such instances are not to be considered confirming instances.[6]

One risk run in such an approach is that a sufficiently parallel argument can be advanced for a instances also. If so, then it is to the effect that the size of the class of potential a instances of the hypothesis at issue is also so large that the initial degree of confirmation of the hypothesis is again effectively nil. The introduction of a range of relevance requirement then can serve two purposes. One is to provide a justification for not including d or b instances. The second is to reduce the class of potentially confirming a instances to a sufficiently small and finite set, enabling meaningful confirmation. It would seem that this is what von Wright has in view in his later essays.

But a closer examination of all this indicates that there are still problems, and most serious problems. The set of potential instances of the hypothesis is to constitute a finite range whose exhaustive examination without the discovery of a disconfirming instance is to provide maximal or—if one must be cautious—approximately maximal confirmation of the hypothesis. This presupposes that the range is in some appropriate sense a fair sample of *all* the possible instances of the hypothesis. Otherwise, it cannot be held that the satisfaction of the hypothesis by each and all of the instances *in this range* of evidence instances constitutes confirmation in the sense that it justifies the application of the hypothesis in 'new' instances—ones outside this evidence set. If the set is not such a fair sample, then it can be said to provide confirmation of the hypothesis only in a specious sense: the hypothesis is satisfied for that range, and never mind its further applicability.

It may be responded that it is not necessary to view the set of evidence instances examined and supposedly providing instantial support for a generalization as being a finite, exhaustively examined range such that the generalization is confirmed as a 'summary generalization' for that range. It may, instead, be maintained that these instances can be viewed as in some sense a proportion of the total instances to which the hypothesis is applicable, that the hypothesis can be viewed as thus not restricted to any specific range, and that we can still talk about degrees of confirmation. Unfortunately, such an attempt has been made, is well-known in the literature, and is an utter failure. On this view, the number of instances which the generalization incorporates is effectively infi-

nite, the number of potential evidence instances is effectively infinite, and the ratio of known instances satisfying the generalization to total possible instances is tantamount to a ratio of one to infinity. On this assumption, then, the probability of the hypothesis is effectively nil. This is precisely the outcome which Carnap found when he attempted exactly such a development in the closing pages of his *Logical Foundations of Probability,* and nothing further need be said.[7]

There is, it must be noted, yet one more alternative available. This alternative is suggested by some of the comments and examples used by von Wright in his discussions of his revised paradox solution, e.g., pp. 265 ff of his 1965 essay. In such discussions, and in parallel discussions by other writers, the hypothesis concerns some single event, e.g., the color of a ball drawn from an urn or a box. The several draws with replacement of balls from the container are taken as evidence instances, and all this is supposedly parallel to the relationship between the probability of a generalization and the support provided to it by its evidence instances. This then leads to the view that the determination of the statistical distribution of the evidence instances provides a determination of the degree of confirmation of a nomic hypothesis. But this is a complete intermingling of two quite different kinds of things. If what we are concerned with is the statistical distribution of outcomes of draws from a container, we are dealing with statistical hypotheses, and with probabilities in that sense. We are not dealing with the degree of confirmation of a nomic hypothesis.

If what is at issue is the confirmation of a statistical hypothesis, e.g., the probability that a thing is G, given that it is F, is $x\%$, then the appropriate 'rules of evidence' and patterns of procedure are those for the testing of statistical hypotheses. If, on the other hand, what we are concerned to discover is whether or not a given nomic generalization, e.g., all F's are G's, is true or likely to be true, then we want to know the extent to which this hypothesis is supported by the evidence—and if we are dealing with a metricized confirmation calculus, the degree to which this is so. It is simply not the case, with the possible but implausible exception of what may be viewed as a degenerate case, that a statistical hypothesis of the form 'given a thing is F, the probability that it is G is x' is equivalent to the statement 'the degree of confirmation of all F's are G is x'. The degenerate case that is possible here is the case in which the probability incorporated in the statistical hypothesis is one hundred percent, and in which the evidence in support of either the statistical or the nomic version of the hypothesis is utterly conclusive as to its truth. Once these distinctions are recognized, the attempt to provide examples of degrees of confirmation by means of statistical investigations is clearly inappropriate, the need to define 'confirming instance' to match such circumstances is out of order, and the attempt to utilize this to evade the paradoxes is inappropriate. Finally,

it may be noted that the paradoxes do not attach to the testing of statistical hypotheses precisely because the very structure of these tests rules them out.

We are, then, so far as confirmation of nomic hypotheses is concerned, back to two alternatives: instantial confirmation with all its difficulties, or some version of eliminative confirmation. If it is supposed that the testing of an hypothesis must involve variations of circumstances and indeed of relevant circumstances, if it is supposed that these relevant circumstances can be identified, then some version of eliminative induction or confirmation is requisite. Variation of relevant circumstances is of the essence of all eliminative approaches. It is because of the absence of this, and a consequent inability to distinguish happenstance from regular connection, that instantial confirmation can be characterized as exposed to instant contradiction—to paraphrase von Wright's own quotation of Francis Bacon (See *LPI*, p. 60).

In brief, instantial approaches to confirmation are as such seriously deficient in several ways. The paradoxes do, indeed, highlight some of these. But even if it be supposed that von Wright's range of relevance proposal removes these highlights, this basic approach simply does not serve.

4. SOLUTION OF THE PARADOXES AND DEFINITION OF 'CONFIRMING INSTANCE'

Is it then the case that the paradoxes of confirmation are an inescapable, invalidating outcome for any attempt to formulate a confirmation calculus? So it may appear; so it is not in fact. Any eliminative confirmation approach in and of itself removes the paradoxes. Again working with the sort of eliminative confirmation proposed by von Wright, start with either the postulate of completely known instances or the range of relevance requirement as a basis. Either serves to provide as the initial evidence in the confirmation of an hypothesis a limited and finite set of possible conditioning characteristics. Then, taking the more problematic case first, suppose (1) above be read as a sufficient condition statement: F is a sufficient condition of G. Clearly any confirming instance must be a 'd'-type instance; only these can be eliminative here. But there will be a finite and well-determined set of such instances. Any of these that add to the probability of the hypothesis must be ones that by virtue of the characteristics they exhibit (in addition to $\sim F$ and $\sim G$) eliminate some previously uneliminated member(s) of the initial set of possible conditioning characteristics. All of this holds equally well, *mutatis mutandis,* if the hypothesis at issue is (1) read as a necessary condition statement: G is a necessary condition of F. There is, in brief, here no massive confirmation by the indiscriminate amassing of 'd'-type instances.

The other paradoxes are as easily removed. The supposed problem of con-
firmation by 'b'-type instances is no problem; such instances cannot be elimi-
native for (1) or (3) whether read as necessary or as sufficient condition state-
ments. They thus are simply not confirming instances on this approach. They
do, it may be noted, have a function: such an instance serves to establish that
the hypothesis at issue can be at most a conditional statement, not a bicondi-
tional, that the two characteristics are not factually equivalent. Finally, 'a'-type
instances fall under precisely the same sorts of restrictions so far as confirming
value is concerned as do 'd'-type ones. If the hypothesis is that G is a necessary
condition of F, there will be a finite set of initially possible conditioning char-
acteristics. Any 'a'-type instance that is to provide confirmation must by virtue
of its other characteristics in addition to F and G eliminate some previously
uneliminated member(s) of this initial set. There is no massive confirmation by
massive sets of 'a'-type instances either.

One final comment on this resolution of the paradoxes must be made: von
Wright came very close to it. He unfortunately, however, appears not to have
recognized that he virtually said, on page 131 of his *LPI*, all that need be said:

> A thing which has the property B cannot eliminate anything from the possibility of
> being a sufficient condition of B. And a thing which lacks the property A cannot
> eliminate anything from the possibility of being a necessary condition of A. Such
> things are therefore necessarily ineffective from the point of view of elimination.
> . . . But by being necessarily ineffective, the 'paradoxical' confirmations are also
> 'harmless', they do not 'genuinely' or 'really' confirm the generalization in ques-
> tion at all.

This resolution of the paradoxes on the basis of eliminative confirmation is
one that, so far as it goes, meets the equivalence criterion. It does not, it must
be admitted, do two other things. It does not meet the Nicod criterion; it does
not provide an explicit definition—e.g., along the lines of the Nicod criterion—
of 'confirming instance'. But the Nicod criterion, however attractive at first
phrasing, simply will not do: this the paradoxes establish. The provision of an
explicit definition of 'confirming instance' is another matter.

There is a certain appeal to the position that any confirmation calculus is
incomplete unless it includes a definition of 'confirming instance'. Von Wright
accepts this, and proceeds to attempt a definition of 'confirming instance' first
by holding that it is anything which does not disconfirm the hypothesis at issue
and then by advancing the Nicod criterion. Trapped in the paradoxes, he at-
tempts to escape by distinguishing genuine from paradoxical confirming in-
stances. This is supposedly to be achieved by classifying the Nicod and equiv-
alence (non-disconfirming) criteria as admitting 'paradoxical' as well as
'genuine' confirming instances. The latter are to be distinguished from the for-
mer by holding that they are the proper subset of *Nicod plus equivalence cri-
teria confirming instances* that are instances involving risk of falsification of

the hypothesis: "'Genuinely confirmed' . . . means the same as 'saved from falsification after having stood the risk'" (*LPI*, p. 126). The particular difficulties in this have been sufficiently indicated above.

More generally, this may be said: any attempt to provide an explicit definition of 'confirming instance' is subject to precisely the same kinds of risks as those advanced in the relationship between the range of relevance requirement and the postulate of completely known instances. There are, in effect, two distinct ways in which a specification of what constitutes a confirming instance can be provided. One is by some sort of explicit definition. The other is by specifying what constitutes a confirming instance by implicit definition using the various confirmation relations incorporated in a confirmation calculus. Either these two specifications of what constitutes a confirming instance will be the same, or they will not. If they are the same, one of them is redundant. If they are not, then there is again a paradox: what is, by explicit definition, a confirming instance is by the confirmation relationships specification not such, or conversely. Furthermore, the provision of a definition of what constitutes a confirming instance which is not simultaneously the specification of confirmation relations between evidence instances and the hypothesis they are supposed to support is at best vacuous. Thus, the approach to the definition of 'confirming instance' to be selected is that of implicitly defining what constitutes a confirming instance through the specification of the confirmation relations.

5. A Modified Approach to Eliminative Confirmation

In all of the foregoing discussion, a major difficulty has not been answered nor stated, although it has been touched upon and is almost obvious. This concerns the relationship between an hypothesis on the order of (1) above read as a necessary condition statement and the same hypothesis read as a sufficient condition statement. The full application of the equivalence criterion requires that any disparities there may be between these two readings be removed, since once more the function of the two 'versions' of the same hypothesis in any inferences will be effectively the same. All this suggests that the distinction of that hypothesis read as a necessary condition statement from the same hypothesis read as a sufficient condition statement is both artificial and erroneous. Indeed, it suggests that John Stuart Mill was perhaps more nearly correct than contemporary writers have been in analyzing the relationships between what Mill called the method of agreement, the method of difference, and the joint method. These here are the eliminative confirmation of an hypothesis by '*a*'-type instances, '*d*'-type instances, and both simultaneously. What is required if this difficulty is to be resolved is that the entire relationship between the two 'versions' of the hypothesis and their confirming instances be reformulated.[8]

Such a reformulation has been proposed by the present author in another context. It will be outlined here as a suggestion as to how the basic approach taken by von Wright can be amended and extended to provide a more successful approach to confirmation.[9] The leading idea in this approach is that confirmation is provided for an hypothesis by the elimination of possible alternatives to that hypothesis. The eliminative patterns involved in this can be specified as follows. Suppose there be a set of hypotheses H_i whose members are h_1, h_2, . . . h_n. Suppose further that the hypothesis to be confirmed is h_j, that the members of H_i simpler than this one are h_1 . . . h_{j-1}, that the members of H_i less simple than h_j are h_{j+1} . . . h_k, and that the members of H_i which are not comparable with h_j with regard to simplicity but are also possible alternatives to it are h_{k+1} . . . h_n. Confirmation of h_j is then provided by the elimination of one or another previously uneliminated member of H_i other than h_j. With regard to the alternative hypotheses h_1 . . . h_{j-1} elimination is attained by the observation of falsifying instances that do not also falsify h_j. This sort of confirmation shows h_j to be the simplest hypothesis of those 'simplicity-related' to it *not known to be false*. With regard to the hypotheses h_{j+1} . . . h_k elimination is attained by the observation of instances showing that these hypotheses but not also h_j are needlessly qualified. This sort of confirmation shows h_j to be the *simplest* hypothesis of those 'simplicity-related' to it not known to be false. With regard to the possible alternatives h_{k+1} . . . h_n, elimination is again attained by the observation of falsifying instances that, once more, do not simultaneously falsify h_j. This sort of confirmation shows h_j or some hypothesis 'simplicity-related' to it to be *the* simplest *hypothesis* among the set H_i not known to be false.[10]

These three sorts of patterns can be illustrated by the following. Consider hypotheses of these forms:

(6) $(x) : ExFx. \supset Gx$

(7) $(x) . Ex \supset Gx$

(8) $(x) : ExFxMx. \supset Gx$

(9) $(x) . Nx \supset Gx$

Of these four hypothesis forms, let formula (6) be h_j, the hypothesis to be confirmed. Let h_1 be formula (7), h_{j+1} be formula (8), and h_{k+1} be formula (9). Confirmation of h_j by falsification of h_1 is then provided by what is, in the earlier terminology of this paper, a 'd'-type instance having the characteristics $E{\sim}F{\sim}G$; it is essential that F as well as G be absent or h_j as well as h_1 will be falsified. Confirmation of h_j by showing that h_{j+1} is needlessly qualified is provided by an instance having the characteristics $EFG \sim M$; G's occurrence in the absence of M shows that this characteristic is not essential to a sufficient condition of G. Again in the earlier terminology of this paper, this is an 'a'-

type instance. Then, confirmation of h_j by falsification of h_{k+1} is provided by an instance having the characteristics $N \sim G \sim . EF$; the absence of the conjunction of E and F is requisite to such an instance's not also falsifying h_j. This is, once more, a 'd'-type instance.

Certain further comments regarding these examples may be helpful. All of the letters appearing in predicate positions can be taken, if desired, as indicating logically complex characteristics. The extension of these patterns to hypotheses involving relational predicates or predicates stating mathematical functions (consider the classical eliminative 'method of concomitant variations') is straightforward, though not always simple. The use of quasi-numerical subscripts in referring to various hypotheses is not intended to suggest that the members of H_i are susceptible of linear ordering, whether on the basis of some kind of comparative simplicity or on other considerations. Finally, the requirement that confirming instances not falsify h_j nor show it to be needlessly qualified does not mean that it is itself inherently unfalsifiable or non-eliminable as insufficiently simple; it simply prohibits confirming instances from being, simultaneously, disconfirming ones.

One further component of this approach is required, and that is some comment regarding what serves as, or in place of, the range of relevance requirement or postulate of completely known instances. In this context, what is needed is some basis for determining membership in the set of hypotheses H_i. The composition of this set determines those variations of circumstances that, upon observation, provide confirmation of h_j. Obviously not every logically possible hypothesis should be a member of such a set. Indeed, not even every logically possible generalization concerning the same sort of phenomenon as does h_j, say the occurrence of G, is admissible as a possible alternative. But the members of H_i should be plausibly possible alternatives, and there should be evidence supporting their inclusion in this set. One condition, and a partial specification of a 'range of relevance', can be formulated as a general minimum requirement for membership in H_i: every characteristic other than G included in any hypothesis that is a member of H_i must be observed to be present in at least one instance with G; every hypothesis in H_i must have at least one known positive and one known negative instance; no hypothesis in H_i may have any known falsifying instance. This criterion ensures that there is a basis for advancing the several members of H_i. It also, by virtue of the requirement of at least one known positive and one known negative instance for each member of H_i, prevents the inclusion of hypotheses that are either copiously or vacuously true (for a further development of this, see "In Defense of a Principal Theorem" (1969)).

It is not to be maintained that the rather formal set of conditions just presented is all that may be said regarding criteria for membership in the set of initially possible alternative hypotheses. This is of some interest not simply as

an elaboration of this approach to eliminative confirmation, but also as a means of developing von Wright's concept of a range of relevance. If such elaboration cannot be provided, then that concept is open to the charge that it is appealing, perhaps, but so imprecise as to be of no assistance.

Certain elaborations that can be brought to bear here have been suggested in a discussion by W. C. Salmon of the confirmation of hypotheses.[11] One is 'formal criteria': deductive relations the hypothesis at issue and its alternatives may have to other, already accepted, hypotheses. To the extent that any already accepted hypotheses entail that at issue or alternatives to it, these will not only have to be included but assigned degrees of confirmation at least as high as the entailing accepted hypotheses. To the extent, on the other hand, that already accepted hypotheses entail the denial of the hypothesis at issue or its alternatives, these latter can be included only if they can be given some positive probability which is yet no higher than the complement of the degree(s) of confirmation of the hypothesis(ses) entailing such denial(s).

A second sort of consideration advanced by Salmon is 'pragmatic criteria'. Salmon, while insisting that these must be used with care and caution, suggests that the qualifications of the person suggesting the hypothesis—his status as a professional researcher in the scientific area—is a consideration that may be introduced appropriately. But there is, as well, a third sort of consideration advanced by Salmon: 'material criteria'. These considerations involve the presence or absence of analogies between the hypotheses under investigation and other already successful—confirmed—hypotheses. Under this heading Salmon places two things by way of example. One is simplicity; the other is the kinds of causal processes and causally efficacious characteristics of things that are viewed as admissible into an hypothesis or theory.

This last consideration is perhaps the most important of all so far as the explication of the concept of a range of relevance is concerned. What makes this so attractive as a response to the paradoxes is that we *know*—and know very well—that the characteristics of shoes, however black they may be, are simply not relevant to hypotheses about the plumage of ravens. But we know this because we have all too many examples already at hand establishing—by eliminative procedures if you will, although informal ones—such irrelevancies. On the other hand, development of a general proposal regarding the determining factors for plumage coloration by observations of similarities and differences between parents and offspring, effects of coloration upon mating behavior, and so on, is the development of a base for the formulation of the set of alternative hypotheses to be considered by eliminative confirmation. Moreover, when competing views as to what are these causally efficacious characteristics are at issue, it is a particular application of eliminative methods—crucial experiments—that is the means of experimental or observational resolution.

The approach to eliminative confirmation just sketched is admittedly a significant reformulation of von Wright's version of eliminative induction. For better or worse, it includes some Popperian elements—and the Popperians themselves may well think it for worse. But this approach does provide an interpretation of the PT, upon assignment of appropriate values to the probability relationships involved in that. The development of this goes beyond the scope of the present essay. It is feasible in various ways; the requirements to be met are a consistent interpretation of the probability calculus and a plausible assignment of values of degrees of confirmation to the several hypotheses involved. The approach has one further advantage to be noted. It permits the introduction of another theorem, a 'Converse PT'. This says that if a new alternative hypothesis is introduced in the process of the investigation, that reduces the degree of confirmation of the hypothesis at issue. It does not, however, make that latter degree of confirmation nil. The effect of this is to provide as part of the confirmation theory a means for the recognition of disconfirming but non-falsifying evidence discovered or developed in the process of attempting to confirm the original hypothesis. Dealing in terms of alternative hypotheses rather than characteristics, it is more easily extendible to complex hypotheses and to interrelated sets of hypotheses. It is, then, a reformulation—and, as well, an extension and improvement.

6. SUMMARY

The foregoing discussion has addressed a number of issues involved in the paradoxes of confirmation and von Wright's two proposed solutions to these. It opened with a statement of the paradoxes as these have been traditionally formulated. It then considered von Wright's first approach to the paradoxes, indicating what this was and the difficulties rendering it less than successful. The next stage involved consideration of von Wright's proposed alternative resolution of the paradoxes. This, too, was shown less than successful, still leaving the paradoxes in need of some sort of resolution. The possibility that the range of relevance approach is appropriate for an instantial confirmation approach was discussed, and the difficulties in that indicated. Next, this discussion noted that eliminative inductive procedures in and of themselves provide a solution to the paradoxes, or to phrase it more precisely, that such procedures prohibit the paradoxes from occurring. It also noted that the attempt to provide an explicit definition of 'confirming instance' leads to nothing but difficulty, and that implicit definition through development of a confirmation calculus is the appropriate route. Finally, an alternative approach to eliminative confirmation in terms of alternative hypotheses has been sketched. This is, at a

minimum, necessary to remove certain infelicities in von Wright's account resulting from the sharp distinction of necessary condition hypotheses from sufficient condition hypotheses.

That it is necessary, in order to formulate a satisfactory approach to eliminative confirmation, to make changes of some significance in von Wright's original approach should not be permitted to obscure his achievements. It may well be, indeed, that these achievements were not carried through by von Wright himself because of mis-steps resulting from his attempts to respond to considerations raised by others dealing with the confirmation paradoxes. After all, these other discussions were invariably formulated on the basis of an instantial confirmation approach. They thus set the frame of the entire discussion in such a way as to exacerbate the paradoxes by means of the internal problems of any such approach while discounting the advantages of an eliminative approach through neglect. Von Wright must be credited with the provision of a plausible approach to interpreting a confirmation calculus as a formalization and metricization of eliminative induction. It must also be recognized that von Wright has provided, both in his *Logical Problem of Induction* and in his *Treatise on Induction and Probability* some valuable restatements and reformulations of the traditional eliminative inductive approaches. Finally, it must be recognized that the solution to the paradoxes here proposed is to a significant extent a carrying through to completion of the recognition that von Wright himself achieved.

STATE UNIVERSITY OF NEW YORK AT BUFFALO WILLIAM H. BAUMER
MARCH 1975

NOTES

1. In the discussion, von Wright's second book will be cited as '*LPI*' with the appropriate pagination; the three articles will be cited by year of appearance and appropriate pagination. Full bibliographic data on these are: *Treatise on Induction and Probability* (London: Routledge and Kegan Paul, 1951; reprinted by Littlefield, Adams & Co.: Paterson, N.J., 1960); *The Logical Problem of Induction*, 2d rev. ed. (Oxford: Basil Blackwell & Mott, Ltd., 1957), a revision of *The Logical Problem of Induction*, published as Vol. 3 of *Acta Philosophica Fennica* (Helsinki, 1941); 'The Paradoxes of Confirmation', *Theoria*, 31 (1965), pp. 255–274; 'The Paradoxes of Confirmation', in *Aspects of Inductive Logic*, edited by Jaakko Hintikka and Patrick Suppes (Amsterdam: North-Holland Publishing Co., 1966), pp. 208–218; and 'A Note on Confirmation Theory and on the Concept of Evidence', *Scientia*, 105 (1970): pp. 595–606.

2. Jean Nicod, *Le problème logique de l'induction*, (Paris: Presses Universitaires de France, 1961; reprint of the original published in Paris, 1924), p. 23.

3. These paradoxes have been very extensively discussed, and no complete list of those discussions is here provided. The essays initially setting the problem, and to which von Wright referred in his first discussions of the paradoxes, include: Carl G. Hempel,

'Le problème de la vérité', *Theoria*, 3 (1937): 206–246; Hempel, 'A Purely Syntactical Definition of Confirmation', *Journal of Symbolic Logic*, 8 (1943): pp. 122–143; Hempel, 'Studies in the Logic of Confirmation (I & II)', *Mind*, 54 (1945): pp. 1–26 and 97–121, since reprinted with some revision in Hempel's *Aspects of Scientific Explanation*, (New York: Free Press, 1965), pp. 3–51; Janina Hosiasson-Lindenbaum, 'On Confirmation', *Journal of Symbolic Logic*, 5 (1940): pp. 133–148; and Hosiasson-Lindenbaum, 'Induction et Analogie', *Mind*, 50 (1941): pp. 351–365.

 4. See J. S. Mill, *A System of Logic*, 8th ed. (London, 1872; reprinted by Longmans, Green and Co.; London, 1956), Book III, Ch. 8.

 5. W. H. Baumer, 'Von Wright's Paradoxes', *Philosophy of Science*, 30 (1963): pp. 165–172.

 6. The attempt to deal with the paradoxes by invoking the supposedly very low probability of '*d*'-instances has been frequently made. Hosiasson-Lindenbaum did so in 'On Confirmation'; H. G. Alexander followed this route in 'The Paradoxes of Confirmation', *British Journal for the Philosophy of Science*, 9 (1959): pp. 227–233, as did J. L. Mackie in 'The Paradox of Confirmation', also in *British Journal for the Philosophy of Science*, 13 (1963): pp. 265–277.

 7. Rudolf Carnap, *Logical Foundations of Probability*, 2d ed. (Chicago: University of Chicago Press, 1962), pp. 570–71.

 8. Howard Kahane must be given credit for suggesting this problem, both in private correspondence with W. H. Baumer and in his 'Baumer on the Confirmation Paradoxes', *British Journal for the Philosophy of Science*, 18 (1968): pp. 52–56. Kahane maintained that (1) read as a sufficient condition statement is the same as (1) read as a necessary condition statement. W. H. Baumer responded that, on the eliminative induction calculus used, the evidence was different. But this clearly (though not so clearly when the reply was written—see 'Confirmation Still Without Paradoxes', *British Journal for the Philosophy of Science*, 19 (1969): pp. 57–63) will not do. Kahane is right, and some means of dealing with what might be called 'concurrent' confirmation of (1) as a 'necessary condition' and as a 'sufficient condition' statement is required.

 One other credit must also be given. This is to Frederick L. Will for the stimulation provided by his critique of various abuses of the PT. See in particular his 'Consequences and Confirmation', *Philosophical Review*, 75 (1966): pp. 34–58.

 9. W. H. Baumer, 'In Defense of a Principal Theorem' *Synthese*, 20 (1969): pp. 121–142.

 10. This presupposes a definition of 'simpler than' along Popperian lines: one statement is simpler than a second if the first entails the second but not conversely. It should be kept in mind that the confirmation structure sketched permits statements to be either 'simplicity related' to the hypothesis at issue or not; thus any alleged difficulties in applying this definition can be set aside.

 11. Wesley C. Salmon, *The Foundations of Scientific Inference* (Pittsburgh: University of Pittsburgh Press, 1966), pp. 125–27.

6

Brian McGuinness

VON WRIGHT ON WITTGENSTEIN

It would be inappropriate to publish a book on von Wright's philosophy without mention of his work on Wittgenstein. Some tribute is owed to *il lungo studio e'l grande amore*. Yet an evaluation of his editorial work, shared as it was with Professor G. E. M. Anscombe and Mr. Rush Rhees, must in the main be left for another place. Here only a brief allusion need be made to the difficulties that confronted and the success that has attended that work. Wittgenstein wrote something nearly every day of his life; what he wrote, he usually revised; and what he revised, he usually re-arranged; from 1930 on he retained most of the stages of his compositions. To discover, to collect, and to put in order these papers was itself no inconsiderable achievement; but the redaction within two years of the *Philosophical Investigations* and within twenty of all the main works that Wittgenstein designed or may have intended for publication was a labour that might have, and in other cases has, occupied an Institute for twice the time. That some errors have been committed in the first editing of these texts will surprise no one who has himself engaged in this more necessary than rewarding branch of literary activity; but the degree of fidelity observed, even in what appear to be errors or inconsistencies, can be measured only by those who have collated with the original some portion of what has been printed. *Notebooks 1914–16* (1961) alone fails this test: the German was set from faulty copy and Professor Anscombe's translation generally agrees better with the actual notebooks. The German edition by Suhrkamp (in Ludwig Wittgenstein, *Schriften,* 1960 *(sic))* follows the German of the English edition though it corrects, as Suhrkamp is wont to do, some misprints that are obvious and some that are merely supposititious. In general the reader of a volume for which the literary executors are directly responsible will find the German of Wittgenstein himself, sometimes Austrian, sometimes old-fashioned, often varying the punctuation, the division of words, or the use of capital letters to suit the rhythm and emphasis with which Wittgenstein wrote and wished to be read. There is no doubt that this was a correct decision. A

living author can allow or reject the suggestions of an editor or of a publisher's reader: but truth no less than piety demands that the works of the dead should be beyond revision.

The selection and collocation of posthumous writings for publication is inevitably subject to cavil and dispute. Where so many courses *might have* been pursued it is easy for a critic's judgement to light upon one more alluring than that which was. Yet in this case it is proper to remember the especial circumstance that these editors were the choice of the author. Wittgenstein needed editors:

> I have no right (he said in 1948) to give the public a book in which the difficulties I feel (and nothing else) are expressed and chewed over. These difficulties are interesting for me, who am caught up in them, but not necessarily for other people. They are difficulties of *my* thinking, brought about by *my* development. They belong, so to speak, in a diary, not in a book. And even if this diary might be interesting for someone some day, I cannot publish it. My stomach-aches are not what is interesting but the remedies—if any—that I've found for them.[1]

They were to judge where the difficulties and the attempted cure might be useful to the public. Waismann noted in the 1930s that Wittgenstein had "the wonderful gift of always seeing things as if for the first time." This made the joint work on which the two were involved extremely difficult, since Wittgenstein "always followed the inspiration of the moment and demolished all his former projects".[2] Now these editors had the whole course of Wittgenstein's reflections, and the responsibility of judging where to pluck remarks or collections of remarks out of the continuum. This problem was not so severe with Part I of the *Philosophical Investigations* (1953) which was left almost in the form of an (incomplete) book. And death drew a line under the reflections printed in *On Certainty* (1969), which we have in a rawer form than any other work of Wittgenstein's yet printed. But the decision to include what now forms Part II of the *Investigations,* though taken on the basis of the editors' knowledge of the complete corpus, inevitably rested in the end on a subjective decision. The same factors were at work in *Remarks on the Foundations of Mathematics* (1956) and *Zettel* (1967).

The books had varying fates: universal acclaim for the *Investigations,* a slow and still mixed reception for the *Remarks.* The *Notebooks,* puzzling though they often are, have given greater depth to the world-picture of the *Tractatus,* that picture which has long held many imaginations captive. *Zettel* contains many penetrating remarks, but it is impossible for one reader at least to overcome his frustration at not knowing whether the context in which he reads them was devised by Wittgenstein or by the editors. *On Certainty* is the most accessible of Wittgenstein's works, partly because it had not yet grown its armour. (I do not mention here the writings from the 1930s, which have so far been edited by Mr. Rhees alone.)

It is possible to criticize some points of selection or arrangement and to feel that some works (the choice will not always be the same) betray failings in Wittgenstein's inspiration, but every philosopher will be grateful that the editors behaved exactly as they did. As its living representatives and prolongation, it was their task to give us the tradition as a whole—not every word that Wittgenstein wrote, but each of the main directions that his thought followed. This, or nothing—and no one would wish for the second alternative. If it was valuable to have *Investigations,* it was necessary to have *Remarks,* because Wittgenstein drew many of his philosophical ideas from reflection about mathematics and meant them to be applicable there.

As editors they had to continue Wittgenstein's work, to create and to present to the world a corpus: footnotes and explanations were not their first task. By 1969, however, the bulk of such a corpus had appeared. It was an appropriate time to deposit the Wittgenstein papers in the library of Trinity College, Cambridge, and to make photographs of them generally available through Cornell University Library. The main lines of Wittgenstein's thoughts had already been communicated to the world. The world would now make of them what it could, by the methods applied to all great men. Texts would be scrutinized, sources conjectured, biographical details elicited, commentaries and theses multiplied.[3] Wittgenstein began to become an historical figure.

Von Wright had been the first to make the main facts of Wittgenstein's life available in his "Biographical Sketch" (Swedish 1954, English 1955), a paradigm of the memorialist's art. A number of publications after 1969 were designed to present, without much comment or interpretation, material that would throw light on Wittgenstein's life, thought, and writing. In this category fall the editions of the letters to Ludwig von Ficker (1969) and to Russell, Keynes, and Moore (1974). *Prototractatus* (1971), an edition of an early version of the *Tractatus,* contains a publishing history of that work. This is supplemented by an edition (1973) of Wittgenstein's correspondence with C.K. Ogden about the translation and English publication of the work. At the time of writing von Wright is engaged on an account of the composition of the *Investigations.* The most fundamental of von Wright's publications in this field is perhaps "The Wittgenstein Papers" (1969), a calendar of Wittgenstein's literary *Nachlass,* deceptively simple in appearance, actually the fruit of prolonged researches and obviously destined to be the point of origin for any really close discussion of Wittgenstein's writings. Very rationally the papers deposited in Trinity College library have been shelf-marked with the numbers used by von Wright.

The philosophy of Wittgenstein has, therefore, been a major preoccupation of von Wright's during the last twenty years. How far, during and before this time, has Wittgenstein influenced the philosophy of von Wright? It is difficult to give a direct answer to this question which would not be patronizing. It is obvious enough that the two men differ in style or approach. Wittgenstein's

philosophy has what von Wright calls[4] "a singular 'holisticity'. . . . every-
thing in it is connected with everything else". *Nil actum reputans, si quid
superesset agendum*—it may seem an arrogant attitude, and explains some peo-
ple's distaste for Wittgenstein's philosophy. In fact it stems from a form of
humility in the face of the problems of philosophy. These typically have a
feature noted in some of them by Ramsey:

> We seem to get into the situation that we cannot understand, e.g., what we say
> about time and the external world without first understanding meaning and yet we
> cannot understand meaning without first understanding certainly time and probably
> the external world which are involved in it. So we cannot make our philosophy
> into an ordered whole and jump to a simultaneous solution; which will have some-
> thing of the nature of a hypothesis, for we shall accept it not as a consequence of
> direct argument, but as the only one we can think of that satisfies our several
> requirements.[5]

Except that an hypothesis as such would not do. This seems to be the impli-
cation of Wittgenstein's criticisms of Ramsey. "Genuinely philosophical
reflection"[6] could not be content with a provisional solution which enabled one
to get on with the business of mathematical logic or the like. On the other
hand, though the clarity must be absolute, and no difficulties must be blinked,
it could not aspire to be a definitive clarity. Fresh considerations would arise
on another day and a new harmony would have to be sought. Wittgenstein uses
metaphors like these in the very diary-entry in which he criticizes Ramsey: the
subject is an endless band; divide it up vertically and you get strips infinitely
long, which are the despair of philosophers, who try to comprehend them ser-
iatim; but a cross-section is finite and comprehensible and if there is always a
fresh cross-section to examine, this only corresponds to the nature of the enter-
prise.[7] A philosophy that deliberately takes into account at the one time all
conflicting tendencies from different areas, a philosophy that will not allow
piecemeal advance and the holding of ground once won—at first sight this is
very different from the philosophy of von Wright, which characteristically de-
fines and delimits very clearly the question to be answered and moves by care-
fully tested steps towards a solution. Yet, in the belief of the present writer,
there are resemblances between the two much more important than this con-
trast. Von Wright sees very clearly that any artificial system, whether a set of
definitions or a calculus, does not resolve the philosophical question or make
it a matter of mere choice, but rather serves (if well-devised) to make it
sharper, to provide a new and more promising way of discussing it. (Needless
to say, there are also other interesting points about such systems.) Wittgenstein
was aware of the power of formal methods and of the remote consequences of
even philosophical assertions, much more aware than he is sometimes credited
with being. It was not for nothing that Hardy and Littlewood would discuss his
views on mathematics before the First War or that many who were to be leaders

of their profession went to his classes 'for mathematicians' in the early thirties. It is of course true (though now unimportant) that Wittgenstein did not derive much from contemporary discussion on mathematical logic or the philosophy of mathematics. With them, as with many subjects, he tended to worry over what had first struck him as puzzling—Russell's *Principles,* a lecture by Brouwer, Hardy's *Pure Mathematics* played the same role as passages in James's *Principles of Psychology,* or remarks G. E. Moore made in discussion. In order to see that von Wright and Wittgenstein are not to be taken as instances of the contrast between philosophy as a rigorous science and philosophy as a world-view,[8] it will be best to examine one of those writings of von Wright's in which he is concerned to expound and discuss the philosophy of Wittgenstein. It is probably more than a coincidence that all such writings in a major language have been published since 1969, and thus after the point at which, as we have suggested, Wittgenstein began to become an historical figure. The first of them in time was von Wright's discussion of Wittgenstein's views on probability (1969), a topic chosen partly indeed because it seemed to von Wright to be one of the few in Wittgenstein's work that lent themselves to isolated discussion, but obviously also because it was a favourite and early topic of von Wright's own researches.

Wittgenstein re-discovered—unprompted, so it seems—the logical definition of probability sketched by Bolzano. His formulation of it, mediated by Waismann, is the ancestor of Carnap's and other modern logicist accounts of the notion. The essential feature is that probability is defined in terms of logical relations already assumed as known. There is no further logical object or relation to be described and introduced: Wittgenstein's account of inference is also enough to account for probability. This of course was the reason for including a discussion of it in the *Tractatus.*

It will be remembered that Wittgenstein there defines the probability that r gives to s as the proportion of truth-grounds of r that are at the same time truth-grounds of s. Von Wright points out that Wittgenstein could instead have taken the notion of the probability *simpliciter* of a proposition as fundamental, being the proportion of the truth-possibilities of a proposition that are also truth-grounds of it—thus, p and q being distinct elementary propositions, $p \lor q$ has the probability *simpliciter* of $\frac{3}{4}$. The probability that r gives to s will then be the probability *simpliciter* of $r \cdot s$ divided by the probability *simpliciter* of r. Thus p and q being elementary, $p \lor q$ gives to p the probability of $\frac{2}{4}/\frac{3}{4}$, quite in agreement with the circumstance that two of the three truth-grounds of $p \lor q$ are also truth-grounds of p.

The case on which Wittgenstein concentrates is the probability given to s by the totality of our knowledge, call it R. Von Wright claims that if we assume R to consist of a finite set of logically independent propositions each of which is either known to be true or known to be false, and if s is neither known

to be true nor known to be false, then the probability of s given R cannot be other than ½. This is, in fact, not completely accurate. It holds, of course, if s is elementary but if s is a truth-function of elementary propositions, its probability *simpliciter* may be other than ½, its probability given R may be other than its probability *simpliciter,* and its probability given R may be other than ½. As an obvious consequence, variations in the bulk of our knowledge can lead to variations in the probability of s even if we assume the bulk of our knowledge to consist of a finite set of logically independent propositions each known to be true or known to be false. Thus if p and q are elementary and neither they nor their negations occur in R, then R gives $p \lor q$ the probability ¾ (equal to its probability *simpliciter*), whereas if $R' = R \cdot -q$ then R' gives to $p \lor q$ the probability ½.

Von Wright, then, is making the tacit assumption that s is elementary and no doubt does so because it seems that the probability of a given molecular proposition can be determined only by calculation from the probability values of its elementary propositions. But perhaps the typical situation, when a probability estimate is being made, is that the analysis of the proposition in question into elementary propositions is itself not clear. It will not be possible to explore this suggestion here.

What von Wright wished to show with the help of this assumption was that Wittgenstein had to suppose the bulk of our knowledge to contain, alongside elementary propositions and their negations, disjunctions of elementary propositions and negations thereof, such disjunctions being known to be true without the truth of any of their disjuncts being known. Such a supposition is undoubtedly implicit in Wittgenstein's discussion of probability, even if not theoretically necessary in quite the way von Wright suggests. The supposition is not altogether unproblematic for Wittgenstein; von Wright hints as much but does not attempt a more general interpretation of the *Tractatus* than is necessary for his immediate purpose.

The difficulty arises from the doctrine expressed in the 5.1's of the *Tractatus* (which discuss probability as a special case of inference)—that the events of the future cannot be inferred from those of the present and that no future action (and by parity of reasoning, no future event) can be known in advance. If I can *know* a disjunction such as $-p \lor q$, there seems to be no theoretical reason why p should not describe an event known to have occurred and q a future event known in consequence.

Still, as von Wright points out, Wittgenstein does appear to allow some knowledge of disjunctions, consequences, it seems, of "the laws of nature assumed as hypotheses". We need not force him to say that these actually are known, since he explicitly calls them hypothetical: everything proceeds *as if* they were known. Thus suppose that P is a description of all the forces acting on a material particle at a given time and that the laws of mechanics allow us

to predict the exact position of the particle at a certain later time, i.e., to yield an ungeneralized proposition of the form $P \supset q$. Then on the basis of this piece of knowledge and these laws assumed hypothetically, we may say that q is certain, or that we know that q, or that P together with the laws of mechanics gives q the probability 1.[9] This is the limiting case of probability, Wittgenstein says: and of course it is an ideal—we never know all the forces acting on a body, nor do we know all about the laws of mechanics. If a man falls from an aeroplane, it is overwhelmingly probable that he will be killed, but not certain. If a partition between two gases is removed, it is overwhelmingly probable that they will mix, but not certain. (The example is deliberately drawn from the works of Boltzmann,[10] an early influence on Wittgenstein.)

If we now consider a typical case of a judgment of probability—say that a die is as likely to fall with an even as with an odd number uppermost—we assume hypothetically that the laws of mechanics will govern the path of the die from its first shaking to its final rest. These laws we roughly know, but we are aware that in their application to the path of the die they will be modified by special respects in which the material used differs from the rigid bodies of theory, as for example the nature of the surfaces of the die, the dice-box, and the table. These special respects are tantamount to a further set of laws to which these particular objects are subject. Also we do not know the initial position of the die, the configuration of the shaking to which it is subjected, the impetus with which it is cast, all of which (together with the general and special laws assumed hypothetically) would be enough to determine the face that would fall uppermost. If we could know all these things (in the sense of knowledge which includes hypothesis), we should be certain of the result. As it is, we know only certain very general features of the relevant laws—for example, that they are indifferent to which number is initially uppermost. Whichever number that may be, there are an equal number of paths to any of the six possible results. Naturally, on a particular occasion, the shaking, the cast, the frictional properties of the substances in use, etc., make it scientifically necessary that a certain result should in fact eventuate. But here again there are an equal number of possibilities for each alternative, and there is nothing in their antecedents to favour one result. The shakings that lead to a six would not form a recognizable group subject to muscular control, even if all other factors could be held constant. (I am aware, of course, that these are substantial claims.) In short, and in Wittgenstein's own terms,

> What I am aware of in probability propositions are certain general properties of the ungeneralized propositions of natural science, as for example their symmetry in certain respects and their asymmetry in others, etc.[11]

The ungeneralized propositions referred to here correspond to the various paths I have mentioned above, and we know that the ungeneralized proposi-

tions are symmetrical in this case, or in other words that the possible paths are equally divided, because of our knowledge, all incomplete as it is, of the laws of nature:

> I cannot say before drawing whether I shall get a white ball or a black one, since I do not know the laws of nature accurately enough for that. But this much I do know: that if there are equally many black and white balls, then the number of black balls drawn will approach the number of white as drawing continues. My knowledge of the laws of nature *is* accurate enough for that.

The example is different, but the principle the same, and it seems legitimate in this case to use the *Notebooks* to interpret the *Tractatus:* they explain in what way the probability proposition can be regarded as a sort of excerpt from other propositions (Tractatus 5.156). Max Black implies the same interpretation when he says[12] that we are strongly inclined to believe we can 'see' that the propositions describing the various drawings from Wittgenstein's urn have the same logical form.

How can this inclination be supported by sound argument? Black asks, Have we not here "the ancient puzzle of how to choose 'equiprobable alternatives' or 'equally likely cases' in disguise"? Black's doubts are fundamental ones, (as von Wright points out) because the distinguishing feature of the logical definition of probability is that the requirement of equipossibility is *not* worked into the distinction of truth-possibilities. If we had to be able to assign equal possibility to a number of cases in order to reach any judgement of probability, then such judgements would involve a logical constant over and above those involved in tautological inference, and Wittgenstein's main problem would not have been solved.

Black seems to ask too much here. There is bound to be some assumption about the world in any concrete assignment of probability. Wittgenstein locates this assumption not in any direct judgement of likelihood but in the nature of the demands that we make of any framework for describing the world. If we made no demands, and hence had no general assumptions about the course that events would follow, then we should be able to assign to a proposition only a probability corresponding to a number of lines in its truth-table that verified it: probability would simply be the measure of intrinsic nearness to tautology or remoteness from contradiction. But it seems that this is an impossible supposition; we are bound to try to view the world and to describe it economically by the use of some network or other. (The metaphor is developed by Wittgenstein in the propositions 6.3 ff. of the *Tractatus.*) The employment of one network rather than another is equivalent to the assumption that the laws of nature (to be assumed as hypotheses) will have one form and not another. Thus for example we might assume that there were causal laws (6.32–6.321): or we might make the yet more restrictive assumption that all phenomena were somehow to be brought under the laws of mechanics (6.343). It is also possible to

allow for different forms of laws as in different areas (corresponding in the metaphor to a network made up of a mixture of triangles and hexagons—6.342), but for our present purposes we can ignore that. To apply this general view of science to our present case: as long as we are resolved to assume that the movement of a die is governed by the laws of mechanics—for so long will there, from any arbitrary initial position, be no more and no fewer paths by which six could be reached than any other single number, always granted that the die is true (in the sense of symmetrically constructed) and that the properties of the various surfaces are likewise indifferent. Here we know or assume something about the laws of nature involved, namely that they are indifferent to what result will ensue. We are therefore not advocating a Principle of Indifference based on ignorance. *Pace* Black, Wittgenstein does not have to meet "the devastating battery of objections directed by Keynes and others against it".[13]

We do not, therefore, need a specific assumption of equipossibility: equipossibility (or some other assignment of initial probabilities) is given us in practice by the sort of laws we assume to hold in the relevant area (say in dice-playing). We cannot then ask, But *are* these alternatives equally possible? since 'equally possible' means the same as 'being neither favoured nor frowned on by any law of a type known or conjectured by us, such laws being adequate (all circumstances being given) to account for any particular result'. We can indeed ask, Are the laws known or conjectured by us adequate?, and that will have to be answered by the three tests of a picture of the world mentioned by Hertz: Is it logically admissible? Is it true to the facts? Is it serviceable?[14]

Questions of this sort can be seen to arise when the observed frequencies disagree with the predicted probability. It is, of course, not altogether easy to determine when this has happened. At 5.154 Wittgenstein imagines an experiment concerning the probability of drawing balls from an urn. This is envisaged as successful, but had there been divergence from the expected probability, it is clear that some circumstance (some individual fact or some law) to account for that would have to be supposed to exist. To avoid some complications arising from the diminishing number of balls in the urn, let us take our example of the die. At what point do we say that the frequency of sixes diverges sufficiently from the norm for us to alter either our estimate of this die or our calculations about dice in general? Obviously we can and must tolerate some divergence from a frequency of one six in every six throws, but there is no definite answer how much—it depends on our purposes and our convenience. If we wanted a die to produce the equivalent of a set of random numbers, we might reject out of hand one that produced 10 or 15 consecutive sixes in favour of another. A manufacturer of dice for the same purpose, on the other hand, might be very reluctant to accept such a run as proof of falseness, if for example the die were by all obvious tests, a true one. It depends too on the

alternatives available: is it just this die that is biased towards sixes or any die thrown by this person? or, finally, is it to be supposed that all dice are so biased? The last possibility demands such changes in our conception of nature that it will scarcely be entertained. It is much more attractive, as long as the complications do not themselves become unattractive, to assume that there is something peculiar about this die or this thrower.

In these and similar ways, the experiment, if it reveals a divergence, will leave us with 'the choice between attributing the frequency observed to chance and to some further law to be assumed'. Von Wright—for it is his words I am citing here—regards this as a valuable insight of Wittgenstein's. He argues, however, that it makes Wittgenstein's definition superfluous as a method for computing probability-values. If an unknown law can readily be conjectured in order that the calculated probability may match the observed frequency, then we are in fact not using the laws of nature to calculate the probability but are moving directly to it from the observation of a frequency.[15]

Now it is true that the observation of actual frequencies is the only way in which current experience can affect our acceptance of a probability judgement, and for that reason it seems to correspond to the verification or falsification of that judgement. There was thus a strong temptation in the early thirties to explain the meaning of probability judgements in terms of such observation. To some extent Wittgenstein was affected by this temptation.[16] But is it clear that this forces us to abandon the definition of probability given in the *Tractatus?* It seems rather, as von Wright points out, (p. 273) that the definition helps to show that it is not legitimate to make any inference about probability from the mere fact of an observed frequency. The proposition concerning the future whose probability we wish to assess will in general be independent of those propositions descriptive of the past that come into a report of observed frequency. To affect its probability, therefore, we need to add to the bulk of our knowledge some hypothesis inspired, perhaps, by an observed frequency, but not identical with a statement of that observed frequency.

Von Wright, to whom this is perfectly clear, suggests that what the observation of frequencies can inspire is precisely an hypothesis about probability values. The definition will then become otiose in the following way: it purports to define the probability of a proposition as the ratio of the truth-grounds of the proposition in question. If this is to be an adequate definition, the bulk of our knowledge cannot itself include probability statements; but in practice that is precisely what the operative part of the bulk of our knowledge will consist of.

In a trivial sense any laws or hypotheses from which a statement of probability can be inferred will themselves be laws of probability or 'probability hypotheses'. This appears to be the sense of a passage quoted by von Wright from *Philosophische Bemerkungen:*

> The laws of probability, i.e. those on which the calculation [of probability] is based, are hypothetical assumptions, which are subsequently dissected by calculation and, in altered form, confirmed—or refuted—by experience.[17]

Obviously this is no objection to a logical theory of probability, for the point of such a theory is that there will be no more content in a judgement of probability than in the hypotheses on which it is based.

Von Wright's doubts have their origin elsewhere. He notes that Wittgenstein, who initially supposed that probability was calculated by considering the laws of nature and how they applied to the proposition in question, also or eventually held that the resulting statement of probability was to be checked by means of statistical observation, with a view to possible revision of the laws of nature assumed. This leads von Wright to ask, in effect, Is it perhaps not the laws that determine the probability but the observed frequency that dictates what laws are to be assumed? To be sure, von Wright puts this by saying that "it is no longer the measures of the sets of truth-grounds which *determine* the probabilities [but] the hypothetically assumed probabilities which now determine (hypothetically) the measures of the ranges",[18] but this way of putting it, though rhetorically effective, corresponds to nothing real. Logically speaking, a ratio of measures (in the present paper: a truth-ground ratio) *is identical with* the probability conferred on one proposition by another. In the order of discovery, von Wright would not suggest that an assumption of probability itself comes first. His point is that the calculation of probability starts from an observed frequency, not as Wittgenstein suggests from a set of laws of nature.

A superficial answer to von Wright would be to say that while the observed frequency does indeed inspire the hypotheses from which the probability is calculated, nonetheless, (as he himself points out) something more than a statement of observed frequency is needed to yield a statement of the probability-form. The least advance on an observed frequency that will serve for this purpose is a statistical hypothesis, the elevation of the observed frequency into a law. The probability statement will then run: the circumstances known to us, including the statistical laws that experience recommends, give to such-and-such an event the probability p. Wittgenstein's hypothetical laws of nature have been replaced by statistical laws (likewise hypothetical), the experimental testing and the inspiration of probability statements have been assimilated to one another, and the calculation of further probabilities from those so assigned can proceed according to classical methods.

This suggestion amounts to treating a statement of relative frequency as the only, or the chief relevant, law of nature from which initial probabilities are calculated. Von Wright[19] is justly reluctant to adopt this method of harmonizing the various statements of Wittgenstein about probability. There are difficul-

ties of principle about the suggestion—so that if Wittgenstein did adopt it, his
views would be open to criticism and, so far forth, would not work. And there
are exegetical difficulties—that is to, say the suggestion is hard to reconcile
even with the surface meaning of what Wittgenstein states.

The difficulty of principle arises because (if there is any continuity with the
Tractatus in the writings of the 1930s) Wittgenstein's aim is to exhibit proba-
bility statements as a way of showing a certain relation between the logical
forms of statements which are themselves unproblematic—or relatively so.
Typically, as we have seen, this will be between a prediction and a set of
observation statements and laws of nature. Now a law of nature will be a
general hypothetical or disjunction with clear implications for observation. A
statement of relative frequency, however, in the sense of a statistical *law,* can
have no such simple relation to observation. We could proceed to observe any
frequency whatsoever and still maintain that our hypothetical statistical law was
not refuted, since the statistical law contains no stipulation of the time within
which the observed frequency has to approach to the predicted one. In other
words, statistical laws behave, as regards verification and falsification, exactly
like judgements of probability. When we enounce a statistical law we are not
saying what *will* happen within a specified time but what it is *reasonable to
expect* to happen. It is of no use to introduce that notion to explain what prob-
ability is, since it itself is what requires explanation. Or, to put it in terms of
the problematic of the *Tractatus,* a probability value will be part of the content
of our hypotheses, so that probability will not be explicable as a certain pattern
of other logical relations but will be a primitive notion. (This is why von
Wright says—and regards it as an objection to Wittgenstein—that what obser-
vation inspires is precisely an hypothesis about probability values. The objec-
tion is an important one, even though the passage from *Philosophische Bemer-
kungen* by which he supports it has a different *portée,* as explained above.)[20]

This difficulty of principle can be put in another and more acute form. It is
not for nothing that Wittgenstein in the *Tractatus* wants to exhibit probability
as a form of logical relationship between propositions. The alternative is to
suppose that there is such a thing as probability *in rerum natura.* But just as
there *is* no causal nexus (*Tractatus* 5.136) so there is no *tendency* in things, no
tendency, say, to fall out a certain way in 57.8 per cent of all cases on average.
One way of becoming clear about this is to see that nothing will count as
evidence that there is such a tendency. From an observed frequency we can
indeed predict inductively that the same frequency will prevail over the next *n*
cases. But we are never in a position to say with any show of reason that the
observed frequencies entitle us to disregard a particular run and call it chance.
By parity of reasoning we must adjust our inductive prediction with every one
of those *n* cases. This is why Wittgenstein says,

> If we draw inferences from the relative frequency of an event about its relative frequency in the future, we can do so, of course, only in accordance with the frequency actually observed so far, and not in accordance with a frequency obtained from the observed one by some process for calculating probabilities.[21]

If frequency is what we rely on, we are at the mercy of frequency, and we can never arrive at a statement that will allow for a temporary divergence from the 'real' probability.

Probability is essentially something from which the course of events can *diverge:* and they clearly cannot diverge from their own actual course. Is there, then, such a thing as probability? According to Wittgenstein, there is—only not as a feature of the world, but as a feature of our system of description. It is not a tendency in things that enables us to disregard a particular run, for that would involve the arbitrary preference of a shorter statistical series to a longer one. It is, rather, a picture of the world to which we are independently committed. Our world-picture is subject to revision in the light of experience including the statistical results in question, but it does not have to fluctuate with every trough and crest in the series. The concept of probability, as we have it, exists because there is a tension between the a priori expectation and the frequencies we can observe.

These two elements—the a priori and the a posteriori—make their appearance in the last paragraphs of the section on probability in *Philosophische Bemerkungen*.

> What does it mean to determine that two possibilities have the same probability? Does it not mean first that neither of the two possibilities is preferred by the laws of nature known to us and second that the relative frequencies of the two events approximate to one another in certain circumstances.[22]

No matter that the formulation is crude: the presence of the two elements is clear enough—and it is naturally enough a central feature of Waismann's 1929 paper, which professedly and actually developed Wittgenstein's ideas.[23] In his conversations with Schlick and Waismann Wittgenstein discusses the procedure of postulating further causes to make the relative probability agree with the probability a priori and insists that "the further circumstances that we introduce ought not to have the character of assumptions invented *ad hoc*."

In practice, this last demand means that we do not speak of an above-chance probability, for example, of a clairvoyant's being right about the pips on a card unless we are prepared to suppose that in certain physical conditions the number or the gestalt of the pips has some effect (perhaps an ambiguous effect) on her. Some half-way plausible story must be envisaged if there is to be an assertion of probability at all. It should be noted that this is not a recommendation of Wittgenstein's about how to talk or what sorts of demands one

ought to make before introducing the word *probability*. It would indeed be reasonable to make such a recommendation about what sort of predictions to rely on. The point here, however, is a logical one: a statement can be a statement of probability only if it has some independent basis in our picture of the world, some anchorage which makes it resistant for the time being to the fluctuations of frequency.

The criterion is a vague one: clearly it prevents us from saying, immediately we observe a relative frequency, 'The world must be such that this frequency holds', since as already observed we could then have no reason not to alter the probability the moment a variation in the proposed frequency appeared. But how much of a story and how well-supported a one is demanded? The vagueness is in one respect no disadvantage. Obviously assignments of initial probabilities in different areas can be variously supported and can differ in degree of reliability. There are, however, some areas where our information is a mixture of statistical data and reasonable expectations and in these it is not easy to see how Wittgenstein's criterion applies or whether (in consequence) we can properly speak of probability at all. The prime example here (it is his own) is mortality statistics, as used by insurance companies. The a priori probability available to us is of slender importance; we know something about the usual causes of death. Assuming no reason for them to increase in virulence, we suppose that there are changes in the human body as it gets older which increase the number of ways in which each of these agencies can produce death (more briefly put, resistance to each cause of death decreases with age). But whether these agencies will increase in virulence in a particular period, by reason of famine, pestilence or war, we cannot always say. This suggests a fairly simple age-pyramid—or different ones for men and for women, since the ageing process is obviously different in the two sexes. But these are very general considerations; and there is very little reason to expect a particular height for the pyramid or a particular direction of difference in longevity between men and women. We can imagine physiological theories that would allow a shape other than pyramidal—say theories allowing for a climacteric. It is possible to accommodate our theories to the statistics, and this may indeed prove a fruitful source of ideas for research into cellular structure or other phenomena associated with ageing. But just by themselves, and if they have no purpose except to fit the statistics, such theories are (as in the present paper) the merest vapourings. They would not alter by a tittle the odds that a person knowing the statistics would be prepared to accept.

It seems then (and practice agrees with this) that in these cases it is simply the observed frequency that determines the assignment of a probability value. In the conversation referred to above Wittgenstein drew the conclusion:

> 'Here it is a matter of probability *a posteriori*. There is no connexion with probability [scil., with probability proper]'.[25]

An insurance company, according to this view, obtains the 'probability' that a forty-year old man will live to be sixty purely by induction from the number of persons known to *have* survived for so long (Wittgenstein does not specify over what period). This is a prophecy of what will happen 'over the next ten or seventy years' and is straightforwardly verified or falsified by the way things actually turn out.

Very little, I believe, speaks against the above account as an interpretation of Wittgenstein. It is the general tendency of his remarks in the three sources from the early 1930s *(Philosophische Bemerkungen, Philosophische Grammatik, Wittgenstein und der Wiener Kreis)* though a little obscured by an allusion (not followed up) which appears to make the gambler parallel to the insurance company.[26]

More doubt will be felt about the truth of the account. It is a bold claim that no amount of statistical evidence can alone provide a basis for judgements of probability. It is a nice distinction which allows that we have inductive grounds for expecting k percent of men now aged forty to die in the next twenty years but refuses to admit that there is a probability $= 100 - k/100$ of such a man's living to be sixty. Both claim and distinction, however, rest on an insight and a conviction which have (like Wittgenstein's whole doctrine of probability on von Wright's account) both a logical and an epistemological aspect. The epistemological point is that no more can be drawn from statistical data than they contain: you cannot combine two statistical probabilities to obtain a third without some grounds for assuming independence in respect of the relevant properties, but these grounds will either consist of an a priori theory (contrary to hypothesis) or of a further statistical observation, which would by itself serve to establish the statistical probability. The logical point is a deeper one and explains some of the obliquity with which the epistemological point has been expressed: a statement of probability must place a proposition against a background taken for granted and say of the proposition, not indeed that it is true, but that it is a reasonable expectation (up to a certain degree). In order to utter a statement of probability, therefore, we must posit some such background; and the word 'posit' is chosen because the background is fixed and the expected frequency (in cases of recurring phenomena) is derived from it. If the background were to alter immediately with the observed frequency, then there would be in effect an immediate inference from observed to expected frequency and the calculation of probability would indeed be an idle step in the inference.

It will not be argued here that Wittgenstein was successful either in excluding purely statistical reasoning from the realm of probability or in showing that reasoning about probability was only apparently statistical. Either task is difficult and this perhaps accounts both for the indecisiveness of Wittgenstein's pronouncements in the early 1930s and for his not returning to the precise subject in his later work.[27] The purpose of this paper is to suggest that the

logical definition of probability advanced by Wittgenstein was on the one hand
an ingenious answer to a relatively isolated problem, but also rested on a fun-
damental insight or tenet of Wittgenstein's. The insight I have in mind re-
mained with him in some form or other throughout his philosophic life. At the
time of the *Tractatus* it is to be seen in his view of the most general proposi-
tions of science as a network which, once elected, determines our description
of the world. The network imports necessary propositions and inferences which
logic alone would not suffice to produce. At the end of his life, in *On Cer-
tainty,* it reappears in his notion of a world-picture which embodies the way of
life of a community: such a world-picture too, like the network of the *Tracta-
tus,* issues in certainties that are not those of logic.[28]

Further discussion of this point would lead very naturally into the two other
areas of Wittgenstein's philosophy on which von Wright has written—the place
occupied in a philosophy by modal notions, and the special logical role that
Wittgenstein assigned to certainties.[29] The aim of this paper has been to show
that in the particular area of probability-theory Wittgenstein exhibited not only
the considerable technical proficiency pointed out by von Wright but also his
customary eye for the connexion of these details with the deepest problems of
philosophy—exhibited, in fact, that particular combination of qualities in
which von Wright most resembles him.

QUEEN'S COLLEGE BRIAN McGUINNESS
OXFORD, ENGLAND
DECEMBER 1974

NOTES

1. Quoted by Rush Rhees in *The Human World* 15–16 (1974), p. 153. The trans-
lation is slightly adapted from his.
2. My translation from a letter to Schlick, 9 August 1934, for sight of which I am
indebted to Mrs. Barbara van de Velde-Schlick.
3. Some, but not all, of this can now—1988—be seen to have occurred.
4. In 'Wittgenstein's Views on Probability', *Revue Internationale de Philosophie*
23 (1969): 259–279, 259, hereafter cited as *RIP*.
5. Frank P. Ramsey, *The Foundations of Mathematics*, p. 268.
6. For the phrase, see Rhees in *The Human World*, p. 154.
7. "Die Philosophen wollen also gleichsam den unendlichen Streifen erfassen und
klagen, dass dies nicht Stück für Stück möglich ist. Freilich nicht, wenn man unter
einem Stück einen endlosen Längsstreifen versteht. Wohl aber wenn man einen Quer-
streifen als ganzes definitives Stück sieht. Aber dann kommen wir ja mit unserer Arbeit
nie zu Ende. Freilich nicht, denn sie hat ja auch keins." From Wittgenstein's *Tagebuch*,
1.11.1931. In compressing I no doubt interpret.
8. A contrast interestingly discussed in Hao Wang, *From Mathematics to Philos-
ophy* (1974), p. 353.

9. This accords, I think, with Miss Anscombe's interpretation of Tractatus 4.464 and 5.525: "The certainty of a situation is expressed not by a proposition, but by an expression's being a tautology etc." It is not the tautology itself that is 'known' or 'certain' (see 5.1362), but one or more propositions can make another certain or enable us to know it, and this is expressed by a tautology. See G. E. M. Anscombe: *An Introduction to Wittgenstein's* Tractatus, pp. 155 ff.

10. See, for example, *Populäre Schriften*, p. 36; *Theoretical Physics*, p. 17.

11. This passage and the one quoted immediately below are taken from Wittgenstein's *Notebooks* for 8 and 9.11.14

12. *A Companion to Wittgenstein's* Tractatus, p. 257.

13. A prominent objector, much cited by Keynes, was J. von Kries. It is quite possible that his work was known to Wittgenstein either through conversation with Keynes or by his reading of Boltzmann. But von Wright's conjecture that the notion of *Spielraum* was drawn from von Kries is rather bold, since Wittgenstein does not in fact use this notion in connexion with probability, that application being made by Waismann.

14. Hertz: *Principles of Mechanics*, pp. 1–3: for an account of the parallels between Hertz and Wittgenstein see J. P. Griffin, *Wittgenstein's Logical Atomism*, pp. 99–108.

15. *RIP* (1969): 275–76.

16. I will not discuss here the shift from the logical to the epistemological pole in Wittgenstein's thinking which von Wright describes convincingly.

17. *PhB*, p. 290, quoted in *RIP* (1969): 275–76.

18. The notion of measure introduced by Waismann is not essential to the argument of the present paper.

19. See the reported discussion after his paper (*RIP* 88–89 (1969): 381) where he describes the use of the term 'laws' for statistical laws as a piece of mystification.

20. See footnote 17 above and text.

21. *Philosophische Grammatik*, p. 234 (*Philosophische Bemerkungen*, p. 292).

22. *PhB*, p. 297.

23. The paper was printed in *Erkenntnis* I (1930–31): 228–248 and reprinted in Friedrich Waismann, *Was ist logische Analyse?* (Frankfurt, 1973).

24. *Wittgenstein und der Wiener Kreis*, p. 95 (conversation of 5 January 1930).

25. To this remark Waismann appended a mark of interrogation. Much of this conversation may have been intended as criticism of Waismann's paper which was delivered in 1929.

26. *PhGr*, pp. 234–35. On my interpretation of Wittgenstein, the gambler, in contrast with the insurance company, is guided by a priori probabilities.

27. The probability mentioned in *Philosophical Investigations* §§ 482 and 484 is the probability of an hypothesis, and so, according to Witttgenstein, is something totally distinct from that in question in the present discussion.

28. Some parallels between *On Certainty* and the *Tractatus* were drawn by the present writer in his comments on von Wright's own paper in *Problems in the Theory of Knowledge* (1972).

29. See, respectively, 'Some Observations on Modal Logic and Philosophical Systems', *Contemporary Philosophy in Scandinavia* (1972) and 'Wittgenstein on Certainty', *Problems in the Theory of Knowledge* (1972).

7

David Braybrooke

THE CONDITIONS ON WHICH RULES EXIST

W hat is a rule? The best answer that we have so far, I think, is that to talk about rules is to talk about forms of words used by human beings to control their own actions or the actions of others and susceptible of the three-tier analysis that von Wright supplies in *Norm and Action* and other works—a tier of deontic logic superimposed upon a logic of action which rests in turn upon a tier consisting of a logic of change.[1] For example, the prescription addressed to Members of Parliament defeated in an election just past: 'You must give up your seat to the opponent with the largest number of votes,' where 'must' operates deontically upon the description of a generic action designed to 'change the world' from state p, in which the defeated member sits in Parliament and his victorious opponent does not, to state non-p, in which the defeated member no longer sits and his victorious opponent sits instead.

Of course, to talk about any one rule is not to talk merely about one form of words, since one and the same rule may be expressed in many different forms and in some cases none of these forms is canonical, though any one form may serve to illustrate the rule and concentrate discussion of it. Familiar difficulties, parallel to those affecting the notion of a proposition, immediately rear their heads. To distinguish between the formulation of a certain rule and the rule itself inevitably suggests that rules exist separately from their formu-

Versions of this paper have been read to the Halifax Philosophy Circle; the Department of Philosophy at the University of Western Ontario; and the Philosophy Club of Sir George Williams University. I am grateful for the comments made then and afterwards by people present on these occasions; in particular to my Dalhousie colleagues Robert M. Martin, who read a prepared comment at the meeting in Halifax, and Alexander Rosenberg; and to Robert W. Binkley, David A. Gerber, and William L. Harper, who took the leading parts in the discussion from the floor at Western. I also wish to thank W. H. Dray, who encouraged me to treat causal conditions as well as ascription conditions; and J. Murray Beck, who advised me about certain aspects of Canadian politics.

lations; and indeed it is convenient to talk this way, especially since we want to consider rules that have never yet been formulated and want to treat rules that have been formulated as continuing 'in force' during intervals of oral tradition in which no one is currently expressing them. In principle, however, I am ready, or very nearly ready, to assume that every statement (for von Wright, every 'normative statement') asserting the existence of a rule can be translated by more or less strenuous efforts into some finite combination (perhaps a very lengthy and entirely unperspicuous one) of statements about the uses or possible uses of forms of words (tokens) that are functioning as rule-formulations.[2] 'Very nearly ready': my reason for hesitating is that I do not want to forfeit the opportunity to claim that rules are theoretical entities, entitled in explanatory connections to the same respect as any other; and the prevailing view of theoretical entities seems to be that they would lose their peculiar virtues if they were reducible by way of finite translations into an observation language. I think this view may well underestimate the theoretical disadvantages of inconvenience—why should the convenience of a way of talking not foster the same theoretical virtues as any necessity of talking that way? But I am not going to attack the prevailing view in the present paper.

The difficulties of existence are at their minimum with formal rules, like those of statute law, where canonical forms of words can be identified and found to persist (in tokens that are inscriptions) during the whole time of their being in force. Even there the most important and interesting difficulties arise within the ontology of convenience, which accepts the existence of rules, rather than about the reduction of that ontology to one more austere and fundamental. People concerned with legislating and applying formal rules carry on their business within the ontology of convenience. Most of the chief problems have to do with understanding how they understand their business given this ontology: Which rules do they accept as being in force, and on what grounds? What is the source of authority for valid rules? Can it be inconsistent? Must it operate itself according to certain rules, and do these rules depend upon sanctions in the same way as the rules which the authority enacts according to them? How are rules related formally to actions that conform to them? To actions that violate them? In what sense can rules be inconsistent with one another, or an action inconsistent with a rule? These are the sorts of questions that have preoccupied von Wright and he has treated them chiefly in connection with formal rules. Much remains to be done, in spite of all that he has accomplished: He has, for example, treated these rules as if they were identical in logical form with commands addressed to individual agents; and while one can easily transpose his observations to the field of law by thinking of a law as a conjunction of commands addressed to indefinitely many individual agents one has to make the transposition without benefit of formalism. One may wonder, meantime, whether the notion of a command has not been given so much prominence that the differences between commands and laws have been lost from sight.

Even as things stand, however, von Wright's analysis of formal rules offers an invaluable means of tackling the much more formidable difficulties surrounding informal rules.[3] There too, as von Wright's discussion implies,[4] the people who have to do with the rules—those who generate them and are subject to them, as well as those who ascribe them to others—carry on their business within the ontology of convenience; but their business is much more difficult to understand, and the rules that they deal with much more elusive. Yet I think, in accordance with von Wright's own view of the potential scope of deontic logic—which he surely never intended to be confined to the analysis of statute law—the rules can in every case be expressed in forms of words susceptible of the three-tier analysis: as prescriptions analysable, to use the symbols of *Norm and Action,* as $Od(pT \sim p)$ (etc.); as prohibitions, $Of(pTp)$ (etc.); as permissions, $Pd(pT \sim p)$, $Pf(pTp)$. (In their most generalized, hypothetical form these formulas provide also for mentioning the *conditions* on which the actions in question are to be done or forborne.)

Von Wright has, I think, been too diffident about the generalizability of the three-tier analysis—in *Norm and Action* he claims for it direct application only to formal rules. He has not given enough weight, perhaps, to the freedom with which people occupied with informal rules (including social scientists seeking to find them) think of them indifferently as rules of games ('rules' in the narrow sense that von Wright adopts at the beginning of *Norm and Action*) or as technical norms, as well as interpreting them as laws or commands, the objects which von Wright has had chiefly in view in the three-tier analysis.[5] (A technical norm may be expressed by an if-then sentence, in which the consequent expresses a norm offered as contingent on a want hypothesized in the antecedent: for example, 'If you want to sit in Parliament, you must win a plurality of votes in a riding.')

More important, as his discussion (in *Norm and Action*) of customs and moral norms seems to show, he may have sensed a radical difference in form between a norm in which deontic operators suitably figure and what David K. Lewis has recently analysed[6] as a *convention,* namely, a system of mutually congruent expectations and preferences on the part of a number of agents who accordingly conform to a regularity useful to each of them. Lewis himself, however, has given us the clue to fitting the two things together: A convention is not a rule (norm), but it may serve as the foundation for one[7] (as natural obligation in Hume serves as the foundation for moral obligation); and the rule once founded may be supposed to have as one form of expression a form in which the deontic operators and other features distinguished by von Wright's analysis figure.

The notion of convention, as developed by Lewis, in fact furnishes a remarkably useful bridge between the two fields of rules, formal and informal. For we may hypothesize that it is by processes like the adoption of conventions and the subsequent generation of rules that laws originated before men fully

developed explicit procedures for legislation. Formal rules now codified were in many instances preceded by rules (like those of the common law), informal in origin though tending to become formal in the tradition of the courts, and throughout having much the same significance and effect. ''Formal'' and ''informal'' here clearly do not mark a hard and fast distinction. The notion of convention also helps us to find reasonably solid grounds for identifying some of the informal rules that we may wish (for purposes of understanding their actions) to ascribe to various groups of people; and I shall take due notice of this fact. It is far, however, from clearing up all the chief difficulties about the existence of informal rules (and it is not so intended). These, which I take to be the most important of the problematic aspects of the general theory of norms, fall under two main heads, ascription-conditions and causal-conditions. I shall treat both, but since the treatment suitable for permissions is very different from the treatment suitable for the easier cases of prescriptions and prohibitions, I shall put off treating permissions until I have dealt fully and separately with both sorts of conditions as they apply to prescriptions and prohibitions.

1.1 Existence-Conditions for Prescriptions and Prohibitions: Ascription

In accordance with my preliminary remarks, I am adopting the working hypothesis that when we ascribe a certain prescription or prohibition to a group of people (as one of their rules, at least during their current activity) we are saying, fundamentally, that they may be looked upon as acting in accordance with a certain form of words, which could be used to produce much the same effect, since we might suppose that the people concerned would heed the words. The words, specifically, will take a form given by the three-tier analysis (in one version, $Od(pT \sim p)$ etc., or $Of(pT \sim p)$ etc.); or a form that can be translated into such a form.

What conditions must be satisfied in a given case if we are to make such an ascription and justify doing so? I shall consider four: group-definition, conformity, enforcement, and intentionality. They are, I believe, individually necessary conditions; I dare hypothesize, they are jointly sufficient.

The first of these conditions, group-definition, is relatively unproblematic. There must be a group for the rule to be ascribed to as a rule of that group; and it must be a group of a certain kind. Invoking a familiar sociological distinction, one excludes merely statistical aggregations (curly-haired men under five feet five inches in height; people the world over who have been bitten by bats). One would perhaps like to say one excludes them because they do not—like genuine, organized groups—carry on any joint, continuous activity in

which the members play interacting rules. Yet this reason carries too far. The most convincing cases of rule-ascription may have groups in view that carry on continuous joint activity with interacting roles governed in part by the rules ascribed, in part by other rules that can be invoked to identify the groups. But apparently groups whose activities are very little organized and quite intermittent still have rules: The people in a theatre queue, for example—who exemplify what Sartre calls a 'serial' grouping rather than what he considers a genuine group—may have no direct relations with each other apart from the queue; but intermittent and transitory as their activity in the queue may be, it conforms to rules: for example, a rule of precedence.[8] Likewise, games and rituals that are seldom played are still played according to rules that may be ascribed to their players (and to the larger organized group from which the players are drawn). The Estates-General did not meet for 175 years, but it is not unreasonable to say that the rules governing its composition and operations were rules of French society all along. The fact that people in a given society are not always playing tennis—indeed that some of them never play—does not imply that they do not have rules for playing tennis when they wish to.

A sensible solution to the problem about groups seems to be to say: let a group be identified as a number (set) of people all of whom are engaged in carrying on some joint activity, distinct in kind or in epoch or in location; or all of whom communicate with other people in the group distinctly more frequently than any of them communicate with people outside. The Society of Jesus or an international sports association would be embraced by the first of these provisions; a society of subsistence farmers, with little if anything in the way of government or other central institutions, would be embraced by the second. It is to groups embraced by one or another of these provisions that rules are ascribed, as rules of those groups. We may include among their rules the rules of their intermittent activities, some of them activities with *ad hoc* selections of participants. Thus while the group waiting in the queue could be regarded as qualifying under the first branch of the solution, we can escape the embarrassments caused by the tenuous nature both of their activity (waiting) and its jointness (waiting together), and caused also by the suspicion that there is little to distinguish the group itself beyond the rule which we ascribe to it. We can escape by ascribing the rule of precedence according to which the queue is formed to (for example) the nation from which the members of the queue are drawn, or within whose territory (where its customs apply) they have come together.

The conformity condition, to take up this ascription-condition next, is easier to deal with on the side of formal rules than on the side of informal ones; for strict conformity need not be required, so long as it can be established that the rules have been promulgated with due authority. One must find conformity for the most part even so, and some effort to deter or punish violators, else the

rule will be a dead letter. However, one may begin an inquiry about what rules to ascribe to the group by trying to identify the source of the authority and the criteria (Hart's secondary rules) that a rule must meet to be accepted as emanating from that source.[9]

On the other side of the analogy, with informal rules, the approach must be the reverse, for there the authority—if authority is to be reckoned with— may be so diffused through the group as to have no definite source, and no definite plan of action governed by secondary rules. There one wants to identify rules only as means of generalizing or explaining observations of behavior. There is no generalizing or explaining to be done unless there is an impressive amount of conformity. So with informal rules one begins with conformity. If there is perfect conformity, the existence of the rule can be upheld (in respect to the conformity condition) without any need to inquire into authority or some analogue of authority. But suppose that there is not perfect conformity; then the question about authority may come in by way of the question of enforcement. Conformity for the most part, and prosecution followed by penalties for the rest, would substantially fulfill the conformity condition. Of course the penalties need not be severe ones. Verbal reprimands, perhaps disgusted looks from the spectators, may suffice as the penalties required; so may self-reproach. The authority in such cases would be simply the members of the group, concurring (though imperfectly concurring) in upholding the rule. It may be taken as a mark of an informal rule that there is no specialized institutional authority for enforcing it (though authorities specialized for enforcing formal rules may carry special weight in enforcing informal ones: imagine the Queen reprimanding someone for discourtesy). In societies where there is no specialized authority for enforcing any rules (e.g., Plains Indians laughing all night at a violator) the distinction between formal and informal rules breaks down.

In general, it appears that a prescription or prohibition will fulfill the conformity condition for ascription to a group if there is enough in the way of a mixture of conformity and enforcement to give ascribing the rule a point. The point may be that the rule in question is useful by itself in predicting the behavior of members of the group or useful by itself as a guide to participating in the life of the group in that branch of its activities. In addition to serving both of these functions, the rule may be lent significance by the alternatives which it excluded (familiar ones, which it is surprising to see set aside; or bizarre ones, which would have far-reaching consequences). But the point may be, as well, with the emphasis lying here, that the rule is an ingredient in a connected account or system of several rules, perhaps many rules, where the account or system either itself supplies a theory that goes some distance in explaining the conduct of members of the group or lends itself, with the behavior that it describes, to explanation by such a theory.

Theoretical interests thus help determine which rules will be mentioned in accounts of a group and its activities by determining how stringent the conformity condition will be which rules have to meet to be ascribed to the group. Theoretical interests also operate more directly on choices about mentioning. The prescriptions and prohibitions that might be truly ascribed to a group in respect to any given activity, or in respect to all its activities, might not be quite so unmanageably numerous as the permissions. They will nevertheless sometimes be very numerous indeed and sufficiently unmanageable to require practical decisions governed by theoretical interests. There are, for example, very likely prescriptions of some kind assigning more or less attractive office space to Members of the Canadian House of Commons; it is easy to imagine having no theoretical interest in mentioning them and hence no occasion for doing so.

I have indicated that I conceive of 'theoretical interests' as attaching to almost anything that one would want to call a theory, from antropologists' hypotheses about what the actions of people in a given culture signify as to the rules prevailing therein, to psychologists' attempts to explain conformity to certain behavior-patterns by conditioning in childhood. They embrace questions of form (as suited, for example, to the construction of axiomatized systems) as well as questions of content. Thus 'theoretical interests' will govern choices among equivalent forms of expression: Instead, for example, of citing a prescription about defeated Members of Parliament giving up their seats and instead of presupposing a definition of 'defeat', I might have given a prescription and a prohibition applying to all candidates—the prescription requiring the candidate with the largest number of votes in a riding to take the seat in Parliament assigned to the riding, the prohibition requiring the other candidates to stand aside while he does. There are of course many other possibilities. There always are. One of the disturbing things about the informal use of the concept of rule (perhaps also a disturbing aspect of the ontology of convenience) is that it lends itself to such fluid manipulation. Yet the significance of expressing the rules in one way is not really undermined by the multiple possibilities of expressing them otherwise. The multiple possibilities in fact afford a useful freedom to theory-construction, and theoretical interests do in fact lead to sensible selection among the possibilities, as the literature of social science abundantly shows, though the selections can no more be predicted in detail than the theoretical interests.

Deliberately, and I think inevitably (since without it I could not have explained how imperfect conformity might suffice as the basis for inducing a rule), I have brought in the enforcement condition in the course of discussing conformity. The enforcement condition deserves some separate attention, however, for it is characteristic of rules that they are enforced against lapses from

conformity. Some writers (e.g., A. R. Anderson)[10] have insisted upon connecting rules with sanctions in the course of applying von Wright's early proposals about deontic logic. Von Wright himself doubts whether every rule is accompanied by sanctions;[11] but this is not perhaps the same thing as doubting that every existing rule is necessarily associated with enforcement.

Nullification and ostracism (exclusion) may seem to be penalties too promiscuous to be classed with particular sanctions like fines or imprisonment, since, unlike the latter sanctions (and unlike moral reproach among the particular sanctions) they attach to every rule that lacks particular sanctions. Whether they are painful or not is beside the point, since some particular sanctions are negligibly painful. In real life they may be quite painful, and often are; moreover, they often operate in conjunction with particular sanctions backing associated rules. Behind the prescription addressed to defeated Members of Parliament there is a rule about what shall count as defeat, namely, obtaining fewer votes than at least one other candidate in the same riding. Looked at as only a definition for the vocable 'defeat', it would have no sanctions attached to it at all; it would be no more than a convention (which had perhaps not yet attracted the support of a rule upheld by people who seek to enforce 'correct English' with their reproaches) and failure to conform to it would lead to nothing worse than incomprehension (though here only a hair's-breadth separates support for a convention from enforcement of a rule). It is not in fact just a definition, nor a convention: A Member of Parliament who refused to abide by it and acknowledge therefore that the other rule about giving up one's seat applied to him would be compelled to heed it, by nullification of his attempts to act otherwise; by exclusion, if necessary by invoking particular sanctions attaching to the second rule (for example, penalties for disorderly conduct).

Nevertheless, there are people who could flout the definition of 'defeat' without exposing themselves to any measures of enforcement. Even members of the public having business with Members of Parliament could choose to use 'defeat' in a deviant way and accordingly refuse to recognize that some Members of Parliament had lost their seats; they would act in vain, perhaps, applying to those former Members for assistance, but they would not (like people trying to take seats in the House of Commons that they were not entitled to; or—former Members or their staffs—trying to keep their official rooms and emoluments) necessarily suffer any counter-measures intended to nullify their actions or exclude their persons. Members of the public who had no occasion to deal with Members of Parliament past or present would not even be liable to having their actions go in vain; their only danger in refusing to abide by the definition of 'defeat' would be that of jeopardizing their chances of communicating with people who did abide.

We might try to save the connection with enforcement by saying that the definition of 'defeat' generates a rule to be ascribed only to people (Members

of Parliament, their staffs, the payroll office and other branches of the civil service) against whom measures of nullification and exclusion (failing particular sanctions) would be taken. For other people it would be at most a linguistic convention. (Similarly, 'out of bounds' is a matter both of convention and of rule for players, referees, and scorekeepers; but of convention only for the spectators.) However, an example that von Wright brings forward to illustrate rules that he holds are not backed by sanctions[12] succeeds at least far enough to make some adjustment in this solution desirable. People who live together without being married might be liable to some sanction; but how does that sanction attach to the rule or rules which define valid marriages? As I have indicated, I am inclined to say, the sanction attaches indirectly, by coming into play against people who flout the defining rules and nevertheless live together; moreover, nullification and exclusion will operate against some attempts to flout the defining rules (e.g., to claim a dependency under the income tax laws; or—for a judge—to waive the sanction). But what of people who are not married and who do not wish to live with anyone to whom they would be marriageable?

I think von Wright is justified in assuming that they nevertheless belong to a group to the whole of which the defining rules as well as the sanctioned rule about only married people living together may be ascribed. A better solution than the one of holding that the definition supports a rule to be ascribed only to those people to whom measures of enforcement apply—in this case, only people who live together or propose to live together, plus some people (judges, income tax agents, et.al.) involved in administering associated rules—is, I think, this: A prescription or prohibition may be said to be a rule of a group G even if the measures of enforcement associated with it apply only to the sub-class of the group who voluntarily take part in certain activities carried on within the group. People outside that sub-class will heed a linguistic convention that corresponds to the rule; moreover, they will be ready to recognize that the measures of enforcement will apply to them too if they should take part in the activity. I might note that the need for such a view of the enforcement condition arose as soon as I mentioned games and rituals seldom played, perhaps not played at all by some members, nevertheless having rules that are to be treated as rules of the whole group.

The rule about what is to count as 'defeat' looks like a constitutive rule, which von Wright, like Searle and other philosophers, wishes to distinguish from other rules that regulate an activity already constituted.[13] This is a different distinction from Hart's distinction between secondary rules and primary rules, since not all constitutive rules (I suppose) have to do with conferring or taking away powers and statuses, or with the gestation of further rules. The two rules about defeat and giving up a seat in Parliament were secondary rules, and counterexamples to Hart's contention that secondary rules are not accom-

panied by sanctions; they were also constitutive rules of the practice of parliamentary government. Other rules, constitutive but not secondary, equally consort with the enforcement condition, which neither distinction should be allowed to overshadow. Nothing, so far as I can see, prevents a rule, constitutive but not secondary, that one would choose as a defining condition of a certain activity or practice from being a rule that is not only enforced, but even directly accompanied by sanctions. Is not the rule 'players must not carry the ball' among the most eligible candidates for recognition as a constitutive rule of soccer? But this rule is enforced by sanctions not consisting merely of nullification and ostracism. Moreover, the division between constitutive rules and non-constitutive ones is surely optional. One perhaps does not have entire freedom respecting what rules will be considered constitutive ones in characterizing a given activity, but one can certainly choose between smaller and larger sets of constitutive rules. It would be odd to suppose that a rule could be accompanied by sanctions under one option and not under another; how could opting for a richer definition of the activity change observable features of the rules? However, again, the fundamental issue is one of enforcement: If the constitutive rules are not enforced, directly or indirectly, and whether by sanctions or not, then the activity is not receiving normal protection for its character and conduct against lapses from conformity.

The enforcement condition implies intentionality on the part of the people concerned with making provisions for enforcement and invoking them; but it does not imply all the intentionality that is needed as a basis for rule-ascription. Once set up, the provisions for enforcement might work automatically. (One could imagine penalties being dealt out by a computer which, for example, turned off for a time the electric power going to violators' houses.) People might give an appearance of conforming to a prescription or prohibition when all that they were trying to do was avoid certain misfortunes which they regarded, in effect, as natural. A separate intentionality condition is thus needed to cover the way in which people treat prospects of enforcement (and, no doubt, treat other aspects of any putative rule as well).

How strong should this condition be? Formal rules, of course, generally fulfill a strong intentionality condition. Even when they are unexpected deductions from explicit legislation, there is no doubt in anyone's mind about their resulting from intentions to set up rules on the general topic to which they relate, and from deliberated choices that led to certain rules rather than others. Some informal rules, too, satisfy rather strong intentionality conditions. The prohibition (unknown in Britain) against members of the Parliament of Canada accepting pay as lobbyists (spokesmen for interest groups, hired to be spokesmen) is known to all members, who also know perfectly well that they could choose to abolish the rule (or, if the public reacted adversely, deliberately make departures from it, beginning with small departures) and that they could violate

it individually, though with a certain risk of punishment. Rules that rest on conventions (as Lewis conceives of conventions) are strongly intentional too. Lewis requires, as one condition of conventionality, that the people involved be aware of the conventional nature of their behavior,[14] as well as have congruent expectations about each other's behavior and certain preferences about conformity. (Consider the rule of language, still intentionally supported in some quarters, prescribing conformity to the old convention under which 'now', not 'presently', was used when 'now' was meant.) If people have only the expectations and preferences and are not aware of any alternative regularity which would be similarly useful, or are not otherwise aware of how close their behavior approaches being conventional (without quite being so), the fact that their observed behavior can (presumably) be shown to follow from their expectations and preferences may suffice to establish intentionality in a form only slightly weaker. Many of the regularities of language are quasi-conventional in this way: for example, the regularity by which speakers of English shift from one sound of 's' to another when they shift from using 'house' as a noun to using 'house' as a verb. People might deplore the accent of someone who failed to make the shift, and so support an informal rule as well as the quasi-convention—and do so without being able to quite put their finger on what they are objecting to.

Applied to informal prescriptions and prohibitions, the intentionality condition is perhaps best conceived of as calling either for underlying conventionality in Lewis's sense or for conscious concurrence in a rule known to have to originated by example and imitation; or for approximations to conventionality or concurrence in imitation. Agreement by the whole group may be a mode of origin best reserved for formal rules. Informal rules, however, may originate with an agreement among a few members who set an example—perhaps only one member suffices to set an example, if he is prominent enough and his behavior is commented on vividly; or a number of members might start up parallel examples independently, each inducing imitation in his milieu. The rule forbidding Canadian Members of Parliament from taking pay as lobbyists could have begun this way, and not by way of a convention, since any of those Members falling into line in imitation may have done so not individually seeking to promote his own interest in a situation without a prevailing convention or rule, but seeking instead to avoid the penalties that he apprehended his leaders or the public would attach to his not obeying the incipient rule.

Allowing for the approximations weakens the intentionality condition for prescriptions and prohibitions to allow for rules of which the people conforming to them are not (fully) aware: for example, the universal rule that the linguistic form of address "used to an inferior in a dyad of unequal status is, in dyads of equal status, used mutually by intimates; the form used to a superior in a dyad of unequal status is, in dyads of equal status, used mutually by

strangers''[15]; or the rules, likewise founded on approximations to a Lewis-like convention, about distance and voice-level in casual conversation, rules in which North American culture evidently differs from Latin American.[16] The allowance captures for the concept of rules such things also as the rule about wearing shirts as well as undershirts to a dinner party. No one, of course, would have much trouble in recognizing the latter rule when it is brought to his attention, and in this respect it is perhaps distinctly closer to being an object of awareness than the other two inexplicit rules; but I daresay most of the people who conform to the rule about shirts do so without ever thinking of it as a rule, much less thinking of the example-and-imitation process by which it is maintained. Yet they would hardly regard either their own conformity or the conformity-enforcing conduct of others as independent of human intentions.

One might ask whether the fact that such rules met only a weakened intentionality condition did not signify that they were best not treated as rules at all. Certainly the distinctiveness of the concept of rules would be better preserved if the concept were limited to explicit rules. Moreover, I am inclined to agree that a relatively strong intentionality condition (stronger than the intentionality condition to be required for permissions) is worth insisting upon in the case of prescriptions and prohibitions. Otherwise—accepting, for example, merely an ability to deviate as constituting the condition—we might have to contemplate ascribing to all human cultures a prohibition against pulling out all one's natural teeth immediately after all the teeth had come in. Weakening to the degree suggested here does, however, seem to me to be called for on the grounds chiefly relevant to deciding the issue, given that there is no a priori criterion for deciding it: Namely, that social scientists find it useful to extend the concept of rules to cover cases like those I have just mentioned. Moreover, any objections to so extending the concept would tend to obscure the continuity between regularities that are associated with rules and regularities that are not. Any line that we draw to mark the bounds of intentionality will arbitrarily leave intentional-like phenomena on the other side. (People do intentionally keep their natural teeth as long as they can, even if we might hesistate to say that they do so conforming to a prohibition or prescription.)

The intentionality condition that I have sketched would, it might be noted, be strong enough to reject as rules the principles of universal grammar championed by Chomsky.[17] Chomsky allows that people may deviate from them, for instance, by constructing artificial languages in which transformational operations are not structure-dependent; but such a deviation would no more imply the prior existence of a rule to that effect, or of a conventional foundation for one, than the dental phenomena mentioned a moment ago. Nor does there seem to be a conventional foundation of the sort called for by Lewis's criteria; for although the principles of universal grammar no doubt enter into the expectations that language-users have of each other, they are not expectations contin-

gent upon each other's expectations. The principles, moreover, are (on Chomsky's account) not built up (or even "imprinted") in the course of mutual adjustment of these expectations.

1.2. EXISTENCE-CONDITIONS FOR PRESCRIPTIONS AND PROHIBITIONS: CAUSATION

Besides the several conditions of ascription, there are causal conditions on which the existence of rules depends. Moreover, rules themselves are causal conditions. Both of these facts have been denied, however, for reasons which von Wright seems inclined to share[18] and which have to do with the intentionality condition. Acting with intentionality and under a rule has seemed to some philosophers to be *toto caelo* different from operating as a cause, and concern about intentionality has served as the major obstacle to conceding that rules are themselves objects of causation. For an intentionality condition taken in its strongest form appears to demand that the rules be freely invented by men, and if not freely agreed to and freely conformed to, at least submitted to in conscious efforts to avoid the risks of doing otherwise. This demand, of course, consorts very gracefully with the notion—which is at first sight too obvious to wonder about—that rules are human artifices, and moreover artifices by commission which men set up by active intervention with what would otherwise be the course of nature. However (to say nothing of the ancient difficulties of trying to suppose that nature in the relevant senses does not embrace human conventions) the demand may go farther than the champions of exclusive attention to rules can wish; for as we have seen, a weaker intentionality condition must be adopted if (on the side of informal rules) rules that those conforming to them are not aware of are to be brought within our accounts of human activity. Moreover, as we shall see, when we turn from prescriptions to permissions, theoretical interest may carry recognition of informal permissions far beyond the intentionality condition for informal prescriptions. We may be led, dealing with permissions, to take in even Chomsky's principles of universal grammar, which would seem to be (if they exist) clear examples of phenomena installed by natural causation whatever approach one takes to them.

Asking for causal explanations for the existence of rules is really inevitable. Suppose rules were to have the distinctive importance that some writers[19] attribute to them in the business of social science, excluding causal considerations from the central preoccupations of that business. One would still be bound to ask, 'Where did the rules come from?' We cannot treat them all as innate, in view of the fact that some of them satisfy a strong intentionality condition; and if we did, they would all be effects of natural causation. Is that the implication of the attack on causal explanations in social science? That all causes

operating upon human beings are to be assigned to natural processes not designed by human beings?

We might entertain the possibility of an infinite regress of rule-explanations, with rules always being explained as adopted according to the prescriptions, prohibitions, and permissions of deeper rules. The deeper that one would go, however, the farther away one would be from a strong intentionality condition and thus from rules adopted by human design; the more compelling would be the conviction that what we were formulating as rules were actually descriptions of the operation of natural causation. As von Wright notes, rules and regularities can be formulated in exactly the same language-indicative sentences:[20] Thus, 'Americans when speaking to intimates or to social inferiors use other people's first names; when speaking to social superiors or to strangers they use the last names, prefixed by "Mr.", "Mrs.", "Miss", or "Ms."'; or 'Speakers of English shift from one sound of "s" to another when they shift from using "house" as a noun to using "house" as a verb.' Not even a verbal difference need stand in the way of assimilating rules to natural regularities sooner or later, as we go from deeper level to level deeper still. All that could make a difference would be our attitude toward the formulas—what we were prepared to do (including what we were prepared to infer) on learning of them. This attitude, left to work unprejudiced by philosophical doctrines, would work in favor of assimilation sooner or later; and then of inviting causal interpretations or explanations of the assimilated regularities. For those deeper rules, were they to be discovered, would be rules to which our behavior had conformed already; we need change nothing about our activities for the rules to go on operating; indeed, if we tried changing them we would disarrange our surface behavior over its whole extent. Once again, moreover, we find ourselves dealing with rules implanted by natural causation.

Still, it might be the case that no causes operating upon rules, at least no causes enlisting human activities, could be found before one arrived at rules below and beyond human intentions, deep enough to be assimilated to natural regularities or treated as the effects of natural causation. A fair examination of our actual knowledge, including knowledge attained by common sense, will dispel the illusion that this is the actual case. Various sorts of causes into which the activities of human beings enter and which operate in the relations of human beings to one another can be cited as causal conditions affecting the existence of rules. The degree to which the conformity condition is fulfilled (and hence the existence of the rule so far confirmed) may be shown to be causally related to the proportion of stable households among those in which the persons in question were brought up; or the frequency with which human beings label others of the species as 'delinquents' in view of their first one or two crimes. I have in fact just cited two of the chief explanations of delinquency offered by sociologists: They are aggregative causes, founded on statistical evidence and

may be taken to typify the aggregative causal conditions that, operating in a great variety of combinations, are conditions on which rules exist.

There are other sorts of causal conditions to take note of, however. Some of them occupy the same ground as the intentionality condition. Suppose we do not follow (as I am inclined to do) those writers for whom wants and desires and the having of reasons—in short, intentions, like the intentions of particular people conforming to particular rules—operate as causes. We may still regard the fulfillment of the ascription condition for intentionality as at least an INUS condition of the existence of a rule. (An INUS condition, which is what the concept of cause most often seems to amount to, is an insufficient but necessary element in a combination itself unnecessary but sufficient—we may add, sufficient beforehand—for a certain effect.[21]) Clearly, arriving at a convention in Lewis's sense may serve as such a condition. Without the convention, the rule or rules that come into existence to reinforce the convention would have nothing to reinforce; but it cannot serve alone, because if human beings were not inclined to moral backing or something like it to their conventions, and did not follow up this inclination with measures of enforcement, no rules would be arrived at via this route. Besides being an INUS condition, fulfilling the intentionality condition evidently meets von Wright's narrower criteria for a cause: "p is a cause relative to q, and q an effect relative to p, if and only if by doing p we could bring about q or by suppressing p we could remove q or prevent it from happening".[22] Reaching an agreement, concurring in following an example, and arriving at a convention are all things within human power to do or to forbear.

Finally, there are causal conditions which operate in just the way that the champions of intentionality most wish to repudiate—namely, as behavioristic conditioning. People learn many rules—and with the rules, what reward and punishment are—by a process of conditioning, in which other people reinforce their behavior positively or negatively. That is the way for example, in which people learn the rules for casual conversations, about degrees of stridency and distances between people, and the rules about forms of address. But the reinforcements themselves are carried out by people conforming to rules (the rules being learned, and also, if one likes, rules about enforcing those rules); so there is no incompatibility here between intentionality and conditioning. Nor is there any incompatibility on the side of the people learning the rules; that these people should be aware of the reinforcements, and consciously shape their own behavior to obtain rewards rather than punishments, does not take away anything from the operation of the basic pattern of conditioning (more basic than Skinner's specialized concentration upon external movements, though even that may give substantial results here). Operants that are reinforced become predictable features of the organism's repertoire. In some cases (as with the distance rules for conversation) the people learning the rules may in fact not be

conscious of the conditioning; but so long as an acceptable ascription condition for intentionality is satisfied, the process there, too, produces a rule. It will, furthermore, be easy enough to satisfy the intentionality condition I described earlier: The same phenomena may be consistently analyzed simultaneously as a process of conditioning and as (for example) a process amounting or approximating to example and imitation. If the intentionality condition is satisfied on the side of the people teaching the rule, the rule emerges from rule-governed behavior as well as eventuating in it.

Not all rules are learned by direct conditioning. Many, like the prohibition against members of the Canadian Parliament taking pay as lobbyists, are certainly not acquired by the people who know it and follow it being subjected to a reinforcement schedule specific (however intermittent and unintentional) to refraining from taking such pay. People learn it and its full force by observing that it involves sanctions analogous to the sanctions with which they have become familiar in learning other rules; and people are motivated to conform to it because conforming is instrumental to other ends as well—i.e., to achieving impartial legislation. One might well wish in this case to stress the intellectuality of the operations involved in drawing the analogy or in appreciating the means-ends relationships; and say with von Wright, "Normative pressure is . . . built up under the joint teleological influence of fear of sanction and anxiety to secure the ends for whose attainment the norms are considered instrumental."[23] But teleology—the conscious pursuit of certain ends—cannot be the whole story. Beginning (one may suppose) with notions about sanctions and instrumentality associated with rules that have been learned by conditioning, one must learn to extrapolate those notions to rules that are not so learned. I shall not try to describe the process of extrapolation, which appears to be still waiting for systematic psychological investigation; but I assume that in its early stages at least it is a process itself controlled by conditioning, and that conditioning continues to be important until the organism has acquired something like an algorithm for extrapolation, which enables it to identify a rule and the associated measures of enforcement in advance of being conditioned to it.

The sanctions and other measures of enforcement associated with such a rule enter into causal explanations of the aggregative phenomena associated with the rule. That there is more conformity than not in a group to which a certain rule is ascribed often depends on the presence of systematic provisions for enforcement—rewards for conformity, penalties for deviation. Such a fact, however, does *not* constitute an explanation by conditioning—nobody is being conditioned by the aggregative fact about provisions for enforcement. Nor does it imply that the conformity of those who do conform is to be explained by direct conditioning to that rule. It does invoke the same sort of causes as are invoked in explanations by conditioning.

Besides being objects of causation in the several ways mentioned, and hence existing only insofar as sufficient conditions of those sorts have been

satisfied, rules may operate as causes themselves. Clearly they can be INUS conditions: Were it not for the existence of the rule against doing so and the sanctions behind it, would not a number of members of the Canadian Parliament cheerfully accept pay as lobbyists (as their British counterparts openly do)? But they are more than INUS conditions (whenever they are at least that); for human beings bring them into existence and human beings can suppress them.

Furthermore, a curiously neglected fact, rules can serve as the backing required to confer law-like properties upon the major premisses of deductive-nomological explanations. Consider the regularity (stated in terms which again are also in standard use for expressing rules): 'Whenever a sitting Member of the Canadian Parliament loses an election, he gives up his seat to the opponent with the largest number of votes.' This regularity might reasonably figure in the major premiss of a deductive-nomological explanation showing why a certain politician is no longer to be seen in Ottawa. Of course, it would be pedantic to spell the explanation out and state the regularity on any real occasion that would call for the explanation; but that fact should not be thought to derogate from the reality of the occasions: People in Ottawa must often ask, 'Why haven't we seen old Bud Olson recently?' and be reminded, enthymematically, 'He lost his seat in the last election.'

Might it not be objected to the major premiss, overtly expressed or enthymematically hidden, that it describes no more than a coincidence or a simple induction from an arbitrarily limited set of instances? The backing that the regularity has in the rule, mentioned earlier, and stated in the same terms, saves it from any such objection. The intentionality condition sees to that; so also do the conformity and enforcement conditions in their joint relation to theoretical interest (even though the theory in question may not be a causal theory but a theory about the contents of a rule-structure). With these conditions fulfilled, the premiss supports counterfactual conditionals: 'If Bud Olson had not lost the last election, he would not have given up his seat.' Most discussions of law-likeness stress the crucial importance of counterfactuals, and I concur. How much does it matter that (because the Canadian Parliament is mentioned) the premiss is not a pure universal? I think (somewhat heretically) it does not matter to the question of providing an explanation of a deductive-nomological kind. It matters the less when we take into account the fact that the premiss applies to future cases not yet observed and on that ground too escapes from the charge of being merely a simple induction from enumerated cases. If it is not without qualification universal in scope, it is in principle capable of accommodating infinitely many cases.[24]

Among the effects that rules may have, operating as causes, is the generation of further rules. There are at least two ways in which they bring about such effects: One, the less problematic, is the way in which rules prescribing rewards and punishments enter into processes of conditioning. The other way

is entangled, since it runs over much the same terrain as a logical process of generation. In my treatment of ascription-conditions, I gave little attention to the fact that a rule may be inferable from another rule or conjunction or rules, though this alternative *sufficient* condition for ascription has been given a great deal of attention by writers on deontic logic, with von Wright no exception. It is a condition more important for formal rules than for informal ones, however, since before we accept any of the latter we are (I think) more inclined to ask whether it stands on its own feet in meeting ascription-conditions. Nevertheless, it must be granted some power in explaining the existence of many informal rules too; one can reasonably hypothesize that they exist because one can say that they are deducible from other rules. There is a sort of causal generation that can be described in much the same language: A certain rule exists (i.e., has come into existence) because the people to whom we ascribe it were already committed to another rule. The new rule, I think, may or may not be a logical consequence of the other. People may adopt it as a contingent way of promoting the observance of the source-rule, as when they adopt a rule requiring cars to bear license plates as a means to enforcing the rule that drivers assume responsibility for accidents. But the new rule may in fact be a logical consequence of the source-rule, as when people discourage advertisers from surrounding the war monument with neon signs. The prohibition against neon signs is a consequence of a general rule concerning respect for the dead, especially the heroic dead. The point of insisting that there is a causal connection as well as a logical one is that there is no logical necessity for people to behave logically.

2. EXISTENCE-CONDITIONS FOR PERMISSIONS

Clearly permissions cannot figure in deductive-nomological explanations or in their backing with the same straightforward force as can prescriptions or prohibitions. That it is permitted for a member of the Canadian Parliament to change his party affiliation between elections does not imply that any given member will do so; in fact members rarely change their parties at this (or any other) time. Nevertheless, this permission can assist in certain explanations: It helps explain, for instance, why it happens that members so violently dissatisfied during a session of Parliament with their parties' policies that they feel impelled to change or resign change their party affiliations instead of resigning; whereas priests disaffected to the same degree leave the Church. The same example seems to teach us that there is no barrier to supposing permissions can themselves operate as causes as well as figure somehow in causal explanations or their backgrounds. For clearly the existence of such a permission is an INUS condition of members' changing their party affiliations: If they were not per-

mitted to do so, there would be some prohibition, enforced to a passable degree, against their doing so; hence they would not (or at least would not so often). Moreover, since the permission originates by agreement or concurrence (conventionality or imitation or approximations thereof) on the part of the members of the parties and survives only so long as they continue to agree or concur upon it, it is an INUS condition that satisfies von Wright's narrower requirement about human intervention.

The case for considering permissions 'rules' like any others looks much more problematic, however, when one turns from causal conditions to ascription conditions. The conformity condition applying to prescriptions appears to have no application to permissions, since both doing the permitted thing and equally not doing it conforms to the permission. And what shall we say about intentionality in this connection? There appear to be some grounds for allowing that everything done in a group which the members could stop doing at will may be regarded as a matter of permission, backed by a specific rule. Thus if people in a given tribe do not file their teeth, one may ascribe to them the rule that it is permitted not to file one's teeth; but then are we not committed to calling the dental rule mentioned earlier, under which people retain their adult teeth instead of wrenching them out as soon as they all come in, a permission (which it happens, so far as I know, that every tribe of man gives itself)?

To be sure, the permission in this case is probably at best only what von Wright calls a 'weak' permission,[25] i.e., one that follows merely from the absence of a prescription or prohibition with the opposite effect, and thus one that is not backed by undertakings on the part of the authority not to interfere or let other people interfere. Though in fact we might predict that the authorities would not interfere or let other people interfere, there are no such undertakings; and there never has been any need for them. But even strong permissions, where such undertakings can be assumed, are problematic. If strong permissions fulfill the conformity and enforcement conditions, for example, it is only vicariously, by the way of prescriptions about support and prohibitions against interference that do meet the conformity and enforcement conditions together, in some mixture as before.

Should permissions, then, be treated as rules at all? If they are not, then the analogy between necessity and possibility on the one hand and obligation and permission on the other that inspired deontic logic does not suffice to explain both the latter notions. Von Wright himself has in fact refused to rely on the analogy so far. He has firmly denied that a weak permission is a norm at all.[26] Permissions strong enough to be rights, with at least immunity to punishment afterwards attaching to acts falling under them and perhaps prohibitions against interference or prescriptions of active support, seem to be sufficiently rich in normative backing to claim some attention in complete accounts of norm-structures. From a logical point of view, however, will it be more than

an extra convenience to include even them, since their existence can always be inferred from that of the corresponding prescriptions and prohibitions?

On the other hand, in favor of treating permissions as rules, there is, besides my suspicion that convenience of discussion is an enormously important consideration in theory-construction, the principle *nullum crimen sine lege*. If this principle is in force, then, as von Wright points out, the structure of norms is closed[27] and closed by converting even what would otherwise be weak permissions into strong ones backed by general guarantees. The guarantees will cover at least immunity to punishment for doing the action permitted; they may also extend to a disposition on the part of other members of the group to punish interference with actions of that kind, or, beyond, to a disposition on the part of others to assist such actions. Thinking of informal features of social organization rather than formal ones, let us mean by 'immunity to punishment' simply that by and large other members will not take offense and seek to retaliate and that if any do take offense and retaliate they will be subject to sanctions for doing so; and let us suppose that the guarantees accompanying the *nullum crimen* principle go no further than conferring immunity in this sense. Few things could be more important to notice about a culture than whether the people belonging to it support such a principle; an important part of the value that they put on human freedom will be determined by the presence of such support. But as an incident of detecting the presence of such support, and with it the *nullum crimen* principle, one must infer that every permission accepted in the given culture is a strong permission, with a genuine normative character.

There will be no way, however, of enumerating all such permissions, given a language which allows for infinitely many descriptions of actions that can be the topics of permissions. Which permissions are selected for ascription and assertions of existence will depend upon theoretical interests. Many of these interests grow out of considerations of comparative structure and are pursued by elaborating such comparisons: Thus it is important to notice that members of the British Parliament are permitted, as their Canadian counterparts are not, to take pay as lobbyists. This difference—a permission present in one case, absent in the other—signifies far-reaching differences in other rules and indeed in the whole political side of the two cultures. The British differ from Canadians (and from Americans) in their conception of what official political representation involves.[28]

Von Wright suggests, "It is more reasonable to think that one can decide . . . whether something is or is not prohibited in a system S of norms than whether something is or is not permitted in it."[29] I take it that the same asymmetry would hold between prescriptions and permissions. Von Wright goes on, thinking of formal rules, to indicate that the asymmetry arises in part from the fact that the primary task of the legislator is "to impose obligations and state prohibitions", making sure also that people subject to his laws will be punished

if they are delinquent. "About all this he must be *explicit:* whereas he may leave it to be concluded from his silence on some point that this or that is permitted, since it is not forbidden."[30] In part the asymmetry is due to the fact that the people subject to the law are primarily interested in having it made explicit what they must do or forbear in order to avoid punishment.

The asymmetry also, I think, holds for informal rules; it is reflected in the difference between the relatively strong intentionality condition that I have stipulated for informal prescriptions or prohibitions and the very weak intentionality condition that, in accepting what without the *nullum crimen* principle would be weak permissions only, I am ready to accept for (informal) permissions. One might feel happier if the condition were more stringent, so that some limit could conceivably be put on the number or kind of permissions which may be supposed to exist. Failing a more stringent condition for existence, one might feel happier if the condition for mentioning something as a permission were more stringent. However, there is no way of stating such a condition, without prejudging the variety of theoretical interests that mentioning might serve; and this difficulty, which informal permissions share with informal prescriptions or prohibitions, but may well have to a larger degree, aggravates the asymmetry about decidability. There is no general answer that connects mentioning with theoretical interests. The theories in question may vary from crude to subtle, or (along quite a different dimension) from traditional-folk to breakaway-sophisticated—all the way from the raw materials of ethnomethodology to game-theoretical accounts of rational choice; or, in another dimension, from the raw materials of ethnomethodology to structuralist analyses of myths.

Political interests, as well as theoretical interests and in combination with them, also affect the choice of rules for mentioning. It is no accident that some permissions—strong permissions, stronger than most in variety of guarantees—are much better known than others, having been singled out time and again for mention as rights, and given the same recurrent names on each mentioning. As rights they are rallying points for social action; and they reflect folk-theories (modified by the contributions of political philosophers, legislators, and jurists) about what concerns it is most vital to protect and which social devices are most effective in protecting them. The fact that from a logical point of view all these rights could be effaced from a norm-structure so long as the corresponding prescriptions and prohibitions remain does not determine the social efficacy of recognizing the permissions by name and rallying round them, any more than it determines the gains that recognizing them offers social theory. It does not even imply that they would be exercised if they were not mentioned.

DALHOUSIE UNIVERSITY
HALIFAX, NOVA SCOTIA
MARCH 1973

DAVID BRAYBROOKE

NOTES

1. *Norm and Action* (London: Routledge, 1963). Among the other works see chiefly *An Essay in Deontic Logic and the General Theory of Action* (Amsterdam: North Holland Publishing Co., 1968). I shall have the logic of *Norm and Action* chiefly in mind: von Wright's later versions of deontic logic, improved as they no doubt are in answer to further problems that have occurred to him, do not seem to me to vary from *Norm and Action* in any ways relevant to the points that I shall bring up in the present paper.

2. Thus I envisage an ultimate ontology in which rules disappear in favor of verbal tokens with much the same effect as facts disappear in the ontology of explanations discussed by Israel Scheffler in *The Anatomy of Inquiry* (New York: Knopf, 1963), pp. 57–76.

3. I am using 'formal' and 'informal' more as a sociologist would than as a logician would. 'Formal' rules are explicit and official features of the 'formal' organization; they are seldom expressed with any use of logical symbols. 'Informal' rules are often explicit, but need not be; and they are never official (where 'official' and 'unofficial' can be distinguished).

4. See for instance the discussion of types of norms in the first chapter of *Norm and Action*.

5. *Cf.* my article, 'Taking Liberties with the Concept of Rules', in *Monist* 52, no. 3 (July 1968): pp 329–58.

6. In *Convention: A Philosophical Study* (Cambridge, Mass.: Harvard University Press, 1969).

7. Ibid., pp. 97–100. Lewis speaks of 'norms' where I would speak indifferently of 'norms' or 'rules'.

8. *Cf. Critique de la raison dialectique* (Paris, 1960), pp. 308 ff.

9. H. L. A. Hart, *The Concept of Law* (Oxford: Clarendon Press, 1961), pp. 91 ff. See my review, in *Dialogue* 3, no. 4 (1965): 441–44, of Lon L. Fuller, *The Morality of Law* (New Haven: Yale University Press, 1964). Hart's conception of these criteria must be strengthened if they are to meet von Wright's demand that the authority not be given simultaneously to contradictory rules; and if this strengthening occurs, one of the chief criticisms that Hart's work invites will be laid to rest.

10. A. R. Anderson, 'The Formal Analysis of Normative Systems', in *The Logic of Decision and Action* (Pittsburgh: University of Pittsburgh Press, n.d. [preface dated June 1966]), edited by Nicholas Rescher, pp. 147–209. (The paper was originally circulated in mimeographed form in 1956.) See also A. R. Anderson, 'Comments on von Wright's "Logic and Ontology of Norms" ', in *Philosophical Logic* (Dordrecht: Reidel, 1969), edited by J. W. Davis et al., pp. 108–13.

11. See for instance his essay 'On the Logic and Ontology of Norms', in the collection *Philosophical Logic* cited in n. 10 above, pp. 89–107.

12. Ibid., pp. 99–101.

13. Von Wright, *Explanation and Understanding* (Ithaca, N.Y.: Cornell University Press, 1971), pp. 151–53. Cf. J. R. Searle, *Speech Acts* (Cambridge: Cambridge University Press, 1969), pp. 33 ff.

14. The other conditions for conventionality must not only be fulfilled but it must be 'common knowledge' that they are. Cf. Lewis, op.cit., p. 78.

15. Roger Brown, *Social Psychology* (New York: The Free Press, 1965), p. 92.

16. Edward T. Hall, *The Silent Language* (New York: Doubleday, 1959), Chap. 10, and *The Hidden Dimension* (New York: Doubleday, 1966), Chap. 10.

17. See, for instance, *Language and Mind* (New York: Harcourt, Brace & World, 1968), pp. 51–53. Chomsky himself speaks in this place of the principles of universal grammar as 'conditions on grammars' rather than as rules; they would thus be conditions on grammatical rules rather than rules themselves. They could easily be cast in the form (imperative or indicative) of prescriptions, however—of rules about rules.

18. See Chap. V, Sec. 5, of *Explanation and Understanding*.

19. E.g., R. Harré and P. F. Secord, *The Explanation of Social Behaviour* (Oxford: Basil Blackwell, 1972). See, for example, pp. 12 and 17. (In later passages the apparent proscription of causal explanations is somewhat moderated.)

20. "Indicative sentences, other than deontic sentences [which contain deontic terms like 'must'], are also quite commonly used for expressing norms" (as, for example, in the Swiss and Swedish penal codes). *Norm and Action*, pp. 101–02.

21. See J. L. Mackie in 'Causes and Conditions', *American Philosophical Quarterly* 2, no. 4 (October, 1965): pp 245–64.

22. *Explanation and Understanding*, p. 70.

23. Ibid., pp. 148–49.

24. In the preceding paragraph I have had in mind Ernest Nagel's discussion of the logical character of scientific laws in Chap. IV of *The Structure of Science* (New York: Harcourt, Brace & World, 1961).

25. *Norm and Action*, pp. 86 ff.

26. Ibid., p. 86.

27. Ibid., pp. 87–88.

28. *Cf.* S. Beer, *Modern British Politics* (London: Faber, 1965), pp. 22–24; p. 77. The difference is subtler than the terms in which I have stated the example suggest. 'Lobbyist' would have to be given an elaborate definition if those terms are to serve: A Canadian M.P. may continue to have business interests; a British M.P. who speaks in the Commons for a certain interest normally believes in its cause anyway—he does not hire his opinions out.

29. *An Essay in Deontic Logic and the General Theory of Action*, pp. 88–91.

30. Ibid.

8

Herbert W. Schneider

TELEOLOGICAL PRESCRIPTIONS AND DESCRIPTIONS

In von Wright's own comments on his Gifford Lectures it is quite evident that the two volumes should be regarded as a single work. It is also clear why *Varieties of Goodness* (B191) should come first logically though it is second chronologically. Its final section on Justice leads directly into the theory of norms. I shall confine my comments and problems to these two volumes, especially to *Norm and Action* (B190), though some of von Wright's more recent publications contribute new material for the discussion.

The general theme of my comment can be summarized as follows. In the volume on *Norm and Action* there is an explicit exploration of varieties of norms, analogous to the varieties of goodness explored in the second volume. However, von Wright concentrates on one variety, prescriptions, presumably because this variety lends itself best to the formulations of deontological logic. I cite a basic passage:

> The character, the content, and the condition of application constitute what I propose to call the *norm-kernel*. The norm-kernel is a logical structure which prescriptions have in common with other types of norm. . . . Here we are concerned directly with the kernels of prescriptions only.
>
> The authority, the subject(s), and the occasion seem to be specific characteristics of prescriptions which do not belong to the other types of norm. . . .
>
> The *character* of a norm depends upon whether the norm is to the effect that something ought to or may be or must not be or be done. . . .
>
> Advice, counsel, prayer, recommendation, request, warning are related categories to command, permission, and prohibition. We shall not, however, call *them* prescriptions or norms. . . . This seems in good accord with ordinary usage.
>
> By the *content* of a norm we mean, roughly speaking, *that which* ought to or may or must not be or be done. (pp. 70, 71)
>
> If a norm is hypothetical its condition of application cannot be concluded from its content alone. . . . Mention of the (additional) condition must therefore be made in its formulation. An example would be an order to shut a certain window, *if* it starts raining. (p. 75)

My impression is that the norm-kernels, though they are conceived in the context of values and decisions, are given an exclusively logical structure. The teleological character thus disappears in the formal analysis of the content of obligation, permission, and prohibition as these appear in prescriptions. The content of prescriptions is abstracted from the intent which enters into the "condition of application" of the norm-kernel only in the case of logically hypothetical norms. The whole kernel has a logical structure. If teleological conditions of application were introduced into the kernel, the deontological logic would be faced with an onto-teleo-logical analysis. To such an analysis the two volumes taken together make a great contribution. But the formal logic of norms by itself suggests that the theory of norms is tending toward the dualistic deontology of the separation of the right and the good, norm and value, prescription and description, against which von Wright is protesting. Though prescriptions may be categorical in form, in action they are surely teleological, conditional, hypothetical.

It may be well to approach the analysis of this problem by dealing first with those prescriptions that are in action 'must' imperatives, and that express what von Wright terms *anankastic* relations, when a given means is the necessary condition for an end. Such necessity may be derived from a causal necessity in the natural order, or it may be a teleological necessity of forced choice. The needs that generate such norms may be naturally or culturally necessary; in either case the situation is not contingent, though teleological. Some medical prescriptions, for example, are clearly compulsory norms, whereas others are more like directives or professional advice. Where the facts of the case force the decision, the 'must' appears to be a factual norm, and the prescription both a categorical imperative and the description of a factual inevitability. But even such *anankastic* commands or necessary prescriptions, however categorical and non-problematic they may be, are not teleologically unconditioned. They demand an unconditional response, but the condition of application in their norm-kernel is related to values. The kernel has both a logical and a teleological structure. When the need is thus evident and the relation between means and end thus fixed, this relation makes the distinction between means and end useless. The availability of a necessary utility may be experienced more with a sense of value or goodness than with a sense of norm serving an end. If you are alive, you need air, food, and drink; these elemental needs are more apt to be evaluated as intrinsic goods than life itself. Happiness is felt in the enjoyment of the various goods that compose it. Such intimate union of means and ends in daily life with its common needs does not imply the absence of telic structure, though it may not require teleological ethics.

I dwell on these observations about necessary conditions and telic structure in order to suggest that such conditioning is not merely in the "background"

(p. 11) of a norm which has prescriptive force, but is an aspect of the norm-kernel as well as of the world of action in which norms operate. Even necessary norms have a telic structure.

The line is not sharp which distinguishes between such necessary or merely 'technical' normalities where there is a union of goods and norms and the problematic, contingent situations where the relations between means and ends involve deliberate decisions and art. Activity, as it becomes intelligent and skillful, reflects the increasing complications, conflicts, and interrelations among varieties of goodness and among conditional norms. The telic structure of action then requires a teleological science of norms. The need for such science becomes evident in the arts and crafts, and along with it an onto-teleo-logic becomes appropriate. Such a logic is essential for the analysis of the varieties of goodness as well as for the formulation of norms in action. The teleological situation is not mere context but is an essential aspect of the kernel of a prescription in operation.

Linguistically a command or prescription is 'given' by an 'authority' to a 'subject'. Similarly an action may be linguistically and statically analyzed into 'agent' and 'patient': the doer does something to something. Such an analysis of action is now generally discarded in favor of a 'process' analysis. Von Wright, too, begins his analysis of action with changes involving transforma-tions. When the practical arts make changes deliberately, the process acquires a telic structure and the artist requires norms to guide the process. The chief kinds of norms distinguished by von Wright are rules, directives, and prescrip-tions. Prescriptions have 'authors' who command 'subjects'; rules and direc-tives, though actually normative, may have obscure origins. They are 'handed down' more or less impersonally, often from generation to generation, and their value and application are being continually tested under changing circum-stances. 'The law', before the art of legislation developed, was handed down in this sense as 'given', as 'law and order'. But with the rise of legislation and the theory of jurisprudence, the legitimacy of law became subject to teleologi-cal norms; the 'authority' was no longer a 'law-giver' but an administrator of justice. The meaning and use of obligation, permission, and prohibition became increasingly experimental as the application of law became ambiguous. To rob even legal prescription of this teleological operation may be useful for purely 'legalistic' logic and its formal operations, but such logic surely robs it of most of its norm-kernel.

Similarly, the critical use of norms by artists, whether in the fine arts or the practical, implies a continual examination of the value of prescriptions under changing circumstances. If conventional rules and specific prescriptions are not reinterpreted in view of the changing circumstances to which they are applied, they soon lose their practical functions as directives of art and norms of trans-formation.

Even such simple instances as von Wright uses to illustrate the form of a prescription 'Shut the door', though they may be obeyed unconditionally, are apt to raise the question, 'Why?' in the subject privately. Military commands, of course, are unquestionable in practice, but in theory even they are subject to justification.

Promises, too, which create moral obligations, though formally they are 'deontic' and 'proper', are durable norms only if they retain some semblance of reasonableness despite changing circumstances. Like most prescriptions, they too are in part also descriptive, in so far as they imply the conditions and motivations under which they were made. The promised norm for the future continually raises the problematical situation which generated them and in terms of which their continued reasonableness must be estimated. The utility of a promise as a norm depends on these considerations.

Propositions about what ought-to-be *(Seinsollen)* are, as von Wright suggests, normally not mere ideals for contemplation. They can function as norms because they are usually teleological devices for putting what-can-actually-be-done-if into the telic perspective of a larger frame of reference and transformation process. They refer to Becoming. If Being is regarded as a timeless reality, talk about what ought-to-be is either foolish or descriptive; it is irrelevant to the world of norms and goods.

Aristotle had a clever device for putting the right or norm in the context of opposite temptations of going wrong by excess or by deficiency, by over-doing or under-doing. Von Wright, too, makes a similar suggestion when he raises the question whether the opposite of 'doing' is 'not-doing' or 'un-doing'. Such consideration of opposites is relevant not only to logic but also to the arts. An artist in the course of creating is apt to ask himself, consciously or unconsciously, Have I gone far enough? To stop when a work of art is 'just right' requires good judgment. But as a general fact there are more than two vices for every virtue. The attempt to make a theoretical dialectic out of the practical problem is misleading. Success is surrounded by the many ways of making mistakes. Prudence, excellence, justice, and the other norms operate within the process of trial-and-error learning. A beginner, who accepts a prescription as given gratis to him by an authority, as he would accept correct spelling from a good dictionary, is taking a norm as a rule that is basic or constitutional. But an artist or intelligent worker needs to know why the rule should be followed, or when it is reliable as a norm. Norms need justification, as assertions need verification. Norms, like opinions, operate among probabilities, not authorities. Principles of legitimacy or formal validity are after all hypothetical generalizations. Eventualities, future experience is more decisive than past experience and prescribing authorities.

Von Wright's lectures are full of this insight and of the complications it creates for an adequate theory of goodness and norm. He is fully aware of the

limitations of any deontic logic in the face of these complications of both reasons and existence. He selected prescriptions knowingly because they are relatively precise and formal norms. He wanted material for his logic. But, in both volumes, he puts the logic in its place philosophically. Now that we are looking for teleology as a philosophical 'kernel' for the logic, we find good material in the two volumes for our analysis. They raise the problems which trouble him and us. Von Wright evidently recognizes the teleological operations of norms in practice, in the world of action, and in the midst of a variety of goods. Action implies teleological existence, but how can this fact obtain more formal recognition in the logic of good and of norm? Or are there two logics here? I call attention to the wilderness of existence in which logic exists, because von Wright's lectures have called attention to it so thoroughly. We should be aware of how much analysis he has performed that goes beyond his or any logic.

CLAREMONT, CALIFORNIA HERBERT W. SCHNEIDER
APRIL 1972

9

Thomas Schwartz

VON WRIGHT'S THEORY OF HUMAN WELFARE: A CRITIQUE

Among the leading philosophers of this century, Georg Henrik von Wright will likely be remembered as the great *pioneer*. His considerable influence issues less from doctrines he has defended than from subjects he has studied. Largely avoiding the controversies of his contemporaries, von Wright has extended the frontiers of post-war analytic philosophy time and again, opening fertile fields of inquiry newly conceived or long neglected.

Varieties of Goodness is a stunning example of von Wrightian pioneering, especially when viewed as the centerpiece of its author's total contribution to the study of norms and values. While others were content to issue sweeping pronouncements about the peculiar status of ethical and other normative and evaluative assertions, scarcely troubling to draw the most rudimentary distinctions, von Wright worked to sort and systematize that vast array of phenomena crudely characterized as 'value judgments', 'prescriptive utterances', or whatnot, uncovering a richness and diversity unanticipated in the literature of 'metaethics'. Commonplace species of non-moral evaluation (instrumental, technical, utilitarian, medical, etc.) enjoy their first sustained study in this book. Here, too, is a work of contemporary philosophy that takes seriously such half-remembered antiques as virtue, the Platonic conception of justice as division-of-labor, and, of course, human welfare—'the good of man'.[1]

That von Wright had to pioneer the contemporary philosophic examination of human welfare is astonishing when one considers the central and ubiquitous role this concept plays in ethics, philosophic psychology, and political philosophy, not to mention social science, public affairs, and everyday life. It is just the sort of concept non-philosophers expect philosophers to say a lot about.

In discussing human welfare, von Wright took up a subject as murky, complex, and problem-laden as it was neglected. My criticisms of his treatment are all to the effect that he made the subject out to be clearer and simpler than it really is, ignoring some tough problems.

In company with many economists, von Wright favors what he would call a *subjectivist* account of human welfare, taking people's *preferences* to be the measure of what is good for them. Although his version of this idea avoids certain pitfalls, I will argue that there are difficulties no subjectivist account can overcome.[2]

I. The Problem of Defective Preferences

Some philosophers would reject subjectivism on the ground that a man's preferences can be *defective* in ways that discredit them as a measure of his welfare.

One way preferences can be defective is by being *ill-informed*—based upon incomplete or false information. Someone with ill-informed preferences can actually prefer what is *bad* for him. Example: Standing next to a tall building, unaware that a huge safe dropped from an upper window is about to land on him, Ignatz would naturally prefer that I not push him aside. To do what is good for him—to prevent harm to him—I must act contrary to one of Ignatz's preferences.

Keenly aware of this, von Wright has formulated his account so as to avoid making *ill-informed* preferences the measure of a man's welfare:

> Assume that X is something, which is not already in our world (life), *i.e.* is something which we do not already possess or which has not already happened or which we have not already done. . . .
>
> We introduce the symbol '$X + C$' for the complex whole, consisting of X and those other things, which are causally connected with it either as prerequisites or as consequences of its coming into being, i.e., of the change from not-X to X. The symbol 'not-$X + C$'' shall stand for the complex whole, consisting of the absence of X and the presence of those things which are causally connected, either as prerequisites or as consequences, with the continued absence of X.
>
> The question . . . is whether we should prefer $X + C$ to not-$X + C'$ or whether we should have the reverse preference or whether we should be indifferent (have no preference).
>
> Let the answer . . . be that we . . . prefer $X + C$ to not-$X + C'$. Then we shall say that $X + C$. . . is a *positive constituent* of our good (welfare). Of the thing X itself we say that it is *good for us* or *beneficial*. . . .
>
> Let the answer . . . be that we . . . prefer not-$X + C'$ to $X + C$. Then we shall say that $X + C$ is a *negative constituent* of our good. Of the thing X itself we say that it is *bad for us* or *harmful*. . . .
>
> The answer can, of course, also be that we should be indifferent to the alternatives. Then $X + C$ is neither a positive nor a negative constituent of our good, and X is neither beneficial nor harmful (p. 107f).

I think this account is fairly summarized as follows:

> X is *good for* S if, and only if, in the absence of X from S's world, S would prefer the presence of X, if S knew the causal prerequisites and consequences of the presence of X and of the absence of X.

Compare this with a simpler, ostensibly 'purer' version of subjectivism:

X is *good for* **S** if, and only if, X satisfies **S**'s preferences.

Von Wright did not so much reject this formulation as flesh it out to make it clearer.

To see how, consider poor Ignatz. He prefers not to be pushed aside. He also (we may suppose) prefers not to be mashed on the pavement. His preferences conflict. It is not possible to satisfy both. It is clear enough which preference takes priority: not to be mashed. Why? Perhaps because that is the preference Ignatz would himself maintain if he were aware of the conflict.

In effect, von Wright's formulation incorporates this point. Like the simpler formulation, it equates doing good for a man with satisfying his preferences. Unlike the simpler formulation, von Wright's goes on to specify how to satisfy a man's preferences in cases of conflict: Satisfy the preference the man would himself maintain if fully aware of the conflict. Because this resolves conflicts by appeal to the subject's own preferences, it leaves von Wright's subjectivist credentials intact.

Besides being ill-informed, a man's preferences can have other defects that might discredit them in the eyes of certain philosophers—not von Wright—as a measure of the man's welfare. Here are three such defects:

Irrationality. Though fully and correctly informed, a man's preferences might not be consistent with rational canons of decision-making—with reasonable rules for pursuing one's own objectives, whatever those objectives happen to be. For example, seeking above all to minimize pain, and aware that going to the dentist right away would cost him less pain in the long run than not doing so, a man of weak character might nevertheless prefer not to go.[3]

Lack of cultivation. A man might have or lack certain preferences because he has not cultivated certain powers of appreciation. You probably will not much like to ride or play squash if you have not learned *how*—if you have not developed the necessary skills. Equally, you probably will get comparatively little enjoyment out of fine wines, great music, or the philosophic classics if you have not learned *how* to enjoy them—if you have not *cultivated* the necessary *powers of appreciation*. To lack such cultivation is not exactly to have 'wrong' or 'skewed' tastes. It is to lack an *ability:* the ability to perceive those attributes of fine wines, great music, and the philosophic classics whose perception gives people enjoyment.

It is a common belief that we promote the welfare of children and adolescents when we provide them with good education, including education designed to cultivate their powers of appreciation. And we tend to feel that a man is less well off than he could have been if he has grown up without the benefit of such education, hence without having cultivated his powers of appreciation, even if *he* feels no lack.[4]

Mal-conditioning. The circumstances in which a man lives can warp or distort his preferences; they can *condition* his preferences in 'unhealthy' ways. Commercial advertising can condition you to relish unwholesome foods. Religious training can condition you to loathe sexual pleasure. Political propaganda can condition you to prefer national glory to your own continued existence. Peer pressure can condition you to want to try dangerous drugs.

A major theme of social theorists like Plato, Marx, and Skinner is that 'bad' social systems condition people's preferences in ways that favor those systems but conflict with people's 'true needs', while an 'ideal' society would condition preferences differently. According to this view, the reformer or revolutionary bent on promoting people's *welfare* often must act in ways radically contrary to people's *preferences,* forcing his beneficence upon unwilling beneficiaries.

Can mal-conditioning discredit someone's preferences as a measure of his welfare? Not according to von Wright.

In defense of von Wright, one might advance considerations such as the following: Suppose Paul prefers not to do something which busybody Peter thinks Paul should do (eat Peter's favorite food, attend Peter's church, marry Peter's sister-in-law). And suppose Peter says the thing in question would really be good for Paul despite Paul's preference, which is the result of mal-conditioning. Our normal reaction would be that Peter is just trying to foist his own values on Paul, barely veiling his meddling by claiming to be promoting Paul's welfare.

Against von Wright, one might cite examples like this: By hypnosis, brainwashing, or whatnot, I so warp Professor von Wright's preferences that he wants me to cut off his nose, though he is fully aware of the causal prerequisites and consequences of doing so and of not doing so. Von Wright seems committed to the consequence that my cutting off his nose would be good for him.

As I have argued, von Wright was able to discount *ill-informed* preferences as the measure of a man's welfare without compromising the subjectivist character of his theory. Perhaps something similar can be done with defective preferences of other types. Perhaps one could show that every genuinely defective preference conflicts with another of the subject's preferences and that the subject himself would give up the defective preference if fully aware of the conflict. Much depends upon how one imputes preferences to people, what one counts as a conflict of preferences, and what one means by 'fully aware'.

II. THE PROBLEM OF SELF-REGARDING VS. OTHER PREFERENCES

Suppose my daughter and I both need medical treatment badly. I can afford the treatment for one of us—either one—but not both. There is nothing defective about my preferences. Fully aware of the relevant causal connections, I

decide that my daughter will get the treatment, not I. All things considered, I prefer my daughter's getting the treatment she needs to her not getting it, and so prefer my not getting the treatment I need to my getting it.

Von Wright's account has the preposterous consequence that my daughter's getting the treatment *she* needs would be good for *me* (because *I* prefer its 'presence' to its 'absence'), as well as the even more preposterous consequence that *my* getting the treatment *I* need would be *bad* for me (because I *prefer* its 'absence' to its 'presence').

The reason doing what would be good for me was not the same as satisfying my preferences is that my preferences were *not self-regarding*. I preferred my daughter's welfare to my own.

Roughly speaking, *self-regarding preferences* are ones not based upon any ultimate objective of promoting the welfare, the goals, or the happiness of anyone but the subject. Only such preferences (and perhaps not even they) constitute reasonable evidence of what is good for their subject.

My criticism of von Wright amounts to the accusation that he is advocating a form of *psychological egoism,* or something very like it. His account of human welfare obviously has the following consequence:

> A person who knows the causal prerequisites and consequences of the choices open to him always prefers (and so chooses) what is good for himself.

Is this not a version of psychological egoism?

It is not the only version. It is not the one von Wright attacks (p. 185). To prefer, or choose, only what is good for oneself is not the same as *aiming* solely at one's own *welfare*. You can choose what (and only what) is good for yourself without doing so *because* it is good for yourself, or *in order* to promote your own welfare—although this would hardly be likely if it were true (by the very definition of 'good for', yet) that *everyone* prefers *only* what is good for himself *whenever* his preferences are non-defective.

Be this as it may, the above consequence, and therewith von Wright's account of human welfare, is objectionable in just the way psychological egoism is objectionable. It denies the fact of selfless behavior—of self-sacrifice. It denies that a fully informed person can ever sacrifice his own welfare for someone else's—or for a 'higher goal'. It implies that the soldier who knowingly throws himself on a live grenade to save his fellows is really doing *himself* some good (which is even less credible than the claim that his *ultimate objective* is his own good).

III. Welfare as Minimal and Basic

Suppose I want a drink. Not yet having gotten it, I prefer its presence in 'my world' to its absence. My preference, we may suppose, is not in any way

defective. In particular, I know all the causal prerequisites and consequences of having the drink and of not having it. We may also suppose my preference is self-regarding. I want the drink solely for my own sensory enjoyment—not to benefit the bartender financially, to amuse someone who likes to see me drink, or any such thing.

Still we cannot conclude that the drink would be *good* for me—*beneficial* for me. In the circumstances, if you said the drink would be *good* for me, you would likely be taken to mean that the drink would calm my nerves, or that it has some nutritional or medicinal value, or some such thing. Although I have a non-defective, self-regarding preference for the drink, it would be a distortion to call the drink *good* for me. The truth is that I *merely want* it.

Sometimes, indeed, a man has a non-defective, self-regarding preference whose satisfaction, far from being *good* for him, would actually be (somewhat) *deleterious* of his welfare—witness the man who prefers to eat too much, knowing that it is too much. Often this is due to a character defect (p. 113). But not always. The man who knowingly sacrifices his welfare (somewhat) for the sake of enjoyment may have made the perfectly rational decision to risk shortening his life that he might enjoy it more.

This brings out two important and closely related features of our concept of human welfare:

First, there is something very *minimal* and *basic* about welfare. To promote someone's welfare is to provide him with just the *minimum* requisites of good living—just life's *basics*.[5]

Second and more specifically, to promote someone's welfare is to satisfy his *essential human needs,* not his 'mere' wants. If something would be *good* for a man, there is a sense in which he really *needs* it (or, more commonly, something of its *kind*). What would merely *please* him is not properly called *good* for him; it might even be *bad* for him.

Although von Wright's account of human welfare apparently does not square with the minimal, need-related aspect of human welfare, von Wright does hint at this aspect when discussing the connection between welfare and *happiness:*

> Happiness is allied to pleasure, and therewith to such notions as enjoyment, gladness, and liking. Happiness has no immediate logical connection with the beneficial. Welfare again is primarily a matter of things beneficial and harmful, *i.e.* good and bad, for the being concerned. As happiness, through pleasure, is related to that which a man enjoys and likes, in a similar manner welfare, through the beneficial, is connected with that which a man wants and needs (p. 87). . . . Happiness and welfare are . . . closely allied. What then is their mutual relation? This is a question, on which I have not been able to form a clear view. Welfare (the good of a being) is, somehow, the broader and more basic notion. . . . It is also the notion which is of greater importance to ethics and to a general study of the varieties of goodness. Calling happiness an 'aspect' or 'component' or 'part' of the good of

man is a non-committal mode of speech which is not meant to say more than this. Of happiness I could also say that it is the consummation or crown or flower of welfare. But these are metaphorical terms and do not illuminate the logical relationship between the two concepts (p. 88).

To call welfare 'broader' than happiness, or to call happiness an 'aspect' or 'component' or 'part' of welfare, is misleading at least. You can promote someone's happiness without positively affecting his welfare. For one thing, you can sometimes make a man happy by giving him what he merely likes but does not really need. And when you make a man happy by satisfying his *non-self-regarding* preferences, you do not necessarily promote *his* welfare. As we have seen, you might even *diminish* his welfare; he might be *happy* to sacrifice his own welfare (to a degree) for the sake of someone else's.

For the same reason, happiness cannot be called the 'broader' notion; welfare cannot be called an 'aspect' or 'part' of happiness. If a man would be happy to sacrifice his welfare either for the sake of someone else's welfare or for the sake of his own pleasure, then promoting his welfare would not necessarily contribute to his happiness.

I do not think you can explain the sense in which welfare comprises the *basic* and *minimal* requisites of good living by relating welfare to happiness— or, indeed, that you can adequately explain the relation of welfare to happiness without *first* explaining what is basic and minimal about welfare.

What, then, *is* this basic, minimal aspect of welfare?

Maybe this: To promote someone's welfare is to help ensure that he enjoys those conditions which *any* normal person needs in order successfully to pursue his life-plan—his goals and projects—*whatever* that plan be. On this view, welfare-needs are *basic* in that they are needed for the successful pursuit of *any* (normal) life-plan and so provide a *basis* whence to lead one's life; *less* basic needs are peculiar to this or that *particular* life-plan. And since welfare-needs include only those needs that are common to *all* normal life-plans, they are *minimal* in that their satisfaction takes one only a short distance toward the fulfillment of one's own *peculiar* life-plan.

This also explains the sense in which welfare has to do with *essential human needs*. Once my welfare-needs are met, I will need other things in order to pursue my peculiar life-plan. But I do not *have* to pursue *that* life-plan. I can alter my life-plan, thereby eliminating the need for those other things. By contrast, my *welfare*-needs are *essential*—are more genuinely *needed*. I cannot eliminate them by changing life-plans, because they are common to *all* (normal) life-plans. For the same reason, welfare-needs are *human* needs in that one has them just because one is human and so pursues some life-plan or other, not because of one's peculiar goals and projects.

Although human welfare involves essential human needs, one should not infer that it always is unreasonable to sacrifice one's own welfare for other

ends—'higher' goals, the welfare of other people, even one's own enjoyment. In pursuing your peculiar life-plan, you might well have certain needs, any one of which can be satisfied, but not all of which can be satisfied together. In such a case, you must sacrifice some needs for others—less important needs for more important ones. But there is no a priori reason why those needs that are common to *all* normal life-plans should *all* be more important for *your* life-plan than each of those needs that are *peculiar* to your life-plan, hence no a priori reason why your welfare-needs should all be more important than each of your other needs, hence no a priori reason why you should not sometimes sacrifice your own welfare for other ends. For example, there is no a priori reason why a nearly penniless painter should not sacrifice a complete diet for a complete palate.

IV. THE MEDICAL MODEL

Although his 'official' account of human welfare is a subjectivist one, von Wright also suggests another account:

> The concept of health may be considered a model on a smaller scale of the more comprehensive notion of the good of a being. That is: it may be suggested that one should try to understand this good (welfare) in all its various aspects on the pattern of the notion of health. On such a view, the good of man would be a *medical* notion by analogy, as are the good of the body and of the mind literally.
>
> The conception of the good of man on the basis of medical analogies is characteristic of the ethics and political philosophy of Plato. The idea is profound and, I think, basically sound. It is worth a much more thorough examination than will be given to it in the present work (p. 61).

Despite his extensive discussion of the concepts of health and illness, von Wright does not further pursue the medical model of human welfare. That is too bad. The idea of regarding the concept of human welfare as an extension, or enlargement, of the concept of health is a very promising one.

Two common ways of using the phrase 'good for' lend support to the medical model of human welfare:

Application to animals and plants. We call things *good for* animals and plants as well as people. At least in the case of plants and lower animals, such usage cannot be given a subjectivist construction.

When we call something good for an animal or plant, we apparently mean it would favorably affect (enhance, restore, protect) the *health* of the animal or plant. This often includes health in the broad, *positive* sense of strength, hardiness, growth and long life, not just the narrow, *privative* sense of freedom from disease.

Although man has a life of the mind not shared by any animal, it would be surprising if human welfare differed so radically from animal welfare that it were not a recognizable extension of *health*.

The functional use of 'good for'. 'Good for' is used *functionally* when we say that oil is good for engines, or that jumping rope is good for prize fighters. Used functionally, 'good for' occurs in phrases of the form ⌜good for Φs⌝, where Φ is a *functional* general term as opposed to a merely *morphological* one—the sort of term for which ⌜good Φ⌝ expresses either instrumental or technical goodness.

In the functional sense, ⌜*a* is good for Φ s⌝ means (roughly) ⌜*a* helps Φs to function well as Φ s⌝. For example, 'Oil is good for engines' means (roughly) 'Oil helps engines function well as engines'; 'Jumping rope is good for prize fighters' means (roughly) 'Jumping rope helps prize fighters function well as prize fighters'. Understood this way, something is *good for* a *kind* of thing, functionally specified, not an *individual* thing.

Aristotle apparently tried to elucidate human welfare in terms of the functional use of 'good for'. Something is good for an individual man, he seemed to think, only if it is *good for men* in the functional sense, hence only if it enables men to function well as men. This view led Aristotle to seek the essential function of man—to try to explain what it is to function (or function well) *as a man.*

F. H. Bradley took a different tack, basing judgments of what is good for individual men, not on the essential function of man, but on the particular *social functions* of those individual men.

Von Wright hints at yet a third way to analyze human welfare judgments in terms of the functional use of 'good for'. Although there may be no such thing as the essential function of man, we do speak as though *organs* have essential functions. The function of the heart, we say, is to pump blood. And it is plausible to construe somatic health, as von Wright does, as the well-functioning of organs. So if welfare is health writ large (the medical model), then welfare, too, might be interpretable as a kind of well-functioning. This would mean that something is good for a man if it helps certain of the man's 'components' (organs, mental faculties, or whatnot) function well, hence that 'good for' is used in something close to its functional sense when we call things good for men.

Can we regard the concept of human welfare as an extension of the concept of health? Consider the various objectives parents pursue when they promote their children's welfare. Can these objectives be regarded as *medical,* at least analogically? The most obvious such objective is health itself, positive and privative, somatic and psychological.

The good parent also ensures that his child is properly *educated.* I mean this to include, not just formal schooling, but all those things we call *training* and *upbringing* and regard as essential to a child's welfare. The principal over-all aim of such education is to promote strengths and excellences of intellect, character, and the higher perceptual faculties—the intellectual, moral, and aesthetic virtues.

Might not this objective be described as the *health* of the intellect, character, and perceptual faculties? To pursue this objective, after all, is to help ensure that certain 'parts' of a person function well—'parts' that admit of defeat and weakness as well as normality and strength.

True, this sort of 'health' attaches to the intellect, character, and higher perceptual faculties, not to bodily organs or to those parts of the psyche to which we customarily ascribe illness and health. But that may just be an historical 'accident': As the medical arts grew, they extended their stewardship from the body to *certain* parts of the mind, leaving other parts to other arts.

Much else that parents do in promoting their children's welfare may be regarded as *providing and securing external protections* for the somatic and psychological strengths and excellences (the forms of 'health') just surveyed: shelter, clothing, food, financial solvency, and the like.

To regard human welfare as health writ large is to accept something like this account of human welfare: To do what is good for a man is to promote or protect certain strengths and excellences of his body and mind.

But not all strengths and excellences of body or mind. Boxers, ballerinas, and banjo players need certain strengths and excellences of body and mind not needed by the run of men. *Such* strengths and excellences are not *welfare* needs, just because they are not needed by the run of men. Certain types and amounts of exercise promote bodily and mental strengths and excellences needed by (or at least very useful to) *all* normal men, whatever their goals and projects, and hence are *good for* all normal men, including banjo players. But we would not normally say of anyone, *even a banjo player,* that banjo-playing exercises are *good* for him, although such exercises promote strengths and excellences *he* needs to pursue *his* goals and projects. To do what is good for a man is (roughly) to promote or protect such strengths and excellences of *his* body and mind as *any* normal man needs in order to pursue his goals and projects.

V. Illness and Health

An important part of von Wright's contribution to the subject of human welfare, and another typical pioneering venture, is his discussion of illness and health.

Von Wright's concept of health is a *privative* one: Health is the absence of illness.

The loci of health and illness—at least the health and illness von Wright wishes to discuss—are *organs* and *faculties:* organs in the case of somatic illness, faculties in the case of mental illness. *Ill* and *weak* organs and faculties are also called *poor* organs and faculties *of their kind.* Other organs and faculties are called *good* ones of their kind. For example, an ill or weak heart is

sometimes called a poor heart, while a heart that is not ill or weak can be called a good heart. Used this way, the word 'good' expresses 'medical goodness'.

Von Wright holds that illness is a *functional* rather than a *morphological* defect. Every organ and every faculty has an *essential function*. That of the heart, for example, is to pump blood. Whether an organ or faculty is ill depends on how it performs (or would perform) its essential function.

Mere deviation from normality does not constitute illness. To be ill, according to von Wright, an organ must cause its owner to suffer, either by feeling a pain-like sensation (pain, ache, nausea, discomfort) or by having his wants frustrated. For example, a poor heart might function in a way that causes chest pains, while an arthritic hand cannot grasp what its owner wants. Abnormality as well as suffering can be called constitutive of illness, but only in the sense that the abnormality of an organ would *normally cause suffering*.

Mental illness has an important *social* aspect. Whereas the suffering that constitutes somatic illness must be the *subject's* suffering, the suffering that constitutes the illness of a *faculty*—mental illness, in von Wright's view—can be suffering by people other than the subject.

While there is much that I like in von Wright's approach to illness and health, there also are a number of problems raised by this approach. Here are five:

The meaning of normality. We commonly speak of health as a kind of normality, illness as a kind of abnormality. But in what sense of 'normality' and 'abnormality'?

According to von Wright, mere deviations from normality do not constitute illness. A genuinely pathological abnormality must cause *suffering,* or at least be of a kind that would cause suffering in normal men.

While this is very clarifying, further questions remain. Are medical normality and abnormality *statistical* concepts? Are they *normative* ones? If they are statistical, with respect to what *population* is normality determined? Or might medical normality and abnormality be *evolutionary* concepts, normal traits being those that survive and abnormal ones those that do not survive the process of natural selection? And just what is the difference between those deviations from normality that are genuinely pathological and those that are perfectly healthy responses to non-normal situations?

Are functions essential? Whether an organ or faculty is ill, in von Wright's view, depends upon how it performs its *essential function.* What is that? What does it mean, for example, to say that the essential function of the heart is to pump blood? Perhaps that 'heart' is a *functional* term, one whose very meaning involves the function of blood-pumping, much as the meaning of 'knife' involves cutting. The trouble is, hearts are not literally *designed* or *used* to pump blood—or to do anything else.

I suspect that sense can be made of the notion of an essential function of an organ, perhaps in evolutionary terms. But is this notion really needed to define illness and health? If an organ behaves abnormally, causing its owner to suffer, why can we not conclude straightway that the organ is ill, without bothering to determine whether the abnormality lies in the organ's performance of its *essential function?*

Function vs. morphology. Von Wright holds that illnesses are *functional* rather than *morpohological* defects. Pathologists would flatly deny this. They classify all *lesions* and *traumas* as diseases, or illnesses, regardless of whether they cause any functional impairment. An itchy rash, a painful skull fracture, or an ugly bruise need involve no dysfunction.

The loci of illness and health. Von Wright discusses illness and health of *organs* and *faculties,* But how often can illnesses be located in specific organs or faculties? In the case of a viral or bacterial infection that causes fever, headache, nausea, and other symptomatic discomforts throughout one's body, *what* organ is ill? If a spinal trauma causes leg paralysis, is the locus of illness the legs, the injured vertebrae, or the spinal chord? And how many common psychiatric diseases can be located in namable faculties?

Illness and suffering. A great merit of von Wright's account is that it does not classify deviations from organic normality as pathological (as *ab*normalities) unless they are bad for the subject in some *further* sense (or *would* be bad for a *normal* subject). But von Wright is wrong, I think, to suppose that illnesses always cause pain-like sensations or the frustration of wants, even in normal men. The bad effects of an illness, even a very serious one, are sometimes only potential, not actual. If a carcinoma has just started to grow on a man's brain, he may *as yet* suffer no bad effect of any sort, and he may *never* suffer any bad effect if treated in time. Sometimes, as in certain cases of leukemia, the *only* bad effect is a *shortened life*—not necessarily a shorter than normal life, nor even a life shorter than the subject had wished, but only a life shorter than the subject would have had without the illness in question. And sometimes a medical condition has no 'bad' effect at all, yet a pathologist would classify it as a 'disease'—witness a painless pimple.

VI. A Family of Concepts

The concept of human welfare is one of a variety of concepts having to do with the quality of human life. Von Wright has attempted to elucidate a number of these concepts and to explain how they are related to the concept of human welfare—another bit of pioneering. While he has accomplished a lot in this area, I believe he has also missed the significance of a number of distinctions.

It is important to distinguish the following seven concepts (or, in some cases, concept-clusters). Each is a 'value for'-concept—the concept of a kind of value things can have *for* other things, particularly for people.

Goal-relative value for a subject. This concept is a form of von Wright's 'utilitarian goodness'. It is expressed by the following predicates:

_____ is useful for . . .
_____ is valuable for . . .
_____ benefits . . .
_____ favors [is favorable for] . . .
_____ is advantageous for [is to the advantage of] . . .
_____ is in the interest of . . .

These predicates stand for the relation of a thing to a subject when the thing is efficacious in realizing a *contextually specified goal* of the subject's (or, at least, a contextually specified goal that the subject might reasonably be expected to have).

That goal can be anything. It needed have nothing to do with the subject's *welfare*. For example, if it is clear from context that a man is pursuing a certain athletic, commercial or military goal, and if a change in the weather helps realize that goal, it would be natural to say that the weather change *benefitted* the man, was *advantageous* to him, was *in his interest*—although the goal were not the man's welfare. Sometimes, of course, the contextually specified goal *is* the subject's welfare, or some aspect thereof. But not always.

Welfare value. This is von Wright's concept of 'the beneficial'. It is expressed by these predicates:

_____ is good for . . .
_____ is beneficial for . . .

They stand for the relation of a thing to a being whose *welfare* (well-being) the thing favorably affects (promotes, restores, protects).

In a way, the predicates listed under "goal-relative value for a subject" also are commonly used to express welfare value. But only in the sense that they are commonly used in cases where the subject's contextually specified goal happens to be (an aspect of) his own welfare.

I have already suggested that welfare is the same as health—in the broad, positive sense—when the being in question is an animal or plant, and a goal more inclusive than health but still very 'health-like' when the being in question is human.

Functional value. This is the concept expressed by the functional use of 'good for', explained earlier.

Von Wright does not explicitly discuss this concept. He does, however, classify certain functional uses of 'good for' as "metaphorical" uses of the 'good for' of welfare value (p. 50).

But the functional 'good for' is very different from the 'good for' of welfare value (even if the former be somehow explicable in terms of the latter). In the functional sense, something is *good for* a *kind* of thing, functionally specified, not an *individual* thing. And to call something good for so-and-sos, functionally construed, is to say (roughly) that it would help so-and-sos to function well as so-and-sos; it is not (necessarily) to say anything about the *welfare* of so-and-sos.

There is another sense of 'good for' that is very close to the functional sense—too close, really, to warrant a separate rubric. In this sense, we say of a thing *x* that it is *good for* another thing *y*—an *individual* thing, not a *kind* of thing—provided *x* helps *y* perform well a certain contextually specified function. Example: A second quart of oil would be good for your engine.[6]

Human welfare value. This is just welfare value applied to humans.

Von Wright sharply separates his treatment of human welfare value ("the good of man") from his treatment of welfare value generally ("the beneficial"). While the former certainly deserves special attention (we are human, after all), this separation apparently encouraged von Wright to depict human welfare in such a way that it bears no evident resemblance to the welfare of animals and plants.

Subjective value. This large concept-cluster includes von Wright's 'hedonic goodness' and related notions. The concepts comprising this cluster are expressed by such predicates as the following:

_____ makes . . . pleased
_____ makes . . . happy
_____ makes . . . content
_____ satisfies . . .'s preferences
_____ helps bring about . . .'s goals

Each of these predicates stands for a relation of a thing to a subject when the thing contributes to bringing about consequences which *he,* in some sense, *values*.

I have already pointed out some of the differences between human welfare value and certain forms of subjective value. As a subjectivist, von Wright mistakenly analyzed human welfare value as a form of subjective value. Unlike the classical utilitarians, however, he took pains to distinguish welfare, happiness, and pleasure.

Self-interest value. This concept is a special form of subjective value with strong affinities to welfare value. It is typically expressed by the predicate:

_____ is in . . .'s own self-interest.

This stands for the relation of a thing to a subject when the thing helps realize some *self-regarding goal or preference* of the subject's.

That goal or preference can but need to coincide with the subject's *welfare*. Suppose I praise Peter's generosity in offering to help Paula carry some books up to her apartment. Someone inclined to a more cynical analysis of Peter's behavior might say something like this: 'Peter was really just acting in his own self-interest, hoping Paula would succumb to his amorous advances when they reached her apartment.' If the cynic is right, Peter has pursued a self-regarding goal, but the achievement of that goal probably would not favorably affect Peter's *welfare*. More likely it would 'merely' *please* him. Peter's act of apparent generosity may have been self-serving, but it would be misleading to call the act *good* for Peter. It could even have been *bad* for him, though he were well aware of its consequences—if, for example, it kept him from keeping a badly needed dental appointment.

Life value. This concept is closely connected with welfare value as well as subjective value. It is expressed by the following predicates:

———— helps . . . to thrive
———— helps . . . to flourish
———— helps . . . to enjoy a good life

Roughly speaking, these predicates stand for the relation of a thing to a subject when the thing helps the subject lead a life in which he enjoys a high level of well-being (welfare), develops his peculiar potentials, has plenty of opportunity to realize those potentials, and enjoys their realization.

Although he does not explicitly discuss life value, von Wright seems to have this concept, or something very like it, in the back of his mind when he characterizes the second of two 'aspects' of welfare:

> The basic aspect . . . is conceptually allied to the needs and wants of beings and to the notions of the beneficial and harmful . . . The other aspect of welfare . . . has a primary conceptual alliance with pleasure. Of the being, who enjoys this aspect of its welfare, we say that it is happy. Happiness could also be called the flower of welfare (p. 62).

In addition, much of von Wright's rich and profound discussion of happiness can profitably be interpreted in terms of life value.

DEPARTMENT OF POLITICAL SCIENCE THOMAS SCHWARTZ
UCLA
FEBRUARY 1975; REVISED FEBRUARY 1976

NOTES

1. Most of von Wright's discussion of welfare generally and of human welfare in particular can be found in Chapter III, 'Utilitarian and Medical Goodness. The Beneficial and the Harmful. Health and Illness', and in Chapter V, 'The Good of Man'. Chap. 3 also has much of importance to say about *illness and health,* and a substantial part of Chapter V is an extensive and profound discussion of *human happiness.* Other relevant material can be found in Chapter I, esp. § 5; in Chapter IV; and in Chapter VI, esp. §§ 4–6. Those portions of *Varieties* most relevant to our topic have been assembled and edited to form a short reading selection in Chapter 3 of my textbook-anthology, *Freedom and Authority: An Introduction to Social and Political Philosophy* (Belmont, Calif.: Dickenson, 1973). Further references to *The Varieties of Goodness* are in parentheses in the text.

2. For a clear statement of the subjectivist conception of human welfare by a distinguished economist, see Kenneth Arrow, 'Public and Private Values', in Chap. 8 of *Freedom and Authority* (ibid.). Arrow is unusual among (non-Communist) economists in being explicitly aware that a subjectivist conception of human welfare is not wholly uncontroversial.

In a way, Marx's *Economic and Philosophic Manuscripts of 1844* (the most relevant portions of which are reproduced in *Freedom and Authority,* Chap. 3) is a sustained attack on the subjectivist view. Professor Amartya K. Sen's Inaugural Lecture, *Behavior and the Concept of Preference* (London School of Economics and Political Science: 1973), contains a more clear-headed and convincing attack, anticipating the present paper in some respects.

3. On p.113, von Wright makes pretty much this point himself but does not seem to notice that it conflicts with his account of human welfare.

By the way, I have characterized the defect at issue as 'irrationality' rather than 'character weakness' because I want to allow the possibility of irrational preferences not associated with weakness of character, e. g., preferences resulting from poor estimation of probabilities, incorrect computation, erroneous canons of decision-making under uncertainty, and the like. One could always argue, however, that irrational preferences of these latter kinds are also *ill-informed* preferences—particularly if one uses the term 'ill-informed' in a broad sense. I used the character–weakness example to show that *irrational* preferences do not just constitute a sub-category of *ill-informed* preferences.

4. Whence it does *not follow,* as Mill apparently thought, that a man who did not have the ability to appreciate, say, good music would still somehow be better off listening to good music than to inferior music which he enjoyed more. All that follows is that he'd be better off (other things equal) if he *had* the ability to appreciate good music.

5. This aspect of the concept of welfare is lucidly and convincingly brought out by Nicholas Rescher, *Welfare* (Pittsburgh: The University of Pittsburgh Press, 1972), pp. 10ff.

The minimal, need-related aspect of welfare makes it questionable how much importance should be attached to welfare, as opposed to broader, less minimal, less essential kinds of benefit; whereof see David Braybrooke, 'Let Needs Diminish that Preferences May Prosper', in *Studies in Moral Philosophy,* American Philosophical Quarterly Monograph Series (Oxford: Basil Blackwell, 1968).

6. Instead of speaking of *a contextually specified* function, one might speak of *the* function *of y,* thereby presupposing a *designer* or *user* of *y*—or some form of essentialism.

10

Kurt Baier

PREFERENCE AND THE GOOD OF MAN

The first half of von Wright's *The Varieties of Goodness,*[1] the second of his Gifford Lectures, is a magisterial examination of the many types of claims that can be made with the word 'good' and its cognates, such as 'beneficial' and 'useful' and 'virtuous', the different ways in which they can be supported, and the logical connections among them. The work is a milestone in the history of the subject. It invites comparison with Aristotle by its combination of deep-cutting, painstaking, and exhaustive detail on a vast scale, its fresh examinations of important if currently unfashionable subjects, and its unrivaled conspectus of the field as a whole. It should be obvious that my essay, though largely critical, is the tribute of one convinced that the way to the truth is *through* von Wright.

1. The book's three major theses on the good are: (*a*) that there is no obvious unity underlying the multiplicity of forms or varieties of goodness, that is, uses of the word 'good' (i, 12-17); (*b*) that there is no such thing as intrinsic, absolute goodness, as G. E. Moore conceived of it—things being good from no particular point of view or from the point of view of the universe (103)—and that its replacement as "the central notion of our whole inquiry" (86) is the good of man; and finally (*c*) that this central notion, the good of man, can be explicated in terms of a certain sort of idealized preferential choice (103ff). Although I am in agreement only with (*b*), I shall be able to take up only (*c*) which is the most important, but seems to me untenable, not only as it stands, but also in any of the revised forms I can think of.

Von Wright expounds the major part of his central thesis in chapter V, entitled "The Good of Man". But the claims made there presuppose and build on others contained in the three preceding chapters with which it forms a close unity. The varieties of goodness discussed in these chapters fall into two major groups. One is centered on utilitarian goodness, which does not involve value judgments but only causal ones and which are, therefore, capable of being true or false (48). The other is centered on hedonic goodness, "the goodness of

sensations and other states of consciousness'', which involve genuine value judgments and are therefore incapable of being true or false (75)[2]. The good of man has close logical relations to both these groups. Through the beneficial, a subcategory of the useful, it is related to utilitarian goodness (42), and through happiness to pleasure, and so to hedonic goodness (87f). Lastly, it is also related to another important variety, namely, medical goodness, the goodness of bodily organs and mental faculties (51). And since bodily organs ''immediately'' serve the good of the body, which ''is also called bodily health'' (61), and ''remotely'' the good of man (61), ''the concept of health may be considered a model on a smaller scale of the more comprehensive notion of the good of a being'' (61). After such preliminary elucidations of the notion of the good of a being and its relations to other varieties of goodness, von Wright then offers an explication of the good of man as what a certain sort of idealized man would preferentially choose (101-113).

I have set myself four main tasks: to explain the central question, What is the good of man?; to elucidate von Wright's account of the relation of the good of man to other varieties of goodness; to clarify the nature of the preferential choice in terms of which he explicates the good of man; and to offer critical comments on von Wright's theses on these three topics.

I

2. Von Wright begins his investigation in chapter V with the observation that his central question 'What is it?' can be understood in a multitude of senses (86). However, he then specifies only one of them, namely, the request for ''a verbal equivalent of that which we *also* call 'the good of man' '' (86). Even this question is not examined thoroughly or answered consistently. Since the inconsistency is, in my opinion, a symptom of an important vacillation, if not confusion, I shall begin by straightening out these matters.

Von Wright considers ''three candidates for a name of the good of man'', 'happiness', 'well-being', and 'welfare' (87). He ''accepts without discussion'' the suggestion that 'the good of man' and 'the welfare of man' are synonymous phrases, but thinks that 'happiness' and 'welfare' are most commonly treated as ''concepts of different logical category or type'', and so not as synonyms (87). His main reason for the view that 'happiness' and 'welfare' are not synonyms is their having ''logically different relationships to time and causality'' (88). Thus he says, ''happiness is more like a 'state' (state of affairs) than welfare is'' (87). But then, surely health is as much a state as happiness is, and the good of the body, like the good of anything, no more like a state than the good (welfare) of man (42, also 61). So 'health' can be a synonym of 'the good of the body', although the two are concepts of different logical category

or type. At the same time, he also says things which appear to drive a wedge between the good and the welfare of man, which he has declared synonyms. According to him, "a being who, so to speak, 'has' or 'enjoys' its good, is also said to *be well* and, sometimes, to *do* well." (86). Thus, he wishes us to distinguish between a person's good and his having or enjoying his good— presumably everybody *has a* good, (i.e., there is something which is his good) but not everybody *has his* good. And so we must distinguish between, on the one hand, a person's good and, on the other, his being well or doing well, for these latter are cases of a person's having (some of ?) his good. Elsewhere, as we have seen, he also draws a parallel between the welfare of the body and the welfare of man (61–62). There, perhaps because of his identification of the good of the body with health, he treats 'the welfare of man' as a general term having two different levels or degrees, being well and doing well, by analogy with the two levels or degrees of health: mere absence of illness and glowing health (55, 61-62, 87). But then, if we must distinguish between man's good and man's having his good, and if man's having his good is either his being or his doing well, and if 'welfare' is the general name covering both being and doing well, then a man's welfare (faring well) is *his having* his good, and so we must also distinguish between the good of man and the welfare of man.

I think von Wright's inconsistency is due to the fact that he has not settled on an answer to, perhaps never clearly raised or examined, the question 'What is the good of man?' in a second sense. I mean, 'What *category of thing* is it?'. He does indeed imply that the good of a being is *not* a state or state of affairs (87), but he does not say positively what sort of thing it is. Indeed, he does not seem to notice that in treating 'health' and 'the good of the body' as synonyms or at any rate as 'names of the same thing', he implies that the good of a being is a state after all. Well, what category of thing is the good of a being? The answer will not emerge until after we have become clearer about the relation between "the good of a being" and those terms which, according to von Wright, are at least prima facie synonymous with it.

3. *Health*. There are two importantly different uses of 'health': one to refer to one particular, highly ranked state of a being, the opposite of illness (analogous to warmness, the opposite of coldness), and the other to refer to the range of such ranked states, from glowing, via radiant, excellent, good, and so on down to poor, bad, ill health. When we ask *what* health is, when we congratulate someone on the recovery of his health, or when we say that someone's health is our end or aim, we use it to refer to the highly ranked state rather than the range. When we ask *how someone's* health is, we use it to refer not to the highly ranked state but to the range and at the same time request to be told the specific level of the range he is at.

The good of a being obviously is neither a whole range of states nor a highly ranked state of the being in question. If it were, it would not be odd to

ask 'How is your good?', or to congratulate you on the recovery of your good or to grieve with you over its loss. The nearest equivalent, in the language of the good of a being, to 'How is your health?' would seem to be, 'How much of your good do you have or enjoy?' (86/87)—or in other words, 'How much of your good has come your way?' If they advance your good, then wholesome food and exercise, as well as certain changes which they bring about, are part of your good. This is not true of health. Wholesome food and exercise are not part of one's health, however much they advance it. What's more, it would seem that wholesome food and health are part of your good, whether or not they come your way, as long as they *would* advance it *if* they came your way.

We can therefore say, in terms of a helpful comparison von Wright draws (46) between 'evil' and 'harm', that 'the good of a being' is more like 'evil' than like 'harm': 'The word "evil" sometimes means the cause of harm and sometimes the harm caused. The word "harm", it would seem, has not the same double meaning. It nearly always means the thing (damage) caused or suffered.' Like 'evil', the expression 'for the good of a being' sometimes refers to the cause of a certain sort of change in the life of the being and sometimes to the change itself, and 'the good of a being' to all such causes and changes.

Evil is not, however, the negative analogue of the good of a person: there is no such thing as a person's evil. The true opposite of the good of a person is that person's detriment, i.e., whatever is to his detriment. The good and the detriment of a being are unlike the health *of* a being, the harm *to* a being, and even goods and evils. For whereas the health of a being is a kind of state, harm to a being is a kind of change (for the worse) in that being, and goods and evils are either changes (for better or worse) in a being or its condition, or the causes of such changes, the good or detriment of a being are not themselves states, changes of such states, or even causes of such changes. We shall presently see how they are to be characterized.

4. *Happiness*. We can agree with von Wright that 'the happiness of a being' and 'the good of a being' are not synonyms, not even near-synonyms. For one thing, there are many things that can have a good, but can't be happy, e.g., the body. But even if one restricted von Wright's account to the good of *human beings*, it would still be defective on two counts. Von Wright himself stresses one, namely, that while health and well-being do not, happiness does involve judgment: "To judge oneself happy is *to pass judgment on* or *value* one's circumstances of life" (98) [my italics]. A person may be happy, even (pace Wittgenstein) only for a minute, as when he learns by telephone that he has received the Nobel Prize, but a minute later the operator calls back to say, with apologies, that the Prize went to another person of the same name. What matters is not that he should actually have got his good but that he should think, rightly or wrongly, that he has.

The second point, and this runs counter to von Wright's suggestion (86–87), is that the judgment about the circumstances of one's life need not concern one's good at all. A married man may think that his neighbor's wife will shortly yield to his advances and this may make him happy, perhaps radiantly so, even if this course of events is not for his good, and even if he does not think it is.

What makes us happy involves our favorable judgment on our life. In this respect it is like contentment, fulfillment, and being satisfied. But the judgment may be false, and when we discover the error, we are no longer happy. In this respect, happiness is unlike fulfillment. If the judgment on which fulfillment depends is false we merely *think* we are fulfilled, and when we discover the error we cease to think so. Of course, while the error lasts we *feel* fulfilled; when it is discovered, we no longer feel thus. There does not appear to be a comparable difference between *feeling* and *being* happy.

It is not clear to me what is the content of the favorable judgment of one's life on which one's happiness depends. Is happiness a certain introspectivley recognizable feeling of varying degrees of intensity (say, from being pleased to being euphoric) or perhaps rather of varying intensity *above* a certain degree (say, above being delighted), so that we can discover empirically what makes people happy? Could we, for instance, discover that certain sorts of people can be made happy by their judgment that they have been severely injured? Or is happiness, rather, that range of agreeable feelings of varying intensity which are the result of *a certain sort* of favorable judgment on one's life? If the latter, it seems to me more than dubious, for the reason given above, that it is judgments to the effect that one is getting an unusually high portion of one's good. But I cannot pursue this topic here.[3]

5. I can be only very tentative about welfare, since the linguistic clues I have been able to find are few and hard to read. Perhaps the most important difference is this. We can perfectly naturally speak of some event or development (winning a lottery) being *for* someone's good. But if we can say at all that it is for *his* welfare, it seems to be in another sense of 'for', as in 'for your health'. 'This (e.g., elixir) is for your health' means roughly 'Take this and your health will improve'. Thus, 'is for X' here means 'would favorably causally affect X'. i.e., 'bring about an "upward change" in X's life'. In 'this is for your health', 'your health' refers to *what* this (the elixir) is *for*, not to *that* (the elixir) *which* is for your health. Von Wright sometimes treats 'for your good' in this way (42f, 47), for he renders it as 'causally favorably affects *someone's good*'. This would imply, however, that 'your good', like 'your health', refers to a range of states of yourself, whereas in fact it refers to *that* (the elixir) which is for your good and not what that is for. This seems to imply that 'one's welfare' is more like a state (e.g., one's health) than is 'one's good'.

Conversely, we can say things about welfare which we cannot say about the good. Thus we can *ensure* someone's welfare, but not, it seems, his good. This too, would seem to imply that a person's welfare is, somewhat like his health, a highly ranked condition within a range.

How, then, are we to construe welfare? It will not quite do to say that a person's welfare is simply his faring well, for a person may be faring well in all sorts of enterprises (a bridge tournament, a job interview, a love affair) which can have no bearing at all on his welfare, though they may well affect his good or his happiness. Nor must we think that a person's welfare is simply his being well (his being in good health) or his well-being (range or highly ranked state relating to the quality of his life in general, not only health), for the latter two are (physical or mental) states of the person or a range of such states, whereas welfare seems to relate, rather, to *his condition*: how well the circumstances in which he is placed *enable him* to fare, to make out, to progress.

My hunch is that 'a person's welfare' refers to certain conditions, whose satisfaction ensures his actually *having* the ability to satisfy his *basic needs*. This seems to be the truth in von Wright's claim that welfare is tied to the minimum requirements of enjoying or having one's good (86). But, of course, this is peculiar to welfare, and not something it shares with the good of a being. By the same token, there is nothing analogous, in welfare, to the positive notion of health: glowing or radiant health. One's welfare does not relate to the things, the enjoyment of which constitutes the person's happiness (67, 87); one's good does.[4]

6. The upshot of this discussion is that 'the good of X', 'the welfare of X', and 'the happiness of X' really are closely related terms, but related not so much by synonymity, near-synonymity, or sameness of reference, as rather by a set of interconnected background conditions. They all presuppose: (a) that there is a being with a life lived in an environment which is not part of that life but which can influence it in important ways; (b) that this life has a course composed of stretches for each of which there are possible alternative stretches; (c) that in every actual such stretch there are factors delimiting the number of possible alternative later stretches, and thus determining some aspects of such later stretches; (d) that there are factors in the environment of the being and possibly also in its thinking and acting which determine which of these possible alternative stretches are actualized; (e) that there are certain respects important to these beings, in which these alternative stretches can be and are compared, ranked, and possibly graded (i.e., assessed by an objective standard); (f) that the beings in question experience pleasure, delight, euphoria, or the opposite at the thought of which of the possible alternatives have, or will probably, come to be realized in their lives, and how their actual life measures up to some appropriate standard.

As we saw, claims made with the terms under discussion all presuppose this common background state of affairs, but they do not all refer to the same aspect(s) of it. Ascriptions of happiness, contentment, and fulfillment make reference to (f). Judgments of a being's welfare or good are complex judgments about which of the alternatives possible at given points in that being's life were a good, or the best thing from a point of view identical with or closely related to the point of view of one seeking to know what is, and to realize, the best possible life for himself.[5] The difference between judgments of the good and the welfare of a being appears to be twofold: (i) the welfare of a being is measured by a comparatively modest standard, so that from the point of view of its welfare there may be nothing to choose between a number of alternative possible stretches of its life, since each of them ensures its welfare, while from the point of view of the good there is still something to choose because some may promote its good more than others; (ii) a person's good can be said to *be what* (e.g., wholesome food) is for, or promotes, his good, while the things that are, or promote, a person's welfare cannot be said to *be* his welfare. In this respect, welfare is more like health than is the good of a being.

7. We can now return to the question, 'What category of thing is the good of a being?' Von Wright appears to be committed to at least four different answers:

(a) The good of a being is a certain highly ranked state in a ladder, i.e., a hierarchically ordered range, of states, or an upward change in that sort of state of the being in question. Von Wright has this answer in mind when he thinks of the good (welfare) of a being on the analogy with health in the privative sense: the absence of certain negative or undesirable features, e.g., unsatisfied needs (62, 86f).

(b) The good of a being is the range of states above the highly ranked state mentioned in (a), or any such upward change without the limit envisaged under (a). Von Wright has this answer in mind when he thinks of the good (welfare) of a being on the analogy with health in the 'positive' sense: the presence, beyond a certain minimal level, of positive features, "an overflow or surplus of agreeable states and things" (42f, 47f, 61f, 86f).

(c) The good (or welfare) of a being is all those things, (the actualization of all those possible stretches of its life) which will bring its life nearer, or up, to a certain minimal level of well-being. On this view, the good of a being is not itself a certain level of well-being, or an upward move on a ladder of states of well-being. Rather, it is whatever is (and because it is) a necessary condition or a cause of the being's approaching or reaching that minimal level. This is the answer von Wright embraces in his explication of the notion of the good of a being in terms of a certain sort of preferential choice (101-113, esp. 106-108). For, as we shall see, he there implies that the good is the beneficial and the needed, i.e., the nucleus (the core minus the causal implications) of a pos-

itive constituent of the good, i.e., that alternative stretch out of all the possible ones which an appropriate chooser would preferentially choose.

(d) The good (or welfare) of a being is again all those preferred stretches of the being's life, only this time there is as in (b) no minimal limit on the upward move.[6] We have already seen reason to reject (a), (b), and (c). We have also brought to light one reason why (a) and (b) should at first sight be so plausible: the failure to notice that in, 'this (elixir) is for your health' and 'this (winning the lottery) is for your good', 'for' is used in significantly different ways. If one identifies health with the good of the body, as von Wright does, one is bound to overlook this difference. One is, furthermore, likely to construe them both on the model of 'for your health', and so to think that 'X is for your good' means the same as 'X favorably causally affects your good', as von Wright does (42f). But then one will naturally think that the good of a being is a certain state or change in that state, of that being—just as health is.

The second reason is this. If one construes 'for the good of a being' in this way, then the following will seem to one absurd: that in 'X (e.g., exercise) is for the good of a being', 'the good of a being' refers to X. For then one must believe that one has made the sort of blunder someone makes who claims that in 'exercise is for the health of a being', 'the health of a being' refers to exercise. But, as we have already seen, these two claims are very different. For 'exercise is for the good of a being' cannot be analyzed into 'exercise favorably causally affects the good of that being'. It must be analyzed, rather, into 'exercise favorably causally affects that being (or the life of that being)'. And that means that exercise makes a favorable difference to the life of that being, by raising the level of the creature's well-being, and that therefore exercise is to be included in the good of that being, in the totality of things which *for that reason*, can be said to be for its good.

8. This brings us to the third and most important reason for the initial plausibility of (a) and (b): the failure to distinguish two further interpretations of the question, 'What is the good of a being?', both from one another, and from other interpretations of that question. Clarity about this is of considerable importance for the question of how substantive theories of the good of man, such as von Wright's preferential choice theory, could be confirmed or disconfirmed. Clarity on this matter will enable us also to do two other things: To understand the question to which 'the good of the body is health' is a plausible answer;—it should be obvious by now that it is not a plausible answer to a request for a synonym or other name for, 'the good of the body', as von Wright construes it (42f, 61f, 86f); and to apply to the concept of the good of man von Wright's own helpful analysis of another variety of good. He calls that variety, somewhat infelicitously, "instrumental goodness".[7]

Let us note, first, that questions of the form, 'What is the good of X?' can be posed at various levels of the generality/specificity scale, depending on what

is substituted for 'X'; 'a being', 'a country', 'man', 'the body', 'Jones', 'Jones's body' and so on. Note also that for each level of specificity there are available what might be called 'different modes of specification' in which to couch these answers. If we spell out *wherein something consists*, e.g., a person's happiness, the quality of a thing, or the good of something, we use a 'functional mode of specification'. If we spell out *wherein these things lie*,[8] we use 'a descriptive mode of specification'. Now there are important connections between these various types of answers to 'What is the good of a being?' which we must now examine. We can use von Wright's own illustration of "instrumental goodness" (24-27), i.e., the degree of usefulness (44f) of a thing of a kind "for the purpose(s) essentially associated with the kind" (20f). Von Wright's example of such a thing is a carving knife. The essentially associated purpose of such a thing is *carving meat smoothly*. We can then ask the completely general question wherein the instrumental goodness of things of a kind with essentially associated purposes consists, and get the conceptually establishable answer that *it consists in the extent of their capacity to serve the essentially associated purposes*. This completely general answer has two expressions which are place-holders for more specific expressions, 'things of a kind' and 'essentially associated purpose(s)'. But they are not entirely empty place-holders: they contain formulae for deriving the more specific expressions with the aid of further information. If we know what are the essentially associated purposes of carving knives, then we can derive, from this general principle about the instrumental goodness of things with essentially associated purposes, that in which the essential goodness of carving knives consists: the capacity to cut smoothly. We accomplish this derivation by simply putting 'carving knives' and 'carving meat smoothly' into the places marked by the place-holders, 'things of a kind' and 'essentially associated purpose(s)'.

However, such conceptual knowledge still does not enable us to tell about particular knives whether they possess this capacity of cutting smoothly. We could acquire the necessary additional knowledge by trying out such knives, but this is often inconvenient. Quite often we want to be able to tell, e.g., when buying one, what is the quality of various knives on sale, without actually having to try them out. What we need to know, therefore, are those readily observable morphological properties *on account of which* knives have the capacity to carve smoothly. It is now known, of course, on the basis of ample experience, that in the case of carving knives this property is *sharpness*. Thus we can say that the quality of such knives *consists in* their capacity to carve smoothly, but that it *lies in* their sharpness. While conceptual investigations may enable us to determine wherein the quality of something consists, only empirical investigations resulting in causal knowledge will enable us to tell wherein its quality lies.

Ideally, an account of 'the good of X' should begin with the most general

case, 'the good of a (any) being'. An account of what that good *consists in* should be a conceptual truth analogous to the conceptual truth that the quality of a thing of a given kind consists in its capacity to serve its essentially associated purpose(s). From this general truth we should be able to derive what the good of more fully specified beings consists in, simply by filling in the peculiarities of the beings we are now talking about: a (any) country, man, the body, France, Jones, Jones's body, and so on. It may well be that our knowledge of these peculiarities would suffice to enable us to work out, without additional empirical information, what the good of a being so specified consists in; just as our knowledge of "the kind" (carving knife) might enable us to infer the associated purpose(s) and thereby what the quality of things of that kind consists in. Suppose, as I do, following von Wright (55f, 86) that it makes sense to speak of the good of those and only those beings who can be said to have a life. Then it would seem that the good of a being must be closely related to something in its life. Perhaps the good of a being are those things (events, changes etc.) with the capacity or tendency to cater to the tastes of the being, to make its life worthwhile, valuable, meritorious, happy, contented, fulfilling, or simply as good as possible. Suppose it is the last. Then the good of any being consists in a life as good as possible. Might we not be able, by spelling out more fully what we mean by the somewhat nebulous term 'the life of the body', to show by a purely conceptual argument that the good of the body consists in its health because the health of a body does, and nothing else can, ensure that the life of that body is as good as possible? We can do that if we can give a functional account of bodily health, e.g., the body being in a state *such as to* perform certain functions adequately, and if the good of the body actually *consists in* those changes in it or in its environment which favorably affect the body, i.e., affect it in a way which brings it closer to or prevents it moving further away from that state. If it is possible to give such a derivation of what the good of the body consists in, then the claim that the good of the body *is*, i.e., *consists in*, health is an obvious because a conceptual truth. But it is not, as von Wright suggests, a tautology. Nor is it, as he also suggests ("another name for", 42), what some call a contingent identity. For if such a derivation is possible, we do not have to discover by observation that health is a good of the body, as we discover that 'Hesperus' and "Phosphorus' are different names of the same planet.

Even if such a derivation is possible, this does not yet tell us wherein that good lies, for it leaves us with only a functional account of health. We still have to discover by observation what morphological or descriptive properties the body must possess in order to be in a state of health. It is these properties and their causal prerequisites (101), in which the good of the body lies.

But now it should be clear that neither the answer to what the good of a

being consists in nor to what it lies in, can be an answer to what category of thing it is, although all three of these questions may be posed with the words 'What *is* the good of a being?' For the question as to what that good consists in asks for a criterion on the basis of which to apply the expression 'the good of X'. When we have that answer, we can determine which changes in the life of X are favorable ones, are for X's good. And in doing so we are answering the question wherein X's good lies. But when we ask what category of thing the good of a being is, we are asking a question about the good of *any* being, not of this or that being, and so we cannot be asking for a criterion or for what that criterion singles out. We want to know what category of thing 'the good of X' refers to. Since we have seen reason to reject (a) and (b) above, the answer is that it does not refer to a state of X, or a favorable change in that state, but rather to what (i.e., *whatever*) that good lies in. Thus, we can answer 'What category of thing is the good of a man?' without answering wherein a particular man's good consists or lies.

II

9. My second task is the elucidation of von Wright's account of the relation between the good of man and certain other varieties of goodness. This is interesting and important not only on its own account but also because, surprisingly, von Wright nowhere directly tackles the question wherein the good of man consists or wherein it lies. As far as his central inquiry, *the good of man*, is concerned, von Wright does not give us anything analogous to his contention that *the good of the body* is (i.e., consists or lies in) health. The answer to his central question has to be extracted from his discussion of judgments of the beneficial and harmful, judgments which are, no doubt, closely related to judgments of the good of man. Does von Wright perhaps think they are not merely related but the same? If he did, then this would explain why in his chapter on "The Good of Man" he focuses so singlemindedly on the beneficial and harmful. I shall give reasons for thinking that von Wright really is under the impression that the two types of judgment are the same, and reasons, I hope cogent, that this is a mistake. Because of this mistake his account of his central question is defective, a defect which has important consequences: it is at least partly to blame for the major flaw in his account of the good of man.[9]

10. Von Wright says that judgments of the beneficial and harmful have a causal and an axiological component (48-49, 101). His most general way of characterizing this causal factor is "favoring" (10), "being favorable to" (47) and "being favorably causally relevant to" (43) the affected thing or being in question. His most general account of how we determine the range of proper-

ties, changes in which constitute a favorable or unfavorable effect, is in terms
of what "is, to it, a good", i.e., an end of action or object of desire or want
or need (10). The distinction between a favorable and an unfavorable effect is
drawn by von Wright only in terms of metaphor, namely, the "reduction or
increase of the distance" from what to a certain being is a good, a distance at
which this being finds itself as a result of the causal impact. According to von
Wright, there are "two principal ways" in which such distance reductions can
occur, "the promotive" and "the protective" (42, 47, 101-103, 133ff). The
former takes us, "metaphorically speaking, nearer or even up to this end" (or
other good) (47).

It is plain that von Wright's account implies some reference point or other,
relative to which the being in question is now nearer or farther away from its
good. Von Wright's formulations strongly suggest, if they do not imply, that
the appropriate reference point is the distance *prior to the impact*: the being in
question is now, in virtue of the causal impact, nearer to its good than before
the impact. Thus, von Wright characterizes the promotive way as either "mak-
ing bad better" or "making good better" (47), and this surely suggests an
actual improvement, a shortening of the metaphorical distance compared to
what it was *previously*. Similarly, in characterizing the protective way, von
Wright implies that the protectively affected being is no worse, no less well,
no farther away from its good, than it was prior to the causal impact. And this
suggests or implies that, at the least, maintenance of the pre-impact distance
from the being's good is a necessary condition of being causally favorable.

But this is surely not so. If a dentist treats a patient's tooth, he may cause
him a great deal of prolonged pain. The patient may therefore be further away
from what to him is a good, namely, freedom from pain, than he was before
treatment. The treatment may therefore be causally favorable to the patient
neither in von Wright's 'promotive' nor in the 'protective' way. Yet even so
the treatment was causally favorable to the patient if, as may be virtually cer-
tain, he would have been even farther away from that good without the treat-
ment. There are thus other and no less 'principal' ways of being causally fa-
vorable to something than the 'promotive' and the 'protective'. Besides, von
Wright's account of the causally favorable suggests the wrong reference point
for measuring the "distance from a good." The appropriate reference point is
not the distance prior to the causal impact, but the distance at which the being
would be from the good *but* for that impact. This is quite plain in the case of
protection. For the impact is not protective simply because the being is not
now any farther away than it was before, but only if it also would have been
farther away without the impact than it now is. And though perhaps less plainly
so, the same is nevertheless equally true in the case of promotion. For here too
the impact is promotive, not simply because the distance is now shorter than it

was before the impact, but only if in addition it would, at best, not have been as small as it is now in the absence of the impact. We cannot for instance say that the psychoanalysis cured the patient (a case of "promotion", or "making bad better" 47) just because he got better after the analysis; we can say it only if, in addition, it is true that he would not have got better *in any case*.

11. Von Wright seems to distinguish two sub-classes of judgments of the causally favorable, namely, the useful in the widest sense, i.e., that in which the good to the being in question is the particular good we call an end or purpose (42-44), and that in which the good to the being in question is the object of a desire, want, or need, (10) or something in itself wanted (104). Right now we can ignore this second subclass about which von Wright does not say much. The first he divides (by implication) into four further subclasses, namely, the instrumentally good, the technically good, the merely useful, and the beneficial. For our purposes here we need to look more carefully into the relationship between the useful in the widest sense, the merely useful, and the beneficial.[10]

According to von Wright, judgments of the beneficial, as in 'To take a holiday or to get married will do him good' (41) are that subclass of judgments of the useful in the widest sense which satisfy two conditions: (a) that the way in which the useful causally favors the being in question be the 'promotive' rather than merely the 'protective' way (43), and (b) that the good of which the useful is promotive be "that peculiar good which we call the good of a being" (43). Because of (b) judgments of the beneficial differ from the other subclasses of judgments of the useful in the widest sense in not being "purely causal" (48), in having an axiological as well as a causal component (49, 101). And the causal component, too, is special, namely, promotive. Even where something favorably affects the good of a being, if it does so merely protectively, it must be classed as *merely* useful.

In von Wright's view, virtues are merely useful rather than beneficial because, although they are causally favorable to the good of a person, they are so only protectively. I do not find this plausible. Thus, von Wright says that "physical exercise, for example, is beneficial because good for the health. . .that it affects favorably, immediately, the good of the body, and ultimately the good of man" (43). However, prudence and self-discipline are virtues. Do they not necessarily involve the practice of things which are good for one, such as exercise, and *because* they are? But I shall not pursue the question of whether this apparent mistake is due to an error about virtues or about the beneficial.

12. The difficulty is, however, related to another matter which is central to my main purpose here, and which I must pursue. I mean the manner in which von Wright characterizes the two ways of being causally favorable to the good

of a being. The promotive way, i.e., the beneficial, is "the being good for somebody", where, he says, this phrase can be replaced by "the doing good to somebody" (42), while the protective way, i.e., the merely useful, is "the being good for somebody" where this phrase cannot be so replaced. Von Wright makes a similar point elsewhere when he raises the question of whether a man's welfare can be an end of his own action (90). He explains that one's good would be the end of one's own action if one did something for the sake of promoting or protecting one's own good, i.e., because one considers doing it *good for oneself* or not doing it *bad for oneself* (91). Thus it seems that, on von Wright's view, the good of a person is a logical construction out of what is *good* and what is *bad for* that person.

But it is easy and important to see that this is a mistake. That something would be good for Jones (e.g., exercise, an education, perhaps suffering) or that it would do him good (e.g., a vacation, a sip of brandy) concerns only that part of Jones' good which is, so to speak, *very close to him*. That it would be good for him means that it would be for his good by improving *him*, either by making him *better at* things (exercise, training) or by improving his *character* (suffering). That it would do him good, means that it would be for his good by improving his current (physiological or psychological) *state*, whether or not it would also improve *him*. Lastly, winning a lottery, buying a car, or receiving a television set promote one's good since through such acquisitions one becomes *better* positioned to improve one's life or prevent it from deteriorating. Hence, contrary to what von Wright implies, not everything that promotes someone's good is beneficial to him, though providing what is beneficial to him is indeed promoting his good. Von Wright may have been misled by a failure to note the difference between that which confers benefits and the beneficial, for the beneficial is what confers benefits of only a certain sort—improvements of the person or of his current state. Thus a new contract may confer certain fringe benefits, such as free schooling for one's children or a free annual medical check-up, but the contract is not *ipso facto* beneficial.

Here now emerges the possible explanation of why von Wright does not tackle his central question head-on: because he tackles one which appears to him to be identical with it. The question he tackles head-on concerns that subcategory of the useful in the widest sense where the good in question is "that peculiar good we call the good of a being" (43). And about this category von Wright believes, erroneously, that it is identical with what "is good for a being" in the wide sense, that is, the sense which leaves open the question of whether this phrase can "be replaced by 'do good to somebody' " (42). (If it can be so replaced, the usefulness amounts, in his view, to beneficiality; if not, to mere usefulness. According to him, it can be so replaced, as we saw, if it is causally favorable in the promotive way; it cannot if it is causally favorable in the protective way.) But why does von Wright believe this? Apparently

because he believes, erroneously, that "being causally favorable to that good which we call 'the good of a being' " is synonymous with "providing the beneficial and 'securing' the needed (providing it and taking care that it is not lost, (108))'"; and believes also that the beneficial is that the having of which by a being is *good for* it, and that the needed is that the not-having of which by a being is *bad for* it. But if these beliefs were sound, then von Wright would indeed have tackled head-on one interpretation of his central question, namely, the sense in which it asks wherein man's good lies. But, as we have seen, 'What is the good of a being?' in that sense is a much wider question than, 'What is good for it and what does it need?' The failure to note the difference may be partly due to a confusion of what is *for the good of a being* with (the narrow) what is *good for it*, and similarly, of what is *to its detriment* with what is *bad for it*.

Thus, von Wright has not adequately characterized the difference between what is causally favorable to something and what immediately or mediately serves (is for) the good of a being. On his view, the causally favorable is what reduces a being's distance from what is to it a good, a purely causal matter (48). This is misleading. True, whatever is someone's ultimate end or is to him something in itself wanted can be said to be a good to him. But such a remark, though not itself evaluative, is nevertheless a bridge to evaluative judgments. For by it we mean that the end, or the thing wanted, is something which *appears to him to be a good*, i.e., something having which *would be* for his good. To say that it is *to him* a good is thus not the value judgment that it actually is *a good for* him, but merely that it so appears *to him*. If it did not involve even the latter, such a claim would not only be 'merely' psychological, but would fail to link the 'merely' psychological fact it states (that a person desires or aims at something) with his evaluations of this psychological fact. Such 'value appearances' are related to value judgments in much the same way in which perceptual appearances are related to material object statements. The gap between being desired and being desirable is no deeper than that between looking red and being red.

But whether or not I am right in this, we must sharply distinguish between what is causally favorable to a being and something with which von Wright seems to identify it: what mediately serves the good of that being. And we must note that there are more than the three ways of thus serving the good of a person which von Wright has in mind. One he mentions explicitly. "The organs of the body, one could say without distorting language, serve *immediately* the good of the body. This good is also called bodily health. The faculties of the mind serve *immediately* the good of the mind, our mental health. *Remotely*, organs and faculties serve the good of man" (61). The other two ways which he clearly has in mind, though he does not list them as such, are favorably affecting the current state of a person (providing him with what does him

good) and improving him (providing him with what is good for him, the beneficial). But as we have seen, there are other things—which he does not appear to have in mind—by favorably affecting which one also mediately (or remotely) serves the good of a person: his wealth, his connections; in short, his position. Unlike the changes which are brought about by the causally favorable, those brought about by what serves the person's good, need not be (i.e., appear) to that person goods but, of course—again unlike the former—they must be for his good. And if what improves a person's health mediately serves his good, as von Wright says, then the good of a person is tied to certain things such as health, irrespective of whether such improvements are to that person a good and, it seems, even irrespective of whether he would preferentially choose them.[11]

III

13. In section II, I argued that judgments of the beneficial are indeed the same as judgments of being good for a person and doing a person good (though not judgments of *doing good to* a person, i.e., of the beneficent), but that they are narrower than judgments of what is for a person's good. The former do not, the latter do, comprise judgments relating to the improvement in a person's *position*. We must now note certain problems about how to interpret the causal component in judgments of the beneficial and the good of a person.

Is 'the cause', that wherein the good lies, that which, if the being had it, would favorably affect it? Or is it that which the being actually has and which therefore does so affect it? Shall we say that what Jones' good lies in includes the winning of a lottery whether or not he wins it, or shall we say that it is to be included in his good only if he actually wins it? Von Wright seems to favor the first alternative. For he claims (86) that a being can 'have' or 'enjoy' its good, which seems to imply that it can also fail to have it. But no sense could be given to the expression 'not having one's good' unless something which one does not have, and which therefore does not favorably affect one, could nevertheless *be* one's good.

However, this account gives rise to important and difficult problems. In the first place, obviously, some things which happen are *more* for a person's good than others, i.e., are or bring about a more favorable alternative than others. We can ask whether Uncle John's gift of uranium shares was *more* for John's good than Uncle Charles' gift of a piano. And we can similarly ask counterfactual questions, such as whether it would have been more for John's good if Uncle John had given him IBM shares than the uranium shares he actually gave him. But this raises the awkward question whether, if IBM shares had been more for his good, the uranium shares were for his good at all. To bring out

what is troublesome about the question, let us consider another example. Suppose an incompetent doctor cures a patient's illness by a method which involves the amputation of his leg, but that another more competent doctor could have cured it without such amputation. Was this treatment of his illness for his good or to his detriment? We have already seen, in our discussion of 'promotion' and 'protection', that such questions involve the selection of an appropriate reference point, namely, an appropriate counterfactual alternative. But what is here appropriate? It will not help to say that it is 'what would have happened if the doctor had *not* performed the operation'. For this does not tell us what the alternative is, but only what it is not. If the alternative is treatment by a competent doctor, then he is now worse off than he would have been if his doctor had not operated. But if the alternative is no treatment at all, then he is now better off than he would have been if his doctor had not operated.

The question is extremely complex and cannot here be developed in detail. For our purposes it is enough to point out that the very notion of a *causal* impact on something implies the distinction between what actually happened after the 'impact', and, since it was 'an impact', what *would* have happened *but for it*. But if we generalize this, we get something like a 'natural', 'impact-free' succession of events as our basis of comparison; something like 'natural motion', motion as it would be if no force were to be impressed on the moving body. It is comparatively easy to construct such a natural course of events for certain developments, such as the course of specific illnesses, or the growth of the fetus or the deterioration of certain organs in old age, and so on, but it is not easy to do this for a human life. The reason for this is obvious: people's lives are too much influenced in their *normal* course, by the enormously varying impacts of the doings of other people around them. One can perhaps draw some rough outline of a life path for the typical farmer or teacher or businessman in a given society, where all the people in his environment do what they can in reason be expected to do in relation to him. To the extent that we can draw such a life path, given this assumption, we can also point to the appropriate alternative which can serve as a basis of comparison. In our example, we can for instance ask whether the doctor who amputated the leg 'saved' or 'ruined' the amputee's life. He ruined it if the amputee is now worse off than he would have been by comparison with the alternative *he could in reason expect*. Could he in reason expect that there would be a competent doctor available? Or was he lucky to find a doctor at all? Was the doctor doing his best or was he drunk, or careless, or negligent? What is the normal course of events seems to depend on factors of this sort as does the question whether what actually happened was better or worse than what would have happened if the impact in question had *not* occurred, i.e., if the course of events had been *normal*.

IV

14. Next, let us look at the axiological component of judgments of the beneficial and the good of a person. Put very briefly and roughly, von Wright's account of this component is as follows. There are certain things which to a person are goods or bads, things in themselves wanted or unwanted. People can obtain these things only in the form of package deals. That is to say, at any moment in their lives, they are confronted by the opportunity or need to make preferential choices between alternative courses of action, each of which is a package of various mixtures of things in themselves wanted, unwanted, and indifferent. The good of a person at any moment of his life is that package which at that moment he would preferentially choose if the choice were offered to him, if he were—in a sense—completely rational, and if he had complete information about the causal implications of all the alternatives involved.

Now, as we noted above, in judgments of wherein someone's good lies, *that on which* the things constituting his good make an impact, are certain aspects of his life: His health, his skills, his wealth, his position, and the like. Such changes constitute changes in the excellence of his life, in 'how well off' he is, in the widest, non-economic sense of the term. There is a necessary connection between the following two things: (a) that such changes are upward changes in his well-being, and (b) that things making such an impact are for his good. One could take the view (as we have seen, von Wright's account of the good of the body seems to commit him to it) that *there is some criterion* by which such changes are graded as upward changes in the excellence of that life; and that something is said to be for a person's good on the basis of whether it is or brings about such upward changes. This is not von Wright's considered doctrine, however. He sees no need for such a criterion. For him, the necessary connection between (a) and (b) runs in the opposite direction. He thinks that whether something is a favorable impact or upward change follows from whether it is for the person's good, and that in turn follows from whether a suitably endowed person would choose to undergo such changes or impacts in preference to his other options (109).

15. We must now examine the details of this theory. To determine the axiological component of judgments of the beneficial and harmful, von Wright asks us to envisage two kinds of preferential choice both of which are "logical fictions" (103, 106, 108). They are choices under idealized conditions. The account is thus not offered as an empirical theory about the conditions under which people choose their own good rather than their detriment nor as a practically usable method for ascertaining *what* a person's good is, but rather as an explication of the good of a person, or rather, of the axiological component of that good.

Both these choices are from among changes in the relation between the chooser and specific things he could 'have' or 'fail to have'. In both cases we

must distinguish between choices in which there is a transition from *not having* a thing either to continuing not to have it or to having it, and those in which there is a transition from *already having* a thing to either continuing to have it or ceasing to have it (103f). The first kind of choice focuses on what is involved in having or not having the thing, quite apart from the causal implications of making the transition. Such a choice elucidates the meaning of 'in itself wanted', 'in itself unwanted', and 'in itself indifferent'. Suppose you are in your bed which has one blanket on it and you feel cold. There is a spare blanket in the cupboard. When you disregard the fact that you have to get up to get it, you would rather be with an additional blanket than continue to be without it. Von Wright then says both that the additional blanket itself and getting it is 'in itself wanted' or 'in itself welcome' (103). If, however, you already feel quite comfortable with the one blanket and so would prefer to continue with only one, then (getting) the additional blanket would be 'in itself unwanted' or 'unwelcome'. These two cases must be distinguished from the two others where we already have the thing in question. Suppose you now have two blankets and feel hot. When you disregard the fact that you would have to rouse yourself in order to get rid of the second blanket, you would rather be rid of it than continue to be with it. Now, ordinarily, we should be prepared to say both of the case in which you prefer to continue with only one blanket and the case where you prefer to get rid of the second blanket, that the second blanket is unwelcome. But von Wright is prepared to say this only of the first case. Of the second he would say instead that getting rid of or losing the second blanket is welcome. Despite this, he uses the letter 'X', rather confusingly, to refer both to the thing (blanket) and the transition from not having the thing to having it, and similarly not-X to refer to the absence of the thing and to the transition from having it to not having it (104). And he draws attention to the fact that "from our definition of the in itself wanted, unwanted, and indifferent it does not follow that, if X is wanted in itself, then not-X (the absence of X) is unwanted in itself" (104). We should note right away a point which will become important later, that this result is as much a consequence of the way one uses 'X' and 'not-X' as of the way one has defined the 'in itself wanted', and its cognates.

The nature of the axiological component of judgments of the beneficial and harmful fully emerges only in the second type of preferential choice which reintroduces the causal implications excluded from the first type. Here the chooser must include "considerations of things which you will have to do in order to get X, and of things which will happen to you as a consequence of your having got the thing X" (103). This second type of choice also is a logical fiction. But that now does not mean simply that it is not an actual choice, i.e., not a choice between alternatives a person actually knows he has, but rather a choice he *would* make if he *were* presented with the alternatives, whether or not he is presented with them. It means, in addition, that the chooser has com-

plete knowledge of the relevant causal implications of all the alternatives, i.e., that there are no imperfections in the subject's knowledge which are such that, if they were detected and corrected, he would revise his preferences (108).

The beneficial and the harmful are then explained in a manner closely parallel to the in itself wanted and unwanted. Von Wright discusses only the case of a transition from not having something to having it, but presumably he envisages also cases of the transition from having the thing to not having it. He symbolizes the transition from not having it to having it as $(X+C)$ where 'X' stands for the alternative as presented and 'C' for its causal implications. And he symbolizes the transition from not having the thing to continuing not to have it as $(not\text{-}X+C)$.[12] Von Wright then calls $(X+C)$ 'a positive constituent of the person's good' if the person prefers $(X+C)$ to $(not\text{-}X+C')$, and 'a negative constituent of a person's good' if he prefers $(not\text{-}X+C')$ to $(X+C)$. Presumably if he is indifferent between the two, $(X+C)$ is not a constituent of the person's good at all. 'X' itself he calls the *nucleus* of a constituent of a person's good. And now he defines 'the beneficial' (or 'good for us') and 'the harmful' (or 'bad for us') as "the nuclei of positive and negative constituents, respectively, of the good of a person" (108).

How this relates to the good of the person itself, he does not say in so many words. One way to extract an answer would be to take quite literally his technical term 'constituent of the good of a person', and so construe the good of a person as the sum-total of the positive constituents. If we think of a person's life as composed of events which are the consequences of his interventions in the course of nature (where this includes his non-interventions and failures to intervene), then his good is composed of those alternatives at these choice or intervention points which he would have chosen *if* the alternatives had been presented to him and he had the qualifications already mentioned.

Alternatively, we could construe it out of his remarks about promotion and protection of a person's good. Then the good is not only the sum-total of the positive constituents of a person's good whose nuclei are beneficial, but is also the securing of the needed, that is providing it and taking care that it is not lost, where the needed is that which is preventive of the harmful, i.e., of that which would be the nucleus of a negative constituent of a person's good (108). On this construal, the good of a person includes not only the good-promoting but also the harm-preventing.

V

16. This concludes my exposition of von Wright's theory. However, before turning to a critical discussion of it, I must raise a number of questions about its content. I group my questions under three heads: (a) the alternatives from

which the choice is to be made; (b) the nature of the choice itself; (c) the nature of the chooser.

(a) What are the alternatives between which the choice is to be made? The choice, we have seen, is not an actual one but one the person in question would make "if he were presented with the choice" (108). But this can mean three quite different things: either that the person's attention is drawn to alternatives of which she was not aware (she is told that Jones is in love with her); that someone confronts her with alternatives she would not otherwise be confronted by (Jones asks her to marry him); or that she is simply presented with certain conceivable alternatives to what actually happens whether or not she has them. Does a person's good include what *would* be for her good whether or not she gets it? Von Wright seems committed to this much, as we saw. But this only raises the further question of what is contained in the implied if-clause: what would be for his good *if he knew* he could get it; if someone *enabled him* to get it; if he merely *thought* about it whether or not he could get it? I am not clear about von Wright's view on the matter. I seem to detect a certain ambivalence on the issue. On the one hand, he seems to take the last and most generous view of the alternatives to be included. For he says that the good of a person is a good to that person (43), and goods to a person include ends of action but also things in themselves wanted which befall one (104 f) and which are therefore not ends of action. There would therefore seem to be no reason not to include in the good of a person those things that befall him which are beneficial, i.e., nuclei of positive constituents of his good, and perhaps also those which are needed. There is, moreover, considerable prima facie plausibility in this view. In certain circumstances it may be for my good that, let us say, my son should continue to live rather than die, yet I may never have this option of protecting my good, and no one may be in a position to present me with it, either.

On the other hand, it does not look to me like an oversight on his part that he never includes, among the things that can be beneficial or even useful, the class of things that can befall a person. Thus after raising, in §10 of Chapter V, the problem of the connection between ultimate ends and things wanted in themselves, he does not, in §11 where he discusses the beneficial, go on to discuss this in terms of the larger class ('goods, to a person') which includes the class of things in themselves wanted which befall a person and therefore are not ends of action. He discusses it, rather, in terms of the narrower class, ends of action. And he does the same in his discussion in Ch. III, §4 of the useful in the wide sense. But does not this discussion in terms of the narrower class at least suggest that the wider class is not applicable? And this, too, is quite plausible if the beneficial is, as von Wright claims, a subcategory of the useful. For by 'the useful' he means, as we have seen,[13] that subcategory of the causally favorable where the good from which the distance is reduced is

something in itself wanted that is also an end. Hence the useful excludes what befalls one, since the latter is that other subcategory of the causally favorable where the relevant good is something in itself wanted that is not an end. Thus von Wright seems to hold that the alternatives are confined to those which he actually has or at most those which someone is in a position to present to him, or perhaps some special subclass of that; and that they do not include those merely thinkable possibilities which are necessarily beyond the reach of choice, like tomorrow's weather.

But perhaps von Wright just never raised this question in his own mind. It is possible, if not very likely, that his inconsistent formulation of the alternatives in terms of 'X' and 'not-X' has concealed this problem from him (cf. below, §17 (a), and above §15). Of course, there are choice situations in which we can quite plausibly formulate the alternatives in this way. This is so, for instance, whenever we are confronted by a practical problem and we are considering whether to do something or nothing about it; whether, let us say, to complain to the neighbor about the noise or forget the whole thing. But we have already noted that in asking whether a particular thing was for our good, we must consider precisely what alternative we should compare it with. And the same is true for asking whether some future course would be for our good. When we contemplate the purchase of a suit, we cannot ask whether we would prefer to get or to continue *not to have it*. We must know in positive terms what *not having it* amounts to: having another suit, having a sports outfit, not having any new clothes but a new watch instead, or not buying anything at all but putting the money in the savings bank, and so on. And if this is not to be a hopelessly indefinite group of alternatives, we must have some method of ordering the alternatives in a mutually exclusive and jointly exhaustive classificatory scheme. Von Wright's formulation of the choice as being between 'X' and 'not-X' conceals this crucial problem about the content of the choice.

(b) I now turn to the question of what von Wright means by 'preferential choice'. Since choosing determines only two properties, the chosen and the rejected, the emphasis cannot be on choice. For the preferential choice is supposed to determine three: A being preferred to not-A; not-A being preferred to A; and indifference between A and not-A.[14] The emphasis therefore seems to be on the sorts of things that *determine* the choice rather than the choice itself. It would in other words seem to mean the preferences the person would have if he had the relevant causal knowledge. And preferential choices would be those based on (i.e., in accordance with) such preferences, including presumably those 'toss-up' choices in which the chooser has no preference one way or the other.

There are, however, two different interpretations of 'preference', namely, 'intrinsic preference' and 'preference for reasons'. The distinction is parallel to one now frequently drawn[15] between two interpretations of 'wanting'. I want

to visit my friend, but my wife has asked me to mow the lawn. If the lawn mower is out of order, I can say in the evening, 'I wanted to mow the lawn, but the lawn mower has not yet been fixed.' And it may be true that I really was prepared to mow the lawn and would not have visited my friend if the lawn mower had been usable. But it may at the same time be true that I *did* want to visit my friend and *did not* at all want to mow the lawn. One could therefore also say that in one sense I preferred visiting my friend to mowing the lawn (since I did not in this sense want to mow the lawn at all), while in another sense it is true that I preferred to mow the lawn to visiting my friend (since in that sense I did not want to visit my friend at all). In the first sense of 'want' and 'prefer', my choice would be based on the *attractiveness* of the alternatives themselves, in the second sense it is based on *reasons*.

One might argue that the second sense is simply the first sense with the single difference that the description of the alternatives comprises more of their properties including their causal implications. But I think this would be a mistake. Suppose I want to mow the lawn because I acknowledge this to be one of my domestic duties. And suppose I regard the fact that it is one of my duties as a reason (and a sufficient reason) for saying that I must do it and must not do what I want or prefer doing. Then in my opinion this does not amount to the same as saying that I prefer (like better, find more attractive) the alternative which includes doing something I do not enjoy doing but which is the doing of my duty, to the alternative which includes something I enjoy doing but which is also a neglect of my duty. I shall not press this point here, but it is perhaps worth mentioning that von Wright must believe that 'preferential choice of A over B' means the same thing as 'voluntary choice of A over B, that what I have called 'preference in the second sense', i. e., voluntary choice of A over B for reasons, rather than because one likes A better than B, means the same as what I have called 'preference in the first sense'; and that the apparent difference in meaning is simply due to the fact that in one case the formulation of the relevant alternatives does, in the other it does not, include their causal implications. It would seem to be a consequence of this view, and a counterintuitive one, that no one can ever voluntarily choose an alternative he thinks he will like less well than some other alternative he would have chosen instead.[16]

(c) Finally, it is clear that the chooser, in terms of whose preferential choice his good is explained, is not any actual person but an idealized one. Von Wright's account of the good of a person is thus a form of 'ideal agent' theory. The extent of the idealization is, however, comparatively modest. It consists partly in the idealization of the person's own knowledge—complete knowledge of the causal implications of the relevant alternatives from which he must choose, and partly in the idealization of his will—the absence of weakness of will and similar weaknesses or irrationalities, e.g., capriciousness or contrari-

ness, all of which he attempts to bring under the one heading of choosing so as never to regret having made the choice. The idealization in the area of causal knowledge is necessary because, otherwise, people could not preferentially choose what is *really* to their detriment. The reason for the second modification plainly is that otherwise no ordinary person conceivably could preferentially choose what he (rightly or wrongly) *believes* to be to his detriment. For believing an alternative confronting one to be to one's detriment would on this view be believing it to be one which, if one had the relevant causal knowledge, one would *not* preferentially choose. But, of course, this is not a plausible psychological consequence. Many people 'preferentially', i.e., voluntarily, choose to do what they believe is to their detriment. Von Wright therefore adds the qualification that the chooser must be choosing in such a way that he will not later regret his choice (112–113). He thinks, in other words, that persons who have the relevant causal knowledge and who are set on choosing in such a way that they will not later need to regret their choice are necessarily choosing what is properly called their own good.

VI

Having set out von Wright's theory as clearly as I could, I want now to offer several critical comments.

17. Is the good of a person related to the beneficial and the harmful in the precise way von Wright suggests? It seems to me that it is not, for the following reasons. I said, it will be remembered, that there is an inconsistency in von Wright's symbolization of the two preferential choices. I must now explain this. The preferential chooser is confronted by four alternative transitions. We can classify these on the basis of *starting point:* (*a*) *from* not having something to. . ., or (*b*) *from* having something to. . .; and *continuity:* (*c*) *switching* from not having to having, and vice versa, or (*d*) *continuing the same,* whether continuing not to have, or continuing to have. We can then call the four transitions, self-explanatorily, 'getting' (switching from not having (*ac*)), 'not getting' (continuing on from not-having (*ad*)), 'not keeping' (switching from having (*bc*)) and 'keeping' (continuing on from having (*bd*)).

Now, in his definitions of the in itself wanted and unwanted, von Wright so uses '*X*' and 'not-*X*' that it sometimes stands for the *thing* the chooser may have or not have, and sometimes for *a transition.* When it stands for a transition, '*X*' stands for getting and 'not-*X*' for not keeping. Von Wright could therefore say, correctly, that "from our definition of the in itself wanted, unwanted, and indifferent it does not follow that, if *X* is wanted in itself, then not-*X* (the absence of *X*) is unwanted in itself" (104). For by '*X* is wanted in itself' he mostly means that getting *X* is preferred to not getting it, and by 'not-

X is unwanted in itself', he mostly means that keeping it is preferred to not-keeping it (104). When von Wright turns to the symbolization of his second preferential choice, however, we find a different terminology. 'X' again refers to getting, but 'not-X' refers, not to not-keeping, but to not-getting. Thus, while it would not even make sense for the chooser in the first choice to ask himself whether he prefers X to not-X, since these two have incompatible pre-suppositions (X implies not having the thing, not-X implies having it), the chooser in the second choice *must* ask himself whether he prefers X together with its causal implications, to not-X together with its causal implications. But, for this reason, von Wright is mistaken when he says "From our definitions of the beneficial and the harmful it does *not* follow that, if not-X is harmful, then X is beneficial, and vice versa" (108). We must, of course, remember that the consequences follow not solely from his definitions of 'the beneficial' and 'harmful' but follow from them together with his uses of 'X' and 'not-X'. No doubt if he had used 'X' and 'not-X' as he used it in connection with his definitions of 'the in itself wanted', then the objectionable consequence would not follow from his definitions of 'the beneficial' and 'the harmful'. But as he actually uses them, it is quite plain that they do. For 'the beneficial' and 'harmful' are defined in terms of preferences between alternatives (getting and not-getting) which are mutually exclusive and jointly exhaustive, when the presupposition of either is satisfied. The beneficial is the nucleus of the preferred alternative, the harmful the nucleus of the rejected alternative, i.e., the one to which the other is preferred. X is beneficial if $(X + C)$ is the preferred alternative. But if $(X + C)$ is the preferred alternative, then (not-$X + C$) necessarily is 'dispreferred', i. e., is the alternative to which $(X + C)$ is preferred. But the nucleus of this rejected alternative is not-X, hence not-X is harmful.

18. No doubt this slip about the use of 'X' and 'not-X' could be remedied. If it is remedied, von Wright can say that from the fact that someone's getting *something* is beneficial to him, it does not follow that not keeping *it* is harmful. If my getting an additional blanket at midnight is beneficial (because my room is cold), my not keeping it at 2 a.m. need not be harmful (if my room is then warm). But that is not in itself an important thing to be able to say. What is important, however, is that von Wright's definitions of 'the beneficial' and 'the harmful', and not just his careless use of 'X' and 'not-X', do commit him to the view that if *my getting something* (my additional blanket), is beneficial, then *my not-getting it* is harmful. But it seems to me that this is in conflict with von Wright's explicit views of the relation between the beneficial and the harmful, and that it is, in any case, false. Thus, von Wright claims (I think correctly) that if getting something is beneficial, then not getting it is necessarily not beneficial but not therefore necessarily harmful. The harmful is not identical with the non-beneficial, the harmless not identical with the beneficial (45). Von Wright seems to be under the impression that he has avoided this contra-

diction because he mistakenly thinks, as a result of his inconsistency in symbolization, that from his definitions of 'the beneficial' and 'harmful' it does not follow that if X (= getting something) is beneficial, then not-X (= not getting it) is harmful, and vice versa.

19. There are two further distinctions which, if not noticed, would help to conceal this error. The first is the difference between the fact (a) that from 'X (= getting something) is beneficial' it does not follow that not-X (= not getting it) is harmful, and the fact (b) that from 'X (= getting something) is not beneficial' it does not follow that X (= getting it) is harmful. Thus (a) getting the additional blanket may be beneficial without not-getting it therefore being harmful, and (b) getting it may not be beneficial without its therefore being harmful. Now, von Wright's definitions of 'the beneficial' and 'the harmful' in terms of a preferential choice allow for something being neither harmful nor beneficial, and so they are compatible with fact (b). If one fails to distinguish between the two facts, one may wrongly think that they are compatible also with fact (a).

20. The second distinction is that between the harmful and what I shall call 'the detrimental'. One may so use 'detrimental' that if X (= getting something) is beneficial, then not-X (= not getting it) necessarily is 'detrimental'. On this interpretation, the 'detrimental' is both that which makes one worse off than, or not as well off as, one would be by comparison with an appropriate reference point. In that case, if one of the relevant alternatives is X (= getting something beneficial), then if one does not get it, one is not as well off as one would have been if one had got it, and so not getting it is 'detrimental'. Hence if von Wright meant by 'harmful' what I here mean by 'detrimental', then his definitions would be compatible with both facts (a) and (b) above. But, of course, von Wright's own account of the harmful does not allow him to substitute the 'detrimental' for it (45).

21. My second comment concerns von Wright's idealization of the will of the chooser. He imposes on the will of his preferential chooser the qualification that he must be free from weakness of will (and, we may add, similar imperfections of the will, such as capriciousness and contrariness). For then and only then will the chooser necessarily be one who will not regret his choices. For to regret one's choice implies that one has changed one's judgment of whether the good one chose was worth its price, of whether the thing one chose was beneficial or harmful (112): It implies that one has made "a mistake, a bad choice with a view to his welfare, i.e., with a view to what he 'really' wants for himself" (113), and that one would not choose in the same way again if given another "opportunity of making good his folly" (112).

Let us note, first, that this formulation implies an untenable account of regret. If regret involved the determination not to make the same mistaken

choice again (112), it would be inexplicable how weak-willed persons could he capable of *sincere* (expressions of!) regret, as von Wright says they are (112–113). For as he rightly says of weak-willed persons, "There is no logical absurdity in the idea that a man sincerely regrets something as having been a mistake, a bad choice with a view to his welfare, i.e., with a view to what he 'really' wants for himself, and yet wilfully commits the same mistake over again, whenever there is an opportunity" (113). If this is true, as I think it is, then we must allow that weak-willed persons, and also capricious and contrary ones, may later really regret choices (and not just insincerely say they do) which they made, without *ipso facto* being set not to make them again when the opportunity offers. Von Wright's account of regret must therefore be modified somewhat as follows. To regret a choice one has made is to *wish* that one had not made it because it was, as one thinks, something one ought for some reason (moral or otherwise) not to have done.

But the moment this is granted, it is clear that regret is really a red herring. What matters is whether the person has *cause* to regret. He may have cause for regret, yet not regret, perhaps because he has persuaded himself that regret is useless and has trained himself out of it. Such a person still has made a mistake and so not chosen what was for his good. Conversely, a person who regrets his choice when he has no cause, need not have failed to choose what was for his good. It is therefore not essential that the weak-willed person, at the time of his choice, only half-realize, or only vacillatingly realize that his choice is a mistake. It does not seem to me true that "One could say that, if he lets himself be carried away by the short perspective, then he was not capable of viewing clearly his situation in the long perspective" (113). In any case, even if this were true of the weak-willed person, it is not even prima facie plausible for the capricious or contrary person. Such persons may know quite clearly at the time of their choice that what they are doing is not for their own good. But the idealization of the chooser's will must exclude *their* imperfections also.

22. Whatever the correct account of weakness of will, capriciousness, and contrariness may be; whether or not it is true "that, if a man has an *articulated grasp* of what he wants, he can never harm himself through weakness of will" (113) (and, presumably, capriciousness and contrariness); the important point is that he must not choose contrary to what, at the time or later, he *judges to be contrary to his good*. He must not choose something which, at the time or later, he judges to be harmful to him or not worth its price. Von Wright can deal with the first case, one's choosing something which, even at the time, one thinks harmful or not worth its price. Such a choice would simply not be a preferential choice. For according to him, the beneficial, it will be remembered, is the nucleus of an alternative which one *prefers* to all others. The problem for von Wright is to explain the other case, the case in which the

chooser changes his mind about whether what he chose was really beneficial, really worth its price, because he now thinks his previous judgment was *a mistake*.

It seems to me that von Wright cannot account for this case. There is simply no room left for a mistake. For it would have to be a mistake about the particular choice he made at some time in the past. It is this past choice he now regrets. If he now discovered, to use von Wright's example, that the end he pursued and thought beneficial in fact ruined his health (112), then indeed he has made a mistake and now has cause to regret his choice. But this is possible only because he made a mistake about the causal implications of attaining his end. Had he known then what he knows now, he would not have had the preference for the alternative he chose. Thus, this possibility of a mistake is already eliminated by the postulate of complete relevant causal knowledge. And the only other possibility of a change in the chooser's judgment is one which is irrelevant because it does not amount to a mistake and so does not give him cause for regret. I mean a change in the chooser's *settled* preferences. Suppose that while I hear well, I find concerts worth their price, but now that my hearing has deteriorated, I don't. Hence while previously I chose going to concerts in preference to other available alternatives, now I don't. But this does not give me cause for regret about my past choices. Preferential choices can be said to be mistaken only against a background of stable settled preferences. A change in one's preferential choice pattern does not imply a mistake somewhere unless one's settled preferences have remained the same.

23. If von Wright wanted to allow for a mistake in valuation, he would have to introduce something like "inadequate appreciation of the nature of the causal implications", a device used by Sidgwick and, more recently, by Falk, Rawls, and Brandt.[17] It is, however, extremely difficult to distinguish, along these lines, between what is a mere change in settled preferences owing to extended exposure to the sorts of implications our choices have, and so *not* a mistake, and what is a more adequate appreciation of these implications without a change in settled preferences and so a mistake. When Jones is leaving the priesthood to marry, have his settled preferences changed since the time when he chose to remain celibate, or did he fail fully and adequately to appreciate the consequences of his choice at the time he made it? In the absence of such a distinction, von Wright cannot formulate a qualification he must impose on his idealized chooser if he is not to get the undesirable consequences which his qualifications of the chooser's will are supposed to eliminate. But if he introduces such a distinction, it seems to me that it cannot be expressed in terms of preference as I imagine von Wright would want to use the term. For although this distinction would allow von Wright to say that Jones' choice was a mistake, i.e., based on what were not his real settled preferences, it has also become quite impossible for Jones to *know at any time* what his real settled

preferences are and so to know which of the alternatives before him he really prefers. And this would significantly change the approach to the good of a being which von Wright espouses. It seems to me completely foreign to that approach to have to say that the preferential chooser does not know what his (real) preferences are.

24. I can now turn to my last comment. I want to discuss a corollary of von Wright's theory which seems to me to conflict with a conceptual truth about the good of man and which, moreover, does not seem easily eliminable within the framework of preferential choice by the simple device of adding further qualifications on the nature of the chooser. I offer this comment with some hesitation, because the corollary is such an obvious one and because von Wright himself takes great trouble to refute views similar to the one to which this corollary would commit him. It may well be, therefore, that I have over-looked some distinction or some qualification von Wright himself makes to escape this consequence.[18]

I take von Wright's basic idea to be that 'the good of man' or 'the good of a person' is necessarily *whatever* a person of a certain sort in circumstances of a certain sort would preferentially choose. The enterprise is comparable to that undertaken by Rawls in his account of justice, except that von Wright's chooser is equipped with complete knowledge covering a certain range of topics rather than placed behind a suitable veil of ignorance. Here, too, the qualifications placed on the nature of the chooser, the choice, and the circumstances are selected so as to yield preferential choices which, as we would intuitively agree, constitute the good of the chooser. Unlike Rawls, von Wright does not, however, come up with a substantive criterion; at least not for the good of man—for he may think that his claim that health is the good of the body amounts to offering such a criterion for the good of the body. The intuitive touchstone is, rather, a conceptual connection between on the one hand, the nature of the chooser, the choice, and the circumstances, and on the other hand, the good of the chooser. Our question therefore is: Is it necessarily true that a chooser with certain information and a flawless will would choose what he knew, or to the best of his knowledge believed, to be for his good? I imag-ine that, in view of the arbitrary way in which qualifications are imposed on the chooser, the choice, and the circumstances, von Wright would have to allow considerable weight to our intuitive judgment about such corollaries. They seem the only test available of the soundness of his explication.

Well, then, what is the intuitively embarrassing corollary that I have been leading up to? It is a commitment to a certain form of egoism. For if the good of a person is whatever he would choose if he were idealized in certain re-spects, then there is a sense in which that sort of person is of conceptual ne-cessity an egoist, i.e., a person who always chooses his own good. The ideal-ized chooser von Wright has constructed is such an egoist. For all his choices

necessarily are choices of what is for his good. His good is a logical construction out of these choices.

25. Now, at first sight, such a von-Wrightian ideal chooser is not what might be called 'a motivational egoist'. He necessarily always chooses *what* is for his good, but it seems he does not necessarily do so *for the sake of it*, i.e., because it is, to the best of his knowledge, for his good (91, also 183f). It seems that he may choose what is for his good for the sake of his mother or his subjects who would want him to make such a choice, or for the sake of annoying his cousins who hate him. He is, however, necessarily what might be called 'a result egoist', that is, someone who of conceptual necessity cannot choose anything but his good. He cannot, for example, choose to sacrifice his good for the sake of his mother, his subjects, his country, or for the good of those he loves. For nothing that he chooses would count as such choice. Whatever he chooses *is* for his good and not to his detriment. And since this is so, there is in such a case little if any force to the distinction between motivational and result egoism. The distinction marks a difference only because ordinarily people do not always choose even what to the best of their knowledge is for their good; because they are not 'result egoists' either. Hence when they choose what is for their good, it makes a difference whether they do so for their own sake or for the sake of someone else. In the context of von Wright's preferential choice theory of the good of man, we need not therefore distinguish between 'motivational' and 'result' forms of egoistic behavior.[19]

26. About forms of behavior which are, in this technical sense, egoistic, we can advance two quite different types of theory, scientific or normative ones. The most widely discussed scientific theory, usually called Psychological Egoism, is the theory that *all* human beings are egoists. The most discussed normative theory, usually called Ethical Egoism, is the theory that it is *morally wrong* to do anything which is to one's detriment. There is, however, another normative theory relevant here, usually called Rational Egoism, the theory that it is *contrary to reason* to do anything that is to one's detriment. I believe that von Wright's account of the good of man commits him to Rational Egoism.

27. To see this more clearly, we must distinguish between what I shall call 'self-centered' and 'self-regarding' egoism. A person is a self-centered egoist if he always chooses to do only what is for his own greatest good and never does anything for the good of others even if it is not to his detriment to do so. A person is a self-regarding egoist if he always does what is for his own good, but also whatever is for other people's good except where doing so would be to his own detriment. The self-regarding egoist does, the self-centered egoist does not, stop to treat an injured motorist if in his view doing so is not for his own good even though it would not be to his detriment either because, say, the losses in time and energy would be exactly compensated by the victim's gratitude.

28. It seems to me that von Wright is at least committed to Rational Self-regarding Egoism. This is so, I believe, because the idealization of his preferential chooser involves the elimination of those imperfections in an ordinary chooser which are imperfections from the point of view of reason. Giving the chooser perfect knowledge of the relevant causal implications of the alternatives confronting him ensures that his choice will not be *mistaken* or *misguided* and so open to the claim that the chooser may *have reason* to correct his choice. Similarly, the imposition of the qualifications on the will of the chooser ensures that he will not make choices which even at the time he has reason not to make and so reason to regret later. Given this characterization of the chooser, it would seem to follow that, since whatever such a chooser chooses to do is necessarily for his good, it is *always in accordance with reason to do what is for one's good;* and since such a chooser necessarily never chooses what is to his detriment, it is never in accordance with reason and *therefore* always contrary to it to do anything that is to one's detriment.[20]

29. It is, however, easy to see, though it would take a theory of practical reasoning to prove, that Rational Self-regarding Egoism is mistaken. We need only consider what is, after all, a commonplace, the fact that for many people friendship and love for others are essential conditions of the good life for them. A friendless, loveless life would leave such people unfulfilled and unhappy. It would therefore seem to be in accordance with reason if such people entered into relations of friendship and love with suitable other people. Such relationships would be a good thing from *their own point of view,* that is to say, from the point of view of people trying to make their life as good as possible. A life as good as possible must be (perhaps among other things) a fulfilling life, fulfillment being the satisfaction that comes from judging one's life to be as one ideally would want it to be. But if a person loves another, then he desires the other person's good, and what is more, desires it to the extent of being willing at least to respect the other person's good, even if this involves some harm or detriment to himself. And, the greater the love, the greater the willingness to sacrifice his own good for the sake of respecting, protecting, or promoting the good of the beloved. It does not therefore seem true that it is necessarily not in accordance with reason to choose to do what is to one's detriment or detracts from one's own good.

Let us distinguish between people who act on merely self-centered, merely self-regarding, and merely self-anchored considerations. Considerations are self-centered if they are facts, showing that doing a certain thing, A, would be for the good of the agent without taking into account how it affects other people. They are self-regarding if they are either self-centered or are facts showing that doing A would have effects on other people whose consequences will be for the good of the agent, or at least will not be to his detriment or detract from his good. They are self-anchored, if they are either self-centered, or self-

regarding or are facts showing that doing A would make the agent's life such
as the agent would ideally want it to be. If, as I think is plausible, and as von
Wright himself appears to think (183–186), certain self-anchored considera-
tions are reasons, that is, are such that acting on them is acting in accordance
with reason, and if such self-anchored reasons include those considerations
which arise out of relations of friendship or love, then rational self-regarding
egoism must be false. For then it is in accordance with reason to choose certain
alternatives which are not for one's own good. But then von Wright's account
of the good of a person is seriously mistaken for it implies rational self-regard-
ing egoism.

30. Two objections may now be raised. The first[21] is that self-anchored
reasons are after all only self-regarding reasons. For, if one acts on self-an-
chored reasons, then one makes one's life as good as possible, but that is to
promote one's good.[22] Now, it has to be admitted that there are cases in which
the relationship of love or friendship brings about a change in the nature of the
lover and thereby in his good, so that the promotion of the loved one's good
which, prior to the love relationship, would at the same time have been to the
detriment of the lover, now no longer is so. In a recent popular film, the her-
oine, a New York call-girl, in the course of plying her trade meets and falls in
love with a rather square young man from the Midwest. She gives up her life
in New York and remoulds her nature to fit in with his entirely different life
and ideals. Perhaps such a person can completely remodel her personality so
as to find fulfillment in the new life. If that happens and the cost is small, then
what she does out of love is not really a sacrifice, because love, by bringing
about a change of her nature, has also brought about a change in what is for
her good. In New York her good lay in receiving as many offers from wealthy
men as possible. Her now refusing such offers is not a sacrifice. In refusing
them she is not acting to her detriment.

But obviously this is not true of all cases in which there is a love relation-
ship. In some cases, a person may be able to find fulfillment only by promoting
the loved one's good and at the same time sacrificing her own. Suppose a
married woman has left her husband and child to live with a young officer of
noble family whom she loves. After a while she finds that their affair is ruining
his prospects, that he has tired of her and stays with her only out of a sense of
duty. She then leaves him, pretending that she no longer loves him. Here, her
love has not necessarily changed her conception of the good life for her. She
may leave him, thinking that doing so is for his good and to her detriment.
And of course she may well be right in both these assumptions. She may find
some consolation in her sacrifice, but this does not turn the sacrifice into a
gain.

31. The second objection that may now be raised is that my thesis involves
a failure to distinguish between the good of a person and his "merely personal

good''. Von Wright draws a similar distinction between happiness and personal happiness (90). If the delight of a king is the happiness of his subjects, then the promotion of their happiness is what his happiness "consists in",[23] even to the extent of "sacrificing his so-called 'personal happiness' ". But if his happiness lies in the happiness of his people, then he is not sacrificing anything if he toils for them, and so on. If he were sacrificing something, then the happiness of the subjects would not be the (only) thing his happiness lies in. It would lie (also) in certain personal matters, such as his wife's love and theatre or golf. The happiness of his people would not then be all that is needed for his happiness. Can we, similarly, distinguish between the (overall) good and "the merely personal" good of a person? Von Wright does not seem to have such a distinction in mind. If a person's end is his own good, he calls this a "self-interested end" (183). But 'self-interest' normally means what may also be meant by one's personal good. In any case, the central question concerning rational egoism always was whether it is ever in accordance with reason to do knowingly what is to one's detriment, where this means contrary to either one's own interest or one's overall good. Even if this were not so, it would still be necessary to explain what that personal good is; what it is that it can be in accordance with self-anchored reasons to sacrifice; and what that other sense of a person's good is which it is not in accordance with self-anchored reasons to sacrifice, even for the sake of any kind of good of another. But von Wright nowhere draws such a distinction.

32. In any case, there is a further important difficulty. Even if such a distinction can be drawn and we therefore grant the previous objection, I think we also have to grant that there are reasons even further removed than are self-anchored ones from self-centered and self-regarding reasons. I mean, of course, moral reasons. I am persuaded, though I cannot show this here, that moral reasons can conflict with and do override even self-anchored ones. It may be morally wrong to do something even though not doing it would be detrimental from one's own point of view, the point of view of the best possible life for one. Hence even if we can distinguish between the (overall) good of a person and his personal good or interest, we must admit that not only is it not necessarily contrary to reason to choose what is to one's personal detriment, but it may well be in accordance with reason to choose something (one's duty) which runs counter to the best self-anchored reasons and so affects unfavorably one's not merely personal good; and it may sometimes be contrary to the highest reasons (the moral ones) to choose what is for one's (not merely personal) good.[24]

33. Perhaps it will now be admitted that my point is well taken, but maintained that the mistake is easily corrected. What von Wright should have argued, it will perhaps be said, is that the good of a person is what our idealized chooser would choose in circumstances in which the good of others is not

affected, as when he lives on a desert island. Now, I have to concede, of course, that on a desert island our idealized chooser could not want to sacrifice his own good *for the sake of another*. But does it follow from this that he could not have reasons of an idealistic, religious or moral nature, and possibly others which could require such a sacrifice? But let us waive this point. The decisive thing is that an important part of what is for people's good in normal conditions lies in their relations with others. Thinking away other people could thus provide only a very partial account of what is for the good of man. And since no substantive criterial account has been given, we should have no way of transferring to the conditions of social life our knowledge of what is for a desert islander's good. Hence such a method of isolation is a cul-de-sac.

DEPARTMENT OF PHILOSOPHY KURT BAIER
UNIVERSITY OF PITTSBURGH
DECEMBER 1974; REVISED FEBRUARY 1975

NOTES

1. (London: Routledge and Kegan Paul, 1963).

2. I have formulated my disagreements with von Wright's account of value judgments on another occasion ('Value and Fact', in *Ethics and Social Justice,* Vol. 4 of *Contemporary Philosophic Thought: The International Philosophy Year Conference at Brockport* (New York: State University of New York Press, 1968) and will not, therefore, touch on this topic here.

3. I have discussed this question in 'Maximisation and the Good Life' in *Ethics, Foundations, Problems and Applications.* Proceedings of the 5th International Wittgenstein Symposium, 25th to 31st August, 1980, Kirchberg/Wechsel, Austria.

4. I have profited from the interesting account of welfare given by Nicholas Rescher in *Welfare* (Pittsburgh: Pittsburgh University Press, 1972).

5. For further discussions of this point, see below, section 6.

6. For further details about this, see below, §10, 13, 16 (a).

7. In order to present von Wright's analysis, as far as possible in his own words, I first follow him in speaking of instrumental goodness, but later switch to the more natural term 'quality'. 'Goodness' is normally reserved for a special quality of human beings, that of having the good of others at heart, whether from natural inclination or from a sense of duty (moral goodness). It is, for this reason, somewhat misleading to speak of forms or varieties of 'goodness', as if all uses of the word 'good' involved goodness.

8. Von Wright says, erroneously I think, that the happiness of a king whose delight is the happiness of his subjects, *consists in* giving all his energies to the promotion of this end (90). Giving his energies to this project is, rather, that in which *his*—though not everybody's—happiness *lies*. His happiness—like everyone else's—*consists in* the pleasure (delight?) he derives from a certain sort of thing, in this case the happiness of his subjects. For a few further details, see below, §8, pp. 13–15.

9. For further details, see below, §§11, 12, 17–20.

10. It may be helpful to represent von Wright's classificatory scheme in diagrammatic form. I am, however, uncertain about the logical relation between IIA, IIB, and IIIA. I have represented IIIA as a subclass of IIA. But it may be that von Wright would want to have it represented as a subclass of I, for it may be that not only ends but anything that to a being is a good, can be (part of) *the good of that being.*

I. The causally favorable
to a thing or
being: what "reduces its distance"
from what is to it,
a good.

IIA. *The useful in the*
widest sense:
The good in
question is an
end.

IIB. *Nameless:* The good
is object of desire
want, need, or something in itself
wanted.

IIIA. The good is the peculiar
good we call the
good of a
being; *what*
is good for
the being:

IIIB. *Nameless:*
the good is
not the good
of a being.

IVA. *The benefi-*
cial: where the
causally favorable
is promotively so;
what does the
being good.

IVB. *Nameless:*
where the causally
favorable is protectively so.

IVC. *Nameless:*
where the causally
favorable is promotively so.

IVD. Nameless:
where the causally
favorable is protectively so.

V. The merely
useful.

11. Cf. 109: also n.20.

12. We shall see that von Wright's terminology is inconsistent and that this inconsistency has important consequences.

13. Cf. note 9 above.

14. Refusal or failure to choose can hardly be the same as indifference between the alternatives, since one may refuse or fail to make a choice for any number of reasons other than indifference between the alternatives.

15. For instance, by J. C. B. Gosling, *Pleasure and Desire* (Oxford: Clarendon, 1969), pp. 87–88.

16. I have discussed this point in greater detail in 'Rationality Value, and Preference', in *Gauthier's New Social Contract Social Philisophy & Policy* 5, no. 2 (Spring 1988): pp. 19–45.

17. Henry Sidgwick, *The Methods of Ethics* 7th ed. (London: MacMillan, 1907), pp. 111ff; David Falk, 'Action-guiding Reasons', *Journal of Philosophy* 60, no. 23 (Nov. 7, 1963): pp. 702–718; Kurt Baier, 'Reasons for Doing Something', *Journal of Philosophy* 61, no. 6 (March 12, 1964): pp. 198–203; John Rawls, *A Theory of Justice* (Cambridge, Mass.: Harvard University Press, 1971), p. 417; R. B. Brandt, 'Rationality, Egoism, and Morality', *Journal of Philosophy,* no. 20 (Nov. 9, 1973): pp. 682ff.

18. I confess to some puzzlement about von Wright's views on egoism. On p. 89 he says: "A doctrine to the effect that every end-directed act is ultimately undertaken for the sake of the agent's welfare (good) has, to the best of my knowledge, never been defended. We need not here invent a name for it." As far as I can tell, Hobbes' view that "of all voluntary acts the object is to every man his own good" (*Leviathan*, Chap. 15) is this very doctrine. Hobbes surely thinks of this proposition as stating not an accidental generality, but a law. But this implies that if Jones' pursuit of Smith's good *were* not to seem to Jones also to advance (promote, protect) his own good, he *would not* so pursue. And does not this imply that the ultimate end of every end-directed act is ultimately undertaken *for the sake of* the agent's own good? Having said on p. 89 that "we need not here invent a name for it", von Wright refers on p. 91 to his discussion (183–86) of what appears to be exactly the same doctrine under the name of 'Psychological Egoism': "By the thesis of Psychological Egoism one could understand the idea that promoting and respecting his neighbor's good is never anything but (at most) an intermediate end of a man's action. " (184) He then goes on to refute Psychological Egoism. Has von Wright really formulated two different doctrines, Psychological Egoism, which has been defended by others, e.g., Hobbes, and which therefore deserves to be named, discussed, and refuted, and another similar doctrine which has never been defended and need not be named, discussed, or refuted?

19. Von Wright claims that psychological "egoism misconstrues the necessary connexion, which there exists between my neighbor's welfare as an end of my action and my welfare, as an impossibility of pursuing the first except as a means to safeguarding or promoting the second" (184). In other words, psychological egoism holds not only, and rightly, A: that the fact F that one person aims at the good of another, implies that he is promoting his own good, but also, and wrongly, B: that F implies that he is promoting the good of the other *as a means to his own*. But if A is true, can B be false? Surely, on von Wright's view of an ultimate end of action (88f, 104f,) a person pursues the good of another as an ultimate end only if that pursuit does not depend entirely on its promising to promote his own good; i.e., C: only if he might well pursue the other's good even though it did not promise to promote his own. But if A is true, then C would necessarily be counterfactual.

No one ever in fact aims at the good of another except in so far as this also promises to promote his own, for otherwise A would be false. But then the distinction between promoting another's good as an ultimate and as an intermediate end would lose its application and so its raison d'être. And so the psychological egoist would not be wrong in believing B also. If von Wright believes that there is the necessary connexion he mentions, because the mere fact that another person's good is one of my ultimate ends, makes that end *my* good, he would have to reformulate and so fatally weaken his point as follows: "Egoism misconstrues the necessary connexion there exists between my neighbor's good as an (ultimate) end of my action *and its being to me a good*." There can, indeed, be such a necessary connexion without the consequence that my pursuit of my neighbor's good is a means to my own good. This is so because, as von Wright points out (48f, 106f), there is no necessary connexion between what is to a person a good and what is that person's good, and so no necessary connexion between my neighbor's good as an end of my action and my own good. Does von Wright here, like Hobbes, overlook the difference between the thesis that "of all voluntary acts the object is to every man *his own good*" (*Leviathan*, Chap. 15) and the thesis that "of the voluntary acts of every man, the object is *some good to himself*" (*Leviathan*, Chap. 14)?

20. It should be noted that whereas 'rational/irrational' are contraries, 'in-accordance-with-reason/contrary-to-reason' are contradictories. Hence while from the fact that following certain sorts of considerations (e.g., moral ones) is rational and in accordance with reason, not following them is necessarily contrary to reason, but not necessarily irrational. Cf. the discussion in §§31, 32.

21. I owe this objection and the way to meet it to a suggestion by Peter Herbst of the Australian National University, Canberra, Australia, where in 1974 I read portions of this paper.

22. Here emerges one of the possible conceptual links between the good of a being and some property of its life: the good of a being is the series of those alternatives among the possible courses of its life which constitute its best possible life. For reasons discussed below (§§ 29–34), this seems to be false. My own hunch, though this is hardly the place to develop it, is that the good of a being is the series of those alternatives among the possible courses of its life which make it as "well-off", in a wide, noneconomic sense, as possible.

23. This should, of course, read "lies in". Cf. above, note no. 7.

24. Cf. the discussion in §20 above.

11

Philippa Foot

VON WRIGHT ON VIRTUE

Until recently it was rare to find a discussion of the virtues in a modern work of moral philosophy, and it was with pleasure that one discovered a whole chapter in von Wright's *Varieties of Goodness* devoted to this topic. Von Wright believed, and he is surely right, that the subject is unjustly and unfortunately neglected in contemporary ethics. The study of ethics was, for philosophers such as Aristotle and Aquinas, largely the study of the virtues, and as the foundations of western morality were laid down by Greek and Christian thinkers it would be surprising if we could neglect the topic without loss. It was not, however, in any revivalist spirit that von Wright took us back to the virtues. One might think that by neglecting the study of the virtues we have managed to lose an important body of knowledge. Von Wright, however, suggests that we have allowed a backward part of philosophy to remain in its underdeveloped state. Kant's dictum about logic—that it had made no real progress since Aristotle—could, he says, be applied with at least equally good justification to the ethics of virtue, and he seems to see the future development of the philosophy of the virtues in terms of radical change. So he sets out to shape a new concept of *virtue* and one sees how far von Wright is prepared to go in throwing over old doctrines when one realizes that he is happy with a definition which excludes two of the four cardinal virtues of ancient and medieval morality.

Why is von Wright so dissatisfied with the traditional theory of the virtues? Perhaps this is not made altogether clear in his discussion, but several themes appear. In the first place, von Wright himself seems to be somewhat preoccupied with the need to distinguish a virtue, in the sense in which we now use that term, from an art or a skill, and he believes that Aristotle, "misled by the peculiarities of the Greek language", did not see how different they are. We might start by considering what von Wright has to say on this subject, and thinking about the justice of his charge.

Von Wright's own answer to the question 'How does a virtue differ from an art or a skill?' is as follows. If one possesses a skill, or is master of an art, one has what he calls 'technical goodness' and technical goodness is a matter of being *good at* performing some specific activity, such as running, skiing, or singing. A virtue must be different because there is no specific activity connected with any virtue, and therefore nothing for a man of virtue to be *good at*.

> The lack of an essential tie between a specific virtue and a specific activity distinguishes virtue from that which we have called technical goodness. We attribute technical goodness or excellence to a man on the ground that he is *good at* some activity. But there is no specific activity at which, say, the courageous man must be good—as the skilled chess-player must be good at playing chess and the skillful teacher must be good at teaching.[1]

Is von Wright correct in the account he gives of the possession of a skill or art? Clearly he is right in saying that it is a matter of being *good at* doing something, though one might query whether what the skillful man is good at is always an *activity* in von Wright's special sense, and we should pause to consider the distinction between activities and acts which he often refers to in the discussion of the virtues.

What von Wright calls an act is the intentional production of a certain result, as, e.g., lighting a cigarette or opening a window. "Acts are named after that which I have called the *results* of action, i.e. states of affairs brought about or produced by the agent in performing the acts."[2] An activity, on the other hand, is related not to an event but to a process. "Events happen, processes go on. Acts effect the happening of events, activities keep processes going".[3] Acts, says von Wright, necessarily leave an imprint on the world whereas activities may or may not do so.

> Activity is not internally related to changes and to states of affairs in the same manner in which acts are related to their results. Activity, however, may be externally or causally related to changes and states which are consequences of performing this activity. Running need not leave any "imprint" on the world, but smoking may leave smoke.[4]

It is at first sight puzzling that von Wright, who has made this distinction between act and activity, says that every skill or art has to do with being good at some *activity*. It certainly is so in the case, e.g., of the singer, who must do well in the activity of singing rather than produce some result in the world. But what about a doctor's skill, which seems to lie in his ability to bring about a cure in the patient? Why should we not say that what he is good at is performing the act 'curing a patient' which is defined in terms of this result? He is able to do this difficult thing, and in circumstances where others could not, though of course the skilled doctor need not always produce the result, even in cases within his general competence; the expression 'being good at effecting a cure'

allows for some failures, particularly where external factors intervene, and this gives us no reason to deny that what he is good at is producing the result.

Perhaps von Wright would reply that there are some activities defined in terms of the result produced, but which are activities none the less. It would seem to be necessary to give some such account of the meaning of a form of words such as 'He was writing a letter'. In terms of the distinction made by Kenny and others between performances and activities this names a performance rather than an activity.[5] Yet 'he was writing a letter' implies that the result had not yet been accomplished, and does not imply that it ever would be accomplished, so that one would expect von Wright to deny that any act was named. If activities and acts divide the field between them there should, therefore, be activities named after the intended result, and it could be said that some skills were a matter of being good at the performance of such activities.

I shall leave this problem unsolved and will accept at least the outline of von Wright's account of skills and arts. It still remains to be seen whether he has drawn the right distinction between skills and arts on the one hand and virtues on the other. Is he right that the difference depends on the fact that to a virtue no specific activity corresponds? Is it indeed true that none of the virtues has an essential connection with a specific activity?

Von Wright argues to this conclusion by insisting that when we know that a man is acting courageously, for example, we do not know *what he is doing*, since the activities a man can perform in acting courageously can be so very diverse. Is this really enough to show that we do not know what he is doing? Are there not many activities which can be performed by doing any one of a number of things, as a man who is cooking can be stirring, weighing, reading a cook book, testing the oven, etc., and one who is looking after children can be walking, bathing, joking, nursing, and a thousand other things? Perhaps it is going too far to say that because we know that a man who is acting courageously is facing the fearful for the sake of some good we also know *what he is doing*, but is it certain that we would want to say that there are no 'specific activities' essentially connected with any of the virtues? Does not benevolence, for instance, have such a connection with such things as *helping*? And if one refuses to call helping a 'specific activity' what is one's reason for so restricting the use of this expression? In any ordinary sense we know what a man is doing if we know that he is *helping* even though a great deal is left unsaid.

In any case von Wright seems to be mistaken in thinking that the distinction between arts or skills and virtues depends on the denial that the latter are connected with specific activities. For however close the connection between certain virtues and certain activities a man does not possess the virtue by being *good at* the activity. The reason for this was indicated quite correctly by Aristotle when he said that in art he who errs voluntarily is preferable, whereas in the matter of wisdom, justice, etc., it is the reverse.[6] Thus, to use Aristotle's

example, a grammarian who commits a solecism *on purpose* does not give any evidence of deficiency in the art of grammar, whereas no one could rebut a charge of injustice or folly by saying that he chose to act unjustly or foolishly. A man may be good at 0ing—may possess the relevant skill or art—whether he chooses to 0 well or badly: he may possess the skill but not choose to exercise it; whereas the virtue gives its use.

It may be that there are other things that can be said about the difference between a virtue and a skill. Traditionally it was held that virtues have to do with human good in general while skills do not, and Aquinas, for instance, insisted that it is characteristic of virtues that they cannot be used to bad ends.[7] But the latter point is controversial, and we do not need to look further than the consideration raised in the previous paragraph to show that virtues are different from arts and skills. A skill is shown by the congruity between a man's intentions and his performance: if he chooses to 0 well and is skillful, then by and large he will 0 well. For a virtue on the other hand this congruity between intention and performance is not sufficient. And nor is it necessary. For it is rather by his intention that a man is judged virtuous than by the successful accomplishment of what he intends. And this last point shows one way in which it is quite right to deny that virtues correspond to specific activities. A man might have the virtue of benevolence, and be acting out of benevolence on a particular occasion, without *actually* being engaged in any such activity as helping, rescuing, etc.; he might be doing that which he reasonably believed to be helpful but which actually was not helpful at all—like ringing at the wrong doorbell to rouse a doctor or nurse. I am not, of course, asserting that benevolence is *simply* a matter of what a man intends, since failure might be due to negligent execution, or culpable ignorance such as ignorance of elementary first-aid, and this might show the lack of the virtue itself. Nevertheless a man who is displaying the virtue need not actually be engaged in those activities which have an essential connection with benevolence, and to this extent von Wright is correct in what he says.

A similar point can be made about the connection between particular virtues and particular kinds of acts. The virtue of benevolence cannot be defined without reference to a particular aim, But it is true that the class of benevolent actions does not coincide with the class of acts having this *result*. It is therefore true to say as von Wright does that "Virtuous acts cannot be characterized in terms of their results, and therefore virtues not in terms of achievements."[8]

Moreover there is more to the definition of benevolence than is given by specifying the intention. First of all the aim of helping another person must not be merely an intermediate end; there must be no ulterior motive in the case. And secondly benevolence is not defined as seeking the good of others on any occasion, and by whatever means. According to the traditional account of the virtues a man who does a bad act such as perjuring himself in a law court in order to help someone is not performing an act of any virtue; and even those

who would not accept such a close connection between virtue and good action would admit that no one shows a lack of benevolence in refusing to do such a thing. I do not know whether this is what von Wright has in mind when he says at one point that the path of virtue is never laid down in advance,[9] but it certainly is true that the path of the benevolent man is not laid down by a description such as 'aiming at the good of others'; he often has to *decide* whether he will be failing in charity if he does not do this.

We are now in a position to consider another of the revisions that von Wright wishes to make in the traditional doctrine of the virtues: his insistence that virtues are not to be described as dispositions. The argument has to do with his thesis that acts of virtue do not correspond to specific activities or act categories, and he says explicitly that dispositions are what the virtues would be "if there existed act-categories or specified activities answering to the virtues."[10] Dispositions, he says, are 'inward' things with 'outward' criteria, and he thinks that virtues fail to meet the second condition. I am not myself clear why von Wright insists that the manifestations of a disposition must be 'outward' in a sense that excludes the manifestations of virtue. There are, it is true, dispositions such as allergies of which the signs are involuntary happenings like sneezes, and to which a man's thoughts, intentions and motives are irrelevant. But there are other dispositions, which von Wright allows as dispositions, for which this is not the case. If a man has an irascible disposition he may, when crossed, go red in the face and put on an involuntary scowl, but we cannot describe the occasion of these happenings without referring to his understanding of the situation, and the involuntary manifestations of irascibility would not be very significant without intentional behavior such as insult, protest, or refusal of cooperation. Intentional action is a large part of the manifestation of the disposition. It seems therefore that one should not put too narrow an interpretation on the condition that the manifestation of any disposition must be something 'outer'; and by the same token there seems no reason to deny that virtues are dispositions.

By far the most radical break that von Wright makes with the past appears, however, not in his criticisms of traditional theories but in his idea that a new definition of virtue is needed, and in the offering of a definition that excludes so many of the traditional virtues. I am not clear why he thinks that such a definition is useful—whether he thinks, for instance, that no account *could* be given of a virtue which would embrace wisdom, justice, and benevolence, as well as such virtues as courage and temperance. But what is certain is that he claims for the concept that he is, by his own account, 'shaping', that it fits some of the most obvious examples of virtues. "We cannot claim that everything which is commonly and naturally called a virtue falls under the concept as shaped by us. But, unless I am badly mistaken, some of the most obvious and uncontroversial examples of virtues *do* fall under it." And he adds, "It is therefore perhaps not vain to hope that our shaping process will contribute to a

better understanding at least of *one* important aspect of the question, what a virtue is.''[11]

According to von Wright's definition of virtue each individual virtue is said to be a form of self-mastery. To each virtue there is to correspond a particular passion, as fear corresponds to courage and the desire for pleasures to temperance, and the virtue is to consist in the mastery of that passion. One notices that von Wright has already broken with tradition in insisting on a specific passion corresponding to each virtue. For traditionally a distinction is made between courage and temperance which are 'about passions' and justice which is 'about operations'. A man who is going to act justly must indeed have control over his passions, but there is no one passion against which he is fortified by this virtue. A man who lacks courage must be overcome by fear, whereas one who acts unjustly may be motivated in many different ways.

Von Wright thinks of each virtue as a form of self-mastery or self-control, and we must ask whether any such theory could be satisfactory. But first we must notice that he gives a rather surprising account of what this self-mastery is. It is, he says, the ability to prevent passions from interfering not with actions directly but with these as they are affected by judgements. And the judgements involved are a special class of judgements, that is judgements about what is harmful or beneficial to the agent himself or to others. (Von Wright equates these with judgements of right and wrong via the thought that they tell us what it is right or wrong to do with a view to someone's good.) A passion is, therefore, seen as disorderly or uncontrolled only in so far as it affects this kind of judgement. If one is courageous, fear does not interfere with a clear perception of what would benefit oneself or others.

This is, on the face of it, a curious account of the mastery of the passions, since it seems that these can affect our behavior not only by corrupting our judgement, but also by interfering with our performance of what we see clearly to be the best thing to do. Von Wright will not, however, admit the second case, at least so far as judgements of our own good and harm are concerned. Where we are inclined to say that a man is led by present passions to act against his own foreseen long-term interest von Wright insists that he was not at that time capable of seeing clearly the disadvantages in what he does. In fact von Wright offer the time-honoured solution to the problem of *akrasia* which consists in denying that we do ever truly see the better and choose the worse. On the other hand he does not deny that we may see clearly that what we do is harmful to someone else and do it all the same, and I am not clear how he will argue that such conduct is *never* caused by our lack of control over our passions.

I intend to put such problems aside, for quite apart from the possible difficulties in von Wright's special account of the mastery of the passions, there are difficulties in *any* theory which equates virtue with self-control.

In the first place the definition is, as already mentioned, one that must exclude from the class of virtues such things as honesty, charity, fairness, generosity, and truthfulness. The reason for this is obvious, since these virtues are all concerned with the readiness to do certain things, such as paying debts, helping others, or telling the truth, and for this mastery of the passions is a necessary but not a sufficient condition. If a man is a ruthless self-seeker he may act dishonestly or unjustly or unkindly with his passions perfectly under control; he sees clearly what he is doing and coolly proceeds with his plans. He has control over the passions but lacks the virtues; therefore if a virtue is said to *be* a form of self-control, honesty, justice, and so on turn out not to be virtues after all.

Von Wright does not for a moment deny this strange conclusion. Indeed he says explicitly that neither charity nor justice possesses the features he takes as characteristic of a virtue and gives arguments like the ones in the preceding paragraph to show that considerateness is not a virtue in his sense of that word. The argument about considerateness is interesting in showing just how things would work out if von Wright's definition of virtue were accepted. There is, he says, a virtue (a form of self-mastery) forming part of what we call considerateness. A considerate man must have learned to control his selfish impulses so far as these might interfere with his judgements about the harm that will come to others through possible action of his. If he wants to avoid what will harm them, the man with this 'virtue' will be well-placed to know how to do so and, we may add, to follow through a decision that that is what he should do. It will not, however, follow that he acts considerately since he may not mind harming them. Von Wright's 'virtue', which is something for which we have, I think, no name, is therefore not the virtue of considerateness, and considerateness is not a von Wright type virtue, since it is not a form of self-control.

Whether or not this is a fatal objection to von Wright's theory depends on the reasons he has for shaping his new concept of virtue. What would certainly be fatal would be the discovery that the new concept did not fit even those virtues for which it was bespoken, as, for instance, courage and temperance. As courage seems to be von Wright's favourite virtue—the one to which he refers most often in his discussion—we may usefully ask whether courage is adequately defined in terms of self-control. There is no doubt that courage involves mastery of the passion of fear. If a man is courageous fear does not lead him to overestimate dangers, nor to see happiness in terms of safety as a timid man may do. Nor does he run away where he thinks it would be better to stand. But it is one thing to say that courage requires mastery of fear and quite another to say that this is what courage consists in. For if we know that a man has mastered the passion of fear we know nothing about his ends, except that he is not a fearful, safety-loving individual. For all that has yet been shown

he may be a foolish braggart, or a villain, and he may show his 'courage' (his mastery over fear) in his foolish or villainous acts. Von Wright does not seem to see any difficulty in this position since he speaks of the courage "which burglars or robbers display".[12] But I wonder why he dismisses without discussion the opposite point of view. Neither Aristotle nor Aquinas would allow that an act of a virtue could be a bad act: a virtue is something of which, as Aquinas put it, no one can make bad use. The courageous man faces the fearful *where he should*.

Many people would, of course, agree with von Wright in thinking that there is no difficulty about the idea of courage used for foolish or villainous ends. And yet if faced with clear examples they may feel some doubts about so identifying courage with daring or boldness. Hardly anyone is ready to say that a man who murdered his wife to get her out of the way would be acting courageously or doing a courageous act so long as he was sensible of the risk that he ran. They are more likely to use expressions such as 'an act of courage' where the example is slightly different, and the evil distant from the action concerned, as when, for instance, a man does something to save his own life or that of his companions in the course of some wicked enterprise, such as an unjust war. But this tells against rather than for the idea that courage is simply mastery of fear; why should the presence of immediate good ends and the remoteness of the bad ones make any difference if the goodness and badness of action does not come in to the definition of courage? Perhaps some compromise may be suggested, by which we shall indeed refuse to call the act of murder a courageous action but will say of the murderer that he 'shows courage'. But then one must ask 'What is this courage that he shows?' If it is identical with daring why should a daring act not be the same as a courageous act? If we say that the disposition of which the act is the criterial manifestation is indeed boldness or daring rather than courage, but that it is nevertheless evidence that the man also possesses courage, we shall want to know how the inductive basis for such a judgement is reached. Have we observed that men who do bold and daring acts of the kind we have been considering also do acts of courage? The most that can be said for this argument is as follows. A man who is to act courageously must have the capacity to face the fearful, and this capacity is shown by the performance of acts of boldness and daring, however foolish or villainous. Therefore that capacity which is a necessary condition of courage may be shown in bad or foolish acts. Someone who does them may be *unready* to face the fearful for good ends, but not because he is incapable of mastering his fears.

I believe, then, that there is a closer connection between the concept of courage and that of good action than von Wright allows. I do not, of course, mean that courageous actions have to be what people normally think of as morally good actions such as acts of charity or justice, since it is clear that a

man may act courageously (may do a courageous action) for the sake of some good in his own life, as he might submit to the amputation of a limb under appalling conditions in order to save his health or his life. But I think that there is a sense of 'good action' in which courageous actions must be good actions, and a sense which definitely excludes the action of the villain or the foolish braggart. To face the fearful where one should not does not indeed show *lack* of courage, and therefore courage is not to be defined as 'getting it right' about when the fearful is faced. But only good acts are courageous actions, and if the villain or fool is courageous, as he *may* be, this is not shown by his bad or silly acts.

In this essay I have concentrated on those parts of von Wright's discussion of the virtues in which he criticizes and departs from the traditional doctrine of the virtues, and have suggested that there is more to be said for the point of view of Aristotle and Aquinas than he allows. But I do not mean to suggest that the subject was brought to finality by these philosophers. Von Wright is clearly correct in thinking that the topic needs to be reopened and developed, and he himself has said many true and interesting things that will contribute to this development.

SOMERVILLE COLLEGE, OXFORD PHILIPPA FOOT
THE UNIVERSITY OF CALIFORNIA AT LOS ANGELES.
APRIL 1974

NOTES

1. *The Varieties of Goodness* (New York: Humanities Press, 1963), p. 139.
2. Ibid., p. 141.
3. *Norm and Action: A Logical Enquiry* (London: Routledge and Kegan Paul, 1963), p. 41.
4. Ibid., p. 41.
5. See e.g. Anthony Kenny, *Action Emotion and Will* (London: Routledge and Kegan Paul, 1963).
6. Aristotle, *Nicomachean Ethics*. Bk. VI, Chap. 5. See also Aquinas. *Summa Theologica*. The First Part of the Second Part. Question 57, articles 3 and 4.
7. Aquinas, *Summa Theologica*. The First Part of the Second Part, Question 55, article 4.
8. *Varieties of Goodness*, p. 141.
9. Ibid., p. 145.
10. Ibid., p. 142.
11. Ibid., p. 138–39.
12. Ibid., p. 153.

12

William K. Frankena

VON WRIGHT ON THE NATURE OF MORALITY

In *The Varieties of Goodness (VG)* von Wright remarks, "Whether so-called
moral duties are [duties in our sense] or not, will depend upon the view we
take of the nature of morality."[1] My purpose here is to look at the view *he*
takes of morality. His remark indicates that he may be proposing a considerable
reconstruction of morality, as some other recent writers are doing, and, if he
is, we must know what it is and what we should think about it. It is true that
neither in this book nor in its companion volume, *Norm and Action (NA)*, is
he offering us "a treatise on ethics"—what he offers us is a "general theory"
of value, norms, duties, virtues, and justice—but he does think that "it con-
tains the germ of an ethics," and he certainly has morality in mind much of
the time.[2] I shall review what he says about it, partly as a way of examining
his view, and partly as a way of moving him to say more. One hesitates to
criticize or disagree with a philosopher as able as von Wright, and I do admire
his work and approve much of what he says, but at the same time I also feel a
deep disquiet about the view of morality he seems to take. This is what I hope
to put into words, sometimes only by asking questions or posing problems of
interpretation, sometimes by raising objections.

First, some words about von Wright's general approach. (1) He begins by
mentioning "the distinction between the ought and the is", and one senses that
he questions it; at any rate, he does question the allied distinction between
meta-ethics and normative ethics. Even so, he regards his investigations as
'conceptual', i.e., as being concerned with "the *meaning* of certain words and
expressions". He happens to believe, however, that conceptual investigations
in the area of practical philosophy should "take the form of a moulding or
shaping of concepts" and aim in at least this way "at *directing our lives.*"[3]
With this feature of von Wright's approach I am in essential agreement, except
that I am less inclined to think that engaging in normative conceptual proposals

entails breaking down the distinction between normative ethics and meta-ethics—or between the Ought and the Is.[4] (2) Von Wright is also convinced of the desirability of approaching ethics through a general theory ''of the good (and of the ought).''[5] Of this I am much less persuaded. While I have no wish to denigrate such general theories, I do have some feeling that von Wright's approaching morality in this way is partly responsible for some of the features of his view of morality that trouble me, though I shall not try to show this explicitly. (3) Coming to his view of morality, we find him maintaining that morality is not conceptually autonomous, that moral norms are not *sui generis,* that there is no peculiar or special *moral* sense of 'good', 'duty', etc., and that a deontological view of morality is unsatisfactory and must be given up for a teleological one.[6] We may begin here, for there are more distinct claims being made here than von Wright seems to realize.

I

Let us look first at *NA,* Chapter I. Here von Wright distinguishes several kinds of norms. There are three basic or ''major'' types of norms:

1. rules, e.g., the rules of a game or of grammar;
2. prescriptions, e.g., commands, permissions, prohibitions, laws;
3. directives or technical norms, e.g., 'If you want A, you ought to do B.',

There are also three ''minor'' types:

4. customs;
5. moral principles, e.g., that of keeping promises;
6. ideal rules, e.g., 'A man ought to be generous', including 'moral ideals'.

In the course of presenting this interesting and useful classification, von Wright asks whether moral norms belong to any of the first four classes. His answer seems to be that some of them (e.g., moral ideas about sexual life) are customs, which resemble both rules and prescriptions, but others are not. Some of these are, or present the aspect of, rules, e.g., the obligation to keep promises, but *''on the whole,* moral norms are *not* like rules (in the sense which we here give to the term).''[7] Are the remaining moral norms prescriptions issued by some human or divine authority? Von Wright seems to answer that they are not, even though he seems to me to think too much of the time in terms of this conception of norms. In this connection he does, however, go so far as to say that it is ''a logical feature of morality'' that prescriptions play a prominent role in the moral life of man; he thinks there is ''this logical tie between moral norms and prescriptions'' even though it does not follow that we may ''reduce the former to a species of the latter.''[8] What he is thinking here is not very

clear, but it seems to be that, although moral norms are not necessarily pre-scriptions, they must be embodied in prescriptions, e.g., in civil laws or paren-tal commands. I see no reason for believing this. It may be that morality nec-essarily includes the verbalization of moral norms and the uttering of moral judgments, but this does not mean that it entails prescribing in von Wright's sense, unless one regards moral utterances as *ipso facto* having the aspect of commands, permissions, etc., which strikes me as false.[9]

The remaining alternative is that the moral norms not reducible to customs or rules "are a kind of technical norm or directives for the attainment of certain ends," as a teleological view would hold. This is the view that it would seem von Wright must adopt, since he refuses to regard any moral norms as *sui generis.* Yet he does not here adopt it, and even refers to "the difficulties encountered by both a law-conception of moral norms and a teleological con-ception of them."[10] He therefore concludes by denying that moral norms can all be subsumed under rules, prescriptions, customs, or directives, and also that any of them are *sui generis,* arguing that

> they have complicated logical affinities to the other main types of norm and to the value-notions of good and evil. To understand the nature of moral norms is there-fore not to discover some unique feature in them; it is to survey their complex relationships to a number of *other* things. . . . Irrespective of which view one accepts as basically true, one cannot deny that moral principles have important relationships both to prescriptions *and* to technical norms.[11]

I find this most puzzling. If moral principles and/or moral ideals cannot be subsumed under any of the other four types of norms, they must, it seems to me, be regarded as *sui generis* in the sense of forming a distinct genus of norms. This is quite compatible with their having various affinities with and resemblances to norms of other sorts or to judgments of good and evil. It seems to me that von Wright fails to see this, because he does not clearly distinguish between saying that (some) moral norms are *sui generis* in the above sense and saying that they have no affinities to other things, that they are conceptually autonomous, etc. Also puzzling is the fact that von Wright does not here sim-ply subsume moral norms under directives or technical norms, for this seems to be required by any teleological view of the kind he apparently means to expound and defend. Perhaps he is here intending only to describe our ordinary ways of thinking about moral norms, leaving his teleological reconstruction of them to *VG.* As we saw, he thinks of his enquiry as a moulding of concepts, and he may be meaning to go on to remould our concept of a moral norm, and, in general, to argue for reconceiving morality as an explicitly teleological enterprise.

Von Wright's view is made even more puzzling by a discussion in *VG.*[12] There he first says that norms, "in the sense here contemplated, may be said to be prescriptions for human action" and then distinguishes "three main as-

pects of such prescriptions'': ''norms as *commands,* norms as *rules,* and norms as *practical necessities'',* though without giving his reasons for calling them 'aspects' rather than 'kinds' of norms (as he does in *NA).* This suggests that somehow all norms are prescriptions with three aspects or faces, perhaps in different degrees, but I am not at all sure this is what von Wright holds; he may only mean that norms are prescriptions and have one or another of these aspects, or perhaps sometimes more than one. He also distinguishes three main ways of formulating norms in language, corresponding, though only roughly, with their three aspects:

1. Sentences in the *imperative* mood, e.g. 'Open the window!'
2. *Deontic* sentences, e.g.., sentences using 'ought to', 'may', and 'must not'
3. *Anankastic* sentences, e.g., sentences using 'must', 'have to', 'cannot', and 'need not'.

Sentences of the first kind correspond primarily to the command aspect of norms, those of the second to the rule aspect, and those of the third to the practical necessity aspect; but sentences of any of the three forms may be and are used to express norms in any of the three aspects. Again, it is not clear whether von Wright is thinking that each norm has all three aspects and therefore may be expressed in all three ways, or that some norms have one aspect and some another, but any norm may be expressed in any way. All that is clear is that von Wright means to distinguish between being commanded, being required by a rule, and being a practical necessity, and between three roughly corresponding kinds of sentences. What is not clear is which of these aspects moral norms have and which kind of sentence corresponds to them, if any.[13]

II

Another general discussion in *VG* must be looked at here.[14] In it von Wright first divides ''the concepts which are relevant to ethics'' into three 'main' groups:

1. Value concepts like *good* and *bad;*
2. Normative concepts, especially ''the notions of an obligation, a permission, a prohibition, and a right'';[15]
3. 'Psychological' concepts like *action, choice, motive, reason,* etc.

Then he lists three other groups of concepts that fall between these main groups and have a foothold in two or more of them:

4. The notions of *right* and *wrong* and the idea of *justice.* These have affinities with the concepts in (1) and (2).

5. The notions of *pleasure* and *happiness* and their contraries, which fall somehow between (1) and (3)

6. The notion of a *virtue* and those of *courage, generosity,* etc., which appear to have a foothold in each of the three primary groups.

About the last group he says,

> Because of their connexion with the important notion of character they are anthropological (psychological) concepts. They get a normative tinge from their connexion with ideas of a (choice of) right course of action. And finally they are value-tinged due to the connexion between the virtuous and the good and the vicious and the bad man and life.

Von Wright goes on to indicate that he will look for "a foundation of morals in a 'horizontal' direction, trying to place moral notions in a broader setting of value-concepts and normative ideas," rather than in the "vertical" direction of relating them to 'psychological' concepts.[16] I take it that by moral concepts he here means some of the concepts in (4) and (6). For he says that the concepts in (4) can be understood in a 'legal' sense "which seems to be purely normative" or in a 'moral' sense "which relates them to ideas of good and evil and therewith makes them value-tinged."

Some comments and points. (a) Von Wright adds that his horizontal approach will stress value-concepts rather than normative ones as basic in ethics or morality, thus again indicating the teleological drift of his thinking. (b) This is also indicated by his saying that 'right', 'wrong', etc., have a *moral* sense when they are related to the ideas of good and evil. But this statement suggests that he may have in mind an implicit definition of the 'moral' (as versus the non-moral), and of 'morality', as being concerned in some way about good and evil. If so, then he is associating himself with those who favor 'material' definitions of morality, as Toulmin, Baier, Foot, and I do, rather than with those who favor 'formal' ones, as Hare and others do. Depending on the way in which he constructs his 'material' definition, he may also incur the charge of building deontological views out of morality by the way he moulds his concepts. (c) It is not clear from this section of *VG* where concepts like *duty, ought,* etc., fall—or the concept of moral goodness, for that matter. It is also not clear whether we should call 'deontic' the concepts in (2), (4), or both, or whether the concepts in (2) have moral senses or not (i.e., whether or not morality contains normative concepts in von Wright's sense, even if they are 'relevant' to it).[17]

III

Something has been said about von Wright's view that moral norms are none of them *sui generis*. Now I should like to take up other views that he asserts

at the same time and hardly seems to distinguish from one another or from that view, viz.:

1. That morality and its norms are not conceptually or logically autonomous;
2. That there is no peculiar or special *moral* sense of 'good', 'duty', 'ought', etc.;
3. That a deontological view of morality is unsatisfactory.

Take (1). This may mean:

1a. Moral concepts (or the concepts appearing in moral norms) are definable in terms of non-moral ones.
1b. Moral norms are logically derivable from non-moral premises.

If (1a) is true, (1b) is true; it is not so clear that (1b) entails or presupposes (1a) but I am inclined to think it does. Furthermore, each of them has two sub-senses. Thus we get:

1ai: Moral concepts are definable in terms of non-moral value, normative, or deontic concepts, e.g., in terms of the good of man.
1aii: Moral concepts are definable in terms of non-moral descriptive concepts, e.g., psychological or biological ones.
1bi: Moral norms are logically derivable from non-moral value, normative, or deontic premises.
1bii: Moral norms are logically derivable from non-moral descriptive premises, e.g., from psychological ones or from statements of natural necessities.

In which of these senses is von Wright holding that morality is not autonomous? I am not sure. He may be holding that it is non-autonomous in all four senses. Then he is a naturalist or descriptivist in his meta-ethics. If he holds only 1ai and 1bi, he could still be an intuitionist or non-naturalist, as G. E. Moore was in *Principia Ethica*. He certainly does mean to reject any view that insists a *moral* norm or premise is conceptually or logically necessary for the derivation or justification of a moral norm or judgment; but rejecting such views is compatible with being an intuitionist or a non-cognitivist (e.g., an emotivist or 'ethical skeptic'). My impression is that von Wright means to be a naturalist or descriptivist of some sort, in the sense of making moral concepts and judgments logically dependent on non-moral ones—not just in the sense of making moral ones dependent on axiological ones, but also in the sense of being a naturalist or descriptivist about all value concepts and judgments too, as Moore was not. I must admit, however, that I find few clear definitions or other statements to this effect in *VG* or *NA*. Moreover, von Wright tends to equate the meaning of a term with the criteria or standards for applying it in such a way that I am not certain that Moore, Stevenson, or Hare would have to regard him as a naturalist. In any case, however, he is at least denying the

autonomy of morality in the sense of holding lai and lbi, i.e., that it is conceptually and logically dependent either on norms of a non-moral sort, on value premisses, or on Ises. This is one of the points in his view about which I have grave doubts, and I shall return to it later when we have more of what he holds before us.

Now take (2), which is reminiscent of Ms. Anscombe's attempt to bring about a shot-gun divorce between us 'modern' moral philosophers and the notion of a 'special' *moral* Ought. It is also ambiguous. It may mean any one of the following:

2a: Terms like 'good', 'right', 'ought' have precisely the same meanings in their moral as in their non-moral uses.
2b: Such terms, in their moral uses, are analyzable or definable by reference to their non-moral uses—or perhaps even by reference to descriptive concepts.
2c: Moral judgments have no special kind of ground or reason,

(2a) is compatible with holding that morality is conceptually or logically autonomous, but (2b) is not. Both, except for the last disjunct in (2b), may be maintained by intuitionists and emotivists; W. D. Ross, for example, maintains (2a). (2b) is compatible with holding that moral norms are *sui generis* in the sense formulated above, but (2a) is not. One may hold either (2a) or (2b) and deny (2c); for example, Ross denies (2c) even though he accepts (2a) (and maybe the first part of 2b).

What is von Wright maintaining? I doubt he is asserting (2a), for he equates the quest for meanings with the quest for grounds or standards whereby to judge and does not believe that the latter are always the same. I see no reason for agreeing with him. My own view is like Ross's, except that I am not an intuitionist; viz. that (2a) is true and (2c) is false—'ought', etc., have the same meaning in moral as in non-moral uses but require *grounds* or *reasons* of different (distinctive but not necessarily 'peculiar') kinds. This does mean, of course, that I agree in a way that moral terms have no 'special' *meaning,* but, as I say, intuitionists, emotivists, and prescriptivists can also agree to this.

We have already seen that von Wright asserts (2b), which is another way of saying that morality is not conceptually autonomous. Does he assert (2c)? We have also seen that he believes moral norms to have different grounds from legal ones, and that he does not believe the grounds and reasons for practical judgments always to be of the same sort. It looks therefore as if he must reject (2c). But again, we shall return to this question. I should point out, however, that those who define morality in purely formal terms must assert (2c); and also that it never does seem to occur to von Wright that morality may be defined as a special group of customs, rules, prescriptions, duties, ideals, or whatever, in the sense of consisting of those that have a certain kind of background or

support. Yet I do not see that he must or even how he can object to such a definition.

We come now to (3). As far as I can see, von Wright holds deontological theories of morality to be mistaken because they assert (1) and (2) and also that moral norms are *sui generis*. But must they assert these things? All a deontologist needs to contend is that purely teleological views are mistaken, i.e. that a consideration of the relative amount of good and evil involved in performing an action, living by a rule, or having a trait of character, etc., is not always conclusive in questions about its moral status. One can, however, maintain this, it seems to me, even if one accepts (2a), (2b), or any of the other theses ascribed to von Wright so far (excepting only his teleologism) which involves asserting not just (2b), etc., but also a particular sub-thesis under (2b), viz. that moral concepts are logically dependent on *value* concepts. Deontologists can be non-autonomists; they can even be naturalists or descriptivists (if these positions are not defined so as to entail teleologism, as they sometimes are,[18] but were not by Moore or Broad). It should also be pointed out that a teleologist may insist on the autonomy of morality; he might hold exactly the same position Moore did in *Principia Ethica,* except for insisting that rightness (ought, etc.) is also indefinable. In fact, this was Moore's view when he wrote *Ethics* later, as he himself told me when I asked him in 1935.

IV

So far we have been reviewing in a preliminary fashion von Wright's general views about morality, leaving for later his more specific views about moral goodness, moral duty, moral virtue, etc. Still on general matters I should like, even at the cost of some repetition, to pose the following question. If we look at the writings of Anscombe, Foot, MacIntyre, etc.,[19] it appears that we may distinguish three views about the nature of moral Oughts, including for the moment all kinds of moral judgments and principles under Oughts, aretaic ones as well as deontic ones, judgments about agents, motives, and traits, as well as about actions and choices.

A. Moral Oughts are all institutional in the sense of presupposing the existence of institutional rules of some sort, divine or human, as do the Oughts of etiquette, law, social clubs, etc.
B. They are all 'ordinary' in something like Anscombe's sense, i.e. they presuppose only that some action, trait, etc., is necessary or useful in bringing about an agent's end or ends or in bringing about something good or preventing an evil.
C. They are all 'special' in the sense of being neither institutional nor ordinary.

Kant and the deontological intuitionists seem to have held (C), but so did Sidg-wick and Moore in *Ethics*. Except for 'duties', Moore's view in *Principia Ethica* was (B). It is, of course, also possible to combine these views in various ways, holding that some moral Oughts are of one and others of another kind.[20] My question is what view von Wright holds. It sometimes looks as if he believes that moral Oughts are or may be of any of these three kinds (or may have any of these three 'aspects'). But he also seems to be rejecting (C) in his official pronouncements and though I think he has the institutional model too much in mind when discussing norms, including moral ones[21], it seems to me, as I indicated earlier, that he is rejecting (A) for at least some moral norms (or for at least one 'aspect' of such norms). It looks on the whole, therefore, as if von Wright means to hold (B) or some combination of (B) and (A). If the latter, one would like to know just what kind of combination of the two kinds (or aspects) of Oughts morality is supposed to be.

Since von Wright is in any case holding that some moral Oughts are ordinary, we should notice that ordinary Oughts may be of three kinds:

1. Hypothetical Oughts in Kant's sense, which say that X ought to do Y because Y is necessary or helpful in achieving something *he desires;*
2. Egoistic Aristotelian Oughts, which say that X ought to do Y because Y is necessary or helpful in achieving some *good* or preventing some *evil* for him
3. Non-egoistic Aristotelian Oughts, which say that X ought to do Y because Y is necessary or helpful in bringing about some *good* or preventing some *evil* for *someone,* in promoting the general good etc.

Now, I understand Foot to be proposing that moral Oughts be conceived as hypothetical Oughts, and Anscombe that they be conceived as egoistic Aristotelian ones. Moore in *Principia Ethica,* on the other hand, maintains that they must be conceived as non-egoistic Aristotelian Oughts. All three are thinking of their views as conceptual accounts of the meaning of 'ought', etc., in moral contexts. As for von Wright—he rejects psychological and ethical egoism; and it appears, so far, that he means to propose that moral Oughts are or should be conceived as non-egoistic Aristotelian ones, except insofar as they are institutional. We shall see, however, that his view is more complicated and somewhat unclear.[22]

V

Among more specific topics, we may consider first von Wright's views about moral goodness. He opens *VG* by saying, among other things, in objecting to the view that morality is conceptually autonomous,

As I shall try to argue presently, moral goodness is not a form of the good on a level with certain other basic forms of it. . . . The so-called *moral* sense of 'good' is a derivative or secondary sense, which must be explained in the terms of non-moral uses of the word. Something similar holds true of the moral sense of 'ought' and 'duty'.[23]

He then goes on to distinguish several basic or primary senses of 'good' (or forms' or 'varieties' of goodness) and denies again that 'morally good' (or moral goodness) is one of them.

The relationships mentioned between forms of the good do not, as far as I can see, open up a possibility of defining some of the forms in the terms of some other forms. The notion of *moral goodness,* however, holds a peculiar position in this regard. *It* craves for a definition. The fact that there has been so much dispute about its nature, and relatively little about the nature of the other forms of the good, may be regarded as symptomatic of this very craving. Some philosophers would perhaps regard the craving as satisfiable only through the insight that moral goodness is *not* definable, but *sui generis,* an irreducible form of the good. I would hold the exact opposite of this view. I shall later propose an account of moral goodness (as an attribute of acts and intentions), which defines it in terms of the beneficial. Moral goodness is thus not, logically, on a level with the other forms which we have distinguished. It is a 'secondary' form. I shall prefer not to talk of it as a special form of goodness at all.[24]

The basic forms or varieties of goodness are instrumental goodness, technical goodness, utilitarian goodness or "usefulness", medical goodness, hedonic goodness, and welfare or "the good of man". Under the useful von Wright puts "the beneficial", of which the opposite is the harmful. The beneficial is "that which . . . is good for or does good to some being or thing" as medicine is good for the sick, rain for the crops, lubrication for the car, or a king for a people, or as taking a holiday does good to a worker. More accurately, the beneficial is that which is "favourably causally relevant" to the good or welfare of some being or thing. After discussing the various forms of goodness listed, von Wright has a chapter in which he takes up three attributions of goodness: to acts, to intention or will, and to men. It is here that he deals with moral goodness. In line with what we have already quoted he writes.

The form of goodness, in the terms of which I propose to explicate the notion of the morally good, is the sub-form of utilitarian goodness which we have called the beneficial. To put my main idea very crudely: Whether an act is morally good or bad depends upon its character of being beneficial or harmful, *i.e.* depends upon the way in which it affects the good of various beings.[25]

But then he decides that this is not quite right because "the moral quality of an act" depends on its intention rather than on its consequences. The notion of a morally good act is secondary to that of a morally good intention. A morally good intention, however, is to be defined as follows: "The intention in acting

is morally good, if and only if, good for somebody is intended for its own sake and harm is not foreseen to follow for anybody from the act".[26] Thus being morally good is not strictly a way of being beneficial, it is more like intending or being intended to be beneficial. It is only that the notion of moral goodness can be defined in terms of that of being beneficial, plus that of intention.

Coming to our talk about a good man, on page 134 von Wright points out that 'good' may here have an instrumental or a technical sense, but that it may also have a moral tinge, in which case it is related to "the notions of doing good and having good intentions." He suggests, not that "a [morally] good man" means "a benevolent man", but that "when the phrase 'a good man' is used with a moral meaning, it is *related* to [definable in terms of?] our idea of a benevolent man." He remarks, however, that a benevolent man is not necessarily a virtuous man, and may lack a sense of justice, and that a complete elucidation of our notion of the good man must wait until virtue and justice have been discussed.

A number of points must be made about this treatment of moral goodness. (1) Once again it appears that von Wright distinguishes moral attributions of goodness from non-moral ones by the fact that the former necessarily involve a reference to the (intended) good or evil of some being, i.e. that he leans toward a material rather than a formal definition of morality and the moral. Even if we agree, however, that moral attributions of goodness are based on considerations of intention and benevolence, it does not follow that judging X to be morally good *means* simply that those considerations are true, as von Wright seems to think. It also does not mean, as far as I can see, that a teleological view of ethics is correct.

(2) In the passages quoted, von Wright claims more than once that the concept of moral goodness must be explicated in terms of some other form of the good. But is this true? Kant, Prichard, Ross, and others, would reply that an action and its agent are morally good only if he does it because he believes it to be *right* (morally right) for him to do. This view may be unsatisfactory, but it is possible and must be taken seriously. The writers mentioned are, of course, deontologists, but so far von Wright has not shown them to be mistaken, and, anyway, the view can be accepted by an intuitionist who regards the principle of utility as the one and only self-evident moral principle; e.g., it could have been accepted by Moore in *Ethics*. Perhaps von Wright will reply that the concept of moral rightness must either be identified with that of moral goodness or be defined in terms of conduciveness to the non-morally good. But one of these positions must then be defended before he can claim to have justified his view.

(3) Some of the time, indeed, it looks as if he means to make no distinction between moral goodness and moral rightness. Thus he says that 'the moral quality' of an act depends on its intention, as if an act can have but one moral

quality. But, surely, when a person asks what the right action for him to do in a certain situation is, he is asking what is right independently of his intentions—as both Moore and Ross held. In fact, von Wright himself says later that it is not at all obvious that a morally good act is morally obligatory, thus apparently implying that acts may have two distinct moral qualities. To me, at any rate, it seems clear that acts may be morally good or morally right or both, and that the rightness does not depend on the intention even though the goodness does.

(4) On p. 129 of *VG* von Wright argues that the moral value of the act and the moral value of the intention should be distinguished, contending that when the *intention* in acting is morally good but the good that is intended fails to materialize, then the *act* is not morally good but neutral. Actually this contention runs counter to my own intuitions in such a case, but it also seems to me that one may have been mistaken in thinking that the act was the right one to do in the first place—and then it is not entirely neutral. (5) A bit later von Wright considers the following example: X can save either Y or Z but not both from an impending disaster, and he foresees that while he rescues one of them the disaster will overtake the other. X has two choices: to save one or to leave both to perish. Von Wright then says that if X makes the first choice, we would all agree that his choice is morally right; if the second, it is morally wrong. Is "right" here just another word for "good" and "wrong" for "bad"? I am not sure what von Wright thinks, but it seems to me that X may ask what choice is right for him to make and that he will not determine the answer by looking at his intentions but (on a teleological view) by trying to foresee what choice will promote the least evil. If so, rightness (moral) and moral goodness are distinct.

Actually von Wright does not say much about rightness and wrongness, moral or non-moral, though he does sometimes mention them and even talks as if "right" and "wrong" are not just other words for "good" and "bad" (in the case of actions and choices).[27] For that matter, he also has rather too little to say about the concepts of moral obligation and of what we morally ought to do. My guess is that he would try to define all of these concepts, insofar as they belong to morality proper, in terms of the notion of the beneficial, with or without the help of those of intention and being commanded. If I am correct in what I was suggesting a moment ago, then at least *one* of them must be defined, without reference to intentions, in terms of conduciveness to the good of certain beings—if one wishes to make out a teleological view of the kind von Wright has in mind. And then one must answer the objections to naturalistic theories as well as to utilitarian ones. I do not say these objections are insuperable, but they are there, and von Wright does not explicitly deal with them.

VI

Next, von Wright on virtue. He makes a point of mentioning the neglect of this topic in modern ethics and rightly regards it as important. But he is himself concerned primarily to sketch a general theory of the virtues, and I am not even sure that he believes there are moral virtues, for he only speaks of moral virtues where Aristotle does and says (rightly) that the use of 'moral' here is misleading. Moreover, while he mentions the use of 'virtue' in a generic sense that does not admit of a plural (as in 'Virtue is its own reward'), and says it has a moral tinge and so is related to goodness and rightness, he also disclaims any concern with it. (Is this because he equates virtue in this sense with moral goodness?) Nevertheless, I venture to assume that von Wright is thinking that there are moral as well as non-moral virtues, and that his general account goes for the moral ones as well as the non-moral ones, though I find no statement of any criterion for distinguishing the two groups.

Here, as elsewhere, I shall bring in only what I need to get at von Wright's conception of morality. The virtues, he says, are traits of character, not skills, dispositions, habits, or features of temperament. They are essentially concerned with action and choice—with the choice of the *right* (N.B.) course of action, right, that is, with a view to the good of some being involved. "Virtues . . . are needed in the service of the good of man. This usefulness of theirs is their meaning and purpose"[28] They fulfill this role by helping us to choose rightly. More accurately, "the role of a virtue . . . is to counteract, eliminate, rule out the obscuring effects which emotion may have on our practical judgment, i.e. judgment relating to the beneficial and harmful nature of a chosen course of action".[29]

I take this to imply, not that the virtues somehow tell us what is right, but that they keep our emotions and desires from interfering with our attempt to determine what is right or from causing us not even to make the attempt. It also seems pretty clear that, for von Wright, the right is what is beneficial—conducive to the good of some being. It appears to be implied that 'right' means 'for the good of the beings in question', and that rightness and moral goodness are not identical even when it is moral rightness we are referring to, for no reference to intention seems to be required in determining what is right. To this extent we may here have answers to some of our earlier questions. We can also say, I think, that von Wright is not running an 'ethics of virtue', since he does not make the virtues basic (but only ancillary) in the determination and pursuit of what is right. What we do not know is when it is moral rightness that we are talking about, and when we should call a virtue a moral one. It may even be that von Wright is thinking that the rightness being spoken of here is all moral, and the virtues too.

The chapter ends with a distinction between self-regarding and other-regarding virtues. The former, e.g. courage, temperance, and industry, essentially serve the welfare of the agent himself who has them; the latter, e.g. consideration, helpfulness, and honesty, essentially serve the good of other beings. Von Wright does not, however, say that virtues of the one kind are moral and those of the other non-moral, though he may think so. But he does raise the question whether practicing other-regarding virtues is in any sense incumbent on a man independently of what his contingent ends or interests may be—and tells us the rest of the book will be devoted to this problem.

VII

We come thus to von Wright's account of duty. Before entering on this he distinguishes the three 'aspects' of norms mentioned earlier. He also distinguishes autonomous and heteronomous norms, and well-grounded norms from others. Autonomous norms are conclusions of first-person practical syllogisms; one wants *A,* one does not want to do *B* as such, but one finds that doing *B* is necessary to reach *A,* and concludes that one must do *B.* In Kant's (and Ms. Foot's) terms they are assertoric hypothetical imperatives. "The autonomous norms . . . are [practical] necessitations of the will to action under the joint influence of wanted ends and insights into natural necessities."[30] Heteronomous norms are commands issued by a norm-authority in an effort to make agents do or forebear things, where the norm-authority is different from the one to whom the command is addressed. They have no essential connection with ends. But *issuing* a command to Y may be practically necessary for X to do if issuing it is needed for X to achieve his end, and then the norm is 'well-grounded', i.e., issuing it is autonomously necessitated. Also, *obeying* it may be incumbent on Y if obeying it is necessary to Y's ends.

At this point von Wright defines (moulds?) the concept of a duty:

> When the ultimate end, relative to which the norm is well-grounded, is the good of some being . . . it imposes a *duty* on the norm-subject. . . . Here [the term 'duty'] is used as a technical term. Not everything which is called a "duty", is a duty in our sense. Legal duties, *e.g.,* need not be. Whether so-called moral duties are or not, will depend upon the view we take of the nature of morality. But I think . . . our use of 'duty' as a technical term is in good agreement with one of the uses of this word in ordinary language.[31]

There are, he believes, four kinds of duties in this sense:

1. An autonomous self-regarding duty is an autonomous necessitation of the will to do something in view of promoting or protecting the agent's own good. Self-care is the foundation and source of all such duties, but it is not itself an autonomous self-regarding duty.

2. An autonomous other-regarding duty is one that arises if and when the agent wants to promote or respect the good of another for its own sake and sees that in order to do so he must do Y. Again, concern about another's good is not itself an autonomous other-regarding duty, though acquiring other-regarding virtues may be.

3. A heteronomous self-regarding duty is one that arises if and when X wants to promote or respect the good of Y for its own sake, and sees that the good of Y can be promoted only if Y does Z. Then X has an autonomous duty to make Y do Z, e.g. by commanding him to, and, if X commands Y to do Z, then Y has a heteronomous self-regarding duty to do Z. The duty is heteronomous because Y is not moved to action by his own wants and insights into necessities (apart from being commanded by X).

4. If X's end in commanding Y to do Z is the good of some being other than Y for its own sake, then his command imposes a heteronomous other-regarding duty on Y in relation to that other being.

Here we must notice that, while autonomous duties are hypothetical duties in Kant's sense, heteronomous duties are not. The latter may not be categorical in Kant's sense, but they are non-hypothetical in Ms. Foot's sense, since Y's having a duty to do Z does not depend, according to von Wright, on Z's being necessary or being regarded by Y as necessary to any of Y's ends. In other words, a duty need not be a practical necessity for the agent involved. It should also be noticed that there are such heteronomous duties only where there are commands that are made out of an interest in the good of some being as such. The mere fact that my doing A is for the good of some being does not entail that A is my duty. Even then A is my duty only if *either* it is commanded by someone who has the good of that being as an ultimate end *or* the good of that being is something I am concerned about for its own sake. This is very interesting, but it troubles me if it is supposed to be true in the case of moral duties too. However, we do not yet know what von Wright's views about moral duties are, since they appear only in his final chapter on justice.

His discussion of duty does, however, contain some remarks about the use of 'moral'. He proposes to call commands issued in the name of the good of the commanded *moral commands,* educational purposes served by such commands *moral education,* and an authority who gives such orders a *moral authority*. Then he writes,

> This use of the adjective 'moral', incidentally, is not unnatural or at great variance with ordinary usage—though maybe not very familiar in moral philosophy. It has no immediate connexion with so-called *moral goodness* nor with so-called *moral duty*. I am not suggesting that the duties imposed by what I call moral commands are those which we ordinarily call moral duties. The activity, however, which in common speech is called *moralizing,* largely consists in advising and recommending to other people things in the name of their good, and also in drawing their

attention to various ways in which people may have neglected their own welfare. Moralizing is not co-extensive with that which I here call moral commanding. But that which I here call moral commanding falls under that which is ordinarily called moralizing.[32]

No doubt, von Wright is largely correct here. But one does have questions. Is all education aimed at the good of the educated moral education? Has his use of 'moral' here any immediate connection with what *he* calls moral goodness and moral duty even if it has none with what is ordinarily so-called? We may at least note, however, that he seems here again to connect the use of the word 'moral' with a concern for the good of some being.

The big question remaining is this: how can respect for another's good (or the practice of other-regarding virtues) become one's duty? The essence of von Wright's answer seems to fall in his chapter on justice. He begins by saying, "that something is duty, we have said, means that it is a practical necessity with a view to the welfare of some being or beings."[33] This seems to tell us that judging something to be a duty is, by definition, judging that it is naturally necessary for the good of some being. But this is not what von Wright means, as we have seen. The something must be a practical necessity in view of the good of some being. To be a practical necessity in his sense is to be the conclusion of a practical syllogism—or to have the necessity stated in such a conclusion. Even so, it seems to me, the statement quoted does not really represent von Wright's view, for there are duties, according to him, that are not (or at least may not be) practical necessities at all for the agent in question, viz. heteronomous ones. In the case of such duties all that is practically necessary is that the commander (and there must be one) *issue* the command with a view to the good of some being. Von Wright's statement is misleading, in that it suggests that if *A* is a duty for B to do, then *A* is a practical necessity for B to do, when all that is true is that *either* this is so *or* it is practically necessary that someone command B to do *A*. That *A* is B's duty, in his sense, means only that there is in the offing a practical necessity with a view to the good of some being. This, however, means only that someone, either B or some 'norm-authority', wants to promote the good of some being and finds that B's doing *A* is needed to promote it. Either B's having a duty has this disjunctive meaning or it has two meanings, one in the case of autonomous duties, which are hypothetical in Kant's sense, and another in the case of heteronomous ones, which are not. It seems to me that this view of the meaning of 'duty' is a far cry from what we usually mean by a moral duty, but let us see what von Wright goes on to say about this.

What he says is the following: there is a Principle of Justice (PJ), viz:

No man shall have his share in the greater good of a community of which he is a member, without paying his due [by giving up some good]. . . . This Principle of Justice I would regard as the cornerstone of the idea of morality.[34]

Here then we finally have von Wright's view of the nature of morality. Apparently to explicate it, he says that the PJ has as many applications as there are communities of men of the appropriate kind. This seems to mean that in application what the PJ requires is relative to the community. Then he adds, "I shall call any such community a *moral community* of men and a duty to act in accordance with the Principle of Justice a *moral* duty."[35] This restricts a moral duty to a moral community. It is, however, ambiguous. Von Wright may mean to say that action called for by the PJ is a moral duty as such—by definition. Then an action can be a moral duty without being a duty, and vice versa. It is a duty only if, besides being called for by the PJ and hence being a moral duty, it is an autonomous or a heteronomous duty in the above senses; and action in accordance with the PJ is not necessarily an autonomous or a heteronomous duty in these senses. Or von Wright may mean to say that, if and only if acting in accordance with the PJ is a duty, is it a moral duty. Then, to be a moral duty an action must both be in accordance with the PJ and be a duty in the sense explained earlier. Action conforming to the PJ is a *moral* duty, by definition, if it is a duty *simpliciter,* and only then. And a moral duty is necessarily a duty, though a duty is not necessarily moral.

If von Wright's meaning is the latter, then, to find out whether action called for by the PJ is a *moral* duty, he must ask whether it is necessarily or ever duty *simpliciter* in his sense. If his meaning is the former, he must ask whether a moral duty (= acting according to the PJ) is necessarily or ever a *duty simpliciter*. I shall assume von Wright's meaning to be the former. Then, on his view, to say that X has a moral duty to do *Y* is to say that his doing *Y* is in accordance with the PJ and his not doing *Y* is not. I am not very clear just what it is to say the latter, but will pass on. More generally, it seems to me, von Wright is conceiving of morality as something only a community of the relevant sort has, and suggesting that moral goodness, moral duty, and perhaps moral rightness, moral virtue, etc., be defined in some way by reference to the PJ as it applies in such a community, the application differing from one such community to another.

Still, is a moral duty in the sense just defined a duty in von Wright's technical sense, as defined earlier? If so, action in accordance with the PJ must be either an autonomous other-regarding duty or a heteronomous one. Von Wright points out that self-interest may suffice to move people to act in accordance with the PJ, respecting other people's good as well as one's own. I take this to mean that if one has one's own good as one's end, but perceives action in accordance with the PJ as necessary for one's own good, then one will judge that he should (as an autonomous self-regarding duty) so act. Again, though von Wright does not say this here, if one has the good of one's neighbors as an ultimate end, etc., then one has an autonomous other-regarding duty to act according to the PJ. Actually, von Wright stresses another interesting possibility.

I shall say that an agent acts from a *moral motive,* when he observes his moral duty, neither from a self-interested motive such as fear of revenge or punishment, nor from an altruistic motive such as love or respect for the neighbour, whose welfare might become affected through his action, but from a will to secure for all the greater good which similar action on the part of his neighbours would secure for him. Action prompted by a moral motive is thus beyond both egoism and altruism. The moral will is, in a characteristic sense, a *disinterested and impartial will to justice.* Its impartiality, however, consists in treating your neighbour as though his welfare were yours and your welfare his. Therefore the moral will is also a love of your neighbour *as yourself. . . .*

That which is here called action from a moral motive has a certain resemblance to that which Kant calls actions from a motive of duty (*Handeln aus Pflicht* as distinct from *pflichtmässiges Handeln*). The resembling features are those of disinterestedness and impartiality, and the detachment of the moral will *both* from self-interested concern *and* from altruistic sentiment.

The moral will is a will to do to others something which we want others to do to us. It is not, however, a will to do this, because we count upon or demand a return of service. It is a will to do this because we think it but fair that we too should contribute to the agreed good of all. One could say that the moral will is a will to observe the principle known as the Golden Rule from a motive, which comes at least very close to that which is a Christian love of our neighbour. But one could also call it a will to treat our fellow humans as ends in themselves. Here is another resembling feature with the ethics of Kant.[36]

One must remember here, however, that autonomous duties are hypothetical imperatives in Kant's sense, and that, if and insofar as moral duties are autonomous ones, they are still only hypothetical ones in this sense. They bind an agent if and only if he has certain ends and certain "anankastic understandings."

Are moral duties, in von Wright's sense, ever heteronomous (and non-hypothetical) duties? Only if some norm-authority other than the agent, having the good of some beings as an ultimate end in view, commands the agent to act according to the PJ. Von Wright suggests that the state may be thought of as commanding this through its laws; a divine commander such as William James postulated would be another possibility, though von Wright does not mention it here. But then, to say that acting justly or morally is a heteronomous duty is just to say that someone who has the good of some being (possibly his own) in mind commands one to do it; it is not yet to say that one *should* do it, morally or otherwise.

On von Wright's view there can be 'moral duties' that are *duties* only if the agent *or* someone who commands him wants to promote the good of some beings in the way required by the PJ. This aspect of his argument, he remarks, may seem unsatisfactory, since it makes the existence of moral duties that *are* duties dependent on the existence of such a want, which is a contingent matter. I do not find his discussion of this point very persuasive. Most of it deals with the somewhat different question whether the restriction of moral duties to the members of a moral community is objectionable (and whether the moral com-

munity necessarily includes everyone). In the course of it, however, he allows that there might be a 'superman' (or group of men) who does not belong to the moral community and says, as he must, that such a superman would have no duty ('moral' or otherwise) not to harm his neighbor. For respecting his neighbor is not (let us suppose) a means to his ends and he cannot be commanded to respect his neighbor, since fear of punishment is no motive for him.[37] This does seem to me a very unsatisfactory conclusion to have to come to.

Von Wright ends by asking whether justice and the observance of moral duty have any "utilitarian justification." He answers that they necessarily have public utility but are not necessarily of private utility. Action in accordance with the PJ is not necessarily an autonomous self-regarding duty, at least not from the standpoint of a secular morality. Such a morality must allow that it is "possible for a man to add to the profits of justice the profits of injustice," even though this is "an extremely difficult game" to play and "it is probably right to say that few are successful at playing it."[38] All this seems to me to be—unfortunately—true. Of course, being just or moral may still be an autonomous other-regarding duty, but only if one seeks the good of another; and it may still be a heteronomous duty, but only if someone else who intends the good of some being commands one to do it. Even then, however, it does not seem to follow that one should be just or moral. Can this be shown without showing that being just or moral is to one's interest, i.e., a self-regarding duty? I think so, but, in the end, I am not sure that von Wright does.

VIII

In conclusion, we may now summarize, gathering up loose ends, and trying to put together von Wright's view of the nature of morality. (1) It seems clear that von Wright subscribes to a 'material' definition of morality; as he conceives of it, it is an enterprise involving agents and commanders if, only if, and insofar as they have a concern about the good of some being or beings. By definition of morality, all moral judgments have in their background someone's being concerned about the good of some being. This aspect of von Wright's view I can only approve. My complaint about it, thus stated in general terms, is that he does not sufficiently insist that morality must involve a concern for the good of *others*. I must point out however that on his view, although moral concepts and norms are not conceptually autonomous, they do in a sense form a distinct group of norms, having a special background, and are not necessarily logically deducible from non-moral norms or value-judgments—a point von Wright does not sufficiently appreciate. Also, it does not follow that a teleological theory is correct. (2) More specifically, von Wright puts at the core of the idea of morality a certain principle of justice, thus tying the enterprise of morality logically to the notion of a certain kind of

community, viz. one in which all members "agree that each of them has to gain more from *never being harmed by anybody* else than from *sometimes harming somebody* else."[39] This strikes me as too narrow a definition of morality; it actually describes only one kind of thing covered by the wider definition suggested in (1). It also makes it hard to find a place in morality for ideals, supererogation, and the like.

(3) What kinds of norms does or may morality include? (a) It may include moral duties that are not duties, i.e., requirements of justice that are not really duties in von Wright's sense. At least this is true if there are any such moral duties, and he does not show there are not. (b) It may include moral duties that are autonomous duties, but only if and insofar as its agents want to promote the good of beings in a moral community; and it may include moral duties that are heteronomous (non-hypothetical), but only if and insofar as agents are *commanded* by someone who is concerned to promote the good of beings in such a community. (c) Perhaps it may include customs, rules, prescriptions, and directives that are not covered by (a) or (b). I still do not see, however, that it is logically necessary for morality to contain prescriptions in the sense of commands, as von Wright claims. (d) I suppose that he thinks morality may also include moral ideals (i.e. a certain kind of ideal rule)—he does mention the possibility "that moral goodness is 'over and above' obligation"[40]—but it is not easy to see how this can be, if "the cornerstone of the idea of morality" is the PJ. (4) It may also, I take it, include judgments of moral goodness centering on an agent's intentions, and judgments to the effect that certain character traits are (moral) virtues. It is not clear, however, whether these would all be related to ideal rules, or whether all ideal rules would be or yield judgments of moral goodness or of virtue.

(5) It is also not clear to me just what place deontic judgments—especially judgments about what we ought to do, what it is right to do, and what it is wrong to do—have in morality as von Wright conceives of it. Do they all come under one of the above headings? Are they all directives or technical norms or judgments?

(6) As we saw, von Wright does think there is such a thing as moral motives that are neither egoistic or altruistic. This seems to me to be correct. It seems to me, however, that he does not enough insist that agents can be moral (as opposed both to being non-moral and to being immoral) only if they have such moral motives. Perhaps he does not believe this, but I myself find it hard to believe that a society of people who observe their moral duties but not from moral motives is moral in either sense, especially if they act out of self-interest, fear, etc.

(7) It is also clear that von Wright holds that morality is not conceptually autonomous, i.e., that all of its concepts and judgments can be analyzed wholly in terms of non-moral ones, more specifically, in terms of the concepts of beneficiality, intention, being commanded, etc. This suggests that all moral

norms and judgments are statements made up of these concepts, but that can hardly be von Wright's view, since he believes that some of them may take the form of moral commands. He does mean to claim, however, that statements to the effect that something is morally good, a virtue, a duty, or a moral duty, etc., are all reducible to statements involving the concepts of the (non-moral) good of some being or beings, commanding or being commanded, intention, etc. This claim I do not find very plausible; the intuitionists, emotivists, and prescriptivists had more of a point, it seems to me, than von Wright recognizes. One can, of course, give terms like 'duty', 'morally good', etc., the technical meanings he does, but, as far as I can see, if one does one will come out with something rather different from morality as we have been practicing it and not obviously better. I do not object to the general kind of definition von Wright proposes if it is conceived of as a way of defining the words 'moral' and 'morally', but he seems to conceive of it as also a way of defining 'right', 'ought', 'virtuous', etc. These terms seem to me to be intrinsically normative in a way in which 'duty', etc., as von Wright defines them, are not, especially if he himself is correct in doubting "that value-concepts are intrinsically normative notions."[41] My point here is essentially the same as the one I tried to make in discussing G. E. Moore's line of thought in *Principia Ethica* years ago.[42] It is all the more cogent if, as I think, von Wright means to be a naturalist about 'good', which Moore held to be indefinable (i.e. conceptually autonomous) and non-natural.

(8) As we saw, von Wright thinks of his view of the nature of morality as teleological. And it is true that, like Moore, he regards moral concepts as definable in terms of that of the good, together with certain others like intention, being commanded, etc. This, however, is not enough to make him a teleologist in anything like the usual sense, i.e., in the sense in which ethical egoists and utilitarians are teleologists. They all say that the criterion of having P (being morally right, good, virtuous, duty, or whatever) is *conduciveness to the greatest balance of good over evil for some being or set of beings*. As far as I can see, however, von Wright's definitions of moral concepts entail nothing of this sort, nothing a deontologist must deny. It is true that he regards *intention to promote the good of somebody* as the criterion of moral goodness, but moral goodness is only one of the concepts he seeks to define, and, while his analyses of 'right', 'ought', etc., remain unclear, those of 'duty' and 'moral duty' go along somewhat different lines. Indeed, that of moral duty is defined by reference to his principle of justice and hence seems to be more a matter of fairness than of a maximization of good.

There are a few somewhat scattered remarks I am tempted to add. (9) One must approve of von Wright's attempt to find a place for heteronomous or non-hypothetical duties; it does seem to me that moral Oughts are and should be conceived as non-hypothetical (in Kant's sense). But it is not clear that von Wright thinks any moral duties or norms represent duties of this kind, and

neither is it clear that something being a duty of this kind means only that someone who wants to promote the good of some being (perhaps himself) commands an agent to do it. But the fact that someone who wants to promote the good of some being or set of beings commands me to do something hardly makes it my duty to do it, unless I already have a duty to obey him or to promote the good of the being in question. And von Wright insists one has no straight out duty to promote the good of any being, which I find hard to accept anyway, at least if he also means to deny that one *ought* to promote that good.

(10) If morality includes heteronomous norms, then, it seems to me, commands, prescriptions, and what I call institutional Oughts, must be more central in morality than some of von Wright's discussions, referred to early in this paper, suggest. Indeed, one senses that the drift of his thinking about morality is toward a two-part conception of it, viz one part consisting of commands, permissions, etc. by some beneficently-minded norm-authority, and a second part consisting of hypothetical imperatives based on its agents' own beneficent-mindedness, moral ideals, etc. Then von Wright's view is a certain kind of combination of the views earlier labelled (A) and (B), and one would like to hear more about it, e.g., does it find a place in morality for ordinary Oughts of all three kinds, as well as for institutional ones?

(11) Finally, we saw in dealing with his views about moral goodness, that von Wright says there that a complete elucidation of the concept of a (morally) good man must wait until virtue and justice have been discussed. His point seems to be that our picture of moral excellence includes virtue and justice, and cannot be elucidated wholly in terms of benevolence (or moral goodness) because "a benevolent man is not necessarily a virtuous man, and he may be lacking in a sense of justice."[43] He does not, however, explicitly take up the notion of a good man again, and it is not clear just what he has in mind. Is he thinking that a good man will have other virtues besides benevolence, that virtue includes a concern for rightness of judgment or a moral motive not necessarily present in benevolence, or that being a good man includes a respect for the PJ that a benevolent man may not have? Is benevolence essential to being a good man at all?

That a moral philosophy may be 'extracted' from von Wright's general theory of norms and value is clear, and, indeed, he has himself done some of the extracting in his many discussions of morality and its norms and concepts. It is also an interesting moral philosophy in the context of contemporary discussion and deserves further elaboration and study. In this paper I have sought mainly to be a midwife participating in bringing it into the world and trying tentatively to test its health and viability, hoping that von Wright will finish the labor he has begun.

THE UNIVERSITY OF MICHIGAN WILLIAM K. FRANKENA
AUGUST 1974

NOTES

1. *VG*, p. 178.
2. Ibid., p. vi; *NA*, p. 113.
3. *VG*, pp. 2–6, 171.
4. See my "On Saying the Ethical Thing," *Proceedings and Addresses of the American Philosophical Association*, XXXIX (1966), p. 23. I also think he conflates meaning and criteria too readily. See *VG*, pp. 4–5, 25n.
5. *VG*, pp. vi, 2, 8, 156–57. This approach is not so new as von Wright thinks. Cf. R. B. Perry, *General Theory of Value* (1926) and *Realms of Value* (1954); P. W. Taylor, *Normative Discourse* (1961); and J. N. Findlay, *Axiological Ethics* (1970).
6. *VG*, pp. vf, 1–8; *NA*, pp. 11ff.
7. *NA*, p. 11.
8. Ibid., p. 12.
9. Here see von Wright's own remarks, *NA*, p. 99.
10. *NA*, p. 13.
11. Ibid., pp. 13, 16.
12. *VG*, p. 157f.
13. Again, however, see *NA*, pp. 96–99.
14. *VG*, pp. 6–8; cf. p. 136f.
15. Von Wright tends to equate normative and deontic concepts, whereas I usually include both deontic and value concepts under normative ones.
16. He also says he is approaching "ethics from the side of value rather than from the side of norm". *VG*, p. 8.
17. On *VG*, p. 136, von Wright says 'right', 'wrong', and 'duty' are normative terms. Again, see also *NA*, p. 99.
18. E.g. by A. MacIntyre, *Against the Self-Images of the Age* (1971), p. 138.
19. Cf. esp. MacIntyre, op. cit., pp. 134ff, 142–172.
20. MacIntyre holds that the three views are true for different periods in history or for different cultures. See loc. cit.
21. The same is true of Scandinavian moral philosophers generally.
22. My own view is (a) that ordinary Oughts of all kinds are non-moral, (b) that basic moral Oughts are in *some* sense special, and (c) that some derivative moral Oughts are or should be institutional.
23. *VG*, p. 1.
24. Ibid., p. 18.
25. Ibid., p. 119.
26. Ibid., p. 128.
27. Cf. e.g., 6f, 136, 145f, 154.
28. *VG*, p. 140.
29. Ibid., p. 147. Is von Wright also thinking that a virtue is needed to ensure our acting in accordance with our judgment?
30. Ibid., p. 171.
31. Ibid., p. 178.
32. Ibid., p. 187.
33. Ibid., p. 207.
34. Ibid., p. 208.
35. Ibid.
36. Ibid., pp. 209–11.
37. Ibid., p. 214.
38, Ibid., p. 215f.

39. Ibid., pp. 202, 207.
40. Ibid., p. 155.
41. Ibid.
42. See 'Obligation and Value in the Ethics of G. E. Moore', in *The Philosophy of G. E. Moore* (1942), edited by P. A. Schilpp, pp. 93–110.
43. *VG*,. 135.

13

Frederick Stoutland

VON WRIGHT'S THEORY OF ACTION

Von Wright's interest in the philosophy of action arose as a result of his investigations into deontic logic. After publication of his classic 1951 paper,[1] he came to think that certain distinctions essential to the theory of norms were not expressible in the formalism of that paper. This led him into developing a 'logic of action', first in *Norm and Action*[2] and then in *An Essay in Deontic Logic and the General Theory of Action*.[3] It was out of this work that his interest in philosophy of action in a more general sense grew, leading to the publication of *Explanation and Understanding*[4] and then a number of other works.[5]

My concern in this paper will be with philosophy of action in this more general sense—often called 'theory of action'. I shall devote the first section to discussing distinctions von Wright develops as a kind of prolegomena to philosophy of action. I shall then use these distinctions to state three theories of action: the causal theory, the agency theory, and von Wright's. My intent is to state them in a common language and to consider their answers to some common questions, in order to gain an historical perspective on von Wright's approach. The causal theory is, I believe, in the Cartesian tradition, the agency theory is Aristotelean, and von Wright's is best seen as Kantian or Wittgensteinian. Next I shall turn to critical comments on von Wright's theory, focusing on its difficulty in relating intentional action to the agent's bodily move-

This paper is a brief version of one finished in 1973 and which benefitted from discussion at the Northfield Noumenal Society and from the comments of Tom Carson, Gary Iseminger, and Edward Langerak. At the request of the editor, I abridged it in 1983, but did not significantly alter its contents, either by taking account of developments in von Wright's thought since 1973 or of various ways in which I have changed my own mind. I would write a different paper today, though the *fundamental* ideas would be similar. Some of the changes in von Wright's thinking and in my own are discussed in my "The Causation of Behavior" in *Essays on Wittgenstein in Honor of G. H. von Wright* (*Acta Philosophica Fennica,* 1976) and "Davidson, von Wright, and the Debate Over Causation" in *Contemporary Philosophy: A New Survey,* Vol. 3 (The Hague, 1982).

ments. I shall conclude by considering a way out of this difficulty implicit in von Wright's work, arguing that the way out is not adequate.

I

1. To act, von Wright writes, "is intentionally ('at will') to *bring about* or to *prevent* a *change* in the world" (G.T., 38). This presumes that to draw a non-arbitrary line between doing and suffering requires the concept of intention—that action is marked by intentionality. There are, of course, non-intentional acts (done inadvertently, by mistake, etc.), but only where there is also intentional action. I may intend to turn on a light and succeed instead in turning on a fan. But if I acted at all, there was some act I performed intentionally, perhaps snapping a switch. Even that may have been a mistake, in which case my only intentional act was moving my hand.

Moving my hand is a *basic* act, an act I do not (normally) perform *by* doing anything else. Basic acts seem to be necessarily intentional. Whenever I act there must, on pain of infinite regress, be a basic act I perform. Von Wright is able, therefore, to characterize acting as intentionally bringing about or preventing a change and at the same time allow for non-intentional action.

2. Von Wright understands acts to include (logically) changes or events. It would not be correct, he writes, "to call acts a kind or species of events. An act *is* not a change in the world. But many acts may . . . be described as the bringing about or *effecting* ('at will') of a change" (N & A, 35f). An event is construed as a temporally ordered pair of states of affairs: an event takes place when the state of affairs *p* is replaced by the state of affairs *not-p* (or vice versa). Actions, then, can be described in terms of events provided we are given three items (G.T., 43):

(a) First, we must be told the state in which the world is at the moment when action is initiated. I shall call this the *initial* state.
(b) Secondly, we must be told the state in which the world is when action is completed. I shall call it the *end*-state.
(c) Thirdly, we must be told the state in which the world would be had the agent not interfered with it but remained passive or, as I shall also say, independently of the agent.

States (a), (b), and (c) together are said to determine the 'nature of the action'.

Thus to describe an act, say of a person's opening a door, we must specify (a) the initial state: that the door is not open, (b) the end state: that the door is open, and (c) the state of the world had the agent not interfered—in this case that the door is not open. For if the door would have opened by itself, then the agent could not (logically) have opened it on that occasion. A description of

an act must give not only the event which did occur (a & b) but also what would have occurred had there been no act (c). The latter von Wright refers to as "the counterfactual element in action". "Every description of an action contains, in a concealed form, a counterfactual conditional statement."

One of the advantages of this way of relating events and acts is an elegant typology, which admits acts which bring about changes as well as those which prevent changes, and which also allows for two corresponding forms of omissions to act. On this scheme there are four elementary act types: (1) producing a change, (2) preventing a change, (3) forbearing to produce a change, (4) forbearing to prevent a change. Complex acts may involve mixtures of different types. I may keep my friend from leaving (preventive act) by closing the door (productive act). Or I may forbear to prevent an accident by forbearing to give a warning.

3. What is referred to above as the 'end-state' von Wright also calls the *result* of an act, a term he introduces in contrast to the *consequences* of an act. The result of an act is logically intrinsic to it: it is logically impossible for an act to have been done unless its result occurred. That I opened a door *entails* that the door opened. Consequences, on the other hand, are logically extrinsic. A consequence of my opening a door is that a fly comes in, or that molecules of air are disturbed; as consequences, these are not logically necessary to the performance of the act.

The crucial point about this distinction for von Wright is that since a result is logically intrinsic to an act, it cannot be *caused* by that act: "The result is an essential 'part' of the action. It is a *bad* mistake to think of the act(ion) itself as a cause of its result" (E & U, 68). An act, however, can cause its consequences: its consequences will be (among) the effects caused by the occurrence of the act's result.

It is clear that this distinction is relative: the same state of affairs which is the consequence of one act may be the result of another. A fly coming in is a consequence of my opening the door; it is the result of my letting in a fly. Here I can say that I let in a fly by opening the door. In general if the result of *B* is a consequence of *A,* then I have done *B* by doing *A.* A basic act, being an act I do not do by doing anything else, will be one whose result is not a consequence of any act of mine. If I simply raise my arm, my arm's rising is a result of that act but not the consequence of any act.[6]

This raises the question of what determines whether a state of affairs is result or consequence of an act, and hence what determines whether a state of affairs is something done or something which happens because of something done. In N & A (p. 41) von Wright writes that "what makes it the one or the other depends upon the agent's *intention* in acting. . . ." It is natural to interpret this to mean that results are what are intended in an act, while consequences are what occur because of the act but are not intended in it. An equiv-

alent way of making this point is to say that results constitute the teleological component in an act and consequences the non-teleological component. To say, then, that every act has a result is to say that every act has a teleological component, that is to say, something intended (or aimed at) in it. If I intentionally opened the door, then the intention in the act was that the door be open. If I did not intentionally cool the room, the room's getting cooler was a consequence of but not the intention in my act.

To follow this line of thought is to lay down not one but two necessary conditions for a state of affairs being a result; *a* will be a *result* of an act: 1) only if doing the act requires logically that *a* occur, and 2) only if the agent intended that *a* occur.[7] The problem here is that only an intentional act will have a result which meets both conditions; no non-intentional act will have a result in this sense. This seems to me a serious difficulty in von Wright's notion of result (and consequence): while illuminating in many ways, the notion obscures rather than clarifies the relation between intentional and non-intentional acting. I shall, nevertheless, use this notion of result, for the basic point von Wright makes in terms of it seems correct: doing A intentionally entails that *a* occur and that the agent have intended that *a* occur. There will, therefore, be an intention—a teleological component—in every intentional act.

This does not imply that every act has a teleological *explanation*. There are acts performed intentionally but with no intention, and these have no teleological explanation. Consider a case Melden discusses: "I pass the salt to my dinner companion not in order to please him or with any other motive or purpose in mind, but because I am polite. I act out of politeness rather than for the sake of politeness."[8] This is a correct observation, but we must not conclude that because an act has no teleological explanation that it has no teleological *component*. I may pass the salt out of politeness, there being no intention *of* the act, but there is an intention *in* the act, namely that the salt reach my dinner companion (the act's result).

I propose to mark this distinction by the terms 'intention in' and 'intention of', the former denoting the telos internal to acts, the latter denoting the (external) telos in terms of which acts can be explained. There is an intention *in* every intentional act; its object is the state of affairs whose occurrence is logically necessary for the performance of that act. There is not an intention *of* every act (only of acts whose explanation requires a reference to what the agent was intending to do); its object is not a state of affairs but an act.

4. A term von Wright uses a great deal in *Explanation and Understanding,* though only seldom in works prior to that, is 'behavior'. This term is extraordinarily difficult to handle, partly because it has been used loosely historically, partly because, though indispensable for stating the issues, its very use raises some difficult problems. One is whether it is also used to refer only to the

bodily behavior of an agent or whether it is also used to refer to events outside
the agent (e.g., a door's opening). Von Wright mainly uses the term to range
in a non-committal way over both actions and non-actions, the use of the term
leaving it open whether or not the behavior is in fact intentional in any sense.
If the term ranges over intentional action, then it will also range over events
outside the agent, since it is a cardinal point of von Wright's theory that acts
have results (and not merely consequences) which extend out beyond changes
in the agent. His claim is that when we describe an agent as intentionally
opening a door, we are not simply describing bodily events in the agent in
terms of what they caused; we are describing something which has as a *logical*
constituent the opening of a door.[9]

I shall, however, normally use 'behavior' to apply only to changes in an
agent, in particular to peripheral bodily movements, the use being non-
committal as to whether or not these movements are intentional. (If they are
intentional, we would not normally refer to them as 'bodily movements'.) The
performance of an act (other than a purely mental act) by an agent requires
behavior by the agent which brings about the *result* of the act, though a de-
scription of the act may make no reference to that behavior. (Describing me as
having opened a door says nothing about my behavior in this sense except that
it had a certain result—namely, a door's opening. Saying that performance of
that act required behavior rules out telekinesis: the result came about because
of behavior on my part, not as a result of mere thought.) I shall, therefore,
speak of the 'behavior in the act', meaning those peripheral bodily movements
(known or unknown) which brought about the result, and which may or may
not be intentional; to speak of them as 'behavior in the act' leaves it open
whether or not they are intentional. When it is necessary to refer to behavior
simply *as* peripheral bodily movements—as behavior apart from intentional-
ity—I shall use either 'mere behavior' or 'bodily movements'.[10]

II

Given these distinctions, it should be possible to pose the issues on which
classical theories of action divide. Before discussing von Wright's theory I
shall sketch out two alternatives—the causal theory and the agency theory—
developing their answers to three questions: (a) What account should be given
of the intention in the act, that is, of an agent's intending (aiming at) a result?
(b) Does the intention in the act *explain* the occurrence of the behavior in the
act? In other words, does attributing an intentional act to an agent entail an
explanation of why his behavior occurred on that occasion? (c) Are explana-
tions of (intentional) *acts* different in kind from explanations of *mere behavior*?

1. After a period of retreat the causal theory is experiencing a renaissance.[11] All versions of it share a central thesis, namely, that an agent performs intentional act A if and only if: (1) a (the result) occurs because of the agent's mere behavior, (2) the agent desires something which he believes his behavior will bring about, and (3) this desire and belief cause his behavior.[12] Thus an agent will have intentionally opened a door (1) if the door opens because of his behavior, (2) if he desires to let in some fresh air and believes his behavior (which caused the door to open) will bring that about, (3) if this desire and belief cause that behavior.

Results are distinguished from consequences in that a result is the object of a desire, which (with belief) causes the behavior in the act. In this way the causal theory construes the teleological component in action as causal. A (mere) consequence of an act, on the other hand, is not an object of my desire which caused the behavior (though it may in fact be desired). In opening the door I may let out a fly, but that will be a mere consequence of my act, even if I wanted the fly out, if the desire did not cause my behavior.[13]

Let us now consider the three questions raised above. (a) The causal theory construes the intention *in* the act as certain desires (and beliefs), considered as mental events. (This sense of 'mental' is, many would argue, not incompatible with materialism; materialists will regard these mental events as neural.) (b) It regards the intention in the act as explaining the occurrence of the behavior in the act, for those desires (and beliefs) necessary for intentional action *cause* the (mere) behavior which eventuates in the result. Hence to attribute an act to an agent entails an explanation of why his behavior occurred on that occasion. (c) Explanations of action are not different in kind from explanations of mere behavior: both involve event causation. To say an agent is intentionally opening a door is to say his *mere behavior* is caused by his desire for *some* end for which he believes this behavior is a means. This attribution of action is an *explanation* of mere behavior not action. But we can make it an explanation of *action* by specifying what the agent's desire was. If we don't know *why* he opened the door, then we have no explanation of his action, though in knowing he opened the door intentionally we have an explanation of his (mere) behavior, namely that it was caused by some desire (and belief). But if we are told that what he wanted was fresh air, then we have an explanation of his *action*. Explanations of actions are, in general, only more detailed explanations of behavior, and since explanations of behavior are causal so are explanations of action. Just as the causal theory construes the internal teleology of actions as causal, so it construes the external teleology of actions—that is, teleological *explanations* of action—as causal.

2. Something like the theory of agency can be found in Aristotle and Thomas Reid, and it has been developed with care and ingenuity by Chisholm, whose writings will guide my formulation.[14] Its central thesis is that an agent

intentionally does A if and only if: (1) a (the result) occurs because of his (mere) behavior, (2) the agent intends (or aims at) a, and (3) his behavior is caused *by the agent* himself in intending (or aiming at) a.[15] Thus to say an agent intentionally opened a door is to say that the door opened because of his behavior, that he intended (or aimed at) that result, and that his behavior was caused by something the agent himself caused in intending that the door open (though *this* causing is not intentional).

What is distinctive about this thesis is the introduction of agent causality in addition to event causality. The proximate cause of the behavior in the act is neural events but these are caused ultimately, not by any events at all (even desires or beliefs) but by the agent himself, who causes them in aiming at the result of the act. Agent causality is, therefore, essentially *teleological;* it operates only when an agent intends an end. Since the behavior in intentional action is ultimately caused by an agent, it has, in the last analysis, a teleological explanation.

The difference between a result and a consequence is that a result is what the agent intends in his agent causality. The theory sees the result of an act as the 'direction' in which agent causality is 'pointed' in causing the behavior. Mere consequences of an act, on the other hand, are not aimed at by the agent, even if his aiming causes them to occur (as a 'by-product').

Let us now consider our three questions. (a) The agency theory construes the intention *in* the act not as a mental event but as the direction toward which agent causality is directed. Consider my giving an object a push across a smooth surface: I push it in one direction (though it may go in another); the direction in which I push it is like the intention in the act. The intention in the act *is* the agent exercising agent causality. (b) It regards the intention in the act as *explaining* the occurrence of the behavior in the act. That behavior is aimed at a result entails that the behavior was caused by the agent in intending that result. While the behavior in the act is proximately caused by prior events, those events are caused by the agent himself. (c) Explanations of action are different in kind from explanations of mere behavior. To attribute an act to an agent is to explain his behavior but not (necessarily) to explain his action. In acting he is aiming at a result; *why* he is aiming at that result is another question, whose answer will give the explanation of his action. A causal explanation *might* be given—that the agent was in some way caused to aim at an end—but we might also say that the agent was not caused to aim at an end but did so in order that he might achieve something. This is a teleological explanation of his *action,* and agency theorists generally argue that it is not reducible to a causal explanation. The agency theory does not, therefore, regard either the intention *in* the act or the intention *of* the act as involving event causality; both involve the teleology of agent causality.

III

Von Wright states his account of intentional action succinctly in "On So-Called Practical Inference" (p. 49):[16]

> To establish that the agent's causing A to come about is a case of his doing A is not to establish, in addition to the happening of A, a different event which so to speak occurs "inside the agent." It is to *understand* (the meaning of) the agent's conduct, i.e., to see that by certain changes in his body or changes causally connected with changes in his body the agent is *aiming* at this result. If he aims at it without achieving it, we shall have to say that the agent tried but failed.

The central thesis is that an agent intentionally does A if and only if: (1) a (the result) occurs because of the agent's behavior and (2) *by this behavior* the agent intends or aims at a. Thus an agent will have intentionally opened a door if by the various movements of his body which caused the door to open, he was aiming at that result—if that was what he intended (aimed at, meant) by his behavior. On the other hand, if the agent's behavior did not result in a, but if, nevertheless, by his behavior he intended a, then, though he did not do A, he was trying to do A.

The *result* of an act will be that state of affairs which the agent intended by his behavior. *Consequences* will be states of affairs which occurred because of the agent's behavior but which he did not intend *by* his behavior. If a occurred because of what the agent did, but was not intended, then a is a mere consequence. When an agent, in opening a door, accidentally lets in some flies, flies coming in is a consequence of his intentional act, because he was not aiming at that by his behavior (even if he could foresee it would happen).

1. One way of illuminating von Wright's thesis is to note that whereas the causal and agency theories lay down three conditions for intentional action, he lays down only two. That the result of an act occurs because of the agent's behavior continues as a necessary condition. But instead of the two requirements that the agent intend (desire) the result and that this intending (desiring) bring about his behavior (either through event or agent causation), there is substituted the single requirement that *by his behavior* the agent intend (or aim at) the result. The intention *in* the act is here seen as not only having an object but as also having a "vehicle," namely the agent's behavior. The object of the intention is the result; but for there to be that intention, there must be something intended to become the result, namely, the agent's behavior: it is *by his behavior* that he intends a result.

There is a negative and a positive aspect to this thesis. The negative is that an agent's intending a result by his behavior is not a matter of the behavior's being caused, either by agents or by mental events. Agent causality, von Wright writes, "is connected with insurmountable difficulties" and should be ruled out (E & U, 191). If the intention in the act (e.g., the agent's desire) is

itself the cause, it must be a mental event. But "intentionality is not anything 'behind' or 'outside' the behavior. It is not a mental act or characteristic experience accompanying it" (E & U, 115). Intentionality rather should be said to be *in* the behavior, for normally we just see behavior as action.

> In the normal cases we say off-hand of the way we see people behave that they perform such and such actions. . . . Many of these actions we ourselves know how to perform; those, and others which *we* cannot do, have a familiar 'look' or 'physiognomy' which we recognize (PI, 51).

And that means that in the normal cases what we see (directly) is not mere behavior but intentional action: we see behavior as aimed at an end. We see people unlocking doors or opening windows, and such seeing is not inferring the mental causes of their behavior.

We may be in doubt that what we see is intentional action or what the intention in an act is. Then we must inquire whether we *do* see an intentional act, whether the agent *is* aiming at anything by his behavior, and if so what. But, argues von Wright, our inquiry here is not for the causes of the behavior, for the logic of this inquiry is represented by a 'practical inference', and a practical inference is not causal.

We see an agent making some movements at a window. Is he doing anything intentionally? If so, what? At this point we cannot tell by seeing; we do not see his action, that is, what he is aiming at by this behavior (or whether he is aiming at anything). Then we notice he has a glass cutter. A practical inference emerges:

> He intends to get into the house.
> He believes that he cannot get into the house unless he cuts a hole in the window.
> Therefore, he cuts a hole in the window.

What he is doing (or trying to do) is cutting a hole in the window. We have determined that he is doing something intentionally, and now we can *see* what it is.

This is not a causal inquiry, von Wright argues, for these premisses (with suitable qualifications) all by themselves *entail* the conclusion; this is a valid inference, mediated by a logically necessary principle. If what is stated in the premisses caused what is stated in the conclusion, however, the inference would not be mediated by a logically necessary principle but would be valid only with the addition of a causal law, and such a law cannot be logically necessary. The intention and belief in this inference cannot be, as the causal theory requires, Humean causes of the conclusion.[17]

It is crucial to notice that the conclusion of this practical inference refers to an intentional act, not to *mere* behavior, and that its premisses refer to intentions and beliefs which have as objects not mere behavior, but intentional acts. The second premiss, for example, involves a belief with regard to one *act* being

necessary for another, for if I do something because I believe it necessary, then what I do must be intentional. This means that if our inquiry into the intentionality of the agent is accurately represented by this inference, it is not an inquiry about the causes of (mere) behavior because it is not an inquiry about mere behavior at all, but about action. In asking whether the agent intended anything by his behavior, we consider possible *acts* and the agent's possible intentions and beliefs with regard to *acts*. We consider what sort of act the agent might be performing by his behavior, given that he had this tool, was (possibly) looking in a certain direction, etc. This is the act he might be performing; let us consider his behavior in that light and see if what results constitutes further acts done *by* doing the first act. Our inquiry concerns, that is to say, the wider context of action, not the causes of behavior.

This is the clue to the positive aspect of von Wright's notion of an agent intending a result by his behavior. "Intentional behavior," he writes, "resembles the use of language. It is a gesture whereby I mean something" (E & U, 114). An agent's intending something by his behavior is similar to a speaker's meaning something by an utterance. Sounds are not words because of their causes but because of their place in a language, their role in a language community, and the specific context in which they are uttered. The utterance of the sounds 'pass the salt' is a request for salt because of the grammar of English, the presence of a community in which English is spoken, and the context of a dinner, not because of its causal origin.

Just as persons speak when the sounds they utter are understood as having a certain meaning, so agents act when their behavior is understood as intending a certain result. An utterance has its meaning from its place in a linguistic context; behavior has its intentionality from its place in an action context.

> Just as the use and understanding of language presuppose a language community, the understanding of action presupposes a community of institutions and practices and technological equipment into which one has been introduced by learning and training. One could perhaps call it a life community.
>
> Behavior gets its intentional character from being *seen* by the agent himself or by an outside observer in a wider perspective, from being *set* in a context of aims and cognition (E & U, 114, 115).

2. Let us now consider von Wrights's theory in the light of the three questions posed earlier. The answer to the first question—what account should be given of the intention in the act?—is implicit in what has already been said, though it is a difficult matter, whose complexity I will not pursue. For von Wright the intention in the act is the intentionality of the agent's behavior, that is, its *meaning*—what it is meant to be, what result it is aimed at. What behavior is meant to be is not to be identified with any mental events in the agent nor with any facts—categorical or dispositional—in behavioristic terms. Indeed, it is misleading to say it is to be identified with anything at all, for it is

not an isolable event or state. We determine the meaning of an agent's behavior by appeal to a wide diversity of factors—his previous activity, his roles, what else he is doing, what he did later, and so on. These do not *point to* an isolable state called 'the agent's intention' or 'the meaning of his behavior'; given their pattern, they *are* the intentionality of his behavior, what he means or intends by it. The intention in the act is what the agent means by his behavior, and what he means by his behavior is the place it has in the context of human life.[18]

The second question is whether the intention in the act explains the behavior in the act. This is the most subtle feature of von Wright's theory, as well as the most problematic; it is better discussed after considering his answer to the third question: Are explanations of action different in kind from explanations of (mere) behavior? Von Wright sees two fundamental differences between explanations of action and explanations of (mere) behavior. (a) Explanations of action are teleological and explanations of behavior are causal. (b) "The *explanandum* of a teleological explanation is an action, that of a causal explanation an intentionalistically noninterpreted item of behavior" (E & U, 124). These two differences are necessarily and intricately connected.

What characterizes a genuine teleological explanation, von Wright argues, is that it "does *not* depend on the validity of the assumed nomic relation involved in it" (E & U, 84). The explanation that an agent opened a window in order to cool a room, for example, depends only on the agent believing the room can be cooled in that way, not on whether it actually can. On the other hand, the (causal) explanation that the room got cooler because a window was opened depends on a nomic connection between opening the window, and the room getting cooler. A causal explanation depends on a nomic connection between *explanans* and *explanandum,* whether or not the agent (or anyone) knows this. A teleological explanation depends on what the agent believes of his behavior—on what he thinks of himself as doing, on what he means to be doing. My opening the window is explained, not by a nomic connection, but by the fact that in so doing I think of myself as cooling—I intend to cool—the room.

It is for this reason that von Wright connects the distinction between teleological and causal explanation with the distinction between action and mere ("intentionalistically non-interpreted") behavior. A teleological explanation of *A* in terms of *B* depends simply on an agent's believing that *A* is necessary (or perhaps sufficient) for *B,* whether or not it is. Only intentional acts can be explained in such a way, not mere behavior. My belief that I am on a precipice, for example, causes me to perspire. This explanation does not depend on my actually being on a precipice, but that is not the point; it does depend on a nomic connection between the belief and the perspiration, and so it involves a causal explanation, not of an action, however, since there is none, but of mere behavior. On the other hand, believing I am on a precipice may be my reason

for warning my children. This explanation is like the previous one in not depending on the belief's being true, but again, that is not the point. The point is that the explanation does not depend on whether I actually warned my children but only on my believing that my behavior was warning them, whether or not it was. But here there is necessarily intentional action, for what is being explained is what I intended (meant) by my behavior, and to intend something by one's behavior is to act intentionally. A belief can enter into an explanation "that does not depend on the validity of the assumed nomic relation involved in it" only if what is being explained is intentional action.

It would seem then that the concept of teleological explanation *presupposes* the concept of intentional action, for apart from intentional action there is no *explanandum* for a teleological explanation. Yet earlier, when we were discussing how to determine whether an agent intended anything by his behavior (and hence was acting), we saw the crucial role practical inference plays in this. We look for premisses about an agent's intentions and beliefs which might help us understand his behavior; these premisses are satisfactory provided they constitute a teleological explanation of the behavior. So in this case it looks as though the concept of intentional action presupposes the concept of teleological explanation (rather than the other way around).

But it is just this reciprocal relationship which is the key to von Wrights' understanding of practical inference.[19] For the premisses of a practical inference constitute both a teleological explanation of the act referred to in the conclusion *and* a set of conditions in terms of which to understand what the agent intends by his behavior and hence to understand that *what* he is doing is the act referred to in the conclusion. It is the latter—the practical inference as giving a set of conditions for understanding—which renders it logically valid, and the latter is, therefore, primary, because unless the inference is logically valid we have a causal rather than a teleological explanation.[20]

I shall not discuss the various modifications von Wright believes are required in order to make the inference logically valid.[21] What is decisive is that in order to be logically valid its premisses must be considered as "a set of conditions under which the conduct of an agent has to be interpreted or understood in a certain way, viz., as the doing of A or as aiming at the result" (P.I., 50). "The formal validity of the practical inference requires that the item of behavior mentioned in its conclusion is described (understood, interpreted) as action In order to become *teleologically explicable* . . . behavior must first be intentionalistically understood" (E & U, 121).

This means that von Wright does not believe (though sometimes he says things that suggest the contrary) that the premisses of a practical inference entail any mere behavior statements: no statements about a person's intentions or beliefs entail that any specific behavior did or will occur. "The premisses of a practical inference do *not* with logical necessity entail behavior. They do not entail the 'existence' of a conclusion to match them. . . . It is only

when action is already there and a practical argument is constructed to explain or justify it that we have a logically conclusive argument'' (E & U, 116).

It is difficult to see how it could be otherwise, if a teleological explanation does not depend on the validity of any nomic connections involved in it. Mere behavior *cannot* be the *explanandum* in that kind of explanation. That an item of behavior occurs on a given occasion cannot be explained in terms of its nomic connection with some E if it would have occurred *whether or not* it had a nomic connection with E. Believing there is nomic connection between E and the behavior is not sufficient. Nor can one construe the belief itself as a cause, because then a nomic connection between beliefs and certain events becomes necessary for the validity of the explanation, and it ceases to meet the criterion for being teleological.

A teleological explanation, therefore, requires that the *explanandum* be behavior *understood intentionalistically*. What the premises of a P.I. entail is (a statement about) the act the behavior is understood to be, regardless of what the mere behavior is. If it is true that an agent intends to cool the room, and believes that opening the door now is necessary for that, then it follows *logically* that whatever his mere behavior may be, his intentional act is opening a door (or trying to). That is what he is doing, what he intends (means) by his behavior, whatever it is, and that is how we must—logically must, given the truth of the premisses—understand his behavior. Whatever behavior is occurring, he is doing something intentionally. It may not even be opening a door, for he may be failing at that, hence only trying. But to try to open a door is itself to act, to do something with the intention that it result in the door's opening.[22]

Let us now return to our second question: Does the intention in the act *explain* the behavior in the act? As we have seen, both the causal and the agency theories think that to attribute an intentional act to an agent is necessarily to explain the occurrence of the mere behavior in the act: for the causal theory, action attributions entail that the behavior in the act was caused by desires (and often beliefs), for the agency theory, that it was caused by the agent himself.

This question takes on a different character in von Wright's theory, for he sees the intention in the act as not separable from the behavior in the act, since the intention just is the agent intending (aiming at, meaning) something by his behavior. We have to ask whether intending a result by one's behavior can be an explanation of that behavior.

Von Wright discusses this issue most directly in connection with what he calls a 'mutilated practical inference', mutilated because the belief premiss is missing. Here is a mutilated practical inference:

A intended to press the button.
Therefore A pressed the button.

The significance of the omission of the belief premiss is that a teleological explanation depends not on a nomic connection but only on the agent's belief about his behavior; this inference, lacking any reference to belief, might be taken both to set conditions for the intentionality of an act and to express a non-teleological explanation, an explanation therefore of the mere behavior involved in pressing a button. This could play a crucial role in the scheme, given that acting on a belief *presupposes* an intentional act, for here we have an intentional act in which the agent's beliefs play no role. This kind of act could be the kind presupposed by intentional action generally.

Von Wright, however, regards this inference too as expressing, insofar as it is explanatory at all, a teleological explanation.

> The action of pressing the button is not explained by saying that it was intentional, willed. For that it was this is already contained in calling it an action. . . . But if we want to explain or, which would be a better form of expression here, to *understand the behavior* which has taken place in the situation under consideration, then it would *not* be trivial to say that A intended to press the button. That is, it would not be trivial to interpret that which happened as an act of pressing the button. . . .
>
> The mere understanding of behavior as action . . . is itself a way of explaining behavior. Perhaps it could be called a rudimentary form of a teleological explanation. It is the step whereby we move the description of behavior on to the teleological level, one could say. But it seems to me clearer to separate this step from explanation proper, and thus to distinguish between the *understanding of behavior* (as action) and the *teleological explanation of action* (i.e., of intentionalistically understood behavior) (E & U, 123f).

The argument here is that if we attribute to someone the simple act of pressing a button, then, while there is a sense in which we have explained his behavior in terms of the intention in the act, that explanation is teleological. And that entails that the *explanandum* is behavior understood intentionalistically. Insofar as that is the *explanandum,* however, we have an (intentional) act, and this inference hardly *explains action.* Hence von Wright's suggestion that it is better to speak of the mutilated inference as yielding not an explanation at all but an *understanding of behavior* as action.

But isn't the understanding here purely trivial? For in the case under discussion the behavior is a button-pressing, the act is an agent's pressing a button. To say this is purely trivial, however, overlooks that 'the behavior of button pressing' does not refer to a single case. There are many ways buttons can be pressed; there is diversity of behavior here. Hence the mutilated inference is not *in principle* different from the complete inference. It also sets the conditions in terms of which we must (logically) understand diverse behavior. If the agent intends to press a button now, then regardless of the movements he is making, we must understand him as intentionally pressing a button. By his behavior, whatever it may be, he is aiming at pressing a button, and since this result is occurring, he is intentionally pressing a button.[23]

Von Wright's answer to the second question, therefore, differs significantly from that of the causal or agency theory. The only sense in which the intention in the act *explains* the behavior in the act is in that sense of teleological explanation better thought of as intentionalistic *understanding*. If this is construed as explanation, the *explanandum* is not mere behavior, for mere behavior *cannot* be the *explanandum* of a teleological explanation. Von Wright's view is that attributions of (intentional) action do not entail an explanation of the occurrence of mere behavior.

IV

I turn now to critical evaluation of the answers von Wright gives to the three questions I have posed, saying something about the comparative adequacy of the other theories.

1. I shall not comment on the agency theory's account of the intention in the act, as it seems to me it *could* accept much of von Wright's account. The causal theory seems to me weak at this point, the account being flawed by its almost invariably speaking of desires rather than intentions. This reduces the concept of an intentional act to a voluntary act. But not all intentional acts are voluntary; I may do *A* as a means to doing *B*, even though I do not want to do either *A* or *B*, but do so because I feel obliged or am compelled to do them. Moreover, I can want but not intend ends I think incompatible or impossible. I can want but not intend to do at a certain time what I do not believe I know how to do at that time. If I intend an end, then I also intend the means (I believe to be) required for it; but if I want an end I do not necessarily also want the means to that end.

The reason for the persistent appeal to desires rather than intentions must be that the former fit better the causal theorist's model of mental events that cause behavior. I may want a steak, and that will cause my mouth to water; intending to get a steak will have no such behavioral consequences. If we approach intentional action apart from this model, the notion that an intention is a mental event is not plausible. For inquiry into an agent's intentions is primarily a process of interpretation, whose model is explication of a text rather than hypothesizing about causes. In approaching a text one may ask for the causes of the words, but that is quite different from either reading or interpreting it.

There are two salient characteristics of interpreting a text. One is that what the author says he meant by it is significant but not definitive. Our understanding of a text may override what the author says he meant. The other is that there is no finally definitive understanding of a text, no definite set of facts which determine that the text says this and no more or no other.

These are also characteristics of intention. What the agent says he did intentionally is significant but not decisive; he may not know what he is doing, even intentionally. And there is no finally definitive understanding of what an agent has done, even intentionally. The line between what an agent has done intentionally and what not is not sharp, and it may shift as he comes to understand himself better or as others come to understand him. Conceiving intentions as mental events makes it very difficult to accommodate these characteristics, and that is good reason for rejecting the causal theory's account of the intention in the act.

2. The second question seems to me to raise the most intractable issues. Does attributing an action to an agent entail an explanation of why his behavior occurred? Von Wright thinks not, but I have difficulties with this response.

The causal and agency theories require of an intentional act that the agent intend (want) the result and that this intention cause (either through event or agent causality) the mere behavior which eventuates in the result. Von Wright substitutes for this double requirement the single requirement that the agent *by* his behavior intend the result. The immediate question is what the requirement presupposes: are there conditions behavior must meet if an agent *can* intend (or aim at) a result *by* it?

Can I by *any* behavior intend a result in the sense required for intentional action? Clearly not. My behavior causes a door to open, but I may not be doing anything intentional, for I may be sleepwalking. When my head shakes on a certain occasion, it may appear that I am gesturing, but I may in fact have a kind of tic which overcomes me in situations like this one. I cannot by such behavior intend (aim at, mean) any result.

The simplest kind of condition behavior must meet for me to intend something by it is that it be *mine*. I cannot by *your* behavior aim at a result. But this does not say what makes behavior *my* behavior. Not every movement of my body is behavior of mine; for example, my hair moving in the wind or the movements of a useless arm that, as we say, hangs limp. Behavior of mine is behavior that is under my control; and that means behavior that normally occurs when I act and only when I act. The latter—only when I act—is the crucial point here: in order for me to intend a result by my behavior, the behavior must not have occurred on that occasion had I not acted. Some constituent of my act must be a necessary condition of my behavior on that occasion.

Consider the case where my head shakes in certain situations. The behavior here is just what occurs when I intentionally shake my head, but it is in fact a nervous tic. Can I by this behavior intentionally reply, 'no'? Assume someone has asked me a question to which I intend to reply, 'no'. Just at that moment the tic occurs and my questioner understands me to have replied, 'no'. I do not correct him because that is what I intended to reply, and hence I *consent* to this understanding of my behavior. But it is an incorrect understanding in this

sense: I did not reply, 'no', because by this behavior I not only did not but *could* not mean, 'no'. To avoid embarrassment, I may even say, 'Yes, I did reply in the negative—I did mean to say no.' But that would not be true. The limits to the behavior by which I can intend or mean anything are set by the requirement that that behavior not have occurred unless I had acted.

This case may not by itself establish the necessity of this condition. The best argument for it is in von Wright's own work, in his discussion of 'the counter-factual element in action'. In his earlier work he argued, as we have seen, that in order for an agent to act, it must not only be the case (a) that the result has not occurred when the agent begins to act but (b) that the result does not occur 'of itself.' (A) expresses that I cannot close a window which is already closed, or raise my arm if it has already risen; (b) expresses that I cannot have closed a window on a certain occasion, even if the window closed, if it would have closed whether or not I had acted (ruling out the possibility that if I had not acted at *t* another agent would have).

(a) is unproblematic. (b) is complex and von Wright wavers on it. In *Norm and Action* he speaks of an occasion for an action as constituted by two successive occasions on the first of which the result has not occurred and on the second of which it has. But in addition, for an action to have been done on this occasion, it is necessary that the change "does not happen . . . 'of itself,' i.e., *independently of the action of an agent,* from the first to the second of the two occasions" (p. 43). In *General Theory* he writes: "Every description of an action contains, in a concealed form, a counterfactual conditional statement. When we say, e.g., that an agent opened a window, we imply that, had it not been for the agent's interference, the window would, on that occasion have remained closed" (p. 43).

In *Explanation and Understanding* von Wright changes his mind about the counterfactual element in action. He continues to maintain the thesis for non-basic action, but drops it for basic acts. About non-basic acts he writes:

> If the result of an action which an agent intends to accomplish by doing certain other things materializes 'of itself' . . ., then what the agent *undoubtedly does* on the occasion in question 'shrinks' or is 'confined' to those things by the doing of which he meant to perform his action. Thus the (subsequent) discovery of a cause operating independently of the agent may lead to a *redescribing* of his action under, so to say, a 'mutilated' aspect (E & U, 127).

Thus if we discover of a situation where an agent appeared to push open a door, that the door would have opened 'by itself' on that occasion (perhaps because of some timed mechanism), then we could not say that the agent pushed open a door, but only that he tried, and that all he *did* was push. We have to say this because the result would have occurred even if there had been no action.

But this account will not do for basic acts, for here no 'shrinking' or 'confinement' of action is possible. If the result of my (basic) act would have occurred whether or not I had acted, then I cannot say that, although I did not do this act, there is some act I did which was my trying to do this one, for basic acts are not done *by* doing something.

At this point von Wright withdraws his thesis that there is a counterfactual element in every act. He considers a case where my arm rises and if asked why, I answer that I raised it in order to make a philosophical point about free will.

> If it were then pointed out to me that a certain event in my brain had just occurred which we think is a sufficient condition of my arm's rising, I need not withdraw my initial answer, but could just say: Well, I see, my arm would have risen in any case. This is not saying that the event had, as it were, two 'causes': the neural event and me. It is saying that the *interpretation of behavior as action is compatible with the behavior having a Humean cause* (E & U, 129).

The compatibility here is universalizable: "The fact that I can raise my arm does not conflict with the possibility that, every time my arm goes up, there is a sufficient condition, causally responsible for this event, operating in my nervous system" (E & U, 130). Von Wright's thesis, therefore, is compatibilist: causal explanation of behavior is compatible with intentionalist understanding of it as action, and hence with teleological explanation of it.

Von Wright does not simply eliminate the counterfactual element in action, however; he modifies it.

> What I have called 'the counterfactual element in action' is thus *not* that certain changes would not happen were it not for the agent's making them happen. The element of counterfactuality consists in that the agent *confidently thinks* that certain changes will not occur unless he acts (E & U, 199).

This means that the condition for my intending a result by my behavior is not that the behavior would not have occurred had I not acted but that I *believe* it would not have occurred had I not acted. We might say that von Wright substitutes subjective counterfactuality for objective (or epistemic for ontic). What this excludes in particular is:

> . . . That at one and the same time I raise my arm and *observe* the operation of the cause When I observe I *let* things happen, when I act, I make them happen. It is a contradiction in terms both to let and to make the same thing happen on the same occasion. Therefore no man *can* observe the causes of the results of his own basic actions (E & U, 130).

The argument for this last point is decisive. Moreover, it extends also to *believing* that the result of my act will not occur unless I act, for to believe that something is happening is also to let it happen, and that is not compatible with doing it.

But I remain unconvinced that subjective (or epistemic) counterfactuality is strong enough; it seems to me that von Wright's earlier thesis that the belief must also be *true* is the correct one. If my belief that the result would not have occurred had I not acted is *false*, then I did not perform the act which had this result. As von Wright said in *Norm and Action,* to act is "to interfere with the 'course of nature' " (p. 36), and that means not merely to believe I am interfering.

There is a converse side to this argument, which lends support to its general thrust. An apparently legitimate demand on a theory of action is that it also provide an account of why the behavior by which I intend a certain result occurs on the occasion of my acting. Why does behavior occur *when* I act?

I raise my arm and my arm rises. Why does my arm rise just then? Can it be merely a brute (but fortunate) fact that when I intend to reach for a book and believe I must raise my arm to do so, that my arm rises so that by that behavior I can intend to get a book? Does not the very possibility of action require that a constituent of action also be, on the occasion of the act, a sufficient condition of the behavior in the act?

Von Wright writes that "it is an empirical fact that a man *can do* various things when he decides, intends, wants to do them" (E & U, 81). The problem I have with his compatibilist thesis is that it appears to render this fact unintelligible, not only by making it unclear why it obtains but making it difficult to understand how it could obtain. If the behavior by which I intend a result has a Humean cause as sufficient condition, then it is a mystery why behavior occurs *when* I act. If no causes are necessary constituents of action, there is no explanation why the behavior in the act is there when I act.

Von Wright writes:

> The events which are the results of basic actions thus happen, on the whole, only when we 'vest' these events with intentionality, i.e., perform the basic actions. That this should be so is an empirical fact, but a fact which is fundamental to the *concept* of an action. The conceptual basis of action, one could therefore say, is partly our ignorance (unawareness) of the operation of causes and partly our confidence that certain changes will happen only when we happen to be acting (E & U, 130).

But what could possibly be the basis of our confidence that "certain changes will happen only when we happen to be acting"? The question asks, not for a mechanism, but for an account of action which relates the factors in terms of which behavior is understood as action to the factors explaining the occurrence of the (mere) behavior in the act. That requires that a necessary constituent of an intentional act also account for mere behavior. Without this we have a version of classical parallelism, which makes the very possibility of action unintelligible. But that appears to be what is yielded by von Wright's thesis that in attributing an action to an agent we (at most) offer a teleological explanation

of his behavior. For the *explanandum* here is not mere behavior but intentional action and the *explanans* gives neither necessary nor sufficient conditions for the occurrence of mere behavior, but rather sets the conditions for the understanding of behavior as action, regardless of what the behavior is. Both the causal and the agency theories give such an account, and that is a major reason for their persistent philosophical appeal.

3. Whether these theories give an *adequate* account of the conditions for behavior is a different question. The attempt to relate the factors in terms of which action is understood and explained to the factors which account for the occurrence of mere behavior is fraught with great difficulty. The causal theory simply takes the factors in terms of which we understand and explain action (desires and beliefs) and construes them as causes of mere behavior. But this in the end comes to the claim that explanations of action and of mere behavior are of the same kind, and on that issue I think von Wright is right.

Consider again the kind of practical inference von Wright formulates:

(a) S intends to do B.
 S believes doing A now is necessary for doing B.
 Therefore, S does A now.

This he thinks is logically valid, given suitable modifications. Should we construe the causal theory as differing simply on whether this scheme is logically valid? To do so misconstrues the situation, for it presumes that von Wright and the causal theory understand the conclusion in the same way, which they do not. The practical inference is not only a scheme for the *explanation of action,* it is also a scheme for the *understanding of behavior;* in von Wright's case the same scheme serves both functions. If we do not know what an agent is doing, then the scheme functions for *understanding;* the premises set the conditions in terms of which to understand the behavior. If we know what an agent is doing but not why, then the scheme functions for *explanation;* we begin with the conclusion and seek to construct premises that will entail it. In either case the conclusion refers to an intentional act.

For the causal theory the schemes for understanding and for explanation are somewhat different. The first is a scheme setting forth the conditions for intentional action, which requires that behavior be caused in a certain way. The conclusion must, therefore, refer to mere behavior not to action. *This* scheme should be as follows:

(b) S intends to do something.
 S believes emitting behavior *a* now is necessary.
 Therefore S emits behavior *a* now.

The scheme becomes an explanation of action if we specify *what* the agent intends (desires). If we do this, and instantiate the scheme we have the following:

(c) S intends to open the door.
 S believes his hand's turning now is necessary for the door to open.
 Therefore S's hand turns now.

The real point of dispute between von Wright and the causal theory is not, therefore, over whether (a) is or is not logically valid, but whether the adequate scheme for understanding and explanation is (a) or (b) (and (c)). Von Wright's claim that the practical inference is logically valid is not inconsistent with the causal theory's claim that it is not (since they have in mind different inferences), and hence his argument, that since the inference is logically valid, the causal theory is wrong in thinking that intentions (and beliefs) are causes, is not quite to the point. The causal theory claims that intentions (and beliefs) are causes of *mere behavior,* and that is what is expressed in its inference scheme. The logical validity of von Wright's is quite consistent with this. The point is not the validity of the inference but which scheme is adequate.

The causal scheme is not, I believe, adequate because it is not plausible. What is embedded in inferences (b) (and (c)) is the claim that mere behavior will occur just because it is *believed* to be necessary for something the agent intends (or wants) to do—that a hand will turn jut because an agent believes that behavior necessary for opening a door. But why should anyone hold that beliefs cause mere behavior or that true beliefs cause appropriate behavior? As I read the arguments, they rest on a confusion of action with mere behavior. *Actions* are performed all the time because they are believed to be necessary; but to act on a belief is one thing, for beliefs to cause mere behavior another. An inference like (c) appears plausible only because of an equivocation in the second premiss, between 'S believes his hand's turning now is necessary' and 'S believes turning his hand now is necessary' If the first version is used, the inference is not plausible; if the second version is used the inference turns into (a), and that inference may very well be logically valid. To put the point in another way, the evidence that exists for the plausibility of the practical inferences involves explanations of action not of mere behavior; when reformulated explicitly in terms of mere behavior, they lose their plausibility.

<center>V</center>

We are now back with the issues of the second question, which appear more intractable than ever, for the argument is *both* that it is not plausible to think that beliefs (or intentions or desires) cause mere behavior *and* that an adequate theory of action must show how action attributions explain the occurrence of the behavior in the act. Since von Wright regards the factors in terms of which *action* is understood and explained as playing an explanatory role only in a

teleological sense, which means that they cannot explain mere behavior, it appears that his theory *cannot* meet the demand that action attributions also explain mere behavior.

There appear to be only two possible ways out. One is the agency theory. The strength of this theory is that it, on the one hand, construes the factors in terms of which action is understood and explained in a teleological sense, and, on the other hand, provides an account of the occurrence of the behavior in the act. It does not adopt the implausible thesis that beliefs cause mere behavior, and yet it construes a necessary constituent of the act as explaining mere behavior. The crux is agent causality: the agent intends a result and in his intending causes behavior to occur. Since the agent is both the locus of the intention in the act and the cause of the behavior in the act, these two factors are brought together in a way that makes the possibility of intentional action intelligible.

The concept of agent causality, however, raises very difficult problems. Chisholm admits that it requires that we make "somewhat far-reaching assumptions about the self or the agent."[24] Von Wright thinks that it is "connected with insurmountable difficulties" (E & U, 191). Whether they are insurmountable is an open question but they have been much discussed, and since von Wright does not discuss them, I shall not pursue the topic.

The other possible way out is to show that the demand that action attributions explain mere behavior is illegitimate, and this is, I believe, the strategy of von Wright's later work. It involves developing a kind of Kantian account of the role that categories of understanding play in observation and explanation.

The difficulty I have raised concerns the relation between understanding behavior as action and explaining mere behavior. If we could simply begin with intentional action and go on from there, then things go smoothly. The difficulty arises when we try to make intelligible the possibility of intentional action by requiring an explanation of the behavior by which agents intend a result. To show that this is illegitimate it must be shown that to ask for such an explanation presumes something false, namely that mere behavior is *basic* in a sense intentional action is not. This, I believe, is von Wright's strategy, his thesis being that intentional action is no less basic than mere behavior and that there are no more problems about the possibility of the one than the other.

Let us say that something is *ontologically basic* if there are no conditions for the possibility of its occurrence. The argument then will be that mere behavior is no more basic than intentional action because both are ontologically basic. There is no answer to the question of how it is possible that mere behavior occurs, only to the question of why it occurs on a specific occasion, and then we give the causes of that occurrence. The claim now is that *basic acts* are also ontologically basic. Basic acts are basic, not only in the sense that one does not do them by doing anything else, but also in the sense that there is no answer to the question of how it is possible for agents to perform them, only

to the question of why they perform them on specific occasions, and then we give the agent's intentions and beliefs (or his desires, etc.). Explanations of basic acts presuppose *acts* for their *explananda,* so that what we explain is why an agent acts in a particular way at a particular time, not what makes it possible for him to act at all. An explanation of a basic act says *why* not *how,* for to say how can only be to describe the line act by which agents perform a basic act; but if the act is basic, it is not done by doing some act.

If basic acts are ontologically basic, then no mere behavior is a condition of their performance, and that means that the behavior *in* an act is not mere behavior. If it were, basic acts would not be ontologically basic, and an account would be required of the role mere behavior plays in them. Once mere behavior enters the horizon, an explanation of why it occurs when an agent acts is in order, and the question we are seeking to exclude becomes legitimate again. The behavior in the act must, therefore, be behavior as intended by an agent to result in a certain end—behavior as understood to be a certain act— and the word 'behavior' in this locution refers, not to mere behavior, but non-committally to behavior as understood *either* intentionalistically or non-intentionalistically. For if 'behavior' refers to mere behavior, then the latter becomes a constituent of the basic acts and they are no longer ontologically basic. The locution "behavior as intended by an agent" is best seen, therefore, as indissoluble: the behavior in the act is behavior-as-intended-by-an-agent. When I raise my arm (intentionally) the mere movement of my arm is not a constituent of my act; what is a constituent is that by-my-arm-raising-I-intend-to-give-a-signal. And that just is my basic act, what I do in signalling (or attempting to).

Given this, the demand that action attributions explain mere behavior is illegitimate. For if we ask why behavior occurred on a certain occasion, the question makes sense only if we construe it as a dual question; there is no answer to the question, why behavior occurred, where 'behavior' is used in the non-committal, non-dual sense. If it is mere behavior we are asking about, then the answer will be in causal terms—presumably neural events which cause the behavior. If it is the behavior in the act, then we are dealing with behavior-as-intended-to-result-in-a-certain-end, that is, with a basic act, and the answer will be in the teleological terms of intention and belief. Each answer is adequate to its correlative question. But the different question, of why a certain item of behavior occurred when we acted and wouldn't have occurred (on that occasion) otherwise, is illegitimate. Whenever persons act, mere behavior occurs, but that is a purely contingent relation which it is conceptually impossible to explain.[25] It is impossible to explain because saying why mere behavior occurred when _____, will require that the blank be filled in with a causal factor, with something understood non-intentionalistically, with something, therefore, that does not cross the line to action and its intentionalist context. Answering the question requires crossing the line; asking it requires that it not be crossed.

To speak of duality here does not mean there are two behaviors—mere behavior and the behavior in the act—but one behavior understood in different ways. The behavior in the act is behavior-as-intended-by-the-agent, as understood intentionalistically. But mere behavior is also behavior-as-understood; it differs from action, not in being observed and explained apart from any understanding, but in being tied to a different form of understanding. Otherwise intentional action, but not mere behavior, will represent an overlay of meaning and understanding on something more basic; and it will not be possible to maintain the thesis that intentional action is no less basic than mere behavior.

It is clear that a different sense of 'basic' has now entered the discussion and that in this sense basic acts are not basic, for their explanation logically presupposes an understanding of the behavior in the act. "In order to become teleologically explicable . . . behavior must first be intentionalistically understood" (E & U, 121). Let us call this sense of 'basic' the 'epistemic sense'. Basic acts are not epistemically basic, for they are not brute data given for explanation apart from understanding; without an intentionalist understanding of behavior, explanations of basic acts are not possible.

To show, then, that intentional action is no less basic than mere behavior, it must be argued that mere behavior is no more *epistemically* basic than basic acts. Von Wright's argument here proceeds at two levels. At one level the argument is that explanations both of mere behavior and of intentional acts— that is, both causal and teleological explanations—presuppose an understanding of the phenomena. The contrast is not between giving a causal explanation of mere behavior, apart from any understanding, and a teleological explanation of behavior as understood intentionalistically, but between giving a causal explanation of behavior as understood in one sense and a teleological explanation of it as understood in a different sense. A basic act will be, therefore, no less basic epistemically than mere behavior, for mere behavior also has an explanation only in a context of understanding. "Understanding is a prerequisite of every explanation, whether causal or teleological" (E & U, 135).

At the second level the argument is that the observation of basic acts is as direct as the observation of mere behavior. Von Wright develops this by comparing the understanding of action with the observation of physical objects. He warns that the intentionalist understanding of behavior is not normally a matter of *interpreting* behavior; the practical inference does not give a description of a psychological process by which we understand what people are doing. Understanding behavior as action is no more a matter of *interpreting* behavior than seeing physical objects is a matter of interpreting sense data. "In the normal cases we can say off-hand of the way we see people behave that they perform such and such actions" (PI, 51). If I mistake mere behavior for action, it is tempting to speak of a false *interpretation* of what I saw.

> We say: I interpreted what I *really saw,* viz his arm rise, as a case of seeing him raise his arm—but this was premature. This is like the case, when we withdraw a physical object statement and replace it by a sense-data statement, because it turned out that the object we saw was only illusory. In both cases, however, it is misleading to say that we interpreted what we saw in the wrong way. For we did not *interpret* what we saw at all (PI, 52).

It is not that we *see* an agent's arm rise but *interpret* his behavior as his raising an arm. We really see not only arms rise but people raising their arms. The one is as much a datum as the other, though both presume understanding.

A major reason for thinking that this is von Wright's strategy is his ingenious arguments for an 'actionist understanding' of causation. "We cannot understand causation," he writes, "without resorting to ideas about doing things and intentionally interfering with the course of nature. . . . The idea of a causal or nomic relationship . . . depends on the concept of action. . . . To think of a relation between events or causal is to think of it under the aspect of (possible) action . . . That p is the cause of q . . . *means* that I could bring about q, if I could do (so that) p" (E & U, 65, 72, 74).

I shall not discuss these arguments. If they are cogent, then we have a strong defense of the thesis that basic action is as basic as mere behavior. Indeed the arguments go further by making action concepts logically prior to causal concepts. For behavior has causes only if persons can act, and the intelligible possibility of the latter is a prerequisite for the intelligible possibility of the former, rather than the other way around.

At the same time these arguments suggest that in the end this kind of Kantian way out, no less than the theory of agency, involves far-reaching assumptions, which raise difficulties to which von Wright has not addressed himself. To say that the discovery of causes presumes intentional action is one thing, to say that the occurrence of causes presumes it another. To say, "That p is the cause of q . . . *means* that I could bring about q, if I could do (so that) p," suggests that the occurrence of causes presumes action. To make this move is to transform epistemic conditions for observation and explanation into ontological conditions.

I recognize that this is not von Wright's intent and that he disavows it in the case of causality, and yet I think that without it this way out will not succeed. Let us grant that basic action is not less basic than mere behavior in the epistemic sense; the observation and explanation of both presume understanding. There remains this difference between mere behavior and basic action; mere behavior *occurs* whether anyone understands it or not, but basic actions do not. "Behavior gets its intentional character form being *seen* by the agent himself or by an outside observer in a wider perspective, from being *set* in a context of aims and objectives" (E & U, 115). "The understanding of

action," von Wright writes, "presupposes a community of institutions and practices and technological equipment" (E & U, 114), and the same might be said of the *understanding* of mere behavior. But von Wright's thesis is that there *is* no intentional action apart from the context of understanding provided by that community. And that means that in the end intentional action is not as basic *ontologically* as mere behavior *unless* one wishes to argue that there *is* no mere behavior either apart from the "community of institutions and practices." To argue that is to transform the epistemic thesis about the conditions for observation and explanation into an ontological one. That is a very far reaching assumption, and yet it seems necessary to maintain the illegitimacy of the requirement that action explanations also explain mere behavior.

That assumption seems to me too far reaching, and we are left, therefore, with a fundamental difficulty in von Wright's theory of action. Some have argued that the underlying mistake is to seek for a theory at all. We can take it for granted that persons do act intentionally; no theory is required to show that they do. The desire to show that this is *intelligible* is, however, a persistent and strong desire in the history of philosophy, and the desire has not been quenched nor the search to satisfy it shown to be fruitless. Von Wright has sought a theory of action which will accomplish this end, and though I do not think that he has thus far been entirely successful, he has significantly deepened our understanding of these extraordinarily difficult matters.

St. Olaf College Frederick Stoutland
Northfield, Minnesota
October 1973; revised August 1983

NOTES

1. 'Deontic Logic', *Mind,* N.S. 60 (1951).

2. (London, 1963); hereafter cited as '*N&A*'.

3. *Acta Philosophica Fennica,* Fasc. XXI (Amsterdam, 1968); hereafter cited as '*G.T*'.

4. (Ithaca, N.Y., 1971); hereafter cited as '*E&U*'.

5. Of the works on philosophy of action published since this paper was written in 1973 the most important are *Causality and Determinism* (New York, 1974) and *Freedom and Determination* (*Acta Philosophica Fennica,* 1980).

6. Von Wright notes that "the division of actions into basic and nonbasic ones applies . . . to *individual* and not to *generic* actions. Whether an (individual) action is basic or not depends on *how it is performed*— directly or by doing something else—on the individual occasion for its performance" (E & U, 199). The same should be said of the result-consequence distinction. Whether a given state of affairs is a result or a con-

sequence of an act will depend on the particular circumstances of the individual performance. Indeed, the notion of consequence seems to have no application at all to a generic act, for how would one determine the *contingent* consequences of a generic act?

7. I shall from now on use capital letters for acts and small letters for the states of affairs (sometimes events) which are results or consequences of acts.

8. A. I. Melden, 'Action', *Philosophical Review* 65 (1956): 527. Cf. *E&U*, p. 89: "It cannot be said that we intend to do everything we do intentionally. Nor does it seem indisputable that, whenever we do something intentionally, there is also something we intend to do."

9. Von Wright, therefore, would reject Davidson's claim that "Our primitive actions . . . mere movements of the body—these are all the actions there are. We never do more than move our bodies: the rest is up to nature." *Essays on Actions and Events* (Oxford, 1980), p. 59.

10. The issues here are complex, and I return to them in the last section.

11. E.g., Donald Davidson, *Essays on Actions and Events;* A. Goldman, *A Theory of Human Action* (Englewood Cliffs, N.J., 1970); D. M. Armstrong, *A Materialist Theory of the Mind* (London, 1968).

12. I ignore complications necessary to deal with such difficulties as 'wayward causal chains'.

13. Davidson draws the contrast in this way: "To describe an action as one that had a certain purpose or intended outcome is to describe it as an effect [of a desire]; to describe it as an action that had a certain outcome is to describe it as a cause" (*Essays on Actions and Events,* p. 50). Intended outcomes are results, outcomes are consequences.

14. Roderick Chisholm, 'Freedom and Action', in *Freedom and Determinism,* edited by Keith Lehrer (New York, 1966), pp. 11–44; 'The Structure of Intention', *Journal of Philosophy* 67 (1970): 633–647.

15. Cf. Chisholm, 'The Structure of Intention', p. 635: "He acts with the intention of bringing it about that = df. There is a state of affairs p such that he brings it about that p occurs in intending to bring it about that"

16. *Acta Sociologica,* 15 (1969), pp. 39–53. Henceforth *'PI'*.

17. Cf. *E&U*, p. 93: "A distinguishing feature of the causal relation is that cause and effect are *logically independent* of one another. A causal relation which satisfies this requirement . . . I shall call *Humean.*"

18. Von Wright's account here is similar to that of Wittgenstein in *Philosophical Investigations.* E.g., the following passages: "'I am not ashamed of what I did then, but of the intention which I had.'—And didn't the intention lie *also* in what I did? What justifies the shame? The whole history of the incident" (# 544). "An intention is embedded in its situation, in human customs and institutions" (# 337). "Why do I want to tell him about an intention too, as well as telling him what I did?—Not because the intention was also something which was going on at that time. But because I want to tell him something about *myself,* which goes beyond what happened at that time" (# 659). I have discussed this matter further in "The Causation of Behavior" (cited in the note on the first page of this paper).

19. Cf *E&U*, p. 116: "In this mutual dependence of the verification of premises and the verification of conclusions in practical syllogisms consists . . . the truth of the logical connection argument."

20. *PI,* p. 52: "Explanation of action follows *after* understanding of behavior as action." Cf. *E&U*, p. 132.

21. Cf. especially *PI,* pp. 47–49. The final form is as follows: "X intends to make it true that *E.* He thinks that, unless he does *A* now, he will not achieve this. Therefore X does *A* now, unless he is prevented or else cannot accomplish the action."

22. Cf. *PI,* p. 49: "Given the premisses . . . then his actual conduct, whatever it may 'look like', either is an act of doing A or aims, though unsuccessfully, at being this. Any description of his behavior which is logically inconsistent with this is also logically inconsistent with the premisses. Accepting the premisses thus forces on us this understanding of his conduct—unless for some reason we think that a preventive interference occurred right at the beginning of his action."

23. The notion that diverse behavior can be understood in terms of a single end relates von Wright's intentionalist understanding of teleology to the traditional notion, whereby the appeal to teleological explanation is made to account for an organism's ability to reach a specific goal (or maintain a specific condition) under diverse and varying circumstances.

24. 'Freedom and Action', p. 11.

25. Cf. *E&U* p. 129: "If a Humean cause of my arm's rising operates, my arm will rise of 'necessity,' i.e. *natural* necessity. If I intend to take a book from the shelf and consider the raising of my arm (causally) necessary for this, then normally I raise my arm unless prevented. This is a statement of *logical* necessity. But between the events on the two levels, the level of natural and that of logical necessity, the relation is *contingent.*"

14

Alan Donagan

VON WRIGHT ON CAUSATION, INTENTION, AND ACTION

In the opening chapter of *Explanation and Understanding,* von Wright briefly recalls Windelband's distinction, in his rectorial address at Strassburg, between what he described as the 'nomothetic' character of the *Naturwissenschaften* and the 'idiographic' character of the *Geisteswissenschaften.*[1] A nomothetic science seeks in the phenomena it studies properties or characteristics in terms of which those phenomena may be subsumed under general laws; and, in explanation, its object is to connect the phenomenon to be explained with other phenomena, according to those general laws. An idiographic science, by contrast, does not presuppose that every characteristic it treats of in phenomena is subsumable under general laws. It acknowledges that some phenomena in its domain may be in some respect unique, even though in fact few or none may seem to be, and its explanations employ concepts which allow for that possibility. Many of them, in consequence, are in terms of the concepts of agency, purpose, and intention.

Yet von Wright dismisses as shallow any dualism, like Windelband's, according to which the domain of science is divided into two provinces, *Natur* and *Geist,* each of which is to be treated by a distinct method appropriate to it. What Windelband took to be distinct scientific methods, each valid in its own province, von Wright insists are two traditions about the proper method of a unified science; and as such, ultimately irreconcilable. For the last hundred years, philosophy of science has been their battlefield, and the fortune of battle has repeatedly changed:

> After Hegel came positivism; after the antipositivist and partly neohegelian reaction around the turn of the century came neopositivism; now the pendulum is again swinging towards the Aristotelian thematics which Hegel revived (p. 32).

This paper is almost entirely about G. H. von Wright's *Explanation and Understanding* (Ithaca, N.Y.: Cornell University Press, 1971) [Hereafter, *Explanation*]. Page references to this work are incorporated into the text in parentheses, without further identification.

Having described the parties to this struggle as basically opposed, von Wright surprises us by renouncing all pretensions to decide between them, declaring it to be an illusion that "truth itself unequivocally sides with one of the two opposed positions" (p. 32).

Even after four years, I remember the joy with which I read this acknowledgement, by a philosopher whom nobody can imagine to be hostile to the great tradition of the *Naturwissenschaften,* of the irreducibility and the validity of that of the *Geisteswissenschaften.* Yet von Wright's ultimate theme is deeper still: the opposition between the traditions, while basic, is

> removed from the possibility both of reconciliation and of refutation—even, in a sense, removed from truth. It is built into the choice of primitives, of basic concepts for the whole argumentation. This choice, one could say, is 'existential'. It is a choice of a point of view which cannot be further grounded (p. 32).

My contribution to the discussion of this ultimate theme must be indirect. I propose to investigate some of the problems about causation, action, and intention that arise in the study of the *Geisteswissenschaften,* for whose solution von Wright has done much, in the hope of providing him with an occasion for doing even more.

I

The core of von Wright's theory of causation is that the concepts of causation and action 'meet' in the idea of putting a system in motion (p. 64).

A multitude of concepts are signified by the word 'cause', its cognates, and other causal terms. With regard to them, von Wright appears willing to allow both Hume's contention that they are not empirical (p. 35), and Russell's even bolder one that they are not necessary for presenting the results of theoretical physics (pp. 36–37). Yet he argues against Russell that there is a familiar concept of cause of which scientists must make use if they are to give an account of their laboratory procedures (p. 36). This concept is that of one or other of two relations obtaining between generic states of affairs, p and q, in a system S that can in principle be put in motion by an agent's intervention in the course of nature: namely, (1) the relation between p and q which obtains when putting S in motion brings about the occurrence of p, and by bringing p about, q is brought about; or (2) that which obtains when putting S in motion brings about the suppression of p, and, p being suppressed, the occurrence of q is either terminated or prevented from occurring. If either relation obtains between p and q, p can be said to be the cause of q: if (1) obtains, p is the cause of q in the sense of its sufficient (causal) condition; if (2) obtains, p is the cause of q in the sense of its necessary (causal) condition.

The radical idea from which this analysis of causation springs is that of a system closed to causal influences outside it: or, for short, of a "closed system" (p. 54). Such a system von Wright defines as one in which "no state (or feature of a state) at any stage in [it] has an antecedent sufficient condition occurring outside [it]" (p. 54). And when some, but not all, of the states of affairs comprising a system have antecedent sufficient conditions outside it, he describes it as closed relative to (or 'relativized' to) those that do not (pp. 54, 56). It is essential to sufficient conditionship that no chain of sufficient conditions may be interrupted: if *a* is a sufficient condition of *b*, and *c* of *d*, but *b* only a necessary condition of *c*, then *a-b-c-d* can neither be a chain of sufficient conditions, nor can *a* be a sufficient condition of *d*. Hence, if a state of affairs *A* will not change into a state of affairs *a* unless an agent intervenes in the course of nature, then neither *A*, nor any state before *A* out of which *A* would have arisen as a stable state, can be a sufficient condition of any state of affairs that will not occur unless *A* changes into *a*.

Causal analysis is possible only because closed systems can be isolated from their surrounding circumstances (cf. p. 60), and closed systems can be isolated for repeated study only if they can be set in motion at will by intervening in the course of nature (pp. 63–64). Admittedly, accidents in the course of nature may set in motion new closed systems. For example, a stable planetary system may be changed into a new system by the intrusion into it of a wandering heavenly body; and the new system will be closed relative to all the states of affairs in it that would not have occurred but for the intrusion that set it in motion. However, accidental happenings of this sort are not enough for scientific causal analysis, which demands that tests be both repeatable and varied. The confirmation of causal hypotheses "is not a mere matter of repeated lucky observations", but of controlled experimentation: "we can be as certain of the truth of causal laws as we can be of our abilities to do, and bring about, things"—no less, and no more (p. 73).

Taking an agent who "can do various things when he decides, intends, wants to do them" to be, in respect of those things, free (p. 81), von Wright concludes that "the concept of causation presupposes the concept of freedom . . . in the sense that it is only through the idea of doing things that we come to grasp the idea of cause and effect" (pp. 81–82). This activist doctrine (concerning which von Wright acknowledges a debt to Douglas Gasking)[2] is not the vulgar mistake that "whenever a cause can be truly said to operate some agent is involved" (p. 73; cf. p. 81). Causes are causes wherever they are, whether or not they occur by human manipulation (p. 74). But we establish the existence of causal relations by manipulating into motion closed systems in which we can study their *relata* (cf. p. 72).

Nevertheless, it would be a mistake to infer from the activist theory of causation alone that there must be kinds of scientific knowledge outside the

Naturwissenschaften. When closed systems are isolated by natural accidents, as when a new planetary system is set in motion by a wandering body intruding into an old one, the intrusion that isolates the new system is presumably itself causally determined. And so the theory that the concept of causation presupposes the concept of freedom does not in itself imply that the human manipulations that set in motion the closed systems studied by experimental scientists are not also causally determined. All that can be said is that, if free human action in von Wright's non-tendentious sense should turn out to require a distinctive *Geisteswissenschaft* to understand it, then a claim of Collingwood would be vindicated: that "natural science as a form of thought exists and always has existed in a context" that is not natural science;[3] the *Naturwissenschaften* would exist in a context of *Geisteswissenschaft*.

II

How is free human action to be scientifically studied?[4] In *Explanation and Understanding* von Wright treats such actions as individual processes which take time. Some of them involve changes from one state of affairs to another, and some do not: thus, standing still is an action as well as walking. Actions, so understood, must satisfy two conditions. They must be *action-like*, in the sense of having genuine teleological explanations; and they must have two aspects: an inner or intentional one, and an outer or physical one (pp. 67, 86–87).

A teleological explanation of a process has the form *This happened in order that that should happen*. It points from the time at which this happened to what has happened or will happen afterwards. It does not depend on nomic connexions, at least in their overt form (pp. 83, 85). Hence a teleological explanation differs from what von Wright calls a quasi-teleological one; that is, one in which an earlier event in a causal system is explained as being a necessary condition of a later one, the occurrence of which is taken for granted (pp. 57–58). Quasi-teleological explanations are causal; but von Wright proposes to term genuine teleological explanations 'quasi-causal' (p. 85).

The inner aspect of an action is "the intention or will 'behind' its outer manifestations" (p. 86). The outer aspect is a physical process or set of processes. It may be divided into two phases, an immediate one, and a remote one. The immediate one must be intended to occur by the agent (cf. pp. 68, 92, 194 *n*. 12), and may not be caused by any other phase of the same outer aspect. The remote one consists of any processes, whether changes of state or persistences in the same state, which are caused by the immediate one (p. 87).

The division of the outer aspects of an action into an immediate one and a remote one holds whether the action be an intervention in the course of nature

or a forbearance—an "intentional passivity" (pp. 90–91) —and no matter how it may be described. But von Wright makes a further division of the outer aspect of an action, which applies only to interventions, and which is relative to how the action in question is described. This division is into *result* and *consequence*. The result of an intervention is that which must be realized if the intervention as described may be said to have been completed or fully performed; a consequence of it is the bringing about of any further effect that is caused by the result (pp. 67–68, 87–88). It follows from the relativity of the result-consequence distinction to the description of an action that

> [t]he phase of the outer aspect (if it has many phases) which may be regarded as the result . . . can usually be shifted (within the aspect). The shift answers to subsuming the action under different descriptions (p. 88).

Thus *X's pressing of a bell-push* and *X's ringing of a bell* are two descriptions of the same action (he rings the bell by pressing the bell-push): relative to the former description, the depressing of the bell-push is its result and the ringing of the bell one of its consequences; but, relative to the latter, the ringing of the bell is the result, and the consequences will be the bringing about of whatever effects may be caused by the bell's ringing.

When the result of an intended intervention remains wholly unrealized, as when a paralysed patient tries to move a limb, and fails to make any movement at all, what would in happier circumstances be the inner aspect of an action occurs, but without any outer aspect.[6] Such 'acts', according to von Wright, are often called 'mental', although they are not normally called 'actions', and could not appropriately be termed 'behaviour' (p. 87). However, there seems to be no place in his classification for what are most naturally called mental actions: such things as doing sums in one's head without telling anybody of it.

Von Wright identifies the realizing of the immediate outer aspect of an action with a basic action; that is, with doing something *simpliciter,* and not by doing something else (p. 68). The terminology of 'basic' and 'non-basic' action, due to Danto,[7] is confusing, as Davidson has pointed out.[8] For the realizing of the immediate outer aspect of an action and the realizing of its remote outer aspect are not two realizings, but one. Hence there are not two actions, basic and non-basic but, as von Wright himself implicitly acknowledges, basic and non-basic descriptions under which the same action is subsumed (p. 88), the latter of which—those of the realizing of the various phases of its remote outer aspect—are divisible into others. If we speak, not of basic and non-basic actions, but of basic and non-basic descriptions of an action, the basic descriptions of an action may provisionally be defined as those from which all reference to its effects have been eliminated. Such descriptions will describe an action as the realizing or making happen of its immediate outer aspect.[9]

Von Wright identifies this immediate outer aspect with a muscular activity or tension (pp. 87–88, 92). On the face of it, this is a mistake. Since muscular activities or tensions are known to be caused by earlier events in the central nervous system, it appears that the immediate outer aspect of any action involving muscular activity or tension must be the events in the central nervous system which cause that activity or tension. In rejecting this line of thought, von Wright draws upon an interesting argument of Descartes.[10] The immediate outer aspect of an action must be intended by the agent, but neural events in the central nervous system cannot be so intended, partly because few or no agents know what neural events cause what muscular activities or tensions, and partly because, even if they did know it, no direct willing that those activities or tensions should happen would be an intending, any more than willing that one's eyes should change colour would be. If an agent chooses to make happen the neural events that cause the muscular tensing involved in raising his arm, the most direct way in which he can do it is—to raise his arm. In view of this, von Wright does not shrink from describing the neural events that cause the muscular contractions involved in raising one's arm as themselves consequences of raising one's arm, and hence as caused by it; and he accepts the corollary that such causation is from the present towards the past (p. 77).

Descartes obviated that corollary by supposing that one's arm's going up is caused by one's willing or intending to raise it, by way of certain temporally intervening neural events.[11] The reason for which von Wright rejects this line of thought is unpersuasive: namely, that

> I might have decided or intended to raise my arm and not carried out the decision (intention), in which case [the neural events] might not have occurred at all. Only by putting my decision into effect, *i.e.* by actually raising my arm, do I do something which necessitates [their] occurrence (p. 77).

Descartes might have replied, first, that only an intention to act *now,* and not at some time in the future, can cause the neural events in question; and second, that there are cases, such as those in which the efferent nerves are injured, in which such intending will cause those neural events without causing one's arm to rise. Here Descartes' science may be challenged; but von Wright's objection is not a scientific one.

These considerations call into question the coherence of von Wright's concept of the immediate outer aspect of an action as a physical process which its agent in acting intends to make happen, and which is not itself caused by anything else he makes happen in acting. Von Wright correctly endorses Anscombe's conclusion that an action cannot be intended *per se,* but only under a description (p. 89).[12] Hence the concept of an action's immediate outer aspect presupposes that there is some description of that aspect which (1) does not identify it with any phase of the whole outer aspect that is in fact caused by some earlier phase, and (2) is such that under it the agent intends to make happen the aspect it describes. But it appears that no description can satisfy

both these conditions. The only description of an action's immediate outer aspect that does not identify it with a phase that is in fact caused by some earlier phase would seem to be one stated in terms of neural processes in the central nervous system; because to describe it as any peripheral bodily process would identify it with a phase that is in fact caused by an earlier phase. Yet it would seem, for the reasons given by Descartes, that agents seldom if ever intend to make anything happen under such a description.

The error that generates this difficulty has been exposed and corrected by Davidson. Suppose that a man raises his arm. Suppose, too, that the first phase of the outer aspect of his doing so is the making happen of the neural process N in his central nervous system. And finally, suppose that, as is usually if not always the case, he did not intend to perform any action whatever under the description "the making happen of the neural process N in my central nervous system". Davidson has pointed out that theories like von Wright's, while they indeed entail that an agent in acting must intend to make happen the initial phase of his action's outer aspect—under *some* description that does not identify it with any phase caused by an earlier phase—nevertheless do not entail that he must intend it under a basic description as defined above. Such theories require no more than that there be some description under which an agent intends to make happen the immediate outer aspect of his action, and which does not misidentify it. And Davidson has implicitly provided a formula for constructing such descriptions, which may be slightly modified as follows: for any agent a and any kind of bodily action K, a's K-ing will have an immediate outer aspect the making of which happen is describable as "*a's making happen such a process within his body as is sufficient for K-ing*". Let D be such a description, and suppose that the process whose making happen D describes is in fact the neural process N in a's central nervous system. Then a, in K-ing, must intend to make N happen in his central nervous system, but *under a description equivalent to D*. And this is far more plausible than von Wright's identification of the immediate outer aspect of any action with a muscular activity or tension. "What was needed", as Davidson has remarked, "was not a description that did not mention effects, but a description that fitted the cause".[13]

Davidsonian descriptions of this kind, in which an action is described by referring to an initial phase identified as having certain bodily effects, will also be accounted basic descriptions in the sequel.

III

Von Wright's distinguishing two aspects of action, an inner and an outer, raises two fundamental philosophical questions: What is the relation of an agent to the inner aspect of each of his actions? and What is the relation of the inner

aspect of an action to its outer aspect? Some philosophers answer that in both cases the relation is causal, although not of the same kind; others, who appear to be more numerous at present, answer that it is causal in the latter case but not in the former; von Wright answers that it is not causal in either case.

The answers von Wright gives to these questions can best be understood in relation to an analysis of action he dismisses in the end, although not altogether (pp. 191–192, *n.* 44): namely, Chisholm's analysis of it in terms of a revived traditional theory of causation.[14]

The foundation of that theory is the represententation of causal relations in terms of a fundamental concept of *power to make happen*.[15] Chisholm does not pretend to elucidate this concept, but he does claim that it is familiar to most of us, that its intellectual history is ancient and distinguished, and that definite and consistent principles can be given for its application. Power to make specific kinds of events happen may be exercised either necessarily or freely. When a thing exercises such a power necessarily, as a body hotter than its surroundings necessarily exercises the power to warm its surroundings by transfer of heat, that exercise can be represented as a process involving a sequence of states of the body and its surroundings. For that sequence a law can in principle be given, having to do with the nature of heat and the composition of the body and its surroundings, according to which the later states follow necessarily from the earlier. By contrast, when a thing freely exercises its power to make an event happen, as when Socrates, according to his own account as reported by Plato, made it happen that his body remained in prison at Athens, and that it did not escape into exile, no such analysis is possible.

This difference is crucial. When a thing necessarily exercises a power to make something happen, its state and circumstances when it does so are a sufficient condition of its doing so. Hence its doing so can be analysed as a causal relation between events, one of which (the occurrence of its being in a certain kind of state in circumstances of a certain kind) is a sufficient (causal) condition of the other (the event that is made to happen). Chisholm's name for this relation is 'transeunt causation'; Richard Taylor's is 'event causation'. By contrast, a free exercise of a power to make something happen cannot be analysed in terms of sufficient conditionship. A possessor of a freely exercised power, given the kind of state he is in and the kind of circumstances he is in, can either exercise it or not. Yet the exercise of such a power has been traditionally understood as causing an event to happen. And, because such exercises of power have been traditionally identified with agency, and because the power exercised in agency has been taken to be immanent in its possessors (agents), Richard Taylor has called the causation exemplified in agency 'agent causation'; Chisholm has preferred 'immanent causation'.

Since the scientific revolution of the seventeenth century, event causation, which is the only kind of causation studied by the natural sciences, has in the

minds of philosophers gradually supplanted causation in the wider traditional sense. In consequence, philosophers have gradually ceased to represent causation in terms of the concept of power to make happen, and have come to think of it as a relation between events, to be represented in terms of the concept of *the nomologicality of natural processes*. It is postulated that, in ideal fundamental science, there is one set of terms in which the course of nature can be correctly described, and one set of laws formulable in those terms under which all correctly described natural processes can be subsumed, inasmuch as they stand in causal relations at all. The *relata* of causal relations are events, and every proposition of the form 'The event A causes the event B' is analysable into another to the effect that there are correct descriptions of A and B in terms of fundamental science (which may not yet have been developed) such that the occurrence of B, under its descriptions in fundamental science, follows according to laws of nature (perhaps as yet unknown) from the occurrence of A under its description in fundamental science.

Which of these two ways of representing causal relations enables us truly to describe what happens in the world? Does either? Do both?

Consider an archaeological reconstruction of the interaction, over several generations, of a bronze age community with its environment. It will refer to natural processes in that environment, both seasonal and not, to interventions in those processes by the community, to what follows in the course of nature from those interventions, and to further interventions in view of those consequences. In most such reconstructions, what follows in the course of nature, whether or not it follows from a human intervention, will be assumed to exemplify known laws and to be illustrable by simplified causal models; on the other hand, while the human interventions will be explained as resulting from complex patterns of aims, acquired skills, and situational appraisals, to the question 'Why did that community pursue those aims, in view of those skills and those appraisals?' no ultimate answer will be vouchsafed except, 'That was how they chose to act.' Both kinds of explanation will be expressed in terms of causation.

How may such causal narrations be rendered according to the two ways of representing causal relations I have outlined? According to the older one (in terms of the concept of power to make happen) the natural processes will be represented as necessary exercises of some powers, the human interventions as free exercises of others; and every causal relation in the narrative will have a representation. According to the newer one, in terms of the nomologicality of natural processes, the natural processes will be represented as occurring in accordance with laws, known or unknown, and the human interventions, as described in the narrative, will appear as causal gaps. Of course, few who accept the newer way of representing causal relations will be content with historical narratives as they stand: the fact that their representation exhibits causal gaps

will be held to show that they are incomplete and require supplementation in terms of natural processes (psychological, sociological, or even physiological) occurring in the members of the community whose history is being narrated. Such a view is no more plausible, and no less, than are the scientific promissory notes on whose security it rests.

If the rate at which you would discount those promissory notes is high (and my rate would be very high indeed), then you will have good reason to look favourably on Chisholm's revival of the older way of representing causal relations, according to which only some of them are nomological. Unfortunately, in recent philosophical discussion, the scientific question has, on both sides, been answered perfunctorily, and attention has been absorbed by the question whether the concept of agent causation is even intelligible.

An effective tactic in questioning its intelligibility, persuasively followed by Irving Thalberg,[16] is to complain that the concept of agent causation set out by Chisholm and Taylor is unclear, and to invite 'agent causationists' to clarify it, if possible by examples that will show how it works. Once irrelevant cases of making one event happen by making another event happen have been cleared away, agent causationists who respond find themselves in a dilemma: either they offer explanations in terms of event causation, and so contradict themselves or generate infinite regresses, or they protest that Chisholm's exposition of the concept is clear as it stands, and so expose themselves to the imputation of complacent obscurity.

Yet the demand for examples that will show how agent causation works betrays a misunderstanding of the kind of concept it is. Since it is not empirical, but theoretical, the search for such examples must prove as futile as Hume's search for impressions from which the idea of necessary connexion may be derived. There are no examples that will show how either event causation or agent causation works, and nobody who finds them unnecessary in one case has any right to demand them in the other. That is what underlies Chisholm's neat *tu quoque:* "the nature of transeunt [event] causation is no more clear than that of immanent [agent] causation."[17]

Provided that improper standards of clarification are not demanded, it is difficult to perceive why anybody should object that Chisholm has not made clear what he means by agent causation. But some remarks by Heinrich Hertz on complaints that the concepts of electricity and force are mysterious come to mind:

> Now, why is it that people never in this way ask what is the nature of gold, or what is the nature of velocity? Is the nature of gold better known to us than that of electricity, or the nature of velocity better than that of force? Can we by our conceptions, by our words, completely represent the nature of anything? Certainly not. I fancy that difference must lie in this. With the terms 'velocity' and 'gold' we connect a large number of relations to other terms; and between all these relations we find no contradictions which offend us. . . . But we have accumulated around the terms 'force' and electricity' more relations than can be completely reconciled

amongst themselves. We have an obscure feeling of this and want to have things cleared up. Our confused wish finds expression in the confused question as to the nature of force and electricity. But the answer which we want is not really an answer to this question.[18]

Inasmuch as what Hertz says applies to complaints of the obscurity of the nature of agent causation, it attributes them to the complainers' confused sense that contradictions exist in the relations by which the concept of agent causation is connected to others.

Von Wright intimates that he finds such contradictions by remarking that "Chisholm's notion of 'immanent causation' seems . . . connected with insurmountable difficulties" (p. 191, *n*. 44). What has he in mind? Except for mistaken objections arising from confusions or indefensible demands, the only ones known to me arise from connecting the concept of causing an event with that of an action.[19] According to Chisholm, an action is the making happen of an event (b) by an agent (a). The proposition '$M(a,b)$', in which '. . . M . . .' is a dyadic relational predicate standing for the relation of making happen, therefore exhibits the form of propositions asserting the occurrence of an action. It is tempting to think of such propositions as '$M(a,b)$' as each asserting the existence of a second event in addition to the event b, namely, a's causing of b to happen. If you yield to that temptation, you will not be able to escape postulating a cause for that further event: presumably an agent cause, and presumably the same agent cause as the cause of b. And so you will be committed to a principle that generates an infinite regress: namely, using 'e', 'e_1' as variables ranging over events,

$$(\forall e)\, M(a,e) \rightarrow [(\exists e_1)\, M(a,e_1) \wedge (e \neq e_1)]$$

And if the action of making e happen should now be recognized as the event cause of e, the regress thus generated will plainly be vicious: in order to make any event happen, an agent would have to make an infinite series of distinct causally related events happen. He could cause nothing to happen except by way of an infinite number of distinct causings of causes.

In this line of thought it is assumed that $M(a,e)$ cannot be true unless an event other than e occurs, namely, a's making e happen. But that assumption is false. It is mistakenly made because in most cases of making happen, one event is in fact made to happen by making something else happen.[20] I make the light go on, by making the switch move to its 'on' position, by making my hand move in a certain way. But each such series, as we have seen, terminates in an event that is *not* made to happen by making something else happen. And although we are almost irresistibly tempted to contradict ourselves by thinking even of the first events in such series as happening because other things were made to happen, the point of the theory of agent causation is that we should not; for to say that an agent 'makes happen' the first event in a series of that kind is just to say that *he* and *not some further event*, is its cause. Representing

event causation in terms of power to make happen, that the event c causes the event d (i.e., makes it happen) might be expressed by writing '$M(c,d)$'. Nobody would infer from this that there must be a third event in addition to c and d, namely, the causing of d by c. There is just as little reason, when an agent a and an event b stand in the relation of agent causation, as expressed by the proposition '$M(a,b)$', to infer that there must be a second event in addition to b; namely, the causing of b by a.

Whatever may be the 'insurmountable difficulties' which von Wright believes to be connected with the concept of agent causation, he is far from dismissing that concept out of hand. For he agrees with the 'agent causationists' that action calls for understanding of a kind different from that of the explanation of natural processes. Discussing Chisholm, he even allows that

> One could, if one wished, *call* action 'immanent causation', and thus give this phrase a meaning. But I do not think the notion of immanent causation can be employed to *elucidate* the concept of an action (p. 192, *n.* 44).

In offering this concession, however, he mistakes the situation.

As Wittgenstein revealed by his celebrated problem, "what is left over if I subtract the fact that my arm goes up from the fact that I raise my arm?"[21] there is a mystery in the relation of my raising my arm to its going up, a mystery prolific of philosophical confusions. Were he to content himself with the concept of action as ultimate and *sui generis*, von Wright would incorporate that source of confusion into his fundamental analysis, and would have to resign himself to treating piecemeal the various difficulties that spring from it.

By contrast, analysing the concept of action in terms of agent causation connects it with the concept of power to make happen, the varieties and the relations of which have long been studied, and not always without profit. So analysing it not only yields a solution to Wittgenstein's problem (what is left over is the relational property of having myself as agent cause), but also shows that no action is distinct from whatever event, according to its basic descriptions, is made to happen in doing it; and, in addition, it shows why an event which is found to have been made to happen by an agent—even though it was not by his making anything else happen—is nevertheless thought to have been causally accounted for. Such results go some way to elucidating the concept of an action, and to forestalling philosophical misunderstanding.

IV

To von Wright's implicit question, 'Is the relation of the immediate inner aspect of an action to its immediate outer aspect a causal one?' the analysis of agency developed in the preceding section by itself supplies no answer. To arrive at one, it must be supplemented by an exploration of the relation of

intending to do something, to doing it. This topic von Wright approaches by investigating teleological explanations of action; for he considers the schemata of such explanations to be the schemata of practical inferences 'turned upside down', and practical reasoning characteristically has to do with how intentions are carried out (pp. 96–97).

After reviewing various proposed schemata for practical inference which he shows to be invalid, von Wright offers the following one as 'final':

> From now on A intends to bring about p at time t.
> From now on A considers that, unless he does a no later than at time t^1, he can not bring about p at time t.
> Therefore, no later than when he thinks time t^1 has arrived, A sets himself to do a, unless he forgets about the time or is prevented (p. 107).

In this schema, by way of a second premise about the prospective agent's judgement of his situation, an inference is drawn from what he intends; that is, from the immediate inner aspect of his prospective action, to a conclusion about its immediate outer aspect. For that A's setting himself to do a belongs to the outer aspect of his action is established by von Wright's own gloss:

> Instead of 'sets himself to do' one could say 'embarks on doing' or 'proceeds to doing' or, sometimes, simply 'does' in the conclusion. Setting oneself to do something I thus understand in a way which implies that behavior has been initiated (p. 96).

Is von Wright's final schema valid? Does its conclusion follow from its premises as a practical conclusion should?

Whether or not its conclusion follows, the schema is enthymematic, as is shown by the following completion:

> (1) From now on A intends to bring about p at time t.
> (2) From now on A considers that, unless he does a no later than at time t^1, he can not bring about p at time t.
> (3) Therefore, at some time no later than when he thinks time t^1, has arrived, A intends to do a then and there, unless he forgets about the time or is prevented.
> (4) And therefore, no later than when he thinks time t^1 has arrived, A sets himself to do a, unless he forgets about the time or is prevented.

In this completed version, I take it to be obvious that if (4) follows at all from (1) and (2), it does so because it follows immediately from (3). And I accept the view that (3) follows from the conjunction of (1) and (2). But does (4) follow immediately from (3)?

John Watkins has taken a position which implies that it does not. He quotes an amusing inner monologue from Iris Murdoch's novel *The Bell*, in which a character, Dora is considering whether or not to give up her seat in a crowded train to an old lady:

> She had taken the trouble to arrive early, and surely she ought to be rewarded for this. . . . There was an elementary justice in the first-comers having the seats.

. . . The corridor was full of old ladies anyway, and no one else seemed bothered by this, least of all the old ladies themselves! Dora hated pointless sacrifices. She was tired after her recent emotions and deserved a rest. Besides, it would never do to arrive at her destination exhausted. . . . She decided not to give up her seat. She got up and said to the standing lady, 'Do sit down. . . . '[22]

The novelist's point can be taken, as it is by Watkins, to be that Dora really did intend to remain seated, even as she gave up her seat; or it can be taken to be that Dora's inner monologue, including her conscious 'decision' not to give up her seat, merely accompanied her real process of decision—much as, in plays written for audiences that kept servants, comic servants grumble defiances as they obey unwelcome commands.

Between these positions von Wright attempts to mediate. He concedes that, taken abstractly, "the premises of a practical inference do not with logical necessity entail behavior" (p. 117). But practical inferences are reconstructed in two distinct kinds of explanatory context: those in which behaviour has taken place which accords with the intentions imputed in the reconstruction, and those in which it has not. In contexts of the second kind, as is shown by examples like that of Watkins', in which behaviour is contrary to the imputed intention, von Wright contends that if the agent avows the intention imputed to her and denies changing her mind or forgetting the time, and if there is no evidence that she was prevented from carrying out her intention, then the "only thing which would make us insist upon contradicting her . . . is that we turn the validity of the practical syllogism into a standard for interpreting the situation. This may be reasonable. But there is no logical compulsion here" (p. 117). On the other hand, in cases of the first kind, in which behavior accords with the imputed intention ("when action is already there and a practical argument is constructed to explain or justify it"), sometimes at least the practical inference is logically conclusive. "The necessity of the practical inference schema", von Wright remarks, "is . . . a necessity conceived *ex post actu*" (p. 117).

Yet how can the logical validity of a schema be affected by contexts that do not affect its meaning? The answer von Wright appears to offer is that the context of the schema of practical inference affects the verifiability of the propositions that satisfy it. He argues as follows: In contexts of the first kind, the verification of the conclusion and the verification of the premises are mutually dependent (cf. p. 116). Let us suppose that Dora retained her seat, and that a practical argument had been constructed to explain it along the lines of her inner monologue. With respect to its conclusion that Dora's body remained in a certain posture is evidence that she kept her seat, according to von Wright, only if it can be shown to have been the result of an action, and not, say, of a physical collapse; and of an action, moreover, that was "intentional under the description given to it in [that] conclusion" (p. 115). On the other hand, with

respect to its premiss, that Dora intended then and there to keep her seat can only be established indirectly, by evidence about her behavior. It cannot be directly verified by asking her; for her avowal that she intended keeping her seat would be good evidence only if it were truthful and knowledgeable, and von Wright argues that an avowal can be adjudged truthful only by establishing its utterer's intentions (pp. 112–113).[23]

This line of thought is hard to follow. It is true that if one proposition entails another, then the evidence that verifies the first must also verify the second; but that the converse does not hold seems to follow from cases exactly like those under consideration. Take a pair of true propositions, in which the second is alleged to follow from the first:

(1′) X (in Kew Gardens) is a swan,
(2′) X is white.

These satisfy the schema:

(1) x is a swan,
(2) Therefore, x is white.

But this schema is generally held to be logically invalid because of pairs of true propositions such as:

(1″) Y (on the Swan River, in western Australia) is a swan,
(2″) Y is black.

Let it be conceded that there are contexts—that of (1′) and (2′) may be one—in which the verification of the proposition satisfying (2) and that of the proposition satisfying (1) are mutually dependent, and the proposition satisfying (2) is verified: yet in view of (1″) and (2″), not even in those contexts would the schema '(1) therefore (2)' be logically conclusive. At most, there may be a further unformulated condition (for example, that the swan be a *cygnus olor*) such that, were it to be added to (1), then it would be made logically conclusive.

This conclusion is reinforced by von Wright's analysis of how the conclusion of a practical inference may be shown to be true. The conclusion that Dora kept her seat can be verified, in von Wright's opinion, only by showing that her body's posture in relation to the seat was the result of an action, and that that action was intentional under the description of it implicit in that conclusion, namely, ('Dora's keeping of her seat'.) The implication is that it can be verified that Dora kept her seat only if it can be verified that she did so intentionally.

But that is obviously false. Suppose that Dora had not seen the old lady standing, but had glimpsed somebody in the corridor she wished not to encounter, and so buried her face in a newspaper and devoted all her attention to making herself inconspicuous. A consequence of her efforts was that she re-

mained in her seat without thinking about it, and so without any intention of doing so at all. Would it be impossible to verify that she, without intending to, kept her seat?

Although there are complex actions which it would be virtually impossible to do except intentionally—to make a speech, to go through the ceremony of marriage, or to play a game of tennis—most actions that do not consist in a complicated sequence of simpler actions can be done either intentionally or not intentionally, and that such actions have been done can be established both when they are intentional and when they are not. The truth underlying von Wright's mistake is one which has been forcibly argued by Davidson, that the bringing about of an event is an action (and hence can be shown to be one) only if it is intentional *under some description or other.*[24] But that truth implies no more than that the action described in the conclusion of a practical inference can be shown to have been performed, *either* by showing that it was intentional under the description in that conclusion, *or* by showing that it satisfies some other description under which it was intentional. That Dora's keeping her seat was an action, although perhaps not an intentional one, may be established by showing that she was intentionally doing something or other, with the consequence that her position in her seat was not changed. And if that is so, it is possible to verify the conclusions of some practical inferences without verifying their premises.

It follows that perfectly accurate reports of an action, even though they report it as an action—that is, as intentional under some description or other—may give practitioners of the *Geisteswissenschaften* no indication at all of the description under which that action was in fact intended, and so may afford no hint as to which of the various possible reconstructions of the practical reasoning that gave rise to it is in fact true. Unfortunately, von Wright says very little about how historians and social scientists decide between alternative possible teleological explanations of the same action.[25] But that should not surprise us. For if it were true, as he maintains, that the verification of the conclusion of a teleological explanation and the verification if its premises are mutually dependent, there would be no problem at all of deciding between alternative explanations.

Once it is recognized that deciding between putative explanations is as much a problem in the *Geisteswissenschaften* as in the *Naturwissenschaften,* the answer to another question raised by von Wright becomes clearer. As we have seen, after mentioning the possibility that we should turn the validity of the practical syllogism into a standard for interpreting intentional action, he remarks, "This may be reasonable. But there is no logical compulsion here" (p. 117). Why may it be reasonable? Well, a putative *explanans* cannot be tested by specific evidence as yet undiscovered, unless one can deduce from it, together with other truths established or assumed, whether that evidence would be consistent or inconsistent with it. In other words, unless the conclusion of a

practical inference follows with logical necessity from its premises, there would be no way of disconfirming any putative teleological explanation. It is not from dogmatism that one must insist that the explanatory schemata of the *Geisteswissenschaften* must be logically conclusive, but from methodological necessity. Hence, unless von Wright's schema of practical inference is logically conclusive, it cannot serve as the fundamental explanatory schema of the *Geisteswissenschaften*. Would it be dogmatic to maintain that it is logically conclusive?

It is difficult to answer this question, because the word 'intend' and its cognates are used in a variety of ways, in some of which von Wright's schema would certainly be invalid. True, there are analyses according to which it would be valid: for example Davidson's, according to which 'pure' intending, as opposed to conditional intending, is distinguished from all other pro-attitudes as being one that tends immediately to cause action.[26] However, this is not the place to canvass the various analyses of intending that may be seriously advanced. It must suffice to consider the one that arises most directly from the analysis of action in the preceding section.

If an action is both an event, the making happen of which is intentional under some description, and an event the cause of which is an agent (and not another event), it is natural to conclude that an agent causes an event only inasmuch as he thinks of it as falling under some description. His so thinking of it is, of course, a (mental) event, but it does not cause the happening of the event of which he thinks; for that would imply that, having thought about that event, the agent could not have forborne to make it happen; and he could have. The agent's thought is related to the event he makes happen, not as cause to effect, but as plan to execution. The making of a plan does not cause its maker even to adopt it, much less to execute it. Intending to make something happen is adopting a plan, however rudimentary, to make it happen. In a measure as the plan is practicable, adopting it will (unless the agent changes his mind) lead to executing it, and so to making happen all those consequences, foreseen and unforeseen, which its execution will cause. In a measure as it is impracticable, adopting it will lead to a miscarriage and to all the consequences that will cause.

It follows that, unless he has lost the power to act (for example, by paralysis or hypnosis), an agent who intends here and now to perform a certain action under a basic description must thereby carry out his intention. If he retains his normal powers, there is no room for his action to miscarry. Since the conclusion in von Wright's schema asserts no more than that the agent 'sets himself' to do what he intends, our analysis supports the position that it logically follows from its premises.

CALIFORNIA INSTITUTE OF TECHNOLOGY ALAN DONAGAN
JULY 1975

NOTES

1. *Explanation,* p. 5, citing Wilhelm Windelband, 'Geschichte und Naturwissenschaft', reprinted in *Praeludien,* vol. 2, (Tubingen: J. C. B. Mohr, 5th ed. 1915), 136–160.

2. He describes Gasking's 'Causation and Recipes' (*Mind* 64, 1955: 479–487) as containing "the position most similar to mine which I have found in the literature" (pp. 189–190). He also mentions R. G. Collingwood's "notion of the cause as 'handle' " in *An Essay on Metaphysics* (Oxford: Clarendon, 1940), p. 296.

3. R. G. Collingwood, *The Idea of Nature* (Oxford: Clarendon, 1945), p. 177.

4. Two pioneering studies to which von Wright acknowledges special debts are G. E. M. Anscombe *Intention* (Oxford: Blackwell, 1st ed., 1957, 2nd ed. 1963) and Arthur C. Danto, 'What Can We Do?', *Journal of Philosophy* 60 (1963): 435–445, and 'Basic Action', *American Philosophical Quarterly* 2 (1965): 141–48.

5. Von Wright cites no papers of Davidson's later than 1967; but his results may be usefully compared with those of Davidson in 'Agency', in *Agent Action and Reason,* edited by Robert Binkley et al. (Toronto: University of Toronto Press, 1971), 3–25.

6. Such cases have been investigated by Hugh McCann in 'Volition and Basic Action, *Philosophical Review* 83 (1974): 451–473; and 'Trying, Paralysis, and Volition', *Review of Metaphysics* 28 (1974–1975): 423–442.

7. Danto, *Journal of Philosophy* 60 (1963): 435–445.

8. Davidson in Binkley and others, *Agent, Action, and Reason,* p. 23.

9. This is inadequate; for non-basic descriptions may be constructed not only by taking account of an action's effects (causal generation), but also by taking account of its circumstances (simple or circumstantial generation), including the conventions in force for its doer and those affected by it (conventional generation). The fundamental treatment of those topics, although unfortunately in terms of what he calls 'act-tokens' and not of descriptions, is by Alvin Goldman, *A Theory of Human Action* (Englewood Cliffs, N.J.: Prentice Hall, 1970), ch. 2.

10. Descartes, *Les Passions de l'Ame,* I, 44. Cf. R. M. Chisholm, 'Freedom and Action', in *Freedom and Determinism,* edited by Keith Lehrer (New York: Random House, 1966), esp. 18–20, 34–36, 43–44.

11. Descartes, *Les Passions de l'Ame,* I, 41, 43.

12. Anscombe, *Intention,* 41–43.

13. Davidson in *Agent Action and Reason,* p. 14; cf. 11–15. Davidson's implicit formula is: *a,* in *K*-ing, moves his body in just the way required for *K*-ing (cf. p. 13).

14. Chisholm, in Lehrer, *Freedom and Determinism,* 11–25. I have taken this paper as my point of departure, although Chisholm has developed the ideas in it in a number of subsequent papers.

15. My exposition inverts the order of Chisholm's, and begins with p. 22. The expression 'power to make happen' is mine: Chisholm prefers "causal efficacy" and Reid's "power to produce certain effects". I have also drawn upon Richard Taylor, to whom Chisholm acknowledges a debt: see Richard Taylor, *Metaphysics* (Englewood Cliffs, N.J.: Prentice Hall, 1963) ch. 4, and *Action and Purpose* (Englewood Cliffs, N.J.: Prentice Hall, 1966), chs. 2–4. Although their conclusions diverge, Chisholm also acknowledges a debt to A.I. Melden, *Free Action* (London: Routledge, 1961), ch. 3.

16. Irving Thalberg, *Enigmas of Agency* (London: Allen and Unwin, 1972), 35–47.

17. Chisholm, in Lehrer, *Freedom and Determinism,* 22.

18. Heinrich Hertz, *The Principles of Mechanics,* translated by Jones and Walley (New York: Dover, 1956), 7–8.

19. For the seeds of these difficulties see John Locke, *An Essay concerning Human Understanding,* II, 21, 1–34. I have drawn heavily upon the writings of Davidson, Goldman, and Thalberg already cited, on Wilfrid Sellars' extensive contributions to action theory (for a bibliography see *Action, Knowledge and Reality, Essays in Honor of Wilfrid Sellars,* edited by H. N. Castaneda [Indianapolis: Bobbs-Merrill, 1975]), and on Arthur C. Danto *Analytical Philosophy of Action* (Cambridge: Cambridge University Press, 1973), ch. 3, to reach conclusions none of them would approve.

20. As is shown by Max Black's investigation of a normal case, 'Making Something Happen', in Max Black, *Models and Metaphors* (Ithaca, N.Y.: Cornell University Press, 1962), pp. 153–169.

21. Wittgenstein, *Philosophical Investigations,* translated by G. E. M. Anscombe (3rd ed., Oxford: Blackwell, 1967), I, 621.

22. John Watkins, in *Explanation in the Behavioural Sciences* edited by R. Borger and F. Cioffi (Cambridge: Cambridge University Press, 1970), 229.

23. Von Wright also argues that knowledge of my own intentions, even when immediate, "is . . . of no use for verifying the premises of a practical inference" because it "is not based on reflection about myself . . . but *is* the intentionality of my behavior" and so "is itself the very thing which must be established" (p. 114). Since I do not understand how my intentions can be the same as my immediate knowledge of them, I do not find this argument persuasive, but it is superfluous in discussions of knowledge of others' intentions.

24. Davidson, in *Agent Action and Reason,* pp. 5–8.

25. I have discussed some of the issues that arise in 'Alternative Historical Explanations and their Verification', *Monist* 53 (1969): 58–89.

26. Davidson has expounded this view in a forthcoming paper, 'Intending'; his argument is partly anticipated in his 'How is Weakness of the Will Possible?' in *Moral Concepts* edited by Joel Feinberg (London: Oxford University Press, 1969): pp. 93–113, esp. 109–111.

15

Norman Malcolm

INTENTION AND BEHAVIOR

I

In *Explanation and Understanding*,[1] Georg Henrik von Wright studies a perplexing problem about the nature of the relationship that holds between intentions (or rather, intentions and beliefs), on the one hand, and behavior (actions) on the other. Put crudely, the problem is whether intentions and beliefs *cause* actions. Stated just like that no real problem appears, since obviously it is often right to say that a person's doing a certain thing is caused by a particular intention and belief of his. For example, the cause of Robinson's staying away from the bar he formerly frequented is his intention to stay sober, together with his belief that if he goes back to the bar he will get drunk.

The problem acquires a bite when a particular model of this causal relation is proposed. According to one well-known tradition, every genuine causal explanation conforms to what is called the 'deductive-nomological' or the 'covering law' model. The schema of this model of causal explanation, as expounded by von Wright,[2] is the following: Let E be an event, or state of something, the occurrence of which we want to have explained. To arrive at an explanation we should need to learn of some other events or states, A_1, . . ., A_n, and also of some causal laws, L_1, . . ., L_n, such that the occurrence of E is logically deducible from the existence of the laws, together with the fact that those other events or states did occur. The events or states, A_1, . . ., A_n, I shall call 'antecedents' of E, without implying that they could not be simultaneous with E, and without taking up the question (raised by von Wright), as to whether it is possible that there should be cases in which an effect *preceded* its cause.[3] The laws, L_1, . . ., L_n, are the so-called 'covering laws' under which the causal explanation subsumes the causal antecedents, A_1, . . ., A_n, and their effect, E. The explanatory force of a causal explanation that accords with the covering law model would consist in its showing that if those antecedents did occur, and if those 'laws' are genuine laws, then E *had* to occur; that is, it was logically impossible that E should not have occurred.[4]

As said, it happens often enough that we speak of a person's intentions (or desires or motives) and his beliefs, as causing some action of his. A much disputed question is whether causal explanations of this kind conform to the covering law model. The view that answers this question in the affirmative I shall, following von Wright, call the 'causalist' position. There is a contrary view, called the 'intentionalist' position—according to which causal explanations of the kind mentioned do not conform to the covering law model. The reason for this, according to the intentionalist position, is that desires, intentions, beliefs, and so on, cannot be properly regarded as antecedents in causal explanations of the covering law type, since when desires, intentions, etc., do explain actions, they are not 'logically independent' of the actions they explain.

This notion of 'logical independence' has been surrounded by a good deal of confusion. The idea that a *cause* and its *effect* are 'logically independent' derives mainly from Hume, who said the following things:

> And as the power, by which one object produces another, is never discoverable merely from their idea, 'tis evident *cause* and *effect* are relations, of which we receive information from experience, and not from any abstract reasoning or reflexion. There is no single phaenomenon, even the most simple, which can be accounted for from the qualities of the objects, as they appear to us; or which we cou'd forsee without the help of our memory and experience.[5]
>
> There is no object, which implies the existence of any other if we consider these objects in themselves, and never look beyond the ideas which we form of them.[6]
>
> Reason can never shew us the connexion of one object with another, tho' aided by experience, and the observation of their constant conjunction in all past instances.[7]
>
> Reason can never satisfy us that the existence of any one object does ever imply that of another. . . .[8]
>
> There are no objects, which by the mere survey, without consulting experience, we can determine to be the causes of any other; and no objects, which we can certainly determine in the same manner not to be the causes. Any thing may produce any thing.[9]
>
> Every effect is a distinct event from its cause. It could not, therefore, be discovered in the cause. . . .[10]

The covering law model of causal explanation appears to embrace Hume's view that the existence of a cause does not 'imply' the existence of its effect. The 'connection' between a cause and its effect is provided *solely* by the law or laws under which cause and effect are subsumed. Some writers have employed the expression 'Humean causation' or 'Humean causal relation' to specify a causal relation in which there is no 'logical' or 'conceptual' connection between cause and effect. Melden, for example, says that when he speaks of something, A, as a 'Humean cause' of something, B, he is stipulating that A and B "are logically independent of one another".[11] And he declares that a person's motive for doing X, or his intention in doing X, is not a Humean

cause of his doing X, because this requirement of logical independence is not satisfied. Von Wright says: "A causal relation which satisfies this requirement of logical independence between its terms I shall call *humean*."[12] He thinks that these philosophers who contend that the connection between intention and behavior "is a logical relation and therefore not in the humean sense a causal relation", are "substantially right"; but he also thinks that this view has remained obscure, and he seeks to clarify it by expounding what he calls "the Logical Connection Argument".[13]

How should we understand the expression 'logical independence'? Von Wright wishes to employ it in a precise sense. Restricting his discussion to singular, contingent propositions, he seems to assume the following definition of 'logical independence' in respect to any two propositions, p and q: p and q are logically independent of one another if and only if none of the combinations, $p \& q$, $-p \& q$, $p \& -q$, $-p \& -q$, is a logical impossibility. In other words, p and q are logically independent if and only if they neither entail nor contradict one another. This definition is not explicitly stated by von Wright, but is implied by the following remarks:

> In order to show that two singular propositions, p and q, are not logically independent, one has to show that at least one of the four combinations, $p \& q$, $-p \& q$, $p \& -q$, $-p \& -q$, is a logical impossibility. The mere fact that it is logically impossible to verify, or falsify, the one proposition without also verifying, or falsifying, the other one does not entail that the two propositions are logically independent *(sic)*. Only in combination with the further thesis that it must be *logically* possible to come to know the truth-value of, i.e., to verify or falsify, any singular contingent proposition does it follow that the propositions are independent *(sic)*. I consider this view of the relation of verifiability and propositional meaning acceptable, but I shall not argue for it here.[14]

Despite the two typographical errors, it is pretty clear that von Wright assumes the definition of 'logical independence' that I stated. He goes on to study the relationship between the premisses and the conclusion of the so-called 'practical syllogism', or 'practical inference', or 'practical argument', in order to determine whether the premisses and the conclusion are logically independent. He arrives at the view that when the premisses of a practical argument are adequately formulated and the conclusion correctly interpreted, then (with a very important qualification, to be discussed) the premisses do entail the conclusion.[15] That is to say, it is logically impossible that the premisses should be true and the conclusion false. If this is correct, there is a very tight logical dependence between premisses and conclusion. My first aim in the present essay will be to argue that there is indeed a 'logical' or 'conceptual' dependence, but that this is a looser bond than von Wright thinks. My second aim will be to criticize a recent thesis that attempts to reconcile the causalist and intentionalist positions.

II

I begin by noting certain features of von Wright's way of presenting the prem-
isses and conclusion of a practical argument. His aim is to show that they are
logically dependent. In terms of his own definition of 'logical independence',
to say that premisses and conclusion are *not* logically independent will mean
either that the premisses entail the conclusion, that the latter entails the prem-
isses, or that there is a mutual entailment. I will concentrate on the question of
whether the premisses entail the conclusion.

The main concepts that von Wright brings into the premisses are *intention*
and *belief*. He does not attempt to study the conceptual connections, if any,
between desires, motives, wants, decisions, or reasons, on the one hand, and
actions on the other.[16] I will follow him in this.

In his book von Wright says, surprisingly, that a practical argument is a
"logically conclusive argument" *only* when the action referred to in the con-
clusion has already occurred.[17] In a subsequent article[18] he distinguishes be-
tween the "retrospective" and the "prospective" uses of practical inference.
In the retrospective case we start from the fact that an agent *has done* a certain
thing, and we construct premisses to explain why he did it, or to justify his
having done it. In the prospective case we anticipate that an agent *will do* a
certain thing, and we construct premisses to explain or justify his doing it. In
the article von Wright says that, in the retrospective case, if the premisses were
true then it "was logically bound to happen" that the agent would do, or try
to do, the act described in the conclusion; whereas in the prospective case "we
have no logical guarantee" concerning what the agent will do.[19]

My first aim will be to try to determine whether the premisses of a correctly
formulated practical argument do *entail* the conclusion. I will fix my attention
on the retrospective case, since it is only in this case, according to von Wright,
that the entailment holds. Since the retrospective case deals with past action
both the premisses and the conclusion of a retrospective practical argument
should be formulated in the past tense.

It is convenient to think of a practical argument as having two premisses,
one with a component of intention, the other with a component of belief (or
knowledge, or realization). The schema of a retrospective practical argument
may be presented as follows:

1. A person, X, had the intention of bringing about a certain state of affairs, S, by
 a particular time, t.
2. X believed (knew, realized) that unless he did something, A, at time t', he
 would not be able to bring about S by time t; and X knew that t' had arrived.
 Therefore, X did A at t'.

To give an example, suppose that there is a convict (call him "R") who was
being transported across Lake Cayuga by motor launch in the custody of prison

guards. Just as the boat passed Bolton Point, R fell over the side of the boat. Subsequently an explanation is demanded for this occurrence, and the following practical argument is proffered:

1. R intended to escape before the boat landed.
2. R believed he could not escape unless he fell over the side at Bolton Point; and he knew the boat was at Bolton Point.
 Therefore, R fell over the side.

Is this a 'logically conclusive' argument? Obviously not. We can think of a number of circumstances in which those premises would be true but the conclusion false. For example: Brooding over his lot, R momentarily forgot his intention to go overboard at Bolton Point, or even failed to remember his intention to escape; or due to a temporary dizziness he was physically incapable of standing up in order to topple over the rail; or R was prevented from going over the side, e.g., he was chained to the deck, or the guard rail was too high; and so on.

Von Wright seeks to eliminate such contingencies by suitably modifying and amplifying the premises and the conclusion in his schema of the practical argument. What he does, in effect, is to stipulate that the agent, R, was physically able to do A at t', and that nothing prevented him from doing it, and that R did not forget, even momentarily, that it was necessary for him to do A at t'.[20] And although von Wright does not make an express stipulation, he certainly wants it understood that R did not forget his intention to bring about S.[21]

I will reformulate my example in order to include these stipulations. I will consider them to be a set of conditions constituting a third premiss, rather than as modifications of the conclusion (this latter being how von Wright handles at least some of them). The supplemented practical argument concerning the convict, R, may be presented as follows:

1. R intended to escape before the boat landed.
2. R believed he could not escape unless he fell over the side at Bolton Point; and he knew the boat was at Bolton Point.
3. R was able to fall over the side; nothing physically prevented or mentally inhibited him from doing it; he did not forget his intention to escape; nor did he forget that unless he fell over the side at Bolton Point he would not be able to escape; nor was he momentarily distracted.
 Therefore, R fell over the side at Bolton Point.

Is this a 'logically conclusive' argument? I do not see that it is. I think that if we believed everything about R that is stated in the three premises we would not *understand* how R could have failed to go over the side. But from this it does not follow that the premises *entail* the conclusion.

In his book von Wright seems to concede this. He imagines a situation in which a man is resolved to assassinate a 'tyrant', but when the moment of opportunity arrives he does not pull the trigger. There is no evidence that any-

thing, physical or mental, prevented him from carrying out his intention. He swears, we may suppose, that he did not give up his intention or revise his plan. Presumably he does not himself understand why he did not shoot the tyrant. Von Wright says, "If this sort of case can be imagined, it shows that the conclusion of a practical inference does not follow with logical necessity from the premises. To insist that it does would be dogmatism."[22] He goes on to draw a conclusion that I find puzzling:

> Thus, despite the truth of the Logical Connection Argument, the premises of a practical inference do *not* with logical necessity entail behavior. They do not entail the 'existence' of a conclusion to match them. The syllogism when leading up to action is 'practical' and not a piece of logical demonstration. It is only when action is already there and a practical argument is constructed to explain or justify it that we have a logically conclusive argument. The necessity of the practical inference schema is, one could say, a necessity conceived *ex post actu*.[23]

Von Wright seems to be saying that when the action described in the conclusion has occurred ("is already there"), and we are trying to explain why it occurred, then the practical argument *is* logically conclusive.

What does it mean to say that the "action is already there"? It can only mean that the conclusion of the retrospective practical argument is *true*. In my imaginary case it means that R did in fact fall over the side of the boat at Bolton Point; in von Wright's imaginary case, that the assassin did in fact shoot the tyrant. But what is the relevance of this to the question of the logical validity of the practical argument? None, that I can see. If it is uncertain whether the premises entail the conclusion, the fact that the latter is true does nothing to remove the uncertainty. If the premises were true and the conclusion false, then for sure the premises would not entail the conclusion. If, instead of being false, the conclusion is true, this does not guarantee the logical validity of the inference.

I can think of only one explanation of why someone might suppose that the stipulation that the conclusion is true does provide such a guarantee. In stipulating that "the action is already there", one might be regarding the occurrence of the action as part of the *data* of the inference. That is, one might be half-consciously, thinking of the fact that the action did occur as belonging to the *premisses* of the practical argument. If the conclusion of the practical argument was thus included in the premisses then, of course, the inference would be logically conclusive; but it would also be trivial. I am reluctant to attribute this confusion to von Wright.

In his later article von Wright says the following about the use of a practical argument in a retrospective case:

> That the agent did or tried to do *A* is not called into question and is, moreover, something that was logically bound to happen, assuming that the teleological

frame, the intention and the epistemic attitude which the premises attribute to him, lasted up to the moment of action. For, granting the truth of this assumption, the premises then set the conditions for *interpreting* what happened.[24]

Here again I am perplexed by von Wright's remarks. It is one thing to say that, in the retrospective case, "it is not called into question" that the agent did or tried to do *A;* it is another thing to say that it was "logically bound to happen" that the agent did *A* or tried to do *A*. I can only understand this latter remark to mean that in the retrospective case the premises of the practical argument *entail* the conclusion. I do not believe that this is clearly right. Going back to my second, three-premissed formulation of the practical argument concerning the convict, I am assuming that "the teleological frame, the intention and the epistemic attitude which the premises attribute to him," *did* last "up to the moment of action". I also assume that *R* did fall over the side of the launch at Bolton Point. But I fail to see any clear-cut logical contradiction in the supposition that those very premises *might* have been true, just as they were, and yet *R might* neither have fallen over the side nor have tried to fall over the side.

In the last quoted remarks of von Wright's he seems to be offering a reason for saying that the premises of the practical argument do entail the conclusion. He says that if it is assumed that the intention, belief, and all the rest, that the premisses attribute to the agent, "lasted up to the moment of action," then the action was "logically bound" to occur. Why is this? Because, von Wright says, "the premises then set the conditions for *interpreting* what happened." I am not sure that I know exactly what this means, but I think I do. It means, I believe, that we would *understand* the occurrence of *R*'s falling over the side *in the light* of the intention, belief, and other things that are attributed to *R* in the three premises.

I do not wish to dispute that point. But I do fail to see how this provides a reason for holding that the premisses entail the conclusion. Given that *R* did go over the side, and given that we believe everything in the three premisses, then it is at least very likely that we would *interpret* what happened in terms of the facts mentioned in the premisses. Almost certainly we would think that in going over the side *R* was attempting to escape.

Still, this consideration seems to be irrelevant to the question of whether the premisses entail the conclusion. Supposing it is true that we would interpret the incident as an attempt to escape. How does this determine an answer to the problem of whether the practical argument is logically conclusive? The facts stated in the premisses would indeed provide an adequate explanation of why *R* fell over the side at Bolton Point, adequate, that is, for a court of inquiry, a coroner's inquest, or an insurance investigation;—but inadequate, of course, for a neurophysiological investigation. But however adequate the explanation

for certain purposes, do the facts stated in the premisses *entail* that R did fall over the side? To put the question in an equivalent way: Is the conjunction formed out of these premisses *and* the proposition that R did *not* fall over the side, a self-contradictory proposition? Whether R did or did not fall over the side, does not help us to answer that question.

We have already noted how von Wright says in his book, *both* that "the premisses of a practical inference do *not* with logical necessity entail behavior," *and* that when the behavior in question has in fact occurred ("when action is already there") and an argument is constructed to explain it, then we *do* have "a logically conclusive argument." Presumably von Wright was thinking that the practical argument is not logically conclusive in general, but is logically conclusive in the retrospective case. We have seen that this cannot be correct. The logical validity of the argument is not affected by the question of whether or not the action has occurred.

<h1 style="text-align:center">III</h1>

I wish now to give an account of what the actual state of affairs is, in regard to the question of whether the three premisses, in my example, do or do not entail the conclusion. We certainly do have a strong inclination to feel that *if* it had turned out that R did not go over the side, then *something* stated in the premisses would not have been true. R's resolve to escape must have weakened. Or R must not have fully realized that the launch was at Bolton Point. Or he must have become frightened by the riskiness of his planned action, and lost his nerve. Or he must have decided that Bolton Point was not, after all, the best place to make the attempt. Or his attention was momentarily distracted by something or other. Or he suffered a 'psychological block.' Or . . .

Suppose, however, there was absolutely no evidence that any of these things were true. Let us suppose that R has a friend, K, also a convict, who knew of R's determination to escape and of his full plan. We will suppose that R did not go over the side, and that K is surprised and wants an explanation. K knows that R is a fearless, resolute man; he cannot believe that R would have lost his nerve. In a subsequent talk between them, R declares in all candor that he did not change his plan in any way, or become frightened or distracted, and that he had been fully aware that the launch was exactly at Bolton Point. R says there was no kind of physical obstacle: he did not discover, for example, that his limbs would not move. R confesses that he *just does not know* why he failed to go over the side.

If we heard all of this, we should be inclined to think that R had suffered some sort of 'mental block' or 'unconscious inhibition'. Suppose that K has the same thought and persuades R to visit the prison psychiatrist. Yet extensive

psychiatric testing, employing the best techniques, discloses no 'block' or inhibition that would help to explain R's strange failure to act: for example, no unconscious fear of falling into the water, nor any unconscious feeling of guilt about escaping comes to light.

On learning of these negative results, we might insist that R *must* have had some mental resistance, whether or not any evidence of it will ever appear. If we thought in that way, it would mean that we were insisting that the premisses of the practical argument do entail the conclusion. As von Wright nicely states the matter, we should be accepting the validity of the practical argument as "a standard for interpreting the situation".[25] And von Wright adds:

> This may be reasonable. But there is no logical compulsion here. We could just as well say: if this sort of case [his example of the assassin] can be imagined, it shows that the conclusion of a practical inference does not follow with logical necessity from the premises. To insist that it does would be dogmatism.[26]

These remarks seem to me to be exactly right. I regret that von Wright went on to the further statement (which I have argued to be a mistake) that when the conclusion of a retrospective practical argument is *true* ("when action is already there"), then we *do* have "a logically conclusive argument".

It is unquestionable that the three premisses of the argument concerning the convict push us *hard* towards the conclusion, so hard that when we consider the possibility that the conclusion *might* have have been false, i.e., that the action *might* not have occurred, we are strongly inclined to feel that in that event something stated in the premisses would have been false. Yet, on the other hand, when we consider the possibility that the most thorough investigation we could imagine might fail to reveal that anything stated in the premisses was in fact false, then we have an inclination to feel that the premisses do not definitely *entail* the conclusion.

I believe the true upshot is that the logical connection between premisses and conclusion of a practical argument is not absolutely tight, as it is in a so-called 'proof syllogism'. To put the point in a way that may seem absurd, but really is not, we could say that the premisses of a practical syllogism *almost* entail the conclusion. The truth of the premisses does not exclude with perfect definiteness and sharpness, the falsity of the conclusion.

This less than tight connection between premisses and conclusion is still, of course, a 'conceptual' or 'logical' connection. Just our understanding of the concepts of intention and belief would lead us to *expect* that if the premisses were true than the conclusion would be true. If we believed the premisses, we should be justified in believing the conclusion. The premisses could be said to "imply" the conclusion, solely on the basis of the meaning of the language in which both premisses and conclusion are stated. But this 'implication' I believe, does not attain the rigidity of an entailment.

We are, as it were, pulled in opposite directions. We are strongly drawn towards the assumption that there would have to be some falsity in the premisses in order for the conclusion to be false; yet when we reflect on the possibility that careful inquiry might not reveal any hidden countervailing factors nor any falsity of any sort in the premisses, we are not averse to thinking that the logic of the language is not airtight here; and although we should not *understand* how the conclusion could be false, yet that it might be false cannot be dismissed as *logically impossible*.

I will now proceed to a somewhat different question. Let us suppose that the convict actually did fall over the side of the boat, and that the question subsequently raised is whether he fell over the side intentionally. Von Wright says that in order to verify that a man did a certain thing intentionally, we must "establish the intentional character of the behavior": we need to find out what the man was aiming at in doing that thing, and perhaps also what beliefs he had about means and ends.[27] "And this means," says von Wright, "that the burden of verification is shifted from the verification of the conclusion to that of the premises of a practical influence."[28] He continues: "The verification of the conclusion of a practical argument presupposes that we can verify a correlated set of premises which *entail logically* that the behavior observed to have occurred is *intentional* under the description given to it in the premises."[29] I shall assume that von Wright is correct in holding that in order to verify that a person did a certain thing intentionally, it is necessary to verify a set of propositions that could serve as the adequately formulated premises of a practical argument. But will those propositions *entail* the conclusion that the person did the thing intentionally?

Let us consider this question by returning to the example of the convict, and let us alter the conclusion from the proposition that R fell over the side to the proposition that R fell over the side *intentionally*. Do the three unaltered premisses of our previous practical argument *entail* the new conclusion? An obvious objection is that if those three premisses do not entail the proposition that R fell over the side, then *a fortiori* they do not entail the proposition that he fell over the side intentionally.

But let us waive this consideration and, since we are stipulating that R did fall over the side, let us add this latter proposition as a *fourth premiss* of the practical argument. I think it is still not definitely correct to say that the four premisses entail the proposition that R fell over the side at Bolton Point *intentionally*. I agree that we should regard the information contained in the premisses as a perfectly convincing verification, or proof, that R did fall over the side intentionally, and that his purpose was to escape. But we often accept information as verifying or as proving a certain conclusion, without requiring that the information *entail* that conclusion. Given all the information in the

premisses concerning *R*, a warden or judge would not take seriously the suggestion that perhaps, despite all that, *R* may have fallen overboard accidentally. But if a logician were to say that it nevertheless does not follow "with logical necessity" from that information that *R* fell overboard intentionally, how could he be proved wrong? I do not believe any plausible definitions of the key terms could be provided, such that the substitution of definitions would make the inference *formally* valid. And if we look at the language of the practical argument, just as it stands, then surely it will not be generally obvious to native speakers that a flatly self-contradictory proposition would result from conjoining those four premisses with the proposition that *R* did *not* fall over the side *intentionally*.

I am trying to distinguish between two types of *unintelligibility*. By accepting all of the information in the four premisses we should have forestalled any possible *explanation* of why *R*'s going over the side might not have been intentional. Any *ground* for supposing that *R* may not have done it intentionally has been cancelled out by the various clauses of the premisses. If there is some possible ground I have overlooked, it too can be eliminated by the addition of a suitable clause to the premisses. In constructing an example of a practical argument, my aim has been to eliminate every thinkable explanation for the falsity of the conclusion. I believe this was also von Wright's aim as he framed, by successive modifications and additions, his schema of practical argument. Let it be assumed that in both cases the aim was realized. Thus we are presented with a schema of practical argument, and a concrete example of a practical argument, in which every possibility of explaining or understanding the falsity of the conclusion has been eliminated. It would be thoroughly *unreasonable* to accept the premisses but to doubt or deny the conclusion.

That is the first type of unintelligibility. It consists in the fact that within the framework of practical reasoning (a framework that deals in motives, intentions, beliefs, abilities, distractions, forgetting, moods, emotions, etc.) it would be impossible to *understand* how the conclusion could be false. The second way in which it would be unintelligible that the conclusion should be false would consist in the fact that the premisses were true and also entailed the conclusion. What seems to me to be the case is that in an adequately formulated practical argument, the falsity of the conclusion is 'unintelligible' in the first sense, but not in the second. My main difference with von Wright is that I make this distinction but he does not. His Logical Connection Argument does show, to my satisfaction, that a conclusive verification of the premisses of a practical argument would provide a conclusive verification of the conclusion, whether the latter is of the form '*R* did *A*' or of the form '*R* did *A* intentionally'. His Logical Connection Argument also shows that, given the truth of the premisses, the falsity of the conclusion would be unintelligible, in the first

sense. Where he is wrong, I believe, is in thinking that his Logical Connection Argument shows that, in the retrospective case, the premises entail (logically imply) the conclusion.

Despite this disagreement with von Wright, I do accept his view that the premises and the conclusion are not 'logically independent'. Their relationship is 'conceptual': that is, it is a relationship of meaning. Given that the premises were known by us to be true, we should count on the conclusion as being true, and it would be unreasonable to think otherwise. If we are reliably informed that N intends to bring about a certain state of affairs and also believes that doing A is necessary to achieve this, we are entitled to think that in the absence of countervailing factors, N will do A. If anyone thought, on the basis of the same information, that we are entitled to believe *just the opposite,* this would reveal that he had not understood the meaning of what he was told. Suppose we are setting the table for dinner. We ask, 'Will N be coming to dinner?' Someone replies, 'He intends to eat dinner with us.' On hearing this we proceed to set a place for N. This would be an appropriate response to that information. If instead our response was to say, 'Oh, then we needn't set a place for him,' our informant would know he had been misunderstood.

Roughly speaking, we do not ascribe to a person the intention to do a certain thing unless we expect him to do it. That is a feature of the concept of intention. If inexplicable non-performances were other than extremely rare, this expectation would be destroyed, and consequently we could no longer apply the concept of intention to that person. We should cease to place reliance upon his expressions of intention. We should be unable to enter into engagements with him, since we could not count on his performance, even in the absence of countervailing factors. It might even be difficult to regard him as a fellow human being. Thus there is a deep relation of meaning between sentences of the form 'He intends to do A' and sentences of the form 'He will do A'. This relation is 'conceptual' (pertaining to how we think and act) and also 'logical' (pertaining to the 'logical grammar' of the language in which we think). The strength of this relation is illuminatingly revealed in the practical syllogism. This connection of meaning is so strong that we are even *inclined* to feel that the premises of the practical syllogism really entail the conclusion. But, on the other hand, further reflection will leave us uneasy on this point: we are not ready to affirm, with complete assurance, that it is definitely self-contradictory (as it is in the proof syllogism) to affirm the premises and deny the conclusion. Previously I described this somewhat ambiguous relationship by saying that the premises *almost* entail the conclusion. I will call this logical connection, which holds between the premises and the conclusion of a practical argument 'semi-entailment'. Although semi-entailment is a weaker relation than entailment, still it is a form of logical dependence between propositions.

IV

Assuming that there is the kind of logical dependence I have attempted to describe, between the adequately formulated premises and the conclusion of a practical argument, can it also be true that the intention and belief ascribed to the agent by those premises should stand in a Humean causal relation to the action ascribed to the agent by the conclusion? A number of philosophers think so. David Armstrong, in speaking of the relation of intention to behavior, says: "The intention is an inner cause of a certain sort of response. . . ."[30] Armstrong stipulates that the causal relation he is referring to here, is a Humean causal relation, in the sense of requiring the logical independence of cause and effect: "I will assume that the cause and its effect are 'distinct existences', so that the existence of the cause does not logically imply the existence of the effect, or *vice-versa*".[31] Armstrong further assumes that "if a sequence is a causal one, then it is a sequence that falls under some law."[32] The law, however, may not be known; and even the description of the sequence, in terms of which the law would be stated, may not be known. Armstrong says: "In speaking of the sequence as a causal sequence, we imply that there is *some* description of the situation (not necessarily known to us) that falls under a law."[33]

So Armstrong holds that intentions are states that cause behavior, in the Humean mode of causation. But he *also* holds that intentions are connected conceptually with the behavior they cause. He regards intentions as 'mental states'. (He uses the word 'states' broadly to cover events and processes as well as states.)[34] He says: "The concept of a mental state is primarily the concept of *a state of the person apt for bringing about a certain sort of behavior*."[35] I take the expression, "apt for bringing about X", to mean roughly the same as the expression, 'tending to bring about X'; or perhaps as having the stronger meaning of the phrase, 'that will bring about X in favorable circumstances'; or perhaps the still stronger meaning of the phrase, 'that will bring about X unless prevented'. Thus, Armstrong thinks that the concept of a mental state, and therefore the concept of an intention, is the concept of something that tends to cause certain behavior, or that will cause it in favorable circumstances or unless prevented from doing so by some interference.

The behavior to which an intention to bring about a state of affairs, S, is conceptually tied in this way is (presumably) either the behavior of bringing about S or the behavior of doing something, A, that the agent deems to be necessary for bringing about S. It is this same behavior that the intention causes or tends to cause, or to the causation of which it is a contributing factor.

Armstrong is holding, therefore, that an intention can be the cause, or part of the cause (in the Humean sense), of a certain piece of behavior, although the intention is conceptually connected with the occurrence of that same piece

of behavior. Since he understands a causal connection to be a contingent connection, and a conceptual connection to be a noncontingent connection, he is holding that a particular intention can be connected, on the same occasion, both contingently and noncontingently, with one and the same piece of behavior.

Armstrong is well aware of the paradoxical aspect of his view. He says:

> But is the connection between the intention and the occurrence of the thing intended a purely contingent one? Admittedly, the intention does not logically necessitate the occurrence of the thing intended. But is it just a contingent fact that having the intention to strike somebody is fairly regularly followed by hitting the person and only irregularly by the purchase of postage stamps? Might it have been otherwise in a less ordered universe? There seems to be some logical bond between intention and the occurrence of the thing intended that there cannot be between ordinary cause and effect.[36]

Armstrong's view is that it not merely seems but *is* the case that there is a "logical bond" between an intention to do *A,* and the doing of *A.* He holds, however, that this is so *only if* the intention is referred to by the description 'the intention to do *A'.* If the intention had another, 'neutral' description, then under that description it would be contingently connected with the behavior of doing *A.*

Armstrong draws an analogy between a person's intention to do *A,* and the brittleness of a brittle thing. He says: "It is no mere contingent fact that brittle things regularly break."[37] By calling something 'brittle' we mean that it is likely to break if dropped, struck or bent. We mean, to use Armstrong's phrase, that it is 'apt for breaking'. Since there is a 'logical bond' between the descriptions 'brittle' and 'apt for breaking', there is a noncontingent connection between being brittle and breaking. But, according to Armstrong, this does not prevent there also being a contingent, causal connection between being brittle and breaking. There is a state of the brittle thing that *causes* it to break if dropped or struck:

> Although speaking of brittleness involves a reference to possible breaking, the state of the brittle thing has an intrinsic nature of its own (which we may or may not know), and this intrinsic nature can be characterized independently of its effect. And it is a mere contingent fact that, in suitable circumstances, things with this nature break. Now may not the relation of the intention to the occurrence of the thing intended stand in much the same relation as brittleness stands to actual subsequent breaking? And, if so, intentions may still be causes of the occurrence of the thing intended.[38]

Armstrong's view is that any particular intention has two true descriptions, one of which might be called 'intentional', the other 'intrinsic'. Under the first description the intention is conceptually, i.e., noncontingently, tied to a certain action. Under the second description that same intention is causally and contingently tied to the same action. Suppose that the intentional description of a

particular intention was the following: 'Armstrong intends to strike a man standing before him.' Armstrong says:

> Suppose I form the intention to strike somebody. My mind is in a certain state, a state that I can only describe by introspection in terms of the effect it is apt for bringing about: my striking that person. It is a mental cause within me apt for my striking the person. In the order of being it has a nature of its own. . . . Whatever its nature, it is simply a contingent fact that that sort of thing is apt for bringing about the striking of the other person. But, if we turn to the order of knowledge, my direct awareness of this mental cause is simply an awareness of the sort of effect it is apt for bringing about. It is this that prevents us from being able to characterize the mental cause, except in terms of the effect it is apt for bringing about, and which gives the appearance of a quasi-necessary connection between cause and effect.
>
> The peculiar 'transparence' of such mental states as the having of intentions, our inability to characterize them except in terms of the state of affairs that would fulfil them, is thus explained without having to give up the view that purposive activity is the effect of a mental cause, and an ordinary contingent cause at that.[39]

Armstrong is holding that whether a mental state, *M,* is contingently or non-contingently related to a piece of behavior, *B,* is wholly a matter of how *M* (and also *B*) is characterized. The contingency or noncontingency of the relation is *relative to the descriptions* of *M* and *B*.

In an article that preceded Armstrong's book, Donald Davidson put forward a somewhat similar view. The article deals with the relation between *reasons* for actions, and *actions*. Sometimes a person's reason for doing something explains his doing it. Davidson employs the word 'rationalization' (although not in its ordinary sense) to designate this kind of explanation, and he holds that "rationalization is a species of ordinary causal explanation."[40] He says: "Whenever someone does something for a reason . . . he can be characterized as (a) having some sort of pro attitude toward actions of a certain kind, and (b) believing (or knowing, perceiving, noticing, remembering) that his action is of that kind."[41] The pro attitude and the related belief constitute the 'primary reason' why the person did the thing. And, says Davidson, "The primary reason for an action is its cause."[42]

The expression 'pro attitude' is, of course, extremely vague. It is certain that Davidson regards desires as pro attitudes, but not certain at all that he thinks of intentions as pro attitudes. He says two things which may indicate that he does not consider an intention to be a pro attitude. One of these remarks is the following: "The expression 'the intention with which James went to church' has the outward form of a description, but in fact it is syncategorematic and cannot be taken to refer to an entity, state, disposition, or event."[43] I am not sure, however, that this remark implies that Davidson would think that *R*'s intention to escape was not a state, disposition, or event. Davidson may be talking *only* about expressions of the form 'the intention with which *x* did *y*'.

The other remark of Davidson's that might raise doubt on this point is the following: "It is not unnatural . . . to treat wanting as a genus including all pro attitudes as species."[44] One might suppose this to imply that Davidson does not regard an intention as a pro attitude for the reason that he would not think that intentions are a species of wanting or desiring. I do not find this consideration persuasive, since in fact some philosophers have believed (incorrectly, I think) that an intention to do X is a species, or a special case, of wanting to do X. Davidson might have the same belief.

I shall assume that Davidson would agree that if a person intends to do X then *ipso facto* he has a pro attitude towards doing X, simply because I think this is the most natural way to take the expression 'pro attitude'. I assume, therefore, that Davidson would agree that R's 'primary reason' for falling over the side of the boat consisted of (1) R's intention to escape ('pro attitude') and (2) R's belief that in falling over the side of the boat he was, or might be, escaping. Thus this intention and belief would, on Davidson's view, be *the cause* of R's falling over the side, and the explanation of R's action in terms of this intention and belief would be 'ordinary causal explanation'. If Davidson would not accept R's intention to escape as a 'pro attitude', then I can only apologize for having misunderstood him.

Davidson says: "Central to the relation between a reason and an action it explains is the idea that the agent performed the action *because* he had the reason."[45] This is surely right. The problem is how to understand it. Davidson takes it to mean that the reason explains the action only if it causes the action. He thinks, moreover, that causal explanation requires the covering law model. The agent's reason for the action (or his having that reason) is the causal antecedent, the action is the effect, and the two are bound together by a causal law.

Here Davidson warns us against two errors. One is to suppose that a causal explanation has not been given unless a covering law is *stated*. Another and more important error is "The idea that singular causal statements necessarily indicate, by the concepts they employ, the concepts that will occur in the entailed law."[46] R's intention and belief caused him to fall over the side; but the law that covers this instance of causation will not employ the concepts of 'intention' or 'belief' or 'falling over the side':

> The laws whose existence is required if reasons are causes of actions do not, we may be sure, deal in the concepts in which rationalizations must deal. If the causes of a class of events (actions) fall in a certain class (reasons) and there is a law to back each singular causal statement, it does not follow that there is any law connecting events classified as reasons with events classified as actions—the classifications may even be neurological, chemical, or physical.[47]

Another feature of Davidson's view should be mentioned. He holds that the cause of an event must itself include an event. He says: "mention of a causal

condition for an event gives a cause only on the assumption that there was also a preceding event."[48] R's intention to escape and his belief that in falling over the side he would be, or might be, escaping, would presumably be fairly long-standing 'states' of R and not 'events'. What event would be included in the 'total' cause of R's falling over the side? It is not hard to think of one, namely, R's seeing or noticing at a certain moment ('now!') that the boat was at Bolton Point. In discussing the cause of a driver's raising his arm to signal a turn, Davidson says that in addition to the driver's intention to make a turn at that particular intersection, "there is a mental event; at some moment the driver noticed (or thought he noticed) his turn coming up, and that is the moment he signaled."[49] If the requirement that there be an event in the causal conditions is satisfied in this way in the case of the driver, there is an equally satisfactory event in the case of the convict.

If I understand him correctly Davidson has the following view: There may be more than one true description of a person's primary reason for doing something, and also more than one true description of his action. Under one pair of descriptions the relation of reason to action may be noncontingent. Davidson says, for example, that "the relation between desire and action is not simply empirical."[50] If this is right, Davidson is holding that, for example, the intention to go to church, and the action of going to church, are noncontingently connected under *those* descriptions. But he also holds that if there were a true neurophysiological (or chemical or mechanical) description of a person's intention and belief, i.e., of his primary reason, and also of his action, then his reason and his action, under these descriptions, could be logically independent and connected by causal law. He states, "The truth of a causal statement depends on *what* events are described; its status as analytic or synthetic depends on *how* the events are described."[51] The general point that Davidson makes would seem to be true. It is possible to refer to something, X, by different descriptions. It would be possible to refer to one and the same person as 'The Duke of Kent', and also as 'that man standing in the corner'. If one said, 'The Duke of Kent is a member of the peerage', one would be making a noncontingent ('analytic') statement; whereas if one said, 'That man standing in the corner is a member of the peerage', one would be making a contingent ('synthetic') statement.

Armstrong holds, that intentions and beliefs are neurological events or states. Davidson does not definitely assert, in the article to which I have referred, that this is so; but he implies that it may be so. If this is possible, then it is also possible that there should be what I have called an 'intrinsic' description of a person's intention and belief (that is, of his 'reason' for his action),— and also an intrinsic description of his action, such that his reason and his action would be logically independent and causally connected, under those descriptions.

V

I wish to try to determine whether the Armstrong-Davidson view is true. I will consider its application only to intentions. I will call the view, in this application of it, the 'Double Connection Thesis' (DCT, for short), since it implies that an intention can be connected with a certain action, both contingently and noncontingently. At the heart of the DCT is the idea that a particular intention can have both an 'intentional' and an 'intrinsic' description. An intention does, of course, have an intentional description. The intentional description of the intention of the convict, R, is simply 'the intention to escape'. Under this description, R's intention is tied noncontingently (by the relation I called 'semi-entailment') to his doing something that he envisages as escaping or trying to escape. The DCT says that this intention of R's could be given a true intrinsic description, such that the relation between R's intention (under its intrinsic description) and his behavior of escaping or trying to escape, would be purely contingent.

Can there be an 'intrinsic' description of an intention? Does a person's intention to do Y have an 'intrinsic nature' which can be described, independently of the description 'the intention to do Y'? Do we have any conception of what this intrinsic nature might be, and of what a description of it would look like? Charles Taylor says, quite rightly, that "no such description is forthcoming on the ordinary level of observation on which we all live."[52] He means that no images, thoughts, feelings, pangs, throbs, stirrings, moods, or any combination thereof could be identified with, say, R's intention to escape. We might put the point by saying that an intention, as such, has no 'introspective content'. If you were asked to 'identify' or describe an intention of your own, what could you say other than that it is the intention to do Y? As Taylor remarks, to explain a man's doing X by saying that he intended, or wanted, to do Y, is to say that doing X was, or was thought by him to be, a way of doing Y or part of what was involved in doing Y. And, as Taylor further remarks, "it is not a contingent fact" that intending or wanting Y "will tend to issue in doing X in just those circumstances where X is (seen to be) identical with Y (or part of what is involved in encompassing it)."[53]

I take it that the proponents of the DCT will agree with Taylor that the familiar, daily language in which we speak of mental states, moods, emotions, feelings, sensations, etc., will not yield intrinsic, introspective descriptions of intentions. Armstrong is explicit about "our inability to characterize" the mental state of having a certain intention "except in terms of the state of affairs that would fulfil" it: he denies that "introspection could characterize mental states independently of the behaviour they are apt for bringing about."[54] In our ordinary, nonscientific, language, we can identify an intention only as the intention to do something, X. Armstrong further agrees with Taylor that in this

mode of designating an intention, the relation between the intention and the behavior of doing or trying to do X, is not contingent.

Armstrong believes in the possibility of intrinsic descriptions of mental states because he holds the view that mental states *are* states of the brain. On this view, R's intention to escape from prison (or, perhaps, his having that intention) just is a particular state of R's brain. This state could, presumably be identified by a neurophysiological description, which would say or imply nothing whatever about any behavior of R's in which it would tend to issue or be apt for bringing about. Yet, according to the DCT, shared by Armstrong and Davidson, this neurophysiological state could be connected, by causal law, with R's behavior of trying to escape.

The Double Connection Thesis seems to me to encounter the following formidable difficulty. It ought to be logically possible to designate a neural state very accurately. The neural state that is supposedly identical with R's intention to escape (or with his having that intention) could, for example, be designated as a set of specified neurons that fire in a certain order. Let us suppose that such a set has been picked out, and let us call it *"N"*. Under its neural description, N is presumed to be logically independent of R's behavior of falling over the side of the boat. Furthermore, the causal laws that are presumed to connect N with that behavior are deemed to be contingent laws. In other words, it would be a logical possibility that the laws should have been different and, therefore, that this very same neural state, N, should have been causally connected with entirely different behavior. N might, for example, have been causally connected with the behavior of whistling "Old Black Joe". Since the DCT holds that R's neural state, N, is identical with R's intention to escape (or with his having that intention), the DCT implies that R's intention to escape *might* have been the intention to whistle "Old Black Joe"). This would not mean that instead of having the intention to escape, R might have had a different intention. It would mean that the very intention that R did have, namely, the intention to escape, might have been the intention to whistle Old Black Joe. This seems to me to be an absurd result.

In *Zettel*, Wittgenstein says:

> Here my thought is: If someone could see the expectation itself—he would have to see *what* is being expected. (But in such a way that it doesn't further require a method of projection, a method of comparison, in order to pass from what he sees to the fact that is expected.)[55]

This is a colorful way of saying something true, namely, that if *what* was expected (the *object* of expectation) were different, then the person would have a different expectation. One could express the point by saying that the object of an expectation is 'essential' to that expectation.

This point about expectation applies exactly to intention. The object of an intention (what is intended) is essential to the intention. A different object of

intention means a different intention. If one convict said, 'My intention is to escape', it would be silly for another to reply, 'My intention is the same as yours, except that my intention is not to escape but to whistle "Old Black Joe"'.

In my thinking about this matter I am influenced by Saul Kripke's article, 'Naming and Necessity'.[56] Kripke makes a distinction between an expression that designates something "rigidly" and an expression that designates something "non-rigidly." He says;

> Let's call something a *rigid designator* if in any possible world it designates the same object, a *non rigid* or *accidental designator* if that is not the case.[57]

The test for whether an expression '*D*' is rigid is whether it makes sense to say that *D* might not have been *D*. It makes no sense, for example, to say that Eisenhower might not have been Eisenhower: thus the name 'Eisenhower' is a rigid designator. In contrast, it does make sense to say that Eisenhower might not have been The Supreme Commander; someone else might have been chosen for that position. It even makes sense to say that The Supreme Commander might not have been The Supreme Commander—meaning that the person who in fact was The Supreme Commander might not have been The Supreme Commander. So the expression, 'The Supreme Commander,' is a non-rigid designator.

Kripke argues convincingly that if any two expressions '*D1*' and '*D2*' are both rigid designators, then if the identity statement, '*D1* is identical with *D2*', is true it is necessarily true; and if it is not necessarily true it is false. To give one of Kripke's examples, if '*A*' were the name of a particular sensation of pain, and '*B*' were the name of a particular brain state, then if *A* and *B* were identical the identity would have to be necessary. That brain state would have to be identical with that sensation of pain in all possible worlds.

It seems to me that the expression '*R*'s intention to escape' is a rigid designator. It makes no sense to say that the intention of escaping that *R* had, might instead have been some different intention, or even no intention at all but instead a sensation or an emotion. As Kripke points out, *being a sensation* and *being a pain,* are both *essential* properties of a particular sensation of pain. *That very sensation* could not have existed without being a sensation; nor could it have existed without being a pain. In contrast, Benjamin Franklin could have existed without being the inventor of bifocals.[58] The point about a particular sensation of pain applies equally well to the particular intention that *R* had: namely, the intention to escape. That particular intention could not have existed without being an intention, nor could it have existed without being an intention to escape.

The difficulty for the DCT is the following: the DCT holds that there is an identity between a particular brain state of *R*'s and a particular intention of *R*'s,

namely, his intention to escape. The DCT also requires that this identity be a contingent identity. But because of the argument given by Kripke, we see that it could not be a contingent identity. If it were an identity at all it would have to be a necessary identity, one that holds in all possible worlds. Since this cannot be so, there is no identity at all between R's particular intention and some particular state of his brain. Therefore that intention of R's cannot have an intrinsic, neurophysiological description, in accordance with which it might stand in a contingent, causal connection with R's behavior of trying to escape.

Let us be perfectly clear as to why the DCT requires that the putative identity should be contingent. According to the DCT, the reason that R's intention is referred to, or 'conceptualized', as the intention to escape is that R's intention is a state of his brain that is connected by causal laws with that behavior of trying to escape. In another possible world, the causal laws could have been different. That very same brain state of R's, namely, N, could have been causally connected with the entirely different behavior of whistling 'Old Black Joe'. In that possible world, the brain state N would be identical not with an intention to escape, but with an intention to whistle. The identity between N and R's intention would not hold in some possible world. Kripke's contention is that the statement 'A is identical with B' (where 'A' and 'B' are both rigid designators) is either true in all possible worlds or else false. If this is correct, as it seems to be, and if it is also true, as it seems to be, that both the name 'N' and the expression 'R's intention to escape' are rigid designators, then there is no identity at all between N and R's intention to escape, or between R's having brain state N and R's having the intention to escape.

A related way of putting the difficulty for the DCT is the following: Since the DCT holds that brain state N is identical with R's intention to escape, the DCT implies that if the causal laws had been different, that intention of R's might not have been an intention at all, or might have been an intention with an entirely different object. That very same intention of R's might, for example, have been the intention to avoid escaping. I repeat that what this point means is not that instead of intending to escape R might have intended to avoid escaping. What it means is that the particular intention that R had, namely, to escape might have been the intention to avoid escaping. This consequence is flagrantly absurd. I conclude that the Double Connection Thesis fails in its attempt to reconcile the intentionalist and causalist positions.

VI

To summarize: There has been a long-standing controversy concerning the relation between intention and action. The two classical positions around which dispute has swirled may be called the 'causalist' and the 'intentionalist' posi-

tions. The causalist view holds that every genuine causal explanation conforms to what is variously called the 'deductive-nomological', 'covering law', or 'Humean' model, according to which a cause and its effect are logically independent, and are connected by causal law. The causalist view maintains that in so far as intentions, desires, and beliefs explain human actions, they can do so only in conformity to this model. The 'intentionalists' hold, on the contrary, that a person's intention to do a certain thing and his action of doing it are not 'logically independent', but are related 'conceptually' or 'noncontingently' and that an explanation of action in terms of the person's intention does not fall under the 'covering-law' or 'Humean' model.

Von Wright has offered a valuable clarification of the matter by presenting the relation between intention and action in the form of the so-called 'practical syllogism' or 'practical argument'. He succeeds in showing that in an adequately formulated practical argument, the facts described by the premisses are not logically independent of the facts described by the conclusion. Von Wright, in my opinion, overstates the matter in holding that in the 'retrospective' case, the premisses *entail* the conclusion. But he is right in his view that the relation of premisses to conclusion, in the practical argument, is noncontingent. This amounts to a refutation of the causalist position.

Recently there has appeared a sophisticated view that attempts to combine the causalist and intentionalist outlooks, and for this reason I call it "The Double Connection Thesis." Central to this thesis is the idea that an intention (or desire or belief) can have both an 'intentional' and an 'intrinsic' description, and that the intention is noncontingently related to an action under the one description, but contingently related under the other. My criticism of this thesis is basically that there cannot be an 'intrinsic' description of an intention (other than its 'intentional' description). Proponents of the thesis will agree that this is so at the level of psychological or introspective description. They hold, however, that an intention (belief, desire) is, or may be, a state of the brain, and will, therefore, have an 'intrinsic' neural description. This version of the psychophysical identity theory involves an absurd consequence of the kind pointed out by Kripke, namely, that it is logically possible that a particular intention that some person has, should have been no intention at all, or should have been an entirely different intention.

My overall conclusion in respect to the true account of the relation between intention and behavior is that the intentionalist position holds the field. Neither the causalist view nor the Double Connection Thesis is a serious rival.

CORNELL UNIVERSITY
FEBRUARY 1973 NORMAN MALCOLM

NOTES

1. G. H. von Wright, *Explanation and Understanding* (Ithaca: Cornell University Press, 1971).
2. Ibid., p. 11.
3. Ibid., Ch. 2, Sec. 10.
4. The deductive-nomological model is deemed to have a wider application than to just causal explanation; but this is irrelevant to my purpose.
5. Hume, *Treatise,* Bk. I, Pt. 3, Sec. 1.
6. Ibid., I, 3, 6.
7. Ibid.
8. Ibid., I, 3, 7.
9. Ibid., I, 3, 15.
10. Hume, *Enquiry Concerning Human Understanding,* Section 4, Pt. 1.
11. A. I. Melden, *Free Action,* New York: 1961, p. 105, fn.
12. Von Wright, p. 93.
13. Ibid.
14. Ibid., p. 195, fn. 18.
15. Ibid., pp. 115–116.
16. Ibid., p. 95.
17. Ibid., p. 117.
18. G. H. von Wright, 'On So-Called Practical Inference', *Acta Sociologica* 15, no. 1 (1972): pp. 49—51.
19. Ibid., pp. 50, 51. Von Wright also distinguishes first person and third person cases, but I will confine my consideration to the third person case.
20. *Explanation and Understanding,* pp. 106, 107.
21. Ibid., p. 105.
22. Ibid., p. 117.
23. Ibid.
24. 'On So-Called Practical Inference', p. 50.
25. *Explanation and Understanding,* p. 117.
26 Ibid.
27. Ibid., p. 109.
28. Ibid.
29. Ibid., p. 115 [my italics]
30. David Armstrong, *A Materialist Theory of the Mind,* New York: 1968, p. 80.
31. Ibid., p. 83.
32. Ibid.
33. Ibid., p. 84.
34. Ibid., p. 82.
35. Ibid.
36. Ibid., pp. 133–34.
37. Ibid., p. 134.
38. Ibid.
39. Ibid., pp. 134–35.
40. Donald Davidson, 'Actions, Reasons, and Causes', *Journal of Philosophy,* 60 (1963). Reprinted in *Readings in the Theory of Action,* edited by Norman S. Care and Charles Landesman (Bloomington: Indiana University Press, 1968), page references to Care and Landesman; p. 179.

41. Ibid.
42. Ibid., p. 180.
43. Ibid., p. 184.
44. Ibid., p. 182.
45. Ibid., p. 186.
46. Ibid., p. 194.
47. Ibid., p. 195.
48. Ibid., p. 189.
49. Ibid.
50. Ibid., p. 192.
51. Ibid., p. 191.
52. Charles Taylor, 'Explaining Action', *Inquiry 13* (1970): pp. 62–63.
53. Taylor, p. 61.
54. Armstrong, p. 135.
55. Wittgenstein, *Zettel,* Blackwell: Oxford, 1967, § 56.
56. Saul Kripke, 'Naming and Necessity', *Semantics of Natural Language,* edited by Donald Davidson & Gilbert H. Harman, D. Reidel, 1972.
57. Ibid., pp. 269–270.
58. Ibid., p. 335.

16

G. E. M. Anscombe

VON WRIGHT ON PRACTICAL INFERENCE

Logic is interested in the UNASSERTED propositions.
Wittgenstein

I will write in appreciation of, but some dissent from, this paragraph of von
Wright's:

> Now we can see more clearly, I think, wherein the claim to logical validity of the
> practical inference consists. Given the premises
>
> > X now intends to make it true that *E*
> > He thinks that, unless he does *A* now, he will not achieve this
>
> and excluding, hypothetically or on the basis of investigations, that he is prevented,
> then his actual conduct, whatever it may "look like", either is an act of doing *A*
> or aims, though unsuccessfully, at being this. Any description of behaviour which
> is logically inconsistent with this is also logically inconsistent with the premises.
> Accepting the premises thus forces on us this understanding of his conduct,—
> unless for some reason we think that a preventive interference occurred right at the
> beginning of his action.[1]

I

If there is practical inference, there must be such a thing as its validity. Validity
is associated with necessity. I take it that this is what leads von Wright always
to consider only the 'unless' forms, giving

> I want to achieve *E*
> Unless I do *A,* I shall not achieve *E*

as a scheme in the first person. Suppose, having that end and that opinion, I
do *A.* "What sort of connexion would this signify between want and thought

on the one hand, and action on the other? Can I say that wanting and opining *make* me act? If so, would this be a form of causal efficacy? Or would it be more like a logical compulsion?''[2]

Donald Davidson opts for 'causal efficacy' here, on the ground that there is a difference between my having a reason and its actually being my reason. I act because. . . . We need an account of this 'because'. The psychological 'because', he supposes, is an ordinary *because* where the *because* clause gives a psychological state. The solution lacks acumen. True, not only must I have a reason, it must also 'operate as my reason': that is, what I do must be done *in pursuit* of the end and *on grounds* of the belief. But not just *any* act of mine which is caused by my having a certain desire is done in pursuit of the object of desire; not just *any* act caused by my having a belief is done on grounds of the belief. Davidson indeed realises that even identity of description of *act done* with *act specified in the belief,* together with causality by the belief and desire, isn't enough to guarantee the act's being done *in pursuit of the end* and *on grounds of the belief.* He speaks of the possibility of 'wrong' or 'freak' causal connexions. I say that any recognisable causal connexions would be 'wrong', and that he can do no more than postulate a 'right' causal connexion in the happy security that none such can be found. If a causal connexion were found we could always still ask: 'But was the act done for the sake of the end and in view of the thing believed?'

I conjecture that a cause of this failure of percipience is the standard approach by which we first distinguish between 'action' and what merely happens, and then specify that we are talking about 'actions'. So what we are considering is already given as—in a special sense—an action, and not just any old thing which we do, such as making an involuntary gesture. Such a gesture might be caused, for example, by realising something (the 'onset of a belief') when we are in a certain state of desire. Something I do is not made into an intentional action by being caused by a belief and desire, even if the descriptions fit.

Von Wright has no taste for this explanation by causal efficacy, but is drawn to the alternative which he gives—logical compulsion. He has difficulties with this which lead him to substitute 'intend' for 'want' and the third person for the first, prefixing 'he believes' to the second premise. Even so, there is still a time gap; so he closes the gap with a 'now' which is to be quite narrowly understood. He must also exclude instant prevention. But he now has a rather obscure difficulty about the 'instantaneous' application of the argument. ''Is there explanation of action only on the basis of what is *now* the case—and is there intentional action which is *simultaneous* with the construction of a justification of it?'' He thinks not; but he does not explain why not.

He *seems* to conceive the application like this: one *makes use* of an argument. Now one can hardly be said to make use of an argument that one does

not produce, inwardly or outwardly. But the production takes time. If I do *A* 'on the instant', there isn't time. Given time, the argument or calculation will look to a future action. Or, if I have done the action, I may be justifying it. I cannot *be reaching* the action as a conclusion. (This is interpretation on my part; I hope not unjust.)

This raises the interesting question: is inference a process? Is 'infer' a psychological verb? Is 'reasoning' a psychological concept? If so, it is perhaps curious that people don't usually put inference and reasoning into lists of mental phenomena. Bernard Williams once wrote that an inference must be something that a person could conduct. What has one in mind, if one speaks of someone as 'conducting an inference'? Presumably not reproducing an argument, but rather: thinking first of one proposition, say, and then another, which is seen to follow from the first. Is there something else which one could call not just *seeing* that the second follows from the first, but actually *inferring* it? I take it, no. That is, it is of no importance that I 'wouldn't have produced the one except because I had produced the other'. One may feel inclined to say such a thing in a particular case, but one wouldn't say 'You didn't infer, if the second proposition merely flashed into your mind; you saw it followed from the first and added 'then' to it!' Nor need one even have added 'then'. If inferring is a particular mental act, one might suppose that it was 'conceiving the second proposition under the aspect 'then' in relation to the first. But now, how is it that when one considers or examines inferences, one has no interest in whether anything like that has gone on in someone's mind, i.e., whether he has experienced something which he would like to express in that way? It is because we have no such interest that it does not come natural to classify 'inference' as a mental content, 'infer' as a psychological verb.

Von Wright's observation about the simultaneous construction of a justification comes in a passage where he is asking 'what uses has the type of argument which I here call practical inference?' and it therefore seems entirely fair. Construction, production, going through, all these take some time; therefore no 'instantaneous' use. And yet it appears as if something deeper had been said. Has he perhaps not exhausted the 'uses' of this type of argument?

Practical inference was delineated, as anything called 'inference' must be, as having validity. The validity of an inference is supposed to be a certain formal character. The appreciation of validity is connected with the evaluation of grounds *qua* grounds. Therefore, one use (which von Wright has not mentioned) of his type of argument will be not to get at a conclusion or explain or justify an action, but to form an estimate of an action in its relation to its grounds. Now can a person act on grounds upon the instant? E.g. he steps behind a pillar to avoid being seen, as soon as he sees someone enter the building. If so, the setting forth of the grounds, displaying the formal connex-

ion between description of the action and propositions giving grounds, will indeed take time but will relate to something instantaneous.

Von Wright's investigation has led him to the curious position that there is such a thing as the validity of a practical inference, but that when it *is* valid, it has no use as an argument—that is, to say as an inference. Its use is connected, rather, with understanding action. Where it is of use as an argument it lacks validity because of the time-gap: "with this gap there is also a rift in the logical connexion between the intention and epistemic attitude on the one hand and the action on the other." Thus when we obliterate the time-gap we "obliterate the character of an argument or an inference": we obliterate it from the propositional connexions which we were investigating.[3]

II

If there is such a thing as practical inference, it is surely exhibited not only by the 'unless' form:

> I want to attain *E*
> Unless I do *A* I shall not attain *E*

after considering which I do *A*.

It is also exhibited by the 'if' form:

> I want to attain *E*
> If I do *A* I shall attain *E*

I have conjectured that von Wright does not consider this latter form because with it there is no shadow of a sense in which doing the action *A* is necessitated by the premises. With the 'unless' form, the action is required if my desire is not to be frustrated. However, we have seen the difficulty in making out a necessity about *its being true that the action happened,* which I take to be his picture of making out the *validity* of inference here. He looked for the relation to be "one of logical compulsion".

He notices my remark that the conclusion of a practical syllogism is not necessitated; perhaps he thought I said this because of these difficulties. But in fact my view was completely different: I thought that the relation between the premises and the action which was the conclusion was this: the premises show what good, what use, the action is.

If someone acts on the premises, that shews that he is after—or perhaps that he wants to avoid—something mentioned in the first premise. In 'On So-called Practical Inference', von Wright says: "According to Anscombe the first premise . . . mentions something wanted", and he claims that this doesn't fit Aristotle's version of practical inference, which "subsumes a particular thing

or action under some general principle or rule about what is good for us or is our duty".[4] He contrasts with this the inference in which the first premise mentions an end of action, and the second some means to this end.

He seems to think that 'mentioning an end of action' or 'mentioning something wanted' is saying that a certain end is wanted. Otherwise, he would not contrast the well-known Aristotelian forms with the form 'in which some end of action is wanted'.

> Pure water is wholesome
> This water is pure

—followed by drinking the water, would be an example on the most frequent Aristotelian pattern. It mentions the wholesome, and this is shewn to be what the person wants by his acting on these propositions as grounds for drinking the water. It seems to me incorrect to call such a premise 'A general rule about what is good for us'. It is a general statement about what is good for us, not a rule.

It is true that Aristotle's first premises in these forms are always some sort of 'general principle'. But 'principle' here only means 'starting-point'. This generality is indeed important, and I will return to it. However, an end calculated for certainly might be very particular and no general considerations about the kind of end be stated. Let us concentrate for the moment on the question whether the wanting or intention of the end *ought to figure in the premises*.

As I formerly represented the matter, 'I want' does not go into the premises at all unless indeed it occurs as in the following example. (I owe the point and example to A. Müller.)

> Anyone who wants to kill his parents will be helped to get rid of this trouble by consulting a psychiatrist[5]
>
> I want to kill my parents
> If I consult a psychiatrist I shall be helped to get rid of this trouble.
> *NN* is a psychiatrist
> So I'll consult *NN*

Here my wanting to kill my parents is among the facts of the case; it is not that wanting which we picture as, so to speak, constituting the motor force for acting on the premises. *That* is evidently the desire to get rid of the trouble. The decision, if I reach it on these grounds, *shews* that I want to get rid of the trouble. It is clear that the roles of these two statements of wanting are different.

If a set of premises is set out without saying what the person is after who is making them his grounds, then the conclusion might be unexpected. It might be opposite to what one would at first expect. For example, in the given case: 'So I'll avoid consulting *NN*'. This seems perverse and pointless; why then get

as far as specifying consulting *NN,* at least if it is a thing one would be in little danger of doing inadvertently? On the other hand identical considerations:

> Strong alkaloids are deadly poison to humans
> Nicotine is a strong alkaloid
> What's in this bottle is nicotine

might terminate either in careful avoidance of a lethal dose, or in suicide by drinking the bottle.

That being so, there is a good deal of point in having the end somehow specified if we want to study the form. This at least is true: if you know the end, you know what the conclusion should be, given these premises. Whereas if you do not know the end, (a) the conclusion may be either positive *or* negative. Aristotle, we may say assumes a preference for health and the wholesome, for life, for doing what one should do or needs to do as a certain kind of being. Very arbitrary of him. But also (b) how do we know where the reasoning should stop and a decision be made? For example note that in the case above we left out a premise, 'I am human'. As Aristotle remarks somewhere, this premise is one that would seldom be formulated, even by someone who was actually going through the considerations of a practical inference, and though 'strictly' that premise belonged among them. Replacing it by '*NN* is a human' can suggest a different tendency altogether for the reasoning! However, in saying that we are betraying our actual guess what the reasoning is for. Our idea of where the reasoning should terminate depends on this guess.

Thus the end ought to be specified, but the specification of the end is not in the same position as a premise.

A rather pure example of practical reasoning, as we are at present conceiving it, is afforded by the search for a construction in geometry. In Euclid all we are given is the problem, the construction, and then the proof that it does what is required. That saves space, but it does not represent the discovery of the construction.

We have the requirement stated, e.g., *To find the centre of a given circle.* We may then reason as follows, reaching Euclid's construction:

> If we construct the perpendicular bisector of a diameter, that will give us the centre.
>
> If we construct the perpendicular bisector of a chord, and produce it to the circumference, that will give us a diameter.

We can draw a chord, and we can construct the bisector of any given line. So we conclude by drawing a chord, bisecting it, and bisecting the resultant diameter.

This is different from most of Aristotle's examples. It is of the form:

> Objective: to have it that p
> If q, then p.
> If r, then q.

Whereupon, *r* being something we can do, or rather immediately make true, we act. But this form is something like one once sketched by Aristotle:

> The healthy state comes about by reasoning as follows: since health is such-and-such, it is necessary, if health is to be, that such-and-such should hold, e.g. homogeneity, and if that, then heat. And so one goes on considering until he comes to some last thing, which he himself can do.[6]

This last thing, Aristotle indicates, may be rubbing: 'In treatment, perhaps the starting-point is heating, and he produces this by rubbing.' Here 'starting-point' evidently means the thing the doctor starts by considering how to procure.[7]

In the geometrical example, the construction of a diameter is not the only possible construction for finding the centre of a circle, but in Aristotle's example, the 'homogeneity' is said to be *necessary* for restoration of health, and heating for homogeneity. Friction, however, is merely a way of producing heat. What is important is surely that the end will be attained by the means arrived at, not whether it is the only means.

The relation between the premises given for the more usual type of Aristotelian reasoning, and these 'if, then' premises, is an obvious one. 'The healthy is such-and-such' is rather of the standard type. Somewhat tediously, we could put the two side by side. For 'such-and-such' I put *'X'*:

Being healthy is being *X*	Only if this patient is *X*, will he be healthy
Only the homogeneous is *X*	Only if he is homogeneous, will he be *X*
Only by heating does the unhomogeneous become homogeneous	Only if he is heated will he be homogeneous
This patient is in an unhomogeneous state	
Rubbing is heating.	If he is rubbed, he will be heated

Similarly, we could equip our 'if, then' propositions in the geometrical search with accompanying justifications. 'The centre of a circle is the midpoint of a diameter'. 'The perpendicular bisector of a chord, produced to the circumference, is a diameter'. These might have stood by themselves as premises on which the enquirer acts by constructing a chord, etc. Aristotle's 'light meats' syllogism again can be cast in the 'if, then' form:

Light meats suit so-and-so's	If I eat light meat, I'll be eating what suits me
I am a so-and-so	
Such-and-such a kind of meat is light	If I eat such-and-such, I'll be eating light meat
	If I eat this, I'll be eating such-and-such
This is such-and-such a kind of meat	

There is an interesting difference between the forms. I said that the first premise mentions, not that one wants something, but something that one wants. Applying this to the left, it claims that what is wanted (by someone acting on these grounds) is something that suits beings of a certain kind—to which, indeed, he belongs. Applying it to the right, it claims that what is wanted is to eat something that suits oneself.

Suppose we refashioned the right hand column in an attempt to avoid this apparent difference

> If a so-and-so eats light meat, he eats what suits him
> If a so-and-so eats such-and-such, he eats light meat
> If I eat this, a so-and-so eats such-and-such

This would make it look as if the objective were the somewhat abstract or impersonal one, that a being of a certain kind should eat suitable food. This is after all, not what is suggested by the left hand column together with the comment that if these are premises of practical reasoning, what is wanted is something that suits beings of a certain kind. I shall return to this matter when I take up the topic of the nature of the *generality* of Aristotle's first premises.

For the moment, it is only necessary to say first that the considerations on the left justify (prove) those on the right, a point that we saw also for the geometrical example; and also that the 'abstract' aim would seem to be an absurdity. I do not mean, however, that all aims must concern one's own doing or having something. That there should be adequate food in prisons, or a Bible in every hotel room, or fireworks on every New Year's Day, are possible aims in which the reasoner's doing or having something are not mentioned. I mean only that *in this case* the abstract aim is absurd. In other cases, indeed, one might do something so that *someone* of a class to which one belongs shall have done a thing of a certain kind. But that is evidently not what is in question in Aristotle's 'light meats' syllogism.

III

The previous section has shewn, not what practical reasonings are, but at any rate what are practical reasonings, and how great is the contrast with reasonings for the truth of a conclusion. Practical grounds may 'require' an action, when they shew that *only* by its means can the end be obtained, but they are just as much grounds when they merely shew that the end *will* be obtained by a certain means. Thus, in the only sense in which practical grounds *can* necessitate a conclusion (an action), they need not, and are none the less grounds for that.

The difficulty felt is to grasp why this should be called 'inference'. Inference is a logical matter; if there is inference, there must be validity; if there is

inference, the conclusion must in some way *follow* from the premises. How can an action logically follow from premises? *Can* it be at all that, given certain thoughts, there is something it logically *must happen* that one does? It seemed no sense could be made of that. Von Wright indeed came as near as he knew how to making sense of it, but he did not succeed. He was indeed assured of failure by the move which ensured that he was speaking clearly in speaking of logical necessity—namely by going over into the third person. What—hedged about by various saving clauses—became the logically necessary conclusion, was not the doing, but merely the *truth* of the proposition that the agent would do something. But in this way the practical inference degenerated into a theoretical inference with the odd character of being invalid so long as it was truly inferential!

I have given a very different account, but the question remains outstanding: in what sense is this *inference?* One speaks of *grounds* of action indeed, as of belief; one says 'and so I'll . . .' or 'Therefore I'll . . .', and we understand such expressions. But are they more than mere verbal echoes? The frequent non-necessity of the 'conclusion' is a striking feature. In order to eat *some* suitable food, one eats *this*. Or again: either A or B will do, and so one does A.

Some philosophers have tried to develop an account of 'imperative inference'—inference from command to command, or from command to what to do in execution of a command, conceived as self-administration of a 'derived' command by one who seeks to obey the first command. This has some bearing on our topic. If someone has the objective of obeying an order which does not tell him to do what he can simply do straight off, his problem is a problem of practical inference: he has to determine on doing something, in doing which he will be carrying out the order. The picture of this as reasoning from a more general to a more specific command or from a command to achieve something to a command to do such-and-such with a view to this, is of some interest to us.

R. M. Hare maintained that imperative inference repeated ordinary inference; if one proposition followed from another, the corresponding imperatives were similarly related. And also, from an imperative p! and a proposition *if p then q,* there would follow an imperative *q!*

Anthony Kenny was struck by the 'non-necessary' character of many Aristotelian inferences. He suggested that there was a 'logic of satisfactoriness' by reasoning within which one could move from 'kill someone' to killing a particular individual, from a disjunctive command to obeying one of the disjuncts, and from a requirement that *q,* with the information that if *p* then *q,* to the decision to effect *p*. All these reasonings would be fallacious in the logic of propositions. Accordingly, Kenny suggested that this logic was the mirror image of ordinary logic; what would be conclusions in ordinary logic figure as

premises in this logic—premises of the form Fiat p! —and the reasoning pro-
ceeds to conclusions, also Fiats,[8] which are what in the indicative mood would
be premises in ordinary logic. To see whether an inference in the 'logic of
satisfactoriness' is valid, you check whether the reverse inference is valid when
instead of Fiats you have the corresponding propositions.

Hare's 'imperative inference' of course does not allow of such inferences
as these. Also, as had earlier been pointed out by Alf Ross such a 'logic'
admits the inference of $(p$ or $q)$! from p! Kenny's system allows many natural
moves, but does not allow the inference from 'Kill everyone' to 'Kill Jones!'
It has been blamed for having an inference from 'Kill Jones!' to 'Kill every-
one!' but this is not so absurd as it may seem. It may be decided to kill every-
one in a certain place in order to get the particular people that one wants. The
British, for example, wanted to destroy some German soldiers on a Dutch is-
land in the second world war, and chose to accomplish this by bombing the
dykes and drowning everybody.[9] (The Dutch were their allies.)

This 'logic', however, curiously and comically excludes just those forms
that von Wright has concentrated on. Expressing the end as a 'Fiat', and given
that unless one does such-and-such the end will not be achieved, it seems ob-
vious that if there is such a thing as inference by which a command or decision
can be derived, there must here be an inference to 'do such-and-such'. It also
seems absurd that $(p$ & $q)$! for *arbitrary q,* follows from p! Effecting two things
may indeed often be *a way* of effecting one of them; but the admission of
arbitrary conjuncts is one of those forced and empty requirements of a view
which shew that there is something wrong with it. It is in this respect like the
derivation of $(p$ v $q)$! from p! in Hare's system.

Kenny's suggestion has this value: it suggests that we consider a pas-
sage *from* what would be a conclusion of inference from facts, *to* what
would be premises of such a conclusion, when the conclusion is something
to aim at bringing about, and the premises are possibly effectible truth
conditions of this, or means of effecting them. A truth-condition is a cir-
cumstance or conjunction of circumstances given which the proposition is true.
Execution-conditions for commands are truth-conditions for the corresponding
propositions. A proposition implies that a (some or other) truth-condition of it
holds, but the truth of a given truth-condition of it does not usually follow from
its truth. If we find a conjunctive truth-condition, it may be that the truth of
one of the conjuncts follows from the truth of the proposition, but this need
not generally be so.

In reckoning how to execute an order, one may be looking for straightaway
practicable execution-conditions. Also, perhaps, for practicable conditions
whose falsehood implies that the order is not carried out. If there is something
of this sort, the proposition stating that it is true *will* follow from the proposi-
tion corresponding to the original order. But there may be no particular condi-

tion of that sort. Thus, one may not be looking for anything, and certainly will not be looking for everything, which will necessarily have been made true if the original order is carried out.

Let us illustrate. An administrator for a conquering power gives the order: 'Bring all the members of one of these committees before me.' There are a dozen or more committees in question. So if all the members of any one of them are brought before him, the order is obeyed. But there is no committee that must be brought before him. If, however, there is someone who is a member of all the committees, then if *he* is not fetched the order has not been obeyed. Let there be such a man. The executor of the order picks up this man and one by one a number of others, until he knows he has a set among them that comprises a committee. He may not aim at any particular committee but let chance decide which one he makes up as he gets hold of now this man, now this pair of alternatives, now that man. All the time he is calculating the consequences of his possible moves as contributions to the achievement of his goal, and acting accordingly.

This brings out the relation we have mentioned between the idea of practical inference and imperative inference. The one seeking to obey this order has a goal, expressed by what the order requires should become the case.

But now, it appears that all the reasoning is ordinary 'theoretical' reasoning. It is, for example, from potential elements of truth-conditions for the attainment of his goal. 'If he does this, he will have that situation, which has such-and-such relevance to the attainment of the goal.' Such conditionals and such relevance will themselves be established by 'ordinary' inference from various facts. What he is trying to do is to find a truth-condition which he can effect, make true, (practicable ways of making not straightaway practicable truth-conditions true). As he does so, or as he finds potential conjuncts of a truth-condition which he can effect, he acts. Where in all this is there any other than 'ordinary' reasoning—i.e., reasoning from premises to the truth of a conclusion?

Let us suppose that the order is placed at the beginning of a set of considerations, but is cast in the form of a 'Fiat' ('May it come about that') adopted by the executive.

Fiat: some committee is brought before X

He now reasons:

If I get all the members of some committee rounded up, I can bring them before X

and adopts a secondary Fiat:

∴Fiat: I get all the members of some committee rounded up.

He reasons further:

Only if A is rounded up will all the members of any committee be rounded up.

And he can pick up A, so he does. Let us verbalise his action:

∴Let me pick up A. (Or: So I pick up A)

He reasons further:

> If the occupants of this bar are rounded up, several members of committees will be rounded up
> If several members of committees are rounded up, we may be able to pick a whole committee from among them, together with A.

And he can round up all the occupants of the bar, so he does.
Verbalised:

> ∴Let me round up all the occupants of this bar. (Or:
> So I round up all the occupants of this bar.)

He now finds he hasn't yet got all the members of any one committee, but he reasons:

> If I pick up B and C, or D, or E and F, or G or H, then, with what I have already I shall have a whole committee.

He now gets an opportunity to pick up B, C and G. Verbalising his action as before, we have:

> ∴Let me pick up B, C, and G) Or: So I pick up B, C and G.)
> or:∴Let me pick up B and C (Or: So I pick up B and C)
> or:∴Let me pick up G. (Or: So I pick up G.)

Now, what is the relation between the original Fiat and the secondary Fiat, and between the secondary Fiat and the actions (or, if you like, their verbalisations)? The relations, if the man is right, are severally given in the reasoning; that is, in the conditionals that I prefaced with the words 'he reasons.'

What, then, does the *therefore* signify? 'Therefore' is supposed to be a sign of reasoning! But what we have been calling the *reasoning* was the considerations. These will just be truths (or, if he is wrong, falsehoods). If they in turn were conclusions, the reasoning leading to them wasn't given. If we say 'He reasons. . .' should it not run 'He reasons. . . . ∴'? We gave a 'therefore' indeed, but it is just what we are failing to understand. The therefores that we'd understand are these:

(a) I pick up B and C.
∴ I have a complete committee rounded up.
(b) I get all members of some committee rounded up.
∴ I can bring some committee before X.
(c) A will not be picked up.
∴ No complete committee will be rounded up.
(d) A will not be picked up.
∴ It will not be possible to bring a complete committee before X.

whereas the corresponding ones that we actually gave were:

(a) Let me get a complete committee rounded up.
∴ Let me pick up B and C.
(b) Let me bring some committee before X.
∴ Let me get all the members of some committee rounded up.
(c) Let me get a complete committee rounded up.
∴ Let me pick up A.
(d) Let me bring a complete committee before X.
∴ Let me pick up A.

Now first note this: what I implicitly called the 'reasoning'—by putting "he reasons" in front of the examples—were considerations which would be the same in corresponding cases; I mean that the same conditional propositions mediate between 'premise' and 'conclusion' for a and a^1, for b and b^1, for c and c^1, for d and d^1.

For a and a^1 it is:

If I pick up B and C, with what I already have I shall have a whole committee

For b and b^1:

If I get all the members of some committee rounded up, I can bring some whole committee before X.

and so on. Criticism of the transition as incorrect, whether in the 'Fiat' or the 'ordinary' form, will be exactly the same, e.g., 'What makes you think that if you round such people up, you will be able to bring them before X?'

Let us also note that the 'reasoning' that we seemed to understand, where there was 'ordinary' inference, was purely suppositious. The premises were not asserted; they concerned future possible happenings, and were merely supposed.

With these observations we have already indicated the relation between the different 'Fiats' and between them and the decisions. Where this relation exists, *there* we have the practical 'therefore'.

We should note, however, that to the transition

Fiat q!
∴Fiat p!
or ∴I'll make p true

there corresponds not one but four different patterns of suppositious inference:

p will be	$\sim(p$ will be$)$	p will be	$\sim(p$ will be$)$
∴q will be	∴q will not be	∴q will be possible	∴q will not be possible

The hypotheticals, 'If p will be, q will be, etc., prove the correctness of the inferences 'p will be, ∴q will be', etc. Such a hypothetical may be true,

either because p is or is part of a truth-condition of q, or because the coming about of p will bring about the truth of q, or of at least part of some truth-condition of q. The difference between these is not reflected in the schemata. That is quite as it should be. In his reasonings our executive considered execution-conditions and ways of bringing about the truth of execution-conditions all in the same way. Nor in 'ordinary' inference, when, for example, we use 'if p, then q' in *modus ponens*, do we have to ask ourselves whether p is a truth-condition of q, or q is some other sort of consequence of p.

And now we can say in what sense there is, and in what sense there is not, a special 'form' of practical inference. We can represent any inference by setting forth a set of hypothetical considerations:

If p, q
If q, r

The question is: what are these considerations *for*, if they are not idle? There may be at any rate these uses for them: We may be able to assert p, and go on to assert r. Or we may want to achieve r, and decide to make p true—this being something we can do straight away. In either case we may appeal to considerations. Looked at in this way, we find no special form of practical inference; we have a set of propositions connected with one another the same way in the two cases. The difference lies in the different service to which they are put.

Not that these two are the only uses. These hypotheticals might of course be used to make a threat or offer a warning. But we are interested in cases where the first and last propositions get extracted from the hypothetical contexts, and the hypotheticals get used to mediate between them. In the cases we have considered, the extracted propositions are either asserted or made the topic of a Fiat.

But again, those are not the only cases. There is also a use in seeking an explanation; we have it given that r, and the hypotheticals suggest p, which we will suppose is something we can check for truth. If p turns out true, it may perhaps explain r.

The hypotheticals can be put to *practical* service only when they concern 'what can be otherwise', that is: what may happen one way or the other, that is: future matters, results which our actions can affect. Then the hypothetical mediates between will for an objective and decision on an action.

A passage in von Wright's 'On So-called Practical Inference' is relevant here:

> The conclusion of the first person inference, we said, is a declaration of intention. This intention may not have been formed until we realised practical necessities involved in our aiming at a certain end. So its formation may come later, after the first intention was already formed. We can speak of a *primary* and a *secondary* intention here.

The connexion between the two intentions is, moreover, a kind of logically necessary connexion. The second (epistemic) premise can be said to "mediate" between the primary intention of the first premise and the secondary intention of the conclusion. One can also speak of a transfer or *transmission of intention*. The "will" to attain an end is being transmitted to (one of) the means deemed necessary for its attainment.[10]

I have taken cases where the means chosen aren't supposed to be necessary. Yet here too there can be a 'transmission of intention'. Von Wright finds "a kind of logically necessary connexion" between the primary and secondary intentions. Now can we not say that there is a logical connexion—but beware! this does not mean 'a relation of logical necessitation'—between the truth-connexion of p, $p{\supset}q$, and q on the one hand, and the transmission (1) of belief from p to q and (2) of intention from Fiat q! to Fiat p!? But the logical necessity involved is only the truth-connexion of p, $p{\supset}q$, and q; this truth-connexion is common to both kinds of inference.

'But the logical necessity is *the justification* of assertive inference from p to q, and its apprehension *compels* belief!' That is a confusion. The justification is simply the truth of p and $p{\supset}q$: Where there is such a justification, we *call* the connexion one of 'logical necessity'. And how can belief be 'compelled'? By force of personality, perhaps, or bullying. But that is not what is in question. One may also *feel* compelled, but again, that is not what is in question. What is claimed is that the belief is 'logically' compelled. But what can that mean except that there is that 'logical necessity', the truth-connexion? But it was supposed to be not *that* necessity, but a compulsion produced by perceiving that necessity. Once again: if it is a feeling, a felt difficulty so strong as to create incapacity to refrain from belief, that is still not 'logical'. And the same would hold for any other 'state of the subject'. As soon as we speak of 'logical' compulsion, we find that we can mean nothing but the 'necessity' of the truth-connexion.

(Von Wright would here slide into the third person: "X consciously believes p and consciously and simultaneously believes $p{\supset}q$ and the question whether q is before X's mind" *entails* "X believes q". But how do we know this? Only as we know 'Treason doth never prosper': if X doesn't then believe q, we won't *allow it to be said* that those other three things are true of him.)

I conclude that transmission of intention and transmission of belief should be put side by side; that there is no such thing as the transmission's being 'logical' in the sense that the 'necessity' of the truth-connexion has an analogue in a 'logical compulsion' to be in one psychological state once one has got into another. And therefore that there never was a problem of how the action or decision could be 'logically compelled'. This is obscured for us if we make the assumption that there is such a thing in the case of belief, and that *it* at least is unproblematic. I believe this is a common scarcely criticised assumption.

Nevertheless, we cannot *simply* say: practical inference is an inference, a transition, that goes in the direction from q (Fiat q!) to p (Fiat p!) when, e.g., we have the truth-connexion of p, $p{\supset}q$, and q. For that is not the whole story. We have observed that when the propositions are turned into Fiats they are restricted in their subject matter to future matters which our action can affect. But we have also noticed that not just any effectible truth-conditions are of practical relevance. That is, that $p\&q$ may be a condition of r *merely* because p is so, merely a truth-condition. If there is a way of effecting $p\&q$ jointly, that may be a practical conclusion, however outrageous, for one who wants to effect r (like burning the house down to roast the pig). But what if the only way of effecting $p\&q$ is to effect them separately?

In such a case 'If $p\&q$, then r' may still have practical relevance; namely, that effecting q as well as p does not impede r. 'If p then r, and if p and q then still r', the agent may say. The consideration is of service to him if e.g. he independently wants to effect q. (Or someone else does). But there is here no 'transmission of intention' *via* $(p\&q){\supset}r$, from the primary intention that r to a secondary intention that p and that q. That is, the truth-connexion of $(p\&q)$ and $(p\&q){\supset}r$ does not 'mediate' such a transmission.

We cannot state *logical* conditions for this restriction on the relevance of effectible truth-conditions. We cannot do it by saying, for example, that $p\&q$ won't be a relevant effectible truth-condition of r if $p\&{\sim}q$ too is an effectible truth-condition of r. For that may be the case, and effecting *(p & q) still* be *a* way of effecting r. For example, I invite a married couple to dinner; I really want to just see the wife and I could invite her alone, but (for some reason or none) the way of getting to see her that I choose is, to issue a joint invitation.

What is in question here is something outside the logic that we are considering, namely whether there is 'one action' which is a way of effecting $(p\&q)$ and therefore a way of effecting p. But what counts as 'one action' may be very various in various contexts and according to various ways of looking at the matter.

We have now given the sense in which there is *not* a special 'form' of practical inference. The considerations and their logical relations are just the same whether the inference is practical or theoretical. What I mean by the 'considerations' are all those hypotheticals which we have been examining, and also any propositions which show them to be true. The difference between practical and theoretical is mainly a difference in the service to which these considerations are put. Thus, if we should want to give conditionals which are logical truths, which we might think of as giving us the logically necessary connexions which 'stand behind' the inferences, *they will be exactly the same conditionals* for the practical and for the corresponding 'theoretical' inferences.

I must therefore make amends to Aristotle, whom I formerly blamed for speaking of practical inference as 'just the same' as theoretical. I wanted to say it was a *completely different form*. I believe Aristotle might have had a difficulty in understanding the debate that has gone on about "whether there is such a thing as practical (or imperative) inference." For what I believe has lurked in some of our minds has been something which his mind was quite clear of.

That is the picture of a logical step: an act of mind which is making the step from premise to conclusion. Making the step *in logic*, making a *movement* in a different, *pure*, medium of logic itself. So the dispute seemed one between people who all agreed there was such a thing as this 'stepping' for assertions or suppositions; but some thought they could see such a 'step' also in the case of practical inference, while others just couldn't descry it at all. But there is no such thing in any case!

There is, however, a distinct 'form' of practical inference if all we mean by the 'form' is (1) the casting of certain propositions in a quasi-imperative form, and (2) how the matters are arranged. What is the starting point and what the terminus? The starting point for practical inference is the thing wanted; so in representing it we put that at the beginning. Then there are the considerations (to which I formerly restricted the term 'premises') and then there is the decision, which we have agreed to verbalise. So:

Wanted: that *p* (or: Let it be that *p*)

If *q*, then *p*
If *r*, then *q*

Decision: *r*!

While for theoretical inference the starting point is something asserted or supposed:

r (or: Suppose *r*)
if *r* then *q*
if *q* then *p*
p

The change of mood and different order of the same elements give what may be called a different form. But that is all. We would have as much right to call 'a different form' that search for an explanation which we noticed. In arrangement it is just like practical inference. The mood is not changed, and the reasoning is towards a hypothesis proposed for investigation.

Given: *p*
if *q*, then *p*
if *r*, then *q*
To investigate: *r* (Is '*r*' true?)

For example, we may either seek to attain something, or to explain it when given it as a phenomenon:

To attain: Spectacular plant growth To explain: Spectacular plant growth
 If plants are fed with certain sub-
 stances, there will be spectacular plant
 growth. If these substances are in the
 soil, the plants will be fed with them.

Conclusion: To put those substances in Conclusion: To examine the soil as to
 the soil check whether those sub-
 stances are present

Both of these uses are different from the 'theoretical' use to reach the truth of a conclusion:

Premise: There are certain substances in the soil
 If those substances are in the soil, the plant will be fed with them.
 If the plants are fed with those substances, there will be spectacular plant growth.
Conclusion: There will be spectacular plant growth.

If the common characteristics of these three patterns are recognised, and it is also clear wherein they differ, then it seems a matter of indifference whether we speak of different kinds of inference or not.

Those, however, who have objected to the idea of 'practical inference' have this speaking for them: though there is a 'validity' of practical inference, it is not of a purely formal character.—By that, I mean one that can be displayed by the use of schematic letters, such that any substitution instance of the forms so given will be valid. The restriction of subject matter to future contingents may be formally characterisable. The restriction, which we have mentioned, on inferences to *bringing it about that p and q,* apparently cannot be.

The transmission of belief can be called 'logical' in a derivative sense: if *r* follows from *p and q* and one *believes r 'because p and q'.* Given the truth-connexions of the propositions, *any* such belief will be 'logically transmitted' in our derivative sense. A parallel sense of 'logical transmission' for practical inference would be empty and vain, failing to catch the idea of 'transmission of intention'. For there *is* such a thing, but it is excluded in the case where *p* will be relevant to the end and we add just any arbitrary conjunct *q,* whose truth would have to be effected 'separately'.

In his earlier 1963 article on practical inference, in *The Philosophical Review (B195),* von Wright mentions a form in which the second premise says that the end won't be attained unless someone *else, B,* does something. With his assumptions, he cannot give an account of a reasoning whose conclusion is *B*'s action; "the agent who is in pursuit of the end and the agent upon whom the practical necessity is incumbent must be the same."

Nevertheless, there are such forms. They will be practical (rather than idle) if the considerations on the part of *X*, whose objective is mentioned in the first premise, lead to the other's doing the required thing. But this might be because *X forces B* to do it! If so, then the terminus is that action on *X*'s part which compels *B* to do *A*. But it might also exemplify some relation of affection or authority or co-operation. Then we could treat the action on *B*'s part (without verbalization) as the conclusion. At any rate, we can do so just as much as where the person who acts is the same as the person whose objective is promoted.

If the reasoning terminates in the utterance of an order, then of course B does not have to derive that conclusion; he is already given it. That will not be a case that interests us; the cases we are after are ones where B makes the inference. Now in discussion of 'imperative inference', people have usually had in mind the derivations to be made by someone obeying other people's orders. I described this as a problem of practical inference: such a person, I supposed, has the objective of executing an order. But what have people in mind who discuss whether '*Do r!*' follows from 'Do *r* or *q*', or conversely? I think that either the initial order is supposed to be accepted, in the sense that the one who accepts it as it were administers it to himself, after which he 'infers' derivable orders, or he is conceived of as ascribing the derivable orders to the person giving the initial order. In either way of looking at it there is a supposed or putative inference on the part of someone who seriously means the first order, to the derived order.

Reverting to von Wright's first person form, suppose I say to you:

> I want to get this message to N by four o'clock. Unless you take it to him, I shan't get it to him by four o'clock.

and suppose I then hand you the message with nothing more said, whereupon you carry it to *N*. (Such is our relationship). So *you* act on *my* grounds. I state the premises (as premises are conceived by von Wright); you draw the conclusion.

Now if it were 'theoretical' reasoning, i.e., reasoning to the truth of a conclusion, you might 'draw the conclusion' without believing it. I make assertions, you produce a statement that is implied by them. If you did believe what I said, and are clear about the implication, very likely you will believe the conclusion. But you may not have believed me. Nonetheless, you can still produce the conclusion precisely as a conclusion from the premises without asserting it and without believing it.

How is it with action? The way we are looking at the matter, drawing the conclusion in a practical sense is acting. Then you act in *execution* of my will. But what are you after yourself?

You may be after promoting my objectives. If so, we might represent the matter by setting forth *your* 'practical grounds':

I want what she wants to be attained.
Unless I do *A*, what she wants won't be attained,

so. . . . But may it not be that you have no objective of your own here? That you are functioning as an instrument? Asked for the grounds of your action, you point to *my* grounds, as a man may point to his orders.

You are then speaking as one who had a certain role, but whose own objectives do not yet come into the picture.

Do you, for example, have to believe the 'second premise'? No! Then you act, but perhaps woodenly or even as it were ironically. Surely slaves and other subordinates must often act so.

Not aiming at what the directing will aims at, not believing his premises, but still drawing the conclusion in action: *that* will be what corresponds to not believing the assertions and not believing the conclusion but still drawing the conclusion in the theoretical case.

These considerations make a distinction between what a man is up to and what he is after. In the case imagined, what he is up to is: being the executive, the instrument, a kind of rational tool, and *so* acting as a subordinate. But this does not show what, if anything, he is after: it does not show *for the sake of what* he acts. It might be objected that he *has* the objective of 'acting as a subordinate'; this no doubt is an intermediate end, for him, pursued perhaps for the sake of getting by, of not getting into trouble. This may be so sometimes. Then the man does not merely act as a subordinate, *he thinks* he had better do so in order to keep out of trouble. But it would be a mistake to think this must always be the situation. We can go directly from taking the message in these circumstances to the end of not getting into trouble. The means, acting as a subordinate, are not required as an intermediate term. That he acts as a subordinate in the way I have described is a true characterization or summary description of his thus acting under the will of his master or superior. But perhaps his 'consciousness has not been raised' sufficiently for the idea to enter into his calculation.

Now I can at last bring out the objection to von Wright's putting wanting, and believing—the psychological facts of wanting and believing—into the premises. It is as incorrect as it would be to represent theoretical inference in terms of belief. No doubt we could argue that '*A* believes that *p* and that if *p* then *q*' entails '*A* believes that *q*'. I have already remarked on a certain emptiness in this contention when it is decked out with such saving clauses as are needed to make it true. One will then take the failure to believe *q* as a criterion for the falsehood of the statement of conjunctive belief: we won't *call* it 'really' believing that *p* and if *p* then *q*. Similarly for '*X* intends to attain *E* and believes

that unless he does *A* he will not'—if he does not now do *A*. Yet the objection may not impress. For if *p* entails *q*, then of course *not–q* will entail *not–p*, and one may not be sure of the weight of the notion of a 'criterion' here.

But there is a clearer objection. We would never think that the validity of '*p*, if *p* then *q*, therefore *q*', was to be expounded as the entailment of '*X* believes *q*' by '*X* believes that *p* and that if *p* then *q*'. It is, we feel, the other way around.

Belief is the most difficult topic because it is so hard to hold in view and correctly combine the psychological and the logical aspects. Beliefs, believings, are psychological states, something in the history of minds. But also, a belief, a believing, is internally characterized by the proposition saying what is believed. This is (mostly) not about anything psychological; its meaning and truth are not matters of which we should give a psychological account. Propositions, we say, are what we operate the calculi of inference with, for example the calculus of truth functions; and this is the calculus. We then display it. Certainly what it is *for* is, e.g., to pass from beliefs to beliefs. But we should throw everything into confusion if we introduced belief into our description of the validity of inferences. In setting forth the forms of inference we put as elements the propositions or we use propositional variables to represent them.

Just the same holds for the patterns of practical inference. I have argued that the *logical facts* are merely the same as for theoretical: e.g. the truth-connexions of *p*, if *p* then *q*, and *q*; and of *not–p*, only if *p* then *q*, and *not–q*. But the patterns are different; the elements are put in a different order; and the propositions are not asserted but propounded as possibilities that can be made true.

There would be no point in the proof-patterns, if they were never to be plugged into believing minds, if nothing were ever asserted; and equally no point in patterns of practical inference if nothing were aimed at. But *still* one should not put the wanting or intending or believing into the description of the inferences.

Now this point about the inference itself appears to me capable of demonstration from the cases we have just been considering. Just as, without believing it, I can draw a conclusion from your assertions, so our ironical slave can draw a conclusion in action from the specified objective and the assertion made by his master. In both cases the inference is something separable from the attitude of the one who is making it. The elements of the inference must all be in one head, it is true; that is, they must be known to whoever makes the inference; but the cognate believing and willing do not have to exist in that soul. So the inference patterns should not be given as ones in which these psychological facts are given a place.

Theoretical inferences do essentially concern objects of belief, and practical ones do concern objects of will and belief. This can put us on the wrong scent

if we think that belief and will are themselves experienced soul or mind states, happenings, actions or activities, as are pains, feelings of all sorts, images, reflections, and sometimes, decisions. It is easy to think this. Then 'I believe *p*' would mean, say, 'I get assent-feelings about the idea that *p*.' But if one does adopt such a view, one will find the greatest difficulty in maintaining that there is anything at all in the entailment: '*X* believes that *p* and that if *p* then *q*, therefore *X* believes *q*'; Or by the same token, anything at all in the argument '*X* intends to attain end *E*; *X* believes that unless he does action *A* now he will not attain *E*; so *X* is just about to do action *A*'.

<h1 style="text-align:center">V</h1>

One of von Wright's moves, which helped to obtain necessity in the conclusions of practical inferences, was to change 'want' to 'intend': *X* intends to make the hut habitable. This has the effect of restricting his first premise to definitely accomplishable objectives. A man may hubristically say that he intends to be rich, healthy, happy, glorious, to attain the knowledge of things worth knowing, or to enjoy life. Whether he will do so is very much on the knees of the gods. If we speak, as I am willing to speak, of an *intention of the end* even for such ends, intention here means nothing but 'aiming at', and the verb 'intend' remains inept.

We have seen that the pursuit of necessary connexion or logical compulsion is pursuit of a Will o'-the-wisp. So we need not limit ourselves to such restricted ends. Von Wright himself did not stress the purpose of securing some kind of necessity of a conclusion; nevertheless that purpose was served by the restriction in the following way: when ends are of such a diffuse character as the ones I have just mentioned, it is rare for some highly specific action here and now to be quite necessary in pursuing them. Not that it is out of the question. I might for example have the end of leading an honourable, unblemished life, and then there will sometimes be situations in which, as we say, some 'quite particular' act is necessary for me. All the same, the case is exceptional. But it is a quite frequent one for the attainment of such very specific objectives as I can properly be said to *intend to bring about*.

Von Wright gives a different reason for the restriction: a man may want incompatible things. But his purpose of ruling out incompatible ends is not guaranteed success by changing 'want' to 'intend'. Although no doubt a man can intend only what he at least thinks he can achieve, still the objective is always at a remove from the action; it is thus quite possible for him in his actions seriously to intend to achieve things which are severally possible, but not possible together; nor does he have to *think* that they are compossible; he may never have brought them together in his mind—if he had, he would perhaps have realised at once that they were not possible together. Thus he may

do one thing to help bring it about that two people meet, and another to help bring it about that one of them travels overseas, though this will prevent their meeting.

We may therefore confidently abandon this impoverishing restriction. This allows us to consider an important fact of human nature, namely, that men have such 'diffuse' ends. They are not merely concerned to bring about such circumstances as that object *A* be moved to point *B*. They want, e.g., happiness, glory, riches, power.

We might call these ends 'generic'. But here we must avoid a confusion: 'generic' does not mean the same as 'general'. The generic is contrasted with the more specific: what *form* of wealth, for example, is a man who wants to be wealthy aiming at in his calculations, when he has worked out something to do in order to be wealthy? The possession of lands, or of a regular income, or of a large sum of money? His heart may just be set on being wealthy, but if he is to achieve this it must take a more specific form, perhaps determined for him by his opportunities.

An end may be called 'particular' either by contrast with being generic or by contrast with being general. It will be convenient to avoid this ambiguity. When I call an end *particular*, I will henceforth mean that the end is that something shall hold about a given individual. *This hut* is to be inhabitable, *I* am to be rich or happy. Thus all these generic ends of health, wealth, knowledge, etc., are in this sense particular. That *this hut* is to be inhabitable is particular but not very specific. More specific is that it is to be warm, or furnished. Still more specific: that it is to be warmed with a coke stove. We descend from the merely specific to the particular on the side of *what is to be done* to the hut if I make it my objective that it be warmed with the stove I found in a certain shop; at least, if I mean the very example of the stove, and not the type.

Ends can be general. I may not be aiming at NN's doing or being something, but have, e.g., the aim that some men know classical Greek, or again that men be free. This last is not merely general but generic. But if my aim is: that there be a copy of the Bible in every hotel room, that is a general but specific end.

It is human to have generic ends. These are particular when they are ends that one shall oneself be or do something. I don't know if it is humanly possible to have no *general* ends. I suppose that a good man will be likely to have some. (Though I don't mean that it *takes* a good man to have any.)

Having thus far cleared the ground, we can make some observations on the role of 'general principles' in practical inference.

If, as in Aristotle, 'principle' means 'starting point', we might first think that a starting point is wherever you happen to start. But this would not be quite satisfactory, since you might happen to *start* with some quite particular fact, as, that *N* is married to *M*. It is not a historical order of actual consider-

ation that is meant; a man's considerations leading to an action can be arranged in an order that displays a progress from something mentioning an end to the particular action adopted. This is so whether the first thing merely mentions an end as 'pure water is wholesome for humans to drink' mentions the wholesome to drink, or specifies it *as* an objective, as 'Health is to be restored' does. In either case we can call the thing aimed at the starting point. If the objective is not specified *as* an objective, then the statement mentioning it which we put first in an orderly arrangement *may or may not be a general statement*. Thus, 'Only if this hut is heated will it be habitable' is not a general statement; yet it might be the first in a set of considerations which we give as the grounds of an action.

However, its truth will be connected with general facts as well as a particular one. E.g., 'Humans need a certain degree of warmth in their habitations' as well as 'This hut lacks such a degree of warmth as it is'.

Aristotle's 'general' or 'universal' premises are of that kind. It is a reasonable view that such premises are always, in some sense, in the offing. But maybe only in the sense that they ought to be reachable. '*This* hut needs heating if *you* are to live in it' might be the judgment of a sensible person who had not formulated a general statement—for perhaps another person rather hardier could manage well without heat in this hut. "General propositions derive from particular ones", Artistotle remarks, and an experienced person may just have good particular judgment. He has just spoken of 'intelligence' (nous), which in practical considerations—and here I will translate with the uncouthness of a close rendering of the Greek—"is of the particular, of the possible and of the second premise; for these are starting points of that for the sake of which". Here 'starting points' does not mean *considerations* or things put in some arrangement of propositions; it means rather *causes*. That for the sake of which something is done has its source, if it does get achieved, in perfectly particular contexts, where there is possibility of things turning out one way *or* another, and in the particular premise, which is the immediate ground of action. Thus the general premises may be dispensable. But if we could not simply and directly judge the particular '*You* need *this* hut to be heated' we might reach it from generalisation, as also if we heard it and looked for a justification of it. Somewhat vague generalisations like 'Humans need a certain degree of warmth in their dwellings' are of course readily available.

So much for the relation of general and particular premises. I now turn to what is much more important, the matter of generic ends.

Aristotle has a teaching which is useful to mention because of the contrast that it offers with von Wright's. I stick to my principles of close translation:

> Of theoretical thinking which is neither practical nor productive, the *well* and *badly* is the true and false, for this is the business of any thinking; but of what is practical and intellectual, truth in agreement with right desire.[12]

By contrast, we may say: in von Wright's picture the business of practical thinking is simply *truth in agreement with desire*[13], i.e. getting things the way you want them to be without the qualification that Aristotle puts in "getting things a way it's all right to want them to be".

This may be a little unfair to von Wright, who after all has not addressed himself to the question. But we can ask: is not the truth about it a necessary component of the essential characterisation of practical inference?

I claimed that in practical inference the relation between the premises and the conclusion (the action) is that the premises show what good, what use, the action is. Now if, following von Wright, we put 'I want' into the first premise, this aspect assumes insignificance. It could be admitted, but it would be of no consequence. Of course the premises show what use the action is—it is that of bringing about something one wants, which has to be achieved, if it is achieved, by some means.

But in Section IV I shewed that the wanting, the psychological attitude, does not properly go into the reasoning at all. "I want" is not a reason; a reason must shew or be connected with further reasons that shew what good it is to do the thing. Now does this mean merely; what it will effect or help to effect—which, as it happens, one wants?

Admittedly, that is how I have been presenting it so far. There are strong reasons for doing so. If an end, an objective, is specified, then how is correctness of calculation to be judged? By whether it indicates an action that is necessary for, or will secure, that objective. Not *only* by this, indeed, since an effective means may be cumbersome or clumsy or difficult, and a better means may be available. But a criticism of the means on any other ground, e.g., on grounds of outrageousness, makes an appeal to other ends which ought not to be violated in pursuing this one. If you don't mind burning the house down to roast the pig, and it is easy and effective, the pig getting well roasted that way, then why not do it?

Criticism of means which are good purely in relation to the given end, must be in the light of other ends which it is assumed that you have or ought to have. If you have them, we can put them in and criticise the calculation for failure in relation to its ends. If not, then this criticism of means is a criticism of ends and can be considered together with a possible criticism of the given end, either as such or in those circumstances. Now the question becomes: what has a criticism of ends got to do with an evaluation of practical reasoning as such?

Aristotle discusses an intellectual virtue, *euboulia*, which is translated 'good counsel'. This does not imply that one is a giver or receiver of advice, only that the actions of one who has it are, as we might say, 'well-advised', of one who lacks it 'ill-advised'. He observes that it is a certain kind of correctness of calculation; not every kind, because 'the self-indulgent or bad man

will obtain what he purposes by calculation if he is clever, and so he will have calculated correctly, but will obtain for himself a great evil',—whereas good counsel will not produce such a result. We can now say: hitherto we have been considering that 'correctness of calculation' which can be common to the well-advised and the ill-advised. That correctness of calculation which produces 'truth in agreement with desire', i.e. things as one wants them to be.

It is easy to say at this point: 'Ah, what is in question here is *moral* criticism, and that is something else. It is not a criticism of practical inference as such'. But I cannot accept this observation: I have long complained that I don't know what 'moral' means in this sort of use. 'Perfectly sound practical reasoning may lead to bad actions', Yes, that is true, in just the same sense as it is true that 'Perfectly sound theoretical reasoning may lead to false conclusions'. If we limit what we mean by 'soundness' to what is called 'validity', both observations are correct. And in our philosophical training we learn carefully to use this idea of soundness of reasoning and to make the distinction between truth and validity and we are right to do so. Equally right, therefore, to distinguish between goodness and validity; for in the sphere of practical reasoning, goodness of the end has the same role as truth of the premises has in theoretical reasoning.

This is the great Aristotelian parallel: if it is right, then the goodness of the end and of the action is as much of an extra, as external to the validity of the reasoning, as truth of the premises and of the conclusion is an extra, is external to the validity of theoretical reasoning. *As* external, but not *more* external.

We know that the externality is not total. For truth is the object of belief, and truth-preservingness an essential associate of validity in theoretical reasoning. The parallel will hold for practical reasoning.

In the philosophy of action we often hear it debated to and fro whether something, p, 'is a reason' for action. We sometimes hear it said that 'moral considerations' *just are* 'reasons'. But what does all this mean? It seems to be discussed independently of anybody making the thing *his* reason. With our present insight, we can clarify. 'p is a reason', in theoretical contexts, assumes that some proposition q is in question. It may mean that *if* p is true to believe, then q is true to believe or is probable. And that someone believing p would intelligibly believe q 'because p'. Or it may mean that p *is* true, and that anyone would be right to believe q, absolutely or with more or less confidence, 'because p'. Similarly in practical contexts 'p is a reason' assumes that some act A is in question, and then it may mean one of two things. Either that p mentions an end E or states something helping to show that A will promote an end E, such that if p is true and E is good to pursue, A is good to do. And that someone who had the end E would intelligibly do A 'because p'; *Or*, that E *is* good to pursue, that p is true, and someone would be right to do A 'because p'.

What sort of proposition is 'that E is good to pursue'? There are two types of cases: one, where one can ask "good for what?" As, e.g., if I am proposing to do various things to build a bonfire. Building a bonfire is my aim—what's the good of that? In the second type of case E is already specified as some good, e.g., as health is the good state of the body, knowledge of what is worth knowing that good of the intellect. Pleasure is a specially problematic concept, pleasantness therefore as a terminal characterisation especially problematic and I won't concern myself with that question here.

But may not someone be criticisable for pursuing a certain end, thus characterisable as a sort of good of his, where and when it is quite inappropriate for him to do so, or by means inimical to other ends which he ought to have?

This can be made out only if man has a last end which governs all. Only on this condition can that illusory 'moral ought' be exorcised, while leaving open the possibility of criticising a piece of practical reasoning, valid in the strict and narrow sense in which in theoretical contexts validity contrasts with truth. The criticism will be of the practical reasoning as not leading to the doing of good action. An action of course is good if it is not bad, but being inimical to the last architectonic end would prove that it was not good.

Now, that practical reasoning so understood should be of use in understanding action, including the action of a society, I can accept.

<div align="right">G. E. M. Anscombe</div>

Faculty of Philosophy
University of Cambridge
Cambridge, England
April 1974

NOTES

1. 'On So-Called Practical Inference', *Acta Sociologica* 15, no. 1(1972): 49.
2. Ibid., 40.
3. Ibid., 50.
4. Ibid., 39–40.
5. This is the Aristotelian general premise which does not appear in von Wright's examples. It is easily supplied, e.g., "Unheated huts in cold climates are uninhabitable by humans," or "Unheated huts are not rendered inhabitable unless they are heated." But the hypothetical statement seems to make the general one redundant and vice versa. See Part V.
6. Aristotle, *Metaphysics* Z 1032b, 7–10.
7. Ibid., 25–26.

8. In a special sense: not that the 'conclusion' has to be fulfilled or implemented. But the proposition is given the 'Fiat' form to shew that it is not being asserted or supposed, but proposed as something to make true.

9. Alf Ross shews some innocence when he dismisses Kenny's idea: "From plan B (to prevent overpopulation) we may infer plan A (to kill half the population) but the inference is hardly of any practical interest." We *hope* it may not be.

10. 'On So-called Practical Inference', 45.

11. *Ethica Nicomachea* 1143b4ff.

12. Ibid., 1139a 27–30.

13. I mean truth which you make true by acting. For some reason, people find this idea very difficult. In lecturing I have sometimes tried to get it across by saying: "I am about to make it true that I am on this table." I then climb on the table. Whether I have made it true that my hearers understand, I do not know.

17

Max Black

SOME REMARKS ABOUT 'PRACTICAL REASONING'

PROEM

Nobody who has wrestled with the perplexing questions connected with so-called 'practical reasoning' can feel confident of having a perspicuous grasp of the subject. The following tentative—and, I fear, somewhat disorganized—reflections are offered in partial repayment of the intellectual debt I owe to Georg Henrik von Wright for his illuminating discussions. If they provoke him to elaborate his position, I shall not be alone in having still further reason to be grateful.

VON WRIGHT'S PROBLEM

If I am not mistaken, von Wright's interest in 'practical reasoning' arose as a by-product of his preoccupation with a basic problem in the philosophy of action, expressed in the question, 'Can the intention or will be a *humean cause* of behavior, i.e., of the immediate outer aspect of an action?'[1]

'Causalists', as von Wright calls them, answer in the affirmative. If we ascribe to the putative agent, in addition to his 'intention or will' (his 'volitional attitude'), a belief in the sufficiency or necessity or an available means for producing the desired end-in-view (his 'epistemic attitude'), the two together are, according to the causalists, enough to *cause* the resulting action (or, perhaps, more precisely, 'the immediate outer aspect' of that action). Von Wright, on the other hand, has steadily favored the 'intentionalist view' that the relation between the combination of volitional and epistemic attitudes and the subsequent action is not causal, but rather of a 'conceptual or of a logical nature'.[2]

TWO COMPETING ANALYSES OF ACTION

Consider for the time being a case in which somebody, *P*, does *A* because he thinks it a *necessary* means to the achievement of some desired end-in-view, *E*. A causalist explanation of such an episode looks somewhat as follows:

(1) *P* intends to achieve *E*.
(2) *P* thinks that doing *A* is necessary in order to achieve *E*.
So, (3) *P* does *A*.

Here, the 'So' is meant to refer to some *causal* connection between the three facts, with an implication that some unstated empirical law guarantees that the volitional and epistemic attitudes of *P* will *in fact* produce his action. A causalist, therefore, is bound to deny that (1) and (2) alone *entail* (3), although he will grant that an entailment would obtain if the premises were strengthened by the addition of the implied causal law. If, on the other hand, (1) and (2) did entail (3), it would, on 'humean' principles, be a mistake to suppose that the connection between the three facts was causal.

This, I surmise, may be one reason for von Wright's sustained interest in trying to show that entailment or something like it does hold between the two attitudes and the corresponding action. (No doubt, he also has independent reasons for thinking so.) To establish the presence of such an entailment would be a particularly effective way of refuting the causalist thesis.

Consider now how a 'practical syllogism' is involved in the action. Von Wright works with the following first person reconstruction of the agent's train of thought:

(1') I intend to make it true that *E*
(2') Unless I do *A*, I shall not achieve this.
Therefore, (3') I will do *A*.[3]

In this schema, the 'Therefore' is of course supposed to indicate that (1') and (2') are the agent's *reasons* for the action, and the whole account is regarded by von Wright as providing a special kind of explanation, peculiarly appropriate to understanding human action.

A causalist might object that the conclusion of this so-called 'practical syllogism' does not yet correspond to an *action*. If we were to follow von Wright in taking (3') to be a 'declaration of intent'[4] and agreed with him, provisionally, that such a declaration is entailed by the two attitudes that explain it, we should still have a logical gap between the transformed intention and the subsequent action, if it occurs. (An agent may intend to do *A*, and still not do it.) So a causalist might concede that the transformation of the original intention to achieve *E* (when accompanied by belief that *A* was necessary for this) into the intention to do *A* might be of a 'conceptual or logical nature'—and still regard

the connection between the transformed intention and the subsequent action as 'humean'.

I am not certain, though I think I can guess, what von Wright's answer to this objection would be.

A Working Definition of 'Practical Reasoning'

Let us identify a 'practical argument', very broadly for the present, as 'an argument supposed to supply reasons for performing an action'. Then a statement of volitional and epistemic attitudes, in the above style, with a terminal intention to act accordingly, might qualify, since any reasons for *intending* to do A would necessarily be reasons for *doing A,* and vice versa. But from the standpoint of such a comprehensive conception of practical reasoning, it will seem arbitrary to insist that the 'volitional attitude' should consist of a declaration of *intention* and arbitrary also to confine oneself to the case of supposedly necessary means. So let us consider what the complete form of a practical syllogism might be, if these two restrictions were dropped.

Problems for a 'Logic' of Practical Reasoning

I take it as beyond dispute that people do sometimes reason to conclusions that designate actions as the ones to be undertaken, and that some such deliberations can be censured as unsatisfactory or praised as sound.

Briefly, then: there *is* such a thing as 'practical reasoning', if by that we mean reasoning that does lead, sometimes correctly, to a conclusion identifying what action is to be taken. If we are then interested in developing a 'logic' of such reasoning, i.e., in identifying canons for the criticism and endorsement of the corresponding forms of argument, we shall be led to raise such questions as these: What would be appropriately canonical forms of the premises of such reasoning? Also, what would be appropriately canonical forms of the conclusions? Above all: What is the nature of the inferential connection between the premises and the conclusions in an acceptable practical argument? (An answer to the last question will determine whether we want to regard practical reasoning as a distinct and special kind of reasoning, differing from ordinary 'theoretical reasoning' as Elizabeth Anscombe thought at one time.)

In considering the merits of practical *inferences,* in which the premises are *affirmed,* we shall also need some understanding as to what, if anything, corresponds to the demand that an acceptable 'theoretical' inference shall be composed of premises that are, or at least are thought to be, *true.*

These questions about the logical forms of a standard practical argument are still unsettled and controversial. I shall say something about each of them.

The Canonical Form of Practical Conclusions

The easiest of the questions to answer might seem to be the one concerning the form of the conclusion. If we identify the forms of practical reasoning, at least provisionally, as those exemplified in deliberations—reasonings directed to answering a question of the form, What should be done?—an appropriate form for the conclusion would seem to be: *such-and-such should be done by P*. However, we ought to allow also for negative cases, where the conclusion has the form *Such-and-such should not be done*. And, if we are to have a reasonably comprehensive theory, we shall also need to consider conclusions of the form *Such-and-such can be done* and *Such-and-such must* (or, *must not*) *be done*. Let us call statements having any of these forms 'verdicts'.

Identification of a 'verdict,' as I have chosen to use that expression, will accordingly require the following: a specification of the action in question (which might be called the *agendum*), a specification also of the person or persons by whom the action is to be performed, and, finally, a modal operator *(can/cannot, should/should not, must/must not)*.

Presence of such modal operators in the proposed canonical form of the conclusion of the practical argument might suggest that the logic of practical reasoning belongs to modal logic. I have, however, suggested elsewhere[5] that by construing a deliberative situation as one of finding the solution for a problem or *task*, it is possible to avoid recourse to a modal logic. I shall not pursue that suggestion here.

Practical Conclusions are Not Actions

In the last section, I have parted company with the insistence of Aristotle (and occasionally von Wright) upon treating the conclusion of practical reasoning as an *action*. In defense I would urge that there is a logical absurdity about supposing that an action, something occurring in the material world, can literally stand in the relation of *entailment* to premises. The best sense that I can make of this is that a *proposition* to the effect that somebody, say P, did action A is entailed by a certain complex proposition about his intentions, beliefs, and so on. In this curious sense, one might even say that an earthquake was entailed by certain terrestrial circumstances, but perhaps this kind of talk should be avoided.

In any case, I doubt that genuine entailments to conclusions about *actions,* in the form *P does (did) A,* ever arise except in cases where the relevant premises have been strengthened to the point of making the 'practical syllogism' trivial. It is, no doubt, possible to impute 'unconditional commitment', 'intention to accomplish at all costs', or something of the sort to an agent, in such a way that any evidence that the relevant action was left undone would impugn that truth of the premise. However, in interesting cases, where there is some genuine intellectual or practical problem to be solved, the relation between the epistemic attitudes and the conclusion seems to be less rigid.

One might say that the 'strongest' practical conclusions ever resulting from a deliberation has the form 'Such-and-such *must* be done'. It is worth noticing that the provision of satisfactory reasons for such a 'must'-verdict (or alternatively a 'should'-verdict) exhausts the process of rational deliberation, since any good reason for affirming the verdict is, *ipso facto,* a reason for performing the corresponding action and vice versa. Thus criticism of a course of practical reasoning leading up to action ends with appraisal of the 'verdict'. As to a further question concerning the relation between affirming a verdict and performing or not performing the corresponding action, that seems to me not to belong to logic. There are, no doubt, pathologies of akrasia (or, for that matter, what might be called 'weakness of belief' or 'apistia') which should interest psychologists, but in normal cases it 'goes without saying' that, other things being equal, a person will do what he is convinced that he should do. Indeed, one might argue that this transition from the affirmation of a verdict to the normal performance of the corresponding action is built into our uses of 'should'.

Does Truth-value Attach to the Elements of Practical Reasoning?

In deciding whether to regard practical reasoning as having a distinct logic, a crucial question will obviously be whether the conclusions of practical arguments—the 'verdicts' as I have called them—should be regarded as propositions having truth-value.

Something can be said on both sides of this issue. On the one hand, it may be urged that somebody expressing or thinking a 'should'-verdict is thereby expressing a *resolution* to bring something about, and that therefore, strictly speaking, no question of truth or falsity arises. Similarly, it might be said, that in second-person uses of 'should'-statements we have instances of admonition or advice rather than assertion, and so once again questions of truth or falsity are irrelevant, though questions of appropriateness might be in order.

On the other side, the following points have much force: One can *agree* or *disagree* with the affirmation of a 'should'-verdict, and 'should'-verdicts can appear as antecedents in hypotheticals or conditionals. On the whole, then, while recognizing the special aptness of 'should'-verdicts for the expression of resolutions or admonitions, and their particularly intimate connection with actions, it seems reasonable to treat them as *propositions*.

I suspect that resistance to this contention and a corresponding inclination to adopt a more 'subjectivist' view of the nature and function of 'should'-statements arises from qualms concerning their verification. But such qualms ought to be assuaged by recalling the grounds we actually employ in establishing such 'should'-propositions. If our notions of verification are not perversely procrustean, there is no reason to deny that 'should'-propositions can, at least in favorable circumstances, be verified or falsified. I do not therefore regard the nature of the conclusions to practical arguments, as I conceive of them, to be any obstacle to treating practical reasoning as on a footing with 'theoretical' reasoning.

THE PREMISES OF PRACTICAL REASONING

If we turn now to the premises that people actually use in arguing to verdicts, we shall find a job lot of propositional or quasi-propositional forms: expressions of wants or desires ('I want a raise'), or of intention ('I intend to be there at all costs'), statements of obligation ('I promised to do such and such'), permissions ('It is alright to use that account for this expense'), and a large variety of verdicts (statements containing 'should', 'must', etc.). To these must, of course, be added a variety of unproblematic propositions concerning the setting of the envisaged action, such as—the available alternatives, their probable outcomes, and so on.

All of these, I think, can properly be treated as propositions having truth-values. Some of the premises can, to be sure, express various attitudes or dispositions on the part of the reasoner, but they are still available for acceptance or rejection, affirmation or negation, by another. This is as it should be if we are to arrive at any rational and therefore communicable critique of practical reasoning. The notion of processes of reasoning, cogent and approvable for the reasoner himself, but inaccessible to rational appraisal by a critic, seems unacceptable.

I conclude that the interestingly variegated character of the premises that may occur in 'practical reasoning' is no bar to regarding such reasoning as merely a specially interesting case of reasoning in general. The contention that practical reasoning is a special sort of reasoning must, therefore, turn upon the nature of the connection between the premises and the conclusion.

ARISTOTLE AND THE MYTH OF LOGICAL NECESSITY

Von Wright's interest in the supposed logical connection of entailment between the premises and the conclusion of a practical syllogism brings his investigations into direct relation with Aristotle's famous though sketchy and inconclusive discussions of related topics. A key passage in Aristotle's discussion is the following:

> Now when the two premises are combined, just as in theoretic reasoning the mind is compelled to *affirm* the resulting conclusion, so in the case of practical premises you are forced at once to *do* it.[6]

Here we can see the attraction of the developed theory of the 'theoretic' syllogism. It is as if Aristotle thought that, failing a relation of logical necessity between the premises and conclusion in practical reasoning, the latter should not really count as firmly established. Given, however, the notorious fact that agents sometimes act 'contrary to reason', by failing to perform actions that they think they should perform, Aristotle is at once faced with the ancient problem of *akrasia,* which preoccupies him in Book 7 of the *Nicomachean Ethics.* Von Wright is enmeshed in similar difficulties, since he too would like to treat the practical syllogism as exemplifying a logical or 'conceptual' connection, while recognizing that sound reasoners sometimes fail to perform the designated action.

In the passage I quoted from Aristotle there lurks a persuasive mythology, that is worth unmasking. "[T]he mind is compelled to affirm the resulting conclusion . . ." This suggests the action of some mental or psychic force that literally compels the reasoner to believe a valid conclusion. As the body sometimes slides down an icy slope, willy nilly, so the mind, in spite of anything we can do, is compelled to 'move', as people say, to belief in a conclusion. But the supposed analogy has no basis.

If the position of a reasoner considering an argument genuinely resembled that of some material body under the action of external forces, it should be *impossible* for him to withhold assent from a conclusion whenever he thought it to be entailed by true premises. This sounds plausible enough if the argument is a *modus ponens* or something equally simple, but may be false otherwise. In a long and intricate argument, a reasoner may (a) think the premises, *P,* to be true, (b) think that *C* follows from *P,* and (c) still not really 'accept' *C,* because he finds it unpalatable, absurd, or even self-contradictory. 'Weakness of belief' (or *apistia*) has as much claim to philosophical attention as the more familiar 'weakness of the will' *(akrasia).*

If there really were some mental force that 'compelled' a reasoner to accept a conclusion, such a force ought to be uniform and invariable in its operation. Then there would be no room for a critical *logic* of reasoning—any more than

there could be a question of criticizing the operation of the law of gravitation. But the alleged 'force' of the logical tie in 'theoretical reasoning' is felt only by those who *want* to be consistent or rational—and who succeed in being so. Logic, one might say, is a theory of *rational* reasoning.

Logic, however, is not concerned with psychological facts about whether persons do or do not feel drawn or pushed towards certain beliefs but rather—not to shirk banality—with criteria for the correctness or validity of such transitions. *Mutatis mutandis,* the same ought to be true about 'practical reasoning'. Questions about why persons who accept practical syllogisms sometimes fail to act upon the conclusions, interesting as they are, belong to psychology. Our interest here should be only that of establishing, if we can, the canons of sound or *correct* 'practical reasoning'.

The modern way of coping with the supposed 'logical necessity' in reasoning is of course to set aside the 'psychological factors' and to attend exclusively to the validity of the argument-*form*. So, nowadays, instead of saying that a reasoner is forced to accept the conclusion, one says rather that it is logically impossible for the premises of a valid argument to be true when the conclusion is false. Then the reasoner can do as he pleases: all that the logician can do is to tell him whether he has reasoned well or badly.

Aristotle and von Wright share a desire to have the premises of a sound practical argument entail a corresponding action. A curious feature of this approach is that it seems to disqualify practical syllogisms for use in *deliberation*. For in such situations, we typically think about *what to do,* in a situation where the action has not yet been performed. But according to Aristotle's conception, the premises will *compel* the ensuing action; while in von Wright's use of the practical syllogism in explanation, the action is supposed to be already given as an explanandum. Now, whatever value an appeal to practical reasoning may have in explanation, it seems to me necessary also to recognize its importance for deliberation. Indeed, explanation, one might say, recreates the situation of somebody deciding what to do before the action has been performed.

PRACTICAL ENTHYMEMES

In determining the logical relationships between the conclusion and the premises of a practical argument, a gratuitous difficulty is introduced by the practice of Elizabeth Anscombe and other writers of supplying only enthymemes. In *Intention,* for reasons that I find unintelligible, she refuses to admit a statement of want or desire into "a formal account of practical reasoning".[7] Thus she writes:

> The form, 'I want a Jersey cow, they have good ones in the Hereford market, so I'll go there' was formally misconceived: the practical reasoning should just be given in the form 'they have Jersey cows in the Hereford market, so I'll go there'.[8]

Imagine now that somebody is called upon to appraise the argument supplied by Anscombe. In order to do so, one would have at least to impute some *interest* on the reasoner's part in buying Jersey cows, e.g., that she needed them for milk, or had been required by her employer to buy some. Failing some such imputation, criticism is brought to an immediate halt. So a premise about want, desire, or something else motivating action seems necessary for a full and explicit reconstruction of the reasoning.

Von Wright's examples of practical syllogisms are not subject to the same strictures, since he is always concerned with necessary rather than sufficient conditions. But consider the following example, modeled on his own treatment:

> I intend to warm this hut.
> Unless I burn some firewood I shall not succeed in this.
> *Therefore,* I must burn some firewood.

Well, even in this case, a number of questions can arise, if one is to engage in serious criticism of the argument. First, the conclusion would certainly be mistaken if the means in question were unavailable. Hence, a fully explicit argument would need a further premise to the effect that the firewood was there and could be used. Suppose now that the firewood was available but there was reason to think that the end in question could not be achieved by using it because, say, the chimney was blocked. Then, the conclusion that the person in question must burn the firewood would be mistaken. Also, as I have argued before, a good deal turns upon the emphasis placed upon 'intention' in the first premise. In ordinary uses of that word, it by no means follows from the existence of an intention that a certain action, necessary though not sufficient for the satisfaction of that intention, 'must' be performed. It might be more natural sometimes simply to conclude that the action must be performed *if the intention is to be sustained*. So the relationship between the premise as given and the conclusion is not as clear as von Wright's treatment might suggest.

INDEPENDENT DISCUSSION OF THE FORM OF A PRACTICAL ARGUMENT

I propose now to start afresh by formulating a straight-forward example of what would be regarded in ordinary life as an argument to a conclusion concerning action and then to add *seriatim* every implicit assumption that would be needed to render the argument 'formally complete'. My object is to exclude nothing that upon reflection would seem to have a bearing upon the question whether the conclusion was justified, given the premises.

The following is a clear instance of the kind of situation in which deliberation and the use of a practical argument arise:

> Having written a letter, I need a stamp. I realize that I have no more on my desk. But I remember that I have one tucked away in my diary. (I go and get it.)

Let us call this episode *E*. I assume that in *E* the reasoner found a satisfactory answer to a question of the form, 'What shall I do?' by means of a sound argument.

If we set out the reasoning formally, we might arrive at something like the following:

> I need a stamp.
> [I have no stamps here.]
> There is a stamp in my diary.
> [I can get the diary without undue trouble.]
> If I get my diary, I shall have a stamp.
> I should get the diary.

Here, in line with my previous remarks, I am taking the conclusion to be a 'should'-statement, treating the final transition to action as outside the argument's scope.

One way to determine whether this should count as a *complete* argument is to consider how the train of thought might be faulted by a carping critic. He might object: (i) the letter didn't need a stamp; or (ii) you were wrong about the diary being where you thought it was; or (iii) the diary didn't have a stamp after all; or (iv) you didn't realise how much trouble was involved; or finally (v) there was a stamp in your pocket, so you didn't need to go all the way up to the attic. Of these objections, the first two are directed to the supposed truth of the original premises, while the last might be characterized as an objection to the supposed correctness of identifying the proposed action as *the most satisfactory* in the circumstances.

It looks therefore as if the argument form set out above should be supplemented by some such premise as the following:

> It is worth my trouble to get the diary (to choose *this* means) and no other available means will involve less trouble.

Such an *optimality premise,* as it might be called, really does seem necessary for the correctness of the argument. For if it were false, a critic would be justified in rejecting the original deliberation as unsatisfactory.

The schematic form that has now emerged for the argument under consideration is approximately as follows:

> *X* wants (needs, would like, must achieve, etc.) *E*.
> Doing *A* would allow *X* to achieve *E*.
> Doing *A* would not be more trouble than it is worth to get *E*.
> *A* is preferable to any other action available for achieving *E* (involves less trouble, expense, conflict with other goals, etc.)
> *So, X* should do *A*.

Is Practical Reasoning Valid?

With this form, it seems to me that we have obtained a *valid* scheme of inference. Given acceptance of the first premise, i.e., 'commitment' to the end in question, and given the relative preferability of *A* over any other sufficient means for achieving *E*, it follows with necessity that *A* should be chosen as the preferred means.

In more sharply defined or more closely analyzed deliberative situations, the 'optimality premise' referred to above would need to be replaced by estimates of the comparative utilities of pursuing *A* or other alternative actions, and estimates of the corresponding net benefits (expected utilities less expected cost of attainment) in each case.

Here again, it seems to me that the appropriate 'should'-conclusion is entailed by the elaborated premises. Given that an end has been accepted, and also that the advantage of doing *A* is greater than that of any alternative, and is also great enough to be worth pursuing, *A* is properly designated as 'what should be done'. For the most 'advantageous and feasible' action in the circumstances is, quite simply, the best action available.

There would be an absurdity about an objector saying, for instance, of a position in a game of chess, 'I agree that *X* is the best move to make in this position, but in spite of that you should not make it.' The only sense one could make of this would be to suppose that the objector was leaving the chess context for another one, say a medical or ethical context. He might have in mind something like: 'That would be the best *chess move* to make, but the action you contemplate would be dangerous to your health or morally offensive, considering that it might provoke a heart attack in your opponent.' All of which is beside the point in the case we are considering.

If I am right then, our language contains built-in transitions from certain statements of ends and the feasibility and relative advantage of available means to corresponding 'should'-propositions. Behind these linguistic conventions are certain ways of responding to circumstances. The point in making first person 'should'-judgments is to prepare oneself for action or, even, to initiate the action. 'Should'-talk seems most appropriate in situations where action is in the offing or in situations where an onlooker or critic is appraising the nature of the reasoning that designates a given action as the one to be done. But, in either case, no 'special logic' is needed. 'Practical reasoning' is merely reasoning, *simpliciter*—applied to answering questions as to what can, should, or must be done.

CORNELL UNIVERSITY MAX BLACK
DECEMBER 1974

NOTES

1. *Explanation and Understanding*, p. 93.

2. Ibid., p. 95.

3. Cf. 'On So-Called Practical Inference', *Acta Sociologica* 15, no. 1 (1972):46.

4. Ibid.

5. See 'Some Questions about Practical Reasoning', Max Black, *Caveats and Critiques* (Ithaca: Cornell University Press, 1975), pp. 56–71. Originally presented to the International Institute of Philosophy at Amsterdam in 1972.

6. *Nichomachean Ethics*, 7, 1147a, 26–28.

7. G. E. M. Anscombe, *Intention* (Oxford: Basil Blackwell, 1957), p. 64.

8. Ibid., p. 65.

18

Dag Prawitz

VON WRIGHT ON THE CONCEPT OF CAUSE

To analyse the concept of cause may seem a dubious undertaking. The reasons for doubt are many.

Some people maintain that the concept is of no real importance. Since, too, it is surrounded by so much confusion, some say that it is best avoided altogether. In an often quoted passage Russell said: "the law of causality . . . is a relic of a bygone age, surviving like monarchy, only because it is erroneously supposed to do no harm." Also according to Russell, "the word 'cause' is so inextricably bound up with misleading associations as to make its complete extrusion from the philosophical vocabulary desirable."[1]

In view of everyday experience such opinions seem extravagant. We constantly ask about the causes of the events that occur around us, and we assume normally that there are such causes to be found and that it is important to find them. A person who on returning home finds his house burnt down will ask about the cause of the fire, and doubts about the real existence or importance of a cause would be absurd. It may be granted that he does not necessarily demand a Humean answer to his question, i.e. an answer in terms of a generic event which occurred before the fire and which is generally followed by fire. He may be quite satisfied on learning *how* the fire happened. Such an answer might, e.g., tell him that the neighbour had been burning grass, that the grass fire had been carried by the wind in different directions, that a pile of trash close by the house caught fire, that the flames from the pile reached the south-

I am much indebted to Professor A. Wedberg who read the manuscript and made many valuable suggestions. In particular, I want to mention that the definition H6 of proper cause was suggested by him in place of a less felicitous definition of mine. I also want to thank Dosent A. Hannay and Docent P. Needham for correcting my English.

east corner of the house, that the fire spread from the corner to the attic, which was soon all ablaze, etc. No specific event is here mentioned which can be said to have caused the burning down of the house. But the man would clearly understand these events as causally connected, in some way determining each other in the order mentioned.

It is well described by Gestalt psychologists how we directly experience an outer event determining or causing an emotion: the emotion is experienced *as* determined by the outer event.[2] Similarly (as is also pointed out, e.g., by Black[3]), we may experience directly that our bodily movements have certain effects. Perhaps, it is also correct to say, contrary to Hume's view, that we can directly experience outer events causing each other as in the case of a series of events such as the fire described above. This does not preclude the possibility that such an experience contains an anticipation that similar events will be followed by similar effects and that the experience would be denied or redescribed if the anticipated regularity failed.

In other contexts it is indisputable that a question about causal connections demands the isolation of generic events. When a farmer finding his potato crop badly discoloured or his wheat growing unusually well asks about the causes of these events, he is interested in finding repeatable sequences of generic events which will allow him to avoid, produce, or predict similar happenings in the future.

As we all know, causal considerations are not limited to everyday life but are frequent, e.g., in law, both civil and criminal, in many philosophical discussions, especially in ethics, and in many sciences (although perhaps not in the most advanced onces). The importance of the concept of cause can not be reasonably doubted.

But just because the concept is so widely used in so many different contexts, other doubts about its philosophical analysis can arise. It can be argued that there can be no fruitful analysis of *the* concept of cause, but that one must differentiate between many different concepts of cause, and that the analysis of any one of them requires the specification of a precise context in which the concept occurs and a clear idea of the purpose of the analysis.

A clarification of different uses of the word 'cause' is certainly of great interest. However, it seems reasonable to assume that the many uses have not merely the word but also a core of meaning in common. Presumably, this common core of meaning has to do with the fact that we conceive what happens in the world not as isolated happenings occurring at random but as in some way 'causally' connected events—events that in some way determine one another. It should be possible, and philosophically important, to isolate such a concept of cause. I am thus arguing for the analysis or reconstruction of what we may call a philosophical concept of cause. Understood in this way, the

concept is on a par with such concepts as those of space and time and mind and matter; i.e., it constitutes one of the fundamental categories with the help of which we grasp the world.

Such an analysis may of course take its starting point in a study of some different uses of causal terminology. But it does not stop at registering different usages, which may well be conflicting and "bound up with misleading associations". Rather it aims at a reconstruction of a causal concept allowing us to express a philosophically interesting idea of the interconnection of events, an idea which is presumably at least vaguely intended in most uses of causal terminology. The value of such a reconstruction depends also on how well it fits together with other concepts related to causation in our philosophical vocabulary and how fruitful it is in discussions of philosophical topics such as determinism, the causation of actions, and an agent's responsibility for the consequences of his actions. The analysis for which I am arguing can thus be understood as an explication in Carnap's sense.

I think that von Wright's analysis of the concept of cause can be understood as such an explication. Von Wright argues for the importance of causal concepts much as I have done here, and he speaks about his concept of cause as a "prototype for the idea of cause" in many philosophical discussions. But I have taken up the question of the nature of his analysis here, because he says rather little about its methodological status, and also because he sometimes expresses himself as if he aimed only at (what seems to me) the less interesting task of describing one particular usage of causal terminology.

Von Wright's analysis is a contribution to the discussion which has been going on since Hume as to whether the relation between cause and effect amounts to anything more than the regular conjunction of two kinds of events. In opposition to Hume, von Wright thinks that it does, and he argues that the relation is to be understood in terms of the notion of action. The concept of cause, von Wright claims, presuppposes etymologically, epistemologically, and logically the notion of action.

I agree with von Wright to the extent of thinking that any analysis of causation along the lines of Hume must be inadequate. But I want to maintain that the inadequacies of the Humean analysis cannot be met by basing the concept of cause on that of action, and that the latter concept is not presupposed by the former.

I shall take as my starting point Hume's definition of the concept of cause. In section I, I shall consider how this definition could be improved without departing from Hume's main idea. I shall then discuss what seems to be the inherent weaknesses in the Humean approach (section II). In the light of this discussion I shall then describe and discuss von Wright's proposed alternative analysis (section III).

I

1. Hume's Definition. The Humean idea that causation involves nothing more than the regular concurrence of two kinds of things is expressed in the following well-known passage from Section VII, Part 2, of *An Enquiry Concerning Human Understanding:*

> (H1) We may define a cause to be an object followed by another, and where all the objects, similar to the first, are followed by objects similar to the second. Or, in other words, where, if the first had not been, the second never had existed.

Two often noted difficulties in this definition immediately spring to the eye. First, the word "similar" is unacceptably vague. Complete similarity is of course not meant, since that would imply identity, ruling out the possibility of repetition. What is meant is thus something like 'sufficiently similar'. But clearly not all similarities are relevant and when specifying those that are relevant one has to beware of circular definitions like 'all objects, similar to the first in causally relevant aspects'.

Secondly, the second part of the definition, which begins "in other words", is in fact far from being another way of expressing the first part. While the first part says roughly that a cause is a sufficient condition of the effect, the second part expresses (seemingly by means of a counterfactual) that the cause is in some way necessary for the effect.

The second part of the definition may seem rather incongruent with Hume's general view about causation and is usually passed over in accounts of the 'Humean concept of cause'. I shall return to it at the end of section I.

2. States and Events. The objects spoken about in Hume's definition are usually taken to be such things as states or events. To avoid circularity when defining the (relevant) similarities alluded to in the definition, one often speaks about aspects or properties of the cause and of the effect and construes the definition as requiring that all states or events having the property attributed to the cause be followed by a state or event having the property attributed to the effect.

In a similar vein, in *Explanation and Understanding* von Wright speaks about *generic* states of affairs. Generic states are such as "may obtain or not, on given occasions—and thus obtain, and not obtain, repeatedly". An 'occasion' is here "a location in space and/or time" (pp. 43–44). As a first approximation, von Wright takes the field of the causal relation to consist of such generic states. In some later writings, he defines a (generic) event as the changing of a (generic) state into its contradictory or opposite, and takes the elements of the causal relation to consist instead of such events and their negations. Here

I shall use 'state' and 'event' synonymously, usually preferring the latter word, and shall comment upon von Wright's distinction later (in section III).

But what more precisely is a 'state' and a 'generic state'? Von Wright expressly states that he leaves this question unanswered. However, if we want also to relate individual states or events causally with each other, we must be able to say what generic event a given individual event is an instance of. An individual event normally has many properties. Can it be an instance also of many generic events?

The question pertinent to both Hume's and von Wright's analyses is whether or not any of the many properties that an individual state can have enjoys a privileged status. Both the affirmative and the negative answer have their advocates. The negative one has often been advocated by Davidson [4] who understands individual events as constituting an ontological category whose members are determined by their location in space and time and their positions in the net of causal relations, but which are independent of any specific descriptions that we can give of them. For instance, according to Davidson, Brutus killing Caesar and Brutus stabbing Caesar are the same event. According to this approach an event is an extensional entity in the same way as a set is extensional: when we think of an event we are to abstract from all possible descriptions of it.

Contrary to Davidson, Kim[5] suggests that an event is determined by a property P, an individual a, and an instant of time t such that a has the property P at time t; or more generally, it is determined by an n-are relation R, an n-tuple of individuals, and an instant of time t such that the individuals stand in the relation R at time t. According to this approach there is a constitutive property or relation of each individual event. Brutus killing Caesar and Brutus stabbing Caesar are then different events although they occurred at the same time and the first event happened to be a stabbing.

I am not clear about von Wright's position with regard to these two ways of understanding a state or event. Both Davidson's and Kim's position can be supported by good arguments, and both give rise to problems. However, in the present context Kim's events seem much more suitable as elements of the causal relation. First, in Davidson's approach the individuation of events seems to require the concept of cause and also some principle of causality. Secondly, Kim's conception of individual events allows one directly to single out the relevant similarities mentioned in Hume's analysis or, in von Wright's terminology, the generic event which the individual event instantiates. I am even inclined to go one step further than Kim, thinking that the elements of the events in a causal relation are to be understood as intensional objects: when we identify causes and effects we seem to attend to certain aspects of the world rather than to extensional constituents of it.

I shall not pursue these questions further, but shall assume in the sequel that an individual event is built up along the lines suggested by Kim. The generic events are then obtained from the individual ones by simply leaving out the time; and conversely, by adding an instance of time to a generic event we obtain an instance of the generic event. I shall let the letters E, F, and G stand for generic events and t, u, and v for instants of time. By a notation such as E_t, I shall then denote an individual event, viz., the instance of E that occurs at t. Note that, according to the assumptions I have made, each individual event can be written in the form E_t in a unique way.

3. *Two Reformulations of Hume's Definition.* With this understanding of individual and generic events, we can now try to reformulate Hume's definition as follows:

(H2) An event E_t is a cause of an event F_u if and only if t comes before u and every instance of E is followed by F.[6]

However, such a definition is immediately seen to be inadequate. Consider an event F that occurs regularly, such as rain in Bergen or robbery in New York. An instance F_u of F will then be classified by H2 as caused by every individual event E_t that occurs before F_u because any instance of E will be followed sooner or later by an instance of F. To overcome this difficulty one may consider the following definition:

(H3) An event E_t is a cause of an event F_u if and only if t comes before u with a time interval of length τ such that whenever E occurs at a time v, F occurs at the time $v + \tau$, i.e. at the time when an interval of length τ has passed after v.

The requirement that there is to be a constant time interval between the cause and the effect seems consistent with ordinary understanding. If the effect were asserted to occur after the cause with varying delays, it would be appropriate to ask about the cause of these varying delays, i.e., to demand that the alleged cause be specified in more detail so that the delay becomes determined.

One can easily generalize the definition above by replacing the time interval τ by some more general relation between t and u, e.g. so as to allow t and u to be continuous periods of time with u following immediately upon t. We can also admit simultaneous causation by allowing τ to be 0.

(H3) defines the causal relation for individual events. Similarly, we can define it for generic events by

(H4) A generic event E is a cause of a generic event F with delay τ if and only if for any instant of time t, if E occurs at t, F occurs at $t + \tau$.

A generic event E can then be said to cause a generic event F when there exists a time interval of length τ such that E causes F with delay τ.

However, against this definition of causation between generic events, one can immediately raise the objection that the definiens is vacuously satisfied by events E which have no instances. There seems to be no easy remedy for the difficulty raised by such events. Generic events which in fact never happen may also be thought of as causes; and hence it would not seem natural to restrict H4 to events E that have instances.

Causation defined between individual events as in H3 is not beset with this difficulty. Nevertheless, it gives rise to problems of a somewhat similar nature. Before I turn to these problems in section II, I shall consider in the next two subsections some conceptions of causation which may seem to conflict with H3 but which may be accounted for either by generalizing or specialising the causal relation defined in H3, thus yielding some notions of causation derivative of the one defined in H3.

4. Contributory Causes. The definition above may seem to disagree with many uses of the word 'cause'. Often an event F_t is said to be a cause of an event G_u although all instances of F are not followed by instances of G. For example, we may say that the cause of the breaking of a window was that it was hit by a stone, that the cause of a person's getting ill was that he was exposed to contagion, and that the cause of an aircraft's crashing was that the stewardess poured hot coffee onto the pilot's back, and certainly, we do not want to maintain that all such events are followed by similar effects.[7]

But this objection seems to have little weight when we are interested in analysing a philosophical concept of cause that can be used to express our understanding of the phenomena of the world as causally determining each other. I think that in the examples above we are willing to say that the alleged cause E_t produced its effect in a situation some other aspects of which were also essential to the production of the effect. These other aspects of the situation can be conceived as another event G_t. We can then say that the real cause is the composite event consisting of E_t and G_t, which we may write $(E \cap G)_t$.

This does not mean that we are prepared to describe the aspect G_t of the situation. But if we seriously insist that the events mentioned in the examples are causally connected, in spite of the fact that the alleged cause is not always followed by its effect, then we must admit that there is such an aspect of the situation whether we can isolate it or not. A typical kind of scientific progress consists in the description of such an extra condition G_t after the discovery that an alleged cause is not always followed by the expected effect. For instance, in the case of the examples above, we describe the pressure tolerated by a window or the conditions of immunity. That there is little hope of finding any scientific law covering the coffee-pouring stewardess does not mean that we do not assume here too the existence of conditions that can enter into a 'full cause'.

We may try to cover this frequent use of the word 'cause', illustrated by the examples above, by means of a definition which uses and also generalizes the concept defined by H3. Calling the new concept 'contributory cause' we may consider:

(H5) E_t is a contributory cause of F_u if and only if there is an event G_t such that $(E \cap G)_t$ is a cause of F_u while G_t (alone) is not a cause of F_u.

The requirement that G occurs at exactly the same time as E may be relaxed by a more sophisticated treatment of the relations between the time instances as hinted at in subsection 3.

5. *Necessity.* We can note that, in a weak sense, a contributory cause is necessary relative to the complete cause: if it is left out as a factor in the cause, the remaining factors do not constitute a cause of the effect. A cause in which all the factors are necessary in this sense could be called a *minimal cause.* Let us say that an event E_t (properly) *contains* an event F_u if the existence of E_t logically implies that of E_u (but not vice versa). Then we may define a minimal cause of an event F_u as a cause of F_u that does not properly contain any cause of F_u.

The sense of necessity involved in the notion of minimal cause is of course very weak. Sometimes it is held that a cause should be necessary for its effect also in a sense which amounts to ruling out what may be called 'overdetermining causes' as proper causes. Consider the case of a barn in which a man drops a burning cigarette onto some hay at the same time as the barn is struck by lightning. One could say of each of the two events that neither is a proper cause, since the effect would also have occurred without that event. At least in some situations, e.g. legal ones, such a concept of cause, which we may call 'proper cause' may be important. We may consider the following definition of it:

(H6) E_t is a proper cause of F_u if and only if E_t is a minimal cause of F_u, and for any other minimal cause G_v of F_u it holds either that G_v is a cause of E_t or that E_t is a cause of G_v.

A proper cause E_t is necessary for its effect F_u in the still rather weak sense that no other event occurring before F_u—except events containing either E_t or causes or effects of E_t—is a cause of F_u. From this fact we cannot infer that F_u would not have occurred if E_t had not occurred. For all we know, F_u could have occurred anyway, being caused by nothing. Only if we assume the deterministic hypothesis that every individual event has a cause would the inference be justified. Assuming this hypothesis, we could designate a proper cause E_t *necessary post factum*[8] for its effect F_u; in the situation prevailing at the time t, E_t was necessary for F_u.

If we want to ensure this necessity of the cause without assuming determinism and without resorting to counterfactuals, we could consider the following definition, where $-E$ stands for the event consisting in the absence of E:

> (H7) E_t is a cause necessary post factum of F_u if and only if E_t is a cause of F_u and there is some event G_t such that G is consistent with $-E$ and such that the composite generic event $G \cap -E$ is a cause of the generic event $-F$ with delay τ, where τ is the length of the interval between t and u.

That E_t is a cause necessary post factum of F_u does not imply that E is a necessary condition for F: nothing prevents F from having other causes than E, or more generally, from occurring without being preceded by an occurrence of E. But it says that relative to the situation in which E_t occurred, E is necessary for F_u, since its absence in this situation is sufficient for the absence of F_u. One may ask whether it implies the counterfactual 'if E_t had not been, F_u had not been'. For reasons that will be discussed in section II.4, the answer to this question must be no. But H7 may come as close as possible to expressing the meaning of such a counterfactual, which occurs, as we remember, in the second part of Hume's definition H1, without actually using a counterfactual.

Needless to say, the notions of necessity considered here have nothing to do with the idea of a causal connection being necessary in the sense that the cause *must* be followed by its effect. As already noted, neither do they concern the idea of a cause as a (strictly) necessary condition for the effect. Nevertheless, the kind of necessity required in especially the definiens of H7 but also in that of H6 is rather strong; too strong to be reasonable in a definition of causation as here understood. The case of overdetermining causes treated in H6 is a rather special case and only of marginal interest. That a necessity of the kind introduced in H6 may seem a reasonable requirement for a cause is perhaps due to the fact that we clearly do not consider the conjunction of two events as *evidence* of a causal connection between them, if we suspect that there is another event present which causes the second event. But that is another matter with which we shall deal in section III.5.

II

Unfortunately, serious objections can be made to the Humean idea of defining causation, objections which cannot be met by refinements of the kind considered above and which seem to show that there is something basically wrong with the very idea of the definition. I shall consider four such objections.

1. The Problem of Unique Generic Events. If an individual event is described in sufficient detail, the corresponding generic event will have only one

occurrence, viz., the individual event in question. The event will then, according to the definition H3, be a cause of each later event. This consequence of H3 is, of course, unacceptable.

The problem cannot be dismissed as artificial. To support a claim that an event E_t is a contributory cause of some other event F_u, we try to describe the relevant aspects of the situation in which E_t occurred in as much detail as possible to obtain a composite event G (embracing E) which is always followed by F (after a time interval of the same length as the one between t and u). If counterinstances to the generalization that G is always followed by F are found, we try to make the description of the antecedent G still more specific. This is a familiar scientific strategy, but if this is all there is to finding causal regularities (as seems to be suggested by the Humean analysis), then the strategy described could never fail. The more specific we make the cause, the less the chance of finding a counterinstance, and the extreme case of a unique generic event guarantees our final success.[9]

It is to be noted that the problem is not solved by considering the notion of proper cause (H6) or of cause necessary post factum (H7) as the correct analysis of causation. To be sure, the new requirement added to the definiens of H6 excludes such a unique event from being a proper cause. But it does so only at the expense of no event being the proper cause of any event whatsoever: the required non-existence of another 'cause' of the effect can never be satisfied since there will always be some unique event that preceded the effect.

It hardly seems reasonable to construe the notion of event in such a way that the possibility of a generic event having only one instance is excluded. Furthermore, such a move would leave the heart of the problem untouched as will be clear from our discussion of three related problems.

2. The Problem of Accidental Concurrences. If E is an event that occurs only a finite number of times, it is presumably always possible to define a (perhaps very artificial) event F that always occurs with a delay τ after the occurrence of E. Clearly, we do not want to say that E is a cause of such an event F.

It is true that when E and F are 'natural' kinds of events and E occurs a great number of times always followed by F, we take this as a *sign* showing that these concurrences are not accidental but that there is some causal connection between E and F. But we must note that no element in the Humean concept of cause allows us to make a distinction between causal and accidental regular sequences of two events. Of course, the point of the Humean analysis is that there is no such distinction to make. When we expect the sequence to occur infinitely (or unsurveyably) many times, this Humean claim does not immediately strike us as absurd, because we tend to confuse the above distinction with another distinction, viz. that between sequences which, although reg-

ular as far as our observation goes, are 'accidental' in the sense of failing in cases not (yet) observed, and sequences which are 'non-accidental' in the sense of having no exceptions of that kind. But as soon as a generic event has only a finite and surveyable number of instances, it becomes immediately clear that this latter distinction cannot be identified with that between those regular sequences of events that occur without exceptions but only as a matter of fact, and those that occur because of a causal connection.

An often quoted example which may illustrate the point that I have tried to make here is the case of a hooter at a certain factory in Manchester, the sounding of which is always immediately followed by the workmen leaving a certain factory in London. Assuming as an historical fact that the two events always occur together in this way throughout the existence of the factories, the first event must be said to cause the second event according to the definition H3. It is to be noted again that the situation is not helped by replacing H3 by H6 or H7 as the correct definition of the concept of cause. True, the sounding of the hooter at the factory in Manchester is not a proper cause of the workmen leaving the factory in London. But unfortunately, because of the existence of the first event, neither is the sounding of the hooter at the factory in London.

3. The Problem of Nomic Connections That are Not Causal. Failing to distinguish between acccidental concurrences and causal connections, the Humean analysis can of course not be expected to make the finer distinction between, on the one hand, connections that are nomic but not causal and, on the other hand, connections that are not only nomic but also causal. The example with the two factories quoted at the end of the last section may after all not be an example of two kinds of events that occur together only accidentally. Perhaps these events always occur at a certain time of the day because of general habits or labour legislation in England.

Other examples which illustrate the same point are the fact that the growth of hair in infants is regularly followed by the growth of teeth and that in the development of diphtheria the first symptom is the appearance of red spots in the throat which are later followed by other symptoms such as fever. Contrary to what follows from the definition H3, we do not think of the growth of hair as the cause of the growth of teeth or of the red spots in diphtheria as the cause of the fever. But neither do we think of the events in these examples as occurring together only accidentally. In the last example we say that the two events have a common cause in a certain bacillus, and in the other example we may not speak about a common cause but say that the growth of infants follows certain nomic regularities. Clearly, the Humean analysis is unable to make any such distinctions.

4. The Problem of Subjunctive Conditionals. The connection between causal relations and counterfactuals has often been noted and is stressed by von

Wright. It is claimed that a characteristic difference between causal implications and universal implications that hold accidentally is the fact that the former but not the latter support counterfactuals or, more generally, subjunctive conditionals. If E is a cause of F with a delay τ, then it is correct to say that if E had happened at t (or if E would happen at t), F would have happened (would happen) at $t + \tau$. But on the Humean analysis of cause one cannot draw this conclusion. That all instances of E were (will be), in fact, followed by instances of F after an interval of length τ does not by itself give any reason to suppose that if E had happened (or were to happen) at a time t at which, in fact, it did not happen (will not happen), then F would have happened (would happen) at $t + \tau$.

In view of the notorious difficulties in explicating the meaning of counterfactual or subjunctive conditionals, one could perhaps be inclined to doubt the importance of such considerations. But it must be admitted that we often use subjunctive conditionals when contemplating whether to make an event E happen at a time t or not. Our decisions often depend on our beliefs in subjunctive conditionals, such as 'if E were to happen at t, then . . . ' and 'if E were not to happen at t, then'.

The problem which subjunctive conditionals raise for the Humean analysis of causation may be illustrated by the following schematic example. Let E be a generic event such that all its instances (which could be infinite in number) have so far been followed by an instance of an event F after a delay τ. For simplicity assume that E is an event which I can make happen once more at time t but which will never happen any more otherwise. My decision whether to make E happen may now depend on whether I think that E causes F. The event $F_{t+\tau}$ is, say, an undesired event and I do not want E_t to happen if I believe that E causes F. A person who believes in the Humean analysis of cause and who happens to think that, as a matter of fact, I am not going to make E_t happen must now automatically also believe that E causes F. But this consequence of the Humean analysis is of course absurd. I may refrain from doing E_t (thus making it true that E causes F (with a delay τ) according to H4) and yet I may later acquire good grounds for believing that if E_t had happened, then $F_{t+\tau}$ would (still) not have happened; in other words, for believing that the counterfactual 'if E_τ had happened, then $F_{t+\tau}$ would have happened' is false. In any reasonable sense of cause and contrary to the Humean analysis, this is of course also a good ground for believing that E does not cause F; because that E causes F means among other things that the counterfactual in question is true.

The four related problems discussed here which confront the Humean analysis of the concept of cause are not easily solved, and this seems to show that there is something basically wrong with the Humean analysis. This criticism does of course not concern Hume's more basic idea that our knowledge about

causation is rooted in experience, and that causation does not involve any "power or necessary connection". But it seems to show that Hume's more specific suggestion that a causal relation involves nothing more than the factual, repeated occurrence of a sequence of two kinds of events is at least an oversimplification. I have discussed these questions here at such length in order to be able to separate the arguments against the Humean analysis from the arguments for the alternative analysis suggested by von Wright, to which I shall now turn.

III

Von Wright's writings on the concept of cause date from rather recently and are essentially confined to three works: the paper "On the Logic and Epistemology of the Causal Relation", read to the Fourth International Congress of Logic, Methodology, and the Philosophy of Science in 1971; the 1972 book *Explanation and Understanding;* and the recent Woodbridge Lectures of which I have only seen a draft. Most of the material that is relevant here can be grouped under the following headings:

(i) The development of formal languages for expressing causal propositions and interpretations of them relative to a world tree.

(ii) So-called 'causal analysis' relative to such a world tree.

(iii) Causal explanations by drawing world trees.

(iv) Arguments for the claim that the concept of cause presupposes the concept of action and that the former can be analysed in terms of the latter.

(v) Discussion of determinism and arguments for the position that human actions do not have causes.

In the next section, I shall shortly comment upon (i)–(iii). The rest of my paper will then be concerned with (iv). For lack of space, I shall have to refrain from taking up (v).

1. Von Wright's Causal Languages and World Tree. There are some differences between the formal languages that von Wright employs in the various publications. The language used in the Woodbridge Lectures is the most developed. Here four primitives \overrightarrow{M}, \overrightarrow{V}, \overleftarrow{M}, \overleftarrow{V}, are added to a propositional logic whose variables p, q, . . . are supposed to range over generic states of affairs. The semantics of this language can be described by saying that for a given assignment of values to the variables, a formula p is true if the state assigned to p obtains now, $\overrightarrow{M}p$, and $\overrightarrow{V}p$ are true if it is causally possible that the state assigned to p will obtain 'tomorrow' (i.e., at the next moment after the present one) or at some future moment, respectively, and $\overleftarrow{M}p$ and $\overleftarrow{V}p$ are true if the state assigned to p obtained 'yesterday' (i.e., at the moment immediately preceding the present one) or at some past or present moment, respectively.[10]

The causal possibility is here understood relative to a *world tree*. The points of the tree represent total states of the world. A point that represents a state S has as its immediate successors points that represent those states that may obtain immediately after the world has been in the state S, i.e., those states which it is causally possible that the world assumes immediately after having been in a state S.

Relative to such a world tree, $\vec{M}p$ and $\vec{V}p$ are thus true at a given state of the world represented by a point P if and only if the state denoted by p is a part of some state represented by an immediate successor or a successor, respectively, of P. Defining the causal necessities, $\vec{N}p$ and $\vec{\bigwedge}p$ as $\sim\!\overleftarrow{M}\!\sim\!p$ and $\sim\!\vec{V}\!\sim\!p$, respectively, we find that $\vec{N}p$ and $\vec{\bigwedge}p$ are true at a stage represented by P if and only if the state denoted by p is a part of each state represented by an immediate successor or any successor, respectively, of P. We can similarly define $\overleftarrow{N}p$ and $\overleftarrow{\bigwedge}p$ as $\sim\!\overleftarrow{M}\!\sim\!p$ and $\sim\!\overleftarrow{V}\!\sim\!p$, respectively.

That p is an immediately preceding cause of q can be expressed in this language by $\overleftarrow{\bigwedge}\,\vec{\bigwedge}\,(p\!\to\!\vec{N}q)$, which says that it has always been the case that in all possible future stages where p obtains, q obtains at all the immediately succeeding stages.

Total determinism, in one sense of this expression, means that the world tree never branches, while complete freedom means that at each point, the tree branches maximally to points representing all (logically possible) states of the world. Betweeen these extremes, we have the case of a moderately branching tree where several different states are causally possible after a given one, but some are causally impossible.

That the world tree branches at point P may be due to the fact that some human agent is free to act at such a stage. Which one of the courses, represented by the different branches, the world will actually follow will then depend on whether the agent acts or not and how he acts. In his first paper on this topic, von Wright seems to assume that all branchings are of this nature. In other words, it is assumed that if nature is 'left alone' without human interference, then there is only one unique course that is causally possible for the world to take. In the later works there is no such assumption, and at the end of the Woodbridge Lectures, von Wright adds an operator $\vec{M}\varphi$ such that $\vec{M}\varphi p$ is true at a certain stage in the world's history when it is causally possible that p obtains tomorrow 'provided no agent interferes with the world today so as to produce or prevent p''. Since no good arguments are known to support the assumption that the world is without alternatives when it is left alone, it seems more interesting to explore the situation where no such assumption is made.

In another respect the Woodbridge Lectures are more restrictive than the earlier works. Although there may be several causally possible alternatives for the future development of the world at a given stage, it is of course certain that the world will take the unique course. In the language employed by von Wright

in his earlier publications, there are means to express this. We can, e.g., say there that p will in fact be true tomorrow but is not causally necessary, i.e. it is causally possible that p is false tomorrow. But in the language of the Woodbridge Lectures, one cannot distinguish between what will in fact be true and what will be true necessarily (in the causal sense). There is no real discussion of this shift. But von Wright's standpoint in the Woodbridge Lectures is clearly that the distinction in question cannot be made. Although it is true today that $p \vee \sim p$ will be true tomorrow, von Wright argues that, unless one assumes determinism, it is in general not correct to say that either it is true today that p will be true tomorrrow or it is true today that $\sim p$ will be true tomorrow. According to von Wright, an assertion that p will be true tomorrow either means that it is causally necessary that p will obtain tomorrow (in the formal language: $\vec{N}p$) or is a careless assertion which could be modified to 'p will probably be true tomorrow' or to something of that sort.

One can perhaps agree with von Wright that in careful speech one should not assert that p will be true tomorrow unless one thinks that this is causally necessary. But from this it does not follow that a statement that p will be true tomorrow, understood factually (i.e., not as a causal necessity), cannot be *meaningful*. Although there may be no room in careful speech for the assertion of isolated factual statements about the future, such statements may be quite useful as components in legitimate compound statements, especially when one wants to contrast factual statements about tomorrow with causal ones. For instance, von Wright differentiates between the statement that in the past, p was in fact always immediately followed by q (formally, it can be expressed by $\overset{\leftarrow}{\wedge} (\sim q \rightarrow \vec{N} \sim p)$) and the statement that in the past, it was always necessary that p would immediately be folllowed by q (in formulas: $\vec{N} \overset{\leftarrow}{\wedge} (p \rightarrow \vec{N}q)$). Similarly, one may want to distinguish between the statement that as a matter of fact in the future, p will always immediately be followed by q and the statement that it is causally necessary that in the future, p will always immediately be followed by q. In the Woodbridge Lectures, an accidentally universal statement is given the form $\overset{\leftarrow}{\wedge}A$ & $\overset{\rightarrow}{\wedge}A$, while a nomically universal statement gets the form $\overset{\leftarrow}{\wedge} \overset{\rightarrow}{\wedge}A$ (provided we assume that there is no first moment). It seems to me that the first formula is half factual and half nomic and that the second conjunct in a purely accidental universal should rather say that in fact A will always be true, which cannot be expressed in the language of the Woodbridge Lectures. It thus seems to me that there is a loss in going over to this more restrictive language; indeed, part of the objection to the Humean analysis considered in section II.2, which I share with von Wright, cannot be expressed in this poorer language.

The causal languages constructed by von Wright and the idea of a world tree seem to me to be of great interest and to raise fruitful questions. However, it is clear that they take a causal concept for granted. They do not constitute

an attempt to understand the concept of cause in terms that do not already presuppose this concept. Since such an attempt is my main concern here, I shall not discuss the formal part of von Wright's work in any more detail.

For the same reason, I shall not comment upon what von Wright calls causal analysis and causal explanations in *Explanation and Understanding*. A causal analysis in von Wright's terminology consists in establishing causal connections within a given fragment of a world tree. A causal explanation, on the other hand, consists in embedding a state of affairs into a fragment of the world tree, where a causal analysis then can be given. In both cases, von Wright makes a number of interesting distinctions, but it is clear that they all depend on how we understand a world tree, i.e., what we understand by a causal possibility or, in the end, what we understand by a cause.

Before turning to this question, I shall briefly remark on von Wright's standpoint concerning the field of the causal relation. As mentioned in section I.2, von Wright restricts this field to events and their negations, where an event is understood as the changing of a state into its contradictory. However, most of von Wright's discussion is independent of this restriction, which is made first at the end of the Woodbridge Lectures. Therefore, it is not necessary for the purpose of my subsequent discussion to go into this question. I shall only suggest, by way of some examples, that this limitation to events understood as changes of states is unduly restrictive.

It seems to me that we often consider causes and effects that are not the change of a state p into its opposite $\sim p$ but which rather consist of a quantitative aspect of a situation. The cause (or effect) is then that a certain variable assumes a certain value, which seems best described as a state and not as the change of a state into its opposite. For instance, the farmer who asks about the cause of the rich growth of wheat or of the discolouring of his potato crop may, e.g., find that they are due to heavy rainfall or insufficient moulding, respectively. It may be possible but it does not seem natural, to describe the events involved here as the changing of a state to its opposite: the effects in question may perhaps be understood as changes when compared to the harvest last year, but that can hardly make it qualify as a change in von Wright's sense (because of the time span).

It also seems irrelevant that at the time immediately before the harvest there was no harvest at all. Similarly, the cause here is, e.g., a certain amount of rain during a certain period (e.g. the summer) and it is largely irrelevant what rainfall there was at the period immediately before (a change of location may be more relevant as when the growth is compared at different places with different precipitation).

2. The Nature of the Dependence of Causation on Agency. That the concept of cause presupposes or depends on the concept of action is a central thesis

in von Wright's writings on causation. Similar ideas have earlier been proposed by, e.g., Collingwood and Gasking.[11] Von Wright suggests that in this dependence we are to see the kind of necessity involved in a causal relation, the way in which a causal relation transcends a merely factual one.

The dependence of causation on agency asserted by von Wright is of many different kinds. In order of increasing importance, we may classify them as etymological, epistemological, and logical. The etymological connections in many languages (von Wright mentions Greek, Latin, and Finnish, and he could have added the Germanic languages) between the word for cause and legal terms for guilt are certainly of great interest in themselves. Observations about such etymological roots of a concept may be of heuristic value for an explication of the concept. But as von Wright points out, they can have no decisive importance, and this is especially true when it comes to reconstructing the concept (as suggested in the introduction).

The epistemological and logical dependences are interwoven with each other. Von Wright argues, as we shall see, that causal relations are ultimately established epistemically by interfering with the course of nature. But this is so because of a conceptual, i.e., logical, connection between cause and action.

But what does it mean that one concept depends logically on another? Von Wright says that "we cannot understand causation, nor the distinction between nomic connection and accidental uniformities of nature, without resorting to ideas about doing things and intentionally interfering with the course of nature".[12] Perhaps we can also express this idea by saying that the concept of cause cannot be taken as a philosophical primitive and that an adequate definition or explication of the concept has to use the concept of action essentially.

What this means is again not unproblematic. But one way of discussing the idea is to investigate the prospects of an explicative definition of the concept of cause in terms of the concept of action. It may be to press von Wright's writing too far to say that he proposes such a definition of the concept of cause. But unless one can construe such a definition, it seems difficult to understand in what sense causation could depend logically on agency.

3. Von Wright's Definition of the Concept of Cause. On page 70 of *Explanation and Understanding,* the idea that a cause must be thought of in terms of human action is summed up in the following definition-like sentence:[13]

(W1) The generic event p is a cause relative to the generic event q if and only if by doing p we could bring about q.

The word 'we' in W1 could give the impression that the concept of cause is to be relativized to a person as suggested by Collingwood. According to him one should use the form of words 'p is a cause of q *for the person P*' which is to imply that p is something under P's control. (Collingwood's argument for

this amounts to saying that such causes are the most fruitful ones to consider—
an idea somewhat similar to the congenial maxim that one should first blame
oneself for things that go wrong.) It is clear that the word 'we' is much more
innocently meant by von Wright, and I think that it could easily be eliminated
as in W2 below.

Is W1 meant as a definition? Taken as a definition in the way it stands W1
is quite circular. Von Wright distinguishes between *doing* things and *bringing*
about things. For example by opening a window we let fresh air into the room
(bring about ventilation), lower the temperature, etc. The thing done in an
action is called the result of that action. That q is brought about by doing p
means in von Wright's terminology that p is the result of an action and causes
q; the things brought about by an action are also called the effects of the action.

However, I think that it would be consonant both with von Wright's ter-
minology and with his intentions to rephrase W1 as follows:[14]

> (W2) To say that p is a cause of q is equivalent to saying that if p were to occur
> as the result of an agent's action, then it would be followed by q.

Provided that one can agree with von Wright's analysis of the concept of
action, which does not presuppose the concept of cause, W2 is no longer cir-
cular. W2, however, gives rise to the same problems as noted in connection
with the definition H2. We may try to reformulate W2 in the manner of section
I.3 (cf. H4), which will give

> (W3) An event E causes an event F if and only if there is a time interval of length
> τ such that for any time t, if E were to occur at t as the result of an agent's
> action, then F would occur at $t + \tau$.

I think that W3 is also in line with von Wright's intentions. He considers
various time delays between cause and effect (including the case when τ is 0
and even the case when it is negative).

To be in line with von Wright's intention, the "if-then" in W3 should be
understood subjunctively and could be strongly counterfactual. Von Wright ex-
pressly remarks that he is not to be understood as meaning that a cause is
always the result of an agent's action. Thus, to do E may (at present) be in
nobody's power, and to assume that E is a cause is then an assumption about
the situation '*if we could* produce E'. Similarly, regardless of whether E is in
somebody's power, E may actually have occurred at t yet not as the result of
an action. But to think of E as a cause is to think of it under the aspect of a
(possible) action. To quote von Wright: 'Causes do their jobs whenever they
happen, and whether they 'just happen' or we 'make them happen' is accidental
to their nature as causes.'[15]

Two elements are thus to be noted in the definition W3 as distinguishing it
from H4: the subjunctive (and sometimes strongly counterfactual) character of
the conditional in the definiens, and the idea that the cause is always to be

thought of as the result of an agent's action. Both elements give rise to some questions. First, admitting that causal sentences and subjunctive conditionals are strongly connected (as was argued in II.4), one may still question an analysis which depends so heavily on subjunctive conditionals. To explain causation in terms of subjunctive conditionals may seem to make a difficult topic more obscure. The import of the definition must essentially depend on how these problematic subjunctive conditionals are analysed in their turn. Secondly, one may question the idea of limiting the (hypothetical) event E_t in W3 to the result of actions. If we drop the clause that the cause is to be thought of as the result of an action, we get the following definition:

(W4) An event E causes an event F if and only if there is a time interval of length τ such that for any time t, if E had happened (or will happen) at t, then F would have happened (will happen) at $t + \tau$.

One may ask about the difference between W3 and W4. A comparison simply of their forms suggests that W4 is more reasonable since it rightly puts a stronger requirement on a cause; in W4 one demands that F shall follow E regardless of whether E is the result of an action. Indeed, W4 seems to be just another expression of von Wright's own statement quoted two sections ago.

I think that von Wright's own answer to these questions is to deny that there is any real difference between the two elements noted in the definition W3: the kind of subjunctive conditional that occurs there is again to be analyzed in terms of actions. He would perhaps say that the subjunctive conditional 'if p were to happen, then q were to happen', means roughly 'if p were to be done, q would happen'. In other words, he may say that there is no difference between W3 and W4, because if we analyse the subjunctive conditional in W4 we get W3 back.

To this answer, one may object that it is a strange analysis of subjunctive conditionals which replaces them by other subjunctive conditionals, with the difference only that the notion of action has been introduced into the antecedent. Of course, this cannot be a complete analysis. On the other hand, by limiting the possible form of the antecedent, one could make it easier to understand this kind of conditional. One may thus say that von Wright offers us a partial understanding of the causal relation and the subjunctive conditionals by suggesting that the cause or the antecedent, respectively, is always to be thought of as the result of an action. One could also say that the connection between the concept of cause and the concept of action maintained by von Wright is made through the subjunctive conditionals: one may first define the causal relation as in W4, then a further analysis of the subjunctive conditional leads to W3. However, von Wright's own arguments in support of his analysis of causation in terms of actions, to which I now turn, are not arranged in this way.

4. Von Wright's Arguments in Support of His Definition. Von Wright gives essentially three kinds of reason (numbered below as (i)–(iii)) why the concept of cause depends logically on the concept of action.

(i) As long as we are confined only to observing the regular sequence of an event q upon an event $p,$ the possibility remains open, von Wright says, that q does not happen because of p but would have happened anyway regardless of whether p happened before. However, when p is an event under our control, one which we can make happen, then we can eliminate the possibility that p has no share in bringing about q by refraining from doing p and noting that then—'on the whole'—q also remains absent. The phrase 'on the whole' is inserted here because it is not required that p is a necessary condition for $q,$ i.e., it is allowed that on some occasions q is caused by events other than $p.$

(ii) Similarly, von Wright argues that observation cannot exclude the possibility that the regular sequence of q upon p depends on a common cause, i.e., that there is a third event r which is the cause of the series of events consisting of p followed by $q.$ When p is an event that *we* have 'done', however, this possibility is excluded, because, that p is done on a certain occasion by a human agent means that if the agent had not acted, p would not have occurred on that occasion. The counterfactual used in the immediately preceding sentence is not a causal one as is that in W2, or W3, von Wright says. But it implies that there can be no cause r of p present on that occasion, since if there were such a cause r of $p,$ p would have happened regardless of the action of the agent and cannot then be said to have been made to happen by the agent.

(iii) Thirdly, von Wright considers the problem of accounting for the asymmetry between cause and effect: if p is the cause of $q,$ von Wright says, then it cannot be true at the same time that q is the cause of $p.$ Von Wright wants to explain this asymmetry without resorting to a temporal order between p and $q;$ indeed, if causation can also be simultaneous, there *is* no such resort to a temporal order. He suggests that his definition of the causal relation allows one to distinguish the cause among two causally related events as the event which is made to happen, i.e., the one which is the result of an action.

5. Discussion of the Arguments for the Definition. Although von Wright's arguments contain important observations, I think that none of them is able to support the idea that the concept of cause presupposes the concept of action. I shall try to show this by considering his arguments in order.

(i) It is true and important to note that the repeated observation of a regular sequence of events, say E followed by $F,$ does not exclude the possibility that the true cause of F is not E but, e.g., some other event G which happened to be present every time the sequence was observed. This is connected with the problems discussed in sections II.2 and II.3. But it has nothing to do with whether E is the result of an action or not: whenever we do $E,$ G might be

present. The definition W3 is in fact unable to deal with the problematic case that we are considering here. Suppose that G is a nomically necessary condition for doing E and is the true cause of F. Then, on a normal understanding of subjunctive conditionals, it is true that whenever we were to do E, F would follow. Yet, we would not say that E causes F. Furthermore, to exclude the possibility of the existence of a cause G which was present every time E was followed by F, it is of course not sufficient to observe that sometimes when E is absent, F is also absent. Such an observation has nothing to do with our problem here, because it is not required that E be necessary for F (cf. the remark about the phrase 'on the whole' in section 4(i)).

I think that the requirement for causation which von Wright's argument brings to light cannot be formulated in terms of generic events alone. It has rather to do with the problem of what observations of individual events we will count as *evidence* for thinking that there is a causal connection between two kinds of events. Evidence showing that E causes F must consist of observed individual events E_t followed by observed individual events $F_{t+\tau}$ where there is reason to believe that no other event caused $F_{t+\tau}$. Compare the idea of the definition H6 of proper cause and the subsequent discussion: that $F_{t+\tau}$ is over-determined, being the effect also of G_t, should not *prevent* us from saying that E_t is a cause of $F_{t+\tau}$; but of course, when such a G_t is thought or suspected to exist we do not count the sequence of $F_{t+\tau}$ upon E_t as *evidence* for a causal connection between E and F!

A kind of ideal evidence supporting the hypothesis that E causes F may consist, first, of observations of $F_{t+\tau}$ following E_t; and secondly, of observations of situations where everything is exactly as when E_t occurred except that E is now absent, followed by the observation after an interval of length τ that F is absent too. Of course, we can expect neither to find *nor to create* such situations. Instead, we must be satisfied with situations of a "similar generic character" (a phrase used by von Wright in the Woodbridge Lectures). This means that we must be satisfied with situations which are similar with respect to factors which we think might be causally relevant for F (cf. the first problem noted in connection with the definition Hl, but now we are dealing with questions of evidence). For instance, if G was present at time t (when E was followed by F) and is to be eliminated as a cause of F, we want a situation where G is present but E is absent and where then F is absent too. But again, in principle, this has nothing to do with whether E is 'done' or not. That E is under our control facilitates the finding of the desired situation: we have only to wait until G occurs and then refrain from doing E. When E is not under our control, we have to wait until nature presents us with G and $-E$.

(ii) The problem about common causes is rather intricate. We should not insist, I think, that the causal relation is intransitive. On the contrary, if G causes E and E causes F, we should also say that G causes F. But then, E and

F have a common cause, namely G, in spite of the given premiss that E causes F. In other words, the existence of a common cause of E and F does not *disqualify* E from being a cause of F. What von Wright's example shows is rather that we should be careful not to *infer* that E causes F in situations where it is only the case that E and F have a common cause and E has no share in bringing about F.

The problem is thus reduced to the one we dealt with under (i) above: E is invariably followed by F but the true cause of F is another preceding event G. However, we have here a special case of problem (i), which we did not discuss above. G is now supposed to be a cause also of E, which means that it is causally impossible to have a situation with G and $-E$. This special case deserves separate attention.

For the sake of illustration, let us suppose (somewhat contrary to the actual medical facts), that smallpox starts with intrusion of a virus, and that invariably its first symptoms are pocks followed by a high fever which results in the patient's death. We can then assume that it is correct to say about a person who died of smallpox that his death was caused by high fever and also that it was caused by contamination with smallpox virus. But we can further assume that the pocks are only symptoms in the causal chain: virus - fever - death. They are, according to this assumption, caused by the virus but do not influence the rest of the chain. It is thus not correct to say that the occurrence of pocks caused the fever or the death.

If the pocks are described vaguely, it is not true even on the Humean analysis (as formulated in H4, e.g.) that they cause fever or death. But if they are described in enough detail to limit their occurrence to cases of smallpox, then it would be true on our assumptions that they are followed invariably and not only accidentally by fever and death; yet we should not consider their occurrence as a cause of these events.

The problem raised by von Wright's argument as illustrated in this example is thus really the problem discussed in section II.3 of differentiating between those connections that are nomic but not causal and those that in addition to being nomic are also causal. As we saw, the Humean analysis cannot solve this problem. Unfortunately, von Wright's analysis does not seem entirely successful either.

Why is fever in smallpox a cause of death according to von Wright's definition? We may suppose that we cannot produce fever in a person directly. In von Wright's terminology, this means that to make a person have a fever is not a *basic* action.[16] But it is not required in von Wright's definition that the cause be thought of under the aspect of a *basic* action. And there are many ways in which we can make a person have a high fever, for instance, by contaminating him with smallpox virus. Furthermore, there is good evidence for the hypoth-

esis that a sufficiently high fever (whenever and however we produce it) would always be followed by death.

However, by exactly similar reasoning, the pocks are causes of fever. We cannot inflict pocks on a person directly. But when we contaminate a person with smallpox virus, we also carry out an action which in von Wright's terminology can be described as making him have pocks.[17] Furthermore, this action whenever we produced it, would be followed by fever.

It is at most basic actions for which von Wright's argument (ii) is relevant: the argument can show at most that the result of a basic action has no cause. It is true that when we investigate the possible effects of actions in practice we usually try to consider the actions under an aspect which makes them relatively close to a basic action. But I do not think it is fruitful to introduce such considerations into a definition of cause. This way of excluding pocks from being a cause of fever might have the undesired result of excluding high fever from being a cause of death. Nor does it seem illuminating to say that we can conceive of some other way of making a person have pocks which would not be followed by fever.

It seems a reasonable surmise that a solution of the present problem is not connected so closely with the concept of action. The reason why we do not consider pocks as a cause of fever but fever as a cause of death is, I think, connected with, among other things, the requirement that a causal connection should allow certain kinds of generalizations. For instance, we have grounds for generalizing the connection between fever and death (life is not possible except within certain temperature ranges) while we do not believe in generalizations about a connection between skin disorders and fever. Our rejection of pocks as a cause of fever and acceptance of fever as a cause of death seem thus connected not so much with our actions as with the way certain generalizations fit into our general medical knowledge.

(iii) The asymmetry between cause and effect noted by von Wright can only be maintained when the cause and effect are understood as individual events. One instance of a generic event E may be a cause of some instance of a generic event F while some other instance of F may be a cause of another instance of E. Von Wright construes the causal relation as a relation between generic events, and hence, strictly speaking, the asymmetry is not relevant for his concept of cause. Given the notion of event that I have assumed here, one may think that one could simply extend von Wright's causal relation to individual events by defining an individual event E_t as a cause of an individual event F_u when E is a cause of F. However, it appears from one of von Wright's examples that such a definition would make the proposed criterion for distinguishing between cause and effect ineffective; indeed, it would imply that the causal relation is not asymmetrical. In the example in question there are two events E

and F such that whenever one were to make E happen F would occur simultaneously, and vice versa. Hence, by W3, E is a cause of F and F is a cause of E.

Von Wright's causal relation must thus be extended to individual events in some other way. Presumably, von Wright intends that an event E_t is a cause of an event F_u if E is a cause of F *and* E_t is the result of an action. It must be noted that this extends the causal relation only to such pairs of individual events in which one of the events is really the result of an action. When this is not the case it is of no help to think of the individual events as if they had been the result of an action; as we saw in the example, this may not reveal any asymmetry between two simultaneous and causally related events.

But it turns out, as von Wright remarks himself, that also when one of the individual events is in fact the result of an action the proposed criterion for distinguishing between cause and effect is not successful unless the actions are also basic ones. The reason for this is, I think, really the same as the reason considered above why the concept of action cannot help us to distinguish between nomic connections and true causes. If one is aware of the fact that E and F always occur together, then when one does E, one also carries out the (non-basic) action of doing F. Hence, both the cause and the effect are the results of actions.

The problem of distinguishing cause and effects is often an important practical problem (Alcoholics have bad family relations, but what is the cause and what the effect here?), and as stressed by von Wright, it constitutes a serious challenge for every analysis of causation. Gasking also uses it as an argument for assuming that causation depends on agency. But the discussion above seems to indicate that such an approach cannot be very successful. Also when dealing with this problem, it may be more fruitful to consider instead such questions as how certain generalizations fit into a general background knowledge.

To take an example, consider the connection between tides and the motion of the moon. The occurrences of a flood tide and a certain position of the moon are simultaneous events and it is clear that we think of the position of the moon as the cause of the tide; it would be absurd to think conversely that the tide causes the moon to have a certain position. Of course, one could say that this asymmetry depends on the possibility of imagining ourselves displacing the moon and thereby changing the tide whereas, conversely, an imagined human alteration of the tide would not bring about a change in the position of the moon. This may be correct in itself, but it does not seem very illuminating as an explanation of the asymmetry. It seems more illuminating to say that the law about the connection between tides and positions of the moon is of a relatively low level of generalization. On a higher level of generalization the connection holds only one way. As far as we know, it is true for any heavenly

body covered with water that different positions of a sufficiently big satellite cause tidal phenomena. But conversely, it does not follow that a heavenly body on which tidal phenomena occur has a satellite (the tide could be caused by something else, such as the regular occurrence of volcanic activity). These more general statements do not refer to actions explicitly nor, I think, implicitly. Instead, they are supported by or in agreement with our laws of nature, which in turn support counterfactuals (e.g. the fanciful ones about our interferences with the position of the moon and with the tide, respectively).

6. Concluding Remarks. Von Wright suggests that we can illustrate the prerequisites of a concept by considering the requirements the world has to satisfy in order that the concept should be formed by its inhabitants. Thus he illustrates his thesis that the concept of cause presupposes the concept of action by suggesting that in a world where there were no actions our concept of cause would not exist either.

Granting the close connection between the concept of cause and the idea of subjunctive conditionals, this may at first sight seem plausible. The idea underlying a subjunctive conditional is the idea that the world could have been different from what it in fact is. And one typical situation in which we consider such a possibility is when we could have made the world different by an action.

It would clearly be absurd to deny the role action plays in acquiring most of our causal knowledge. But the question is whether the existence of actions is logically necessary for the existence of the concept of cause. The arguments advanced to support this claim, which we have discussed above in some detail, do not seem conclusive. It also seems to me that there is no difficulty in *imagining* a world with intelligent beings who were able to observe the events of the world but not to interfere with them through action and yet who still had a concept of cause essentially like ours.

We can imagine such a world in which the events showed the characteristic behaviour of the events of our world, namely that some events appeared invariably together or in sequence after each other, while others appeared more irregularly without any reliable omens (perhaps because they were the results of the actions of other creatures unknown to the beings that we are now considering, or because they just happened by chance, undetermined by earlier events). The beings in such a world would observe that instances of some generic states were always followed by instances of certain other generic states, while other states developed sometimes into one state, sometimes into another. Thus, they too would naturally develop the picture of a world tree described in section 1. Statements 'if E_t would have happened, then $F_{t+\tau}$ would have happened' would be meaningful also to them, and would mean: if nature at t had taken a course other than that which it did in fact take and E had appeared, then the world

would have contained F after an interval of length τ. (Of course, this is not offered as a reductive analysis of subjunctive conditionals, but as we saw above, neither is such an analysis provided by the concept of action.)

Furthermore, when all observed instances of an event E were observed to be followed by instances of an event F, and E occurred sufficiently often in situations which did not seem to have anything in common—or if, when they had instances of G as a common element, it was observed that when G occurred alone without E, F did not follow—the beings would consider this good evidence for the hypothesis that E causes F (implying that whenever E were to appear it would be followed by F). In this way, our beings could start to form laws. The credibility of new hypotheses about causal connections could then be estimated by their relations to already accepted laws, especially with regard to their level of generalization as compared to that of other laws.

One could ask why the beings of that world would be interested in making causal statements and forming laws when they could not act; indeed, one could ask why they would care to make observations at all. It must be admitted that the richness of causal concepts is reduced when they lose their contacts with the concept of action. In a way, no concept remains the same when other concepts with which it stands in contact are removed. But that is another matter.

In summary: I have tried to argue in section II, in agreement with von Wright, that a causal relation involves something more than the invariable succession of two kinds of events. But as suggested in the last sections, the problems surrounding the Humean analysis are not solved by connecting causation with the concept of action. Nor does the concept of cause seem to presuppose the concept of action either logically or epistemologically. It is true, as pointed out by von Wright, that there is a close connection between causation and subjunctive conditionals. But the equivalence in W4 does not seem to express this connection correctly. Although the causal sentence on the left hand of the equivalence implies the subjunctive conditional on the right side, the assertion of the converse implication would seem to overlook the problem of differentiating between nomic and causal connections (sections II.3 and III.5 (ii)), and the problems about the asymmetry of the causal relation (sections 4(iii) and 5(iii)). Furthermore, the subjunctive conditional in W3 is in need of further clarification, and it does not seem relevant to bring in the concept of action here. As suggested by some examples, our acceptance of causal hypotheses depends rather upon how well the hypotheses agree with already accepted laws and upon considerations of the possibility of further generalizations of the causal connection (besides depending upon the observation of the repeated concurrence of two kinds of events).

It is of course not at all original to stress the connection between causal statements and (natural) laws and their levels of universality. The problems

surrounding the concept of law may seem as intricate as the problems associated with causation and subjunctive conditionals. Von Wright attempts a simultaneous clarification of all three concepts—cause, law, and subjunctive conditional—by bringing in the concept of action. In wanting rather to base causation and subjunctive conditionals on the concept of law, I am suggesting that it may be more fruitful to draw on those many discussions about the kinds of evidence that are able to support a law, where attention has also been paid to the distinction between the nomical truth and the accidental truth of a universal statement (as, e.g., in Goodman's *Fact, Fiction and Forecast*). But this is of course far from suggesting a solution of the problems of causation. I have rather stressed some of the problems surrounding the concept of cause, raising doubts about suggested solutions of them, and have only hinted at another direction in which it seems to me more promising to seek a solution.

UNIVERSITY OF OSLO DAG PRAWITZ
MARCH 1974

NOTES

1. *Proceedings of the Aristotelian Society,* n.s. 13(1912–1913): 1.

2. See Wolfgang Köhler, *Gestalt Psychology* (London, 1929); especially chapter x.

3. Max Black, 'Making Something Happen'. in *Determinism and Freedom in the Age of Modern Science,* edited by Sidney Hook (New York, 1958).

4. E.g., Donald Davidson, 'The Individuation of Events', in *Essays in Honor of Carl G. Hempel,* edited by Nicholas Rescher (Dordrecht, 1969) or 'Causal Relations', *Journal of Philosophy* 64 (1967): 691–703.

5. Jaegwon Kim, 'Causation, Nomic Subsumption, and the Concept of Event', *Journal of Philosophy* 70 (1973): 217– 236; also 'Events and Their Descriptions: Some Considerations', in *Essays in Honor of Carl G. Hempel,* edited by Nicholas Rescher (Dordrecht, 1969).

6. It is here assumed (with Kim) that it belongs to the conditions for the existence of an individual event E_t that it occurred at t. Otherwise, it should of course be added that E and F occurred at t and u, respectively.

7. This point is made, e.g., by H. L. A. Hart and A. M. Honoré, *Causation in the Law* (Oxford, 1958).

8. The term is used by Konrad Marc-Wogau, 'On Historical Explanation'. *Theoria* 28 (1962): 213–233. But it is defined there in another way.

9. A similar point has been made by Arthur Pap in 'Philosophical Analysis, Translation Schemas, and the Regularity Theory of Causation', *Journal of Philosophy* 49 (1952): 657–666.

10. As seen, von Wright assumes that time is discrete here.

11. Robin G. Collingwood, 'On the So-called Idea of Causation', *Proceedings of the Aristotelian Society,* n.s. 38 (1937–38): 85–112; and Douglas Gasking, 'Causation and Recipes', *Mind* 64 (1955): 479–487.

12. *Explanation and Understanding,* pp. 65–66.

13. Von Wright considers both what he calls sufficient cause-factors and what he calls necessary cause-factors. Because of the symmetry between the two notions, I restrict myself to the former. W1 is the result of rephrasing one of von Wright's statements accordingly.

14. This impression is derived from reading von Wright's works, but was also supported by private discussions with him.

15. *Explanation and Understanding,* pp. 73–74.

16. An action is said to be basic when its result is not the effect of another action. For instance, the opening of a window is not a basic action, being the effect of an action consisting of certain arm movements. But the raising of an arm will normally be a basic action. That the arm is raised is the *result* of the action of raising the arm and is not *brought* about by any action.

17. It does not matter here whether the action of contaminating a person with small-pox virus and the action of making him have pocks are understood as the same action following Davidson or as two different actions (although carried out simultaneously and in the same way) following Kim. It is sufficient for the argument that there exists an action of making a person have pocks.

Mihailo Marković

VON WRIGHT ON EXPLANATION VERSUS UNDERSTANDING: THE RELATION OF THE SCIENCES OF NATURE AND THE SCIENCES OF MAN

Many contributors to the Library of Living Philosophers must have wondered how one can write critically about a philosopher for whom one feels profound admiration and respect? Can criticism be fruitful when the authors belong to different methodological orientations and have different basic assumptions?

The only answer that comes to mind is that thinking need not suppress warm feelings in order to be objective and critical. Living greatness (as opposed to the greatness of a monument) needs a critical awareness of its limits, for only by superseding them can further development take place. But these limits are relative to a specific theoretical framework. Is it possible to indicate them from a different theoretical and methodological point of view? Can an analytical philosopher and a Marxist understand each other and contribute to each other's philosophical development? This happens very rarely: philosophers are notoriously poor interpreters of ideas that belong to a school other than their own. Many are guilty of philosophical 'imperialism', that is, a tendency to dominate the scene, not to tolerate anything different, and to war constantly with other philosophical camps. Nevertheless, intersystemic communication and interaction seem possible under the following conditions:

1. Differences in sources of ideas, terminology, philosophical assumptions, and methodological procedures can be so great that a careful *translation from one philosophical language to the other,* from one system of reference to the other, is necessary. What makes this translation possible is the existence of certain *extrasystemic invariables.* In the thinking of all philosophers there are linguistic and logical structures which express universal human capacities and crystallize the accumulated experience of many generations of humankind in

practical interaction with one and the same physical world. The precondition
for such translation (and indeed for any meaningful communication) is the rec-
ognition that ideas make sense only in relation to their system. No matter how
meaningless or irrelevant they look from our own point of view, they may be
significant within their own framework. Thus the task is to reconstruct what an
idea is and to find out what its limitations are *against its own social and cul-
tural background*. Both dialectical materialists who effortlessly characterize all
modern analytical philosophy as mere variations on the subjective idealism of
Berkeley and Hume and those analytical philosophers who almost proudly de-
clare that they have never studied Hegel's dialectic only demonstrate their pa-
rochialism, sectarianism, and arrogance.

2. When the interest and ability to communicate are there, everything de-
pends on the kind of strategy that a participant in a dialogue decides to follow.
Little progress can be expected if one dogmatically sticks to one's own views
and is interested only in refuting the opponent's ideas. 'Let's agree to disagree'
is an equally unpromising strategy of pseudotolerance. One is ready to talk
across the trenches, but not to reconsider staying in them. A really fruitful
dialogue requires readiness (a) to test and further develop one's own initial
point of view, and (b) to embrace the opponent's view (or some improved
version of it) as a special case of one's own (developed and generalized) view.
This kind of criticism opens the way for further self-development of all those
philosophical trends which allow room for their own evolution.

VON WRIGHT ON NATURAL SCIENCES AND THE SCIENCES OF MAN

Von Wright has developed a conception of the relation between natural and
human sciences which is more sophisticated and does more justice to what is
going on in actual scientific inquiry in those fields than either of the well-
known extreme approaches which have clashed with each other throughout the
century.

One of these, the 'unity of science' approach, was advocated by positivist
and empiricist philosophers, who, eager to draw a sharp demarcation line be-
tween science and philosophy, positive knowledge and metaphysics, etc., have
treated all 'science' as one unique block taking the objectives and procedures
of the natural sciences for the paradigm of science in general.

The opposite 'separatist' approach was advocated by Dilthey's philosophy
of life and the Neo-Kantian Baden School who, in their resistance to the posi-
tivist transfer of concepts and methods from the natural to the human sciences,
drew a sharp demarcation line between 'nomothetical' sciences, which establish
laws and search for the explanation of phenomena, and 'ideographical' sci-
ences, which study the meaning of individual events and seek to understand

them in terms of the motives of human agents, and not in terms of causality, law, and determinism.

Von Wright holds, in opposition to Logical Empiricism, that the natural and human sciences are two different types of science: "Natural science can be characterised as a study of phenomena under the 'reign' of natural law. Human science again is primarily a study of phenomena under the 'reign' of social institutions and rules."[1]

However, in contrast to the German idealists (Dilthey, Windelband, Rickert, and others) von Wright holds that ideas of determinism "play an important role both in the natural and the human sciences". The difference between these two types of science is to a great extent the consequence of the difference between two types of determinism.

> In the natural sciences deterministic ideas are connected with such other ideas as those of universal regularity, repeatability, and experimental control. In the human sciences the connexions are with ideas such as motivation and social pressure, wants, goal-directedness and intentionality. In the natural sciences determinism serves in a large measure the forwardlooking aims of prediction; in the human sciences there is a relatively much stronger emphasis on retrospective explanation, or understanding of what is already a *fait accompli*.[2]

Von Wright's solution seems to be a synthesis of earlier proposals. It is neither simple 'methodological unity of all science' nor complete disparity of methods, but 'methodological parallelism' between laws of nature and rules of a society: "deterministic ideas in the human sciences have a relation to societal rules which is analogous to the relation in the natural sciences between deterministic ideas and natural laws." This view does not imply that "laws of the state and other social rules were, in themselves like laws of nature". They are, on the contrary, very different. The former are normative, the latter descriptive. "And from this profound difference it follows that . . . determinism in the study of man means something utterly different from determinism in the study of nature."

This solution of the problem has obvious advantages over both earlier methodological approaches. It tends to do justice to the specific nature of social events, to the phenomenon of human subjectivity, to the normative character of social regularity, and to the method of understanding as a characteristic procedure in the study of man. And von Wright has effectively shown that understanding and intentionality need not remain vague concepts, unrelated to determinism and associated with intuition and other forms of inarticulate, uncontrollable, direct insight. One of von Wright's greatest contributions is his application of analytical method to the problem of intentionality and the explanation of human activity, his practical demonstration that the structure of these can be rationally examined and that the results reached by them can be the subject of validation and testing.

However, once we embark on this kind of examination, making distinctions within an apparently continuous whole and, conversely, overcoming initial conceptual cleavages (e.g., between explanation and understanding) and establishing the characteristics common to different fields of study, there is no reason to stop.

First, the character of social phenomena depends very much on the degree of human *reification*. The more reified human individuals are, i.e., the more they behave like things, the more social behavior resembles a natural process. Marx, Lukács, and others introduced the concept of reification to cover those cases where human beings, under certain unfavorable social conditions, fail to realise their potential for specifically human, free, and creative activity and behave in a routine, repetitive, easily predictable and controllable way. There is no essential methodological difference between this kind of regularity—produced by learning, manipulation and fear—and that produced in nature by physical causes. Of course, human individuals who work on the assembly line, or sell their goods on the market, or attend a too highly organized political manifestation, have certain specific goals, intentions, and motives, and yet their interaction will produce unexpected consequences, and the total phenomena will take place as if 'under the reign of natural law'.

On the other hand, there are historical processes that resist explanation or understanding in terms of either natural laws or antecedent social rules. These might be new, surprising, abolishing traditional institutions, breaking old rules, generating new social norms and life styles. Between these two poles there is a continuity of cases varying in their degree of determination or freedom.

Second, although the situation in the natural sciences is much simpler, and one can properly speak about 'phenomena under the reign of natural law', the degree to which nature is *humanized* should be taken into account. The more humanized the nature, the more often phenomena occur as though under the 'reign' of social institutions and rules. A waterfall in the wilderness of Africa belongs to brute nature, which is independent of human intentions and actions. A waterfall at the Aswan dam still occurs according to natural laws, but the laws operate under conditions regulated consciously by man.

Another sense of the humanization of nature is theoretical rather than practical. What we mean by 'the study of phenomena' is a series of procedures which to a lesser or greater extent involve selection, interpretation, construction of meaningful wholes. Consequently, no scientific research is entirely free of 'goal-directedness' and 'intentionality'. Surely there is an essential difference between the study of social events where the intentions of both the examined agents and the examiner are relevant to the result of research (they appear at both *object-* and *meta*-level), and the study of natural events where intentionality could be relevant only at the meta-level, when we examine critically the results of the study of natural objects. However, at this latter (meta-) level, the

important difference is not so much between natural and social phenomena as between the empirical and theoretical levels of either. When we describe the *given* content of experience with either kind of phenomena, various rules of scientific method help us to maximize objectivity and to 'bracket' our interests and goals. However, when we build up general theoretical models (such as theory of relativity, theory of biological evolution, dynamic theory of personality, Keynesian economics, or Parsons's social system theory) an element of human subjectivity, of choice, of ideological orientation is invariably and unavoidably there.

When we take into consideration the degree of reification of social phenomena and the degree of humanization of natural phenomena then von Wright's criterion for distinguishing phenomena regulated by natural laws from those regulated by social norms and intentions yields not two, but at least four categories; or rather, a continuum of intentionality and freedom which could for the sake of clarity be divided into the following four segments:

1. Phenomena of nature unaffected by human activity. (Zero intentionality.)
2. Natural phenomena humanized to a lesser degree; social phenomena reified to a higher degree. (Low level of intentionality)
3. Natural phenomena humanized to a higher degree; social phenomena reified to a lesser degree. (High level of intentionality.)
4. Social phenomena free of domination by blind natural or social forces. (Maximum of intentionality).

This more complex typology will require overcoming cleavages between descriptive and normative laws, and between prediction and retrospective explanation (or understanding).

1. Phenomena of brute nature are governed by purely descriptive laws; provided that we know enough about them, they can be both predicted and explained; the determinism involved is either rigid or statistical.
2. Slightly humanized natural processes and highly reified human behavior take place according to descriptive laws. But the normative element is there in both. In the primitive phases of human interaction with nature, man merely modifies conditions for various natural processes or changes their duration. In cases of reified social behavior the intentions of individuals neutralize and cancel each other out. Therefore both explanation and prediction are possible. The underlying determinism is predominantly statistical and objective determinants play decisive role.
3. Highly humanized natural processes (for example in modern industrial production) and slightly reified social events are governed by social norms but the very nature of norms is such that they are adjusted to the given reality, and therefore also to the given natural laws. Explanation should here take

into account both causes and intentions, descriptive laws and social norms and aspirations. Because the latter may vary, prediction becomes difficult and tentative, feasible only for short-range periods. Determinism here is exclusively statistical and subjective determinants (human mental states) are extremely important.

4. Free social actions are governed only by internalized social norms and aspirations; descriptive laws are indirectly relevant insofar as they determine the range of real possibilities. Explanation in terms of rules must be supplemented by understanding in terms of intentions and motives. Prediction is hardly possible, because some of the decisive subjective determinants are generated in the very process of action. Therefore the whole process has the character of *self-determination*.

The cases of self-determination in specifically human activity and of blind, rigid determination in brute, uncultivated nature constitute only extreme poles of a continuum. Human and natural sciences overlap and do not allow drawing a sharp demarcation line. Therefore methods of explanation and understanding will often have to be applied in the same research instead of being split and referred to two different domains of science. From the preceding analysis it follows that two customary questions,

(a) how does one understand an action in terms of some covering laws? and
(b) how does one understand an action in terms of some intentions of its agents? should be supplemented by two others
(c) how does one explain a phenomenon in terms of intentions? and
(d) how does one understand an action in terms of historical or psychological laws?

Von Wright examines the former two in great detail. The latter two have apparently remained outside the scope of his work until recently, apparently for two reasons. First, von Wright considers accounts of phenomena in terms of laws only as special cases of Hempel's covering law scheme. Second, as a consequence of his behaviorist bias, von Wright never refers to psychological laws, and reduces historical laws to laws of sociology and economics.

VON WRIGHT'S CRITIQUE OF THE COVERING LAW MODEL OF EXPLANATION

Von Wright, like most contemporary philosophers of science, holds that Hempel's scheme of explanation of an event in terms of certain antecedent events and one or several general propositions (laws in the Deductive-Nomological model, probability-hypotheses in the Inductive-Probabilistic model) applies to many cases of explanation, especially in natural sciences. However, he has two

essential criticisms. First, under the customary positivist interpretation, Hempel's scheme does not really carry the weight of an explanation. Second, the scheme is not applicable to the explanation of historical events.

As to the first: positivist philosophers of science define a law in terms of a regular or uniform concomitance (correlation) of phenomena. Thus "the truth-value of a law is contingent upon the testimony of experience. And since any law's claim to truth always transcends the experience which has actually been recorded, laws are in principle never completely verifiable".[3]

Now, if a law is nothing more than an empirical generalization, then in many cases we will instinctively doubt whether a subsumption of an individual case under such a general proposition is really an explanation.[4] "What is required if our search for an explanation is to be satisfied, is that the basis of the explanation be somehow more strongly related to the object of explanation than simply by the law stating the universal concomitance of the two characteristics. . . ."[5]

Such a stronger relation could be *logical* necessity. If a scientific law is a definition of one concept by means of another, then it is "immune to refutation since its truth is analytical, logical".[6] Von Wright holds that this *conventionalist* view of scientific law does not really contain conceptual elements alien to positivism, since the latter need not deny that some scientific principles have the character of analytic truths. But he endorses a much more serious challenge to positivism, the view that laws state "*necessary* connections between *events in nature*".[7]

The idea of natural necessity is both incompatible with positivism, and an indispensable element of all variants of philosophical realism, including critical realism and Marxist materialism (where it has never been explained in a sufficiently clear way). It will be interesting to see what light can be thrown on this controversial philosophical idea by the use of modern analytical method. After indicating that the notion of natural necessity within analytical philosophy springs from two sources—modal logic and the problem of *counterfactual conditionals*—von Wright relates it to the idea of causation and eventually to the idea of action.

This whole criticism of the positivism implicit in the customary interpretation of the covering-law model of explanation is remarkably convincing. It bears witness to the integrity of a great analytical philosopher who tends to consistently pursue all the consequences of a conceptual breakthrough without caring about traditional dogmas. Rejecting or accepting the concept of natural necessity makes a whole world of difference; once one accepts it, there is no way back to positivism and empiricism. But it is very difficult to come to grips with it by means of the existing conceptual apparatus of analytical philosophy.

Von Wright holds that modal ideas of natural necessity and nomic connection "are closely associated with the ideas of cause and effect, so much so that

one could conveniently group them all under the general head of causation''.[8] He then proceeds to analyze the notions of cause and effect in terms of *necessary* and *sufficient* conditions. These in turn obviously involve the idea of natural necessity: how else does one interpret the statements: 'Whenever p is, q will be there too', and 'Whenever q is, p has to be there too'?

A really fruitful approach to the explication of the idea of natural necessity is the study of action. According to von Wright: "The idea of natural necessity . . . is rooted in the idea that we bring about things by doing other things."[9]

Here again there seems to be an implicit idea of causality. When I do a thing I am the cause and the thing is the effect. We seem to be the victims of a vicious circle. But this is only the consequence of a certain ambiguity in the use of the terms 'cause' and 'effect'. On the one hand, every man's interaction with his surroundings involves causation. The words 'cause' and 'effect' here have empirical, practical meaning based on an immediate awareness of the results of our activity. But when we speak about causal relations between natural phenomena, about 'causal laws', 'causal explanation', and even 'the principle (or law) of causality', we presuppose a general theoretical, more or less abstract knowledge of natural necessity. We have good grounds to say that an event of type A is a cause of another event of type B when there is a law connecting classes of events A and B. When we analyze the law we find that it is an abbreviation for a necessary connection between A and B. And to say that there is such a necessary connection makes sense if there is an immediate (causal) interaction between us and events A and B. This leads us to an extremely important insight: the whole cluster of basic theoretical concepts (causality, law, necessity, determinism, etc.) is ultimately grounded on the analysis of human activity.

Following Reid, Collingwood, and especially Gasking, von Wright makes an important contribution to this analysis. His interpretation of the notions of 'necessary condition' and 'sufficient condition' is a good example:

> By 'removing' p from a situation in which p occurs together with q and finding that q then vanishes as well, we aim at showing that p is a necessary condition of q. This has been established when we can confidently say: 'We *can* make q vanish, *viz* by removing p.'
>
> Similarly, we aim at showing that p is a (relative) sufficient condition of q by, introducing p into a situation from which both p and q are missing and finding that then q too comes about. The causal relation has become established when we can say: 'We can produce q, *viz* by producing p.'[10]

This is very illuminating, and yet von Wright knows that in this way we can at best only come 'very close' to a verification. The reason why one may wonder whether even 'coming close' is at all possible is that the analysis presupposes a much too simple and static model of action. Possible elements of the situation other than p and q have been abstracted; 'we' who act do not have

any antecedent theoretical knowledge. Therefore we don't suspect that there might be a third element r such that r is conjoined with p and is the real cause of q so that we remove or introduce both p and r and wrongly attribute the effect of r to p.

If the person who manipulates the factor p is well informed about the field to which this situation belongs (and this is really the case in laboratory experimentation), he will be able to make a rational guess about the likelihood of the existence of such an intermediary variable. Or he can make use of multi-variant analysis—which is, however, theory-laden.

Here a difficulty arises and I don't see how it can be solved by means of analytical method. If diachronic, historical relations are neglected and all analysis made in terms of synchronic, logical relations, then explication of the concepts of causality and necessity in terms of the practical activity of a researcher equipped with some a priori theoretical knowledge would constitute a vicious circle, for a priori knowledge in its turn would contain laws and causal relations—the very concepts which are to be clarified.

Solution of the difficulty is possible only if we use a method that introduces time and reconciles the principle of system with the principle of history. Then the subject of action at a given historical moment t_0 will be equipped with a certain body of knowledge which is aposteriori with respect to earlier moments up to t_0, but is apriori with respect to the moment t_0. This knowledge will help him to eliminate all fictitious correlations and 'come close' to verification. If the dialogue between theory and action takes place within one timeless system, then grounding the idea of nomic relationship on the concept of action, which in its turn presupposes some knowledge of nomic relations, would be fallacious. When this dialogue takes place within a series of systems in time, the vicious circularity disappears: The relatively crude and abstract initial idea of the law in t_1 becomes more articulated and concrete as a result of practical application in t_2.

It is essential to note that the idea of 'natural' necessity depends not only on our ability to do and bring about things (when we are enlightened by some antecedent theoretical knowledge), but also upon our readiness to try and preserve a law by all operations compatible with the basic principles of scientific method. There is a whole continuum between two extreme attitudes toward a law in case of the discovery of falsifying instances. At the one pole is Popper's view that a law is falsified by a single counter-instance. At the other extreme pole is conventionalism, which transforms the empirical law into an analytically true statement (a definition) and makes it independent of any facts. Von Wright keeps a reasonable middle position by making the law relative to a more or less vaguely conceived frame of 'normal circumstances'. When an assumed connection (law) fails to hold in an individual case, we need not drop the law, but can make the circumstances responsible for an accidental failure.[11] Follow-

ing the same line (in a paper read at the Third International Congress of Logic in Amsterdam) I have listed seven possible procedures by which a law can be preserved when it conflicts with some empirical data:

(1) Critical examination and modification of empirical statements which seem to falsify the law L. It might be shown that they can be given a more complete and accurate formulation which makes them compatible with *L*. (2) Limitation of the range of application (the model) of L by excluding all those elements as instances of *L* which allow an interpretation of data that falsifies *L*. (3) Elucidation of the differences between the model and empirical reality which are the results of deliberate simplifications introduced into the model. (4) Reformulation of the law by revising the specifying conditions and preserving the same basic relations among variables. (5) Changing the meaning of certain terms. (6) Changing the theoretical status of some constituents of *L;* assertions about objective relations can be interpreted as definitions. (7) Revision of some implicit fundamental assumptions (scientific principles).[12] There are some criteria (that remain to be examined) according to which scholars decide in each particular case which of these procedures it would be most rational to apply and how far they should go in the attempt to save a scientific law.

In conclusion: if the idea of 'natural' necessity implicit in the concept of a 'law of nature' depends so much on the decision of the community of researchers, then realism turns out to be a rather dogmatic position. Reality that we meaningfully speak about is human reality; 'natural' necessity is the necessity of a world constantly affected by man's physical and theoretical activity. Now human activity involves, in addition to the more *ontological* fact of 'doing' and 'bringing about' things, a certain *knowledge* that precedes doing (the *epistemological* dimension) and the *purpose* of doing (the *axiological* dimension). In his analysis of the roots of the idea of natural necessity Von Wright has emphasized the first: 'bringing about things by doing other things'. The second root is the idea that we always act guided by a set of preceding general beliefs which help us to think critically and to establish that there is a *real* permanent connection between things that we do and things that we thereby bring about (and not an *apparent* connection mediated by a third, hidden variable). The third root is the idea that some elements of our beliefs are so important for a stable, consistent organization of both our knowledge and our activity that we decide to resist any pressure to drop them unless the challenge would be overwhelming.[13]

What scholars never do is follow the rules of Popper's 'empirical method', i.e., to reject a law as false as soon as a counter-instance has been met. (Which means that Popper's explication of 'empirical method'[14] is a convention that does not fit actual scientific practice.) On the other hand, neither do scholars behave in a conventionalist way, according to which *whenever* a hypothesis *(h)* and a set of accompanying assumptions *(A)* together entail an observation state-

ment *O*, and a non-*O* statement is established, a modification of *A* into *A'* is possible such that *h* and *A'* together entail non-*O*. (Duhem's thesis). Such a strategy would make all laws immune from experience and would block scientific development. In fact one has to have good reasons in *each particular* case why the modification of *A* into *A'* and the preservation of *(h)* is preferable to the rejection of *(h)*. Thus when we say that there is a *necessary* connection between things of the type *P* and things of the type *Q* this means:

(1) Whenever under conditions *C* we have produced *P, Q* has also been brought about: whenever under conditions *C* we have removed *P*, we have made *Q* vanish. (2) We have good reasons to believe that, under conditions *C, P* and *Q* are really and not apparently connected (due to the mediation of some unknown factors). (3) In a particular case when we produce *P* without bringing about *Q* or remove *P* without making *Q* vanish, we shall not stop holding that *P* and *Q* are necessarily connected; rather, we shall modify conditions (*C* will be transformed into *C'*) to fit the new case.

TELEOLOGICAL EXPLANATION AND INTENTIONALITY

Von Wright holds that an improved version of Hempel's covering-law model is applicable to many important cases of explanation. The improvement consists in the realization that covering laws state natural necessity and not merely empiricial generality. Von Wright considers that for cases that fit such an improved model, the term 'causal explanation' should be reserved.[15]

His second essential objection to this model is concerned with its claim to universal validity. The primary test of this claim is whether the model also captures *teleological explanations*. Von Wright's answer is that it does in the domain of biological function and purposefulness, whereas it does not in the domain of intentionality that figures prominently in social study and history. Von Wright makes the difference between these two domains and two corresponding types of explanation very clear.

The behavior of organisms or self-regulating (homeostatic) machines can be called 'purposeful' in the sense of "being needed for the performance of functions characteristic of certain-systems". Actions of conscious beings are 'purposive' in the sense of "intentionality aiming at ends".[16] To explain the former means to answer the question, How something is—or becomes—*possible*. Such explanations "may be couched in teleological terminology but nevertheless depend for their validity on the truth of nomic connections."[17] Therefore they have a "distinctive *causal* character",[18] and von Wright calls them "quasi-teleological".[19]

Genuine teleological explanations deal with 'action-like' behavior and do not depend for their validity upon the truth of nomic connections. Therefore they are quite different from causal explanations and do not fit Hempel's sub-

sumption model. One of von Wright's greatest contributions is his development of an elaborate theory of teleological explanation.

Von Wright considers the work of William Dray, Elizabeth Anscombe, and Peter Winch in the years 1957–1958 important for his own project. They were all inspired by the philosophy of the later Wittgenstein and to some extent by European non-analytic philosophy. Dray rejected the covering-law scheme for historical explanations because, in his opinion, these do not rely on general laws. Anscombe emphasized the importance of the notion of intentionality for the philosophical analysis of action and drew attention to some logical peculiarities of the Aristotelian idea of practical syllogisms. Winch stressed the importance of understanding the meaning of the behavioral data in terms of the concepts and rules which determine the social reality of the agents studied.

The problem of understanding is of secondary importance for von Wright, as I shall try to show in the next section. His main concern is with the *explanation* of actions. In a recent paper he answers the question, 'What is action'? in the following way; "Action normally is behavior understood, 'seen', or described under the aspect of intentionality, i.e., as aiming at something, goal-directed."[20] To explain an action is to answer the question 'Why does someone act the way he does?' This kind of explanation is different from causal explanation in the natural sciences. Its pattern can be best elucidated by examining the scheme of reasoning called 'the practical syllogism'. The simplest form of this reasoning is:

> *A* intends to bring about *p*.
> *A* considers that he cannot bring about *p* unless he does *a*.
> Therefore *A* sets himself to do *a*.[21]

In teleological explanation the starting point is that someone does something *(a)*. When we ask 'Why'? it would be a satisfactory answer to point out that he intends to bring about *p* and considers *a* necessary to this end. What makes such an explanation teleological, according to von Wright, is (1) that we know that a certain behavior is goal-directed, intentional—otherwise, as a purely natural event it could only be causally explained; (2) that its validity does not depend on whether the action, *a, is* causally related to the end *p*. The only relevant question here is whether the agent *thinks* that *a* is necessary to *p*.

How can we establish whether an item of behavior is an action, i.e., directed toward some goal, and whether the agent really considers that what he does is necessary for attaining his goal?

Von Wright gives a whole list of procedures that could be used to verify the presence of a certain intention and a cognitive attitude. Some are indirect—knowing that the agent "belongs to a certain cultural community, has a set education and a normal background of experiences", and possesses certain traits of character and temperament, we could make a plausible estimate about

the intentional character of his action. There are also more direct ways: verbal communication with the agent.

However, even one's immediate knowledge of one's own intentions need not be very reliable. Furthermore, to the extent to which an agent is 'reified', he behaves in a routine, mechanical way without any accompanying intentions and beliefs. These will be absent where acting is normally preceded by conscious choice and commitment. This whole analysis seems to lead to the conclusion that one cannot conclusively verify that an item of behavior is an action or what the intention is in a given case. It follows from this failure to give a clear-cut operational definition of the concepts 'intention' and 'action' that the concept 'teleological explanation' is also rather blurred and overlaps with 'causal explanation'—a conclusion that perfectly fits dialectical method but cannot be considered satisfactory from the point of view of analytical philosophy. This difficulty in itself need not be too serious. Provided there is a good theoretical (analytical) explication of the concept 'intention', its satisfactory operationalization might eventually follow. But it seems to me that even the theoretical explication opens up very serious problems.

Von Wright tries to avoid the extremes of behaviorism and mentalism. His objection to saying that 'the intentionality is in the behavior' is that it misleads us by suggesting 'a location' of the intention, 'a confinement of it to a definite item of behavior'.[22] Intentionality is not "like a quality inherent in the movements of limbs and other bodily parts."[23] On the other hand, he sees an important and true element in such a formulation: "Intentionality is not anything 'behind' or 'outside' the behavior. It is not a mental act or characteristic experience accompanying it."[24] Von Wright's solution is the following: "The behavior's intentionality is its *place* in a story about the agent. Behavior gets its intentional character from being *seen* by the agent himself or by an outside observer in a wider perspective, from being *set* in a context of aims and cognitions." In his 1973 Jyväskylä lecture, *Determinism and the Study of Man* (B265 and 281) von Wright repeats and further clarifies essentially the same solution. An outside observer is "familiar with a number of both internal and external objects of intention which are possible determinants" of an agent's behavior. He thinks it likely that some such determinants will be at work there. 'This is what it is to see his behavior as intentional'.[25]

A number of questions may be raised at this point.

First, is not some kind of circularity involved in the attempt to explicate intentionality in terms of 'a context of *aims*' or 'objects of intention'?

Second, is it possible for both the agent himself and an outside observer to see the agent's behavior as intentional? Some passages allow this possibility explicitly (*EU*, 115) or implicitly: a legitimate way of ascertaining a person's intentions is by asking him (*DSM*, 11). But some passages give the impression that unless there is someone who observes the agent's behavior and thinks

about its possible determinants no one could *see* his behavior as intentional
(*DSM*, 11). Intentionality would, in that case, turn out to be something outside
the behavior—which was explicitly denied previously.

Third, if intentionality is not a mental act, how does one understand terms
by means of which its explication is attempted, such as: *seeing, observing,
thinking, aiming at*. What does it mean to say that 'the behavior's intentionality
is its *place* in a story about the agent'? A story must be *told* by somebody, and
telling like *seeing*, etc., is both behavioral and mental at the same time.

It seems to me that the source of all these difficulties is a traditionally sharp
dichotomy between the behavioral and the mental. Intentionality is a concept
which does not bear on this dichotomy; neither behaviorism nor mentalism can
give a satisfactory account of it, and von Wright's analysis helps us to realize
this. But the question then arises: How do we overcome this dualism if we
continue to distinguish so sharply between the 'behavioral' and the 'mental'?
We can only vacillate between extremes: first, by denying that intentionality
involves any mental act, suggesting that we are behaviorists; then, by denying
that intentionality could be reduced to behavior, creating the impression that
we are mentalists.

If one approaches the study of human activity ready to replace one's initial,
crude dichotomies by more articulated conceptual structures, one will sooner
or later have to ask the question: Is there any mental act which is not, at least
indirectly, associated with some form of overt behavior? Is there any item of
overt human behavior which is not 'purposeful' if it is not also 'purposive' (in
Von Wright's sense)? Cases which allow positive answers to these two ques-
tions constitute extremes of a continuum: at one pole, unintended, reified bod-
ily movements; at the other, completely impractical, chimerical projects unre-
lated to any existing or historically possible behavior. Intentionality
characterizes the range between these two poles, where we do not find those
fictitious end results of our analysis called 'items of behavior', but *'behaving-
human-subjects'*, where intending does not occur as purely mental activity of
some disembodied spirits but as consciously directed activity of individuals
endowed with some physical and psychic powers, conditioned by their past,
belonging to a social community, surrounded by a natural and social environ-
ment that opens up and at the same time limits a range of real possibilities for
action.

Von Wright has a very interesting analysis of various determinants of ac-
tion, such as wants, duties, abilities, opportunities. He calls the interplay
among situational change, intentionality, ability and a motivational and nor-
mative background *the logic of events*. In his opinion "it constitutes the cog-
wheels of the 'machinery' which keeps history moving".[26] Instead of assuming
a static, invariant concept of intentionality as one of the elements in this logic,

it would be very interesting for further development and concretization of that concept to see how all those determinants affect the very nature of intentionality. One could consider several dimensions in which change takes place. Thus:

1. Individuals of very undeveloped *abilities* and *needs* intend to bring about few things, their intentions are simple, uniform, short-range, habitual, not yet very different from the conditioned reflexes out of which they historically emerge. Development of abilities and needs increases the scope of objectives, makes intentions more diversified, complex, refined, long-range, creative. Beyond a certain limit (imposed by such factors as scarcity, social limitations, duties, traditions, customs, and individual habits), development of abilities and needs gives rise to intentions which are so sophisticated or idealistic or radical that they get divorced from practical activity and find their expression in pure theory, arts, play, and culture.
2. When individuals have little control over their natural and social surroundings (when the level of opportunity is very low) their intentions have predominantly the character of *reactions* to external stimuli. The more control and the greater the scope of opportunities, the more specifically humane intentions become, involving initiative, free choice, boldness, active intervention in the play of natural and social forces. Beyond a certain level of control, intentions tend in various ways to lose touch with overt behavior: they turn into unrealistic aspirations,[27] purely spiritual undertakings, game-like designs. It is interesting to note that Marx projected a true realm of freedom into a future time when labor and material production would be so developed that they would lose any importance for man.[28]

This typology of intentions could be made more concrete by examining the way they are determined by social institutions and norms of different kinds. Nevertheless this sketchy analysis seems to suggest that:

1. The difference between actions and unintentional behavior is very complex and requires a whole set of relevant conditions to be explicated.
2. There is no demarcation *line* but a demarcation *range* between causal and teleological explanation; many cases of human activity are hybrids between *conditioned reflexes* and 'actions'.
3. There are not only two but at least three kinds of human activity. One is non-intentional behavior which can be explained causally. Another is 'actions' to be explained both causally and teleologically. The third is cultural and psychological phenomena in which intentions are associated with symbolic forms rather than with overt behavior. The practical syllogism model of teleological explanation does not cover these latter cases. They should be *understood* rather than *explained*.

Understanding in Terms of a Law

Before he expounds his own ideas on understanding von Wright mentions two important previous uses of the term. One originated in German anti-positivist philosophy at the end of the nineteenth century (Droysen, Dilthey, Simmel, and others). 'Understanding' for them meant a form of empathy,'recreation in the mind of the scholar of the mental atmosphere, the thoughts and feeling and motivations of the object of his study'. Another notion of understanding, which has appeared in recent hermeneutic philosophy, which continues to defend the specific character of the methods of understanding in the social sciences, but interprets 'understanding' as a semantic rather than a psychological category.

Von Wright takes a very important step toward over-coming the onesidedness both of positivism's rejection of the method of understanding and of hermeneutics' complete lack of interest in explanation. He makes a sharp distinction between the two methods, but indicates that they are "interconnected and support each other in characteristic ways".[29] Understanding is essentially interpretation of the meaning of what is going on. In contrast to explanation which answers the question *why,* "the results of interpretation are answers to a question 'What *is* this?' "[30] Understanding in this sense is "a prerequisite of every explanation, whether causal or teleological". The characteristic preliminary of causal explanation is understanding what something is like, the preliminary to teleological explanation is understanding what something is, in the sense of what it *means* or *signifies.*[31]

Before we can explain behavior teleologically we must understand whether it is intentional and whether it can be classified as an action.

Von Wright is obviously much less interested in understanding than in explanation. Two of his remarks deserve attention. One is his distinction between norms which regulate (enjoin, permit, or prohibit) conduct and rules which define various social practices and institutions. The latter are of fundamental importance to understanding. It is interesting to note that when he analyzes concrete examples, Von Wright recognizes a difficulty in the application of the dichotomy between explanation and understanding. To insist upon a sharp distinction between answers to the questions, What? and Why? would, in his opinion, be pedantic.[32]

The other point is a very important insight into the interconnectedness of the two methods at different levels of the same research.

> Explanation at one level often paves the way for a reinterpretation of the facts at a higher level. . . . Something which used to be thought of as a reformatory movement in religion may, with a deepened insight into its causes, come to appear as 'essentially' a class struggle for land reform. With this reinterpretation of the facts a new impetus is given to explanation. From the study of the causes of religious dissent we may be led to an inquiry into the origin of social inequalities as a result, say, of changes in the methods of production in a society.[33]

No Marxist could better and more clearly express the idea of this interrelation of methods. However there are three questions that seem to require answers.

1. Can 'understanding' be reduced to the interpretation of behavior in terms of some purpose and some means–end relation?
2. Does understanding answer only questions of the form '*What* (is it?)' or does it also answer questions of the form '*Why* (do people act or use some symbols in a certain way)?' In the latter case how can we construe the difference between explanation and understanding (if there is any)?
3. Are there, in the sciences of man, cases of understanding *in terms of laws?*

1. Von Wright deals with understanding only insofar as it is related to teleological explanation. Therefore one can get the impression that it is only 'behavioral data' which we tend to understand, and that 'to understand' means to 'extract' a purpose. However, we also try to understand linguistic expressions and all other cultural forms. Since the beginning of teleological explanation, in Dilthey's philosophy of life, all these three types of phenomena (of 'expressions') have been considered objects of understanding. No matter how much we might wish to make clearer the method of understanding, there is no reason to reduce the scope of its application, since all three types do express something that we might wish to understand, do function as signs the meaning of which need not be clear.

On the other hand 'the meaning of a sign' is a much broader notion than intentionality. 'Understanding' is becoming (more or less) aware of a set of relations among a sign S and various other entities that constitute a semiotic situation.[34] In other words 'to understand' is to find out:

(a) which psychic disposition of an individual or collective subject has been expressed by S (a motive, or purpose, is only one of these);
(b) what are other objective phenomena toward which S stands in one of the following relations: means-end, cause-effect, particular-general, antecedent-subsequent (phase of some development);
(c) which social rules and norms regulate the use of $S;$
(d) how S can be defined or described in linguistic symbols;
(e) how it could be practically identified, produced, or reproduced.

2. The basic difference between understanding and explanation does not seem to lie in the different kinds of questions they try to answer (What?—Why?), but rather in the immediate presence in the former of a subjective, interpretative function which is taken for granted and only implicitly present in the latter. To 'understand' is to interpret meaning; to 'explain' is to see an already interpreted object or action as a particular case of some regularity, of some objective determination. Now what makes meaning distinct from regular-

ity, determination, or order is the fact that the latter may be there without anyone being conscious of it; whereas the former is the *expression* of an act of consciousness and is related to another consciousness that grasps what it expresses. Naturally it would be too simple to say that the latter is *objective* and the former *subjective*. Thinking of a law, explaining something in terms of a law, is already giving a *subjective form* to something objective. Interpreting, understanding the meaning of an action or symbol, is not only revealing thoughts, feelings, intentions expressed by it; it is also disclosing a structure of its other, *objective relations* (with other actors and symbols, with various environmental objects, and with practical operations necessary to generate it or measure it or identify it). However, the essential characteristic of the interpretation of a human action or symbol (as distinct from any other behavior, from any other physical object) is an attempt to establish a link between thoughts, feelings, or intentions of the (individual or collective) subject that acts or uses symbols, on the one hand, and those of the (individual or collective) subject which interprets those actions and symbols, on the other.

A modern discussion of the relation between 'explanation' and 'understanding' that would give a behaviorist interpretation of understanding and avoid any reference to psychic (mental) states, acts, or dispositions, would completely miss the point. Because the point of hermeneutic philosophy's introducing 'understanding' as a specific method for humanities was precisely resistance to a behaviorist treatment of social phenomena. Understanding was from the beginning defined as a process of experiencing other persons' inner mental states through the overt expression of those states in acts or symbols. This process should be made more articulate and testable, instead of being simply replaced by a rather different denotation of the term 'understanding'. For example, the idea of *empathy* as the form of experience *(Erlebnis)* specific to understanding could for good reasons be discarded, as it is hopelessly vague and what it refers to is uncontrollable. By contrast, introspection as a specific means of establishing data about psychic processes can be made intersubjective and reliable by comparing a series of introspective statements and examining their coherence.

3. If introspection could yield reliable evidence, it seems to follow that nomic connections between variables designating psychic phenomena could be reasonably well established and used in the process of interpretation. The necessary conditions for some introspective data to be considered reliable evidence are: first, that there be a sufficiently large set of introspective statements obtained from a number of different persons in a given situation; second, that there be a high degree of agreement among statements. It would then be possible to formulate general statements of the following type:

(1) (x) $(x$ experienced E under conditions $c)$.

(2) (x) $(x$ decided to do a under conditions $c)$, where x would be a group of persons (A, B, C, \ldots) and E experience of a certain type (fear, joy,

hunger, desire . . .). In the same way it would be possible to establish a
link between that type of experience and the decision to do a:

(3) *(x)* (If x under conditions c experienced E then he decided to do a).

Once we establish general conditional statements of the form *If experience
E then decision (motive, intention) to do a,* we shall be able to understand the
behavior of a group of persons x or an individual a who belongs to the group
in the conditions c. The pattern of understanding would fit the following
scheme:

> A has experienced E (under conditions c).
> If one experiences E (under conditions c) he decides to do a.
> Therefore A does a.

The lawlike conditional statement need not have the importance and the
reliability of a law, but it would be a good basis for understanding. After all,
understanding, like explanation and prediction, need not be fully successful in
all cases. Such a conditional statement would become a law under the follow-
ing three conditions discussed earlier:

(1) if it generalizes the results of our practical activity: when we create con-
 ditions c, A does a; whenever we remove conditions c, A stops doing a;
(2) if what it states can be derived from the general a priori knowledge;
(3) if what it states is so important that in case of a counterinstance we shall
 try to modify our assumptions rather than give it up. (This we will do
 within certain limits; otherwise the statement would stop being an empiri-
 cal statement.)

When these conditions are satisfied the connective *if . . . then* in general
conditional statements may be considered an expression of a relation of (non-
logical, 'natural') necessity.

Interpretation of this kind differs from the older hermeneutic philosopher's
idea of understanding. In the latter case, the interpreter tries to internalize cer-
tain factors of the situation and to conjecture how experiences, thoughts, and
feelings would be related to motives and decisions. There the pattern of under-
standing would be:

> A has experienced E.
> As a result of experience E, A decided to do a.
> Therefore A does a.

The connection here is not necessary but factual. Thus far, this type of
understanding is analogous to von Wright's model of teleological explanation.
The essential difference consists in the fact that the latter explains why A does
a in terms of a *purpose* of a (or in terms of a *means-end* relation where a is a
means), whereas the former allows us to understand why A does a (or what a
is) in terms of an earlier *experience* out of which the given purpose has been
generated.

On the other hand, understanding in terms of a law is similar to what von Wright calls 'causal explanation'. A non-causal, teleological explanation of an action a in terms of intentions of the agent A would become causal if there were a covering law that connected the intention a and a cognitive attitude concerning means to end with doing a. The pattern of such 'causal' explanation in terms of intentions would be:

> A intends to bring about p and considers that a is necessary to p.
> If someone considers that a is necessary to p and intends to do p this invariably leads to doing a.
> Therefore A does a.

Thus, while teleological explanation is supposed to explain only why, *as a matter of fact, a* takes place, this is an explanation of why *a must have* taken place. Von Wright consistently calls all such explanations 'causal', but perhaps the term 'causal' should be reserved only for the cases where the necessary connection in the covering law is causal in the more narrow sense; otherwise it could also be genetic or functional.

The difference between the above model of explanation and the model of understanding in terms of laws consists in the fact that the former subsumes an action under an objective regularity, whereas the latter offers the interpretation of the meaning of that action in terms of a *psychological* law.

It seems to me that laws play a more important role in explaining and understanding social phenomena than von Wright's texts indicate. One of his examples is worth examining: "There was an uprising among the people, because the government was corrupt and oppressive".[35] This is a case of explanation: an account of the uprising is given in terms of an objective relation between the character of a government and an appropriate reaction of the people. (If we answer the question: 'Why was there an uprising among the people?' by saying: 'Because they *felt* they could no longer bear existing corruption and oppression' the latter would be a case of *understanding,* ie., an interpretation of an event in terms of the agents' feelings and motives.) Von Wright resolutely denies that the validity of such explanations depends on the validity of a nomic connection, and he therefore classifies them as either quasi-causal or teleological.[36] In both cases, what connects *explananda* and *explanantia* 'is not a set of general laws, but a set of singular statements which constitute the premises of practical inferences.'[37] In the historical examples that he analyses, von Wright sees only a nexus of successive events connecting the *explanandum* and the event that is usually considered its cause. The latter usually changes in some way the factual situation and existing interactions; thus it also indirectly affects the motivation background of the agent. None of these relations and interactions has, according to von Wright, general and nomic character.

This is true in some cases, but not in all of them. Consider the explanation: 'There was an uprising among the people because the government was corrupt and oppressive.' What could be the reason to accept this explanation as valid rather than a dozen 'explanations' of the type 'There was an uprising among the people because the enemy agents stirred up dissatisfaction'; '. . . because opposition spread vicious propaganda'; '. . . because there is an inborn instinct for aggression in people', '. . . because the people hated the fatherlike figure of the king', etc. If there were no enemy agents and political opposition working against the government and no aggressive instincts in people it would be possible to answer: the *explanans* in the accepted explanation is factually true, whereas in all other attempts it is not. But suppose the *explanans* in at least some other candidates for explanation were also factually true. It could be the case that there were some enemy agents who stirred up dissatisfaction among the people and some kind of an opposition that spread vicious propaganda. And still such 'explanations' deserve to be laughed at. Why give incomparably more weight to the fact that the government was corrupt and oppressive? We might, of course, ask people why they rebelled. We might collect quite reliable and valid data about their experiences and motives and we would be able to *understand* why they rebelled. We could establish: 'There was an uprising among people because they *felt* they could no longer bear existing corruption and oppression'. But in order to establish that 'there was an uprising among people because the *government was* corrupt and oppressive' we must also have, first, some objective behavioral data about the nature of the government, and second, we must have grounds to hold that there is some kind of general and necessary connection between the government's behavior and the people's tendency to rebel. The grounds would be: (1) This connection has been observed many times in history, (2) Knowing human nature it is reasonable to expect that social injustice beyond a certain limit gives rise to violent collective reactions, and (3) that human beings are ready to resist corruption and oppression—and rebel against it when it reaches a certain limit—is such an important consequence of the principles of human freedom and equality that we are ready to explain away counterinstances by the presence or absence of certain circumstances rather than to consider the principle and its consequence falsified.

There are several apparently good reasons why von Wright was reluctant to accept that there are general and nomic statements underlying explanations in history.

First, Dray had already objected that so many limiting and qualifying conditions have to be added to a supposed law of history in any case of its application for explanatory purposes, that its range would be reduced to the single instance it is supposed to explain.[38] Von Wright, analyzing the case of the assassination of the Austrian archduke at Sarajevo in July 1914 as the cause of

the outbreak of the First World War,[39] sees there only a sequence of independent complex events, a complex of various circumstances by force of which the war became inevitable.

Second, there are many intermediate links between the assassination and the outbreak of war, between government, corruption, and people's uprising. "These links are, typically, motivations for further actions." (*EU,* 140). But motives, intentions, acts of will, cannot be defined without reference to their supposed effects—results of action. Therefore, they do not satisfy Hume's condition of being logically independent and cannot be considered genuine (Humean) causes and affects. Since Humean causes and effects differ from all other 'causes' and 'effects' insofar as they are connected by law, it follows that in history, where all events are mediated by motives and acts of will, there are no Humean causes and consequently no laws.[40]

Third, even 'if there existed law-like connections between historical events, we should rather think of them as applications of general laws of sociology, and perhaps of economics, than as laws of history proper.'[41]

Fourth, even if we speak about sociological and economic 'laws', they are very different from the laws of nature. They 'are not generalizations from experience but conceptual schemes for the interpretation of concrete historical situations'. These laws presuppose some institutional structures, some social norms and rules; they are "subject to historical change—unlike the laws of nature which are valid *semper et ubique*".[42]

As to the *first* point: the cases of explanation analysed by Dray and von Wright really do not involve any laws. Surely not everything in history takes place according to law or is related to all other events by law. There is no historical law that connects the Sarajevo assassination with the outbreak of the First World War. But there are underlying historical laws that connect the accelerated industrialization of a big country with the need to control foreign sources of raw materials and markets, that need with the *Drang nach Osten* policy of the Central Powers in the years preceding 1914, that policy with the sharp, latent political conflict among great European powers, and that latent conflict with the outbreak of the First World War. These laws are of various degrees of generality: through-out the history of class society any attempt by a great power to change the *status quo* and to redistribute 'spheres of influence' have been met with violent resistance from other great powers; on the other hand, only for the early period of capitalist society (that ended with the Second World War) was the law valid according to which accelerated industrialization gives rise to a tendency for military occupation of colonies.

It is of course true that these laws hold under certain conditions and that exceptions will occur whenever these conditions are not met. But this is (to a lesser degree) also true of the laws of nature. Our airplanes only exceptionally and even then only approximatively fall according to Galilean laws.

Some historical laws involve reference to individual events, countries, or cultures (Greece, the Enlightenment). Again there are parallels in the natural sciences: many natural laws contain constants specific to the earth or describe regularities of the solar system, which is also an individual object. If there are different levels of individuality, a much richer conceptual apparatus is needed than a simple distinction between 'general' and 'singular' statements. It is possible to have a general (and nomic) statement about an individual stating that for all its states at all moments, during a significantly long interval, there was an invariant relation among some of his (its) stable characteristics.

As to the *second* point, there really and inevitably are mediating links among historical events and phases of historical change. These really are acts of will and other mental states. But it does not seem to be the case that they cannot be defined without reference to the results of action. An *intention* could be defined: *genetically,* by reference to an antecedent event or mental phase, *analytically,* by expounding the psychological structure of motivation, or *operationally,* by indicating the operations of identification or in von Wright's words: verification procedures (*EU*, 109–116) of a certain intention.

It follows, then, that intentions may be construed as logically independent of intended acts and can be causal factors of human activity. In fact human creativity would be inconceivable without the assumption of an indeed 'invisible' but empirically testable power to imagine, project, want. All development of science and civilization after Hume has demonstrated a tendency of growing independence and growing productive power of thinking and projecting. In an age in which machines act without intending and intentions become increasingly bold; in which ideas, like material forces, cause profound change across whole continents, Humean behaviorism becomes conservative force rather than a force for liberation from animism and magic. Finally, even if intentions did not qualify as Humean causes, it would not follow that they could not appear as constituents of some non-causal laws. Even if 'Humean' causes involve nomic relations, it does not follow that all nomic relations are causal. Von Wright actually uses the term 'causal' in two senses: narrowly as the relation of two phenomena, tied to the ideas of action and experiment and more broadly in its close association with the ideas of natural necessity and nomic connection—so close 'that one could conveniently group them all under the general head of causation.'[43] Therefore von Wright calls all covering-law explanations 'causal'. This seems to be an unfortunate ambiguity. A genetic connection in history need not be causal, yet it may still have all the characteristics of a law.

This leads us to the *third* point. Laws of history could be construed as applications of general laws of sociology or economics, only if all division of work within the study of man were superseded. Then such a unified, systematic, and historical science of man (Marx considered it essentially *history*) would no longer make a distinction between 'sociological' and 'historical' laws

but only between laws of greater and lesser generality, between laws that hold for phases of greater or lesser reification. While there are special disciplines of the social sciences and humanities, the task of systematic sciences like sociology is to study *synchronic* relations and patterns, whereas the task of history is to account for events in terms of *diachronic* relations. Such, for example, is the relation between the development of capitalist production and growth of the bourgeois class within late feudal society, and the emergence of the political form of absolute monarchy. This is a *nomic* relation because it is characteristic of all of the civilized world in a certain early period of its industrial development. To be sure, it is only a tendency, but many laws of nature and all social laws have a tendential character. What is *necessary* in such cases is not just one, inevitable, unavoidable, universally present consequence but a consequence which is both logically and factually possible (i.e., compatible with all the logical and factual limiting conditions of the system to which it belongs) and which has the best chance (in comparison with other factual possibilities) of being realized. A negative interpretation of *determinism* is assumed here: to determine is to deny, exclude possibilities (Cf. Spinoza: *Omnis determinatio negatio est*).

Fourth von Wright's point is very important as it emphasizes some specific features of social laws: they presuppose institutions, norms, and rules that are not mere reflections of given regularities, but involve the construction of conceptual schemes, and unlike laws of nature, they are subject to historical change. This view is greatly superior to all those views that fail to distinguish between natural and social laws. However, the impression remains that the distinction is now drawn too sharply. To the extent to which brute nature is being transformed into nature for man, there is an element of conceptual construction, of conventionalism, of choice in human formulations of natural laws. To the extent to which social life is reified, there is in social laws too an element of blindness, uncontrollability, and surrendering. In fact social laws allow a typology starting at one pole with (a) laws which merely describe blind social forces (eg., laws of a laissez-faire market economy), proceeding then to (b) laws which are the result of conscious human interaction with given necessities (e.g., laws of the market in a semiplanned economy); and next, along the dimension of increasing freedom, to (c) laws implicit in norms and rules imposed by an elite of economic and political power, and finally, at the opposite extreme pole, to (d) laws which are superseded in a freely accepted social order and in *internalized* norms and rules that regulate social life.

To the extent to which social order becomes less and less external and compulsory and more and more a matter of free, rational, and responsible choice, understanding becomes an increasingly important method of social inquiry. Nevertheless, it need not remain inarticulate and incapable of validation. Analogously to the two forms of 'explanation' (causal, teleological), 'under-

standing' also has at least two forms (one in terms of singular factual connection, and the other in terms of psychological laws).

These forms still await a proper analysis. But von Wright's great contributions to the study of human activity and the extremely important improvements that the analytical method has undergone in his hands allow hope that such a sufficiently clear and sophisticated analysis of understanding will emerge in his future works.

DEPARTMENT OF PHILOSOPHY MIHAILO MARKOVIĆ
UNIVERSITY OF BELGRADE AND
UNIVERSITY OF PENNSYLVANIA
NOVEMBER 1973

NOTES

1. G. H. Von Wright, *Determinism and the Study of Man,* a lecture given in Jyväskyla, Finland, July 1973, p. 1. Hereafter abbreviated *DSM*.

2. Ibid.

3. G. H. Von Wright, *Explanation and Understanding,* (Ithaca, New York: Cornell University Press, 1971), p. 19. Hereinafter abbreviated *EU*.

4. Von Wright illustrates this point with this example: The question 'Why is this bird black?' would be answered accordingly to Hempel's scheme 'It is a raven and all ravens are black.' But does this response really explain why the bird is black? *EU*, 19.

5. *EU*, 19.

6. *EU*, 19.

7. *EU*, 20.

8. *EU*, 27–38.

9. *EU*, 190.

10. *EU*, 72.

11. *EU*, 73.

12. M. Marković, 'Apodictic Universality of Scientific Laws', *Abstracts of Papers,* 3rd International Congress for Logic, Methodology, and Philosophy of Science, Amsterdam, 1967: 89.

13. As explained earlier, resistance here involves adequate modification of other elements of our beliefs, whereas a challenge would be 'overwhelming' if further resistance would lead to stagnation and sterile dogmatism.

14. Popper, *The Logic of Scientific Discovery* (London 1959), p. 42, § 20

15. *EU*, 15.

16. *EU*, 59–60.

17. *EU*, 84.

18. *EU*, 59.

19. *EU*, 59, 84–85, 153.

20. *DSM*, 10.

21. *EU*, 96.

22. *EU*, 115.

23. *DSM*, 10.

24. *EU*, 115.

25. *DSM*, 11.

26. *DSM*, 13–19.

27. Most dictators lose the capacity of correctly estimating the feasibility of their undertakings.

28. Karl Marx, *Capital*, Vol. 3 (Moscow 1959), 799–800.

29. *EU*, 134.

30. *EU*, 134.

31. *EU*, 135.

32. *EU*, 153.

33. *EU*, 134–135.

34. I have analysed these 'dimensions' of meaning in my book, *Dialectical Theory of Meaning* (Dordrecht: Reidel, 1984), 171–328.

35. *EU*, 85.

36. *EU*, 85, 142.

37. *EU*, 142.

38. William Dray, *Laws and Explanation in History,* Oxford University Press, 1957.

39. *EU*, 139–143.

40. "Acts of will differ interestingly from other things which may figure as (humean) causes and which *can* be defined without reference to their supposed effects To call the shots at Sarajevo a cause of the 1914–1918 war is a quite legitimate use of the term 'cause'—only we must remember that we are not now speaking about humean causes and nomic connections." (*EU*, 94, 142.)

41. *DSM*, 21.

42. *DSM*, 21.

43. *EU*, 37–38.

20

W. H. Dray

VON WRIGHT ON EXPLANATION IN HISTORY

In the final chapter of his *Explanation and Understanding,* von Wright offers a brief account of explanation in history and cognate fields which, although it draws upon extensive recent literature on the subject, is in many ways novel and suggestive. Distinguishing in general between monistic, positivistic, or 'Galilean' approaches to the social studies, and pluralistic, hermeneutic, 'Aristotelian' ones, von Wright places himself firmly in the latter tradition. More specifically, he urges the recognition of a sharp distinction between causal and teleological explanation, neither being reducible without remainder to the other, and argues that typically historical explanations, although they may often use causal or teleological language, are seldom straightforwardly one or the other.

By causal explanation, von Wright means a subsumption-theoretic pattern of argument which asserts a law-instantiating connection between two events whose descriptions are logically independent of each other. Against weaker forms of so-called 'covering-law' theory, he insists that explanatory laws must be universal in form, and that satisfactory explanation must be deductive. Even deduction is held to be insufficient, however, if it employs 'laws' which state only correlations, however exceptionless. For the hallmark of causality is necessity, not universality, and thus explanatory laws must themselves have causal force. How then is the difference between causal laws and mere generalizations to be conceived? Von Wright's answer is a bold one, especially with historical applications in view. Following activist theorists of causation like R. G. Collingwood, he declares that p is the cause of q "if and only if by doing p we could bring about q or by suppressing p we could remove q or prevent it from happening."[1] The concept of causality thus presupposes the concept of manipulability, and hence the concept of human action itself. Faced with a causal judgment apparently involving a non-manipulable event like the eruption of Vesuvius, von Wright draws the required conclusion. Since we cannot analyze such an event into components of a sort we know we can control, we can

only be said to 'assume' a causal connection between it and such further events as the destruction of Pompeii.

Historians may find such a doctrine surprising, but they will probably see it as somewhat peripheral to their main theoretical concerns. Somewhat closer to them is von Wright's recognition of two distinct types of causal explanation, the one identifying sufficient conditions of what occurred, the other only necessary ones. Sufficient conditions show why things *had* to happen; they therefore explain in a sense of showing 'why-necessary'. Necessary conditions, by contrast, show how things were *able* to happen; they explain rather in a sense of showing 'how-possible'. Both kinds of explanation are appropriately called causal, von Wright maintains, provided the conditionship relation in each case is nomically grounded.

Just how final von Wright considers this distinction between types of causal explanation is not entirely clear. He notes a number of cases in which explanation by necessary conditions is converted through further inquiry into explanation by sufficient conditions. The question thus arises whether such convertibility is seen as a requirement of good 'how-possible' explanation—a requirement which would, in effect, reduce its status to little more than that of an Hempelian 'explanation sketch'. Against such a reductive view it seems plausible to argue that an explanation showing only the causal possibility of what occurred could be complete as an answer to a 'how-possible' question. It might be argued, further, that such explanation could legitimately be offered even where what is to be explained is believed to have had no sufficient conditions at all (von Wright is agnostic about universal determinism). Of special interest for historiography might be a kind of case in which one agent provided another with a nomically necessary but not sufficient condition of doing some harm. Even if it were assumed that the second agent's seizing his opportunity was not fully determined, it would be natural, given appropriate moral or legal circumstances (as Hart and Honoré have shown), to speak of the first as 'causing' the ensuing harm. Oddly enough, von Wright seems reluctant to admit that the conditions which explain human actions are ever nomically necessary for them.

He concedes that his own talk of causal explanation may depart somewhat from ordinary usage. His distinction between necessary and sufficient condition forms of such explanation probably doesn't constitute such a departure; but something that does, without being acknowledged as such, is his apparently regarding as causes (or parts of the cause) of what they condition, *all* the conditions mentioned in an explanation which pass the controllability test. In fact, in experimental science as well as in everyday life and historiography, causal answers to 'why-necessary' questions almost always contrast some necessary conditions with others in a way which goes beyond the question of controllability. As Collingwood himself emphasized, human *interests* as well as human

powers enter into the identification of causes.[2] A reference by von Wright to the close connection in ordinary speech between the ideas of causation and responsibility, if it had been followed up, might have pointed him towards one type of human interest which often seems to enter into causal analysis, especially in history. 'How-possible' explanations, it might be added, express interests even more obviously than explanations of the 'why-necessary' sort; for they, at least, seem clearly to presuppose some determinate context of inquiry. Thus, in one of von Wright's own examples, the discovery that certain historical agents possessed a hitherto unsuspected building technique is said to explain causally how they could have left such surprising monuments (p. 138). The availability of certain building materials, on the other hand, although equally a necessary condition, and, it would seem, equally a controllable one, is in that particular context not regarded as a cause.

Von Wright's interest in causal explanation is, in fact, less with refinements of this sort than with a larger distinction he wishes to draw between all explanation in terms of causal conditionship, and teleological explanation, which he considers not to be causal at all. Causal explanation, he says, represents events as occurring 'because of' what happened earlier (a formulation which presumably stretches to include causes which allow, as well as causes which ensure). Teleological explanation, by contrast, represents things as happening 'in order that' still further events should occur. The first sort, it might be said, 'point to' the past; the second sort 'point to' the future (p. 83). Teleological reference to the future, however, unlike causal reference to the past, is compatible with the referenced future events not actually coming to pass. And explanations which logically require such 'reference' are themselves of two fundamentally different sorts, only one of which, in von Wright's view, really deserves the name of 'teleological explanation'.

The latter is the explanation of human actions in terms of what agents were trying to bring about. Here what is referred to is an envisaged future, and what explains the action is the agent's regarding it as a means to that future's realization. In such cases, teleological explanation formulates the practical inference which guided the agent in acting as he did. Von Wright concedes that, as actually reported, explanatory practical inferences assume many forms. Wants, wishes, desires, reasons are all, from time to time, regarded as explaining actions. The case which he takes as paradigmatic, however, is one in which action is explained by reference to the agent's *intention* to bring about a certain result, together with the beliefs or 'cognitive attitudes' which led him to regard his action as necessary—and perhaps also, in some contexts, as sufficient—for its attainment. Von Wright's claim for the explanatory efficacy of such practical inference is high. He sees it as offering to the human sciences a distinctive logical model for explanation—a model especially suited to its subject matter in much the same way that the 'covering-law' model of causal explanation suits

the subject matter of the natural sciences. For only human action, he holds, can be explained by reference to practical inferences. And human action, *qua* action, cannot, with formal strictness, be explained in any other way.

To support such claims, von Wright must deny that the relation between an agent's intentions and beliefs and the action which they explain is itself causal or law-instantiating, as some positivist theorists of the social sciences have maintained. The connection, he insists, is rather a conceptual one. Appropriate statements about beliefs and intentions *logically require* statements about actions. The connection between premises and conclusion of a teleological explanation is thus not, as some have thought, too loose to be genuinely causal: it is too tight. To show this, however, is no easy matter. Von Wright rejects some versions of the so-called 'logical connection' argument—for example, A. I. Melden's that an agent's explanatory intentions cannot be *defined* without reference to the action which they are called upon to explain (p. 195). His own argument is that the verification of the conclusions of explanatory practical inferences is not logically independent of the verification of their premises. Nomic causal claims may, of course, enter into teleological explanations of actions in an 'oblique' way: an agent's belief may well be explanatory because it represents what he does as causally necessary or sufficient for what he intends to bring about. But the viability of the explanation itself does not depend upon the truth of such a nomic claim.

When von Wright actually tries to work out what would constitute a logically conclusive or complete explanation on the model of the practical inference, the claim that statements about intentions and beliefs logically require conclusions about actions being performed turns out to require considerable qualification. For, on the face of it at least, there seem to be a number of ways in which an agent's failing to act would be logically compatible with his having formed intentions and beliefs which, had he acted accordingly, would have explained his doing what he did. For example, having formed a relevant intention, he may forget to carry it out at the appropriate time (or even forget the time at that time); he may form an intention and then change it, whether because of changes in his situation or in his appraisal of what is necessary to bring about the envisaged result; or he may set himself to do the appropriate thing at the appropriate time but be prevented. Von Wright's way of absorbing such possibilities into a reformulated statement of the logical connection thesis is tortuous, and sometimes puzzling (see further below). The difficulties envisaged, however, are alleged not to destroy the main claim: that the connection between explanatory premises and conclusion is conceptual rather than empirical.

A peculiarity of von Wright's account of teleological explanation is his distinguishing it from mere *understanding* behaviour as an expression of the agent's intentions. A teleological explanation always has as its *explanandum*

the conclusion of a practical inference, and this is always the specification of an action, not a bodily movement. Thus there can be no teleological explanation of mere behaviour; any alleged case of it will be formally invalid. All teleological explanation will in fact require the prior intentional understanding of some item of behaviour to be explained. Von Wright tends to associate intentional understanding with answering the question 'What was he doing?' rather than 'Why did he do it?', although conceding that ordinary usage may not entirely support him in this. He points out that all explanation, even causal, presupposes understanding, at least in the sense of knowing the nature of what is to be explained. The case of teleological explanation is nevertheless distinctive, he argues, in presupposing knowledge of what something was *meant as*. And he writes approvingly in this connection of those theorists of history who have spoken of the historian's subject matter as having an 'inside' as well as an 'outside', or of the need for 'empathy' on the part of the inquirer.

But although much of what he says about intentional understanding by contrast with teleological explanation assumes that what is understood is mere behaviour, von Wright also, at times, employs the notion in a broader sense. He so employs it, for example, in discussing a familiar manoeuvre in ordinary talk about human actions: the incorporation of intended consequences already cited in a teleological explanation of an action into a new, expanded description of what the agent was doing. Someone who presses a button (in order to open an automatic window) may also be described as opening the window (by pressing the button); and if his intention in so doing was to ventilate the room, he can be said, further, to be ventilating the room. Von Wright represents a progression of this sort as the achievement of new and higher levels of understanding. So to conceive it, however, is clearly to give up the original limitation on what we can intentionally understand; for what is understood at each new level is already conceived as an action at the previous level. In such cases, indeed, understanding could be said to presuppose teleological explanation as appropriately as the reverse. All this somewhat obscures the point of von Wright's distinguishing between explanation and understanding in the first place.

The distinction is rendered precarious in other ways as well. At one point, for example, von Wright at least considers telescoping it from the opposite direction, when he suggests that understanding at the level concerned with mere behaviour could be regarded as a 'rudimentary' form of teleological explanation (p. 124). Understanding is also, at times, identified with what is achieved by the whole intentional-teleological approach to a subject matter (as is suggested by the title of the book). At other times it is held to be an aspect even of causal explanation, this being said to require understanding of the *kind* of thing being explained, the teleological sort requiring understanding of what it *means*. An attempt to relate the difference between understanding and explaining to a contrast between two sorts of rules of conduct also fails entirely to eliminate am-

biguity. A teleological explanation, von Wright points out, often involves ref-
erence to rules which the agent followed in acting as he did. But there are two
fundamentally different sorts of rules (pp. 151, 203), the one determining what
shall *constitute* an action of a certain kind (e.g., 'To greet a lady, raise your
hat'), the other *enjoining* actions of a certain kind (e.g., 'Greet a lady whenever
you meet her'). It is the latter sort, we are told, that 'characteristically' pro-
vides teleological explanation; the former is of importance primarily for under-
standing. It must be noted once again, however, that the understanding thus
achieved could not be at the first, or behavioural level, with reference to which
the notion was first introduced. And as von Wright's guarded language seems
to recognize, reference to constitutive rules can sometimes (even if 'uncharac-
teristically') provide teleological explanation. For example, where modes of
greeting have changed, the discovery that someone was following an old rule
about how to greet a lady may be just what is needed to explain why he took off
his hat.

 Von Wright contrasts the teleological explanation of action not only with
intentional understanding, but also with what he calls *quasi-teleological* expla-
nation, the latter being found chiefly in the biological sciences. In dealing with
living organisms, although we may not wish to imply that what happened was
meant or intended to happen as it did, we nevertheless often speak quite natu-
rally of its having a function or even a purpose relative to the organism. When
physical exercise is taken, we say, breathing accelerates 'in order to' replenish
the blood's oxygen supply. According to von Wright, such explanation is un-
like genuine teleological explanation in having to be nomically grounded. It
stands or falls on there being a relation of necessary conditionship between
faster breathing and the restoration of oxygen to the blood, the former thus
showing at least how the latter was causally possible (and providing a basis for
a second sort of 'reference' to the future). Quasi-teleological explanation may
also be said to be causal, or at any rate potentially causal, in still a further
sense. For a statement of functional dependence of the sort indicated can often
be expanded into a causal explanation of the 'why-necessary' kind. We may
be able to discover sufficient conditions both for the acceleration of breathing
when the oxygen supply is depleted and for the increase of oxygen in the blood
when breathing accelerates. Our explanation would then resemble the sort we
could give of the course of a homing torpedo. Like the latter, the relation of
the blood's oxygen level and the intensity of muscular activity would exhibit
'negative feedback', the one system, by causal process, keeping the other 'in-
formed', this causing it in turn to react back upon the first in a way that main-
tains it in a certain state.

 Von Wright prefers to call phenomena open to such explanation 'purpose-
ful' rather than 'purposive'—a way of talking which applies rather more hap-
pily to artificial systems than to natural ones. What his account may not suffi-

ciently acknowledge is the need, if intelligible answers of the quasi-teleological sort are to be offered, for something to be taken by the investigator himself as a norm or goal, or at least a state of affairs in the maintenance of which he has some special interest. Von Wright's own concern is chiefly to show why reductionists are mistaken in trying to assimilate teleological explanation of actions to explanation of the quasi-teleological sort. One of these reasons is the absence of anything that can properly be called 'intention' in the quasi-teleological case—another way of saying that the system to be taken as norm is not determined for the investigator by the subject matter itself. It is never really explained, however, why intentions couldn't be attributed to unconscious organic processes, this omission being rendered the more critical by a denial that human agents can verify their own intentions directly in private experience. The other reason is, of course, the presence of a nomic tie in the quasi-teleological case, and its alleged absence in the explanation of human actions as purposive.

Typical historical explanations, according to von Wright, are neither quasi-teleological nor causal in either of the senses which have been explicated. But they are not straightforwardly teleological either, and they often employ causal language. Thus the outbreak of war in 1914 is often, if not very profoundly, said to have been caused by the assassination of the Austrian archduke. Von Wright calls this *quasi-causal* explanation, since although an alleged cause of the outbreak is cited, the connection between the two events is not likely to be conceived as nomic. Historians know no law connecting assassinations of archdukes with outbreaks of world wars: the explanatory connection must be established in quite another way. The historian points out how the assassination gave the Austrians an excuse to send an ultimatum to Serbia, which in turn drove the Russians to mobilize in support of southern Slavdom, which in turn fortified the Serbs in their resistance to Austrian threats, which in turn induced the Austrians finally to march. Each link in this connecting chain shows that what was antecedently done by various agents either afforded fresh conceptions of how existing intentions of their opponents could be realized or modified those intentions by changing the situation in which decisions had to be made. Each explanatory link consists, ideally, of showing that what the relevant agents did was entailed by their intentions and their beliefs about what needed to be done to realize them. The large quasi-causal connection is thus established neither by appeal to overall covering laws nor by reference to a series of intervening events, each a nomically guaranteed consequence of its predecessor. It is established rather by linking relevant actions by 'motivational mechanisms'.

Historical explanations are often quasi-causal, von Wright avers, in the even stronger sense of containing ordinary causal explanations as connecting links. Thus if the problem is to explain the economic decline of a certain region, and the historian cites as cause the rivalry between two cities, a part of

his explanation may consist of references to the military assault by one city on the other resulting in its destruction. And the assault may well be called the cause of the destruction. According to von Wright, the relation between assault and destruction is not itself a nomic one. But *part* of what it involves, even if this is not always explicitly recognized, is a causal connection of the ordinary sort between the physical form actually taken by the assault (which von Wright refers to technically as its 'result') and the collapse of buildings, bridges, etc., (which he calls the 'effect' of that result). In shifting attention from the sheer physical events to what it was that the operative agents were doing, the historian is said to move from considering nomic causes to considering quasi-causes. For it is not *qua* action, but only *qua* event, von Wright maintains, that the assault constituted a nomic cause. The distinction is more important than it may at first seem. For, no physical events entail the performance of any action; neither does any action entail the occurrence of any particular events.

The role of causal explanation proper, then, is a subordinate one in historical explanation. It is to provide links between what the historian is really interested in—military operations or economic developments, for example—which are not themselves nomically related. Von Wright envisages causal explanations of the 'how-possible' as well as the 'why-necessary' type providing such links. He speculates, plausibly, that in 'why-necessary' cases, the causal part of an historical explanation will often be rather trivial, the connections asserted being obvious and uncontroversial. Even the intentions of the agents may be rather obvious in such cases, he adds, since actions are often performed for 'universal motives' which can be taken for granted, the interest of the explanation then centering on the agents' changing conceptions of what was required to realize their goals in changing circumstances (p. 144). By contrast, in the case of 'how-possible' links, it will more often be the causal part that is of special interest and poses the greater challenge to the researcher. Even so, this will remain subordinate to the historian's overall teleological interest in his subject matter.

Von Wright's account of historical explanation as, in general, quasi-causal is illuminating as far as it goes, but it leaves a number of problems to be considered. One is how to relate its apparent methodological individualism to what is also said about the need to treat large-scale social phenomena as a species of "collective action" (p. 134). Von Wright's original explication of causal and teleological explanation was given with reference to natural processes and individual human actions respectively; and his treatment of the First World War example suggests that quasi-causal explanation is thought to be dependent upon the historian's being able to reduce social conditions and events to the actions of individuals—at any rate, to those of homogeneous if anonymous groups of them ('the Austrians', 'the Russians') which can be said to express a common intention in a distributive sense. Yet, at times, von

Wright seems to see historians as dealing with 'collective actions' in some more holistic sense.

He is moved in this direction by difficulties encountered in trying to stretch what he said about understanding and explaining individual actions to fit demonstrations, folk festivals, economic declines, civil wars, and the like. Interpreting the activities of a number of individuals 'as a demonstration', he wants to hold, constitutes a further, 'higher order' act of intentional understanding—a further step up a ladder of explanation and understanding the lower rungs of which treat mere behaviour and individual action. What allows a certain series of physical causes and effects to be interpreted as a single individual action, he notes, is not the causal connections between the various elements but the single intention that binds them all together as something meant. What more natural, then, if a demonstration is to be regarded as a 'collective action', than to expect it to have a common purpose which would bind together the actions of many individuals—a purpose which could be 'extracted' from the purposes of the participants (p. 133). Unfortunately, as von Wright himself admits, it is far from easy to say just how such 'extraction' is to be accomplished. The difficulty is even greater, as he notes, if we turn to something like a folk festival, which can be at least partly constituted by actions of individuals who have no common intention, not even that of participating in a folk festival (at any rate, not under that description).

Part of the problem here facing von Wright may arise less from peculiarities of the concept of 'collective action' than from the narrowness of the concept of *individual* action with which he appears to be working. In his basic analysis of human action, he distinguishes between what we do and what we bring about. In an example already cited, a person is envisaged as opening a window and by that means bringing about the ventilation of a room. This consequence, as we saw, may be incorporated into a redescription of what was done. But the impression given by von Wright's discussion of such examples is that only *intended* consequences can be thus incorporated; at one point, indeed, the incorporation of unintended consequences is explicitly repudiated on what appear to be moral grounds (p. 90). Yet the logic of the ordinary concept of action is in fact more permissive than this. If a consequence of my ventilating the room was that certain rare birds caged in it die of cold, I can, under certain circumstances, be said to have killed the birds. Thus if a folk festival can be at least partly constituted by actions of individuals who had no intention of holding one, that is not in itself a reason for refusing to call it their 'collective action'.

A second strange restriction which von Wright apparently places upon the concept of action at both individual and social levels derives from his envisaging only the incorporation of *nomically* related consequences of an action as originally described (or of its 'result'). In fact (and this is important for historical cases), the actions of other people, connected to the original action by

motivational rather than causal mechanisms, can also often be incorporated into its redescription. Take, for example, a ruler's act of levying war. As von Wright points out, there is a logical or conceptual connection between any action and its 'result' such that, if the latter does not materialize, the action has not been performed. In the case of levying war, however, what is in this way logically required is to a large extent the motivationally related actions of those who accept the ruler's authority. The incorporation of nomically unconnected elements into a 'social whole', like the incorporation of unintended consequences, is thus not in itself a good reason for denying it the name of 'collective action'.

Von Wright's failure to work out very clearly the extent and nature of his methodological individualism raises problems for another of his major claims: that whereas quasi-causal explanation, teleological explanation, and even ordinary causal explanation have a place in historiography, quasi-teleological explanation does not. Von Wright concedes that something *analogous* to the latter may sometimes appear in the work of historians; but the analogy, he contends, will be found to dissolve upon examination. The following example is offered of the way an historian's 'in order to' might bear a superficial resemblance to that of a quasi-teleological biologist. Under Casimir the Great, Poland experienced an economic boom which was made possible largely because of the reception of Jews expelled from Germany. Here, just as the biologist might say that breathing *has to* accelerate *in order for* the blood's oxygen level to be maintained, so, von Wright observes, the historian might tell us that "the Jews *had to* leave Germany *in order for* Poland to flourish" (p. 154). This, he adds, exemplifies a well-known feature of historical studies, namely that earlier achievements continually take on 'a new significance' in the light of later ones: "They acquire as it were a purpose, unknown to those who were responsible for the achievements," this leading to talk of it being the 'destiny' of some men to 'pave the way' for a future they never contemplated.

Von Wright is doubtless correct to deny that such historical hindsight is quasi-teleological. What is surprising is to find him basing this denial entirely on the claim that the relationships asserted depend on motivational rather than on nomic mechanisms. Even after the Jews arrived, we are reminded, it was still up to the Poles whether there would be an economic boom. The Polish example, however, is surely an unplausible candidate for quasi-teleological status for other, and more obvious reasons. For one thing, while the replenishing of the blood's oxygen supply is easily seen as an *explanation* of accelerated breathing, there is no temptation to interpret the stimulation of the Polish economy as an explanation of the Jewish migration. It would be odd indeed to find an historian saying that this was its 'function', and odder still its 'purpose'. The only resemblance between the historical and biological cases is in fact their both asserting a certain condition to be necessary (in some sense) for an envis-

aged result. In the biological case, however, it is the necessary condition itself which is said to be explained, while in the historical case it is what it is necessary for. Like von Wright's example of a building technique explaining an architectural achievement, the availability of Jewish skills may provide materials for a 'how-possible' explanation of Polish economic recovery. But the historian's 'in order to'—if indeed he occasionally talks the way von Wright represents him as doing—will assert no more than this necessary condition relationship; and any retrospectively assigned significance will simply be that of having in fact been what was needed.

Thus, when von Wright tells us that what is distinctive about the historical case is that the Jewish migration, since the mechanism of recovery is motivational, is not a causally necessary condition for it, he goes both too far and not far enough. He does not go far enough because the biological and historical cases would not be alike even if an historical condition *were* taken to be causally necessary. Mere necessary conditionship does not afford functional or purposive explanation. And he goes too far in denying that Jewish skills would be seen by the historian as causally necessary for Polish recovery at that time (it is obscure why building and financial skills should be treated so differently). Von Wright is on stronger ground when he denies that apparently quasi-teleological explanations in history attribute 'negative feedback' to social processes, since here the question is whether causally sufficient conditions are cited. He constructs a case where the actions of a power group can be said to 'steer' a society in a certain direction by building up 'normative pressures' for people to act in desired ways, these policies having to be continually revised in the light of the reactions of opposition groups, old goals thus having to be aimed at in a succession of new ways. As von Wright observes, the analogy to 'negative feedback' in such a case is 'striking'; but the connections between the actions of the various groups will, at most, be quasi-causal (p. 158).

Yet the question whether there is a place for quasi-teleological explanation in historiography can scarcely be answered by von Wright with any finality until some of the problems surrounding his notion of 'collective action' have been resolved. The problem, as he puts it himself, is whether 'individual men and groups exhibit behavior which fulfills a purpose without being intended to do so'' (p. 153). His own answer tends to be affirmative, and many would agree if he said 'fulfills a function'. But if it is legitimate, in consequence for an historian, through a 'higher order' act of understanding, to 'bind together' the actions of many individuals into a social unity of a functional sort, the nearest von Wright comes to characterizing this seems to be quasi-teleological explanation. It would have been helpful here if, instead of discussing unplausible examples like the Jewish contribution to Polish prosperity, he had considered cases in which it is at least tempting to explain in terms of function. It is tempting, surely, only where one can speak of a 'system' which is more than

'collective action' for a common purpose; thus von Wright's example of rulers and 'feedbackers' is not quite the right sort either. What needs consideration is something more like the function of the monarchy in Victorian England or of the university in mediaeval Europe—to take two examples at random which are likely to involve more than what participating individuals intended.

Von Wright's general objection to quasi-teleological explanation in history seems in any case to require further explication. He points out that, whereas quasi-teleological explanation asserts connections of a nomic sort, individual actions which constitute social wholes are themselves explicable non-nomically. But exactly why this should count as an objection is puzzling in view of von Wright's 'compatibilist' view of the relationship between *individual* actions and the physical events which he calls their 'results'. He argues that, although action is event expressing intention, this doesn't mean that we must give the same sort of explanation of the action and of the event *qua* event. Why then, if 'collective actions' are individual actions interpreted as socially contributory (and are indeed 'actions' only in some extended sense of the word), shouldn't they be explicable in a different way from the individual actions in themselves?

Von Wright's position with regard to historical determinism is of interest in its own right. He offers a number of reasons for repudiating this doctrine, or for not standing committed to it. One very general reason arises out of his account of the concept of causation. As was mentioned earlier, he holds the applicability of this concept to presuppose a human power of intervention in the course of events. Any good reason we can have for asserting causal relations in the world is thus an equally good reason for denying that such relations hold universally (p. 81). It follows that to see causality as a threat to freedom is a deep metaphysical illusion. The strength of this argument, however, is difficult to assess. For even if von Wright's compatibilism is correct, the argument seems to leave open the possibility that the sense of freedom which must be admitted by actionist theorists of causality is not a contra-causal kind. Why should it be thought to follow from there being no sufficient condition for a certain happening without my intervention, that my intervention itself lacks causes?

Two other very general arguments offered are more rebuttals of arguments *for* determinism than themselves arguments in its favour. One is that universal physical determinism, even if it meant that all those bodily movements which express our intentions have sufficient conditions in antecedent physical events, still would not entail that actions as such were determined. For no relation of entailment holds in either direction between statements about events and statements about actions, so that no claim to know the antecedent nomic conditions of a bodily movement would be equivalent to knowing the causes of an action. This doctrine shares the difficulties of other compatibilist arguments. Von Wright's rebuttal of the claim that successful prediction at the social level sup-

ports determinism also seems questionable. Such prediction, as he points out, is based on statistical laws; and such laws do not state nomic conditions. In fact, statistical social laws are just the logical consequences of the way people choose to act. This argument seems little more than a reminder of the empirical corrigibility of statements of natural laws. And its force becomes quite obscure if von Wright concedes, as he seems to, that causal laws are corrigible in the same way.

The more interesting arguments against historical determinism relate more directly to what he has to say about teleological or quasi-teleological explanation. First of all, having observed that if all actions could be teleologically explained, a kind of teleological determinism would reign, he denies flatly that they can all be so explained. And he does not say this merely because some actions are habitual, mechanical, or even reflex. It is rather that people sometimes change their minds. They give up intentions and formulate new ones; or, faced by the possibility of realizing their intentions in more than one way, they simply choose one of these arbitrarily. Von Wright states this as a matter of fact—a conclusion presumably based on empirical study of behaviour. But the same conclusion might perhaps have been given a more theoretical standing. Every teleological explanation of action involves relating it under one description to some intention of the agent which is not itself explained under that description. It seems at least plausible to claim that such a chain of explanatory intentions must come to an end, leaving the action inexplicable under one final, but correct description. This consideration would not of course rebut determinism in general—only teleological determinism. But, although it seems to leave open the possibility that non-teleological explanation might continue where teleological explanation left off, von Wright himself, as we saw, denies that actions can be explained non-teleologically.

In fact, what he wants primarily to deny is that teleological explanation asserts a deterministic connection in cases where it can be given. One would have thought it enough for this purpose to point out that such explanation asserts a conceptual connection, not a causal one. Von Wright, however, goes on to say that teleological explanation does imply a kind of determinism: a determinism of *intelligibility* by contrast with the determinism of *predictability* that would follow from universal causal explanation (p. 161). A causal determinism, he maintains, is a *pre*-determinism; a determinism of intelligibility is only a determinism *ex post facto*. A failure to notice this difference, it is alleged, lies at the root of much confusion in the social studies. The distinction itself, however, could easily be misunderstood. Von Wright is not denying the predictability of human actions because of their determining factors being unknowable before the event. Nor is he implying that, after the event, we shall be able to see that they were pre-determined after all. Nor does he mean simply that, once something has happened, it is determined in the sense that it cannot

be changed (in fact, he accepts the possibility of some retroactive causation). The distinction seems to mean little more than the contrast between the availability of nomic and of teleological explanation.

The more important, and at the same time more puzzling way in which von Wright apparently limits historical determinism arises out of a concession he seems eventually to make about the logical structure of teleological explanation itself. He had begun by considering the view that a practical inference entails action in accordance with it, the action following 'of necessity' from the agent's intentions and beliefs, and he had referred to well-formed teleological explanation as logically conclusive when appropriately refined. Yet even with the proposed refinements made, he seems curiously reluctant to say without qualification that if the premisses of a practical inference are true, then the conclusion is true too. Practical inference, unlike the theoretical sort, he says, is not a form of 'demonstration'. The connection asserted is 'practical' (even 'normative'). What this implies becomes clearest at the point where von Wright asks what would follow if a man, said to be resolved to kill a tyrant, failed to act in ways he believed appropriate at the time he considered appropriate (p. 116). He points the gun; but nothing happens. Even then, apparently, we could not say that the falsity of the conclusion of the envisaged practical inference entails the falsity of at least one of the premisses. The man *may* be paralyzed, or he *may* have been insincere with regard to his announced intentions; but this *need* not be the case. Thus the practical inference turns out not to be logically conclusive after all: to say otherwise, von Wright adds, would be 'dogmatic'.

This certainly looks like a retreat from much of what was said elsewhere about practical inference as a logical model for human studies analogous to the covering law model in natural science. There were early warnings perhaps in some of the remarks already noted. But it was natural to interpret at least some of these as just ways of recognizing that practical inferences, unlike theoretical inferences, have first- as well as third-person employments. When they are formulated in the first person, the conclusion is, of course, asserted as what ought to be done, not as what will occur. But formulated in the third person, and supplemented with additional premisses about the agent not changing his mind, not having been prevented, not forgetting, and so on, it is not easy to see how the denial of the conclusion could be logically compatible with the premisses. When the inference is phrased in terms of wants, desires, or wishes, this may be possible; but scarcely so when phrased in terms of intentions. This seemed, indeed, to be von Wright's reason for preferring to work with the latter form of the inference.

Von Wright's discussion of the degree to which practical inference is conclusive is made the more difficult to appraise by a peculiarity of his treatment of various proposals for refinement. Originally, the inference took the inconclusive form of a first premiss stating that an agent intended to bring about a

certain result, a second stating that he regarded a certain action as necessary for this, and a conclusion stating that he performed the action. What is puzzling is that the refinements considered necessary to remove the inconclusiveness from this simple form of argument are incorporated sometimes into the premisses and sometimes into the conclusion. Thus the requirement that the agent not change his intentions before the time arrives for acting is assigned to the premisses whereas the requirement that he not forget the time is assigned to the conclusion. Since the question is what can constitute a complete *explanans* for a certain sort of *explanandum*—the latter being a datum derived from the practice of historians, not selected arbitrarily by the philosopher—any alteration of the conclusion really makes the refined model of explanation irrelevant. The conclusion of the practical inference from which von Wright's whole discussion begins is, in any case, irrelevant to most historical explanation. For it states only that the agent 'sets himself' to do a certain thing, not that he actually does it.

Any proper analysis of a teleological explanation of *action* must be applicable to an *explanandum* which asserts that the action was performed. If this is so, it has to be conceded that a practical inference of the sort an agent might actually recite to himself is not enough for a 'complete' teleological explanation. Additional premisses asserting the agent's not being prevented, his not forgetting, and his not changing his mind are required. But none of these will turn the explanation into an assertion of nomic connection; thus von Wright's main thesis is not endangered by their incorporation. With regard to his position on determinism, the most interesting of the additional premisses is that the agent must be assumed not to change his mind. Von Wright is aware that teleological explanations, as actually offered, usually refer to intentions antecedently formed. To rule out the possibility of a change of intention, the premisses are therefore required to state that the agent has the relevant intention *from the time of its formation on*. This is as good as admitting that an antecedently formed intention is not sufficient for explanation—where logical conclusiveness is what is sought. The same sort of reasoning might well lead to the conclusion that an intention's being antecedently formed is explanatorily redundant: all that is needed for conclusive explanation is a relevant intention at the time of acting.

The fact that intentions need not be antecedent to action to be explanatory in the teleological way, and are in a sense redundant to explanation when they are antecedent, raises a further question about von Wright's account of historical understanding. That is whether historians' attempts to make their subject matter intelligible contain no more than teleological explanation of actions as he explicates it, and the assertion of nomic causal connections between their 'results' as displayed in his model of quasi-causal explanation. On the face of it at least, von Wright seems to attribute to historians many causal expressions

which do not obviously reduce without remainder to either of these elements. He speaks of events 'reshaping' or 'maturing' intentions, 'releasing' practical inferences which were only implicit before, 'creating' new situations which 'force' agents into reappraising them. He admits that social rules may exert 'normative pressure', allowing explanations of actions in which genuine teleological mechanisms have long since become remote. He insists that he has no wish to deny that desires, wants, and motives can have a causal influence on behaviour, and says indeed that they 'force' or 'prompt' agents to act. He even concedes explicitly that the aims of historical agents are often products of cultural, political, religious, and economic traditions, it being a worthy object of historical explanation to try to get at such origins.

How exactly does he envisage intentions and beliefs being changed through historical process? He allows, of course, that intentions can change gratuitously. They can also, presumably, change because the agent forms other intentions which, together with his beliefs, logically entail such a change. Changes of belief can also change intentions. A peculiar case noted by von Wright, which appears more logical than causal, is one in which an agent comes to believe it impossible to achieve an aim he had previously adopted, his intention thus having to be 'given up'. Does von Wright allow that adopting or abandoning intentions can have causes, where this means something different from having teleological explanations? Some of the locutions cited above suggest that he does; yet he denies that an action can have nomically sufficient conditions. One simply does not know how to interpret such claims as that, with the advent of new resources in mediaeval Poland, implied wishes "matured" into "well-formed intentions" (p. 155).

What then of changes of belief? Although von Wright does not mention it, something very like teleological explanation is often given for beliefs being adopted or rejected. In the case of beliefs, however, it is surely unplausible to say that nomic explanations must be completely ruled out. Von Wright gives examples of historical agents being forced by their changing circumstances to change their beliefs. Such agents, among other things, perceived or misperceived their situations. This, at least, is a matter neither for teleological explanation nor for the only kind of nomic explanation von Wright discusses, namely that involving physical causation (in his paradigm of quasi-causal explanation in history, only the part concerning collapsing bridges, etc., is allowed to be nomic). But this suggests a serious gap in von Wright's whole account of historical process—one which makes it difficult to see how the historian could ever claim to have fully explained a substantial change through time. In discussing the migration of the Jews to Poland, for example, von Wright asserts that although the Polish economy would not have flourished as it did if the Jews had not been persecuted, there are no *nomic* connections between these two historical conditions. Yet it is difficult to see how their

connection could be represented as a matter of teleological mechanism and physical causation alone. There seems to be a missing sense of 'cause' in von Wright's account.

This suggests a final reflection about historical determinism. Von Wright has left it questionable whether teleological explanation is logically tight; but let us say that it is. He has also expressed doubts as to whether all actions are teleologically explicable (at any rate, under all their correct descriptions); but let us say that they are. The assertion of universal teleological explanation would not itself be an assertion of a predictive determinism for reasons given, e.g., its being a logical relation between simultaneous conditions. But when the missing sense of cause is filled in, would we not, after all, get such a determinism? Let us say that intentions and beliefs have nomically sufficient conditions. Then the fact that their connection with action is only logical does not mean that the actions themselves are not determined. Indeed, we would seem to have a tight connection between situations, intentions and beliefs, and actions. The fact that the second link in this explanatory chain is different in kind from the first would not greatly comfort the anti-determinist. If von Wright is to deny historical determinism, he seems therefore very much to need his 'dogmatic' claims that intentions cannot be nomically caused, and need not be teleologically explicable.

FACULTY OF PHILOSOPHY W. H. DRAY
UNIVERSITY OF OTTAWA, CANADA
MAY 1974; ABRIDGED JUNE 1982

NOTES

1. *Explanation and Understanding* (London, 1971), p. 70. Further references to this work are in parentheses in the text.
2. R. G. Collingwood, *An Essay on Metaphysics* (Oxford, 1940), Part IIIc.

21

Knut Erik Tranøy

VON WRIGHT'S HUMANISM: HIS CRITIQUE OF CULTURE AND HIS PHILOSOPHY OF LIFE

INTRODUCTION

The title under which I have agreed to contribute may puzzle or cause negative reactions in some of the readers of this volume. On my view, however, it is clearly appropriate, precisely in this volume, that an essay should be attempted on topics which are as well, or as inadequately, signalled by this as by an alternative title.

I share von Wright's interest in these problems, and I am familiar with the Swedish language—necessary but far from sufficient qualifications for taking on the assignment. Von Wright has a most unusual familiarity with western culture and its history, not only its logic and philosophy, which is bound to make his commentator feel inferior, and (worse in this case) may cause him to draw an unavoidably fragmentary picture. The sources to which I cannot expect my readers to turn, are too rich for me to attempt a summary.

Most of von Wright's writings falling under the heads of humanism, critique of culture, and philosophy of life are available in Swedish only. Many readers will therefore be denied access to them. Some know him personally, but not many enough to make redundant the presentation of a writer and thinker whom some of his readers suppose to be non-existent. My own experience tells me that he has readers even in Scandinavia who ignore this part of his authorship.

Whoever does so, and for whatever reason, will be left with an incomplete picture. They may even be deprived of important clues to the understanding of other aspects of his philosophy with which they are familiar.

I shall, therefore, try to convey some idea of the development of von Wright's humanism as well as trace some of the connections, not always ap-

parent and rarely articulated by the author himself, with his philosophy as it appears in his other works.

Von Wright's Swedish and Finnish language writings are quite extensive. In part they overlap with his work in English. These I shall not consider here, nor what would be covered by the term 'popularization'. There are three or four titles which I want to single out for special mention.

Thought and Prophecy is a 300 page collection consisting of four major essays: one on Werner Jaeger's *Paideia* (subtitle, *The Ideals of Greek Culture*), the second on Dostoevsky, the third on Spengler and Toynbee, and finally a 100 page essay on Tolstoy as a thinker.[1] Three of the essays were originally printed during the years 1947–51 in the Helsinki monthly *Nya Argus*.

'Kunnskapens träd' ("The Tree of Knowledge")[2] is a 30 page essay whose general topic is well indicated by the title: the relation between human knowledge and the condition of man, his happiness and his misfortunes. The theme is provided by three myths—the one from Genesis, the myth of Prometheus, and the legend of Doctor Faustus. Finally there is his 'Essay on Nature, Man, and the Scientific Revolution',[3] a 25 page essay from 1962. One of its main topics is a comparison of Greek and modern views of our attitudes to and our knowledge of nature.

There are many more, as will appear both from the bibliography and from references below. The writings now listed are, in my opinion, von Wright's major works in the area defined by the title of my paper, until the year 1962. *My* purpose, so far, has been to establish the fact that von Wright's interest in the problems of humanism is as old as his own philosophical maturity.

To Werner Jaeger's *Paideia* the term 'humanistic' is applicable in two senses. It is a major piece of humanistic scholarship. And its main topic is "humanism, the cultivation and education of man in accordance with a universally valid ideal of human life".[4]

The period after 1962 actualizes the double question of (a) the relationship between the two senses of humanism, and (b) the interconnections between two phases or aspects of von Wright's philosophy, the 'scientific' and the 'humanistic'. It is worth recalling that three of von Wright's major English language works belong to this period: *The Varieties of Goodness, Norm and Action* (both 1963), and *Explanation and Understanding* (1972).[5]

Most Scandinavian philosophers address two distinct audiences. One is professional and international. The other is the general educated public of his native country, the ubiquitous intelligent layman in local dress. Most of them, consequently, have an alter ego speaking in the vernacular to their own people on subjects not so freely or informally treated when they address their colleagues, at home or abroad. I am not suggesting that the double audience situation is restricted to Scandinavian philosophers. Bertrand Russell's alter ego became familiar to all his English-speaking readers, and it is —therefore—

perhaps not even appropriate to make the distinction. I see little reason to hold, however, that the distinction is more appropriate in the case of a philosopher whose native language is shared by few. Rather on the contrary. But contingent circumstances may force the distinction on the majority of his readers: his international colleagues who do not know his vernacular—and those of his native readers who, for whatever reason, cannot read his technical works.

Such alter egos are not necessarily improper egos. It may be intriguing and fruitful, nevertheless, to raise questions concerning the nature and scope of the interconnections between them. At first glance the two egos may appear rather different in the case at hand.

Von Wright's earlier writings in English certainly do not reveal, and even his later major works do not *obviously* reveal a thinker who is at home with Aeschylus no less than with Aristotle, who knows Milton and Toynbee as well as Berkeley and Russell, who has taken Goethe and Spengler as seriously as he has Kant and Wittgenstein, who has studied Tolstoy, Dostoevsky , and the Bible as attentively as he has Descartes and modern logic. This catalogue leaves unmentioned the authors of this native Finnish and Scandinavian culture. But the point in compiling it is simple. If in reply to the question, 'Who is G. H. von Wright?' we were to answer: 'The founder of modern deontic logic', or 'A logician of positivist descent who turned around and wrote *Explanation and Understanding'*—an answer I have heard recently from young philosophers in Scandinavia—we have said less than needs to be said.

So let me return briefly to the interconnections between the two egos, the bridges or the barriers between, on the one hand, the deontic logician, Gifford lecturer, and author of *Explanation and Understanding,* and, on the other, the humanistic scholar who writes, and writes well, about Milton, Goethe, and Tolstoy. As my work has proceeded, *this* problem has come to emerge as one of the main general problems concealed in the task I have undertaken. I may not even be able to arrive at satisfactory formulations of a problem which I have so far tried to identify by way of metaphor. There can be no question of solving it. For it is obvious, I now suppose, that the problems thus raised do not only concern one man and his personal history. They go to the heart of the problem of humanism, its place and functions in our type of culture.

2. THE VALUES OF AN EMPIRICIST

The connection between humanism and values is intimate. A trivial commonplace? Not, certainly, in an historical perspective. One of the merits of Max Weber is to have made it clear to us that all culture concepts are value-laden. The concept of humanism is an important one in our culture.

Philosophers of the same general breeding and background as von Wright

have been sceptical as to the meaningfulness and philosophical relevance and tractability of values and value concepts. Von Wright never quite shared the typical logical positivist view of ethics as a philosophical discipline. In 1943 he published an exposition and examination of logical positivism, *Den logiska empirismen* (abbreviated *LE*)[6] which contains his version of the meta-ethical doctrines of logical empiricism. It is a version so personal and singular that I find it appropriate to summarize it.

Values are understood 'as expressing emotional reactions' but, none the less, compatible with objectivistic theories of the kind proposed by Max Scheler whose theory is ''in no way in conflict with a view constituting values on the basis of emotional reactions, just as the positivist constitution of colors, shapes, and other sensible properties fails to deprive these of their objectivity.'' (*LE*, p. 114, note.) When logical empiricists talk about 'the relativity and sub- jectivity of values', this should not be taken to mean that a 'factual universal validity as regards ethical and esthetic valuations is excluded' (*LE*, p. 115.). It is clear 'that a close empirical scrutiny of those emotional reactions which are called forth by things subject to moral or esthetic judgment, will show these reactions to stand within certain limits in lawlike, i.e., invariant relations to their external objects'. Proof of this he finds in the fact that

> an activity such as art criticism is of any practical importance at all. Just as the eye of the mathematically disciplined natural scientist can discern simple regularities where the ordinary person finds nothing but a confusing welter of phenomena, so also the competent judge of the arts knows how to distinguish between the masterly and the worthless where the untrained eye is easily the victim of deception. (*LE*, p. 115 f.)

And he concludes:

> Consequently, that universal validity which according to the empiricist theory we can ascribe to value judgments, is not something *we* prescribe *vis-á-vis* reality, but on the contrary something the real world forces upon us. Thus the same is true of the emotive theory of value concepts as is true of so many other stigmatized philo- sophical doctrines: their deepest concern is precisely the opposite of what its pur- blind critics want to ascribe to them. (LE, p. 116)

This is not the place or the time for a critical discussion of these views, although one may safely say that they are hardly representative of the ethical doctrines of most logical positivists in the 1930s and 1940s. Besides, my sum- mary omits details from an argument which even in the original pretends to be no more than a sketch. There is hardly reason to believe that von Wright would hold precisely these views today. What I find remarkable is that in 1943 he held such views to be defensible on premises drawn from the general armory of logical positivism. And it shows conclusively that even then he was seri- ously concerned about the philosophical status of the arts and art criticism as well as about theoretical attempts to penetrate beneath the surface of individual artistic and moral experience. The influence of his great countryman Edward

Westermarck is perhaps discernible in von Wright's interpretation of positivist ethical doctrines.[7]

The general objectivist attitude to values and to value theory displayed in *LE* is, indeed, compatible with the interests and attitudes manifested in *T&F*. The latter work presupposes a philosophical position, which, to say the least, regards as meaningful the ascription of validity to values (value judgements). This would have to be true of any such humanistic study and its author. (It seems to me immaterial whether or not this validity is conceived of as dependent of truth and falsehood.)

To reiterate: I'm not merely making a biographical point about von Wright; we are, in fact, here confronting one of the major philosophical problems contained in my assignment. Let me try to reformulate it.

Is it at all possible to reconcile: (A) views, attitudes, and valuations (of von Wright's kind) toward the Greek tragedies, Tolstoy, and Goethe—in short, to the problems of humanism with: (B) a general, 'nihilistic' theory whereby values and value statements are subjective and relative in the unmitigated senses of these words? In the case of (B) I take it that no notion of validity (let alone universal validity) worth the name could be articulated, be it of the cross-cultural variety, or of some species of necessity. For I also take it that in the case of (B), any agreement on values is simply contingent in the radical Ockhamian sense, meaning that it might just as well have been disagreement, or agreement about other values instead.

I confess that I find it impossible to achieve this reconciliation. Now, logical positivists have (always?) insisted that their 'meta-ethical' doctrines have no normative ethical implications. (So also von Wright in 1943. See *LE,* p. 115.) It is now clear and generally accepted, I assume, that this position is no longer tenable. Meta-ethical positions are not without normative implications. There is, in other words, a normative logical aspect to the reconciliation I have referred to.

I do not know what von Wright would have to say to this problem today. He would agree, I think, that the problem is both difficult and important. Not all philosophers would agree even to this modest extent. There are those who find the reconciliation easy, who have no theoretical problems in this connection. How? By some 'existential' recipe of co-existence which they need not, and perhaps cannot even articulate. Of course, no animal has at the same time such horror of logical contradiction *and* such remarkable psychological tolerance of it as has the rational animal.[8] And this is perfectly fair and unobjectionable. The course of a life is not the course of a logical proof.

In a sense, this is to suggest a slightly different type of answer: it depends on what you really mean by 'reconciliation'. You could mean one of two things. A *logical* reconciliation would involve us in some kind of reductionist problem, at least methodologically,[9] although such reduction need be no more than partial. What seems inconceivable is a state of affairs in which the worlds

of fact and value were completely disconnected. An *existential* reconciliation could be (among other things) a more individual solution, which need not pretend to be valid for others. I am simply doing what comes naturally, to *me,* when at t_1, I do proof theory, and when at t_2, I write about the humanism of the Greek tragedies, and the question of how these two activities are related just does not arise. The generalized import of this approach points toward a *justification* of humanistic studies by reference to what human needs they satisfy and frustrate—which, in itself, may be all right. But is it enough?

It seems to me that these two views of the reconciliation do not exclude each other. We can have both. Perhaps we must have both. It remains legitimate, then, to raise the question of the relationship between the two views. Is it always a contingent matter how they are related (some persons need more logical coherence than others), or is there an element of necessity even here (all men need at least *some* logical coherence in such matters)? This issue— here brought to light by a theoretical consideration of the presuppositions of humanism—also concerns the nature of *rationality,* the use of reason, in human life. More specifically, the issue concerns the functions of rationality in "the cultivation and education of man", a process which must always presuppose more or less generally accepted ideals of human life and sometimes ideals seen as being "a universally valid ideal of human life". The Sophists and Socrates were at one in recognizing the problem; they disagreed on the answer.[10]

Indeed, there are some who practice and plead a plain, unreflective co-existence between a primitive, emotive theory of ethics and belief in (or: acceptance of?) humanistic values, and again in both senses of 'humanistic'. I do not think their enjoyment of such values need be affected. But sooner or later they have to face, in theory or in real life, a thorny question. What defence can *they* propose for the values by which they live, what defence except chance, power, or the police? They can hardly defend them by rational argument. (We may disagree on what rational argument is, too, but within limits.) And it is always something that claims some kind of validity. Not that justification by argument can or should replace the support of political and other power; but nothing save argument can legitimate or justify certain uses of such power, and condemn certain others. To a humanist this can hardly fail to be of importance.

I am not blind to the possibility that those who think otherwise may be 'proven' right by the way the world goes if not by logic. I feel sure that von Wright would hope to be able to deliver a rational defence, a justification by the use of argument. But note: what we see here is politics rearing its head, and it is, as usual, Janus-faced. 'Of course', we may feel inclined to add today. But at the time of *T&F,* in the forties and fifties, von Wright was still, comparatively speaking, politically 'innocent', which he is not now.

As I read *Varieties of Goodness* and *Norm and Action,* there is nothing in these works which (clearly) provides answers to questions about the relation-

ship between one's theoretical view of the 'status' of values and one's 'material' or 'substantive' value commitments, between humanism as a branch of academic theorizing and as an action-guiding view of life, individual and social. To many these are now important questions, urgently in need of greater clarity, and I wish von Wright would take it upon himself to attempt an explicit contribution. He has, in fact, made a beginning of which I shall speak later, in section 6.

3. MORALS AND RELIGION

Nowadays the step from ethics to politics is short. It has not always seemed a natural step to take. I recall an episode from Cambridge (around 1950): a fellow student of philosophy insisted, angrily, that Hitler's massacre of six million Jews was a matter for political but not for moral concern, and was thus out of place as an illustration in a lecture on ethics. I am in no way suggesting that von Wright had anything but distaste for such views. It remains my impression, however, that at that time, in the late forties and the early fifties, politics did not 'turn him on'. What always had interested him were certain problems concerning the relationship between morality and (the Christian) religion. Convincing evidence is found in the studies on Dostoevsky and Tolstoy.

I have taken this to mean that he was then (and is now) neither a believer nor a disbeliever; nor yet was his attitude that of the agnostic. But he was no religious 'innocent'. He always found religious and theological problems important (bleak word), and meaningful. One reason may be found in his belief that humanism and religion (Christianity, to be more precise) are not compatible.

In the essay on Werner Jaeger's *Paideia* I find most of my support for this contention. This essay contains in the first place, a definition or a characterization of humanism which is worth noting. (I see no reason to think that von Wright has essentially changed his view since; and I think it was his own view although expressed in a discussion of Jaeger's contribution.) Recall, once more, the initial description of humanism as "the cultivation and education of man in accordance with a universally valid ideal of human life". (*T&F*, p. 13.) He warns, a little later, that exhaustive definitions of humanism are not to be had. With this reservation he goes on to say:

> For what formula comes closer to the essence of humanism than this: man has a 'nature', characteristic of man as man, and it is his inalienable right and profoundest destiny to try in his life to actualize this nature as fully as possible. (*T&F*, p. 28.)

Against this background we must read his statements on the incompatibility of humanism and Christianity.

The Christian believer's way to God is thus in a certain sense a *de-humanization*, an ascent from the reality of the human flesh to the spiritual world of the divine. Socratic man's way to God is, on the contrary, a *humanization*, an actualization of the self or a liberation of the I from "the fetters of worldly concerns". (*T&F*, p. 57, italics original.)

Why not have the best of both worlds, "revere Pascal and Augustine on a par with Plato and Goethe", why not be both Christian and humanist? Because such a conception is, as a rule, no more than superficiality and confusion.

Perhaps there exists a way of life which reconciles Greek humanism and Christian religiousness. But certain it is that no one can have the faintest idea of what this reconciliation is who has not had the painful experience of the gulf that separates Greek from Christian ideals. (*T&F*, p. 58, italics original.)

The ideals of the Greek are at the root of all later European versions of humanism (not least, may I add, when they assume the cloak of the Christian religion as, for instance, in Aquinas). Now, the ideals of the Greek are essentially *moral* rather than religious; they are moral and other non-religious ideals. *Non-Christian*, that is to say, although this is not stated by von Wright in so many words.

The attempt to characterize the difference between morality and religion is, in fact, one of the key themes in von Wright's essay on Tolstoy as a thinker in T&F. Without understanding these distinctions, it will be difficult not to misunderstand von Wright's conception of humanism as a way and view of life.

Religion means surrender and submission. A religious man is humble, a moral man demanding. And closely linked to this: a religious man is 'love-centered', moral man is severe. Grace is a religious concept, judgment a moral one. The religious and the moral attitudes to life can be closely interwoven; perhaps they *must* be if something of value is to result. (*T&F*, p. 312.)

Let us not make the mistake of reading these statements as empirical generalizations about the actual attitudes and behavior of two types of person. No matter by what evidence or argument these conclusions are supported, they are consequential. Von Wright's humanism is not a religious and Christian humanism (like that of Maritain), nor is it an atheist humanism (like that of Sartre—or Raskolnikov's perversion of an atheist humanism). Nor yet is it an agnostic's humanism which rests its case on a cosmic PERHAPS AFTER ALL.[11]

Essential, it seems to me, is the qualification that the aspects of love (grace, mercy) and judgment (justice, reward and punishment) must be integrated and balanced in human life if the outcome is to be of value. (Theologians may prefer to speak of the gospel and the law, but then *within* the Christian framework.) If we state this distinction in terms of *merit* (or desert) and *need,* we are perhaps closer to the language of our own day although no nearer to the truth. Few things are more frightening, and perverse, in the eyes of this type of humanism, than ideologies which set out to reform and rebuild the world

predominantly or even exclusively on one of the two—on 'merit' alone which gives nothing but law and order; or on 'love' alone, and that is to say, unavoidably, on hate also. (The scare quotes are indispensable here.) Such one-sided ideologies can be moral, or religious, or political. We have seen many such, or have had the chance to see them if we have had our eyes open, at least those of us who are old enough to remember the thirties. It is only, as we also know, so enormously difficult to secure a balance of love *and* order, that minimum of each which sane individuals and groups cannot do without.

In my own, and slightly different words: the deep insight which lies behind these arguments, is this. It holds for our wholly human lives in *this* world as it is said to hold for our interaction with the divine that if we were to be given all that we deserve and only what we deserve, we would get less than we need and more than we could bear.

Von Wright's non-religious humanism means, moreover, that moral and other 'secular' values and norms come to figure significantly because autonomously in the axiological basis of his humanism. It is not surprising that this must lead to a serious interest in the logical status of norms and values: look back to *LE;* look ahead to his Gifford lectures.

Ever since I first read *Thought and Prophecy* 20 years ago I have been impressed by the importance and the relevance (I'm expected not to say 'truth', I suppose) of his remarks about the relationship between morality and religion. Their intent or import seems to be to convey a double message: a 'descriptive' one concerning the condition of man, and another and 'normative' one, saying, what this condition necessitates. It makes poor sense to demand (as we used to do) that such remarks, like whatever we say, must be either descriptive or normative, or else meaningless. There was a time when not even the distinction between the latter two was made; the best we can say about that today is that it turned out to be clumsy and inefficient legislation. It is also, I think, a mistake to argue against von Wright that norms cannot logically follow from facts. I am trying to suggest that a certain doubleness of nature is characteristic of and perhaps essential to some of the concepts and insights which humanists have and try to communicate.[12] Why should each use belong to one and only one family of usages?

It is logically possible, of course, that one might instead postulate a doubleness not in the concepts of humanism but in the nature of von Wright. It strikes me as impossible to believe that von Wright should have been in any sense disingenuous when he wrote the essays I discuss in these pages. It is equally clear that he did not intend them as fiction or poetry is intended by their authors. Nor is this the language of theology; that must also be clear by now. It is the voice of *one* integrated self, communicating perfectly meaningful and 'cognitive' messages. What he says is intended to be taken seriously in a straightforward manner; and it is easy to do so although it may be very difficult

to say what it is to do so. A dogmatic theory of meaning which would rule such ways of speaking out of order would necessarily have to be silent about the discourse of humanists (and not only about that). It now appears, however, that both philosophy and linguistics are moving away from the older, one-dimensional conceptions of meaning.

Along such lines of thought, where are we led? Toward conclusions about 'the conditions of humanism', of humanism as a rational (intellectual, cognitive) inquiry, communication, and discourse; of humanism as an expression of human rationality.

Some philosophers and critics have a different reaction to what I tried to characterize by speaking of two kinds of message or meaning. They say such talk is prophetic, and the epithet is not meant to be a purely descriptive one.

Well, perhaps there is a streak of the prophetic in von Wright as a humanist thinker and writer. Perhaps there is such a streak in all humanist authors, and even necessarily so.[13] Some would perhaps be happier and might more readily accept the thesis implicit in my remarks if we were to speak of a language game of prophecy. But a language game, we know, is also a form of life.

The upshot, then, so far is this. Von Wright is saying, not always explicitly, that humanism (in the two closely connected senses) is a form of life which is not only perennial and unavoidable[14]—that is a plain empirical fact—but even indispensable, and that is an admission of a different nature.

4. PROPHECY AND DESTINY

The study and teaching of history hold a central place in humanistic studies. Questions concerning the legitimate functions of historical inquiries are important questions for all the humanities, and thus also, by implication, for the other sciences. What we call the philosophy of history has been approached and studied in many different ways since the time of Augustine. Von Wright has always been concerned with the philosophy of history, and I find I must say something about this without, I hope, trespassing on ground assigned to others.

One of the major essays in *T&F* is 'Spengler and Toynbee', originally published in 1951. I confess that I have been somewhat surprised by the strength of the author's sympathy for these two historians, partly, perhaps, because I did not share it, partly (and later) because I found it difficult to reconcile with his own attitudes to historical explanation as expressed (for instance) in *Explanation and Understanding*. In the latter work there is much emphasis on the closely analysed action of individuals and groups and little room for prophecy and sweeping generalization.

One need not be an old-fashioned positivist to have trouble accepting studies of history of the Spengler-Toynbee variety. Many—as far as my experience goes, most—bona fide professional historians do.

Conceivably von Wright might want to draw a sharp distinction between essays such as that on Spengler and Toynbee, and more 'analytical' writings on the nature of historical explanation. He is, in any case, fully aware of the problem of how to relate and connect (or dissociate) these two apparently different kinds of humanistic enterprise, the 'analytic' and the 'prophetic' ways of writing and understanding history.

In 1951 von Wright noted that enormous growth in our actual historical knowledge which

> makes difficult or perhaps impossible a scientific writing of history in the big temporal format while at the same time it provides the basis for a new kind of universalistic view of history. It is too early to decide whether this kind of view will receive scientific sanction or whether it is doomed to remain a more or less arbitrary product of the imagination. The fact is that in our own time serious efforts have been made at creating a new historical world picture, a task which must appear legitimate and pressing to those who look for orientation and guidance in the cultural and political welter of the modern world. (*T&F*, p. 118.)[15]

I take it that he counted himself among those who were looking for such orientation. The passage just quoted makes it clear, moreover, that even in his philosophy of history von Wright is mindful of a program which he had formulated already in 1943—a 'unity of science' aspiration whereby the humanities were to become integrated into an extended family of sciences.[16]

But this program runs into special difficulties, it seems to me, in his philosophy of history. The pivot of von Wright's philosophy of history as stated in *Explanation and Understanding* is the practical inference model.[17] He uses it to construe an 'intentionalist' understanding of historical events which, together with regular causal explanations, co-operate to give the full understanding and explanation sought in historical studies. In spite of the considerable ingenuity of the theory thus developed I feel that at least one important type of historical event will not be adequately covered. Let me illustrate by an example.

Since Roman times the African desert has spread, as it is still spreading, to ever-new territories as an unintended and undesired effect of (ignorant, careless, greedy, intelligent) human action. It would be awkward not to call this expansion of the Sahara an historical event of the first magnitude. But it seems that von Wright could not do so.

The Sahara example is an instance of that kind of change which has been called 'counter-finalistic' and which was first brought to our attention by Hegel and Marx. One of the classic examples is the theory of the falling rate of profit. I do see the difference between these two types of example: the latter is 'purely social', so to speak, whereas the former involves natural physical causality in a central manner. This is why I want to use both examples as illustrations. They are both, however, counter-finalistic in the same sense, for the distinguishing feature of such events is that, as a consequence of the deliberate ac-

tions of several individual agents to bring about an outcome, *a*, their actions
necessarily produce another outcome, *b*, which entails non-*a* or which makes
a impossible.[18]

It is easy to find other examples, from the past as well as from the present.
There can be little doubt that counter-finalistic events are a crucial and common
type of historical event. They are at the heart of many of those social and
economic changes which have produced the world in which we live, industrial-
ized twentieth-century civilization. Certainly, in the complete explanation of a
counter-finalistic change, whether it affects arable land or an economic market,
the practical inference model has its indispensable place.[19] But, although I see
how the practical inference model will co-operate with a causal model to give
satisfactory understanding of other types of change (e.g., the city destroyed by
intentional and successful enemy action, discussed by von Wright in *E&U*,
p. 136 f.), I fail to see how they can be made to cover counter-finalistic events.
For *their* outcome is precisely not a sum or aggregate of individual actions, as
a battle or even a revolution might be said to be.

I shall not even try to answer the questions which would follow in the wake
of my argument. I am merely tempted to suggest that if the practical inference
model is inadequate in such cases, it is, at least partly, because it operates
basically on the individual actions of individual agents. Counter-finalistic
events are typically the outcome of social, collective behavior, the actions of
many agents.[20] There is something 'lawlike' in the generation of counter-
finalistic outcomes of action, although I shall not attempt to characterize further
the nature of such 'laws'. Again, of course, political problems appear on the
horizon. If we can learn from historical knowledge of this kind, the lesson is,
indeed, what we may call a political one.

My general feeling is, then, that a methodological individualism or partic-
ularism of the kind implicit in the practical inference model is not adequate as
a basis for understanding social events and historical changes of at least one
important kind. I have considerable sympathy for a certain 'reductionist' ten-
dency in the attempt to acquire and organize human knowledge. It is a neces-
sary aspiration insofar as it is connected with a striving for order and system.
But there are limits to the 'unification' that can thus be brought about, and the
distinction or divide between causality and intentionality may mark one such
restriction to which von Wright pays considerable attention—witness *E&U*.
There may be another barrier in the distinction between the individual and the
social: the problem obviously is close to if not identical with the problem of
the relationship between psychology and sociology. One may have reason to
think that there are indispensable social concepts which are not 'reducible' to
non-social, 'individualistic' concepts. Von Wright touches but does not come
properly to grips with this type of problem.[21] In so far as he does, he is inclined
to take a reductionist position. From a 1967 paper I quote: ''Furthermore all

goal-directed group behavior such as class struggle, war, or political, religious, and social movements can be regarded as complex forms of action".[22] This apparently uncompromising position has been toned down in *Explanation and Understanding* but the basic view seems to me essentially the same as in 1967.[23] I doubt that this view can be upheld.

It is difficult to say what should replace it. Spengler's (and Toynbee's) notions of 'cultures' as 'organic' or 'holistic' entities is one type of answer, but one which von Wright rejects. The concept of class has similar functions, methodologically speaking, in the scheme of Marx; von Wright is no more inclined to accept that. A fortiori he rejects concepts like group soul, national mind, class consciousness as 'supra-personal collective forces, fundamentally different from the forces behind the intentional conduct of individual men'.[24] All of this may be granted; it will hardly affect the issues I have raised.

In the essay on Spengler and Toynbee there is a chapter entitled 'Causality and Destiny' with the suggestion "that 'destiny' as a category in the philosophy of history is comparable to that of causality in the philosophy of nature" (*T&F*, p. 182). By 'destiny' von Wright does not mean a predetermined and/or foreseeable outcome of the history of some particular culture or nation. We may note that in *Explanation and Understanding* he rules out the really prophetic writing of history as scientifically illegitimate.[25] To speak of destiny is "a way of looking at the past" (*T&F*, p. 184). Indeed, the same holds for the practical inference model. It can help us understand the past, actions already performed, but not to predict the future.

I would add: to speak about history and destiny is not only to speak about ways of looking at the past; it is also to speak about the functions of historical knowledge and beliefs as moulding our (individual and national) identities as creatures of culture and history. Precisely from a retrospective historical point of view we could also give a sense to the term 'destiny' by connecting it with the notion of counter-finalistic events. I suppose this is precisely what Marxist philosophers of history do.

I see no reason to think that we have arrived at a definitive understanding of the functions of history as a humanistic discipline. It is hardly necessary to argue for the importance of such understanding; it determines the place we give to history in our schools, it conditions the role history assumes in political life.

Predictions based on historical knowledge have been a controversial issue. In any case we should take note of the fact that knowledge of and beliefs about history affect fears, hopes, and plans for the future—which is to say that they have political relevance. (The conduct of the 'new nations' lends strong support to this assertion.) It may also be noted, again, that historical explanation based on the practical inference model does not lend itself to prediction, whereas in principle an adequate understanding of counter-finalistic events, in addition to explaining the past, can also provide a basis for predictions or foresight, a

foresight which can be used to interfere with processes of social and other change for purposes of political (social, economic, agricultural) planning. Neither Spengler nor Toynbee was blind to the political relevance of history. It is understatement to say the same of Karl Marx. It lies at hand that the problem of the political use, and misuse, of history is intimately connected with our interest in and concern with the place and function of human knowledge in our lives as individuals and as members of human societies, topics to be discussed in sections 5 and 6.

5. Zoon Politicon

In the present world, 'critique of culture' can scarcely avoid being a political activity. We did not always see it in this light: we (the generation born around 1920) were raised to think of politics and culture as separate. It was considered virtuous to keep them apart, a situation analogous to that thought to obtain between science and politics, epitomized in the 'ivory tower' metaphor.

Looking back, we tend to think we were the victims of harmful illusions. Some have already acquired the new illusion that since scientific activity is not politically neutral or irrelevant, we should not even try to make a distinction between scientific and cultural activities on the one hand, and political ones on the other. Von Wright is under no such illusion.

I have the impression, however, that for a long time von Wright remained aloof from politics. It was the war in Vietnam which roused him to political activity. Many were surprised when, in 'The War Against Vietnam' (see below), he came out publicly with sharp and clear criticism of the United States. Yet this reaction, implying a changed view of the duties of a humanist, appears well in line with—or even as a necessary consequence of—some of his well-entrenched convictions. In the essay on *Paideia* (*T&F*, p. 29ff) he stresses, approvingly, the Greek views of man as a *fellow* citizen; he points to the humanism of the Sophists as being determined by a predominantly political view of the nature of man; he underlines the intimate relationship between the humanism of the Greeks and Athenian democracy.

As his political consciousness was sharpened and focussed, the inevitable consequence was a sense of new duties and obligations toward the public: "For those who believe that they could contribute ever so little, by word or action, to change the world, this anxiety [over the situation in Vietnam] will be connected with a responsibility we must be willing to take on."

'The War Against Vietnam' is a long, carefully written and argued plea for an American withdrawal from Vietnam and Southeast Asia as a whole. It was printed almost simultaneously (in November 1967) in three leading Scandinavian newspapers in Helsinki, Stockholm, and Copenhagen.[26] It contains an

unmistakable criticism of the American administration's involvement and its conduct of the war, a criticism which struck so much the harder since its author was so obviously not to be written off as just anti-American. The article attracted considerable attention in Scandinavia.

It happens, occasionally, that well-known figures in other fields (physicists or artists or whatever) suddenly feel called upon to make a public appearance with a political pronunciamento. Frequently such appearances betray ignorance and lack of political judgment, and they tend to remain once-only affairs. Von Wright's article on Vietnam reveals an author who knows the factual and historical background and whose own political judgement is obviously balanced and mature. I am *not* saying that it could not be the subject of controversy and criticism—of course it could since it is a *political* judgement and presents itself as such. (The latter point is essential. Is it not a sign of the politically immature specialist that he presents political arguments as though they sprang from his own speciality?)

To avoid misrepresentation, I should add that after the invasion of Czechoslovakia in September 1968 von Wright spoke up again:

> Since the beginning of this year a storm of despair sweeps across the world . . . headed by intellectual youth in all countries and by older intellectuals whose sensibilities have not become corrupted by their affirmed positions within the established order of society. . . . For this protest movement the events in Czechoslovakia appear as another deadly infringement of values one would want to protect and to further.[27]

An active interest in political affairs is likely to feed back into the springs from which it came—von Wright's humanism. The individualistic strain in those of his writings on which I concentrate, is now apparently undergoing modification. In the article 'Marxist Humanism' in the Swedish newspaper *Dagens Nyheter* (August 13, 1972)[28] he distinguishes three major schools of Marxist doctrine and exegesis: the orthodox (Leninist) interpretation, the 'scientistic' (neo-Stalinist-Althusser) type of view, and, finally, that "Marxist humanism" whose foremost representatives are the Yugoslav philosophers associated with the journal *Praxis*. It is the last which he finds the most congenial—and also, on the whole, the closest to the real Marx. This deserved, I think, to be called a new feature in the humanist outlook of von Wright, and it is consequential. For one thing it makes him pay greater attention to the importance of *structural* social change. About some of the disturbing problems of our time (the population explosion, the pollution of the environment) he now writes:

> It is vain to believe that they can be solved merely by means of functional changes within the frame of existing social structures. The structures themselves must also be changed. *This cannot come about without knowledge of the very principles of social change.* And about these the resuscitated Marx has more to tell us than any

other writer who has grappled with the problem of human coexistence on a global scale. (Ibid., my italics.)

There is, perhaps, a traditional affinity between humanism and individualism, an affinity which, if it has had politically identifiable implications at all, may have had a tendency to favor a certain type of liberalism. Insofar as von Wright exemplifies the development of a modern humanist (and I think in many ways he does), it is this affinity which is now in the process of being weakened or reshaped.

I think he would now agree with Marx: the important thing is to change the world. I do not think he has lost his belief in the importance of an adequate description and understanding of the world as a necessary condition of sane and desirable changes: recall the italicized sentence in the passage just quoted from 'Marxist Humanism'. But this is also the point where his apparent failure to recognize the importance of counter-finalistic events becomes conspicuous. (See section 4.)

It should hardly be necessary to add that von Wright is not one of the new revolutionaries. At one time he said that Plato and Dostoevsky were both revolutionaries and both absolutely 'non-bourgeois'. But in contrast to Marx "they are both also firmly convinced that it is impossible to reform man solely by changing and overthrowing the external frame work of his life" (*T&F*, the essay on Dostoevsky, p. 92). Does he still hold the view he thus expressed in 1949? I find no reason to think that his new belief in the necessity of structural social change has caused him to abandon the belief he then shared with Plato, in principle if not in the details, in the importance of *paideia*. But a modern belief in *paideia* may require as a condition a species of democratic freedom; and again I leave the key terms undefined except for adding that it would entail a damaging anachronism to apply our term 'democratic freedom' to ancient Greece.

One of the dangers attending a move from an individualistic to a more collectivistic political position is the risk of legitimating a rule of law and order (from the left or from the right) in replacement of love and order, if I may be allowed an aphoristic turn of phrase. In the same essay (*T&F*, p. 83f) von Wright discusses 'the tragedy of freedom'. It has two main forms: one individualistic, the other collectivistic. The former materializes when man is made god; the collectivistic version is the belief in the Revolution and the dream of a socialist millennium. He feared both of them then. I think he still does.

Such a shift in his political interest could hardly fail to affect his *praxis* as a humanist. But without his ceasing to be one. On the contrary, it may entail a necessary broadening of the base of action, necessary to forestall or neutralize the devastating objection that one's view of life and of man in *this* world has little to contribute except to improve the complexion of those who are living

and living well on the spoils of the past which, in my view, a laborer can do just as well as a professor or a so-called capitalist. When I say 'living well', I am not only thinking of material welfare.

Whether this change in political outlook and interests will also affect his more theoretical philosophy of (social) science, I shall not venture to say. The theoretical ('reductionist') problems concerning the relationship between two sets of concepts and theories—the logic of individual action and the logic of social (political or historical) events—so far remain unsolved, it seems to me (and von Wright is, of course, not the only one who has tried). These problems constitute, today no less than before, a challenge to philosophers concerned with the theoretical foundations of humanism, the humanities, and the social sciences.

There are indications in von Wright's most recent writings that he is about to address himself to these problems.

6. KNOWLEDGE AND RATIONALITY

The search for knowledge is in a double sense necessary for man—unavoidable as well as indispensable. His nature is such that he cannot forbear using his native cognitive powers. His needs are such that he cannot do without their aid although the aid they give is often inadequate.

This understanding of the nature of human knowledge—itself a species of self-knowledge—is very old, and it has long exerted a special fascination over its possessor, as reflected in some of our most pervasive myths: Prometheus who stole the fire from the gods to give man the gift of practical knowledge; the tree 'of the knowledge of good and evil'—again the object of theft paid for by the loss of innocence; Doctor Faustus who traded his soul for experience, knowledge, and power in this world.

The acquisition of these endowments entails for the recipient at the same time a blessing and a misfortune. This is especially clear in the first of the two essays in which these topics are predominant: 'The Tree of Knowledge' from 1957 and 'Essay on Nature, Man, and the Scientific Revolution' from 1962.[29] It is equally clear, and not only on Christian premises, that without the loss of an original innocence the infant will not become man at all. If he were by nature perfectly innocent *and* perfectly obedient (to God, or to other powers) it would be difficult to understand why man should have been given the light of reason in *this* life. (The medievals, as we know, held that God never did anything 'in vain', for no good purpose.) One who is already perfectly happy without such knowledge and power would have no motive to strive for them.[30]

Underlying von Wright's two essays on the nature and functions of human knowledge is the question of whether (and in what possible sense) knowledge

is good for man. Von Wright distinguishes two types of knowledge and, cor-relatively, two types of attitude to nature. In the Greek conception, nature is "the ideal to be imitated, not a raw material and brute force to be subdued and made to serve human ends".[31] Knowledge of nature was meant to enable man to obey and follow nature, not master it. In contrast, the Baconian conception justifies knowledge by mastery of nature through technological achievement.

In either case knowledge is subservient to human welfare. The significant difference is found in the types or ideals of welfare involved. The Greek con-ception reached one of its culminations in the Aristotelian idea of the highest happiness, available to man, or, in von Wright's words, in a "striving for knowledge as . . . a *form of life,* i.e., as a striving to know and to understand for the sake of knowing and understanding in itself and not for any other pur-pose."[32] This ideal is an impossible one to-day as the only or even a dominant ideal (as von Wright is well aware). The instrumental necessity of knowledge is now such that the world would perish without it. (Or, more correctly, per-haps, perish prematurely.) Secondly, the purpose even of the Greek striving for knowledge is not quite properly described by the words "for the sake of knowing and understanding in itself". The Greeks found its *justification* in the welfare attending successful striving of this kind, in a betterment and perfecting of human nature attended by that particular species of happiness which Augus-tine, much later, described as 'gaudium de veritate'. There is hardly any form of welfare and happiness more human than this. But not even Aristotle thought it sufficient.

There is nothing original or unexpected in all this. It is part of what we call our cultural heritage, none the poorer for that. Was there ever a humanism or a humanist to whom the conclusions were not *broadly* the same, although the weight attached to the different forms of knowledge and the correlative attitude to nature, must vary with the ideals of welfare adopted?

Is it even conceivable that it could be different? Humanism is not self-contained and 'autonomous', in either of its two senses: not as a view of life, and not as a family of academic disciplines. The causal and ideological condi-tions of progress, of creative thinking, of new departures, that which compels change (often) lie outside humanism itself. Where? In the general growth of our cultures, in warfare, welfare, and the arts, for instance. They lie, above all, in the growth and development of other kinds of human knowledge, call it 'scientific' or something else.

It is almost a platitude now—perhaps before we have properly understood the importance of it—that the forms and products of human creative and cog-nitive activities form what we might call an 'eco-system', a specifically human one. To understand and analyse these *inter*dependences are central tasks of humanist inquiry today. Von Wright tries to do so, and this is no longer a trivial endeavor.

It was Bacon, he reminds us, who aphoristically formulated the new view of nature, the condition of modern natural science and technology: 'Natura enim non nisi parendo vincitur.' It is only by obeying nature that we can master it. But *our* type of obedience is radically different from that entailed by the Greek view of nature. That, at least, is our understanding of Bacon.

We have successfully obeyed nature, almost too successfully. This insight and this fear have given us a new interest in problems concerning the use and justification of human knowledge. (The rise of 'science ethics' is one response to this stimulus.)[33]

Perhaps our understanding of Bacon's aphorism was not so perfect after all. The traditional technologist's (and industrialist's) interpretation of 'obedience to nature' has not been that of the Greeks. It now appears that it ('obedience to nature') must also be so understood unless nature shall let loose a new and uncontrollable dominion over us. This situation may require a critical reexamination of the value and uses of our various forms of knowledge *and* a new attitude to nature.[34] It may require a new inventory of what we *need* to know more about: the interactions of man with his human and his non-human environment. This is very different from the pious verbiage we sometimes must suffer to the effect that we must have more 'non-scientific' knowledge and more humanism to redress an imbalance of investments in what some call 'the knowledge industry'.

It follows that one of the central humanist tasks today is to seek a better understanding of the place and functions of the humanistic disciplines in our universities, in the total universe of human knowledge. Philosophers of science (especially of the Anglo-Saxon variety) have only hesitantly moved from physics and biology to the social and behavioral sciences. By and large the humanities have been left out altogether, partly, one may surmise, because the term 'science' does not now cover the humanities, in contrast to the German 'Wissenschaft' and the Swedish 'vetenskap'.[35] History has usually been singled out, as an exception among the humanities, but often apparently in an attempt to erect the fence *between* science and the humanities on the neighbor's ground. C. P. Snow's 'two cultures' was a half-truth and therefore misleading, as von Wright also argues.[36] What we still fail to understand (it seems to me) are the nature and functions of humanist types of knowledge of man and his world (his *Lebenswelt,* if you will) and of how knowledge of this kind is related to the creative arts (poetry, novels, drama, etc.) on the one hand, and to neighboring social and behavioral 'exact' sciences on the other.

There is one particular aspect to which von Wright has given attention during the last few years: the relationship between the human sciences and exact knowledge of the kind exemplified in cybernetics, information theory, and theory of games. His endeavors in this field reveal innovation as well as continuity in the picture of von Wright as a humanist thinker. In the first place, it is now

one of his basic *premises* that man is a political animal: "To have the ability to think is to be able to live as a member of a community of men".[37] Secondly, he does not share the view that there is an inherent opposition between the human sciences (here including the social/behavioral sciences) and exact methods and knowledge. Thirdly, the dream (or hope, or program) of a unification of the natural, the social, and the human sciences (first articulated in *LE* in 1943) now reappears in a new shape.

In 1965 von Wright contributed two articles to a series printed in the Swedish *Dagens Nyheter* under the general heading 'New View of Man'. His main topic is how the new exact sciences, cybernetics, theory of games, and information theory may help overcome Cartesian dualism. Aristotelian and scholastic science assigned to man (an undivided man) a well-defined place in the world order. Cartesian dualism splits man in two. One half belongs to the context of nature and is a proper object of scientific knowledge. The other half leads a problematic and insecure existence outside this realm. An exact science of behavior, liberated from animistic relics, will, he hopes, restore to our picture of the world a unity which it had during the Middle Ages, and which was shattered by the rise of the modern natural sciences. The traditional dichotomy between the natural and the human sciences is then seen to be a by-product of Cartesian dualism. A unification of these severed sciences will, he predicts, bring about a re-unification in our total view of nature and life.

> Thus exact science is no longer natural science only. It is also a science of man. It is, therefore, a residue of an outmoded way of thinking to say—let alone to stress the limitations entailed by it—that exact human science is a 'natural science' view of man, and thus also to place it in opposition to a 'geisteswissenschaftlich' or a 'humanistic' science. All elegies about the abyss between 'the two cultures' notwithstanding, an integration of the scientific view of the world is in progress. In consequence, the sharp contrast between man and nature, living and lifeless, mind and matter is being eradicated.

This is not, he says, a new species of naturalism; it is rather "a rehabilitated 'rationalist' conception of man and society".

Von Wright is not blind to the technological aspects of the new exact sciences of human behavior:

> they give reason a weapon, a new possibility to influence and steer the life of human communities, To think that this weapon should not be used is groundless pessimism. It would be naive, however, to think that it will not also be misused to further the unjust ends of selfish individuals and groups.[38]

The position now outlined is neither a traditional humanist one, nor a camouflaged return to a familiar 'scientistic' neo-imperialism entailed by the methodological monism of the old positivists. If proof of this contention is desired, it is found in *Explanation and Understanding* with its recognition of the im-

portance for the human sciences of intentionalist concepts. It is also available in the form of an explicit declaration:

> Thus there are also other *scientific* ways of looking at reality, including man, in addition to those of the exact sciences. And I would want to add: there are also other (essential) *modes* of viewing reality and man in addition to the scientific one. To these other modes belong the moral and the religious, and, in a certain sense, presumably also the artistic and the philosophical attitudes to world and life If, while realizing that the scope of exact scientific knowledge is in principle unrestricted, we forget that it is not exhaustive, our belief in the potentialities of science and technology degenerates into superstition.[39]

Some of the threats and problems posed by the introduction of exact scientific methods into the behavioral sciences are of a political nature, as already indicated. It is possible to overlook this, and mistakes about the differences and similarities between computers and men may prevent us from seeing that all the disquieting consequences for our lives of computer technology "must be faced as problems concerning human organization and purposes in a social context". He believes, along with many others, that the techniques of automation and data processing make possible an unprecedented concentration of social and political power. What we need and lack, so far, is a fully developed "ideological complement". Again he points to Marx, not as having the answer but as being the "most topical" social philosopher in the present situation.

> It is a reasonable presumption, however, that a mass movement which, in modern industrial societies might acquire an importance matching that of the labor movement in earlier times, presupposes a broadly shared consensus on central human values the validity of which would have to be independent of class or race or religious belief. Perhaps we can discern the beginnings of such a *social humanism* (von Wright's italics) in the steadily growing scepticism toward the use of GNP and industrial growth as the only measure of improved living conditions, in a more conscious endeavor to protect the environment against harmful disturbances of the ecological balance, and in the sharpening demands for a more equitable distribution as well as a better planned use of the earth's resources—with a view to the welfare of all mankind.[40]

The author of these essays has not turned his back on the author of *Thought and Prophecy*. Talk about an alter ego is misleading. It could suggest itself only because one and the same ego has several interlocutors who are sometimes isolated from each other.

The prominent place of knowledge must be an important feature of that social humanism which he sketched in 1972; exact knowledge, the outcome of scientific inquiry, as a necessary but insufficient basis for global political action. No less prominent must be the other part of the basis—human values transcending class, race, and religions; and, we must add, the other types of knowledge and insight as well as the other modes of viewing reality. These last are essen-

tial for our potentialities as *individuals* to experience and to accept such values. This, it seems to me, is no unlikely vision of a union of the rational and the political animal. It is not to say that he who looks at man in this way, thinks the realization of the vision is within reach, as the following quotation may prove: "The pursuit of something as an end of action is *rational,* if and only if a man, when considering the price, is also willing to pay it."[41]

7. CONCLUSION

I doubt that I have succeeded in accomplishing what I may have been expected, or what I had hoped, to achieve. My assignment was, as I understood it, to present a portrait of von Wright as a thinker in the tradition of western humanism. I had no choice but to attempt, first of all, to produce an acceptable likeness. A good portrait should also be a comment and a characterization, not necessarily uncritical, but at the same time it must not unfairly distort those features which catch the attention of the observer as significant and characteristic.

It has been more difficult than I imagined to begin with. I thought, for one thing, that there would be more disagreements to exploit. It is easier to characterize critically; records of agreement or admiration become boring and pointless. The original product is better, and practically all the time the original is in Swedish and unknown, even to many of his Scandinavian readers. If I am guilty of quoting too freely, this is my excuse.

I thought, as I said, that I should have more to criticize. I almost hoped, as I began writing, that the simile of the two egos would be true, that I could exploit the Jekyll and Hyde theme again. My own rereading and rethinking the essays I had first read nearly 25 years ago made this inadvisable. Nor could I, as at one point I suspected, very well identify his blueprint for a 'social humanism' with the vaguely well-meaning benevolence of old-fashioned liberalism, at present the target of political marksmen from the left and from the right. I have found it astonishing to see how, in his comments from 1947–48 on Jaeger's *Paideia,* the connection between humanism and political man is brought out so explicitly. It was the humanism of the Sophists which was characterized by a clearly political view of human nature: it is by way of his attitude to and relations with the community, *polis,* that man becomes virtuous and actualizes his best potentialities (section 5 above). This attitude is shared by many today, although with varying views of what the consequences ought to be (and thus of the price we ought to be willing to pay). The equivalent in the 1970s to the *polis* of the Greeks is an (ecologically) indivisible world where both politics, economics, science, and ethics seem to converge on the problems now confronting us.

I cannot even try, in conclusion, to sum up von Wright's humanism in a neat and quotable formula, and I do not find this regrettable. When such feats of compression are executed, the result is usually of doubtful value. (I confess I am thinking of Albert Schweitzer's 'reverence for life', for example.) There is no ready-to-wear ideology to be extracted from von Wright's humanistic writings. But there is (if I can now avoid platitudes in saying it) a sustained, deep, and thoughtful concern about important things in the lives of individuals and groups, in the historical past as well as in the turbulent present, and a determined will to search for methods for dealing with them. Revelation is not one of these methods; systematic intellectual effort is.

I have been critical on a few points only, and perhaps I could have found more to question if I had not chosen to emphasize other aspects instead. For one thing, I would like to hear him say more about what the values are on which a social humanism could be built. I hope such lack of patience on the part of his readers may be rewarded in his future writings.

The full title of my essay also charges me with a duty to discuss von Wright's 'philosophy of life'. I may have said little about this topic and I shall not say much more now. For the main part I take it, in fact, to be covered as well as I can cover it by what I have said, although I have not until now mentioned or made use of the phrase.

There is one comment, however, which I cannot now withhold: what a very Aristotelian humanist von Wright turns out to be! Let me have recourse again to two quotations which bear on the theme of an Aristotelian philosophy of life.

In his *Paideia*-essay, discussing the Sophists' belief in the importance of education, he says that "in order to be effective and workable, any form of humanism must embrace a certain measure of faith in the possibility of men to develop into something different from that to which by birth and external conditions of life they would seem predestined." (*T&F*, p. 28f.) Indeed; and in the Christian scheme not even the death of the individual is seen as extinguishing these possibilities of actualization. Not so in the Aristotelian. I have already stated that von Wright is sceptical of attempts to merge humanism and the Christian religion. His view of death reaffirms the impression of the Aristotelian humanist.

The essay, 'Death as Professor of Metaphysics' (*Dagens Nyheter*, May 8, 1957) distinguishes the idea of (personal) survival from that of (impersonal) immortality. There is nothing in what is said about personal survival which would comfort those whose need is consolation. What the essay says about immortality is worth recording here. The danger inherent in many philosophical attempts at making sense of the notion of immortality

> above all seems to be that one fools oneself into construing a timeless immortality by relying on ideas—for instance, about the concepts 'individual' and 'human-

ity'—to which one has only apparently given a meaning outside the temporal order. A so-called 'belief' in immortality cannot be genuine if its motive is a search for consolation in the miseries of our temporal existence. The only acceptable motive which I can find for it is a striving for clarity about the import of our ideas about life, death, and eternity. Maybe such striving could also be called an intellectual love of the world as an ordered whole.[42]

If I were, after all, to choose one phrase which better than any other characterizes von Wright as a thinker in the tradition of Western humanism, it might be the final sentence of this passage.

INSTITUTE OF PHILOSOPHY KNUT ERIK TRANØY
UNIVERSITY OF BERGEN
MARCH 1974

NOTES

1. Swedish title: *Tanke och förkunnelse* (Helsingfors: Söderström & Co. Förlagsaktiebolag, 1955). The word 'förkunnelse' has no English equivalent; it is the same as the German 'Verkündigung'. I shall refer to this work as *'T&F'*. Three of the essays were originally printed in the Helsinki monthly *Nya Argus*. 'Tolstoy as a Thinker' was published for the first time in *T&F*. (Bibliography, no. 147; hereinafter abbreviated *B*.)

2. The essay orginally appeared in *Nya Argus* in 1957. (Bibliography, no. 155; for a revised and expanded version see *B*. 179.)

3. Swedish title: 'Essay om naturen, människan och den vetenskapligt-teknisk revolutionen'. (*B*. 195.)

4. *T&F*, p. 13. All translations from the Swedish are mine; they have been approved by von Wright.

5. Cf. *B* 191; 190; 242.

6. *Den logiska empirismen. En huvudriktning i modern filosofi* (Logical Empiricism. A Principal Movement in Modern Philosophy) (Stockholm: Natur och Kultur, 1943). I refer to this work as *'LE'* (*B* 28) As a classical expression of the logical positivist view of ethics I cite A. J. Ayer's *Language, Truth and Logic*.

7. One may also, perhaps, recognize a similar 'empiricist inclination' in *Varieties of Goodness* (especially Ch. I, sect. 8, and Ch. VI) and in *Norm and Action* (especially Ch. VII).

8. I realize that the matter is more complex than my brief statement might suggest: certain kinds of attempt to accept more or less consciously recognized contradictions cause psychological disturbance. I do not see this as an objection to my point.

9. I am thinking, for instance, of Ayer's position in *Language, Truth and Logic,* especially Ch. IV, 'Critique of Ethics and Theology', which can (in part) be summarized as follows: there is no intersubjectively acceptable method by which the validity of value judgments can be assessed. A positive instance is provided by von Wright in *LE,* p. 115 f., where he argues that values can be validated by empirical methods.

10. I recognize, with a mixture of regret and relief, that I can do no more than mention the place of rationality in education, in the *paideia* of our own time.

11. I am thinking of J. Maritain, *Humanisme Integral* (Paris: Fernand Aubier, 1936) and of J.-P. Sartre, *L'Existentialisme est un humanisme* (Paris: Les Editions Nagel, 1946). Raskolnikov's position, "If God is dead, everything is permitted", is mentioned by Sartre; it is discussed by von Wright under the heading 'The Tragedy of Freedom' in the essay on Tolstoy, *T&F*, pp. 82ff.

12. Elsewhere I have argued in some detail for the 'doubleness of nature' of certain concepts which are important in psychology as well as in moral philosophy, esp. the concept of *need*. See '"Ought" Implies "Can": A Bridge From Fact to Norm?', Part II. *Ratio*, vol. XVII, no. 2 (Dec. 1975): 147–175.

13. This may be the place to reflect upon the motto of *Explanation and Understanding*: ". . . und tiefer als der Tag gedacht . . ." (borrowed from Nietzsche's *Zarathustra*). It may appear puzzling to one who reads *Explanation and Understanding* only.

14. In case I should not have made myself clear: I refer to the fact that as far as we know we have *always* had persons preferring this form of life in our culture.

15. Von Wright sees Spengler as a historian who radically rejects causality in history. Toynbee he lists as a 'causalist' of a special type which (if I may coin a phrase) might be termed the 'S-R variety'. It should be noted that the term 'scientific' as it occurs in this (and in several other quotations from von Wright) is used in the sense of the German 'wissenschaftlich', i.e. so as to comprise the social sciences and even the (academic and scholarly) humanities. It is difficult to achieve, in regard to these terms, that combination of consistency and clarity which one would like to have.

16. See *LE*, p. 116. The idea is of logical positivist descent, but von Wright's development of it is a very personal one. See also sect. 6 below.

17. Practical inference is discussed in *Explanation and Understanding*, pp. 96 ff. (hereinafter referred to as *'E&U'*).

18. The term 'counter-finalistic' I have borrowed from the Norwegian philosopher of science Jon Elster who has taken it from J.-P. Sartre, *Critique de la raison dialectique* (Paris: Editions Gallimard, 1960), for instance, p. 233f: 'la contre-finalité'. Elster discusses problems connected with counter-finalistic processes in *Nytt perspektiv på ökonomisk historie* (Economic History in a New Perspective) (Oslo: Pax forlag A/S, 1971) and esp. in *Det distributive flertall* (The Distributive Plurality) (Oslo: Mimeo, 1972). In the former work Elster says about the 'logical form' of a counter-finalistic process: "Each individual behaves as if none of the others intended to change his behavior, but when everybody acts in this way, the presuppositions of each individual's behavior fail and the result can become different from those intended." (Economic History p. 109.) (Strictly speaking, my examples illustrate events which are *negatively* counter-finalistic. They can also be of a positive variety, i.e., produce unintended and desirable results. Elster, Economic History . . ., p. 110 f.) Further, Elster contends that "deep and structural social changes . . . are more likely to occur when the separate individual wills of a distributive plurality bring about the performance of actions the collective result of which is in conflict with what each agent is trying to achieve." (Elster, The Distributive Plurality, p. 15 f.) This may be sufficient to indicate the nature of Elster's fundamental distinction: that between a 'collective' and coordinated plurality, and an uncoordinated 'distributive' one.

19. This is also compatible with Elster's view: "We must *understand* each individual action before we can *explain* how the sum of individual actions can come to manifest itself *vis a vis* the agents as a kind of ('quasi') nature." (The Distributive Plurality, p. 9, italics original.) ('Understand' is here used in the sense of *verstehen*, 'explain' in the sense of *erklären*.) This is also to say, of course, that the Marxian idea of *alienation* is tied to the notion of counter-finalistic processes.

On p. 136 in *E&U* von Wright discusses the case of a city which has been physically destroyed—by earthquake, flood, or enemy conquest. And he comments: "*That* the city disappeared may be historically relevant in a variety of ways; . . . *Why* the city perished, the actual cause of its destruction, would normally be thought much less interesting to the historian." (Italics original.) Even granted that 'cause' may here be used in a very specific sense, it does not seem plausible to me to suggest that the 'actual cause' of the expansion of the Sahara, or of the falling rate of profit, or of any such similar phenomenon, would be less interesting to the historian than *that* these events occurred.

20. As one may see it instantiated in western capitalism, the theme is not so much that of Goethe's *Faust* as that of his *Zauberlehrling*.

In *E&U,* von Wright says about Marx and historical explanation that 'Marx's conception of the historical process is *essentially* an effort to trace the great changes in society back to changes of a technological nature'. (Note 7 to Ch. IV; my italics.) It is notoriously difficult to agree on interpretations of Marx, and I doubt that Elster, to whom von Wright refers in the same note, would find the statement quoted an acceptable understanding of the Marxian understanding of social change.

21. —in spite of what he says about 'emergence' and the transmutation of 'quantity into quality' in E&U, p. 135.

22. 'On Explanations in the Science of History' printed in *Historiallinen Arkisto* 63 (1967): p. 7. (B 226.) In this paper von Wright also distinguishes several types of *objects* of historical explanation and adds that he dares not assert the reducibility of them all to human action. But these reservations hardly seem to affect my criticism, even though von Wright might think that "changes in global states of affairs, such as the decline of a major power, the transition in a given country from an agricultural to an industrial type of society, . . ." and similar such changes are not reducible to actions, as he may be taken to indicate in the paper quoted.

23. I refer in particular to what he says in *E&U,* Ch. IV, sect. 1, about 'analogy' between individual and collective action which 'could be worked out in great detail'. (*E&U,* p. 133.) But *E&U,* and Ch. IV not least, contains so many brief indications of ideas and theories that it is difficult to be categorical about its messages.

24. 'On Explanations in the Science of History', p. 7.

25. Cf. *E&U,* p. 166: 'an absolute rationalism which attributes a goal to history or the social process as a whole' is rejected as transcending the boundaries not only of empirical study but "also of anything which could reasonably claim to be a 'science' in the broader sense of the German word *Wissenschaft*".

26. See B 218 for the detailed references.

27. Quoted from 'Attempt at a Postscript', printed in the Helsinki newspaper *Hufvudstadsbladet,* Sept. 9, 1968. (B 228.)

28. B 257.

29. B 179 and 193.

30. This argument seems to presuppose that man did not in such a case think he had *knowledge* of his own happiness, for then he might also think himself mistaken.

31. 'Essay on Nature, Man, and the Scientific revolution', p. 24, von Wright's English summary.

32. 'The Tree of Knowledge', p. 71, italics original. To avoid being unfair to the author I should add the following. Intellectual hubris is a greater evil than the *hubris* of power and wealth, for the former is self-destructive: it proves that you are *not* wise. 'Therefore knowledge as a form of life can be the highest but also the most destructive for the individual.' Ibid., p. 75.

33. In this connection, see my article 'The Ideology of Scientific and Scholarly Conduct', in *Contemporary Philosophy in Scandinavia,* edited by R. E. Olson and A. M. Paul (Baltimore and London: The Johns Hopkins Press, 1972), pp. 331–349.

34. "If one cannot look up to nature, there are two ways of relating to it. Either one can turn away from it, toward a 'higher and better world'—or one can turn against it in order to gain mastery over it." 'Essay on Nature . . .', p. 10.

Julius Weinberg, the eminent knower (and lover) of medieval philosophy, once half jokingly remarked as our conversation touched on the problem of God as an object of love and as an object of knowledge in medieval philosophy, that he had regretfully come to the conclusion that the object of love and the object of knowledge never coincide. If they never do, the omens of the present seem fateful and frightening. The more we have come to know about nature, the less lovingly have we treated her. The new attitude to nature which ecologists have and which is inspired by a deeper and more comprehensive knowledge of nature, may give reason to hope, after all, that the objects of love and knowledge may come to coincide in our future attitude to nature. (See also the final paragraphs of the present paper.)

35. A fairly good example, picked at random, is Peter Caws, *The Philosophy of Science. A Systematic Account* (Princeton: Van Nostrand, 1965). Caws does indeed devote a chapter to the humanities—to explain why they should be mentioned without really being included in a philosophy of science.

36. 'Exact Science and the Human Sciences', p. 146. (B 196.)

For my own part I find it appropriate that the following observation should be taken account of. All the academic humanities are also characterized by a certain doubleness of nature (cf. note 12). The study of any humanistic discipline (of art, or literature, or languages, or . . .) is partly a *historical* study (art history, history of literature, . . .), partly it is a *systematic* or 'theoretical' study (esthetics, linguistics, theory of literature, etc.). This doubleness is necessary in the sense that neither part is dispensable—there is fairly universal agreement on this point—although there is much less agreement on how the two are related, on how, say, the history of literature (e.g., biographical material about authors) is/should be related to its general theory (e.g., the understanding or interpretation of a given novel). This divergence is, of course, partly grounded in the following apparent fact: the historical studies (of art, music, or whatever) are empirical studies (in the same sense as any study of history is) while the systematic or 'theoretical' part of a humanistic discipline is always and essentially a theory of value and/or meaning (or similar 'intentional' entities). 'Ontological' questions in esthetics (e.g., questions concerning the nature and existence of artistic qualities or 'esthetic objects') are not 'value free' questions. There will be interesting differences from one humanistic discipline to another (a drama 'exists' in a way different from that in which a painting 'exists'); and such differences are reflected in the various histories with which the humanities endow us. This variety (so seldom referred to in the philosophy of history) may throw new light on problems concerning the nature of history as a science. For instance: *what* is the history of a language the history of? My remarks here can only scratch the surface of important problems—which invite further investigation.

37. From 'Men, Mathematics, and Machines', a paper read to an EDP-congress and printed in *Data* 7 (1972). The quote is from p. 26. (B 255.)

38. The articles from which these quotations are taken, are 'An Exact Science of Man' and 'Man In the World Order'. (B 206 and 207.)

39. 'Exact Science and the Human Sciences', p. 147.

40. All material and quotations in the preceding paragraph are taken from 'Men, Mathematics, and Machines', p. 26. Again it seems fair to add that the very passage

from which I quote, contains an equally clear criticism of 'dogmatic and orthodox Marxism', including its theory of class struggle.

41. 'Essay on Nature . . .', English summary, p. 25. 'The price' is here defined as "the necessary requirements for attaining the various ends and the consequences which follow upon their attainment". (Ibid.)

42. See B 160. I do not find the Spinozistic echo disturbing.

By way of epilogue I want to add a brief remark on the nature of rationality—which is to say, also, on *the nature of man,* a nature which it is in some sense right or valuable to use and to actualize. Traditions closely connected with Cartesian dualism tend to identify rationality—and thus, in a sense, human nature—with 'reason' and intellectual capacities, in contradistinction to 'sentiment' and the emotions. Hume's ethics may be one of the high water marks in the history of this tradition which *severs* reason and the emotions just as Descartes severed mind and body. I agree with those who now think this dichotomy is false and misleading. And I tend to believe von Wright would also do so. The main theme which these remarks introduce can be dealt with under many heads, one of them being the 'reunification' of man. It is implicit and sometimes very close to the surface in many of the central topics discussed above. (1) It is directly involved in the problem of the coincidence or non-coincidence of the objects of love and of knowledge and thus also in the expression 'intellectual love of the world as an ordered whole'. (2) The same dichotomy is in some way connected with the notorious fact-value (is-ought) problem, and as a consequence it is (I think) at the heart of the reconciliation between one's theoretical view of and one's practical attitude to values. It is also pertinent to the merit and need, the 'love and order' topic of section 3. (3) Finally, one's attitude to the dichotomy (between the 'rational' and the 'irrational' in man) is reflected in one's concept of rationality. One traditional and well-entrenched notion identifies rationality with a wise or intelligent choice of means to the attainment of ends which are not, and cannot be selected by any kind of 'rational' choice. It is obvious that von Wright's definition of rationality is *not* of this kind.

A further elaboration of these themes would take me far beyond the boundaries of my assignment, though by no means beyond the limits of problems which are now central concerns in humanist thought.

22

Jaakko Hintikka

VON WRIGHT ON LOGICAL TRUTH AND DISTRIBUTIVE NORMAL FORMS

Most of von Wright's work in deductive logic is characterized by a common technique. It is the use of distributive normal forms. The same technique is the basis of von Wright's main idea concerning the nature of logical truth.[1] This is the idea that logical truth is tautological (empty). Hence this philosophical idea is best discussed in conjunction with the technique of distributive normal forms.

The technical ideas underlying distributive normal forms did not originate with von Wright. They are already foreshadowed in Boole, at least in certain special cases.[2] In propositional logic they were part of logicians' *Gemeingut* already in the twenties.[3] In monadic predicate logic, they were used by Hilbert and Bernays[4] following Behmann.[5,6] However, no one before von Wright seems to have realized the full force of this technique or used it in an equal variety of cases. He was the first to use distributive normal forms in certain non-monadic parts of first-order predicate logic (quantification theory), principally those characterized by the presence of at most two layers of quantifiers.[7] Von Wright also seems to have been aware at a fairly early stage of the possibility of defining distributive normal forms in the full first-order logic, although such normal forms were first defined explicitly by others.[8] In any case, he does not appear to have been deterred, as others seem to have been, by the erroneous opinion of Hilbert and Bernays[9] to the effect that no easily characterizable distributive normal forms exist in the full first-order logic. Furthermore, von Wright was the first to use distributive normal forms in modal logic,[10] and has since employed them in his studies of many different kinds of non-classical logic, often of the same general sort technically as alethic modal logic.[11] This

I am indebted to Mr. Ilkka Niiniluoto for his assistance in writing and editing this paper.

technique is thus the unmistakable hallmark of von Wright's work in deductive logic.

As was already indicated, one of the uses of these normal forms by von Wright is in his philosophy of logic. He has used them to defend—and to deepen—the idea of logical truth as tautological truth. (Strictly speaking it would be more appropriate to speak of empty or nugatory truth here, for there need not be anything pleonastic about tautologies in the intended sense. I shall ignore the solecism, however.)

The source of von Wright's concept of tautology, acknowledged in so many words by him, is Ludwig Wittgenstein's *Tractatus Logico-Philosophicus*.[12] He has sought to recapture and to extend the vivid and suggestive idea which Wittgenstein had sketched and which will be explained in the next few paragraphs. As a consequence, von Wright's concept of tautology has little to do with the watered-down uses of the term 'tautology' by some Logical Positivists to refer to all truths they argued to be analytical, conventional, or linguistic.[13]

The connection between the idea of tautology, as conceived of by Wittgenstein in his *Tractatus* and developed further by von Wright, and distributive normal forms is easy to explain. Consider first the case of propositional logic. There our resources of expression include a number of unanalyzed atomic propositions A_1, A_2,. . ., A_k and such propositional connectives as \sim, &, \vee. (All other truth-functional connectives can be defined by their means.) The Wittgenstein-von Wright idea of tautology (as we may call it) can be presented in a nutshell as follows:

Each proposition using the resources of expression just indicated admits of certain basic possibilities and excludes the others. It is the more informative the more possibilities it excludes. If it excludes none, it does not convey any information. This case turns out to be characteristic of the logical truths of propositional logic. They are thus tautological (empty) in a vivid sense. This vividness is due to the closeness of the concept to pragmatics, that is, to what we know of the use of language. From the fact that a truth of propositional logic is tautological in the Wittgenstein-von Wright sense, we can see straightaway that it cannot be used (in its literal sense) to convey, to receive, or to record information. As Wittgenstein puts it,[14] "I know nothing about the weather when I know that it is either raining or not raining."[15]

The basic possibilities just mentioned are in propositional logic described by the following sentences, called *constituents:*

(1) $\pm A_1$ & $\pm A_2$ & . . . & $\pm A_k$

Here each " + " may be replaced by "\sim" or by nothing at all independently of the other signs. Hence there will be precisely 2^k constituents.

It is not surprising that the basic possibilities should be described in prop-

ositional logic by consti.uents. All we can say by means of the vocabulary and syntax of propositional logic of the world is which atomic sentences hold in it in which combinations.

The distributive normal form—in the more elaborate terminology of Hilbert and Ackermann, it is called the complete disjunctive distributive normal form[16]—of a sentence S spells out which basic possibilities S admits of by representing S as a disjunction of the corresponding constituents. The possibilities described by all the other constituents are excluded by S.[17]

Two special cases deserve special attention here. A logical truth of propositional logic is characterized by having a maximally long distributive normal form. This brings out the nature of such a truth as a tautology, and serves to connect the idea of tautology to distributive normal forms. Inconsistent sentences do not admit any possibilities. They can be accommodated in a theory of distributive normal forms by allowing disjunctions (of constituents) with zero disjuncts as a special case of the normal forms.

The same ideas govern the situation in first-order *monadic* predicate logic, that is, in the case in which only properties but no relations are being employed. For simplicity, we restrict our attention to languages without individual constants and without identity. (These restrictions are inessential.) Our new vocabulary consists then of a finite number of one-place predicates "P_1", "P_2",. . ., "P_m", a supply of bindable variables "x", "y", "z",. . ., and the two quantifiers "$(\exists x)$", "(y)" where other bindable variables than "x" and "y" may of course be used. The only novelty in the conceptual situation here as compared with propositional logic is that we can now speak of the kinds of individuals there are and are not in the world. This suggests a straightforward procedure in building up the constituents of first-order monadic logic: We first list all the different kinds of individuals that can be specified by means of our resources of expression. They are specified by the following *attributive constituents* (Carnap's "Q-predicates"):

$$(2) \qquad\qquad \pm\, P_1x\; \&\; \pm\, P_2x\; \&\; .\;.\;.\; \&\; \pm\, P_mx$$

Let these be $Ct_1(x)$, $Ct_2(x)$,. . . .,$Ct_{2^m}(x)$.

Then the constituents of monadic first-order logic can be specified by indicating which of these different kinds of individuals are exemplified:

$$(3) \qquad\qquad \pm\,(\exists x)Ct_1(x)\; \&\; \pm\; (\exists x)Ct_2\,(x)\; \&\; .\;.\;.$$

If $Ct_{i_1}(x)$, $Ct_{i_2}(x)$,. . . are the unnegated (exemplified) constituents in (3), we may also write instead of (3)

$$(3)^* \qquad\qquad (\exists x)Ct_{i_1}(x)\; \&\; (\exists x)Ct_{i_2}(x)\; \&.\;.\;.$$
$$\& \;(x)\,[Ct_{i_1}\,(x)\; \vee\; Ct_{i_2}(x)\; \vee\; .\;.\;.]$$

This form, which is easily seen to be equivalent with (3), is useful for many purposes.

Again each well-formed consistent sentence admits some (or all) of these constituents, and can be represented as their disjunction. It excludes all the others. It is logically true only if its distributive normal form contains all the constituents, that is, if it admits all the basic possibilities, excludes none. Such logical truths are uninformative (tautologies) in the same way and for the same reason as the logical truths of propositional logic.[18]

This sense can be spelled out further by defining measures of information (semantic information) for monadic first-order sentences.[19] All reasonable measures of this kind assign a zero information to logical truths.

Thus the concept of tautology describes, as von Wright has forcefully pointed out, very aptly indeed the truths of monadic first-order logic.[20] But can it be extended beyond this case? It can easily be extended in certain directions, for instance to propositional modal logic. However, the most interesting and important test case is constituted by the full first-order logic.

The resources of expression we must consider in this case may be taken to include a finite set π of predicates (some of them with more than one argument-place)[21] plus quantifiers, variables, and propositional connectives, as before. It is clear that without further restrictions on our freedom of expression we cannot hope to find a *finite* set of alternative possibilities for our sentences to admit of or to exclude, as in the monadic case. However, a natural further restriction lies close at hand. Each quantifier invites us to consider one individual, however 'random' or 'arbitrarily chosen' it may be, as we occasionally say in our naive logical reasoning.[22] For instance, the universal quantifier '(x)' may be read 'for each individual (member of our domain)—call it "x"—it is true that'. (The vulgar reading 'for each x' is of course a howler, although it has insinuated itself into textbooks and linguists' theories.) It follows that the number of layers of quantifiers (i.e., the maximal length of sequences of nested quantifiers) in a sentence S is a kind of measure of the complexity of the configurations of individuals considered in S (in their relation to each other.) We shall call it the *quantificational depth* or simply the *depth* of S.[23] The idea of restricting it is as natural an idea as we may find in this area. What is more natural than to try to restrict the complexity of the situations we are considering in S?

The naturalness of this idea can be enhanced further by examples illustrating the import of the notion of depth. For instance, in 'every man loves a woman' we are considering two individuals in their relation to each other, whereas we are considering three in 'there is a point between any given point and any other'. In 'every man has a father and a mother' two individuals are considered together in their relation to each other, although three quantifiers are being used, for the father and the mother are not explicitly considered together in the sentence.

If we impose a restriction on depth, the situation is once again the same *mutatis mutandis* as in the monadic case and in propositional logic. A finite set of alternative possibilities can again be described in such a way that each sentence (subject to the restriction) again admits some (all, none) of them and excludes the rest. Again, logical truths are precisely those sentences which admit *all* alternatives, exclude none. Clearly, they are tautologies in a perfectly good and indeed quite striking sense. The Wittgenstein-von Wright notion of tautology thus seems to be completely vindicated, as it in a certain sense is. In fact, von Wright has seen the extension of distributive normal forms to the whole of first-order logic along these lines as "an affirmative answer to the question . . . whether the idea of tautology can give a satisfactory account of formal truths and 'independence of content' in the Logic of Relations."[24]

This important thesis requires certain explanations and qualifications, however. First, we have to see what constituents—that is, descriptions of those alternative 'possible worlds' which our sentences are supposed to admit or to rule out—look like in the full first-order case.[25] This is a straightforward task. In fact, constituents may still be taken to be of the very same form (3) or (3)* as in the monadic case. In other words, a constituent is still a specification of which kinds of individuals exist and which ones do not. However, these 'kinds of individuals' described by "$Ct_1(x)$", "$Ct_2(x)$", . . . cannot be defined any longer by specifying simply the properties x has and has not. They have to be characterized by speaking, over and above the properties x has and the relations it bears to itself, also of what kinds of further individuals there exist in relation to x. In other words, each $Ct_i(x)$ is now of the form

(4) $$\pm A_1(x) \& \pm A_2(x) \& \ . \ . \ .$$

$$\& \pm (\exists y)Ct_1(x,y)$$

$$\& \pm (\exists y)Ct_2(x,y)$$

$$\& \ . \ . \ .$$

where $A_1(x)$, $A_2(x)$, . . . are all the atomic formulas that can be formed from the members of π and 'x' and where $Ct_1(x,y)$', '$Ct_2(x,y)$', . . . specify all the different kinds of individuals y there may exist in relation to a fixed x. How they do this depends on what the restriction on depth is that we are presupposing. If the restriction is ≤ 2, then each $Ct_i(x,y)$ is simply of the form

(5) $$\pm A_1(x,y) \& \pm A_2(x,y) \& \ . \ . \ .$$

where '$A_1(x,y)$', '$A_2(x,y)$' are all the atomic formulas which can be formed from π, 'x' and 'y', and which contain 'y'.

We shall call the Ct-expressions *attributive constituents*.

In the general case we may indicate depth by a superscript and define deeper attributive constituents in terms of shallower ones in analogy with (4), the only difference being the presence of further parameter-like variables:

(6) $Ct_i^{(d-e)} (x_1, \ldots , x_e) =$

$\pm\ A_1(x_1, \ldots , x_e)\ \&\ \pm\ A_2(x_1, \ldots , x_e)\ \&\ \ldots$

$\&\ \pm\ (\exists y)Ct_1^{(d-e-1)} (x_1, \ldots , x_e, y)$

$\&\ \pm\ (\exists y)Ct_2^{(d-e-1)} (x_1, \ldots , x_e, y)$

$\&\ \ldots$

where '$A_1(x_1, \ldots , x_e)$', '$A_2(x_1, \ldots , x_e)$', and all the atomic formulas that can be formulated out of π and 'x_1', , 'x_e' and which contain 'x_e'.

When $d = e$, only the unquantified part of (6) is needed. This gives us a basis for using (6) as a recursive definition (course-of-values recursion on depth) of attributive constituents. Since (3) serves to define constituents of depth d in terms of attributive constituents of depth $d - 1$, this suffices to characterize constituents in general.

In the same way as in the monadic case, we can rewrite (4) and (6) in terms of the non-empty (exemplified) attributive constituents only:

(4)* $\pm\ A_1 (x)\ \&\ \pm\ A_2 (x)\ \&\ \ldots$

$\&\ (\exists y)Ct_{j_1} (x,y)\ \&\ (\exists y)Ct_{j_2} (x,y)\ \&\ \ldots$

$\&\ (y)[Ct_{j_1}(x,y) \bigvee Ct_{j_2} (x,y) \bigvee \ldots]$

(6)* $\pm\ A_1 (x_1, \ldots x_e)\ \&\ \pm\ A_2(x_1, \ldots , x_e)\ \&$

$\&\ (\exists y)Ct_{j_1}^{(d-e-1)} (x_1, \ldots , x_e, y)$

$\&\ (\exists y)Ct_{j_2}^{(d-e-1)}(x_1, \ldots , x_e, y)$

$\&\ \ldots$

$\&\ (y)[Ct_{j_1}^{(d-e-1)}(x_1, \ldots , x_e, y) \bigvee Ct_{j_2}^{(d-e-1)}(x_1, \ldots , x_e, y) \bigvee \ldots]$

where $Ct_{j_1}(x,y)$, $Ct_{j_2}(x,y)$, . . . and $Ct_{j_1}(x_1, \ldots x_e, y)$, $Ct_{j_2}(x_1, \ldots x_e, y)$, . . . are all the exemplified (nonnegated) attributive constituents listed in (4) and (6), respectively.

There is one completely new thing here, however, as compared with the monadic case. When only monadic predicates were present, no constituents could be inconsistent. In the full first-order case, constituents (as defined above) are often inconsistent. For a fixed π and d (maximal depth allowed), we can of course eliminate all the inconsistent ones effectively, since there are only a finite number of them. This cannot be done independently of d (as soon as there is even a single relation in π), for it is readily seen that this would

yield a decision procedure for the whole first-order logic, which is known to be impossible. (For instance, showing the logical truth of a formula F of depth d is tantamount to showing that the constituents of depth d which are missing from the distributive normal form of F are all inconsistent. Showing that F logically implies G amounts to showing that the constituents occurring in the normal form of F but not in that of G are inconsistent, and so on.) Moreover, even when d is as low as three, there exists no effective method for locating all inconsistent constituents independently of π.[26] Von Wright has shown that the case $d = 2$ admits of a decision method.[27] This result, which also follows easily from earlier decision results,[28] shows that Quine's emphasis is not quite right when he says[29] that "what evidently gives general quantification theory its escape velocity is the chance to switch or fuse the variables attached to a predicate letter, so as to play 'Fyx' or 'Fxx' against 'Fxy'." This chance exists after all already in the case $d = 2$.

Apart from the recursive unsolvability of the problem of recognizing inconsistent constituents, the situation is precisely the same in the general first-order situation as in the earlier, simpler cases.[30] A sentence of a given depth can be effectively turned into a disjunction of constituents of the same depth (and with the same π, of course.) Constituents in turn behave in the same way as of old, and hence can be thought of with the same justification as before as representing a set of pairwise mutually exclusive and collectively exhaustive possibilities. Hence the only thing that might make a difference to the thesis of the tautologicity of logical truth is the elimination of inconsistent constituents. Once they are eliminated, logical truths are precisely those sentences whose distributive normal form is maximally long, just as in propositional logic. The tautologicity of the logical truths of quantification theory therefore hinges on the question whether the elimination of inconsistent constituents yields or presupposes non-tautological information.[31]

In order to gain a perspective on this matter, let us have a quick look at the reasons why some constituents are not satisfiable. Suppose, for the purpose, that (4)* occurs in (3)*. Let us suppose that (3)* is true in a model M with the domain D. Then the kinds of individuals there are in D are listed twice here, first by the attributive constituents $Ct_i(x)$ of (3)* and then by the attributive constituents $Ct_j (x,y)$ of (4)*. These two lists differ in that the latter is relative to the 'fixed-point individual' x, and also in that the relevant 'kinds' are in the latter specified by means of d-2 layers of quantifiers but in the former by means of d-1 layers. Apart from these harmless discrepancies, the two lists must match, for they are lists of the very same individuals. This imposes a structural requirement on the constituent (3)*. If the requirement is not satisfied, the constituent in question is inconsistent. The same requirement admits of a straightforward generalization to the attributive constituents occurring (unnegated) in a given constituent, or attributive constituent, e.g., in (6)*.

More specifically, each member of the 'absolute' list (3)* must find a niche

in each 'relative' list (4)* occurring in (3)*, and *vice versa*. Here we have a more general formulation of the requirements von Wright has referred to in picturesque terms as the 'Fitting-in-Problem' and the 'Completing-Problem', respectively.[32] It may be shown, with a qualification which we may here forget,[33] that the failure of one of these two requirements is at bottom the only kind of inconsistency in first-order logic.

However, another qualification which we cannot leave alone is the fact that in order for these requirements to become operative we usually have to expand a given (as it were) 'latently inconsistent' constituent into a disjunction of deeper ones. Apart from these two qualifications, however, it can be shown that von Wright's discussion in 'On Double Quantification' (DQ) of what might perhaps appear to be a trivial special case of first-order decision problems is in a sense highly indicative of the general reasons why first-order sentences can be inconsistent.

How is this relevant to the tautologicity problem? Again pragmatic considerations are the relevant ones in answering the question. The best line of argument I can see for the tautologicity of the truths of first-order logic is the following. These truths of logic turn on the elimination of inconsistent constituents. Since these constituents are not satisfiable in any model, eliminating them does not eliminate any real possibilities (possible states of affairs, possible courses of events, or whatnot). Hence eliminating inconsistent constituents, that is, proving logical truths, does not eliminate any objective possibilities a sentence serve to rule out, and hence does not add any information that the sentence did not already possess. Hence the tautologicity of first-order logic.

This line of thought can be put to a further perspective which brings to light important philosophical repercussions. We shall return to them later. Meanwhile, the force of the argument can be illustrated by pointing out a near-analogy[34] to the way in which a constituent specifies a possibility concerning the reality it can say something about. It does not specify this possibility in the way an ordinary ready-made picture specifies one, but in the way a jigsaw puzzle could picture whatever it depicts in its completed state. Inconsistent constituents fail to describe a world in the same way an incoherent jigsaw puzzle fails to depict a state of affairs. In fact, failing to solve a Fitting-in-Problem is like having two irreconcilable pieces at hand, and failing to solve a Completing-Problem is like having a piece with a gap which cannot be filled by any of the available pieces.

Thus throwing out an inconsistent constituent does not mean dismissing a possibility concerning the world. Such a constituent just cannot be used to express any conceivable state of affairs. For this reason, dispensing with it cannot increase the 'real' information of any sentence in whose distributive normal form it occurs. Eliminating such a constituent therefore *is* a tautological process, and the tautologicity thesis obtains.

It seems to me that this is in fact a valid and important insight and that von Wright deserves a great deal of credit for emphasizing it. It requires a major qualification, however.

Before explaining what this qualification is, we must add a few comments on the techniques used in arriving at it. First, the defense of general philosophical theses is not the only important use to which distributive normal forms can be put. Technically these normal forms have been used by von Wright (partly together with Peter Geach) mainly to investigate certain special decision problems, especially those involving only two layers of quantifiers.[35] Curiously, a special case of von Wright's treatment of the case of formulas with at most two layers of quantifiers has subsequently been repeated by Quine using precisely the same technique.[36] Quine does not acknowledge von Wright's anticipation, however, and seems unaware of it.

From the impossibility of eliminating inconsistent constituents recursively already when three layers of quantifiers are present—even when we restrict ourselves to one binary relation over and above a number of monadic predicates[37]—it seems to follow that the uses of distributive normal forms are probably rather limited in the direction of solvable cases of the decision problem. In fact, the main cases dealt with by von Wright have been shown by Ackermann to reduce to previously-known decidable cases (see note 28 above.) It is not impossible, however, that more can be done in this direction.[38] A practical difficulty is of course posed by the enormous length and number of constituents in most of the interesting cases. The resulting abstractness of the decision procedure has even occasionally caused minor slips in their application.[39] Constituents and distributive normal forms appear much more useful for the purposes of systematic logical theory. An illustration is offered by the different results concerning various kinds of definability in first-order theories.[40] Although these have only partly been discovered by means of constituents and distributive normal forms, most of them can be given simple and illuminating formulations and proofs by their means.

The theory of distributive normal forms also remains to be developed in several directions, for instance in higher-order logic and in infinitary logics. Even in propositional modal logic, a more elegant treatment can be given than is found in the literature.[41]

The technique of distributive normal forms, and the philosophical morals drawn from it, can be cast into a sharper profile by contrasting it to certain other approaches to logic. Von Wright has sometimes (for instance in *Form and Content in Logic* (FCL) explained the tautologicity thesis by starting from the idea of *logical form* and by partly assimilating to each other the ideas of tautological truth and of formal truth. Notwithstanding the obvious connections between the two ideas, a sharper contrast between them is likely to enhance the interest of the Wittgenstein-von Wright notion of tautology. The strategy

on which the form-content idea is based is familiar. We replace in a given sentence certain expressions (the non-logical constants) by variables, leaving only logical expressions intact. If now a true sentence results whenever the variables are again replaced by constants (of suitable type), the original sentence and the formula obtained from it are said to be formal or logical truths.

This line of thought is too full of loose ends, however, to be satisfactory. For one thing, it has never been carried out seriously for any interesting fragment of natural language. Instead, logicians have quietly introduced their own canonical notation instead of seriously trying to derive it from the structure of natural language. To this day, the 'logical form' of the quantifier-expressions of natural language remains a problem.[42]

Secondly, the explanation of logical truth so given depends on one's supply of constants of different types. It is not clear that one can even assume with a good theoretical conscience that there always are enough such constants.

The kind of syntactical approach for a while encouraged the notion that logical truths are somehow based on the syntactical rules ('conventions') governing our language. The term 'tautology' was widely used, or misused, by logical positivists in the thirties to express such alleged 'conventionality' of logical truth. No satisfactory analysis of the conceptual situation, and in particular of these alleged syntactic conventions, was ever given, however, and this watered-down sense of 'tautological' as a near-synonym of the (already problematical) term 'analytical' has since been gradually forgotten.

In contrast to it, the Wittgenstein-von Wright sense of tautology is much crisper. As was already emphasized, it yields a sharp conceptual reason why tautologies so understood are uninformative in a perfectly good sense of the word.

The technique of distributive normal forms has certain affinities with the increasingly important semantical or model-theoretical conceptualizations. Earlier (note 17 above) it was mentioned that in propositional logic the use of distributive normal forms is a syntactical mirror image of the technique of truth-tables, which is essentially a semantical method. In many of his writings in deductive logic, von Wright shows how distributive normal forms yield in many cases decision methods which are very much like truth-table techniques. One might even consider the whole idea on which distributive normal forms are based as a kind of systematic generalization of truth-table techniques on a syntactical level.

This does not bring distributive normal forms within the orbit of logical semantics or model theory, however, at least not in any customary sense of these disciplines. Certain differences are especially important to note here. Among other things, the crucial notion of considering so many individuals together in their relation to each other, which is codified in our concept of depth,

is not a model-theoretical one. It has little relation to the cardinality of the domain from which the individuals in questions are thought of as being drawn. For instance, the sentence, 'every man has a father and a mother' in a sense speaks of billions of human beings. Yet in our sense only two individuals are considered together in it.

In FCL von Wright uses model-theoretical ideas to explain how the truths of monadic first-order logic are 'empty' in the sense of being valid in every finite domain. He points out, however, that there are relational formulas which are true in every finite domain but which can nevertheless be false in an infinite model. This shows that the model theory of finite domains cannot serve as an explication of the Wittgenstein-von Wright idea of tautology. The resulting disillusionment with simple-minded model-theoretical ideas is one of the things that have prompted von Wright to look for a better account of the idea that logical truths are tautological and devoid of content.

The technique of distributive normal forms, which according to von Wright provides such a better account, occupies in fact a curious position between model theory and proof theory. It is a proof technique which in some suggestive sense is especially close to model-theoretical ideas. The purely syntactical operations it involves in proving and disproving formulas—as we shall see, the chief operation in question is simply increasing the depth of our constituents—are naturally seen as step-by-step attempts to construct suitable models for the formula in question or for its negation. A proof is obtained when a counterexample construction is frustrated in all directions, and a disproof results for a sentence when an attempted model construction for it likewise turns out to be abortive.

This strategic position of distributive normal forms half-way between model theory and proof theory is to some extent shared by certain other techniques, notably by the method of Herbrand expansions.[43] The technique of distributive normal forms is more systematic (and hence in practice usually more cumbersome) than Herbrand methods because in it the models are constructed as fully as possible at each stage and as it were simultaneously from all different directions. The same feature brings it even closer to model-theoretic ideas, however.[44] One may even raise here the strategic question whether the technique of distributive normal forms might perhaps be used to build a kind of approximative model theory for certain proof-theoretical methods and results—a kind of model theory of proof theory, as it were. The prospects of this idea remains to be investigated, however. Here it merely serves to highlight the peculiar and interesting character of distributive normal forms.

One important further philosophical point remains to be made. At the same time as the theory of distributive normal forms in a sense vindicates (in the important case of first-order logic) the Wittgenstein-von Wright idea of the

tautological character of logical truth, it also shows—somewhat ironically—
that there is a no less interesting sense in which many of the very same truths
are *not* tautologies. An important qualification to von Wright's philosophy of
logic thus has to be registered, especially as he does not seem to have empha-
sized the point himself. This result may perhaps not be entirely unexpected in
view of the undecidability of first-order logic, which suggests that there must
be some important differences between the tautologies of propositional logic
(as well as of monadic first-order logic) and the 'tautologies' of the relational
part of first-order logic.

In order to see what this important qualification is, we cannot do better than
to have a look at von Wright's own illustration of the allegedly tautological
character of logical truth. There is a beautiful example in *Den logiska empir-
ismen* (LE), pp. 71–75. There von Wright is discussing a proof of the Euclid-
ean theorem that the internal angles of a triangle equal two right angles (Eu-
clid's Prop. 32 of Book I). The proof can be carried out by reference to the
following figure:

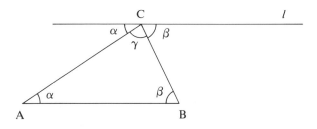

Figure 1

Here the line *l* has been drawn through C parallel to AB. By appealing to the
theorem about the equality of alternate angles when a line meets two parallel
lines (Euclid's Prop. 29 of Book I) the desired proposition can easily be made
equivalent by noting the equality of the different angles as indicated in Fig-
ure 1.

Von Wright now argues that the stop from the former theorem to the latter
is tautological. "The proposition about the internal angles is therefore 'con-
tained in' the proposition about the alternate angles. That this relation of being
'contained in' means a tautological connection can be seen most easily by
thinking of the former theorem as a *special case* of the latter."

This von Wright proposes to do by considering Fig. 1 as a special case of
the following figure, where line *l* is again assumed to be parallel to AB.

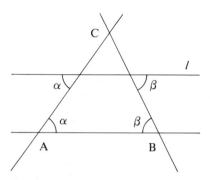

Figure 2

The sense in which Fig. 1 is a special case of Fig. 2 is clear: in the former the point C 'happens to lie' on the line *l*. All that is involved in Fig. 2 are merely two different applications of the theorem about alternate angles. Since Fig. 1 is obtained as a special case of Fig. 2, the proposition depicted by the former is therefore a 'special case' of the one depicted by the latter, it is suggested.

This illustrates aptly the kind of tautologicity with which we have so far been concerned.[45] What it shows is that in every conceivable state of affairs (geometrical configuration) in which the theorem about alternate angles holds the theorem about the internal angles of a triangle also holds. Nothing is ruled out that was not already ruled out by the former; hence, in a sense, no new information is added by the latter to the former.

From this it does not follow, however, that the latter is, in the most natural sense of the word, a tautological consequence, let alone a special case of the former. In order for their relation to become evident, more is required than that the point C merely happens to lie on the line *l*. We must have drawn all the four lines AB, AC, BC, and *l*, which is more than is required to illustrate *either* theorem. For to illustrate the theorem about alternate angles we need only the lines AC and *l* (or BC and *l*), and to illustrate the theorem about the internal angles we do not need the line *l* at all. In other words, we must consider more complicated geometrical configurations in order to bring out the desired relationship between the two propositions than are considered in either proposition alone. This is an important fact, for it implies that the latter proposition cannot be seen to hold simply by looking at figure which illustrates the former one nor therefore just by contemplating what the two propositions say (in a perfectly good sense) of geometrical configurations. Hence in a natural sense the latter proposition cannot be a merely special case ('corollary', as truly special cases are often called in geometry) of the former. We must carry out

what in the old geometrical jargon used to be called *auxiliary constructions* in order to see the relation between the two.[46] We must apply the former repeatedly in more complicated geometrical situations than the ones in which it already comes into play, with which it ostensibly deals and which are normally used to illustrate it. If geometrical arguments (deductive arguments used in geometry) are called tautological, then this tautologicity is of a rather strange character in that it is manifested only after suitable auxiliary constructions have been carried out.

This role of auxiliary constructions did not escape the attention of several earlier philosophers of logic and mathematics. For instance, I have argued on earlier occasions that it is what underlies Kant's description of the mathematical (as distinguished from the philosophical) method and also underlies his idea of the synthetic character of mathematical truths.[47] Recently, it nevertheless has often been dismissed as having merely to do with the peculiar way figures are used to illustrate the 'real' logical proofs which go into a satisfactory axiomatic treatment of geometry and which allegedly are not affected by this need of 'auxiliary constructions'.

This dismissal is in reality mistaken. We can in fact use distributive normal forms to explain in what sense the need of auxiliary constructions in geometry is merely an indication of a much more general phenomenon which thoroughly confounds much of the usual talk of the tautological character of logical truth and of a conclusion's being 'contained in' of merely being a 'special case' of the premisses of a logically valid inference. Although the underlying general point is of course independent of the technique of distributive normal forms, they offer us an especially vivid illustration of the situation.

Earlier, it was said that in the full first-order case (relational case), some constituents are inconsistent. Moreover, a sketch of the reasons why they can be inconsistent was outlined. These reasons have to do with the way in which the several parts of a constituent C must hang together. These several parts are essentially lists of a model in which C is true. Since these individuals are always drawn from one and the same domain,[48] all these different lists must be compatible with each other. Constituents which fail to satisfy this requirement (which can easily be spelled out explicitly) are called *trivially inconsistent*. They can be recognized by an effective procedure.

Now the truly remarkable feature of the conceptual situation is that a trivially consistent (i.e., not trivially inconsistent) constituent may nonetheless turn out to be inconsistent. In other words, there are constituents which cannot be faulted by an internal evidence. However you compare the different parts of such a constituent, you will find them coherent (unlike the different parts of a trivially inconsistent constituent). The story the constituent tells of the different individuals that are supposed to exist in the world is unflawed. No matter how

you turn the constituent around and no matter how minutely you collate its details, you will not detect any discrepancies between them.

How, then, can the inconsistency of some such constituents be nevertheless established? Why can we say that in the last analysis the incompatibility of those different lists that a constituent contains must be the reason for its inconsistency?

The answer is that each inconsistent constituent C eventually becomes a disjunction of *trivially* inconsistent constituents when its depth is increased more and more. Although we could not gather the inconsistency of C from any comparison between the different things it says of the world, this inconsistency is manifested through such comparisons if C is first expanded into a disjunction of sufficiently deep constituents. But we cannot always predict how far we must go to reach this depth. In the same way as the inconsistency of C cannot be perceived from C itself, we cannot have any effective method of telling from C how deep we may have to go to detect whatever hidden inconsistencies may lurk in C. This difficulty is compounded by the fact that often we may have to go quite deep, for the function that tells us (as a function of the Gödel number of C) how many new layers of quantifiers have to be introduced can be shown to grow faster than any recursive function.

Logical truths which turn on the elimination of non-trivially inconsistent constituents are thus themselves non-trivial in a striking sense. The additional depth to which we have to go to eliminate the relevant inconsistent constituents can in fact serve as a rough index of the non-triviality of these logical truths.[49] They are non-trivial and non-tautological both in the sense that their logical truth cannot in any reasonable sense be seen from them alone and also in the sense that they cannot be done justice to by any talk of special cases. For instance, when an implication $(F \supset G)$ expresses a non-trivial logical truth (of quantification theory), this means that its logical truth cannot be accounted for by saying that the possibilities (expressed by constituents) ostensibly admitted by F are all among those admitted by $G,$ too. In order to bring to light the status of $(F \supset G)$ as a truth of logic, we have to consider finer distinctions between different cases (i.e., consider deeper constituents) than are acknowledged in $(F \supset G)$. In this important sense, G is not a 'special case' of F (unlike a trivial consequence of F).

What, thus, does this inevitable increase in depth mean in intuitive terms? An answer is implicit in the explanation given above of the notion of depth: it is the number of individuals considered together in a proposition, or, in other words, the maximal complexity of the configurations of individuals we are considering together in it. The necessity of increasing it for the purpose of establishing non-trivial logical truths hence amounts to the necessity of considering, say, in a non-trivial proof of a proposition from another configurations

of individuals more complex than those considered in either proposition alone. This, clearly, is nothing but the general logical counterpart to the need of carrying out auxiliary constructions in elementary geometry.[50] Even though we can carry out the arguments which take us from one geometrical theorem to another by means of formal logic, these logical arguments must themselves contain steps that are but translations of auxiliary constructions into a logician's jargon. They are steps introducing new geometrical entities into our argument. Even if figures drawn for our eye's benefit serve merely illustrative purposes, it by no means follows that auxiliary constructions don't have a better job to do, either.

The contrary is in fact the case. In abstract logical terms, constructions amount to deductive steps in which we introduce new individuals into a geometrical argument or, perhaps better expressed, begin to consider more complex configurations of geometrical entities. This is in principle precisely the same thing as moving from shallower constituents to deeper ones. What is crucial in both cases is just that we begin to consider more individuals together in their relation to each other than before, i.e., begin to consider more complex configurations of our individuals (members of our universe of discourse).

This necessity of considering configurations of more individuals in establishing a logical truth than in this truth itself (and even of considering unpredictably many auxiliary individuals) is not a peculiarity of the technique of distributive normal forms but can be shown to obtain much more widely.[51] These normal forms merely offer an especially vivid illustration of the need of 'auxiliary individuals'. Moreover, the special case they constitute is in certain respects representative of the customary proof procedures.[52]

Now we can return to the observations we made above in terms of von Wright's own geometrical illustration of the (in a sense) tautological nature of logical truth to the effect that in a different sense these truths are *not* tautological. The former sense we shall call *depth tautology,* the latter *surface tautology.*[53] What we have since found is that this example is not tied to any peculiarities of its geometrical subject matter but is completely representative of the typical situation in first-order logic. Many logical truths of first-order logic (quantification theory) are not trivial in that they are not surface tautologies. They are non-trivial because they cannot be established without introducing auxiliary constructions in many geometrical proofs. Because of this need of considering more complex configurations—and even configurations of effectively unpredictable complexity—the logical truth of a proposition cannot always be seen from this proposition itself in any reasonable sense of the expression. It simply is not the case that by looking at a logical truth or at a geometrical theorem (or at a figure illustrating it) in a suitable way and in a suitable mood we can in principle always *see* the validity of the truth of the theorem right there, as such empiricists as Ernst Mach have alleged. Even God

could not *see* it there without introducing the auxiliary individuals needed in the proof. In this important and vivid sense, many first-order logical truths are non-trivial (i.e., are not surface tautologies).

Von Wright has called mathematics "the . . . discipline which in the course of two and a half millenia has gradually built one of the most sempiternal and noblest achievements of the human spirit."[54] This statement need not contradict the thesis of the tautological character of mathematical and logical truth when the precise import of this thesis is appreciated. However, the conjunction of the two claims amounts to an outright challenge of accounting for the non-triviality ('nobility') of mathematical truths by some means other than the notion of tautology (depth tautology) employed in the tautologicity thesis.

Not many recent philosophers have risen to this challenge. Like a whole generation of philosophers, von Wright has not realized that we already have tools in our hands for trying to spell out some of the objective bases of the non-triviality of the marvellous structure of mathematics and logic. In fact, what seem to me the best paraphernalia for the purpose, distributive normal forms, happen to be his own favorite tools in deductive logic and have even been partly developed by him.

DEPARTMENT OF PHILOSOPHY JAAKKO HINTIKKA
FLORIDA STATE UNIVERSITY
TALLAHASSEE
MARCH 1973

NOTES

1. The works of von Wright most relevant for this essay are perhaps the following:

Den logiska empirismen. En huvudriktning i modern filosofi. [Logical Empiricism. A Principal Movement in Modern Philosophy.] Helsingfors: Söderströms, 1943.

'On the Idea of Logical Truth (I)'. *Societatis Scientiarum Fennica*. Commentationes Physico-Mathematicae 14: 4. Helsinki 1948.

Form and Content in Logic. London: Cambridge University Press, 1949.

'On the Idea of Logical Truth (II)'. *Societatis Scientiarum Fennica*. Commentationes Physico-Mathematicae 15: 10. Helsinki 1950. (ILT II)

An Essay in Modal Logic. Amsterdam: North-Holland Publishing Company, 1951. (EML)

'Deontic Logic.' *Mind,* n.s. 60 (1951), 1–15. (DL)

'On an Extended Logic of Relations'. By P. T. Geach and G. H. von Wright. *Societas Scientiarum Fennica*. Commentationes Physico-Mathematicae 16: 1. Helsinki 1952. (ERL)

'On Double Quantification'. *Ibid.* 16: 3. Helsinki 1952. (DQ)

Logical Studies. London: Routledge & Kegan Paul, 1957. (Includes reprinted versions of ILT I, FCL, DL, and DQ.) (LS)

Logik, filosofi och språk (Logic, Philosophy and Language.) Helsingfors: Söderströms, 1957. Second rev. and extended ed., Stockholm: Aldus/Bonniers, 1965.

Norm and Action. A Logical Inquiry. London: Routledge & Kegan Paul, 1963. (NA)

The Logic of Preference. An Essay. Edinburgh: Edinburgh University Press, 1963. (LP)

An Essay in Deontic Logic and the General Theory of Action. Amsterdam: North-Holland Publishing Company, 1968. (EDL)

The philosophical perspectives here emphasized are perhaps most prominent in FCL and LE. The avowed aim of ILT I is "to show that the idea of tautology has a wider range of application than is sometimes thought."

2. George Boole, *An Investigation of the Laws of Thought* (London: Walton and Maberly, 1854), p. 75 (Ch.V, sec. 11).

3. David Hilbert and Wilhelm Ackermann, *Grundzüge der theoretischen Logik* (Berlin: Springer, 1928).

4. David Hilbert and Paul Bernays, *Grundlagen der Mathematik* I–II (Berlin: Springer, 1934–39).

5. H. Behmann, 'Beiträge zur Algebra der Logik, insbesondere zum Entscheidungsproblem', *Mathematische Annalen 86* (1922), 163–229.

6. Von Wright's treatment of the monadic case is given in ILT I and sketched in FC.

7. See ILT II, ERL, and DQ.

8. Jaakko Hintikka, *Distributive Normal Forms in the Calculus of Predicates* (Acta Philosophica Fennica, 6, Helsinki, 1953).

9. See *Grundlagen* I, pp. 146–8: "Eine einfach charakterisierbare Normalform erhalten wir auf diese Weise im allgemeinen nicht."

10. First in EML.

11. Examples are offered by DC, NA, LP, and EDL.

12. The connection is pointed out by von Wright in FCL, p. 13. For Wittgenstein's idea of tautology, see the *Tractatus,* Propositions 4.46–4.661, 6.1–6.1256, and Max Black, *A Companion to Wittgenstein's Tractatus* (Cambridge: Cambridge University Press, 1964), pp. 228–235, 317–322.

13. In the index of A. J. Ayer's *Language, Truth, and Logic* (London: Gollancz, 1936) we read: "Tautology, *see* analytical truth."

14. Proposition 4.461.

15. The concept of tautology used here can be given a deeper foundation by first

characterizing the notion of information as it is naturally used here and then identifying tautologies with sentences whose information equals zero. Cf. Jaakko Hintikka, *Logic, Language-Games, and Information* (Oxford: Clarendon Press, 1973), Chapters VII–VIII.

16. No distributive normal forms of any other sort will be discussed in this paper. Conjunctive normal forms are simply duals of the disjunctive ones.

17. It is easy to describe procedures for converting a formula F into its distributive normal form. Such procedures are found, e.g., in Hilbert and Ackermann. In fact, each constituent in the normal form of F corresponds to a row in its truth-table which makes F true, and vice versa. The truth-values of such a row correspond to the pluses and minuses in (1). From the truth-table of F we can therefore read its distributive normal form, and vice versa. Thus there is a close connection between the truth-table technique and the use of distributive normal forms. The latter might even be considered as a kind of syntactical counterpart to the former.

18. A small problem is here posed by the constituent (3) in which there are only minuses and no pluses. This constituent describes an empty world, that is, a world devoid of all individuals. In most of the usual formulations of quantification theory, such a constituent is disprovable. Yet it describes logically possible states of affairs, and hence ought to be admitted as a consistent sentence.

Since we have identified disjunctions of zero members with contradictions, (3)* becomes in the case equivalent to (x) $(Ct_i(x)$ & $\sim Ct_i(x))$, which clearly is true in an empty world and in such a world only.

19. Hintikka, *Logic, Language-Games, and Information* (note 15 above), Chapters VII–VIII.

20. Pointing this out is the avowed purpose of ILT I.

21. Thus what essentially distinguishes the general first-order situation from the special case of monadic logic is the presence of at least one relation.

22. There are all sorts of important problems connected with the idea of a 'random individual'. They extend from Aristotle's concept of *ecthesis* to problems connected with the instantiation rules of modern logic. See Hintikka, *Logic, Language-Games, and Information,* (note 15 above) pp. 110–111.

23. This definition may—and for certain purposes must—be sharpened somewhat by pushing further the question as to when the individuals considered in S are really considered *together* in their relation to each other. This sharpening is beside our purposes here, however. Another question is when these individuals are really *different* from each other. For such details, see Hintikka, *Logic, Language-Games, and Information*, pp. 139–143.

24. LS, pp. 19–20.

25. With the following, cf. Hintikka, *Logic, Language-Games, and Information*, Chapter XI.

26. See, for instance, Janos Surányi, *Reduktionstheorie des Entscheidungsproblems in Prädikatenkalkül der ersten Stufe* (Budapest: Verlag der ungarischen Akademie der Wissenschaften, 1959.) The result in question was first established by Surányi in 1943.

27. See DQ; also ILT II and ELR.

28. See Wilhelm Ackermann's review of DQ in the *Journal of Symbolic Logic, 17* (1952), 201–203.

29. See W. V. Quine, 'On the Limits of Decision'. *Akten des XIV. Internationalen Kongresses für Philosophie I–III* (Vienna: Verlag Herder, 1969), Vol. 3, pp. 57–62, especially pp. 61–62.

30. The presence of identity makes little difference here. (As an example, it may be mentioned that ELR is in effect the treatment of a case parallel to that treated in DQ (and ILT II) except for the presence of identity.)

31. Cf. on the question Hintikka, *Logic, Language-Games, and Information*, pp. 168–173.

32. DQ, p. 7.

33. There is strictly speaking a third type of inconsistency, due to the fact that every relative list will have to provide a niche for each 'fixed-point individual'. Explicit criteria for this type of inconsistency are easily formulated; see, e.g. *Logic, Language-Games, and Information*, p. 261, condition (C).

34. Cf. *Logic, Language-Games, and Information*, pp. 169–173. As pointed out there, more than a mere analogy is actually involved here. First-order decision problems reduce in fact to a kind of logicians' jigsaw puzzles called (by Hao Wang) *domino problems*. The restraints employed to define these problems are localized analogues to the 'Fitting-in-Problem' and to the 'Completing-Problem.'

35. See ILT I-II, DQ, ELR, and in part also, e.g., EML.

36. "On the Limits of Decision" (note 29 above).

37. See Surányi, *Reduktionstheorie* (note 26 above).

38. Especially in ILT II and in ELR, von Wright computes the number of consistent constituents in certain special cases. These calculations cannot be generalized, either, so as to become independent of depth. It is easily seen that, for each π (which contains at least one relation), the function $f(d)$ which specifies, as a function of the depth d, the number of consistent constituents of this depth is nonrecursive. Further connections between functions of this sort and decision problems are pointed out in Hintikka, *Logic, Language-Games, and Information*, pp. 255–257.

39. Cf. the review of ELR in the *Journal of Symbolic Logic 22* (1957), 72–73.

40. See Jaakko Hintikka, 'Constituents and Finite Identifiability', *Journal of Philosophical Logic, 1* (1972), 44–52. Further results (and further systematizations of earlier results) have been obtained in this direction by Jaakko Hintikka and Veikko Rantala.

41. Distributive normal forms have been used in modal logic outside von Wright's writings, for instance in A. R. Anderson, 'Improved Decision Procedures for Lewis' Calculus M', *Journal of Symbolic Logic 19* (1954), 201–214 (cf. the correction ibid. *20* (1955), 150); in M. J. Cresswell, 'A Conjunctive Normal Form for S 3.5', *Journal of Symbolic Logic 34* (1969), 253–255; and in Kit Fine, 'Normal Forms in Modal Logic', *Notre Dame Journal in Formal Logic 16* (1975), 229–237.

42. Out of vast and inconclusive literature, see, for instance, Barbara Hall Partee, 'Negation, Conjunction, and Quantifiers: Syntax vs. Semantics', *Foundations of Language, 6* (1970), 1153–165; Richard Montague, 'The Proper Treatment of Quantifiers in Ordinary English', *Approaches to Natural Language*, edited by Jaakko Hintikka, Julius M. E. Moravcsik, and Patrick Suppes (Dordrecht: D. Reidel, 1973); George Lakoff, 'On Generative Semantics', *Semantics: An Interdisciplinary Reader*, edited by Danny D. Steinberg and Leon A. Jakobovits, (Cambridge: Cambridge University Press, 1971), pp. 232–296, especially pp. 238–246.

43. See Jacques Herbrand, *Logical Writings*, edited by Warren D. Goldfarb, translated by Jean van Heijenoort (Dordrecht: D. Reidel, and Cambridge, Mass.: Harvard University Press, 1971) and the literature referred to there, especially the writings of W. Craig and Burton S. Dreben.

44. An attempt to develop a kind of model-theoretic counterpart to the technique of distributive normal forms is made in Jaakko Hintikka, 'Surface Semantics: Definition and Its Motivation', *Truth, Syntax, and Modality*, edited by Hugues Leblanc (Amster-

dam: North-Holland, 1973). See also Jaakko Hintikka and Ilkka Niiniluoto, 'On the Surface Semantics of First-Order Proof Procedures', *Ajatus 35* (1973), 197–215.

45. Von Wright's happy example may be compared with Ernst Mach's formulations (and illustrations) of the same point in *Erkenntnis und Irrtum* (Leipzig: Johann Ambrosius Barth, 1905), pp. 300–303.

46. For the traditional terminology for the different parts of a geometrical proposition, see Thomas L. Heath, *Euclid's Elements* I–III (Cambridge: Cambridge University Press, 1926), Vol. 1, pp. 129–131.

47. *Logic, Language-Games, and Information,* Chapters VIII–IX, and 'Kant on the Mathematical Method', *Kant Studies Today,* edited by Lewis White Beck (La Salle, Illinois: Open Court, 1969), pp. 117–140.

48. With the possible exception that successive draws may be, as a probability theorist would put it, 'without replacement'. (This will be the case when identity is present.) Recently, it has also turned out that even successive draws from a domain which is *not* constant but is varied in certain specific ways may have interesting applications. Cases in point are the "uncertainty descriptions" of Veikko Rantala; see his *Aspects of Definability* (Acta Philosophica Fennica 29, nos. 2–3). (Helsinki: Societas Philosophica Fennica, 1977).

49. Finer measures are discussed in Jaakko Hintikka, 'Surface Information and Depth Information', *Information and Inference,* edited by Jaakko Hintikka and Patrick Suppes (Dordrecht: D. Reidel, 1970), pp. 263–297.

50. This connection is not spoiled by the fact that in elementary geometry, unlike the general logical situation, the number of 'auxiliary constructions' *can* be effectively predicted. This follows from the existence of a decision procedure for elementary geometry. See Alfred Tarski, *A Decision Method for Elementary Algebra and Geometry,* 2nd ed. (Berkeley and Los Angeles: University of California Press, 1951.)

52. See Hintikka, *Logic, Language-Games, and Information,* pp. 183–185; also Hintikka and Niiniluoto, 'On the Surface Semantics of First-Order Proof Procedures' (note 44 above).

53. Cf. Hintikka, 'Surface Information and Depth Information' (note 49 above).

54. LE, p. 44.

23

Dagfinn Føllesdal

VON WRIGHT'S MODAL LOGIC

1. Introduction

Von Wright's work in modal logic proper, excluding deontic logic, tense logic, etc., makes up less than three percent of his total number of publications so far. Still, his contributions to modal logic are sizable, comprising most of two books and several additional articles. First there was *An Essay in Modal Logic* (1951), followed by 'Interpretations of Modal Logic' (1952) and 'A New System of Modal Logic' (1953), both of which were reprinted in *Logical Studies* (1957), with the latter essay considerably expanded. *Logical Studies* also contained two previously unpublished essays closely related to modal logic, 'On conditionals' and 'The Concept of Entailment'. After *Logical Studies* von Wright has published seven more articles on modal logic and related issues: 'A Note on Entailment' (1959), 'Logikens modernisering' (1962, a popular survey article in Swedish on the development of nonclassical logic in our century), 'Quelques remarques sur la logique du temps et les systèmes modales' (1967), 'Some Observations on Modal Logic and Philosophical Systems' (1972), 'Truth as Modality: A Contribution to the Logic of Sense and Nonsense' (1973), and more recently 'A Modal Logic of Place' (1979) and 'Diachronic and Synchronic Modalities' (1979). In addition there is a review of Becker (1953) and scattered remarks in books and articles on other topics.

The first of these works, *An Essay in Modal Logic,* contains the four basic ideas that recur as the main themes in all of von Wright's work on modal logic: first, the observation that there is a thoroughgoing analogy between the modal operators and quantifiers; second, the utilization of this analogy to extend von Wright's earlier decision procedures for fragments of quantification theory, based on distributive normal forms, to various systems of modal logic; third,

I am grateful to Henrik Sahlqvist and Jon Barwise for their valuable comments.

the use of the distributive normal forms to define logical truth in modal logic; fourth, the exploration of different interpretations of modal notions in order to create a general study of modality, including not only deontic, epistemic, and doxastic modality but also other areas that exhibit similar structural patterns of interrelatedness and distributivity.

In this article, I shall first outline briefly the development of modal logic and place von Wright's work within it. Thereafter I shall present von Wright's ideas concerning the analogies between quantifiers and modal operators and discuss his applications of this analogy to get decision procedures and interpretations of modal logic in terms of distributive normal forms. Finally, I shall discuss briefly von Wright's ideas concerning other interpretations of modal logic and probability as a modal logic.

2. The Development of Modal Logic

One may distinguish four periods in the development of modal logic. First, there were the attempts by Aristotle, the medievals, Leibniz, MacColl, Peirce, and others to throw light on our use of modal expressions and modal reasoning. Notable achievements of this period were Aristotle's theory of modal syllogisms (which has been developed in modern form by von Wright in Appendix I of *An Essay in Modal Logic)* and Leibniz's attempt to provide a semantics for the modalities by appeal to possible worlds.

The second period was prompted by Russell's and Whitehead's unfortunate use in *Principia Mathematica* of 'implies' for the horseshoe. C. I. Lewis observed, rightly, that this is not how we usually use the word 'implies'. Instead of setting matters straight by pointing out that 'implies' is not a connective at all but refers to a relation between sentences,[1] Lewis followed Whitehead and Russell in regarding 'implies' as a connective and set to work on a calculus that would reflect the formal properties of a connective that he called 'strict implication'. This work started in 1912 and culminated in Lewis and Langford's five modal systems S1–S5 in 1932. It inspired a hectic activity which has continued to the present, of proving theorems, proposing new systems, and exploring their properties and interrelations.

In the years 1946–47, a third era in the development of modal logic started through two new developments. First, Ruth Barcan Marcus and Rudolf Carnap, independently of one another, presented the first systems of *quantified* modal logic.[2] Modal operators had been prefixed to sentences containing quantifiers earlier, e.g., by C. I. Lewis. However, what is new in Barcan Marcus and Carnap is that they quantify *into* modal contexts. Second, and more importantly, the *semantic* study of modal logic got underway with Carnap's theory of state descriptions.[3] Until then, almost all work in modal logic had been syntactic; systems had been constructed and theorems derived, but the distinc-

tion between validity under an interpretation and provability in a system had rarely been made. There were exceptions to this, e.g., the algebraic semantics for intuitionistic and modal logic developed in the late thirties and early forties by Stone, Tarski, Tang Tsao-Chen, McKinsey, and others, which is closely related to the use of so-called 'Boolean frames' in model theoretic semantics of the late sixties. However, this work had little impact on the philosophers who were working in modal logic in the forties and fifties.

Iterated modalities received no natural interpretation in Carnap's approach. For Carnap, what is true in every state description is necessary, what is true in some is possible, and any sequence of iterated model operators collapses into the last member, giving Lewis's system S5 as the only natural counterpart to Carnap's semantics.

The fourth period in the development of modal logic started in 1957 when Stig Kanger and Jaakko Hintikka independently of one another extended the semantic approach to iterated modalities.[4] They did this by introducing the notion of a so-called 'alternativeness relation' between state descriptions or possible worlds. Iterated modalities could be interpreted: to be necessarily necessary is to be true in all alternatives to the alternatives, and so on. This Kanger-Hintikka approach was further developed by Kripke in papers from 1963 on,[5] and has gradually been superseded by even more flexible approaches, like neighborhood semantics, etc. (Montague, Scott, and others[6]).

3. Von Wright's Work

Von Wright's work dates largely from the third and fourth of these periods, in which both quantifiers and semantics had entered the scene. However, although von Wright brings together quantifiers and modal operators, his aim is not primarily to use them together, as did Barcan Marcus and Carnap, although he does this too, in chapter VI of *An Essay in Modal Logic*. Von Wright is much more interested in the analogy between quantifiers and modal operators and the possibility it opens for extending decision procedures from quantification theory to modal logic. As for semantics vs. syntax, von Wright is primarily interested in the notion of validity, or logical truth, and this is a semantic notion. However, von Wright approaches validity not via state descriptions or models but via the notion of tautology, which he first extends from sentence logic to a fragment of quantification theory by developing a decision procedure for this fragment based on distributive normal forms. Thereafter, he adapts this decision procedure to modal logic with the help of the analogy between modal operators and quantifiers and extends the accompanying definition of logical truth correspondingly: a modal formula is logically true if and only if it is a tautology in this extended sense. Hence the semantic notion of logical truth is defined via the syntactic notion of a decision procedure and not by models.

We shall now consider these two basic ideas of von Wright's in more detail.

4. Quantifiers and Modal Operators

That there is a resemblance between modal operators and expressions like 'all' and 'some' has been long recognized. It is manifest in Leibniz's conception of the necessary as that which is true in all possible worlds and the possible as that which is true in some possible world. It also underlies Bolzano's definition of 'logical validity' as truth of all substitution instances, Carnap's interpretation of necessity as truth in all state descriptions, and many other interpretations of modality, early and late.[7]

However, von Wright seems to have been the first to explore and exploit systematically the analogy between modal operators and quantifiers. There are *two* analogies which von Wright notes and makes use of. First there is the structural analogy between the way the quantifiers relate to one another and the way in which the modal operators relate to one another. The quantificational notions 'every(thing)', 'some(thing)', and 'no(thing)' are interrelated and can be defined in terms of one another in just the same way as the modal notions 'necessity', 'possibility', and 'impossibility'. Secondly, and this has been less noted, the quantifiers and the modal operators have the same distributive properties: just as '$(\exists x)$ $(Fx \lor Gx)$' is equivalent to '$(\exists x)$ $Fx \lor (\exists x)Gx$', so '$\Diamond(p \lor q)$' is equivalent to '$\Diamond p \lor \Diamond q$'; and similarly '$\Box$', like the universal quantifier, distributes over conjunction.

5. Decision Procedures for Modal Logic by Means of Distributive Normal Forms

It is this second, distributive analogy between quantifiers and modal operators which is stressed by von Wright and is the basis for much of his work in modal logic, notably in *An Essay in Modal Logic*. This analogy enables him to extend to modal logic the decision procedure for monadic quantification theory that he had developed in 'On the Idea of Logical Truth (I)' (1948). Von Wright's decision procedure for monadic quantification theory consists in driving the quantifiers inward as far as possible and then applying the truth table decision procedure to check whether the resulting truth-functional compound is true for all choices of truth values for the sentence letters and existentially quantified constituents. As von Wright points out,[8] this decision procedure is essentially the same as that of Quine's in 'On the Logic of Quantification' (1945);[9] its basic idea goes back to Behmann's 'Beiträge zur Algebra der Logik, insbesondere zum Entscheidungsproblem' (1922).[10] However, von Wright's application of this decision procedure to modal logic is new.

In *An Essay on Modal Logic,* von Wright uses the same technique of normal forms to give decision procedures for a number of different modalities, including the epistemic and deontic modalities in addition to the logical or alethic ones. He also presents systems that combine epistemic and logical modalities, i.e., systems of quantified epistemic logic, and solves the decision problems for these too, using the same basic facts about the distributivity of the modal operators and of the quantifiers.

Strictly speaking, von Wright does not prove in *An Essay in Modal Logic* that his proposed decision procedures actually work. As pointed out by Krister Segerberg,[11] the first proof that a system equivalent to *M* is decidable is therefore due to J. Ridder, who in 1952 proved that system *t,* which was proposed by Feys in 1937, is decidable.[12] B. Sobociński in 1953 proved that this system, which he calls *T,* is equivalent to the system *M* of von Wright.[13]

The first decision procedures for any system of modal logic were, as far as I know, J. C. C. McKinsey's, which used matrices for Lewis's systems S2 and S4. These can easily be modified so that they also fit von Wright's systems *M, M',* and *M".*[14] However, McKinsey's decision procedures are very cumbersome; as McKinsey points out, in order to prove the validity of even relatively simple formulas one has to consider matrices with extremely large numbers of elements. In von Wright's decision procedures the corresponding check would be much shorter but still too long to be practical in anything but the most rudimentary cases. Alan Ross Anderson has improved von Wright's decision procedures further, so as to reduce the number of lines that must be checked to only a fraction of those that were needed in von Wright's original procedures.[15]

More recently, Kit Fine has extended the technique of normal forms to obtain the following result, among others.[16]

Let us call a system of modal logic *normal* if it includes classical truth-functional logic with *modus ponens* and substitution as rules of inference and in addition has the rule of necessitation:

$$\text{If } \vdash p, \text{ then } \vdash \Box\, p.$$

(This definition of 'normal' follows Lemmon and Scott;[17] Kripke calls a logic 'normal' only if in addition to the rule of necessitation it also contains the axiom schema '$\Box\, p \supset p$'.)

Let *K* be the system which in addition to being normal also has the axiom schema:

$$\Box\, (p \supset q) \supset (\Box\, p \supset \Box\, q).$$

Let us finally call a system *uniform* if it includes *K* and '$\Diamond\, (p \vee \bar{p})$' and if it contains as an axiom schema some uniform formula, i.e., a formula where

any two maximal strings of nested modal operators are of the same length. Thus, for example, '$\Box \Diamond p \supset \Diamond \Box p$' is a uniform formula, whereas '$\Diamond (\bar{p}.$ $\Diamond q) \vee \Diamond \Diamond r$' is not.

What Fine has proved, using the technique of normal forms, is the following theorem:

> *Each uniform system is complete and has the finite model property, and it is decidable if it is finitely axiomatizable.*

(That a system has the finite-model property means that given any nontheorem of the system, its negation is satisfiable in a finite model of the system.) One case of Fine's theorem is of special interest. Let M be the axiom '$\Box \Diamond p \supset$ $\Diamond \Box p$'. As just observed, this axiom is uniform. The system KM that we get by adding M to K has '$\Diamond (p \vee \bar{p})$' as a theorem and is therefore uniform. In virtue of Fine's theorem, it therefore is complete, has the finite model property, and is decidable.

This system, which has proved useful in tense logic, has received considerable attention in the literature. For several years it resisted numerous attempts to decide whether it was complete and decidable. Lemmon and Scott left the question open, and it remained open until Fine solved it. It is interesting that the solution was reached through using the method of distributive normal forms.

As was shown by Robert Goldblatt in his dissertation 'Metamathematics of Modal Logic' (1974),[18] Fine's result is particularly interesting for the following reason. The result may be interpreted as showing that the system KM is simply determined by the class of (finite) K-frames that satisfy a certain second order condition. Goldblatt shows that this condition cannot be replaced by a first order one, or even a set of first order ones. The stronger system, $KM4$, where 4 is the transitivity axiom '$\Box p \supset \Box \Box p$', was shown by Lemmon and Scott to be (strongly) determined by the class of transitive frames satisfying a certain first order condition. Goldblatt's result shows why Lemmon and Scott were not able to extend their results to the system KM.

(A *frame*, or *K-frame*, ('K' for Kripke), is an ordered pair $<U,R>$ where U is a nonempty set of elements called worlds; and R is a binary relation on U, called the accessibility relation or alternativeness relation for U. A frame is called *finite* if and only if U is finite.

An *assignment* or valuation V on the frame assigns to each sentence letter p a subset $V(p)$ of U, intuitively the set of all worlds in which p is true. Given an assignment V for a frame, we define the truth value $V(A, x)$ of a given formula A in a world x inductively, starting with $V(p, x) = T$ if and only if x is in $V(p)$, and continuing for nonatomic formulae by help of the usual induc-

tion steps for the truth-functional connectives and the following step for the modal operator '□':

$V(□ A,x) = T$ if, and only if, $V(A,y) = T$ in every world y which bears the relation R to x.

A is said to be *valid* in a frame if and only if $V(A,x) = T$ for every assignment V on the frame and every world x in U.

By imposing constraints on the relation R, for example requiring it to be transitive, one gets various classes of frames. A class of frames is said to (simply) *determine* or characterize a modal system if and only if all and only those formulas that are theorems in the system are valid in that class of frames. A class of frames *strongly determines* a modal system if and only if, given any set Φ of well-formed formulas, all and only those formulas that are derivable from Φ in that system are implied by Φ in that class of frames.)

Although Fine's theorem is probably the most interesting result reached by applications of distributive normal forms, they have also been used to get a large number of other results in modal logic. Kit Fine uses techniques similar to those of normal forms in other papers, e.g. in 'Logics Containing K4' (1974),[19] where he uses them to prove a theorem which is a modal analogue of a result of Fraïssé and Ehrenfeucht's (cf. section 6 below, n. 31). Hughes and Cresswell use them in *An Introduction to Modal Logic* (1968)[20] in order to obtain decision procedures for various modal systems, and Cresswell makes use of them in 'A Conjuctive Normal Form for S3.5' (1969).[21] J. F. A. K. van Benthem, in his dissertation (1976), uses normal forms to prove that if a modal formula has degree 1, then it is first order definable.[22]

In these and many other articles and books, the technique of distributive normal forms has partly contributed to give elegant and constructive proofs of standard results. Partly it has also made it possible to prove results that are not readily available by standard methods.

Lately, techniques related to those of normal forms have also become used in the theory of computer programming. In 'An Elementary Proof of the Completeness of PDL' (1980),[23] Dexter Kozen of IBM Thomas J. Watson Research Center uses techniques of this kind to give an elementary proof of the completeness of Krister Segerberg's axioms for propositional dynamic logic. Propositional dynamic logic is a logical system designed to describe and prove results concerning computer programs, their correctness and termination, their equivalences, etc. Early work in this field was done by C. A. R. Hoare and others in the late sixties. It was unified and generalized by V. R. Pratt in 1976,[24] using ideas from modal logic. Michael J. Fischer and Richard E. Ladner in 1977[25] defined a formal syntax and semantics for the propositional dy-

namic logic of regular programs. One problem they raised was to find a complete and natural set of axioms of rules for propositional dynamic logic. Such a set was proposed by Segerberg in 1977[26] and proven to be complete by R. Parikh in 1978.[27] The completeness of propositional dynamic logic had then long been a source of considerable controversy. Several completeness proofs had been proposed by various researchers. Many of these were shown to contain errors that in some cases were subtle, and all were complicated. Kozen's proof is essentially the same as Parikh's but is much simpler, partly due to its use of techniques similar to those of normal forms.

6. Interpretation of Modal Logic Through Use of Distributive Normal Forms

The motivating force behind von Wright's distributive-normal-form approach to quantification theory and modal logic is not primarily to develop decision procedures. Above all, from the time he introduced the notion, in 'Form and Content in Logic' (1949), his concern has been to extend—beyond the limit of propositional calculus—the definition of logical truth as tautology.[28]

What is characteristic of the third and fourth stages in the development of modal logic, sketched in section 2 above, is the distinction between semantics and syntax. The notion of logical truth is a semantic notion and is usually defined as truth in all models. Von Wright's definition of logical truth is syntactical: the normal forms are described syntactically as certain formulae written out in the language of first order logic.

Von Wright does not seem to be much disturbed by this. And, in fact, it is very easy to go from normal forms to model theoretic notions and back; one may, e.g., let the constituents in the normal forms correspond to certain sets that can be considered apart from the usual formal language.[29] In his thesis 'Distributive Normal Forms in the Calculus of Predicates' (*Acta Philosophica Fennica 6*, 1953), Hintikka showed that the definition of logical truth in terms of distributive normal forms is equivalent to the traditional criterion in terms of satisfiability. He thereby gave an affirmative answer to the question raised by von Wright in 'Form and Content in Logic' (1949), as to "whether the concept of a tautology of existence-constituents can give a satisfactory account of the idea of logical truth or 'independence of content' in the logic of Relations".[30]

Related ideas were developed independently and for a different purpose by Fraïssé and Ehrenfeucht in the mid-fifties.[31] They defined equivalence relations, not normal forms. However, the idea is basically the same. Hintikka and some of his co-workers have developed the idea further and given it a variety of applications in definability theory, information theory, and semantics. It has also been applied by Hanf and others to prove certain types of theories decidable. In his contribution to the *Festschrift* for Hintikka (1979),[32] Dana Scott

surveys the situation in the field of distributive normal forms and gives a set-theoretical definition of the notion of a normal form and its constituents. He gives an application to axiomatic set theory and shows that an apparently simple recursive definition is impossible because it would be equivalent to the truth definition.

The apparently simple idea of a definition of logical truth in terms of distributive normal forms hence has come a long way during the thirty years that separate von Wright's applications of it in 1949 and Dana Scott's 1979 paper.

7. Other Interpretations of Modal Logic

Distributive normal forms are only one of the approaches von Wright takes to interpreting modal logic. Examples of various other approaches abound in his writings. Von Wright does not think that there is one system of modal logic that can be singled out as the right one. He states his position succinctly in his 1953 review of two of Oskar Becker's works on modal logic:

> The very problem, however, of *deciding* between various modal logics does not appear to me important. The urgent problem in this connection is rather that of interpreting the systems, thus showing under what conditions and for what purposes they have a meaning and a use. Particularly promising appear to me such interpretations of modal logics which relate the notions of possibility and necessity to various types of effects (dispositions, potentialities) among natural phenomena.[33]

In 'Interpretations of Modal Logic' (1952) von Wright considers not only a geometrical interpretation of modal logic but also several physical models, including, for example, a population of human beings, some of whom have an epidemic disease. Letting 'p' stand for the class of people who have the disease and 'Mp' for the class of those who either have it or may catch it from members of p, von Wright discusses whether laws containing iterated modalities, like '$MMp \supset Mp$' hold under this interpretation. This is an empirical question, whose answer depends on the nature of the disease. Von Wright claims that the existence of various natural processes that illustrate different modal systems shows that neither of these systems "can claim universal validity for the concept of the possible (and the necessary) in modal logic, nor can either of them be rejected as contrary to the 'true' nature of modality".[34]

Alan Ross Anderson, in his review of von Wright's article in *The Journal of Symbolic Logic*, finds this argument unconvincing: ". . . the fact that we may be able to instance certain physical models of modal systems hardly seems even relevant to the question of determining which system (if any) most adequately represents our intuitive ideas of natural possibility or logical possibility."[35]

Von Wright may seem inconsistent on this point. Thus the year before he wrote the article that Alan Ross Anderson criticized, von Wright discussed in

An Essay in Modal Logic whether the Principles of Reduction, '$\Diamond \Diamond p \supset \Diamond p$' and '$\Diamond p \supset \Box \Diamond p$' are true or not. He concludes his discussion of the second principle in the following way:

> It may be helpful to consider epistemic modalities. The equivalent of the Second Principle of Reduction for epistemic modalities states that, if a proposition is not known to be false, then it is known that the proposition is not known to be false. This deduction of knowledge from ignorance appears plainly unacceptable, and should be considered at least a strong warning against assuming the Second Principle of Reduction to be true for the alethic modalities.[36]

These considerations, which might seem congenial for Alan Ross Anderson, drew criticism from the opposite side. P. F. Strawson, in his review of *An Essay in Modal Logic* in *Philosophy* (1953), writes:

> Prof. von Wright asks whether the Principles of Reduction are true or not. . . . For my part, it is his question I find difficult to understand. Since there is (as far as I know) no well-established usage of second and higher-order modalities to which we can appeal, how are we to answer his question unless it means "Shall we accept either or both of these principles?" Even this question we could answer other than capriciously only if there were some use we had in mind for higher-order modalities. But Prof. von Wright poses his question quite as if it stood, and called for an answer, independently of any use we made or might propose to make of higher-order modalities.[37]

Note that all of these reviews, von Wright's, Ross Anderson's, and Strawson's, came out during the same year.

The most reasonable interpretation of von Wright's view seems to me to be that, in the passage quoted from *An Essay in Modal Logic,* von Wright has already settled on an interpretation of the modal operators: that of logical necessity and possibility. In the article criticized by Ross Anderson and the review of Becker, von Wright is considering various other interpretations of different modal systems and is pointing out that there are many varieties. Even when one limits oneself to natural necessity and possibility, different natural phenomena exemplify different modal systems.

This latter point is illustrated also in von Wright's latest article on modal logic, 'Diachronic and Synchronic Modalities' (1979). Von Wright here distinguishes two kinds of modality, both having to do with processes in nature: *synchronic* modality expresses that it is necessary or possible at a certain time *t* that a proposition *p* is true at *t; diachronic* modality expresses that it is necessary or possible at *t'* that *p* has been or will be true at some other time *t*. Von Wright argues that the logic of the synchronic modalities is S5, while the logic of the diachronic modalities is S4.

Given the great variety of modal systems even within the realm of natural necessity, one might wonder whether epistemic parallels have any bearing on the reduction principles in alethic modal logic, as von Wright seems to take for granted in the passage quoted above. It seems to me that von Wright in *An*

Essay in Modal Logic was enthused by the idea that the same modal structures tend to recur from field to field, the alethic, the epistemic, the doxastic, and the deontic modalities—with some exceptions, like '\square p \supset p', which does not hold in doxastic and deontic logic, but which has its closest parallel in the deontic principle '0(0p \supset p)' or something like it.

Like Strawson, I find that our intuitions concerning iterated modalities in alethic logic are extremely vague. They remain vague as long as it is not made clear what is meant by 'logical necessity'.

If by 'logical necessity' we mean the same as 'validity relative to the logic of truth functions, quantification or classes', then, as Quine has pointed out,[38] our notion of necessity may be clear, but there seems to be little point in the iterated modalities unless we should want to extend the notion of validity from the semantics of logic to the semantics of semantics. Without iterated modalities we get a very meager modal logic; we could just as well have used 'necessary' as a semantic predicate that applies for sentences and hence is followed by sentences between quotation marks.

If, however, by logical necessity we mean something like provability, then we may easily get an interesting modal logic with iterated modal operators. This kind of interpretation seems to have been first proposed by Oskar Becker in 'Zur Logik des Modalitäten' (1930).[39] Kurt Gödel in 'Eine Interpretation des intuitionistischen Aussagenkalküls' (1933)[40] showed that there is a mapping of the theorems of Heyting's intuitionistic logic onto the theorems of the modal system S4.

Some further results concerning this mapping were reached by McKinsey and Tarski in 1948[41] and in later work by, among others, Grzegorczyk (1967) and Fitting (1969).[43]

One contribution in particular that deserves to be mentioned is Richard Montague's 'Syntactical Treatments of Modality' in *Acta Philosophica Fennica 16* (1963).[44] Montague's results show how important it is, when one has a provability interpretation in mind, to distinguish between '\square' as a predicate of sentences and '\square' as an operator.

By far the most important contribution to a provability interpretation of modal logic is Robert Solovay's 'Provability Interpretations of Modal Logic' (1976).[45] In this paper Solovay discusses several provability interpretations of modal logic. He begins with an interpretation in Peano's arithmetic and defines this interpretation as follows: An interpretation of a modal language M in Peano arithmetic P is a function that assigns to each formula χ of M a sentence, χ^* of P, and which satisfies the following requirements:

(1) $\qquad\qquad ('\bot')^* = \;'0 = 1'$

(2) $\qquad\qquad (\ulcorner\chi\supset\psi\urcorner)^* = \;\ulcorner\chi^*\supset\psi^*\urcorner$

(3) $\qquad\qquad (\ulcorner\square\chi\urcorner)^* = \;\ulcorner Bew(^g\chi^{*g})\urcorner$

where $^g\chi^g$ is the numeral of the Gödel number of the expression χ, the corners are Quine's quasi-quotes, and Bew(x) is the formula that expresses 'x is the Gödel number of a theorem of P'. A modal formula χ is P-valid if, in every interpretation, χ^* is a theorem of P. Solovay then shows that the P-valid formulae are precisely the theorems in the following system G for modal logic ('G' for Gödel) since the third axiom for G is an expression of 'Gödel's second incompleteness theorem', viz., Gödel's corollary that if S is consistent, then it is not provable in S that S is consistent): G is the smallest collection of formulas containing the following axiom schemata and closed under the following rules of inference:

A0	All tautologies are axioms
A1	$\Box(\chi \supset \psi) \supset (\Box\chi \supset \Box\psi)$
A2	$\Box\chi \supset \Box\Box\chi$
A3	$\Box(\Box\chi \supset \chi) \supset \Box\chi$
R1	If $\vdash\chi \supset \psi$ and $\vdash\chi$, then $\vdash\psi$
R2	If $\vdash\chi$, then $\vdash\Box\chi$

(As Solovay mentions in his paper, A2 has been proved redundant and the set of theorems of G recursive.)[46]

Here A0, A1 and the two rules are standard axioms and rules that were mentioned earlier in connection with the system K. It is A3 which is the key axiom, that expresses Gödel's second incompleteness theorem

The system G was discussed by Krister Segerberg in *An Essay in Classical Modal Logic* (1971).[47] Segerberg calls the system K4W and proves that its theorems are just those modal sentences that are valid on all finite strictly ordered frames. Segerberg there also discusses a modal system S4Grz which instead of A3 has the axiom $\ulcorner\Box(\Box(\chi\supset\Box\chi)\supset\chi)\supset\Box\chi\urcorner$ (Grzegorczyk's axiom). He shows that its theorems are precisely those sentences that are valid on all finite partially ordered frames. This system, too, is of interest in connection with provability interpretations of modal logic; Rob Goldblatt[48] has shown that the theorems of this system are precisely those sentences that are P-valid relative to an interpretation where we interpret the box as meaning 'it is provable and true that. . .' rather than 'it is provable that. . .'. That is,

$$(\ulcorner\Box\chi\urcorner)^* = \ulcorner\text{Bew}(^g\chi^{*g}).\ \chi^*\urcorner$$

In the system S4Grz, too, the axiom A2 is redundant.[49]

From the point of view of interpretations of modal logic it is now interesting that, as Solovay shows, other provability interpretations often give other modal logics. Solovay considers a succession of various alternative interpretations: He first considers various notions of interpretation of M in ZFC (Zer-

melo-Fraenkel set theory including the axiom of choice) and finds that the appropriate modal logic is again the system G.

The next interpretation of $\ulcorner \Box \chi \urcorner$ is that χ^* holds in all transitive models of ZFC. The relevant assumption here is: ZFC has an uncountable transitive model. The set of modal formulae valid for this interpretation is precisely the set of theorems of the system H that we get by adding to G the following axiom:

$$\ulcorner \Box(\chi \supset \Diamond \psi) \vee \Box (\psi \supset \Diamond \chi) \vee \Box(\Diamond \chi \equiv \Diamond \psi) \urcorner$$

The proof of this result yields that H has the finite model property and also yields decision procedure for H and an upper bound for the number of steps the procedure goes through before it halts.

Finally, Solovay considers the following interpretation of '\Box': For every inaccessible cardinal κ, $R(\kappa) \vDash \chi^*$. Here the valid formulas correspond exactly to the theorems of the system that we get by adding to H the following axiom:

$$\ulcorner (\Diamond \chi \cdot \Box(\Diamond \chi \equiv \Diamond \psi)) \supset \Box((\chi \cdot \Box \sim \chi) \supset \psi) \urcorner$$

I have devoted relatively much space to Solovay's results because I regard them as by far the most important and interesting attempt to throw light on the alethic modalities and also because they bring out how nuances in the notion of necessity are crucial to the kind of modal logic that results. The various systems that Solovay arrives at all arise from making precise in various directions what one often has called *the* provability interpretation of modal logic. From the point of view of von Wright's interest in various interpretations of modal logic it is particularly pertinent to note how Solovay's approach makes it possible to give strict logical arguments to show how different clearly defined interpretations of alethic modal logic correspond to particular modal axioms. A fuller presentation and discussion of Solovay's work and related results may be found in George Boolos, *The Unprovability of Consistency* (1979).[50]

The results that have been reached concerning provability interpretations of modal logic depend heavily on work in proof theory, in particular Gödel's incompleteness theorem. Proof theory, on the other hand, has not had much to gain from modal logic. What then is the point of doing modal logic? There are, it seems to me, two main reasons: First, modal logic has helped to clarify our thinking concerning some modal notions that are important in philosophy and daily life. A particularly good example is deontic logic, where in the early stages of development of this discipline many axioms were formulated that later were found to have strongly counter-intuitive consequences. These counter-intuitive consequences usually helped one see what was wrong with the axioms, and they thereby helped improve one's intuitions. The development of deontic logic illustrates very well the process of searching for a 'reflective equi-

librium'. Von Wright gives examples of this in "Deontic logic" (1951) which initiated an upsurge of interest in deontic logic. Also *An Essay in Modal Logic* contains good examples, e.g., the analysis of promising to do something which is forbidden (pp. 39–40). Further examples from the history of deontic logic may be found in Føllesdal and Hilpinen 'Deontic Logic: An introduction.'[51] Von Wright's work in deontic logic will be discussed in another essay in this book and is mentioned here only as an example of what makes modal logic worthwhile.

The second main reason for devoting attention to modal logic is that modal logic brings into focus many semantical issues that are easily overlooked when one is only concerned with extensional contexts. In particular, this is true of questions concerning reference, identity, and quantification. The criticism that was directed against modal logic and in particular quantified modal logic in the 1940s and 1950s forced the more thoughtful modal logicians to think through the semantical issues, and in particular to get clear about what the objects are that one refers to and quantifies over in modal contexts. These reflections have led to a better understanding of quantification into modal contexts and also of the use of quantifiers in connection with propositional attitude constructions. The issue of objectual vs. substitutional quantification has received more attention than it would have received otherwise, and much recent work on reference, e.g., the theory of rigid designators, is clearly in part motivated by the attempt to make sense of quantified modal logic.

8. Probability as a Modal Logic

The semantical insights that have been gained through reflections on how to interpret modal logic have unfortunately not penetrated very well into all areas to which they are pertinent. Probability is one such area, the theory of confirmation another. Von Wright has pointed out parallels between probability and modal logic in several of his works. In 'A New System of Modal Logic' (1953) he set forth a system of dyadic modal logic whose metricized form is a calculus of probability.

The parallels between the modal notions and probability and other notions that are used in science are also noted and explored by Patrick Suppes in 'The Essential but Implicit Role of Modal Concepts in Science'.[52] The most extensive and interesting exploration of the parallel between probability and modal notions seems to me to be Jerome Keisler's long essay 'Hyperfinite Model Theory' (1977)[53], where a notion of probability quantifiers is introduced. Intuitively the probability quantifier means that a certain set has a probability greater than some number r. Quantifiers, as was noted in Section 4 above, have many features in common with the modal operators. Douglas Hoover has pursued Keisler's ideas further in 'Probability Logic' (1978).[54]

In Keisler's and Hoover's work the quantifiers have the probability inter-pretation, and no normal quantifiers are used in addition to them. Quantification into the contexts governed by the probability quantifiers is therefore not per-mitted. Likewise, in von Wright's system of dyadic logic, there are no quanti-fiers in addition to the modal operators. Such quantification is necessary for some applications of probability theory, and it is needed if one wants to work out a theory of confirmation. The problems connected with quantification into modal contexts will then arise, and in order to avoid them, one will have to give much thought to the use of singular terms. The only study I know that shows awareness of these issues is Howard Smokler's 'The Equivalence Con-dition' (1967).[55]

STANFORD UNIVERSITY AND
THE UNIVERSITY OF OSLO
MAY 1980

DAGFINN FØLLESDAL

NOTES

1. Cf., e.g., W. V. Quine, 'Three Grades of Modal Involvement'. *Proceedings of the XIth International Congress of Philosophy,* Brussels, 1953. (Amsterdam: North-Holland, 1953), vol. 14, pp. 65–81. See also W. V. Quine, 'Reply to Professor Mar-cus', *Synthese* 13 (1961), 323–330, and *Boston Studies in the Philosophy of Science,* (Dordrecht: Reidel, 1963), vol. 1, pp. 97–104. The two essays are reprinted in W. V. Quine, *The Ways of Paradox and Other Essays* (New York: Random House, 1966). Revised and enlarged edition, Cambridge, Mass.: Harvard University Press, 1976. The relevant passages occur on pp. 165–66 and 177–78 of the revised edition.

2. Ruth Barcan Marcus, 'A Functional Calculus of First Order Based on Strict Implication'. *Journal of Symbolic Logic* 11 (1946): 1–16. Rudolf Carnap, 'Modalities and Quantification'. *Journal of Symbolic Logic* 11 (1946): 33–64.

3. Rudolf Carnap, *Meaning and Necessity* Chicago: (University of Chicago Press, 1947).

4. Stig Kanger, *Provability in Logic* Stockholm: (Almquist & Wiksell, 1957). Jaakko Hintikka, *Quantifiers in Deontic Logic,* Societas Scientiarum Fennica, Commen-tationes humanarum litterarum, vol. 23, no. 4 (Helsinki 1957).

5. Saul Kripke, 'Semantical Analysis of Modal Logic I, Normal Propositional Calculi', *Zeitschrift für mathematische Logik and Grundlagen der Mathematik* 9 (1963): 67–96. 'Semantical Considerations on Modal Logic', *Acta Philosophica Fennica* 16 (1963): 83–94. 'Semantical Analysis of Modal Logic II, Non-normal Modal Proposi-tional Calculi', *The Theory of Models,* edited by I. W. Addison, L. Henkin, A. Tarski (Amsterdam: North-Holland, 1965), pp. 206–220. Kripke's earliest article 'A Com-pleteness Theorem in Modal Logic', *Journal of Symbolic Logic* 24 (1959): 1–14, does, like Kanger's 1957 dissertation, give a model theoretic interpretation of modal logic. However, only S5 is discussed and the idea of worlds being possible relative to one another does not occur.

6. Richard Montague, 'Pragmatism', *Contemporary Philosophy I. Logic and the*

Foundations of Mathematics, edited by R. Klibansky (Florence: La nuova Italia, 1968), pp. 102–122. Dana Scott, 'Advice on Modal Logic'. In *Philosophical Problems in Logic,* edited by K. Lambert (Dordrecht: Reidel, 1970), pp. 143–173. See also Krister Segerberg, *An Essay in Classical Modal Logic.* Filosofiska studier utgivna av Filosofiska Föreningen och Filosofiska Institutionen vid Uppsala Universitet, no. 13 (Uppsala, 1971).

For a brief survey see Bengt Hansson and Peter Gärdenfors, 'A Guide to Intensional Semantics'. In *Modality, Morality and other Problems of Sense and Nonsense: Essays Dedicated to Sören Halldén* (Lund: Gleerup, 1973), pp. 151–167.

7. For more on this, see Arthur Prior's essay 'The Parallel between Modal Logic and Quantification Theory'. In A. N. Prior and Kit Fine, *Worlds, Times and Selves* (London: Duckworth, 1977), pp. 9–27.

8. G. H. von Wright, *Logical Studies,* p. 19 and p. 14n. Cf. also Alonzo Church's review of von Wright's 'On the Idea of Logical Truth (I)' and 'Form and Content in Logic', *The Journal of Symbolic Logic* 15 (1950): 58–59, 199 and 280.

9. W. V. Quine, 'On the Logic of Quantification', *The Journal of Symbolic Logic* 10 (1945): 1–12.

10. Heinrich Behmann, 'Beiträge zur Algebra der Logik, insbesondere zum Entscheidungsproblem', *Mathematische Annalen* 86 (1922): 163–229.

11. E. J. Lemmon, in collaboration with Dana Scott, *An Introduction to Modal Logic.* Edited by Krister Segerberg, (American Philosophical Quarterly Monograph Series No. 11. Blackwell, Oxford 1977), p. 39.

12. J. Ridder, 'Über modale Aussagenlogiken und ihren Zusammenhang mit Strukturen II', *Indagationes mathematicae* 14 (1952): 459–467. Feys's system was proposed in Robert Feys, 'Les logiques nouvelles des modalités', *Revue néoscholastique de philosophie* 40 (1937): 517–553, and 41 (1938): 217–252.

13. Boleslaw Sobociński, 'Note on a Modal System of Feys-von Wright', *The Journal of Computing Systems* 1 (1953): 171–78.

14. J. C. C. McKinsey, 'A Solution to the Decision Problem for the Lewis Systems S2 and S4, with an Application to Topology', *Journal of Symbolic Logic* 6 (1941): 117–134. Cf. Alan Ross Anderson, 'Improved Decision Procedures for Lewis' Calculus S4 and von Wright's Calculus M', *Journal of Symbolic Logic* 19 (1954): 201–214. Correction in ibid., vol. 20 (1955): 150.

15. Alan Ross Anderson, op. cit., 213.

16. Kit Fine, 'Normal Forms in modal logic', *Notre Dame Journal of Formal Logic* 16 (1975): 229–237.

17. E. J. Lemmon, op. cit., 30.

18. Robert Goldblatt, 'Metamathematics of Modal Logic', Dissertation, Victoria University, Wellington, 1974. Published in *Reports on Mathematical Logic,* no. 6 (1976): 41–77, no. 7 (1976): 21–52.

19. Kit Fine, 'Logics Containing K4', *Journal of Symbolic Logic* 39 (1974): 31–42.

20. G. E. Hughes and M. J. Cresswell, An *Introduction to Modal Logic,* (London: Methuen, 1968).

21. M. J. Cresswell, 'A Conjunctive Normal Form for S3.5', *The Journal of Symbolic Logic* 34 (1969): 253–255.

22. J. F. A. K. van Benthem, *Modal Correspondence Theory* (Diss.), Universiteit van Amsterdam, 1976, pp. 45–47. Benthem refers to the result, but does not include the proof, on page 28 of his 'Two Simple Incomplete Modal Logics', *Theoria* 44 (1978): 25–37.

23. Dexter Kozen, 'An Elementary Proof of the Completeness of PDL' IBM RC 8097 (1980) 5pp. I am grateful to Henrik Sahlqvist for bringing this paper to my attention.

24. V. R. Pratt, 'Semantical Considerations on Floyd-Hoare Logic', *17th IEEE Symposium on Foundations of Computer Science,* 1976, pp. 109–121.

25. Michael J. Fischer and Richard E. Ladner, 'Propositional Dynamic Logic of Regular Programs', *Journal of Computer and System Sciences* 18 (1979): 194–211.

26. Krister Segerberg, 'A Completeness Theorem in the Modal Logic of Programs', *Notices of the American Mathematical Society* 24:6 (1977): A-552.

27. R. Parikh, 'The Completeness of Propositional Dynamic Logic', *Symposium on Mathematical Foundations of Computer Science, Zakopane, Poland, Sept. 4–8, 1978.* (Lecture Notes in Computer Science, Vol. 64, Berlin: Springer, 1978), pp. 403–415.

28. See von Wright's preface to the Spanish edition of *An Essay in Modal Logic,* viz., *Ensayo de lógica modal,* (Buenos Aires: Santiago Rueda, 1970).

29. See, e.g., Dana Scott, 'A Note on Distributive Normal Forms', *Essays in Honor of Jaakko Hintikka,* edited by E. Saarinen, R. Hilpinen, I. Niiniluoto and M. Provence Hintikka. (Dordrecht: Reidel, 1979), pp. 75–90.

30. Page 18 of the reprint of 'Form and Content in Logic' in *Logical Studies.* See also Appendix II to that article in *Logical Studies,* p. 20.

31. Roland Fraissé, 'Sur quelques classifications des relations, basées sur des isomorphismes restreints'. *Publications scientifiques de l'Université d'Alger,* Série A, sciences mathématiques, vol. 1, no. 1 (for 1954, pub. 1955), pp. 35–182. Andrzei Ehrenfeucht, 'Applications of Games to Some Problems of Mathematical Logic'. *Bulletin de l'Académie Polonaise des Sciences* 5 (1957), 35–37.

32. Dana Scott, op. cit.

33. G. H. von Wright, review of Oskar Becker, *Einführung in die Logistik, vorzüglich in den Modalkalkül* and *Untersuchungen über den Modalkalkül, Mind* 62 (1953): p. 559.

34. G. H. von Wright, 'Interpretations of Modal Logic', page 88 of the reprint in *Logical Studies.*

35. Alan Ross Anderson, review of von Wright 'Interpretations of Modal Logic', *Journal of Symbolic Logic* 18 (1953): p. 177.

36. *An Essay in Modal Logic,* p. 77.

37. P. F. Strawson, review of *An Essay in Modal Logic. Philosophy* 28 (1953): 78.

38. W. V. Quine, 'Three Grades of Modal Involvement', esp. pp. 169–171 of the reprint in the expanded edition of *The Ways of Paradox.*

39. Oskar Becker, 'Zur Logik der Modalitäten'. *Jahrbuch für Philosophie und phänomenologische Forschung* 11 (1930): 497–548, esp. p. 501.

40. Kurt Gödel, 'Eine Interpretation des intuitionistischen Aussagenkalküls', *Ergebnisse eines mathematischen Kolloquiums* 4 (1933): 39–40.

41. J. C. C. McKinsey and Alfred Tarski, 'Some Theorems about the Sentential Calculi of Lewis and Heyting', *The Journal of Symbolic Logic* 13 (1948): 1–15.

42. A. Grzegorczyk, 'Some Relational Systems and the Associated Topological Spaces', *Fundamenta mathematicae* 60 (1967): 223–231.

43. M. C. Fitting, *Intuitionistic Logic, Model Theory, and Forcing,* (Amsterdam: North-Holland, 1969).

44. Richard Montague, 'Syntactical Treatments of Modality, with Corollaries on Reflexion Principles and Finite Axiomatizability.' (Proceedings of a Colloquium on Modal and Many-valued Logics, Helsinki, 23–26 August, 1962), *Acta Philosophica Fennica* 16 (1963): 153–167.

45. Robert M. Solovay, 'Provability Interpretations of Modal Logic', *Israel Journal of Mathematical Logic* 25 (1976): 287–304.

46. According to Solovay, A2 has been proved redundant by de Jongh and by the Sienna group (Magari, Montagna, and Bernardi), which also has proved that the set of theorems of G is recursive. A proof that A2 is redundant is given on p. 306 of Roberto Magari, 'Representation and Duality Theory for Diagonalizable Algebras', *Studia Logica* 34 (1975): 305–313. The proof is there attributed to Giovanni Sambin. De Jongh's proof is given by van Benthem in 'Two Simple Incomplete Modal Logics' (cf. note 22 above), p. 36. The redundancy of A2 has also been proved by Kripke, according to Boolos's *The Unprovability of Consistency* (cf. note 50 below), p. 30.

47. Krister Segerberg, *An Essay in Classical Modal Logic*. See note 6 above.

48. Rob Goldblatt, 'Arithmetical Necessity, Provability and Intuitionistic Logic', *Theoria* 44 (1978): 37–46.

49. The syntactic proof of this is due to Wim Blok and appears in J. F. A. K. van Benthem and W. J. Blok: 'Transitivity Follows from Dummett's Axiom'. *Theoria* 44 (1978): 117–18.

50. George Boolos, *The Unprovability of Consistency: An Essay in Modal Logic*. (Cambridge: Cambridge University Press, 1979). Cf. also George Boolos, 'Provability, Truth, and Modal Logic', *Journal of Philosophical Logic* 9 (1980): 1–7.

51. Dagfinn Føllesdal and Risto Hilpinen, 'Deontic Logic: An Introduction', *Deontic Logic: Introductory and Systematic Readings,* edited by Risto Hilpinen (Dordrecht: Reidel, 1971): 1–35.

52. Patrick Suppes, 'The Essential but Implicit Role of Modal Concepts in Science', *Boston Studies in the Philosophy of Science,* edited by R. S. Cohen and M. W. Wartofsky. vol 20. (Dordrecht: Reidel, 1974), pp. 305–314.

53. Jerome Keisler, 'Hyperfinite Model Theory', *Logic Colloquium 76,* edited by R. O. Gandy and J. M. E. Hyland (Amsterdam: North-Holland, 1977): 5–110. I am grateful to Jon Barwise for bringing this article to my attention.

54. Douglas Hoover, 'Probability Logic', *Annals of Mathematical Logic* 14 (1978): 287–313.

55. Howard Smokler, 'The Equivalence Condition', *American Philosophical Quarterly* 4 (1967): 300–307.

24

P. T. Geach

ON MODAL SYLLOGISMS

This paper is concerned with a restricted part of modal syllogistic, namely, the theory of syllogisms obtained by prefixing the modal operators 'possibly' and 'necessary' to the premises or conclusion of a plain categorical syllogism. The plain syllogism is here understood *existentially,* so that each constituent proposition in it affirms or denies the existence of some property in a chosen Universe of Discourse. Lewis Carroll devised diagrams that provided an effective test for the validity of plain syllogisms; von Wright in *An Essay on Modal Logic* sketched a method of modifying Lewis Carroll Diagrams so as to test the validity of syllogisms modalized in the way I have just specified— of what are traditionally called *de dicto* modal syllogisms. My aim is to show that von Wright's modified Lewis Carroll Diagram test is indeed effective; and thus I definitively solve a problem unsolved since it was originally attacked by medieval logicians. (I speak here of these logicians, rather than Aristotle, as having posed the problem, because it seems clear that Aristotle did not fully grasp the difference between *de re* and *de dicto* modals.)

It is commonly stated that no existential reading will preserve as rules of inference the laws of conversion and subalternation and the traditionally valid syllogistic moods. This is a mere mistake, as I shall show. (Medieval thought on the matter was not wholly clear and consistent, but we must credit medieval logicians at least with supplying the key to a solution.)

Let P, Q, R, and S stand for (unspecified) properties: let a mark $'$ represent the negation of a property, and let adjunction of letters stand for the coexistence of properties in one individual (so that, e.g., PQ' stands for the property of having the property called P *and* lacking the property called Q). I use & for propositional conjunction, \lor for propositional disjunction, \lnot for propositional negation, and E for existence of a property (in the chosen Universe of Dis-

course). Then the four traditional categorical forms SaP, SeP, SiP, SoP will for our purposes be defined as follows:

SaP: ESP & $\neg ESP'$
SeP: $\neg ESP$
SiP: ESP
SoP: $\neg(ESP$ & $\neg ESP')$ (or, of course, $\neg ESP \lor ESP'$).

It is an easy matter to verify that on this interpretation monadic predicate logic shows the validity of the laws of subalternation (SaP yields SiP, and SeP yields SoP), of the laws of simple conversion (SeP yields PeS and SiP yields PiS), and of all the twenty-four traditional syllogistic moods.

For certain metatheoretic purposes, however, it will be convenient to recognise a strengthened O-form, which I shall write as $S\hat{o}P$ and interpret as ESP'. $S\hat{o}P$ yields SoP, but not conversely.

It has been usual to call the term occurring first in a categorical its *subject* and the term occurring second its *predicate*. I avoid these expressions; they have no proper place in an existential treatment of syllogisms, and merely add a confusing reminder of other modes of treatment. My own expressions 'first term' and 'second term' cannot mislead.

An existential syllogism has as its premises two propositions of the form A, E, I, or O, and one such proposition—say, SaP, SeP, SiP, or SoP—as its conclusion. The first term (here S) of the conclusion is called the *minor* term, and the second term (here P) is called the *major* term. Each premise has one term in common with the conclusion and one in common with the other premise. The term common to both premises is the *middle* term of the syllogism. The premise containing the major/minor term is called the *major/minor premise*.

Syllogisms are of four kinds (*figures*) according to the position of the middle term in the premises. In the first and fourth figures the middle term is first term in one premise and second in the other; in the second figure the middle term is second term in both premises; in the third figure the middle term is first term in both premises. The difference between the first and fourth figure is that in the first figure the middle term is first term in the major premise, second term in the minor premise; whereas in the fourth figure (sometimes called 'the indirect moods of the first figure') the middle term is first term in the minor premise and second term in the major premise.

A syllogistic schema containing the schematic letters P, Q, R is a valid form if and only if the conjunction of the premises with the negation of the conclusion is always logically inconsistent, no matter which properties these letters are supposed to stand for. Such an inconsistent conjunctive schema is called an *antilogism*. Since the contradictory of a categorical is always itself a

categorical, we readily see that if $p\&q\&r$ represents an antilogism, then p, q, *ergo* $\neg r$ and p, r, *ergo*, $\neg q$ and q, r, *ergo* $\neg p$ will all represent valid forms of syllogism. If three syllogistic forms are interrelated in this way, then the validity of one of the three stands or falls with the validity of the other two. This is the *Principle of the Antilogism*; it depends simply on truth-functional logic of propositions, so it is not restricted to the plain syllogistic. (It forms the basis of the traditional procedure called *reductio per contradictionem*.)

The traditional mnemonic verses (for which cf. Neville Keynes's *Formal Logic*) enumerate 19 named syllogistic forms: five other less important 'subaltern' forms were recognised but not given standard names, merely labels—e.g., AAI in figure 1 is the mood:

$$QaR, PaQ, ergo\ PiR.$$

The 18 moods of the first three figures can be arranged in antilogistic triads as follows: in each line the mood named first/second/third after an antilogism is a mood of the first/second/third figure, obtained by drawing the *negation* of the first/second/third conjunct of the antilogism as a conclusion from the remaining two conjuncts as premises:

(1) *PoR & PaQ & QaR*	Barbara	Baroco	Bocardo
(2) *PeR & PaQ & QaR*	(AAI)	(AEO)	Felapton
(3) *PiR & PaQ & QeR*	Celarent	Festino	Disamis
(4) *PaR & PaQ & QeR*	(EAO)	(EAO)	Darapti
(5) *PeR & PiQ & QaR*	Darii	Camestres	Ferison
(6) *PaR & PiQ & QeR*	Ferio	Cesare	Datisi

And the six moods of the fourth figure can be arranged in two antilogistic triads: the first/second/third mood in each row is obtained by negating the first/second/third conjunct of the antilogism and treating this as the conclusion drawn from the other two conjuncts as premises:

(7) *PaR & QeP & RiQ*	Fresison	Dimaris	Camenes
(8) *PaR &QeP & RaQ*	Fesapo	Bramantip	(AEO)

Lewis Carroll Diagrams

If we consider the presence or absence in the Universe of Discourse of the properties called P, Q, and R we see that a priori the presence or absence of any one property in a given individual may go with the presence or absence of any other property in that individual; so there are 2^3 or eight conjunctive prop-

erties, which we represent by the expressions PQR, PQR', $PQ'R$, . . . , $P'Q'R'$. Lewis Carroll represented the Universe of Discourse by a square subdivided as shown below:

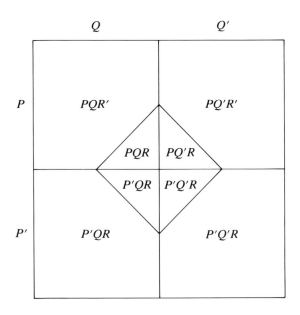

Figure 1

A conjunctive property in whose designation only two letters figure, e.g., PQ, will always be represented by two adjacent areas in the diagram, separated by a boundary line that Lewis Carroll called the *fence*. I have slightly modified Lewis Carroll's own diagram, so that a boundary (a fence, as he calls it) is always a single straight line. We lay down the following rules as regards existence and emptiness of properties mapped onto *undivided* areas: we represent existence by putting a cross (X) in the area, and nonexistence by putting a nought (0) in the area. Since no property can be both existent and empty, we lay down a rule against putting both a nought and a cross in the same undivided area. If two adjacent areas together represent a conjunctive property, e.g., the property called PR is mapped on the two adjacent areas labelled PQR and PQR', then the existence of the property will have been represented if there is a cross in *at least one* of the two areas, and the emptiness of the property will have been represented if there is a nought in *each* of the two areas.

We now have means for representing in a Lewis Carroll Diagram the three propositional schemata that make up an antilogism. The necessary and sufficient condition for their forming an antilogism is that when two of them are represented in the diagram we cannot represent the third without violating the rule that excludes putting a nought and a cross in the same undivided area. Since for every syllogistic form there is a corresponding antilogism, this is an effective decision procedure for the validity of syllogisms.

For example, let us take antilogism (3) *PiR & PaQ & QeR*.

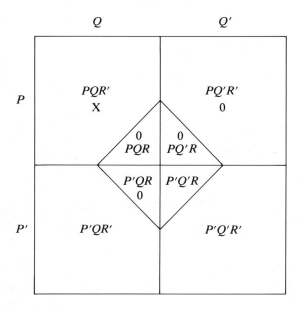

Figure 2

To represent *QeR*, we put a nought in each of the areas labelled *PQR* and *P'QR*. To represent *PaQ*, i.e., E*PQ* & ¬E*PQ'*, we first put a nought in each of the areas labelled *PQ'R* and *PQ'R'*; we must then put a cross in the PQ area, to represent E*PQ*; we cannot put it in the PQR area, where there is already a nought, so it must go in the *PQR'* area. To represent *PiR*, we should have to put a cross in one part or other of the *PR* area; but there is already a nought in the *PQR* area and a nought in the *PQ'R* area, so we cannot do this. Thus (3) comes out as an antilogism by our test.

Let us now test antilogism (1): *PoR & PaQ & QaR*.

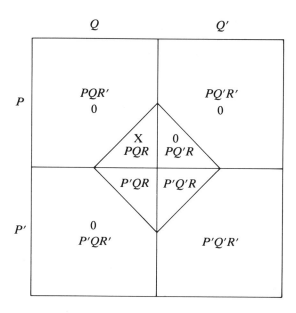

Figure 3

To represent *PaQ*, i.e., E*PQ* & ¬E*PQ'*, we begin by representing ¬E*PQ'*: we put a nought in each of the areas labelled *PQ'R* and *PQ'R'*. To represent *QaR*, i.e., E*QR* & ¬E*QR'*, we begin by representing ¬E*QR'*: we put a nought in each of the areas labelled *PQR'* and *P'QR'*. To represent E*PQ*, we must place a cross either in the *PQR* area or in the *PQR'* area; since the *PQR'* area has a nought in it already, we place the cross in the *PQR* area—and thereby also show the E*QR* part of *QaR*. To represent *PoR*, i.e., E*PR'* ⋁ ¬E*PR*, we should have to place a cross in the *PR'* area, which already has two noughts in it, or else a nought in *both* parts of the *PR* area, which already has a cross in the *PQR* part; and neither is allowed, so *PoR* cannot be represented, so once again we have an antilogism.

We may similarly show that the Lewis Carroll Diagrams establish the inconsistency of each of the eight antilogisms on which the 24 traditional valid syllogisms are based. But to make the use of diagrams legal as a decision procedure, we must also satisfy ourselves that for each of the 232 (256 minus 24) 'possible' syllogistic forms that are *not* valid, it *is* possible to represent in one diagram the two premises *and* the negation of the supposed conclusion. In carrying out this program, we encounter a technical difficulty. The O proposition is in our scheme a disjunction of a proposition affirming existence and one affirming emptiness; e.g., *PoR* is the disjunction of E*PR* and ¬E*PR*. Such a

disjunction cannot be represented *as such* in a Lewis Carroll Diagram; only its disjuncts can. How then can we be satisfied that the test works?

Lewis Carroll probably felt a difficulty here, for he interpreted *PoR not* as we are doing but as E*PR'* (which we shall also write as *PôR*). This made his square of opposition lopsided, since his *PôR* is not subaltern to his *PeR,* and it invalidated just two syllogisms out of the traditional 24 (the subaltern moods AEO in figure 2 and figure 4). The most serious effect of his British compromise about existential import is that since *PôR* and *PaR* are not contradictories, the metalogical use of antilogisms is severely restricted.

All the same, there is something to be said for Lewis Carroll's strong O; it has its uses. Consider the following test procedure for the validity of syllogisms.

1. Form the conjunction of the premises with the contradictory of the conclusion.
2. If any one of the conjuncts is an O proposition, replace it by the corresponding ô proposition. (In honour of Lewis Carroll, let us call the result the *carrollized* conjunction.)
3. See if the result of step 2 can be represented in a Lewis Carroll diagram.

Now it turns out that the carrollized conjunction answering to a syllogism is representable in the Lewis Carroll Diagram iff the syllogism is *not* valid. For the 24 valid syllogisms, the matter is easy: the antilogism has an O proposition as a conjunct only in one case, namely (1); and the carrollized form of (1), *PôR & PaQ & QaR,* is inconsistent, being stronger than (1). For the 232 invalid syllogisms, the carrollized conjunction can in every case be represented in a Lewis Carroll Diagram and is thus consistent: since an ô proposition that replaces an O proposition *strengthens* a conjunction, the original conjunction is a fortiori consistent.

Example. To test the syllogism: PoR & QaR, ergo QoP.

The conjunction to be tested for consistency is *PoR & QaR & QaP.* The carrollized form of this is *PôR & QaR & QaP.* To represent *QaR,* i.e., E*QR* & ¬E*QR'*, we begin by marking the emptiness of the *QR'* area. To represent *QaP,* i.e., E*PQ* & ¬E*P'Q*, we mark the emptiness of the *P'Q* area. We have to mark the *QR* area as nonempty, so we must mark the *PQR* area (the *PQR'* area is already marked as empty); and we have to mark the *PQ* area as nonempty— but we have already done this by having a mark in the *PQR* area. To represent *PôR,* we must put a cross somewhere in the *PR'* area; we cannot do this in the *PQR'* area, where there is already a nought, but we can in the *PQ'R'* area. So

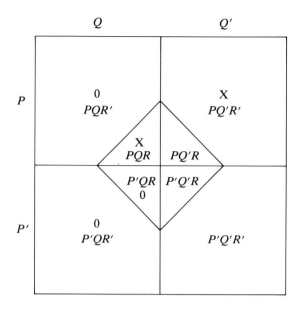

Figure 4

the carrollized conjunction is consistent: a fortiori the original conjunction to
be tested is, and the syllogism is invalid.

A similar proof works for any of the 232 invalid plain syllogisms.

MODAL SYLLOGISMS: VON WRIGHT DIAGRAMS

A categorical is said to be modalized *de dicto* if it has a modal operator
prefixed to it. It will be convenient to recognise three modal operators, M, L,
and T. M and L may respectively be read as 'it is possibly the case that' and
'it is necessarily the case that' T means 'it is the case that', and is a vacuous
operator introduced for making certain formulations neater.

A *de dicto* modal syllogism is one obtained by prefixing a modal operator,
M or L or T, to each premise and to the conclusion. I do not, however, count
as a modal syllogism the result of prefixing T all three times. There are thus 3^3
− 1 or 26 ways of forming a modal syllogism from a plain one; since there
are 256 forms of non-modal syllogism, there are 6656 possible *de dicto* modal
forms.

(I shall henceforth speak simply of modalization and modal syllogisms,
omitting '*de dicto*'.)

The diagrams for testing modal syllogisms that von Wright devised may be described by the following set of rules (which follow the *Essay on Modal Logic* with minor modifications). The arrangement and labelling of areas is unchanged, but we have new rules for noughts and crosses.

As regards the existence or emptiness of a property corresponding to an undivided area:

Rule 1. Possible existence is represented by inserting one cross.

Rule 2. Actual existence is represented by inserting two crosses.

Rule 3. Necessary existence is represented by inserting three crosses.

Rule 4. Possible emptiness is represented by inserting one nought.

Rule 5. Actual emptiness is represented by inserting two noughts.

Rule 6. Necessary emptiness is represented by inserting three noughts.

To avoid inconsistent representations it suffices to add the rule:

Rule 7. No undivided area may contain more than three marks (here 'mark' is used to cover noughts and crosses alike).

Let us now consider a property represented by two *adjacent* areas on the diagram. Such a property is the property of having one or other (or both) of the properties represented by the two areas separately. For consistent representation, then, we must observe the following conventions, corollaries of our rules.

Corollary 1. The possible existence of such a property will consist in the possible existence of one or other (or both) of the two properties represented by the two undivided areas: we put a cross in one or both areas.

Corollary 2. The existence of such a property will consist in the existence of one or other (or both) of the two properties represented by the two undivided areas: we put two crosses in one or both areas.

Corollary 3. The possible emptiness of such a property will require the possible emptiness of each of the two properties represented by the two undivided areas: we put a nought in each area.

Corollary 4. The emptiness of such a property will consist in the emptiness of each of the two properties represented by the two undivided areas: we put two noughts in each area.

Corollary 5. The necessary emptiness of such a property will consist in the necessary emptiness of each of the two properties represented by the two undivided areas: we put three noughts in each area.

To complete the method of representation, we need a further pair of devices not to be found in Von Wright's work. Suppose we wish to represent M¬E*PR*.

The relevant part of the Von Wright Diagram will then look like this, in view of Corollary 3:

Figure 5

But thus far we shall only have represented *M¬EPQR* & *M¬EPQ'R*, whereas we need to represent the stronger proposition *M(¬EPQR* & *¬EPQ'R)*, equivalent to *M¬EPR*. We get over the difficulty by adding a new convention for the diagrams:

> *Rule 8.* Possible emptiness of a property whose representation is an area divided by a fence is represented by putting a nought on the fence *as well as* one in each of the two sub-areas. Since actual emptiness, and a fortiori necessary emptiness, of a property entails its possible emptiness, Rule 8 carries with it a corollary:
>
> *Corollary 6.* If there are at least two noughts on each side of a fence, there must be a nought on the fence as well.

Again, suppose we have *L¬EPQR* & *M¬EPQ'R*. By propositional modal logic, *Lp* & *Mq* yields *M(p&q)*. So we shall now have *M(¬EPQR* & *¬EPQ'R)*, that is *M¬EPR*; so by Rule 8 the relevant part of the Von Wright Diagram will look like this:

Figure 6

To cover this case, we ought to amend Corollary 6 as follows:

> *Corollary 6'.* If there are at least four noughts altogether in the two areas that have a fence in common, then there must be a nought on the fence as well.

Let us now consider how to represent *LEPR*. This is the contradictory of *M* ¬*EPR*. So we must devise our rules so that each shall be representable but not both in the same diagram. There are two distinct cases: *LEPR* is equivalent to *L*(*EPQR* ⋁ *EPQ′R*), so we may have (Case 1) *LEPQR* or *LEPQ′R* represented in the diagram, or (Case 2) neither of these represented.

For Case 1 we need no new diagrammatic convention or rule. Suppose, for example, that *LEPQR* is represented.

Figure 7

Thus we cannot consistently put a nought on the fence. For, by Rule 8 the nought on the fence is to signify emptiness of *both* the properties called *PQR* and *PQ′R*, so there would have to be a nought in each sub-area; but the resulting diagram violates Rule 7:

Figure 8

Case 2 requires a new device. We may have, e.g., *LEPR* & *EPQR* & *EPQ′R* without having either *LEPQR* or *LEPQ′R*. So we lay down the following rules.

Rule 9. To represent the necessary existence of a property whose representation is an area divided by a fence, we place a cross on the fence.

Rule 10. The same fence may not have both a nought and a cross on it.

Corollary 7. If there are three crosses on one or the other side of the fence, there must be a cross on the fence as well.

Thus, the conjunction *LEPR* & *LEPQR* & ¬*EPQ'R* & *MEPQ'R* would look thus:

Figure 9

and the conjuction *LEPR* & *EPQR* & *EPQ'R* & *M*¬*EPQR* & *M*¬*EPQ'R* thus:

Figure 10

Clearly, if there is a cross on the fence there must be two crosses at least on one side or the other of the fence, since *L* (*EPQR* \bigvee *EPQ'R*) entails *EPQR* \bigvee *EPQ'R*. But furthermore, our rules must forbid a diagram looking like this:

Figure 11

For this would represent the conjunction: *LEPR* & *L*¬*EPQ'R* & *EPQR* & *M*¬*EPQR*. But *LEPR* is equivalent to *L*(*EPQR* \bigvee *EPQ'R*): and since in propositional modal logic *L*(*p* \bigvee *q*) and *L*¬*q* yield *Lp*, we get in this case *LEPQR*, incompatible with *M*¬*EPQR*. To exclude this sort of case *and* meet the requirement that *LEPR* entails the truth of *EPQR* or of *EPQ'R*, it suffices to lay down the rule:

> *Rule 11*. If there is a cross on the fence, then the two areas separated by the fence must between them contain at least three crosses.

It is possible now to show that all the cases of necessary or contingent existence or emptiness for a property represented in such a two-area diagram are covered by our rules.

I. Suppose the property called *PR* is necessarily empty. In this case both the properties called *PQR* and *PQ'R* are necessarily empty. So we get just one possible diagram:

	PQR-area	*PQ'R*-area	Fence
1.	000	000	0

The nought on the fence is required by Corollary 6.

II. Suppose the property called *PR* is contingently empty. To represent emptiness, we must put two noughts in the *PQR*-area *and* in the *PQ'R*–area— and also, by Corollary 6, a nought on the fence. Since the emptiness is only contingent, there must be a cross in one or the other of the *PQR*- and *PQ'R*- areas to represent possible existence; we thus get three cases.

	PQR-area	*PQ'R*-area	Fence
2.	00X	000	0
3.	00X	00X	0
4.	000	00X	0

III. Suppose the property called *PR* is contingently existent. To represent the possibility of its being empty, we must put a nought on the fence—and, by Rule 8, in each of the sub-areas as well. To represent the existence of the property, we put two crosses on one or other side of the fence. Thus one of the two sub-areas will contain two crosses and a nought; the other must then contain a nought, and otherwise its marking is undetermined. We get six cases:

	PQR-area	*PQ'R*-area	Fence
5.	0XX	000	0
6.	0XX	00X	0
7.	0XX	0XX	0
8.	000	0XX	0
9.	00X	0XX	0
10.	0XX	0XX	0

IV. Suppose the property called *PR* necessarily exists, but neither of the properties called PQR and PQ'R necessarily exists. To represent the existence of the property, we must put two crosses on one or the other side of the fence; to represent its necessary existence, we must put a cross on the fence. To represent the possible emptiness of both the properties called *PQR* and *PQR'*, we put a nought on both sides of the fence. Thus there must be two crosses and a nought on one side of the fence, and at least one nought on the other

side; there must likewise, by Rule 11, be at least one cross on that side. We thus get three cases:

	PQR-area	PQ'R-area	Fence
11.	0XX	00X	X
12.	0XX	0XX	X
13.	00X	0XX	X

V. Suppose that the property called *PR* necessarily exists because one of the properties called *PQR* and *PQ'R* does. We represent this by putting three crosses in one or the other of these areas, *one* on the fence; the marking of the other area is quite undetermined. We thus get seven cases:

	PQR-area	PQ'R-area	Fence
14.	000	XXX	X
15.	00X	XXX	X
16.	0XX	XXX	X
17.	XXX	XXX	X
18.	XXX	0XX	X
19.	XXX	00X	X
20.	XXX	000	X

No Modalized Form of an Invalid Plain Syllogism Is Valid

We may use the Von Wright Diagram to prove that no modalized form of invalid plain syllogism is valid.

Let us begin by enumerating the 26 ways of modalizing a given syllogism. It will be more convenient to consider the modalized forms of the corresponding conjunction got by conjoining the two premises and the contradictory of the conclusion: let us represent this by $p\&q\&r$. Then the 26 modalized conjunctions will be the following:

i.	*Lp&Lq&Lr*	x.	*Tp&Lq&Lr*	xviii.	*Mp&Lq&Lr*
ii.	*Lp&Lq&Tr*	xi.	*Tp&Lq&Tr*	xix.	*Mp&Lq&Tr*
iii.	*Lp&Lq&Mr*	xii	*Tp&Lq&Mr*	xx.	*Mp&Lq&Mr*
iv.	*Lp&Tq&Lr*	xiii.	*Tp&Tq&Lr*	xxi.	*Mp&Tq&Lr*
v.	*Lp&Tq&Tr*		*[Tp&Tq&Tr]*	xxii.	*Mp&Tq&Tr*
vi.	*Lp&Tq&Mr*	xiv	*Tp&Tq&Mr*	xxiii.	*Mp&Tq&Mr*
vii.	*Lp&Mq&Lr*	xv.	*Tp&Mq&Lr*	xxiv.	*Mp&Mq&Lr*
viii.	*Lp&Mq&Tr*	xvi.	*Tp&Mq&Tr*	xxv.	*Mp&Mq&Tr*
ix.	*Lp&Mq&Mr*	xvii.	*Tp&Mq&Mr*	xxvi.	*Mp&Mq&Mr*

Of all these conjunctions, (i) is plainly the strongest. So all we need to prove is: If the conjunction *p&q&r* is consistent, so is the conjunction *Lp&Lq&Lr*. In that case all the other modalized conjunctions will be consistent. From this it follows that if the syllogism *p*, *q*, *ergo* ¬*r* is invalid, so is any modalized form of it. For *p*, *q*, *ergo* ¬*r* is invalid iff the conjunction *p&q&r* is consistent; but then, if we can prove our main result, *Lp&Lq&Lr* will be consistent. So we cannot have (say) the syllogism *Mp*, *Lq*, *ergo* *M*¬*r* valid; for it would be so iff *Mp&Lq&Lr* were inconsistent; but on the contrary the stronger conjunction *Lp&Lq&Lr* is consistent.

Our procedure will be to show that if *p&q&r* is shown consistent by a Lewis Carroll diagram, then we can construct a Von Wright Diagram representing *Lp&Lq&Lr* together. We saw that if *p&q&r* is consistent, then so also is the carrollized form of this conjunction—in which every O-conjunct is replaced by a corresponding ô-conjunct—and that then all three conjuncts of this stronger conjunction can be represented in one Lewis Carroll Diagram. Let us represent the carrollized form of *p&q&r* as *p'&q'&r'*, where *p'* either just is *p* or is the carrollized substitute for *p* if *p* is an O proposition—and so similarly for *q'* and *r'*. Then *p'&q'&r'* is representable in the Lewis Carroll Diagram. Now construct a Von Wright Diagram as follows: If in an undivided area of the Lewis Carroll Diagram there is a nought (a cross), replace it by three noughts (three crosses). Place a cross on every fence adjoining a three-cross area, and a nought on every fence dividing two three-nought areas. It will be found that we have thus represented in the Von Wright Diagram the conjunction *Lp'&Lq'&Lr'*: since each of *p'*, *q'*, *r'* either is identical with *p*, *q*, *r* respectively or is a stronger proposition, the consistency of *Lp'&Lq'&Lr'*, shown in the Von Wright Diagram, establishes a fortiori the consistency of *Lp&Lq&Lr*.

Example.

We showed earlier that the conjunction *PoR* & *QaR* & *QaP* is consistent—and thus the syllogism *PoR*, *QaR*, *ergo* *QoP* is invalid—by representing in the following Lewis Carroll Diagram the corresponding carrollized conjunction *PôR* & *QaR* & *QaP*.

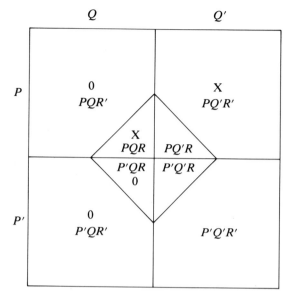

Figure 12

We now construct this Von Wright Diagram; for simplicity, I omit the lettering of the areas, which would correspond exactly to the Lewis Carroll Diagram.

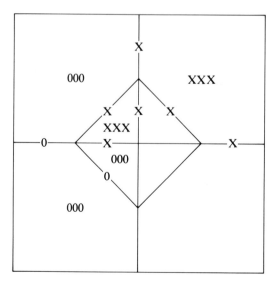

Figure 13

Some of the areas are left blank, but it would be easy to fill them in so as not to violate our rules, e.g., by inserting two noughts in each. We have now represented the conjunction $L\neg EQR'$ & $LEPQR'$ & $LEPQR'$ & $L\neg EQP'$. Now from $LEPQR$ there follows $LEPQ$ & $LEQR$; and from $LEPQR'$ there follows $LEPR'$. So we have represented $L\neg$ EQR' & $LEPQ$ & $LEQR$ & $LEPR'$ & L $\neg EQP'$; or, equivalently, since L distributes over conjunction, $L(EQRR$ & $\neg EQR')$ & $L(EQP$ & $\neg EQP')$ & $LEPR$; that is, $L(QaP)$ & $L(QaR)$ & $L(P\hat{o}R)$. Hence the conjunction $L(P\hat{o}R)$ & $L(QaR)$ & $L(QaP)$ is consistent, and a fortiori so is $L(PoR)$ & $L(QaR)$ & $L(QaP)$.

VALID MODALIZATIONS OF VALID SYLLOGISMS

Certain modalizations of valid syllogisms may be shown to be valid by simple considerations which do not appeal to diagrams.

First: Any syllogism obtained from a valid syllogism by strengthening premises or weakening the conclusion is valid. More simply: If $p\&q\&r$ is an inconsistent conjunction, any stronger conjunction is inconsistent; and any syllogism derived from this conjunction by taking two conjuncts as premises and the contradictory of the third as conclusion will be valid.

Now of our 26 modalized conjunctions, the following are stronger than $p\&q\&r$—or $Tp\&Tq\&Tr$:

 (i), (ii), (iv), (v), (x), (xi), (xii).

Consequently, all these modalizations of an antilogism $p\&q\&r$ will themselves be antilogisms, and each of them will yield a valid syllogism.

Secondly: Aristotle has a sound rule that if p, q, ergo s is a valid syllogism, so is Lp, Lq, ergo Ls. The corresponding rule for antilogisms is: If $p\&q\&r$ is a valid antilogism, so is $Lp\&Lq\&Mr$. For p, q, ergo $\neg r$ will be a valid syllogism; so Lp, Lq, ergo $L\neg r$ will be a valid syllogism; so $Lp\&Lq\&\neg L\neg r$, or $Lp\&Lq\&Mr$, will be an antilogism. We may similarly show that $Lp\&Mq\&Lr$ and $Mp\&Lq\&Lr$ are antilogisms. Accordingly, the following modalizations of antilogisms yield antilogisms: (iii), (vii), and (xviii). (We get no further antilogisms by strengthening these, beyond those listed already.)

INVALID MODALIZATIONS OF VALID SYLLOGISMS

It will suffice to show that if $p\&q\&r$ is no antilogism, neither $Lp\&Tq\&Mr$ nor $Lp\&Mq\&Tr$ nor $Tp\&Lq\&Mr$ nor $Tp\&Mq\&Lr$ nor $Mp\&Lq\&Tr$ nor $Mp\&Tq\&Lr$ is an antilogism: i.e., that none of the modalizations (vi), (viii), (xii), (xv), (xix), (xxi) is an inconsistent conjunction when $p\&q\&r$ is inconsistent. For all

the modalizations not already shown to be antilogisms are weaker than one or another of these six. (ix) is weaker than (viii); (xiv) is weaker than (xii); (xvi) and (xvii) are weaker than (xv); (xx) and (xii) and (xxiii) are weaker than (xix); (xxiv) and (xxv) and (xxvi) are weaker than (xxi).

Unfortunately, the use of Von Wright Diagrams here proves insufficient. For a Von Wright Diagram cannot represent a proposition $M(PaR)$ nor yet a proposition $L(PoR)$.

$M(PaR)$ is equivalent to: $M(EPR$ & $\neg EPR')$; i.e., to $M((EPQR \lor EPQ'R)$ & $\neg EPQR'$ & $\neg EPQ'R')$; i.e., to $M(EPQR$ & $\neg EPQR'$ & $\neg EPQ'R')$ \lor $M(EPQ'R$ & $\neg EPQR'$ & $\neg EPQ'R')$. To represent this disjunction in a Von Wright Diagram, we should need to represent one of these disjuncts. But although our rules enable us to represent, e.g., the conjunction $MEPQR$ & $M(\neg EPQR'$ & $\neg EPQ'R')$, we cannot represent the situation in which not only do these two possibilities hold but they are actually *compossible*. No disposition of marks can show that the simultaneous emptiness of (the properties represented by) two adjacent areas is compatible with the non-emptiness of a third area.

$L(PoR)$ is equivalent to: $L(\neg EPR \lor EPR')$. We can see without more ado that our rules for Von Wright Diagrams make no provision for representing the *necessary* alternative between the non-emptiness of one area and the emptiness of another.

However, by an artifice we can circumvent the unfeasibility of directly representing in Von Wright Diagrams the 'necessitated' form of an O proposition or the 'possibilified' form of an A proposition.

If we consider the eight antilogistic conjunctions for plain syllogistic, we see that all of the antilogisms (1) to (6) may be obtained from the antilogism

 PaR' & PaQ & QaR

by weakening one or more conjuncts and a relettering that consists in switching the contradictory predicates R and R'. (Since R stands for the same property as $(R')'$, this is legitimate.)

 To get (1): weaken PaR' to PoR

 To get (2): weaken PaR' to PeR

 To get (3): replace R and R' by each other; then weaken PaR to PiR, and QaR' to QeR.

 To get (4): replace R and R' by each other; then weaken QaR' to QeR

 To get (5): weaken PaR' to PeR and PaQ to PiQ.

 To get (6): replace R and R' by each other; then weaken PaQ to PiQ and QaR' to QeR.

As for the two antilogisms answering to fourth-figure syllogisms, (7) may be rewritten as QeP & PaR & RiQ, (8) as QeP & PaR & RaQ. Both are derivable

from *PaQ'* & *PaR* & *RaQ* by weakening *PaQ'* to *PeQ,* or equivalently *QeP,* and for (7) additionally weakening *RaQ* to *RiQ.* And *PaQ'* & *PaR* & *RaQ* is a mere relettering of our fundamental inconsistent conjunction *PaR'* & *PaQ* & *QaR.*

It follows from this that if modalizing the conjuncts of our fundamental antilogism in ways corresponding to the modalizations (vi), (viii), (xii), (xv), (xix), and (xxi) of 'syllogistic' antilogisms never yields an inconsistent conjunction, then such modalizations of the 'syllogistic' antilogisms cannot be inconsistent either. For let the 'syllogistic' antilogism be *p&q&r,* and consider the modalization (vi), *Lp&Tq&Mr.* We shall obtain this by modalizing the conjuncts of our fundamental antilogism with *L, T,* and *M* in *some* order—which must correspond to *one* of the six modalizations mentioned—and weakening one or more conjuncts and then if necessary permuting conjuncts and relettering predicate-letters. But if this stronger modalized conjunction is consistent, so is *Lp&Tq&Mr.*

Our problem is thus reduced to the representability in Von Wright Diagrams of the following six conjunctions—numbered, for convenience, according to the style of modalization:

(vi)	*L(PaR')* & *T(PaQ)* & *M(QaR)*
(viii)	*L(PaR')* & *M(PaQ)* & *T(QaR)*
(xii)	*T(PaR')* & *L(PaQ)* & *M(QaR)*
(xv)	*T(PaR')* & *M(PaQ)* & *L(QaR)*
(xix)	*M(PaR')* & *L(PaQ)* & *T(QaR)*
(xxi)	*M(PaR')* & *T(PaQ)* & *L(QaR)*

None of these conjunctions includes a 'necessitated' O-conjunct; so we are relieved of the need to devise some diagrammatic representation of that. We deal with 'possibilified' A-conjuncts by the following artifice: *M(SaP)* is equivalent to *M(ES* & *¬ESP').* But since in modal logic *Lp&Mq* is stronger than *M(p&q),* *LES* & *M¬ESP'* will be stronger than *M(ES* & *¬ESP').* We accordingly replace each conjunct of the form *M(SaP)* by the corresponding conjunction of the form *LES* & *M¬ESP';* it then turns out that for each of our six conjunctions there is a Von Wright Diagram that shows this *stronger* conjunction to be consistent.

(vi) *L(PaR')* & *T(PaQ)* & *M(QaR)* is equivalent to:
LEPR' & *L¬EPR* & *EPQ* & *¬EPQ'* & *M(EQ* & *¬EQR').*

We replace the last conjunct with *LEQ* & *M¬EQR',* and get the following diagram. (The filling in of marks in areas sometimes admits of alternatives. Readers wishing to check for themselves the construction of diagrams should fill in noughts for emptiness-propositions before inserting crosses for existence-propositions.)

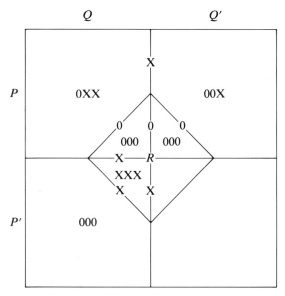

Figure 14

(viii) *L(PaR′)* & *M(PaQ)* & *T(QaR)* is equivalent to:

LEPR′ & *L¬EPR* & *M(EP & ¬EPQ′)* & *EQR* & *¬EQR′*.

We replace the third conjunct with *LEP* & *M¬EPQ′*—or rather just with *M¬EPQ′*, since we already have *LEP via LEPR′*—and we get the diagram:

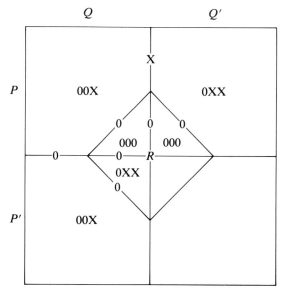

Figure 15

(xii) $T(PaR')$ & $L(PaQ)$ & $M(QaR)$ is equivalent to:

EPR' & $\neg EPR$ & $LEPQ$ & $L\neg EPQ'$ & $M(EQ$ & $\neg EQR')$

We replace the last conjunct by LEQ & $M\neg EQR'$—or rather just by $M\neg EQR'$, since given $LEPQ$ we need not add LEQ. We get the following diagram:

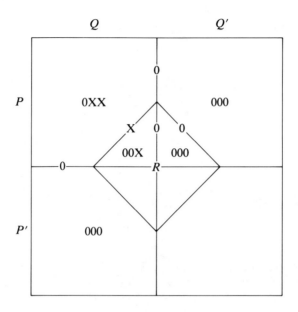

Figure 16

(xv) $T(PaR')$ & $M(PaQ)$ & $L(QaR)$ is equivalent to:

EPR' & $\neg EPR$ & $M(EP$ & $\neg EPQ')$ & $LEQR$ & $L\neg EQR'$

We replace the third conjunct with LEP & $M\neg EPQ'$. We get the following diagram:

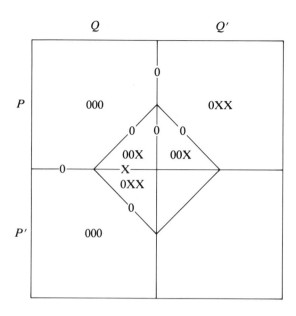

Figure 17

We have here represented $L\neg EPQR'$ & $\neg EPR$ & $M\neg EPQ'$; but all these to-
gether do not add up to $\neg LEP$, or $M\neg EP$. So this diagram is still *compatible*
with *LEP*—which we might perhaps represent by a cross perched uncomforta-
bly upon the point where the four fences of the *P*-area meet! The other con-
juncts, namely:

EPR' & $\neg EPR$ & $M\neg EPQ'$ & $LEQR$ & $L\neg EQR'$,

in our strengthened conjunction, are already represented in the diagram.

(xix) $M(PaR')$ & $L(PaQ)$ & $T(QaR)$ is equivalent to:

$M(EP$ & $\neg EPR)$ & $LEPQ$ & $L\neg EPQ'$ & EQR & $\neg EQR'$

We replace the first conjunct by LEP & $M\neg EPR$—or rather just by $M\neg EPR$,
since LP is superfluous given $LEPQ$—and we get the diagram:

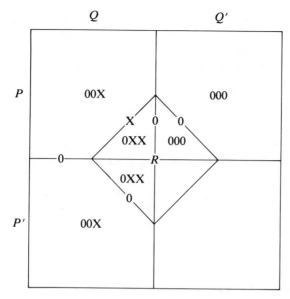

Figure 18

(xxi) $M(PaR')$ & $T(PaQ)$ & $L(QaR)$ is equivalent to:

$M(EP$ & $\neg EPR)$ & EPQ & $\neg EPQ'$ & $LEQR$ & $L\neg EQR'$

We replace the first conjunct by LEP & $M\neg EPR$, and we get the diagram:

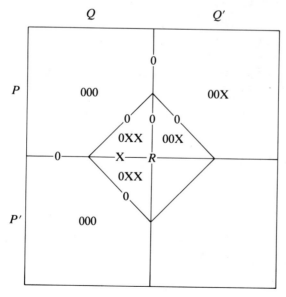

Figure 19

We have represented $L\neg EPQR'$ & $M\neg EPR$ & $\neg EPQ'$: but these all together do not add up to $M\neg EP$ or $\neg LEP$. As before we have a diagram *compatible* with LEP—which we might represent by perching a cross on the meeting-point of the four P-fences. The other conjuncts of our strengthened conjunction, namely:

$M\neg EPR$ & EPQ & $\neg EPQ'$ & $LEQR$ & $L\neg EQR'$,

are all already represented in the diagram.

(The reasoning for (xv) and (xxi) may be simply presented in propositional modal logic. Put $\neg EPQR' = p$, $\neg EPQR = q$, $\neg EPQ'R = r$, $\neg EPQ'R = s$. Then $\neg LEP$, or $M\neg EP$, is equivalent to $M(p\&q\&r\&s)$. But what we have represented in the diagram for (xv) is the conjunction $Lp\&q\&r\&M(r\&s)$; and in the diagram for (xxi), the conjunction $Lp\&M(q\&r)\&r\&s$. From neither of these can $M(p\&q\&r\&s)$ be inferred; p,q,r, and s are, of course, all logically independent.)

SUMMARY AND CONCLUSION

No modalization of an invalid plain categorical syllogism is valid (Aristotle already asserted, but could not prove, this result). If we start with a valid categorical syllogism p, q, *ergo r*, the valid modalizations of it, corresponding to modalized antilogisms, will be the following (for convenience I retain the numbers of the antilogisms):

(i)	*Lp, Lq, ergo Mr*	(vii)	*Lp, Mq, ergo Mr*
(ii)	*Lp, Lq, ergo r*	(x)	*Tp, Lq, ergo Mr*
(iii)	*Lp, Lq, ergo Lr*	(xi)	*Tp, Lq, ergo Tr*
(iv)	*Lp, Tq, ergo Mr*	(xiii)	*Tp, Tq, ergo Mr*
(v)	*Lp, Tq, ergo r*	(xviii)	*Mp, Lq, ergo Mr*

All other *de dicto* modalizations of valid syllogisms are invalid. The decision problem for these syllogisms is thus solved.

UNIVERSITY OF LEEDS P. T. GEACH
MARCH 1975

25

Alan Ross Anderson

VON WRIGHT ON ENTAILMENT

> One may try to defend the view [that entailment is the same as strict implication] by saying that the *sense,* in which impossible propositions can be said to entail certain consequences and not others, is a different sense of 'entail' from the one, in which impossible propositions can be said to entail anything and everything. But then our answer is that it is in this other sense of 'entail' that we are here interested (*and which alone is interesting*).—Von Wright 1957 (p. 174)

In this essay I will try to answer three questions. Since the topic of *fallacies* will arise naturally in the ensuing discussion, there is probably no harm at the outset in mentioning that the questions themselves are examples of one of the more fanciful toys in the battery of fallacies available to writers of elementary disquisitions on logic from Aristotle's time to our own, namely, the Fallacy of Many Questions—to the extent that that perplexing idea can be understood. (Hamblin says correctly in his elegant study (1970) of the traditional literature on fallacies, that (in effect) the "Fallacy of Many Questions" simply cannot be understood: "A fallacy, we must repeat, is an *invalid argument;* and a man who asks a misleading question can hardly be said to have argued, validly or invalidly, for anything at all. Where are his premises and what is his conclusion?" (p. 39).

What I shall do at the outset is to state the three questions bluntly, and indicate where the Many-Questions bit may (or may not) arise. I shall then proceed to take up each in turn. In a final section I shall try to summarize

(*Note by Nuel D. Belnap, Jr.:*) When Alan Ross Anderson died in December, 1973, he left an unfinished manuscript for this paper; it was the last thing he worked on. The portion through p. 25 (Ms.) I found in essentially final form and with it I have tinkered very little. The brief part from p. 26 (Ms.) through the end of II, as indicated in the text, I wrote on topics suggested by a few gnomic phrases left by Anderson in a margin. Part III was put together from scattered and unorganized paragraphs of rough draft. Accordingly, they are piecewise due to Anderson, while I am responsible for their present order and form (and for an occasional bit of connective tissue).

findings, and give my good friend and mentor a target at which to shoot in explaining where I have gone wrong.

(1) What new questions arose in the celebrated passage in which G. E. Moore (1920) introduced "entails" as a synonym for "the converse of deducibility"? Evidently Moore felt that there was a new question, and many agreed, as is evidenced by a literature of hundreds of articles on "entailment" since 1920—see Wolf 198 + . (But perhaps there *was* no new question; at any rate Frege, Peano, and Whitehead-Russell had *claimed* to answer whatever question there was.)

(2) What gives us reason for associating von Wright's name with the notion of entailment, so as (for example) to move the editor of this distinguished series of books to feel that an article with the present title would be required for inclusion in the present volume? (Perhaps nothing. It is true that von Wright *uses* the term "entails" frequently in his abundant writings, but only two of his many articles are devoted explicitly to the topic, and both of these are inconclusive, as von Wright himself points out.)

(3) What have been the influences of von Wright's contributions to the study of entailment? (Perhaps none, because he made none.)

If the reader finds the questions surly in tone, we urge him to read on; the answers and summary become more mellifluous.

What *did* G. E. Moore have in mind when he demanded of us, in the well-known passage from his 'External and Internal Relations'

> . . .some term to express the *converse* of that relation which we assert to hold between a particular proposition q and a particular proposition p, when we assert that q *follows from* or is *deducible* from p,

and added,

> Let us use the term "entails" to express the converse of this relation, . . .?

In the first place it should be noticed that all of those giants who were involved in developing mathematical logic as we know it today thought that 'material implication' *was* the 'converse of deducibility'. I shall concentrate for this claim only on the writings of Frege, Peano, and Whitehead-Russell though the available evidence is much vaster, and could be documented almost endlessly. There is, however, a special reason for my wanting to treat a few cases with some care and in some detail, a reason associated with the following historical circumstances surrounding the case.

The fact is that the giants who founded the modern mathematical tradition in logic *did* take material implication to be doing *exactly* what Moore wanted 'entailment' to do—as indeed Moore said of Russell. Nor is it altogether surprising that this should be so; important and powerful innovations in mathematics as elsewhere are frequently announced with an initial youthful exuber-

ance which, while giving due recognition to the importance of the innovation, gives insufficient attention to possible limitations. The latter are attended to only after maturer reflection gives one a chance to see what is really going on. (How often have we heard, since the advent of digital computers, announcements to the effect that 'within the next ten years, the International Chess Champion of the World will be a computer program!'? I suppose that in spite of these announcements, most of us are still willing to put our money on Fischer—or Spassky, for that matter.)

The initial enthusiasm for material implication as 'the converse of deducibility' of course waned, after countless convincing counterexamples to the idea that 'not-p or q,' with extensional 'or', could be thought of as meaning 'if p then q' came to light. It would have been nice, even beautiful, if there had been some alternative to material implication, equally satisfactory from a mathematical point of view, on which to fall back. But there wasn't, and the (again very important) innovations of strict implication of C. I. Lewis suffered from defects which, while not *quite* as disturbing as those of material implication, were still sufficient to convince many that *this* wasn't the theory they were looking for either.

What does one do in such a case, i.e., where one has an important, deep, powerful theory (that of material implication) which does *lots* of enormously important work, but *does not* have some of the important properties properly to be expected of it if it is to be taken correctly as a theory of 'if . . . then---'? The most common attitude among contemporary mathematical logicians is simply to acknowledge that neither material nor strict implication has all the properties one might antecedently expect 'if . . . then---' to have, and then to maintain stoutly that those properties which are lacking (such, for example, as requiring relevance of antecedent to consequent in a true 'if . . . then---' statement) are *unimportant,* and can be safely ignored. Going with this attitude is a frequent explicit claim that the notion of logical relevance, or of the logical dependence of one proposition on another, is hopelessly obscure, and that it is *infra dig* to pay attention to it.

Had there *been* a viable alternative to the extensional theories proposed by Frege, Peano, Whitehead-Russell, and their followers, in which such notions as relevance were given an adequate mathematical treatment, of course no one would have been forced into the position just described, which is to be found stated most explicitly and persuasively throughout the writings of Quine. But *without* a viable alternative to an existing theory, which is already extremely powerful, beautiful, important, and successful in handling an appallingly wide range of significant mathematical situations, there seems little to do other than to insist that the available theory (which is all we have) is all we need. And that is the misguided position in which most contemporary logicians find themselves, or so I claim—at any rate I can say with utmost sincerity that it was

the position in which I found myself 20 years ago (which provides indisputable evidence that at least one person has been in that awkward situation).

My reason for carrying on about this topic at such length is that I think we should all abandon the position just described as quickly as possible—and one way of *pretending* to abandon it gracefully is to pretend that one never held it, or that *no one* ever did. Which is why I want to spend some time making good the claim of four paragraphs ago that *in fact* "the giants who founded the modern tradition *did* take material implication to be doing *exactly* what Moore wanted *entailment* to do." This is simply to prevent some obviously possible attempts at weaselling.

In fact I shall give most of the available space to Frege, since, if the case can be made convincing for him, a handful of references will do the job for Peano and Whitehead-Russell.

At the risk of boring the reader by being too repetitious, I would like to state the issue once again (taking Moore's literary style in writing about philosophy as my model). We were all told as freshmen in logic that 'not . . . or---', with extensional 'or', meant 'if . . . then---'. And then on noticing that *any* contradiction $p\&\sim p$ has the feature that 'if $p\&\sim p$, then q,' for arbitrary q, under this understanding of 'if . . . then---', we *rejected* this as an adequate account. But our teachers then told us that of course it doesn't fit *exactly,* but '*no one was ever confused* about the closeness of fit.' That's a lie, and our first job is to show that is. It is also my conviction that the woods are even now full of logicians who believe that orthodox extensional logic is altogether adequate as an analysis of formal logic as it is used in any scientific discipline, but of course I don't have the sociological data required to buttress that claim. The historical facts at least are clear and incontrovertible, however, and it is to these that we turn first.

Frege

We back up a little historically to observe that *whatever* logicians in the Aristotelian tradition thought they were doing, either finding tests for the validity of immediate or mediate inferences (syllogisms), or discussing sophistical refutations and fallacious reasoning, it is perfectly clear that neither in their formal nor informal discussion of logical problems were they trying to create either a formal or informal general account of *deducibility.* And this is true in spite of the readily available *Elements* of Euclid, which, from a methodological point of view, had a stranglehold on philosophic and scientific methodology for a good two thousand years. It provided *the* example *par excellence* of the 'ground-consequent' style of explanation. 'How do you determine and explain the properties of triangles?' 'Well, something like this. First you lay down some common rules of reasoning (*koiné*) which you allow yourself to use in

constructing proofs, then you lay down a series of assumptions or postulates (*axiomata*) appropriate to the subject matter at hand (in this case geometry), and then you look for appropriate *definitions*. And when you find the correct definition of the term "triangle" as ground, then its properties flow with ineluctable rigor by applications of the principles of right reason already laid down, as *consequences* of the *ground,* or definition.'

This approach to explanatory theories generally, because of its spectacular success in Euclid's application of it, seems to have caught the imagination of practically everyone, and the problem of specifying the *essential* definitional attributes of a thing or quality (Man, God, the Good, the Beautiful, the True, etc.) was a continuing preoccupation of scientists and philosophers from the time of the Academy and the Lyceum until Hume finally wakened Kant and the rest of us from our dogmatic slumbers. And of course Spinoza's *Ethics* has long been held up as another *example par excellence* of the vice-like grip in which the Western philosophical imagination was held by Euclid's model.

It is then somewhat surprising, perhaps, that virtually no one during the period from Euclid's time to the end of the nineteenth century thought of the possibility of treating Euclidean geometry as a special case of a more general notion of a *deductive system,* and studying the properties of the latter in abstraction from the particular Euclidean case. All that qualifying of the word 'surprising' in the sentence above is occasioned of course by the fact that it may not be surprising at all. There was after all only one example (Euclid), and it is difficult to talk abstractly about a topic when you have only one example. And such abstractions were certainly not in the air anywhere else in mathematics—even what we think of as abstract algebra, or as 'pure' mathematics, dates only from the nineteenth century.

At any rate, no one in the Aristotelian tradition *did* treat anything at all as a deductive system; this idea had to wait the arrival of Frege. The Aristotelians were concerned rather with two not very closely related topics: formal logic, dealing with mediate inferences and syllogisms, and informal logic, dealing with fallacious arguments, under the heading of *sophismata.*

Aristotle's own treatment of mediate and immediate inferences seemed to proceed satisfactorily enough, prompting Kant's remark in 1787 that "It is remarkable also that to the present day this [Aristotelian] logic has not been able to advance a single step, and is thus to all appearance a closed and completed body of doctrine" (p. 17). And though of course no one now holds such a view, it is certainly understandable that Kant should have; after all, syllogistic theory had undergone only the slightest of inessential changes from the time of Aristotle to that of Kant, and there was every reason to see it as a good job, well and completely done at the very outset.

I suggested in the next-to-last paragraph that Aristotle's consideration of informal logic was the primary place in which his tradition concerned itself

with fallacies. This is not altogether accurate, though it is true that the study of fallacies, among them fallacies of relevance, was the focal point of Aristotle's own consideration of informal logic. But it also developed that the study of fallacious or invalid syllogisms led to a set of criteria for identifying valid syllogisms, i. e., that set of rules involving the ambiguous middle term, illicit process of the minor (major) term, negative premisses, etc., as set forth, e.g., by Jevons (1870) Lesson XV. (These rules are to be distinguished from simply listing the valid forms, for which we have what *must* be the most unmemorable 'mnemonic' ever contrived by anyone for remembering anything: "*Barbara, Celarent, Darii, Ferioque, prioris,*" etc.) The rules tell us how to identify valid syllogisms by telling us how to identify the invalid ones, and the criteria provided by the rules are *formal* in the sense that they apply only to formal properties of syllogisms.

But of course even Aristotle recognized that not all arguments or disputations are syllogistic in form, and it seemed natural to hope to find ways of classifying other arguments in some equally effective way so as to tell the good from the bad. Aristotle tried to give such a classification in his *Sophistical Refutations,* and his successors tried manfully to improve and clarify the list. But as Hamblin (1970) makes abundantly clear, the topic began as a morass, and has remained so until today. Aristotle and his followers give many examples of arguments or disputations in which something has somehow gone wrong, but it has thus far proved impossible to give a taxonomy of such arguments that has even the remotest plausibility; the subject remains in the same hopeless state in which Aristotle left it.

Indeed one of Aristotle's examples of a fallacy of relevance is surely the only place in the entire Aristotelian corpus where one may find something approximating a joke. At 172a 8 in *De sophisticis elenchis,* he asks us in effect to envisage a group of Athenians concluding a banquet, at which point one of their number suggests that they go for a walk, adding that it is frequently a good idea to go for a walk after eating a heavy meal. But another member of the group, a doctor, denies that it is "better to take a walk after dinner", and being asked why, he begins trotting out Zeno's arguments against the possibility of motion. Aristotle comments with ponderous solemnity that this "would not be a proper argument for a doctor, because Zeno's argument is of general application", which appears to this writer to mean not much more than that Zeno's arguments are *not relevant* to the issue at hand, and should be rejected on that account.

Now in the *formal* parts of Aristotle's work on logic, the fact that the premisses are *relevant* to the conclusion in a valid syllogism is guaranteed by the presence of an unambiguous middle term, and the presence of both of the extreme terms in the conclusion. So no special discussion of relevance is required—the notion is already built into the formal machinery. But in non-

syllogistic arguments, the varieties of irrelevance are so vast as to seem to defy classification.

The situation became if anything worse with the discovery of Stoic logic, for it led eventually to one familiar 'implicational paradox', the recently (i.e., hereby) named *consequentia horribilis:* if p and not-p, then q. Here we deduce a conclusion from premises which may be entirely irrelevant to the conclusion (which is obviously the reason why the principle has been called 'paradoxical'). And by throwing the notion of relevance of antecedent to consequent entirely out the window in this way, the attempt to capture or classify our intuitive ideas of relevance and irrelevance became even more hopeless. (This argument form apparently did not occur in the writings of the ancient logicians, but it does crop up in the writings of Albert of Saxony (Boehner, 1952); whether there is any continuous tradition from Albert to C. I. Lewis concerning this argument I have not been able to ascertain.)

This concludes the rather breathless historical backup announced above. The need for condensation has led me to ignore many subtleties and perhaps introduce some inaccuracies which a more leisurely treatment might avoid, but as preparation for getting on to Frege, I wanted to remind the reader of two points of historical importance to Frege's *Sinn-Bedeutung* distinction.

(1) As remarked before, the rules for syllogistic reasoning guarantee that the premises will be relevant to the conclusion, this guarantee being built into the requirement that a valid syllogism must have three terms, each being used twice in the argument in formally specifiable ways.

(2) Both the Aristotelian and modern symbolic traditions have foundered completely (until recently) on the concept of relevance as applicable in other than syllogistic contexts, which are *so* restricted that we may fairly say that for all intents and purposes, until the early 1950s there simply was no formal characterization of relevance of any kind. And this is true even for that restricted sense of relevance which we might call 'logical relevance' as opposed to 'informal relevance'. The distinction I have in mind is not altogether clear, but examples will enable the reader to guess what I have in mind. (a) Clearly the antecedent of 'if p and q, then p' is *logically* relevant to (and in this case logically sufficient for) the consequent. On the other hand in 'if p and not-p, then q', the antecedent is not logically relevant to and *hence* not logically sufficient for, the consequent. (I won't argue the point here; see Anderson and Belnap, 1975.) (b) But there is also a mushier notion of relevance, in which we can all recognize the disjuncts in 'Either I planted peas in that part of the garden, or else I planted beans there' as in some sense relevant to each other, and those in "Either I planted peas in that part of the garden, or else $1 = 0$" as totally irrelevant to each other. We still have nothing even remotely satisfactory as an account of the informal sense of relevance, though we do now have a satisfactory mathematical treatment of 'logical relevance', a topic to which I

shall return later. But at the time of Frege's extraordinarily original insights the theory of logical relevance was in as hopeless a state as was that I have just called 'informal relevance'.

Recalling (1) and (2) to the reader's attention was the point of this historical digression, and we may now return to the question which prompted it: we asked whether Frege thought of his 'if. . .then---' as 'the converse of deducibility' (against the background of his theory of deducibility and deductive systems). My contention is that he did, and I begin by introducing some documents in evidence for the claim.

We do not know how familiar Frege was with the literature on sophisms, or of the implicit (and explicit, in Aristotle and his followers) demand for relevance of p to q when q is deducible from p. His generally irascible tone in discussing the opposition which his own views met, or the views of contemporaries which disagreed with his, suggests that he would have dismissed the whole corpus of discussions of relevance in the Aristotelian tradition as beneath contempt. But of course he was perfectly familiar with syllogisms and the like, and in particular with the Aristotelian emphasis on the subject-predicate character of propositions which the Aristotelian tradition had emphasized as so essential to Rational Thought. He was at least familiar enough with the latter to make the point explicitly that the subject-predicate distinction *had no place* in the system of his motivation. And indeed, though he was, as Church (1956, n.66) points out, a "thorough-going Platonic realist", both concerning the *Sinne,* or conceptual content of judgments, and their *Bedeutungen,* or truth values *das Wahre* and *das Falsche*—when it came to constructing a theory of deducibility, his new broom swept astonishingly clean. For the *only* requirement placed on the laws of deducibility was preservation of *truth;* conceptual content had nothing to do with the matter *at all.* It should be emphasized that the conceptual content of *Sinn* was not *simply* ignored as of little or no importance, as the following quotation from the *Begriffsschrift* of 1879 (pp. 13–14) makes clear:

Conditionality

§5. If A and B stand for contents that can become judgments (§2), there are the following four possibilities:

(1) A is affirmed and B is affirmed;
(2) A is affirmed and B is denied;
(3) A is denied and B is affirmed;
(4) A is denied and B is denied.

Now

stands for the judgment that *the third of these possibilities does not take place, but one of the three others does.* Accordingly, if

is denied, this means that the third possibility takes place, hence that *A* is denied and *B* affirmed.

Of the cases in which

is affirmed we single out for comment the following three:

(1) *A* must be affirmed. Then the content of *B* is completely immaterial. For example, let ├── *A* stand for 3 × 7 = 21 and *B* for the circumstance that the sun is shining. Then only the first two of the four cases mentioned are possible. There need not exist a causal connection between the two contents.

(2) *B* has to be denied. Then the content of *A* is immaterial. For example, let *B* stand for the circumstance that perpetual motion is possible and *A* for the circumstance that the world is infinite. Then only the second and fourth of the four cases are possible. There need not exist a causal connection between *A* and *B*.

(3) We can make the judgment

without knowing whether A and B are to be affirmed or denied. For example, let *B* stand for the circumstance that the moon is in quadrature with the sun and *A* for the circumstance that the moon appears as a semicircle. In that case we can translate

by means of the conjunction "if": "If the moon is in quadrature with the sun, the moon appears as a semicircle". The causal connection inherent in the word "if", however, is not expressed by our signs, *even though only such a connection can provide the ground for a judgment of the kind under consideration.* [Italics supplied.]

Frege's use of the word "causal" in the last sentences of each of (1)–(3) above is perhaps unfortunate, in that it may suggest the Humean sense of the word; the suggestion is reinforced by the words italicized just above. But of course Frege does not mean this, since he surely wants to be able to put (say) arithmetical truths or falsehoods in place of the schematic letters; his intention is better expressed in English when he says, e.g., under (1) that "the content of B is *immaterial*" (which we take to mean *irrelevant* in the sense in which we have intended that term).

He then goes on to say immediately:

§6. The definition given in §5 makes it apparent that from the two judgments

$$\vdash \begin{array}{l} A \\ B \end{array} \quad \text{and} \quad \vdash B$$

the new judgment

$$\vdash A$$

follows. Of the four cases enumerated above, the third is excluded by

$$\vdash \begin{array}{l} A \\ B \end{array}$$

and the second and fourth by

$$\vdash B,$$

so that only the first remains.

We could write this inference perhaps as follows:

$$\vdash \begin{array}{l} A \\ B \end{array}$$
$$\vdash B$$
$$\overline{}$$
$$\vdash A.$$

This would become awkward if long expressions were to take the places of A and B, since each of them would have to be written twice. That is why I use the following abbreviation. To every judgment occurring in the context of a proof I assign a number, which I write to the right of the judgment at its first occurrence. Now assume, for example, that the judgment

$$\vdash \begin{array}{l} A \\ B, \end{array}$$

or one containing it as a special case, has been assigned the number X. Then I write the inference as follows:

$$(X): \frac{\vdash B}{\vdash A.}$$

Here it is left to the reader to put the judgment

$$\vdash \begin{array}{l} A \\ B \end{array}$$

together for himself from $\vdash B$ and $\vdash A$ and to see whether it is the judgment X above.

Notice especially the word "follows" [*folgt*] at the end of the first sentence under §6. Absolutely nothing elsewhere in Frege's writings even remotely suggests that he is not taking *folgt* seriously, in spite of the renunciation of the idea that the *Sinne* of the antecedent and consequent are relevant to each other. A sympathetic reading of these passages, and others which elaborate on them, leads *me,* at any rate, to the conviction that in developing a theory of deducibility, Frege was simply taking his (to us, many years later) rather clumsy sign for the conditional as expressing it so completely, indeed, that no new notation is needed. That is to say, we read *both*

$$\vdash\!\!\begin{array}{l} A \\ B \end{array}$$

and

$$(X): \quad \dfrac{\vdash B}{\vdash A.}$$

indifferently as 'if *B* then *A*', or '*A* follows from *B*', or '*A* is deducible from *B*'. And since the same formulas admit of both deducibility-readings and conditional-readings, no distinction is to be made between the latter two sorts of readings.

The situation was made clearer to us much later by Tarski's *deduction theorem* of 1930. Otherwise put, the display marked '(X):' above is to have exactly the significance as the displayed formula just beneath it. And the extent to which the 'clumsy' sign is intended to capture 'the converse of deducibility' is made clear to us finally in the celebrated *Deduction Theorem* of Tarski (1930), which has as a special case (for propositional calculus, and in modern notation): $p \vdash q$ if and only if $\vdash p \supset q$, i.e., q is deducible from p just in case p ('implies', 'entails' [?!]) q.

So relevance as between the *Sinne* of premiss and conclusion has been thrown out lock, stock, and barrel, as a necessary condition for the validity of a valid inference. . .and what a *relief!!* For now we can simply tear up all that mysterious and miserable nonsense associated with sophisms, and commit it to the flames already blazing with the paper in Hume's fire (it still being well supplied with writings concerning neither "Relations of Ideas" nor "Matters of Fact"). We shall return to this point later, but before doing so it might be well simply to mention that Frege was not alone in thinking of his project as involving an analysis of deducibility.

Peano

Having taken so much time on Frege, we can be briefer with the rest.

Peano, for example, takes his inverted, backward letter 'C' to meet the

notion of deducibility head-on. We learn from van Heijenoort's translation (1967, p. 87) of the *Arithmetices principia,* that

> The sign C means is a *consequence* of; thus *b*C*a* is read *b is a consequence of the proposition a.* But we never use this sign. The sign Ɔ means *one deduces* [*deducitur*]; thus *a*Ɔ*b* means the same as *b*C*a*.

To which van Heijenoort adds as a footnote:

> Peano reads *a*Ɔb "ab a deducitur b". Translated word for word, this either would be awkward ("from a is deduced b") or would reverse the relative positions of a and b ("b is deduced from a"), which would lead to misinterpretations when the sign is read alone. Peano himself uses "on déduit" for "deducitur" when writing in French. . ., and this led to the translation adopted here.

Peano's succeeding list of 43 *Propositions of Logic,* which involve signs for negation, disjunction, equivalence, and adjunction for conjunction, then constitute a redundant set of axioms for the two-valued calculus (with no explicit statement of a rule of *modus ponens*). But there can be no doubt that Peano thought of himself as offering a formal characterization of *deducibility,* and that his "Ɔ" (which later became the horseshoe of Whitehead and Russell) simply represented formally the converse thereof.

Whitehead-Russell

Whitehead and Russell endorsed the sentiments of both Frege and Peano. They write (1910 XX, p. 94): "When a proposition *q* follows from a proposition *p,* so that if *p* is true, *q* must also be true, we say that *p implies q*." We can presumably ignore the trivial terminological variant in this passage and that quoted earlier from Moore: *evidently* both 'implies' and 'entails' are being taken to express the converse of 'following from'; and it is luminously clear in Russell (1903 and 1919) that this relation is, as Moore complained, to be identified with material implication.

There simply cannot be any doubt that as von Wright (1957, p. 166) points out, *all* these writers *thought* they were discussing Moore's problem.

> 'Entailment' as a technical term in logic and philosophy was, as far as I know, first introduced by Moore in the paper on 'External and Internal Relations' (1919). We require, Moore says, "some term to express the *converse* of that relation which we assert to hold between a particular proposition *q* and a particular proposition *p,* when we assert that *q follows from* or *is deducible from p.* Let us use the term 'entails' to express the converse of this relation."

> Russell and Lewis and others had used the term 'implication' to mean what Moore called 'entailment.' "When a proposition *q follows* from a proposition *p*", Russell says, "so that if *p* is true, *q* must also be true, we say that *p implies q*."

Similarly, Lewis says of the word 'implies' that it 'denotes that relation which is present when we 'validly' pass from one assertion, or set of assertions, to another assertion.'

All this leads to a sensible answer to the first question with which I began: Moore, probably partly out of ignorance of the remarkable things Frege had accomplished, simply rejected any notion of "Deducibility' which led to such classical twentieth century nonsense as

$$p \rightarrow (q \rightarrow p)$$
$$p \rightarrow (q \rightarrow q)$$
$$(p \& \sim p) \rightarrow q$$

and the like. That is, since q is patently *not* deducible from the conjunction of p and not-p, we reject the last formula above as a valid *conditional* (Frege), *deduction* [?] (Peano), *implication* (Whitehead-Russell), or *entailment* (Moore).

Moore did not put the matter explicitly in the way I just did, but whether or not Moore would be satisfied with this restatement, putting the problem in this way brings out clearly a certain misunderstanding on Moore's part of what was going on (a misunderstanding which we can see without the restatement). Moore doesn't seem to realize that the question as he put it can have a clear sense only in the context of some theory of *deducibility*. (This is not meant as a criticism of Moore; formal, mathematical logic was just not his cup of tea.)

Frege, Peano, Whitehead and Russell had, either explicitly or implicitly, a theory (the same theory) of deducibility, the clearest and best-formulated version of which is to be found in the writings of Frege. But Moore had *no* theory, beyond what English common sense provides, and English common sense simply does not tolerate the three bizarre specimens displayed above, or any of their cousins—not, at any rate without a good bit of fancy footwork designed to destroy certain of our naive logical intuitions. (Groundwork for this destruction takes place by brainwashing in our elementary logic courses.)

So Moore's *new* question (or rather, the question which arose in the literature under the heading of 'the problems of entailment' in response to Moore's new, intendedly technical, sense of 'entails') comes to: is there a theory of formal deducibility which recognizes as valid the healthy 'if. . .then---'s which we *use* in going about our logical business, and rejects the 'paradoxes'? The fact that it *was* a new question is made evident not only by the large numbers of unsuccessful attempts to answer it, but by the fact that, with the help of fundamental papers of Moh, Church, and Ackermann, it can be shown to have an affirmative answer.

And the answer now serves to sharpen Moore's sense of wanting a difference between the theory of 'if. . .then---' given as the converse of deducibility in the sense of Frege-Peano-Whitehead-Russell, and a more sane theory of

entailment, which keeps the good 'if. . .then---' propositions, and chucks out the bad ones.

Moore of course was not alone in being bothered by what came to be called the 'Paradoxes of Implication', a term coined by W. E. Johnson, according to von Wright (1957, p. 170) for such odd-sounding entailments in the two-valued system as, e.g., $p \supset (q \supset p)$: 'if a proposition is true, then *anything* entails or implies it'; or as a special case, $p \supset (\sim p \supset p)$: 'if p is true, then even if it is false, it is true.'

The reader will no doubt have noticed that the English renderings of the formulas above are rife with use-mention confusions, and are on other accounts as well totally unacceptable to anyone writing seriously in the 1970s. But a survey of the literature on the topic in (say) the 1920s assures us that those *were* very common among the idioms used in discussing the paradoxes in the literature, and the reader must remember that all these discussions preceded the general dissemination and acceptance of Tarski's *Wahrheitsbegriff,* and the work of Carnap, both of which accomplished so much toward getting our jargon straightened out, to the point where we could talk more intelligibly about these topics.

Meanwhile, during the murkier period before 1920, C. I. Lewis undertook to construct an alternative analysis of 'the converse of deducibility', notably in his 1918 *Survey of Symbolic Logic,* under the name of *strict implication,*—an analysis which would be closer to our intuitive grasp of entailment than that of Frege-Peano-Russell. His aim was to avoid at any rate, some of the recognized 'paradoxes of implication', such as $p \supset (q \supset p)$, and in this he succeeded, since, e.g., $p \Rightarrow (q \Rightarrow p)$ (where we use \Rightarrow for strict implication) was not a theorem of Lewis's (1918) or any of the several systems of Lewis and Langford (1932). But some analogues of the more noisome paradoxes remained, among them $(p \& \sim p) \Rightarrow q$, and $p \Rightarrow (q \vee \sim q)$. The reply given to objections to *these* theorems was a series of ingenious arguments to the effect that, e.g., $(p \& \sim p) \Rightarrow q$ *did* after all reflect 'a fact about deducibility', and that consequently strict implication did represent entailment. This controversy lives on—for recent discussions see Bennett (1969) and Anderson (1972).

Two further remarks before coming finally to a consideration of von Wright's role in the discussions.

(1) Lewis's enterprise was intended to follow the logistic method, as exemplified by *Principia Mathematica.* The motivational discussion in prose is proportionately larger in Lewis and Langford (1932) than in *PM,* but the mathematical parts are set forth with the same aim of rigor, so that proofs can be checked mechanically—and on the whole, if the book does not measure up to the very highest standards of rigor (as exemplified by Kleene, 1952, for example, or Church, 1956) it is a close approximation.

(2) The vast majority of American extensionalist logicians and mathemati-

cians with side-interests in logic, led largely by Quine, dismissed Lewis's program of finding a more intuitively satisfactory formal characterization of entailment as mish-mash of use-mention confusions, involving no possible interpretation, and worth attention only for the purpose of pointing out that the program was impossible, and ought to be abandoned. Lord Russell's attitude was even loftier; he ignored Lewis completely (see Rescher, 1974). (Robin Dwyer points out that there should be an 'almost' here; see Russell, 1919, p. 153. NDB)

One down, two to go.

II

There still remained, however, a small but stouthearted band of philosophically inclined logicians who felt that an interesting problem remained. Why *do* we have such difficulty in convincing the naive that $(p\&\sim p)\Rightarrow q$, whereas it is child's play to convince them that $(p\&q)\Rightarrow q$? There were a handful of Americans, notably E. J. Nelson, and a rather larger group in England conspicuously including von Wright, who felt that an interesting problem about entailment remained. But that discussion took a quite different course than the one initiated by Lewis, in two respects.

In the first place the arguments were not carried on in the vernacular of mathematics to the same degree *at all,* but rather in the *patois* of the Senior Common Rooms of distinguished English Universities. This led in fact (I do *not* say inevitably) to ambiguities, vaguenesses, and other sorts of unclarity which made assessments of arguments difficult. I shall give examples presently, but first I should mention that many of those who discussed entailment and modal logic more generally in England *did* use the logistic method, or an approximation of it, as for example in von Wright's 'A New System of Modal Logic', 1953.

In the second place, the term 'entails', which Moore introduced by a nominal definition, took on a life of its own, and came to mean something like this: 'we say "*p* entails *q,*" when any of us sane, sensible, rational, reasonably well-educated chaps would recognize that the truth of *q* would follow from the truth of *p* without the help of any funny business involving crazy use of contradictions or tautologies, or other outrages.' For it is simply true that there *are* crazy cases; consult, e.g., Stevenson 1970, or the following delightful example which I owe to Geoffrey Hartmann: you and a friend have been searching through a large assembly for a common acquaintance, and after about 15 minutes of strolling and peering, you say 'Well, if he's here, I don't see him.' What's the contrapositive of *that*?

(The remainder of this section was written by NDB; see note off title.) So

the problem of entailment came to be the separation of the crazy from the sane, and it is this truly challenging problem to which von Wright addresses himself in his 1957 article and 1959 note on this topic.

Of particular interest in the former piece is von Wright's round rejection of those who would 'solve' the problem of separating the crazy from the sane by a wholesale Declaration of Insanity. That is, he rejected the suggestion of Strawson 1948 that *no* impossible propositions are capable of entailing, nor necessary ones of being entailed, a suggestion which comes to this: there is no problem. And von Wright's rejection is based, interestingly and rightly, on precisely the same reason which led him to reject a wholesale 'Declaration of Sanity' according to which *all* impossible propositions entail everything and all necessary ones are entailed by everything. I return to this reason in a minute, but first note the critical importance of von Wright's insistence against Strawson: it keeps us from throwing out the problem of making judgments in particular cases. The problem given us by Moore cannot be solved by making blanket decisions but must instead involve strictly retail procedures for deciding (for example) which particular contradictions do not entail which particular propositions.

Picking up now the bit just dropped, von Wright's reason for rejecting *any* wholesale tendency, either the classical or the Strawsonian, is that entailment must be "essentially relational" (p. 175). The relation grounding inference (p. 190) cannot subsist on the basis only of some status—truth-functional or modal—to which its terms are entitled. This grand idea is the direct ancestor of the fundamental notion of Anderson and Belnap (1975), namely, relevance. Doubtless it is safe to assume that von Wright recognizes the legitimacy of the offspring, but as emerges below relevance dictates an even closer tie between the terms of an entailment than that suggested in these explicitly tentative papers of von Wright.

Von Wright's insistence that entailment is essentially relational can be converted into a First Criterion: if you've got yourself a formal system which you take to contain truth functions, modalities, and also an entailment connective, then your system ought *not* contain as a theorem that a (possibly modal) statement about p is sufficient for p's entailing q, and it ought *not* contain as a theorem that a (possibly modal) statement about q is sufficient for p's entailing q. But the dialectic drives von Wright beyond this to an even stronger Second Criterion: your system ought not even contain as a theorem that a (possibly modal) statement about p conjoined with a (possibly modal) statement about q is sufficient for p's entailing q; such an external conjunction of modal statements about p and q "cannot be sufficient to establish a bond of entailment between them." Of course not, since entailment is essentially relational, while the 'relation' provided by mere conjunction is not enough to bear the weight

of this essence: "implication has something to do with the *meaning* of propositions, and . . . any mode of connecting them which disregards this meaning and ties them together in despite of it is too artificial to satisfy the demand of thought" (Blanshard 1939, vol. 2, p. 390). Though not explicitly relying on a doctrine of meaning, so far von Wright 1957 goes. But there is a third stage to the dialectic implicit in the following: "It appears to be of the essence of entailment to be a relation between propositions which subsists quite independently of either the truth-values or the modal status of the propositions" (p. 177).

And this suggests the following Third Criterion: no modal information about each of p and q, no matter how combined, nor any modal information about truth-functional combinations of p and q, nor, most generally, any statement involving p and q involving merely truth functions and modalities, can ever provide a sufficient basis for declaring that p entails q.

Von Wright does not in his 1957 paper on entailment himself take this third step, and indeed makes a suggestion inconsistent with it, namely, that the following is sufficient for p's entailing q: p contingent, q contingent, and necessarily, either p false or q true (p. 177). The suggestion is clearly tentative and it is not possible to say what von Wright's current opinion is; but it is anyhow clear where we stand: *no* combination of truth functions and modalities can warrant the intimate connection required by the demand of thought for relevance. And it is possible to show that the various relevance logics of Anderson and Belnap (1975) do indeed satisfy the Third Criterion.

A related question is the following: "Can a condition of entailment be found (constructed) in modal logic which is both necessary *and* sufficient and which safeguards the 'independence' of the entailment relation of the modal status of its terms?" (p. 177). Von Wright does not presume to answer the question definitively, though the thrust of his researches certainly suggests a negative answer. But in any event it is an excellent question, the sort so typical of von Wright, to which only recently do we have a 'no kidding' answer, at least if we take entailment to be as in Anderson and Belnap (1975): for then we can take Meyer 1974 as proving that there is *no* way to combine relevance logics (including entailment) with modalities and truth functions so as to provide a definition of the entailment connective in terms of the modal and truth functional part. A gratifying result indeed if one interprets it as establishing that there is no way of defining an 'essentially relational' concept by composing concepts none of which are themselves essentially relational.

In addition to these criteriological suggestions, von Wright proposes with his usual honest tentativeness that there is something essentially epistemological about entailment; he put forth as his analysis that "p entails q, if and only if, by means of logic, it is possible to come to know the truth of $p \rightarrow q$ [material

"implication"] without coming to know the falsehood of p or the truth of q" (p. 181). This suggestion, also advanced by Geach 1958, has not been much pursued by later researchers for, I think, two reasons.

In the first place, it proved difficult to get a formal grip on the epistemological part of the definition. Von Wright's own 1957 explanations were sufficiently vague to allow the criticism of Strawson 1958; and it seems to me that von Wright's 1959 reply, which indeed sharpens the notion, can be seen as insufficient. There he appears to suggest that a truth table "demonstrates [hence allows us to 'come to know'] the truth of every tautology (and the falsity of every contradiction), all the constituents of which may be identified as headings of some column in the table", and on the basis of this von Wright disallows Strawson's use of a truth table for $p\supset[(p\&q)\lor(p\&\bar q)]$ in coming to know the truth of $p\supset(q\lor\bar q)$; for any such table will contain both q and $\bar q$ as column headings and will hence demonstrate the truth of $q\lor\bar q$. And why won't this particular sharpening of 'come to know' do? Because it would mean that even such a formula as $\bar q\supset\bar q$ or $(p\supset q)\supset(\bar q\supset\bar p)$ or $q\supset\bar{\bar q}$ or *any* formula containing $\bar q$ would contain the seeds of $q\lor\bar q$ in its tables, since evidently both q and $\bar q$ must occur as column headings. But this is neither in the spirit of von Wright (I think), nor right (I think).

So at least from von Wright there has come no clear way of getting a grip on the required epistemological concepts. It is true that Smiley (1959) and Geach (1970) came up with a concept of entailment which Geach at least suggests is "tailormade to capture the intuitions that our papers [von Wright 1957 and Geach 1958] sought to express", a concept based on looking at those formulas $p'\supset q'$ of which $p\supset q$ is a substitution-instance to see if there is one such that neither is p' a contradiction nor q' a tautology; but in the first place it seems to me that the epistemological flavor has completely disappeared, and in the second, it leads to such curiosities as counting $((p\&\bar p)\lor q)\to q$ and $p\to[p\&(q\lor\bar q)]$ as valid entailments. Furthermore, in spite of Geach's remark, it is possible that the idea does not do justice to von Wright's intuitions, and that accordingly Anderson and Belnap (1975) erred in labelling the substitutional criterion the 'von Wright-Geach-Smiley' criterion; it would be enlightening to know.

The second reason that von Wright's proposed epistemological analysis of entailment was not taken up by others is the familiar one of displacement. The work of Moh 1950, Church 1951, and especially Ackermann 1956 led to a line of research, summarized in Anderson and Belnap 1975, which issued in a concept of entailment which is (we think) completely free of epistemological overtones and which seems nonetheless to solve the problems of entailment to which von Wright addressed himself. So a little Occam let epistemology fall by the wayside.

In any event, although the last decade and a half has not picked up von

Wright's notion that there is something essentially epistemological about entailment, and although it is my reasonably fixed opinion that the most profound analyses of entailment have to rest on other grounds, nevertheless von Wright's suggestion should not be forgotten; it may yet prove fruitful.

Two down, one to go.

III

(The following paragraphs are patched together from what ARA had evidently intended as beginnings of drafts later abandoned; but I think they contribute fundamentally to his answer to his third query. NDB)

When one thinks of those writers who have influenced the literature on the analysis of the concept of entailment, von Wright's name comes to mind almost as naturally as it does in connection with topics on which he has written at much greater length, such as modal logic, problems concerning norms and actions, and with probability and induction. This is perhaps in part because he uses the word 'entails' in many contexts where he is clearly intending to be evoking a sense of 'if . . . then---' which is distinct from any of the familiar formalized versions: material implication, intuitionistic implication, or any of the many varieties of strict implication. Another reason for thinking of him as a principal motive spirit in the study of entailment can no doubt be found in the frequency with which the topic comes up in informal philosophical discussions with him. He and I have over the years since 1950 had many exchanges of perplexities concerning entailment both in correspondence and conversation, and I'm certain that the same has been true of many of his friends other than myself.

Von Wright's contributions on the whole have been of a tentative, suggestive nature and though there are interesting and thought-provoking insights aplenty, he nowhere suggests that he has found a final solution to the question, nor even a solution which entirely satisfied him—in fact it is hard to elicit from his writings a *crystal*-clear statement of what the problem is.

This latter remark is not intended as a criticism; indeed, taken together with the tentative and totally nonarbitrary character of his investigations, it is intended rather as singular praise. The history of science and mathematics is filled with cases where initially the problems are vague and ill-defined (and where solutions are sometimes dogmatically put forward which turn out to be solutions to other problems, if to any at all), and it seems to me that the tentative exploratory period is essential to such endeavors, especially when the investigator has a clear realization that the situation is exploratory, as is certainly true in the case of von Wright.

I mentioned Anderson and Belnap (1975), which, I claim, solves von

Wright's problem of entailment. This is no place to rampage around explaining and advocating novel theories of my own or others—it is after all von Wright's Schilpp volume—but I cannot do justice to Number Three without just a little trumpeting. For what I want to say is that *Entailment: The Logic of Relevance and Necessity* owes as much to von Wright as to any of its other sources. He kept the problem alive, permitted no easy solutions, and, especially, provoked others to ponder the puzzle of entailment.

The answer to the third of my questions, then, is that von Wright's influence in standing there with a few other stalwarts as a (non-native) English bulldog (see again the quotation from him at the outset of this essay) helped many of us, myself not least, in feeling that there was a real problem here, which might be amenable to the sort of precisely-refined mathematical treatment which extensional logic has enjoyed for the past one hundred years or so.

DEPARTMENT OF PHILOSOPHY ALAN ROSS ANDERSON
UNIVERSITY OF PITTSBURGH
FEBRUARY 1975

REFERENCES

Ackermann, Wilhelm 1956. 'Begründung einer strengen Implikation', *Journal of Symbolic Logic* 21:113–128.

Anderson, Alan Ross, and Nuel D. Belnap, Jr., 1975 *Entailment: The Logic of Relevance and Necessity,* vol. 1, Princeton: Princeton University Press, (vol. 2, Princeton: Princeton University Press, forthcoming).

Anderson, Alan Ross, 1972. 'An Intensional Interpretation of Truth-Values', *Mind,* n.s. 81:348–371.

Bennett, Jonathan F. 1969 'Entailment'. *Philosophical Review* 68: 197–236.

Blanshard, Brand, 1939. *The Nature of Thought.* 2 vols. London: George Allen & Unwin.

Boehner, Philotheus. 1952. *Medieval Logic.* Chicago: University of Chicago Press.

Church, Alonzo. 1951. 'The Weak Theory of Implication'. *Kontrolliertes Denken, Untersuchungen zum Logikkalkül und der Logik zur Einzelwissenschaften.* Munich: Kommissions-verlag Karl Albert.

———. 1956. *Introduction to Mathematical Logic,* vol. 1. Princeton: Princeton University Press.

Frege, Gottlob. 1879. *Begriffsschrift, eine der arithmetischen nachgebildete Formelsprache des reinen Denkens.* Translation in van Heijenoort, 1967.

Geach, Peter. 1958. 'Entailment'. *Aristotelian Society, Supplementary Volume 32,* pp. 155–72.

———. 1970. 'Entailment Again'. *Philosophical Review* 79:237–239.

Hamblin, C. L. 1970. *Fallacies.* London: Methuen.

Jevons, William Stanley. 1870. *Elementary Lessons in Logic.* London: Macmillan.

Kant, Immanuel, 1781. *Kritik der reinen Vernunft*. Riga: Johann Friederich Hartknoch. (We have consulted the Kemp Smith translation.)

Kleene, Stephen C. 1952. 'Permutability of inferences in Gentzen's Calculi LK and LJ'. *Memoirs of the American Mathematical Society*. No. 10:1–26.

———. *Introduction to Metamathematics*. New York: Van Nostrand.

Lewis, Clarence Irving. 1918. *A Survey of Symbolic Logic*. 2nd ed. abr. New York: Dover Pub., Inc., 1960.

Lewis, Clarence Irving, and Cooper Harold Langford. 1932. *Symbolic Logic*. 2nd ed. New York: Dover Pub., Inc., 1959.

Meyer, Robert K. 1974. 'Entailment is not Strict Implication'. *Australasian Journal of Philosophy* 52:212–231.

Moh, Shaw-Kwei. 1950. 'The Deduction Theorems and Two New Logical Systems'. *Methodos* 2:56–75.

Moore, G. E. 1919. 'External and Internal Relations'. *Proceedings of the Aristotelian Society*, n.s. 20:40–62. Reprint. *Philosophical Studies, 276–309. London: Lund Humphries, 1922*.

Peano, Giuseppe. 1889. *Arithmetices principia, nova methodo exposita*. Translation in van Heijenoort, 1967.

Rescher, Nicholas. 1974. 'Bertrand Russell and Modal Logic'. *Studies in Modality*. American Philosophical Quarterly Monograph Series, no. 8. 85–96.

Russell, Bertrand. 1903. *The Principles of Mathematics*. London: George Allen & Unwin.

———. 1919. *Introduction to Mathematical Philosophy*. London: George Allen & Unwin.

Smiley, T. J. 1959. 'Entailment and Deducibility'. *Proceedings of the Aristotelian Society*. 59:233–254.

Stevenson, Charles L. 1970. 'If-iculties.' *Philosophy of Science* 37:27–49.

Strawson, P. F. 1948. 'Necessary Propositions and Entailment'. *Mind*, n.s. 57:184–200.

———. 1958. Review of von Wright 1957. *Philosophical Quarterly* 8:372–376.

Tarski, Alfred. 1930. 'Über einige fundamentale Begriffe der Metamathematik'. *Comptes rendus des séances de la Société des Sciences et des Lettres de Varsovie*, classe III, vol. 23, pp. 22–29. English trans. by J. H. Woodger, 'On Some Fundamental Concepts of Metamathematics', in *Logic, Semantics, Metamathematics, Papers from 1923 to 1938* . Oxford: Clarendon Press, 1956.

Van Heijenoort, Jean. 1967. *From Frege to Gödel*. Cambridge, Mass.: Harvard University Press.

Von Wright, George Henrik. 1957. 'The Concept of Entailment'. In *Logical Studies*, 166–191. London: Routledge and Kegan Paul.

———. 'A New System of Modal Logic'. In *Proceedings of the 11th International Congress of Philosophy*, vol. 5, 59–63. Amsterdam: Louvain, 1953. An expanded and revised version of this essay appeared in *Logical Studies*, pp. 89–126.

———. (1959). 'A Note on Entailment', *Philosophical Quarterly* 9:363–365.

Whitehead, Alfred North, and Bertrand Russell. 1910. *Principia Mathematica*, vol. 1. Cambridge: Cambridge University Press.

Wolf, Robert. 'A Bibliography of Entailment'. In vol. 2 of Anderson and Belnap. *Entailment: The Logic of Relevance and Necessity*, Princeton: Princeton University Press, forthcoming.

26

Krister Segerberg

VON WRIGHT'S TENSE LOGIC

My first contact with von Wright's tense logic—and indeed with von Wright—was in a small seminar he gave at the 1964 Summer University at Vasa in northern Finland. The main topic was a new temporal connective of his, the T-operator, a kind of 'asymmetric conjunction'. Von Wright had discovered it in connection with his work on the concept of change, but he thought that the logic of his new operator might provide insights into other problem areas as well, such as the analysis of counterfactual conditionals, for example. We—the students—enjoyed that seminar. Von Wright lectured *con brio e amore intellettuale* and even succeeded in lending a touch of fascination to the T-operator. Later I have learned that that enthusiasm and that special way of beaming with intellectual delight are features characteristic of von Wright. I believe it was the first time that I had encountered them in a philosopher.

I remember how firmly convinced von Wright was of the importance of tense logic. It is easy to share that conviction today, but in 1964 it required some foresight. Von Wright, I believe, knew only of the work of Prior, and he expressed astonishment at the supposed fact that more had not been done. Now it seems that, unbeknownst to von Wright and most other philosophers, significant work in tense logic was already in progress in several places at that time. Von Wright's work was therefore not as novel as he may have thought. Presumably that is why, relatively speaking, it has not been especially important historically; which is not to say that what von Wright has done in tense logic

Work on this paper was begun while the author was a visitor in the Mathematics Department at Simon Fraser University, Burnaby, Canada, during July 1972. Parts of the paper, in different stages of development, have been read at Simon Fraser University, Ohio State University, and the universities of Helsinki, Lund, and Uppsala, as well as at the logic symposia at Uppsala, April 1973, and in Moscow, March 1974. I wish to thank Kit Fine, Per Lindström, Dag Prawitz, and S. K. Thomason for the valuable comments they have offered. I am especially indebted to Fine for the extremely generous way in which he has shared his ideas with me.

is not important. But by the time he published his papers—I am thinking of
[1], [2], [3], [4], and [5]—others had moved on to more advanced problems
and methods. One may compare the situation in tense logic with that in modal
logic or deontic logic. *An Essay on Modal Logic* appeared in 1951, at a time
when only a limited amount of competent work had been done in modal logic,
and the book was a genuine contribution to the subject. The paper 'Deontic
Logic', published in *Mind* the same year, had an even greater impact, for it
delivered a whole new discipline that was waiting to be born. On the other
hand, when von Wright's work on tense logic appeared, which is of the same
ilk as his modal and deontic logic, much had happened: in the mid-1960s in-
tensional logic had seen the advent of Kripke, and von Wright's ideas had lost
some of their relative momentum.

By far the greatest portion of von Wright's tense logic is his analysis of
discrete time. There is more in von Wright's tense logic, but here I deal exclu-
sively with this topic. The paper is divided into seven sections. Sections 0 and
1 are introductory. In section 2, I summarize and discuss von Wright's solution
of the completeness problem for the logic of his T-operator. In sections 3 and
4, the main part of the paper, I investigate some of the questions von Wright
raised about richer logics in which operators of his kind are mixed with tradi-
tional ones. In the two concluding sections, 5 and 6, I make some further
remarks more or less suggested by von Wright's work.

0. Conventions

ω denotes the set of natural numbers. Throughout, the structure of that set is
denoted by \mathfrak{N}, a symbol we give a systematically ambiguous reading and in-
terpret variously as $<\omega, {}^+>$, $<\omega, S>$, $<\omega, \leq >$, $<\omega, \leq, {}^+>$, or $<\omega, \leq,$
$S>$, where ${}^+$ is the successor operation, S the binary relation 'is the immediate
predecessor of', and \leq the binary relation 'is not greater than'. We regard 0
as a natural number.

If R is a binary relation, then $R^0 = \{<u, v> : u, v$ are in the field of R,
and $u = v\}$, $R^{n+1} = \{<u, v> : \exists w(u \ R \ w \wedge w \ R^n \ v)$. The ancestral of R is
$R^* = \bigcup_{n\epsilon\omega} R^n$. The empty set is denoted by \emptyset.

Except in section 5 we often, although not always, identify a formal system
with its set of theorems. For example, '*W0*' will usually refer to a certain set
of formulas, but sometimes to a certain axiom system. The context will make
it clear which reading is intended. In section 5 the practice of identifying a
formal system with its set of theorems would be misleading. There we instead
identify a formal system with the set of ordered pairs $<\Sigma, \mathbf{A}>$ such that Σ is
a set of formulas and \mathbf{A} a formula deducible in the formal system from Σ.

Several different object languages are discussed in the paper, namely, those
described early in sections 1, 2, 3, and 6. Thus words like 'formula' and '*S4.3*'

are also systematically ambiguous. We use the symbols \wedge, \vee, \rightarrow, \leftrightarrow, \neg, \square, and \diamond in connection with object languages. They must not be confused with the symbols \wedge, \vee, \Rightarrow, \forall, and \exists which are used as a shorthand notation, in the same way as we sometimes use 'iff' to abbreviate 'if and only if'. Not much effort is made to honour the distinction between use and mention.

The following typographical conventions are used and sometimes tacitly understood: i, j, k, l, m, n for natural numbers, \mathbf{p}, \mathbf{q} for propositional letters, $\mathbf{A, B, C, D, E, F}$ for formulas, Σ, Ψ, Ω for sets of formulas, $\mathfrak{A}, \mathfrak{B}, \mathfrak{F}, \mathfrak{M}$ for structures, ξ, η, ζ for (at most countable) ordinals.

1. The Diodorean Logic

In this section we briefly go over some well-known facts about monomodal logic.

Let there be given some language consisting of (i) brackets, (ii) denumerably many propositional letters, (iii) a functionally complete set of Boolean connectives, and (iv) a unary operator \square. We shall assume that the reader is familiar with Kripke-type semantics. The key concept is that of truth of a formula at a point in a model, and the key clause of the definition of that concept is this:

$$\mathfrak{A}\vDash_u \square\mathbf{A} \text{ iff, for all } v, \text{ if } u \, R \, v \text{ then } \mathfrak{A}\vDash_v\mathbf{A},$$

where \mathfrak{A} is a model with accessibility relation R and u is a point of \mathfrak{A}.

If we wish to do tense logic and associate with \square a reading such as 'always in the future', then there are various conditions that have to be imposed on the concept of frame. Exactly which conditions to impose will of course depend on one's conception of time. Of special interest to us is the view of time as a linear structure of type ω. However, with an object language as restricted as that of monomodal logic, that view is indistinguishable from hosts of others. Let us call a frame *Diodorean* if it is reflexive, transitive, connected, and discrete, where discreteness is meant in the following nonstandard sense. Suppose $\mathfrak{F} = <U, R>$ is a transitive, connected frame. If ξ is any ordinal, possibly infinite, then we call a sequence $<u_\eta>_{\eta<\xi}$ of elements of U an \mathfrak{F}-*chain* if (i) for every $\eta < \xi$, $u_\eta \, R \, u_{\eta+1}$ and $u_\eta \neq u_{\eta+1}$, and (ii) whenever $<v_0, v_1, \ldots, w>$ is a subsequence of type $\omega + 1$, then, for all n, not $w \, R \, v_n$. Then \mathfrak{F} is said to be *discrete* if there is no \mathfrak{F}-chain of type $\omega + 1$.

The prime example of a Diodorean frame is \mathfrak{N}. Let D be the set of formulas valid in \mathfrak{N}. D is identical with Prior's so-called Diodorean logic. Our term Diodorean is now easily explained. First, the class of Diodorean frames validates exactly the formulas of D. Second, a generated frame validates D if and only if it is Diodorean. Thus the class of Diodorean frames is the largest class of generated frames that determines D.

It is well known that D may be axiomatized by taking as inference rules *modus ponens,*

$$\frac{A \quad A \rightarrow B}{B},$$

and \square-*necessitation,*

$$\frac{A}{\square A},$$

and as axioms some sufficient set of tautologies and all instances of the following schemata:

(1) $\square[A \rightarrow B] \rightarrow [\square A \rightarrow \square B],$

(2) $\square A \rightarrow A,$

(3) $\square A \rightarrow \square\square A,$

(4) $\Diamond A \wedge \Diamond B \rightarrow \Diamond[A \wedge B] \vee \Diamond[A \wedge \Diamond B] \vee \Diamond[B \wedge \Diamond A],$

(5) $\neg A \wedge \Diamond \square A \rightarrow \Diamond[\neg A \wedge \square[A \rightarrow \square A]].$

This axiomatization is particularly natural as, in a certain sense, the schemata (2)-(5) correspond to the properties mentioned above. More precisely, if \mathfrak{F} is any frame, then

$$\mathfrak{F} \vDash (2) \text{ iff } \mathfrak{F} \text{ is reflexive,}$$

$$\mathfrak{F} \vDash (3) \text{ iff } \mathfrak{F} \text{ is transitive.}$$

Moreover, if \mathfrak{F} is generated and transitive,

$$\mathfrak{F} \vDash (4) \text{ iff } \mathfrak{F} \text{ is connected,}$$

and, if \mathfrak{F} is reflexive, transitive, and connected,

$$\mathfrak{F} \vDash (5) \text{ iff } \mathfrak{F} \text{ is discrete.}$$

Bull [1] contains the first published proof of a completeness theorem for D, although Kripke is credited with an earlier, never published, proof. The author gave a model theoretic proof in [2]. An entertaining account of the research leading up to the results of Kripke and Bull is found in Prior [2]. In addition to Prior's work, contributions were made by Dummett, Geach, Hintikka, Lemmon, and others.

2. The Successor Logic

Let there be given some language consisting of (i) brackets, (ii) denumerably many propositional letters, (iii) a functionally complete set of Boolean connectives, and (iv) a unary operator **o**. **o** is meant to have the intuitive meaning of

'next' or 'tomorrow' and, like the operator \Box of the preceding section, it is not Boolean. In a Kripke semantics the general condition of **o** would be

$$\mathfrak{A}\vDash_u \mathbf{o}A \text{ iff, for all } v, \text{ if } u\,S\,v \text{ then } \mathfrak{A}\vDash_v A,$$

where \mathfrak{A} is a model with accessibility relation S, and u is a point of \mathfrak{A}. But if our formalism is to reflect our intuitive reading of **o**, then it is necessary to impose rather heavy conditions on the frames we wish to consider. The conception of time upon which we focus has two important features. For one thing, day follows upon day: there is no last day. So call a frame $<U, S>$ *serial* if

$$\forall u\ \exists v(u\,S\,v).$$

For another thing, every following day is unique: no day has two tomorrows. So call a frame $<U, S>$ *functional* if

$$\forall u\ \forall v\ \forall w(u\,S\,v \wedge u\,S\,w \Rightarrow v = w).$$

Let S (for 'successor') be the set of formulas valid in the class of serial, functional frames. S is a normal modal logic, easily analysed with standard methods. Thus there is a canonical-models proof in Lemmon/Scott [1] to the effect that S is axiomatized by the following axiom system: As axioms take a sufficient set of tautologies and add all instances of the schemata

$$\mathbf{o}\neg A \leftrightarrow \neg \mathbf{o}A,$$
$$\mathbf{o}[A \wedge B] \leftrightarrow \mathbf{o}A \wedge \mathbf{o}B,$$

as inference rules take *modus ponens* and **o**-necessitation. As the reader may verify for himself, we get another axiomatization of S if we take *modus ponens* as our only inference rule and as axioms a sufficient set of tautologies and all instances of the schemata

$$\mathbf{o}^k\neg A \leftrightarrow \neg \mathbf{o}^k A,$$
$$\mathbf{o}^k[A \wedge B] \leftrightarrow \mathbf{o}^k A \wedge \mathbf{o}^k B.$$

When one is dealing with functional frames $<U, S>$ it would be possible to introduce instead—as Lemmon and Scott did—a slightly modified notion of frame, namely, structures $<U, f>$ where U is as before and f is a partial function on U. The new semantic condition becomes

$$\mathfrak{A}\vDash_u \mathbf{o}A \text{ iff } f \text{ is defined for } u \text{ then } \mathfrak{A}\vDash_{fu} A.$$

If one deals with frames that are serial as well as functional, the same effect is achieved by requiring f to be total on U, for the semantic condition then reduces to the simpler condition

$$\mathfrak{A}\vDash_u \mathbf{o}A \text{ iff } \mathfrak{A}\vDash_{fu} A.$$

It is easy to see that the set of formulas valid according to the latter semantics is exactly S.

Thus S is a simple, if unusual, modal logic. Given Lemmon's and Scott's result and the Generation Theorem, it is clear that S is the logic we set out to capture, namely, the set of formulas valid in \mathfrak{N}. In effect there is a constructive proof of that result in von Wright [1], where it is also shown that S has the finite model property and is decidable. Yet another proof was given in the author's paper [1]. Actually von Wright's proof and mine are quite similar. The problem to be solved is this: Given that a formula \mathbf{A} is not provable in the axiom system, show constructively that \mathbf{A} is not valid in \mathfrak{N}. Both proofs are cast as two-step solutions: first \mathbf{A} is transformed into a provably equivalent normal form \mathbf{A}', and then known facts about the classical two-valued propositional calculus are used to conclude that \mathbf{A}'—and hence \mathbf{A}—is not valid in \mathfrak{N}. I shall go over a proof in some detail as the idea will recur in two later sections.

Suppose that \mathbf{B} is any formula. Informally speaking, we obtain the normal form of \mathbf{B} by pushing all occurrences of \mathbf{o} as deeply into the formula as possible. Thus a normal form is characterized by the fact that every occurrence of \mathbf{o} operates on a formula of type $\mathbf{o}^k\mathbf{p}$, where \mathbf{p} is a propositional letter and k a natural number, possibly 0. More formally, the normal form \mathbf{B}' of a formula \mathbf{B} can be introduced in the following way (assume, for simplicity, that \neg and \wedge are the only Boolean primitives):

$$(\mathbf{o}^k\mathbf{p})' = \mathbf{o}^k\mathbf{p}, \text{ if } \mathbf{p} \text{ is a propositional letter,}$$
$$(\mathbf{o}^k\neg\mathbf{C})' = \neg(\mathbf{o}^k\mathbf{C})',$$
$$(\mathbf{o}^k[\mathbf{C} \wedge \mathbf{D}])' = (\mathbf{o}^k\mathbf{C})' \wedge (\mathbf{o}^k\mathbf{D})'.$$

The axiom system is sufficiently strong to make it possible to show that, for all \mathbf{B}, the formula $\mathbf{B} \leftrightarrow \mathbf{B}'$ is a theorem of the calculus; the simple proof is omitted. (In fact, the strength of the axiom system is *exactly* that—we would obtain yet another axiomatization of S if to a base for classical two-valued propositional logic we would add as an axiom each formula $\mathbf{B} \leftrightarrow \mathbf{B}'$.)

Consequently, if \mathbf{B} is a formula on normal form, then \mathbf{B} is a Boolean combination of formulas $\mathbf{o}^k\mathbf{p}$, where \mathbf{p} is a propositional letter. In other words, there is some \mathbf{o}-free formula \mathbf{C} and some substitution function * such that (i) $\mathbf{B} = \mathbf{C}^*$; (ii) if \mathbf{q} is a propositional letter occurring in \mathbf{C}, then $\mathbf{q}^* = \mathbf{o}^k\mathbf{p}$, for some propositional letter \mathbf{p}; and (iii) if \mathbf{q} and \mathbf{r} are distinct propositional letters occurring in \mathbf{C}, then $\mathbf{q}^* \neq \mathbf{r}^*$. It should be noted that \mathbf{C} is unique only up to its set of propositional letters, and that * is uniquely defined only for the propositional letters actually occurring in \mathbf{C}. Let v be any truth-value assignment; that is, function from the set of propositional letters to $\{T, F\}$, where T and F are two distinct objects associated with truth and falsity, respectively. By the

model on \mathfrak{N} *induced by* v we shall mean the model \mathfrak{A} on \mathfrak{N} defined by the valuation V such that $u \in V(\mathbf{p})$ if and only if $v(\mathbf{q}) = T$ and $\mathbf{q}^{\star} = \mathbf{o}^u\mathbf{p}$, for some propositional letter \mathbf{q} in \mathbf{C}. It is immediate that if \bar{v} is the extension of v to the set of all \mathbf{o}-free formulas, then for every \mathbf{o}-free \mathbf{D} whose propositional letters are included among those of \mathbf{C},

$$\mathfrak{A}\models_0\mathbf{D}^{\star} \text{ if and only if } \bar{v}(\mathbf{D}) = T.$$

The completeness argument sketched above can now be made precise. If \mathbf{A} is not derivable in the axiom system, then neither is \mathbf{A}', the normal form of \mathbf{A}. Let \mathbf{B} be an \mathbf{o}-free formula and * a substitution function of the kind specified above such that $\mathbf{A}' = \mathbf{B}^{\star}$. Then \mathbf{B} cannot be a tautology, for \mathbf{A}' is a substitution instance of \mathbf{B}, so if \mathbf{B} were a tautology then \mathbf{A}' would be derivable, contrary to what has been assumed. Therefore there exists some truth-value assignment v such that $\bar{v}(\mathbf{B}) = F$. Hence $\mathfrak{A}\not\models_0 \mathbf{A}'$, where \mathfrak{A} is the model on \mathfrak{N} induced by v. Consequently $\mathfrak{A}\not\models_0\mathbf{A}$, the desired result.

The account given here differs from von Wright's in at least three ways. One is that von Wright's notion of normal form differs from ours. According to von Wright, a formula is a normal form if there is some positive n such that the formula is a disjunction of conjunctions of type

$$\mathbf{A}_0 \wedge \mathbf{o}\mathbf{A}_1 \wedge \ldots \wedge \mathbf{o}^{n-1}\mathbf{A}_{n-1},$$

where $\mathbf{A}_0, \mathbf{A}_1, \ldots, \mathbf{A}_{n-1}$ are \mathbf{o}-free; such conjunctions are called 'histories of length n' (cf. section 6 below). In the present context this difference is not important. Another difference is that our treatment is model theoretic whereas von Wright's is syntactical throughout. However, our model theory is only von Wright's intuitive semantics made explicit. A third difference is that von Wright does not use our primitive \mathbf{o} but instead a binary operator T, the so-called T-operator. The formal truth condition for T in a total function frame $\mathfrak{A} = <U, f>$ is

$$\mathfrak{A}\models_u\mathbf{A} \mathsf{T} \mathbf{B} \text{ iff } \mathfrak{A}\models_u\mathbf{A} \text{ and } \mathfrak{A}\models_{fu}\mathbf{B}.$$

Intuitive readings associated with $\mathbf{A} \mathsf{T} \mathbf{B}$ are '\mathbf{A}, and next \mathbf{B}' and 'today \mathbf{A}, and tomorrow \mathbf{B}'. It is easy to see that \mathbf{o} and T are interdefinable: if T is any tautology, then $\mathsf{T} \mathsf{T} \mathbf{A}$ and $\mathbf{B} \wedge \mathbf{o}\mathbf{C}$ have the same truth conditions as, respectively, $\mathbf{o}\mathbf{A}$ and $\mathbf{B} \mathsf{T} \mathbf{C}$. Thus in one sense it does not matter whether we take \mathbf{o} or T as primitive. Yet I find it difficult to see what we would gain by following von Wright—certainly we lose simplicity and formal elegance. It would be interesting to know why von Wright was first attracted to the T-operator, and also why he has continued to favour it over the \mathbf{o}-operator.

It may be added that S is identical with a logic described—but not identified as S—in Prior [1]; see Prior [2], app. B:1 and my paper [1].

3. W0: Completeness

In this section and the following two, our language will consist of (i) brackets, (ii) denumerably many propositional letters, (iii) some functionally complete set of Boolean connectives, and (iv) two unary operators □ and **o**. This language is simply the languages of the two preceding sections combined. In a similar way, the semantics of this section is the result of combining the semantics of the preceding sections. Now the general concept of frame is a structure $<U, R, S>$, where U is a set and R and S are binary relations on U. As before, only frames satisfying certain conditions are of interest to us. Thus R and S will have to satisfy the conditions mentioned in sections 1 and 2, respectively. But in addition there must be some interrelation between R and S. Intuitively, the future is the sum of now and all following moments of time, of today and all the days that follow. Hence the formal condition that $R = S^\star$, where S^\star is the ancestral of S. Frames satisfying those conditions we shall call *Peano frames*. A *Peano model* is a model on a Peano frame.

A frame $<U, R, S>$ is *generated (by t)* if U is the smallest set such that $t \in U$, and $v \in U$ if $u R v$ or $u S v$, for any $u \in U$. It is easy to see that \mathfrak{N} is the only infinite generated Peano frame. It is also easy to see that if $<U, R, S>$ is a finite generated Peano frame, then there are subsets U_0, U_1 of U such that $U_0 \cup U_1 = U$, $U_0 \cap U_1 = \emptyset$, R is linear on U_0 and universal on U_1, and, for all $u_0 \in U_0$ and $u_1 \in U_1$, $u_0 R u_1$. Thus the general structure of finite generated Peano frames may be represented as in Figure 1, where the arrows stand for the successor relation.

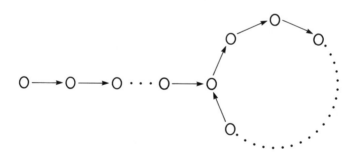

Figure 1

Our problem in this section, raised by von Wright in [4], is to axiomatize the logic of formulas valid in \mathfrak{N}. Von Wright has put forth a conjectured axiomatization of which the following—call it *W0*—is a version. The inference rules of *W0* are *modus ponens* and □-necessitation. The axioms of *W0* are

divided into three groups: (i) all instances of theorems of the Diodorean logic D (with \square as the non-Boolean operator); (ii) all instances of theorems of the Successor Logic S (with \mathbf{o} as the non-Boolean operator); (iii) all instances of the following schemata:

(1) $\mathbf{o}\square A \leftrightarrow \square \mathbf{o}A,$

(2) $\square A \rightarrow \mathbf{o}A,$

(3) $A \wedge \square[A \rightarrow \mathbf{o}A] \rightarrow \square A.$

We write $\vdash_{WO} A$ if A is a theorem of WO. Strictly speaking, 'WO' is the name of the axiom system just given, but in keeping with our usual practice we will also use it as a name of the set of theorems of WO. Note that \mathbf{o}-necessitation is a derived rule of WO.

In his axiomatization von Wright actually used his own operator T as primitive instead of \mathbf{o}; the same comments apply as at the end of section 2 above. Another difference is that under (i) von Wright mentions the theorems of $S4.3$ only. The reason for our choice is to emphasize that, as von Wright knew, WO includes the Diodorean system; that there must be some connection between (iii:3) and schema (5) of section 1 above becomes very plausible if the former is written in the following deductively equivalent form:

$$\neg A \wedge \Diamond A \rightarrow \Diamond[\neg A \wedge \mathbf{o}A].$$

Similarly we have included (iii:1) as an axiom schema even though it is derivable in the axiom system obtained by deleting it from WO. In this case our reason for keeping it is that it indicates that there is a normal form theorem for WO analogous to that for S in section 2. That is important, for it suggests that when we go for a completeness proof for WO we may try to generalize the normal form completeness proof for S we gave in section 2. In this section we shall show that such a generalization is indeed possible; the existence of (iii:2) and (iii:3)—without which the axiomatic system would be uninteresting— makes for complications, but they can be overcome.

The formal definition of a normal form A' of a formula A is as easy as in section 2, only this time we must provide for formulas that might contain \square in addition to Boolean connectives and \mathbf{o}. If, for the sake of simplicity, we assume that \neg and \wedge are the only primitive Boolean connectives, then the full definition is this:

$$(\mathbf{o}^k p)' = \mathbf{o}^k p,$$
$$(\mathbf{o}^k \neg A)' = \neg(\mathbf{o}^k A)',$$
$$(\mathbf{o}^k[A \wedge B])' = (\mathbf{o}^k A)' \wedge (\mathbf{o}^k B)',$$
$$(\mathbf{o}^k \square A)' = \square(\mathbf{o}^k A)'.$$

Again we obtain the result that every formula is provably equivalent to its normal form. The proof is trivial, but the fact is important and worth displaying:

NORMAL FORM THEOREM FOR *W0*. *For every* \mathbf{A}, $\vdash_{W0} \mathbf{A} \leftrightarrow \mathbf{A}'$.

We shall establish not one but several (related) completeness results for *W0*. Philosophically the most interesting one is this:

COMPLETENESS THEOREM FOR *W0*. (1) *W0 is determined by* \mathfrak{N}.

We remarked above that a generated frame is a frame for *W0* if and only if it is a Peano frame, and that \mathfrak{N} is the only infinite generated Peano frame. Thus the preceding theorem is a minimal result in the sense that \mathfrak{N} is the only generated frame that by itself determines *W0*. At the other extreme we have the following:

COMPLETENESS THEOREM FOR *W0*. (2) *W0 is determined by the class of all Peano frames.*

This is a maximal result in the sense that no larger class of frames determines *W0*. It is easy to see that the two versions are equivalent.

 We now turn to the completeness proof which occupies the remainder of the section. Actually it establishes a third completeness result for *W0*, namely, that *W0* is determined by the class of all finite Peano frames.

Proof of the Completeness Theorem for W0. Fix any formula not derivable in *W0;* let \mathbf{E} be that formula. Assume that \mathbf{E} is in normal form—it will become clear that no loss of generality arises from that assumption.

 Suppose there are n propositional letters occurring in \mathbf{E}—call them $\mathbf{p}_{0,0}, \ldots, \mathbf{p}_{0,n-1}$. Let Ω be a set of distinct propositional letters $\mathbf{p}_{k,l}$, where k, l are natural numbers such that $\mathbf{o}^k \mathbf{p}_{0,l}$ is a subformula of \mathbf{E}. The three important facts about Ω are: (i) Ω is finite; (ii) $\mathbf{p}_{k,l} = \mathbf{p}_{k',l'}$ if and only if $k = k'$ and $l = l'$; (iii) $\mathbf{p}_{k+1,l} \in \Omega$ only if $\mathbf{p}_{k,l} \in \Omega$. (It should be observed that we have said nothing about the physical shape of our propositional letters. Hence for example '$\mathbf{p}_{0,0}$' is a name of a propositional letter and not necessarily itself a propositional letter.)

 For all propositional letters \mathbf{p} we define

$$\mathbf{p}^\star = \begin{cases} \mathbf{o}^k \mathbf{p}_{0,l}, & \text{if } \mathbf{p} = \mathbf{p}_{k,l} \in \Omega, \\ \mathbf{p}, & \text{if } \mathbf{p} \notin \Omega. \end{cases}$$

That defines a substitution function: for every \mathbf{A} it yields a uniquely determined formula \mathbf{A}^\star. Since \mathbf{E} is in normal form there exists a unique \mathbf{o}-free formula \mathbf{F} such that $\mathbf{E} = \mathbf{F}^\star$. Note that every propositional letter of \mathbf{F} is a member of Ω but that the converse need not hold.

In order to parallel the completeness proof for S in section 2 we ought now to find a suitable logic L that would enable us to reason as follows. L is contained in $W0$ and is closed under substitution. \mathbf{E}, a substitution instance of \mathbf{F}, is not a theorem of $W0$, hence \mathbf{F} is not a theorem of L. Therefore, the argument would continue, \mathbf{F} has a countermodel for L which, it turns out, can be used to construct a Peano frame that invalidates \mathbf{E}.

Thus the first problem is to find a logic L which is to bear the same relation to $W0$ as the ordinary classical propositional calculus bears to S. Note that if axiom schemata (iii:2) and (iii:3) had not been added to our axiom system the problem would have been easy: then for L we would have taken the Diodorean logic D (with \square as the non-Boolean operator). However, that easy way out leads nowhere when (iii:2) and (iii:3) are present. To be certain, we can prove the existence of a (finite) countermodel for D of \mathbf{F}, but what we really want is a (finite) countermodel for $W0$ of \mathbf{E}, and it is not clear how to take that last step. In fact, if we do not modify the outlined strategy we do not seem to be able to carry it out. For no logic other than D can be considered a candidate for L—if the theorem really holds—yet it would appear that D is not enough.

If we scrutinize the preceding attempt at an argument, we see that it hinges on three points: that \mathbf{F} is not a theorem of L; that the completeness problem for L is solved or easily yields to known methods; and that L and $W0$ are intimately related—in particular, models for L must be convertible somehow into models for $W0$. We shall show now that, even though artificial, there is such a logic L.

Define $D\star$ as the set of \mathbf{o}-free formulas \mathbf{A} such that $\vdash_{W0} \mathbf{A}^\star$. In other words, $D\star$ is characterized by the condition that, for all \mathbf{o}-free formulas,

$$\vdash_{D\star} \mathbf{A}^\star \text{ if and only if } \vdash_{W0} \mathbf{A}^\star,$$

where '$\vdash_{D\star}\mathbf{A}$' means the same as '$\mathbf{A} \in D\star$'. The following features of $D\star$ may be noted. (i) As indicated by the symbolism, $D\star$ explicitly depends on the substitution function \star. (ii) $D \subseteq D\star$. (iii) $D\star$ is closed under modus ponens. (iv) $D\star$ is closed under \square-necessitation. (v) $D\star$ is not, in general, closed under substitution. For example, if we assume that $\mathbf{p}_{1,0} \in \Omega$, then $(\square\mathbf{p}_{0,0} \rightarrow \mathbf{p}_{1,0})^\star = \square\mathbf{p}_{0,0} \rightarrow \mathbf{o}\mathbf{p}_{0,0}$, and so $\square\mathbf{p}_{0,0} \rightarrow \mathbf{p}_{1,0}$ is a theorem of $D\star$. Hence $D\star$ could not be closed under substitution without becoming inconsistent.

Not closed under substitution, $D\star$ is not a normal modal logic in the usual sense; in fact, not even a logic. However, $D\star$ is a normal modal logic in a weaker sense, namely, the sense that requires only containment of the basic modal logic K and closure under modus ponens and necessitation. That weaker sense of modal logic is sufficiently strong to guarantee that the canonical model $\mathfrak{M}_{D\star} = <U_{D\star}, R_{D\star}, V_{D\star}>$ exists (see Lemmon/Scott [1]). This is a fact we shall exploit presently.

With $D\star$ for L, the beginning of our argument runs as follows. Since

\nvDash_{wo} **E** it follows that \nvDash_{D_*} **F.** Therefore by the Fundamental Theorem of Lemmon and Scott, there is some model $\mathfrak{M} = <U, R, V>$ generated by some element $t \in U_{D_*}$ from the canonical model \mathfrak{M}_{D_*} such that **F** $\nless t$ or, equivalently, $\mathfrak{M} \nvDash_t$ **F.** To continue the argument we will now draw on work done by Håkan Franzén; our immediate objective will be to derive from \mathfrak{M} a finite counter-model \mathfrak{M}' for D_* of **F.** A report of Franzén's work was published after his untimely death, in my paper [3]. Work similar to that of Franzén was carried out independently by Kit Fine; see his paper [1].

Let Ψ be the smallest set of **o**-free formulas that includes Ω, contains all subformulas of **F,** and is closed under modalities in terms of \square. Thus Ψ is closed under subformulas, and if **A** $\in \Psi$ then also ¬**A** $\in \Psi$ and \square**A** $\in \Psi$. By a classic result of W. T. Parry $S4$ is known to have only finitely many irreducible modalities, so from the fact that $D_* \supseteq S4$ it follows that Ψ is logically finite. (Let **A** *eq.* **B** mean that \vdash_{D_*}**A** \leftrightarrow **B.** Then Ψ is logically finite (in D_*) if and only if there are only finitely many equivalence classes in Ψ under the equivalence relation *eq.*)

The following definition clearly introduces an equivalence relation in U:

$$u \equiv v \text{ if and only if } u \cap \Psi = v \cap \Psi.$$

For $u \in U$, let $|u|$ denote the equivalence class of which u is a representative, and let U' denote the set of all equivalence classes. Note that since Ψ is logically finite, U' is finite. For $u, v \in U$ define:

$$|u| \leqslant |v| \text{ iff } \forall u' \exists v' \ (u \equiv u' \Rightarrow (v \equiv v' \wedge u'R \ v')),$$
$$|u| \nleqslant |v| \text{ iff not } |u| \leqslant |v|,$$
$$|u| < |v| \text{ iff } |u| \leqslant |v| \text{ and } |v| \nleqslant |u|,$$
$$|u| \sim |v| \text{ iff } |u| \leqslant |v| \text{ and } |v| \leqslant |u|,$$
$$V'(\mathbf{p}) = \{|u| : \mathbf{p} \in u \cap \Psi\}, \text{ for all } \mathbf{p}.$$

It is easy to check that the definitions are correct. Define $\mathfrak{M}' = <U', \leqslant, V'>$. A proof of the following result is found in the author's paper [3]:

FRANZÉN'S LEMMA. *If* **A** $\in \Psi$ *and* $u \in U$, *then* **A** $\in u$ *if and only if* $\mathfrak{M}'\vDash_{|u|}$ **A.**

Thus, in particular, $\mathfrak{M}'\nvDash_{|t|}$ **F.**

Using the fact that $D_* \supseteq S4.3$ we may verify that, in addition to being finite, \mathfrak{M}' is generated, transitive, and strongly connected. However, since $D_* \supseteq D$ we can say more. Clearly \sim is an equivalence relation in U'. Let the equivalence classes under \sim be called *clusters,* and call a cluster C an *end-cluster* if, for all $u, v \in U$, $|u| \leqslant |v|$ implies that $|u| \in C$ only if $|v| \in C$. (Surely the definition of end-cluster is correct.) Since \mathfrak{M}' is finite there is a unique end-cluster. We shall show that every cluster, except possibly the end-cluster, con-

tains only one element. In other words, we shall show that \leq is antisymmetric on U' minus the end-cluster; that is, that for all $u, v, w \in U$

$$|u| < |v| \Rightarrow (|u| \sim |w| \Rightarrow |u| = |w|).$$

Assume that there are $u, v \in U$ such that

(1) $$|u| < |v|.$$

We note for later use that (1) implies the existence of some $v' \in U$ such that

(2) $$\forall\, u'(u \equiv u' \Rightarrow \text{not } v'R\, u');$$

on the other hand, because R is connected,

(3) $$\forall u'(u \equiv u' \Rightarrow u'R\, v').$$

Let \mathbf{A} be a Boolean combination of formulas of Ψ such that, for all $x \in U$,

$$\mathfrak{M}'\vDash_{|x|} \mathbf{A} \text{ if and only if } |u| = |x|.$$

By Franzén's Lemma,

(4) $$\mathbf{A} \in x \text{ if and only if } u \equiv x.$$

In particular,

(5) $$\mathbf{A} \in u.$$

Take any x such that $v'\, R\, x$. By (2) not $x \equiv u$, so by (4) $\neg\mathbf{A} \in x$. Hence $\square\, \neg\mathbf{A} \in v'$. But by (3) $u\, R\, v'$. Therefore

(6) $$\Diamond\square\neg\mathbf{A} \in u.$$

By schema (5) in section 1 and truth-functional reasoning it follows that the formula $\mathbf{A} \wedge \Diamond\square\,\neg\mathbf{A} \to \Diamond[\mathbf{A} \wedge \square[\neg\mathbf{A} \to \square\,\neg\mathbf{A}]]$ is a theorem of D, and a fortiori of $D*$. Together with (5) and (6) that implies that $\Diamond[\mathbf{A} \wedge \square[\neg\mathbf{A} \to \square\,\neg\mathbf{A}]] \in u$. Hence there exists some element x such that

(7) $$\mathbf{A} \in x,$$

(8) $$\square[\neg\mathbf{A} \to \square\,\neg\mathbf{A}] \in x.$$

(4) and (7) imply that $u \equiv x$. Assume w is such that

(9) $$|u| \sim |w|.$$

Then there is some $w' \equiv w$ such that $x\, R\, w'$, so by (8)

(10) $$\neg\mathbf{A} \to \square\,\neg\mathbf{A} \in w'.$$

Assume that

(11) $|u| \neq |w|.$

It follows from (4) and (11) that $\neg A \in w'$, whence by (10) $\Box \neg A \in w'$. By (9) there is some $u' \equiv u$ such that $w'R\,u'$. Hence $\neg A \in u'$, which is impossible in view of (4). As (11) leads to a contradiction we conclude that

(12) $|u| = |w|.$

The argument shows that (1) and (9) imply (12), so we have proved our contention that every cluster, except perhaps the end-cluster, is a singleton.

 Now we have a good idea of what \mathfrak{M}' looks like. Certainly it is strikingly similar to a finite generated Peano model. For let C_0, \ldots, C_{m-1} be the clusters of \mathfrak{M}' in the order induced by \leq; thus m is a positive natural number and $U' = C_0 \cup \ldots \cup C_{m-1}$. If $m > 1$, then by what we have just shown there are elements $u_0, \ldots, u_{m-2} \in U$ such that $C_0 = \{|u_0|\}, \ldots, C_{m-2} = \{|u_{m-2}|\}$. We shall call $|u_0|, \ldots, |u_{m-2}|$ the *initial* elements of \mathfrak{M}'. So far we know nothing about C_{m-1}, the end-cluster, except that it is nonempty and finite, and that unlike the initial elements it always exists (if $m = 1$ then $C_0 = C_{m-1}$). Because of the special importance of the end-cluster we introduce E as a name for it. Thus \mathfrak{M}' consists of $|u_0|, \ldots, |u_{m-2}|$, in that order, followed by the elements of E which are all related to one another. Our next step will be to show that \mathfrak{M}' can be transformed into a model for $W0$ that rejects \mathbf{E}.

 Evidently, the problem at hand is to define the right successor function on U', or to show that one exists. To solve it we shall make use of the relationship between the canonical models \mathfrak{M}_{D_*} and \mathfrak{M}_{W0}. The definition of the latter is obvious—$\mathfrak{M}_{W0} = <U_{W0}, R_{W0}, S_{W0}, V_{W0}>$, where U_{W0} is the set of all $W0$-consistent maximal sets of formulas, and the following conditions obtain:

$$x\,R_{W0}\,y \text{ iff } \forall A(\Box A \in x \Rightarrow A \in y),$$

$$x\,S_{W0}\,y \text{ iff } \forall A(\mathbf{o}A \in x \Rightarrow A \in y),$$

$$V_{W0}(\mathbf{p}) = \{x \in U_{W0} : \mathbf{p} \in x\}, \text{ for all } \mathbf{p}.$$

Note that S_{W0} is serial and functional; if $x\,S_{W0}\,y$ we shall write $x^+ = y$. It is clear that the Fundamental Theorem of Lemmon and Scott holds. One difference between \mathfrak{M}_{D_*} and \mathfrak{M}_{W0} that must be stressed is that the elements of U_{D_*} are sets of \mathbf{o}-free formulas, whereas the elements of U_{W0} are sets of formulas that may contain \mathbf{o}.

ISOMORPHISM LEMMA. $<U_{D_*}, R_{D_*}>$ and $<U_{W0}, R_{W0}>$ *are isomorphic.*

Proof. For each $u \in U_{D_*}$ let fu be the set of formulas A for which there is some \mathbf{o}-free formula B such that $B \in u$ and $\vdash_{W0} A \leftrightarrow B^*$. Evidently f is a function defined on U_{D_*}. Actually f is the desired isomorphism. To prove this, one has

to prove that (i) the range of f is included in U_{WO}, (ii) f is one-one, (iii) f is onto U_{WO}, and (iv) f is order-preserving, that is, $u\ R_{D_*}\ v$ if and only if $fu\ R_{WO}fv$. All this is straightforward, and we omit the details. ∎

Since $<U_{D_*}, R_{D_*}>$ and $<U_{WO}, R_{WO}>$ are isomorphic, the successor relation S_{WO} of \mathfrak{M}_{WO} induces a relation on U_{D_*} which, serial and functional, is also a kind of successor relation. However, our real interest lies in obtaining a suitable successor relation on U'. To this end we now define the following auxiliary relation on U':

$$|u|\ Q\ |v| \text{ iff } \exists u'\exists v'(u',v' \in U \land u \equiv u' \land v \equiv v' \land (fu')^+ = fv').$$

(Certainly the definition of Q is correct.) The importance of Q lies in the fact that whenever a propositional letter $\mathbf{p}_{k+1,l} \in \Psi$, then $|u|\ Q\ |v|$ implies that $\mathfrak{M}'\vDash_{|u|} \mathbf{p}_{k+1,l}$ if and only if $\mathfrak{M}'\vDash_{|v|} \mathbf{p}_{k,l}$. To prove that fact, assume that $|u|\ Q\ |v|$. Nothing is lost if we also assume that $(fu)^+ = fv$, where f is the isomorphism defined in the proof of the Isomorphism Lemma. If $\mathbf{p}_{k+1,l} \in \Psi$ then by using Franzén's Lemma, the definition of f, and the truth definition, we obtain the following chain of inferences:

$$\mathfrak{M}'\vDash_{|u|} \mathbf{p}_{k+1,l} \text{ iff } \mathbf{p}_{k+1,l} \in u$$
$$\text{iff } \mathbf{o}^{k+1}\mathbf{p}_{0,l} \in fu$$
$$\text{iff } \mathbf{o}^{k}\mathbf{p}_{0,l} \in fv$$
$$\text{iff } \mathbf{p}_{k,l} \in v$$
$$\text{iff } \mathfrak{M}'\vDash_{|v|} \mathbf{p}_{k,l}.$$

That observation will be used below, in the proof of the Final Lemma.

LEMMA ON Q. *(i) If $|u|\ Q\ |v|$ then $|u| \le |v|$. (ii) If $|u| \le |v|$ then $|u|\ Q^*\ |v|$.*

Here Q^* is the ancestral of Q (see section 0).

Proof of (i). Suppose $|u| \nleq |v|$; then $|v| < |u|$. It is possible to find a Boolean combination \mathbf{A} of formulas of Ψ such that, for every $w \in U$,

(1) $\mathfrak{M}'\vDash_{|w|} \mathbf{A}$ iff $|u| \le |w|$.

In particular $\mathfrak{M}'\nvDash_{|v|}\mathbf{A}$, whence by Franzén's Lemma

(2) $\mathbf{A} \notin v$.

There is no loss of generality in assuming that u is such that, for every $w \in U$, $u\ R\ w$ only if $|u| \le |w|$. Hence by (1), for every $w \in U$, $u\ R\ w$ only if $\mathfrak{M}'\vDash_{|w|} \mathbf{A}$, whence by Franzén's Lemma $\mathbf{A} \in w$ (the lemma is applicable since \mathbf{A} is a Boolean combination of formulas in Ψ). Hence

(3) $\square\mathbf{A} \in u$.

Suppose now, for a *reductio ad absurdum* argument, that $|u| \ Q \ |v|$. Let u', $v' \in U$ be such that $u \equiv u'$, $v \equiv v'$, and $(fu')^+ = fv'$, where f is the isomorphism defined above. \mathbf{A} is an **o**-free formula, so by (3) and the definition of f

$$\text{(4)} \qquad\qquad\qquad \Box \mathbf{A}^\star \in fu'.$$

$S_{w0} \subseteq R_{w0}$, because of schema (iii:2), so $(fu')^+ = fv'$ implies that $fu' \ R_{w0} fv'$. Hence by (4) $\mathbf{A}^\star \in fv'$, whence, by the definition of f, $\mathbf{A} \in v'$. Since \mathbf{A} is a Boolean combination of formulas of Ψ,

$$\text{(5)} \qquad\qquad\qquad \mathbf{A} \in v.$$

The desired contradiction is provided by (2) and (5). ∎

Proof of (ii). Fix any $|u| \in U'$ and let U^* denote the set $\{|w| \in U' : |u| \ Q^* \ |w|\}$. It is possible to find some Boolean combination \mathbf{A} of formulas of Ψ such that, for all $w \in U$,

$$\text{(1)} \qquad\qquad \mathfrak{M}' \models_{|w|} \mathbf{A} \text{ iff } w \in U^*.$$

Hence in particular

$$\text{(2)} \qquad\qquad\qquad \mathfrak{M}' \models_{|u|} \mathbf{A}.$$

Suppose, by way of contradiction, that there is some element $v \in U$ such that $|u| \leqslant |v|$ and $|v| \in U' - U^*$; there is no loss of generality if we assume that $u \ R \ v$. Hence by (1)

$$\text{(3)} \qquad\qquad\qquad \mathfrak{M}' \not\models_{|v|} \mathbf{A}.$$

Since $u \ R \ v$, and \mathbf{A} is a Boolean combination of formulas of Ψ, Franzén's Lemma applied to (2) and (3) yields $\mathbf{A} \in u$ and $\neg \mathbf{A} \in v$. Hence $\mathbf{A} \wedge \Diamond \neg \mathbf{A} \in u$. Therefore, by the definition of f,

$$\mathbf{A}^\star \wedge \Diamond \neg \mathbf{A}^\star \in fu.$$

But by the 'induction postulate' of $W0$, schema (iii:3),

$$\vdash_{w0} \mathbf{A}^\star \wedge \Diamond \neg \mathbf{A}^\star \rightarrow \Diamond [\mathbf{A}^\star \wedge \mathbf{o} \neg \mathbf{A}^\star].$$

Hence

$$\Diamond [\mathbf{A}^\star \wedge \mathbf{o} \neg \mathbf{A}^\star] \in fu.$$

Therefore—here we use the Isomorphism Lemma—there exist some w, $x \in U_{D^*}$ such that $u \ R_{D^*} w$ and $(fw)^+ = fx$, and furthermore

$$\text{(4)} \qquad\qquad\qquad \mathbf{A}^\star \in fw,$$
$$\text{(5)} \qquad\qquad\qquad \neg \mathbf{A}^\star \in fx.$$

Note that since $u \in U$ and U is generated by R, w, $x \in U$. It follows from (5) that $\neg \mathbf{A} \in x$. Therefore by Franzén's Lemma

$$(6) \qquad \mathfrak{M}' \not\models_{|x|} \mathbf{A}.$$

Similarly, (4) implies that $\mathfrak{M}' \models_{|w|} A$, whence by (1) $|w| \in U^\star$. But $(fw)^+ = fx$ implies that $|w| \ Q \ |x|$, so also $|x| \in U^\star$. Therefore by (1)

$$(7) \qquad \mathfrak{M}' \models_{|x|} \mathbf{A}.$$

(6) and (7) yield the wanted contradiction. ∎

Note the following consequences of the Lemma on Q: If $|u|$, $|v|$ are consecutive initial elements of U', then $|u| \ Q \ |v|$. If $|u|$ is the last initial element of U', then there is some $|v| \in E$ such that $|u| \ Q \ |v|$. If $|u|$, $|v| \in E$, then $|u| \ Q^\star \ |v|$. Hence there exists some sequence

$$\sigma = <u_0, \ldots, u_{m-2}, v_0, \ldots, v_{r-1}>$$

such that the following conditions are satisfied: (i) $|u_0|, \ldots, |u_{m-2}|$ are the initial elements of U' in \leqslant-order; (ii) $E = \{|v_0|, \ldots, |v_{r-1}|\}$; (iii) if x, y are consecutive elements of σ then $|x| \ Q \ |y|$; (iv) $|v_{r-1}| \ Q \ |v_0|$. Note that it is not excluded that r exceeds the cardinality of E—there might be distinct $i, j < r$ such that $v_i \equiv v_j$ or even $v_i = v_j$.

We define a new model $\mathfrak{M}^\# = <U^\#, R^\#, S^\#, V^\#>$ as follows:

$$U^\# = \{<-1, u_i> : i < m-1\} \cup \{<i, v_i> : i < r\},$$
$$R^\# = \{<<i,x>, <j,y>> \in U^\# \times U^\# : |x| \leq |y|\},$$
$$S^\# = \{<<i,x>, <j,y>> \in U^\# \times U^\# : |i-j| \leq 1, \text{ and } x, y$$
$$\qquad \text{are consecutive elements of } \sigma\} \cup \{<<r-1, v_{r-1}>, <0,v_0>>\},$$
$$V^\# (\mathbf{p}) = \{<i,x> \in U^\# : |x| \in V'(\mathbf{p})\}, \text{ for every } \mathbf{p}.$$

$S^\#$ is serial and functional. As usual, then, we call $<j,y>$ the successor of $<i,x>$ if $<i,x> \ S^\# \ <j,y>$, and write $<i,x>^+ = <j,y>$.

FINAL LEMMA. *If \mathbf{A} is an \mathbf{O}-free formula and $<i,x> \in U^\#$, then $\mathfrak{M}' \models_{|x|} \mathbf{A}$ if and only if $\mathfrak{M}^\# \models_{<i,x>} \mathbf{A}^\star$.*

Proof. The proof is by induction on the length of \mathbf{A}. We shall exhibit only the basic step, when \mathbf{A} is a propositional letter, for the inductive step is trivial.

Fix $<i,x> \in U^\#$. If \mathbf{A} is a propositional letter \mathbf{q} not in Ψ, then there is nothing to prove (since in that case $\mathbf{q}^\star = \mathbf{q}$ and $V'(\mathbf{q}) = V^\#(\mathbf{q}) = \emptyset$). Suppose therefore that $\mathbf{A} \in \Psi$. Then there are unique natural numbers k and l such that $\mathbf{A} = \mathbf{p}_{k,l}$. We contend that

$$\mathfrak{M}' \models_{|x|} \mathbf{p}_{k,l} \text{ iff } \mathfrak{M}^\# \models_{<i,x>} \mathbf{o}^k \mathbf{p}_{0,l}.$$

The proof of the contention is also by induction, on k this time. The basic step is straightforward:

$$\mathfrak{M}' \models_{|x|} \mathbf{p}_{0,l} \text{ iff } |x| \in V'(\mathbf{p}_{0,l})$$
$$\text{iff } <i,x> \in V^\#(\mathbf{p}_{0,l})$$
$$\text{iff } \mathfrak{M}^\# \models_{<i,x>} \mathbf{p}_{0,l}.$$

For the inductive step, assume the contention has been proved for k. Suppose $<i,x>^+ = <j,y>$. Then

$$\mathfrak{M}' \models_{|x|} \mathbf{p}_{k+1,l} \text{ iff } \mathfrak{M}' \models_{|y|} \mathbf{p}_{k,l}$$
$$\text{iff } \mathfrak{M}^\# \models_{<j,y>} \mathbf{o}^k \mathbf{p}_{0,l}$$
$$\text{iff } \mathfrak{M}^\# \models_{<i,x>} \mathbf{o}^{k+1} \mathbf{p}_{0,l}.$$

Here only the first equivalence is problematic. That it actually obtains follows from an observation above, for it is clear from the definition of $S^\#$ that $|x|$ Q $|y|$. This ends the proof of the contention, and hence that of the lemma. ∎

We are now at the end of the completeness proof begun so many pages ago. By Franzén's Lemma, \mathfrak{M}' rejects **F**. By the Final Lemma, then, $\mathfrak{M}^\#$ rejects **F***, and so rejects **E**. As $\mathfrak{M}^\#$ is a Peano model, the completeness proof is finished!

A by-product of the preceding completeness argument is worth noticing. $\mathfrak{M}^\#$ is finite; in fact, given **E** it would be possible to compute an upper bound on its cardinality. Thus we have got the finite model property of *W0* into the bargain. Since our axiomatization of *W0* provides a way of recursively enumerating the theorems of *W0,* we therefore conclude that *W0* is decidable.

Before ending this section some comments on the historical background are in order. Von Wright is not the only one to have considered *W0*. Prior [2], p. 69, contains an axiom system equivalent to ours—indeed, differing only slightly from it—and states that E. J. Lemmon devised it in 1964. Evidently Lemmon did not prove his system to be complete. In fact, when this is written there does not seem to be any completeness proof in the literature. At least three unpublished proofs exist, however. The first was that of Dana Scott who was able to work out a connection between the kind of tense logic we have studied in this section and the theory of finite automata; questions of completeness and decidability could then be reduced to known problems about finite automata. Scott's work would seem to date from the latter part of the sixties. Later, but independently of Scott, Hans Kamp found an algebraic proof. His work, which was prompted by von Wright's paper [4], builds on R. A. Bull's papers [2] and [3]. I should like to thank Kamp who kindly put a written

version of his proof at my disposal. A third as yet unpublished proof is due to Kit Fine and dates from 1973. Like the proof of the present paper, his is model theoretic, and although it does not employ Franzén's Lemma or the concept of an auxiliary monomodal logic, it parallels mine. I had conceived the outline of my own proof before talking to Fine, but only after discussing it with him and later seeing his proof was I able to carry it out. In particular, it was from Fine I learned how to impose a successor relation on the end-cluster of \mathfrak{M}'; the relation Q and the Lemma on Q are essentially due to him.

4. W0: k-reduced Counterparts

Although von Wright has published no proof that W0 is complete and decidable, he has pointed at a way in which a proof may be attempted. As explained in section 2 there is a decision procedure for S; von Wright himself gave one in [1]. Thus it makes sense to suggest, as von Wright did in [4], that in order to decide whether a certain formula is a theorem of W0 we look for a suitably defined class $\Gamma(\mathbf{A})$ of \square-free formulas which is such that (i) $\vdash_{W0} \mathbf{A}$ if and only if, for all $\mathbf{B} \in \Gamma(\mathbf{A})$, $\vdash_S \mathbf{B}$, and (ii) it can be decided (in a finite number of steps) whether, for all $\mathbf{B} \in \Gamma(\mathbf{A})$, $\vdash_S \mathbf{B}$. So as to be able to define his candidate for $\Gamma(\mathbf{A})$ von Wright introduced the concept of 'k-model' or 'k-reduced counterpart'; here we adopt the latter locution in order to avoid confusion with the semantic concept of model. To obtain (ii) even though $\Gamma(\mathbf{A})$ is infinite, as it always is by his definition, von Wright suggested a certain inductive argument. The sketch was not carried out.

In this section I shall summarize in my own terms von Wright's suggested project, and then carry out part of it. Von Wright's own exposition is complicated, and I have preferred to give a rather free account of it here. The idea behind von Wright's approach begins with the observation that, in a sense, what one can 'say' using the \square-operator, one can also 'say' without it. For example, instead of asserting $\square \mathbf{p}$ one might equally well assert, collectively, every member of the set $\{\mathbf{p}, \mathbf{op}, \mathbf{oop}, \ldots\}$. A way to circumvent the difficulty that the latter set is infinite would be somehow to contrive to make only finitely many of the $\mathbf{o}^n\mathbf{p}$'s count. One might try to achieve that by considering finite initial segments of \mathfrak{N}; that is, models induced on $\langle k, \leqq, ^+\rangle$ where $k = \{0, 1, \ldots, k-1\}$ and $^+$ is as usual except that $(k-1)^+ = k-1$. For example, in a model with domain 3, the formulas $\square\mathbf{op}$ and $\mathbf{op} \wedge \mathbf{oop}$ would 'say' the same at 0, so the latter might be regarded, in that context, as a \square-free counterpart of the former. Formulas not containing \square would be expected to be their own counterparts. But then care must be taken to consider sufficiently large initial segments, as shown by the fact that, for example, $\mathbf{o}^4\mathbf{p} \wedge \mathbf{o}^5\neg\mathbf{p}$ is contradictory in any model with domain $k \leqq 5$. (The vagueness of the

preceding discussion will probably make it incomprehensible to readers not familiar with von Wright's paper [4]. Its sole purpose is to provide an intuitive motivation for the more formal development that follows.)

In place of the finite initial segments of \mathfrak{N} mentioned above we will use the following equivalent concept. Suppose k is a positive integer, and let \mathfrak{A} be a model on \mathfrak{N} with valuation V. Then \mathfrak{A} is *k-stable* if, for all \mathbf{p}, either $l \in V(\mathbf{p})$ for all $l \geq k-1$, or $l \not\in V(\mathbf{p})$ for all $l \geq k-1$. In the sequel, whenever we say that a model is k-stable, we assume that \mathfrak{N} is the frame of the model. A *stable* model is a model k-stable for some k.

By the *maximal* **o**-*degree* and the *minimal* **o**-*degree* of a formula \mathbf{A}, denoted by dmax (\mathbf{A}) and dmin (\mathbf{A}), respectively, we understand the greatest and the least number of nested occurrences of **o** in \mathbf{A}. The exact definitions run as follows (for simplicity, assume that \neg and \wedge are our only Boolean primitives):

$$\text{dmax } (\mathbf{p}) = 0,$$
$$\text{dmax } (\neg\mathbf{B}) = \text{dmax } (\mathbf{B}),$$
$$\text{dmax } (\mathbf{B} \wedge \mathbf{C}) = \max \{\text{dmax } (\mathbf{B}), \text{dmax } (\mathbf{C})\},$$
$$\text{dmax } (\square\mathbf{B}) = \text{dmax } (\mathbf{B}),$$
$$\text{dmax } (\mathbf{oB}) = \text{dmax } (\mathbf{B}) + 1.$$

$$\text{dmin } (\mathbf{p}) = 0,$$
$$\text{dmin } (\neg\mathbf{B}) = \text{dmin } (\mathbf{B}),$$
$$\text{dmin } (\mathbf{B} \wedge \mathbf{C}) = \min \{\text{dmin } (\mathbf{B}), \text{dmin } (\mathbf{C})\},$$
$$\text{dmin } (\square\mathbf{B}) = \text{dmin } (\mathbf{B}),$$
$$\text{dmin } (\mathbf{oB}) = \text{dmin } (\mathbf{B}) + 1.$$

Obviously, for all \mathbf{A}, dmax $(\mathbf{A}) \geq$ dmin $(\mathbf{A}) \geq 0$.

The following lemma shows that in a k-stable model nothing changes after a certain point—only the first k elements are ever interesting.

LEMMA 1. *If \mathfrak{A} is a k-stable model on \mathfrak{N}, then either, for all $l \geq k - 1 -$ dmin (\mathbf{A}), $\mathfrak{A} \models_l \mathbf{A}$, or, for all $l \geq k - 1 - $ dmin (\mathbf{A}), $\mathfrak{A} \not\models_l \mathbf{A}$.*

We omit the simple proof (by induction on the length of \mathbf{A}).

If \mathbf{A} is a formula and k a positive natural number, then '(\mathbf{A},k)' will denote the formula we shall call the *k-reduced counterpart* of \mathbf{A}. The definition is recursive (again we assume that \neg and \wedge are our Boolean primitives):

$$(\mathbf{p},k) = \mathbf{p},$$
$$(\neg\mathbf{A},k) = \neg(\mathbf{A},k),$$
$$(\mathbf{A} \wedge \mathbf{B},k) = (\mathbf{A},k) \wedge (\mathbf{B},k),$$
$$(\square\mathbf{A},k) = (\mathbf{A},k) \wedge \mathbf{o}(\mathbf{A},k-1) \wedge \ldots$$

$$\ldots \wedge \mathbf{o}^{k-1-\text{dmin} (A)} (\mathbf{A}, \text{dmin} (\mathbf{A}) + 1),$$

$$(\mathbf{oA}, k) = \begin{cases} \mathbf{o}(\mathbf{A}, k-1), & \text{if } k > 1, \\ (\mathbf{A}, 1), & \text{if } k = 1. \end{cases}$$

The intuitive idea behind the definition, that (\mathbf{A}, k) is what \mathbf{A} 'says' at 0 in a k-stable model, is made precise in the following lemma:

LEMMA 2. *If \mathfrak{A} is a k-stable model on \mathfrak{N} and $i < k$, then $\mathfrak{A} \models_i \mathbf{A}$ if and only if $\mathfrak{A} \models_i (\mathbf{A}, k - i)$.*

Proof. By induction on the length of \mathbf{A}. We give the interesting parts of the proof. Suppose the lemma holds for \mathbf{A}.

If $i < k - 1$, then $\mathfrak{A} \models_i \mathbf{oA}$ iff $\mathfrak{A} \models_{i+1} \mathbf{A}$ iff (by the induction hypothesis) $\mathfrak{A} \models_{i+1} (\mathbf{A}, k - (i + 1))$ iff $\mathfrak{A} \models_i \mathbf{o}(\mathbf{A}, k - i - 1)$ iff $\mathfrak{A} \models_i (\mathbf{oA}, k - i)$. Moreover, $\mathfrak{A} \models_{k-1} \mathbf{oA}$ iff $\mathfrak{A} \models_k \mathbf{A}$ iff (by Lemma 1) $\mathfrak{A} \models_{k-1} \mathbf{A}$ iff (by the induction hypothesis) $\mathfrak{A} \models_{k-1} (\mathbf{A}, 1)$ iff $\mathfrak{A} \models_{k-1} (\mathbf{oA}, 1)$.

It is easy to prove that $\mathfrak{A} \models_i (\Box\mathbf{A}, k - i)$ if $\mathfrak{A} \models_i \Box\mathbf{A}$. The converse requires more attention. Suppose that $\mathfrak{A} \models_i (\Box\mathbf{A}, k - i)$. Using the definition of $(\Box\mathbf{A}, k - i)$ and the induction hypothesis we conclude that $\mathfrak{A} \models_j \mathbf{A}$ for all j such that $i \leq j \leq k - 1 - \text{dmin} (\mathbf{A})$. Hence Lemma 1 implies that $\mathfrak{A} \models_j \mathbf{A}$ for all $j \geq i$. Therefore $\mathfrak{A} \models_i \Box\mathbf{A}$. ∎

COROLLARY. *If \mathfrak{A} is a k-stable model on \mathfrak{N}, then $\mathfrak{A} \models_0 \mathbf{A}$ if and only if $\mathfrak{A} \models_0 (\mathbf{A}, k)$.*

Counterparts have been introduced so as to enable us to draw on our knowledge of the system S. The following lemma establishes a connection between counterparts and S.

LEMMA 3. *If $k > \text{dmax} (\mathbf{A})$, then $\vdash_S (\mathbf{A}, k)$ if and only if, for all k-stable models \mathfrak{A} on \mathfrak{N}, $\mathfrak{A} \models_0 (\mathbf{A}, k)$.*

Proof. Assume that $k > \text{dmax} (\mathbf{A})$. It follows from a result in section 2 that if \mathbf{B} is any \Box-free formula such that $k > \text{dmax} (\mathbf{B})$, then $\vdash_S \mathbf{B}$ if and only if, for all k-stable models \mathfrak{A}, $\mathfrak{A} \models_0 \mathbf{B}$. Now (\mathbf{A}, k) is indeed \Box-free, and an inductive argument shows that $\text{dmax} (\mathbf{C}, l) < l$ for all \mathbf{C} and positive l. ∎

Let us say that a formula \mathbf{A} is *valid in von Wright's sense* if, for all $k > \text{dmax} (\mathbf{A})$, $\vdash_S (\mathbf{A}, k)$. Furthermore, let *WOE* be the axiom system that results from adding to our axiomatization of *WO* all instances of the McKinsey/Sobociński schema $\Box\Diamond \mathbf{A} \rightarrow \Diamond\Box\mathbf{A}$. (Thus, in particular, *WOE* is closed under \Box-necessitation.) We are now ready for the main result of this section.

THEOREM. *$\vdash_{WOE} \mathbf{A}$ if and only if \mathbf{A} is valid in von Wright's sense.*

Proof. We claim, without going through the details, that it is easy to modify

the argument presented in section 3 to prove that *WOE* is determined by the class of stable models on \mathfrak{N}. (In the presence of the McKinsey/Sobociński schema, \leq becomes antisymmetric throughout the Franzén structure \mathfrak{M}'; that is, the end-cluster becomes a singleton like the other clusters. Note that the \square-fragment of *WOE* is identical with Makinson's logic in [1]; it was axiomatized by Schumm in [1] and, independently, by the author in [2].)

Consider the condition

(1) $\vdash_{WOE} \mathbf{A}$.

By the claim just made, (1) is equivalent to

(2) $\forall k > 0 \ \forall i \ (\mathfrak{A} \text{ is } k\text{-stable} \Rightarrow \mathfrak{A} \models_i \mathbf{A})$.

It is obvious that if \mathfrak{B} is m-stable, for any positive m, then $\mathfrak{B} \models_i \mathbf{A}$ if and only if $\mathfrak{B}^i \models_0 \mathbf{A}$, where \mathfrak{B}^i is the $(m - i)$-stable model isomorphic to the model generated from \mathfrak{B} by i. Hence (2) is equivalent to

(3) $\forall k > 0 \ (\mathfrak{A} \text{ is } k\text{-stable} \Rightarrow \mathfrak{A} \models_0 \mathbf{A})$.

Consider the condition

(4) $\forall k > \text{dmax} (\mathbf{A})(\mathfrak{A} \text{ is } k\text{-stable} \Rightarrow \mathfrak{A} \models_0 \mathbf{A})$.

Evidently (3) implies (4). But also the converse holds. For if a model is k-stable then it is $(k + l)$-stable for every l, so \mathbf{A} will fail in an m-stable model for any sufficiently large m if it fails in any stable model. So (3) and (4) are equivalent. But by the corollary to Lemma 2, (4) is equivalent to

(5) $\forall k > \text{dmax} (\mathbf{A})(\mathfrak{A} \text{ is } k\text{-stable} \Rightarrow \mathfrak{A} \models_0 (\mathbf{A},k))$.

By Lemma 3, (5) in its turn is equivalent to

(6) $\forall k > \text{dmax} (\mathbf{A}) \vdash_S (\mathbf{A},k)$.

By definition, (6) is the same as

(7) \mathbf{A} is valid in von Wright's sense.

So (1) and (7) are equivalent. ∎

It is time to take stock of the foregoing exposition. We have carried out step (i) of the two-step program outlined in the introduction to this section: with $\Gamma (\mathbf{A})$ as the set of k-reduced counterparts of \mathbf{A} for which $k > \text{dmax} (\mathbf{A})$, (i) reads like the theorem just proved. With one exception, of course: instead of *WO* our theorem has *WOE*. The reason for that outcome is that k-stable models on \mathfrak{N} have one feature in common that models on \mathfrak{N} do not have generally: only a finite initial segment is interesting. It so happens—by a sort

of bad luck, from the point of view of von Wright's program—that that feature makes a difference even for an object language as restricted as ours. I take it that this is just an oversight of von Wright's. The oversight is not serious. To amend it, all that is needed is a modification of the definition of k-reduced counterpart. The fact that *W0* is determined by the class of finite Peano frames suggests how to carry out such a modification. (In a letter to the author Kit Fine has proposed a specific definition of that kind.)

This leaves the problem to carry out the second step. I do not quite understand von Wright's own efforts to advance a solution. For example, he makes a claim on p. 217 of [4] which in our terminology amounts to the claim that, for all **A** and positive k, $(\Box \mathbf{A}, k + 1) = \mathbf{A} \wedge \mathbf{o}(\Box \mathbf{A}, k)$. But that claim is false, as is seen by putting $\mathbf{A} = \Box \mathbf{p}$; for then the left hand member does not contain any occurrence of the \Box-operator, while the right hand member does. (Is this an indication that my avowedly 'rather free account' of von Wright has become too free—that I have misunderstood him?) Apart from that negative remark I have no comment to offer as regards step (ii). Of course, it can be deduced from the completeness proof in section 3 that for each formula **A** there is a natural number m, depending on **A** only, such that in order to decide whether, for all $(\mathbf{A}, k) \in \Gamma (\mathbf{A})$, $\vdash_S (\mathbf{A}, k)$, it is enough to check only the (\mathbf{A}, k)'s for which dmax $(\mathbf{A}) < k < m$. However, that 'solution' does not do justice to von Wright's hope for an induction principle. That idea of his may yet prove interesting.

5. Infinitary Inference Rules

Consider the set

$$\Theta = \{\neg \Box \mathbf{p}\} \cup \{\mathbf{o}^n \mathbf{p} : n \in \omega\}.$$

Θ is consistent in *W0*, yet Θ has no model on \mathfrak{N}. (To see that Θ is consistent in *W0*, note that every finite subset Θ' of Θ has a model on \mathfrak{N}; that is, some model \mathfrak{A} on \mathfrak{N} such that, for a certain point, every member of Θ' is true in \mathfrak{A} at that point—thus from a finite subset of Θ we shall never be able to deduce, in *W0*, a contradiction. That Θ has no model on the intended frame \mathfrak{N} is obvious. Note, however, that there are other models for Θ, as there are for every *W0*-consistent set—the canonical model \mathfrak{M}_{w0} is one. For a more specific example, let ζ be the set of integers and define $\mathfrak{Z} = \langle \zeta, R, S, V \rangle$ where R is the universal relation on ζ, S the ordinary successor function defined on ζ, and V any valuation such that $V(\mathbf{p}) = \zeta - \{-1\}$. Then $\mathfrak{Z} \vDash_0 \mathbf{A}$, for every $\mathbf{A} \in \Theta$.)

The argument of section 3 established that *W0* is *weakly complete* with respect to \mathfrak{N} (every finite *W0*-consistent set of formulas has a model on \mathfrak{N}). The preceding example shows that *W0* is not also *strongly complete* with re-

spect to \mathfrak{N} (not every *W0*-consistent set of formulas has a model on \mathfrak{N}). Indeed, no axiomatization of *W0* with finitary rules—rules with only finitely many premisses—can be strongly complete with respect to \mathfrak{N}. Let *L* be a logic and *F* a family of sets of formulas. We say that *L* is *compact over F* if a set $\Sigma \in F$ has a model on a frame for *L* whenever every finite subset of Σ has a model on a frame for *L*. Furthermore, we say that *L* is *compact* if *L* is compact over the family of all sets of formulas. It is clear from the discussion of Θ that *W0* fails to be compact. In a private communication Kit Fine has pointed out that *W0* is not compact even over the family whose members are sets of **o**-free formulas in one fixed propositional letter. His counterexample is

$$\Gamma = \{\Diamond\square\mathbf{p}\} \cup \{\mathbf{C}_n : n \in \omega\},$$

where $\mathbf{C}_0 = \mathbf{p}$, $\mathbf{C}_{n+1} = \mathbf{p} \wedge \Diamond[\neg\mathbf{p} \wedge \Diamond\mathbf{C}_n]$; clearly every finite subset of Γ has a model on \mathfrak{N}, whereas the whole set Γ has no model on any Peano frame. As Fine remarked, his example gathers additional interest when one considers the situation in monomodal logic: there are frames for *D* on which Γ does have a model. For example, let $\mathfrak{F} = <U, R>$ be the frame where $U = \omega \cup \{\omega\}$ and *u R v* if and only if $u \geq v$. Then \mathfrak{F} is a frame for *D*, and any valuation *V* such that $V(\mathbf{p}) = \{n \in \omega : n \text{ is odd}\} \cup \{\omega\}$ yields a model for Γ.

We shall now exhibit a formal system which turns out to be strongly complete with respect to \mathfrak{N}. The system, which we call *W1*, is in the style of natural deduction systems, but a Hilbert style axiomatization would also have been possible (for example, extending *W0* with something like the infinitary rule \squareI(0) below and adjusting the notion of a formal proof accordingly). In order to save space we shall assume that the reader is familiar with Chapter I of Prawitz [1], or some similar text.

The inference rules are those listed in Figure 2. They divide into elimination rules and introduction rules, infinitely many for each connective except **o**. Thus, for \wedge there are the elimination rules \wedge E(0), \wedge E(1), \wedge E(2), . . . and the introduction rules \wedge I(0), \wedge I(1), \wedge I(2), . . . , and similarly for \vee, \rightarrow, \neg, and \square. There are no special rules for **o**. All rules are finitary except the introduction rules for \square—that is, \square I(0), \square I(1), \square I(2), Only \vee E(n), \rightarrowI(n), $\neg E(n)$, and $\neg I(n)$ are improper rules. There are no axioms. The deduction rules are the obvious ones. If Σ is a set of formulas and **A** is a formula we say that **A** *is deducible from* Σ—in symbols $\Sigma \vdash_{W1}$ **A** or simply $\Sigma \vdash$**A**—if there is a deduction of **A** in *W1* all assumptions of which are drawn from Σ. **A** *is deducible in W1*, or is a *theorem* of *W1*, if $\emptyset \vdash_{W1}$ **A**.

Deductions where an infinitary inference rule is applied can never be fully written down. Nevertheless it may be possible to describe even an infinite deduction and thus use it without writing it down in complete detail. This is important, and we shall give a few examples to illustrate the point.

$$\wedge E(n)\quad \frac{\mathbf{o}^n[A \wedge B]}{\mathbf{o}^n A} \qquad \frac{\mathbf{o}^n[A \wedge B]}{\mathbf{o}^n B} \qquad\qquad \wedge I(n)\quad \frac{\mathbf{o}^n A \qquad \mathbf{o}^n B}{\mathbf{o}^n[A \wedge B]}$$

$$\vee E(n)\quad \frac{\mathbf{o}^n[A \vee B] \quad \overset{(\mathbf{o}^n A)}{C} \quad \overset{(\mathbf{o}^n B)}{C}}{C} \qquad\qquad \vee I(n)\quad \frac{\mathbf{o}^n A}{\mathbf{o}^n[A \vee B]} \qquad \frac{\mathbf{o}^n B}{\mathbf{o}^n[A \vee B]}$$

$$\rightarrow E(n)\quad \frac{\mathbf{o}^n A \qquad \mathbf{o}^n[A \rightarrow B]}{\mathbf{o}^n B} \qquad\qquad \rightarrow I(n)\quad \frac{\overset{(\mathbf{o}^n A)}{\mathbf{o}^n B}}{\mathbf{o}^n[A \rightarrow B]}$$

$$\neg E(n)\quad \frac{\overset{(\neg A)}{\neg \mathbf{o}^n B} \quad \overset{(\neg A)}{\neg \mathbf{o}^n \neg B}}{A} \qquad\qquad \neg I(n)\quad \frac{\overset{(A)}{\mathbf{o}^n B} \quad \overset{(A)}{\mathbf{o}^n \neg B}}{\neg A}$$

$$\Box E(n)\; \frac{\mathbf{o}^n\Box A}{\mathbf{o}^n A} \; \frac{\mathbf{o}^n\Box A}{\mathbf{o}^{n+1}A} \; \frac{\mathbf{o}^n\Box A}{\mathbf{o}^{n+2}A} \; \cdots \qquad \Box I(n)\; \frac{\mathbf{o}^n A \quad \mathbf{o}^{n+1}A \quad \mathbf{o}^{n+2}A \; \cdots}{\mathbf{o}^n\Box A}$$

Figure 2

Consider the formula-tree (deduction) indicated by the following sketch, where n is some fixed natural number:

$$\frac{\dfrac{\mathbf{o}^n\Box A}{\mathbf{o}^n A} \quad \dfrac{\mathbf{o}^n\Box A}{\mathbf{o}^{n+1}A} \quad \dfrac{\mathbf{o}^n\Box A}{\mathbf{o}^{n+2}A} \quad \cdots}{\Box\mathbf{o}^n A}$$

The sketch already is a kind of description. A verbal description would be this: For each $k \in \omega$ we use the rule $\Box E(n)$ to infer $\mathbf{o}^{n+k}A$ from $\mathbf{o}^n\Box A$. Then from the infinite set $\{\mathbf{o}^i A : i \geq n\}$ we infer $\Box\mathbf{o}^n A$ by means of the rule $\Box I(0)$. So $\Box\mathbf{o}^n A$ is deducible from $\mathbf{o}^n\Box A$.

Similarly, consider the formula-tree indicated by the following sketch, where again n is a fixed natural number:

$$\frac{\dfrac{\Box\mathbf{o}^n A}{\mathbf{o}^n A} \quad \dfrac{\Box\mathbf{o}^n A}{\mathbf{o}^{n+1}A} \quad \dfrac{\Box\mathbf{o}^n A}{\mathbf{o}^{n+2}A} \quad \cdots}{\mathbf{o}^n\Box A}$$

A verbal description would be this: For each $k \in \omega$, by $\Box E(0)$, $\Box\mathbf{o}^n A \vdash \mathbf{o}^{n+k}A$. Moreover, by $\Box I(n)$, $\{\mathbf{o}^i A : i \geq n\} \vdash \mathbf{o}^n\Box A$. So $\Box\mathbf{o}^n A \vdash \mathbf{o}^n\Box A$.

The two examples just given show that the following are derived rules in *W1*:

$$\frac{\mathbf{o}^n\Box A}{\Box \mathbf{o}^n A} \qquad \frac{\Box \mathbf{o}^n A}{\mathbf{o}^n \Box A}$$

It may be noted that one obtains an axiom system equivalent to *W1* by adding as primitive those two rules and instead deleting the rules $\Box E(n)$ and $\Box I(n)$ for all $n > 0$—that is one of many ways to modify our axiomatization of *W1*.

As an example of a slightly more complicated deduction we shall show that schema (4) of section 1 is deducible in *W1*. Let '\Diamond' be regarded as an abbreviation of '$\neg \Box \neg$'. Then it will be enough to show that

$$\Box[A \to \Box \neg B], \Box[B \to \Box \neg A], \Diamond A \vdash \Box \neg B.$$

We proceed as follows, using Prawitz's conventions for marking the discharge of assumptions. Consider the following formula-trees:

$$\frac{\mathbf{o}^i B \qquad \dfrac{\Box[B \to \Box \neg A]}{\mathbf{o}^i[B \to \Box \neg A]}}{\dfrac{\mathbf{o}^i \Box \neg A}{\mathbf{o}^i \neg A}}$$

$$\dfrac{\mathbf{o}^i B \qquad \dfrac{\dfrac{\dfrac{\Box[A \to \Box \neg B]}{\mathbf{o}^i[A \to \Box \neg B]} \qquad \mathbf{o}^i A \quad (1)}{\mathbf{o}^i \Box \neg B}}{\mathbf{o}^i \neg B}}{\dfrac{\neg \mathbf{o}^i A \qquad \qquad \neg \mathbf{o}^i \neg A \quad (2)}{\mathbf{o}^i \neg A} \;(2)}$$

Let i be a fixed natural number, and assume that j is any natural number. If $i \le j$ then the first formula-tree is a deduction establishing

$$\Box[B \to \Box \neg A], \mathbf{o}^i B \vdash \mathbf{o}^i \neg A.$$

If $i \ge j$ then the second formula-tree is a deduction establishing

$$\Box[A \to \Box \neg B], \mathbf{o}^i B \vdash \mathbf{o}^i \neg A.$$

Thus whether $i \le j$ or $i \ge j$ we have

$$\Box[A \to \Box \neg B], \Box[B \to \Box \neg A], \mathbf{o}^i B \vdash \mathbf{o}^i \neg A.$$

But this holds for every j! Hence by $\Box I(0)$

$$\Box[A \rightarrow \Box \neg B], \Box[B \rightarrow \Box \neg A], \mathbf{o}^i B \vdash \Box \neg A.$$

Using $\neg I(0)$ and $\neg E(i)$ we get

$$\Box[A \rightarrow \Box \neg B], \Box[B \rightarrow \Box \neg A], \Diamond A \vdash \mathbf{o}^i \neg B.$$

The preceding argument has been carried out for some fixed i. But the reasoning holds no matter what the value of i. Hence by $\Box I(0)$ the desired result.

The argument given shows that a certain deduction exists—a deduction which it is humanly impossible to visualize except in outline. By contrast it is trivial to check the links in the chain of argument and convince oneself that the deduction exists.

We state the following result without proof:[1]

THEOREM. *A set Σ of formulas is consistent in W1 if and only if Σ has a model on \mathfrak{R}. Moreover, if Σ is finite, then Σ is W1-consistent if and only if Σ is W0-consistent.*

Hence *W0* and *W1* agree in the sense that they recognize exactly the same set of theorems; their deductive powers differ only where infinite sets are concerned. (Therefore it would be possible to regard *W1* as an axiomatization of sorts of the monomodal logic *D* where **o** enters as an *auxiliary connective*. By a theorem one would then understand a formula deducible in *W1* such that, even though formulas containing **o** are permitted in the deduction of it, yet it itself is **o**-free.)

Given the conception of time adopted in this paper, is it *W0* or *W1* (or neither?) that is the 'correct' tense logic? It all depends on what we mean by 'correct', we will perhaps be told. Certainly. If we are only interested in what formulas are valid in \mathfrak{R} then *W0* is a good enough logic, for *W1* yields no new theorems over *W0* and is more complicated in some important respects. If, on the other hand, it is derivability we are interested in, then *W0* seems insufficient and *W1*, infinitary rules and all, a likelier candidate. As von Wright only discusses weak completeness in his published works he has never commented on this topic. Nevertheless it seems to merit attention.

6. Infinitary Tense Logic

A key term in von Wright's tense logic is 'history'. The meaning he gives this term is explained by the following two quotations ([5], pp. 8 and 10):

> Let us suppose that the total state of the world on a given occasion could be completely described by stating, with regard to every one of the members of a set of logically independent (generic) states of affairs, whether it obtains or not on that occasion. A description of this kind is called a *state-description*. I propose to say that the cardinal number of the set measures the logical *width* of the world.

If the number of 'elementary states' is finite and n, the number of possible total states of the world, or of 'possible worlds', is 2^n, we can order the states in a sequence p_1, \ldots, p_n and the possible worlds in a sequence w_1, \ldots, w_{2^n}.

Consider m successive occasions. If for every one of them we indicate which total state of the world obtains on that occasion, we get a complete description of how the world changes (and does not change) over that period of time. Such a description I shall call a *change-description* or *history* of the world of *length m*. It is easy to see that the number of possible histories of length m of a world of width n is 2^{mn}.

If, with von Wright, one wants histories to be formulas of an object language such as that used in the previous few sections of this paper (cf. von Wright [4], p. 209), then one must accept that histories are always of finite width and finite length. Those limitations seem arbitrary and perhaps even undesirable. There are two obvious ways to lift them. One is to let histories be sets of formulas rather than formulas. The other is to permit formulas to be infinitely long. This section is devoted to a brief exploration of the latter alternative. (Cf. Prior [2], first sentence on p. 198. For an account of classical infinitary propositional logic, see Scott/Tarski [1].)

The primitive symbols of our new object language will be (i) brackets, corners, and commas, (ii) denumerably many propositional letters, (iii) the unary operators \neg and \mathbf{o}, and (iv) the infinitary operators \bigwedge and \bigvee. The unary operators are the same as before, whereas \bigwedge and \bigvee stand for generalized conjunction and disjunction, respectively. Before defining the new concept of formula we find it convenient to define the concept of *formula derivation:*

1. The empty sequence $<>$ is a formula derivation (of type 0).
2. If $<A_\eta>_{\eta<\xi}$ is a formula derivation of type ξ, for any at most countable ordinal ξ, then the sequence $<A_\eta>_{\eta\leq\xi}$ is a formula derivation (of type $\xi + 1$) if either $A_\xi = \mathbf{p}$, for some propositional letter \mathbf{p}, or $A_\xi = [\neg A_\zeta]$ or $A_\xi = [\mathbf{o}A_\zeta]$, for some $\zeta < \xi$, or $A_\xi = [\bigwedge<A_{\eta_0}, A_{\eta_1}, \ldots, A_{\eta_\zeta}, \ldots>]$ or $A_\xi = [\bigvee<A_{\eta_0}, A_{\eta_1}, \ldots, A_{\eta_\zeta}, \ldots>]$, for some well-ordered sequence $<\eta_0, \eta_1, \ldots, \eta_\zeta, \ldots>$ of type less than ξ, where $\eta_0, \eta_1, \ldots, \eta_\zeta, \ldots < \xi$.
3. If λ is an at most countable limit ordinal and $<A_\eta>_{\eta<\xi}$ is a formula derivation, for every $\xi < \lambda$, then $<A_\eta>_{\eta<\lambda}$ is a formula derivation (of type λ).
4. Nothing is a formula derivation except as defined by (1)–(3).

We say that A is a *formula* if there is some (at most countable) ordinal $\xi > 0$ and formula derivation $<B_\eta>_{\eta\leq\xi}$ such that $A = B_\xi$. We define the *rank* of a formula A as the smallest ordinal ξ such that there is a formula derivation $<B_\eta>_{\eta\leq\xi}$ with $A = B_\xi$. Note that even though there are nondenumerably many formulas, every formula has at most denumerable rank.

As usual we drop brackets as we please. We also adopt the following ways of abbreviating formulas:

$$\mathbf{A} \wedge \mathbf{B} \text{ for } \mathbb{M}\!<\!\mathbf{A}, \mathbf{B}\!>,$$
$$\mathbf{A} \vee \mathbf{B} \text{ for } \mathbb{W}\!<\!\mathbf{A},\mathbf{B}\!>,$$
$$\mathbf{A} \to \mathbf{B} \text{ for } \mathbb{W}\!<\!\neg\mathbf{A},\mathbf{B}\!>,$$
$$\mathbf{A} \leftrightarrow \mathbf{B} \text{ for } \mathbb{M}\!<\!\mathbb{W}\!<\!\neg\mathbf{A},\mathbf{B}\!>,\mathbb{W}\!<\!\neg\mathbf{B},\mathbf{A}\!>\!>,$$
$$\mathbb{M}_{\eta<\xi} \mathbf{A}_\eta \text{ for } \mathbb{M}\!<\!\mathbf{A}_0, \mathbf{A}_1, \ldots, \mathbf{A}_\eta, \ldots\!>,$$
$$\mathbb{W}_{\eta<\xi} \mathbf{A}_\eta \text{ for } \mathbb{W}\!<\!\mathbf{A}_0, \mathbf{A}_1, \ldots, \mathbf{A}_\eta, \ldots\!>.$$

(In the last two cases it is of course assumed that ξ is the type of the sequence $<\!\mathbf{A}_0, \mathbf{A}_1, \ldots, \mathbf{A}_\eta, \ldots\!>$ and an at most countable ordinal.)

The semantics for the new language is obvious. For example, given a model \mathfrak{A} on the frame \mathfrak{N} the clauses pertaining to \mathbb{M} and \mathbb{W} are,

$$\mathfrak{A}\models_u \mathbb{M}_{\eta<\xi}\mathbf{A} \text{ iff, for every } \zeta < \xi, \mathfrak{A}\models_u\mathbf{A}_\zeta,$$
$$\mathfrak{A}\models_u \mathbb{W}_{\eta<\xi}\mathbf{A} \text{ iff, for some } \zeta < \xi, \mathfrak{A}\models_u\mathbf{A}_\zeta.$$

We now proceed to define a new axiom system, called *W2*. The axioms of *W2* are some sufficient set of classical (finitary) tautologies, together with all instances of the following schemata ($k \in \omega$ and ξ at most countable):

1. $\neg \underset{\eta<\xi}{\mathbb{M}} \mathbf{A}_\eta \leftrightarrow \underset{\eta<\xi}{\mathbb{W}} \neg\mathbf{A}_\eta.$

2. $\neg \underset{\eta<\xi}{\mathbb{W}} \mathbf{A}_\eta \leftrightarrow \underset{\eta<\xi}{\mathbb{M}} \neg\mathbf{A}_\eta.$

3. $\underset{\eta<\xi}{\mathbb{M}}\mathbf{A}_\eta \to \mathbf{A}_\zeta$, if $\zeta < \xi.$

4. $\mathbf{A}_\zeta \to \underset{\eta<\xi}{\mathbb{W}}\mathbf{A}_\eta$, if $\zeta < \xi.$

5. $\mathbf{o}^k\underset{\eta<\xi}{\mathbb{M}}\mathbf{A}_\eta \leftrightarrow \underset{\eta<\xi}{\mathbb{M}}\mathbf{o}^k\mathbf{A}_\eta.$

6. $\mathbf{o}^k\underset{\eta<\xi}{\mathbb{W}}\mathbf{A}_\eta \leftrightarrow \underset{\eta<\xi}{\mathbb{W}}\mathbf{o}^k\mathbf{A}_\eta.$

7. $\mathbf{o}^k\neg\mathbf{A} \leftrightarrow \neg\mathbf{o}^k\mathbf{A}.$

The rules of *W2* are three, namely, modus ponens and the following two unnamed rules (ξ is at most countable):

$$\frac{\mathbf{A} \to \mathbf{B}_0, \mathbf{A} \to \mathbf{B}_1, \ldots, \mathbf{A} \to \mathbf{B}_\eta, \ldots \ (\eta < \xi)}{\mathbf{A} \to \underset{\eta<\xi}{\mathbb{M}}\mathbf{B}_\eta}$$

$$\frac{\mathbf{A}_0 \to \mathbf{B}, \mathbf{A}_1 \to \mathbf{B}, \ldots, \mathbf{A}_\eta \to \mathbf{B}, \ldots \ (\eta < \xi)}{\underset{\eta<\xi}{\mathbb{W}}\mathbf{A}_\eta \to \mathbf{B}}$$

The notion of a formal proof is a generalization of the ordinary one: if Σ is a set of formulas and \mathbf{A} a formula, then we say that \mathbf{A} *is deducible from* Σ—in symbols, $\Sigma \vdash_{W2} \mathbf{A}$—if there is a *deduction of* \mathbf{A} *from* Σ, that is, a well-ordered, at most countable sequence $\langle \mathbf{B}_0, \mathbf{B}_1, \ldots, \mathbf{B}_\eta, \ldots, \mathbf{B}_\xi \rangle$ of type $\xi + 1$ such that $\mathbf{A} = \mathbf{B}_\xi$, and, for every $\eta \leq \xi$, either \mathbf{B}_η is an axiom, or $\mathbf{B}_\eta \in \Sigma$, or \mathbf{B}_η follows from some of the first η formulas by one of the rules of $W2$. If $\emptyset \vdash_{W2} \mathbf{A}$ we write $\vdash_{W2} \mathbf{A}$ and say that \mathbf{A} is a *theorem* of $W2$. A set Σ is $W2$-*inconsistent* if a contradiction is deducible from it, otherwise $W2$-*consistent*. It follows that a set Σ is $W2$-consistent if and only if every at most countable subset of Σ is $W2$-consistent; for by the definition Σ is $W2$-consistent if and only if there is no sequence $\langle \mathbf{B}_0, \mathbf{B}_1, \ldots, \mathbf{B}_n, \ldots \rangle$ of type ω of formulas in Σ such that $\vdash_{W2} \neg \bigwedge_{\eta < \omega} \mathbf{B}_\eta$.

If one deletes from the axiom system $W2$ all the axioms (5)–(7)—that is, all axioms where the operator \mathbf{o} occurs in an interesting way—one obtains the axiom system given in Scott/Tarski [1] (except that they specified a particular set of tautologies). Furthermore, axioms (5)–(7) assign to \mathbf{o} the same role it played in the Successor Logic S of section 2: commuting with or distributing over all classical operators. Thus it is natural to say that $W2$ is the result of combining S and classical infinitary propositional logic. It is an interesting fact that that straightforward combination indeed yields the expected result, stated below as a theorem. What is more, to prove it we may use the same basic idea as in sections 2 and 3. For thanks to the good behavior of \mathbf{o} we may prove a normal form theorem and thereby reduce our completeness problem to the known one of classical infinitary propositional logic.

THEOREM. $\vdash_{W2} \mathbf{A}$ *if and only if* \mathbf{A} *is valid in* \mathfrak{N}.

Proof. Notice that if \mathbf{A} is a formula, then there is a unique natural number k, possibly 0, and a unique formula \mathbf{B} such that $\mathbf{A} = \mathbf{o}^k \mathbf{B}$ and, for all \mathbf{C}, $\mathbf{B} \neq \mathbf{o}\mathbf{C}$. Therefore the following defines a *normal form* \mathbf{A}', for every formula \mathbf{A}:

$$(\mathbf{o}^k \mathbf{p})' = \mathbf{o}^k \mathbf{p},$$
$$(\mathbf{o}^k \neg \mathbf{B})' = \neg(\mathbf{o}^k \mathbf{B})',$$
$$(\mathbf{o}^k \bigwedge_{\eta < \xi} \mathbf{B}_\eta)' = \bigwedge_{\eta < \xi} (\mathbf{o}^k \mathbf{B}_\eta)',$$
$$(\mathbf{o}^k \bigvee_{\eta < \xi} \mathbf{B}_\eta)' = \bigvee_{\eta < \xi} (\mathbf{o}^k \mathbf{B}_\eta)'.$$

It is clear that \mathbf{A}' is a formula if \mathbf{A} is. We claim (the Normal Form Theorem for $W2$) that, for all \mathbf{A}, $\vdash_{W2} \mathbf{A} \leftrightarrow \mathbf{A}'$. The claim is easily proved by transfinite induction on the rank of \mathbf{A}. Notice that it is for this induction that axioms (5)–(7) are needed.

Let \mathbf{F} be any formula. It is clear that in the normal form \mathbf{F}' of \mathbf{F} every occurrence of \mathbf{o} operates on a formula of type $\mathbf{o}^k \mathbf{p}$. Thus \mathbf{F}' is a substitution

instance of some formula of classical infinitary propositional logic (not containing \mathbf{o}) obtained by substituting formulas of type $\mathbf{o}^k \mathbf{p}$ for propositional letters. The same kind of argument as given in section 2 can now be used to show that if \mathbf{F} is not a theorem of $W2$, then there is some model on \mathfrak{N} in which \mathbf{F} is false at 0. Some care must be taken when the substitution function $*$ is defined, for \mathbf{F} may contain infinitely many—indeed all—propositional letters. But otherwise the situation is analogous. We may therefore leave the details to the reader.

COROLLARY. *An at most countable set of formulas is consistent in W2 if and only if it has a model on* \mathfrak{N}.

It is worth noting that $W2$ has a feature similar to that of $W0$ mentioned at the beginning of section 5: the preceding corollary is false if the words 'at most countable' are deleted. Suppose that $\mathbf{p}_0, \mathbf{p}_1, \ldots, \mathbf{p}_n, \ldots$ are all the propositional letters. Let 2^ω be the set of functions from ω to the set $\{0, 1\}$. We introduce the notation '\mathbf{A}^1' for the formula \mathbf{A} and '\mathbf{A}^0' for the formula $\neg \mathbf{A}$. Consider the following set:

$$\Delta = \{\bigvee_{n<\omega} \mathbf{p}_n^{f(n)} : f \in 2^\omega\}.$$

It is easy to show that every proper subset of Δ has a model (in fact, on every frame), so Δ is $W2$-consistent. Yet, as is easily seen, Δ itself does not have any model, let alone one on \mathfrak{N}. In correspondence Per Lindström has observed that in the present context there are available counterexamples which utilize but a single propositional letter, for example

$$\Delta' = \{\bigvee_{n<\omega} \mathbf{o}^n \mathbf{p}_0^{f(n)} : f \in 2^\omega\}.$$

This ends our formal treatment of $W2$. We append some final remarks.

It is interesting to compare the relationship between \square and \mathbf{o} in $W0$, $W1$, and $W2$. In neither $W0$ nor $W1$ can \square be defined in terms of \mathbf{o} and the classical operators, yet they are closely connected. It follows from our discussion in section 4, although we did not carry out the actual construction, that for every formula \mathbf{A} (in the object language of sections 3–5) there is a certain, effectively defined \square-free formula \mathbf{B} (in the same language) such that $\vdash_{W0} \square \mathbf{A}$ if and only if $\vdash_{W0} \mathbf{B}$. In $W1$ we may be said to be even closer to a definition, since for all formulas \mathbf{A} (in the object language of sections 3–5) the sets $\{\square \mathbf{A}\}$ and $\{\mathbf{A}, \mathbf{o} \mathbf{A}, \ldots, \mathbf{o}^n \mathbf{A}, \ldots\}$ are interdeducible in $W1$, in the sense that every member in either set is deducible in $W1$ from the other set. But only in $W2$ can \square be explicitly defined in terms of \mathbf{o} and the classical (now infinitary) operators. For example, we might introduce as an abbreviatory device the notation

$$\square \mathbf{A} \text{ for } \bigwedge_{n<\omega} \mathbf{o}^n \mathbf{A}.$$

We could also change our object language by introducing \square as a new primitive unary operator and add as a new set of axioms all instances of the schema

$$\mathbf{o}^k\square\mathbf{A} \leftrightarrow \mathbf{o}^k\bigwedge_{n<\omega}\mathbf{o}^n\mathbf{A} \ .$$

Assume that we take the latter course—adding \square as a primitive—and identify the new version of $W2$ with the old one. By the \square,\mathbf{o}-fragment (\square-fragment; \mathbf{o}-fragment) of $W2$ let us understand the set of theorems of $W2$ that can be written in abbreviated form (as explained above) without using infinitary operators (or \mathbf{o}; or \square). Then, by our completeness result for $W2$, the \mathbf{o}-fragment of $W2$ is exactly the Successor Logic S, the \square-fragment exactly the Diodorean Logic D, and the \square,\mathbf{o}-fragment exactly $W0$. Furthermore, an at most countable set of \square,\mathbf{o}-formulas is consistent in $W1$ if and only if it is consistent in $W2$. So if Σ is an at most countable set of \square,\mathbf{o}-formulas and \mathbf{A} is a \square,\mathbf{o}-formula, then $\Sigma\vdash_{W1}\mathbf{A}$ if and only if $\Sigma\vdash_{W2}\mathbf{A}$.

Philosophers will no doubt regard $W2$ as a very artificial system. However, it does permit a definition of 'history' along von Wright's lines that is not hampered by the finiteness of the language he used. For by a history it would be natural to mean, in $W2$, any formula of type

$$\bigwedge_{k<\omega}\bigwedge_{n<\omega}\mathbf{o}^k\mathbf{p}_n^{f_k(n)}$$

where $f_0, f_1, \ldots, f_k, \ldots \in 2^\omega$. Note that if χ is a history in this sense, then there is one and only one model \mathfrak{A} on \mathfrak{N} such that $\mathfrak{A}\models_0\chi$. Thus histories, in this sense, determine models on \mathfrak{N}. Conversely, for every model on \mathfrak{N} there are histories describing it.

DEPARTMENT OF PHILOSOPHY KRISTER SEGERBERG
ÅBO ACADEMY, FINLAND
APRIL 1974

REFERENCES

1. BULL, R. A. 'An Algebraic Study of Diodorean Modal Systems'. *Journal of Symbolic Logic* 30 (1965): 58–64.
2. _____'An Algebraic Study of Tense Logics with Linear Time'. *Journal of Symbolic Logic* 33 (1968): 27–38.
3. _____'Note on a Paper in Tense Logic'. *Journal of Symbolic Logic* 34 (1969): 215–18.
1. CHELLAS, BRIAN F. *The Logical Form of Imperatives*. Diss., Stanford University. (Stanford: Perry Lane Press, 1969).
1. FINE, KIT. 'The Logics Containing S4.3.' *Zeitschrift für mathematische Logik und Grundlagen der Mathematik* 17 (1971): 371–76.

1. LEMMON, E. J. & SCOTT, DANA *Intensional Logic*. Dittographed. Stanford: Department of Mathematics, Stanford University, 1966.
1. MAKINSON, DAVID 'There are Infinitely Many Diodorean Modal Functions', *Journal of Symbolic Logic* 31 (1966): 406–408.
1. PRAWITZ, DAG *Natural Deduction. A Proof-Theoretical Study*. Diss., Stockholm University (Uppsala, 1965).
1. PRIOR, A. N. *Time and Modality* (Oxford: Clarendon Press, 1957).
2. _____ *Past, Present, and Future* (Oxford: Clarendon Press, 1967).
1. SCOTT, DANA & TARSKI, A. 'The Sentential Calculus with Infinitely Long Expressions'. *Colloquium Mathematicae* 6 (1958): 165–170.
1. SCHUMM, G. F. 'On a Modal System of D. C. Makinson and B. Sobociński'. *Notre Dame Journal of Formal Logic* 10 (1969): 263–65.
1. SEGERBERG, KRISTER 'On the Logic of 'To-morrow'. *Theoria* 33 (1967): 45–52.
2. _____ 'Modal Logics with Linear Alternative Relations'. *Theoria* 36 (1970): 301–322.
3. _____ 'Franzén's Proof of Bull's Theorem'. *Ajatus* 35(1973):216–221.
1. THOMASON, S. K. 'Towards a Formalization of Dialectical Logic'. To appear.
1. VON WRIGHT, G. H. ' "And Next" '. *Acta Philosophica Fennica*, fasc. 18 (1965), 275–303.
2. _____ ' "And Then" '. *Commentationes Physico-Mathematicae*. Societas Scientiarum Fennica, vol. 32, no. 7, 1966.
3. _____ 'Quelque remarques sur la logique du temps et les systèmes modales'. *Scientia* 102 (1967–1968): 1–8.
4. _____ ' "Always" '. *Theoria* 34 (1968): 208–221.
5. _____ *Time, Change and Contradiction*. The Twenty-second Arthur Stanley Eddington Memorial Lecture (London: Cambridge University Press, 1969).

NOTE

1. [*Added 1984*] Conversations with Göran Sundholm revealed that the suppressed "proof" of the theorem was incorrect. Fortunately, Sundholm was able to patch it up: see his article "A Completeness Proof for an Infinitary Tense-Logic," *Theoria* 43 (1977): 47–51.

27

Maria Luisa Dalla Chiara

VON WRIGHT ON TIME, CHANGE, AND CONTRADICTION

In 1968, on the occasion of the 22nd Arthur Stanley Eddington Memorial Lectureship at Cambridge University, von Wright read a paper titled 'Time, Change and Contradiction'. This paper proposes a first important approach towards a kind of nonstandard temporal logic, which gives up the hypothesis of 'atoms of time' and admits of certain forms of contradictions. Von Wright's main idea consists of the introduction of a special operator **N**: if α is a sentence, **N**α can be intuitively interpreted as 'α happens during the whole time-interval which is considered'. A characteristic feature of this operator is represented by the fact that, for certain α's, the sentence ¬**N**¬(α∧¬α) may be true. In other words, it might be the case that the noncontradiction principle *does not hold* with respect to the whole time-interval under consideration. As a consequence, 'contradictory regions' of our intervals are admitted, provided only that these contradictions should not last 'too long'. Indeed, at the same time, it is assumed that ¬**N**(α∧¬α) is always true, for any α.

As is well known, the concept of 'time-instant', which is generally adopted by standard temporal logics, is derived from classical mathematical physics. It is essentially founded on the assumption of existence of 'atoms of time', where no *change* is supposed to happen (recall Zeno's arrow). Such a conception can be formally described, in a natural way, by means of a kind of Kripke-semantics, where each Kripke-world M_i is labelled by an instant-index i, and all indices are supposed to be ordered in a temporal order-relation. Each M_i represents a classical model, where both the noncontradiction principle and *tertium non datur* hold (namely, α and ¬α cannot be both true, but α or ¬α must be

Part of this article has been published in Italian in *Rivista di Filosofia,* 64, no. 2 (1973):95–122. I am indebted to Sergio Bernini, Ettore Casari, and Giuliano Toraldo di Francia for some useful suggestions.

true). With respect to this kind of semantics, a *change* can be formally described through convenient transformations of the truth-values of the sentences of our language with respect to the Kripke-worlds M_i's.[1]

Can we reasonably give up the hypothesis of time-atoms, which has proved to be so successful? From the viewpoint of Kripke-semantics, this would mean, for instance, accepting as index for a Kripke-world the time-intervals Δt_i, during which a world $M_{\Delta t_i}$ can undergo some change. As a consequence, a model $M_{\Delta t_i}$ no longer represents a classical model, for it can violate the noncontradiction principle. From an intuitive point of view, the duration of a Δt_i can be, in many cases, regarded as a kind of *temporal threshold;* in none of its subintervals (which are physically distinguishable from the whole Δt_i) can our sentences have well-determined values.

But how can one describe a change within a Δt_i without referring to a division of Δt_i in atoms of time? We could imagine, for instance, that a change from α to $\neg\alpha$ within Δt_i 'occurs in a region' where both α and $\neg\alpha$ happen. In other words, a change can involve a contradiction which must be 'sufficiently brief' and cannot last during the whole Δt_i. We want to show that these intuitive ideas, which seem suggested by a kind of 'dialectical logic,' admit of a rigorous formal description.

The calculus proposed by von Wright for his operator N[2] appears to be a kind of informal calculus, giving rise to a number of different problems. For instance, can such a calculus be an extension of classical logic? What kind of semantics can be associated with it?

From an intuitive point of view, one may distinguish in von Wright's approach three possible assumptions:

a. change is compatible with contradiction;
b. any change involves a contradiction;
c. everything is always changing and causing contradictions.

Clearly, (b) is stronger than (a), and (c) is stronger than (b). In a sense, (a) and (b) correspond to a kind of 'dialectical' position, whereas (c) expresses in addition a Heraclitean claim.

We will try to develop a formal semantics suitable for only the weakest assumption(a). Von Wright's operator N will be interpreted as follows: $N\alpha$ will mean 'α is true in a whole Δt_i'. In order to technically develop this semantical characterization of N, we make use of a *Kripke-continuous semantics,* where the Kripke-worlds are labelled by Δt_i's (we use for the intervals Δt_i the special variables $\tau, \tau_1, \tau_2, \ldots , \tau_n, \ldots$). Our set of truth values is the real interval $[0,1]$. Intuitively, the truth value of α in M_τ *measures the duration* of α in τ: value 1 corresponds to the case where α lasts during the whole τ, value 0 to the case where $\neg\alpha$ lasts during the whole τ. If α assumes an intermediate value, it will turn out that $\neg\alpha$ must also assume a value different from 0 and

from 1; in this case a contradiction will happen 'in a region' of τ, but this region will never coincide with the whole τ.

In order to develop this intuitive approach in a rigorous form, let us first introduce the abstract concept of *system of* Δt_i's.

1. Any partial ordering $\langle \mathbf{T}, < \rangle$ (where $<$ is an irreflexive, asymmetric, and transitive relation on τ) is a *system of* Δt_i's.[3]

On any system of Δt_i's we can define three binary relations, which we call respectively: *contiguous precedence* $(C\tau_1\tau_2)$, *overlapping* $(O\tau_1\tau_2)$, and *inclusion* $(I\tau_1\tau_2)$:

2. $C\tau_1\tau_2 \leftrightarrow \tau_1 < \tau_2 \wedge \neg \exists \tau_3(\tau_1 < \tau_3 \wedge \tau_3 < \tau_2)$
 (τ_1 contiguously precedes τ_2 iff τ_1 precedes τ_2 and there exists no τ_3 which is between τ_1 and τ_2).
3. $O\tau_1\tau_2 \leftrightarrow \neg\tau_1 < \tau_2 \wedge \neg\tau_2 < \tau_1$
 (τ_1 overlaps τ_2 iff neither of them precedes the other).
4. $I\tau_1\tau_2 \leftrightarrow \forall \tau_3(O\tau_3\tau_1 \rightarrow O\tau_3\tau_2)$
 (τ_1 is included in τ_2 iff any τ_3 overlapping τ_1 also overlaps τ_2).
 Clearly, a concrete example of a system of Δt_i's will be represented by the case where \mathbf{T} is a set of intervals of real numbers, and $<, C, O, I$ represent respectively the usual relations of precedence, contiguous precedence, overlapping, and inclusion between intervals.

Let us now define the concept of *W-history (von Wright's history)*. Let $<\mathbf{T}, <>$ be a system of Δt_i's and let L be a formal (first order) language with three temporal operators: von Wright's \mathbf{N}, \mathbf{F} (in the future), and \mathbf{P} (in the past).

5. A system $H = \{M_t\}_{\tau \in \mathbf{T}}$ is called a *W-history* for L iff each $M_\tau = <D_\tau,$ $\psi_\tau>$ (the 'state of the world at τ') satisfies the following conditions:
 (a) D_τ is a nonempty set (the universe at τ). Let $D = \cup\{D_\tau\}_{\tau \in \mathbf{T}}$ and let L' represent an extension of L containing an individual name d for any $\mathbf{d} \in D$.
 (b) ψ_τ realizes the nonlogical constants of L' and associates to each sentence α of L' a truth value in $[0,1]$. If c_i is an individual name of L, $\psi_\tau(c_i)$ is an element of D; $\psi_\tau(d) = \mathbf{d}$. If P_i^n is an n-ary predicate of L, $\psi_\tau(P_i^n)$ is an n-ary *continuous attribute*, i.e., an element of $[0,1]^{D^n}$ such that:

$$I\tau_1\tau_2 \rightarrow \left([\psi_{\tau_1}(P_i^n)](\mathbf{d}_1, \ldots, \mathbf{d}_n) \neq 0 \rightarrow [\psi_{\tau_2}(P_i^n)](\mathbf{d}_1, \ldots, \mathbf{d}_n) \right.$$

$$\left. \neq 0 \right) \wedge \left([\psi_{\tau_2}(P_i^n)](\mathbf{d}_1, \ldots, \mathbf{d}_n) = 1 \rightarrow [\psi_{\tau_1}(P_i^n)](\mathbf{d}_1, \ldots, \mathbf{d}_n) \right.$$

$$\left. = 1 \right)$$

Let α be a sentence of the language L'. The truth-value $\psi_\tau(\alpha)$ is determined as follows:

$$\psi_\tau(P_i^n t_1 \ldots t_n) = [\psi_\tau(P_i^n)](\psi_\tau(t_1), \ldots, \psi_\tau(t_n))$$

where t_1, \ldots, t_n are individual names of L'.

$$\psi_\tau(\neg\alpha) = 1 - \psi_\tau(\alpha)$$
$$\psi_\tau(\alpha \wedge \beta) = \min(\psi_\tau(\alpha), \psi_\tau(\beta))$$
$$\psi_\tau(\alpha \vee \beta) = \max(\psi\tau(\alpha), \psi_\tau(\beta))$$
$$\psi_\tau(\alpha \rightarrow \beta) = 1 \text{ if } \psi_\tau(\alpha) \leq \psi_\tau(\beta);\ 1 - \psi_\tau(\alpha) + \psi_\tau(\beta) \text{ otherwise}$$
$$\psi_\tau(\exists x\alpha) = \sup\{\psi_t(\alpha(d))\}_{d \in D_\tau}$$
$$\psi_\tau(\forall x\alpha) = \inf\{\psi_\tau(\alpha(d))\}_{d \in D_\tau}$$
$$\psi_\tau(N\alpha) = 1 \text{ if } \psi_\tau(\alpha) = 1;\ 0 \text{ otherwise.}$$
$$\psi(P\alpha) = 1 \text{ if } \exists\tau_1(\tau_1 < \tau \text{ and } \psi_\tau(\alpha) = 1);\ 0 \text{ otherwise.}$$
$$\psi_\tau(F\alpha) = 1 \text{ if } \exists\tau_1(\tau < \tau_1 \text{ and } \psi_\tau(\alpha) = 1);\ 0 \text{ otherwise.}$$

Our semantical conditions concerning the connectives and the quantifiers correspond to the conditions stated in the L_{\aleph}-logic of Łukasiewicz (which represents a particular case of a *continuous logic* in Chang's and Keisler's sense[4]). It is worthwhile noticing that our condition concerning the implication-connective appears to be, in this framework, intuitively reasonable only assuming that $\psi_\tau(\alpha)$ 'measures the duration of α in τ' without 'locating' this duration within τ. Indeed $\alpha \rightarrow \beta$ turns out to 'happen' during the whole τ iff α is not longer than β within τ. Now this condition would seem to be quite unreasonable if we could *always* divide a Δt_i into some smaller intervals. But as we already know, this is not the case, for a Δt_i must be regarded as a whole which generally cannot be further analysed.

At this point we can define, in a natural way, two different concepts of truth: an *evanescent* and a *durable* truth.

6. A sentence α is an *evanescent truth at τ in a W-history* $H = \{M_\tau\}_{\tau \in T}$ ($\underset{\tau}{\models}\alpha$)

iff $\psi_\tau(\alpha) \neq 0$.

It is a *durable truth at τ* ($\underset{\tau}{\models}\alpha$) iff $\psi_\tau(\alpha) = 1$.

There results immediately: $\underset{\tau}{\models}\alpha$ iff $\underset{\tau}{\models}N\alpha$. One easily sees that the non-contradiction principle holds only for the concept of durable truth, whereas *tertium non datur* holds only for the concept of evanescent truth. Indeed we have: not [$\underset{\tau}{\models}\alpha$ and $\underset{\tau}{\models}\neg\alpha$] (for $\underset{\tau}{\models}\alpha$ and $\underset{\tau}{\models}\neg\alpha$ would imply $\psi_\tau(\neg\alpha) = 1{-}1 = 1$); but if $\psi_\tau(\alpha) \neq 0,1$ neither $\underset{\tau}{\models}\alpha$ nor $\underset{\tau}{\models}\neg\alpha$. At the same time there holds: $\underset{\tau}{\models}\alpha$ or $\underset{\tau}{\models}\neg\alpha$ (for not $\underset{\tau}{\models}\alpha$ implies $\psi_\tau(\alpha) = 0$ and thus $\psi_\tau(\neg\alpha) = 1$); but if $\psi_\tau(\alpha) \neq 0,1$, we have $\underset{\tau}{\models}\alpha$ and $\underset{\tau}{\models}\neg\alpha$ (hence $\underset{\tau}{\models}\alpha \wedge \neg\alpha$).

7. A sentence α is *true in a W-history* H ($\underset{H}{\models}\alpha$) iff it is a durable truth at any τ of H.

α is called *W-valid* iff it is true in any W-history H.

α is called a *W-consequence* of a set of sentences K iff for any W-history H and any τ of H, α is a durable truth at τ whenever all sentences in K are durable truths at τ.

Clearly not all the classical laws turn out to be W-valid (for instance $\alpha \bigvee \neg\alpha$, $(\alpha \bigwedge \neg\alpha)$, $(\alpha \to (\alpha \to \beta)) \to (\alpha \to \beta)$ are not W-valid).

The following classes of sentences consist of W-valid sentences:

a. All N-*transformations* of classical laws. Where the N-transformation of α is obtained by replacing in α each atomic subformula $P_i^n t_1 \ldots t_n$ with $NP_i^n t_1 \ldots t_n$.

(Intuitively this means that classical logic preserves its validity with respect to any event that 'lasts' a whole Δt_i).

b. All N-transformations of the axioms of minimal temporal calculus.[5]
c. All L_\varkappa-valid sentences.
d. The following sentences which involve the operator **N**:

(8.1) $N\alpha \to \alpha$

(8.2) $N\alpha \to NN\alpha$

(8.3) $N(\alpha \bigwedge \beta) \leftrightarrow N\alpha \bigwedge N\beta$

(8.4) $N(\alpha \bigvee \beta) \leftrightarrow N\alpha \bigvee N\beta$

(8.5) $N\neg\alpha \to \neg N\alpha$

(8.6) $\neg N\neg N\alpha \to N\alpha$

(8.7) $N(\alpha \to \beta) \to (N\alpha \to N\beta)$

(8.8) $(N\alpha \to N\beta) \to N(N\alpha \to N\beta)$

(8.9) $\forall x N\alpha \leftrightarrow N\forall x\alpha$

(8.10) $\exists x N\alpha \leftrightarrow N\exists x\alpha$

(8.11) $NP\alpha \leftrightarrow PN\alpha$

(8.12) $NF\alpha \leftrightarrow FN\alpha$

(8.13) $\neg N(\alpha \bigwedge \neg\alpha)$

Note that (8.3), (8.4), and (8.13) correspond to three axioms of von Wright's calculus (in particular, (8.13) asserts that no contradiction can last 'too long').

The question of axiomatizability of W-logic can be negatively solved. Namely, using a result of Scarpellini[6] (which has stated the non-axiomatizability of L_\varkappa-logic) one easily shows that the set of W-valid sentences cannot be recursively enumerable.

Let us now consider a particular W-history $H = \{M_\tau\}_{\tau \in T}$ and let L be a language for H.

9. A w.f.f. $\alpha(x_1, \ldots, x_n)$ of L is called *classical* with respect to H iff for any $\mathbf{d}_1, \ldots, \mathbf{d}_n \in D$ and any τ, $\psi_\tau(\alpha(d_1, \ldots, d_n)) \in \{0,1\}$.

In other words, for any sentence β which is an instance of a classical formula, either β or the negation of β must be a durable truth.

Among the nonclassical formulas we may distinguish the *mutable* and the *evanescent* formulas:

10. A formula $\alpha(x_1, \ldots, x_n)$ is called *mutable* in H iff for any τ there exists a τ_1 such that $\tau \leq \tau_1$ or $\tau_1 \leq \tau$ and for certain $\mathbf{d}_1, \ldots, \mathbf{d}_n \in D$, $\psi_\tau(\alpha(d_1, \ldots, d_n)) \notin \{0,1\}$.
 A formula $\alpha(x_1, \ldots, x_n)$ is called *evanescent* in H iff for all τ and all $d_1, \ldots, d_n \in D$, $\psi_\tau(\alpha(d_1, \ldots, d_n)) \notin \{0,1\}$.

A predicate P_i^n will be termed *classical, mutable,* or *evanescent* according as the formula $P_i^n x_i \ldots x_n$ is classical, mutable, or evanescent. Clearly, when H is a *linear* history (i.e., $<$ is a linear ordering) the class of all mutable formulas coincides with the class of nonclassical formulas. A sentence which contains only classical predicates turns out to be classical, but the inverse relation does not generally hold.

Let us now consider the three following schemas:

(11.1) $\forall x_1 \ldots x_n(\alpha(x_1, \ldots, x_n) \rightarrow N\alpha(x_1, \ldots, x_n))$
(11.2) $\exists x_1 \ldots x_n M\neg N\neg(\alpha(x_1, \ldots, x_n) \wedge \neg\alpha(\mathbf{x}_1, \ldots, x_n))$[7]
(11.3) $\forall x_1 \ldots x_n \neg N\neg(\alpha(x_1, \ldots, x_n) \wedge \neg\alpha(x_1, \ldots, x_n))$

One readily sees that (11.1) – (11.3) represent necessary and sufficient conditions for α to be respectively classical, mutable, and evanescent in H((11.3) corresponds to a possible axiom discussed by von Wright).

Combinatorially, the following cases are possible:

(a) The class of classical formulas coincides with the class of all formulas of L.
(b) L contains some nonclassical formulas but no mutable or evanescent formula (in this case H is not a linear history).
(c) L contains mutable and/or evanescent formulas.
(d) The class of formulas of L coincides with the class of the nonclassical formulas.

Case (d) can be immediately ruled out, for all W-valid sentences of L must be classical. As a consequence, von Wright's axiom which corresponds to schema (11.3) is not W-valid: from an intuitive point of view this means a refusal of the Heraclitean assumption considered by von Wright. Case (a) corresponds to the case where H behaves as a classical history; cases (b) and (c) correspond to the intuitive assumption according to which change and contradiction are compatible.

Now let T be a theory which admits at least a W-model (i.e., a W-history where all the axioms of T are true). We can define, in a natural way, the concepts of *classical, mutable, evanescent* formula of T as follows:

12. A formula $\alpha(x_1, \ldots, x_n)$ is *classical (mutable, evanescent)* iff (11.1) (respectively (11.2), (11.3)) is a W-consequence of T.

If all formulas of T are classical, we can say that T 'behaves' as a classical theory. The mutable formulas of a theory will describe those properties for which at least sometimes a change involves a contradiction. Finally the evanescent formulas will describe those properties that, roughly speaking, continuously change without ever coming to light. It is not easy to offer a concrete example of an evanescent predicate: however, an interesting possible application seems to be suggested by the properties of *virtual particles* in microphysics.

Actually, our last assertion opens an important problem: has this kind of temporal logic any relevance for a formal description of physical theories? At first sight, not only von Wright's logic, but even standard temporal logic, appears to be very far from the usual physicist's way of thinking. It has often been observed that physics seems to be 'atemporal'. Indeed, temporal logicians use time-parameters (instants as well as intervals) *mainly* (even if not *only*) as indices for models, and on this ground ask the question, 'What does it mean that a sentence is true with respect to a given time-parameter t?' On the contrary, physicists generally do not privilege in such a way time-parameters. Time is only one among other quantities, and the interesting question is, 'What does it mean that a sentence α (t_i) (possibly containing some time-parameters) is true?'

Nevertheless, one can easily recognize that these different 'ways of speaking' can be translated into one another. For instance, an obvious possible 'temporalization' of the language of physics could be described as follows. From an abstract point of view, a physical theory T may be characterized as a set of axioms (with appropriate logic) plus a set of models. A physical model—will generally have the form $<M_0, S, Q_1, \ldots, Q_n>$, where M_0 represents the *mathematical part* of the model (generally it will be the standard model of the mathematical subtheory of T); and the substructure $<S, Q_1, \ldots, Q_n>$ is the *operational part* of M: S is a set of *physical situations* (consisting of physical systems in specified states) and Q_1, \ldots, Q_n are operationally defined quantities. Of course one of these Q_i's (let us suppose for instance Q_1) will correspond to the quantity 'time'. The formal language L_M associated with M will contain, for each quantity Q_i, special variables q_{i_1}, q_{i_2}, \ldots. As a consequence, a sentence of L_M will generally have the form $\alpha(q_{ij})$, where at most a finite sequence of special variables q_{ij} may occur free, and $\alpha(x)$ is constructed by means of the mathematical sublanguage of T. One can define, in a natural

way, the concept of truth of $\alpha(q_{ij})$ in a physical situation s ($\underset{s}{\models}\alpha(q_{ij})$) and in the whole model M ($\underset{M}{\models}\alpha(q_{ij})$).[8] This definition must take into account essentially the precisions that occur in the operational definitions of the quantities Q_i's.

Now, let us assume that, for a given physical situation $s \epsilon S$, $\underset{s}{\models}\alpha(q_{l_k}, q_{ij})$, where q_{l_k} is a time-variable. As a particular case, $\alpha(q_{l_k}, q_{ij})$ could assert, besides other things, that q_{l_j} is equal to a certain time-constant, say t. Clearly one can easily define, in a reasonable way, a concept of truth with respect to time-parameters and obtain

$$\underset{t}{\models} \alpha \text{ iff } \underset{s}{\models}\alpha$$

On this ground, one could even introduce, in the language of T, by means of natural semantic definitions, such temporal operators as **P** and **F**.

However, it is quite doubtful that such a trivial temporalization of the language of a physical theory will turn out to be in any way useful. The reason is that the choice of the quantity time seems to be, in this framework, completely arbitrary: we could do the same thing with any other quantity Q_i. Further, why not choose a pair or even a multiple of quantities and ask the question: 'what does $\underset{<Q_{i_{j_1}}, \ldots, Q_{i_{j_n}}>}{\rule{3cm}{0.4pt}}\alpha$ mean?', where $Q_{i_{j_k}}$ represents a result obtained by measuring the quantity Q_i in a given physical situation. Now a particularly interesting system $<Q_{i_{j_1}}, \ldots, Q_{i_{j_n}}>$ will be represented by the case of a *maximal* system of results. Such a system determines a *state* of a physical system. But the state of a physical system is an example of a 'simple' physical situation. Thus, in a natural way, we are led again to our initial question: 'What does it mean that a sentence is true in a physical situation?'

Even if privileging time appears to be arbitrary, one can see that the 'logic of Δt_i's' has some real connections with physics. For let us interpret τ no longer as a Δt_i, but more generally as a cell of phase-space. We know that these cells are essentially bounded to some precisions ϵ_{Q_i} which for theoretical reasons cannot be reduced to zero (uncertainty principle of quantum mechanics). In this sense the question 'What does $\underset{t}{\models}\alpha$ mean?' appears to be a very realistic one.

As an example, let us consider the following simple case: let s be a physical situation in microphysics which is considered at a 'sufficiently brief' τ. Now we know that, owing to the uncertainty principle, some assertions α concerning the energy in s are undetermined we could consistently imagine that such α's

represent evanescent truths.[9] As a consequence, some properties of virtual particles are susceptible of being logically described as evanescent predicates.

INSTITUTE OF PHILOSOPHY MARIA LUISA DALLA CHIARA
UNIVERSITY OF FLORENCE, ITALY
SEPTEMBER 1975

NOTES

1. Of course, such an assumption of 'atoms of time' turns out to be compatible with different hypotheses on the order-type of the time-relation. Consequently, a change which is intuitively characterized by the 'passage' of a sentence α to its negation $\neg\alpha$ does not necessarily involve a last instant where α is true and/or a first instance where α is false.

2. Von Wright has discussed different possible calculi for his operator **N**. I refer here to the system of axioms A 1, A 2, A 4. See G. H. von Wright, *Time, Change and Contradiction* (Cambridge: Cambridge University Press, 1969), pp. 23–31. I have also found helpful as a general discussion of tense logic N. Cocchiarella, *Tense Logic: A Study of Temporal Reference* (Los Angeles, 1966).

3. For an abstract theory of time-intervals see C. L. Hamblin, 'Starting and Stopping,' *Monist* 53 (1969): 410–425.

4. C. C. Chang and H. J. Keisler, *Continuous Model Theory* (Princeton: Princeton University Press, 1966).

5. For a description of a minimal temporal calculus see for instance M. K. Rennie, 'On Postulates for Temporal Order', *Monist* 53 (1969): 457–468.

6. B. Scarpellini, 'Die Nichtaxiomatisierbarkeit des unendlichwertigen Prädikatenkalküls von Łukasiewicz', *Journal of Symbolic Logic* 27 (1962): 159–170.

7. **M** is the temporal operator 'sometimes': $\mathbf{M}\alpha \underset{df}{=} \alpha\lor\mathbf{P}\alpha\lor\mathbf{F}\alpha$.

8. For a technical development see M. L. Dalla Chiara and G. Toraldo di Francia, 'A Logical Analysis of Physical Theories', *Rivista del Nuovo Cimento,* Series 2 3 (1973): 1–20; 'The Dividing Line between Deterministic and Indeterministic Physics', in *Contributed Papers of the Fifth International Congress of Logic (Methodology and Philosophy of Science* (London, Ontario, 1975).

9. Of course a quantitative evaluation of the truth value of α in τ cannot be carried out by means of physical arguments.

28

Jan Berg

VON WRIGHT ON DEONTIC LOGIC

Deontic logic studies the logic of normative concepts such as obligation, permission, prohibition, rightness, etc. It has long been assumed that there is a certain symmetry between the quantifiers of elementary logic and such concepts of modal logic as possibility and necessity. Modern deontic logic received its greatest impulse with the observation that this symmetry can be applied to normative concepts. This observation was systematically exploited for the first time in von Wright's renowned paper B123.[1]

Since 1951, von Wright's conception of deontic logic has undergone a number of changes. I shall try to isolate four of the main positions emerging out of his thought on these matters, namely: the monadic deontic logic of action-types in B123, the dyadic deontic logic of propositions developed in B215 and B219, the basing of deontic logic on a logic of action as in B263, and finally the attempt in B222 to eliminate deontic concepts within the framework of a modal logic. The first-mentioned theory is probably an instance of a more general system, a so-called Q-System, involving the notion of a Boolean algebra. The first three sections of this essay deal with the connection between the notions of class logic, Boolean algebra, and Q-Systems. Limitations of space prohibit digressions into the logic of preference and into tense logic. Furthermore, von Wright's contributions to the philosophy of law, to the general theory of norms and to the discussion on practical inferences will be passed over here. Only one example of a logic of action bearing on deontic logic will be discussed, in § 6.[2]

1. Class Logic

Von Wright's theory of Q-systems (cf. § 3) seems to involve class logic. The system of class logic described here will be referred to by 'CL'. The basic symbols of CL consist of class variables, class constants, the class-logical constants '∩' (for intersection), '−' (for complement), '=' (for class identity),

and the auxiliary signs '(' and ')'. The set of *terms* of CL is the smallest set K such that (1) if α is a class variable or constant of CL, then α belongs to K; (2) if α and β belong to K, then $(\alpha \cap \beta)$ and $-\alpha$ belong to K. As syntactic variables referring to terms we use 'α', 'β', 'γ', The set of *equations* of CL is the smallest set K such that if α and β are terms of CL, then $(\alpha = \beta)$ belongs to K. When no confusion can occur, an outmost pair of parentheses may be dropped from a term or an equation.

This class-logical language may be added to a calculus of sentential logic, SL, by adding to SL the basic symbols of CL and the rules of terms and equations of CL. This amounts to a *formalization* of CL. The definitions of the notions of *derivability* and *theorem* will then be analogous to those of SL. As logical constants of SL we take the following signs, each with its usual logical interpretation: '\wedge' (conjunction), '\vee' (disjunction), '\rightarrow' (material implication), '\leftrightarrow' (material equivalence), and '\neg' (negation).

As *axioms* of the formalized CL we take all equations and formulas of the following form and only these:

(C1)	$\alpha = \alpha$
(C2)	$\alpha = \beta \rightarrow \beta = \alpha$
(C3)	$\alpha = \beta \rightarrow (\beta = \gamma \rightarrow \alpha = \gamma)$
(C4)	$\alpha = \beta \rightarrow -\alpha = -\beta$
(C5)	$\alpha = \beta \rightarrow \alpha \cap \gamma = \beta \cap \gamma$
(C6)	$\alpha = \beta \rightarrow \gamma \cap \alpha = \gamma \cap \beta$
(C7)	$\alpha \cap \beta = \beta \cap \alpha$
(C8)	$(\alpha \cap \beta) \cap \gamma = \alpha \cap (\beta \cap \gamma)$
(C9)	$\alpha \cap -\beta = \gamma \cap -\gamma \rightarrow \alpha \cap \beta = \alpha$
(C10)	$\alpha \cap \beta = \alpha \rightarrow \alpha \cap -\beta = \gamma \cap -\gamma$
(C11)	$\neg(\alpha \cap -\alpha = -(\alpha \cap -\alpha))$

An *interpretation* of CL is effected by assigning a nonempty domain D of classes to the variables and assigning operations to the logical constants of CL in such a way that (1) the values of $\alpha \cap \beta$ and $-\alpha$ belong to D if the values of α and β belong to D, (2) $\alpha = \beta$ holds if and only if the values of α and β are identical, and (3) the axioms (C1)–(C11) become true.

The set of basic symbols of CL may be enlarged through the introduction per definition of the following signs: '0' (the null class), '1' (the universal class), '\subset' (inclusions), '\cup' (sum), '\ni' (implex), and '$\in\ni$' (bilateral implex).

(C12)	$0 = \alpha \cap -\alpha$
(C13)	$1 = -(\alpha \cap -\alpha)$
(C14)	$\alpha \subset \beta \leftrightarrow \alpha \cap \beta = \alpha$
(C15)	$\alpha \cup \beta = -(-\alpha \cap -\beta)$

(C16) $\alpha \ni \beta = -(\alpha \cap -\beta)$

(C17) $\alpha \in \beta = -(\alpha \cap -\beta) \cap -(\beta \cap -\alpha)$

If the symbol '$=$' is interpreted as an identity relation in the way indicated, then the axiom system (C1)–(C11) is, of course, not independent. For example, (C2) and (C3) then logically imply (C1), and (C5) and (C7) logically imply (C6). (C1)–(C3) state that identity is an equivalence relation. (C4) says that the complement operation is extensional with respect to identity. (C5) and (C6) say that the product operation is extensional with respect to identity. (C7) and (C8) mean that the product operation is commutative and associative, respectively. (C9) and (C10) state sufficient and necessary conditions for inclusion (cf. (C14)). (C11) says that the null class (cf. (C12)) is not identical with the universal class (cf. (C13)), i.e., there are at least two elements in the domain D.

The notions of implex and bilateral implex defined in (C16) and (C17) do not belong to the standard machinery of class logic. They were introduced by Quine.[3] The implex of α into β is the class of all objects which belong to β if they belong to α; it thus embraces all nonmembers of α and all members of β. The bilateral implex of α and β is the class of all objects which are members of α if and only if they are members of β; it thus embraces all common members of α and β and, in addition, all common members of $-\alpha$ and $-\beta$.

The following theorems of CL will be needed in the sequel:

(C18) $1 = \alpha \cup -\alpha$

(C19) $\alpha = 0 \cup \alpha$

(C20) $\alpha = (\alpha \cap \beta) \cup \alpha$

2. Boolean Algebra

Let D be an arbitrary nonempty set. As variables ranging over D we use 'x', 'y', 'z', . . . , and for n-place operations we use 'f_1^n', 'f_2^n', In the sequel 'iff' will stand for 'if and only if'. We call $<D, f_1^n, \ldots , f_{p_n}^n, f_1^{n-1}, \ldots , f_{p_{n-1}}^{n-1}, \ldots , f_1^1, \ldots , f_{p_1}^1>$ an *operative system* iff D is a nonempty set and f_j^i is an i-place operation from D to D.

Now $<D, f^2, f^1>$ is *a Boolean algebra with at least two elements* [*a BA*] *iff* $<D, f^2, f^1>$ is an operative system such that for all x, y, z in D:

(i) if $x = y$, then $f^1(x) = f^1(y)$

(ii) if $x = y$, then $f^2(x,z) = f^2(y,z)$

(iii) $f^2(x,y) = f^2(y,x)$

(iv) $f^2(f^2(x,y),z) = f^2(x,f^2(y,z))$

(v) $f^2(x,y) = x$ iff $f^2(x,f^1(y)) = f^2(z,f^1(z))$

(vi) $f^2(x,f^1(x)) \neq f^1(f^2(x,f^1(x)))$.

Conditions (i)–(ii) imply the extensionality with respect to identity of the operations of 'complement' and 'intersection'. (iii) and (iv) assert the commutativity and associativity of the latter operation. (v) states sufficient and necessary conditions for an 'inclusion' operation. (vi) insures the existence of at least two elements. That $<D,f^2,f^1>$ is closed follows from the fact that it is an operative system. The properties of the identity operation are assumed to be either known in the informal metalanguage or stated in a logical calculus which is to be used in a possible formalization.

Furthermore, $<D,f_1^2,f_2^2,f^1>$ is a BA iff $<D,f_1^2,f^1>$ is a BA and for all x, y in D: $f_2^2(x,y) = f^1(f_1^2(f^1(x),f^1(y)))$. In this BA we have the notion of 'sum'.

$<D,f_1^2,f_2^2,f_3^2,f^1>$ is a BA iff $<D,f_1^2,f_2^2,f^1>$ is a BA and for all x, y in D: $f_3^2(x,y) = f^1(f_1^2(x,f^1(y)))$. In this BA we have in addition the notion of 'implex'.

$<D,f_1^2,f_2^2,f_3^2,f_4^2,f^1>$ is a BA iff $<D,f_1^2,f_2^2,f_3^2,f^1>$ is a BA and for all x, y in D: $f_4^2(x,y) = f_1^2(f_3^2(x,y),f_3^2(y,x))$. In this BA we have, moreover, the notion of 'bilateral implex'.

For example, under the interpretation of the class-logical signs given in § 1, $<\{1,0\}, \cap, ->$ and $<\{1,0\}, \cap, \cup, \ni\!\!-, -\!\!\ni, ->$ are two-element Boolean algebras whereas $<\{1,0\}, -, \cap>$ is not.

An equation $\alpha = \beta$ is *valid* in a Boolean algebra iff $\alpha = \beta$ is true for all values in D of its variables.

3. Q-Systems

Let 'Q' be the name of a property which is applicable to the elements of D. Hence, the meaning of 'Q' is taken to be a monadic operation from D to a truth-value. The set of *terms* may be defined as in the metalanguage of CL (cf. § 1). The logical constants of SL: '\wedge', '\vee', '\rightarrow', '\leftrightarrow', and '\neg', are incorporated with the usual logical interpretations. The set of *monadic Q-formulas* is the smallest set K such that (1) if α is a term, then the expression $Q(\alpha)$ belongs to K; (2) if A and B belong to K, then $(A \wedge B)$, $(A \vee B)$, $(A \rightarrow B)$, $(A \leftrightarrow B)$, and $\neg A$ belong to K.

In B136, the general notion of a monadic Q-system is implicitly introduced. I believe the following definition makes this idea explicit:

$<D, \cap, \cup, \ni\!\!-, -\!\!\ni, -, Q>$ is a *monadic Q-system* iff
(i) $<D, \cap, \cup, \ni\!\!-, -\!\!\ni, ->$ is a two-element Boolean algebra,
(ii) Q is a monadic operation over D,
(iii) for all terms α and β the following laws hold:

 (P1) $Q(\alpha) \vee Q(-\alpha)$
 (P2) $Q(\alpha \cup \beta) \leftrightarrow (Q(\alpha) \vee Q(\beta))$
 (P3) If $\alpha = \beta$ is valid in $<D, \cap, \cup, \ni\!\!-, -\!\!\ni, ->$, then $Q(\alpha) \leftrightarrow Q(\beta)$
 is a theorem.

(iv) for all monadic Q-formulas the laws of SL hold.

In later publications, von Wright also introduces several applications of what may be called 'dyadic Q-systems'. Let Q be a relation between elements of D and propositions. Hence, Q is taken to be a dyadic operation from both D and a set of propositions to a truth-value. The set of *dyadic Q-formulas* is the smallest set K such that (1) if α is a term and C is a formula of SL, then the expression Q(α/C) belongs to K; (2) if A and B belong to K, then (A ∧ B), (A ∨ B), (A → B), (A ↔ B), and ¬A belong to K. Instances of the dyadic form Q(α/C) may be expressed in ordinary language as follows: Q(α) is the case under the condition C.

The set of dyadic Q-systems may be divided into two main groups, namely, strong and weak systems. This distinction plays an important role in von Wright's treatment of certain paradoxes of deontic logic. The following two definitions endeavor to state this distinction explicitly:

<D,∩, ∪, ⊒, ∈∋, −, Q> is a *strong dyadic Q-system* iff
(i) <D, ∩, ∪, ⊒, ∈∋, −> is a two-element Boolean algebra,
(ii) Q is a dyadic operation on elements of D and propositions,
(iii) for all terms α, β, and all formulas C, C_1, C_2 of SL the following laws hold:

(P1′) $Q(\alpha/C) \vee Q(-\alpha/C)^4$
(P2′) $Q(\alpha \cup \beta/C) \rightarrow Q(\alpha/C)$
(P3′) If α = β is valid in <D, ∩, ∪, ⊒, ∈∋, −> and $C_1 \leftrightarrow C_2$ is logically true, then $Q(\alpha/C_1) \leftrightarrow Q(\beta/C_2)$ is a theorem
(iv) for all dyadic Q-formulas the laws of SL hold.

A *weak dyadic Q-system* is similar to a strong dyadic Q-system except that

(P2″) $Q(\alpha/C) \rightarrow Q(\alpha \cup \beta/C)$

holds instead of (P2′). (This notion of weak dyadic Q-system is only tentative; I have not been able to locate any clear position on this issue in von Wright's writings.)

The first distinction between weak and strong Q-concepts appears in B165. Several instances of the two general notions as just defined are investigated in B219, ch. I (cf. § 5 below). A similar distinction is applied to monadic Q-concepts in B222 (cf. § 7 below).

An n-adic Q-formula is *valid in an n-adic Q-system* (n=1,2) iff it is true for all values in the domain of its class variables and for all propositions as values of its propositional variables. An n-adic Q-formula is *valid* iff it is valid in all n-adic Q-systems. The following are some valid monadic Q-formulas:

(T1) Q (1) (From (P1), (P2), (P3), and (C18) of § 1.)

(T2) $Q(\alpha) \to Q(\alpha \cup \beta)$ (From (P2).)

(T3) $Q(0) \to Q(\alpha)$ (From (P3), (T2), and (C19) of § 1.)

(T4) $Q(\alpha \cap \beta) \to Q(\alpha)$ (From (P2), (P3), and (C20) of § 1)

With the following definitions

(D1) $Q'(\alpha) \leftrightarrow \neg Q(-\alpha)$

(D2) $Q''(\alpha) \leftrightarrow \neg Q(\alpha)$

further theorems emerge:

(T5) $Q'(\alpha \cap \beta) \leftrightarrow (Q'(\alpha) \wedge Q'(\beta))$ (From (D1) and (P2).)

(T6) $Q'(\alpha) \to Q'(\alpha \cup \beta)$ (From (D1),(T4), and (C15) of § 1.)

(T7) $Q''(\alpha) \to Q'(\alpha \rightqsupset \beta)$ (From (T6), (P3), and (C16) of § 1.)

(T8) $Q''(\alpha \cup \beta) \leftrightarrow (Q''(\alpha) \wedge Q''(\beta))$ (From (D2) and (P2).)

(T9) $Q''(\alpha) \to Q''(\alpha \cap \beta)$ (From (D2) and (T4).)

The set of valid monadic Q-formulas can be finitely axiomatized, e.g., by (P1)–(P3) and (C1)–(C13) of § 1. In B123, von Wright even develops a decision method for valid monadic Q-formulas[5] which is substantially the same as certain decision methods for the first order logic of one-place predicates.[6] It may be indicated here by means of an example.

Let us check the formula:

$$(Q'(\alpha) \wedge Q'(\alpha \rightqsupset \beta)) \to Q'(\beta).$$

First of all, the constants 'Q''', '\rightqsupset', and '\to' are eliminated by definition (in terms of some of 'Q', '\cap', '\cup', '$-$', '\wedge' , '\vee', and '\neg'):

$$\neg(\neg Q(-\alpha) \wedge \neg Q(\alpha \cap -\beta)) \vee \neg Q(-\beta).$$

Next, the scopes of the Q-operator are expanded to include all variables occurring in the original formula by replacing $-\alpha$ and the last occurrence of $-\beta$ with the coextensive terms $(-\alpha \cap \beta) \cup (-\alpha \cap -\beta)$ and $(\alpha \cap -\beta) \cup (-\alpha \cap -\beta)$ respectively; the postulate (P2) of distribution is then applied:

$$\neg(\neg(Q(-\alpha \cap \beta) \vee Q(-\alpha \cap -\beta)) \wedge \neg Q(\alpha \cap -\beta))$$
$$\vee \neg(Q(\alpha \cap -\beta) \vee Q(-\alpha \cap -\beta)).$$

This is transferred to a normal form by using the laws of SL:

$$(Q(-\alpha \cap \beta) \vee Q(-\alpha \cap -\beta) \vee Q(\alpha \cap -\beta) \vee \neg Q(\alpha \cap -\beta)) \wedge$$
$$(Q(-\alpha \cap \beta) \vee Q(-\alpha \cap -\beta) \vee Q(\alpha \cap -\beta) \vee \neg Q(-\alpha \cap -\beta)).$$

This formula is valid by SL. Two general restrictions on this decision method are that $Q(\alpha \cup -\alpha)$ is valid (by T1) and that $Q(\alpha \cap -\alpha)$ is not valid (otherwise $Q(\alpha)$ would be valid for all α, by (T3)). Von Wright even holds that $Q(\alpha \cap -\alpha)$ is not invalid.

4. Monadic Deontic Logic

Von Wright's first system of deontic logic is the monadic system laid down in B123. Here the domain is a set of *action-types*. Favored examples of action-types in writings on deontic logic are theft, murder, smoking, and mailing of letters. $Q(\alpha)$ means that the action-type referred to by the substituend of 'α' is permitted. For 'permitted' von Wright uses 'P'. What it means to say that an action-type is permitted is not further analyzed. $Q'(\alpha)$ and $Q''(\alpha)$ mean respectively that the action-type referred to by the substituend of 'α' is obligatory or forbidden. For 'obligatory' von Wright uses the letter 'O'. In place of '\cap', '\cup', '\Rightarrow', '$\in\!\ni$', and '$-$' he uses the same logical constants as in his implicitly presupposed version of SL, namely '&', 'v', '\rightarrow', '\leftrightarrow', and '\sim'.

Under this interpretation of $Q(\alpha)$, $Q'(\alpha)$, and $Q''(\alpha)$, theorem (T6) of § 3 expresses the so-called Ross Paradox; the counterpart of (T7) has been labelled the 'Paradox of Commitment'; and (T9) turns into a version of the Paradox of the Good Samaritan.

In B219, p. 16, doubts are expressed as to whether it is legitimate to form compound names of action-types. I hope that my exposition in §§ 1–3 may remove any such doubts. Von Wright sees another difficulty in the above application of monadic Q-systems in the fact that the operator Q and its derivatives Q' and Q'' are not iterative. For example, $Q(\alpha)$ is a Q-formula, not a term, and hence $Q(Q(\alpha))$ is not a Q-formula. There are more fundamental difficulties, however, with von Wright's system as applied to action-types.

An action-type may be considered as a set of (past or future, simple or complex) single *action-instances*. The permissibility of an action-type must have some logical connection with the permissibility of the corresponding instances. That the action-type a is permitted might mean that at least one instance i of a is permitted.[7] If we express the permissibility of an instance i by '$\pi(i)$' and introduce 'ϵ' for class-membership, the suggested definition can then be formalized in elementary logic:

$$P(\alpha) \leftrightarrow \bigvee i(i \in \alpha \wedge \pi(i)).$$

But then the counterpart of postulate (P2) for a monadic Q-system (cf. § 3) turns into a theorem of elementary logic. Furthermore, if we make the reasonable supposition that there is at least one permitted action-instance $\bigvee i(i \in 1 \wedge \pi(i))$, then the counterpart of (P1) follows by elementary logic. Finally, (P3) turns into a trivially valid rule of inference. In other words, (P1)–(P3) hold for all interpretations of 'π' (with the usual definition of the class-logical equation $\alpha = \beta$). Hence, the deontic notions for action-types evade any interesting characterization under this approach.

A better interpretation of $P(\alpha)$, then, would seem to allow that every instance of the substituend of 'α' be permitted:[8]

$$P(\alpha) \leftrightarrow \bigwedge i(i \in \alpha \rightarrow \pi(i)).$$

However, the counterpart of (T1) of § 3, $\bigwedge i(i \in 1 \to \pi(i))$, now tells us that everything is permitted. Hence this approach does not amount to a fruitful characterization of deontic concepts for action-types either.

In later publications (cf. B198, B215, B219, B222) von Wright turned to another deontic application of the monadic Q-systems. Here the domain D is a set of propositions. The terms turn into formulas of SL. As syntactic variables referring to formulas of SL we use 'A', 'B', 'C', Q(A) [Q'(A)] now means that it is permitted [obligatory] that p, where 'A' stands for an expression of the proposition that p. The symbols '∩', ∪, '⇒', '⇔', and ' − ', are then interpreted in the same way as the logical constants '∧', '∨', '→', '↔' and '¬' of SL. Finally, '1' and '0' denote the truth-values true and false, respectively. The valid Boolean equations turn into logically true equivalences.

Under this interpretation of $Q(\alpha)$ and $Q'(\alpha)$, (T6) of § 3 turns into the following version of Ross's Paradox (with 'O' for 'obligatory'):

(i) $\qquad\qquad\qquad O(A) \to O(A \lor B).$

In B219, p. 21, it is maintained that this becomes especially problematic in combination with the intuitively reasonable principle:

(ii) $\qquad\qquad\qquad P(A \lor B) \to (P(A) \land P(B)),$

where 'P' means permitted. For (i) and (ii) imply by (P1), (P3), and (D1) of § 3 that

(iii) $\qquad\qquad\qquad O(A) \to P(B),$

i.e., if something is obligatory, then anything is permitted. The root of the trouble does not seem to lie in (i), however. The main clash obtains rather between (P2) and (ii), from which (iii) follows by (P1), (P3), and (D1). Fortunately, though, (ii) is not a theorem of the system in question. This can be seen by reducing (ii) to a normal form, which in turn reduces to:

(iv) $(\neg P(\neg A \land B) \lor P(A \land B) \lor P(A \land \neg B)) \land$
$\qquad\qquad\qquad (\neg P(A \land \neg B) \lor P(A \land B) \lor P(\neg A \land B)),$

which is not valid by SL.

5. Dyadic Deontic Logic

The impossibility of combining the intuitively desirable principle (ii) of § 4 with Ross's formula (i) and the difficulty of formalizing the notion of commitment showing up in the Paradox of Commitment (cf. § 4 and (T7) of § 3) led von Wright to the investigation of applied dyadic Q-systems in B151, B198, B203, B215, and B219. The most thorough treatment of these systems is in B219, which will serve as the basic source in this section.

Von Wright developed his dyadic deontic logics mainly for sets of prop-

ositions and not for sets of action-types. Hence, the domain D is a set of propositions. The terms (cf. § 3) are formulas of SL, to which we refer by the syntactic variables 'A', 'B', 'C', The dyadic Q-formula Q(A/B) [Q'(A/B)] now means that p is permitted [obligatory] under the condition that q, where 'A' and 'B' stand for expressions of the propositions that p and that q, respectively. For 'permitted' and 'obligatory' von Wright uses 'P' and 'O'. The Boolean symbols '∩', '∪', '⊐', '∈∋', ' − ', '1', and '0' are given the same logical interpretations as the corresponding symbols of SL. The valid Boolean equations turn into logically true equivalences.

If we imagine that every member of a finite set K of propositional variables expresses exactly one 'elementary fact' of the world, then a 'total state' of the world with respect to K could be expressed by a so-called state description consisting of a conjunction of all members of K, with or without negation sign. State descriptions will be referred to by the syntactic variables 'S', 'S_1', A state description S is a formula of SL and hence all expressions of the form $P(S_1/S_2)$ are formulas of the dyadic deontic systems. An expression of this particular form is translated into ordinary language according to the following pattern: With respect to the possible total state (or possible world) described by S_2, the possible total state described by S_1 is a permitted alternative to S_2.

By manipulating in the metalanguage various combinations of quantifiers of elementary logic, new dyadic secondary concepts of permission can be defined in terms of P(A/B) and schemes of state descriptions. If we let T(A,S) mean that A is true in the state description S and $\vdash P(S_2/S_1)$ mean that $P(S_2/S_1)$ is a theorem, six plausible schemes of definition, corresponding to the six informal definitions of B219, p. 24, emerge:

$P_1(A/B)$ is true iff there is an S_1 and there is an S_2 such that :

$$T(B,S_1) \wedge T(A,S_2) \wedge \vdash P(S_2/S_1);$$

$P_2(A/B)$ is true iff for every S_1 there is an S_2 such that:

$$T(B,S_1) \rightarrow (T(A,S_2) \wedge \vdash P(S_2/S_1));$$

$P_3(A/B)$ is true iff there is an S_2 such that for every S_1:

$$T(A,S_2) \wedge (T(B,S_1) \rightarrow \vdash P(S_2/S_1));$$

$P_4(A/B)$ is true iff for every S_2 there is an S_1 such that:

$$T(A,S_2) \rightarrow (T(B,S_1) \wedge \vdash P(S_2/S_1));$$

$P_5(A/B)$ is true iff there is an S_1 such that for every S_2:

$$T(B,S_1) \wedge (T(A,S_2) \rightarrow \vdash P(S_2/S_1));$$

$P_6(A/B)$ is true iff there for every S_1 and every S_2:

$$T(B,S_1) \rightarrow (T(A,S_2) \rightarrow \vdash P(S_2/S_1)).$$

After a complete formalization of the definientia in the metalanguage, corresponding dyadic secondary concepts of obligation can be deduced in elementary logic according to the scheme of definition:

$$O_i(A/B) \leftrightarrow \neg P_i(\neg A/B) \ (i = 1, \ldots , 6).$$

Between the dyadic secondary concepts P_1, \ldots , P_6 the following logical relations hold:

$$
\begin{array}{ccc}
 & P_5 \Rightarrow P_4 & \\
\nearrow & & \searrow \\
P_6 & & P_1 \\
\searrow & & \nearrow \\
 & P_3 \Rightarrow P_2 &
\end{array}
$$

where '\Rightarrow' symbolizes logical consequence. For the corresponding secondary concepts of obligation the converse order holds. If a tautology is substituted for 'B' in the definition schemes for P_1 through P_6, corresponding monadic secondary concepts of permission result.

Thus, the dyadic secondary permission concepts and the corresponding monadic concepts are defined by means of a primary, unanalyzed dyadic concept of permission applied to pairs of state descriptions. The question which inevitably arises is how statements of the form $P(S_2/S_1)$ are to be analyzed. The remarks on this issue in B219, p. 24, are indeed evasive. The only thorough characterization of primary dyadic deontic concepts in von Wright's writings is in B198. If 'P' is taken as a primitive, then the deontic postulate schemes of this system are essentially as follows:

(1) $P(A/B) \lor P(\neg A/B)$;
(2) $P(A \lor B/C) \leftrightarrow (P(A/C) \lor P(B/C))$;
(3) $P(A/B \lor C) \leftrightarrow (PA/B) \lor P(A/C))$;
(4) If $A \leftrightarrow B$ and $C_1 \leftrightarrow C_2$ are tautologies, then $P(A/C_1) \leftrightarrow P(B/C_2)$ is a theorem.

According to the terminology introduced in § 3, this is an example of a weak dyadic Q-system. However, one of these postulates, namely (3), is suspect.[9]

It is now possible to construct new systems of deontic logic on the basis of the six dyadic pairs $\langle P_i, O_i \rangle$. An axiomatic construction of all these systems was never carried through by von Wright, at least not explicitly; therefore parts of the exposition in his main work on deontic logic, B219, are left hanging in the air. For example, the following equivalences where 't' stands for a tautology:

$$P_2(t/t) \leftrightarrow P_2(p \lor \neg p/q \lor \neg q)$$
$$\leftrightarrow (((P_2(p/q) \lor P_2(\neg p/q)) \land (P_2(p/\neg q) \lor P_2(\neg p/\neg q))),$$

are not justifiable solely on the basis of the scheme of definition for $P_2(A/B)$. Probably an axiom such as A2DP$_2$ of B215:

$$P_2(p \lor q \, / \, r \lor s) \leftrightarrow ((P_2(p/r) \lor P_2(q/r)) \land (P_2(p/s) \lor P_2(q/s)))$$

was conceived of in this connection.[10] But this axiom is known to be false.[11]

The systems of P_4, P_5, and P_6 are strong dyadic Q-systems in the sense of § 3. This implies that the dyadic formula:

$$P_i(A \lor B \, / \, C) \rightarrow (P_i(A/C) \land P_i(B/C))$$

holds for $i = 4,5,6$. On the other hand, the following equivalent of the critical formula (i) of § 4 does *not* hold for $i = 4,5,6$:

$$P_i(A \land B \, / \, C) \rightarrow (P_i(A/C).$$

Hence, in the systems $<P_i, O_i>$ ($i = 4,5,6$) the difficulties in connection with Ross's Paradox are overcome.

An alarming consequence of the definitions of $P_i(A/B)$ ($i = 4,5,6$) is, however, that sentences of the form

$$P_i(A/C) \rightarrow P_i (A \land B/C)$$

are valid in the corresponding systems. If C represents a tautology, this formula reduces to

$$P_i(A) \rightarrow P_i(A \land B),$$

which holds in the corresponding monadic systems. (That these monadic systems deal with "weak" permission concepts, as stated in B219, p. 33, must be a misprint.) But this is really counterintuitive for any concept of permission: if something is permitted, then anything is permitted in combination with it; if I am permitted to drive a car, then I am permitted to drive and to be drunk. The remark (B219, p. 33) that the formula $P_i(A \land B) \rightarrow P_i(A)$ is not valid for $i = 4,5,6$ does not seem to be much of a comfort here.

The systems P_1, P_2, and P_3 are weak dyadic Q-systems. The following converse of a consequence of postulate (P2″):

$$Q(\alpha \cup \beta \, / \, C) \rightarrow (Q(\alpha/C) \lor Q(\beta/C))$$

holds for P_1 and P_3 but not for P_2. The latter can be proved by a simple counterexample. Let there be only four possible worlds described by the state descriptions s_1, s_2, s_3, and s_4 such that exactly $P(s_2/s_1)$ and $P(s_4/s_3)$ are provable, and such that the following truth-value assignments hold (with '1' for 'true' and '0' for 'false'):

	A	B	C
s_1	0	0	1
s_2	0	1	0
s_3	0	0	1
s_4	1	0	0

Thus, $P_2(A \lor B \,/\, C)$ is assigned the value 1 whereas $P_2(A/C)$ and $P_2(B/C)$ take the value 0.

The dyadic systems $<P_i, O_i>$ form a subset of the set of systems $<P_i, O_j>$ $(i,j = 1, \ldots, 6)$. If $i \neq j$ holds, we get systems with two dyadic primitives and double sets of axioms. Such systems are utilized in chapter IV of B219 to investigate the meta-juristic problem of loopholes in the law. Von Wright conjectures that the system $<P_2, O_1>$ would correspond most closely to our intuition about normative concepts. The intuitive concept of obligation would then correspond to the strongest dyadic O-concept whereas the intuitive concept of permission would correspond to a rather weak dyadic P-concept. However, according to the discussion in B219, chapters I–II, the property of obligation expressed in $O(A) \to O(A \lor B)$, which holds for O_1, is intuitively undesirable and the property of permission expressed in $P(A \lor B) \to (P(A) \land P(B))$, which does not hold for P_2, is intuitively desirable, making the selection of P_2 and O_1 difficult to understand in this connection.

6. Logic of Action and Deontic Logic

In B263, available to me as a copy of a manuscript from December 1972, von Wright returns to his first conception of deontic logic as a theory of operations on action-types. But now he explicitly uses a so-called logic of action as a basis instead of implicitly employing a Boolean algebra. I shall try to reconstruct (in my own notation) this notion of a logic of action.

The basic symbols of a logic of action consist of variables ranging over a set of agents, constants denoting agents, variables and constants for action-types, and the action-logical constants '\cap' and '$-$'. As syntactic variables we use 'x', 'y', . . . for agent variables and constants, and 'α', 'β', . . . for action-type variables and constants.

The set of A-*terms* is the smallest set K such that (1) if α is an action-type variable or constant, then α belongs to K; (2) if α and β belong to K, then $(\alpha \cap \beta)$ and $-\alpha$ belong to K. The set of A-*formulas* is the smallest set K such that (1) if α and β are A-terms and x is an agent symbol, then $(\alpha = \beta)$ and $(\alpha)x$ belong to K; (2) if A and B belong to K, then $(A \land B)$, $(A \lor B)$, $(A \to B)$, $(A \leftrightarrow B)$, and $\neg A$ belong to K.

A-formulas of the form $(\alpha)x$ mean that the person denoted by the substituend of 'x' performs a particular action of the type referred to by the substituend of 'α'. Two action-types may be identical:

$$\alpha = \beta \text{ iff } (\alpha)x \leftrightarrow (\beta)x \text{ for all } x.$$

The instances of the form $(\alpha)x$ must be conceived of as involving a time reference in x. Otherwise $(\alpha)x$ would not be a sentence form but would represent rather a class expression (viz., a specification of a general action-type of doing

a, say, to the less general action-type of a particular person's doing *a*, which in turn can have particular instances). Hence, the agent variables properly speaking range over a set of (small, four-dimensional) intervals in the lives of the various agents.

When we let '∩' and '−' denote an intersection and a complement operation over D_1, respectively, $<D_1,D_2, ∩, −>$ is a *logic of action* iff

(i) D_1 is a set of action-types closed under ∩ and − and D_2 is a set of persons at particular moments of time

(ii) for all A-terms α and β the following axioms hold:

(A1) $(−α)x → ¬(α)x$

(A2) $(−−α)x → (α)x$

(A3) $(α ∩ β)x ↔ ((α)x ∧ (β)x)$

(A4) $(−(−α ∩ −β))x ↔ ((α ∩ β)x ∨ (α ∩ −β)x ∨ (−α ∩ β)x)$

(iii) for all A-formulas the laws of SL hold.

Furthermore, $<D_1,D_2, ∩, ∪, −>$ is a *logic of action* iff $<D_1,D_2, ∩, −>$ is a logic of action and it holds for all *x* that: $(α ∪ β)x ↔ (−(−α ∩ −β))x$. And $<D1,D_2, ∩, ∪, ⊐, −>$ is a *logic of action* iff $<D_1,D_2, ∩, ∪, −>$ is a logic of action and it holds for all *x* that: $(α ⊐ β)x ↔ (−α ∪ β)x$. The notions here symbolized by '∪' and '⊐' are introduced in B263, p. 39.

An A-formula is *valid in a logic of action* iff it is true for all values in the respective domains of its variables.

A monadic deontic logic can now be constructed on the basis of a logic of action. First we define the set of *deontic formulas* as the smallest set K such that (1) if α is an A-term, then the expressions P(α) and O(α) belong to K; (2) if A and B belong to K, then (A ∧ B), (A ∨ B), (A → B), (A ↔ B), and ¬A belong to K. Under the intended interpretation, 'P' stands for 'permitted' and 'O' for 'obligatory'.

Von Wright uses essentially the following type of deontic logic: $<D_1,D_2, ∩, ∪, −, P, O>$ is a *deontic logic* iff

(i) $<D_1,D_2, ∩, ∪, −>$ is a logic of action

(ii) P and O are operations over D_1

(iii) for all A-terms α and β the following laws hold:

(B1) $O(α) → ¬O(−α)$

(B2) $P(α) → ¬O(−α)$

(B3) $O(α ∩ β) ↔ (O(α) ∧ O(β))$

(B4) $P(α ∪ β) ↔ (P(α ∩ β) ∧ P(α ∩ −β) ∧ P(−α ∩ β))$

(B5) $(P(α ∩ β) ∧ P(α ∩ −β)) → P(α)$

(B6) if α = β is valid in $<D_1,D_2, ∩, ∪, −>$, then P(α) ↔ P(β) and O(α) ↔ O(β) are theorems of $<D_1,D_2, ∩, ∪, −, P, O>$,

(iv) for all deontic formulas the laws of SL hold.

In the deontic logic of B263, 'P' and 'O' are taken as deontic primitives which are not interdefinable. That this is a sound policy can be seen if we apply the two possible explications (cf. § 4) of the concept of permission for action-types (P) by means of permission of action-instances (π):

(1a) $P(\alpha) \leftrightarrow \bigvee i(i \in \alpha \wedge \pi(i))$,

(1b) $P(\alpha) \leftrightarrow \bigwedge i(i \in \alpha \rightarrow \pi(i))$,

Under both interpretations, definitions of the form $O(\alpha) \leftrightarrow \neg P(-\alpha)$ amount to intuitively questionable explanations of the concept of obligation for action-types, namely $\bigwedge i(i \in -\alpha \rightarrow \neg\pi(i))$ and $\bigvee i(i \in -\alpha \wedge \neg\pi(i))$, respectively. On the other hand, if 'O' is taken as a primitive in addition to 'P' and if we let '$\omega(i)$' express that the single action i is obligatory, then the concept of obligation for action-types may be understood in terms of obligation for action-instances in either one of the following two ways:

(2a) $O(\alpha) \leftrightarrow \bigvee i(i \in \alpha \wedge \omega(i))$,

(2b) $O(\alpha) \leftrightarrow \bigwedge i(i \in \alpha \rightarrow \omega(i))$.

We can now check the axioms for the present kind of deontic logics in the light of the interpretations (1a), (1b), (2a), and (2b). Under (2a), (B1) is doubtful and (B3) may be meaningful. Under (2b), though, (B1) and (B3) do not seem to be unreasonable extra-logical assumptions. Furthermore, under (1a), (B4) seems questionable and difficult to combine with (A4), while (B5) is logically true. On the other hand, under (1b), (B4) and (B5) are both logically true. Hence, it might seem possible to grasp the meaning of von Wright's axioms under the interpretations (1b) and (2b). The hitch is, however, that if we assume that each single action-instance i corresponds to an appropriate interval x_i in the life of an agent x, and if we identify the proposition that $i \in a$ with the proposition that $(a)x_i$, then by (A3),

$$P(\alpha) \rightarrow P(\alpha \cap \beta)$$

is provable under (1b); i.e., if some kind of action is permitted, then any kind of action is permitted in combination with it. Hence, it seems doubtful after all whether von Wright here succeeds in grasping our intuitive conception of deontic notions.

Von Wright's dilemma is the following: if we want to keep the present, very broad notion of action-type, then the system B of deontic-logical axioms must be changed; but if we try to neutralize the consequence $P(\alpha) \rightarrow P(\alpha \cap \beta)$ by restricting the notion of action-type to those sets which satisfy this law, then the application of deontic logic to ordinary ethical discourse is obstructed, since only very few kinds of action would be permitted under such circumstances.

7. Elimination of Deontic Notions in a Modal Logic

An interesting attempt to combine a concept of strong permission with a concept of obligation for which the Ross formula holds is to be found in B222. That paper develops ideas put forth by Alan Ross Anderson and Stig Kanger.[12] The domain is a set of propositions. We use N(A) [M(A)] to state that the proposition expressed by the substituend of 'A' is logically necessary [logically possible]. M(A) is defined in terms of N(A) as follows:

$$M(A) \leftrightarrow \neg N(\neg A).$$

Two theorems needed are:

$$N(A \wedge B) \leftrightarrow (N(A) \wedge N(B)),$$
$$M(A \vee B) \leftrightarrow (M(A) \vee M(B)).$$

To the modal primitive 'N', von Wright adds the extra-logical propositional constant 'I', which in some cases might be conceived of as stating how some morally perfect world would be.

Monadic obligation is now introduced by definition in terms of non-deontic concepts:

$$O(A) \leftrightarrow N(I \rightarrow A).$$

Ross's 'paradoxical' formula then follows:

$$O(A) \rightarrow O(A \vee B).$$

A concept of monadic permission is defined as follows:

$$P(A) \leftrightarrow \neg N(A \rightarrow \neg I),$$

which amounts to

$$P(A) \leftrightarrow \neg O(\neg A),$$

or, equivalently

$$P(A) \leftrightarrow M(A \wedge I).$$

Now, if the operation symbol 'Q' of § 3 is interpreted as P, the postulate (P1) in the definition of a Q-system reduces to:

$$\neg N(\neg I).$$

If this were not taken as an axiom, O(A) would hold for all A.[13] Furthermore, postulate (P2) takes the form:

$$P(A \vee B) \leftrightarrow (P(A) \vee P(B)),$$

which is provable in the presupposed modal logic. Hence, P is a concept of weak permission.

Von Wright introduces the desired concept of strong permission (to be symbolized here by 'P$_*$') in another definition:

$$P_*(A) \leftrightarrow N(A \to I),$$

from which it follows that

$$P_*(A \lor B) \leftrightarrow (P_*(A) \land P_*(B)).$$

The Ross formula will not cause trouble here, however, since $O(A) \to P_*(B)$ is not a theorem. On the other hand,

$$\neg N(I)$$

must be added as an axiom, for otherwise $P_*(A)$ would hold for all A. But even then nothing prevents one from adjoining any new formula B to the premiss A, obtaining once again the troublemaker:

$$P_*(A) \to P_*(A \land B).^{14}$$

Dyadic obligation is reduced, in turn, to modal concepts and monadic obligation as follows (B222, p. 169):

$$O(A/B) \leftrightarrow (N(B \to O(A)) \land \neg N(B \to A)).$$

Strong dyadic permission can be introduced by the dual scheme:

$$P_*(A/B) \leftrightarrow (M(B \land A) \to M(B \land P_*(A)),$$

which is, however, afflicted with the same paradoxical property as the corresponding monadic concept.

In a modal logic, a definiendum and its corresponding definiens should be interchangeable within modally quantified contexts. Hence, the following must be provable in von Wright's modal logic:

$$N(O(A) \leftrightarrow N(I \to A)).$$

But this implies:

$$N(N(I \to I) \to O(I)),$$

and therefore:

$$N(O(I)).$$

However, the fact that the circumstances described by 'I' are obligatory is most likely to be regarded as synthetic. For example, the fact that anything which is actually obligatory in a given society happens to be obligatory is most likely an extra-logical truth.

This is, as I see it, the main difficulty in von Wright's present approach. The root of the trouble would seem to lie in the implication:

$$N(N(I \rightarrow A) \rightarrow O(A)).$$

Here the antecedent does not contain deontic notions, and lacking a semantical interpretation of the logical system it is difficult to see how it could then follow logically that a certain thing is obligatory. Introducing a new type of 'relevant' implication different from the one expressed by $(A \rightarrow B)$ or $N(A \rightarrow B)$ and defining obligation in terms of this 'relevant' implication[15] would not be of immediate help in getting around 'N(O(I))' as a theorem. The possibility of achieving this will depend, rather, on the conception of the relation between a definiendum and the corresponding definiens in the modal theory used as a basis for the elimination of deontic notions. Thus, a successful completion of von Wright's program will have to deal with a basic problem in the theory of definition.

DEPARTMENT OF PHILOSOPHY JAN BERG
MUNICH INSTITUTE OF TECHNOLOGY
OCTOBER 1973; REVISED MAY 1977

NOTES

1. Reference numbers refer to von Wright's Bibliography.

2. In writing this essay I am in part indebted to discussions in seminars of Stig Kanger at the University of Stockholm in the mid-1950s. Furthermore, I have profited from criticisms of an earlier draft by Dr. Reinhard Kleinknecht.

3. W. V. Quine, *A System of Logistic* (Cambridge, Mass., 1934).

4. In some publications, von Wright expanded (P1′) essentially to: $Q(\alpha/C) \lor Q(-\alpha/C) \lor Q(\alpha/\neg C) \lor Q(-\alpha/\neg C)$.

5. Cf. also D. Meredith, 'A Correction to von Wright's Decision Procedure for the Deontic System P', *Mind* 65 (1956): 548–550.

6. Cf. B92, B104, and W. V. Quine, *Methods of Logic,* 2nd ed. (New York 1959), 116.

7. This is taken for granted in S. Kanger: 'New Foundations for Ethical Theory', R. Hilpinen *Deontic Logic: Introductory and Systematic Readings,* (Dordrecht 1971), 39.

8. A somewhat similar application of existential and universal quantification forms the basis of the main argument in J. Hintikka, *Quantifiers in Deontic Logic,* Societas Scientiarum Fennica, Commentationes Humanarum Litterarum 23: 4 (Helsinki 1957).

9. Cf. B. Hanson, 'An Analysis of Some Deontic Logics', *Noûs* 3 (1969): 373–398, section 12. Von Wright's first system of dyadic deontic logic, outlined in B151, is also a system of weak permission. For from the axioms $P(A/C) \lor P(\neg A/C)$ and $P(A \land B /C) \leftrightarrow (P(A/C) \land P(B/A \land C))$ of this system and an additional principle of extensionality $P(A \lor B/C) \leftrightarrow (P(A/C \lor P(B/C))$ follows.

10. Cf. B219, 35.

11. Cf. W. H. Hanson, review of B215, *Journal of Symbolic Logic* 35 (1970): 462–63.

12. Cf. A. R. Anderson, *The Formal Analysis of Normative Systems* (New Haven 1956), and: 'A Reduction of Deontic Logic to Alethic Modal Logic', *Mind* 67 (1958): 100–03; S. Kanger: *op. cit.* (mimeographed version published in 1957).

13. Von Wright also adds the restriction $M(\neg A)$. I have disregarded this complication, as it does not affect my argument.

14. If von Wright's restriction $M(A)$ is appended to the definiens of $P_*(A)$, we have to add that B be compatible with A.

15. As done in A. R. Anderson, 'Some Nasty Problems in the Formal Logic of Ethics', *Noûs* 1 (1967): 345–360.

REFERENCES TO VON WRIGHT'S WORKS

B92 *On the Idea of Logical Truth (I)*, Societas Scientiarum Fennica, Commentationes Physico-Mathematicae 14:4 (Helsinki 1948).

B104 *Form and Content in Logic* (Cambridge 1949).

B123 'Deontic Logic', *Mind* 60 (1951), 1–15.

B136 'On the Logic of Some Axiological and Epistemological Concepts', *Ajatus* 17 (1952) 213–234,

B151 'A Note on Deontic Logic and Derived Obligation', *Mind* 65 (1956), 507–09.

B165 '*On the Logic of Negation*, Societas Scientiarum Fennica, Commentationes Physico-Mathematicae 22:4 (Helsinki 1959).

B198 'A New system of Deontic Logic', *Danish Yearbook of Philosophy* 1 (1964), 173–182.

B203 'A Correction to a New System of Deontic Logic', *Danish Yearbook of Philosophy* 2 (1965), 103–07.

B215 'Deontic Logics', *American Philosophical Quarterly* 4 (1967), 136–143.

B219 '*An Essay in Deontic Logic and the General Theory of Action* (Amsterdam 1968).

B222 '*Deontic Logic and the Theory of Conditions'*, *Critica* 2 (1968), 3–25.

B263 'Deontic Logic Revisited', *Rechtstheorie* 4 (1973):37–46. Read in manuscript before its publication.

29

Carlos E. Alchourrón and *Eugenio Bulygin*

VON WRIGHT ON DEONTIC LOGIC AND THE PHILOSOPHY OF LAW

> There are a good many facts in favour of the view that nothing can be part of the law of any community, unless it has either itself been willed by some person or persons, having the necessary authority over that community or can be deduced from something which has been so willed.
>
> <div align="right">G. E. MOORE</div>

It is difficult to exaggerate the importance of von Wright's work for the philosophy of law, though there are only scattered references to specifically legal problems in his writings. In spite of the fact that he is not a professional jurist nor a legal philosopher *stricto sensu,* he has already exercised considerable influence on contemporary juristic thinking. This fact is hardly surprising, given his constant interest in such notions as norm, action, and value, which lie at the bottom of nearly all problems of legal philosophy. It may reasonably be expected that this influence will increase strongly in the near future. For, though the relevance of deontic logic or the theory of action for the philosophy of law is fairly obvious, the application of von Wright's analyses to specifically legal problems often involves considerable difficulties. The highly general character of his writings, and the use of logical symbolism, make it difficult for many jurists to grasp their full importance and their possibilities for application to legal issues. Partly the difficulty lies in the fact that many of the concepts introduced by von Wright in the course of his analyses are not entirely adequate for the corresponding legal notions.

Accordingly, this essay pursues two aims: 1. to show the relevance and fruitfulness of von Wright's work for legal philosophy, and 2. to illustrate what sort of transformation or adaptation is needed in order to make his elucidations more suitable for legal discourse. We shall concentrate exclusively on problems of the theory of norms and deontic logic; no reference will be made to the general theory of action or axiology, though their importance for the philosophy of law is obvious enough.

In what follows we shall, for the most part, use von Wright's terminology in *Norm and Action*.[1] We shall be concerned only with norms that are prescriptions, i.e., no reference will be made to customs or customary norms (though they play an important part in legal life). Moreover, only positive norms issued by human authorities will be taken into account (this excludes so-called natural law). Accordingly, by a norm we shall understand a prescription to the effect that something ought to or may or must not be done, i.e., a prescription issued by one or several human agents (called norm-authorities), addressed to one or several human agents (called norm-subjects), enjoining, prohibiting, or permitting certain actions or states of affairs. Commands (John, take off your hat!) are included in this notion of norm. The verbal formulation (whether by means of a sentence in the imperative mood, a deontic sentence or a sentence in the indicative) is immaterial; the important thing is the prescriptive use of the words (or other symbols).

1. Existence of Norms

Von Wright offers a detailed discussion of the problem of the existence of a norm or, as he puts it, 'the ontological problem of norms', in Chapter VII of *Norm and Action*. It is "essentially the question what it means to say that there *is* (exists) a norm to such and such effect." Such questions are often asked by jurists, and our concern here is with the problem whether and to what extent von Wright's analysis may be regarded as an adequate reconstruction of what jurists understand by the existence of a legal norm (even if von Wright himself had no such purpose in mind when writing *Norm and Action*).

In von Wright's account two basic conditions are required for the truth of the statement that a norm is, or exists: 1. the giving of the norm by the norm-authority, and 2. the receiving of the norm by the norm-subject. The 'giving-aspect' is the *normative action* performed by the norm-authority; it can be analyzed into two components: 1.1. the *promulgation* of the norm (which is an essentially verbal activity; it consists of the use of norm-formulations to enunciate the norm), and 1.2. an effective sanction, i.e., explicit or implicit threat of punishment for disobedience to the norm (NA 125). For a sanction to be *effective* a special condition must be fulfilled by the person (or persons) who acts as the norm-authority: this is the (generic) *ability to command,* which is founded on a "superior strength of the commander over the commanded" (NA 127).

But the giving-aspect alone is not enough; the normative action is successful only if it results in the establishment of a *normative relationship* (or relationship under norm) between the authority and the subject(s). "When use of prescriptive language leads to or results in the establishment of this relationship between a norm-authority and some norm-subject(s), then the prescription has

been given, the normative act successfully performed, and the norm has come into existence'' (NA 118). The receiving-aspect being essential for the norm's existence, the norm-subject must 'receive' the norm. But the reception of the norm does not consist of merely becoming aware of the promulgation of the norm; a norm-subject cannot receive a norm ''unless he can do the enjoined or permitted thing'' (NA 111). His ability to act according to the norm is a 'pre-supposition of norms'' (NA 110). This presupposition connects the notion of existence with the Kantian principle that 'ought entails can'.

According to von Wright norms have a temporal duration. They come into existence with the establishment of the normative relationship and they cease to exist when this relationship dissolves (NA 118).

> The life-span of a prescription is thus the duration of a relationship between a norm-authority and one or several norm-subjects. As long as this relationship lasts, the prescription is said to be *in force*. The existence of a prescription is not the fact, as such, that it has been given, but the fact that it is in force (NA 118).

So the existence of a norm depends on the existence of a normative relationship between the norm-authority and the norm-subject.

Before discussing the question of adequacy of the foregoing analysis for legal norms, we must try to determine von Wright's explicandum, the intuitive notion he wants to clarify.

There are at least three possible explicanda, according to three different though related meanings of the term 'norm'. In order to make clear what we mean, we shall consider first the descriptive use of language.

The most common and 'natural' use of descriptive language is to communicate something to somebody else. In a communication at least two persons are involved, the speaker and the hearer (in the case of a written communication the situation is similar). The existence of a communication requires: (i) the utterance of certain words by the speaker, and (ii) the reception of the message by the hearer. There is no effective communcation if the hearer does not receive the message.

But we may abstract from the hearer and concentrate our attention on the speaker alone. Then we have what could conveniently be called an 'assertion'. (We must distinguish, of course, between the act of asserting and the contents of this act, i.e., an actual assertion or statement.) An assertion exists even if nobody has received it; the only condition for its existence being the performance of the act of asserting. (A philosopher who is writing a book certainly makes assertions, even if he hides his ideas for fear of plagiarism.)

On a still higher level of abstraction, we might even dispense with the speaker; in this case we are left with the contents of a possible assertion. This is what logicians usually call a 'proposition'.

Communication, assertion, and proposition are three different concepts, obtained by successive degrees of abstraction. Something analogous happens with

prescriptions, though in this field there are no corresponding terminological distinctions, a fact that makes the ambiguity of the term 'norm' and related expressions the more misleading.

Let us consider first a situation analogous to communication. A typical example would be that of commanding. The communication of the command to the norm-subject seems to be a necessary condition for the existence of a command (at least in normal cases). Hence a command—in order to exist—must not only be given, but also received by the commanded. This meaning of 'norm' we shall call 'norm-communication'.

The most natural use of prescriptions is to influence other people's behavior and the reception of the prescription is certainly a necessary condition to attain this aim. And yet we may abstract from the 'receiving-aspect' of a prescription and concentrate on its 'giving-aspect' alone. Then we shall obtain something analogous to an assertion and we shall call it 'norm-prescription'. Norm-prescription is the content of an actual act of prescribing. People (and especially jurists) often speak of norms in this second, more abstract, sense. All that is needed for the existence of a norm-prescription is its promulgation, i.e., the act of prescribing by the corresponding authority. Its reception by the norm-subject is not necessary for its existence.

Finally, we may regard a norm as the content of a merely possible act of prescribing. This prescriptive counterpart of a proposition will be called 'norm-lekton'. Exactly as in the case of assertion and proposition, the concepts of norm-prescription and norm-lekton are obtained by successive abstractions from a common basis (norm-communication).

2. Existence and Promulgation

It seems clear from von Wright's account of existence, that he takes norm-communication as his explicandum. As an explication of *this* notion his analysis is both illuminating and fruitful. But our concern is with legal language and we are interested in the applicability of von Wright's *explicata* to legal norms. In this sense, the concept of existence as used by von Wright is not entirely adequate, for it may easily be shown that jurists rarely if ever use the term 'norm' with the meaning of 'norm-communication' when they talk of the existence of norms. Normally they use the term in the sense of 'norm-prescription'.

As already mentioned, von Wright's concept of existence is particularly suitable for direct commands and permissions (particularly regarding the subject) and even for general norms addressed to a relatively small or at any rate easily identifiable audience (like military commands). But in the case of general norms addressed to a class of persons whose members are not easily identified—as with most legal norms—the situation is different. It is certainly true

that the legislator tries to inform the population each time he promulgates a new law by publishing it in the newspapers or at least in some sort of official bulletin (though there are also secret laws); but the large number of legal provisions makes it almost impossible for a legal subject to know them all or even those that concern him directly. But this fact does not prevent the jurists from speaking of existing legal norms and treating them as such. Legal norms are treated as existent long before they are 'received' by legal subjects. Here the difference between a direct command and a general legal norm is noteworthy.

Let us illustrate it with an example. Suppose a colonel wants one of his captains to do a certain thing. He gives the order and sends a messenger to the captain. The messenger is killed on his way and so is prevented from communicating the command and as a consequence of it the captain does not do the required thing. Can the captain be charged with and punished for disobedience? Certainly not, for if he can prove that he did not receive the command, the question of disobedience does not arise.

The situation differs radically in the case of general legal norms. A legal subject may very well be punished for not complying with a norm, e.g., for not fulfilling a legal obligation, even if he can prove that he was not aware of its existence. Ignorance of the law is not regarded as an excuse, for there is a legal presumption that all laws are known by everybody and this presumption is *juris et de jure*, i.e., it cannot be disproved. This presumption is of course a mere fiction; in fact nobody, not even a learned jurist, can know all the laws of a country. But it shows very clearly that the existence of legal norms is regarded as quite independent from the receiving-aspect. A law is said to exist when it has been issued, i.e., promulgated by the proper authority.

Moreover, the class of norm-subjects of a legal norm may even (in fact) be vacuous, and yet jurists would not hesitate to treat such a norm as existent. Suppose a law is issued, stipulating that all inhabitants of Platina whose income per annum exceeds a certain amount must pay a special tax. Suppose, further, that Platina is a poor part of the country and there is nobody whose income is as large as that. One day, Onassis decides to settle in Platina and this law is applied to him. Would we say that this law did not exist before and only came into existence at the moment of Onassis's arrival or of his becoming aware of its promulgation? Jurists would certainly say that the law existed since its promulgation, though it could not be applied then, since there was no occasion for doing so.

The foregoing considerations show that in legal language the term 'norm' is ordinarily used in the sense of norm-prescription. It seems reasonable, therefore, to take norm-prescription as the explicandum. Accordingly, a norm is the content of an actual act of prescribing, whose existence begins with the promulgation. The performance of the act of issuing the norm (promulgation) will be the only requirement for its existence. (The concept of promulgation is, of

course, in need of clarification. It may be a simple act of uttering or writing down certain words or it may be the result of a complex process, in which the activity of many persons is involved, as e.g., in the enactment of a law by a parliament. But we shall not discuss this problem here.)

According to our decision, any serious act of prescribing gives rise to (the existence of) a norm. Only non-serious utterances of prescriptive sentences are hereby excluded.

The act of issuing a norm—its promulgation—marks the moment at which a norm begins to exist. It ceases to exist when it is derogated. The derogation of a norm may be tacit or explicit. A norm is tacitly derogated when it comes out of existence by mere expiration of a certain period of time; such is the case with particular norms (particular as regards occasion) or temporal laws (in which it has been stipulated that they should cease at a certain moment). Such norms are rather exceptional; usually a legal norm ceases to exist when it is explicitly derogated by the corresponding norm-authority by means of an act of derogation.[2]

The existence of a norm is temporally continuous: a norm is said to be existent from the moment of its promulgation to the moment of its derogation; but the temporal duration of a norm is a mere logical construction. There are no facts (besides the initial fact of promulgation and the final fact of derogation) which would make the statement true that a norm exists during its life-span. There are only certain criteria for the beginning and termination of norms.

This characterization of the temporal existence of norms—which differs significantly from that of von Wright—is in accord with a current linguistic usage in the field of law. Jurists often say that there is (exists) such-and-such a norm, and all they mean is that this norm has been promulgated (perhaps long ago) and has not yet been derogated. It is a noteworthy fact that legal norms very often outlive their authorities: a general legal norm may exist for a long time after the authority that issued it has disappeared. (Laws continue to exist after the death of a King or the dissolution of the parliament by whom they had been enacted.) This fact shows that the characterization of the continuous existence of a norm in terms of the continuity of the normative relationship between the norm-authority and the norm-subjects is not suitable for most legal norms.

3. The Ability to Command

As a consequence of having chosen a different *explicandum* we had to dispense with the receiving-aspect of norms as a criterion of existence. We shall now focus our attention on the giving-aspect.

According to von Wright, the normative action does not consist of the pro-

mulgation alone, but requires something else. This second component is the ability to command, or—as we prefer to call it—the superiority relation between the norm-authority and the norm-subject. For though von Wright speaks here of a sanction, it is clear that the superiority relation is a more fundamental notion. Indeed, von Wright admits that the threat of punishment, i.e., the sanction, may be implicit. In the case of an implicit sanction, how do we know that there is such a thing at all? Obviously because of the "superior strength of the commander over the commanded"; only when we know that there is such superiority can we infer that there is an implicit threat of punishment for disobedience.

On the other hand, it does not seem to make much sense to speak of sanctions in the case of a permissive norm. And yet it seems reasonable to maintain that not everybody can give a permission to anybody; the person who gives a permission must be qualified in a certain way, he must have an ability to give that permission. What this ability to permit consists of is not quite clear, but a possible criterion could be the ability to command. We would say then that a person can give a permission to do a certain thing to another person if, and only if, he can enjoin or prohibit doing this thing. This would be a reasonable way of extending von Wright's criterion to permissive norms.

What does the superiority relation or the ability to command and give permissions consist of? In von Wright's view it consists of the possibility of punishing: when the commander can actually punish the norm-subject he is said to be stronger. This superior strength of the commander constitutes his ability to command.[3]

It certainly seems reasonable to require some sort of superiority relation between the norm-authority and the norm-subject. We would not normally say that a child who says to an elderly gentleman 'Give me your hat!' has given a command, or that Mr. Jones who says to his neighbor 'I allow you not to pay your taxes' really gives him a permission. But the requirement of the actual possibility of punishing is perhaps a little too strong. The ability to command may be based on a merely moral superiority. When an old, but for some reasons respectable, man tells a much younger and stronger man to do a certain thing, it may be quite naturally described as commanding, even if the commander cannot actually punish the commanded. And there is no need for the commanded to believe mistakenly in the superior strength of the commander: he may be aware that there is no physical superiority and still do the enjoined thing—and his behavior could be described as obeying a command. This is why we prefer to speak of the superiority relation without specifying what this superiority consists of.

Von Wright's requirement of the superiority of the norm-authority over the subjects as a necessary condition for the existence of a norm is in accordance with an important tradition in legal philosophy, which may be called the Ben-

tham-Austin tradition.[4] And yet there are important reasons for not accepting this requirement—at least not as a necessary condition for the existence of *all* types of norms. The main reasons are: (a) The indetermination of the norm-subjects. As we have already seen, the subjects of a legal norm can be indeterminate and even nonexistent and yet this does not prevent the norm from existing. (b) The norm-authority may cease to exist, whereas the norm is said to remain in existence. It is not clear what the superiority relation between Napoleon and the French citizens of today consists of, but the Civil Code promulgated by Napoleon is still existent.

One way of maintaining this requirement is to subscribe to the theory of tacit commands (Austin), according to which every sovereign tacitly commands all that has been commanded by his predecessor. But this theory is little more than a fiction, elaborated *ad hoc*.[5]

The result of our discussion may be summed up as follows: in some situations (such as direct commands or permissions) the superiority relation is a necessary condition for the existence of a norm; but there are also contexts in which it is not required. Consequently, if we want to shape a general concept of existence of norms, applicable to all types of (legal) norms, we must reject the requirement of superiority. The promulgation of the norm is then the only condition for its existence; this may be regarded as a minimal requirement, common to all types of norms.

4. Existence and Validity

An alternative way of interpreting the superiority relation between the norm-authority and the norm-subjects is to replace the factual (physical) superiority by the normative notion of *competence*. On this view, a necessary condition for the existence of a norm is the competence of its authority: a norm comes into existence if, and only if, it is promulgated by a competent authority. An authority is said to be competent to issue a norm, if the act of issuing it is permitted by another norm. A norm given by a competent authority is said to be *valid;* the validity of a norm is the permittedness (legality, lawfulness) of the act of issuing this norm.[6]

Hans Kelsen is perhaps the most conspicuous representative of this line of thought, which is shared by many legal philosophers. Von Wright himself presents this view as a possible way of interpreting what he calls the Principle of Validity: "It can be taken as saying that validity is a (logical) requirement for the success of the normative act, that a norm cannot come into existence in a system as a result of normative action, unless it is given by a proper, i.e., normatively competent, authority."[7] But Kelsen goes so far as to identify existence with validity: "By 'validity' we mean the specific existence of norms."[8]

The identification of existence with validity is a serious logical mistake, because it leads to infinite regress.[9] Indeed, on this view, a norm requires for its validity (existence) the validity of another norm—the norm which permits the issuing of the first norm. But the validity of this second norm requires the validity of a third norm, and so forth. Von Wright points out rightly that the validity of a norm cannot be characterized as being relative to the validity of another norm, but only as relative to the *existence* of another norm. This shows that the notion of validity already presupposes the notion of existence, at least in the sense of promulgation, and is not identical with it. Indeed, validity is a relation between two existing norms. The norm that gives competence (legal power) to an authority (permitting it to issue certain types of norms) makes valid the norms issued by that authority, but the validating norm need not be valid, though of course it must exist. It can also be an invalid norm or a sovereign norm.[10] And if validity were a necessary condition for the existence of a norm, then neither invalid norms nor sovereign norms could exist. This shows that existence is—at least for those who admit sovereign norms—independent of validity. (We shall come back to this question in section 11.)

On the other hand, though it is true that in legal language the words 'existence' and 'validity' are often used as roughly equivalent, this fact does not prove that both concepts are identical. For the term 'valid'—as pointed out by von Wright[11]—is ambiguous: it is sometimes used in the sense of normative validity and sometimes in the sense of existence or being in force. But the normative notion of validity (as legality of the norm-creating act) must not be confused with the factual notion of existence. It is true that jurists usually are interested in those norms which exist *and* are valid, but in some contexts they also consider invalid (though existing) norms. The typical case is that of an unconstitutional law, i.e., a law issued by the legislator (and so existent), but whose issuing is forbidden by the Constitution. Such a law is invalid, but no jurist would say that it does not exist. Precisely because it exists we are interested in its annulment, which may require a complex procedure. But no jurist would care to annul a norm which does not exist, i.e., which has not been promulgated. A nonexistent norm is not a norm; but an invalid norm certainly *is* a norm, provided it has been promulgated.

5. Existence and Consistency

We turn now to the last—and perhaps the most fundamental—question concerning the existence of norms: the problem of its relation to consistency.

Von Wright regards consistency as a necessary condition for the existence of norms: ". . . consistent prescriptions are such as *can exist* and inconsistent prescriptions such as cannot exist—as far as logic is concerned."[12]

What does it mean to say that a norm is (self-) consistent or that two norms

are (mutually) consistent? Von Wright seems to use two different though related criteria of consistency. His criterion of self-consistency of a norm is based on the possibility of performing the prescribed action: a norm is self-consistent when the norm-content is consistent, otherwise it is inconsistent. But, as von Wright points out "it is not clear by itself why a prescription should be called consistent if the prescribed action can be performed and inconsistent if it cannot be performed" (N.A. 135). Only if it were logically impossible to command and permit an agent to do and forbear the same thing on the same occasion would such a prescription be inconsistent. But, given von Wright's concept of existence, a norm cannot exist unless the norm-subject can do the prescribed thing; consequently a norm which cannot be obeyed because the prescribed action cannot be performed cannot exist. Hence it is inconsistent.

What is it for two or more norms to be mutually consistent? Von Wright gives first a *formal criterion* of consistency (compatibility) for norm-formulations, i.e., for deontic (O- and P-) expressions. The definition of formal consistency is given in three steps: for sets of O-expressions, for sets of P-expressions and, finally, for sets of O- and P-expressions (mixed sets). A set of O-expressions (commands) is consistent if, and only if, "it is logically possible, under any given condition of application, to obey *all* commands (collectively) which apply on that condition" (NA 143). A set of P-expressions (permissions) is always consistent. Permissions never contradict each other. This means the following: Although it is perhaps not possible to avail oneself of *all* the permissions at the same time, it is possible to avail oneself of *any one* of them at a given time. A mixed set (of commands and permissions) is consistent "if, and only if, it is logically possible, under any given condition of application, to obey *all* the commands collectively and avail oneself of *each one* of the permissions individually which apply on that condition" (NA 144).

But this formal criterion of incompatibility of norm-formations is *not* von Wright's criterion of mutual consistency of norms. If it were so, then two incompatible norm-formulations could never express norms, for such norms would be inconsistent and, according to von Wright, inconsistent norms cannot coexist: they "annihilate one another" (NA 148). But von Wright believes that two norms expressed by two incompatible norm-formulations can coexist and so are not inconsistent, provided they have been issued by different authorities (NA 148). Only if both norms have the same authority are they inconsistent, because they cannot coexist as expressions of a rational will, and the fact that one and the same authority issues two incompatible norm-formulations shows that its will is not rational. So von Wright's criterion of inconsistency of norms is based on the irrationality of the will and not on the mere impossibility of performing the prescribed actions (it is equally impossible for a norm-subject to perform the actions prescribed by two incompatible norm-formulations when they have been issued by one or by two authorities).

It is important to realize that it will *not* do to answer the question why it should be called logically impossible to command and prohibit the same thing by saying that this is impossible because it is logically impossible for one and the same man both to do and forbear one and the same thing at the same time. For if I order a man to do something and you prohibit him to do the same it is also logically impossible that the man should obey both of us, but nevertheless perfectly possible that there should be this command and this prohibition (NA 148–49).

Thus the notion of consistency is confined to norms which have the same authority; a set of such norms is called a *corpus* (NA 151). The consistency or compatibility of norms is therefore the possibility of their coexistence within a corpus.

The rationality of the will (of the norm-authority) takes the place here of the possibility of performing the prescribed actions as the criterion of consistency of norms. But the two criteria are not independent. Indeed, a will is irrational when the authority issues two incompatible norm-formulations (this seems to be the only criterion of irrationality), i.e., when it prescribes two actions that cannot be performed. So the formal criterion of incompatibility of norm-formulations—restricted by the requirement of identify of the authority— is after all the criterion of inconsistency of norms.

The concept of consistency of norms as shaped by von Wright gives rise to several difficulties:

1. The logic of norms is thereby restricted to norms issued by one and the same authority. If there can be no incompatibility between norms of different authorities, then there are no logical relations between such norms. But the notion of a corpus of norms is of little use in the field of law. There are a great many legal authorities and very often jurists manipulate norms of different authorities and they would not hesitate to call such a set a normative system.[13] According to von Wright's criterion there could be no inconsistency in such a system. Thus his criterion becomes too restrictive, for it leaves out precisely the interesting case of what he calls 'conflict of wills' (i.e., two incompatible norms given by different authorities). This would be the paradigmatic case of what jurists call a contradiction between norms.

2. The requirement of the sameness of the norm-authority is rather problematic. What does it mean that the authority must be the same? The question is not difficult to answer when the authority is a personal agent, but how about impersonal authorities, which is the usual case in law? Von Wright's psychologistic conception of norms (as expressions of a will) seems to imply that the identity of an impersonal authority is given by the identity of all individuals who constitute that authority. So we would say that two norms are given by the same law-court or the same parliament if, and only if, all individual members of the court or the parliament are the same. This would mean—besides the practical difficulty of establishing the identity of the authority—that two

laws enacted by the British Parliament on two successive occasions would count as norms of different authorities and hence not susceptible of being inconsistent in virtue of the mere fact that one M.P. did not attend one of the two meetings.

3. It may seem plausible to say of a man who on the same occasion commands and prohibits the same thing that he behaves irrationally and therefore has issued no norm at all. But how about two incompatible norms issued by the same agent on two different occasions? Would we not say in such a case that the agent has changed his mind, rather than call him irrational? Must we restrict even more the notion of consistency, stipulating that only norms given by the same authority on the same occasion can be inconsistent? This would hardly be a desirable result. We could try to save the theory saying that there is no inconsistency because the first norm ceased to exist in the very moment when the agent changed his mind. But this amounts to requiring the continuous subsistence of the will for the existence of the norm. Such a requirement is clearly unacceptable, at least for legal norms, which as a rule continue to exist long after the will of their authority has vanished.

4. A surprising consequence of von Wright's criterion is that there can be no inconsistent norms: neither within nor outside a corpus. If two incompatible norms 'annihilate one another' when they have the same authority, and if they are not inconsistent provided they have different authorities, then there are no inconsistent norms. This sounds rather paradoxical: it is like saying that there can be no inconsistent propositions, that no two propositions can ever contradict one another. Of course, if by existence of a proposition we understand its truth, then we can say that two contradictory propositions cannot coexist, for they cannot both be true; at most one of them can be true. In the case of norms the situation is different: according to von Wright both norms disappear for they annihilate one another. (One could perhaps take the view that only one of them must vanish, but then it would be extremely difficult to decide which of the two incompatible norms should count as nonexistent.)

Von Wright is very emphatic about the serious nature of the problem of contradiction between norms. "It is serious because, if no two norms can logically contradict one another, then there can be no logic of norms either" (NA 148). But now it looks as if no two (existing) norms could ever contradict each other.

The situation is perhaps not as dramatic as it looks. For even if, as a consequence of von Wright's conception, there could be no logic of norms, there can be a logic of norm-formulations. As a matter of fact, von Wright's logic of norms (prescriptions) is a logic of norm-formulations (deontic expressions).

The source of the difficulties lies in von Wright's decision to make consistency a necessary condition for the existence of a norm, which is based on his

peculiar concept of existence. If we drop this requirement, a satisfactory notion of normative consistency can be elaborated in close analogy to the consistency of propositions. In fact, this notion has already been proposed by von Wright himself, for it is his formal criterion of compatibility of norm-formulations. What our suggestion amounts to is a rejection of his ontology of norms, and an acceptance of his logic, basing it on a different ontology.

In our discussion of the concept of existence we have argued that at least in legal contexts von Wright's concept should be replaced by that of promulgation. If we do so, then there is no need to relate the concept of consistency to the existence of norms. Von Wright's formal criterion of compatibility of norm-formulations, i.e., of the possibility of performing the prescribed action, will then be our criterion of consistency of norms. This means that we will drop his restriction that norms should have the same authority; what he calls a conflict of wills is, in our account, a genuine contradiction, for we need not deny the possibility of coexistence of inconsistent norms.

It should be noticed that 'conflict of wills' is, even in von Wright's account, just a different name for a formally identical situation: incompatibility of norm-formulations. This situation is called a 'contradiction' when the incompatible norm-formulations have been given by the same authority, and a 'conflict of wills' when the authorities are different.

The distinction we have made between norm-prescriptions and norm-lekta (analogous to assertions and propositions) shows that our concept of consistency of norms is similar to that of propositions. Indeed, a proposition is consistent when the state of affairs which it describes *can obtain* (NA 134) and is inconsistent when this state of affairs is logically impossible. Consistency is a property of propositions; but we do not speak of the existence of propositions (except in the sense of truth). On the other hand, assertions can exist, but they can be neither consistent nor inconsistent, unless what we mean is the assertion of an inconsistent proposition, and this certainly can exist. It is perfectly possible to assert a self-inconsistent proposition or several mutually inconsistent propositions. Far from being impossible, it happens very frequently.

A similar distinction can be made in the realm of norms. Consistency is a property of norm-lekta, whereas existence is a property of norm-prescriptions. It seems natural to take as the criterion of consistency of norms, in the sense of norm-lekta, the possibility of performing the prescribed action. But inconsistent norms can be prescribed, in the same way as inconsistent propositions can be asserted. This means that according to our criterion inconsistent norms can exist (as norm-prescriptions) and that, for instance, two (existing) commands will be said to be contradictory if, and only if, the actions prescribed by them cannot be performed (for reasons of logic) by the norm-subject, disregarding the question whether they have the same authority or not.

6. Deontic Logic (DL)

The logic of norms as the logic of the prescriptive normative language (DL) can thus be constructed as a logic of norm-lekta; this would correspond to what von Wright calls the prescriptive interpretation of a deontic calculus.[14] We shall now sketch the main features of such a deontic logic.[15]

The usual expressions of deontic logic will be read as expressions of norms: commands (Op), prohibitions ($O-p$) and permissions (Pp). 'Op' will be read as 'it ought to be that p' or 'p ought to be (done)'; '$O-p$' as 'it ought to be that not p' or 'p must not be (done)', and 'Pp' as 'it may be that p' or 'p may be (done)'.

In ordinary language a norm prohibiting that p may be expressed in different ways, e.g., by saying 'you may not do p', or 'you ought not to do p' or 'you must not do p'. This shows that the expressions '$-Pp$' and '$O-p$' have the same prescriptive import. The same is true of 'Pp' and '$-O-p$'. So we can accept as a law of (prescriptive) deontic logic

$$\text{DL1.} \vdash Pp \equiv -O-p$$

We have accepted, following von Wright's criteria of incompatibility of norm-formulations, that a norm commanding that p is inconsistent with a norm commanding that not-p. This means that 'Op' and '$O-p$' are inconsistent; hence it follows that one of these norms implies the negation of the other. This leads to the acceptance of the following law, as a criterion of deontic consistency:

$$\text{DL2.} \vdash Op \supset -O-p$$

From DL1 and DL2 follows:

DL2.1. $\vdash Op \supset Pp$ (commanding implies permitting).

Further we must accept the following law of distribution:

$$\text{DL3.} \vdash Op.Oq \equiv O(p.q)^{16},$$

for when someone prescribes that it ought to be that p and that it ought to be that q, the prescriptive import of what he has done is the same as if he were prescribing that it ought to be that p and q.

The corresponding law of distribution for the operator P is then

$$\text{DL3.1.} \vdash Pp \vee Pq \equiv P(p \vee q)$$

Finally, it seems clear that when someone prescribes that it ought to be that p he also prescribes (implicitly) that the consequences of p ought to be. In other words, the consequences of the prescribed situation are also prescribed. This idea can be rendered in a logical calculus in the form of a rule of inference:

DLR1. If $\vdash p \supset q$, then $\vdash Op \supset Oq$

It may easily be seen that the principles DL1–DL3 together with DLR1 lead to a deontic logic which is very close to von Wright's first system.[17] Thus his first deontic calculus proves to be an adequate reconstruction of the *prescriptive* notions of permission and obligation.

Two additional comments are perhaps needed. i. If we wish to reconstruct the legal prescriptive discourse as closely as possible to ordinary usage, we must reject as meaningless (ill-formed) those deontic expressions in which a deontic operator is followed by a contradictory or a tautological expression, because they do not prescribe (command or permit) any particular state of affairs. On the other hand, such a rejection would lead to a very complicated calculus.[18] It is for such purely formal reasons that most logicians, including von Wright, accept as well-formed formulas (and eventually as axioms) expressions of the form 'O*t*' or 'P*t*' (where '*t*' stands for a tautology).

ii. We must exclude expressions in which a deontic operator occurs within the scope of another deontic operator. This is so because the content of a norm must be an action, an activity or a state of affairs which is the result of an action or an activity. Therefore, the expression following a deontic operator must be a *description* of one of these things, but it cannot be a prescription. In other words, deontic operators generate norms out of descriptions of a certain kind, but they cannot generate norms out of norms. This rules out the iteration of deontic operators. (We shall come back to this question in section 11.)

7. Norms and Norm-propositions

It is a well known fact that deontic sentences exhibit in ordinary language a characteristic ambiguity: sometimes they are used prescriptively as norm-formulations, and sometimes they are used descriptively to make normative statements. In the first case they express norms, in the second, normative propositions (NA 104–06).

Though there are important differences between norms and norm-propositions, von Wright decides (NA 132) not to use a special symbolism for the latter, retaining the ambiguity of the ordinary language in his formal calculus. So in lieu of two symbolisms he has one symbolism with two interpretations: a prescriptive and a descriptive one. This strategy is based on the idea that there is some sort of logical parallelism or isomorphism between norms and norm-propositions, so that the logical properties of norms are reflected in logical properties of norm-propositions. So though von Wright conceives of his Deontic Logic as a theory of descriptively interpreted deontic expressions, he is (unlike some of his successors in this field) well aware of the fact that the "basis of Deontic Logic is a logical theory of prescriptively interpreted O- and P-expressions" (NA 134).

It is a major thesis of the present essay that this belief in some sort of preestablished harmony between logical properties of norms and those of norm-

propositions—a belief which is widespread among deontic logicians and legal philosophers[19]—is a serious logical mistake, for their logical properties are in fact different. In any case it seems more cautious, instead of accepting dogmatic presuppositions, to investigate norms and norm-propositions separately in order to find out whether and under what circumstances they are isomorphic. This is what we propose to do.

In order to distinguish clearly between the prescriptive and the descriptive deontic sentences we shall stipulate that the usual symbols O and P shall stand for prescriptive operators (with the reading indicated in section 6) and three new symbols '\mathbb{O}', '\mathbb{P}_s' and '\mathbb{P}_w' will be introduced for the descriptive deontic operators. The expression '\mathbb{O}_p' will be read (descriptively) as 'it is obligatory that p' and the expressions '$\mathbb{P}_s p$' and '$\mathbb{P}_w p$' as 'it is permitted that p'. (As we shall see presently, the descriptive expression 'it is permitted that p' is ambiguous; this is why we introduce two symbols for the descriptive permissive operators.)

Norm-propositions convey information about the deontic status of certain actions or states of affairs: they say that an action is forbidden or obligatory or permitted and they are true if, and only if, the referred action has the property of being forbidden or obligatory or permitted. But when has an action the property of being forbidden? This question admits of different answers. Some philosophers believe that forbiddenness is an intrinsic (perhaps non-natural) property of the action itself and its presence can therefore be detected by a close inspection of the action. Other philosophers believe that it is in virtue of God's orders or some eternal principles of Natural Law that certain actions are forbidden and others permitted or obligatory. But we are concerned here with the positive law and the positivist approach which is shared by most jurists. The characteristic of this point of view is that an action p is said to be forbidden if, and only if, there is a norm (of the positive law of the country in question) which forbids or prohibits that p, and not because it is intrinsically bad or disqualified by moral or Natural Law principles. This amounts to saying that the proposition that p is forbidden means the same as the proposition that there is (exists) a legal norm forbidding that p. So norm-propositions can be analyzed into propositions about the existence of norms. Now if we accept that the existence of a norm consists in its promulgation by an authority, then to say that an action p is forbidden ($\mathbb{O}-p$) is to say that a certain authority has promulgated a norm to the effect that p must not be done.

The latter proposition will be represented symbolically as '$NxO-p$', where 'x' denotes the legislative authority and the operator 'N' denotes the dyadic relation of promulgation: the promulgation of a norm ($O-p$) by an authority (x). This leads to the following definition:

$$D1. \mathbb{O}p = NxOp^{20}$$

The property of being obligatory (or prohibited)—as a character of actions—is thus defined in terms of the existence of an obligation-norm. (We need no special symbol for prohibition for it can obviously be expressed in terms of obligation: $\mathbb{O}-p = \text{N}x\text{O}-p$.) By 'obligation-norm' we mean a norm to the effect that p ought to be done, but it can also be expressed in terms of P (we shall see later that the formula 'NxOp' is equivalent to 'N$x-$P$-p$' and 'NxO$-p$' to 'N$x-$Pp').

In a similar way the property of being permitted can be defined in terms of a permissive norm. But this is only *one* meaning of the term 'permitted' when it occurs in norm-propositions. We shall call it *strong* or *positive permission* (\mathbb{P}s).[21]

$$\text{D2.}\mathbb{P}\text{s } p = \text{N}x\text{P}p$$

According to this definition an action p is strongly permitted if and only if there is a legal norm to the effect that p may be done (i.e., a norm permitting or authorizing p). This norm can be expressed in terms of P (NxPp) or in terms of O (N$x-$O$-p$).

But the term 'permitted' is also very frequently used in normative propositions with a different meaning. Sometimes what is required for the truth of the proposition 'p is permitted' is not the existence of a norm permitting that p, but the mere absence of a prohibition to do p. When the legislator has not issued any norm to the effect that p ought not be done, the action p is sometimes said to be permitted. This meaning of 'permitted' will be called *weak or negative permission* (\mathbb{P}w).

$$\text{D3.}\mathbb{P}\text{w } p = -\text{N}x\text{O}-p$$

This ambiguity of the term 'permitted'—when used in descriptive discourse—has no counterpart in the prescriptive language in which the norms are expressed. (A similar distinction can of course be made regarding obligation, defining weak obligation as mere absence of permission. But it is dubious whether the term 'obligatory' is ever used in such a weak sense.)

We must distinguish carefully between norm-characters expressed by prescriptive operators O and P and action characters expressed by descriptive operators \mathbb{O}, \mathbb{P}_s and \mathbb{P}_w. In *Norm and Action* von Wright makes a clear—conceptual and terminological—distinction between strong and weak permission (NA 86), but he does not distinguish between strong permission and the norm-character P. "Weak permission is not an independent norm-character. Weak permissions are not prescriptions or norms at all. Strong permission only is a norm-character. Whether it is an independent norm-character remains to be discussed" (NA 86–87). These phrases seem to imply that strong permissions are norms. But it is important to realize that neither positive (strong) nor neg-

ative (weak) permissions are norms; both are norm-propositions. The first asserts the existence of a permissive norm; the second asserts the non-existence of a prohibitive norm.

8. Negation in Normative Discourse

The use of 'it is obligatory that p' in the sense of '$\mathbb{O}p$' and of 'it is permitted that p' in the sense of '$\mathbb{P}sp$' or '$\mathbb{P}wp$' is typical for many forms of legal discourse. The main aim of legal science is the description of legal norms and not the prescription of actions; nor does a legal counsel prescribe his client to do such or such a thing: he only informs him about the legal status of his actions, saying, e.g., that the action p is obligatory ($\mathbb{O}p$) and the action q is permitted. This last assertion is characteristically ambiguous for it can mean $\mathbb{P}sq$ or $\mathbb{P}wq$ and only the context may make it clear which of the descriptive permission-characters is referred to by 'permitted'.

This ambiguity of 'it is permitted that p' which is highly characteristic of the descriptive normative discourse cannot be expressed in the usual symbolism of deontic logic and constitutes one (but not the only one) reason for developing a separate symbolism for the descriptive normative language.

Another reason for doing it is the possibility of two types of negation of the descriptive operators. Take first the norm-proposition 'it is permitted that p' ($\mathbb{P}sp$). Its negation 'it is not permitted that p' is ambiguous: it can mean (1) that the norm that permits p does not exist, i.e., that the legislator did not promulgate the norm 'Pp'. For this type of negation, called *external negation,* the usual symbol ' $-$ ' will be used; so on this interpretation ' $-\mathbb{P}sp$' means the same as ' $-$NxPp'. But the statement 'it is not permitted that p' can also mean (2) that there is a norm to the effect that p must not be done, i.e., that the legislator did promulgate the norm 'O$-p$' or (which amounts to the same) ' $-$Pp'. This second type of negation of norm-propositions will be called *internal negation* and symbolized by '\neg'. Its definition is:

$$\neg\mathbb{P}sp = Nx - Pp \; (= NxO - p)$$

Taking into account this ambiguity of 'not' when inserted in norm-propositions, one could expect—given the ambiguity of 'permitted'—that the statement 'it is not permitted that p' would yield four different interpretations: external and internal negations of strong and of weak permission. But in fact it is not so, because the external negation of a weak permission is equivalent to the internal negation of a strong permission and, analogously, the internal negation of a weak permission is equivalent to the external negation of a strong permission. This is shown in the following table.[22]

$$- \mathbb{P}sp = -NxPp = -Nx - -Pp = \neg\mathbb{P}wp$$
$$\neg\mathbb{P}sp = Nx - Pp = - -Nx - Pp = -\mathbb{P}wp$$

Therefore, there are only two forms of negation of the statement 'it is permitted that p': the assertion that there is no norm permitting that p and the assertion that there is a norm prohibiting that p.

There are also two forms of negation of the proposition 'it is obligatory that p': the assertion that there is no norm commanding that p ($-\mathbb{O}p$), and the assertion that there is a norm permitting that not p ($\neg\mathbb{O}p = \mathrm{N}x\mathrm{P}-p = \mathrm{N}x -\mathrm{O}p$).

There is a most interesting discussion of the notion of negation in normative (prescriptive and descriptive) discourse in *Norm and Action*.[23] In order to characterize the notion of negation von Wright states five conditions which we reproduce in a substantially equivalent form:

(i) The negation of a given proposition (norm) shall be a proposition (norm).

(ii) Negation shall be unique, i.e., there shall be one and only one negation of a given proposition (norm).

(iii) Negation shall be reciprocal, i.e., if a second proposition (norm) is the negation of a first proposition (norm), then the first is the negation of the second.

(iv) A given proposition (norm) and its negation shall be mutually exclusive.

(v) A given proposition (norm) and its negation shall be jointly exhaustive.

Von Wright considers various alternatives for the negation of a norm. For a norm commanding that p the two possible candidates are: a norm commanding that not p (i.e., prohibiting that p) and a norm permitting that not p (permitting the forbearance of p). Of the two he rejects the first (for reasons that we shall not discuss). So he chooses as the negation norm of the norm commanding that p the norm permitting that not p. In section 6 we have already implicitly accepted this suggestion taking ' $-\mathrm{O}p$' (which on the ground of DL1 is equivalent to '$\mathrm{P}-p$') to be the negation-norm of the norm '$\mathrm{O}p$'.

For the negation of the (descriptively interpreted) norm-proposition '$\mathrm{O}p$' von Wright uses the negation sign ' $-$ '. ' $-\mathrm{O}p$' means that the norm '$\mathrm{O}p$' does not exist. So the negation expressed by ' $-$ ' is an operation that leads from the assertion of the existence of a norm to the assertion of the non-existence of the same norm.

On the other hand, according to von Wright, to every norm corresponds a norm-proposition, i.e., a descriptive sentence asserting the existence of this norm. So we can distinguish between the proposition describing (the existence of) a given norm and the proposition describing (the existence of) its negation-norm. But the operation which leads from the assertion of the existence of a norm to the assertion of the existence of its negation-norm cannot be expressed in von Wright's symbolic language. All we have done so far is to introduce a new symbol (\neg) called internal negation as a name for this operation. And it is

important to stress that this particular type of negation is very frequently used in ordinary (and especially in legal) language.

Do the different kinds of negation so far considered (the two types of 'descriptive' negation—external and internal—and the 'prescriptive' negation) satisfy the requirements (i)–(v)? The external negation ($-$) certainly does. It satisfies not only the first three requirements (which is obvious), but also (iv)—exclusiveness—for the propositions '$\mathbb{O}p$' and '$-\mathbb{O}p$' cannot both be true, and (v)—exhaustiveness—because one or the other of the two must be true. Indeed, '$\mathbb{O}p \vee -\mathbb{O}p$' is a law of propositional logic. The same is true of \mathbb{P}s and \mathbb{P}w.

The internal negation satisfies only the first three conditions; it fails to satisfy the requirements (iv) and (v). $\mathbb{O}p$ and $\neg\mathbb{O}p$ can both be true; they are true when the system is inconsistent, when it is the case that the legislator has issued a norm commanding that p and has also issued a norm commanding that not p, that is, prohibiting that p. For the same reason \mathbb{P}sp and $\neg\mathbb{P}$sp may both be true. Moreover, they may both be false. This occurs, *e.g.*, when the system is incomplete, i.e., when the legislator did not issue any norm at all regarding p. (We shall come back in section 10 to the problems of completeness and consistency.) This is an important difference between the two negations, showing that only the external negation is a negation in the full sense.

We must consider now the prescriptive negation, *i.e.*, the operation that leads from a norm to its negation-norm. That this type of negation satisfies the first three requirements is clear: the negation-norm is a norm, there is only one negation-norm of a given norm, and they are reciprocal. But how about the other two conditions?

In the prescriptive deontic logic sketched in section 6 the norms '$\mathbb{P}p$' and '$-\mathbb{P}p$' are mutually exclusive and jointly exhaustive, for the formulas '$\mathbb{P}p \vee -\mathbb{P}p$' and '$-(\mathbb{P}p.-\mathbb{P}p)$' are valid. So the prescriptive negation satisfies both requirements: (iv) and (v). But it is important to realize what exactly this means. To say that '$\mathbb{P}p$' and '$-\mathbb{P}p$' are mutually exclusive *does not* mean that the norms '$\mathbb{P}p$' and '$-\mathbb{P}p$' cannot coexist in a normative system; it only means that two such norms are inconsistent, because the obedience to the second norm cannot coexist with the enjoyment of the permission given by the first. For deontic logic as the logic of norm-lekta gives the criteria of consistency of possible norms, but it does not say anything about the actual existence of norms. This shows the importance of separating the notions of existence and consistency which was our concern in section 5.

For similar reasons, to say that the norms '$\mathbb{P}p$' and '$-\mathbb{P}p$' are jointly exhaustive *does not* mean that in every normative system there must be a norm permitting that p or a norm not permitting (i.e., prohibiting) that p. It only means that any regulation of a given state of affairs p necessarily implies the permission of p or the prohibition of p. This does not mean that every state of

affairs is in fact regulated, precisely because deontic logic has nothing to say about the actual facts (existence of norms).

It is very important to realize that the acceptance of the formulas 'Pp v − Pp' and ' − (Pp · − Pp)' as laws of prescriptive deontic logic does not commit us to the view that all normative systems are in fact complete and consistent.[24] What these formulas do is to state two types of conditions: (a) a minimal condition which every norm-formulation must satisfy in order to express a norm (if a sentence does neither permit nor prohibit that p, then it does not express a norm referring to p), and (b) a condition that every norm must satisfy in order to be consistent (if a norm permits and prohibits that p, then it is inconsistent regarding p).

Von Wright maintains that a norm and its negation-norm do satisfy the requirement (iv) because they cannot coexist within a corpus, but fail to satisfy (v) because both of them can be absent from a corpus (NA 140, 154–55). But this argument only shows that von Wright cannot draw a clear distinction between the logic of prescriptive norm-formulations (based on the idea of consistency) and the logic of descriptive norm-propositions (based on the idea of existence of norms). And this is so precisely because his criterion of consistency is based on the notion of existence. The separation of the two concepts is a necessary condition for this distinction.

9. The Logic of Norm-propositions (NL)

The logical features of the action-characters \mathbb{O}, \mathbb{P}s and \mathbb{P}w are reflected in the descriptive normative logic (NL) which is the logic of norm-propositions in the same sense in which the (prescriptive) deontic logic is a logic of norms. It can be construed as an extension of the prescriptive deontic logic. To the axioms and rules of inference of DL we must add, in order to characterize the logical properties of the operator N, the two following principles:

$$\text{NL1.} \quad \vdash(N x A . N x B) \supset N x (A . B)$$

(where A and B are well formed formulas of deontic logic) and

$$\text{NL2. If } \vdash(A \supset B), \text{ then } \vdash(N x A \supset \vdash N x B)$$

The intuitive justification of these principles is not too difficult. NL2 reflects the idea—widely held among jurists—that the logical consequences of a promulgated norm are also regarded as implicitly promulgated. The norms which are logical consequences (i.e., entailed by) explicitly promulgated norms are called by von Wright *derived norms* (NA, 156–58). "The derived norms *are*, necessarily, in the corpus with the original ones. They are there, although they have not been expressly promulgated. Their promulgation is concealed in the promulgation of other norms" (NA 158).

The rationale of NL1 is fairly self-explanatory; if two norms have been promulgated separately by the legislator, then both of them are promulgated. The only problem that may arise in this connection is the notion of legislator. We have so far supposed, for the sake of simplicity, that there is only one legislative authority, which has been called x. But there may be—and in most legal orders in fact are—a great many different authorities. The plurality of norm-creating authorities makes NL1 dubious: it is simply false that if two different authorities (of the same legal order) have promulgated two norms, then there is an authority that has promulgated those two norms. (Such would be the result if we decided to quantify existentially over x.) In order to escape this difficulty the notion of '*the* legislative authority' can be construed as a (finite) set of norms $x = \{p_1, p_2 \ldots p_n\}$. If X is the conjunction of all the x-elements ($p_1 \cdot p_2 \ldots p_n$), then Nxp amounts to $\vdash X \to p$, where '\to' represents the notion of logical consequence or entailment. Thus x promulgates p if and only if p is entailed by X. On this interpretation the legislator is a normative system (corresponding to a certain legal order) and he promulgates whatever obtains in the system.[25]

We are now in a position to compare with the aid of NL1 and NL2 the logical properties of the descriptive operators \mathbb{O}, \mathbb{P}s and \mathbb{P}w with that of their prescriptive colleagues O and P. Some of the principles of DL have no counterpart in NL; others are valid only for the strong or only for the weak permissive operator. Thus the deontic law DL1 is not valid for \mathbb{P}s: neither '$\mathbb{P}sp \supset -\mathbb{O}-p$' nor '$-\mathbb{O}-p \supset \mathbb{P}sp$' are laws of NL. This is so because '$\mathbb{P}sp \cdot \mathbb{O}-p$' is not inconsistent, for it is possible for one and the same state of affairs to be permitted by a certain authority and also to be prohibited by the same or some other authority. This happens when the legislator has promulgated a norm permitting that p and has also promulgated a norm prohibiting that p. Far from being impossible, such a situation occurs often enough, as every lawyer knows by experience. Of course, these two norms are inconsistent and lawyers would care for removing such an inconsistency, but what they are anxious to remove is precisely the *inconsistency* of two norms.

There is in NL a law analogous to DL1, but only for weak permission:

$$\text{NL3. } \mathbb{P}wp \equiv -\mathbb{O}-p$$

But there is no counterpart to DL2, for '$\mathbb{O}p \supset -\mathbb{O}-p$' is not valid because '$\mathbb{O}p \cdot \mathbb{O}-p$' is consistent. There are no logical relations between acts or performances; the act of commanding that p is compatible (and can coexist) with the act of prohibiting that p, though, of course, the contents of these two acts (the command Op and the prohibition O$-p$) are incompatible (contradictory). But the existence of incompatible norms—as we have already pointed out—is not impossible.

There is also a law analogous to DL2.1.:

$$\text{NL4. } \mathbb{O}p \supset \mathbb{P}sp$$

but the corresponding formula for weak permission ($\mathbb{O}p \supset \mathbb{P}wp$) is not valid. The principle of distribution DL3 is valid in NL:

$$\text{NL5. } \vdash \mathbb{O}p \cdot \mathbb{O}q \supset \mathbb{O}(p \cdot q)$$

but the distributive principle for P (DL3.1) is only valid for $\mathbb{P}w$ but not for $\mathbb{P}s$.

$$\text{NL6. } \vdash \mathbb{P}w(p \vee q) \equiv \mathbb{P}wp \vee \mathbb{P}wq$$

The rule of inference of DL holds in NL for \mathbb{O} and for both permissive operators:

$$\text{NL7. If } \vdash p \supset q, \text{ then } \vdash \mathbb{O}p \supset \mathbb{O}q$$
$$\text{NL8. If } \vdash p \supset q, \text{ then } \vdash \mathbb{P}sp \supset \mathbb{P}sq$$
$$\text{NL9. If } \vdash p \supset q, \text{ then } \vdash \mathbb{P}wp \supset \mathbb{P}wq$$

10. Consistency and Completeness

We have seen that the formulas
$$(1) \; \mathbb{P}sp \supset -\mathbb{O}-p$$
$$(2) \; -\mathbb{O}-p \supset \mathbb{P}sp$$
$$(3) \; \mathbb{O}p \supset -\mathbb{O}-p$$

are not valid in NL, for they may be false. The possible falsehood of (1) means that the formula '$\mathbb{P}sp \cdot \mathbb{O}-p$' is consistent, i.e., it may be true. It is interesting to investigate in exactly what conditions this last formula is true. It is true when the legislator has promulgated incompatible norms concerning p, he has permitted and prohibited that p. This suggests the following definition of inconsistent regulation of a state of affairs ($\text{IN}(p)$):

$$\text{IN}(p) = \mathbb{P}sp \cdot \mathbb{O}-p \qquad (=\mathbb{P}sp \cdot \neg\mathbb{P}sp)$$

The possible falsehood of (3) shows that a state of affairs p can be commanded and prohibited. It can be proved that when this is the case, the legislator has promulgated incompatible norms. This is reflected in the following formula:

$$\vdash(\mathbb{O}p \cdot \mathbb{O}-p) \supset \text{IN}(p)$$

(Indeed, in presence of $\vdash \mathbb{O}p \supset \mathbb{P}p$ (1) can be inferred from (3). If $\mathbb{O}p \supset \mathbb{P}p$ were not accepted, then there would be two different types of inconsistency, one related to (1) and the other to (3).)

When the formula (2) is true we shall say that the legislator has determined a normative status for p or that p is *normatively determined* ($\text{ND}(p)$).

$$\text{ND}(p) = \mathbb{O} - p \vee \mathbb{P}sp$$

(to be read: p is normatively determined if, and only if, p is prohibited or strongly permitted.)

The idea of normative determination may be used to characterize a concept of completeness for normative systems. The set of norms promulgated by the legislator x is complete if and only if every state of affairs is normatively determined by x. The idea of completeness plays an important part in legal thought, as it lies at the bottom of the famous problem of gaps in law, which has been much discussed by jurists and legal philosophers.[26]

All this proves that a special symbolism is required for the logic of norm-propositions because some important properties of normative systems, such as consistency and completeness, cannot be adequately formulated in the traditional (descriptively interpreted) deontic logic.

On the other hand, our discussion of the differences between the strong and the weak permissive operator and between external and internal negation has shown that these differences are based on the fact that there may be inconsistent and incomplete systems of norms. For systems that are complete and consistent there are no such differences. Indeed, it can easily be proved that if we accept $\vdash - \text{IN}(p)$ and $\vdash \text{ND}(p)$ as axiomatic principles (which is tantamount to the assumption that all systems of norms are consistent and complete), then the formulas '$\mathbb{P}sp \equiv - \mathbb{O} - p$' and '$\mathbb{O}p \supset - \mathbb{O} - p$' become theorems and the difference between strong and weak permission and between external and internal negation vanishes. ('$\mathbb{P}sp \equiv \mathbb{P}wp$' and '$- \mathbb{P}sp \equiv \neg \mathbb{P}sp$' are on this assumption also provable.) Both logics become isomorphic.

Thus isomorphism may serve as a (partial) explanation of the fact that deontic logician tend to overlook the difference between prescriptive and descriptive normative logic, especially as they are mostly concerned with ethics. In typically ethical contexts it is natural to assume that all actions have some deontic character and that no action can be both obligatory and prohibited. In other words, ethical systems are often assumed to be always consistent and complete. But this fact does not lessen the interest in the above-mentioned distinction in the field of law, where inconsistencies of laws and 'gaps' in laws are familiar though disturbing phenomena to whose elimination jurists dedicate a considerable part of their efforts.

11. Iteration of Deontic Operators

There is still another reason for developing two separate symbolisms for the prescriptive and the descriptive deontic expressions, related to a very important idea put forward by von Wright.[27] This idea is to use formulas with iterated deontic operators like 'OOp' or 'POp' to represent norms of higher order. Such norms play an important part in law, especially in the form of norms of com-

petence. There are several notions widely used in legal theory which are characterized in terms of norms of competence, like validity, legal order, authority (organ), etc.

The interpretation of deontic formulae with iterated operators presents some difficulties which did not escape von Wright's attention. Let us consider, as an example, the iteration of the operator O.

In view of the distinction between the prescriptive and the descriptive deontic operators, four different cases are to be considered:

(1) OOp

(2) ⦿Op

(3) O⦿p

(4) ⦿⦿p

The first formula 'OOp' is a norm whose content is another norm (Op). If we accept that only actions or states of affairs resulting from actions can be the contents of norms (section 6), then the formula 'OOp' must be rejected as meaningless. This result appears to be in accordance with von Wright's opinion (NA 189; EDL 91): norms cannot be the contents of norms.

For similar reasons we decide to reject the formula (2). In the expanded form it amounts to 'NxOOp'. Part of this formula (OOp) is a meaningless expression; this is why we prefer to consider the whole formula as meaningless.

The formula (3) is a norm whose content is a normative proposition. In the expanded form it amounts to 'ONxOp', *i.e.*, it is a norm to the effect that the authority x ought to issue a norm of the form 'Op'. This is exactly what von Wright understands by ''norms of higher order', that is, norms that prescribe (enjoin, permit or prohibit) the performance of *normative actions*, i.e., actions consisting in promulgating (or derogating) other norms. An example of a norm of higher order of the form O⦿p may be found among the current prescriptions of a penal code: 'Homicide shall be punished with imprisonment from eight to 25 years' can be interpreted as a norm directed to the judge, enjoining him to issue a norm condemning to imprisonment everybody who has committed homicide.

Perhaps the most important kind of norms of higher order, as von Wright suggests (NA 1982), are the norms of competence. These have the form of P⦿p or P℗sp, *i.e.*, they are permissive norms ''to the effect that a certain authority *may* issue norms of a certain content'' (NA 192ff.). Von Wright makes some short but very illuminating remarks about norms of competence (NA 192ff.), whose careful reading may be recommended to more than one legal philosopher. Especially important seems to us his distinction between the norms delegating powers (norms of competence) which are essentially permissions and other norms of higher order, which may be also orders or prohibitions. But we shall not discuss these problems here.

Finally, the formula $\mathbb{O}\mathbb{O}p$ is a norm-proposition asserting the existence of a norm of higher order, i.e., asserting that the authority x has issued a norm to the effect that another authority y should issue a norm of the form $Op;$ so its expanded form is $NxONyOp$. Here we must distinguish between different authorities, for the limiting case of a self-prescription (autonomous norm) where $x = y$ is of little interest in law. This fact makes it advisable to use subscripts in order to indicate the corresponding authority: '$\mathbb{O}_x\mathbb{O}_yp$' would then correspond to '$NxONyOp$'.

On the ground of these considerations we can establish the following formation rules for expressions with iterated deontic operators:

R1. Prescriptive operators cannot be iterated.

R2. A prescriptive operator cannot occur within the scope of a descriptive operator.

R3. Descriptive operators can be iterated (indefinitely).

R4. Descriptive operators can occur within the scope of a prescriptive operator.

It follows that only descriptive operators can be iterated and that a prescriptive operator can occur only at the beginning of an iterated expression (formula of higher order).

As von Wright shows, *one* important application of expressions of higher order is to characterize the concept of *validity* (NA 194; EDL 94).

According to von Wright, "a norm is valid (in a normative system S), if and only if, the normative act of giving this norm is permitted (in that system)."[28] 'Permitted' must mean here the strong permission, i.e., the existence of a permissive norm of higher order. This is clearly stated in *Norm and Action:* ". . . the validity of a norm means that the norm exists and that, in addition, there exists another norm which permitted the authority of the first norm to issue it" (NA 195). This shows that validity is a *relation* between two existing norms. To say that a norm N_1 is valid in relation to a norm N_2 means that (1) N_1 has been promulgated by a certain authority (say y), (2) the norm N_2 has been promulgated by (usually another) authority x, and (3) N_2 permits the issuing of N_1 by y.

On the other hand, a norm N_1 is *invalid* in relation to N_2 if, and only if, both of them exist and N_2 prohibits the issuing of N_1 (by the authority which has in fact issued N_1).[29] Thus the validity of the norm 'Op' implies '$\mathbb{P}sNxOp$' and the invalidity of 'Op' implies '$\mathbb{O} - NxOp$'.

It follows that a norm can be both valid and invalid in the same system (though in relation to different norms). It occurs when an authority has permitted the issuing of this norm and another or the same authority has prohibited it. Moreover, a norm can be neither valid nor invalid; such a norm is called *sovereign* (NA 199).

A norm is sovereign if and only if the issuing of it is neither strongly

permitted nor prohibited. So to say that 'Op' is sovereign implies ' $-\mathbb{P}sNxOp$ ' and ' $-\mathbb{O}-NxOp$ '. It follows that a norm is either sovereign or not sovereign and it cannot be both sovereign and not sovereign (in the same system).

Von Wright's definitions of validity and invalidity already entail the possibility of sovereign norms (which he, of course, accepts). On the other hand, the acceptance of sovereign norms, i.e., norms which are neither valid nor invalid, commits us to the view that there are open normative systems, for a sovereign norm provides precisely an example of a *deontically undetermined action*, that is, an action which is neither prohibited nor strongly permitted. It is the normative action of promulgating a sovereign norm.

12. Some Concluding Remarks

We have advanced some reasons in favour of the development of a separate symbolism for the descriptively interpreted deontic expressions in order to identify some very common uses of the terms 'obligatory', 'permitted', 'prohibited', etc. These uses are highly typical for legal discourse. The typically *legal sense* of these and similar terms differs substantially from what we might call their *ethical sense*. It is a noteworthy (though not always noticed) fact that deontic words are used in fairly different senses in moral and legal contexts. *One* important difference is this:

No action can be at the same time morally permitted and prohibited. It has been emphasized by G. E. Moore that we cannot say in any typically ethical sense that one and the same particular action is at the same time both right and wrong.[30] This seems to be a characteristic feature of the ethical use of such words.[31] On the contrary, it is perfectly possible for an action to be at the same time both legally permitted and prohibited (as has been argued in section 10).

This difference is closely related to the different nature of moral and legal norms. Legal norms (at least so far as positive law is concerned) are in an important sense dependent on human actions; they are essentially manmade norms. Here again we can quote Moore:

> And . . . it does seem to be the case that every law, which is the law of any community, is, in a certain sense, *dependent* upon the human will. This is true in the sense that, in the case of every law whatever, there always are *some* men, who, by performing certain acts of will, could make it cease to be the law; and also that, in the case of anything whatever which is not the law, there always are *some* men, who, by performing certain acts of will, could make it be the law. . . . It does seem, therefore, as if laws, in the legal sense, were essentially dependent on the human will.[32]

On the other hand, the very idea of a moral legislation seems to be absurd. As Hart puts it, "it is inconsistent with the part played by morality in the lives of individuals that moral rules, principles, or standards should be regarded, as laws are, as things capable of creation or change by deliberate act. Standards

of conduct cannot be endowed with, or deprived of, moral status by human *fiat*. . . ."[33]

This is why the notion of existence of a legal norm is quite different from that of a moral norm and the problems of consistency and completeness have much more importance in legal than in moral discourse. It is also the reason why most deontic logicians attach little importance to the difference between prescriptive and descriptive normative language. We have seen that this difference is based on the possibility of inconsistency and incompleteness because for consistent and complete systems both calculi are isomorphic. Therefore, if it is accepted that a system of moral norms is always consistent and complete, then, as long as we are interested in ethics, there is no need to distinguish between the two logics.

A good many differences of opinion among deontic logicians are due to their (tacit) recourse to different intuitive backgrounds. Some of them, H. N. Castañeda for instance, seem to have in mind only moral norms. Von Wright is one of the few that have also taken into account the legal language. But even in his work, in spite of his sensitivity towards legal problems, there is no clear separation between moral and legal senses of deontic words, and this is perhaps the main source of some of his perplexities.

CARLOS E. ALCHOURRÓN AND EUGENIO BULYGIN
FACULTY OF LAW AND SOCIAL SCIENCES
UNIVERSITY OF BUENOS AIRES
FEBRUARY 1973

NOTES

1. G. H. von Wright, *Norm and Action* (London 1963); abbreviated as NA.
2. There is a brief but very interesting discussion of the concept of derogation or cancellation in NA 191.
3. NA 127.
4. Both Bentham and Austin define the law in terms of commands (volition) of a sovereign, who is a person or set of persons habitually obeyed by a certain community. Cf. J. Bentham, *Of Laws in General,* edited by H. L. A. Hart (London 1970), pp. 1 and 20 ff., and J. Austin, *The Province of Jurisprudence Determined* (London 1954), p. 194.
5. For a penetrating criticism of this theory see H. L. A. Hart, *The Concept of Law* (Oxford 1961), pp. 62–64.
6. NA 195 ff.
7. G. H. von Wright, *An Essay in Deontic Logic and the General Theory of Action* (Amsterdam 1968), p. 94 (abbreviated as EDL).
8. H. Kelsen, *General Theory of Law and State* (Harvard University Press 1943), p. 30.

9. NA 196–97.

10. NA 199; EDL 94–5.

11. NA 194–95.

11. NA 194–95.

12. NA 135.

13. Cf. C. E. Alchourrón and E. Bulygin, *Normative Systems* (Vienna—New York: Springer Verlag, 1971), especially ch. 4, pp. 43–64.

14. DL is a case of what Åqvist calls "atheoretical logic." See L. Åqvist, 'Interpretation of Deontic Logic,' *Mind* 73 (1964): 246–253. Bentham's very interesting discussion of the "aspects of a law" (*Of Laws in General*, pp. 93 ff.) reveals a curiously similar conception of a logic of prescriptive expressions.

15. For the sake of simplicity we shall deal only with monadic calculi; no reference to dyadic calculi (conditional permission and obligation) will be made, in spite of their obvious importance for legal matters. For the same reason we will use the symbolism of EDL instead of that of NA.

16. From the axiomatic point of view DL3 can be weakened to Op · Oq ⊃ O(p · q), because its converse can be obtained from DLR1.

17. 'Deontic Logic', *Mind* 60 (1951): 1–15, reprinted in *Logical Studies* (London 1957), pp. 58–74.

18. Cf. *Normative Systems*, pp. 43f.

19. Cf. H. Kelsen, *Reine Rechtslehre* (Vienna 1960), pp. 76f.

20. The formula Op contains an implicit subscript x (Oxp), which remains implicit as long as no confusion arises; otherwise it is made explicit (see infra 11).

21. In *Normative Systems*, following von Wright, we used the terms 'strong' and 'weak'. This terminology might be misleading, because it seems to suggest that the strong form implies the weak one, which is not the case. Moreover, the terms 'positive' and 'negative' have the advantage of stressing the fact that positive permission requires the existence of a norm-giving act, whereas negative permission means the mere absence of such an act.

22. For the proof see the results given below (§9).

23. NA 135–141.

24. This might be the reason for von Wright's persistent doubts concerning exhaustiveness and completeness. See also EDL and 'Deontic Logics', *American Philosophical Quarterly* 4 (1967): 136–143.

25. Cf. N. Rescher, *Topics in Philosophical Logic* (Dordrecht 1968), pp. 261f. The whole logic for Nx will be construed in close analogy to Rescher's assertion logic, especially to his system A_o.

26. Cf. *Normative Systems*.

27. NA 189ff.; EDL 91ff.

28. EDL 94.

29. NA 197; EDL 94.

30. G. E. Moore, *Ethics* (London 1912), pp. 50ff. Like Moore, what we have in mind when speaking of a typically ethical sense is the rational (objective) morality and not the (historically changing) positive morality, where the situation is very similar to that of positive law.

31. Accepting it does not commit us to any form of ethical intuitionism. Cf. C. L. Stevenson, 'Moore's Arguments Against Certain Forms of Ethical Naturalism', in *The Philosophy of G. E. Moore*, edited by Paul A. Schilpp, Vol. 4 of The Library of Living Philosophers, pp. 71–90.

32. *Ethics*, p. 92.

33. *The Concept of Law*, p. 171.

30

Bengt Hansson

VON WRIGHT ON THE LOGIC OF PREFERENCE

Preferences are studied not only by philosophers but also by economists. There is, however, a striking difference between the two approaches. To the economist, preferences seem to present no special problem. He freely uses them when modelling people's economic behaviour, but he seldom spills much ink on explaining what they are and what properties they have. A preference relation is a tool, a method of describing tastes, and not a part of the subject-matter itself. Most economists agree that individual preference is an asymmetric and transitive relation, perhaps even connected, and that that is all there is to it.

On the other hand, a bibliography of philosophical preference logic would not require many pages. It would hardly contain any item *using* preferences for the study of something else, but would contain almost solely studies of preference for its own sake. No general agreement, not even about very basic principles, is likely to be found. Most preference logicians have confined themselves to a few special questions, and it is symptomatic that, apart from Sören Halldén's pioneering monograph *On the Logic of 'Better'*[1] and von Wright's *The Logic of Preference*[2] and one or two other books, the contributions have been in the form of short articles or notes. A meaningful and unified survey seems to be far away.

What, then, is the difference between philosophical and economic theories of preference? I propose that the answer lies in the nature of the things preferred. To an economist, preference is a relation between well-defined alternatives, each on the same level as the others. Typically, they are thought of as baskets containing different goods in different quantities. Philosophers, on the other hand, tend to think of preferences as something holding between propositions, states of affairs, or other proposition-like entities. They (rightly) point out that to prefer a banana to an orange is to prefer the state where one has (or eats) a banana to the state where one has an orange. To say that one prefers

things is only an elliptic way of saying that one prefers states where one has things.

But is this distinction not a mere triviality? Is there not an obvious one-to-one correspondence between things and states where one has these things? I think not. The states and other proposition-like entities are generally supposed to form a special kind of structure, a Boolean structure, formed by the usual propositional connectives 'not', 'and', 'or', etc. The problem is that, even if some propositions correspond to things in the way just mentioned, molecular compounds made up from them need not do so. 'Not to have x' cannot be rephrased in the form 'to have y'. With respect to conjunction we can do a little better: 'to have x *and* to have y' is 'to have both x and y', where 'both x and y' may be thought of as some sort of thing, if we admit a liberal ontology. But, even if we do so, this liberty would hardly be pushed so far as to include also disjunctive things. So, when the philosopher asks questions like 'if p is preferred to q (symbolized by pPq), is then not-q necessarily preferred to not-p?', they are asking something which cannot be translated into the language of having things. Such questions simply cannot arise in the economist's theory of preference, and it is therefore only to be expected that the disagreement is greater among philosophers than among economists.

Another consequence of the view that the field of compared alternatives is closed with respect to the usual propositional connectives is that we must admit preference comparisons between alternatives which are not on the same level, so to speak, as, e.g., a comparison between p and p & q (in contradistinction to one between p & $\sim q$ and p & q) and also comparisons involving two extreme alternatives: the tautology and the contradiction. There will be reasons to return to this question below.

In fact, many of the most controversial problems in the logic of preference have to do with the interaction between preferences and the Boolean operators. Among the philosophers in this field von Wright is the one who has most persistently discussed that aspect, and I therefore propose to take it as a point of departure for my own discussion of von Wright.

There are only two works by von Wright on the logic of preference: the short book, *The Logic of Preference* of 1963, and the article, 'The Logic of Preference Reconsidered', published in *Theory and Decision*, 1973.

The Logic of Preference divides naturally into two parts. In the first one von Wright analyses the concept of preference and makes several distinctions, such as between extrinsic and intrinsic preferences, between preferences and potential choices, between preferences involving and not involving risk, and others. He then limits his investigation to one special kind of preference, namely intrinsic unconditional preferences not involving risk.

Secondly, von Wright introduces a technique for deciding whether a given formula is logically true or not. This technique is based on five axioms or, as

von Wright prefers to call them, basic principles. This technique is also extended to another relation, called value-equality.

The first two principles amount to an assumption that the preference relation is asymmetric and transitive, i.e., the two assumptions underlying the economic theory of preference. Von Wright accepts these principles, provided we exclude extrinsic preferences and the possibility of changes in preferences; I will not discuss them here, because the problems they raise have no particular connection with the works of von Wright.

The last three principles correspond to three stages in which a given formula may be transformed to a certain normal form. This normal form is a truth-functional compound of preference formulas expressing comparisons between what might be called *complete* state of affairs, i.e., conjunctions containing *all* variables of the whole formula, either in plain or negated form.

To see whether a formula in such a normal form is logically true or not, we imagine that the complete states of affairs are ordered in an asymmetrical and transitive, but otherwise arbitrary way. We give truth values to formulas of the type $s_1 P s_2$ according to whether s_1 is before s_2 in that ordering or not, and to more complex formulas in the usual way. A formula is logically true if it comes out true, no matter what initial ordering we started from.

Such a technique raises two questions: Are there any reasons to believe that an arbitrary formula is always equivalent to a formula in normal form, and, if the answer is affirmative, are the proposed principles the correct ones for finding that normal form?

Elsewhere I have argued[3] that the answer to both questions is 'no'. In this article I will only make a few comments on the third and fourth principle and on von Wright's rules for their application.

The third principle says that p is preferred to q if and only if p & $\sim q$ is preferred to $\sim p$ & q. It is closely related to what Sören Halldén has called the principle of contraposition: that p is preferred to q if and only if $\sim q$ is preferred to $\sim p$. To see this, substitute $\sim q$ for p and $\sim p$ for q in von Wright's axiom. We then obtain an equivalence between $\sim q P \sim p$ and $(\sim q$ & $p)P(\sim p$ & $q)$. But the second of these formulas is the one which was equivalent to pPq by the axiom in its original formulation, so pPq and $\sim q P \sim p$ are equivalent too. A standard argument against this principle runs like this:[4] Consider a lottery with five tickets and four prices, worth 15, 10, 6, and 3 units respectively. Let A be a person with a ticket in this lottery and let p be the state of affairs that he wins the second prize and q the state that he wins the first, third or fourth prize. The value of p is 10 units and the expected value of q (in the statistical sense) is 8 units, so A should prefer p to q. But the expected values of $\sim p$ and $\sim q$ are 6 and 5 units respectively, so he should prefer $\sim p$ to $\sim q$ as well.

This argument is not defeated by the fact that it is often reasonable to evaluate alternatives in other ways than according to their expected value. It is

only assumed that the logic of preference should not *exclude* such a method of evaluation, which seems fair enough.

Sören Halldén has discussed a similar argument[5] and I think that it would be interesting to compare his view with that of von Wright. The first line of thought can be traced back to *On the Logic of 'Better'* (pages 27 and 28), where the formula corresponding to von Wright's third principle is discussed for the first time. In Halldén's example a man is planning his vacations. Should he go to Paris or to Algiers, use several small bags or a few big ones?, etc. Halldén notes: "He is comparing (flying to Paris without going to Algiers by boat) with (going to Algiers by boat without flying to Paris). He is comparing (using several small bags without using any big ones) with (using a few big bags without using any small ones). . . he is always comparing (*x* without *y*) with (*y* without *x*)". Halldén has also made similar comments on other examples in later articles.

I think that Halldén's example is illustrative of von Wright's more abstract reasoning about the connections between preference and change. Von Wright assumes that a subject says that he prefers p to q and he then asks what this would mean in different "kinds of worlds", i.e., in worlds differing in respect to which of p and q do obtain. In a world where p and q both are the case, "the subject already 'has' both p and q 'in his world'. That he prefers p to q must mean that he would rather lose q (and retain p) than lose p (and retain q). He would, in other words, rather see his present situation changed from p & q to p & $\sim q$ than see it changed from p & q to $\sim p$ & q."[6] Similarly, in a world where p & $\sim q$ obtains, to prefer p to q should mean that the subject would rather have the world unchanged than have it changed into a world with $\sim p$ & q, etc; Von Wright summarizes: "to say that a subject prefers p to q is tantamount to saying, that he prefers p & $\sim q$ to $\sim p$ & q as *end-states of contemplated possible changes in his present situation* (whatever that be)."[7]

If we return to our lottery example we see that Halldén's and von Wright's argument seems to work for the preference of p over q, but it does not for that of $\sim p$ over $\sim q$. If we accept this preference, we should also accept a preference of $\sim p$ & $\sim\sim q$ over $\sim q$ & $\sim\sim p$. But these two states are in fact q and p respectively. What, then, is wrong with the argument?

There seem to be two kinds of objections to it; one concerning its relevance and one concerning its tenability. To take the latter kind first, I am not at all sure than an argument from *changes* (potential or actual) yields valid conclusions about *intrinsic* preferences. There may well be situations, intrinsically very attractive, but such that we believe of them that they increase the risk of something very dislikable. There is nothing strange in having even a strong *intrinsic* preference for total disarmament over the present balance of power and still, *extrinsically*, choosing to retain the present state, because a total disarmament would soon enough lead to an invasion by some less trustworthy

power. One can like a certain *aspect* of a phenomenon intrinsically but never want to see it realized because it would inevitably be accompanied by something much worse. Certainly changes are intimately connected with preferences, but usually with the extrinsic sort.

But there is another objection too, and one which I think is more important because it applies *mutatis mutandis* to many other arguments in philosophical logic. Even if we accepted the argument from changes for von Wright's third principle as tenable, there would still be reasons to doubt its relevance. It should be noted that both von Wright and Halldén ask us to consider what s subject really *means* when he *says* that he prefers p to q. But we must be careful when we translate colloquial speech into a formal language. Such a translation is never a mechanical replacement of English words by formal counterparts. A student who translated 'they invited the Browns and the Johnsons' as p & q and therefore 'They didn't invite the Browns and the Johnsons' as, therefore, $\sim(p$ & $q)$ is not likely to pass his exam. In the same way we must ask of a subject who says that he prefers p to q: does he really compare two alternatives which are rightly formalized as p and q, or is he using an elliptic mode of speech to express, e.g., what is really a comparison between the alternatives p & $\sim q$ and $\sim p$ & q? Von Wright and Halldén have given excellent arguments for the thesis that everyday language is normally elliptic when preference expressions are concerned. This is a very important observation about English usage and perhaps about the psychology of man, and it is of great use when formalizing colloquial preference expressions; but it is not an argument to the point that pPq means the same thing as $(p$ & $\sim q)P(\sim p$ & $q)$. It is rather an argument that real comparisons between alternatives of the form p and q are very rare and that the phrase 'p is preferred to q' is normally to be translated as $(p$ & $\sim q)P(\sim p$ & $q)$.

This also explains why it has been so difficult to give a striking example against the debated principle. The examples that have been provided, like the lottery one above, all have an artificial flavour. If I am right, this is due to the fact that they cannot be formulated in everyday language but require an elaborated structure of probabilities and numerical values.

Von Wright's fourth principle concerns the distributiveness of preferences over disjunction. In his original formulation it is a bit complicated, but for the special case that the disjuncts are complete state-descriptions relative to some set of variables it has the form: $(s_1 \lor s_2)P(s_3 \lor s_4)$ if and only if s_1Ps_3 and s_1Ps_4 and s_2Ps_3 and s_2Ps_4. And this special case is all one needs to apply von Wright's technique. I have questioned the validity of unrestricted distributiveness over disjunctions elsewhere[8] and there is little point in repeating the arguments here, though I believe that substantial parts hold for the restricted principle above. It is more interesting to look at von Wright's reasons for accepting the principle.

In one example he considers a man who prefers an increase in salary to reduced working hours, which are in turn preferred to longer holidays. The man is given the following option: either (increased salary or longer holidays) or reduced working hours. If he takes into consideration what he knows about his employer or the job to estimate the relative probabilities of the disjunctive parts of the first alternative and then bases his preferences on this, then his preference is one *involving risk*. If he is not making such considerations but would regard the first alternative as better only if he would be sure to get something better than the second alternative, no matter what the first alternative turned out to be, then he is having a preference *not involving risk*. Von Wright explicitly limits his attention to preferences *not* involving risk. Since they satisfy the fourth principle by definition, the relevant question is: are there really any preferences not involving risk, and if so, are these the interesting kind of preferences?

Of course there may be situations where a subject has tastes such that he prefers every disjunct of a first alternative to any disjunct of a second alternative. But such preferences must be very rare, especially if an alternative comprises many disjuncts. And, since any state of affairs can be written in disjunctive normal form, it normally does. A preference not involving risk is a preference safeguarded against all possibilities. But it can hardly be maintained that all interesting intrinsic preferences are of this kind, and a logic of preference must therefore go further and also try to handle the more problematic kinds of preference.

The technique that von Wright applies to find out whether a formula is logically true or not consists of three steps, closely connected with the third, fourth and fifth principles. The first step is called 'conjunction', and it consists in substituting $(f \& \sim g)P(\sim f \& g)$ for every part of the formula of the form fPg.[9] Then the expressions to the left and the right of every P-sign are transformed into their perfect disjunctive normal forms. These expressions now having the form of disjunctions make the fourth principle applicable. This is the second step, called 'distribution'. The third step is a device for the introduction of new variables. It corresponds to the fifth principle, which I shall not discuss here.

The result of these three steps is a formula with a special structure: each atomic constituent is of the form s_1Ps_2, where s_1 and s_2 are complete state-descriptions in terms of all the variables that occur in the formula. Since each of the steps, according to von Wright, transforms a formula into something logically equivalent to it, we should expect that the order of the transformations is irrelevant as long as we use them in such a way that the final result is of the type mentioned. This is, however, not the case. When the transformations are applied in different orders, they generally yield different results, some contradictory and others not.

Stig Kanger has noticed that the fourth principles is contradictory by itself.[10] The argument runs like this: p is equivalent to $p \lor (p \ \& \ \sim p)$ and q to $q \lor (q \ \& \ \sim q)$. Therefore pPq is equivalent to $(p \lor (p \ \& \ \sim p))P(q \lor (q \ \& \ \sim q))$,[11] which, when unfolded according to the fourth principle, says *inter alia* $(p \ \& \ \sim p)P(q \ \& \ \sim q)$, thus contradicting the asymmetry of the preference relation.

A peculiar thing about this argument is the use of a contradiction as an alternative in a comparison. Perhaps one could escape from the awkward conclusion by somehow blocking such comparisons, e.g., by restricting the class of well-formed formulas. But Kanger's argument cannot be overcome so easily. For even if comparisons between contradictory (and tautological) states are blocked, we can only have preferences between a formula and its own negation. To see this we note that the fourth principle prohibits comparisons between formulas which have a common disjunct in their distributive normal forms. But, if two formulas do not have this, their respective negations do, or else one formula is the negation of the other. By the principle of contraposition the first possibility is ruled out. And we certainly want to be able to have other preferences than those of the type $pP\sim p$.

So, even those who are not convinced by the objections against von Wright's principles taken separately must admit that they do not go very well together. This is a fact that calls for explanation; for even if I hold that the principles are not logically true, this is far from saying that they are intuitively inconsistent. Why shouldn't there exist some set of preference sentences for which they hold contingently?

My answer to this is that I think that von Wright has limited his field of investigation too much and in too many respects. For each principle he introduces a new distinction between different types of preferences. If a preference concept were to accord with all the principles, it would be, so to speak, the intersection of several types. If one makes many distinctions this intersection may well be empty. I think that this is what has happened; and my reasons are the following.

It is an all-pervading characteristic of von Wright's theory that preferences between complete state-descriptions are basic and comparatively safe. They are asymmetric and transitive and the only trouble comes if they are always comparable. Therefore von Wright tries to reduce *all* preferences to preferences between such states. Although there seems to be little reason to believe that this is always possible, the approach is basically sound in the sense that it would have been a very good thing—if it had been successful.

States which are not completely described involve a certain amount of uncertainty, and they can be thought of as disjunctions of completely described possibilities. The very cautious subject does not prefer one such uncertain state to another, unless he is completely assured that every possibility in the first

alternative is better than every possibility in the second. But another subject may, more sweepingly say that he *on the whole* prefers the first alternative (without actually calculating probabilities and the like).

The first line is the safe one and the one that von Wright takes when he limits his theory to preferences not involving risk. This is perfectly all right as long as one does not deny that it may be entirely rational to have other kinds of preferences (and von Wright certainly does not do that). But we must be aware of the general tendency: the less complete a state is or the more uncertain it is, the less often it will be found to be preferred to another state.

On the other hand, the third principle seems to require that there are preferences in abundance even between very uncertain states. For the principle of contraposition says that whenever there is a preference for f over g, there is also one for $\sim g$ over $\sim f$. But, the more completely described are f and g, the more uncertain are $\sim f$ and $\sim g$. And if, in the limiting case, complete state-descriptions are always comparable, so are their negations, the most uncertain of all states. This requires a very happy-go-lucky sort of preference, in sharp contrast with the anxious kind that does not involve risk. Since the two principles are based on such different intuitions it should not be surprising that they don't work well together.

In a sense the basic assumptions of 'The Logic of Preference Reconsidered' are the same as those of *The Logic of Preference*. It is assumed that preferences between complete state-descriptions obey the usual axioms: asymmetry, transitivity, connectedness. But in another sense the approach is reversed. In his first book von Wright started from the general preferences and tried to break them down to preferences between complete states; in the new article he *defines* different preference concepts in terms of preferences between complete states.

Von Wright introduces a few new special terms: a collection of propositional variables under consideration is called a *state-space*; a complete state-description in terms of all these variables is called a *possible world* or simply a *world*. For any formula f in these variables, an *f-world* is a world where f is true.

The starting point is thus that the possible worlds are totally ordered. Since an arbitrary formula is equivalent to a disjunction of possible worlds we can simply identify each formula with a (possibly empty) set of worlds. The mathematical structure of the problem of defining preferences between formulas in general is thus that of defining an order between *sets* of points when the points themselves are already ordered. This can be done in many ways and von Wright suggests two.

In both cases he considers only preferences under specified circumstances. The idea is that if two formulas, f and g, are to be compared, there may be variables in our state-space which are used neither in f nor in g. The possible worlds relative to this smaller state-space constitute possible circumstances for

the comparison between f and g and they are denoted $C_1, \ldots C_n$. When von Wright defines what it means for f to be preferred to g under the circumstances C_i he considers only C_i-worlds. Of the C_i-worlds some are also f-worlds and some g-worlds. In his first definition he disregards those which are both f- and g-worlds and applies a kind of 'sure-thing' principle to the rest: that f is preferred to g under the circumstances C_i in the first sense means that, among the C_i-worlds, every one which is an f-world but not a g-world is preferred to every one which is a g-world but not an f-world. If we regard the formulas as sets, this means that every point in that part of f which is outside g must be preferred to every point in g which is outside f.

It is clear that the idea behind this definition is the same as the one behind the third principle in *The Logic of Preference*. The principle of contraposition is, so to speak, already built into this preference concept. And the sure-thing part of the definition has strong connections with the fourth principle. But, as we saw, the third and fourth principles were expressions of contrary intuitions and lead to very strange results when taken together. Isn't there then a risk that a definition like the one proposed will lead to similar consequences?

The answer, I fear, is yes. Preferences, as defined above, will not be transitive. To see this we assume that a subject prefers four worlds in the order p & $\sim g$ & C_i, $\sim p$ & q & C_i, p & q & C_i, $\sim p$ & $\sim q$ & C_i, where the circumstances C_i are arbitrary, p corresponds to the set of the first and third worlds, q to the second and third ones and $\sim p$ to the second and fourth ones. When p and q are compared we are asked to disregard their common element, i.e., the third world, and since what remains in p is preferred to what remains in q we must have $pP_{C_i}q$. If we compare q and $\sim p$ we disregard the second world and find $qP_{C_i}\sim p$. But $pP_{C_i}\sim p$ cannot hold, for one of the worlds in $\sim p$ (viz., the second one) is preferred to one in p) (the third one). Obviously the trouble stems from the fact that we disregard different worlds in different comparisons.

Von Wright's second definition is more undividedly a version of the sure-thing principle. f is said to be preferred to g under circumstances C_i in the second sense if, among the C_i-worlds, at least one f-world is preferred to at least one g-world and no g-world is preferred to any f-world.

Von Wright explicitly recognizes the possibility of other definitions along the same lines. The idea of defining general preferences in terms of a basic preference ordering between elements of sets of 'outcomes' associated with the propositions has been studied thoroughly by Sven Danielsson in his dissertation, *Preference and Obligation*.[12] One of the several definitions proposed therein is identical to von Wright's second one and others make use of the most and least preferred outcomes. Since there is no reason to suppose that Danielsson has exhausted all reasonable possibilities, it seems unavoidable to agree with him when he says that he finds none of these definitions entirely satisfactory.

From an ontological point of view von Wright is more specific than Danielsson: he speaks not of outcomes, but of possible worlds or complete state-descriptions in which the proposition under consideration is true. A difficulty with this approach is that all preferences are relative to a given state-space. The introduction of a new variable in that space can change the picture radically, for we are then asked to consider a completely new set of possible worlds. In fact, much of the criticism of von Wright's first system was evoked by the fact that the so-called rule of replacement was not unrestrictedly valid—an expression could replace a tautologically equivalent one only if it contained exactly the same variables. Since, e.g. p and $(p \ \& \ q) \ v \ (p \ \& \ \sim q)$ must denote the same state of affairs (which von Wright does not deny), such a restriction is difficult to understand. One way is pointed out by Danielsson: [13] we can think of the preference operator as changing its meaning from one formula to another.

This interpretation of von Wright's is supported by the introduction in his new system of the concept of *preference-horizon*. This important concept makes it possible to distinguish between different kinds of changes in a subject's preferences. Some changes are of a trivial kind and reflect only changes of taste or changes of opinion. But von Wright has called our attention to the fact that there is another kind too. In part, our preferences are determined by how far we follow the implications of the different alternatives at hand. It may well happen, von Wright says, that we take new circumstances into consideration as time passes and also that we omit old ones. The state-space consisting of the circumstances under consideration constitutes the *preference-horizon* of the subject at the given occasion. The choice of preference-horizon has thus to do with the otherwise often overlooked problem of determining the set of relevant alternatives. A wide preference-horizon corresponds to a high level of discrimination.

Many things determine a subject's preference-horizon: the importance of the matter, his experience, his power of imagination, etc. Perhaps we are also more likely to be satisfied with a narrow preference-horizon if one alternative is clearly singled out as superior at an early stage, at least if we regard our preferences as a guide for our action. It is thus perfectly rational to have different preference-horizons on different occasions. But, if we want to make a *logic* about preferences, this factor must be kept constant. This is reflected by the fact that von Wright's preferences are always relative to a state-space.

I think that the concept of preference-horizon will prove to be of great value to the study of preferences. In that field of applied preference theory which is called group-decision theory it would probably help us to understand the problem of so-called irrelevant alternatives.

On the whole von Wright's new article is rather different in character from *The Logic of Preference*. It is much less a closed system and more of a free

discussion. In *The Logic of Preference* one had sometimes a feeling that the distinctions were made only to find a preference concept that obeyed the rules that made it possible to arrive at a normal form. There are many distinctions made in the new article too, but in general both possibilities are found worthy of further discussion.

This applies also to von Wright's discussion of the old question of whether the value-absolutes 'good' and 'bad' can be defined in terms of some preference concept. There are two standard answers to this question: according to the first one a state is good when it is preferred to its own negation; according to the second one it is good when it is preferred to a certain valueless state, e.g., the tautology or the contradiction. I will not enter the discussion between adherents of the two views here, but only draw attention to a new kind of concept used by von Wright in this connection.

A difficulty with von Wright's conception of preference is that it yields, when combined with the view that something is good when it is preferred to its own negation, the result that goodness among possible worlds does not admit of degrees—only the most preferred world(s) is (are) to be called good. In order to handle this difficulty he introduces the concept of 'good in the world w', applicable only to states being *true* in w. f is good in w is defined as $fP_{C_i}{\sim}f$ *and* $f \& C_i = w$. Similarly, f is bad in w is defined as ${\sim}fP_{C_i}f$ *and* $f \& C_i = w$. A companion pair of concepts is 'f would be good in w', defined as $fP_{C_i}{\sim}f$ and ${\sim}f \& C_i = w$, and 'f would be bad in w', defined as ${\sim}fP_{C_i}f$ and ${\sim}f \& C_i = w$. In a similar way 'f is preferred to g in w' can be defined.

These notions are perhaps not perfect as they stand, because there are certain syntactical restrictions that a formula must comply with in order to be a candidate for goodness or badness: since f must be preferred to ${\sim}f$ under circumstances C_i, f and C_i can have have no common variables; since $f \& C_i$ is to be a complete state-description f must itself be such a description in terms of the variables it contains. Similarly, in order to be a candidate for would-be-goodness and would-be-badness a formula must be the negation of such a description.

Nevertheless I think that the future of preference logic lies in the introduction of new concepts such as those mentioned. Another important concept is that of conditional preference. It is closely related to preference under specified circumstances, but does not require the circumstances to be described in other variables than the states compared. I also think that the study of counterfactual conditionals will prove to be of value, especially for the analysis of von Wright's ideas about the connection between preferences and change; for we do not in general prefer an alternative to another in a vacuum, but in relation to the world in which we actually are, it *would* be better to have a change to the effect that p than one to the effect that q, tacitly assuming that the present world would be left intact in as many other respects as possible. And, since

we seem to have a reasonable semantic theory for counterfactual conditional in sight,[14] we may perhaps look forward to a fruitful semantic analysis of preference logic.

DEPARTMENT OF PHILOSOPHY BENGT HANSSON
LUND UNIVERSITY
LUND, SWEDEN
MARCH 1973

NOTES

1. Lund-Copenhagen, 1957.

2. Edinburgh, 1963.

3. In 'Fundamental Axioms for Preference Relations', *Synthese* 18 (1968): 423–442.

4. This is an elaboration of an example I gave in 'Fundamental axioms. . . .' In that version, however, the first alternative entailed the second one. This is in no way essential to the argument, and I therefore chose to change it in order to discuss only one problem at a time.

5. In 'The Better Something Is, the Worse Its Absence,' *Logik, rätt och moral. Filosofiska studier tillägnade Manfred Moritz*, Lund 1969, and also, in more detail, in 'Decision Principles in a Probability-free World.'

6. *The Logic of Preference*, p. 24.

7. *The Logic of Preference*, p. 25.

8. 'Fundamental Axioms,' section V.

9. I use f and g as metavariables over arbitrary but unspecified formulas and s with different subscripts as a metavariable over complete state-descriptions.

10. In 'Preferenslogik' ('Preference Logic'), *Nio filosofiska studier tillägnade Konrad Marc-Wogau*, mimeographed, Uppsala 1968.

11. Since a contradiction can be expressed in any variable, this substitution does not contradict von Wright's restriction on the replacement rule.

12. Uppsala, 1968.

13. *Preference and Obligation*, p. 24.

14. See e.g., Robert C. Stalnaker & Richmond H. Thomason: 'A Semantic Analysis of Conditional Logic', *Theoria* 36 (1970); 23–42, and David K. Lewis: *Counterfactuals*.

31

J. L. Mackie

VON WRIGHT ON CONDITIONALS AND NATURAL NECESSITY

The problem of how to analyse conditional, and especially contrary-to-fact conditional, statements has been an acute and controversial one for nearly 30 years.[1] That of natural or causal necessity is an older issue, but one that has recently been revived, many philosophers having become dissatisfied with a pure regularity theory of causation and with the positivist assumptions that have often seemed to restrict us to such a theory. Von Wright has made distinctive and ingenious contributions to both these problems—which he sees as being closely related—in an essay 'On Conditionals' published in 1957 and in his book *Explanation and Understanding* published in 1971. He has touched on them again in his discussion of causation in his Woodbridge Lectures, *Causality and Determinism.*[2]

His starting point is unusual. Whereas others have tried to analyse conditionals as a special sort of proposition, that is, a kind of item that can be *asserted* (but also believed, judged, known, and so on) he sets out to examine the conditional mode of *asserting,* as contrasted with simple or categorical asserting. He is concerned, therefore, with certain sorts of complex speech act.

A speaker may assert a proposition *q* conditionally upon or relative to some other proposition *p*; then, von Wright says, he "*licenses* others to take him as having asserted *q,* if the condition *p* is found to be, in fact, fulfilled."[3] As an analysis, this looks circular. But it is only a preliminary account: the substantial analysis is still to come.

'If *p,* then *q*' is the standard English form for conditional asserting; but von Wright notes that this form is also used for other purposes, and that conditional asserting can be done without it. It is the speech act itself that he is studying rather than any particular verbal form. As we shall see, he holds that this standard form normally does another job in addition to the asserting of *q* on the condition *p*.

There are, he says, two varieties of conditional asserting, potential and contrary-to-fact (counterfactual). The term 'subjunctive conditional' he rightly rejects as misleading, since grammatically subjunctive forms are used for different purposes, and span the important division between the potential (that is, open) and the counterfactual, which call for separate analyses.

A potential conditional assertion consists in asserting the material conditional $p \rightarrow q$ without either asserting or denying either p on its own or q on its own; this von Wright calls asserting $p \rightarrow q$ *intensionally*.[4] (He speaks throughout of "the material implication $p \rightarrow q$", and of "asserting that p materially implies q", but as this form of words suggests a second-order statement, I prefer to use the term 'material conditional' as a name for items of the form $p \rightarrow q$, conceding, however, that these are not conditional in the sense in which von Wright speaks of conditional asserting. He does not take care to distinguish typographically between uses and mentions of symbolically represented propositions, and I shall follow him in this respect.)

Potential conditional asserting, then, consists partly in asserting something and partly in refraining from asserting (or denying) something. This account has several interesting (and curious) consequences.

First, if someone argues in *modus ponens* or *modus tollens,* he cannot, in the conditional premiss, be making a potential conditional assertion: the asserting of the antecedent (or the denial of the consequent) in the other premiss would be incompatible with potential conditional asserting as von Wright describes it. He admits that one could *first* assert q on the condition p, and *later* discover that p (or that not-q), and so argue that q (or that not-p), but he says that when this happens one's adoption of the second premiss destroys the (potential) conditionality of the first: one is left asserting merely the material conditional $p \rightarrow q$, and it is this combined with the asserting of p (or of not-q) that involves the asserting of q (or of not-p).

A second consequence is that potential conditional asserting does not consist, as a whole, in the asserting of any proposition: refraining from asserting is an irreducible element in it. We can now see why von Wright is dissatisfied with attempts to explain conditionals as a special sort of proposition. He also gives another argument for this: a proposition could be denied, but what *could* "Not: if p, then q" mean?[5] But this argument seems weak. Why should not this denial of an open conditional mean 'It could be the case that p but not q'? Also, as we shall see, von Wright holds that in counterfactual conditional asserting, a proposition *is* asserted; yet one could have asked as plausibly 'What *could* "Not: if it had been that p it would have been that q" mean?' However, it is quite clear that potential conditional asserting *as von Wright analyses it* does not consist as a whole in the asserting of any proposition.

A corollary of this is that an open conditional can never be strictly true or false. But we can say, where p and q both turn out to be true, that q has been

truly asserted conditionally upon p, and, where p turns out to be true but q to be false, that q has been falsely asserted conditionally upon p. Where p turns out to be false, however, q will not have been asserted either truly or falsely conditionally upon p, no matter how q itself turns out.[6]

However, von Wright notes that "if q is asserted on the condition p and p subsequently found to be false, we may wish to 'strengthen' our previous conditional assertion into a counter-conditional assertion to the effect that *had p been true, q* would have been true too." Indeed he thinks that the normal use of the verbal form 'If p, then q' commits one to such a contrary-to-fact conditional assertion if p turns out to be false. So he says that this form of words is normally used to do two bits of potential conditional asserting: to assert q on the condition p and to assert, on the condition not-p, that q would have been true if p had been.[7] (As we noted above, he takes what this that-clause expresses—a counterfactual conditional—to be a proposition, and therefore something that can be asserted on the condition not-p.)

Discussing the grounds for potential conditional asserting, von Wright argues that $(x)(Px \rightarrow Qx)$ can be a ground for asserting Qy on the condition Py only if the general implication is itself asserted *intensionally,* that is, without asserting either $\sim(\exists x)Px$ or $(x)Qx$. But he insists, I believe rightly, that "it is in no way essential even to an act of asserting a singular proposition conditionally, relative to another that there should be some general proposition at hand, which may be given as a ground. . . ."[8]

This description of potential conditional asserting constitutes a coherent account of a possible kind of speech act, and it can be seen to satisfy the preliminary description that the speaker licenses others to take him as having asserted q if p is in fact fulfilled. That he does this is secured by his asserting $p \rightarrow q$; that he does no more than this is secured by his asserting this intensionally. I postpone further discussion of the merits of this description until we have looked at von Wright's more complex and intriguing account of counterfactual conditional asserting.

In this he distinguishes the deductive and the non-deductive case. The former he finds easy to deal with: "If p entails q, then to assert q on the counterfactual condition p is the same as to deny p *and* assert that p entails q."[9] This is just the conjunction of two acts of categorical asserting, since denial is a form of assertion.

Von Wright should, presumably, put into this deductive case all and only those instances where the speaker *claims* that p entails q. Even if the claim is mistaken, the analysis given will hold; and on the other hand, if p entails q but the speaker does not realise this, his speech act will surely belong to the non-deductive group: the sort of asserting in which he engages cannot be affected by an unnoticed entailment.

It is, however, the non-deductive case that is both difficult and important.

In dealing from now on with this I shall assume, for simplicity, that p neither entails q nor is believed by the speaker to do so.

Since von Wright assumes that in counterfactual conditional asserting the antecedent is actually denied (not merely, as might have been more natural, that its falsity is hinted at or presupposed), and since he also takes the asserting of a proposition to carry with it the asserting of all its logical consequences, the asserting of q on the counterfactual condition p will include the asserting of $p \rightarrow q$, and moreover its being asserted *extensionally*, since p is denied. But then what else do we do? Counterfactual, unlike potential conditional asserting, cannot be explained in terms of any refraining from assertion.

After noting, correctly, that the consequent on its own may be asserted, or denied, or neither asserted nor denied, von Wright says that what is common to all three of these cases is that some "connexion" is asserted between p and q.[10] It is here that the analysis of conditionals makes contact with the notion of natural necessity.

He says, however, that the form 'Even if p had been true, q would have been true' is ambiguous. It may express the contrary-to-fact conditional where q itself is asserted, but with the speaker still claiming, as in the two other counterfactual cases, that there is a 'connexion' between p and q: in the actual state of affairs q owes its truth to its 'connexion' with some other true proposition, say r, but the truth of p would *also* have ensured that of q. But the same verbal form can be used for a quite different purpose, to *deny* a 'connexion' between not-p and q, to say that in the actual state of affairs q does not owe its truth to not-p: this would be an "assertion of non-conditionality".[11]

Leaving this last sort of assertion aside, and returning to genuine counterfactual conditional cases where a 'connexion' is asserted between p and q, von Wright examines the suggestion that "to assert q on the counterfactual condition p is to deny p and to assert a ground for asserting q on the condition p." He rejects it, however, arguing that one can assert—even intensionally, as defined above—such a ground for $Py \rightarrow Qy$ as $(x)(Px \rightarrow Qx)$ without asserting any 'connexion' between Py and Qy. For example, we may learn that everyone who voted wore a red tie on election day, and this will be a ground for saying of y that if he voted he wore a red tie—and for asserting that $(y$ voted$) \rightarrow (y$ wore a red tie$)$—but if we learn that y did not vote the supposed ground will not justify our saying that if y had voted he would have worn a red tie. The universal red-tie-wearing among voters may have been an accident: there *need* not have been any such 'connexion' between voting and red-tie-wearing as the counterfactual conditional would require.[12]

To assert a 'connexion' between the characteristics P and Q is, in the terminology von Wright favours, to assert $(x)(Px \rightarrow Qx)$ *nomically*. He has, in effect, been criticising and rejecting the suggestion that to assert this generalisation intensionally is to assert it nomically. He also denies the converse of

this suggestion, arguing that one can assert the generalisation nomically without doing so intensionally. We assert nomically physical laws about how ideal gases (and the like) behave, claiming a 'connexion' between being an ideal gas and doing such-and-such; yet we know that there *are* no ideal gases. The appropriate $(x)(Px \rightarrow Qx)$ cannot be asserted intensionally, since $\sim(\exists x)Px$ is asserted as well.[13]

Von Wright holds that "to deny Py and assert $(x)(Px \rightarrow Qx)$ nomically entails asserting Qy on the counterfactual condition Py." This, he says, is a *partial* analysis of contrary-to-fact conditional asserting.[14] But so far the moves from counterfactual conditionals to 'connexions' and to nomic assertion have added little more than additional terminology: it has not yet been explained what any of these could actually *be*. And von Wright admits that this partial analysis, though true "by definition", will not help to solve the problem of counterfactual conditional asserting, because that problem will reappear in the attempt to clarify nomic assertion.

He considers the suggestion that to assert $(x)(Px \rightarrow Qx)$ nomically is to assert what he calls its *universality,* by which he means just that the classes determined by the characteristics P, Q, and their opposites are all *open*—that is, it is always logically possible that they should have further members. He agrees that if $(x)(Px \rightarrow Qx)$ is true in virtue of a *connexion* it will be, in this sense, universal. But he denies the converse. There can be universal accidents, cases where $(x)(Px \rightarrow Qx)$ is true, where all the relevant classes are open, and yet there is no "connexion" between P and Q.[15] And this seems to be correct.

Another suggestion is that when we assert this generalisation nomically, we say that the class of things which are P but not Q is necessarily empty. He accepts this way of speaking, but asks how this necessity manifests itself: can we say any more about it than that it means not only that everything that is P is Q but also that everything that is not P would, if it *were P,* be Q also?[16] If this were all we could say, we should be caught in a circle: non-deductive counterfactual conditional asserting is (partly) analysed in terms of the nomic asserting of generalizations, the latter in terms of the necessity of the emptiness of a certain class, and this necessity in terms of a counterfactual conditional. In an attempt to break out of this circle, von Wright considers whether there are different *grounds* for asserting $(x)(Px \rightarrow Qx)$ nomically and for asserting it merely categorically.

Deductive grounds will not help, for to assert a deductive ground for asserting this generalisation nomically would necessarily be to assert at least one other generalisation nomically, and the same problem would then arise about this bit of asserting. Von Wright concedes that natural laws form systems, but he denies that incorporation of generalisations into a system can do anything to "nomify" them. "Systems appear nomic by virtue of their coherence alone. But this is an illusion."[17] I am sure that he is right about this.

What, then, about inductive grounds? It seems that what makes us assert of everything that is not P that if it were P it would be Q also, is seeing that as things *change* from not being P to being P, they change also from not being Q to being Q (unless they are Q already), and that as things change from Q to not-Q, they change also from P to not-P (unless they are not-P already). In particular if we ourselves try to produce the characteristic P in some things that are not-Q, but find that we cannot do so without first, or simultaneously, making them Q; or again if we try to remove the feature Q from some things that are P, and find that we cannot do so without also removing the feature P, we shall have good inductive grounds for asserting $(x)(Px \rightarrow Qx)$ nomically. On the other hand the mere observation of Ps regularly, without exception, being Q, but without the observation of changes or responses to experiment, *might* (von Wright commits himself to no more than this) be an inductive ground for the mere categorical assertion of $(x)(Px \rightarrow Qx)$. *If* there are inductive grounds for asserting this proposition categorically that are not grounds also for asserting it nomically, the difference will lie in the contrast between the observation of a mere regular concomitance of features and that of correlated changes of features, particularly in response to active experimentation.[18]

Von Wright suggests, then, that we can *almost* break out of the circle here: we can characterize the nomic assertion of generalisations by reference to its characteristic inductive grounds. And yet, he says, we cannot *quite* break out. Just because these grounds are only inductive, they do not entail the proposition which we assert nomically, and *a fortiori* cannot be equivalent to it. "Therefore any attempt to analyse conditional assertion contrary-to-fact in terms of categorical assertion using the notion of grounds for nomic assertion of general implications must necessarily fail."[19] And certainly we cannot equate the meaning of a nomic assertion, or that of the associated counterfactuals, with the former's inductive grounds.

So, after all, the circle holds fast. We can analyse nomic assertion only in terms of counterfactual conditional assertion: "To assert $(x)(Px \rightarrow Qx)$ nomically is to assert of every x which is P that it is Q, *and* to assert of every x which is not P that, if it were P, it would be Q."[20] It seems that we just have to recognise asserting q on the counterfactual condition p (in the non-deductive case) as something that we do but that cannot be further analysed.

Von Wright draws three corollaries from this conclusion. First, since nomic assertion of general propositions has not yielded a satisfactory analysis, we are free to admit that "the asserting of general implications is no part of the 'meaning' of contrary-to-fact conditional asserting", though such generalisations may appear in the grounds for such conditionals.[21] This seems correct.

Secondly, where general propositions are given as grounds for counterfactual conditionals, they need not be asserted nomically: historical counterfactuals, such as 'If Hitler had not invaded Russia, he would still be ruling Ger-

many', may be supported by statements about what usually happens in certain circumstances.[22] But this argument seems weak. For one thing, although we may be unable explicitly to *state* complete generalisations appropriate for the support of such counterfactuals, it seems reasonable to construe the generalisations on which we rely not in the form '*P*s are usually followed by *Q*s' but in the form of incomplete or gappy but still strictly universal propositions, 'All instances of *P* conjoined with . . . in the absence of . . . are followed by instances of *Q*.'[23] For another, once we have accepted the notion of nomic assertion and the associated notion of natural necessity, we can allow even probabilistic laws to be asserted nomically: it can be by natural necessity, or by an objective chance or propensity that is a strict analogue of it, that changes come about as governed by an indeterministic, statistical, law.[24]

Thirdly, since counterfactual conditional asserting has not, like the potential variety, been analysed into a combination of asserting and refraining from asserting, von Wright sees no conclusive reasons for denying that in the counterfactual case there is a proposition which is asserted. So whereas 'If *p*, then *q*' does not normally express a proposition, 'If *p* had been true, *q* would have been true' does express one. But its truth conditions are elusive. One of them, of course, is that *p* be false. But its *total* truth conditions cannot be given except in counterfactual conditional terms.[25]

Von Wright has been discussing conditional asserting. But, in conclusion, he admits that there can be conditionality without assertion: "one may know or believe or think or judge that if . . . then . . . without asserting anything."[26] In the counterfactual case, there are propositions to be believed, known, and so on. But he avoids introducing, in the potential case, conditional propositions as the objects of these attitudes. He handles them on the analogy of asserting. For instance, to believe that if there is lightning tomorrow there will also be thunder is to believe the appropriate material conditional intensionally: it is to believe that it will not be the case that there is lightning tomorrow but no thunder, without believing that there will (or will not) be lightning or that there will (or will not) be thunder.

This is a subtle and challenging theory of conditionals. Though von Wright explicitly notes several loose ends, several related themes which he refrains from pursuing, he has covered much of the central area of the use of conditionals, and he has provided for many of their peculiarities. It is plausible to claim that there is a close link between contrary-to-fact conditionals and natural necessity. And von Wright has blocked, correctly in my opinion, several popular escape routes from the circle around which we go in tracing this link.

On the other hand, there is a regrettable lack of unity: or rather, the assertion of the material conditional in one way or another is the only unifying feature. There are radically different descriptions of potential conditional asserting, of deductive counterfactual conditional asserting, and of non-deductive

counterfactual conditional asserting, and of non-deductive counterfactual con-
ditional asserting. What are, on the surface, all counterfactual even-if state-
ments, of such forms as 'Even if p had been true, q would have been true', are
divided into those which assert a 'connexion' between p and q and those which
deny a 'connexion' between not-p and q. Moreover, the account combines ele-
ments of several different approaches to the problem (all of which have, of
course, been further elaborated since von Wright's essay was published). His
analysis of the potential case is largely 'materialistic,' that of the deductive
counterfactual case 'metalinguistic,' while he takes a 'consequentialist' view of
non-deductive counterfactuals.[27] But it may well be that the subject itself re-
quires these diverse treatments; the pluralism may be inelegant, but this will
not matter if it is true.

Some might object in principle to a speech-act theory of conditionals.
Though there has been much talk of speech acts in recent years (stimulated by
the pioneering work of J. L. Austin), what we can now call speech-act analyses
have become less popular since that name has become available for them. John
Searle has even coined the phrase ''the speech-act fallacy'' to describe attempts
to explain the meanings of words in terms of the speech acts they are used to
perform.[28] I would not admit that this is always a fallacy, but even it if is von
Wright cannot be accused of it. He is not setting out to explain the meaning of
the phrase 'if . . . then . . .' or of any particular form of words, but is con-
cerned explicitly with studying some of the speech acts such words *may* be
used to perform.

Nevertheless, we can and should distinguish what is said not only from the
grounds for saying it but also from the illocutionary force of the utterance, the
speaker's further purposes, and so on. There is some hope that by pressing
these distinctions we may obtain a more unitary theory. For example, it may
be that in the two kinds of even-if statements some one thing is being said,
and the asserting of a 'connexion' in the one case and the denial of a 'connex-
ion' in the other belong rather to the speaker's grounds or reasons for saying
this, or to further implications or suggestions which his utterance, in its con-
text, may convey. Similarly it may turn out that in the deductive counterfactual
case the speaker is *saying* just the same as in the non-deductive, but that in the
former alone he has the entailment as a ground for whatever it is that he is
saying, and if the entailment is obvious enough (and yet not too obvious) the
natural conversational point of his utterance may be to draw attention to it. But
all these hopes depend upon our ability to supply an alternative, unitary, ac-
count of what is said in all acts of conditional asserting.

These remarks concern the linguistic problem of conditionals. But there is
also the metaphysical or ontological problem of natural necessity—whether
there is any such thing, and if so in what it consists. It is in relation to this that
the admitted circularity of von Wright's account of the non-deductive case is

disappointing. If we really cannot break out of the circle, natural necessity seems to become subjective: what is fundamental in it is a special sort of complex speech act that we perform. Nomically asserted generalisations claim that there is a 'connexion,' and so do singular non-deductive counterfactual conditional assertions. This 'connexion' constitutes a kind of necessity that is not logical necessity. But what *is* it? We are, it seems, debarred from answering this, though we can specify the sort of inductive grounds that support such assertions. We must hope either to find some other way out of the circle or to develop a more objective description of natural necessity from a consideration of its inductive grounds.

But can we first supply an alternative, unitary, account of what is said in all kinds of conditional asserting? Two possibilities present themselves. One is that to assert q on the condition p is to frame the supposition that p and to assert q within the scope of that supposition. The other is that to do so is to say that in the possible situation that p, it is also the case that q. But these are not really rival suggestions. Each is, on its own, rather obscure. Just what is involved, the critic may ask, in framing a supposition and performing some further speech act within its scope? (Of course, the latter speech act need not be asserting: this suggestion leaves room for conditional commanding, conditional promising, conditional questioning, and so on.) And just what is it to describe a possible state of affairs in some selective way, that discriminates in favour of one rather than others of the descriptions which are logically compatible with the that-clause by which the possible state of affairs is introduced or initially identified ('the possible situation that p')? Yet both formulations apply to something that we clearly do on innumerable occasions, and we can perhaps let them complement each other. The second offers a clearer account of what we are saying, but the first provides a deeper understanding of what is going on. It makes it clear that a complex speech act is involved, and it relates this to a well-known formal procedure in natural deduction. Possible situations, on the other hand, are not literally there to be described or discovered; they exist only in our constructing and considering of them.[29] Of course we do this not in an arbitrary but in a fairly systematic and rule-governed way. It is, however, a merit rather than a defect of our second suggestion that there may well be *some* indeterminacy as to what is *the* possible situation that p. For this reproduces an indeterminacy in the conditional assertions themselves. For example, suppose someone says, 'If the weather is fine this afternoon, the match will be played', and then suppose that it is fine, but there is an earthquake at lunchtime, and the match is not played; has he asserted falsely that the match will be played on the condition that it is fine, or has the condition in relation to which he was asserting not been fulfilled? Is the actual situation too different from what could normally be anticipated to count as *the* possible situation that it is fine? No firm answer can be given.

Let us apply this double suggestion to the several parts of von Wright's account. First, we can see that it agrees with his general preliminary description of conditional asserting. If someone asserts q within the scope of the supposition that p, he clearly licenses others to take him as having asserted q if this supposition turns out to be fulfilled.

Secondly, anyone who asserts q within the scope of the supposition that p has, by implication, asserted $p{\rightarrow}q$: in the formal logic of natural deduction 'conditional proof' allows us to draw the conclusion $p{\rightarrow}q$ from an earlier step in which q is stated within the scope of an assumption that p. But what about the 'intensionality'? Von Wright's potential case is, by definition, one in which the speaker leaves it open whether p is true or not. He cannot then be asserting p, or not-p, or not-q, along with $p{\rightarrow}q$. But this does not quite complete the requirements for asserting $p{\rightarrow}q$ intensionally: he might also be asserting q. There is no reason why he should not do this. But there is a reason why, if he is doing so, he should not say something that merely asserts q within the scope of the supposition that p, namely the conversational principle that (without some further reason) one does not make a weaker statement when one is in a position to make a stronger one.[30] Of course, one may have such a further reason. For example, one may be opposing some tendency on the part of the hearer to believe that although q will hold if not-p holds, it will not hold if p holds. The speaker will then be asserting that q whether p or not-p, that is, he is asserting q both on the condition that p and on the condition that not-p, and he will find it natural to express this by saying 'Even if p, q,' where 'even' has the force of 'and also,' and thus conjoins the asserting of q within the scope of p to the presupposed holding of q within the scope of not-p, which is common ground between speaker and hearer. I conclude, then, that the potential conditional asserting of q in relation to p should *not* be taken to preclude the asserting of q on its own. Our suggestion, then, explains *most* of what von Wright calls asserting $p{\rightarrow}q$ intensionally, and where the two accounts diverge, over whether q itself may also be categorically asserted, our suggestion is truer to the facts in that it accommodates a natural use of 'Even if p, q'. Von Wright might object that this is rather the denial of a conditional assertion, that it is saying 'Not: if p, then not-q' (though as we saw earlier he questioned the possibility of such a negation). This may indeed, as I have suggested, be the point of the utterance; but we can see how an utterance can have this point while all it literally says is that q holds within the scope of the supposition that p (as well as within that of not-p). Our suggestion can also more easily accommodate the use of *modus ponens* and *modus tollens*. If conditionality consists in the asserting of q within the scope of the supposition that p, it survives the addition of the assertion that p or the denial that q; it is only the openness of the supposition that goes, and we can still handle a supposition as such even when we are also committed to asserting or denying it. However, the assertion

of q within the scope of p involves the intensional asserting of $p{\rightarrow}q$ in a slightly different sense from von Wright's: it cannot be justified merely by the truth of q or by the falsity of p. It must be, in other words, what Johnson calls a non-paradoxical implicative (compare note 4).

Thirdly, where p is denied (or, rather, where its denial is suggested or presupposed) but the speaker still asserts q within the scope of the supposition that p, we have a piece of counterfactual conditional asserting. This covers von Wright's deductive as well as his non-deductive case. But where the speaker believes that p entails q, he has an excellent reason for asserting q within the scope of p, or for saying that in the possible situation that p, q would also have held. Indeed, it is almost too good a reason. Such a counterfactual will usually be too obvious to be worth stating.

It is the non-deductive case, therefore, that is of crucial interest and importance. As I have said, our general description still seems to apply. But the vital questions are whether our suggestion can throw any light on the link between these counterfactuals and laws of nature and whether it can take up and develop von Wright's point about the inductive grounds for nomic assertion.

Postponing these questions, however, it does seem that we can provide the desired unitary account of what conditional asserting is, and hence that we can actually make the criticisms of von Wright's separate treatments of its varieties which were merely foreshadowed above.[31] Yet most of what he says now falls into place around this unitary core. The key to the understanding of conditionals is indeed a complex speech act. Something like his intensional asserting of $p{\rightarrow}q$ results when q is asserted within the scope of p and it is left open whether p is true or not. The second-order assertion that p entails q does not, indeed, ever form part of the first-order performance (*using* the propositions p and q rather than talking about them) of asserting q relative to p, but the belief that this entailment holds is an excellent ground for such conditional asserting (potential or counterfactual) and the point of the conditional asserting *may be* to draw the hearer's attention to this entailment. Where there is no such entailment, the speaker will normally be relying upon, and therefore also suggesting the presence of, some other 'connexion' between p and q. He will need something if he is to justify his claim that q is to be included in the possible but not actual situation that p. If the class of things that are P and not-Q is necessarily empty, then it is not a possible situation that this thing y should be P and not-Q, and it follows that in the possible but non-actual situation that y is P, y would be Q also. That is, a natural necessity would entail just what we have taken a non-deductive counterfactual conditional assertion as saying.

On the other hand, our suggestion would reverse some of von Wright's conclusions about the presence or absence of conditional *propositions*. On the face of it, 'In the possible situation that p, q also' is always a pseudo-proposition. It purports to describe a possible state of affairs, but there are no such

fully objective entities to be described. There are indeed entailments, but that is a second-order matter which never forms part of what is said in first-order conditional asserting. There may be 'connexions', but surely even they can hold only between existing entities, not between a merely possible Py and Qy. So when, as the user of a counterfactual presupposes, the antecedent is unfulfilled, we always have only pseudo-propositions: if we call the deductive assertings true, it is by a deliberate extension of the ordinary notion of truth.[32] But if the antecedent of a conditional is fulfilled, as potential conditional asserting allows that it may turn out to be, then the possible situation that p has turned out to be the actual situation—subject to the slight reservations indicated by our earthquake example. Consequently what, in the conditional asserting, is said, that in the possible situation that p, q also, has thus come to describe, truly or falsely, the actual state of affairs, and it can therefore be classed as a genuine proposition after all.

Let us return, then, to the problem of natural necessity, 'connexions', and the nomic asserting of generalisations. We have found one way out of von Wright's circle, in that we have given some sort of independent analysis of the counterfactual along with the other sorts of conditional. But this is still a subjective analysis, in terms of what the speaker is doing, framing suppositions and asserting within their scope, or contemplating and developing possibilities; this will not in itself yield any positive account of the ontology of natural necessity.

Our best clue to this is what von Wright has specified as the inductive grounds for the nomic asserting of the generalization $(x)(Px \rightarrow Qx)$. Something changes from being not-P to being P, and (if it was not already Q) it first, or simultaneously, becomes Q. Or something changes from being Q to being not-Q and (if it was previously P) either first or simultaneously becomes not-P. And it is particularly significant if these correlated changes occur in our active experiments: we try to make something that is not-Q into a P, and fail to do so without also making it a Q, or we try to remove the feature Q from something that is P, and fail to do so without also removing the feature P. Conceding to von Wright that since these are only inductive grounds they do not constitute an *analysis* of nomic assertion, we can still ask what sort of relation such observations would be good evidence for. Can we make something of the metaphor of *connexion*? These observed changes (as opposed to mere concomitances) show the characteristic P bringing Q with it, or Q carrying P away with it. The experiments show that when we bring P in, Q comes with it, and when we take Q out, P follows it away. Passively looking at two things will not reveal whether they are connected, but if we pull one and the other moves with it this strongly suggests that they are. Still, this is only a metaphor. What we are trying to grasp is the kind of causal connexion for which it is a metaphor. Essentially, the notion is that the world has certain standard ways of running on from an occurrence of one sort to an occurrance of another sort,

certain *laws of working*. These laws are not subject to our control. But we can use them. The initial occurrences are sometimes, to some extent, in our power. We can intervene to produce an initial occurrence (or to prevent something that would otherwise have come about) and see how things run on from there. In the simplest case the natural necessity for which the observations and experiments that von Wright specifies are evidence is just the holding in particular instances of a law of working, the world's running on in its own way from an intervention.[33]

In 'On Conditionals' we were left with a well-argued but still disappointing circularity which defeated attempts to analyse either counterfactual asserting or natural necessity. But we now seem to have found two ways out of the circle: the suppositional analysis of conditional asserting and the notion of a law of working as constituting natural necessity. But two ways out may be an embarrassment. How are they related to one another? Why should what we have called laws of working involve counterfactuals? Why should the statement that something is a law of working commit us to asserting nomically the corresponding generalisation? Will we not have to *add* the element of counterfactual force to the rather bare concept of things running on in their own way, and so fall back into a subjective account of what was meant to be an ontological feature? Some things that von Wright says in *Explanation and Understanding* are relevant to these questions.

He repeats that "The assumption (hypothesis) that the concomitance of p and q has a nomic character contains *more* than just the assumption that their togetherness is invariable. It contains also the *counterfactual assumption* that on occasions when p, in fact, was not the case q would have accompanied it, had p been the case. The fact that it is a ground for counterfactual conditionals is what *marks* the connection as nomic."[34] He admits that "it is logically impossible to verify on any single occasion when p was (is) not there, what would have been the case, had p been there. But", he says, "there is a way of coming 'very close' to such a verification." If p is a state of affairs which we can, sometimes at least, produce or suppress 'at will', then there are occasions on which p is not already there and, we feel confident, will not come to be unless *we* produce it.

> Assume there is such an occasion and that we produce p. We are then confident that had we not done this, the next occasion would have been one when p was *not* there. But in fact it is one when p is there. If then q too is there, we should regard this as the confirmation of the counterfactual conditional which we could have affirmed had we not produced p, viz., that had p been there q would have been there too. This is as "near" as we can come to the verification of a counterfactual conditional.[35]

Well, it is not very near. It is the verification of what *would* have been a counterfactual if (counterfactually!) we had not produced p. Also, as von Wright notes, it " 'rests' on another counterfactual conditional, *viz.*, the one

which says that p would not have been there had we not produced it''. And whereas he says that the latter "is not a statement of a conditionship relation nor of a causal connection'', I would argue that the necessity and sufficiency in the circumstances of a nonintervention for a non-change is logically just like the dependence of a change on an intervention, and that it is reasonable to extend the concept of causation to cover such persistences of states of affairs.[36]

On the other hand, once we split the counterfactual into its two components, the (presupposed) denial of p and the asserting of q within the scope of the supposition that p—it is, of course, this splitting that enabled us to bring counterfactuals and open conditionals into a single theory—there is no mystery about how it may be supported, though it cannot be conclusively verified. Von Wright's worries here are due partly to an undue concern with conclusive verification and partly to his keeping the non-deductive counterfactual as an unanalysable unit, which makes it look more mysterious than it is. If we have *inductive* evidence—say of the kinds he has specified—for the generalisation $(x)(Px{\rightarrow}Qx)$, then this evidence is logically related in just the same way to a case where y_1 is P, to a (past, present, or future) case where y_2 may be P, and to a case where y_3 might have been P, but we know or believe that it was not—where in none of the three cases do we know whether the y is (was, will be) Q. Then if the evidence supports the assertion that y_1 is Q—and this is what is meant by saying that it is inductive evidence for $(x)(Px{\rightarrow}Qx)$—then it equally supports the asserting of Qy_2 within the scope of the supposition that Py_2, that is, it justifies potential conditional asserting, and it equally supports the asserting of Qy_3 within the scope of the supposition that Py_3; the fact that the denial of this supposition is also presupposed is neither here nor there. Nor does the fact that the open conditionals may, in some cases, be conclusively verified, whereas the counterfactual ones cannot, undermine the exact logical analogy between the support given to the two kinds, in advance of any verification, by the appropriate inductive evidence.[37]

But if this is correct it radically affects the thesis which von Wright has taken over from Kneale and Johnson, and which many others have also endorsed, that it is being a ground for counterfactual conditionals that marks a connection as nomic.[38] This might suggest that what goes on in the world has some peculiar quality, that a nomic (causal) connection, though it falls short, as Hume showed, of logical necessity, has still some extra strength that makes it intermediate between the purely contingent and the logically necessary. But if our account is right the counterfactual force of the nomic asserting of a natural law belongs not to the content of the law statement, not to what it describes as going on in the world, but to the sort of inductive grounds we have for it: what supports the counterfactuals is the evidence for the law rather than the law itself. Ontologically speaking the law is (in the epistemically primary cases) just how the world runs on from an intervention.

But I have not yet answered my own question why laws of working should involve counterfactuals, why recognising something as a law of working should commit us to asserting it nomically. I seem rather to have made this problem more acute by removing any counterfactual *content* from the law and by explaining separately how inductive evidence (of the sorts von Wright specifies) supports a counterfactual. But closer inspection resolves the problem. It is, as we have seen, particularly for a law of working that we can have inductive evidence; it is such a law that is instantiated by the observed pairs of correlated changes—especially when they appear in response to a test, an experimental intervention, for this separates out one pattern of change, one strand of development which in passive observation might more easily be crossed and confused by others. Since it is this inductive evidence that supports counterfactuals, we shall be in a position to assert such a law when and only when we are in a position to engage in the corresponding counterfactual conditional asserting.

(Of course, this is only the simplest case, where the law is directly supported by experiments. A fuller study would have to allow for derived laws, the testing of a proposed new law against a background of already confirmed laws, the justification of counterfactuals by the joint use of several separately established laws, and so on. But if we can understand the basic case, there is little doubt that the complications will fall into place.)

However, our account has one curious consequence: since anything that counts as inductive evidence for a generalisation will support the corresponding counterfactuals, there cannot be inductive grounds for asserting a generalisation categorically without asserting it nomically—a possibility which, as we saw, von Wright left open. This consequence should, I think, be accepted. Passively observed concomitance, which von Wright mentioned as a possible ground for categorical but non-nomic asserting of a generalisation, is just very weak evidence, but in so far as it is evidence at all for the generalisation it supports the statement that if y_3 had been P, it would have been Q. But the stronger evidence of correlated changes supports this counterfactual much better because it mirrors our most natural way of introducing a contrary-to-fact supposition: we construct possible situations by divergences from the actual course of events.[39] We suppose y_3 to have *become P*, and the evidence which bears most strongly upon this consists of observations of other things becoming P.

I have, therefore, substantial disagreements both with von Wright's theory of conditional asserting and with his account of natural necessity. These stem from the suppositional analysis of the counterfactual. This allows us, first, to assimilate to one another all the varieties of conditional asserting, to exhibit them as having differentiating features added to a common core. Secondly it enables us to break out of von Wright's circle, which appeared to block all attempts to give any further analysis of counterfactuals or nomic asserting or

'connexions' or natural necessity. Thirdly, it leads us to take the counterfactual force out of the law itself—leaving the natural necessity merely as the fact that the world (regularly) runs on in a certain way after an intervention—and to locate it in the inductive evidence which we may have for such a law of working. Thus I arrive at a theory of conditionals and of natural necessity which differs considerably from von Wright's own, but which can be developed and defended very largely by the use of materials that he has supplied.

There is, however, a further problem. So far we have introduced natural necessity only as how things run on *after an intervention*. But surely if there is any sort of necessity in any causal process, there is the same sort of necessity in all of them, whether they start from a human intervention or not. Causality pervades the universe; it is not confined to that tiny region of space and time within which all human activities are enclosed, or even to the sum of this-and-such other regions as may be the fields of operation of other finite agents. And divine agency is too problematic to resolve the difficulty. Von Wright, however, insists on the link between causation and agency. Though he admits that "Causation operates throughout the universe—also in spatial and temporal regions forever inaccessible to man" he says that "to think of a relation between events as causal is to think of it under the aspect of (possible) action . . . *that p* is the cause of *q* . . . *means* that I could bring about *q* if I could do (so that) *p*." He concedes that a contrary case could be made out and "sustained by weighty arguments", namely one for the view that the concept of causation is more basic than that of action, but he still adheres to the view that the reverse is the case. "The idea of natural necessity, as I see it, is rooted in the idea that we can bring about things by doing other things."[40]

The experience of bringing things about may well be that in which we first acquire the idea of natural necessity; but must we conclude that this idea incorporates that of such a (possible) experience? Can an 'idea' not be detached from the context in which alone it is originally acquired, and the feature it represents be ascribed to things that are not being considered as even possibly within that original context? This query stirs up very fundamental issues in epistemology—bearing, for example, on the problem of other minds and in general on that of realism as opposed to phenomenalism—but that is all the more reason for taking it seriously. Such detachment is one of the things that Berkeley condemned under the name of abstraction, but his central argument on this theme, to the conclusion that we cannot coherently conceive things existing unconceived and unthought-of, is surely fallacious.[41] Yet it has many echoes in later thought of which von Wright's view about causation and action is one.

If we reject such arguments, we can allow the natural necessity—which we first detect as the way in which the world runs on after an intervention—to be ascribed, by transference, to causal processes at all times and places and of

every degree of magnitude and intricacy, without their being thought of under the aspect even of possible action. The world can run on in the same way from things other than interventions.

But, von Wright argues, the concept of action supplies an essential element in our causal concepts: that of the asymmetry of cause and effect, or what may be called the direction (or directedness) of causation.[42] There is no doubt that the ordinary concept of causation includes this asymmetry, and, as von Wright says, it "cannot be accounted for in terms of temporal relationships alone".[43] His suggestion is that "If p is the cause- and q the effect-factor, then it will have to be the case either that by doing p I could (can) bring about q or by doing $\sim p$ I could (can) bring about $\sim q$." In defending this asymmetry, he insists on the distinction between the generic factors p and q and their instantiations, occurrences on particular occasions. He uses the example of two buttons so connected that by pressing down either I make the other go down also, simultaneously. So far as the generic events—the left-(right-)hand button's going down—are concerned, the situation is symmetrical; but on any particular occasion the relation is asymmetrical: I press down one button and the other goes down as a result. When I thus bring about q by doing p, p is the cause, though on another occasion I may bring about p by doing q, and *then* q is the cause.[44]

Von Wright mentions, as a difficulty, the case where a stone drops (but no one dropped it) on one button and as a result both buttons go down. He asks "would it be right to say in this case that the *sinking* of the button which happened to be hit caused the sinking of the other button?" He does not answer this question, and there is some doubt about how he intends it to be answered. The rest of his discussion suggests a negative answer, so this is probably a rhetorical question.[45] But if so, it shows how different the intuitions of different people can be. To me it seems quite clear that the answer is 'yes', that the sinking of the button which the stone hits is an intermediate cause: it is an effect of the stone's dropping and a cause of the other button's going down. Any reluctance to say this is due to the fact that such an intermediate cause is of little interest or practical use: our attention is naturally directed to the prior cause, the fall of the stone. In defence of this answer, I should compare this case with one where someone did drop the stone. Then, I imagine, von Wright would say that the sinking of the button on which the stone lands caused the sinking of the other button: someone brought about the latter by bringing about the former by dropping the stone. But how can the stone's having fallen naturally, rather than being dropped by an agent, make any difference to the relations within the later part of the process? Different answers in the natural-dropping and dropped-by-someone cases would sacrifice the objectivity of the directedness of causation.

However, I may be misinterpreting von Wright, since he seems to say that

even where I press one button its sinking is not the (simultaneous) cause of the other's sinking because "the pressing down of a button is not a basic action"— that is, "an action which we can do 'directly' and not only by doing something else" such as the raising of my arm.[46] But a view that he might well have adopted is that a basic action is causally prior to anything I bring about by performing it *and* that if the causal chain on a particular occasion runs from the basic action p through an intermediate event q to another event r, then not only is p causally prior to both q and r, but also q is prior to r: causal priority is transmitted along causal chains from basic actions. This would allow von Wright to say that the sinking of the button pressed (q) is causally prior to that of the other button (r) because the chain of causation runs through q to r from the movement of my finger (p) which is a basic action. Still, he does not *say* this. And, as I have argued, if he did he would have either to concede the same with regard to the button struck by the stone (whether dropped or not) or abandon the objective asymmetry of causation.

In fact he concentrates exclusively on the causal priority of basic actions. But this generates another paradox.

> The result of a basic action may have necessary, and also sufficient, conditions in antecedent neural events (processes) regulating muscular activity. These neural events I cannot "do" by simply making *them* happen. But I can nevertheless bring them about, *viz.*, by performing the basic action in question. What I then bring about is, however, something which takes place immediately *before* the action . . . I say to somebody: "I can bring about the event N in my brain. Look." Then I raise my arm and my interlocutor observes what happens in my brain. He sees N happen. But if he also observes what I do, he will find that this takes place a fraction of a second after N. Strictly speaking: what he will observe is that the result of my action, *i.e.*, my arm going up, materializes a little later than N occurs.[47]

Von Wright says that this must be accepted as "causation operating from the present towards the past", as a failure of parallelism between the directions of time and of causation. He rejects the attempt to restore the parallelism by saying it was my *decision* to raise my arm that caused N, on the ground that the decision might not have been carried out: only the actual going up of my arm necessitated the occurrence of N. While I welcome the conclusion that it is in principle conceivable that the directions of time and causation should be opposed, I find this argument unconvincing, and its corollary, a profusion of actual cases of backward causation, highly implausible.

A difficulty which von Wright mentions is that a neurophysiologist may check the hypothesis we have been using—that a certain kind of neural event is a necessary, or a sufficient, condition of the result of a certain basic action. He will test it by somehow preventing the neural event and seeing that my arm does not then go up, or by producing the neural event—stimulating a certain brain centre—and seeing that my arm does go up. Surely in thus checking the

hypothesis he has also shown that the neural event is causally as well as temporally prior to my arm's going up, contrary to what was said above.

Von Wright's reply is to distinguish two different "closed systems". One is set in motion when I raise my arm. In this, the "initial state" is the arm in the upright position; to this system also belongs the neural event N, but though earlier it is causally posterior to the initial state, in that I bring about N by doing so that the arm is upright. But when the neurophysiologist interferes with the brain, he sets in motion another "closed system", in which the initial state is the presence (or absence) of N and the arm's being upright or not is causally as well as temporally posterior. The directions of causation in the two closed systems are different.[48]

But will this really do? Suppose that the neurophysiologist is ready and able to interfere, but does not, and I raise my arm. Then surely von Wright must say that N is the cause of my arm's going up, just because the neurophysiologist *could* have produced or prevented the latter by way of the former. He is committed to this by the definition quoted above, "*that p* is the cause of *q* . . . *means* that I could bring about *q,* if I could do (so that) *p*". Yet the same definition forces him to say that the arm's going up is causally prior to N, since I bring about N by doing so that my arm goes up. Thus his own doctrines force him to abandon the objective asymmetry of cause and effect even on a particular occasion; relatively to the two different closed systems, of which one was set in motion and the other might have been, the same individual sequence of events incorporates two opposite causal directions.

The solution of this paradox lies in a treatment of this asymmetry analogous to that recommended above for natural necessity in general: we can and should detach the idea from the context in which it was first acquired. Causal priority is something which we first encounter in our experience of bringing about one thing by doing another, but it is not to be *defined* in terms of that operation. This will leave us free to say that although neural events may in a sense be said to be brought about by the performance of slightly later basic actions, it is nonetheless these neural events that are objectively causally prior to, for example, my arm's going up. The basicness of these actions belongs to our experience, to what we are ordinarily directly aware of, not to the intrinsic order of events. Of course, this is only the sketch of an answer; it would be a further task to say in what the causal priority consists, if it is not to consist in the link with a (possible) basic action. But this link is to be evidence, and yet not infallible evidence, for it. This is not the place to develop my own ideas on this issue.[49] What I want to argue here is that von Wright has correctly stressed the asymmetry of cause and effect as an ingredient in our idea of natural necessity, that it may also be an ingredient in an objective natural necessity, but that what he offers as an analysis of it is only the first step towards a satisfactory account.

Von Wright returns to these problems in his Woodbridge Lectures. While he does not refer explicitly to the circularity stressed above (that we seem forced to analyze counterfactual conditionals in terms of nomic generalisations, the latter in terms of the necessity of the emptiness of a certain class, and such necessity in terms of counterfactuals), he now seems to make necessity fundamental: his account of counterfactuals and 'nomicity' is a modal one. The relevant modalities are elucidated by a picture of 'branching time': there may be real (not merely epistemic) possibilities that the present state of the world should be followed immediately by any one of a number of different future states, and natural necessity consists in the restriction of such real possibilities to a proper subset of those that are logically possible. Von Wright discusses the formal structure of these modalities and the logical systems to which various sorts of statements about the future and about the past conform, but none of this seems to supply any further analysis of what constitutes such necessity or possibility. He takes refuge in the admittedly metaphorical statement that what is required (to decide whether a generalisation that has held good so far is accidental or nomic) is "a dive under the surface of actual reality into the depths of unactualized possibilities".[50]

He reaffirms his view that the concept of causation which includes such nomicity (and also asymmetry or directedness) is "secondary to the concept of a human action"; he therefore calls it *manipulative* causation. But his fuller account in these lectures brings out clearly that the concept of acting is that of interfering with the history of the world: it involves a contrast between what did happen (when one acted) and what would have happened (if one had not interfered). Action therefore presupposes some (known or believed) regularity which includes a counterfactual element.[51] He argues, indeed, that these counterfactuals (for example that something would have remained where it was if I had not moved it) are not causal. Now it is a mainly verbal issue whether we call such "continuations of normal states of affairs" causal or not, but it is undeniable that both the singular judgements we make about them and the corresponding generalisations involve or entail counterfactuals just as causal ones do; if there are nomic connections anywhere, they are here too. There seems, therefore, to be a vicious circularity in the attempt to analyse the nomicity of causation in terms of action; the concept of action presupposes just that sort of relation which it is being used to explain.

A similar difficulty (additional to those mentioned earlier) affects von Wright's claim about causal asymmetry that "the ultimate basis for the cause-effect distinction is direct action".[52] In explaining why an experimental interference (bringing about p upon which q follows) produces a belief in the *nomic* sequence of q upon p, he argues, correctly, that if we see ourselves as introducing p where it would not otherwise have occurred, we exclude the possibility that there is some other common cause of both p and q.[53] That is, this

experimental interference enables us to distinguish one from another possible pattern of causal directedness, but it does not reveal any source for the idea of causal directedness in general. Indeed, to see one's own action as spontaneous is to see it as *not* being the effect of something else; the concept of causal asymmetry is already contained, albeit negatively, in the concept of an action which von Wright is using.

Moreover, he seems to have great difficulty in deciding how far the concept of manipulative causation is objectively applicable. At one point he argues that causation, nomicity and all, is *ontically* independent of agency, though *epistemically* the former concept is dependent on the latter.[54] But a page or two later he agrees with Hume that "In nature there are only regular sequences", so that "in a sense, 'natural necessity' is a misnomer".[55] He denies, indeed, that natural necessity becomes subjective, that it exists only 'in our minds'. His reason is that action itself is something that occurs objectively, in the world. But the conclusion to which this would lead is that nomic connection and causal asymmetry occur in reality only in processes that are initiated by human actions, and that our extension of these concepts to purely natural processes, though understandable, is illegitimate. And then we are back with the paradox that the movement of one button will bear a cause-effect relation to that of the other if the former is hit by a stone dropped by a human agent, but not if it is hit by one that has fallen naturally.

There are, therefore, obscurities and difficulties here. I suggest that if they were cleared up satisfactorily we should have an account of causal relations which preserved their asymmetry but supplied a not merely objective but also non-anthropocentric substitute for the counterfactual conditional element which, I believe, is at the root of all von Wright's troubles about natural necessity and nomic connection. But such causation would not then be specifically manipulative; instances of it which involve manipulation would not differ essentially from others, though we can admit the importance of manipulative examples for our initial acquisition of causal concepts.[56]

On these further topics, then, of the relations between natural necessity, bringing things about, and the direction of causation I would say much the same as I said above about conditional asserting and natural necessity in general. We need to go beyond the conclusions that von Wright himself reaches; yet a more adequate account can be developed from the suggestions he has made, and his leading notions may all find places within it, though not exactly the places he has assigned to them.

UNIVERSITY COLLEGE J. L. MACKIE
OXFORD UNIVERSITY
SEPTEMBER 1973

728 J. L. MACKIE

NOTES

1. Much of this discussion stems from papers by R. M. Chisholm ('The Contrary-to-Fact Conditional', *Mind* 55(1946): 289–307, reprinted in *Readings in Philosophical Analysis,* ed. Feigl and Sellars (New York, 1949), pp. 482–97) and Nelson Goodman ('The Problem of Counterfactual Conditionals',) *Journal of Philosophy* 44 (1947): 113–28, reprinted, with minor changes, as Chapter 1 of *Fact, Fiction, and Forecast* (Cambridge, Mass., 1955).

2. 'On Conditionals' is published in von Wright's *Logical Studies* (London, 1957), pp. 127–65, and is hereafter referred to as *OC*; *Explanation and Understanding* (London, 1971) is hereafter referred to as *EU*. The Woodbridge Lectures, *Causality and Determinism* (New York and London: Columbia University Press, 1974), are hereafter referred to as *WL*.

3. *OC* 130.

4. *OC* 134–5. It would be interesting to know to what extent von Wright's view here is influenced by W. E. Johnson's account (*Logic* (Cambridge, 1921), Part I, 30–47) of 'implicatives'. Johnson says that the 'constitutive element' of a conditional is always (in effect) a material conditional; differences are only "epistemic", depending on the mode of derivation. He calls conditionals or implicatives paradoxically reached if they are derived either from the denial of the antecedent or from the assertion of the consequent, so his non-paradoxical implicatives are close to von Wright's intensional asserting of material conditionals. But there are differences. Whereas von Wright's account creates difficulties for *modus ponens* and *modus tollens,* Johnson's seems designed to fit in with these argument forms. Non-paradoxical implicatives can be asserted along with the assertion of the antecedent or the denial of the consequent, whereas paradoxical ones, being derived from the denial of the antecedent or the assertion of the consequent, cannot be used in *modus ponens* or *modus tollens* without either contradiction or circularity.

5. *OC* 131.
6. *OC* 136.
7. *OC* 136.
8. *OC* 139–42.
9. *OC* 144.
10. *OC* 146.
11. *OC* 146.
12. *OC* 147–9.
13. *OC* 149–50.
14. *OC* 150.
15. *OC* 151–3.
16. *OC* 153–4.
17. *OC* 155.
18. *OC* 156–9.
19. *OC* 159.
20. *OC* 159.
21. *OC* 160.
22. *OC* 161.

23. Cf. C. G. Hempel 'The Function of General Laws in History', *Journal of Philosophy* 39 (1942): 35–48, reprinted in *Aspects of Scientific Explanation* (New York, 1965), esp. p. 238, on explanation sketches; J. L. Mackie, 'Causes and Conditions', *American Philosophical Quarterly* 2 (1965): 245–64 and Chapter 3 of *The Cement of the Universe* (Oxford, 1974), hereafter referred to as *CU*.

24. This view is adopted by, for example, R. G. Swinburne, *An Introduction to Confirmation Theory* (London, 1973), pp. 21–2: "Taken as a physical probability proposition 'all atoms of carbon-14 have a probability of 1/2 of disintegrating within 5,600 years' is a nomological proposition. It is a law of nature, derivable within a scientific theory, and so elliptical for 'of physical necessity all atoms of carbon-14 have a probability of 1/2 of disintegrating within 5,600 years.' " Von Wright himself explicitly takes this view in *WL*; "As in the case of functional correlation generally, the question of how to distinguish the accidental connexions from the nomic ones is urgent also for probability relations" (Lecture 1).

25. *OC* 162.

26. *OC* 163.

27. These approaches are distinguished and discussed in Chapter 3 of J. L. Mackie, *Truth, Probability, and Paradox* (Oxford, 1973), hereafter referred to as *TPP*.

28. J. R. Searle, *Speech Acts* (Cambridge, 1969), pp. 136–41.

29. Cf. S. A. Kripke, 'Naming and Necessity', in *Semantics of Natural Languages,* ed. G. Harman and D. Davidson (Dordrecht, 1972), pp. 253–355, esp. p. 267: " 'Possible worlds' are *stipulated,* not *discovered* by powerful telescopes."

30. Cf. H. P. Grice, William James Lectures (unpublished).

31. In fact the kind of account sketched here covers an even wider range of conditionals and of uses of 'if', as I argue in *TPP,* Chapter 3, esp. 92–108.

32. Cf. *TPP* 106.

33. I have tried to analyse these notions of natural necessity and laws of working in *CU,* Chapter 8.

34. *EU* 71.

35. *EU* 71–2. A similar but more elaborate account is given in *WL,* Lectures 2 and 3.

36. This is argued in *CU,* Chapter 6.

37. Cf. *CU,* Chapter 8.

38. *EU* 71, 178–79.

39. Such a way of handling counterfactuals is implicit throughout Kripke's 'Naming and Necessity' referred to in note 29 above.

40. *EU* 73–74, 190. This, too, is asserted again in *WL,* Lecture 2.

41. G. Berkeley, *Principles of Human Knowledge,* Section 23, and the corresponding passage in First Dialogue, *Three Dialogues between Hylas and Philonous.* For the fallacy, see J. L. Mackie, 'Self-Refutation—A Formal Analysis', *Philosophical Quarterly* 14 (1964): 193–293, esp. 200–202.

42. Cf. J. L. Mackie, 'The Direction of Causation', *Philosophical Review* 75 (1966): 441–466, and *CU,* Chapter 7.

43. *EU* 43.

44. *EU* 74–75.

45. *EU* 75. On the other hand a similar discussion in *WL,* Lecture 3, allows that we can give an affirmative answer to the question, though only with the help of analogous cases in which human agency is involved.

46. *EU* 76.

47. *EU* 76–77; the argument is due originally to R. M. Chisholm, 'Freedom and Action', in *Freedom and Determinism,* ed. K. Lehrer (New York, 1966).

48. *EU* 78–80.

49. I have tried to answer this question in Chapter 7 of *CU.*

50. *WL,* Lecture 2.

51. *WL,* Lecture 2.

52. *WL,* Lecture 3.

53. *WL*, Lecture 2.
54. *WL*, Lecture 2.
55. *WL*, Lecture 2.
56. I have tried to develop such an account in *CU*, especially in Chapters 7 and 8.

PART THREE

THE PHILOSOPHER
REPLIES

Georg Henrik von Wright

A REPLY TO MY CRITICS

The essays contributed to this volume can be grouped under the following main headings: (I) *Induction and Probability*, (II) *Ethics and the General Theory of Norms and Values*, (III) *Action, Intentionality, and Practical Reason*, (IV) *Causality, Teleology, and Scientific Explanation*, and (V) *Philosophical Logic*. Two essays stand somewhat apart from this classification. One is the paper by McGuinness on some relations between my work and that of Wittgenstein, and the other is Tranøy's article on my thoughts on "humanism". McGuinness's essay, the main topic of which is probability, I shall classify with the papers of the first group; and Tranøy's, because of the queries it raises on explanation, with the papers of the fourth group. Were *Philosophical Logic* listed second instead of last, the order of the main headings would reflect, broadly speaking, the chronological order in which the center of gravity of my interest and work has shifted from one province of philosophy to another. (Cf. the second part of my *Intellectual Autobiography;* henceforth referred to as *IA*.)

The topic of some of the essays falls under more than one of the headings. Classification is thus somewhat arbitrary. Three of the essays in (V) might have been placed in other sections: Berg's paper on deontic logic could have been put in (II), Hansson's paper on preference logic also in (II), and Mackie's paper on counterfactual conditionals in (IV).

I have tried to make my reply to the several essays as self-contained as possible. Since there are many essays which touch on the same topic in my writings, it has not been possible to avoid a certain amount of repetition and overlap between different sections of the 'Reply'. I have used the opportunity, not only for clarifying and defending my earlier positions, but also for commenting on the chronology and history of my writings, and for giving occasional hints of further developments. The concern has thus sometimes been with myself rather than with the opinions of my critics. I have assumed, however, that this self-centeredness is excusable in a work like the present one.

"A Reply to My Critics" was for the most part written in 1974 and the first half of 1975. Changes in my opinions which have occurred since then are, therefore, on the whole not reflected in it.

I. INDUCTION AND PROBABILITY

Under this heading I shall deal with the essays by Hartshorne, Kyburg, Nowak, Hilpinen, Baumer, and McGuinness.

Hartshorne on von Wright and Hume's Axiom

Two things make it difficult for me to answer Professor Hartshorne's criticism adequately. One is that his general position in philosophy is so different from mine. I confess that I find the meaning and message of "process philosophy" very hard to grasp. I shall not embark on a confrontation of my views with it. My second difficulty is that Hartshorne's criticisms largely concern early positions of mine which I now either find immature or have abandoned. I think it is right to say that I have more sympathy now for the *kind* of points made by Professor Hartshorne against my early "Humeanism" than I had in 1941, when I wrote *The Logical Problem of Induction*.

Professor Hartshorne begins by attacking something which he calls "Hume's Axiom". It is not clear to me what this axiom says, but perhaps I could paraphrase it by stating what I think is Professor Hartshorne's objection to Hume.

Hume regarded the ideas of (a) cause and (its) effect as two *distinct* and therefore *separable* notions. By "separable" Hume meant that the notions are logically independent of one another. (This is how I understand the opening passage in *Treatise* Bk. I, Pt. iii, Sect. 6.) Hartshorne agrees that effects are logically independent of their causes. The occurrence of the effect does not follow logically from the occurrence of the cause. But he contests the converse of this statement. Causes are, somehow, contained in their effects and therefore not logically independent of them. We can separate the effect from the cause, but not vice versa. The two, though distinguishable, are not (mutually) separable.

Hartshorne's charge against the "Humists", of whom I in this regard may be counted as one, is that they focus attention on inference from cause to effect. They thereby "fail to deal with the causal theory common to the most characteristic constructive metaphysical systems of recent times" (p. 70). This may be so. But I cannot see that it constitutes a valid criticism of what "Humists" in fact do. "Inference" from cause to effect occurs as a matter of fact. It is a species of inductive inference. And because this inference is *not* deduc-

tive, the future *not* 'contained' in the past, there is a problem here. Or rather, several problems. One is the problem of justifying the non-deductive inferences. This is the 'Problem of Hume' which I dealt with in my early publications. Another problem is to examine the formal-logical features of the relation between inductive conclusions and the evidential data on which they rest. This is a problem of the branch of logic called Confirmation Theory.

I am afraid that nothing Professor Hartshorne says in his paper will affect my opinions either on the Problem of Hume or on questions of inductive logic. This is so because the author, to my mind, has not addressed himself to the problems which bothered me in my thinking about induction. For much the same reasons, I cannot admit that either he, or Whitehead, or any other process philosopher known to me has 'answered' Hume—*if* by an answer one means a suggested way out of Hume's difficulties.

But, even if process philosophy does not answer Hume, the thesis which it puts forward concerning the causal relation is interesting: I mean the thesis that causes are, somehow, contained in their effects or, more generally, that the past is contained in the present and in everything after the present. "Every future situation must strictly entail the present situation as belonging to its past", Hartshorne says (p. 66). And: "We find the past in the present, not vice versa" (p. 69). I find these and similar statements challenging. I think they contain a germ of truth. The difficulty for me is to see clearly what this truth is.

Professor Hartshorne evidently thinks that the relation of 'being contained in' is a relation of logical entailment. He gives as examples (p. 61) that being a fox entails being an animal (animalness is 'contained' in foxness) and (p. 66) that from there being a dog in the room it follows that there is an animal in the room. These are indeed logical entailments. But I doubt whether they serve very well to illustrate the way in which the cause is supposed to be 'contained' in the effect, or the past in the present. For the examples cited are *timeless*. And the thesis which Professor Hartshorne is anxious to defend is characteristically concerned with *time*. The question is: Can the fact that something now *is* the case logically entail the fact that something *was* the case?

Does, for example, the fact that there is a house in a certain place now entail that there were people who built it and that the process of construction went on for some time and that the house has been there continuously since its completion? I think the answer is affirmative and that this is more like a case of 'logical entailment' than a case of 'natural entailment'. It is an unquestioned fact about our *Weltbild*, to use Wittgenstein's language, that houses do not grow up 'of themselves' from the ground, but that they are built by humans and that it takes time to build them. In this sense we can speak about *conceptual* ties between the present and the past—but also between the present and the future. Most things have a certain permanence. The desk (now) in front of

me and many of the things on it will certainly not vanish at once but continue to be there for some time to come. This too is 'entailment'.

Pointing out things like these about the way in which temporally separable facts are conceptually connected is an important move in the refutation of a brand of scepticism. I am thinking of a tradition which runs through Western philosophy at least from the time of Descartes through the British empiricists, chiefly Hume, down to their latter day heirs, as exemplified perhaps foremostly by Bertrand Russell. These sceptics insist for example, that the world could have come into existence only five minutes ago.

I am not sure, however, whether Professor Hartshorne has in mind conceptual ties of the above kind when he says that the cause is contained in the effect. For he seems anxious to underline that there is an *asymmetry* in this regard between past and future.

There is at least one sense in which the past, but *not* the future, can on conceptual grounds be said to be contained in the present. If something is true of the past, e.g., that Socrates died in 399 B.C., then it is also now *certain* that this thing happened. But what will in fact be true need not yet be certain. For, that an event is certain to happen means that it is—causally or otherwise—*predetermined*. A believer in universal determinism thinks that everything is predetermined. Perhaps we cannot prove him wrong. But we certainly cannot prove that he is right either. If determinism is not true, we have to admit the existence of what Professor Hartshorne calls (p. 67) *real possibilities, i.e.,* admit alternative developments "for the future of some given present". But the past necessarily has no alternatives, when viewed from a given present. What was was and cannot be otherwise. *Quod fuit, non potest non fuisse,* as the Schoolmen said. The past cannot be 'erased' from reality. It stays with us, even though we may forget it. This philosophically important truth is *one* sense in which the past may be said to be 'contained' in the present. And the fact that the future, with regard to its possibilities of development, is *open* whereas the past is *closed* is *one* sense in which world development can be said to be 'creative'. (Cf. Hartshorne's remarks about creativity on p. 64f.)

Is the above sense of being 'contained in' a case of entailment? Every past truth is a conjunctive component of a complete description of reality. Thus a complete description of reality may be said to entail everything which is true of the past. But this is trivial. In every non-trivial sense the answer to the above question is 'no'. For, that part of the complete description which concerns the past is, on the whole, logically independent of, and therefore *not* entailed by, that part which concerns the present only. Facts of history proper are not entailed by a description of the present state of affairs.

Hartshorne writes: "Each new experience of a grown man is a new premise from which that man's birth and childhood logically follow." This, I think, is right. But the facts about his biography proper, e.g., that he was born on 14

June 1916 and had a childhood in Brooklyn, do *not* follow logically from his present experiences.

At times Professor Hartshorne writes as though 'creativity', the openness of the future, required a wholesale rejection of the notion of a sufficient cause. Sufficient causes, he seems to think (p. 72), make possible but not necessary that which is going to be. Only connections in the direction of the past are "real necessary connexions"; connections to the future are "probabilistic" only (p. 73). I think this is an overstatement. Causal conditions must be formulated in *generic* terms i.e., they must not be logically tied to individual events in space and time. The events, of which they are conditions, must therefore also be characterized generically. The fact that every instantiation of a (generic) event in space and time will also have features which are not determined by that event's sufficient conditions, is something from which the formulation of the causal law *abstracts*. A convinced determinist would hold that these other features also have sufficient conditions which explain their presence in the given case. The determinist *may* be right. But the existence of sufficient conditions necessitating *some* events does not presuppose that determinism is true throughout.

Kyburg on the Logic of Conditions and Inductive Logic

Professor Kyburg's paper begins with a clear and good account of my contributions to the logic of condition concepts.

1. Kyburg criticizes some of my definitions. He finds (fn. 7, p. 93) my definition of 'independence' defective. If *A* is a necessary and sufficient condition of *B,* then there is a *rule* according to which we can, from the presence of *A* in a thing, conclude the presence of *B* in that same thing. But then, Kyburg says, *A* and *B* cannot be logically independent according to the definition I gave of independence (*Treatise,* p. 36). My defense is simple. When defining *logical* independence, I meant by 'rule' a conceptual tie. There is, of course, a good sense in which *A* and *B* are *not* independent, when they are connected by universal, nonlogical equivalence. But then the rule connecting the two factors is not a conceptual rule. And therefore the mutual dependence of *A* and *B* by virtue of the equivalence is perfectly compatible with their logical *in*dependence. I agree, however, that I ought to have expressed myself with greater clarity, and that the definition given by Kyburg (p. 79) is unambiguous and more elegant than mine.

Kyburg also criticizes the way in which I have defined the notions of Greatest Sufficient Condition and Smallest Necessary Condition. (Fn. 8) This criticism is entirely justified.

2. Kyburg notes (sec. 1) the following change in my position. In my early publications I accepted the 'extensionalist' view that conditionship relations are

universal implications. In my later writings I shifted to the 'intensionalist' view
that these relations are variations of the strict implication pattern. Kyburg then
considers (sec. 3), how, if at all, the logic of induction by elimination will
have to be modified as a consequence of this shift in position. His conclusion
is that "the whole mechanism of elimination developed and described by von
Wright for extensional condition statements works perfectly well for our new
intensional condition statements." This, I think, is right—provided that one
regards the relations of strict implication in question as being strict *and* univer-
sal. This is how I have intended them to be understood.

At the end of section 3 Kyburg raises a further problem relating to the two
ways of interpreting condition statements. "There is, in fact, no empirical evi-
dence *possible* which will allow us to distinguish between $A \subset B$ and
$N_e(A \subset B)$: we are in a position to sample from only one possible world",
Kyburg says. He does not develop the point. I think, however, that I disagree
with him here. Maybe we can sample from only one possible world. (Even this
is not quite clear, owing to the obscurities surrounding the notion of a possible
world.) Still, the problem of how to distinguish, on empirical grounds, between
$A \subset B$ and $N_e(A \subset B)$, i.e., between accidental and nomic universal truths, is
a meaningful and important problem. It could be said to be *the* main problem
in my writings about causation in *Explanation and Understanding* (henceforth
abbreviated *E&U*) and in *Causality and Determinism* (henceforth *C&D*). I can-
not claim, however, to have solved the problem in a conclusive and satisfactory
way. The question will be taken up for further discussion in my replies below
to Mackie and Prawitz.

3. The prototype of what I called in *Treatise* a 'statistical law' is a state-
ment to the effect that a proportion *p* of all *H*'s are *A*. An analysis of the logical
form of such laws shows that they are universal implications of a sort. Thus, I
concluded (*Treatise,* p. 82) that the "definition of Laws of Nature as Universal
Implications or Equivalences is, in fact, sufficiently general to embrace also
Statistical Laws". The interest of this observation to a theory of eliminative
induction is, however, minimal. Kyburg takes great pains (sec. 4) to point this
out. I completely agree with what he says. In my defense I can only answer
that I never meant to suggest that the confirmation of statistical laws should be
treated as simply a subspecies of confirmation of non-statistical inductive gen-
eralizations (p. 88). I am sorry if my formulations were misleading in this
regard.

4. In the concluding part of his essay Professor Kyburg puts forward two
very interesting ideas of his own. The one amounts to a reversal, as compared
with my position in *Treatise,* of the relation between statistical inference and
induction by elimination. Kyburg wants to regard the first as basic and primary,
the second as derivative and secondary. This reversal, he thinks (last of
sec. 4), "provides a useful handle by means of which we get a hold of, and

perhaps even solve some of the deep epistemological problems concerning induction''. The other idea is Kyburg's suggested extension of the extensional-intensional distinction to Statistical Laws. I shall say a few words about each of the two ideas in turn.

The 'point' of reversing the logical order of statistical inference and inference from elimination is, if I understand Kyburg correctly, the following: We introduce a rule of acceptance (p. 90) which tells us under which conditions we may accept a universal generalization relative to a given body of probable knowledge. The empirical 'material' to which the rule applies consists of samples from a population of individuals. To put it roughly: When, on the basis of sampling (and probability calculations), we may conclude that it is highly probable that 'practically all' S's are P and no S has been found which is not P, then the universal generalization that all S's are P is acceptable. If subsequently we find an S which is not P, we exclude, 'eliminate', the said generalization from a set of rival hypotheses about, say, the sufficient conditions of P.

The typical uses of eliminative induction are for the purpose of what might be called *causal analysis*, i.e., the search for causes of given effects and effects of given causes. This was how Mill and most other classic writers on inductive logic saw things—and I think this view is basically correct.

It is, however, hardly essential for these 'typical' uses of eliminative induction, that elimination operates on a set of rival hypotheses which are already, on the basis of statistical sampling, deemed acceptable. The situation is rather that one starts with more or less vague ideas about the range within which the causally conditioning factors of an observed phenomenon can be expected to be localized. Then one records similarities between situations in which the phenomenon is found to occur or, as the case may be, dissimilarities between situations in which the phenomenon appears and such in which it does not appear. In this way one tries to 'encircle' the conditioning factors, i.e., to narrow down as much as possible the range within which the 'cause' or 'causes' may reside. For "speeding up" this process of encirclement experiments often play a crucial rôle. As far as I can see, it is only after this initial stage of elimination has left us with a relatively well-defined set of hypotheses that sampling and related procedures of *enumerative* induction will be resorted to for the purposes of further confirmation and disconfirmation.

Apart from the question whether elimination has a *logical priority* in relation to other inductive methods or not, it seems to me clear that it possesses a *factual independence* of sampling methods. This is so because systematic use of eliminative induction is made in situations which are typically different from those where statistical sampling is used. And for this reason already, I am afraid I must disagree with Kyburg's idea "that statistical inference is basic, and eliminative inference, in a sense, a derivative and secondary mode of inductive inference" (last of sec. 4). I would say: If anything is basic, it is

elimination. But maybe the two types of inductive inference should better be regarded as independent of one another.

5. I shall make a few comments on Kyburg's application (latter part of section 4) of the extensional-intensional distinction to Statistical Laws. "If condition statements can be construed intensionally, so, surely, should statistical statements," he says. I understand him to mean that the *nomic* (intensional) construal of the statement that a proportion p of all H's are A is the statement that p is the proportion of H's which are A in any possible world "in which the maximum number of instances of H are to be found". The actual world need not satisfy this requirement, for example because a coin is being destroyed after it has been tossed a few times.

I am not sure that I fully grasp the nature of the appeal which Kyburg here makes to 'possible worlds'. Perhaps my comment therefore is beside the point. Consider a coin which has been destroyed. It is known to have been a normal coin in the sense that it was not 'loaded' in favour of the one or the other of its two faces. Assume that this coin was tossed only a few times, and that the tosses yielded 'heads' in a proportion vastly different from ½. It could nevertheless be right to say that the probability of getting 'heads' with that coin was ½. If asked what we mean by this, we could answer as follows: It is practically certain that if one had tossed that coin a greater number of times before it was destroyed, one would have noted a 'tendency' of the frequency of 'heads' to cluster around the value ½ in long series of tosses. We have *good reasons* for thinking that this would have been so. The reasons are our experiences from mass-experiments with *other* coins to which the destroyed one was, as far as we can tell, in all 'relevant respects' *similar*.

The *nomic* statement involved here I would call a probability statement rather than a Statistical Generalization. It is a probability statement about the behavior of physical bodies (coins) of a certain kind under certain conditions (tossing). It is essential that there should exist many individual specimens of the kind in question and that the conditions, in which they are supposed to behave in a characteristic way, should be repeatable at will for the purposes of testing. When this is the case, we can use the probability statement as a basis for making counterfactual conditional statements also about cases in which statistical material is no longer available to confirm our opinion.

Nowak on Probability and Randomness

1. I think it is right to say that there is profound agreement between Stefan Nowak and me in approach and attitude to probability. We are both favourably disposed to the frequency view. We agree about the crucial importance for any theory of probability of the notion of random distribution. And we seem to

share, for similar reasons, a critical attitude to the doctrine and uses of Inverse Probability.

It would be interesting to know to what extent we also agree on topics in the philosophy of probability which fall outside the scope of Nowak's paper. For example: confirmation theory in the tradition of Carnap or personalist (subjectivist) probability theory in the followership of de Finetti and Savage. These are two trends in recent developments towards which my own attitude is critical and guarded.

The above note on agreement between Professor Nowak and myself may not be entirely consonant with the impression which a reader of Nowak's paper is likely to get. Professor Nowak seems to have viewed our mutual positions in a slightly different light. He thinks (last of section 5) that he is"—at least in terms of 'emotional attitudes'—more positive toward the frequency theory of probability than von Wright". He says of me (section 2) that I am " 'slightly inclined' toward the range approach to probability" and even (beginning of section 6) that I seem "to be much more in favour of the *range model,* i.e., contemporary continuations of classical theory of probability". Evidently, I have written things which convey this impression. I should, however, like to dissociate myself from it. I do not favour the range theory over the frequency view. But it is true that Nowak is even more of a 'frequentist' than I am. He seems more sympathetic than I to von Mises's notion of a *Kollektiv* and to the usefulness of hypotheses about limiting frequencies. I shall therefore begin with a brief statement of the motives which eventually made me 'turn my back' on the frequency theory, thinking that there exists an alternative view which possesses all the virtues but none of the weaknesses of the (pure) frequentist position.

2. This alternative view, unfortunately, I have only hinted at in my published writings—first in the *Encyclopaedia Britannica* article on probability (B168, 1959); then, in the Stanford symposium paper on subjective probability (B180, 1962); and a little more fully in my analysis of Wittgenstein's views on probability (B233, 1969). I tried to elaborate it in a longish essay from the late 1950s, also mentioned by Nowak. This essay, however, I never finished for publication. The view itself is not unknown in the history of the subject. Some writers who are near the frequency position, have entertained it, for example Cramér[1] and Kolmogorov[2]. An interesting variant of it can be recognized, I think, in Wittgenstein's *later* writings on probability, published in *Philoso-*

[1]Harald Cramér, *Mathematical Methods of Statistics,* Princeton University Press, 1946, especially pp. 148ff.

[2]A. M. Kolmogorov, *Foundations of the Theory of Probability,* New York: Chelsea Publishing Co., 1950.

phische Bemerkungen. (Cf. below, pp. 764ff.) It seems also related to a view which, under the name of the 'propensity interpretation' was recently in fashion.

According to this conception, probability is a hypothetical magnitude, a 'realization measure', which we associate with a generic event on repeatable occasions. The magnitude provides a basis for calculating a *very high* realization measure for long-run frequencies of the event in question. This latter measure is regarded as a 'practical certainty'. If needed, we adjust the magnitudes at the basis of the calculation so as to yield (rough) agreement between statistical observations and such 'practical certainties'.

Thus, on the view under consideration, the role of the concept of a limiting frequency is, in a way, taken over by that of certain asymptotic principles of the probability calculus, also known as Laws of Great Numbers. The simplest and best known of them is the Theorem of Bernoulli. The idea that there is a connection between these laws and statistical applications of probability has a long history, badly marred by mistaken attempts to deduce the limiting frequency interpretation with the aid of Bernoulli's Theorem.

The question may now be raised whether the conception of probability as an uninterpreted hypothetical magnitude can evade or, if not, solve the problems which arise within a theory of 'collectives'. I cannot elicit an answer to this question from Professor Nowak's paper. Nor do I have one myself. I can only hope that the answer will, upon closer investigation, turn out to be affirmative.

At the end of his paper, Nowak quotes some programmatic statements from my unpublished 'Essay on Probability' and then says: "I have the feeling that the only essential differences between Professor von Wright's views and mine are related to the problem as to whether the nature of hypothetical probabilities can be successfully presented." By a 'presentation' of a hypothetical probability Nowak evidently means its interpretation as a limiting frequency within a collective. The notion of a collective, he says, is free from contradictions, and although we cannot strictly verify empirical statements about frequency limits, we can assess them "with (inductive) probability fairly close to certainty".

I find the word 'inductive' in the quoted passage bewildering. Is Nowak here envisaging *another* concept of probability—something like Carnap's probability₁, perhaps—which would measure the degree of confirmation of statements about limiting frequencies? This would, in my opinion, be a blind alley. I tend myself to think that no 'presentation' of the hypothetical magnitudes is needed over and above the long-run frequency statements which we deduce from them with the aid of the calculus and deem 'practically certain'.

3. Whether or not the conception of probability as hypothetical realization-measure overcomes the characteristic weaknesses of the three traditional approaches to probability, viz., the frequency-, the range-, and the belief-

theories, it is clear that the notion of *randomness* (random distribution) calls for special attention. It enters explicitly into von Mises's concept of a *Kollektiv*, and the attention von Mises devoted to it is a great and lasting merit of his frequentist approach to probability. Yet, the randomness or irregularity requirement on collectives was thought to be the weak point of von Mises's theory. There were good reasons for thinking so. In my writings on probability, I have tried to show that the *very same* difficulty which the notion of *random distribution* presents to the frequency view is presented also by the notion of *equipossibility* to the classical (Laplacean) range theory, and by the notion of a *rational* degree of belief to the belief theory. I entirely agree with Nowak when he says (sec. 2) that a notion of randomness "which cannot be defined implicitly by the axioms of the calculus" is involved in the three classical theories and seems "to be unavoidable for any concept of probability".

In my struggles to clarify the meaning of randomness, I arrived at what could be called an *epistemic* view of this notion. (Nowak speaks of a "subjectivization", sec. 4.) To put it briefly: A characteristic A is said to be randomly distributed over the members of a class ("collective") H, when no characteristic B, logically independent of A, is known such that a partitioning of H through B is assumed to affect the probability of A in the subclasses. When this conception of randomness is combined with a frequency interpretation, one has to replace the word 'probability' with 'relative frequency' or, if the collectives are assumed to be potentially infinite, with the term 'relative frequency limit'. (If the classes are infinite, considerations about orderings also become relevant.)

I am not quite sure about Nowak's stand on the problem here. He makes a distinction (sec. 4) between *weak* and *strong* collectives. A strong collective, I understand, is one for which no 'gambling system' exists and a weak collective one for which either gambling systems are not *suspected* to exist or, if suspected, are *ignored* for purposes of prediction. My epistemic notion of randomness applies to those weak collectives for which no gambling system is believed to exist.

I for my part find it doubtful whether the notion of a strong collective *makes sense*. The problematic question is: does it make sense to speak of the *totality* of properties which are logically independent of a given property, and which may be used for partitioning a given class? If the answer is negative, there are no strong collectives in the above sense, i.e., no collectives in the sense of von Mises. And then it would seem practical to redefine Nowak's distinction and say that a collective is *strong* if no gambling system is suspected to exist (for a given characteristic in the collective), and *weak* if gambling systems are suspected but ignored for certain purposes. This, of course, makes the distinction relative to our state of knowledge. Since this state varies, a collective which at one time was thought to be strong, may at some other time be re-

garded as weak—and vice versa. (Something which we imagined was a gambling system may later 'break down'. This relativity or subjectivity of the notions may seem unsatisfactory to many logicians and philosophers. But I think we ought to accept it. In fact, accepting it is no detriment to the applications of probability for the purposes of prediction and calculations of risk. For, since we can never *know* whether a collective is, in the von Mises-Nowak sense, strong, we shall in any case have to be content with *treating* some collectives as strong and others as weak, depending upon our state of knowledge and belief about the distribution of certain characteristics.

With this redefinition, I find Nowak's notion of a weak collective interesting. It is then closely related to my concept of *relative randomness* which Nowak mentions (sec. 4). With one noteworthy difference, however: In the case of a weak collective, we assume that certain partitionings *do* affect the probability. But we ignore these partitionings and treat the characteristic(s) under consideration as randomly distributed in the collective. In the case of relative randomness again, we assume that certain partitionings do *not* affect the probability and treat the characteristic(s) under consideration as randomly distributed with regard to these partitionings of the collective.

It is true that in my earlier publications my interest was focussed mainly on the idea of absolute randomness, trying to argue that it is an *epistemic* and not an *ontic* notion. Nowak, if I understand him correctly, finds the notions of a weak collective and relative randomness more interesting and useful. I shall not dispute this. As far as I can see, it is perfectly consonant with my conception of probability as hypothetical realization measure to use the term 'probability' also for cases "when we consciously omit in our predictions some known modifiers of the overall probability in the collective" (last of sec. 4).

4. I find Nowak's comments on the range theory (sec. 6) extremely interesting. I agree with everything he says about my position—except his initial statement that I have a bias in favour of this particular theory of probability. Some of Nowak's remarks go beyond anything I have said myself, but in a way which I think congenial to my intentions. I am thinking, in particular, of Nowak's conception of a range of equipossible alternatives as a "collective generating situation" or a "chance set-up". Some of the notorious obscurities surrounding the Principle of Indifference become clarified when the conditions which this principle lays down for the adequacy of a probability value are interpreted as conditions for the existence of a "randomness generating device", to use Professor Nowak's term. On this basis, we reach a reconciliation between the frequency and the range theories of probability which does justice to the merits of both views. But I think it is only fair to add that the frequency view holds the more *basic* position of the two, since the equality of the ranges is, in the last resort, measured by frequencies. (One is here reminded of the development of Wittgenstein's thoughts on probability. In the *Tractatus,* Wittgenstein propounded a version of the range theory. Later, in the *Philoso-*

phische Bemerkungen, he came close to the frequency position, though without resort to the frequency-limit definition of probability.)[3]

There is a minor point, relating to the idea of equipossibility, on which I must express disagreement with Professor Nowak. I can attach no meaning whatsoever to the statement that "the rotation of the earth makes day and night equally possible" (sec. 6). Even granting that day and night were of equal duration, I should not understand this. Assume, however, that someone said: 'If I single out a point on the earth's surface *at random,* then it is equally possible that at this point there is now day and that there is now night'. Then I should begin to see my way to understanding the curious statement that day and night are equally possible. But now, in order to assess the truth of the statement, I should wish to know something about the mechanism of selecting points on the surface of the earth at random. Here again the notion of equipossibility would have to be related to considerations about collective generating situations and chance set-ups—in exactly the way nicely characterized by Professor Nowak. Therefore his distinction (sec. 6) between "systematic" and "random" equipossibility seems to me superfluous and unwarranted.

5. It is gratifying to find that Professor Nowak agrees with me, in substance, on the topic of Inverse Probability. My efforts, in a nutshell, have been to show the following: An inverse probability is not a second order 'probability of a probability'. It is a probability that the *conditions* under which experiments or observations are made on the relative frequency of a characteristic, are identical with those under which the characteristic in question occurs with such and such a probability—for example, a probability close to its relative frequency in the sample. Legitimate use of inverse probability is thus made for *identifying with probability* the data relative to which the probability of the occurrence of a certain characteristic is already, for whatever reasons, assumed to be such-and-such. It follows that many of the 'classical' uses of inverse probability are simply illegitimate. But there *are* legitimate uses—if not in practice, at least in theory. I therefore could not follow R. A. Fisher, who completely rejected inverse probability and even thought that Bayes's Theorem was fallacious. A prototype example of a legitimate application would be a case in which sampling took place from urns containing balls of different colours, and we tried to assess the probability that a drawn sample was from an urn in which the probability of drawing a ball of a certain colour was, for independent reasons, thought to be such and such—for example, close to the relative frequency of balls with this colour in the sample.

But, if this is correct, then one application of inverse probability, which Nowak seems to think legitimate and maybe even considers important, is really illegitimate. He refers to it in two places. The first is in sec. 5, where he says

[3]See also the well-known paper by Friedrich Waismann, 'Logische Analyse des Wahrscheinlichkeitsbegriffs', *Erkenntnis* 1, 1930–1931, and my comments below on the essay by McGuinness.

that the existence of a frequency limit "may be estimated with very high probability—if we can observe a sufficient number of members of the collective". The second place occurs near the end of sec. 8, where he mentions the "practical independence", in the inverse limit theorem, of the asymptotic probability from a priori probabilities and then concludes that "we may stop to speculate (B180). I should prefer to regard the earlier writings as immature and suficiently long series for estimating the probability of the events in question." This last observation is, as it stands, quite correct. But the first quotation supports a suspicion that by 'estimating' Nowak here means 'estimating with (very high) probability'. And this I think is a mistake.

It may be true that the longer the sequences are in which we can observe a tendency on the part of the relative frequencies to cluster round a certain value, the more confident do we become in the existence of a frequency limit at this value. Some people might wish to express their confidence in more objective terms and say that it becomes more and more probable that this is the frequency limit. But whether this is a 'probability' in the sense of the calculus of chances is, to say the least, doubtful. In normal cases it is certainly not a probability which increases by virtue of the inverse limit theorem (Bayes's Theorem). It would be this if, and only if, the following conditions were satisfied:

Let there be several collective (sequence) generating devices. For each one of them we associate with one and the same characteristic a hypothetical limiting frequency for its occurrence in the sequence. The grounds for making these hypotheses might be statistical observations on generated sequences, or they might be some a priori considerations about ranges. The prototype example would here again be a collection of urns containing differently coloured balls in definite proportions. Let it then be assumed that we observe a sequence without knowing according to which device it was produced. In the example: without knowing from which urn the balls have been drawn. The question may now be raised: What is the probability that the sequence was produced in accordance with a device such that the limiting frequency hypothetically associated with a certain characteristic is such and such? In the example: produced by drawings from an urn of such-and-such a constitution. In answer to this question the Inverse Law of Great Numbers says that the longer the generated sequence, the more probable does it become that the sequence is generated in accordance with a device, for which the limiting frequency of the characteristic under consideration is a value close to the frequency of this characteristic in the sequence.

As seen, we can imagine a case in which it would be legitimate to apply the inverse limit theorem for the purpose of estimating the probabilities of limiting frequencies. But such a case is—as I think the above thought experiment shows—extremely artificial and far removed from those contexts in which, normally, we make assumptions and statements about frequency limits. To see this clearly is important.

6. Nowak's account (sec. 9) of what I have had to say about the belief or subjectivist theory of probability is very good. He even takes the trouble to try to reconcile what I said about the topic in earlier publications (*Logical Problem* and *Treatise*) with my single more mature writing on it, the Stanford paper about all thinkable alternatives and . . . use the relative frequency in the sufperceded. It was not until I had become acquainted with the personalist probability theory, as expounded by Savage in his *Theoretical Statistics* (1952), that I understood the depth of Ramsey's thinking on these questions. My earlier comments on Ramsey are therefore of no value.

On one minor point Nowak has, I think, misunderstood me. This is when he expresses (near end of sec. 9) disagreement with my statement (in *Logical Problem*) that actual partial beliefs can never contradict one another. I did not mean anything which disagrees with Nowak's statement that "different beliefs may be logically contradictory even if they exist in the head of the same person". To be sure, a man can believe *contradictory things*. He can say, if he wishes, that he then has *contradictory beliefs*. But this must be said with caution. For the co-existence of the two psychological facts that he believes *this* and believes *that,* where 'this' and 'that' contradict one another, demonstrates that it is *not* self-contradictory to believe mutually contradictory things, i.e., demonstrates that actual partial beliefs never contradict each other.

7. In the long penultimate section (sec. 10) of his essay Nowak takes up for discussion the question of the evidential basis for the use of probability for predictions. A much debated methodological principle is connected with this question. It is the idea that in making a prediction one should take into account all available data which bear relevantly on its probability. The application of this device, however, is connected with difficulties. One difficulty has its root in the fact that, as we multiply the number of items of information to be considered, the more difficult does it become to evaluate the relevance of the information as a datum, relative to which the probability has to be assessed. This is so because more data means a narrower reference class or collective, and the narrower this class is, the less statistical evidence will there be for probabilities in it.

Nowak does not address himself directly to the problem which this difficulty creates. Instead he takes up a new problem concerning *intersecting* collectives. Assume that we predict that a certain individual will have a certain characteristic; that this individual is a common member of several collectives; and that the characteristic under consideration is randomly distributed in each one of the collectives and associated with a probability (not necessarily the same) in each one of them. What can then be said about the probability and random distribution of the characteristic in the intersection? It is clear that nothing at all can be said, unless certain assumptions are made about the collective-defining characteristics or what Nowak calls the "antecedents" of the collectives. Nowak takes up for discussion a facet of the general problem here, viz.

the case in which the antecedents are causally related to the conjectured (predicted) characteristic. By 'causally related', if I understand him rightly, Nowak means that the antecedent in question is a conjunctive component of a sufficient condition of the conjectured characteristic. Two cases are distinguished, called by Nowak the additive and the interacting pattern respectively. In the additive pattern the antecedents are components of different sufficient conditions; in the interacting pattern they are components of the same sufficient condition. For both cases he then gives a formula for computing the probability of the occurrence of the conjectured characteristic in an individual, on the datum that this individual belongs to the collectives determined by those antecedents.

Professor Nowak says at the end of sec. 10 that he would be glad to know my reaction to this interpretation by him of the notion of "all relevant information in the case of probabilistic prediction". I am afraid I cannot say much more about this than that I think the problem is of great interest and that Nowak's proposed solution is an important contribution to the theory of what might be called 'probabilistic causal analysis'. But I am doubtful whether Nowak's approach helps us overcome the basic difficulty which I mentioned above, relating to the inevitable narrowing of the evidential basis for probabilistic predictions through the multiplication of data about individuals. The assumptions needed in order to make possible the computation of probability values, though elegant in theory, may be too strong to be helpful in practice.

Hilpinen on Confirmation Theory

1. Professor Hilpinen's essay is a model of a faithful and unbiassed presentation of a complex and controversial subject-matter. It deals with an aspect of my work which has gone relatively unnoticed. It relates some of my views to more recent work by Isaac Levi, Wesley Salmon, and by Hilpinen himself.

2. I shall first take up a minor point. On what Hilpinen calls "the sufficient condition analysis" of a universal implication $(x)(Ax \rightarrow Cx)$, for example 'all ravens are black', the instances which may contribute to the probability of the generalization are afforded by individuals which are neither A nor C. This "may seem 'paradoxical' ", Hilpinen notes. But it should also be noted that the air of paradox depends upon the particular choice of example. With another type of example, the sufficient condition analysis may appear entirely natural and the necessary condition analysis unnatural. Such examples would, I think, be found in typically *causal* contexts because of the close association between the notions of cause and of sufficient condition.

'Whenever there is lightning there is thunder.' Suppose this were a primitive hypothesis about the cause of a type of frightening noise. Then anything which occurs in the absence of thunder cannot be a sufficient condition of it. The more such phenomena we list, the more 'outstanding' among possible

causes of thunder does lightning become. Despite its crudeness, this example shows why a generalization of the form $(x)(Ax \rightarrow Cx)$ is sometimes more naturally regarded as confirmable through observation of instances in which both factors A and C are absent, than through accumulated observations of cases when they are both present.

3. My theory in *Treatise* (B121, but also in B8 (a) and B46) about the probabilifying effect of confirmation is a theory about the effects of elimination of 'concurrent hypotheses' upon the probability of a given hypothesis (generalization). The probabilifying effect of confirmation may thus be regarded as an 'oblique' effect of disconfirmation. Disconfirmation here means falsification, i.e., the inconsistency of a generalization with observation. It seems that this is a too narrow concept of disconfirmation to do justice to all cases. Not only may it sometimes be feasible to regard instances which do not contradict the hypothesis as nevertheless being disconfirming. (See Hilpinen's reference to the paper by Berent in n. 21) Neither can generalizations with multiple layers of quantifiers, for example $(x)(Ey)(Ax \rightarrow R(x,y))$, be accomodated within my theory without 'violence'. Yet they seem to be quite a common and important kind of inductive generalization, and it is natural to think that confirmation has a probabilifying effect on them too. Such considerations, no doubt, considerably restrict the relevance of my confirmation theory in the early publications.

4. The inductive probabilities with which my theory deals, Hilpinen says "give only a rough description of the process of eliminative induction; in most cases they are not adequate credibility-measures (or measures of degree of confirmation) of hypotheses." This is so or not, I would say, depending upon what we demand of a credibility measure. Anyhow, Hilpinen has here laid his finger on an important problem: This is the problem how to apply probabilities which are in the first place treated a functors of some generic entities (attributes, classes, properties) to individual instantiations of these entities (events, propositions). The frequency theory of probability is typically a view for which this 'problem of the single case' constitutes difficulties. It is sometimes urged as an objection against this theory that it is incapable of solving the problem. (Cf. Hilpinen, p. 134.) One could generalize and say that the problem arises for any view of probability which admits of a frequency-interpretation, even if it does not commit itself to a *definition* of probability in the terms of frequencies. This kind of view I have defended myself in various writings on probability, also some of a later date. (The clearest statement is perhaps in B180, referred to by Hilpinen in n. 44.)

Hilpinen quite rightly observes (p. 134) that, on my interpretation of inductive probability, the probability of a generalization is a value associated with a pair of generic entities, viz., with a set of initially possible and a set of actual conditioning properties of a given property. Only secondarily is it a probability associated with a specified instantiation of those entities, viz., with a general-

ization which says that a certain member of the first set is also a member of the second set. Therefore the question arises: What justifies us to 'transfer' the magnitude associated with the pair of generic entities to the single case which the generalization represents? Or alternatively: under which conditions can the first magnitude be correctly said to represent also the probability (or 'credibility') of the generalization?

Hilpinen does not explicitly note—and I am not sure whether he and other recent writers are even fully aware of it—that this 'problem of the single case' is basically the same as the problem to which Richard von Mises addressed himself when defining his notion of a probabilistic collective *(Kollektiv)*. Von Mises thought that the relative frequency of a characteristic in a class is a measure of probability, only if the characteristic is randomly distributed over the members of the class. That is: only on this condition is frequency a measure of the probability of any proposition to the effect that an individual member of the collective has the characteristic in question. When applied to my theory of inductive probability this condition becomes: The relative frequency of actual conditioning properties among a class of initially possible conditioning properties of a given property is a measure of the probability of any generalization to the effect that a given member of the set of possible conditions is an actual condition, only provided the actual conditions are distributed randomly over the possible conditions.

In several of my early contributions to the philosophy of probability (particularly B5, 1940 and B46, 1945) I devoted much effort to dealing with the problem of random distribution. I was not unaware of the pressing nature of the problem also in confirmation theory. But I never dealt with it explicitly in that connection.[1] This I ought to have done. I shall here try to do something to make good the omission.

5. The problem of the single case is a bewildering one. There is a tendency to confuse it with other questions about the nature of the data which determine the reference class for a statistical probability. Which conditions ought ψ to satisfy, if we are to say that the (limiting) frequency of φ's in ψ measures *the* probability that a random x is φ? Reichenbach's answer, quoted by Hilpinen

[1] Hilpinen observes (p. 135) that I did not pay much attention to the problem of the single case in my earlier publications. He then ignores that, in discussing random distribution, I was also ('obliquely') discussing this problem. He quotes (ib.) a remark which I made on the problem in a later publication (B202(a)). I am sorry to say that the remark in the later paper was not a very good one. It simply will not do to say that "if x is an individual in the range of significance of φ and ψ, and if it is true that $P(\varphi|\psi) = p$, then we may, in a *secondary sense*, say that, as a bearer of the characteristic ψ, the individual x has a probability p of being a bearer also of the characteristic φ." For this presumes that the problem of the single case has already been solved when we equate the value of the functor P with a *probability*. One could say: the value p is a probability-value only if the applicability to the individual case is warranted. This warrant, on von Mises's view, was random distribution of the φ's over the individuals belonging to ψ.

on p. 135, that we should take as the reference class "the narrowest class for which reliable statistics can be compiled" is an answer to *that* question, not to the problem of the single case. Salmon's proposal that we should choose "the *broadest homogeneous* reference class to which the single event belongs" (p. 135) is likewise irrelevant inasmuch as it prescribes that the class be 'the broadest'.

But Salmon's proposal of *homogeneity* is relevant. It is, moreover, closely related to, even essentially the same, as von Mises's requirement of 'irregularity'—although Salmon is talking about reference-*classes* and von Mises was talking about *sequences* (of, say, tosses of a coin). In the context now under discussion, viz., the frequency interpretation of the probability of generalizations, it is classes that matter.

When is the reference class ψ for the probability of φ homogeneous? A suggestion would be this: ψ is homogeneous, *qua* reference class for the probability of φ, if there is no characteristic χ such that χ will effect a statistically relevant partitioning of ψ with regard to φ.

Are there such classes? It is immediately clear that the answer is 'No'— unless we somehow restrict the set of characteristics χ. Suppose we specify this set so that it contains just n members $\chi_1, \chi_2, \ldots, \chi_n$. Then it is possible that ψ, if it is infinite, satisfies the requirement of homogeneity perfectly—and that ψ, if it is finite, satisfies it approximately. ('Approximately' then means that the relative frequency of φ's in any $\chi \& \chi_i$ is as close to the relative frequency of φ's in ψ as is logically possible, given the finitude of the classes.)

The above sense of homogeneity might be called actual or *ontic* and contrasted with *epistemic* homogeneity. The reference class ψ is epistemically homogeneous with regard to the distribution of φ's over its members, I shall say, if, and only if, no χ is known such that χ is logically independent of φ, and χ is thought to effect a statistically relevant partitioning of ψ with regard to φ. This definition, be it noted, is somewhat different from the one given by Salmon (cf. Hilpinen, n. 40).

I think it is the epistemic concept of homogeneity which is needed for solving the problem of the single case. When the statistical frequency of φ's in ψ is p and ψ is epistemically homogeneous with regard to φ, then p is said to measure the probability of φ *given* ψ, or the probability that a random individual which is φ is also ψ.

I know that many will think that this elucidation makes probability all too 'subjective'. For it makes an attribution of probability depend on two things: first, a conjecture about the value of a frequency of a characteristic in a reference class; and second, the absence of grounds for conjectures about statistically significant partitionings of the reference class with regard to this characteristic. So, in my view, attributions of probability depend on a Principle of Insufficient Reason. I am fully aware of the notoriety which this principle en-

current hypotheses) concerning a conditionship relation has statistically significant partitionings with regard to the frequency of actual conditioning properties (ns. 40 and 51). The only exception is the case in which the class of possible and the class of actual conditioning properties coincide (n. 51). So, Hilpinen concludes (n. 51), the reference class "can be only epistemically homogenous". (It does not matter here that Hilpinen has Salmon's notion of epistemic homogeneity in mind, and not my notion.) If my notion of the probability of a generalization is a 'probability' at all, i.e., if it is applicable to a specific generalization, then the reference class for measuring its value must be epistemically homogeneous. He does not say this in so many words, but I think this is what he would wish to say—and, if so, I completely agree with him.

All this raises an important problem which I simply ignored in my earlier writings on confirmation theory. What does epistemic homogeneity signify when the notion is being applied to reference classes for statistically interpreted probabilities of generalizations? On this problem I shall now try to say some words.

Let the hypothesis be that C is a necessary condition of A. The generalization, the probability of which is at stake, is then $(x)(Ax \rightarrow Cx)$. The reference class is a set of properties which are initially possible candidates for being necessary conditions of A. Let us assume that a certain proportion of the members of this class *are* necessary conditions of A. If this proportion is to be a fair measure of the probability that C will be one of the actual necessary conditions, then the reference class ought to be epistemically homogenous with regard to the actual conditions. This requirement can also be stated as follows: every member of the reference class should be thought to have an *equal chance* ('possibility', 'probability') of actually being a necessary condition of A. This talk of equipossibility is again but another way of speaking about irregular or random distribution of members of the class of actual necessary conditions of A in the class of possible necessary conditions. It is interesting to note, incidentally, how ideas traditionally associated with entirely different conceptions of the nature of probability meet here. We find Laplace and von Mises standing on common ground.

It is easy to see why the requirement of homogeneity is essential. Assume that some of the members of the class are considered initially much more probable candidates for being necessary conditions of A than some other members. If C happened to be one of the first category of members, we should regard the frequency of actual conditions in the class as too *low* to be a fair measure of the probability that C actually is a necessary condition of A. If C is again one of a sub-class of properties thought much less probable than most other properties in the reference class of being a necessary condition of A, we should then regard the frequency measure as too *high* for the probability. If C is considered neither more nor less probable than most other properties in the class, we

joys in many quarters. I am also aware of some *good* reasons for criticizing it. But in spite of this I think there is something substantially sound and important about this principle.

6. Can these arguments about what turns a frequency into a probability be applied to my interpretation of the probability of generalizations?

Hilpinen makes a number of good observations relating to this question. He notes that any (finite) class of initially possible conditioning properties (con-should feel more satisfied with the frequency as a suggested measure of the probability under consideration. But only if C and all other members of the reference class are thought equally good candidates for being a necessary condition of A, should we not be reluctant to *identify* the frequency with the probability.

What has talk about 'equal chances' to do with (the absence of) 'statistically relevant partitionings'? It should be easy to see the connection. A partitioning of the reference class means that a sub-class and its remainder class is made with the aid of some second order characteristic which some members of the reference class have, and others lack. Let C be a colour, for example blackness. It may be thought, for some reason or other, that the proportion of necessary conditions of A is much higher among colours than among other properties in the reference class. Perhaps there is actually only *one* necessary condition of A and this condition is a colour. Then the entire class of actual necessary conditions is included in the colour-section of the partitioning, and the proportion of necessary conditions in the other section is zero. Members of that other section have no chance of being necessary conditions of A. Whether all members of the colour-section should be judged to have an equal chance of being such a condition depends upon what we think about the possibility of effecting statistically relevant partitionings in the class of colours.

7. I have so far been arguing as if the problem was to attribute to a generalization a definite numerical degree of probability on the basis of a conjectured frequency in a reference class. This is the way Hilpinen, too, is arguing. The question may be raised, however: Do we ever make such numerical attributions? I think *not*. It was always my conviction that the probability of a generalization cannot be *numerically* evaluated. I am inclined to say the same about anything which can reasonably be called a 'degree of confirmation'— whether of a generalization or of some other type of hypothesis. At most one can make estimates of *relative magnitude* here. The Principal Theorem of Confirmation is typically a proposition about comparative probabilities. It says that the probability of a generalization will increase with each new confirmation of it—provided the generalization is not initially or a priori maximally improbable and provided that the new confirmation is not maximally probable relative to the bulk of previous confirmations. Such estimates are, I think, sensible. Perhaps their sense can be brought out in more than one way. The way I did it

myself was by showing that the increasing probability reflects an increasing proportion of true hypotheses (concerning, for example, the necessary conditions of a given characteristic) in a diminishing class of alternative possible hypotheses. The condition of not-minimal a priori probability is then equivalent to a requirement that there be a 'perceptible proportion' of true hypotheses in the reference class of alternative hypotheses. The condition of not-maximally probable confirmations, finally, amounts to a condition that the reference class actually ought to shrink as an effect of the elimination of concurrent hypotheses.

Do we need the assumption that the reference class is epistemically homogeneous in order to uphold such 'modest', comparative statements about inductive probabilities? I think the assumption must be made—for the following reason:

Assume that we thought, for one reason or another, that C belongs to a specified sub-class χ of ψ in which *no* necessary conditions of A are located. Then we should not regard the requirement of a finite a priori probability as satisfied for this generalization. We should initially deem the generalization $(x)(Ax \rightarrow Cx)$ false and therefore incapable of having a probability which can be increased through confirmation. This would not prevent the generalization from having any number of positive instances. But these would not count as genuinely confirming, viz., as long as we stick to the opinion that C cannot be a necessary condition of A.

Assume next that, for some reason or other, we think that C belongs to a specified sub-class of the reference class such that the shrinking of the reference class which is effected by a new instance of A which is also C does not also signify a narrowing down of this sub-class. Then again we should not think that the confirmation contributes to an increase in the probability of the generalization $(x)(Ax \rightarrow Cx)$.

Assume, however, that we entertain neither one of the above two thoughts concerning possible partitionings of the reference class ψ through some specified χ. Let it further be assumed that we *do* think that a finite ('perceptible') proportion of members of ψ are necessary conditions of A. Then it is surely most natural to think that the probability of the hypothesis that C is such a condition increases through confirmation, provided that the confirming instances eliminate from the reference class competitors to C for the position of being a necessary condition of A. *Mutatis mutandis* the same reasoning about epistemic homogeneity also applies to the sufficient condition analysis of $(x)(Ax \rightarrow Cx)$.

I am grateful that Hilpinen raised the problem of 'the single case' for my 'statistical' theory of inductive probability. I hope the above arguments—using ideas which Hilpinen himself introduced into the discussion—will show how this problem has to be solved, and also that the solution cuts deep into the fundamentals of probability theory generally.

8. Towards the end of his essay Hilpinen raises the question of what it "really amounts to" to call a probability a rational degree of belief. In *Treatise* (p. 234) I had suggested that a degree of belief or a partial belief is rational when it "corresponds to the (true) probability of the conjectured event". Hilpinen calls this the Correspondence Theory of Rational Belief. He finds this theory "very implausible". He contrasts it with another view which he calls the Coherence Theory of Rational Belief. (N. 63.) According to it, "the interpretation of probability as rational degree of belief means merely that the axioms of probability are regarded as conditions of coherence for partial beliefs" (ib.).

I disagree with Hilpinen on this matter. The Coherence Theory accounts only for *one* sense in which partial beliefs can be said to be rational. As Hilpinen himself observes at the end of his paper, this sense of rationality is not a feature of individual partial beliefs, but of a system of such beliefs. 'Rationality' then means that the partial beliefs are 'distributed' in accordance with the rules of the calculus. This is an old idea—revived in modern times in connection with personalistic (subjectivist) probability theory.

But there is also another sense of 'rational' to be taken into account. To think that something is thus-and-thus probable is, one could say, to entertain a partial belief in this thing (that it will happen if the belief concerns an event; that it is true if the belief concerns a hypothesis). It is surely a legitimate and even important question to ask on what conditions such a belief is rational in the sense, roughly, of being *justified*.

I agree with Hilpinen that my "Correspondence Theory" does not give the right answer. "Some of our beliefs", Hilpinen says, "can surely be true 'by accident' without possessing the slightest degree of 'rationality', and eminently rational beliefs may turn out to be false." This is certainly so, nor did I wish to deny this in *Treatise*. But I expressed myself badly. What I ought to have said was that to call a degree of belief *rational* and to call it a *probability* is very much the same thing. The grounds for judging a partial belief rational are the same as the grounds for judging an estimate of probability justified.

Estimates of probability are thought justified when there are grounds for thinking that the frequency of a characteristic in a reference class is such-and-such *and* that the class is homogeneous. (I do not wish to say that these are the *only* grounds which would justify a probability estimate.) The grounds for thinking the first are, broadly speaking, past statistical experience. The grounds for holding a class homogeneous with regard to the distribution of a certain characteristic are, I have suggested, *absence* of grounds for thinking that a certain partitioning of the class is statistically significant (with regard to this distribution). The *presence* of grounds of this last category would again consist in past statistical experience.

The grounds justifying estimates of probability can themselves be evaluated as better or worse, stronger or weaker. The estimates of probability, accord-

ingly, have a stronger or weaker justification; the 'rationality' of our partial beliefs stands on a more or less firm footing. This evaluation of the goodness of the inductive grounds for a probability assessment is *not,* however, itself an evaluation of a probability (of an 'hypothesis' on given 'evidence'). Some confirmation theorists seem to think that it is. But I believe that they are seriously mistaken.

Baumer on the Paradoxes of Confirmation

The treatment of the Paradoxes of Confirmation in my later writings owes much to the criticism which Professor Baumer directed against the treatment of these highly interesting logico-philosophical puzzles in some of my earlier works. (Cf. IA, p. 26.) Baumer has written several papers on the topic. His approach can to some extent be said to build on my early treatment; more exactly on that aspect of it which may be termed elimination-theoretic. My own later treatment, however, differs from Baumer's. It is understandable that Baumer has been more interested in what we have in common, and on which he has been able himself to improve, than in what separates us. However, I think myself those latter aspects more characteristic of my position and also more relevant to the problem. I shall therefore take the liberty of dealing with Baumer's paper in such a way that I first restate the essentials of my own position and of its development, and then make some comments on special points in Baumer's essay.

My first treatment of the paradoxes was in *Über Wahrscheinlichkeit.* This longish paper (B46) was written in the later war years and published in 1945. The essentials of the treatment were repeated in *Treatise* (B121, 1951). Only in the second work did I use the name 'Paradox of Confirmation'. By this I meant the counterintuitive flavour which attaches to saying that anything which is *not* an *A* or anything which *is B* ipso facto affords a confirming instance of the generalization that all *A's* are *B.*

I do not recall exactly how I came to notice this puzzle. But I have a vague recollection that I had seen, or heard of, Janina Hosiasson-Lindenbaum's paper 'On Confirmation' in the *Journal of Symbolic Logic* for 1940, though I had not been able to study it carefully. (Cf. *Wahrscheinlichkeit,* p. 60.) Perhaps this was my source of inspiration. I do not think it was Hempel's 'Le problème de la vérité' in *Theoria* for 1937, which appears to be the first mention of the paradox.

In the first edition of *The Logical Problem* (B8, 1941) there is no mention of the confirmation paradoxes. In the revised edition (B8 (a), 1957), however, there is not only an informal restatement of my earlier (1945, 1951) treatment, but also a brief discussion of a second puzzle, viz., the conflict between what is known as the Nicod Criterion and what is usually called the Equivalence

Condition. Following Hempel, I now preferred to speak in the plural of the Paradoxes of Confirmation. It was here, in the 1957 edition of *The Logical Problem*, that I introduced the, not very fortunate, idea that the 'genuine' or 'spurious' character of a confirmation depends upon an epistemic datum, viz., the order in which we come to know whether an examined thing is, or is not, an *A* and whether it is, or is not, *B*.

The essentials of my early (1945–1951) treatment of the puzzle which I named 'Paradox of Confirmation' can be summarized as follows:

a. By a purely formal argument it may be shown that 'ipso facto confirmation' of the generalization that all *A*'s are *B* through things which are not *A*'s or which are *B* cannot contribute to an increase in the probability of the generalization.

b. The fact that such 'confirmations' do not increase the probability of a generalization 'mirrors' in the formal calculus the fact that they cannot contribute to the elimination of possibly true ('rival' or 'concurrent') generalizations from a class, of which the generalization under consideration is a member.

These two points should be kept strictly apart. Baumer has focused interest on the second. This is very understandable. For it is a point closely related to his own original treatment of the confirmation paradoxes. I think myself that it is an interesting point—and that what is interesting about it is that it discloses a formal connection between probabilistic Confirmation Theory on the lines inaugurated by Keynes and Broad on the one hand and by the theory of induction by elimination in the tradition of Bacon and Mill on the other hand. The analogy is beautiful, because unexpected. It remains to this day but little explored. (Cf. IA. p. 26.).

The thing mentioned under a. above, is a more general point than the thing mentioned under b. The distinction, in terms of probability, between 'genuine' and 'spurious' confirmations of a generalization is independent of whether we favour a ('logical') range theory or an ('empiristic') frequency view of this much-debated notion. The analogy between elimination and probabilifying confirmation again presupposes a frequency interpretation of probability.

The formal proof that 'paradoxical' confirmations are probabilistically ineffective, which I had outlined in *Wahrscheinlichkeit* and worked out in more detail in *Treatise,* contained, however, an error. This error also has consequences for the interpretation which relates changes in the probability of a generalization to changes in the size of a class of 'concurrent hypotheses'. The consequences of the error were noted by Professor Baumer in a paper called 'Von Wright's Paradoxes', published in *Philosophy of Science* for 1963. The situation was teasing. On the one hand I felt convinced of the soundness of my basic idea. On the other hand it was obvious that there was an error somewhere. Without too much difficulty I was able to trace the error and put things right. Correcting the error gave me the urge to write a new paper on the prob-

lem. In the course of this work new ideas emerged. The paper was presented at the APA Pacific Division session in Santa Monica in 1963. It was a great honour for me that Hempel agreed to be commentator. (I am not sure, however, that I quite succeeded in conveying my 'point' to him.) I wrote up the paper in two successive versions. The final version is B202(a), published in 1966.

In my later writings on the problem I never returned to the idea mentioned under b. viz., the connection between confirmation and elimination. What I had said earlier about this connection is, I think, substantially right. Some corrections of details are needed. This follows from Baumer's criticism. But the essentials remain untouched.

In the later writings, however, new aspects of the problem cropped up. A new notion became central to the treatment. I called it the Range of Relevance (of a generalization). The name is perhaps not entirely happy. By the range of relevance I understand, roughly speaking, the class of things *about which* a generalization is being made. I shall here try to state what I consider the most important consequence of introducing this new notion:

It turns out that the distinction between 'genuine' and 'spurious' ('paradoxical') confirmations is in an important sense *relative*. It simply is not right to think that a thing which is not an *A* cannot possibly confirm genuinely the statement that all *A*'s are *B*. Even a pair of shoes can afford a genuine confirmation of the generalization that all ravens are black. If this sounds paradoxical (as it of course does), this is so only because we vaguely have in mind some idea as to what the generalization *is about*. It is most natural to think that it concerns just ravens. But it could also, for example, be a generalization about all things which there are. Then it says that all things in the universe either are not ravens or they are black. The identification of an object as a shoe would confirm *this* generalization just as genuinely as does the observation of a black raven. But this generalization would hardly be of any interest to make and to test.

Similarly, whether something which is not *B* does, or does not, afford a genuine, i.e., possibly probabilifying, confirmation of the generalization that all *A*'s are *B,* depends on the range of relevance. If the generalization is (simply) about things which are not *B,* then anything whatsoever which is not *B* affords a genuine confirmation, provided it is also not an *A*. Thus even a white handkerchief could confirm the generalization that all ravens are black, viz., on condition that we understood this generalization to be the hypothesis that all things which are not black are not ravens either. This is a possible, but from the point of view of how we normally speak, a most unnatural way of understanding *the form of words* 'all ravens are black'.

What then about things which are *B?* They cannot possibly disconfirm the generalization that all *A*'s are *B*. Do they ever confirm it genuinely? The answer

again depends on the 'range'. If, for example, the hypothesis is about things which are *A*, then a thing which is *B* affords a genuine confirmation, if it is (happens to be) also an *A*—but not if it is not an *A*. If again the hypothesis is about things which are not *B,* a thing which is *B* does not afford a genuine confirmation. But if the hypothesis is about everything, unrestrictedly—in which case it says that everything is either not an *A* or is *B*—then anything which is *B* indeed genuinely confirms the hypothesis.

What the formal proof (in B202 and B202(a)) accomplishes is, in short, this: Nothing which falls outside the range of relevance of a generalization can, by virtue of the characteristics it possesses, disconfirm the generalization nor contribute to an increase in its probability. And everything which falls inside the range will either disconfirm the generalization or 'genuinely' confirm it. If it does the latter, it *may* contribute to an increase in the probability of the generalization. But whether it *will* thus contribute depends upon whether certain other conditions, laid down in the Principal Theorem of Confirmation are satisfied or not.

The wording of a generalization may be said to 'intimate' for itself what I have called (B202(a), p. 216) a *natural* range of relevance. If a generalization is worded 'all *A's* are *B*' and no further specification of its range of relevance is made, it is natural to take this range to be the class of all *A's*. And then only things which are *A*'s can afford genuine confirmations of the generalization. If again a generalization is worded 'all things which are not *B* are not *A's*', it is natural to understand the generalization to be about everything which is not *B*. Then every such thing which is also not an *A* confirms the generalization genuinely. Thus one can say that "Within the natural range of relevance of a generalization, the class of genuinely confirming instances is determined by Nicod's Criterion" (B202(a), p. 217).

When the range of relevance is specified, it of course makes no difference whether we word the generalization 'all *A's* are *B*' or 'all things which are not *B* are also not *A's*'. For the two wordings are, in any case, logically equivalent. When the range is *not* specified, the above two wordings suggest two different generalizations, one about *A's* and one about things which are not *B*. If, however, in the absence of a specification of the range, one decides to understand the generalization as being about 'everything there is' rather than about things in the 'natural range', then again the two wordings do not signify any difference between the generalizations. How the range of relevance should be understood in the absence of a specification depends on further circumstances of a 'contextual' and 'pragmatic' nature about the case.

After this independent presentation of my position I shall now make some comments specifically about Baumer's paper. In sec. 2 Baumer criticizes my early idea (in B8(a)) that one should pay attention to the order in which we come to know occurrences of the characteristics which are connected in a gen-

eralization. I think Baumer's criticism substantially correct. I would now agree with his statement that "Appeal to the 'order of our knowledge' is not a feasible solution or component of a solution of the paradoxes." The only point here on which I disagree with Baumer is his contention (pp. 152–53) that, if the characteristics connected by the generalization are supposed to appear in temporal succession, then my "order of knowledge" requirement could not be satisfied. This is not so. Even if we accept that a cause must precede its effect in time, it may very well happen that we *first* come to observe the effect and only later, by 'digging in the past', identify its possible causes.

Baumer's criticism of what he calls my "revised approach" is, I am afraid, less successful. He finds difficulties with the notion of a range of relevance. "What, precisely, is the range of relevance of a generalization?", he asks (p. 154). But, as I tried to show above, this question has no simple and straightforward answer. The range has first to be specified if we are to tell which it is. And there is no unique 'prescribed' way of specifying it. All that we can say in the absence of a specification is that the wording of a generalization intimates what I called a 'natural range' for it and that this range conforms to Nicod's Criterion.

Baumer tries to relate the notion of range of relevance to another idea which plays a role in the theory of eliminative induction and for which I have used the name Postulate of Completely Known Instances. This "is the assumption that in any given confirmation situation one knows all of the possible conditioning characteristics of a conditioned characteristic involved in an hypothesis to be confirmed" (p. 154). This postulate, Baumer says (pp. 154–55), makes "the addition of the range of relevance requirement—either redundant or inconsistently restrictive". He then gives (pp. 155–56) some arguments. I must confess that I cannot see how they are relevant to my treatment of the paradoxes. And I am unable to understand what made Baumer think that the postulate of completely known instances "is already built into von Wright's confirmation calculus" (p. 155). This is not the case. And even if it were the case, this would have no bearing on the use of the idea of a range of relevance for dealing with the confirmation paradoxes.

In section 3 Baumer discusses "another approach to confirmation calculi for which the range of relevance requirement may seem more promising". To this end he interprets the probabilities which occur in the Principal Theorem of Confirmation as ratios of classes of things affording confirming instances of a generalization (and not as ratios of classes of characteristics). I do not think, however, that this interpretation is legitimate here—at least not without considerable modifications of the theorem itself.

It also seems to me that Baumer has misunderstood my comparison between the confirmation of a generalization and the drawing of balls from a box. The comparison was a preparatory move for the introduction of the notion of a

relevance range. It has nothing to do with "the view that the determination of the statistical distribution of the evidence instances provides a determination of the degree of confirmation of a nomic hypothesis" (p. 158). If it had, it would indeed be "a complete intermingling of two quite different kinds of thing" (*ibid*).

Baumer says (toward the end of section 3): "We are, then, so far as confirmation of nomic hypotheses is concerned, back to two alternatives: instantial confirmation with all its difficulties, or some version of eliminative confirmation." I should not wish to formulate the alternatives thus sharply. About instantial versus eliminative induction I should like to say the following here:

a. My proposed solution of the 'paradoxes' involves no judgment on the merits and demerits of these two main types of inductive procedure. The solution is a purely formal affair involving only the Principal Theorem of Confirmation and the notion of a Range of Relevance. It consists, to repeat it once again, in the proof that things from outside the range of relevance cannot possibly, through their characteristics, contribute to an increase in the probability of the generalization. If we say that such things afford confirmations, the ground for saying this can only be that they do *not* disconfirm the generalization either; qua confirmations they are 'spurious', 'irrelevant', 'paradoxical'.

b. Considerations about elimination enter only when a further question is raised: What does it 'mean' that confirmation increases the probability of a generalization? Maybe this question can be answered in different ways. *One* answer, however, is this: The increase in probability which takes place as an effect of confirmation reflects a process of elimination of rival generalizations (about things in the range of the given generalization). There are fewer and fewer competitors for the truth, so to speak.

I shall not here comment directly on Baumer's own "eliminative confirmation approach" to the problem of the paradoxes, nor on the "modified approach" which he sketches towards the end of his paper (section 5). The second uses comparisons of *simplicity* in rival hypotheses. It is remotely related to things which I said about the simplicity and probability of hypotheses in *Treatise* (pp. 256ff.). With much of what Baumer writes here, I am in agreement or sympathy. Only, I must protest against the statement (pp. 163–64) that the criteria which Baumer suggests for membership in a set of initially possible rival hypotheses had something to do with the concept of a range of relevance of a generalization. The sets of initially possible hypotheses correspond to sets of *characteristics* (of individual things); the relevance ranges again are sets of *things* (having one specified characteristic in common).

Towards the very end of his essay, Baumer mentions "certain elaborations" suggested by Wesley Salmon. They are all of them interesting, though leading to what "is admittedly a significant reformulation of von Wright's version of eliminative induction". Of particular relevance to induction theory is,

I should think, the possibility "for the recognition of disconfirming but nonfalsifying evidence" of a generalization. This is a topic on which I have myself done some thinking, but not written anything. As I see it, the notion of disconfirming evidence which does not falsify is related to the notion of *analogous,* rather than *rival,* hypotheses. Assume, for example, that we have not (yet) succeeded in refuting the hypothesis that all *A*s are *B*. But we have refuted the hypotheses that all *A's, A"s,* etc., are *B,* where *A, A', A"* etc., are classes of somehow comparable or analogous things such as, e.g., species of animals. Then a further refutation of a hypothesis that all of a class of such things are *B* might be taken as weakening (disconfirming) the hypothesis that all *A*s are *B,* even though it is not a falsification of it. The exact formal treatment of these ideas, however, belong in a different dimension from the Broad-Keynes Principal Theorm of Confirmation. And I am not sure that they can be relevantly related to the problem of the Paradoxes of Confirmation.

McGuinness on von Wright on Wittgenstein

Brian McGuinness's essay falls into two parts. The first (pp. 1–6) comments on my work as one of the editors of Wittgenstein's *Nachlass*. It also makes some remarks, which I think illuminating and perceptive, on some differences and resemblances between Wittgenstein's and my ways of doing philosophy. This part of McGuinness's essay, however, I shall not try to answer. The second part consists of reflections occasioned by one of the three papers of mine in which I have dealt with topics in Wittgenstein's philosophy. The paper selected by McGuinness for comments is the one called 'Wittgenstein on Probability' (B233, 1969). The other two, not mentioned by McGuinness, are B250 (1972) which studies the system of modal logic implicit in the *Tractatus,* and B252 (1972), called 'Wittgenstein on Certainty'. McGuinness's comments are mainly on Wittgenstein and to a lesser extent on my interpretation of Wittgenstein.

Wittgenstein's definition of probability in the *Tractatus* is in all essentials the same as the one proposed nearly one hundred years earlier by Bolzano in his *Wissenschaftslehre*. It therefore seems to me appropriate to call it the Bolzano-Wittgenstein definition of probability. In my paper B233 I said that, according to this definition, if K is a finite conjunction of logically independent propositions, every one of which is known to be true, and if s is a proposition, the truth-value of which is not known, then the probability of s given K is ½. As McGuinness observes (p. 174), this is not quite right as it stands. We must assume that s is atomic. If s is a truth-function of propositions, none of which occurs in $K,$ the probability of s given K equals its probability *simpliciter*, i.e., its probability relative to the tautology. And this prob-

ability, of course, can be different from ½. If we subsequently come to know the truth-value of some of the propositions, of which s is a truth-function, and add this proposition to K, then the probability of s given K *and* this added proposition will, in general, differ from the probability of s given K alone. We could then say that the probability is affected by an increase in our knowledge.

It follows from McGuinness's criticisms that the account, given in my paper, of the relation between knowledge and probability ought to be amended as follows:

Let R be the *set* of all those elementary propositions (in the *Tractatus* sense), the truth-values of which are known. We shall assume that the set is finite. Let r_n be the conjunction of the members of R. r_n is then the present 'bulk of knowledge' ($=K$ above).

Let S be the set of all elementary propositions with unknown truth-value. We shall assume that it, too, is finite and has k members. The 2^k state-descriptions which can be formed of the members of S we call s_1, \ldots, s_{2k} and their disjunction S_d.

The probability of each s_i given r_n equals ½k which is the probability *simpliciter* of s_i. That the bulk of knowledge increases means that n grows and k diminishes. With diminishing k, ½k grows. Thus when the bulk of knowledge grows, the probability that the unknown 'part' of the world shall have a specific constitution, i.e., consist of a specific combination of truth-values in the unknown propositions, increases. If there is only one unknown proposition, this probability has the maximum value ½. If everything is known, there is no longer room for probabilities. As Wittgenstein says in *Tractatus* (5.156): "Nur in Ermanglung der Gewissheit gebrauchen wir die Wahrscheinlichkeit". I ought to have made the above things clear in my essay. Yet they are hardly, in themselves, very important or interesting.

Matters become more interesting when we consider the effects of adding to the 'bulk of knowledge' what Wittgenstein calls (*Tractatus* 5.154) "die hypothetisch angenommenen Naturgesetze" ("the natural laws hypothetically assumed"). For, this addition may impose restrictions on the ranges of possible combinations of truth-value in the propositions with unknown truth-value. (This point, too, ought to have been said more clearly in my paper.) An example:

Let it be that we do not know whether p, nor whether q, but that we assume it to be a 'law of nature' that, whenever it is the case that p, then it is also the case that q. This assumption entails that one of the four logically possible combinations of truth-value in the two propositions is excluded, viz. the combination when it is true that p but false that q. On the said assumption, the probability that it is the case that p is ⅓; whereas without this assumption it is ½. Given the assumption, moreover, the probability that it is the case that q is ⅔, and without this assumption it is ½. Now, suppose that we come to know

that p. Then the probability that it is also the case that q, assuming the validity of the law, is 1, i.e., a certainty—whereas without this assumption it would have remained ½.

Laws of nature require, for their proper expression, the use of quantifiers. We should not say that 'if p, then q' expresses a law—unless we understand 'p' and 'q' as generic propositions and the conditional as meaning the same as 'whenever p, then q'. As is well known, quantification was a troublesome matter for Wittgenstein in the *Tractatus*. But, as I hope I showed convincingly in my paper, these troubles do not affect the idea that laws of nature, 'hypothetically assumed', may influence probabilities which are computed on the basis of the Bolzano-Wittgenstein definition.

How can we, when computing probabilities, take into account the restrictions which the laws of nature impose on the truth-value distributions? As already indicated, we can make assumptions (hypotheses) about laws of nature and base our calculations on these assumptions. But there is also another way: learning from experiments and observations on frequencies. Wittgenstein obviously had this in mind when, in *Tractatus* 5.154, he envisaged an experiment of drawing balls from an urn and replacing the balls after each drawing. The result of the experiment was assumed to be that the numbers of drawn black and of drawn white balls tend to become approximately equal as the drawing continues. Then followed Wittgenstein's conclusion: "Was ich durch den Versuch bestätige ist, dass das Eintreffen der beiden Ereignisse von den Umständen, die ich nicht näher kenne, unabhängig ist."

I think one may also draw from Wittgenstein's statements the conclusion that if the numbers of drawn balls do *not* approximate then the occurrence of the two events *may* depend upon the circumstances. But what does 'dependence upon the circumstances' mean here? In order to be probabilistically relevant, it must mean some restrictions upon the distributions of truth-value over the propositions describing the circumstances such that the probabilities of the two events, when computed according to the Bolzano-Wittgenstein definition, deviate from the value ½.

Wittgenstein is here, implicitly, admitting that factual relative frequencies may be indicative of the dependence of events upon (unknown) circumstances, i.e., indicative of restrictions on truth-value distributions involved in the computation of probabilities. This is, in several ways, a very consequential admission. It paves the way for Wittgenstein's later views on probability and for their further elaboration by Friedrich Waismann in his important paper in *Erkenntnis* (1930–1931).

What Wittgenstein says in *Tractatus* 5.154 is compatible with the idea that the restrictions on truth-value distributions are imposed by laws of nature of the standard form of universal implications—such as 'all A's are B' or 'whenever p, then q'. Whether Wittgenstein still entertained this idea in his later

writings on probability from the late 1920s and early 1930s, we cannot tell. But it would, I think, be in line with his later ways of thinking if he had dropped this idea as an idle or useless link between statistical frequencies and probabilities. For, what is said in 5.154 is equally compatible with the acceptance of the restrictions on truth-value distributions *as a fact*—and not as anything which has to be 'derived' from underlying non-probabilistic laws. Since facts of this character determine values of probability, one could speak of them as *probabilistic laws*. But this use of the term 'law' is rather misleading. For the 'law' is nothing over and above the proposition about a probability, the value of which is 'indicated by' or 'reflected in' statistical frequencies.

Tractatus 5.154 thus prepares the ground for a conception of probability which in fact makes the Bolzano-Wittgenstein definition otiose. Probabilities, one could say, are hypothetical measures of the realizability of (generic) events on particular occasions. Perhaps one could in German coin the word 'Realisierungsmass'. The relative frequencies with which the events occur on repeated occasions do not verify or falsify the measures (values). But close agreement between assumed probabilities and observed frequencies can be said to confirm *(bestätigen)*[1] that the event does not depend upon further circumstances "with which I have no closer acquaintance. Disagreement may induce us to adjust the hypothetical probability so as to accord better with the frequencies. But disagreement can also be interpreted as a chance deviation from the standard laid down by the probability. Which 'conclusion' we draw cannot be dictated by logic alone. It will depend on further investigations into the nature of the circumstances under which the event occurs.

This view of the relation between probabilities and frequencies seems to me the best one to take. It solves the conceptual knots into which both the frequency-theory and the range-theory of probability get involved. But there are other uses and senses of 'probability' which one must not even try to relate to statistical frequencies and which require a different treatment. I think, however, that these other cases are 'marginal' and that the 'core' of the topic of probability is constituted by the piece of (classical) mathematics known as the Calculus of Chances combined with a theory about its (statistical) applications to mass-experiments with repeatable occurrences of (generic) events.

This is a rough and summary statement of the position in the philosophy of probability which I came to adopt in the mid-1950s and to which I have since adhered. (See IA, p. 25f. and the reply to Nowak above.) At the time when my views crystallized I did not yet know Wittgenstein's later writings on the topic. Soon after I became acquainted with them and found unexpected support for my views.

[1]Ogden translated 'bestätigt' in 5.154 'verifies'. This is a straightforward error which McGuinness and Pears corrected when they used, in their translation, 'confirms.'

I have sometimes asked myself whether I have been reading Wittgenstein on probability too much through the spectacles of my own views—and therefore perhaps not done him full justice. I am glad to find that McGuinness has no basic objections to my account of Wittgenstein's position, although he seems to have some doubts (p. 183f.) about the adequacy of this view of probability.

II. ETHICS AND THE GENERAL THEORY OF NORMS AND VALUES

As I stated in IA (p. 32f.), my interest in norms and values got its decisive impetus from the invention of 'deontic logic'. As a consequence, much of the work which I have subsequently done in this field has been of a formal logical nature, even though it has constantly been guided by a desire to come to understand better the great ideas of the Right and the Good.

Three essays deal with the formal aspects of my work in this area. One, written jointly by Carlos Alchourrón and Eugenio Bulygin, and another written by Jan Berg, concern the logic of norms or deontic logic. The third, by Bengt Hansson, treats of the discipline which I have named prohairetic logic or the logic of preference. These three essays are not included in the present section, but appear in Section V. Six papers are included here: those by David Braybrooke, Herbert Schneider, Thomas Schwartz, Kurt Baier, Philippa Foot, and William Frankena. The first two belong to what may be called the 'general theory' of norms and values, the four remaining ones to ethics or moral philosophy.

Of all the contributions to this volume, the essays by Baier on the good of man and by Frankena on the nature of morality have presented the greatest challenge to my thinking. Both contain trenchant criticism of my position in *The Varieties of Goodness*—the work for which I had also contemplated the title (used before me by T. H. Green) *Prolegomena to Ethics*. Much of the criticism, I admit, is justified. The two authors challenge me to rethink the entire subject. The proper form of an answer to them would be another book. What I can say here is bound to be groping and sketchy.

Braybrooke on the Conditions on which Rules Exist

Professor Braybrooke addresses himself to a problem which has much occupied my thoughts but on which I have never been able to arrive at a final position. It is the problem of the *existence* of norms or rules.

It seems to me that there are two basic approaches to the problem. One is from the point of view of the *creation* or coming into being of norms through normative activity. This is the approach taken by Alchourrón and Bulygin.

Their view is that norms come into existence through acts of promulgation and pass out of existence through derogation. It is worth adding that norms which are logical consequences of promulgated norms must, on this view, be acknowledged to exist.

The second approach to the problem of existence is from the point of view of norms *being in force*. This is the approach chosen by Professor Braybrooke. The notion of norms being 'in force' is related to ideas concerning *efficacy* and *validity* of norms. I think it is a pity that Braybrooke's paper does not discuss explicitly these last two ideas.

When is a norm 'in force'? It seems to me that this question can also be approached in two ways. One could answer it by saying that a norm is in force when there is a high degree of conformity to the rule among the members of a group (community, society). The conditions which a norm must satisfy in order to be in this sense in force are, broadly speaking, those which Braybrooke calls (p. 190) group definition, *conformity,* and intentionality. Another answer, however, could be that a norm is in force, when non-conformity to the rule is with a high degree of regularity followed by coercive or punitive measures against the rule-breaking agents. Then the conditions of existence are a combination of group-definition, *enforcement* (p. 190), and intentionality.

Braybrooke thinks (p. 190) that the four conditions which he gives for ascribing a prescriptive norm or rule to a group are individually necessary and jointly sufficient. My suggestion is that conformity and enforcement be regarded not as individually necessary but as disjunctively necessary conditions. For then it is possible to keep distinct the two forms of existence of norms suggested by the above two answers to the question when a rule is in force, viz., existence which consists in the efficacy of the rule and existence which manifests itself in efforts to enforce the rule. These two modes of existence of norms are often, but not always or necessarily, concomitant. And both must be distinguished from existence which is founded in 'promulgation' alone.

There are some marginal cases worth noticing which would not classify as norms or rules proper, if we apply to them Braybrooke's four conditions. A case in point are *habits*. Is not action in conformity with habit an instance of following a rule? A person habitually goes for a walk before going to bed. He 'conforms' with a fair amount of regularity to the habit as long as he retains it. But only in some oblique or secondary sense can one speak of 'enforcement' here. The condition of group-definition, moreover, need not be satisfied. Habits can be purely individual.

Customs and *traditions*, it seems are more 'norm-like' than habits, in that they require a social setting. Customs must be *shared* and traditions *handed down*. But the degree of conformity may be low and enforcement next to non-existent. A somewhat different case is presented by *fashions*. Their existence within a group is more casual and less permanent than the existence of either

customs or traditions. But when fashions flourish, conformity within some—often only loosely-defined—group is high.

I think it is of interest to pay attention to this variety of norm-like categories. It makes us realize that the notion of a norm or rule is typically a *family* of cases—like notions of a game or of language. Therefore, 'the conditions on which rules exist' are also a *family* of criteria. I think this insight helpful in solving the intriguing problem of the existence and ontological status of norms.

Professor Braybrooke makes a sharp distinction (p. 189f.) between the conditions which justify our ascribing a rule to a group and *causal* conditions for the existence of rules. The criteria mentioned above are ascription-conditions. He does not give a corresponding list of necessary or sufficient causal conditions of existence. If I understand him correctly, the fulfillment of the ascription-conditions would itself count as a factor which causally conditions the existence of the rule under consideration (Cf. p. 200f.). But there are other causal existence-conditions.

Braybrooke calls (p. 199) an answer to the question 'Where did the rules come from?' a *causal explanation* of the existence of the rules. He says (p. 200) that there are rules 'implanted by natural causation''. and that ''rules may operate as causes themselves'' (p. 203). For example, the existence of a prohibition backed by sanctions, may *cause* an agent to abstain from doing the prohibited thing (ib.). Since human beings can bring rules into existence and also suppress their existence, rules as causes satisfy the conditions of ''experimental manipulability'' (ibid). The rules support counter-factuals, Braybrooke says (p. 203). Sometimes we can say that, had not a certain rule existed, a certain agent would not have acted as he did on a certain occasion. Rules thus ''can serve as the backing required to confer law-like properties upon the major premises of deductive-nomological explanations'' (p. 203). The explanatory force of rules for explaining actions is essentially the same as the force of covering laws in the famous Hempelian schema of explaining natural events.

I find Braybrooke's discussion (pp. 199–204) of rules and causation rather perplexing. What Braybrooke has to say can hardly be regarded as an explicit criticism of my opinions, since I have had only little to say in my writings about this, admittedly important, aspect of the existence of norms. But Braybrooke's position certainly differs, at least on the face of it, radically from the way I think about causation, norms, and action. I shall therefore try to indicate briefly how I myself tend to view the matters under discussion.

Let us first consider the supposed 'causal efficacy' of norms. The *reason* why people behave as they do, is often the fact that a norm enjoins or prohibits certain actions. 'Why don't you park your car here? The place would be convenient for the purpose.' The answer could be 'Because it is forbidden.' But could the agent not have ignored the prohibition? In one sense of 'could' he could certainly have done this. So, why then did he *not* act against the rule?

The answer might be 'Because he would have been fined, if caught'. Then it is understood that he was anxious not to get fined.

I think it is right to say that the norm itself, that is, the existence of the norm, can function as a reason for action. Someone may suggest that the reason is not the norm, but awe or respect of the norm, or a 'will to obey' or something similar. These reasons are on a par with fear of sanction, e.g., a man's anxiety not to be fined. I think these are only *remote* reasons which may, or may not, be there 'in the background' in situations when a man does so and so, because the norm enjoins it. The *immediate* reason for this action is the norm.

Norms thus function, most importantly, as agents' *reasons* for action and in the *explanations* we give of actions. Norms also have a function in *predicting* behaviour (action, conduct). This is a slightly more complicated case. When we predict that a person will, on some occasion, act in accordance with a norm or rule which he can be expected to know, then we are also implicitly predicting what will be the reason for his action. This implicit prediction can be to the effect that he will follow the rule just because it is the rule—or to the effect that he will follow it because of fear of sanction, or for some other 'remote' reason. The basis for such a prediction is, in a broad sense, *inductive:* we know something about the person's character and about his past behaviour, or we extend by analogy to his case what we know about other agents in similar situations.

Are reasons for action causes of action? Are explanations in terms of reasons causal explanations? Is the fact that a person tends or can be relied upon to act in accordance with a certain rule, a 'causal' feature—like the tendency of a glass window to break when hit by a stone? Some people would answer all these questions affirmatively. Trivially they are right: reasons for action are also what we *call* 'causes' of actions. But this terminology tends to blur important conceptual distinctions; e.g., between a person being obedient and glass being brittle. Therefore I think a warning is appropriate against the use of causal terms when speaking about the relation between rules (norms) and actions.

So much about rules as causes. What shall we say about the causes of rules? Rules may be instituted by human decision—as, for example, when a legislative assembly enacts a law which the head of state 'promulgates'. Various considerations usually motivate the introduction of rules. 'Why has one prohibited the parking of cars in this area?' The answer could be that the authorities thought it better to reserve the open space for recreation purposes. This was their reason for issuing the prohibition, for performing the 'normative action' as a result of which the norm came into existence—in the first place in the sense of 'existence' which is discussed by Alchourrón and Bulygin in their essay.

Not all rules result from acts of creation, however. Nevertheless, they may have a *raison d'être*. This may be found out by considering their function, the purpose which they serve. It can happen that the purpose is forgotten and the rule no longer observed for the sake of its (original) purpose. It may still linger on, say in the form of a custom or tradition, and satisfy at least some of Braybrooke's conditions for existence.

In many cases it will not be possible to answer the question *why* there is such and such a rule. The question simply *has* no answer. Why, for example, are youngsters supposed to rise when an elder enters the room? This is good manners. But who instituted the rule, how did it come into existence? We cannot tell. What is its function, what purpose does it serve? Teaching children good manners *can* serve a purpose—or it can be just a feature of the way children in some societies or social strata are educated.

Professor Braybrooke notes (p. 203f.) that already existing rules may *generate* further rules. Sometimes, the generating simply takes place by logical entailment, in accordance with the laws of deontic logic (p. 204). This case is hardly of much interest. But people may also adopt a new rule "as a contingent way of promoting the observance of the source-rule, as when they adopt a rule requiring cars to bear licence plates as a means to enforcing the rule that drivers assume responsibility for accidents" (p. 204). There is a *good reason* for the rule about plates: it helps to identify drivers and determine liabilities. Alternative rules could have served the same purpose. But to call this a "causal connection" (p. 204) between rules, or between the coming into being of a new rule and the practice of enforcing an already existing one, seems to me *only* misleading.

As an example of rules "implanted by natural causation" Braybrooke mentions (p. 199) "Chomsky's principles of universal grammar, which would seem to be (if they exist) clear examples of phenomena installed by natural causation." What shall we say about this?

I shall not say anything directly about this example, since I myself have doubts about the phenomena in question. But let us take a more familiar and less controversial case: the rules of grammar of natural languages—English, Swedish, Russian—as we find them in grammar books and as applied in the course of instructing people in those languages. Such rules are surely immensely deep-seated. Yet they are *rules,* and not law-like regularities of human speech. Unlike laws of nature such rules can be broken. This means speech which is in disagreement with the rules is not classified as *exceptions* to the rules, as something infringing upon their universality, but as *incorrect* speech. Such deviations, when they occur tend to be corrected—particularly in the process we call 'education'. People are taught to speak correctly, in conformity with the rules. Nobody made the rules. They have been there from time im-

memorial. Some of them were perhaps never even formulated by grammarians or teachers of language. On the other hand, they are not immutable—as laws of nature. The rules of language change. What used to be regarded as incorrect speech can become correct.

One could say that the rules of correct speech are part of the endowments of a speech community. Their description belongs in 'the natural history of man'. Philosophically, it is most interesting and important that rules of this character should exist—so unlike, say, the man-made rules of a legal code. But such rules cannot be said to have been 'implanted by natural causation'. (Braybrooke, of course, did not say this. He mentioned Chomsky's rules of universal grammar "if they exist".) They have not been 'implanted' at all. There are neither causes nor reasons for their existence. They just *are there*. And this— or something very similar—we ought presumably to say also about the mode of existence of the even more deep-seated rules of universal grammar, if there are such things.

Braybrooke carefully separates (p. 190) the problem of the existence of rules which enjoin or prohibit actions from the problem of the existence of permissions. This is a thoroughly justified move. The status of permissive norms is peculiar and problematic.

As noted above (cf. also Braybrooke's essay, p. 205), it is questionable whether *weak* permissions should be counted as norms at all. Since they 'consist' in the non-existence of corresponding prohibitions, their existence does not present any problem over and above the problem of the existence of a prohibition one could say. For the type of *strong* permission which I have called express or explicit permission, the existence problem is best solved on the lines of Alchourrón and Bulygin. Such permissions come into existence by being 'promulgated'. More interesting aspects of the existence problem are presented by permissions which are connected with a declaration of toleration or with prohibitions to a third party to interfere with the permission-holder's possibilities of availing himself of his permission. They challenge the problem of the existence of *rights*.

A problem of its own, finally, is presented by any principle to the effect that a normative system is closed, i.e., is such that anything which is not prohibited is permitted in some *stronger* sense than mere non-existence of a prohibition. The idea *nullum crimen sine lege* may be regarded as a special case of such a closure-principle. It assures immunity to punishment for committing non-prohibited actions. This assurance has itself normative character. And, as Braybrooke says, "few things could be more important to notice about a culture than whether the people belonging to it support such a principle". With what Professor Braybrooke has to say about this special problem of rule-ascription I find myself in complete agreement.

Schneider on Teleological Prescriptions and Descriptions

Professor Schneider calls attention to the *telic structure* of norms. I should myself perhaps not have used the word 'structure' here, but preferred to speak of the telic or teleological aspect, background, basis, or source of norms. Since I have had some difficulty following Professor Schneider's lines of thought, my comments on norms and teleology are perhaps only indirectly relevant to what he wanted to say. But I do not think that we are talking at cross purposes.

Do norms of all kinds or varieties have a telic aspect? Immediately or overtly this aspect belongs only to what I have called *technical* norms. These are rules to the effect that something ought to be done or avoided for the sake of a presumptive end or goal. The question of how pervasive the telic aspect of norms is can therefore also be formulated as a question whether technical norms (means-end norms) hold a basic position in relation to the other varieties of norm or rule.

That ideal rules or ought-to-be-norms *(Seinsollen)* present a telic aspect seems undeniable. This is also hinted at by Schneider (p. 214). The ideal, that which ought to be, is an axiological end of human *praxis*. The relation between the teleology of the ideal and the rules of action *(Tunsollen)* needed for its realization has never, as far as I know, been subjected to a thorough conceptual analysis. Here is a lacuna in the philosophy of norms waiting to be filled.

Deontic logic has, so far, mainly been a logic for prescriptive norms or, strictly speaking, for the 'kernels' of such norms. It is known that deontic logic can be interpreted as an alethic modal logic. This was first shown by Alan Anderson and Stig Kanger. The theme was later taken up and developed by me in B221 and B229. The ideas underlying the Andersonian interpretation is to view obligatoriness as a necessary requirement for the attainment of something. One can therefore say that this interpretation goes at least some way towards meeting Schneider's demand (p. 212) that all norms have a teleological structure. The interpretation shows that the logic of prescriptions can be derived from undisputably valid logical truths about conditionship relations. Perhaps one could say, using Professor Schneider's phrase, that it lays bare the 'telic structure' also inherent in the norm-kernels of purely prescriptive norms.

Anderson's interpretation thus bridges the prescriptive and the teleological aspects of (a logic of) norms. Anderson called his idea a 'reduction' of deontic to alethic modal logic. This is right in as much as the interpretation enables us to replace talk about obligatoriness and permittedness by talk about what is necessary and possible. Some of Anderson's critics have been of the opinion that this entails a reduction of 'ought' to 'is' and, consequently, a commitment to 'naturalism' in ethics. But this is not so. Anderson's idea is, in the first place, a commitment to a very general type of *teleology* in the realm of norms. Whether this is a naturalistic commitment or not, depends on the nature of the

telos toward which the norms are oriented. Many ends have an obvious axiological load. It may even be argued that this is an essential feature of the concept of an end. If this is so, then the Andersonian idea implies a 'reduction' of norms to value-concepts, one could say. But as far as the pure logic of this idea is concerned there is in it neither a commitment to value-ethics nor to naturalism. Between these two positions the Andersonian reduction is strictly *neutral*.

There are conceptual links between prescriptions and various *volitional* attitudes. A command, I said in *N&A* (p. 121), expresses a "will to make do or forbear". The laws of the state, for example, may be regarded as impersonal expressions of the will of a supreme or sovereign legislator.

A will is normally oriented towards a *telos* beyond the mere 'making do'. Usually, commands are issued and laws enacted with a view to some goal or purpose. The teleological motivation of a law is often written into a preamble to the law-text. But the logic of this relationship between the norm and its purpose is, I think, too complex to be captured by an Andersonian type of reduction to alethic modal logic. The enacting of a particular norm is seldom a necessary condition of achieving a particular end of the law-giver's. Nor is observance of the rule strictly necessary for this purpose. The relations are of a laxer and more 'global' nature. If certain goals or purposes are to be secured, there must be *some* norms and the norms must *on the whole* be observed. I think that these relationships too, between the norms and the ends in view, have a logic. But deontic logic, as we know it at present, is not adequate here.

One could speak of an *external* and an *internal* teleology of norms. What the Andersonian reduction brings to light is the internal teleology. It consists in the conception of the norm as a technical rule for the achievement of some good or avoidance of something bad, such as sanction or punishment. Considerations of internal teleology answer questions like: Why should I follow this rule, obey this norm? The external teleology again has to do with the purpose and the function of the *rule* itself, as distinct from particular *acts* of following the rule. Considerations of external teleology answer questions like: Why should there be these norms at all—and not, for example, a quite different set of rules? To give an account of this teleology is, in the first place, a task of legal, political, and social philosophy. Whether logic can be of much help here is uncertain.

Schwartz on Human Welfare

As I said in my IA (p. 34), it has surprised me that few of the principal themes in *The Varieties of Goodness* (henceforth abbreviated *VG*) have been further developed in subsequent ethical discussion. It is therefore gratifying to me to find that Thomas Schwartz has taken up two such themes for independent de-

velopment. One is the main theme centering around the concept of welfare. The second is a sub-theme relating to the notion of health ('medical goodness').

Schwartz's independent treatment of the themes starts from a criticism of my concept of welfare. He thinks it is too subjectivistic. 'Subjectivism' here means a view according to which a man's (subjective) preferences measure what is good and bad for him. Or, using Schwartz's formula (p. 219), subjectivism consists in the view that 'X is *good for* S if, and only if, X satisfies S's preferences'. I think it is a fair characterization when Schwartz says: (ib.) that I "did not so much reject this formulation as flesh it out to make it clearer". It could perhaps be added that the 'fleshing out' was quite substantial, as readers of *VG* will easily verify.

"As a subjectivist", Schwartz says (p. 230), "von Wright mistakenly analyzed human welfare value as a form of subjective value." I am willing to believe that there is truth in this criticism. My notion of welfare is too subjectivist. But a difficulty for me has been to draw a line here between something which is *too* subjectivist and something which still *is* subjectivist. For there surely is something 'intrinsically subjective' about (all) value-notions which no 'objectivism' in value theory can do away with.

Of the many interesting topics touched on in Schwartz's essay I shall here single out a few for discussion.

Irrational preferences. A person prefers not to go to the dentist, because he attaches more weight to the *immediate* consequences (pain) of going than to the long-run consequences (dental disease) of not-going (p. 219). Must we then, on my account of 'good for', say that he is doing what is good for him? *Pace* Schwartz (fn. 1, p. 232), I do not think we must do so. The person may be doing what he *mistakenly thinks* is good for him.

But by what criterion does the person mistake his apparent for his real good? Judgments in the third person concerning the beneficial or harmful nature of things are objectively true or false. (Cf. *VG*, p. 110.) Their truth-value depends partly upon the factual consequences for the subject concerned of having or not having these things in his life, and partly upon how he values the wholes which consist of these things and the consequences of having them. A difficulty is here caused by the fact that the consequences may cover a long period of time, during which the valuations (preferences) of the affected subject may change. Perhaps the man who shrank from going to the dentist, will say later: 'Had I known then how much I should have to suffer later from bad teeth, I should much rather have gone through the pain and now have good teeth than have neglected to go to the dentist and now have all these troubles.' But then he may not remember how strong his fear of the pain was, nor can he know how fearful the pain really might have been. Perhaps the pain would have been 'unendurable', would have made him suffer an incurable psychic trauma for the rest of his life. So what is the truth in the matter? What *would*

he prefer (choose), if he could really see 'in a clear light' and weigh the consequences of going to the dentist against the consequences of neglecting to do so? Was his chosen course of action perhaps, after all, the best one for him?

There are thus considerable complexities connected with judgments of what is good and bad for us. I dealt with the difficulties in some detail in *VG*. I am sure I did not solve them in a satisfactory way. But Schwartz could have shown greater appreciation of the complications of the problem. Then he would not have said, I think, that my treatment of *akrasia* "conflicts" (fn. 3, p. 232) with my account of human welfare.

Malconditioning. A man's preferences can in various ways be *distorted*. This can happen, for example, thanks to the influence on him of 'unhealthy' forces within society, such as commercial advertising, political or religious brainwashing, and so forth. "*Can* malconditioning discredit someone's preferences as a measure of his welfare?" Schwartz asks (p. 220). "Not according to von Wright", he answers (ib.). But is this really so?

Schwartz considers the case of a man, who has been hypnotized and wants his nose to be cut off, "though he is fully aware of the causal prerequisites and consequences of doing so and of not doing so" (p. 220). Will cutting off his nose then be good for him?

The answer depends, I think, upon further details of the imagined example. Assume the hypnosis is only temporary and our man has his wish fulfilled but then 'wakes up' to suffer the consequences. He would almost certainly think that what happened was most detrimental to his welfare. But assume that the hypnosis lasts for the rest of his life. He never revises his preference, but persists in preferring the way he now has it to the life which he would have had, had his nose not been cut off. Who can then stand up and say with authority that 'really' it was not good for him to have his wish fulfilled? At most one could say that it was not good for him to be *hypnotized*. But even that is not quite clear. If before being hypnotized he had been presented with the alternatives, what would he have chosen? Probably, not to be hypnotized. But whether his choice would have been based on considerations pertaining to his true welfare is uncertain. The difficulties of foreseeing the consequences of *not* being hypnotized are considerable, perhaps next to insurmountable. It is more likely that his present revulsion at the thought of what he will look like with his nose cut off would determine his preferential choice than that calculating consequences would do this. But, if he really and truly foresees for himself a most miserable and wretched life if he is not hypnotized, then he might prefer to be hypnotized. If he were never to revise his judgment, becoming hypnotized would be better for him.

Shall we then say that malconditioning can*not* discredit a man's preferences as a measure of his welfare? I am inclined to say that as long as a man remains *victim* to malconditioning his 'distorted' preferences will measure his 'true'

welfare. But a man may be able to resist malconditioning, thinking that it will harm him. And he can urge others to do the same, thinking that malconditioning will be bad for them too.

Self-regarding and other-regarding preferences. Schwartz discusses (p. 220) the case of a man who prefers letting his daughter get the medical treatment *she* needs to getting for himself medical treatment which *he* needs. He cannot afford both and has to make a choice. Then he does what he thinks is good for his daughter. Let us assume that he does this after having carefully calculated the consequences for himself. He has come to the conclusion that he will most probably have to suffer great bodily pains. Still he prefers to see his daughter treated. Does he then not prefer to do what is good for her, but bad for himself? Surely we are inclined to say he does. But my view in *VG* of the good of man seems to commit me to the "preposterous consequence" (p. 221) that letting the daughter be treated is good for the father, and that to get treatment for himself but not for his daughter would have been bad for him.

I don't think this is *as* preposterous as Schwartz makes it appear. The father lets his health be injured and he accepts this, because he will rather suffer himself than see his daughter suffer. Had he made another choice, he might have had another person's life, welfare and happiness 'on his conscience'. This could be bad for him in more ways than one. It could have a distorting influence on his subsequent life, and *not only* by making him feel remorse and feel miserable. Someone might wish to say: to save himself and not his daughter would have been bad for his *soul*. But 'soul' here stands for *the man* himself. What is good for his soul is good for the whole human being and not only for that 'part' of him which is his health or physical well-being.

Choosing something which is thought good for oneself does not mean that one chooses this thing *in order to* promote one's own welfare. Schwartz concedes this point. (p. 221) I therefore find it difficult to see how my position could rightly be accused of being a form of psychological hedonism (ibid). It is true that on my definition of the notion of 'good for', "a person who knows the causal prerequisites and consequences of the choices open to him always prefers (and so chooses) what is good for himself" (ibid). But this only means that what the person chooses, given these (ideal) circumstances, is by definition good for him. He does not then choose the alternative which he (perhaps mistakenly) *thinks* good for him; the alternative he chooses (prefers) is the one that *is* good for him.

In spite of these possibilities to defend my position, I feel inclined to accept the essentials of Schwartz's criticism here. Other-regarding preferences should perhaps not be considered constitutive of the preferring subject's own good or welfare. It is not quite easy to see, however, how the definition of 'good for' ought to be amended so as to make it possible to distinguish between what a

man prefers to have (do, get, undergo) as good for himself and what he prefers because *his* having (doing, etc.) the thing in question is good for *another* being (and maybe bad for himself). Schwartz hardly succeeds in solving the problem completely. But he makes interesting and helpful suggestions. (I shall return to these questions in my reply below to Baier.)

Welfare and essential human needs. Not every self-regarding preferential choice is tantamount to a choice of something an agent considers good for himself. The agent may *just want* the thing in question.[1] But he may also choose to have the thing because he thinks it will *do him good*. This could be true even of wanting a drink. What is the difference between having a drink merely because one wants it and having a drink because one thinks that it will do one good? In the second case, the agent would probably also wish to say that he *needs* a drink. He is tense and a drink will make him feel relaxed. Or he is tired and a drink will cheer him up. The drink is, so to speak, needed for the sake of restoring him to a state which he considers the normal and healthy one. It is a state in which he feels at ease, in which he 'functions' well.

The example of the drink is ephemeral but nevertheless illustrates basic facts about the notion of welfare. One such fact is the connection between welfare and needs. The things a man needs are the things which are required (necessary) for some goal of his. A goal, broadly speaking, is something he wants to attain. Here is a connection between need and want. It is clear, however, that not every need is a welfare-need. The latter must, it seems, be independent of the contingent character of the goals (wanted ends) for the attainment of which the satisfaction of the needs is a necessary condition. They must, furthermore, be something 'standard', that is, something which every normal man needs independently of what he *happens* to want. The wanted thing, for the sake of which a welfare-need has to be satisfied, must be in some sense *necessarily,* not contingently, wanted. It makes no sense to ask *why* one wants it. One cannot ask why a person wants to be relaxed and not tense, or why he wants to feel fresh and not tired. It is *natural* ('normal') to want to be fresh, and it would be (logically) *perverse* to want to be tired.

When we say that a man needs a drink, the need which the drink is supposed to satisfy is a need to be fresh and relaxed. If this need could only be satisfied by taking drinks, then it would be essential to a man's welfare that he is provided with drinks. But there are other, and on the whole better, ways of satisfying the need in question.

Welfare and health. In *VG* I suggested (p. 61) that one should try to under-

[1] I am not sure, whether the observations which Schwartz makes on p. 222 on "mere want" and "good for" are meant to be a criticism of my position. I do not think I have said anything which conflicts with these observations.

stand welfare on the pattern of the notion of health. "On such a view", I said, "the good of man would be a medical notion by analogy, as are the good of the body and of the mind literally."

I did not myself attempt to work out this analogy in detail. The source of inspiration for the thought was Plato and the role of medicine in Greek culture. The author to whom I was indebted for having drawn my attention to this source was Werner Jaeger. I am glad to note that Schwartz thinks this idea promising and makes an effort to develop it further.

According to the 'medical' view of welfare, "to do what is good for a man is to promote or protect certain strengths and excellencies of his body and mind" (p. 226). But not *all* such excellencies have to do with welfare. Only those excellencies of body and mind have a bearing on welfare, it would seem, which are needed by all 'normal' men whatever their specific goals and projects happen to be. This observation by Schwartz nicely connects the medical view of welfare with the view that welfare consists in the satisfaction of the basic needs of a normal life. I think Schwartz wishes to say that these two views are at bottom one and the same. With this I am in sympathy.

Welfare—a normative notion? But problems remain. In the definition of welfare, both in the terms of basic needs and of health, the notion of *normalcy* ('normal men', 'normal life') figures importantly. Health may be said to be the normal or natural state of body and mind—illness a disturbance or loss of equilibrium. (Cf. *VG*, p. 56.)

But who sets the standards of normalcy? Is normalcy a statistical average? Or is it a normative notion? Schwartz raises the questions, but does not discuss them at length. The same was true of the author of *VG*.

If normalcy is, at least partly, a normative concept, then this will also be true of the notions of (welfare-)need and welfare. But from what source could such norms or standards emanate? They cannot flow from individual authority. Nor from the 'impersonal' authority of a legislature. The source must be, it seems, something which might be termed 'the authority of society'. What the community or society regards as a 'normal life' for its members depends upon such factors as, for example, level of technological development, standard of living, social structuring, and also upon inherited customs and traditions. Therefore a 'normal life' in one society will be different from a 'normal life' in another; and what counts as welfare in one will perhaps not count as welfare in another. Moreover, with social change the contents of the notion of welfare will fluctuate within one and the same society.

The account I gave in *VG* of the good of man was subjectivist in the sense that it made welfare dependent, in the last resort, on the verdict of the subjects. The good of man, as I saw it, could also be called an *idealized* subjectivist notion. For the criterion of what is good for a man depends not on what he actually happens to want for himself on the basis of his subjective estimate of

prerequisites and consequences ('the prizes of goods'), but on what he *would want, if* he had *perfect knowledge* of these prerequisites and consequences. (Cf. the reply to Baier, below p. 780)

The account of welfare which Schwartz suggests and which I myself now incline to accept should, I think, be considered a normative account of welfare. It has an objectivist foundation in the fact that the standard of normality is *also* an average. But it has at the same time a subjectivist foundation in the fact that what the normal man needs for his welfare is a prerequisite for the successful pursuit of anything he happens to want.

Illness. A subsidiary question of much interest in this context concerns the notion of illness. Pathologists, Schwartz says (p. 228), classify morphological defects as illness, "regardless of whether they cause any functional impairment". I doubt whether this really holds true, viz., of 'normal' pathologists. Morphological anomalies—for example an ugly bruise—are not necessarily symptomatic of disease. But even when they are not, they may cause discomfort, frustration, and malfunctioning. They may hamper the normal life of a man in ever so many ways and thus detract from his welfare. If morphological anomalies were not evils in any of these ways, there would exist no good reason for classifying them as illness either. But it is a noteworthy fact that morphological defects nearly always *are* inimical to our welfare. This shows, I think, how deeply connected the notion of welfare is with the notion of normalcy. Even small deviations from the standards of normality in our physical constitution tend to have consequences for the possibilities of participating in the pursuits of a normal life.

Schwartz thinks it a mistake "to suppose that illnesses always cause pain-like sensations or the frustration of wants, even in normal men" (p. 228). He gives some examples: a carcinoma on the brain which does not "as yet" (ibid) cause discomfort of any sort; or cases of leukemia, the only effects of which are that they shorten life. To this I should like to say the following:

A doctor may diagnose a disease and cure it before any painful or frustrating consequences have manifested themselves. But the reason for calling this a disease, and for saying that the patient is ill, must surely be that the symptoms, if allowed to develop, would in all likelihood have adverse effects on the patient's well-being. Not necessarily consequences in the form of *actual* frustration and bodily pain for the individual concerned—as my all too subjectivist theory of welfare in *VG* would require—but consequences detrimental to his *possibilities* of leading a normal life. If he does not want to engage in many of the pursuits and activities which are considered 'normal' and if he will never suffer from the evils hidden inside him, then we might say that, although 'objectively' ill, he is 'subjectively' well. This implies, if I am not mistaken, that also in the notion of illness, as in that of welfare, a normative element is concealed.

Baier on the Good of Man

Professor Baier's essay contains severe criticism of the account I gave in *VG* of the notion of the good of man. However, the author does not, at least o-ertly, challenge the central position which I accorded to this notion. Briefly speaking: I thought that all judgments and rules of conduct which deserve to be called 'moral', must rest on considerations of how actions affect the good of man. If this were not so, I could not understand what moral goodness or moral duty and rightness mean. I do not wish to abandon, or even to challenge, *this* thought. But it is obvious that, unless I can give a satisfactory account of the good of man, I have little hope of substantiating my claim that it is in the light of this notion that we have to understand all other notions of importance to the moral life of man.

I shall here make comment on the following five questions, all of which are discussed at length by Baier, leaving aside a good many minor issues on which he also has interesting things to say:

1. What *is* the good of man?
2. How is the good of man related to what is beneficial and harmful for him?
3. How shall we explicate the notion of the beneficial?
4. Can the good of man be explicated in terms of an agent's idealized pref-erential choices?
5. Is my theory a form of egoism?

1. I somewhat regret that I made so much use of the *term* 'good of man'. It is not used very frequently in ordinary speech. The other "three candidates for a name of the good of man" which I mentioned (*VG,* p. 87) have, however, names in common use: happiness, well-being, and welfare. I suggested and accepted 'without discussion' that 'welfare' be a synonym for that which I also called "the good of man" (ibid). This, I now think, was not at all a good suggestion. It was in fact a mistake. Welfare is a notion in its own right and with a narrower scope than the thing to which the term 'good of man' was supposed to refer. My conception of welfare is criticized by Schwartz in his essay. As can be seen from my reply, I agree with much of the criticism. Baier reinforces (pp. 237–39) some of Schwartz's critical points. Like Schwartz, he stresses (p. 238) the close connection between welfare and basic needs. I think that I can accept practically everything Baier has to say on this topic.

With some of the things he says on happiness I disagree, however. Happi-ness need not be construed as a state, and still less as "a certain introspectively recognizable feeling of varying degrees of intensity" (p. 237). One must dis-tinguish, *pace* Baier (p. 237), between feeling happy and being happy. A piece of good news makes one glad or relieved, particularly if we had been expecting disaster. Good news is also commonly called 'happy news' and sometimes said

to make us happy. Then happiness is like a feeling or state. But there is also another sense in which a man can be said to be happy or to have a happy life. This is, roughly, when his basic ('welfare') needs are satisfied, when his work gives him fulfilment, when he does not envy his neighbour, and when great misfortunes do not befall him, such as serious illness or the untimely death of a beloved person. Perhaps one could say that a person who is in this sense happy, *has* or *enjoys* 'his good'. Using Baier's distinction (p. 241) between wherein the good of a being *consists* and wherein it *lies,* one could also say that the good of man consists in his being happy, in his thriving, and that it lies in those contingent circumstances which ensure his happiness.

However, according to Baier (p. 243) "neither the answer to what the good of a being consists in nor to what it lies in, can be an answer to what category of thing it is". This may be so. I am not sure, however, that I quite understand Baier's concluding remarks on "what category of thing 'the good of X' refers to" (p. 243). According to him, the good refers "to what (i.e., *whatever*) that good lies in" (p. 243).

As already said, it was a mistake in *VG* to identify the good of man with his welfare. The notion with which to link it is happiness. Happiness, however, must not then be understood as a transient feeling of joy or gladness, but as a 'quality' of a man's life over a substantial part of it. How 'substantial' a part? This question must have troubled Aristotle when he asked whether any man deserves to be praised as happy in his lifetime and whether a man's happiness can be affected by things which occur after his death.

I should therefore not wish to say with Baier (p. 242) that "the good of any being consists in a life as good as possible". I should instead say that it consists in a happy life. Here my position has become more Aristotelian than it was in *VG*.

2. So much for the notion of 'the good of man'. How is it related to that which is *good for* a man? What is good for a person can, I think, without distortion also be called beneficial.

Baier says (p. 246): "it seems that, on von Wright's view, the good of a person is a logical construction of what is good and what is bad *for* that person. But it is easy and important to see that this is a mistake."

Baier makes a distinction which I think is useful between *being good for* and *doing good to* a person (p. 246). What is good for a man affects him (his 'life') in a more global way than that which (merely) does him good. The former, the beneficial, has a good effect of some duration on a person—like exercise or the company of good friends. The latter can be something ephemeral—like a drink to cheer one up.

One must also, according to Baier (p. 246), distinguish the beneficial from things which make a man better *positioned* for improving his life. An example of the latter would be receiving a television set or winning a lottery. Baier says

(p. 247) that the question, 'What is the good of a being?' is much wider than the question 'What is good for it and what does it need?' "The failure to note the difference may be partly due to a confusion of what is *for the good of a being* with (the narrower) what is *good for it,* and similarly, of what is *to its detriment* with what is *bad for it*" (Ibid).

Baier thus appears to hold that judgments on the beneficial have a narrower scope than judgements on what is for a person's good. "The former do not, the latter do comprise judgments relating to the improvement in a person's *position*" (p. 248). It would seem that, according to Baier, the beneficial, i.e., that which is good for a man, is always also something which is for that man's good, though not necessarily vice versa.

Perhaps one could say that the good of a man is 'constituted' by everything which is for his good. These constituents would then be the beneficial things *and* the things which relate to improvements in his position. But I must confess that I fail to see clearly the difference between these two main types of constituent of a man's good.

Baier says (p. 246) that ". . . the beneficial is what confers benefits of only a certain sort, improvements of the person or of his current state." I doubt whether this is quite accurate. I should say that things which improve a person's current state, make him 'feel' better or happier, *do* him good—e.g., a drink. They could also be said to be beneficial 'in the short perspective'. The things which are beneficial 'in the long perspective' improve the person. But what does "improving the person" mean? One sense, seems to be this: he becomes more capable of leading a happy and full and rich life. This is a kind of improvement in *position*. So why not say, e.g., that winning a lottery can be beneficial, good for the man? I feel inclined to say this and therefore also to stick to my original view that the good of a person is constituted by the things which are beneficial for him.

3. But what *is* the beneficial? To say that the beneficial is what is good for a person is only a verbal move and not a conceptual clarification.

A first step towards an elucidation would be to say that a thing is beneficial for a man if this thing makes him better off than he would be without it. But then we must then distinguish *four* different cases. Let the thing be X. It can be beneficial for a man to *get* this thing if he does not already have it; to *lose* the thing if he has it; to (continue to) *have* the thing if he already has it; or to (continue to) *lack* the thing if he does not have it. It is helpful if, instead of calling the thing itself (X or its 'negation' $\sim X$) beneficial, we say that getting or losing or having or lacking it is beneficial. (Some confusion in *VG* is due to the fact that I failed to observe the above distinctions consistently.)

If it is good for one to get X, then getting X makes one better off than one would be if one continued to lack it. One may, however, also get something else *instead* of X. Getting this other thing may be beneficial and even better

than getting X. Therefore, when one actually gets X and this is beneficial one can usually imagine having got something else which would have been even more beneficial. Baier makes some acute and pertinent observations about this (p. 248f.). He stresses (pp. 249, 254) the necessity of making clear the basis of comparison, the point of reference, when we say, for example, that getting X is good for a person.

How is this to be done? I think it is essential to such comparisons that something should exist which might be called a zero-line. This is a state of affairs or an event which is neither good nor bad for one. Getting X is beneficial if it, so to speak, lifts one above the line, harmful if it sinks one below the line, and indifferent or neutral if it does neither.

Let us assume that a person's situation at a given moment can be described by telling for any one of a number of states of affairs, X, Y, Z, . . . whether or not this state obtains at that moment. I realize that this assumption is loaded with problems. For example: how should the states be related to the person in order to count as belonging to *his* situation? The state that I am hungry obviously counts as part of my situation—and also that my jacket has a hole in the elbow. What happens far away and unknown to me, however, does not belong to *my* situation. But how do we draw the border? I shall not stop to discuss these questions here, but will proceed as if they had been settled.

Let not-X be a conjunctive component of my present situation. Consider the possibility that my situation remains unchanged in this component for a little while. We need not discuss for how long. Nor shall I here consider the question whether my situation during that interval of time may change in other regards, or whether it should be part of our assumption that the situation be entirely stable. I shall symbolize this non-change by $\sim XT\sim X$.

Let us next assume that his non-change does not affect, for better or for worse, the person under consideration, call him A. This assumption I shall write in the form of an equation (a) $\sim XT\sim X = 0$. What it *means* that $\sim XT\sim X$ does not affect the person's good I shall not yet discuss.

Consider now the possibility that A's situation changes in the component under discussion. Instead of not-X, X becomes characteristic of his situation. This change we symbolize by $\sim XTX$.

If this development does not affect A for better or worse, i.e., if we also have the equation (b) $\sim XTX = 0$, then I shall say that *getting X is neutral,* i.e., neither beneficial nor harmful to A (in that situation). If again the change affects him for the better, which I shall symbolize by (c) $\sim XTX > 0$, then *getting X is beneficial;* and if it affects A for the worse, i.e., if we have (d) $\sim XTX < 0$, then *getting X is harmful* to A (in that situation).

By an analogous but not identical argument, I shall now try to explain what it means that *lacking X* (or *retaining $\sim X$*) is beneficial (harmful, neutral) to a person. The 'zero-line' is here given by the assumption that a change in situa-

tion from $\sim X$ to X does not affect the person in question for better or worse. I symbolize this assumption by (a') $\sim XTX = 0$. (As seen, (a') is the same as (b) above.)

With this (non-affective) hypothetical change in A's situation we then compare the hypothetical non-change $\sim XT\sim X$. If we now have (b') $\sim XT\sim X = 0$, then *lacking* X is *neutral*. (As seen (b') is the same as (a) in the case we discussed previously.) If again we have (c') $\sim XT\sim X > 0$ then *lacking* X is *beneficial,* and if we have (d') $\sim XT\sim X < 0$, it is *harmful.*

It may seem strange that $\sim XTX = 0$ should be a condition of the *harmfulness* of lacking X. (That it is a condition of the beneficial nature of lacking X would hardly strike anyone as being strange.) In fact it is natural. Let $\sim X$ mean that I suffer from a headache. Then X means that I have no headache, and the transition $\sim XTX$ means that I am relieved of headache. But is not being relieved a beneficial thing, i.e., must not the transition $\sim XTX$ have a positive value? In a sense: Yes; in the sense that the having of the headache, here: the lacking of X, has a negative value. No-headache is, so to speak, the *normal* state, and restoring the normal does not mean getting something good; it is 'positive' only when set against the background of something which is ('really') 'negative'.

By a procedure exactly similar to the first of the two which I have described, one can now define what is meant by the beneficial (harmful, neutral) character of *losing* X, and by a procedure exactly like the second one we can define what is meant by the beneficial (harmful, neutral) character of *having* X. We need not go through these definitional procedures here.

From the fact that getting X is beneficial it must not follow logically that lacking X is harmful. Of this I was fully aware in *VG*. I thought that my explications of the concepts secured the desired result. But they did not, as Baier's criticism (pp. 257–58) clearly shows. Baier introduces (p. 258) a distinction between the harmful and the detrimental which would 'save' my position, viz., if by 'harmful' I had meant what Baier here calls 'detrimental'. But, as he notes (ib.), "von Wright's own account of the harmful does not allow him to substitute the 'detrimental' for it". So, making this distinction is no real help.

The elucidations which I have given above remove the difficulty, however. That getting X is beneficial means that the two relations (a) and (c) obtain. That lacking X is harmful means that (a') and (d') obtain. From the fact that the first pair of relations obtain it does not follow that the second pair obtain. It is also plain from the elucidations, incidentally, that getting X is *neutral* i.e., neither beneficial nor harmful, if, and only if, lacking X is neutral too. This surely is as it should be.

To get something else *instead* of X entails that my situation remains unchanged in being $\sim X$, but changes in some other feature. This change can be

beneficial or not independently of whether getting X is beneficial or not. And getting the one could be more beneficial than getting the other. I shall not here, however, stop to investigate the exact nature of these value-comparisons.

The above explications of the notions of the beneficial and the harmful rely on the notion of a man being better or worse off after a certain change or non-change. They go only a very short way towards a full explication of the beneficial and its contrary. For we have so far said nothing about what it is (means) to be better off.

The beneficial thing seldom *by itself* makes a man better off. The beneficiality (of getting X, for example) depends on consequences. This is another tricky notion. Although there is an enormous literature on 'the ethics of consequences' (utilitarianism), nobody as yet has succeeded in clarifying this notion satisfactorily.

Assume that A got X and as a consequence Y. What does this mean? There are at least two possibilities to be considered. One is that getting Y was *unavoidable* ('necessary'), once one had got X. The other is that getting X *made possible* the getting of Y—either as a piece of good luck (which otherwise could not have happened) or through some action (which otherwise could not have been done).

I shall here make the following tentative suggestion: getting X was beneficial for A, if, and only if, by getting it and the unavoidable consequences, and by doing certain things which getting X made possible for him to do, and by the happening to him of certain things which getting X made possible, A is better off than he would have been had he not got X (not counting what he might have got instead).

Baier asks (p. 253): "Does a person's good include what *would* be for her good whether or not she gets it?" This question should, I think, be set aside as irrelevant. But it is relevant to note that things which befall (happen to) a person without any doing on her part can also be good for her. For as was seen from the above, getting X can mean either that X 'comes', happens to her, *or* that she chooses, secures it for herself. I think Baier interprets my position too restrictedly when he says (p. 253f.) that I seem to hold that things that befall a person could not be beneficial.

What is it then to *be* better off? To be better off one could say, is to be happier. But in what sense of 'happy'? In a sense which has to do with richness and fullness of life. And with opportunities for 'more happiness'. To be better off may simply consist in being better positioned with a view to doing and getting further things which are for one's benefit. To be better off means that one's life as a whole has increased in actual and potential value.

4. But how does one 'measure' the value which the beneficial things are supposed to enhance? It is at this point the notion of a(n idealized) *preferential choice* enters the picture.

That I am better off after having got X must mean that I prefer a life in which (at that station) I get X and everything consequent upon it to a life in which I continue to be without X and suffer the things consequent upon *that*. This preference is not in conflict with the possibility that, if I were to live my life over again, I should (at that station) choose to get, instead of X, something 556 else which I prefer still more strongly.

But here a new question arises: What is it to prefer? As Baier points out (p. 254f.), one must make a distinction between what he calls 'intrinsic preference' and 'preference for reasons'. The first means 'liking better'. Thus, for example, I prefer oranges to apples, because I like oranges better. I prefer a life with more leisure and less money and influence to one with much power but with little leisure—again because I like better the first way of living. These are intrinsic preferences—I may, on some occasion, prefer to cut paper with a knife rather than a pair of scissors, because the knife makes a more even cut. (The cutting itself might be pleasanter with the pair of scissors.) I may prefer to stay at home and work on my paper for tomorrow's meeting rather than go for a walk, because I am anxious to make my arguments as convincing as possible. These are preferences for reasons.

Must every reasoned preference ultimately be 'anchored' in a liking? If I prefer to finish a strenuous piece of work rather than go for a walk, does this not mean that, somehow, I like better setting my energies to finishing the work? But suppose I work from a 'sense of duty'. Does it then follow that I like better doing my duty than enjoying myself? (Cf. Baier p. 255.)

These questions are difficult to answer. Consider for example the last question. It *could* be the case that I 'genuinely' like better (enjoy more) doing my duties than amusing myself or relaxing. But it would, I think, be a grave distortion to think that whenever I prefer to do my duty rather than doing something else, I like it better that way. In other words: a preference for reasons need *not* be 'anchored' in an intrinsic liking-better.

I did not see this clearly in *VG*, and this was perhaps the biggest mistake I made in that book. I thought of the preferential choices, in the terms of which I wanted to give an account of the beneficial and ultimately of the good of man, as expressions of likings, not as preferences for reasons. This forced on me the 'counter-intuitive' view "that no one can ever voluntarily choose an alternative he thinks he will like less well than some other alternative he would have chosen instead" (p. 255). And this is the root of the trouble into which I got over the problem of egoism. (See below.)

What then *is* the type of preferential choice that is relevant to the good of a being? I do not see why Baier should say (p. 255) "that von Wright must believe that 'preferential choice of A over B' means the same thing as . . . choice of A over B for reasons." As I understand my own past position, the case was the other way round. Perhaps my distinction between things which

are wanted 'in themselves' and things which are beneficial has confused my readers. Both kinds of things were explained in terms of preferences. In both cases the preferences were understood as intrinsic. That, in judging things beneficial, we take into account *consequences* does not make the preferential choice here a choice based on *reasons*.

One could make the notion of the beneficial, and there-with the good of man, dependent on intrinsic preferences only. Then the good of a man would lie in the way he ('genuinely') best *likes* to have his life, the way he is ('feels' in a comprehensive, global sense of the term) happiest. This notion of the good of man would answer, roughly at least, to what Baier (p. 264f.) calls a man's "merely personal good" and what I in *VG* (p. 90) also called a man's personal happiness. It now seems to me that, as far as the notion of the beneficial is concerned, the above is the right (or perhaps one should say: the best) view to take.

But one could also take a broader view of happiness and the good of man— a view within which one can distinguish between the 'overall' good of a man and his 'merely personal' good. The content of the broader notion too may also be explicated in terms of preferential choices between alternative constituents of our life. Not all of these preferences, however, would be intrinsic. Some of them would be reasoned preferences of a specific kind. The problem then is how to specify these reasoned preferences. I shall return to the question in the last section of my reply to Baier. First, two other points connected with the idea of preferential choice must be briefly mentioned.

In *VG* the preferential choice was 'idealized' in two respects. First, it was assumed that the choosing agent has complete knowledge of the consequences of choosing any one of the available alternatives. Second, it was assumed that his valuations do not change so that he will later regret a choice which he made in full awareness of the consequences.

Knowledge of consequences will have to include, not only knowledge of what inevitably happened (or would have happened) to the person concerned. One must also know how he and others used the opportunities for actions which the choice created but which would not otherwise have obtained. (Cf. above p. 785). Considering this, it becomes at least questionable whether the fiction of perfect knowledge is meaningful. For perfect knowledge of the consequences then presupposes that the agent can know in advance which opportunities he is going to use (and with what further consequences!) and which one he is not going to use.

Looking back on what happened to him and how he used the opportunities, a man may say later in life: getting X was good for me. Or he may say: getting X, which I actually got, would have been good for me, had I then also done so-and-so which I did not do. Rethinking his life, he can say: I would rather have got X (get X again) than have been without it. But if he is mistaken about

the consequences, he may also be mistaken in thinking sincerely that getting X was good for him.

Baier rightly criticizes my account of regret (p. 258f.) I think he is right. The 'modification' which he suggests (p. 259) seems to me to hit the nail on the head. To regret a choice is to think that one ought not to have made it "because it was, as one thinks, something one ought for some *reason* (moral or otherwise) not to have done". Baier says (p. 259): "The problem for von Wright is to explain . . . the case in which the chooser changes his mind about whether what he chose was really beneficial, really worth its price, because he now thinks his previous judgment was *a mistake*." And (p. 260): "It seems to me that von Wright cannot account for this case."

Can one, assuming perfect knowledge of the consequences, regret a preferential choice? In what sense, if any, can one speak of a *mistake* here? The fact that one's valuation have changed does not make the previous choice (valuation) a mistake. Nor can one regret the fact that one then, on that earlier occasion, had this intrinsic preference. For one cannot regret, I think, that one's *taste* has changed, i.e., that something which one before liked better as a possible constituent of one's life, one now no longer likes better. At most one might *deplore* it.

What one can regret, however, is that one made a certain choice based on an intrinsic preference, and not another choice based on a preference for reasons. One can, in other words, censure oneself for not having acknowledged and acted upon the reason which there was for not letting one's likings determine one's choice. To regret is to blame one-self for something one thinks one ought not to have done. What one did was a mistake—albeit not an 'intellectual' one. Let us call it a *moral mistake*.

Then the question arises: What is a 'moral' mistake? This, as I see it, is essentially the same question as the one, already raised (p. 786), about the *specific* nature of the reasoned preferences which bear on the good of man. To this question we must now address ourselves.

5. The problem which we are facing is intimately related to that "intuitively embarrassing corollary" (p. 261) which Baier thinks follows from my position in *VG*. This "corollary" is that my position there is a form of *egoism*,—much as I myself tried to argue that it was not. Baier's discussion of this topic is very interesting and he makes a number of useful distinctions and observations.

My ideal chooser, Baier says (p. 262), is not a "motivational egoist". He necessarily chooses *what* is for his good but does not necessarily choose *for the sake of* his good. However, he is "a result egoist" (p. 262). "He cannot, for example, choose to sacrifice his good for the sake of his mother, his subjects, his country, or for the good of those he loves." (Ibid.)

Baier further makes a distinction (p. 262) between Psychological, Ethical, and Rational Egoism. He believes "that von Wright's account of the good of man commits him to Rational Egoism". (Ibid.) Baier also distinguishes (p. 262) between self-centered and self-regarding egoism. My theory, he thinks (p. 263) is Rational Self-regarding Egoism. But rational self-regarding egoism, Baier says (p. 263), is mistaken. He argues as follows: it is in accordance with reason that people enter into relations of love with other persons. This is a good thing from their own point of view. "But if a person loves another then he desires the other person's good . . . even if this involves some harm or detriment to himself." (Ibid.)

Baier then (p. 263f.) introduces a distinction between self-centered, self-regarding, and self-anchored considerations. Considerations are self-anchored if they concern what "would make the agent's life such as the agent would ideally want it to be." "If . . . certain self-anchored considerations are reasons, that is, are such that acting on them is acting in accordance with reason . . . then self-regarding egoism must be false. For then it is in accordance with reason to choose certain alternatives which are not for one's own good."

Baier discusses (pp. 264–65) two objections which, if valid, would save my view (in *VG*) against the charge of egoism. The first objection is "that self-anchored reasons are after all only self-regarding reasons". Baier rejects this. He gives an example to show that genuine sacrifice of one's good is possible. The second objection is that pursuit of one's own good does not necessarily mean pursuit of one's 'merely personal good'. But then, Baier says (p. 265), "it would still be necessary to explain what that personal good is; what it is that it can be in accordance with self-anchored reasons to sacrifice, even for the sake of any kind of good of another. But von Wright nowhere draws such a distinction."

Baier's criticism is, I think, entirely justified. I ought to have made the distinction in question. In the reply to Baier I have already had occasion to indicate how I think this distinction ought to be drawn. It should be a distincton between intrinsic preferences (likings) involved in judgments of what is beneficial, and reasoned preferences 'of a specific kind'. On which condition then can a preference be positively relevant to my 'overall' good, although it does not enhance my 'merely personal' good? I suggest the answer: When the reason for the preference is that it enhances another person's happiness, *his* 'merely personal' good. To prefer to enhance another person's happiness rather than one's own is an aspect of the sentiment we call love. When we prefer to enhance our neighbour's good to the detriment of our own ('personal') good, we sacrifice some of our own good. But acts of love need not be acts of sacrifice. Normally they will also enhance, in an 'unselfish' way, our own happiness.

That the way is unselfish means that the reason for the preferential choice is our desire to promote another person's good. Promoting it may also be what I like to do. But there is a difference between preferring to do this because I like it best and preferring it because I want to promote another person's good.

I think that, modified as above, my position avoids the commitment to egoism. But whether a man will be better off (overall), if he consistently, instead of seeking his own (personal) good, lets his actions be guided by love of his neighbour, is a question which can hardly be decided on conceptual grounds.

Baier, however, seems to think that the distinction between one's merely personal and one's overall good will not be sufficient for a satisfactory solution of the problem under discussion. Agapistic reasons for action, i.e., action out of love, would still, if I understand Baier correctly, count as self-anchored reasons, since acting on such reasons "would make the agent's life such as the agent would ideally want it to be" (p. 264). But, Baier says (p. 265) he is convinced that "moral reasons can conflict with and do over-ride even self-anchored ones. . . . Hence even if we can distinguish between the (overall) good of a person and his personal good or interest, we must admit that not only is it not necessarily contrary to reason to choose what is to one's personal detriment, but it may well be in accordance with reason to choose something (one's duty) which runs counter to the best self-anchored reasons and so affects unfavourably one's not merely personal good; and it may sometimes be contrary to the highest reasons (the moral ones) to choose what is for one's (not merely personal) good."

Here I think I disagree with Baier. For what could moral reasons be, if not reasons which ultimately relate to the good of persons? (Baier does not deny this, at least not explicitly.) At most, they could be agapistic reasons which in some *special way* relate to the ('personal') good of men. Is there such a 'special way'? This question can also be put in the following form: Can care for the good of other men, love of your neighbour, be (moral) duty? To this I actually also addressed myself in *VG*. It was framed as a question of the existence and foundation of what I called other-regarding duties and was taken up in the concluding chapter on Justice. My position is examined critically by Professor Frankena, and I shall return to the question in my reply to his essay.

Foot on Virtue

I am afraid that Foot has somewhat misunderstood my introductory remarks in *VG* on the status of the topic virtue in contemporary moral philosophy. It is true, as she says (p. 271), that I did not approach the subject in a "revivalist spirit". It is not true, however, that I considered the "traditional theory of the virtues" as being "backward" in any sense other than that it has been to a large extent neglected by modern writers. Philippa Foot herself is one of the

few who cannot be reproached for such neglect, and this is one reason why I have always rated her writings on moral philosophy among the most original and stimulating of modern times. Neither is it true that I viewed the future development of the subject "in terms of radical change". But I certainly think that an up-to-date treatment of the subject must take it *further* and cannot rest content with a received body of "traditional theory". We may venerate Aristotle as the greatest of logicians and learn from him an enormous amount—and yet turn our back on the doctrine sometimes presented under the name "Aristotelian logic". Something similar could perhaps be said of Aristotle as an ethicist of virtue.

There is in Foot's paper another misunderstanding which I am anxious to correct. I said in *VG* that I was going to "mould" a concept of virtue. I did not aim at a definition which would embrace everything which is ordinarily called "a virtue". It is therefore not quite right to attribute to me an "idea that a new definition of virtue is needed" (p. 275). What is needed is not so much a 'new' definition as a further penetration into the complexities surrounding the notion.

Foot says she is not clear why I think a "new definition" useful (p. 275) or what the reasons are for shaping my "new concept of virtue" (p. 277) in the way I try to do this. In one place (p. 275) she conjectures that a reason might have been that I think "no account *could* be given of a virtue which would embrace wisdom, justice, and benevolence, as well as such virtues as courage and temperance." About this she is right. I really do not think such a unified and universal account possible. It seems to me one of the interesting features of the conceptual situation in the philosophy of virtue that 'virtue' defies a unique, nontrivial elucidation or definition. The virtues constitute, I think, a nice example of family-resemblance in Wittgenstein's sense. A conceptual analysis of virtue which aims at precision must therefore emphasize contrasts just as much as similarities. This I did not do with sufficient force in the brief chapter on virtue in *VG*. My foremost aim was to pursue one avenue of exploration, and I am sorry if I gave readers the impression that I wanted to narrow down the entire subject and dismiss as irrelevant what I left unexamined.

The essentials of the paradigmatic case which I was anxious to examine in *VG* could perhaps be paraphrased as follows: The virtues are traits of character which possess a utilitarian value for safeguarding the good of man. Their role, roughly speaking, is to help a man choose the right course of action in situations when some passion is likely to obscure his clearsightedness. In the case of courage the peculiar passion is fear. In the case of temperance it is lust. Yielding to passion may have undesirable consequences. Therefore it is in the interest of the individual concerned (and often also of society) that he should be able to overcome the obscuring influence of passion on his decision to act. To this end the traits of character we call virtues render him assistance.

The paradigm virtues on which I focused attention were in the first place those mentioned above, viz., courage and temperance. It would, as Mrs. Foot quite rightly observes (p. 277), be a fatal objection to my treatment, if it could be shown "that the new concept did not fit even those virtues for which it was bespoken, as, for instance, courage and temperance".

Foot discusses one interesting point where she sees a shortcoming in my definition. It concerns the question whether an act of virtue, for example a courageous act, can be a bad act (p. 278.). I mentioned in *VG* (p. 153) the courage "which burglars and robbers displayed". Foot doubts whether their conduct can ever deserve to be called courageous. She thinks "there is a closer connection between the concept of courage and that of good action than von Wright allows" (p. 278). She refers (p. 278) to the opinions of Aristotle and Aquinas on this question.

I find the problem intriguing. In my view there is also an essential connection between virtue and goodness. It is therefore not quite right when Mrs. Foot attributes to me the opinion "that courage is simply mastery of fear" (p. 278). The courageous man who masters fear, is acting in the face of danger. Danger is something which threatens *his* good. Courageous action therefore presupposes an estimate or opinion of what is good or bad for the agent. On a traditional view courage is a self-regarding virtue. What then if the action is thought damaging to somebody else's good? *Can* it then not be courageous? The ultimate question at stake here is whether consciously harming one's neighbour will not also, and necessarily, mean harming oneself. If the answer is affirmative, a man cannot display courage in doing evil.

However, although I find the problem puzzling, my inclination is to think that there is *not* an intrinsic connection between a self-regarding virtue and morally good action. To argue that 'true' courage must have moral worth seems to me to be sophistry. But I may be mistaken. If I am, Foot is right in thinking that something essential is missing from my attempted clarification of the self-regarding virtues, e.g., courage and temperance.

There are two more issues raised by Mrs. Foot in her paper which I should like briefly to touch upon here. The first concerns the relation between skills and virtues. (pp. 271–75) Foot makes a number of good points which I failed to make in *VG*. On a good many of them I agree with her. One on which we seem to disagree is the question whether there can be an intrinsic connection between a virtue and a *specific* act or activity. My reason for denying this was that the practising of virtue is tied to considerations about the right thing to do in a concrete situation—"right" meaning right with regard to the good of some being. Therefore no act or activity which can be described in general terms without reference to human good can intrinsically possess a virtuous character. Helping people, to use Foot's example (p. 273), is in normal cases connected with considerations about goodness. Giving somebody money is not. For that

reason, the last is a 'specific activity' and not intrinsically virtuous. About this I think we can agree. But I regret that my use of the term "specific" may have caused confusion.

Finally, I wanted to say something in defense of my view that virtues are not dispositions. Perhaps I can state my point better now than I did in *VG*. A disposition may be described as a potentiality for reacting in a characteristic way to a certain kind of environment or stimulus. The connection between stimulus and response is 'lawlike' Sugar is soluble in water; if put in water, it dissolves—unless the water is already saturated with sugar. A man is irascible: if teased, he will get cross and show signs of anger—unless he makes a very strong effort to control himself. The irascible man, one could say, is apt to yield to anger as to something that overpowers him. Features of temperament are dispositional in that they are part of our natural endowments and something we have to accept ('suffer'). Traits of character, such as virtues, are to a much greater extent the result of education and training and their manifestations from case to case the outcome of deliberation. I think these are noteworthy differences. Use of the blanket term 'disposition' tends to obscure this. There exist clear paradigm cases of dispositions, e.g., inflammability and solubility of stuffs. Then there are cases which deviate from the paradigm. It would be pedantic to refuse the name 'disposition' to all deviant cases. But there is a point at which the assimilation to the paradigm which the name suggests becomes philosophically obscuring. This happens when philosophers uncritically classify as 'dispositions' virtues or, which is even more misleading, but nonetheless popular in some quarters, beliefs and intentions.

I had not anticipated that my reply to Foot would be mainly polemical. I hope it does not convey an impression of being self-righteous. I am little satisfied with my treatment of virtue in *VG*. It is not false modesty on my part if I say that I consider Philippa Foot's contributions to the subject far superior to my own. But I also feel that certain things which I have been trying to say point in a fruitful direction. Therefore I am anxious to remove misunderstandings which have arisen from what was evidently an insufficiently clear formulation of my thoughts.

Frankena on the Nature of Morality

In the Preface to *VG* I said that the book "contains the germ of an ethics, that a moral philosophy may become extracted from it". Professor Frankena quotes this approvingly (p. 281). It may nevertheless have been an overstatement—considering the many open questions which Frankena encounters in his skilful midwifery to bring to the world the view of morality implicit in *VG*. If he is not entirely successful, the fault is with me and not with him. On the whole, he has understood my intentions correctly and does them full justice.

In the introductory pages of his essay Professor Frankena briefly touches on some points which are characteristic of the spirit in which I have approached the problems of ethics. One such point is that a fruitful discussion of moral concepts must assign to them a place in a wider conceptual frame. This can happen in two ways. One may find a place for ethics within a general theory of norms and values. Or one may look for it within a philosophical anthropology or view of the nature of man. A philosophical anthropology which is relevant to ethics ought, moreover, to be concerned, principally, with man as a social being, a *zoon politikon,* and not with solitary man. Morality is an aspect of human life in communities. These insights were not wholly absent from my earlier works. But their significance has later become much clearer to me. This has also made me increasingly conscious of the poverty of what I have so far succeeded in saying about ethics.

A second general characteristic of my approach is that philosophical ethics should "take the form of a moulding or shaping of concepts" (p. 281). One reason for holding this view is the notorious obscurity, ambiguity, and vagueness of the adjective "moral" as an attribute of words like "action", "duty", "motive", "norm", "rightness", "value". To try to make the meaning of "moral" precise and univocal is *one* way of doing ethics. But the sought-for precision is not there "in the nature of things", to be unearthed by the philosopher in search of meaning. It must be assigned or given. This can be done, for instance, by relating the moral ideas mutually to one another or to something outside the sphere of morality. When the philosopher does this for the sake of attaining clarity and coherence, he at the same time shapes his measuring rods for judging the actions of men from a moral point of view. The philosopher's craving for conceptual clarity, one could say, is inseparable from his quest for clarity in moral matters.

Moral norms and prescriptions. In *N&A* (p. 12) I said that it is "a logical feature of morality" that prescriptions play a prominent role in the moral life of man, that there is a "logical tie between moral norms and prescriptions" even though one cannot "reduce the former to a species of the latter". It is not clear, Frankena says (pp. 282–83), how this should be understood. If I meant that moral norms must be embodied in prescriptions, e.g., in civil laws or parental commands, he sees no reason for believing this. (Ibid.)

Wherein does "the moral life of man" consist? I should say that it consists in the fact that men, living in a society, accept certain rules of conduct such as, for example, that one must not lie, that promises ought to be kept, that one must not appropriate for oneself what belongs to one's neighbour, and so forth. That these rules are accepted in a society means, among other things, that children are taught to observe them, that members of the society on the whole observe them, and that society tries to enforce them by means of various punitive or retributive reactions toward members who break the rules. If this is a

basically correct, although admittedly very rough, characterization of the way morality functions in a society, then it should also be clear in which sense the activity of prescribing moral conduct is *essential* to morality.

To put it in a nutshell, morality is a *social* affair. Morals have to be taught and, in some measures, *enforced*—or else that aspect of life in a community which we call "the moral life" would not exist.

Nothing more than this is meant by saying that there is an "essential connection" between moral norms and prescriptions. The moral norms themselves I should not wish to call prescriptions. What I said in *VG* (p. 157) about commands, rules, and practical necessities being "aspects" of prescriptions was badly put. I should not have said that prescriptions have these three aspects, but rather that what we think of as *one* norm may present the three aspects of prescription (command, rule, and practical necessity). Frankena's complaint about unclarity (p. 284) is, I think, entirely justified.

Are moral norms and values autonomous? I shall try to explain why I wish to deny that the domain of morality is (conceptually) autonomous. There are two main reasons. One could call the one 'immediate' and the other 'remote'. The immediate reason is connected with my teleological view of morality. Morality serves an end. Therefore the moral norms are not norms *sui generis,* but a species of 'technical' norms. They aim at regulating conduct which is thought practically necessary for the attainment of the moral goal. The more remote reason for not regarding moral norms as being *sui generis* has to do with the nature of the end towards which moral norms are supposed to direct us. This end is defined in value-terms. But these value-terms are not specifically 'moral.' This is so because of my commitment to the following position:

To evaluate an action morally is to evaluate the way in which it affects, or is intended to affect, the good of human beings. This is why I say that moral value is not autonomous, but dependent upon the value concept of the good of man. This last is the pivotal axiological idea round which a secular ethics revolves. My chief complaint against ethical theories in modern times is that they make no or little attempt to clarify this idea and to relate the specifically moral notions to it. The good of man is not in itself a moral notion. Its nearest relatives in the family of concepts are happiness and welfare. (Cf. my replies above to Schwartz and Baier.) So much then for my denial of the autonomy of morality and the *sui generis* character of moral norms and values.

Naturalism versus non-naturalism. Where do I stand? The question of the autonomy of morals is related to the issue between naturalists (descriptivists) and non-naturalists (intuitionists) in ethics. How shall my position on this issue be classified? Frankena writes (p. 286):

> My impression is that von Wright means to be a naturalist or descriptivist of some sort, in the sense of making moral concepts and judgments logically dependent on non-moral ones, not just in the sense of making moral ones dependent on axiol-

ogical ones, but also in the sense of being a naturalist or descriptivist about all value concepts and judgments too, as Moore was not. I must admit, however, that I find few clear definitions or other statements to this effect in *VG* or *NA*.

I think the question of where I stand should be put as follows: Is the notion of the good of a being a naturalistic or a non-naturalistic notion? Very roughly speaking, something is good for a man if he would welcome this thing, being fully enlightened about its consequences for him. An outside observer, who has a better judgment of what the consequences of the thing in question will actually be, may also be a better judge than the man himself of whether this or that *will be* good for him, i.e., welcomed by him. But in the last resort the subject's own judgment decides whether something is or was good for him and thus counts as a positive 'constituent' of his good. I simply do not know whether to call this 'naturalism' or not. Perhaps it is naturalism of a sort. It certainly is subjectivism of a sort. (Cf. my reply to Schwartz, above pp. 773–79.)

There was a time when I was acutely aware of the issue between naturalism and non-naturalism, and definitely sided with the non-naturalists. That was before writing *VG*. I was then strongly under the influence of Moore and also of Kant. But later the issue began to lose significance for me. This happened as a consequence of the following shift in point of view:

When one focuses attention on value judgments of the type "this action (thing) is good", it is natural to ask what kind of attribute, property or quality goodness is—and whether it is "naturalistic" or not. But when the focus of attention is shifted to judgments about what is good for a being, or to questions of what constitutes the good of a being, the distinction between naturalism and non-naturalism becomes difficult to apply and the problematic connected with it loses its urgency. Its place is to some extent taken by the problems connected with the distinction objectivism-subjectivism. But even the significance of this distinction is not entirely clear to me in the context of the ideas of 'good for' and 'the good of'.

Meaning and criteria. The question of autonomy is related to the theses (p. 287) that (2a) terms like 'good', 'right', 'ought' have *the same* meaning in their moral as in their non-moral uses, and that (2c) moral judgments have no special kinds of grounds or reasons.

With Frankena (ibid.) I would wish to say that thesis (2a) is true and that thesis (2c) is false. But then I probably understand the two positions in a way which is somewhat different from Frankena's. For Frankena doubts that I am willing to assert (2a) in view of what I say on meaning and criteria. He thinks (p. 286) that I tend "to equate the meaning of a term with the criteria or standards for applying it". He seems to be critical of this and to think that therefore, if I accept (2a), I cannot reject (2c).

I find it difficult to reply to Frankena on this issue, because the meaning-

criteria distinction does not seem to me all that clear as it evidently seems to him and to others who use it. To say that something is morally good or morally obligatory is to say that it is good or obligatory on certain very special grounds, the characteristically *moral* grounds. And I would agree that anything which is, on those grounds, good or obligatory is, in the moral sense, good or obligatory. But, if asked if the word 'good' in the combination 'morally good' has the same or a different meaning from 'good' in some other combination or from 'good' generally, I should not know what to answer. Why not say that 'good' means the same in 'morally good' and in, e.g., 'hedonically good', whereas 'morally' and 'hedonically' have different meanings? So what then does 'good' *mean* in the two phrases? I am tempted to answer: 'good' means good. This is to say that the question is *idle* and that we should ask instead, on what grounds one would distinguish the morally from the hedonically good.

The moral Ought. Professor Frankena distinguishes (p. 289) three views of the nature of moral Oughts, viz. that they are (a) "institutional", (b) "ordinary", and (c) "special". He then asks which of these views I hold, and comes (ib.) to the conclusion that I "hold (b) or some combination of (b) and (a)". I think this is a correct characterization of my position.

I hold the view (b), if it is understood to mean that moral norms are 'technical norms', i.e., rules concerning what has to be done or avoided for the sake of some end. (Cf. above p. 795) In order for the norm to qualify as 'moral', however, the end in view must be the good of some being. This at once rules out what Frankena calls (p. 289) the Hypothetical Oughts in Kant's sense. We are then left with what he calls (ibid.) the egoistic and non-egoistic Aristotelian Oughts. I am not sure whether both kinds of Aristotelian Oughts should be subsumed under the label 'moral', or only Oughts of the non-egoistic sort, i.e., duties with a view to promoting or protecting the good of others. I do not think that a decision between the two alternatives is prejudged by the fact that, as Frankena notes (p. 289), I reject both ethical and psychological egoism.

Whether I hold a combination of the views (b) and (a) depends upon how one understands 'combination'. I am not sure myself how it should be explicated. The question has to do with the relation between moral norms and prescriptions. If I am right in thinking that it is essential to the functioning of morality that it be taught and enforced, then there is a sense in which moral Oughts can be said to be 'institutional' and reflected in the life-patterns of human communities.

Moral goodness. Good and right. Professor Frankena next discusses moral goodness as an attribute of acts and agents (men). His restatement of my position is entirely accurate. I do not see exactly, however, why he should say (p. 291) that even if we agree "that moral attributions of goodness are based on considerations of intention and benevolence, it does not follow that judging X to be morally good *means* simply that those considerations are true". Is it

because Frankena here again wants to drive a wedge between meaning and criteria which I find hard to accept? What 'meaning' could calling an act 'morally good' have over and above the explication of this phrase in terms of the intended consequences of the act for the good of some being or beings—*if* one agrees that this is what constitutes the moral quality of an act?

In *VG* I said that if the good which is intended in an action fails to materialize, one should call the intention good but the action morally neutral. Frankena says (p. 292) that this runs counter to his intuitions in the matter. Perhaps I ought to have expressed myself slightly differently and said that then *the thing done,* i.e., the result and foreseen consequences of the action, has no moral worth. I should be surprised if this also runs counter to Frankena's intuitions.

Incidentally, I think I ought to have made a distinction which I failed to make in *VG.* The moral worth of an action can be evaluated both from the point of view of how an agent *intended* to affect the good of his neighbour(s) and from the point of view of how his action *actually* affected it. When judged from the point of view of the intention, the action may satisfy the criteria of being morally good, but when judged from the point of view of the achievement, it may be found to have done harm. What shall we say then about the moral worth of the action? It seems to me that we should say that the *intention* in acting was good, but the action itself *bad* (not, however, evil).

In discussing the distinction between 'right' and 'good', Frankena's complaint (p. 291) is that I have failed to mark this distinction with sufficient clarity and that at times it looks as if I meant to make no distinction here at all. This is justified criticism. It was certainly not my intention in *VG,* however, to maintain that moral goodness and rightness are the same, though I may have said something which suggested this. I agree with Frankena that the two notions should be kept apart—and, moreover, "that the rightness does not depend on the intention even though the goodness does" (ibid.).

How then shall we distinguish goodness and rightness as attributes of acts? I think there are several senses in which an act can be said to be right without necessarily also being morally good. One sense is when 'right' means roughly the same as 'all right', i.e., when the act under consideration does not violate any moral norm or rule. Another sense of 'right' is at stake in my example in *VG,* referred to by Frankena, of a man who can rescue one of two men in distress, leaving the other one to perish, or omit rescuing either of them, but cannot rescue both. Here one can argue that it is morally wrong to let both perish and right to rescue the one or the other (and therefore also right to let one or the other perish). Whether an act is morally right in either of these two senses does not depend upon the intention in acting. About this I completely agree with Frankena (p. 292).

Virtue. One should distinguish between virtue which is 'one' and does not admit of a plural ('virtues') and virtue in another sense of the word which has

a plural. Do I wish to equate the first with moral goodness?, Frankena asks (p. 293). The answer is 'no'. A man of virtue, I should say, is a man who observes all his moral duties rather than one who does a great many morally good deeds.

All virtues are related to the good of people (see my reply to Foot above) but not all the virtues are equally relevant to morality. I think it may be said that other-regarding virtues are intrinsically of moral relevance, but that the self-regarding ones, such as temperance and courage, are only contingently 'moral'. But I would—contrary to what Frankena seems to think (p. 293)—*not* wish to divide virtues into moral and non-moral ones.

Duty. Frankena gives a very clear account of the idea of duty as it occurs in *VG*. 'Duty' was there used as a technical term for things which are, in one way or another, practical necessities with a view to the good of some being(s). Frankena finds this condensed formulation somewhat misleading (p. 293) in view of the fact that there are many, rather different, ways in which action can be duty even in this sense. This may be so—but I think the different ways are pretty clearly distinguished from one another both in Frankena's exposition and in my own. I agree, of course, that my *term* 'duty' is "a far cry" (ibid.) from what we often—Frankena says usually—mean by a moral duty. Perhaps I ought to have avoided the technical term and said instead that the only sense I can give to the idea of a moral duty is a peculiar form of practical necessitation of action for the sake of the good of some being.

In *VG* I talked about a man's *wanting* to promote the good of his neighbour. In view of what I have later written about the problem of necessitation of action, I should perhaps have spoken of *intending* instead. This would also have been in better accord with my views (in *VG*) on the relevance of intention to good action.

To say that *acts* and *forbearances* which are necessitated by concern for one's neighbour's good are duty is, of course, different from calling *concern* for one's neighbour's good duty. But shall we not say the latter too? This is a question which caused and still causes me the greatest difficulties.

Concern for one's neighbour's good can also be called *love* of one's neighbour. One can understand this in a broad sense which covers not only acts done with the intention of promoting one's neighbour's good as an end in itself, but also acts of respecting (not-harming) it. Then one can say that action necessitated by love is, in my sense, duty. This covers both autonomous and heteronomous duties.

Can love itself be duty? It is not easy to see how it could be this in my sense (in *VG*) of 'duty'. But this sense is admittedly a 'technical' one. Perhaps love can be duty in some other sense? Here, however, lies the difficulty: In what sense, if any, could it be said that I ought to or that it is my duty to love my neighbor?

I can understand why one should exhort people to love their neighbours or

try to implant such love in children as a part of their moral education. One would then use phrases like 'you ought to,' and 'it is your duty' to emphasize the importance of the matter. But what could one say if challenged to justify one's talk of obligation and duty in this context? Perhaps the answer is that one should not attempt to justify it at all, but let talk about duty here stand on its own feet, so to speak. I do not find this solution very satisfactory, however. For it seems to me reasonable to think that it should always be (logically) legitimate to ask *why* something is duty and *for what* this or that ought to be done. And since it makes no sense to ask this for something which is held to be an end in itself, there cannot be an obligation or duty to love one's neighbour either.

Duty in the sense contemplated in *VG* is thus the practical necessity of doing certain things out of love for your neighbour. The ultimate foundation of morality is love. This view of morality could be called 'agapistic.' I was struck by that term when, some time after having written *VG,* I read Frankena's beautiful little book, *Ethics.*

The Principle of Justice. Although in *VG* I could not advance beyond the agapistic basis of ethics, I was still intrigued by the question of how action in accordance with the Principle of Love, if one may coin that name for it, could become necessitated and thus become duty. This led me to consider justice and to introduce what I called a Principle of Justice. It says that 'no man shall have his share in the greater good of a community of which he is a member without paying his due' (Cf. *VG* p. 208.).

The Principle of Justice is a normative idea. But 'behind' it there stands a factual proposition to the effect that every member of a community of men has more to gain from the fact that *all* members observe a certain practice than from the fact that *he* occasionally acts against it. This proposition is true or not, depending (a) upon facts about the relative 'strength' of the members of the community and (b) upon the nature of the practice. All this is very insufficiently dealt with in *VG* and a great deal more must be said about it before one can assess its significance to the concept of morality.

The most general practice of those under consideration is the one of never doing harm to one's neighbour, i.e., of always respecting his good. More specific practices which fall under this general practice of not-harming would be, for instance, promise-keeping or truth-telling. I thought that for such practices the factual backing behind the Principle of Justice is secured by the fact that men 'in a state of nature' are rough equals, i.e., are endowed with roughly the same capacities for promoting and injuring one another's good. But the nature of these practices and the 'naturalistic' basis of morality in the rough equality of men remained insufficiently clarified in *VG.*

One could call the Principle of Justice a sub-principle in relation to the Principle of Love. The first deals only with that aspect of concern for our

neighbour's good which consists in respecting it, not in promoting it. It is a general rule of not-harming. It could also be called the moral norm *par excellence*. I thought in *VG* that all other rules which I am willing to call moral norms could be derived from it—for example the rule that one ought to keep one's promises or speak the truth. But I certainly did not show this.

I would still stick to the view that moral norms are principles concerning not-harming, i.e., respecting our neighbour's good for its own sake. The reason why I think that there are no moral norms concerning the promoting of good is this: I cannot see how action in accordance with such norms could, except contingently, be duty, i.e., be practically necessitated. If one says that moral norms constitute moral obligations, one could say that there can be no moral obligations to promote our neighbour's good and that actions promoting the good of others for its own sake are supererogatory, 'over and above' obligation.

Action in accordance with the Principle of Justice, however, will on certain conditions be necessitated by regard for a man's own good, i.e., be autonomous self-regarding duty. These conditions are not entirely non-contingent. They depend on a man's membership in a community of men, for which it is true that each member has more to gain from never harming anybody else than from sometimes harming somebody in the community. And whether a man belongs to such a community depends upon his strength relative to other men.

Professor Frankena, if I understand him correctly, does not share my conviction about the importance to ethics of considerations pertaining to the strength and rough equality of men 'in a state of nature'. He finds my conclusion that there may exist men who are outside the moral community and therefore 'beyond' duty "very unsatisfactory" (p. 299). I should say that the conclusion may be regrettable, but that it brings to light a limitation which we must acknowledge on the universal validity of claims of moral duty.

One could try to entertain a different idea of moral duty (obligation) which would allow us to say that it is an agent's duty to act in accordance with the Principle of Justice—*regardless* of whether he is a member of the community for which this principle holds true and regardless of whether it is a practical necessity for him to act thus or not. This may sound good common sense. But then my difficulty arises anew: On what grounds could we claim that such action *is* a duty? To this question I know no other answer than the one I gave in *VG*. I tried to show that there are at least three ways in which action in accordance with the Principle of Justice may become duty, i.e., may come to be practically necessary for an agent:

1. Moral action, i.e., regard for our neighbour's good, can be autonomous self-regarding duty. Then action is in an 'external' sense morally right, although its motive force is egoistic.

2. Moral action can be autonomous other-regarding duty motivated by respect for the individuals who are our fellow-members in the moral community. Then the motive force is altruistic; moral action springs from a motive of benevolence, one could also say.

3. Moral action can be autonomous other-regarding duty necessitated by "a will to secure for all the greater good which similar action on the part of his neighbours would secure for him". (*VG*, p. 209.) This is what I called a "disinterested and impartial will to justice". Action necessitated by it was, I said, done from a *moral motive*.

Frankena raises the question (p. 298) whether action in accordance with the Principle of Justice can be heteronomous duty. He states himself the conditions on which this would be so. The answer to the question is, I think, affirmative. This case is worth a more thorough investigation than I have given it. That action is heteronomous duty would require that it be commanded or prescribed by some *authority* who had a loving care for the good of men. One is then left to ponder who that authority could be and what our relations to him are. It need not be a 'supernatural' authority.

'Gathering up loose ends' 1.[1] I am happy to note that Professor Frankena agrees with my view that "all moral judgments have in their background someone's being concerned about the good for some being" (p. 299). This surely is my 'fundamental thought'—but also the basis for my holding that the realm of morality is not conceptually autonomous.

I am a little surprised that Frankena should think (ibid.) that I have not sufficiently insisted on the fact that morality involves a concern for the good of *others*. For did I not say that I doubted whether concern for one's own good *can* have moral worth? (Cf. above p. 797.) Frankena would, I assume, not wish to deny that action which is undertaken for the sake of the agent's own good can be, in an external sense, morally right.

2. It may well be the case that my Principle of Justice is too narrow to serve as a basis for the extraction of moral norms and for the definition of moral duty. But I hope critics of my position will appreciate the difficulties which stand in the way of providing a broader basis. Perhaps one could put these difficulties in a nutshell, as follows: How shall one explain (understand) the *existence* of moral duties? My attempts to answer this question account for my desire to give to morality a 'naturalistic' foundation in facts about human nature. This is the reason why I resorted to considerations on the relative strength and rough equality of men in 'a state of nature'.

[1]The numbers of this section correspond to the numbers in the final section (viii) of Professor Frankena's essay.

3. and 4. The Principle of Justice has no relevance for my definition of (morally) good action. The principle is relevant to moral *duty,* i.e., the normative side of morality, and not to moral goodness. I am sorry if by calling the Principle of Justice "the cornerstone or morality" I have made it difficult for Frankena and others to see how, consistently with this principle, I could *also* hold the view "that moral goodness is 'over and above' obligation".

6. If by action from a moral motive one understands action from a disinterested and impartial will to justice, then it seems to me too 'moralistic' to say with Frankena (p. 300) "that agents can be moral (as opposed both to being non-moral and to being immoral) only if they have such moral motives". I think that a man whose actions are motivated by love, i.e., a concern for the good of his neighbour for its own sake, is acting morally and deserves to be praised as a moral man, provided his actions do not conflict with the Principle of Justice. I do not think Frankena would disagree with me about this. But he would probably wish to give to the term 'moral motive' a wider content than I did in *VG*. Against this I could not feel any strong objection.

7. I agree, of course, that 'right' and 'ought' are normative terms. But should we say that *my* use of the term 'duty' is *not* normative? (P. 301) Is my notion too much tied up with wanting and with necessity to be "intrinsically normative" (ibid.)? This is not an idle question. Practical necessitation under peculiar, axiological ends, however, was the only sense which I was able to connect in *VG* with the normative element in morality. Frankena thinks it is not the only sense. (See e.g., his comments on p. 299 on my example of the "superman" who is "exempt" from moral duties.) Yet I do not find that Frankena or anybody else has convinced us that there is in morality an 'intrinsically normative' element which is independent of the idea of practical necessitation.

8. I agree with what Frankena says (p. 301) about my view *not* being teleological "in anything like the usual sense". I am afraid that I have described my position vis-a-vis teleology in a somewhat misleading way. One can say that I am an axiologist and not a deontologist, since I hold that moral action and moral duty are oriented towards respecting and promoting the good of beings. This position also has affinities to utilitarianism in that it 'measures' the moral value of an action in terms of the good and bad this action calls forth—although it does this in a way very much at odds with the idea of the maximation of good.

9. Frankena finds it hard to accept (p. 302) that "one has no straightout duty to promote the good of any being". But why should this be so difficult, once one agrees that man has a moral duty to respect, i.e., never injure, his neighbour's good? Promoting our neighbours' good as an end in itself is supererogatory, 'over and above' duty. Is this really repulsive to our moral intuitions?

10. I agree that what Frankena calls "institutional Oughts" hold an impor-

tant place in the moral life of men. I think that Frankena has very acutely spotted (p. 302) a drift in my thinking about morality "towards a two-part conception of it, viz., one part consisting of commands, permissions, etc., by some beneficiently-minded norm-authority, and a second part consisting of hypothetical imperatives based on the agents' own beneficient-mindedness, moral ideals, etc". One of my difficulties has been and still is to reconcile with one another these two aspects of my conception of morality.

III. Action, Intentionality, And Practical Reasoning

My interest in action originated in my interest in norms, which in turn grew out of my work in deontic logic. (Cf. *IA*, p. 32f. and above p. 766.) It was therefore only natural that my first work in action theory attempted to create a Logic of Action. The foundations for it were laid in *Norm and Action* (*N&A*, 1963). The topic was further elaborated in *An Essay in Deontic Logic and the General Theory of Action* (*DL*, 1968). A simplified but more accomplished formal system, finally, is embodied in the German paper, 'Handlungs-logik' (B270, 1974).[1] Under this heading I shall deal with the essays by Stoutland, Donagan, Malcolm, Anscombe, and Black, in that order.

None of the essays in this section deals with my contributions to a Logic of Action. The five essays on action theory are all concerned with aspects of my work which, so far, have been most fully elaborated in *Explanation and Understanding* (*E&U*, 1971). I see this book more as a beginning and a program for further work than as a systematization of ideas which had been brewing in me since the late 1950s and early 1960s. My views have changed considerably since the publication of *E&U*. I hope that I shall one day be able to produce a more final and mature contribution to the philosophy of action.

The essays by Anscombe, Black, and Malcolm deal with a problem complex which I used to discuss under the heading 'practical inference'. I also frequently used the term 'practical syllogism'. These headings were not well chosen. I was deluded by an apparent symmetry between explanation and prediction. It is sometimes thought that an explanation is a kind of 'prediction in retrospect' and a prediction a kind of 'forward-looking explanation'. But—at least for actions—this is not the case. The schema of practical inference suggests a predictive relation. From the premises as given we 'look forward' to the action to follow. The attitude here is related to deliberation, decision-making, and planning. But from the beginning my concern was with explanation.

[1] In later publications I have made further contributions to the formal logical study of action concepts. The reader is referred, in particular, to items 327 and 344 in the Bibliography (1984).

Given the action, we 'look back' on the grounds and reasons which make it intelligible. Had I realized how different the two attitudes or perspectives are, I should have separated them and made it clear that the relation whose nature I was anxious to clarify was, in the first place, the relation between the action as a fait accompli and its motivational background. Many confusions of which I have been guilty might have been avoided, and certain misunderstandings of my aims and intentions would perhaps never have arisen.

Stoutland on the Theory of Action

I could not have wished for a better synopsis of the essentials of my philosophy of action than the one given by Stoutland. His essay also raises new problems of great importance and interest. I shall here try to say something about that which Stoutland considers to be *the* main difficulty of my action theory in comparison with alternative views.

Three types of philosophy of action. I find very illuminating the distinction which Stoutland makes between three main types of a philosophy of action or "action theory proper". He traces the ancestry of the three types to Aristotle, Descartes, and Kant, respectively. The first type of action philosophy he calls the agency theory. A modern representative of it is Chisholm. The second type is the causal theory. The most original and prominent modern champion of it is Donald Davidson. My philosophy of action Stoutland places in the Kantian tradition—aware that there are also influences from Wittgenstein. As has often been noted, Wittgenstein's philosophy too, particularly the *Tractatus,* has affinities with Kant's.

Theories of the three types construe in characteristically different ways a connection between the following three 'ingredients' of an action: the *result* of the action, the *behavior* involved in producing the result, and the *intention* to achieve the result.

The main point of disagreement between the theories concerns the question of what 'makes' the behavior which is involved in an action occur. In the discussion the distinction between 'mere' behavior and 'behavior understood intentionalistically' plays an important role. An exemplification of the distinction would be the *rising* of an arm which is a movement occurring in a body, and the *raising* of an arm which is an action performed by an agent.

On the causalist view, the behavior which produces the result is caused by the volitional and epistemic attitudes 'behind' the action. Adherents of the causal theory usually speak about 'wants' and 'beliefs', or about something they call 'pro-attitudes' of the agent to the intended result of his action.

According to some modern forms of the agency theory, the behavior is immediately caused by neural events in the agent's body—but these neural events are caused *by the agent* in intending the result of his action. This last is

a different type of causation from a nomic connection (law-connection) between events or states 'in the world'. It is called immanent causation.

My theory of action, finally, says nothing about the causes of the behavior. The occurrence of the behavior is, one could say, part of the agent's intention in acting. We see the behavior in the perspective of the agent's aiming at an end. When thus understood, behavior is *not* 'mere' behavior in the sense mentioned above. These features of my theory are described very clearly by Stoutland. Not only do I agree with his account; I also think he has made me see more clearly what it is that I have myself been trying to express.

Summarizing the different positions, Stoutland notes (p. 317) that the causal theory regards action attributions as entailing that the behavior in the act has been caused by certain wants (and often beliefs), whereas the agency theory regards them as entailing that the agent, in his intending the result, caused the behavior which eventuated in the result of the act. In my theory the question takes on a different character since I view the intention in the act as not separable from the behavior in the act. The intention just is the agent intending (aiming at, meaning) something *by his behavior*.

Stoutland's objections against my theory. One shortcoming which Stoutland sees in my theory is that it does not explain the occurrence of the 'mere' behavior involved in an action. What the theory explains, 'intentionalistically' or 'teleologically', is behavior as something the agent *does*. It explains, for example, why an agent raises his arm, but not why his arm rises. In this it differs from the causal theory and also from (at least) that version of the agency theory which says that the behavior is caused by neural events which are in their turn 'caused' by the agent's intending the result of the action. This difference, Stoutland thinks (p. 324), is a major reason for the 'persistent philosophical appeal' of those other theories.

Therefore, according to Stoutland (p. 323): "An apparently legitimate demand on a theory of action is that it also provide an account of why the behavior by which I intend a certain result occurs on the occasion of my acting. The crucial question is therefore: Why does behavior occur *when* I act?"

I am a little surprised that Stoutland should be so emphatic about this demand. For, is he not insisting here upon a *causal* account of the ('mere') behavior? And why should one insist on this?

Although I can see no need for insisting on a causal explanation of the behavior involved in an action, I see no need for excluding the possibility of such explanations either. I accept, in other words, what is called the Compatibility Thesis. A causal explanation of why my arm rises is compatible with a teleological explanation of why I raise my arm. The two explanations are logically entirely independent of one another.

In this position, however, Stoutland sees a difficulty—and I must admit that I share his 'feeling'. He puts the matter very succinctly as follows (p.

323): "If the behavior by which I intend a result has a Humean cause as sufficient condition, then it is a mystery why behavior occurs *when* I act." And a little later on the same page he notes that the quest is "not for a mechanism, but for an account of action which relates the factors in terms of which behavior is understood as action to the factors explaining the occurrence of the (mere) behavior in the act. That requires that a necessary constituent of an intentional act also account for mere behavior. Without this we have a version of classical parallelism, which makes the very possibility of action unintelligible."

I shall now try to answer Stoutland and outline what I think is the road to a satisfactory solution of what is perhaps the deepest puzzle in action theory.

Meeting the objections. On my view, Stoutland notes (p. 326): "the demand that action attributions explain mere behavior is illegitimate". But, he adds: "to show that this is illegitimate it must be shown that to ask for such an explanation presumes something false, namely that mere behavior is *basic* in a sense intentional action is not." This, I think, hits the nail on the head.

What is 'mere' behavior? The tension and relaxation of muscles, I presume, including the resulting movements of limbs and other bodily parts. Let us say that 'mere' behavior is 'behavior as movement'. This is a rather sophisticated notion, an abstraction from something more immediately given and primitive. With 'behavior as movement' we contrast 'behavior as action'. It is the contrast between arm-rising and arm-raising, for example.

The contrast is between two ways of conceptualizing or of describing behavior. In a sense, therefore, the term *mere behavior,* as used by Stoutland and by me above, is a misnomer. 'Mere' or 'pure' behavior is neither 'behavior as movement' nor 'behavior as action'.

We are tempted to say: The same item of behavior can be described as arm-rising or as arm-raising. But what is here "the item"? Is it a case of arm-rising which is *also* described as a case of arm-raising? Or shall we say that it is a case of arm-raising which, when 'stripped' of intentionality, becomes a case of arm-rising? The fact that arm-raising entails arm-rising, but not conversely, is not enough to establish that the first conceptualization above is more basic than the second.

Consider the way we describe the behavior of a one-year-old-baby. It is, for conceptual reasons, uncertain whether we can attribute 'actions' to the infant. Nevertheless we describe, without hesitation, its behavior in actionist language. We say: *it* crawls around, screams, reaches out for objects, etc. Soon these activities develop so that it becomes natural to associate them with 'wants', 'intentions', 'understandings'. This happens long before the child itself, still lacking a language, can conceptualize them in this way. Not until the primitive actionist description of the child's behavior has matured into a fullfledged description of it under the aspect of intentionality, is there need for a description of behavior which is 'drained' or 'stripped' of actionist connota-

tions. *Now* we can say: 'His arm rose, but it seems obvious that he did not intend or want this to happen. He was not reaching out for anything in particular. There was just this movement.' A new conceptualization of the situation has become possible.

The new conceptualization serves important purposes. On the level of everyday life it serves to discriminate between purposive and non-purposive behavior. The chief interest in 'behavior as movement', however, is connected with the study of the physiological mechanisms of the living body.

I hope these reflexions on the two ways of conceptualizing behavior give a hint why it may not be, after all, a legitimate demand on a theory of action that it should provide an explanation of why the behavior by which I intend a certain result occurred on the occasion of my acting.

Stoutland says (p. 327): "Whenever persons act, mere behavior occurs, but that is a purely contingent relation which it is conceptually impossible to explain." This way of stating matters, however, can easily be misleading.

It is of the very essence of an action, such as for example the opening of a door, that behavior should occur, e.g., the seizing of a handle and pulling. Acting without behaving would be magic. Action entails behavior and therewith also 'mere' behavior. It is therefore not contingent, but necessary, that behavior should occur when we act. But it is contingent whether the behavior which we explain teleologically as action can *also* be explained causally as movement, and vice versa.

Assume that there existed a causal explanation in addition to a teleological one. Then, presumably, the movements would have occurred even if the agent had not acted. This has some consequences for the component of an action which I have called its 'counterfactual element'. Originally, I thought it was a characteristic of every action that, on the occasion of its performance, the result of the action would not have materialized 'independently of the agent'. I still think that this holds true for all actions resulting in changes which might, on other occasions, materialize without behavior on the part of an agent. For example: if a door opens independently of my efforts, when I am about to open it, then what I *did* was not open the door. My acting 'reduces' to certain movements which I performed on the occasion in question—maybe with the intention of opening the door which then happened to open 'of itself'. But the case is different with doings which are not the causal effects of behavior, but are themselves behavior, such as, for example, arm-raising. Then the counterfactual element consists in my confidence, before proceeding to act, that the behavior by which the result of the action is effected will not occur unless *I* set myself to perform the action. I should, of course, not have this confidence if it were often the case that the behavior either occurs when I do not act or fails to occur when I set myself to act. The confidence I have is something epistemic, but the fact that I have it has an ontic foundation in certain regularities in the world.

If the behavior required for a certain action would occur frequently without being 'embedded' in that action, then we should perhaps give up a claim that we can perform the action in question. And the same might happen, if our limbs and other bodily parts often fail to function, when we intend to perform the action for which they are required. It is a basic fact about man, about his 'natural history', that *he can act,* do various things, and therefore can be confident that his muscular activity, on the whole, 'obeys his will' and does not go on strike or work at odd hours.

Perhaps we should call the fact that men can perform actions a 'mystery'— in the sense that it is something *basic* which defies explanation. At least, I cannot imagine what an 'explanation' of this fact would conceivably look like. We can wonder at this mystery—as we may wonder at the fact that man *can know* things or that *there is* an external world. It is interesting to note that wonder of this type can be both the starting point and the end station of philosophical inquiry.

Donagan on Causation, Intention, and Action

Professor Donagan's essay is divided into four sections. They deal with my account of causation, the distinction between the inner and the outer aspect of an action, the theory of agent causality, and the conclusiveness of practical inferences respectively. I shall not comment here on the first section. In my replies to the papers by Mackie and Prawitz I deal with problems connected with my view that the idea of nomic connection presupposes the idea of action. I only note in passing that Donagan seems to think (p. 336) that my position has to endorse a view that natural science 'as a form of thought' can exist only in the wider context of a science of man. I am not sure whether this is so. But I think that it is illuminating and useful to view what *we* know as 'natural science' as a reflection of an attitude of man to nature which is characteristic of the 'Western' culture of industrialized societies but not of all 'higher' cultures at all times in history.

The inner and the outer aspect of an action. I cannot say that I am happy with this distinction. Professor Donagan's essay helps me to rectify some confusions of which I have been guilty. The outer aspect of an action I should now wish to identify with that which I call the 'result' of the action. The result is a change or not-change in the world which would, normally, not be there had the action not been performed. The result, moreover, is connected *intrinsically* with the action. If it does not materialize, it would be incorrect to describe what was done as an action with that result. What was done might then have been that the agent *tried* to perform the action with that result.

The materialization of the result of an action may call forth further changes and not-changes. If the action was undertaken with the intention of producing those further consequences, then an action was also performed, the result of

which was those consequences. If what was done is a consequence of some-
thing else which was also done, then (at least) two actions were performed by
the agent in question. We then say that he did the first action, e.g., ventilated
the room, by doing the second, e.g., by opening a window.

Thus an agent may be performing several actions when engaged in doing
something. This is often, I think, interpreted to mean that an agent does just
one thing which can then be subsumed under different descriptions as an ac-
tion. "X's pressing of a bell-push, and X's ringing of a bell are two descrip-
tions of the same action", Donagan says (p. 337). I do not think this is right.
X's pressing of the bell-push is a different action from X's ringing of the bell.
X might have performed the first but failed to perform the second—for exam-
ple, because the connecting wires were cut. But normally the first action is
instrumental to the performance of the second; one rings the bell by pressing
the bell-push. The idea that there is only one action involved is, I think, sug-
gested by a false picture of what an action is, viz., that action somehow 'con-
sists in' bodily behavior. The picture of the agent, who rings a bell by pressing
a bell-push, is the picture of somebody moving his finger towards the bell-push
and applying pressure. This is what the agent 'really did'; that the bell-push
sank into the hole and that a sound was heard were things which the agent
effected through his (one) action. His bodily behavior had these effects, yes;
but what he did was not just bodily behavior.

It is thus my opinion that we should *not*, in a case like the one just men-
tioned, speak of two descriptions of the same action. In *E&U* I yielded in a
confused and half-hearted manner to this Multiple-Description Theory of Ac-
tion, as I propose to call it. I think this theory misrepresents action.

A special type of actions are those the results of which are given a signifi-
cance by convention: for example, signalling by waving one's arms. That a
signal appears is a 'logical' rather than 'causal' consequence of arm-waving.
In this case it seems to me correct to say that *one* thing is being done which
can be subsumed under two different descriptions.

An action is basic if it is not performed by doing anything else. Any action
is either basic or its result is the consequence of some basic action performed
by the same agent. One can therefore say that in every action a basic action is
involved. I think this is true and that the notion of a basic action, when under-
stood as above, is important and useful.

In every action bodily behavior is also involved. This consists in the mov-
ing of limbs and other parts of the body, or in restraining such movements.
The movements and not-movements are the causal consequences of muscular
activity, i.e., of the contraction and relaxation of muscles in the body. Mus-
cular activity is, in its turn, causally related to processes and states in the neural
system of the agent. Neural activity may be caused by external and internal
stimulation of the nervous system. The occurrence of the stimuli may also have
causes, *ad infinitum*.

It was an unfortunate move, I think, when in *E&U* I distinguished between the 'immediate' and the 'remote' outer aspect of an action. Every action, I now wish to say, has but one outer aspect, viz., its result.

The bodily behavior involved in an action can also be the result of an action, viz., the action of doing just it. We normally know how to move our limbs, or to restrain their movements, in order to achieve a certain change or not-change in the world outside our body. Given that the agent has sufficient knowledge of the anatomy of the human body, he may also be able to produce muscular activity as a result of action. Normally this would happen by moving one's limbs or other bodily parts, e.g., by performing such (basic) actions as twisting one's hand or raising one's arm. Whether the contraction and relaxation of muscles can be produced as results of *basic* actions is not entirely clear to me. Perhaps one can learn to operate one's muscles directly. Neural events can certainly not be produced as the results of basic actions. But given sufficient knowledge of neurophysiology, one can be taught to produce them as the results of action. This, moreover, can happen in two ways. One can produce them by performing appropriate bodily movements, but also by producing appropriate external stimuli. In either case, the results of acting on our nervous system are the (causal) consequences of the results of certain other, in the last resort, basic actions of ours. Does the first possibility force us to accept 'retro-active causation'? If we think that the neural events produced precede in time the actions which result in bodily movements, then we must, I think, accept this. But I am not sure that we must think in this way about the temporal relationship between the neural events and the actions of moving our limbs. My discussion of this topic in *E&U* is defective and unconvincing.

Whether an event (change or not-change) which occurs should be called the result of an action or not depends upon whether the agent intentionally made it happen or not. Cannot action then be non-intentional? Yes, but only in a sec-ondary sense, I should say. (Cf. above my reply to Stoutland, p. 805f). Move-ments of my arms and legs which I perform without intending anything are behavior but not action. Sometimes, however, they have consequences for which we are reproached or otherwise held responsible, such as e.g., spilling a cup of tea or breaking a vase. 'Look what you did!', someone says to us. 'I did it unintentionally', we reply. Regarding this as an action and as something for which an agent can be held responsible is based upon the fact that the movements in question are something over which we normally have control. This means; they are something which we can produce as the results of (inten-tional) action, or omit to produce.

Primarily, the actions which can be imputed to an agent are actions which he knows how to perform and therefore also how to omit. When we impute an action to an agent on an individual occasion, then the action was (normally) done intentionally. The unforeseen consequences of an individual action are not things which the agent did *on that occasion*. But by learning that these are

the consequences, he learns a new action. He learns that by doing the first
action under similar circumstances he will also do the second. He can no longer
'plead ignorance' of the second if he does the first. He may intend to do the
first, but not intend to do the second. His doing of the second will nevertheless
be intentional, even though not intended.

How radically does my account of the inner and the outer aspects of actions
differ from the account suggested by Donagan's discussion (pp. 336–39), ba-
sically in line, it seems, with Davidson's 'multiple-description theory'? The
answer is not easy to give, since I feel that part of the differences between us
may be terminological. But there surely is a difference in substance, too. It
does not seem to me right to say with Donagan (p. 339), that an agent intends
to make something (N) happen in his central nervous system *under a descrip-
tion* of some intentional bodily behavior of his. Even if he happens to know
that by his behavior (B) he makes N happen, it would not follow that in inten-
tionally behaving in the way B he intends to make N happen. But if he is aware
of this connection and intentionally does B, then his making N happen is inten-
tional, too.

Agent causation. Professor Donagan, if I understand him correctly, looks
favorably on the theory of agency as power to make happen. The revival in
modern times of this theory is due to Chisholm and to Richard Taylor. My own
position is not *very* far from theirs, I should think.

In *E&U* there is a brief discussion of Chisholm's distinction between im-
manent and transeunt causation. Humean or nomic causation, which I have
discussed extensively, is transeunt or event causation. I have tried to argue that
nomic causation is conceptually dependent on action, and thus on something
which is at least closely related to the idea of immanent causation. On the other
hand, I rejected in *E&U* the notion of immanent causation saying that I found
it "connected with insurmountable difficulties". Since I did not specify the
difficulties, I ought perhaps not to have expressed myself in this way. Donagan
makes a conjecture concerning what I might have had in mind, namely a temp-
tation to construe an infinite regress of "causings of causings" (p. 343). But I
certainly did not have this difficulty in mind. And I completely agree with
Donagan's exposure of the confusion at the root of the infinite regress argu-
ment.

So what was it that I did have in mind when rejecting the notion of agent
causality? Perhaps one could frame my objection to the idea as follows: To call
the agent 'cause' is an idle move. As with idle moves generally in philosophy,
it is likely to engender misunderstanding and obscurity. An agent does things,
performs actions. In performing actions he brings about and prevents changes
(events) in the world. An agent's ability to perform certain actions can also be
called his 'power to make things happen'. If the agent is called 'cause', what
then shall we say are the effects of this cause? The actions? Or the events

which are the results of action? Calling the actions effects I find unintelligible unless it simply means that the agent acts, that actions are imputed to him. Calling the results 'effects' seems to me misleading because of the *intrinsic* nature of the connection between action and result. It obscures the fact that the result may indeed be the effect of something in the very palpable sense of being the (causal and thus *extrinsic*) consequence of the result of another action by which the first action is being performed.

To the question: What causes the result of a basic action? one should not reply by saying that the agent causes it. *Must* every event have a cause? I do not see any necessity here. *May* the event which results from a basic action also be the effect of some other event? This is the much debated 'compatibility problem'. I have tried to argue (in *E&U* and again in *C&D*) that the answer to the question is affirmative, that the events which agents make happen on individual occasions may also be the effects of events which those agents, on those occasions, did not make happen.

Practical inference. Since I shall be dealing with this topic more extensively in my replies to Anscombe, Black, and Malcolm I shall here confine myself to a few points only.

In *E&U* I tried to defend the so-called Logical Connection Argument by an argument about the way premises and conclusions of practical inferences are *verified*. I contended that the verification of the premises of such arguments depends conceptually on the verification of their conclusions; and vice versa that the verification of the conclusions depends upon the possibility of verifying a corresponding set of premises. In this verificational interdependence between the premises and the conclusions, I suggested, lies the truth of the Logical Connection Argument.

Donagan misunderstands my argumentation. But for this I cannot blame him. The reasoning in *E&U* is very obscure and unsatisfactory. It was not, however, my intention to maintain that in order to verify the conclusion of a given practical inference we must verify the premises of that *same* inference. If this were so, then "there would be no problem at all of deciding between alternative explanations", as Donagan rightly observes (p. 348). But deciding between such alternatives is surely "as much a problem in the *Geisteswissenschaften* as in the *Naturwissenschaften*" (ibid.).

Perhaps I can, without going into boring details, explain what I meant by the verificational interdependence under discussion in the following way:

In order to understand and therefore correctly describe an observed item of behavior as 'action', we must be familiar with various possible reasons for which such behavior may be undertaken. We should be able to imagine 'stories' about the agent in which actions are performed, the outer aspect of which resembles the behavior that we witnessed. We must in other words be able to construct (alternative) teleological explanations for actions, of which the behav-

ior in question is an adequate outer aspect. Therefore the verification of an action statement depends on the possibility of verifying statements about intentions and epistemic attitudes. But how are *they* verified? That agents have intentions and epistemic attitudes is verified, partly, by observing the way the agents behave.

When I wrote *E&U* I thought that the only way to understand behavior as action was to set it in the perspective of a 'practical syllogism', i.e., see it as flowing from an intention and an attitude on the part of the agent to the 'requirements' of the situation. (In the limiting case the cognitive attitude could be missing, the intention alone present.) This I no longer think is right. For this and other reasons I should no longer be inclined to support the Logical Connection Argument by considerations like those in *E&U* relating to the verificational interdependence of premisses and conclusions of practical inferences. But I do not think that these considerations involved a logical fallacy.

Donagan's comments on the example from a novel by Iris Murdoch reveals maybe a more interesting difference between our positions. Is 'Dora's keeping of her seat' an action? I *do* want to say that it was an action only provided it could have been shown that Dora's remaining in this position was intentional. The fact that Dora "was intentionally doing some thing or other, with the consequence that her position in her seat was not changed" is not enough to establish that her keeping of her seat was an action. It seems to me strange that Donagan's intuitions in the matter should be thus divergent from my own. Perhaps his own example misguides him. What would Dora have done if she "had glimpsed somebody in the corridor she wished not to encounter" (p. 347)? Perhaps she would not only have "buried her face in a newspaper", (ibid.) but also kept her seat in order "to make herself inconspicuous" (ibid.) If this were what she would have done, she would have kept her seat intentionally. If it were not, it is difficult to see how her remaining in the seated position could even be said to be a 'consequence' of her hiding behavior. The two items of behavior just happen to co-exist.

I disagree with Donagan on the question whether my "final formulation" in *E&U* of the practical inference schema is enthymematic (Cf. p. 345). It seems to me that if the first premiss affirms that the agent *from now on* intends something, then no 'reinforced' intention to do the thing 'then and there' needs to be assumed when the time of the action has arrived.

Donagan seems to agree with my position in *E&U* about the logical conclusiveness *ex post actu* of the practical inference schema. I am myself now uncertain about the correctness of my earlier view. An intention to perform a certain action 'here and now' is a commitment to action. If the intention is there but no action is even attempted, we cannot understand the agent. But must we, on conceptual (logical) grounds, *deny* that he had the intention? This question is discussed very fully and penetratingly in the essay by Malcolm.

Malcolm on Intention and Behavior

The main problem to which I have addressed myself under the not very adequate (cf. above p. 804) title "practical inference" concerns, to quote Professor Malcolm "the relationship that holds between intentions, or rather, intentions and beliefs, on the one hand, and behavior (actions) on the other" (p. 353). Malcolm deals with this problem in the first half of his essay. In the second half he criticizes the causalist position in action theory, especially the position taken by Armstrong and Davidson. Since this criticism is not directly concerned with views of mine, I shall not comment on it in my reply. I shall only say that I agree with what I take to be Malcolm's main point, viz. that, for conceptual reasons, it is impossible to provide alternative descriptions of intentions and beliefs as required by Armstrong's and Davidson's theories.

In my various (earlier) writings I tried to defend what is known as the Logical Connection Argument. (Cf. above p. 355.) According to this argument, the connection between the volitional and epistemic attitudes embodied in the premises of a "practical inference" on the one hand and the agent's action on the other hand is a conceptual or logical and not a causal connection. By a causal connection is then meant a nomic or law-like relationship between logically independent (generic) events or states. The two opposed positions on the issue are also referred to as the *intentionalist* and the *causalist* view. I am convinced that there is an important truth hidden in this argument. But in my earlier writings I certainly did not succeed in digging up this truth and presenting it clearly. My position, moreover, has been wavering. Originally I wanted to maintain that the conceptual relation here is an entailment in the strict sense. In order to make this plausible I had to try to close the 'logical gap' which prima facie exists between the premises and the conclusion of a practical argument. I tried various methods: by speaking about 'setting oneself' to act instead of speaking about acting; by introducing supplementary premises to the effect that the agent is not prevented or that he does not forget about the time of the action; by closing the time-gap between the formation of the agent's attitudes and his supposed action in accordance with them. In *E&U* I also introduced an obscure idea to the effect that the practical inference was conclusive only *ex post actu* (cf. above, p. 804f.), i.e., provided an action to match the premises had actually taken place. I imagined the case of an assassin *in spe* who fails to pull the trigger at the moment of action (*E&U*, p. 116f). This was supposed to show that the premises could be true without any action, or initiation of action, following. From this I concluded (ibid., p. 117) that "it is only when action is already there and a practical argument is constructed to explain or justify it that we have a logically conclusive argument".

Malcolm agrees with me that there is a conceptual bond between intention and behavior. But this bond, in his opinion, is not a relation of logical entailment. It is "a looser bond than von Wright thinks" (p. 355). Malcolm calls

(p. 364)) this laxer relation semi-entailment. He also says (p. 361) "that the premises of a practical syllogism *almost* entail the conclusion". This being so, there is no logical contradiction in the supposition that the premises might be true and yet the conclusion false (p. 361). We can imagine such cases. My assassin example was designed to show this—although I think I somewhat mis-described the intended case in *E&U* and did not draw the proper morals from it. (The example, incidentally, was first suggested in a conversation I had with Malcolm.)

Do I agree with Malcolm's criticism? I *think* I agree—but I must confess that I am still under a temptation to close the 'entailment gap'. Given a *firm* intention and a *clear* view of the requirements of the situation, how could an agent fail to embark upon the necessary course of action? If he does not 'move', and if it can be regarded as excluded that he had changed his mind or was physically prevented or had forgotten about the time, must we then not postulate the existence of a psychological mechanism ('inhibition') which ex-plains the apparent failure of the entailment relation for his case? But having gone through this piece of reasoning, I ask myself: Is it not sheer dogmatism to postulate such an explanation in order to 'save the appearances'? Why not simply admit that the relation under discussion is not an entailment, but some-thing weaker? We could still say, with Malcolm, that there is *almost* an entail-ment. But then we must give an account of what we mean by 'almost'. In the account given by Malcolm I think I can discern two different lines of thought.

The first has to do with explanation and understanding. If we believe in a set of premises for a practical inference, when stated with the explicit fullness given to them by Malcolm (p. 357), then we should not understand how the action could fail to take place. "The facts stated in the premises would indeed provide an *adequate explanation*" (p. 359, italics mine) of the action, *if* it takes place. "Within the framework of practical reasoning—it would be impossible to *understand* how the conclusion could be false" (p. 363). The premises, if true, make the action mentioned in the conclusion *completely intelligible,* one could say. But "although we should not *understand* how the conclusion could be false, yet that it might be false cannot be dismissed as *logically impossible*", Malcolm says (p. 362).

The second idea associated with the 'almost' entailment is related to the notions of expectation and prediction. It could also, with caution, be called a 'statistical' idea of entailment. "We do not ascribe to a person the intention to do a certain thing unless we *expect* him to do this" (p. 364, my italics). There is, as Malcolm says, "a deep relation of meaning between sentences of the form 'He intends to do *A*' and sentences of the form 'He will do *A*' If inexplicable non-performances were other than *extremely rare,* this expectation would be destroyed, and consequently we could no longer *apply* the concept of intention to that person" (p. 364, my italics). One could add that, if inexplic-

able non-performances were a common thing with most or with all agents, then the very concept of intention, as we have it, would not exist.

The bond of semi-entailment between premisses and conclusion in practical arguments is thus, partly a condition of the intelligibility of the action, and partly a condition of the applicability of the concept of an intention. On both these grounds the bond can be said to be conceptual and distinguished from relations which are (in the Humean or nomic sense) causal.

In what sense can an intention or a want be a *reason* for an action? The fact that I intend or want to do something is, of course, not a reason for doing *that* thing. But it can be a reason for doing something else which I deem needed or useful for reaching the object of my intention (want). Thus, in the case of practical syllogisms, the *reason* for an agent's q'ing is the fact that he intends to p and considers q'ing necessary for this. The reason thus is a characteristic combination of a volitional and an epistemic attitude.

In the practical inference schema the premisses which warrant the intelligibility of the action can also be characterized as a *compelling* reason for performing the action. This notion of a compelling reason constitutes a condition of complete intelligibility but not a condition of a necessary connection.

In order to understand correctly the relation between a reason for acting and the action itself we ought also to consider reasons of a different, and sometimes 'laxer,' character than the compelling ones. Such considerations will probably show that Malcolm's notion of semi-entailment applies only to special cases of acting on a intention—but I shall not pursue the topic here.

If one agrees that the relation between reason and action is neither causal nor deductive, one may wonder what makes the reason nevertheless 'bear' on the action. Here Malcolm's second point about semi-entailment is relevant. The efficacy of reasons, one could say, is based on the fact that action *normally* takes place in accordance with existing reasons for it. This regularity is guaranteed on conceptual grounds. It is built into the notion of a reason for action. This applies not only to reasons of the special kind which figure in 'practical syllogisms'.

An intention to do something is normally formed before the agent proceeds to action. The same holds for the agent's beliefs about the requirements of the situation. There is thus a time-gap separating the formation of the volitional and epistemic attitude from the execution of the action. This being so, the agent may change his mind before proceeding to act, i.e., he may either give up his intention or alter his opinion of what he has to do in order to attain his objective. The longer the time-gap, the greater the chances that there will occur a change of mind. Some men are more prone than others to such changes. The rate at which predictions of a man's actions on the basis of knowledge of his intentions and beliefs are fulfilled or fail is a 'measure' of features of his character such as constancy (reliability) or capriciousness. If, for a given agent,

predictions were very unreliable even for short time intervals, we should call the agent irrational or perhaps insane. But in this case the following difficulty should be noted:

How could we even *know* what such a man's intentions and beliefs are? Perhaps he says that he intends to do this or that quite soon and that his beliefs are such-and-such. But if he practically never acts accordingly, then surely we should doubt whether he is serious or is perhaps lying all the time. We may even come to doubt whether he is capable of forming intentions or articulating opinions about anything.

This difficulty shows that the conceptual link between intention and behavior has to do with questions of verification, of coming to know the motive forces behind an action. I shall not here inquire in detail into the criteria used for judging what the intentions and beliefs of a person are. But the following conceptual peculiarity should be noted:

In the case of deferred action we on the whole rely on criteria which are independent of whether action takes place or not. (Though even in such cases the failure of action may cast some doubt on a previous judgment about the presence of an intention.) When, however, action is imminent in relation to the time when we ascertain the agent's intentions, action becomes important for determining what the intentions are. Then there is little time for a change of mind. Sometimes, of course, one changes one's mind in the last moment. One says, for example, 'after all, not'—and fails to act in accordance with an antecedently professed intention. But in the absence of any (independent) signs that a change of mind has occurred, how can we know that an intention which we had good reasons for thinking was there sometime ago *lasts* to the very moment of action? Is not then the possibility of knowing completely dependent upon whether the action takes place, or not? The answer is not obvious. When action does not take place—as, for example, in the case of the assassin *in spe*—we can make subsequent investigations, and adjust our judgment of the case in retrospect. Sometimes the result of later investigations would carry greater weight than the failure to act for judging whether there was a persistent intention. But such cases are, I think, exceptional.

In verifying what the intentions and beliefs of a person are we rely on behavioral criteria of a very complex and varied nature. They include antecedent and subsequent verbal reports, actions on analogous occasions, features of the agent's character, education, and social position, etc. It is probably right to say that none of these criteria are, by themselves, necessary or sufficient. The 'weight' each of them carries varies with the occasion. It seems to be the case, however, that the weight which we accord to the occurrence of action in conformity with a supposed intention is greater the more imminent, and smaller the more remote, the action is in relation to the time when the intention, on independent evidence, was judged to exist. This observation seems to me relevant to Malcolm's idea of a semi-entailment between intention and behavior.

One could say that the relation 'approximates to' an entailment as the time-gap diminishes.

But could one not, for similar reasons, speak of a semi-causal relation here? The causal relation would then manifest itself in the regularity with which the adequate action follows upon an antecedently established intention and epistemic attitude. That the attitude is established antecedently means that the action itself carries no weight as a criterion for the motivation background. One would then try to explain failures of the relation to hold by looking for 'counteracting' or otherwise intervening factors: such as that the agent changed his mind, or was prevented, or had forgotten the whole thing. The bigger the time-gap, i.e., the more time that lapses between the established presence of the attitude and the predicted execution of the action, the greater are the chances (risks) that such factors will present themselves. We cannot be sure that we shall always be able to trace them. But we regard it as almost certain that an agent will, at the appointed time, act in accordance with his intentions and beliefs, *unless* some such counteracting factor is operating. This confidence in a semi-causal relation bridging over a time-gap is a 'logical mirror-image' of our confidence in a semi-entailment when the time-gap is closing.

Anscombe on Practical Inference

It has not been easy for me to relate what Elizabeth Anscombe says about practical inference to my own treatment of the topic. Our respective approaches are much more different than I originally thought. Her essay has made me realize this and also understand better both her position and my own. What I propose to do here is to place the two approaches side by side and to examine briefly what bearing the one approach may have on the other. I hope that I shall also succeed in doing justice to Professor Anscombe's position.

My PI-schema. By a practical inference I have understood a schema of the following prototype form: The schema has two premisses. The first premiss states that a certain agent A intends to p. The second states that he thinks q'ing necessary, if he is to attain his intended objective. The conclusion says that the agent sets himself to q. The above is only a *rough* description of the schema, and there are alternative forms of it. But for present purposes this will suffice. For 'p' and 'q' we may substitute verb-phrases such as, 'go to the theatre tomorrow' or 'book tickets in advance'.

What is the relation between the premisses and the conclusion in a schema of the above form? Is it a causal relation? An entailment? Or neither? One can also put the question as follows: How can a certain volitional and epistemic attitude move an agent to action? I find the problem difficult and pressing and I have so far never come to rest in my struggles to solve it. My position has also undergone changes.

Anscombe's criticism of the schema. Professor Anscombe directs several

criticisms against my conception of what a practical inference is. Her three main points are perhaps the following:

1. In my earliest discussions of the topic (in B191 and B195) I had been speaking of wanting and not of intending. Later I shifted from 'wants' to 'intends' in the first premiss of the schema. Anscombe disapproves (p. 398) of this move. For a reason which I do not find cogent, she thinks (p. 399) that we may "confidently abandon this impoverishing restriction".

2. Anscombe disagrees (p. 396) with my putting "the psychological facts" of intending (wanting) and believing into the premisses, i.e., she rejects the formulation of the premisses as statements about a certain volitional and epistemic attitude of an agent. This, she says (ibid.), "is as incorrect as it would be to represent theoretical inference in terms of belief."

3. Furthermore, Anscombe objects to my restricting the second premiss to means which are thought *necessary* for the attainment of the end in question. Surely, means which are thought *sufficient,* even though perhaps not necessary, are equally relevant to practical inference (pp. 377–80). In fact, the means which are at stake in the practical inferences which she herself considers, are sufficient means rather than necessary ones.

I shall try to say something to meet the above criticisms. First, however, I shall attempt to characterize what Miss Anscombe understands by practical inference. I hope my characterization is correct.

Anscombe's PI-Schema. For my purposes I shall avail myself of one of Anscombe's examples which I find particularly illuminating. The premisses are:

> Strong alkaloids are deadly poison to humans
>
> Nicotine is a strong alkaloid
>
> What is in this bottle is nicotine

Two 'opposite' conclusions will match this set of premisses. The one consists in careful avoidance of a lethal dose. The other amounts to suicide by drinking the bottle. (Cf. 382.)

This 'bi-polarity' in the conclusion is, I think, an interesting feature of an Anscombean practical inference. One could say that since the premisses do not univocally determine the conclusion, action will *necessarily* have to follow if the argument is to be intelligible. The action can also consist in an omission— such as—careful avoidance of something. Or it can be an abortive attempt to do something—for example commit suicide. Or it can take the 'rudimentary' form of a decision to do something; for example to consult a psychiatrist. (Cf. 381.)

The relation between the premisses and the resulting action, Miss Anscombe says (p. 380 and again p. 401), is this: "the premisses show what

good, what use, the action is''. The conclusion thus is an action or decision. It *shows* that the agent is after something mentioned in the first premiss (p. 380). We note the role *showing* plays in Anscombe's conception of the PI-schema. It makes superfluous *stating* what the want, the end of action, is. "Thus the end ought to be specified, but the specification of the end is not in the same position as a premise" (p. 382).

The logic, "the logical facts" (p. 397), involved in practical inference is, on Anscombe's view, the same as in theoretical inference. It consists in truth-connections between propositions. To return to the above example: *Since* what is in the bottle is nicotine, it is a strong alkaloid, and *therefore* a deadly poison to humans. This is what logic can extract from the premisses here. Perhaps one could put Miss Anscombe's point as follows: In practical inference ('ordinary') logic gets used; there is no difference *in logic* between theoretical and practical reasoning.

What is the use of practical inference in the form studied by Anscombe? Mainly, I should think, "to form an estimate of an action in relation to its grounds" (p. 379). This, it seems to me, is primarily a first person use. The agent sets forth an estimate of his action in going through the premisses. This can happen either prospectively, before the action, or retrospectively, after the action. In the second case, the agent may be *justifying* his action by stating his reasons for doing what he did. In the first case, the agent would normally already have decided to act and be *deliberating* ways of performing the action. He has perhaps decided to commit suicide. He is deliberating how to do it and comes to think of the bottle of nicotine at hand.

Obviously, the type of reasoning which I have just described is much more deserving of the name 'practical inference' than my PI-schema. My term has been a misnomer. (Cf. above p. 804.) My error was not that I was trying to describe something which ought really to have been described quite differently. (Omitting wants and beliefs from the premisses, for example). But I should have named it differently, since it was something in substance quite different from the thing which Elizabeth Anscombe has discussed under the well-chosen heading 'practical inference'.

One could perhaps, though with caution, characterize the difference between Anscombe's PI-schema and mine by saying that her schema considers action from a practical and mine from a theoretical point of view. Anscombe's schema is related to the ideas of justification and deliberation in much the same way as mine is related to explanation and prediction. Justification and explanation are restrospective points of view; deliberation and prediction are prospective.

Intentions, wants, and explanations. A person drinks a bottle containing nicotine and, as a consequence, dies. Why did he do this fatal thing? There are many possible explanations. Perhaps he was thirsty and thought the bottle con-

tained juice. Or perhaps he knew it contained nicotine but had no idea that nicotine was poisonous, he just wanted to find out how it tasted. Or perhaps he wanted to commit suicide and knew full well that the dose of nicotine was going to be lethal.

Assume this last to have been the case. Setting forth the explanation as above does not conform very well to my PI-schema. The above formulation mentions wants and knowledge of sufficient rather than necessary means. Let us, however, inspect the explanation in more detail.

If the suggested explanation is correct, then it is surely also right to say that the agent intended to commit suicide. Perhaps he had been weary of life for a long time, wanted to commit suicide, comtemplated it—and finally formed an intention to kill himself. The want need not have resulted in an intention. But unless it resulted in an intention, the want is irrelevant to the explanation of the case.

Moreover, the intention might have been there, clearly articulated, but without the want. Perhaps the agent did not at all 'want' to commit suicide. But he heard footsteps on the stairs and thought 'Now they are coming. I know what it will mean. Better finish it all now.' And he takes the lethal dose. Some philosophers would say that the fact that he deliberately killed himself shows that he wanted to do this. But this would be a watered-down use of 'want' for the purposes of a philosophic theory to the effect that anything which is done deliberately is wanted. I am sure Anscombe is not a philosopher who favors this kind of move.

In fact, a good many of our intentions do not 'flow' from wants at all. The shop attendant takes a ladder and places it against the case. He intends to fetch something from the top shelf. A customer has asked for it. This explains why he has this intention. But the customer's order does not make the attendant 'want' to fetch the thing.

The explanatory role of wants is characteristically different from that of intentions. Wants explain, in the first instance, why people have the intentions they have. Intentions sometimes explain why people do what they do. But not always is there a want 'behind' the intention, or an intention 'behind' the action.

I hope this makes it clear why the talk about intentions is not an 'impoverishing restriction' on my PI-schema—and also why talk about wants would not have been adequate for my purposes.

Sufficient or necessary means? Let us go back to our example. There was the bottle of nicotine at hand. But there was also, let us assume, a loaded revolver. Surely the agent must have known that he could have finished his life by shooting himself. So why did he choose the poison? There may exist an explanation for his choice of means. Perhaps he was anxious not to alarm his neighbours by causing a noise. If his intention was to kill himself 'in silence'

and taking poison was the *only* means to this end, we have a *complete* explanation of his action. If there is no explanation of his choice of means—and there need not be any—the explanation is, in a characteristic sense, incomplete. We know why he drank the bottle; viz., in order to commit suicide. But we do not know why he drank the bottle rather than shoot himself. Only if we know this last do we have a complete explanation. Only then does the question arise whether the 'bond' between, on the one hand, the agent's intention and opinion of the means and, on the other hand, his action is a causal relation or a logical entailment. For, when the means are only thought sufficient but not necessary, the 'bond' cannot be of either kind.

Transmission of intentionality. A person argues with himself: 'I intend to *p*. Unless I *q*, I cannot *p*.' If he sticks to his intended end, there will be a *transmission* of intentionality from the end to the means. I used to think (see for example B248(a), p. 45) of this as a logically necessary connection between *two* intentions, viz., a primary intention to attain the end and a secondary intention to use the necessary means. This idea is, I think, in substantial agreement with Kant's thought in the *Grundlegung* that "Who wills the end, wills . . . also the means which are indispensably necessary and in his power". Kant thought, moreover, that this was an analytic truth.

Anscombe is critical of this (p. 391)—but I am afraid she has misunderstood me a little. She makes a parallel here between intention and belief. She mentions a transition of belief in a first proposition to belief in a second which is connected with the first through a relation of material implication. She says (p. 391) that the only logical necessity involved here is "the truth-connexion of *p*, *p* ⊃ *q*, and *q*; this truth-connexion is common to both kinds of inference."

I wish to make two rejoinders to this. First, the parallel with belief is unwarranted. This is so for several reasons. One is that the practical argument was supposed to be about necessary means—and not about what happens if I do a certain thing. (What Anscombe says on p. 392 about there being no transmission of intention from *r* to *p* and *q* is quite correct. It is correct precisely because the means involved here are not necessary.) My second rejoinder is that I do not think Anscombe's example about belief is correct. If the truth-connections between the believed propositions were the only logical connections here, then there would exist no such thing as 'doxastic logic', which studies logical relations between propositions about beliefs (in propositions). This seems to me an unduly restricted position.

Thus I do not find Anscombe's critical point well-taken. But neither can I now entirely agree with what I have said about the transmission problem. If a man intends to do something, then whatever he does *in order* to achieve his objective he will do intentionally. This is in the logic of the case, and it applies both to sufficient and necessary means to the intended end. It does not follow

from this, however, that everything which a man does in order to reach an intended end is something he can correctly be said to intend to do—not even when what he does is necessary for the end. At the time when I wrote the papers on practical inference which Elizabeth Anscombe discusses in her essay I did not fully realize the importance of keeping clear the distinction between 'intention to do' and 'doing intentionally'.

Black on Practical Reasoning

Black's essay is primarily concerned with deliberation. As already noted (p. 804f.), my chief concern under the same heading has been with explanation. The prototype case which I have been discussing is this: An action has been performed. Why was it done? Because the agent thought it necessary for the sake of something which he was pursuing. Turning this retrospective piece of reasoning into the form of a forward looking 'practical syllogism' is, I admit, apt to obscure the issue. Black is right when he calls it (p. 412) "a curious feature" of my approach "that it seems to disqualify practical syllogisms for use in deliberation". He adds (ibid.) "whatever value an appeal to practical reasoning may have in explanation, it seems to me necessary also to recognize its importance to deliberation." I entirely agree. In my writings I have paid only occasional and quite insufficient attention to the deliberation aspect of practical reasoning.

Black's criticism of the form of practical arguments which I have studied must be seen in the light of his own more "comprehensive conception of practical reasoning" (p. 407). If a practical argument is just any "argument supposed to supply reasons for performing an action" (ibid.), then clearly it is arbitrary to restrict the volitional attitude, expressed in the first premiss of the schema, to intentions. It is equally arbitrary to restrict the cognitive attitude, mentioned in the second premiss to supposedly *necessary* means to the intended end. These restrictions, however, were motivated by an interest in the relation (link) between the inner and the outer aspect of an action and in the *completeness* of explanations of action.

A more serious criticism concerns the nature of the conclusion. I have wanted to say, with Aristotle, that the conclusion of a practical argument is an action. I agree that this way of talking can be misleading. On the other hand, it is a common and not unnatural *façon de parler* to say of something we have done that it was the 'conclusion' we drew from a deliberative argument. When setting forth an explanation, it is more appropriate to relate some proposition to the effect that an agent initiated or performed an action to certain other propositions to the effect that he intended something and thought the action in question necessary in order to attain his object of intention (Cf. p. 408).

Black, however, prefers to consider conclusions of practical arguments

which have the character of what he calls "verdicts". Verdicts are not to the effect that certain things *are* done, but to the effect that they *should* be, or *can* be, or *must* be done (p. 408). Whether such verdicts should be regarded as 'propositions' is not unproblematic. Black is aware of this. Somewhat too lightly, it seems to me, he resolves (p. 410) that "it seems reasonable to treat them as propositions". It is a characteristic consequence of the position which Black adopts that it enables him to set aside the question whether the action upon which we pass a 'verdict' in the conclusion of the practical argument is in fact performed or not. This "further question" (p. 409) seems to him "not to belong to logic" (p. 409). "Questions about why persons who accept practical syllogisms sometimes fail to act upon the conclusions, interesting as they are, belong to psychology", he thinks (p. 412). "The final transition to action" (p. 414) is no part of the argument.

The above nicely illustrates how different is the problem to which Black addresses himself in his treatment of practical reasoning from the problem which was vexing me in *E&U*. Black is interested in the relation between 'should'-statements (and some related types of 'verdict') and statements about wants, intentions, means, and various requirements by which we back these 'verdicts'. My interest had been in the relation between action and the combination of volitative and cognitive factors which 'prompt' us to act. This difference between us is related to, even if not identical with, the above-mentioned difference between interest in deliberation ('What shall we do?') and interest in explanation ('Why was this done?').

Considering the way in which Black puts the problem, he is justified in setting aside the question of performance of action as falling "outside the argument's scope" (p. 414). But I do not agree with him that the question ought to be relegated to psychology as not properly belonging to logic. The problem of how the 'will' is related to action is not only, and perhaps not even principally, a psychological problem. It is a conceptual problem, and qua this a 'logical' one. But it is not a problem of formal logic.

With Black (p. 414) the following counts as a basic schema of a logic of deliberation:

X wants E
Doing A would allow X to achieve E
Doing A would not be more trouble than it is worth to get E
A is preferable to any other action available for achieving E
So, X should do A

The schema, Black says, is "valid" (p. 415). "It follows with necessity that A should be chosen" (ibid.). "The appropriate 'should'-conclusion is entailed by the elaborated premisses" (ibid.). Are these claims valid? The answer depends upon some other questions which Black had raised earlier in the essay.

Is practical reasoning "on a footing with 'theoretical' reasoning" (p. 410)?

Or does it employ a "special logic" (p. 415)? Black wants to answer the first question in the affirmative and the second in the negative. He thus disagrees with those writers who have wanted to stress the sui generis character of practical inference. I may be counted as one of them.

It is noteworthy that those who have emphasized a distinction between 'theoretical' and 'practical' reasoning have done so on varying and not always very clear grounds. This fact reflects a genuine difficulty. It is, for one thing, not clear what should count as constituting a difference "in principle" between the two types of reasoning.

One important difference would be there if it could be shown that (some) premisses and conclusions of practical arguments are not true or false propositions. For how can one speak about the validity of an argument if the notion of a truth-value does not apply to its component parts? The indicative form of a sentence, such as 'X should do A', is by itself no guarantee that the sentence expresses a genuine proposition.

I have wrestled with this aspect of the problem in many of my publications, chiefly in those dealing with deontic logic. I do not know the final answer. But I am inclined to think that arguments with non-propositional premisses or conclusions can be 'paralleled' by or 'reflected' in arguments of the ordinary, theoretical type, for which the truth-value question presents no difficulty. This was the line I took in *Norm and Action,* when I interpreted the logic of norms 'descriptively', as a logic of propositions to the effect that such and such norms exist (Cf. my reply to Alchourrón and Bulygin, below pp. 872ff.).

Let us assume that Black's schema above is, or can be 'paralleled' by, a propositional structure. Then it is, as far as truth-value is concerned, "on a footing with 'theoretical' reasoning". Let us also assume that the schema is valid, i.e., that the conclusion is entailed by the premisses. Surely this validity cannot be 'axiomatic', not capable of any kind of proof. If it were axiomatic, then the logic of deliberation would indeed be highly "special" and there would be good reason for denying that it is "on a footing with 'theoretical' reasoning".

Thus something must be done in order to demonstrate or otherwise make obvious the validity of the schema. How is this to be achieved? Presumably by means of further conceptual analysis. As I see the task, it consists, roughly speaking, in the following: One has to show that the concepts of 'want', 'value' ('worth'), 'preference' ('preferability'), and 'should' are linked with one another in such a way that Black's schema is seen to be logically conclusive.

If my analysis of the conceptual situation is correct, then the above task is, after all, not very different from the one which occupied me in my study of what *I* called 'practical inference'. My problem, it will be remembered, was to show how the notion of an action is linked with the notions of intending and judging. For Black the corresponding problem is to show how the idea that one *should* act in a certain way is related to the ideas of valuating and wanting

things. No 'special logic' is needed for coping with either problem. But neither one is merely a matter of applying standard logical inference schemas to a new type of discourse. The task, as already said (above p. 825) is not one of formal logic, but of conceptual analysis. It is still awaiting to be satisfactorily performed.

IV. CAUSALITY, TELEOLOGY, AND SCIENTIFIC EXPLANATION

My early work on induction and probability almost completely bypassed the problem of lawlikeness, and therewith the deeper aspects of the problems connected with causation. This may seem surprising. But one should remember that my work dates back to the time before the war and that its earliest sources of inspiration were in the then flourishing movement of logical empiricism or positivism. A new era in the field began with the classic papers by Chisholm (1946) and Goodman (1947) on counterfactual conditionals. My own first contribution to the discussion which they had started was an isolated piece of work, the essay 'On Conditionals', included in *Logical Studies* (B153, 1957).

My return to this problem area took place some ten years later, when I had become interested in problems of scientific explanation and in the traditional opposition between the causal and the teleological points of view. The area is a vast one, and my contributions to the discussion have a somewhat heterogeneous character. A common trend can be discerned in them, however. This is my insistence on a sharp distinction between two types of causation or determination. The one is central to the natural sciences and connected with the idea of experiment. The other plays a leading role in history and the social sciences and embraces various forms of motivation. I have thus come to advocate a dualism between the natural and the human sciences, between 'nature' and 'man'. This position is not unconnected with an attitude which could, perhaps, be described as a defense of humanism against an 'engineering' and 'manipulatory' approach to the problem of man. It was therefore natural to conclude my replies to the essays on causation and explanation with a reply to Tranøy's paper on my "critique of culture and philosophy of life".

The other essays dealt with in this section of the replies are those by Prawitz, Marković, and Dray. My reply to the late J. L. Mackie's paper about my treatment of conditionals appears in the section dealing with philosophical logic.

Prawitz on the Concept of Cause

Professor Prawitz agrees with me in thinking that the regularity view of causation is inadequate. But he does not think that my theory provides a good alternative. He maintains (p. 419) "that the inadequacies of the Humean anal-

ysis cannot be met by basing the concept of cause on that of action, and that the latter concept is not presupposed in that of the former''.

The ambiguities of 'cause'. It is obvious that the term 'cause' is used with a variety of meanings. I have been anxious to stress that my actionist or experimentalist theory of causation is concerned with one concept of cause only (Cf. *C&D*, Ch. I, Sect. 1). Professor Prawitz is not entirely sympathetic to this pluralistic view. Though he agrees that there are different uses of the word 'cause', it seems to him "reasonable to assume that the many uses have not merely the word but also a core of meaning in common" (p. 418). He is intent on isolating this common core (ibid.). The aim of a philosophy of causation he sees somewhat differently from the way I do.

Humean causation. In the first section of his essay (pp. 420–25) Prawitz works his way to a definition of 'cause' which is meant to be an improvement on the definition given by Hume in his *Enquiry*. I agree in the main with Prawitz's analysis. Since it is not directly concerned with my work, I refrain from more detailed comments. Nor shall I discuss the intriguing question of the ontological status of the terms of the causal relation, viz., events and states. Let it only be mentioned in passing that neither one of the two views referred to by Prawitz (p. 421f.) seems to me entirely satisfactory.

In the second section of the essay (pp. 425–29) Prawitz criticizes the (improved version of the) Humean view of causation. I have no disagreement with this part of the paper. The arguments put forward by Prawitz against Hume are much the same as those I have myself advanced in my later writings. There is no need to repeat them here. But the following comment on the term 'Humean causation' may be called for:

By a 'Humean' analysis or view of causation Prawitz means, roughly, what is also commonly known as the 'regularity view'. This, I think, is an entirely unobjectionable use of the term. It was, moreover, in the spirit of this view that in my early writings (prior to the essay 'On Conditionals') I regarded myself as an adherent and follower of Hume.

In my later writings and chiefly in *E&U* I have also made use of the term 'Humean causation', but with a rather different connotation. Some of my readers may have found this confusing. Perhaps it would have been wiser to employ a different terminology. By a Humean causal relation I later meant a nomic or lawlike relationship between logically independent generic events or states. If by the Humean view of causation one understands the regularity view, then the Humean view is notoriously unable to account for the nomic element in Humean causation.

In the second half (Sect. III, pp. 429–443) of his essay Professor Prawitz examines and criticizes my proposed 'way out' of the difficulties confronting the Humean analysis of causation. With characteristic clarity and precision he groups the topics to be discussed under five headings. On the second and third

topics, viz., causal analysis and causal explanation, he has not much to say. I shall therefore leave these topics aside here. The first topic is preliminary to the theory of causation proper. It concerns the formal language used for describing actual and possible developments of the world and for expressing causal relationships between events and states in these developments. On this Prawitz makes some interesting observations.

Causal alternatives and the linearity of time. Prawitz notes two significant differences between my position in *E&U* (also in B261) and the later publication, *C&D*. In *E&U* I assumed that the future course of the world is an alternativeness, linear succession of total states of the world, provided that no interference with 'nature' through an agent takes place. In *C&D* I expressly admitted that there may exist causal alternatives "in nature". Prawitz thinks this shift in position an improvement. I am decidedly of the same opinion. I think it essential that an unprejudiced discussion of causation should take into account the possibility of 'objective' or 'ontic' alternatives in nature which are independent of agency. For surely there may exist stages in the development of the world such that the world at the next stage may be in this *or* in that total state, quite independently of whether there is any agent present to 'steer' developments in one direction or the other.

The topological representation in *E&U* (and in B261) of world developments by means of a 'world-time-tree' provided for a tripartite distinction between the possible, the factual, and the necessary future. In the formal language of *C&D,* however, "one cannot distinguish between what will in fact be true and what will be true necessarily (in the causal sense)". This, Prawitz thinks (p. 430), is a loss. It obliterates a distinction which is obviously meaningful (ibid.).

I have, of course, not wished to deny the meaningfulness of the distinction between that which *will* be true, though contingently so, and that which will *certainly*, or *necessarily*, be true. But I have felt great dificulties about this distinction and its proper expression in a formal language. At times I have been of the opinion that one cannot express it, so to say, directly as a distinction concerning the future, but must express it obliquely, as a distinction concerning things which were future but are now past. Since the future is that part of history (time) which has not yet become actual, the factual, I thought, must be either past or present. This was my view when I wrote *C&D,*[1] but it is no longer my opinion. I therefore think Prawitz's criticism justified. And I think I now know how to express in a satisfactory manner the distinction between the possible, the factual, and the necessary in matters pertaining to the future also.

[1]The same view is argued independently by R. P. McArthur in 'Factuality and Modality in the Future Tense', *Noûs* 8, 1974.

The terms of the causal relation: events or states? In *C&D* I argue for the basic nature of event-causality. Prawitz considers this an unduly restrictive position. "It seems to me," he says (p. 432), "that we often consider causes and effects that are not the change of a state *p* into its opposite ~*p* but which rather consist of a quantitative aspect of a situation. The cause (or effect) is then that a certain variable assumes a certain value, which seems best described as a state and not as the change of a state into its opposite."

It is obvious that natural laws of an important type convey the functional dependence of the measurable value of some state upon the values of certain other states. An example would be the dependence of the volume of a gas upon pressure and temperature. Such laws we do not normally call causal. Given the values of the states, it is not in general possible to tell which is 'cause' and which is 'effect'. Still, causation is involved in the relationship between the states. This is so by virtue of the fact that a given *change* in value of one of the states will determine a corresponding *change* in the value of some other state(s). For example, by varying the pressure under constant temperature, we may vary the volume of a gas. *This is a causal relation between events.* And I think it must be admitted that it is precisely upon this type of event-causation that laws of the functional type rest. Also, the *applications* of such laws relate to event-causation, as e.g., when we predict a change in the quantitiative aspect of one state consequent upon quantitative changes in some other states.

In view of these considerations I do not think that Prawitz has successfully contested my thesis about the primacy of causal relations between events over causal relations between states. (For further arguments see *C&D*, Ch. III, Sects. 2 & 3.)

Dependence of causation on agency. Prawitz's restatement (pp. 432–33) of my view that causation depends conceptually on agency is as good as any I could have given myself. He touches the heart of the matter when he says (p. 433) that I argue "that causal relations are ultimately established epistemically by interfering with the course of nature. But this is so because of a conceptual, i.e., logical, connection between cause and action."

Prawitz then (pp. 433ff.) proceeds to extract from my writings a definition of cause. He wonders whether he is pressing my words too far. I think he is not, and I agree to his paraphrases W2 and W3 of my formulation W1 in *E&U*. As for W4 I should say, exactly as surmised by Prawitz, that there is no real difference between it and the preceding formulations. For, on my view, the counterfactual in W4 has ultimately to be explicated in terms of possible action. Prawitz finds this analysis "strange" (ibid.), and he is not alone in thinking so. But it must be remembered here that it is only a certain type of counterfactual conditional, viz., *causal* counterfactuals, which, in my opinion, calls for this analysis. The concept of action, in its turn, also involves the idea of counterfactual conditionality. But the counterfactuals involved in action statements are not causal. (This point will be further discussed in my reply to Mackie.)

Having restated my view, Prawitz restates three of my arguments in support of it and then (p. 436) proceeds to a critical examination of them. The restatement is correct. But I cannot quite agree when Prawitz says that it is "essentially" on these three arguments or reasons that my position is based. The arguments discussed by Prawitz are, I think, relevant, but at the same time somewhat peripheral to the core of my theory.

Determining causal relevance. The first 'argument' concerns the question of how to eliminate the possibility that the cause of an event F is, not an event E upon which F has been observed to be regularly consequent, but some other event G. The argument is as follows: If, on occasions when we could produce E but refrain from doing this, we find that F does not occur, then we have reason to think that E is a cause of F. That is: we have reason to think that the occasions for acting do not contain another cause of F. Since, moreover, F was found to occur on all occasions when E was produced, we think that it must have been E which caused F.

We can, of course, be sure of *every* situation when F does not occur that it does not contain an antecedent cause of F. But such situations are irrelevant to the question of the causes of F, unless we can introduce into them something which we think may be a cause of F, for example E. Why do I call them irrelevant? Would not the mere occurrence of E, followed by F, be just as relevant to our causal hypothesis as the production of E? The answer is no. For in the case of a 'mere' occurrence we should have to reckon with the possibility that E was in its turn caused by something which also causes F. And then E need not be a cause of F at all. If, however, E did not merely occur but was produced by action, no such common cause of E and F can be there. Its existence would contradict the assumption that E resulted from interference. This observation takes us to the second argument considered by Prawitz (pp. 437–39).

Common causes. The problem of common causes (multiple effect) "is rather intricate", Prawitz admits (p. 437). It is most important to distinguish here between the following two cases. The first is when G causes E and E causes F. The second case is when G causes both E and F but there is no causal relation between the two effects themselves. In the first case, the 'intricacy' lies in the problem of showing that E causes F. In the second case the problem is to show that E and F are causally unrelated. My 'argument' consists in an effort to show that interference is essential to the solution of both problems.

Prawitz discusses an example (p. 438ff.) which is, in fact, a combination of the above two problems—and therefore, though interesting, somewhat unperspicuous. Affliction by a certain virus is supposed to cause first the appearance of pocks on the skin, and then fever. The fever, thus caused, is in its turn supposed to cause death. It is further being assumed in the example that the pocks are caused *only* by the virus in question. We know of no independent

way of producing the pocks which would make it possible to test whether the pocks cause fever. We do not believe that they have this causal efficacy; rather do we believe that they have not. But how can we differentiate between the accidental nature of the regular sequence pocks—fever and the nomic nature of this same sequence? My analysis, Prawitz says, is not "entirely successful" in coping with this problem.

How shall we understand the alleged fact that one cannot separate the appearance of pocks from the infection by the virus? One way of understanding it would be to regard the pocks as a *part* of the cause of the observed effects. Then the cause of fever (and death) would be virus *cum* pocks. This would accommodate our belief that the pocks have no independent causal efficacy. But it would be contrary to our belief that it is the virus alone which causes the lethal fever.

As long as the pocks do not occur independently, we have no means of testing whether they cause fever or not. If they were to occur independently without fever following, we should know that the pocks alone do not cause fever. If again fever would follow, we should still have to try to determine whether it is caused by the pocks or perhaps by the cause, known or unknown, of the pocks. Against the background of our medical knowledge concerning the connections between skin disorders and fever generally, we should, even without further tests, be confident that the pocks do not cause the fever. It is this background knowledge, Prawitz thinks (p. 439) which carries the burden of discriminating between the accidental and the nomic in the sequence pocks—fever. But is this really so?

Prawitz is no doubt right in thinking that we should appeal to "our general medical knowledge" in dismissing the hypothesis that there is a causal connection between pocks and fever. But this appeal is only an oblique way of appealing to what constitutes the ultimate ground here for a discrimination between the accidental and the nomic, viz., experimental tests and knowledge extracted from experiments. For on what does this "general medical knowledge" rest? How have we arrived at it? In considering these questions we shall, I think, be forced to acknowledge the crucial role of experiments as the basis of causal knowledge—in medicine and elsewhere.

Asymmetry of the causal relation. The third argument which Prawitz takes up for discussion (pp. 439–441) concerns the possibility of distinguishing between cause and effect among two nomically connected factors which instantiate simultaneously.

If one of the two factors instantiates as a result of action, it is the cause-factor. This seems uncontroversial. But only a small minority of cases are of this type. More common, I think, are the cases when one has to spot a 'cause of the cause', i.e., some antecedent factor which is responsible for the occurrence of one of the two simultaneously occurring things. In *C&D* I used as an example the case of a stone which hits the lid of a valve and closes it, thereby

effecting the simultaneous opening of another valve. In such cases, however, there is a new difficulty: How shall one tell which one of the two simultaneous occurrences is the (immediate) effect of the antecedent cause? On my view, the answer in the last resort either rests on accumulated experiences of manipulability of the factors involved or must be discovered by means of further experiments. On Prawitz's view it may be more fruitful to consider instead such questions as how certain generalizations fit into general background knowledge.

Two alternative conceptions of nomicity. Prawitz's discussion of the problem of common causes and of the problem of asymmetry of cause and effect nicely illustrates two different ways of coping with the problem of lawlikeness or nomicity. My way has been to make the notion of nomicity rest on the notion of causal counterfactual conditionals, and then to try to show that this notion of counterfactuality has its conceptual root in the idea of active interference (experiment, manipulability) with the 'normal' course of nature. Prawitz looks for a way out in the opposite direction. He wants to make the notion of law basic and from its platform illuminate the notions of cause and counterfactual conditionals (p. 443). In his analysis the idea of action (experiment) does not play a fundamental role.

Rather than making it depend upon experimental test, Prawitz suggests that "our acceptance of causal hypotheses depends . . . upon how well the hypotheses agree with already accepted laws and upon considerations of the possibility of further generalizations of the causal connection" (p. 442). No doubt Prawitz's suggestions reflects an important fact about scientific practice. The question is how fundamental this fact is. How is it that we already have a bunch of accepted laws? How did we acquire this 'general background knowledge' which we undoubtedly have concerning nature's causal mechanisms? When we consider these questions we shall, I suggest, be led to recognize the basic role played here by the mode of action called experimentation. It is characteristic of the critical and generous spirit of Prawitz's essay that its author by no means wants to deny the importance of "the role action plays in acquiring most of our causal knowledge" (p. 441). But he doubts the existence of *conceptual ties* between cause and action.

Marković on the Sciences of Nature and the Sciences of Man

The essay by Mihailo Marković contains interesting remarks on a wide variety of 'big' subjects. A full reply would require an article of at least the same length. Here I shall single out for brief comments only a few questions. I shall also try to make clear how some of my views differ from those of Marković. This may be regarded as a preliminary step towards a fuller confrontation of our respective positions.

Reification. The important notion of reification plays a prominent role in

Marković's writings. I think a difference between our views can be described as follows: By the reification of man I would not, in the first place, understand an anthropological or social phenomenon, a quality, as it were, of human beings in some societies. I would rather regard it as something conceptual, as a way of viewing men and theorizing about their behavior. Under a reified conception, human actions are viewed as responses to stimuli in accordance with laws of either universal or stochastic generality. It is typically a causalist view of human behavior. It is often connected with various ideas of social 'manipulation': by controlling the stimuli one can, from the 'outside', control and change the reactions within a group of agents.

This reified conception of man is important in social study and its applications—if not for purposes of manipulation, then at least for purposes of prediction. When not asserted to the exclusion of alternative conceptions, it seems to me an entirely legitimate point of view. It may be more fertile when applied to the study of some phenomena than to others. And one could say that the degree to which it is fertile is a measure of the degree to which human beings and groups actually *are* reified. "The more reified human individuals are, i.e., the more they behave like things . . . the more social behavior resembles a natural process", says Marković (p. 448). A very rigid culture or society is in this sense more reified than a mobile society or a society at the time of a revolution. As an anthropological or social phenomenon, therefore, reification is capable of degrees.

The opposite of a reified view of man has not received a name, and it is better not to try to invent one. Nor shall I here attempt to characterize it in detail. This other point of view tries to understand action in the concrete setting of the intentions and wants and shunnings of individual agents or groups who are facing the requirements upon their behavior of changes in natural circumstances or in human institutions. The philosopher, of course, is not interested in the analysis and description of concrete, historically given situations. His task is to give a truthful *general* account of the conceptual peculiarities of this mode of understanding.

The two points of view, the causalist-reified one and the concrete-understanding one are, as I see them, conceptually poles apart. Therefore I am more inclined to emphasize a dualism here than to put stress on a continuum of methods and types of investigation. I would say something like this: In logic (concepts) there are sharp distinctions; in things (phenomena) there are continuity and degrees. Perhaps it reflects a temperamental difference between Mihailo Marković and myself that his ultimate concern as philosopher should be about things, mine about concepts. But this characterization should be taken, very much, cum grano salis.

2. *"Humanization" of nature.* What Marković calls the "humanization" of natural phenomena is not exactly a conceptual counterpart to the 'reification'

of human and social phenomena. That nature has been humanized presumably means that its phenomena have been subjected to human technology, i.e., that nature is being 'steered' or 'tamed' to serve human goals and purposes. A prerequisite for this is that man has acquired a substantial bulk of knowledge of the laws which 'govern' nature. Before there existed a science and a scientifically based technology, nature was in a different sense 'humanized', viz., in that its forces and phenomena were often given an anthropomorphic interpretation in the terms of analogies from human and social life. Man's technological mastery of natural phenomena, one could say, is the outcome of a gradually acquired 'reified' conception of nature. What some people fear is that a correspondingly 'reified' conception of man will foster a social 'engineering' or 'technology' which may be used to cement some men's mastery over other men.

3. *Natural necessity*. Marković agrees with me that natural necessity must be distinguished from logical necessity on the one hand and from regular sequence on the other hand. (P. 451 and *passim*). He also seems sympathetic towards my 'actionist' or 'experimentalist' approach to causality in the natural sciences (p. 452ff.). Whether or not he agrees with my view that the concept of cause depends logically on the concept of action (interference with the world) is not quite clear to me. He says (p. 453) that natural necessity depends not only "on our ability to do and bring about things", but also on "our readiness to try to preserve a law by all operations compatible with the basic principles of the scientific method". This second type of dependence, however, is rather different from the one for which I have been arguing in my theory of causation. This being granted, I completely agree with what Marković has to say (pp. 453–55) on how science steers between the Scylla of 'Popperian' falsificationism and the Charybdis of what may be called 'Dinglerian' conventionalism.

Causality and teleology. Marković credits me (p. 456) with "an elaborate theory of teleological explanation". I cannot accept this compliment without reservations. It is true that I called my theory of action explanation in *E&U* 'teleological'. This, of course, is not entirely a misnomer. But 'intentionalist' would have been a better name than 'teleological'. I ought to have put stronger emphasis on the fact that intentionalist explanations are only one species of explanations of action, and action explanation only one species of teleology.

Marković for his part refuses to make a sharp distinction between causal and teleological explanations. "There is no demarcation *line* but a demarcation *range* between causal and teleological explanation", he says (p. 459). Here again we encounter what I think is a characteristic difference between Marković's and my way of thinking. Up to a point I can agree with Marković. I think there is an important province in which causality and teleology can be said to overlap. This province is biology. I would conjecture that a good many, if not

all, of the purposeful mechanisms which we encounter in animals and plants—
including the 'wisdom' of the human body—are 'at bottom' causal though on
the surface teleological. To prove this conjecture would require analyses which,
to the best of my knowledge, nobody has as yet carried out. If the truth in the
matter is what I believe it to be, then teleology in the animal kingdom is 'te-
leology' in a totally different sense from, say, the teleology of intentionalist
action explanation. As long as the *concepts* of causality and teleology are
blurred, the situation is philosophically unsatisfactory. Not until the distinctions
have been made sharp in the realm of concepts can one clearly recognize and
describe the interplay and overlap of causal and teleological factors in the realm
of phenomena.

Intention. Marković makes a good observation when he says (p. 458) that
neither behaviorism nor mentalism can give a satisfactory account of the con-
cept of intentionality. Intentions are not mental in the sense in which wants or
wishes can be said to be. Nor are intentions behavioral in the same sense as
are the movements of limbs in a living body. Intentions 'link', in a peculiar
way, the mental and the behavioral, the 'inner' and the 'outer'. This is a reason
why the conceptual nature of intentionality is so difficult to characterize. I
agree with what Marković says (p. 458f.) on the degree-character and on the
developing nature of intentionality. What he says holds true of the *phenomena;*
but I am not sure that it helps much to clarify the *concept.*

Psychological laws. Marković's discussion (p. 460 seq.) of explaining and
understanding and of their mutual relation is, on the whole, in line with my
own way of thinking. There are, however, some points where our opinions
diverge. They pertain to that which Marković calls (p. 461) "understanding in
in terms of laws". The topic is important and my treatment of it in earlier
publications insufficient.

Marković says (p. 462): "If introspection could yield evidence, it seems to
follow that nomic connections between variables designating psychic phenom-
ena could be reasonably well-established and used in the process of interpreta-
tion." The kind of psychological laws which Marković has in mind are univer-
sal lawlike connections between *feelings* of, say, joy, fear, or hunger and
various *volitions* like decisions, intentions, or wants to do certain things. It is
not quite clear to me what would be a good example of such a law. *Perhaps*
this would do: When an animal is thirsty (feels thirst), it wants to drink (quench
its thirst). If this were a law, we could in terms of it understand (explain)
drinking and other forms of 'water-seeking behavior'.

If my interpretation of Marković's suggestions and arguments on pp. 460–
64 is correct, then Marković has touched upon a most important problem: In
what sense can, for instance, thirst be said to generate thirst-quenching behav-
ior? (It seems to me that one can without loss to the problem situation here
skip the intention which 'mediates' between the feeling and the action.)

I do not know the answer to the above question. I imagine that there are

nomic ('Humean') causal relations between those processes in our body which we experience as thirst and forms of overt behavior which can be described as 'water-seeking'. But this relation is a complicated one. It involves factors the role of which I find perplexing. What we call 'thirst' is not just a sensation. It is also a *need* to quench the thirst-sensations and thus get rid of them. Moreover, we know (have learnt) how to satisfy this need—for example by drinking a glass of water. Taking all this into account, it becomes doubtful whether one can speak of a law-connection between the thirst which I experience and the actions which I perform in order to quench it. I incline to think that *this* connection is of the 'practical inference' type rather than a 'psychological law' in a nomic-causalist sense.

Social laws. This much about laws in psychology. Their role is unclear to me. What then shall we say about historical, economic, and social laws? Can logically independent phenomena of social life be nomically connected?

Marković thinks "that laws play a more important role in explaining and understanding social phenomena than von Wright's texts indicate" (p. 464). Perhaps this is so. But which *are* these laws? The notorious absence of good, uncontroversial examples makes difficult discussion of laws and their conceptual nature. Only from economics, it seems, can one cite what look like 'laws', e.g., the law of supply and demand or of diminishing marginal utility.

Marković mentions (p. 465) my example from *E&U* that "there was an uprising among the people because the government was corrupt and oppressive". His comments, however, do not succeed in convincing me that there must exist "some kind of general and necessary connection between the behavior of the government and the people's tendency to rebel" (p. 465) which carries explanatory weight for the concrete case. There may have existed *many* rebellions in history which were actually called for by the corruption and oppressiveness of a government (ibid.). But I do not think that the *multitude* of cases affects the trustworthiness of a suggested explanation. The cause of a rebellion could be unique, as far as our historical experience goes, and the rebellion still have an explanation which is absolutely convincing.

Somehow, a 'law' directly connecting rebellion with suppression seems too 'superficial' to be worthy of the name. But there may exist "underlying historical laws" (p. 466) which relate the two surface-phenomena. Speaking of the causes of World War I, Marković hints at such a law with the words "the accelerated industrialization of a big country with the need to control foreign sources of raw materials and markets" (ibid.). Even if this is rather too specific, we have a feeling, I think, that something lawlike lurks in the background here. It could be some general statement about the necessary conditions for the continuation of a certain mode of production.

How is this background-law to be formulated? And how shall we characterize its conceptual status? I think there is a whole *web* of connections involved in the 'underlying law'. Some of these connections are causal, others

are conceptual. In this regard the situation is reminiscent of the thirst exam-ple—only even more complex. There are (genuine) causal connections here between the possibility of doing certain things in a certain way ('mode of pro-duction') and a material basis in resources and technology. There are further motivational connections between the doing of these things and various mate-rial needs and desires (for 'riches and power'). And there are, finally, the prac-tical necessities of taking further measures for the sake of satisfying those de-sires—such as, for example, to secure markets for manufactured commodities. If these motivational and practical connections are called 'causal' or 'law-like'—and there is no objection as such to the use of the terms—then it should be remembered that they are in many respects unlike the causal relations which are involved in laws of nature. They are more like conceptual conditions for a correct description and analysis of a historically given situation.

Consequent upon the development of capitalist production and growth of the bourgeois class within the social framework of late feudal society there emerged the system of absolute monarchy. Surely there were some law con-nections underlying this development. But it is not illuminating to call these connections 'nomic' simply by virtue of the fact that a similar development is "characteristic of all the civilized world in a certain initial period of its indus-trial development". We must first try to understand *why* this should be so, before we can accord explicative force to the 'law' *that* it is so.

To summarize:

1. Social laws of the kind hinted at above are of fundamental importance to understanding history and explaining social change.

2. In my writings so far I have not paid much attention to the laws of social change. This is a great lacuna in my work and one which I hope to be able to fill later.

3. An analysis of the principles of social change will probably reveal that they involve both ('Humean') causal elements and non-nomic motivational mechanisms such as the 'practical syllogism' schema and related schemata. This should mitigate the impression that the difference which is being main-tained between man and nature is "too sharp" (p. 468). But I should—and here I perhaps differ from Marković—insist on sharp differences among the elements themselves which jointly constitute the complex web of relations be-tween the phenomena which history and social science study. Perhaps I suffer from a logician's prejudices here—but I am anxious to avoid giving a blurred picture of complex relationships.

Dray on Explanation in History

Reading Professor Dray's comments on what I have had to say on historical explanation makes me realize, above all, how deficient and fragmentary my contributions to this topic have been so far.

In *E&U* I claimed that the explanation schema which I called 'the practical syllogism' holds a position in the methodology of the human sciences which is analogous to the position of 'covering-law explanations' in the natural sciences. I think there is some truth in this claim—but also much exaggeration.

The truth, as I see it, is that a full explanation of an individual human action does not consist in subsuming the action under a general law or principle, but in relating it to a motivational background or social situation which will make the action appear as 'a thing to do' under those circumstances. This conception is, I think, in basic agreement with the position taken by Dray in his important and influential book on laws and explanation in history.

Professor Dray was the first to draw systematic attention to the importance of a type of explanation which answers the question *how* a certain thing was *possible*. Very often, although not always, explanations of this type state necessary conditions for the happening (existence, occurrence) of the thing in question. It is of interest to consider in detail the nature of these conditionship relations.

Dray notes (p. 477) that, on my view, the explanatory conditions of an action, by contrast with the physical events which are its vehicle, are never nomically sufficient for its occurrence. But could they not, he asks in effect, be nomically necessary?

I am afraid that Dray has here somewhat misunderstood my position. I have not wished to say, e.g., that, although the possession of building skills was causally necessary for the erection of such-and-such monuments, the availability of certain building materials was not a causal condition for this (p. 473). Nor did I want to deny that some people's financial skills might have been necessary for the economic recovery of such and such a country (p. 480). Building skills and financial skills are surely rather different. The former are intimately connected with developments in technology; the latter only loosely, if at all. But both types of skill can play a causal role in historical explanations.

Dray is therefore not right when he says (p. 481) that I am "denying that Jewish skills would be regarded by the historian as causally necessary for Polish recovery at that time [*sc.* of Casimir the Great]". I am not denying this at all. I am only warning against what I believe to be a mistaken interpretation of causally necessary conditions here. This is the interpretation which regards the conditionship relation connecting financial skill and economic recovery as a universal law, similar, say, to the law connecting the presence of oxygen in the surroundings with the possibility for human bodies to stay alive.

The change (or not-change) in the world, in which an individual action results, may have conditions which are causally necessary in the nomic sense. Without the availability of certain building materials such and such a monument could not have come into being. The 'laws of nature' make it impossible. This being so, availability of the materials was also a necessary condition for the (performance of the) actions which resulted in the building. There is thus a

perfectly good, although oblique, sense in which actions too can have—and I should think as a matter of fact nearly always have—nomically necessary causal conditions.

Dray says (p. 472) that I seem to regard as causes "*all* the conditions mentioned in an explanation which pass the controllability test". This, however is not my opinion. First of all, something can be a cause without being controllable. Secondly, I do not wish to call everything which is a causal condition of something, or a conjunctive or substitutable part of such a condition, a cause of this thing. To call it 'cause' would, as Dray observes (p. 472), be to depart considerably (and unnecessarily) from common usage. We should, for example, hesitate to call the availability of building materials a 'cause' of building activity, although the first surely is a causally necessary condition of the second.

The question of when we should call a condition 'cause' is intricate and not uninteresting. Dray suggests (p. 472–73), with a reference to Collingwood, that human *interests* "enter into the identification of causes". This may be true— but only provided certain criteria for conditionship relations are already satisfied.

Causal analysis in history can, I think, always be profitably conducted in the terms of conditionship relations. But this does not mean that such relations among events in history must be nomic relations, nor that causes in history are 'Humean'. On the whole causation in history is not of the nomic kind. Because of its typically non-nomic and non-Humean character, I introduced in *E&U* the term 'quasi-causation'. But my contribution to its analysis was meagre. This was due to at least three reasons. One was an exaggerated reliance on 'practical syllogisms' as an explanation pattern for action. Another was the absence of an explanatory theory of human motivation. A third, finally, was a failure to cope satisfactorily with collective action and historical macrophenomena generally.

Explanations in accordance with the practical syllogism schema and its more "relaxed" variants I now prefer to call 'intentionalist'. They are a subspecies of explanations also called 'teleological'. Intentionalist explanations look for the determinants of actions, so to speak, 'inside' the agents. What I failed to see when I was writing *E&U,* was that such internal determinants of human action, although important, are far from always being able to explain why agents act as they do. Of at least equal prominence are explanations in the terms of various external determinants like requests, injunctions, prohibitions, and so forth. Intentional actions are very often responses to such outward challenges. Then the schema for their explanation is *not* a form of 'practical syllogism'.

Let it be granted in some individual case that the answer to the question why *A q*'ed, is that he intended to *p* and thought *q*'ing necessary for this end.

Then we can raise two further questions: Why did *A* intend to *p?* How did he come to think that *q*'ing was required for this? The volitative-cognitive complex which figures in the premises of a practical inference can in its turn be viewed against a broader motivation background, explaining *its* origin, giving *its* causes.

Dray therefore raises a very pertinent question when he asks (p. 486): "How exactly does he [von Wright] envisage intentions and beliefs being changed through historical process?" and he is right when, after having found no satisfactory answer to this question in *E&U,* he concludes that there is "a serious gap in von Wright's whole account of historical process." Dray feels (p. 487) that there is "a missing sense of 'cause' " in my account.

I get the impression that Dray himself does not regard it as excluded that the "missing sense" is, in fact, the *nomic* sense of 'cause'. (But I may not have fully understood his position here.) He notes (p. 487) that if intentions and beliefs have nomically sufficient conditions and if every action has an intentionalist explanation, then I am committed to historical determinism. So, if I wish effectively to deny determinism in history I must show "that intentions cannot be nomically caused, and need not be teleologically explicable". On this he is no doubt right.

The question of why a person has a certain intention and belief can often be answered. As I have tried to show in a latter publication (B280), intentions flow from two main sources. One is, so to say, internal and consists in a person's likings (preferences) and wants. The other could be called external and consists in the demands which a person's social position and roles impose on his actions. A man's beliefs and other epistemic attitudes again are implanted in him through a process of education and learning; sometimes they are also the products or his personal experiences or fancies. I see no ground for thinking that the answers to 'why'-questions about intentions and beliefs point to nomic causes or connections.

It is far from always natural to call the factors which form a man's intentions and beliefs 'causes'. Usually the most fitting term for them is 'reasons'. But sometimes neither term seems appropriate. 'Why did you choose the sherry and not the port?' 'Because I like sherry better.' Is my liking a cause or a reason for my choice? I think we should say neither. It is also good to remember that not all such 'why'-questions *have* an answer—and that the chain of successive 'Why?'s has an end beyond which the question simply makes no sense.

Many critics would probably label my approach to the problems of historical explanation 'methodological individualism'. It is certainly true that a worked out theory of collective action and of collective phenomena (forces, movements) has been missing from my contributions to the philosophy of history and society. No one can be more acutely aware of this lacuna than I. It is

also true that I have tended to approach the problems of group phenomena from the platform of the actions of individuals. The individualistic approach has something soberly rational about it which contrasts favourably with the mystification often found with various brands of 'methodological collectivism'. But it does not follow from this that a demystification of the working of collective forces in history must consist in their reduction to actions and motivations of single agents.

Dray's account of my 'individualistic' methodology and his assessment of its difficulties (pp. 479–480) is correct and fair. I am not sure, however, that his own suggestions for overcoming the difficulties will take us very far in a new and more fruitful direction.

He is probably right when he says (p. 479) that "the logic of the ordinary concept of action" also incorporates *unintended* consequences of what an agent did. If by ventilating (cooling) a room I unintentionally cause the death of a caged bird, *I* can be said to have *killed* the bird—particularly if I *can be expected to have known* that it was dangerous to expose the bird to cool air. Such observations broaden the range of relevance of individual actions. But I do not think they pave the way to a better understanding of the notion of collective action.

More helpful seem to me Dray's observations (p. 479f.) on the way in which the actions of different agents may be linked to the same "prime mover" of a motivational mechanism. An example would be when an army is set in motion by a general's order. But this too is still a far cry from a full understanding of what makes the 'sum' of a number of similar individual actions *one* collective action.

It seems to me, moreover, that it is *not,* in the first place, a theory of 'collective action' that is required in order to overcome the limitations of an individualist methodology. What is required is rather a theory of how customs, practices, and rules, institutions, offices, and roles influence and regulate the actions of individuals in a community. Action which takes place under the guiding influence of such factors as those mentioned can, in a broad sense, be called 'social action', and the influencing factors themselves 'social determinants' of action. Social action is a broader concept under which fall both collective and individual actions.

Social action is basically intentional—even though unintended consequences may be related to or even subsumed under it. But social action is far from always teleologically motivated, i.e., undertaken with a view to attaining a certain end or objective. Therefore 'practical syllogisms' and other teleological explanation patterns are of only limited relevance for understanding it.

The social determinants of action are themselves 'man-made'. Sometimes they have resulted from actions of outstanding individuals, such as a wise lawgiver or a revolutionary hero. The way in which such determinants influ-

ence life in a community is very unlike the working of 'blind' forces in nature. The limitations which they impose on human freedom are not an unchanging nomic necessity but an order which changes with the historic process. In order to understand this change, however, a much more profound theory of historical explanation is needed than any which I have been able to construct.

Tranøy on Humanism

The essay by Knut Erik Tranøy centers on a topic which has preoccupied me throughout my mature life and is central to my 'intellectual autobiography'. One could call it the problem of humanism. Unlike most topics discussed in the present volume, this problem is not one which can be stated and solved by discursive argumentation. It is 'existential', consisting in a search for an attitude to life and to one's fellow humans.

As could be expected, Tranøy deals with the theme with delicacy and understanding. He reads perhaps a little too much consistency into my development. In *IA* I tentatively distinguished four periods in my search for a humanist attitude: the aesthetic humanism of my early years, the ethical humanism of the late 1940s and the 1950s, the rationalist period of the mid-1960s, and the final orientation towards a social humanism. In the rationalist phase I entertained the vision of an 'exact science of man' which was to be an extension and supplementation of an already existing 'exact science of nature'. This vision was inspired by new conceptual tools for dealing with problems in the life sciences and social study (cybernetics, game theory, operation analysis, systems theory, etc.). But I think that I wrongly interpreted these trends in modern science when I said that "the sharp contrast between man and nature, living and lifeless, mind and matter is being eradicated" (B206, quoted by Tranøy on p. 508). Later I came to reject the methodological program for "a unification of the natural, the social, and the human sciences" which then had seemed to me to be the implication of the new developments. I therefore cannot entirely agree with Tranøy when he regards my position in *E&U* as a confirmation of this rationalist unification of science (p. 508). The position in *E&U* is basically a dualism. It is opposed to the methodological and scientistic monism of the positivist inheritance and of other trends which continue in varying forms what I have called the Galilean, as opposed to the Aristotelian, tradition in the philosophy of science.

I may have overstated the dualism. But I stick to my objection against the monistic tendency that it blurs or ignores conceptual features peculiar to humanistic study. Thus, for instance, I see a conceptual confusion in the tendency to assimilate explanation of human action to patterns of causal explanations backed by universal laws. In the intellectual climate of the scientific-technological revolution, this tendency is understandable. I see it, however, as something

distorting and even dangerous. It provides a quasi-theoretical justification for dehumanizing manipulations of society by individuals and groups who are in a position to 'engineer' or 'steer' the social process.

The above may help to clarify the relation between my professional work as philosopher and my interest in the 'problem of humanism'. A main objective of Tranøy's essay is to discuss "the interconnections between the two egos" as he calls them. But there is a lot of other, more 'impersonal', stuff in his paper too. I have found Tranøy's comments on my position in the philosophy of history of great interest. The rest of my reply to him I shall devote to this topic.

Tranøy says (p. 498f.) that he finds it difficult to reconcile my interest in Spengler with my position, in *E&U,* on the question of historical explanation. I can see why he should say so. There surely is a contrast between Spengler's speculative and sweeping generalizations and my preoccupation with the details of intentionalist explanation of individual action. But it ought not to be difficult to reconcile other aspects of our respective positions. Spengler's views of the role of causality in history and the contrast which he makes between causality and the form of necessitation he calls 'destiny' I always found both congenial and stimulating. The same is true of Spengler's idea of a 'morphology' of history and his reflexions on historical categories such as the state, the nation, the people, etc. The position outlined in the fourth chapter of *E&U* is, I think, on the whole reconcilable with most of what Spengler as a *philosopher* of history has to say. It is, incidentally, a great pity that the prophet and quasi-historian Spengler has so overshadowed the philosopher Spengler that few people seem aware of the fruitfulness and relevance of his philosophic thoughts.

It should also be mentioned here that a chapter, called 'Causality and Destiny' in my study on Spengler and Toynbee (in B147, 1955) contains *in nuce* the view of historical explanation which many years later I elaborated into a more scholarly form. The moving forces of history, I suggested there, are various motivational mechanisms. The factors at work in these mechanisms are not (Humean) causes, but what I then called cause-like factors such as motives, excuses, intentions, aims, etc.

Tranøy makes two very pertinent criticisms of what I have said on historical explanation. The first is that I have not given any good account of *collective* action. The second concerns what Tranøy himself considers to be a particular form of collective action, viz., counter-finality. I agree that my 'individualistic' theory of action and of historical explanation must be supplemented by a theory of the collective forces at work in history and in the life of societies. Here is indeed a lacuna common to all 'analytic philosophies of history' known to me. I tried to say something about this in my reply above to Dray. In what follows I shall only add a few words about the phenomenon of counter-finality which, Tranøy says (p. 499), "was first brought to our attention by Hegel and Marx".

A chain of events is counter-finalistic when ''as a consequence of the delib-
erate action of several individual agents to bring about an outcome, *a,* their
actions necessarily produce another outcome, *b,* which entails non-*a* or which
makes *a* impossible'' (p. 499f.).

One could perhaps paraphrase Tranøy's characterization as follows: An ac-
tivity in which an agent engages in pursuit of some end of his is counter-
finalistic if and only if the practicing of this same (or a similar) activity in
pursuit of the same (or a similar) end by several agents individually has as a
consequence that the end becomes more difficult or even impossible to attain
for each of the agents. The activity could, for example, be some method of
cultivating the soil, the end the maintenance of a certain standard of living,
and the counter-finalistic consequence erosion of the landscape or exsiccation
of the soil. The Sahara example, mentioned by Tranøy (p. 499) fits this de-
scription well.

On the above characterization of the phenomenon, counter-finality is typi-
cally the result of the actions of *several* agents. But I do not think it right to
say that it is the outcome of collective or social behavior (p. 500). One could
rather call it the very opposite of 'social' action. And precisely for this reason
it is socially important—and immensely interesting to social philosophy. For
inasmuch as counter-finality is undesirable for the individuals who engage in
the activity, it calls for collective, socially organized efforts to correct itself. It
is probably right to say that counter-finality is one of the most basic forces
which necessitate human cooperation, that it is a prime mover of social action.

What is the relevance of this to explanation theory? To explain why some
individuals engaged in an activity which turned out to be counter-finalistic, is
to explain individual action. For this purpose the explanation models which I
have described in *E&U* and elsewhere will, at least often, be adequate. To
explain why an activity had detrimental effects when it was practiced by a
multitude of agents, is normally a matter of genuine (nomic) causal explana-
tion. (It concerns the causes of erosion, for example.) Such effects can be
historically important, either because they drastically alter the living conditions
in an area or because they eventually result in spectacular changes in a social
order. Then their causal explanation is also 'obliquely', relevant to history and
sociology. Of greater relevance, however, are the ways in which counter-final-
ity affects the *motivations* of the individuals concerned: 'We must do something
about it.' Awareness of the necessity of doing new things, if the old ends are
to be secured, may call forth a wide variety of different 'practical conclusions'.
It may call forth purely self-centered, anti-social reactions such as killing one's
rival neighbours or withdrawing to another and happier land. For such reac-
tions, the 'practical syllogism' may suffice as an explanation pattern. Other
reactions, however, result in collective efforts, such as organized migration or
organized work to protect the land against erosion or to build a system of
irrigation. The motivational mechanism through which these efforts are articu-

lated is *not* simply that of the practical syllogism or some other pattern for the explaining of individual action. Its nature remains to be investigated. Here I see one of the major tasks for a philosophy of social action yet to be created.

V. PHILOSOPHICAL LOGIC

As I said in *IA* (p. 26f.), my early work in inductive logic was succeeded by a preoccupation with the idea of logical truth. This kept me busy, broadly speaking, during the years from 1947 to 1952. My interest in modal logic was a by-product, at first regarded by me as something casual, of this preoccupation with truth. Yet modal logic became the foundation and starting point of most of my subsequent work of a formal-logical character. Much of this latter, however, is connected with or integrated in more purely 'philosophical' subject matters: for example, deontic logic with the theory of norms, and prohairetic (preference) logic with the theory of value. My contributions to tense-logic, finally, grew out of interest in action, but later became linked with research on causality and determinism.

Most of what I have written could perhaps be classified as 'philosophical logic'. Here I shall place under this heading only logical truth, entailment, modal logic, the logic of time, deontic logic, preference logic, and counterfactual conditionals. The essays in this volume which deal with philosophical logic, thus restricted, are those by Hintikka, Føllesdal, Geach, Anderson-Belnap, Segerberg, Dalla Chiara, Berg, Alchourrón and Bulygin, Hansson, and Mackie.

Hintikka on Logical Truth and Distributive Normal Forms

I think Hintikka's paper superbly good. It does full justice not only to the work I have done on distributive normal forms and decision problems in quantification theory, but also to the philosophical aims connected with this work, viz., the clarification of the nature of logical truth. The essay makes me feel that the great amount of energy I spent in trying to vindicate the idea of logical truth as tautology was not lost labor, even though my applications of this idea for solving decision problems never yielded essentially novel results (cf. the remarks by Hintikka on p. 525). The idea, as is well known, stems from Wittgenstein's *Tractatus*. Hintikka's term ''the Wittgenstein-von Wright idea of the tautological character of logical truth'' seems to me, therefore, appropriate.

Hintikka was the first to *prove* that every expression in first-order predicate logic has a distributive normal form. He was also the first to investigate in detail the logical features of the constituents in this type of normal form (see his dissertation, *Distributive Normal Forms in the Predicate Calculus*, 1953).

What I had done myself was to have *noted* the possibility of decomposing the formulas into the units I called existence-constituents and to have realized that hereby a possibility was open for extending the *Tractatus* notion of tautology to a new domain, predicate logic or quantification theory.

Hintikka has again taken up research on the distributive normal forms, as have other logicians of a younger generation. In these later developments, which I think may turn out to be fruitful and important, I have no share myself. Towards the end of his paper Hintikka outlines new avenues for this research and assesses its philosophic significance.

To me, the most exciting new prospect which opens up here concerns truth in mathematics (cf. the concluding remarks of Hintikka's essay). My own attitude, when I was working on logical truth, was that there existed, somewhere, a sharp border separating truth in logic from truth in (other parts of) mathematics. I used to think, in other words, that the Wittgensteinian notion of a tautology could not be extended to mathematics proper—for example, not to arithmetical truths. I thought, moreover, that this had something to do with the distinction between the finite and the infinite. (Cf. my remark in *IA,* p. 27 on Hermann Weyl's dictum that mathematics is the logic of the infinite.)

It is a curious fact, however, that in my early book on 'Logical Empiricism' (B28, 1943) I accepted the view that mathematical truths are "tautologous" and also tried to illustrate their tautologicity by using an example from geometry. Hintikka draws attention to this (p. 527f.). The view was in fact current then among logical positivists or empiricists. But the notion of tautology which one had in mind when calling mathematical truths "tautologous" was an imprecise and watered-down extension of the notion in *Tractatus.* The aim of my example from geometry was to show that this extended notion could, in fact, be explicated in terms of the truth-functional notion of tautology. My effort was not successful. It failed, as Hintikka shows (p. 529f.), because I ignored the significance of the auxiliary construction involved in the example. The need for making this construction in the proof of the geometrical theorem, Hintikka convincingly argues, is analogous to the need for introducing auxiliary individuals in order to dispel the 'depth' of existence-constituents in the disjunctive normal forms. And it is precisely this need for auxiliary individuals which makes the logical truth of formulas of first order logic with two or more overlapping quantifiers significantly different from truth-table tautologies (cf. p. 528 of Hintikka's essay).

The analogy between the role of auxiliary constructions in geometry and the role of auxiliary individuals for the purpose of penetrating the depths of existence-constituents thus opens interesting prospects for extending the tautologicity thesis beyond the confines of what is, in a narrower sense, logic. But at the same time it helps us to see why the truths of mathematics, though in a sense 'tautologous', are *not* so in the trivializing sense of ordinary truth-tables.

The above reflections are admittedly a poor reply to Hintikka's brilliant paper. My reason for being brief should be obvious: I have nothing to add to the subject. It is different with Hintikka himself—and a part of what he has to add is embodied or sketched in his comments towards the end of the paper on the general significance of the theory of distributive normal forms to the philosophy of logic and mathematics.

Føllesdal on Modal Logic

Professor Føllesdal's contribution differs in certain respects from the rest. It was written some five or six years later than the other essays in the volume, and follows my research up to the year 1979. But it is at the same time more 'historical' than most of the other articles, reviewing my contributions to modal logic in the broader setting of the development of the whole subject roughly from C. I. Lewis to the time when it was written.

I shall first make some comments on Føllesdal's review of the development of modal logic. He distinguishes four periods. The first covers the entire prehistory, beginning with Aristotle, of the modern history of modal logic. I am sure that one can distinguish quite a few innovative landmarks within this period of 2,300 years. One such landmark is the origination, with Duns Scotus, of the now familiar distinction between the logical and natural modalities. For the purpose of placing my earlier work in modal logic in its proper historical perspective, observations on the 'prehistory' of the subject are not very relevant. But it should be mentioned here that my later work on modality is directly related to stages in the subject's remoter past—with Aristotle, Duns Scotus, and Leibniz. Examples are items 273, 282, 306, and 308 listed in the Bibliography. They are, however, neither mentioned nor discussed in Føllesdal's essay.

The modern history of modal logic is commonly said to begin with C. I. Lewis's theories of strict implication. They can in a certain sense be said to have yielded modal logic as a 'by-product'. Lewis's aim was to create an *alternative* to the formalization of logic inaugurated by Frege and continued by Russell and Whitehead. From about the same time as Lewis's work dates another contribution of a related character. This is Łukasiewicz's (re-)discovery of many-valued logic. It too yielded a modal logic as a 'by-product'. An even more radical and philosophically perhaps more important departure from 'classical' logic was initiated by Brouwer and formalized in Heyting's system of an intuitionistic logic. Although this work did not yield a modal logic in the same direct way as the systems of Lewis and Łukasiewicz, it had obvious affinities with these two systems. These affinities were also duly noted in the *chef d'oeuvre* of this first period in the modern history of modal logic, viz., Lewis and Langford's *Symbolic Logic* which was published in 1932.

The rebirth of modal logic in modern times was something of a miscarriage. The conception of modal logic as an *alternative* to the logic which Frege and Russell had placed on a firm footing is basically a *mis*conception. I also find misleading the label 'non-classical' which is still often used for modal logic and its more recent offshoots such as, for example, deontic, epistemic, or temporal logic.

In order to correct this misconception it is helpful to note that the most convenient way of constructing systems of modal logic is adding to "classical" propositional logic a few extra principles specifically about the modal concepts. This type of *Aufbau* was practiced in my *Essay in Modal Logic (ML)*. It has since become standard. At the time of writing *ML* I did not know that it had been used before by Feys in his paper 'Les logiques nouvelles des modalités' of 1937 and, for a somewhat special purpose, by Gödel in a short paper from 1933. (Cf. 1A, p. 29.)

The conception of modal logic as a superstructure based on the propositional calculus makes modal logic in a certain sense appear *parallel* to the predicate calculus. This parallelism is further underscored by the observation that the modal operators exhibit the same formal patterns of *interdefinability* and *distributivity* as the quantifiers. As Føllesdal rightly points out, it was the observation of these parallelisms and analogies that guided my early approach to the subject of modality.

I may be prejudiced in pronouncing on the modern history of modal logic, but to me it seems that it was the break with the conception of this logic as an alternative to 'classical' logic that really marked the beginning of a new era in the history of the subject—the 'modern' era in relation to which the era of Lewis and Łukasiewicz is still 'prehistory'. Within this modern era I would register some decisive breakthroughs in new directions rather than, as does Føllesdal, successive periods.

One such breakthrough occurred in the late 1940s when Carnap and Ruth Barcan Marcus, independently of one another, inaugurated the combined study of quantifiers and modal operators. (Cf. above p. 540, Føllesdal's third period.) Prefixing modal operators to quantified expressions is unproblematic. Not so the reverse operation of prefixing quantifiers to 'modalized' expressions. 'Quantification into modal contexts' became a topic of lively controversy but also of fruitful research in the 1950s and 1960s. Quine played the role of critic and skeptic. Among those who contributed importantly to making the topic respectable were Føllesdal himself, Hintikka, and David Kaplan.

To this chapter in the history of 'modern' modal logic I have contributed but little. Perhaps I should mention the following, thus supplementing Føllesdal's account of my work. In *ML* I made an effort to revive the mediaeval distinction between modalities *de dicto* and *de re*. The combination of quantifiers and *de re* modalities is quantification into modal contexts. I was aware of

problems in this area and suggested the adoption of a principle which might simplify the problem nexus. I coined for it the term 'principle of predication' (see *ML,* p. 27). It can be stated as follows. Given a property and a corresponding domain of individuals, this property either contingently belongs or does not belong to any of the individuals *or* it necessarily belongs to some and impossibly to the rest of the individuals. Later, in the 1970s, this principle became an object of investigation by others.[1] Even if certain claims which I made for it cannot be satisfied, the principle seems to me interesting. It has so far, in my opinion, defied successful formalization. Its philosophic significance still remains to be assessed.

As a second major novelty in modern modal logic I would regard the origination of what may be called a *general theory* of modality, comprising not only the traditional 'alethic' modalities but also a number of related concept families, nowadays known as deontic, doxastic, epistemic, temporal, etc., modalities. The reasons for calling all these families of concepts 'modal' are certain (more or less) pervading formal analogies in patterns of interdefinability and distributivity. If due attention had not been paid to these analogies it is doubtful whether, say, deontic or epistemic logic would have been developed much beyond the rudiments which one can in retrospect discover for them in earlier, partly mediaeval, sources. I hope I am not overly egocentric if I claim that *ML* was a pioneer for the development of these off-shoots of traditional modal logic. (A second big push in a parallel direction came a few years later with Prior's rediscovery of tense-logic or temporal logic.)

As inventor of the term 'alethic' for one of the branches of (general) modal logic, I may be allowed the following remark. By alethic modalities I meant modes of *truth* (necessary truth, contingent truth, etc.), as distinct from the epistemic modes of *knowledge* and the deontic modes of *obligation.* In *ML* I said (p. 18), somewhat sloppily, that the alethic modalities "covered the ground" of *logical* necessity and possibility. But I did not wish to say that the alethic modalities are the same as what are commonly called the logical modalities. Føllesdal seems willing to identify them (p. 543), and I am afraid that this identification has become current. However, I count as 'alethic' also the *physical* (causal, natural) modalities. This must be kept in mind in order to understand why I have repeatedly been anxious to say that there is not *one* correct or true system of (alethic) modal logic, but several systems. There are good reasons for thinking that logical and causal modalities have different logics—and perhaps also for thinking that there are several systems of physical modality. To see whether this is the case or not, one must look for *interpreta-*

[1]Cf. the paper by Th. J. McKay, 'Essentialism in Quantified Modal Logic', *Journal of Philosophical Logic 4,* 1975.

tions of the formalisms of modal logic, i.e., one must supplement the syntax of the calculus with considerations of a semantic nature.

I would regard the creation of a modal semantics as the third major novelty in the modern history of modal logic. The year of the breakthrough is 1957, when Hintikka and Kanger laid the foundations of what has become known as 'possible worlds semantics'. Kripke independently entered the stage a few years later. As observed by Føllesdal (p. 540) semantic considerations of modal logic are already found in Carnap's *Meaning and Necessity* of 1947. Another pioneer who ought not to be forgotten is Oskar Becker. In his *Untersuchungen über den Modalkalkül* (1952), Becker proposed what he called a "statistical interpretation" of modal logic. The term does not seem to me well chosen. Its meaning with Becker, moreover, is somewhat obscure and ambiguous. A proposition, Becker says, is necessary if it is true in all 'cases', possible if true in some 'case', and impossible if true in no 'case'. That a proposition is true in all 'cases' *(Fälle)* can mean *either* that a corresponding propositional function is satisfied by all values of the variable *or* that the proposition holds good in all possible descriptions of the total state of the world, i.e., is true in all possible worlds. (Becker himself makes extensive use of the term 'possible world'.) Under the first alternative we obtain a reductivist interpretation of modality, exemplified by what Prior called "Diodorean modalities" or by Russell's interpretation of the modal notions in *The Principles of Mathematics*. Under the second alternative we obtain a nonreductivist interpretation of the type familiar from possible worlds semantics. As mentioned by Føllesdal on p. 549, Becker also applies his interpretation to iterated modalities. I view as the essentially new thing in the works of Hintikka, Kanger, and Kripke the introduction of a relation of *alternativeness* between possible worlds and differentiating between the modal systems on the basis of formal conditions imposed on this relation.

In *ML* no semantics for the *modal* notions is contemplated. Yet it does not seem to me entirely right to characterize my approach as "syntactic" as opposed to "semantic".

The motive force behind my research on the predicate calculus had been interest in the notion of logical truth. I wanted to show that the idea of logical truth as tautology could be transferred from propositional logic to the logic of properties and relations with quantifiers. It was crucial for the success of these efforts that expressions in the predicate calculus have a distributive normal form in terms of the units I called existence-constituents.

The notion of a normal form is syntactic. The notion of tautology, however, is semantic. Tautologicity reveals itself in a truth-table. A truth-table is a *model* of a sentence in a calculus. For the construction of the model two 'semantic' principles or rules are needed. The first says that any proposition has one of

two truth-values, is true or false. The second says that no proposition has both truth-values, is true as well as false. In B92 I called the first the Principle of Excluded Middle and the second the Principle of Contradiction. They must not be confused with the formulas $p \lor \sim p$ and $\sim(p \& \sim p)$ respectively—since they are presupposed in the construction of the truth-tables in which the tautologous character of these two formulas is exhibited (proved).

The fact that a disjunctive normal form can also be used for showing the tautologous character of a formula is *secondary* to the use of a truth-table in the following sense: There is a one-to-one correspondence between the (consistent) conjunctions in the normal form and the possible distributions of truth-values in the truth-table over the (non-negated) conjuncts in the conjunctions. But this correspondence *depends* on the above two principles (and maybe others in addition) about the assignment of truth-values. It is therefore not entirely correct when Føllesdal (p. 546) says that "von Wright's definition of logical truth is syntactical" or speaks about (p. 546) my "definition of logical truth in terms of distributive normal forms". But I admit that I did not always express myself with sufficient clarity when speaking about the relation between normal forms and tautologies in modal logic. This may be connected with the fact that my shift in interest from the predicate calculus to modal logic was not in the first place prompted by an interest in logical truth (in modal logic) but by the observation of certain analogies in the syntactic *Aufbau* of the two branches of logic. Methods previously used in predicate logic could be transferred to the until then relatively little-explored realm of modality. This meant that normal forms and truth-table techniques could also be used in modal logic for investigating whether formulas express logical truths. Some combinations of truth-values, however, had to be excluded as not being logically possible. Which ones these were, were laid down in certain principles of a semantic character, like the *ab esse ad posse* principle or the reduction principles characteristic of Lewis's S4 and S5. In the syntax these principles are reflected in certain modal formulas—just as the Principle of Excluded Middle is reflected in the formula $p \lor \sim p$ of propositional logic.

The use of truth-tables as a decision method in modal logic becomes very clumsy and complicated as soon as iteration of modal operators is allowed. When this had become fully clear to me—in the course of writing *ML*—my interest in modal logic soon shifted focus and became a search for models or interpretations of the modal notions themselves.

After my research in the period 1947–1952 and the publication of Hintikka's thesis in 1953 (cf. above p. 27) interest in distributive normal forms seems to have laid dormant for some ten to fifteen years. But lately it has come to life again. Hintikka himself has made interesting use of normal forms in confirmation and (semantic) information theory and elsewhere. Later, normal-form techniques have been used by Kit Fine and others for proving important meta-

theorems on modal systems. Føllesdal neatly sketches these developments in his essay (pp. 539–556). I have had no direct share in them myself. But I find it gratifying to think that the spark for these further developments ultimately comes from an idea underlying my early research on logical truth, quantifiers, and modality.

C. I. Lewis had enriched the formal study of modality with a plurality of alethic modal logics. Which system, if any, could claim to be *the* 'correct' logic of the notions of necessity and possibility? The most conspicuous differences between the systems lay in assumptions about the logical behavior of iterated modalities. Since iterated modalities do not have a settled use in ordinary discourse, linguistic intuitions are no safe guide to answering questions of correctness here. The appeal which I made in *ML* to epistemic analogies is, I think, worthless when we consider the alethic modalities. (Cf. Føllesdal, p. 548). More promising is perhaps the attempt which I made in the paper 'Interpretations of Modal Logic' (1953) to relate the notions of possibility and necessity to causal properties of natural phenomena. This enabled me to construct various geometrical and topological models which illustrate, for example, the difference of processes of S4-like and S5-like causal efficacy. This is not uninteresting. It shows how wide is the scope of phenomena, the structural patterns of which mirror a modal logic. But I think Alan Anderson was right when he doubted (cf. above p. 547) whether such interpretations of modal logic really illuminate the nature of either the physical or the logical modalities.

I do not think that the fact that "different natural phenomena exemplify different modal systems" (Føllesdal, p. 548 above) has anything to do with the distinction which I made between *diachronic* and *synchronic* modalities. This distinction is based on the fact that attributions of modal status to propositions are often tensed and that they may *change* with time. Something which is now possible for the future may be impossible later on, etc. I think that the study of tensed modalities is important to the philosophy and logic of the concepts of causation and determinism, and it may also turn out to be relevant to the distinction between logical and physical modalities.

I doubt the success of any attempt to define modal notions—whether 'logical' or 'physical'—in nonmodal terms. Thus, for example, an attempt to identify logical necessity with tautological truth would not do for the simple reason that the notion of logical possibility is *involved* in the notion of tautology. (A molecular proposition is tautologous if it is true under all *possible* combinations of truth-values in its constituents.) Therefore I also distrust provability interpretations of modal logic if they go with a claim that by logical necessity we *mean* provability. (Cf. Føllesdal, pp. 549ff.) Of interest, however, is the fact that one can give different interpretations of necessity in terms of provability which mirror different systems of alethic modal logic.

I shall conclude with the following remark. It is at least plausible to think

GEORG HENRIK VON WRIGHT

that it cannot be a matter of *contingent* fact whether a proposition is *logically* necessary, possible, contingent, or impossible. The proposition that a certain proposition is logically necessary (possible, etc.) is itself either necessarily true or necessarily false (impossible). This being granted, it is easy to show by strict formal argument that the logic of the logical modalities is (at least as strong as) S5. This may seem satisfying in view of the great perspicuity and simplicity of this particular modal system. But I doubt whether there is any argument which would *prove* that modal status is not logically contingent. To think that modal status is a matter of necessity is more like taking a basic point of view which cannot be further grounded or justified.

Geach on Modal Syllogisms

Professor Geach's elegant paper finally solves a problem which for a long time kept both of us busy. This is the problem of how to find an effective test for the validity of any modal syllogism of the *de dicto* type. Here I can do little more than congratulate Geach on the solution and add a few historical remarks about our struggles with the problem. These struggles are but a small chapter in the long and confused history of modal syllogistics. Unlike most chapters in this history, however, it has a happy ending.

In an appendix to my *Essay in Modal Logic* (*ML*) I claimed to have solved the problem. My delineation of the class of relevant formulas was essentially the same as the one given by Geach in the paper under discussion. But my conception of the plain or 'existential' syllogism was a little different from his. I counted with only 15 valid forms as against Geach's twenty-four. This, however, is a point of minor significance. The total number of possible modal syllogisms was the same on my determination as on his, viz., 6656 (cf. above p. 564 and *ML*, p. 80). The decision or test method which I proposed was a further developed form of the diagrams invented by Charles Dodgson, alias Lewis Carroll, for testing the validity of the existential syllogisms.

Unfortunately, however, my solution was defective. It was defective, for one thing, because the rules for constructing diagrams which are given in *ML* and which are essentially the same as the rules 1–7 of Geach's paper do not suffice for representing all the possible cases which arise. They cannot portray the necessary existence nor the possible nonexistence of a property, the representation of which in the diagram is a subdivided area. This insufficiency, however, can easily be remedied by placing a mark on the dividing line, or 'fence', separating the subdivisions. The needed method of representation is provided by Geach's rules 8–10.

The above deficiency of the diagrams in *ML* was pointed out to me by Geach shortly after the appearance of the book. As far as we can remember, it was he and not I who some time later discovered the device of placing marks

on the fence. For this reason alone I think it is too generous of Geach and not quite accurate to call the diagrams Von Wright Diagrams.

The proof that no modalized form of an *invalid* existential syllogism is valid is entirely due to Geach. The crux of the proof was to show that, if the conjunction of the premises and the conclusion of a (possible) existential syllogism is consistent, then the *strongest* modalization of it is also consistent. This can be shown by means of the improved diagrams. The result then holds a fortiori for all weaker modalizations.

The problem which remains is to find the valid modalizations of *valid* existential syllogisms. A partial solution is easily obtained without appeal to diagrams. But for a total solution even the improved diagrams turn out to be insufficient. This is so because they cannot picture the compossibility of the joint nonexistence of the properties represented by two adjacent areas in the diagram and the nonexistence of the property represented by a third area, nor can they picture the necessary alternative between the existence of the property represented by one area in the diagram and the nonexistence of the property represented by another area.

The most difficult and laborious part of the entire task of finding a decision method for the modal syllogisms *de dicto* was to overcome this second deficiency of my originally proposed solution. Professor Geach accomplished the task by proving that the insoluble representation problem can be reduced to a set of cases for which the problem *can* be solved by means of diagrams. *Finis coronat opus!*

Beside the modal syllogisms *de dicto* there are those *de re*. The second are even more tricky than the first. The very notion of *de re* modalities is problematic. The difficulties here are connected with well-known and much-discussed problems about 'quantification into intensional contexts'.

In *ML* I took a sceptical view of the autonomy of *alethic* modalities *de re*. I inclined to the opinion that they were reducible to alethic modalities *de dicto*. But I admitted, as we surely do, that there exists a genuine and independent use *de re* of the *dynamic* and of the *epistemic* modalities. Even if one does not acknowledge the independent status of alethic modalities *de re*, one can therefore construe an epistemic analogue to the entire traditional modal syllogistics such that the distinction between the cases *de dicto* and *de re* remains clear. An epistemic syllogism *de re* would be, for example: All S are known to be P; no P is known to be R; *ergo* no S is known to be R. It is evident that 'all S are known to be P' is not reducible to 'it is known that all S are P.' But it is not clear whether 'all S are necessarily P' differs in meaning from "it is necessary that all S are P.'

A further problem is to give a general characterization of the *form* of modal syllogisms *de re*, i.e., to characterize the class of formulas which represent

possible premisses and conclusions of such syllogisms. The problem, evidently, has no unique solution. It can be solved in alternative ways. For each alternative solution, the questions of determining the valid syllogisms is different. The diagrams, moreover, would have to be much more complicated than for the syllogisms *de dicto*. For they ought to picture not only a class of things with a given property, but also the broader class of things which have this property possibly and the narrower class of things which have it necessarily.

In 1952 Geach gave a simple characterization of modal syllogisms *de re*, for which the corresponding diagrams have sixty-four subdivisions—against the eight subdivisions for the case *de dicto*. There was a time when I thought that I had in my hands a solution to the decision problem for the syllogisms under Geach's characterization. But I was never patient enough to work out the details. Probably I should have come up against difficulties similar to those which Geach encountered in his work on the syllogisms *de dicto*. But I would conjecture that all such difficulties can be happily overcome and that diagrammatic methods can also be provided for dealing systematically with modal syllogisms *de re*. I hope someone will some day clear up this annoyingly obscure corner of traditional logic *completely*.

Anderson and Belnap on Entailment

Alan Anderson's premature death in 1974 was a heavy loss to contemporary philosophical logic. His fatal illness also prevented him from completing his essay for the present volume. In the shape he gave to it, the essay admirably succeeds in setting in its proper historical perspective a problem which had engaged both of us. With the additional comments, skillfully added by Nuel Belnap, the essay also locates my stand on the problem in relation to the very much more elaborated theory in the two authors' book *Entailment* (Vol. I, Princeton University Press, 1975). It is sad to think that Alan Anderson did not live to see this monumental work published.

A few words about our personal relations may be in place here. I first met Alan Anderson early in 1951. He had come to Cambridge as a Research Student for the degree of Master of Arts. He was working on the problem of counterfactual conditionals, with Broad as his supervisor. After a short time he became my supervisee. Modal logic was then my main research occupation. Alan caught my enthusiasm for this new subject, and we agreed that he should write his thesis on the decision problem of Lewis's system S3. While struggling with this problem, he was at the same time a forceful critic of the work which I was doing. The critical spirit of our conversations is reflected in the review which he wrote for the *Journal of Symbolic Logic* of my *Essay (ML)*.

When at Cambridge, Alan also became interested in deontic logic, which was then in the process of being born (see *IA*, p. 28). A few years later he

made a most important contribution to that subject. When I saw him at Yale in 1958 we discussed intensely his "reduction of deontic logic to alethic modal logic". It set a main theme for subsequent developments in the logical study of norms. At the time, however, it left me cool. But some ten years later my thinking took a turn which led me, if not to an identical, at least to a closely related position. It was therefore most gratifying to me that Alan acted as commentator when I presented my "realistic ontology" of norms at a colloquium on philosophical logic in London, Ontario in the Autumn of 1967. (B221 with Comments by A. R. Anderson.)

It is possible, though I cannot recall it distinctly, that we also discussed the problematics of entailment in those early years at Cambridge. In any case our interest in it arose at roughly the same time. But whereas my engagement with the problem was of comparatively short duration, entailment became *the* great thing in Alan's philosophical life. His and Belnap's efforts matured and broadened into a new field of logical study: relevance logic, which is attracting growing attention. Alan's generous words at the end of his comments on my London paper apply to his own achievement. He was one of those lucky philosophers who "have the good sense to dream up a new and interesting discipline".

My contributions to the problem of entailment are embodied in one single essay, included in the collection *Logical Studies* (B153, 1957), and a brief polemical note (B170, 1959). The starting point of my investigations had been dissatisfaction with Russell's and Lewis's accounts of 'implication' and a conviction that entailment is what I called *essentially relative* (p. 0452; cf. also B153, p. 175). Whether a first proposition entails a second never depends on the truth-value or the modal status or any other logical feature of the one or the other of the two propositions considered *by themselves*. Anderson generously acknowledges (p. 27) that this "idea is the direct ancestor of the fundamental notion of Anderson and Belnap," viz., the notion of *relevance*. I am happy to recognize "the legitimacy of the offspring" (ibid).

Given the above starting point, the problem was: Wherein does the 'essential relativity' of the entailment consist? To this question I proposed an answer which can be condensed in the following form: The relational character of entailment lies in the possibility of proving (the truth of) a material implication independently of disproving its antecedent and of proving its consequent. This means that my theory of entailment is closely linked with the notion of demonstrability (provability).

Demonstrability is a compound idea. It has a modal component, possibility, and a second component relating to the activity of proving. (Demonstrable = *possible* to *prove*.) Proving again is a way of *coming to know truth*. Demonstrability, it would seem, is therefore a notion with an epistemic tinge.

In my essay I, accordingly, took the view that entailment, in addition to

being 'essentially relative', is also 'essentially epistemic'. This view was accepted and defended by Peter Geach. It is sometimes referred to as the Geach-von Wright theory of entailment.

In the section of Anderson's paper written by Belnap it is said (p. 598) that the suggestion of linking entailment with verification "has not been much pursued by later researchers". Two reasons are given as to why this is so. One is that "there has come no clear way of getting a grip on the required epistemological concepts" (p. 598). The second is that my approach has been superceded by the Anderson-Belnap one which gives an account of entailment "completely free of epistemological overtones" (p. 598).

What then is my present position on the issue? One thing which I can say is that it is not a *settled* position. I am not convinced that entailment is linked with demonstrability in the way I originally thought and hence that it is "epistemically tinged". But I am not convinced of the opposite either. I am, in fact, not sure that the Anderson-Belnap theory is as free of "epistemic overtones" as its authors seem to think. In their theory entailment is a *Grundbegriff* to be characterized by means of formal principles. Let it be granted that the theory captures all the logical laws of entailment which are agreeable to our intuitions and contains no counterintuitive results. Even then residual questions would remain. Which role does entailment play in logical thinking? What *is* it for a proposition to entail another proposition? In order to answer such questions we must certainly speak about *truth* and, possibly, about *proof*. If the latter, then there is, after all, an epistemic component in entailment.

As I saw things then, the problem of entailment had to be solved by giving an account of the notion of *independent provability*. Strawson claimed that one can establish the truth of material implications which satisfy my requirements of independent provability but which do not agree with our intuitive notions about entailment. In B170 I tried to answer Strawson. I still think my answer satisfactory, but others may disagree. What is certain, however, is that Belnap's argument against my argument against Strawson rests on misunderstanding. Belnap says (p. 598) that it follows from my position that "*any* formula containing $\sim q$ would contain the seeds of $q \lor \sim q$ in its tables, since evidently both q and $\sim q$ must occur as column headings". To this I can only answer: Indeed it would. But what is bad about that? Let us agree, e.g., that $\sim q \rightarrow \sim q$ is a genuine entailment. A truth-table proof of this tautology is also a truth-table proof of the tautology $q \lor \sim q$. This does not mean, however, that the truth of genuine entailment relations containing $\sim q$ could not be established independently of disproving their antecedents or of proving their consequents. But even though Belnap must have misunderstood me here, I have to concede to his general criticism that I have failed to suggest any "clear way of getting a grip on the required epistemological concepts." To make it more specific: I cannot claim to have given a satisfying general characterization of the idea of *independent provability*.

In the 1960s, I returned from time to time to the question of what can be meant by calling the demonstration of a formula independent of proving or refuting another formula. The problem turned out to be very tricky.[1] Not only did I fail to solve it to my own satisfaction. I even came to have doubts about the possibility of giving a *general* account of the notion of independent provability. Therewith I also came to doubt the value of the Geach-von Wright theory of entailment. But I am not prepared to admit that this theory has, as yet, been refuted. The Anderson-Belnap theory need not necessarily be considered a rival to it. Maybe the logic of relevance will one day be able to solve my problem about demonstrability. If that were to happen, I should regard it as a confirmation of Belnap's suggestion that my "notion that there is something essentially epistemological about entailment . . . may yet prove fruitful"(p. 599).

Segerberg on Tense-Logic

Professor Segerberg's essay starts with a personal note and I shall begin my reply in a similar manner.

My earliest contribution to tense-logic—not counting the groping efforts to build a Logic of Change in *Norm and Action*—was the treatment of the connective 'and next' (B201, 1965). To it Segerberg reacted with a paper called 'On the logic of 'to-morrow' ' (*Theoria* 33, 1967). In it he showed that my problem could be treated much more elegantly if one used a monadic operator instead of my binary connective, the asymmetric conjunction 'and next'. Segerberg is a bit too generous in the present essay (p. 604) when he credits me with a solution to the completeness problem of the calculus in question. The 1965 paper gave at most a *sketch* of a solution.

Segerberg says (p. 609) that "it would be interesting to know" why I was attracted by the binary connective and why I have "continued to favor it". The answer to the first question is easy. I came to tense-logic from a study primarily, not of *time*, but of *change*. Change is *from* something (a state) *to* something (another state). Hence it is typically a *binary* operation, to be described by means of connectives such as 'and next' and 'and then'. In reply to the second question I can only say that it is true that for a number of years I worked with binary connectives in tense-logic, but that later I abandoned them in favour of monadic operators.

My second contribution to tense-logic was the paper ' "And Then" '

[1] In my struggles with the problem I made use of ideas originally suggested by Timothy Smiley in his paper 'Entailment and Deducibility', *Proceedings of the Aristotelian Society* 59 (1959). But Smiley's suggestions, although helpful, were not sufficient for my purposes. So, if one speaks with Anderson and Belnap about the "von Wright–Geach–Smiley substitutional criterion", one should remember that no quite satisfactory formulation of the criterion has as yet been given. This remark should answer Belnap's question to me on p. 598.

(B208, 1966), and the third the paper ' "Always" ' (B223, 1968). The main content of the three early contributions is summarized in my Eddington Memorial Lecture (B229, 1969). This also contains the seeds of a new venture in tense-logic which I conceived of as a logical theory of temporal *division* and contrasted with the theory of temporal *succession*, aspects of which had been the subject matter of my early papers. (Cf. below, my reply to Dalla Chiara, pp. 862ff.)

When I published ' "Always" ', I sent an offprint of the essay to Segerberg with a letter urging him to prove that the combined calculus of the tense-logical operators 'and next' and 'always' was decidable and semantically complete. Segerberg's essay for the present volume can be regarded as his reply to that letter. He solves a problem which is, if not identical with, at least closely related to the one which I had posed. The solution, however, is found by the use of rather different methods from mine.

In view of a certain discrepancy between my questions and Segerberg's answers it may be worthwhile to restate here the program which I had set for myself in the paper ' "Always" '.

Every formula involving only the connective 'and next' (or Segerberg's operator "to-morrow") may be said to 'stretch' over a *finite* succession of moments in time. For such formulas one can define a notion of *logical truth* in strict analogy with the notion of a truth-functional *tautology*. I called it a 'history-tautology'.

Every formula with the operator 'always' again stretches over a potentially infinite succession of moments. For any such formula one can construct a *model* in finite time. The idea is simple: we replace the occurrence of 'always' by as many repetitions of 'and next' as are required to cover a given finite succession of moments. In practice this is sometimes complicated by the fact that both operators ('always' and 'and next') occur within the scope of each other. Also, there is a minimum number m of moments required for the construction of a model. The model answering to the minimum number I called a *minimal model*. The model in a succession of k moments, when $k>m$, we can call a k-model or a k-reduced counterpart (p. 621) of the given formula.

Since any k-model formula involves only the connective 'and next', it is logically true if, and only if, it is a history-tautology. And whether it is this or not can always be decided. My idea now was that any given formula involving 'always' is a logical truth if, and only if, its k-model is a history-tautology for every value of k. Accepting this as a truth-criterion, one would then be able to prove that a given formula is logically true by showing:

(i) that its minimal model is a history-tautology and

(ii) that *if* for some arbitrary k its k-model is a history-tautology, then its $k + 1$-model is a history-tautology too.

In the paper, moreover, I proposed a set of twelve formulas of which I said that it *might* constitute a complete axiom system for the combined calculus. (This is the "conjectured axiomatization" referred to by Segerberg on p. 610.) Four of the twelve formulas involve only the connective 'and next' and five only the operator 'always'; three are 'combined' formulas. Using the machinery of model construction, I proved by induction that all models of the five formulas containing 'always', and all models of the three formulas containing both 'and next' and 'always' are history-tautologies. As far as I can see, these proofs are in order. Two questions remained open, however: Could a method be given for deciding whether an arbitrary formula is inductively provable? Could an inductive proof be given of every formula which satisfies the proposed criterion of logical truth, viz., that it is a tautology in all finite successions of moments?

These were the questions I put to Segerberg. In a sense he answered neither of them. What he has done is, in the first place, something rather different. He has given a decidability and completeness proof for the combined calculus W1 which has as its axiomatic basis (the tautologies of propositional logic and) the twelve formulas to which I was referring above. This is an independent achievement of Segerberg's. I can hardly be credited with even having correctly posed the problem for him.

But, as indicated, my two questions remain unanswered. *Perhaps* they have an affirmative answer. This, however, would hardly be of much interest. For in the very conception underlying the questions there is a serious error concealed. A conversation which I had with Segerberg when he was working on his essay made me realize this.

Consider the two formulas $\bigvee\bigwedge p$ and $\bigwedge\bigvee p$. The first says that it will sometimes be the case that it will always be the case that p. The second says that it will always be the case that it will sometimes be the case that p. Obviously, the first formula entails the second, but not vice versa. The minimal model of the formula $\bigwedge\bigvee p \rightarrow \bigvee\bigwedge p$, however, is a history-tautology. It is easy to prove by induction that every k-model of it is also tautological. In finite time, the antecedent formula and the consequent formula are indeed equivalent: if the one is true, the other is true, and vice versa. Only in a model involving an infinity of successive moments of time could the nonequivalence of the two formulas be displayed.

From these observations it follows that tautologicity in all finite segments of time is only a necessary, but *not* a sufficient, condition of logical truth for

tense-logical formulas of the kind I had studied. Not to have realized this was a serious error of mine.

Histories, as defined by me, are finite in 'length' and in 'width'. This means that they stretch over a finite number of occasions in time and register only a finite number of states for every occasion. In the concluding section of his essay Segerberg explores an interesting generalization of this notion of a history to worlds of infinite 'width', i.e., to worlds composed of an infinite number of (obtaining or not-obtaining) elementary states of affairs (p, q, \ldots). The resulting system he calls W2. I do not quite see the reasons why Segerberg should say (p. 634) that "philosophers will no doubt regard W2 as a very artificial system". I should have thought that, on the contrary, it represents a desirable and natural extension of the strictly finitary study of worlds and their histories which I have conducted myself from the feeble beginnings in *Norm and Action* to the provisional end station in *Causality and Determinism*.

Dalla Chiara on Time, Change, and Contradiction

It seems to me that one can distinguish two main approaches to a logical study of time. The one takes its point of departure from *instants* (moments, points) in time and studies the relationships between these units. This leads to a logical study of the *Past, Present and Future*, to borrow the title of Arthur Prior's classic work in the field. The basic concepts of this study are the quantifier-like notions of 'always', 'sometimes', and 'never'. Because of the close formal analogy between them and the basic modalities 'necessarily', 'possibly', and 'impossibly', this approach to the logic of time may be regarded as an offshoot of modal logic, much in the same sense as deontic logic.

The other approach starts from '*bits*' of time and proceeds through an analysis of the internal structure of such bits. One could characterize the difference between the two approaches as one between a study of *succession* in time and *division* of time. One could also, with caution, describe the first as a logical study of *time* and the second as a study of *duration*. The second approach is more closely allied than the first to such notions as *becoming, change,* and *process.* The second approach, moreover, has not the same affinity as the first to modal logic.

The distinction between the two approaches may be an oversimplification, but I think it is useful. My own avenue into the logical study of time can be said to illustrate the relativity of this distinction. My interest in the concept of time stemmed from an interest in the concept of change—and what made me study change was my interest in action. Shamefully unaware of what Prior and others had already accomplished, I devised a Logic of Change of my own in *Norm and Action*. This Logic of Change later turned out to be but a tiny frag-

ment of tense-logic in Prior's sense. Thus the road which I had entered was the *first* of the two approaches I distinguished above. This is mildly ironic, for it might have been expected that a logical scrutiny of the concept of change should from the beginning have led me to take the second approach. That this did not happen has its explanation, too. The changes I initially studied could more appropriately be called *events*. Events can be regarded, at least for purposes of a first approximation, as pairs of states of affairs succeeding each other in time. Change in the sense of becoming or of *process* is something different.

Once on the road, I have in the main been pursuing the first of the two approaches—with one sidestep, however, in the other direction. This happened in my Eddington Memorial Lecture on *Time, Change, and Contradiction*. For all I know, I was here breaking new ground. It remains to this day almost unexplored. The only substantial contribution to this line of research of which I am aware is by Dr. Dalla Chiara; first in her paper 'Istanti e individui nelle logiche temporali' in *Rivista di Filosofia* for 1973 and then in her essay for the present volume.

In the intervening years (since 1968) I have done some additional research myself. I have not been able to complete it and it therefore still remains unpublished. It proceeds on lines which are rather different from those in Dalla Chiara's paper. My aim has been to construe a logic for an (enumerable) hierarchy of *state-spaces*. A state-space is a set of (generic) states of affairs, the presence or absence of which prevails during the whole of a given span or stretch of time. A state which is absent or present only during a part of that time belongs to an inferior state-space. The transition from a superior to an inferior state-space in the description of the 'content' of a span of time entails that changes occur within the span in question. The notion of contradiction enters the picture when we raise the question whether all changes within a given span of time can be described in the terms of an appropriate state-space in the hierarchy. Continuous change can*not* be thus described. A continuous change is a move in time from a state to its opposite 'through a contradiction', i.e., through a stage when the state in question is both present and absent. Whether such changes occur 'in nature', or whether continuity is only 'an idealization', was a question left open in my Eddington Lecture.

Dr. Dalla Chiara explores the problem of change using a different method. She reaches definite and valuable results. She also introduces a number of excellent distinctions which I did not make myself, notably the distinction between durable and evanescent truth, and between classical, mutable, and evanescent predicates. She also distinguishes the three alternatives: that a change may involve a contradiction, that all changes involve contradictions, and that everything always changes and involves contradictions. That a change involves a contradiction means, in Dalla Chiara's terminology, *roughly* the same as what I referred to above as change being a *continuous* transition from one state to

the contradictory state. Dr. Dalla Chiara discusses only the first of the three alternatives. This also seems to me to be the most interesting one. For, if a change *may* but *need not* involve contradiction, we leave open the possibility that some changes are *instantaneous* transitions from one state to its contradictory. The concept of instantaneous change is admittedly problematic, but hardly more so than the concept of a continuous change. It is therefore, in the first place, desirable to construct a logic which has room for both types of change. The 'Heraclitean' idea that *everything* constantly changes, passing through contradictions, seems to me to be too flagrantly in conflict with common sense to be worth taking seriously.

What Dr. Dalla Chiara nicely accomplishes in her essay is the construction of a formal semantics for something which could also be called a Logic of Change and Duration allowing for the possibility of contradictions in (small) 'bits' of time. She calls it W-logic, since it is a theory of a particular kind of histories, called W-histories, within a given span of time. The logical truths of this logic are the formulas which are valid in all W-histories. It turns out to be the case that these truths do not constitute a recursively enumerable set and that W-logic therefore cannot be axiomatized.

In the concluding part of her essay Dr. Dalla Chiara discusses possible applications of this type of time-logic to physical theory. I am not competent to judge the fruitfulness of her suggestions, but I find them extremely interesting. It has often been noted by leading physicists of our era that the classical spatio-temporal frame for a description on the macro-level of physical objects and processes becomes inapplicable on the micro-level. In micro-dimensions space and time become 'fuzzy'; the notion of *definiteness* of spatio-temporal position (location) loses its significance. It is therefore only to be expected that the logic(s) needed for a proper account of the spatio-temporal structures of the world of micro-particles should be different from the 'classical' logics of these structures in the macro-world to which our ordinary perceptual apparatus has access.

Dr. Dalla Chiara does not discuss in detail the prospects for a logical study of change and spatio-temporal structures in microphysics. I can only hope that she will herself in future work apply philosophical logic to the study of the basic concepts of physical theory. Her suggestion that the behaviour of virtual particles in microphysics can be described in the terms of evanescent predicates, i.e., continuously changing and in that sense 'contradictory' properties, may offer an excellent point of departure for further logico-philosophical research.

Berg on Deontic Logic

Professor Berg correctly notes (p. 647) that my conception of deontic logic has undergone "a number of changes" (cf. *IA*, p. 34 on a "chameleon of deontic

logic''). He distinguishes four main positions which I have held at one time or another, and these distinctions are well-taken. There is, however, also a fifth position which could be noted. This is the treatment in *Norm and Action* (*N&A*); it employs a symbolism and techniques which I have not used elsewhere. I mention this because it seems to me that the techniques in question are 'philosophically' more sound for developing a logic of *norms* than the axiomatic and syntactic techniques which I have employed in most of my writings. It seems to me now that the axiomatic techniques are appropriate chiefly for building a logic of normative *propositions*. I shall return to this question in my comments on Alchourrón's and Bulygin's paper. (Cf. below pp. 872ff.) In his essay Professor Berg does not discuss problems relating to the distinction between norms and norm-propositions.

Berg develops a logical apparatus of his own for restating some formal aspects of my thoughts. As the reader can easily see, Berg's Q-operator (or Q-predicate) corresponds to the permission operator, usually denoted by 'P', of traditional deontic logic. While I fully appreciate Berg's motives for distinguishing Q from the deontic operators proper, I shall for present purposes employ the traditional symbolism.

Weak and strong permission concepts. Professor Berg divides (p. 651) the dyadic deontic systems into strong and weak ones. He distinguishes them according to the following criterion (retranslated into deontic terminology): In a weak system one can infer a disjunctive permission from the permitted character of any disjunct (principle P2'' on p. 651). In a strong system, again one can from a disjunctive permission infer the permittedness of any disjunct (principle P2' on 651). A corresponding distinction could also have been made for the monadic systems.

The distinction made by Berg is very elegant from the point of view of topologizing systems of deontic logic. It is related to my distinction between *weak* and *strong* permission, introduced for the first time in my paper on negation, B165 (1959). But it must *not* be confused with it. Berg's remark that he has "not been able to locate any clear position on this issue in von Wright's writings" is entirely justified. The matter calls for a comment of some length.

I think it is both possible and important to distinguish between several senses of 'permission'. With caution one can speak of weak and strong permission concepts. It seems, however, that there is no unique and clearcut way of drawing the distinction, but rather that there are several ways and that they partly overlap.

The permission concept(s) embodied in Berg's strong Q-systems is what I have also called *free choice permission*. It is characteristic of a free choice permission that, when its content is disjunctive, i.e., embraces several alternatives, then every disjunct (alternative) is also permitted. The holder of the permission is, in other words, *free to choose* between the various ways in which he may avail himself of the permission.

There is an obvious and good reason for calling a free choice permission *strong*. It is strong in contrast with a permission which is such that, when it covers alternatives, it only allows the permission-holder to avail himself of *at least one* of the alternatives. This contrast answers to the strong-weak distinction among Professor Berg's Q-systems.

A very natural but quite different way of defining the notion of a *weak* permission is to say that it consists in the absence, lack, or nonexistence of a 'corresponding' prohibition. Something is then in the weak sense permitted if, and only if, this thing is not forbidden. It is debatable whether such weak permissions should be called norms at all. To state a weak permission in words is more like stating a (true or false) norm-*proposition* than expressing a norm proper.

A permission which is weak in the sense that it consists in the absence of a prohibition can, however, be strong in the sense that it is a free choice permission. The various types of permission embodied in Berg's Q-systems, or alternatively: in the six deontic logics which I distinguished in my *Essay in Deontic Logic* (B219, 1968, henceforth abbreviated *DL*) are all of them in this sense weak. This is because these logics accept the defining equivalence "$O(-/-)$" $=$ $_{df}$ "$\sim P(\sim-/-)$". (Cf. *DL*, p. 23.) For example: the free choice permission symbolized by $P_4(p/q)$ just *means* that no possible world of which it is true that p is such that *it* is forbidden in every possible world of which it is true that q.

Another, different, idea of a strong permission is obtained by denying the equivalence "$O(-/-)$" $=$ $_{df}$ "$\sim P(\sim-/-)$"—or, in the monadic case, the equivalence "$O-$" $=$ $_{df}$ "$\sim P\sim-$". Then the one deontic operator is no longer definable in terms of the other operator and negation. This leads to systems of deontic logic with two primitives, O and P. A system of this kind was studied in *N&A* and then again in my paper 'Deontic Logic Revisited' (B263, 1973). The system O_1P_2 suggested in *DL* (p. 35f.) also has two primitives, an obligation-operator O_1 and a permission-operator P_2. They are not interdefinable. But the obligation-operator can be defined in the terms of permission (P_1) and negation, and the permission-operator in the terms of obligation (O_2) and negation. In the O_1P_2–system one cannot from the absence of a prohibition conclude the existence of a corresponding permission. This I should regard as a virtue of the system. Yet there is no good reason for calling permission in the O_1P_2–system 'strong' and for saying that it is anything over and above non-prohibition.

On the view, however, which rejects interdefinability, permission is not 'mere' absence of prohibition, but something over and above this. That is a reason for calling the permission concept(s) corresponding to such a view 'strong' permission. But then the question arises: What is the peculiar feature of permissions which is supposed to distinguish them from absence of corre-

sponding prohibitions? Various answers to this question can be suggested. But I am not sure that any answer I have been able to think of myself is entirely satisfying.

At this stage it may be helpful to consider the actions of giving permissions or permitting things to be done. Is the performance of such actions only an oblique way of *stating* that certain prohibitions do not exist? (Cf. above p. 866.) I do not know the right answer to this question either. But one can surely make a distinction between permissions which, so to speak, result from acts of giving permission—either immediately or mediated by some process of logical inference—and permissions which are just there because of the absence of certain prohibitions. One could call the former 'explicit' or 'express' permissions and say that what they permit is explicitly or expressly permitted. Explicit permissions might be counted a form of strong permittedness. One reason for calling an explicit permission 'strong' is that—in any reasonable deontic logic—it entails the absence of a corresponding prohibition, but not vice versa.

Whether explicit permissions should count as norms or as norm-propositions is, as indicated above, another matter. And whether explicit permissions are, or are not, of the free choice type is also another question.

There is a certain temptation to construe every disjunctive explicit permission as a free choice permission—and also a temptation to say that only an explicit permission can be of the free choice type. But must one construe disjunctive explicit permission in this way? I do not know the answer.

When, in N&A, I did not wish to commit myself to the interdefinability of the two deontic operators, the reason was not that I thought that (disjunctive) permissions were necessarily free choice permissions (cf. N&A, pp. 85–87 and 90–92). My reasons had to do with a view of permissions as declarations of toleration.

Such declarations can be regarded either as declarations of *intention* not to interfere with the permission-holder's conduct in a certain respect, or as a sort of *promise* of noninterference. A promise of this kind again might be viewed as a self-prohibition on the part of the permission-giver. In giving a permission he ties his own hands, as it were, restricts his freedom of interference in relation to the permission-holder(s). This view can hardly be denied a certain plausibility. And it offers a new possibility of defining permission in terms of prohibition—not, however, as mere absence of a prohibition, but as a prohibition of a special and, it must be admitted, a somewhat debatable kind.

What has been said above illustrates the complications connected with the concept of permission. It should also make it clear why one cannot divide systems of deontic logic in a clearcut way into systems for strong and for weak permissions respectively. Berg's division is clear-cut. But for this and other reasons it captures only an aspect of the strong-weak distinction in the field of

permissions. This limitation does not exclude it from being in many regards useful, also for purposes not immediately connected with the concept of permission.

The contents of norms—actions or propositions? In my first (1951) contribution to deontic logic, I took the view that the 'things' which are pronounced obligatory, permitted, and forbidden are *actions*. In several later publications I followed those who have treated these 'things' as propositions (possibly, but not necessarily to the effect that certain actions are committed or omitted). In B263 (1973) I returned to my original position. I now think that both positions are defensible and of independent interest. They answer to two different types of deontic logic. The distinction between the types parallels the well-known distinction which some moral philosophers have made between *Tunsollen* and *Seinsollen*, between that which ought to be *done* and that which ought to *be*. In my, so far, latest contribution to the subject, B273 (1974), I have tried to say something about both types of deontic logic.

Do truth-connectives apply to actions? In my 1951 paper I naively answered the question affirmatively. Later I began to feel doubts. I do not think that Berg's treatment will remove "any such doubts", as he himself suggests (p. 653). Conjunction may be regarded as unproblematic. But negation and disjunction are certainly *not* unproblematic here. I would now insist more emphatically than I did before on the fact that the operations used for forming names of compound actions are to some extent analogous, but not identical with either truth-connectives or Boolean operations on classes.

One must distinguish between generic actions or act(ion)-types (theft, murder, etc.,) and individual actions (e.g., the murder of Caesar). Berg says (p. 653) that an action-type may be considered as a *set* of individual actions (action-instances). I am not certain that this is right. What is obvious is only that individual actions can be classified as actions of this or that *type*. On the basis of such a classification we can then ask, for example, whether the permitted character of an action-type should be understood to mean that *at least one* individual action of that type is permitted or whether it means that *all* individual actions of that type are permitted. Berg shows that the first possibility leads to what he apparently considers a trivialization of deontic logic; the second leads again to the absurd consequence that everything is permitted. Berg does not stop to consider the significance of these interesting observations. Nor shall I do it here.

Later in his essay (pp. 658–660), Professor Berg returns to the question of the distinction between action-types and action-individuals in relation to principles of deontic logic. His object of scrutiny is now the combination of a logic of action with a logic of *Tunsollen* ('ought to do') presented in my paper 'Deontic Logic Revisited' (B263, 1973). In this system of deontic logic, the operators O and P are not interdefinable, but both occur as logical primitives.

Berg suggests (p. 660) an interpretation of expressions of the form Op and Pp (in his notation $O(\alpha)$ and $P(\alpha)$) in terms of the obligatory and permitted character of the act-individuals of the type p (in his notation α) which validates the axioms of the deontic logic in question and which seems intuitively plausible.

However, he also finds a difficulty here. Berg thinks it follows from his interpretation of the deontic formulas and from my axioms of an action logic that "if some kind of action is permitted, then any kind of action is permitted in combination with it" (p. 660). If this really followed, it would be disastrous. But I do not think the argument is valid. It depends on the assumption that we can identify each individual action with an interval in the life of an agent and, moreover, *regard this interval itself as being an agent*. But this is surely not legitimate. The expression $(\alpha)x_1$ means in my action logic that the agent x_1 α's, *i.e.*, performs an action of the type α. Even if this happened to be the only action this agent ever performs and his entire life consisted in the performance of it, it would be nonsense to say that this *slice of history* which is the agent's (only) action *performs an action* of this or that type.

I do not think therefore that the system of deontic logic of the *Tunsollen* type which I sketch in B263 has to face the dilemma which Berg constructs. From this, however, it does not follow that the system may not be found deficient in some other respect.

Dyadic deontic logic. It may be clarifying to note here that I have made several different 'experiments' with dyadic deontic modalities. The first, contained in the brief note B151 (1956) was an offshoot of my efforts then to build a theory of dyadic modal logic (in B138, 1953 and B153, 1957). Its basic idea was embodied in a distribution principle for conjunctive permissions, analogous to the multiplication principle for probabilities. The second was in *N&A*. Related to it was the third attempt in B198 (1964) and its improvement in B203 (1965). The fourth attempt was made in B215 (1967) and was continued and expanded in *DL* (B219, 1968). There I also made a somewhat half-hearted effort to incorporate the main idea of the 1956 approach in this new approach. All these efforts are experimental and none of them I regard as successful. But I still think that the idea of dyadic deontic modalities makes good sense. Its chief importance, as I see it, is for a theory of conditional norms.

Berg deals mainly with the attempt at a dyadic deontic logic set forth in *DL*. There six different systems were distinguished on a systematic basis ("permutation of quantifiers"). Berg notes (p. 656) that I did not characterize the systems syntactically, by means of axioms. This was done on purpose. I thought that a semantic characterization in the form of a definition of conditional or relative permittedness, for each one of the six systems, would substantially suffice as a basis for determining, by means of normal-form transformations and the construction of truth-tables, whether a formula was a logical truth in the system under consideration. The only additional thing needed was

a principle concerning the permittedness of a tautological state of affairs relative to a tautological state of affairs. But such a principle might also be regarded as extralogical and would therefore be dispensable.

Perhaps this was not a good approach—and it certainly led me to make at least one bad mistake. I fancied that the distribution principles mentioned on p. 656 of Berg's paper were valid for the expressions $P_2(p\lor q/r\lor s)$ and $P_2(t/t)$. Contrary to Berg's generous suggestion, I did *not* conceive of the distribution-equivalence for $P_2(p\lor q/r\lor s)$ as an axiom. I simply made a blunder. In the light of my error, I ought also to reassess the interest of P_2 as a notion of conditional permission. I do not know what the final verdict will be. But it still seems to me that P_2 corresponds better than the 'classic' P_1 to our intuitive idea of conditional permittedness (cf. *DL*, p. 34f).

In all three strong systems for free choice conditional permission one can derive the formula $P(p/q) \rightarrow P(p\&r/q)$. In the one corresponding monadic system one can derive the formula $Pp \rightarrow P(p\&q)$. Berg thinks this "an alarming consequence" (p. 657). I do not think one should let oneself be alarmed by it. My 'defense' of the formulas in *DL* was, however, completely unsuccessful. First of all it is marred by a bad misprint, also noted by Berg (p. 657). The sentence in the middle of p. 33 of *DL* beginning "In the monadic weak permission calculi . . . " should, of course, read "In the monadic strong permission calculi . . .". Secondly, the argument presented in the paragraph beginning with the sentence "Speaking in terms of action . . ." is entirely beside the point. The truth in the matter is simply the following:

That it is in the strong sense permitted that p means in the monadic calculus that any 'world' is permitted of which the permitted state is a conjunctive component. Roughly speaking: we may act in whatever way we please, if only we see to it that it is the case that p. One could think of the state that p as of something immensely good or valuable, so that the presence of this state in the world 'excuses' or 'licences' the doing or the presence of anything else.

But is this not absurd? Perhaps it is—but not *logically* absurd. It is not absurd in the way Ross's Paradox, in the opinion of many logicians, is absurd. About this I was also mistaken in *DL*, as can be seen from the discussion on p. 33. The impression of absurdity, moreover, is mitigated when we consider that the strong monadic system in *DL* is a 'degenerate' case of three different *dyadic* systems. In one of these dyadic systems, viz., the P_4-system, $P(p/q)$ means that every possible world in which it is true that p, is permitted in *some* possible world in which it is true that q. Whether this is an 'absurdly' strong permission or not depends upon the scope of the 'worlds' under consideration. Consider, for example, worlds composed of only two states, described by 'p' and 'q'. Then $P(p/q)$ simply means that either when it is the case that $p\&q$ or when it is the case that $\sim p\&q$ it is permitted that it be the case that p (irrespective of whether or not it is the case that q in the permitted world). This could be a thoroughly plausible instance of permittedness.

In *DL* (p.24) I said that the six types of dyadic (conditional) permission, and the corresponding types of obligation, represented six different concepts of permission and obligation. This, however is wrong—or at least misleading. For we can spell out the distinction between the six meanings of $P(p/q)$ in the form of six different ways in which 'worlds' of which it is true that p can be permitted relative to 'worlds' of which it is true that q. (Some p-world relative to some q-world, some p-world relative to all q-worlds, etc.) But the meaning of 'permitted', it would seem, is the same in all six cases. Moreover, since in *DL* I accepted the traditional interdefinability of the *P*- and the *O*-operator, permission is here of the weak type which consists in the absence of prohibition.

It is obvious that the treatment and typology in *DL* of dyadic systems of deontic logic suffers from grave defects. When the defects are remedied, something of value will, I think, remain. It is, for example, of interest to note that if one understands conditional obligation as O_1-obligation and conditional permission as P_2-permission, which appears a very natural way of understanding them, then one cannot from the absence of a prohibition conclude the existence of a corresponding permission. The application of this observation to the classic problem of 'gaps in the law' which is made in the concluding chapter of *DL* still seems to me fruitful—and not vitiated by the error which I committed with regard to the distributivity of P_2-permissions.

Reduction of Deontic Logic to Alethic Modal Logic. This approach was inaugurated by Alan Anderson and, independently, by Stig Kanger. For many years I remained 'cool' to it. (Cf. above p. 33f.) But later I came to think that it contains an important germ of truth. The applicability of the idea, however, is probably restricted. It would hardly be right to think that an Andersonian reduction can do justice to *all* aspects of a logic and theory of norms.

In the concluding section of his essay (pp. 661–63) Berg makes two critical reflections on my attempt to develop an Andersonian type of deontic logic in B222 (1968/1971).

The first concerns the fact that in this logic, too, the formula $Pp \rightarrow P(p$ & $q)$ is deducible. This is a fact, but I do not think the formula need be considered a "troublemaker" here—neither from the formal nor from the material point of view. For in this system the formula Pp is true only provided either that there exist no prohibited acts (states) at all or that no prohibited acts, if there are any, are done ("all obligations are satisfied"). In the latter case, 'p' stands for a conjunction which includes as a part of itself the conjunction of all obligatory acts (or states). It should be remembered that permittedness here means, roughly speaking, that a state of affairs obtains which guarantees immunity to punishment. Permittedness therefore logically requires that nothing forbidden should have been done (no forbidden state of affairs obtain). But I think it is a fair complaint agains the *symbolism* that '*P*' is not a very natural symbol for permittedness, since we cannot by means of it express that a single, not-forbidden action is by itself permitted. As I put it in the publication under consider-

ation (B222 (a), p. 165): "To say of something that it is in the strong sense permitted without including in the description mention of all dutybound things is therefore an *elliptic* mode of speech."

The second critical point raised by Berg (p. 661f.) is very interesting. It consists in the deduction of the formula $N(O(I))$ as a theorem in the proposed system. This formula says that the state of affairs I, for the obtaining of which certain things (or actions) are necessary conditions, is itself necessarily obligatory. But, as Berg says, "the fact that the circumstances described by 'I' are obligatory is most likely to be regarded as synthetic. For example, the fact that anything which is actually obligatory in a given society happens to be obligatory is most likely an extra-logical truth." To this we must surely agree—and therefore acknowledge that Berg has put his finger on a sensitive spot.

I also think that Berg's diagnosis is correct when he suggests that the trouble has to do with the status of a definitory equivalence such as $Op \leftrightarrow N(I \to p)$ in a system of modal logic. I would perhaps put it slightly differently from Berg and say that the necessitation of such an equivalence, viz., the step from $Op \leftrightarrow N(I \to p)$ to $N(Op \leftrightarrow N(I \to p))$, is not to be regarded as a matter of course. Definitions are not logical truths in the same sense in which tautologies or principles of modal logic are logical truths. To justify this statement, however, is a task which transcends deontic logic. I think that Professor Berg's observation affects not only my attempt in B222 but any attempt on the Anderson-Kanger lines to reduce deontic to alethic modal logic. One could therefore say that a successful completion of this program must first settle a basic problem in the theory of definitions.

Alchourrón and Bulygin on Deontic Logic and the Philosophy of Law

A main tenet of the interesting and valuable paper by Alchourrón and Bulygin is the authors' insistence on the distinction between a logic of norms (deontic logic proper) and a logic of norm-propositions (pp. 679ff.). Norm-propositions are to the effect that such-and-such norms exist. They are true or false. That they obey logical rules is clear. Norms, at least those which have the character of prescriptions, are not true or false. Therefore it is questionable whether they have a logic at all.

The two authors think that there exists a genuine logic of prescriptive norms. It is outlined in section 6 of their paper. The system which is described there turns out to be identical with the one which was described in my first (1951) paper on deontic logic. It is characteristic of this system that it does not allow for an iteration of the deontic operators.

According to the authors, the existence of a prescription means that the prescription has been issued by an authority ('legislator'). On their view "any serious act of prescribing gives rise to (the existence of) a norm" (p. 670).

Instead of "prescribing" they also say "promulgating". Thus, according to Alchourrón and Bulygin, a norm comes into existence through an act of promulgation and exists as long as it is not derogated. In the case of a command or an order one would presumably have to say that it ceases to exist when it is either withdrawn ("derogated") or has been obeyed.

If we call the issuing of norms normative action, then Alchourrón's and Bulygin's logic of norm-propositions is also a logic of normative action. One must hope that either the two authors themselves or somebody else will develop this logic in more detail than is done in the paper and in their important book *Normative Systems* (New York, Vienna: Springer Verlag, 1971).

Even in its present, somewhat fragmentary, state this logic can be seen to possess interesting features. It enables the authors to deal elegantly with the difficult and much debated problems of completeness and consistency of a normative system such as a legal order (sect. 10). It also opens good prospects for a theory of iteration of deontic operators and thus for a theory of norms of higher order (sect. 11). The authors' efforts in this second regard are in line with the ideas sketched in *Norm and Action* (*N & A,* Ch. X).

The authors have no difficulty in showing that, if one assumes consistency and completeness for normative systems, then the logic of norms and the logic of norm-propositions become "isomorphic" (p. 688). The authors suggest that the failure to distinguish clearly between the two kinds of deontic logic, viz., the prescriptive and the descriptive variety, may be due to a tendency to assume, tacitly and as a matter of course, that normative systems *are* consistent and complete. In this, I think, they are right.

For certain types or kinds of norm this assumption may, moreover, be justified. The authors seem to think (p. 691f.) that moral norms (ethics) provide a case in point. This is perhaps true for some particular theory of morals, e.g., for a system of utilitarian ethics. But one can easily think of a view of morality under which a system of moral norms might, like a legal order, be incomplete, and perhaps also inconsistent.

It is obvious that completeness and consistency present grave problems for systems of norms which have the nature of prescriptions. It seems to me importantly true, moreover, that one must allow for the possibility of incomplete systems, *pace* Kelsen and some other legal philosophers. Perhaps it is even normally the case that legal systems are incomplete. Whether one can also admit the possibility that a system is inconsistent seems to me more debatable. The question hinges on the criteria for saying that a collection of norms constitutes a 'system'.

Alchourrón and Bulygin seem to think (p. 679 and passim) that I mistakenly regarded the logic of norms and the logic of norm-propositions as being "isomorphic". They complain (p. 685) that I "cannot draw a clear distinction between the logic of prescriptive norm-formulations (based on the idea of con-

sistency) and the logic of descriptive norm-propositions (based on the idea of the existence of norms)''.

I do not think, however, that this gives a quite correct picture of my position. In *N&A* I took the view that deontic logic was a logic of descriptively interpreted deontic expressions and thus was a logic of norm-propositions. At the same time I thought that the distinctive features of this logic reflected conceptual peculiarities of the norms themselves. This does not mean, however, that a descriptively interpreted logic of norms reflects or is isomorphic with an 'underlying' prescriptively understood deontic logic.

Some doubts which I have here could be expressed as follows: *Is* there a prescriptively interpreted logic of norms *at all,* i.e., a deontic logic of the kind which I attempted to construct in my 1951 paper and which is now suggested by Alchourrón and Bulygin in their essay? The grounds for my doubts have to do with the use of the sentential connectives, particularly disjunction, in prescriptive language. If the prescriptive interpretation is to go through, the disjunction of two norms must be a norm. But can expressions such as, say, '*Op* ∨ *Oq*' or '*Pp* ∨ *Pq*' really be said to express norms? 'You ought to write or you ought to read.' A person to whom this 'directive' is given would not know what he has to do in order to comply with it. It is different if he is told 'You ought to write or to read'. Then he knows that by doing one or the other of the two things he will satisfy the requirement. Must not a well-formed norm (-formulation) tell us what we ought to or may or must not do? A conjunction of norms does this and also the negation of a norm can easily be so understood that it does this. But a disjunction of norms, it would seem, cannot be thus understood. What it states is that there exists a norm of this *or* of that content.

But since one can make sense of conjunction and negation, when applied to norms, does it not follow that disjunction must be accepted too? The truth-functional 'or' can be defined in terms of 'and' and 'not'. Why not then define '*Op* ∨ *Oq*' = df '~(~*Op* & ~*Oq*)'? The answer is as follows: The negation of a norm is the negation-norm (see *N&A,* p. 140). But the negation of a conjunction of norms is just as much, or as little, a norm as is a disjunction of norms. As I see things now, the negation of such a conjunction can only be understood as expressing a norm-*proposition* to the effect that not all the conjoined norms exist. For how else *could* it be understood?

If my above doubts are well-founded, it follows that the deontic logic of my 1951 paper and every other deontic logic which makes a free use of truth-connectives for constructing molecular compounds of *O*- and of *P*- expressions cannot be prescriptively interpreted. These systems are not deontic logics 'proper' but logics of norm-propositions.

Does it follow then that there exists no deontic logic proper whatsoever? I think this does *not* follow. And on this question the paper by Alchourrón and Bulygin gives hints which I find very valuable.

The notions of self-consistency and mutual consistency of norms obviously make good sense. Since one can define the notion of a negation-norm of a given norm, one can furthermore also make sense of the notion of norm-*entailment*. It can be defined in terms of negation and inconsistency. In *N&A* I tried to define all the notions in question. To state adequately the conditions of consistency for a set of norms is not easy. Maybe the conditions as I stated them in *N&A* stand in need of correction or modification, but I do not doubt the soundness of the program itself. Nor, for all I can see, do Alchourrón and Bulygin doubt it.

Consistency is a property of what the authors of the essay call norm-lekta (p. 677). The norm-lekta are entities which in normative discourse answer to propositions in descriptive discourse. Just as contradictory propositions may be asserted (by one and the same or by different speakers), in a similar manner contradictory norms may be presented or promulgated (by the same or by different norm-authorities).

A deontic logic proper might now be characterized as a study of relations of consistency and entailment between (sets of) norm-lekta. This characterization would not answer to the conception of deontic logic which I entertained in *N&A*. But it would match the peculiar techniques which were actually used there for dealing with the deontic expressions. These techniques differ from those used both in my initial approach to the subject and in my many 'returns' to it in later years (cf. above p. 865 in my reply to Berg). When systematically developed, they would yield a deontic logic in the 'spirit' of Alchourrón's and Bulygin's sharp distinction between a logic of norms and a logic of norm-propositions. But this deontic logic would *not* be identical with the deontic logic which the two authors themselves seem to think is the correct one (cf. above p. 678f.).

That the consistency of norms can be defined independently of their existence seems clear. The problematic question is whether consistency should, or should not, be regarded as a necessary condition of existence.

Alchourrón and Bulygin think that consistency and existence should be kept conceptually quite apart. This position is a consequence of their view that a norm comes into existence with its promulgation alone (cf. above p. 670). They reject the additional requirement that a norm, in order to exist, must also establish a normative relationship between norm-authority and norm-subject. According to them, "the characterization of the continuous existence of a norm in terms of the continuity of the normative relationship between the norm-authority and the norm-subject is not suitable for most legal norms" (pp. 670).

I am inclined to agree that the authors have characterized *one* sense in which norms can be said to exist—and moreover that theirs is an important and useful characterization. It makes possible still sharper distinctions than those

made in *N&A* between the existence, the validity, and the efficacy of norms. What the authors have to say (pp. 672–73) on validity and on the necessity of separating the formal, norm-logical notion of validity from the empirical notion of existence, is, I think, in complete agreement with my own position. The notion of efficacy, I should say, has two aspects. One is the efficacy of norm-application. It consists, so to speak, in the 'energy' with which the authority behind the norm sees to it that sanctions are applied to cases of disobedience. The other aspect is the efficacy of obedience, i.e., the extent to which people actually conform to norms and 'internalize' them in their behavior.

The efficacy of norm-application is discussed by Alchourrón and Bulygin under the heading 'The Ability to Command'. This ability is also called by the authors the superiority-relation of the norm-authority relative to the norm-subjects (p. 671). The superiority-relation can consist either in some kind of physical superiority (''strength'') or superiority by virtue of norm (competence, right to legislate). The latter falls under the notion of validity. Of the former the authors say (p. 672) that ''in some situations'' it is a necessary condition of the existence of norms. It seems to me that they ought not to have made this concession, considering the view which otherwise they take of the existence of norms. But they could have made it clear that it is a necessary condition of the existence of a normative relationship between authority and subject that the authority should be able to make his will effective by taking coercive measures against recalcitrant subjects. Exactly how this power of norm-authorities should be described is not easy to say and the task remains to be accomplished. To this end it is probably important to distinguish more clearly than I have done in my earlier writings between individual commands (imperatives) and general norms (rules) of conduct.

In *N&A* I took the view that inconsistent norms could exist simultaneously, if they belonged to different systems of norms, but that they could not co-exist within the same system. A system of prescriptive norms I called a 'corpus'. I regarded it as characteristic of a corpus that its member norms should 'emanate' or 'flow' from one supreme authority, a sovereign rational will.

In accordance with this conception of a system, the case when different authorities prescribe contradictory norms to the same subjects can be character-ized as a conflict of will. The case when the same authority issues inconsistent prescriptions (without derogating any of them) is an instance of irrationality. One cannot rationally 'will' contradictory things.

The authors criticize (p. 675ff.) this notion of a corpus and of a sovereign rational will as its source. I do not wish to say that their criticism is unfounded. But it seems to me that they tend to ignore a genuine problem here which a satisfactory logic and philosophy of norms must try to solve. This is the prob-lem of what constitutes the unity or self-identity of a system or corpus of norms. For there surely are such distinctive things as 'normative systems'. The

very title of Alchourrón's and Bulygin's book pays tribute to this fact. But the definition or elucidation of the concept of a system which is given in the book appears to me to bypass this problem of unity or self-identity. The authors seem to wish to set the problem aside. "The notion of a corpus of norms is of little use in the field of law", they say (p. 675, cf. also *Normative Systems,* p. 4). They see difficulties relating to the notion of the identity or sameness of a norm-authority (p. 675). Sameness of authority, however, need not mean the same individual or the same members of a body of individuals who make up, for example, a court or a legislative assembly. I am afraid the authors draw conclusions too hastily about the position on this question which is implicit in *N&A.* I certainly did not commit myself to a view according to which two norms are issued by the same court or parliament "if, and only if, all individual members of the court or the parliament are the same" (p. 675). But I agree that the problems of the unity of a system and of the self-identity of sovereign and subordinate authorities are open questions. They are, moreover, problems of fundamental interest both to a philosophy of norms in general and to legal and political philosophy in particular.

Hansson on the Logic of Preference

The logic of preference or, as I have also baptized it, prohairetic logic, occupies a position in relation to value-theory similar to the one held by deontic logic in relation to a general theory of norms. But the study of prohairetic logic has so far been pursued with much less energy and success than the study of deontic logic.

Hansson starts off by noting that the concept of preference plays a great role in economic theory. The concept is not, on the whole, considered controversial by economists. Philosophical logicians, however, tend to regard the concept as highly problematic, and there is little agreement among them about the basic principles of a 'logic of preference'.

Hansson's diagnosis of the difference between the status of the concept of preference in economic theory and its status in philosophical logic hits the nail on the head. Economists usually treat preferences as a relation between thing-like entities, often spoken of as 'goods'. Logicians are inclined, in the first place, to regard preferences as subsisting between proposition-like entities such as, for example, states of affairs. As a consequence, many of the perplexities which beset the efforts of logicians to build a logic of preference simply cannot arise in the theories of economists.

Is the logician-philosopher perhaps creating unnecessary troubles for himself? Hansson does not explicitly take a stand on the question. But I think he agrees with me that the conception of the terms of preference relations as proposition-like is of great intrinsic interest. Maybe he even shares my opinion

that this conception is basic and also underlies the view of preferences as a relation between thing-like entities ('goods'). If this opinion is correct, the seemingly unproblematic status of preferences in economic theory really rests on a controversial and perhaps shaky foundation. If by the 'foundations of economics' one understands the conceptual groundwork of the subject (by analogy with 'foundations of mathematics'), then the logico-philosophical study of preference is of vital interest to research in the foundations of economics.

My two main contributions to preference logic are the pamphlet, *The Logic of Preference* (B192, 1963), and the paper 'The Logic of Preference Reconsidered' (B254, 1972). Hansson discusses them both. I shall here refer to the first using the abbreviation *LP* and to the second using *LPR*. There is also an earlier paper of mine (B180, 1962) on subjective probability which deals briefly with the relation between the notion of preference and that of utility.

Preference and Contraposition. In *LP* I accepted the contraposition principle for preferences. It says that, if a state is preferred to another, then the negation (absence, nonexistence) of the second state is preferred to the negation of the first. Various objections have been raised against this principle. Hansson mentions one on p. 697. I do not think it is relevant in the context. For this objection concerns a different type of preference, viz., preferences in terms of expected value, from the type for which the principle of contraposition can claim validity. Hansson thinks that the objection cannot be dismissed on such grounds. He says (ibid.) that "the logic of preference should not exclude such a method of evaluation (sc., in terms of expected value)". I am not sure whether Hansson and I agree on this. Needless to say, I admit that preferences in terms of expected value are important and that they must be accommodated in a complete logic of preference. But, as I see things, statements of preference have no unique meaning (or no 'core' meaning). There are several types of preference, or perhaps one should say several concepts of preference, and among the types (concepts) there are hierarchic relations. Thus I think that preferences in terms of expected value, involving the notion of probability, are preferences of a higher type which rest on preferences of the type studied in my two publications. (Some thoughts on this relationship are expounded in B180.) For expected-value-preferences the principle of contraposition is invalid. For *some* (but not for all) simple types of probability-free preference, it is valid.

Broadly speaking, the contraposition principle is valid when the preference of p over q is based on a comparison of the value to us of p & $\sim q$ and $\sim p$ & q respectively—regardless of our chances of ever getting the compared goods. That this is one way of evaluating preferences seems to me undeniable. In *LP*, however, I overstated my case. For not even in the case of risk-free preferences is this the *only* basis on which preference comparisons are made. (For example, risk-free preferences of the D2-type mentioned in *LPR* do not obey contrapo-

sition.) And the argument given in *LP* to show that contraposition is valid was not worth much. About this Hansson is undoubtedly right (p. 698ff.). It was wrong of me (and perhaps of Halldén too) to try to 'deduce' the contraposition principle from considerations about *the* meaning of preference. But it was not wrong, I should say, to argue for the principle from considerations about the *meaning(s)* of preference. Statements of preference are sometimes so *meant* that they satisfy this principle.

I think that the existence of several meanings or senses of statements of preference must be accepted as one of the irremediable complications of the field. But this should not make us despair about the task of building a logic— perhaps we should rather say, logic*s*—of preference.

Distributivity of Disjunctive Preferences. In *LP* I formulated a very strong distribution rule, the intuitive validity of which has seemed debatable to many critics, including Bengt Hansson. The idea behind the rule was to make every relation of preference resolvable into a molecular compound of preference-relations between 'possible worlds'. In *LPR* I showed that the needed distribution principle will differ depending upon how the preference relation is defined (for possible worlds).

I do not think that the distribution rules in question need provoke criticism. They serve a well-defined purpose and they claim validity only for a certain type of preference, viz., for comparisons between states with regard to their intrinsic value. It is of no relevance to such comparisons what the chances are that the states under consideration will, or will not, materialize. Hansson asks (p. 700): "Are there really any preferences not involving risk and, if so, are these the interesting kind of preferences?" He seems to agree that there *are* such risk-free preferences. "But," he says (p. 700), "it can hardly be maintained that all interesting intrinsic preferences are of this kind and a logic of preference must therefore go further and also try to handle the more problematic kinds of preference". I agree with him completely. The passage in Hansson's essay from which I quoted may, however, convey to a reader the impression that I had made a claim which I certainly never wanted to make. I am even willing to concede that the 'interesting' kinds of preference are those which involve considerations of risk (probability). But it is my belief, right or wrong, that a theory of preferences involving risk presupposes a theory of the more 'primitive' kind of value-comparisons of which *LP* and *LPR* treat. This was stated, I hope with sufficient clarity, in *LP* (pp. 16–18 and also in the 1960 paper on subjective probability, where I had argued (B180, p. 338) that "attitudes of preference and indifference in conditioned options depend logically upon attitudes in simple options between accumulated goods".

Transformation of P-Expressions. The transformation of relations of preference between single states to preferences between state-descriptions ('possible worlds') was, in *LP,* governed by three principles. These were contraposi-

tion, distribution, and a principle of 'holisticity'. Hansson notes (p. 700) that the application of the principles yields different results depending upon the order in which they are applied. That this should be the case is indeed natural when one considers what the transformation principles are designed to achieve. The idea is to expand a simple preference relation, for example pPq, into a compound of relations between each member of a set of possible worlds for which it is true that p & $\sim q$ and each member of a set of possible worlds for which it holds good that $\sim p$ & q—when the pairs of worlds selected for comparison agree in all other features except p and q. The necessity of observing the order of transformations was noted and duly stressed in LP. I said (LP, p. 36): "We then perform *in order* the following three operations (transformations) on the P-expression: . . .". The words "in order" were not italicized, however: Perhaps they ought to have been to avoid misunderstandings. A misunderstanding of this sort was, for example, Kanger's argument (cf. Hansson's essay, p. 701) purporting to show that the distribution principle in question leads to contradiction.

The necessity of performing the operations in a determinate order was, incidentally, the reason why I did not attempt to give an axiomatic treatment of preference logic in LP. The transformation-principles are not on a level with the principles of asymmetry and transitivity of preferences. They are parts of a definition of simple preferences in the terms of preferences between state-descriptions. This was not clear to me when I wrote LP, but is made quite clear, I hope, in LPR. In that paper I separated the definitions (D1 and D2) from the relational properties of preferences. The latter can be laid down in an axiomatic system.

The Reconsidered Logic of Preference. After having examined the main ideas of LP, Hansson proceeds to a discussion of LPR. This paper, as I see it, makes obsolete and supersedes a great many of the things said in LP. I hope I am right in thinking that also some of the genuine difficulties which Hansson and others have found with the position taken in LP are happily resolved by the treatment given to the problem in LPR.

On p. 703 Hansson discusses a putative counter-example to the transitivity of conditional preferences. I think the argument is wrong. When explicated in accordance with the definition D1, $pP_{C_i}q$ means that the world $p\&\sim q\&C_i$ is preferred to the world $\sim p\&q\&C_i$, and $qP_{C_i}\sim p$ means that $p\&q\&C_i$ is preferred to $\sim p\&\sim q\&C_i$. These two preferences do not admit an inference by transitivity to a preference which could be expressed in the formula $pP_{C_i}\sim p$. This third preference relation subsists within the bounds of a different preference-horizon from the first two preferences. $p\&C_i$ is not a (complete) state-description within the horizon constituted by p, q, and the members included in C_i. The preference of p over $\sim p$ within the same horizon as the above two preferences of p

over q and of q over $\sim p$, means by definition (D1) that the world $p\&q\&C_i$ is preferred to $\sim p\&q\&C_i$ and the world $p\&\sim q\&C_i$ to $\sim p\&\sim q\&C_i$.

Hansson notes that my definition D2 is identical with one of the six different proposals, for the explication of the preference relation in the terms of 'outcomes', made by Danielsson in his book *Preference and Obligation*. Hansson says that it seems unavoidable to agree with Danielsson's statement that none of the proposed explications is "entirely satisfactory". To this I should say: Don't expect *any* of the definitions to be "entirely" satisfactory. Accept them all as different ways of explicating a preference relation. It makes no sense to ask which way of explication is the right one. But it is of interest to investigate the further (logical) commitments which acceptance of the one or the other explication carries with it.

Mackie on Conditionals and Natural Necessity

J. L. Mackie died on 12 December 1981. He was a philosopher whose sagacity I much admired. Our interests were very similar, as were some aspects of our approach. On questions of detail we often disagreed. I had been looking forward to his reaction to this 'Reply', in which I try to defend some of my views against his trenchant criticism, and to further exchanges of thoughts with him.

Mackie's paper deals primarily with my essay 'On Conditionals'. It is a relatively early work of mine in philosophical logic, written in the mid-1950s. The essay falls into two parts. The first puts forward a theory of conditional asserting. The second deals with the problem of contrary-to-fact conditionals. On the topic of conditional asserting I have not had new thoughts in later years. On the question of counterfactual conditionals and the related topic of 'natural necessity', however, my thoughts have developed. Some of these later thoughts of mine are noted and criticized by Mackie in his essay. They are also the topic of the paper by Prawitz in the section on Causality, Teleology, and Scientific Explanation. Mackie's essay thus is related to the one by Prawitz; and thus are my replies to the two also related.

Mackie's presentation of my position in 'On Conditionals' is clear and correct—the best I could wish for. I think he does me a maximum of justice even when he disagrees with my views. I shall make only one brief comment on what he has to say about my theory of conditional asserting before proceeding to counterfactual conditionals.

Mackie says in a footnote (no. 4, p. 728) that "it would be interesting to know to what extent von Wright's view here is influenced by W. E. Johnson's." The answer is that, at the time when I wrote 'On Conditionals', I was reading Johnson and found him stimulating. But I doubt that it was from him that I got my inspiration for my "speech-act theory" of conditionals. Johnson's

theory avoids what Mackie considers a difficulty with mine. The alleged difficulty is with arguments using *modus ponens* (and *tollens*). If one passes, *modo ponente,* from asserting that *p* and that either not-*p* or *q* to asserting that *q,* then one is *not,* in my opinion, asserting conditionally that *q*. There is surely something unnatural, or even incorrect, about the form of words 'This *is* iron and, *if* this is iron it conducts electricity'. The correct word is 'since' and not 'if'. It is of some interest to note that it sounds much less strange to say '*If* this is iron, it conducts electricity, and this *is* iron'. The difference is due to the fact that the statement implicitly suggests a temporal order. On my view of conditional asserting, it is quite in order *first* to assert that *q* conditional on that *p* and *then* to assert that *p* unconditionally—but incorrect to assert *first* that *p* unconditionally and *then,* without withdrawing or forgetting the categorical asserting, assert that *q* conditionally on that *p*.

Mackie complains (p. 713) "that there is a regrettable lack of unity" in my treatment of conditionals. I agree that there is lack of unity—but I am not sure whether it should be deemed "regrettable". For it is possible that unity can be achieved only at the expense either of trivializing the problem or of raising graver problems than the unification solves. This *may* be the case with the unitary theory which Mackie suggests. My doubts have to do with his notion of asserting a proposition "within the scope of the supposition" of another. The quoted locution may be an acceptable blanket term for conditional asserting. But it is not clear (to me) what it is to assert "within the scope of a supposition". Maybe a further inquiry into this will again disrupt the unity of the theory by revealing that the phrase has a multitude of different meanings. The matter is certainly worth considering. But I shall not stop to consider it here. A fuller inquiry would necessitate a stand on Mackie's theory of conditionals, for which there is ample and forceful argumentation in his book *Truth, Probability, and Paradox.*

After having presented his own 'unitary theory' Mackie devotes the rest of his paper to the problem of natural necessity and nomic asserting of generalizations. He seems to agree with me about the way this problem is connected with that of counterfactual conditionals. But, not surprisingly, he disagrees with and criticizes my proposed solution of the problem.

The question here which has vexed and continues to vex me could be put as follows: Granted that there is a distinction between accidental and non-accidental (law-like, nomic) generalizations and granted that this distinction is reflected in the fact that the latter, but not the former, support causal counterfactual conditionals, how shall one establish or test whether a generalization is nomic or not? I touched upon the problem relatively lightly in the essay 'On Conditionals'. In *E&U* and in *C&D* it is central.

My problem has been to find evidence, in the concrete case, for a distinction between two types of generalization. Mackie gives a slightly different turn

to the problem. He asks us to look for evidence for counterfactuals. What supports the counterfactuals supports the law. Therefore it is admittedly a little misleading to say, as I did for instance above, that it is the law which supports the counterfactuals. Mackie, moreover, substitutes for my concern with *verification* a quest for *inductive evidence*.

I can agree completely with Mackie's way of posing the problem. From the way he reads me I realize that I stated the problem badly. Also, with much of what Mackie has to say (pp. 720–22) about the way to a solution I agree. But there is also disagreement between us. I shall try to locate what I think is its deepest source.

Assume that somebody makes the counterfactual causal statement 'If it had been the case that *p,* it would also have been the case (or would have followed) that *q*'. What could he do in order to substantiate his statement? Or we to check its truth? The characteristic way of providing evidence is to make an 'experiment' (or refer to an experiment already made) of the following kind: In a situation which is, in the 'relevant' respects, similar to the one for which the counterfactual is claimed to hold good, we *produce* the first state of affairs when it is missing. Let us assume that the second state of affairs then makes its appearance too. This we should normally consider strong evidence for the truth of the original counterfactual statement. Maybe we think a few repetitions of the experiment needed in order to convince us completely. But once we are convinced that the counterfactual is true, we are also, I suggest, convinced that there is a law-connection or nomic connection between the two states under consideration—perhaps subject to some specified conditions about the situation or to a more indefinite *ceteris paribus* clause.

I am sure that Mackie would have agreed with me that 'experiments' of the kind just described are important sources of evidence for counterfactual conditionals and for nomic connections. I am not sure whether he also would have agreed with my analysis, as such, of the conceptual nature of the experimental situation. But he certainly disagreed with the conclusion which I think emerges from this analysis. This is the conclusion that the notions of cause, counterfactual conditional, and nomic connection are conceptually dependent upon (and thus in a sense secondary to) the concept of action, i.e., upon the idea that man has the power to interfere with the (man-independent) course of events in nature.

I shall not here repeat the details of the analysis of the interventionist situation which have led me to this conclusion. Nor shall I try to produce additional arguments for my 'actionist' or 'experimentalist' view of causation. (The best statement which I have so far succeeded in giving to my position is, I think, in sects. 2–4 of Ch. II of *C&D.*) But I should like to take issue here with Mackie on one crucial point:

Implicit in the concept of an action there is what I have called an element

of counterfactuality. This can hardly be contested. Wherein this element consists is easy to explain, moreover. It is essential to a wide range of what we call actions that the performance of an action should result in a state of affairs which *would not* have come to be, on that same occasion, *had we not* acted. Therefore the concept of an action can be said to depend upon an idea of counterfactuality. If now the counterfactual conditionals involved in action were causal counterfactuals, this would make my theory of causation (viciously) circular. Mackie thinks this is the case. He maintains (p. 720) "that the necessity and sufficiency in the circumstances of a nonintervention for a non-change is logically just like the dependence of a change on an intervention, and that it is reasonable to extend the concept of causation to cover such persistences of states of affairs." For supporting arguments he refers to his book *The Cement of the Universe*. The arguments given there concern, however, special cases in which it may indeed be argued that certain things persist because some cause 'keeps them going'. But these cases are not like the non-changes which are 'counterfactually correlated' with changes brought about through action. The fact that many things persist unless interfered with is, in normal cases, *not* due to the operations of causality but is due to the *absence* of interfering causes or interfering actions. This, I think, is a most important fact about the structure of reality. Causes are, on the whole, factors that 'disturb' what would otherwise be stable. They are responsible for changes and movement and only occasionally, as 'counteracting' causes, for rest. In this regard natural causes are like actions. It is therefore understandable that at a prescientific stage causation in nature was often attributed to the operation of invisible agents or spirits (animism).

The counterfactual element involved in action must therefore not be confused with causal counterfactual conditionals. Against Mackie (p. 726), I should insist that there is no "vicious circularity in the attempt to analyse the nomicity of causation in terms of action" and that it is not the case that "the concept of action presupposes just that sort of relation which it is being used to explain". I wish we could have agreed about this. For agreeing about this does not commit one to agree with my admittedly controversial thesis about the conceptual dependence of causation upon action.

Towards the end of his essay, Mackie raises two questions on which I should like to comment. The first concerns the asymmetry or directedness of the causal relation. The second, related question concerns the possibility of backward or retroactive causation.

The direction of causation. The problem here is a deep one, and Mackie is one of the relatively few contemporary writers on causality who have recognized this. He agrees that the cause-effect asymmetry cannot be accounted for in terms of temporal relationships alone. My own account of this asymmetry differs, however, in several respects from the one given by Mackie. As can be

expected, my account brings in the notion of action. I am not at all sure that I have succeeded in solving the problem. But I am anxious to defend my proposal against certain misunderstandings.

In *E&U* (pp. 74f.) I imagined a case when cause and effect occur simultaneously. The cause is the pressing down of a button and the effect the correlated sinking of another button. Then I complicated the case by supposing that a stone drops down, hits the first button, and makes it sink. Would it then be right to say, I asked, that the sinking of the first button caused the sinking of the second? I am sorry to hear Mackie say (p. 723) that "the rest of the discussion suggests a negative answer". I certainly meant the answer to be affirmative. To me too "it seems quite clear that the answer is 'Yes', that the sinking of the button which the stone hits is an intermediate cause: it is an effect of the stone's dropping and a cause of the other button's going down." This, moreover, holds independently of whether the stone has fallen 'naturally' or whether it was dropped by an agent. Contrary to what Mackie suggests, I do not think there is any disagreement at all between his and my intuitions in the matter. But I am a little surprised that Mackie sees no problem here. Perhaps I did not state the case with sufficient clarity. So let me make a new effort.

That the hitting of the stone is a 'remote' cause of the sinking of the second button is obvious only if we take it for granted that the sinking of the first button is the 'immediate' cause of the sinking of the second. As such, other possibilities also exist. Maybe the hitting of the stone has *two* effects which are not mutually related causally, viz., the sinking of both buttons. Or maybe the hit caused the second (not-hit) button to sink and that it was the sinking of the second button which caused the sinking of the first, and not the other way around. The nature of the example may make these possibilities seem too abstruse to be taken seriously. If so, consider another example which I discuss in *C&D* (p. 46f.). The tip of a burning cigarette causes the appearance of a brown spot on a sheet of paper and then a hole in the paper. Here the first effect, the appearance of the spot, is not the intermediate cause of the second effect, the appearance of the hole. Therefore, in order to establish as true what we immediately take for granted in the example of the two buttons, we ought to show two things: that the hitting of the stone caused the sinking of the hit button, and that the sinking of the hit button caused the sinking of the not-hit button. What should we do if we doubted the one or the other of these two things? Obviously, we should make experiments. All would probably agree on this. But I think Mackie disagrees with me when I say that experiments are necessary in order to remove persistent doubts here; if for some reason we cannot experiment, we cannot become convinced of the right causal connections either. The connections would remain a matter of conjecture.

What was the point of introducing the fiction of the stone-hitting into the

example? When two simultaneous events are causally connected, then one can distinguish them as causing event and caused event only on condition that either (*a*) one of the two events was made to occur by action or (*b*) one of the two events can be shown to have had a cause ('cause of the cause'). If neither of these two conditions is satisfied, we cannot distinguish cause from effect. Since, moreover, it need not be the case either that the one event was produced by action or that it was caused by some 'cause of the cause', it is logically possible that sometimes (but very rarely, I think) the cause-effect *distinction* cannot be applied to causally connected events. The causal relation is not always and necessarily asymmetrical. This was not clear to me when I wrote *E&U*. I hope I succeeded in remedying this defect with my discussion of the two-valves example in *C&D* (pp. 62–68).

Retroactive causation. Mackie agrees with me that one must take seriously the possibility that time and causation have opposite directions. But he does not find my "neurophysiological experiment of thought" very convincing.

I have not come to clarity in my own thinking on the subject. I see the matter somewhat differently now than I did in *E&U*. I have become more sympathetic to the view—sometimes called the causal theory of time—according to which the direction of time actually *depends* on the direction of the causal relation. This makes me inclined to say that there *cannot,* for conceptual reasons, exist backward causation. But I have not found an argument which would satisfy me.

The imagined example from neurophysiology also continues to puzzle me, although I agree with my critics that I have not succeeded in giving to it a satisfactory presentation. I see no difficulty or inconsistency in acknowledging that *on the generic level* the same event can be both cause and effect of another event. (This *is* the case in my example with the two buttons, and in other and perhaps better examples of two events which are causally connected and always instantiate simultaneously.) The asymmetry comes to play only *on the individual occasion.* In the individual instance referred to by Mackie, when the neurophysiologist does *not* interfere and *I* raise my arm, it is the muscular event which causes the neurophysiological one to take place, and not *also* the neurophysiological event which causes the muscular one. Mackie is therefore not right when he says that my definitions force me "to abandon the objective asymmetry of cause and effect even on a particular occasion". There may nevertheless also exist cases in which the cause-effect distinction is actually not *applicable* (cf. above) to individual instantiations of the causally related neural and muscular phenomena. I think that this restriction on the applicability of the distinction is important to note for a correct understanding of the notoriously obscure and puzzling relationship between the neural and the muscular aspects of an action.

A charge which many critics have made against my view of causation is

that it is anthropocentric and subjective. Sometimes the charge is based on obvious misunderstandings, and then it is easy to meet—for example, when Mackie thinks that, on my view, "the movement of one button will bear a cause-effect relation to that of the other if the former is hit by a stone dropped by a human agent, but not if it is hit by one which has fallen naturally". Surely no such absurdity follows from anything I have thought or written.

The causal relation which I have been studying, but which is not the only one that exists, is objective in the following sense: The relation subsists between events (or states) in the world. It subsists, in the individual case, independently of whether the causing event resulted from human interference or came about 'naturally'. And the relation subsists, or not, independently of whether the cause can or cannot be produced by human action. The relation, finally, between an action and a resulting event in nature is *not* a causal relation. This last is something which philosophers who otherwise take an objectivist view of causation may wish to dispute.

In spite of the above, however, there is admittedly an element of anthropomorphism and even of subjectivism in the account which I have tried to give of causation. This element resides in a conceptual link which I think exists between the notions of cause and of action. I am not sure that I have succeeded in showing what this link is. But none of my critics have, so far, succeeded in convincing me that it does not exist.

PART FOUR

BIBLIOGRAPHY OF THE WRITINGS OF GEORG HENRIK VON WRIGHT

BIBLIOGRAPHY

The bibliography falls into two parts. The first part lists the writings of Professor von Wright; the second lists works with him as editor or co-editor.

The editors wish to express their gratitude to Mr. Olav Flo, Bergen, Norway, for work done by him in preparing this bibliography.

I. WRITINGS OF GEORG HENRIK VON WRIGHT

1. Der Wahrscheinlichkeitsbegriff in der modernen Erkenntnisphilosophie. *Theoria* 4 (1938):3–20.

2. Logistisk filosofi. [Logistic Philosophy] *Nya Argus* 31 (1938):175–77.

3. Edvard Westermarck. [Edward Westermarck, 1862–1939, in Memoriam] *Studentbladet* 27 (1939):165.

4. Maktens filosof. [The Philosopher of Power: Machiavelli] Ibid., 188–190.

5. On Probability. *Mind* 49 (1940):265–283.

6. Eino Kaila som kunskapsfilosof. [Eino Kaila as a Philosopher of Knowledge] *Nya Argus* 33 (1940):57–62.

7. Mystikern Huxley. [Huxley the Mystic. Review of Aldous Huxley: *After Many a Summer Dies the Swan* London: 1939] Ibid., 70–72.

8. *The Logical Problem of Induction.* (Acta Philosophica Fennica. Fasc. 3.) Helsinki 1941. 258 pp.
Thesis for the doctor's degree, University of Helsingfors, 1941.
(a) 2d rev. ed. Oxford: Basil Blackwell, 1957. xii & 249 pp.

9. Induktionsproblemet och kunskapens gränser. [The Problem of Induction and the Limits of Knowledge] *Finsk Tidskrift* 129 (1941):204–214.

10. Betraktelser om Europa. [Reflections on Europe] Ibid., 130 (1941):151–162.

11. Sverige och Ryssland. [Sweden and Russia through History. Review of Eirik Hornborg: *Sverige och Ryssland genom tiderna*. Helsingfors: 1941] Ibid., 193–94.

12. Människokunskap. [Knowledge of Man. Review of *Människokunskap och Människobehandling. Praktisk psykologi för envar*. Helsingfors: 1941] *Hufvudstadsbladet* 6 December 1941.

13. Georg Christoph Lichtenberg. Ett tvåhundraårs minne. [Georg Christoph Lichtenberg. A Bicentenary] *Finsk Tidskrift* 131 (1942):238–248.

14. Georg Christoph Lichtenberg als Philosoph. *Theoria* 8 (1942):201–217.
(a) Lichtenberg, Georg Christoph (1742–1799). In *Encyclopedia of Philosophy*. Edited by Paul Edwards. Vol. 4, pp. 461–65. New York/London: Macmillan & Free Press/Collier-Macmillan, 1967. An adaptation of the preceding, translated by David H. DeGrood and Barry J. Karp.

15. Några anmärkningar om nödvändiga och tillräckliga betingelser. [Some Remarks on Necessary and Sufficient Conditions] *Ajatus* 11 (1942):230–239.
(a) Author's abstract of the preceding in *Journal of Symbolic Logic* 8 (1943):50.

16. Utgivarens efterskrift. [till] Augustin Ehrensvärd som politiker. Av Carl Sanmark. [Editor's Postscript to 'Augustin Ehrensvärd as Politician', by Carl Sanmark] In *Historiska och litteraturhistoriska studier* 17, pp. 64–66. [Skrifter utgivna av Svenska Litteratursällskapet i Finland. 289.) Helsingfors:1942. For particulars, see item 001.

17. Review of K. V. Laurikainen, Matematiikan analyyttisyydestä, *Ajatus* 10 (1941):105–121. *Journal of Symbolic Logic* 7 (1942):42.

18. Review of Uuno Saarnio, Intention merkityksestä käsitteiden konstituutiossa, *Ajatus* 10 (1941):201–218. *Journal of Symbolic Logic* 7 (1942):42.

19. Review of Klaus V. Vartiovaara: *Logiikka ja etiikka, Ajatus* 10 (1941):285–300. *Journal of Symbolic Logic* 7 (1942):43.

20. Review of Oiva Ketonen, Predikaattilogiikan täydellisyydestä, *Ajatus* 10 (1941):77–92. *Journal of Symbolic Logic* 7 (1942):126.

21. Review of P. Siro, Lauseoppi uuden logiikan valossa, *Virittäjä* 45 (1941):192–205. *Journal of Symbolic Logic* 7 (1942):127.

22. Vägen till Minerva. [The Road to Minerva. Review of Ragnar Granit: *Ung Mans Väg till Minerva*. Stockholm: 1941] *Finsk Tidskrift* 131 (1942):44–46.

23. Östproblemet. [The Problem of the East. Review of *Kampen om Östkarelen*, and Jalmari Jaakkola, *Finlands Östproblem*. Helsingfors: 1941] Ibid.: 99–100.

24. Mannerheimiana. [Review of books by and on C. G. Mannerheim] *Finsk Tidskrift* 132 (1942):46–50.

25. Finsk forskning i öster. [Review of *Anteil der Finnischen Forscher an der Erforschung von Kola, Ostkarelien und Ingermanland*. Edited by V. Auer. *Fennia* 67 (1942).] Ibid., 104–05.

26. Populär vetenskap. [Popular Science. Review of translations into Swedish of Lancelot Hogben: *Mathematics for the Million*. 1–2. 2d ed. Stockholm:1939; and E. T. Bell: *Men of Mathematics*. Helsingfors:1940; and Edward Kasner-James Newman: *Mathematics and the Imagination*. Helsingfors:1942] Ibid., 270–74.

27. Hans Larsson 80 år. [Professor Hans Larsson 80 years old, 18 February 1942] *Hufvudstadsbladet* 17 February 1942.

28. *Den Logiska Empirismen: En huvudriktning i modern filosofi*. [*Logical Empiricism: A Principal Movement in Modern Philosophy*] Helsingfors: Söderströms, 1943. 188 pp.

(a) Author's abstract of the preceding in *Journal of Symbolic Logic* 9 (1944):25–26.

(b) Logical Empiricism. On the occasion of Wedberg's review of my book *Den Logiska Empirismen*. [Professor Anders Wedberg's review, *Theoria* 10 (1944):78–82] *Theoria 10 (1944):56–57*.

(c) *Looginen empirismi: Eräs nykyisen filosofian pääsuunta*. [Finnish translation of item 28 by Hilppa Kinos] Helsinki: Otava, 1945. 187 pp. (Otavan kulttuurisarja 2.)

29. Tilastollisen todennäköisyysteorian vaiheita. [On the History of the Frequency Theory of Probability. With an English Summary, 266–67] *Ajatus* 12 (1943): 249–267.

30. Filosofianopetuksesta kouluissa. [On the Teaching of Philosophy in Schools] Ibid., 268–284.

31. Review of Eino Kaila, Reaalitiedon logiikka, *Ajatus* 11 (1942): 21–89. *Journal of Symbolic Logic* 8 (1943):49.

32. Review of Hilppa Kinos, Invarianssin periaatteesta David Hilbertillä, *Ajatus* 11 (1942):90–113. *Journal of Symbolic Logic* 8 (1943):49.

33. Review of Uuno Saarnio, Mitä on filosofia?, *Ajatus* 11 (1942):171–219. *Journal of Symbolic Logic* 8 (1943):49–50.

34. Platon-problemet. [The Plato Problem. Review-discussion of Gunnar Rudberg, *Platon, en inledning till studiet*. Lund: 1943] *Nya Argus* 36 (1943):167–170.

35. Ett självständighetsmonument. [A Monument to Independence. Review of *Fritt Fädernesland*. Helsingfors: 1943] *Finsk Tidskrift* 133 (1943):206–207.

36. Fem decennier kulturhistoria. [Five Decades of Cultural History. Review of Yrjö Hirn: *Akademiska Bokhandeln*. Helsingfors: 1943] Ibid., 134 (1943):108–09.

37. De filosofiska mästerverken. [The Philosophic Masterpieces. Review of *De filosofiska mästerverken*. Edited by John Landquist. 1–4. Stockholm: 1932–1943] Ibid., 195–99. See also item 53.

38. En finsk filosof. [A Finnish Philosopher. Eino Kaila] *Svenska Dagbladet* 13 May 1943.

39. *Carl Olof Nordman. 4 January 1917–20 February 1942. En minnesskrift*. [A memoir of a friend who was killed in the war] Helsingfors: Frenckellska Tryckeri AB, 1944. 61 pp.

40. Ett grundproblem i psykologiens filosofi. [A Basic Problem in the Philosophy of Psychology] In *Eros och Eris*. Kulturessäer tillägnade Rolf Lagerborg. 332–346. Helsingfors: Söderströms, 1944.

41. En huvudlinje i finländsk filosofi. [A Principal Trend in Finnish Philosophy] *Nordisk Tidskrift* 20 (1944):464–473.

42. Skolundervisningen i etik och filosofiens historia. [The Instruction in Ethics and History of Philosophy in Secondary Schools] *Skola och Hem* 2 (1944):1–9.

43. Lärdomshistoria. [History of Learning. Review of the 1943 volume of *Lychnos*, Uppsala] *Finsk Tidskrift* 136 (1944):61–62.

44. Själsbegreppets förvandlingar. [Changes in the Concept of Mind. Review of Alf Nyman, *Själsbegreppets förvandlingar*. Stockholm: 1943] Ibid., 201–03.

45. Ett filosofiskt tolkningsförsök. [An Attempt at a Philosophical Interpretation. Review of J. E. Salomaa, *Arthur Schopenhauer, Elämä ja Filosofia*. Helsinki: 1944] Ibid., 265–66. See also item 57.

46. *Über Wahrscheinlichkeit. Eine logische und philosophische Untersuchung.* Helsingfors: 1945. 66 pp. Acta Societatis Scientiarum Fennica. Nova Series A. Vol. 3, no. 11.

47. Review of Torgny Segerstedt, *Ordens Makt. En studie i språkets filosofi.* [The Power of Words. A Study in the Philosophy of Language. See also item 51.] Stockholm: 1944. *Theoria* 11 (1945):145–47.

48. Review of Veikko Salonen, Reduktioteorian periaatteista, *Ajatus* 13 (1944):262–293. *Journal of Symbolic Logic* 10 (1945):130–131.

49. Filosofi i Finland. [Philosophy in Finland] *Panorama* 2 (1945):2–5.

50. Medvetande och materia [Consciousness and Matter. Review-discussion of Anders Olson, *Medvetande och Materia*. Stockholm: 1944] *Finsk Tidskrift* 137 (1945):231–241.

51. Språkets filosofi. [The Philosophy of Language. Review-discussion of T. T. Segerstedt: *Ordens Makt.* See also item 47.] *Finsk Tidskrift* 138 (1945):86–96.

52. I Minervas tjänst. [In the Service of Minerva. Review of V. T. Aaltonen, *Tieteellinen tutkimustyö*. Helsinki: 1945. See also item 61.] Ibid., 152–53.

53. Engelska tänkare. [English Thinkers. Review of *De filosofiska mästerverken*. 8. Engelska tänkare från 1800– och 1900– talen. Stockholm: 1944] Ibid., 218–220. See also item 37.

54. Problemet som problem. [The Problem as Problem. Review of Alf Nyman: *Problem och problemlösningar inom filosofien*. Stockholm: 1945] Ibid., 277–78.

55. Moderna psykologier. [Trends in Modern Psychology. Review of Alf Nyman: *Nya vägar inom psykologin*. 2d ed. Stockholm:1943] Ibid., 283–84.

56. Review of Jan Gästrin, *Inlärningsprocessens psykologi*. Helsingfors: 1944. *Nordisk Tidskrift* 21 (1945):68.

57. Review of J. E. Salomaa, *Arthur Schopenhauer*. Borgå: 1944. Ibid., 68–69. See also item 45.

58. Review of J. E. Salomaa, *J. V. Snellman, Elämä ja Filosofia*. Helsinki: 1944. Ibid., 212.

59. Review of *Ajatus; Yearbook of the Philosophical Society of Finland*, vol. 13, 1945. Ibid., 265.

60. Review of Konrad Marc-Wogau, *Die Theorie der Sinnesdaten*. Uppsala:1945. Ibid., 325. See also item 78.

61. Review of V. T. Aaltonen, *Tieteellinen tutkimustyö*. Ibid., 407. See also item 52.

62. Hjalmar Neiglick som filosof. [Hjalmar Neiglick as Philosopher] *Hufvudstadsbladet* 12 April 1945.

63. Om framtiden. [On the Future] *Hufvudstadbladet* 3 May 1945.

64. Hjalmar Neiglicks filosofiska insats. [Hjalmar Neiglick's Contribution to Philosophy. Deutsches Referat, 22–25.] Helsingfors: 1946. Societas Scientiarum Fennica. Commentationes Humanarum Litterarum, vol. 14, no. 2 (1947).

65. Muutamia huomattavimpia Suomen ruotsinkielisiä tiedemiehiä. [Some Outstanding Swedish-speaking Finnish scientists] In *Kulttuurin Saavutuksia; Suomalaisten tiedemiesten ja taiteilijain esittämänä*, 1, 129–133. Helsinki: Werner Söderström, 1946.

66. Review of Oiva Ketonen, Luonnollisen päättelyn kalkyylistä, *Ajatus* 12 (1943), 128–140. *Journal of Symbolic Logic* 11 (1946):24.

67. Humanismens förfall. [The Decline of Humanism. Address given to the Union of Swedish-speaking students in Finland, 17 May 1946. Reprinted with minor revisions in item 296] *Finsk Tidskrift* 139 (1946):199–209.

68. Icke-euklidisk geometri. [Non-Euclidean Geometry. Review of C. E. Sjöstedt: *Icke-Euklidisk Geometri*. Stockholm: 1945] Ibid., 43–44.

69. Nietzsche den otidsenlige. [Nietzsche the Lonely. Review of Atos Wirtanen, *Nietzsche den otidsenlige*. Stockholm: 1945] Ibid., 45 [and in] *Nordisk Tidskrift* 22 (1946):76.

70. Ungdomsårens psykologi. [Review of Eduard Spranger: *Psychologie des Jugendalters*. Swedish translation by Alf Ahlberg. 3d ed. Stockholm: 1945] Ibid., 91–92.

71. Filosofien och vetenskaperna. [Philosophy and the Sciences. Inaugural Lecture, given in the University of Helsingfors, 17 April 1946] *Finsk Tidskrift* 140 (1946):93–106.

72. Review of David Katz, *Gestaltpsykologi*. Stockholm: 1942. Ibid., 55–56.

73. Fysiologisk psykologi. [Physiological Psychology. Review of J. Agerberg: *Kropp och själ*. Stockholm: 1942] Ibid., 158–59.

74. Review of Rafael Karsten, *Huvuddragen av sociologiens historia*. Lovisa: 1945. *Nordisk Tidskrift* 22 (1946):149.

75. Review of Olavi Ahonen, *Luonne ja ympäristö*. Helsinki: 1945. Ibid., 149.

76. Review of Anders Wedberg: *Den nya logiken*. Stockholm: 1945. Ibid., 211.

77. Review of Otso Aalto, *Zur Psychologie der euklidischen Raumanschauung*. Dissertation, Helsinki: 1946. Ibid., 329.

78. Tinget och den filosofiska analysen. [Review of Konrad Marc-Wogau, *Die Theorie der Sinnesdaten*. Uppsala: 1945.] *Stockholms-Tidningen* 24 January 1946. See also item 60.

79. Engelsk filosofi. [Philosophy in England] *Svenska Dagbladet* 14 June 1946.

80. Nk. praktillisesta filosofiasta. [On so-called Practical Philosophy] *Ajatus* 14 (1947):383–396.

81. Review of Julius Weinberg, Our Knowledge of Other Minds. *Philosophical Review* 55 (1946):555–563. *Journal of Symbolic Logic* 12 (1947):59.

82. Abstracts of works by Eino Kaila, Uuno Saarnio, and J. E. Salomaa. *Philosophical Abstracts* 7 (1947):2–3.

83. Abstracts of works by Uuno Saarnio and J. E. Salomaa. *Philosophical Abstracts*. 9 (1947):6.

84. Paideia. *Nya Argus* 40 (1947):229–231.
 [In items 84–87, and 93–94, Professor von Wright discusses Werner Jaeger's *Paideia*. The articles are reprinted, with revisions, in item 147.]

85. Upptäckten av kosmos. [The Discovery of the Kosmos] Ibid., 259–261.

86. Grekernas humanism. [The Humanism of the Greeks] Ibid., 288–290.

87. Individen och samhället. [The Individual and Society] Ibid., 319–322.

88. Universiteten och bildningen. [The Universities and Culture. Erratum, see ibid., 123] Ibid., 95–97.

89. Gide och människan. [André Gide and Man. Review-discussion of Göran Schildt: *Gide och Människan*. Helsingfors: 1946] Ibid., 63–68.

90. Review of *Studia Psychologica et Paedagogica, 1: Studier i människokunskap tillägnade John Landquist*. Lund: 1946. Ibid., 107.

91. Socialvetenskapernas metodlära. [The Methodology of the Social Sciences. Review of Svend Ranulf, *Socialvidenskabelig Metodelaere*. Copenhagen: 1946] *Finsk Tidskrift* 141 (1947):190–92.

92. On the Idea of Logical Truth, I. Helsingfors: 1948. Societas Scientiarum Fennica. Commentationes Physico-Mathematicae. Vol. 14, no. 4. [Reprinted in item 153. See also item 115.]

93. Filosofen som statsman. [The Philosopher as Statesman. Cf. item 84;] *Nya Argus* 41 (1948):10–13.

94. Humanism och teologi. [Humanism and Theology. Cf. item 84.] Ibid., 54–56.

95. En insats för bildningen. [A Contribution to Education] Ibid., 67–68.

96. En filosofikongress. [10th Congress of Philosophy, Amsterdam: 1948] Ibid., 233–35.

97. Review of Uuno Saarnio, Kieli ja logiikka, *Ajatus* 14 (1947):167–185. *Journal of Symbolic Logic* 13 (1948):125.

98. Review of Veli Valpola, Negaation asema tietoa esittävässä kielessä, *Ajatus* 14 (1947):325–381. *Journal of Symbolic Logic* 13 (1948):125.

99. Review of Victor Kraft, Logik und Erfahrung, *Theoria* 12 (1946):205–210 *Journal of Symbolic Logic* 13 (1948):156–57.

100. Review of Ludvig Lövestad, The Structure of Physical Laws, *Theoria* 11 (1945):40–70. *Journal of Symbolic Logic* 13 (1948):157.

101. Review of Alf Nyman, *Östligt och västligt i ryskt tankeliv.* Lund: 1947. *Nya Argus* 41 (1948):94–95.

102. Review of *Studia Psychologica et Paedagogica, 2. Studier i människokunskap.* Lund: 1948. Ibid., 255.

103. Review of S. H. Steinberg, *Historical Tables 55 B.C.–A.D. 1945.* 2d ed. London: 1947. Ibid., 143.

104. *Form and Content in Logic.* An inaugural lecture. Delivered 26 May 1949 in the University of Cambridge. London: Cambridge University Press, 1949. 35 pp. [Reprinted in item 153]

105. On Confirmation. In *Proceedings of the Tenth International Congress of Philosophy, Amsterdam 1948.* Fasc. 2. Vol. 1, pp. 794–96. Amsterdam: North-Holland Publishing Co., 1949.

106. Max Söderman. In *Årsskrift utgiven av Åbo Akademi* 31 (1946/47). Åbo: 1949, pp. 69–72.
[Max Söderman, 23 November 1914–1 October 1947, in Memoriam]

107. Some Principles of Eliminative Induction. *Ajatus* 15 (1949):315–328.

108. Review of Arne Naess: *Symbolsk Logikk.* 2d ed. Oslo: 1948. *Journal of Symbolic Logic* 14 (1949):185–86.

109. Dostojevskij. *Nya Argus* 42 (1949):56–70.
(Items 109–114 are parts of an essay on Fyodor Dostoievsky. Reprinted, with minor revisions, in item 147.)

110. Mannen i underjorden. [The Man in the Underground] Ibid., 211–14.

111. Frihetens tragedi. [The Tragedy of Freedom] Ibid., 241–44.

112. Revolutionens demon. [The Demon of Revolution] Ibid., 241–44.

113. Ryssland och Europa. [Russia and Europe] Ibid., 261–64.

114. Den sanna och den falska guden. [The True and the False God] Ibid., 274–77.

115. On the Idea of Logical Truth (II). Societas Scientiarum Fennica. Commentationes Physico-Mathematicae. Vol. 15, no. 10 (1949/50). Helsingfors: 1950. 45 pp. See also item 92.

116. Descartes och den vetenskapliga idéutvecklingen. [Descartes and the Evolution of Scientific Ideas] *Ajatus* 16 (1950): 103–171.

117. Review of Fulton H. Anderson, *The Philosophy of Francis Bacon.* Chicago: 1948. *Mind* 59 (1950):116–17.

118. Om logik, I-IV. [On Logic, I-IV] *Nya Argus* 43 (1950):60–63, 94–97, 110–13, 130–33.

119. Descartes och vetenskaperna. [Descartes and the Sciences] *Dagens Nyheter* 11 February 1950.

120. Valérys Descartes. [Review of *Descartes i urval*. Introduction by Paul Valéry] Stockholm: 1950.] *Dagens Nyheter* 6 June 1950.

121. *A Treatise on Induction and Probability*. International Library of Psychology, Philosophy and Scientific Method. London: Routledge and Kegan Paul, 1951. 310 pp.

122. *An Essay in Modal Logic*. Studies in Logic and the Foundations of Mathematics, 4. Amsterdam: North-Holland Publishing Co., 1951. vi & 90 pp.
 (a) *Ensayo de lógica modal*. Collección Rueda filosófica, 4. Buenos Aires: Santiago Rueda, 1970. 130 pp.
 [Spanish translation of the preceding by Atilio A. Demarchi. Technical revision: E. Bulygin. For this edition, Professor von Wright wrote a new preface.]

123. Deontic Logic. *Mind* 60 (1951):1–15. Reprinted, with minor revisions, in item 153.
 (a) Reprinted in *Contemporary Readings in Logical Theory*, edited by Irving M. Copi and James A. Gould. Pp. 303–315. New York: The Macmillan Company, and London: Collier-Macmillan, 1967.
 (b) German translation in item 291, pp. 1–17.
 (c) Deontisk logik. In *Filosofin genom tiderna, 4: 1900-talet*. Edited by Konrad Marc-Wogau. Pp. 356–362. Stockholm: Bonniers, 1964. [Swedish translation of the preceding by Lennart Åqvist, but with revisions by the author]
 (d) Deonttinen logiikka. [Finnish translation of item 123 by Tauno Nyberg] In *Ajatus ja Analyysi*, edited by Tauno Nyberg. Pp. 147–166. Porvoo: Werner Söderström Oy, 1977.
 (e) Spanish translation in item 303, pp. 23–48.

124. Carnap's Theory of Probability. [Review-discussion of Rudolf Carnap, *Logical Foundations of Probability*. Chicago: 1950] *The Philosophical Review* 60 (1951):362–374.

125. Review of Thoralf Skolem, De logiske paradokser og botemidlene mot dem, *Norsk Matematisk Tidsskrift* 32 (1950):2–11. *Journal of Symbolic Logic* 16 (1951):62.

126. Spengler och Toynbee. [Spengler and Toynbee] *Nya Argus* 44 (1951):47–50. Items 126–132 are discussions of *Der Untergang des Abendlandes* and of *A Study of History*. Reprinted, with revisions, in item 147.

127. De stora kulturerna. [The Great Cultures] Ibid., 79–82.

128. Ödets kurva. [The Curve of Destiny] Ibid., 109–112, 125–29.

129. Rummets symbolik. [The Symbolism of Space] Ibid., 225–29.

130. Den historiska pseudomorfosen. [The Historical Pseudomorphosis] Ibid., 241–45.

131. Kausalitet och öde. [Causality and Destiny] Ibid., 258–262.

132. Västerlandets undergång. [The Decline of the West] Ibid., 275–79.

133. (With P. T. Geach) On an Extended Logic of Relations. Societas Scientiarum Fennica. Commentationes Physico-Mathematicae. Vol. 16, no. 1. Helsingfors: 1952. 37 pp.

134. On Double Quantification. Societas Scientiarum Fennica. Commentationes Physico-Mathematicae. Vol. 16, no. 3. Helsingfors: 1952. [Reprinted in item 153]

135. Interpretations of Modal Logic. *Mind* 61 (1952):165–177. [Reprinted in item 153.]

136. On the Logic of Some Axiological and Epistemological Concepts. *Ajatus* 17 (1952):213–234.

137. Hans Kelsens statsfilosofi. [Hans Kelsen's Political Philosophy. Review-discussion of Jan-Magnus Jansson: *Hans Kelsens Statsteori mot bakgrunden av hans rättsfilosofiska åskådning.* Dessertation. Helsingfors: 1950.] *Finsk Tidskrift* 151 (1952):221–28.

138. A New System of Modal Logic. In *Proceedings of the 11th International Congress of Philosophy.* Brussels: 1953. vol. 5, pp. 59–63. *Logic, Philosophical Analysis, Philosophy of Mathematics.* Amsterdam-Louvain: 1953. See also item 153.

139. Review of Oskar Becker, *Einführung in die Logistik, vorzüglich in den Modalkalkül,* Meisenheim/Glan: 1951; [and] *Untersuchungen über den Modalkalkül,* Meisenheim/Glan: 1952. *Mind* 62 (1953):557–561.

140. Språkvetenskap, logik och filosofi. [Linguistics, Logic, and Philosophy] *Nya Argus* 46 (1953):66–69. Items 140–42 are an expanded version of a lecture on 'Language and Logic' given in the University of Helsingfors, 1953.

141. Språket som kalkyl. [Language as a Calculus] Ibid., 83–86.

142. Logik och språkdräkt. [Logic and Linguistic Form] Ibid., 101–04.

143. En ny lärobok i filosofins historia. [A New Textbook in the History of Philosophy. Review of Sigurd Enegrén: *Filosofins historia.* Helsingfors: 1952] *Skola och Hem* 16 (1953):10–13.

144. Om moraliska föreställningars sanning. [On the Truth of Moral Ideas] In *Vetenskapens funktion i samhället,* pp. 48–74. Copenhagen: Munksgaard, 1954. Moderne videnskab. Orientering og debat. 3.

145. Ludwig Wittgenstein. En biografisk skiss. *Ajatus* 18 (1954): 5–23.
 (a) Ludwig Wittgenstein. A Biographical Sketch. [An English version of the preceding] *Philosophical Review* 64 (1955): 527–545.
 (b) Reprinted also in Norman Malcolm, *Ludwig Wittgenstein: A Memoir,* pp. 1–22. London: Oxford University Press, 1958.
 [Reprinted, with revisions, as paperback, London 1966. Reprinted, with further revisions, London 1967.]
 (c) Schizzo biografico. [Italian translation of item 145(b) by Bruno Oddera. Ibid., pp. 7–35. 1964] In Norman Malcolm, *Ludwig Wittgenstein,* pp. 7–28. Milan: Bompiano, 1960. Portico. Critica e saggi.
 (d) Biograhische Skizze. [German translation of 145(b) by Arvid Sjögren] In Norman Malcolm: *Ludwig Wittgenstein: Ein Erinnerungsbuch,* pp. 7–23. Munich and Vienna: R. Oldenburg Verlag, 1961.
 (e) Esquema biográfico. [Spanish translation of 145(b) by Ricardo Jordana] In *Las Filosofias de Ludwig Wittgenstein,* Collección Libros Tau, 10. Pp. 23–38. Barcelona: Ediciones Oikos-Tau, 1966.
 (f) Biografisk skiss. [Swedish translation of 145(b) by Th. Warburton, with revi-

sions by the author] In Norman Malcolm, *Minnen av Wittgenstein*. Pp. 7–31. Helsingfors: Schildts, 1967.
(g) Kort levensbericht. [Dutch translation of 145(b) by Tony Bartels] In *Ludwig Wittgenstein. Een biografisch essay*, pp. 7–33. Amsterdam: van Ditmar, 1968.
(h) Notice biograhique. [French translation of 145(b) by Guy Durand] In *Ludwig Wittgenstein, De la certitude*, pp. 7–30. Paris: Gallimard, 1976.

146. Tankens gryning. [The Dawn of Thought. Review-discussion of Erik Stenius, *Tankens gryning. En studie över den västerländska filosofins ursprungsskede*. Helsingfors: 1953] *Nya Argus* 47 (1954): 118–123.

147. *Tanke och förkunnelse*. [Thought and Prophecy] Helsingfors: Söderströms, 1955. 316 pp. A Collection of essays. Contents: Till läsaren [To the Reader]. Paideia. Dostoievsky. Spengler och Toynbee. Tolstoj som tänkare [Tolstoy as a Philosopher]. See also items 84–87, 93–94, 109–114, and 126–132 above.
(a) 2d ed., with some revisions, Lund: Gleerups, 1964. 272 pp.
(b) *Ajatus ja julistus*. Helsinki: Werner Söderström, 1961. 353 pp. [A Finnish translation of items 147 and 179 by Jussi Aro]

148. Om s.k. praktiska slutledningar. [On so-called Practical Inferences] *Tidsskrift for Rettsvitenskap* 68 (1955): 465–495. See also item 156.

149. Modern filosofi, I–III. [Modern Philosophy, I–III] *Nya Argus* 48 (1955): 124–27, 140–43, 160–63.
(a) The preceding, reprinted in two parts, in the Swedish journal *Bonniers Litterära Magasin* 25 (1956): 199–205, 288–292.

150. Vorwort der Herausgeber—Editors' preface. In Ludwig Wittgenstein, *Bemerkungen über die Grundlagen der Mathematik*, pp. vi–viii. Oxford: Basil Blackwell, 1956. See also item 002.
(a) Vorwort der Herausgeber. In Ludwig Wittgenstein, *Bemerkungen über die Grundlagen der Mathematik*. Revidierte und erweiterte Ausgabe, pp. 29–34. Frankfurt: Suhrkamp Verlag, 1974. See also item 002(a).

151. A Note on Deontic Logic and Derived Obligation. *Mind* 65 (1956): 507–09. [Reprinted in *Contemporary Readings in Logical Theory*, edited by Irving M. Copi and James A. Gould. Pp. 316–18. New York: The Macmillan Company, and London: Collier-Macmillan, 1967]

152. En modern Lucretius. [A Modern Lucretius. Review-discussion of Eino Kaila: *Terminalkausalität als die Grundlage eines unitarischen Naturbegriffs. I*. Terminalkausalität in der Atomdynamik. Helsinki: 1956] *Nya Argus* 46 (1956): 173–179.

153. *Logical Studies*. International Library of Psychology, Philosophy and Scientific Method. London: Routledge and Kegan Paul, 1957. ix & 195 pp. A collection of eight studies. Five of them had been published before as items 92, 104, 123, 134, and 135 above. Written for this volume are the essays 'A New System of Modal Logic', 'On Conditionals', and 'The Concept of Entailment'.

154. *Logik, filosofi och språk: Strömningar och gestalter i modern filosofi*. [Logic, Philosophy and Language: Trends and Personalities in Modern Philosophy. Partly based on items 118 and 149] Helsingfors: Söderströms, 1957. 250 pp. Contents: Den filosofiska situationen [The Philosophic Situation]. Aristoteles och det axiomatiska vetenskapsidealet [Aristotle and the Axiomatic Ideal of a Science]. Leibniz

och kalkylens idé [Leibniz and the Idea of the Calculus]. Booles logiska algebra [The Logical Algebra of Boole]. Frege och Russell [Frege and Russell]. Från Hilbert till Gödel [From Hilbert to Gödel]. Två kritiker: Brouwer och Wittgenstein [Two Critics: Brouwer and Wittgenstein]. Russell och den logiska analysen [Russell and Logical Analysis]. 'Tractatus logico-philosophicus'. Den filosofiska semantiken [Philosophical Semantics]. Moores analytiska metod [Moore's Analytical Method]. Den senare Wittgenstein [The later Wittgenstein].

(a) *Logik, filosofi och språk. . . .* Aldusbok. A 134 Stockholm: Bokförlaget Aldus/Bonnier, 1965. 233 pp. Revised and expanded version of item 154. Two essays are added: Icke klassisk logik (Non-classical Logics) and Språk, handling och moral (Language, Action and Morals).

(b) *Logiikka, filosofia ja kieli: Ajattelijoita ja ajatussuuntia nykyajan filosofiassa.* Helsinki: Otava, 1958. 242 pp. Otavan filosofinen kirjasto, 7 [Finnish translation of item 154 by Jaakko Hintikka and Tauno Nyberg].

(c) *Toinen, uusittu painos.* Delfiinikirjat, Helsinki: Otava, 1968. 263 pp. [2d rev. ed., based on 154(a)].

155. Kunskapens träd. [The Tree of Knowledge] *Nya Argus* 50 (1957): 43–47, 59–62. Paper read to the Swedish Society of Letters in Finland, 5 February 1957. Reprinted in *Årsbok för Kristen humanism* 22 (1960): 19–38. See also item 179.

156. Om 'praktiska slutledningar'. Ett tillägg. *Tidsskrift for Rettsvitenskap* 70 (1957): 177–183. An Additional Comment to item 148, and reply to Knut Erik Tranøy's discussion of 148. Ibid. 70 (1957): 59–72.

157. Ludwig Wittgenstein och den moderna filosofin. [Ludwig Wittgenstein and Modern Philosophy] *Dagens Nyheter* 14 March 1957. Items 157–59 are a presentation of Wittgenstein and his Philosophy.

(a) Ludwig Wittgenstein ja nykyajan filosofia. [Finnish translation of the preceding]. *Uusi Suomi* 7 April 1957.

158. Wittgenstein's 'Tractatus'. *Dagens Nyheter* 16 March 1957.

(a) Wittgensteinin 'Tractatus'. [Finnish translation of the preceding]. *Uusi Suomi* 10 April 1957.

159. Filosofins passion och problem. [The Passion and Problem of Philosophy] *Dagens Nyheter* 19 March 1957.

(a) Filosofian ongelma. [Finnish translation of the preceding] *Uusi Suomi* 14 April 1957.

160. Döden som metafysikprofessor. [Death as a Professor of Metaphysics] *Dagens Nyheter* 8 May 1957. This essay was one of a series of articles, written for the newspaper about Life and Death.

161. En passionerad skeptiker. [A Passionate Sceptic. Review of Alan Wood: *Bertrand Russell: The Passionate Sceptic*. London: 1957] *Dagens Nyheter* 9 August 1957.

162. Eino Kaila. [Eino Kaila, 9 August 1890 - 31 July 1958, in Memoriam] *Theoria* 24 (1958): 137–38.

163. Räven, igelkotten och tredje ståndpunkten. [The Fox, the Hedgehog, and the Third Point of View. Review of Herbert Tingsten: *På marknadstorget* and *På krigsstigen*. Stockholm: 1958] *Dagens Nyheter* 20 October 1958.

164. George Edward Moore. *Uusi Suomi* 16 November 1958. See also items 173–74.

165. On the Logic of Negation. Societas Scientiarum Fennica. Commentationes Physico-Mathematicae. Vol. 22, no. 4. Helsingfors: 1959. 30 pp.

166. Broad on Induction and Probability. In *The Philosophy of C. D. Broad*. P. A. Schlipp, editor-in-chief. Pp. 313–352. The Library of Living Philosophers. 10. New York: Tudor Publishing Co., 1959. [Reprinted in *Induction, Probability and Causation*. Selected Papers by C.D. Broad. Edited by Jaakko Hintikka, et al. Pp. 228–272. Dordrecht-Holland: D. Reidel, 1968, Synthese Library]

167. Induction. In *Encyclopedia Britannica*, vol. 12, pp. 273–76. Chicago: William Benton, 1959.

168. Probability. Ibid., vol. 18, pp. 529–532.
 (a) *Encyclopedia Britannica*. Revised, pp. 570–574. Chicago: 1965.

169. Wittgenstein, Ludwig (1889–1951). *Encyclopedia Britannica*, vol. 23, p. 692. Chicago: 1959.

170. A Note on Entailment. *Philosophical Quarterly* 9 (1959): 363–65. Reply to P. F. Strawson's discussion in the October 1958 issue of *Phil. Quarterly* of two of the essays in *Logical Studies*, item 153.

171. Thomas av Aquino om rätt och moral. [Thomas Aquinas on Law and Morals] *Nya Argus* 52 (1959): 10–13. Review-discussion of Knut Erik Tranøy, *Thomas av Aquino som moralfilosof*. Oslo: 1957.

172. Wedbergs filosofihistoria. [Wedberg's History of Philosophy. Review of Anders Wedberg, *Filosofins Historia. 1*. Stockholm: 1958] *Dagens Nyheter* 13 January 1959.

173. George Edward Moore—språkbrukets filosof. [G. E. Moore—Philosopher of Linguistic Usage] *Dagens Nyheter* 21 February 1959. See also item 164.

174. Moore, hans väsen och insats. [Moore, his Character and Achievement] *Dagens Nyheter* 25 February 1959.

175. Moralisten och syndabocken. [The Moralist and the Scapegoat] *Dagens Nyheter* 21 July 1959. A rejoinder to an article by Professor Ingemar Hedenius on Wittgenstein.

176. Russells filosofiska självbiografi. *Dagens Nyheter* 29 August 1959. [Review of Bertrand Russell, *My Philosophical Development*. London: 1959].
 (a) Russellin filosofinen omaelämäkerta. [Finnish translation of the preceding]. *Uusi Suomi* 6 September 1959.

177. The Heterological Paradox. Societas Scientiarum Fennica. Commentationes Physico-Mathematicae, vol. 24, no. 5. Helsingfors: 1960. 28 pp.

178. 'Hahmottuva maailma'—Eino Kailan keskeneräiseksi jäänyt maailmankatsomusteos. [On an Unfinished Work by Eino Kaila] *Ajatus* 23 (1960): 34–44.

179. Kunskapens träd. [The Tree of Knowledge] In *Historiska och Litteraturhistoriska Studier. 35*, pp. 43–76. Skrifter utgivna av Svenska Litteratursällskapet i Finland.

375. Helsinki: 1960. A revised and much expanded version of item 155. Reprinted, with revisions, in item 296.
 (a) A Finnish translation of item 179, by Jussi Aro, is published in item 147(b).

180. Remarks on the Epistemology of Subjective Probability. In *Logic, Methodology and Philosophy of Science: Proceedings of the 1960 International Congress*, pp. 330–39. Stanford, CA.: Stanford University Press, 1962.

181. Vorwort des Herausgebers. In Eino Kaila, *Die perzeptuellen und konzeptuellen Komponenten der Alltagserfahrung*. Helsinki: 1962. See item 004.

182. On Promises. *Theoria* 28 (1962): 277–297.
 (a) "Lupauksista." [Finnish translation of the preceding by Tauno Nyberg] In *Ajatus ja analyysi*, edited by Tauno Nyberg, pp. 190–210. Porvoo: Werner Söderström Oy, 1977.

183. Enhet och splittring i vetenskapen. [Integration and Specialization in the Sciences] *Horisont* 9 (1962): 1–8. Lecture given in the Academy of Finland, 3 October 1962. The above essay was also published separately in Vasa, 1963, in the series *Horisonts småskrifter*, 4. Republished in *Kertomus Suomen Akatemian toiminnasta vuonna* 1962, pp. 22–30. Helsinki: 1963. Reprinted in *Vinghästen*, Helsingfors: Schildts, 1984, pp. 75–85.]
 (a) Erikoistuminen ja yhtenäistyminen tieteessä. *Uusi Suomi* 27 November 1962. [A Finnish version of item 183. Address given to the Students Union at Helsingfors University, 26 November 1962].
 (b) A revised version of item 183 included in item 296.

184. Synpunkter på den vetenskapliga återväxten. [Reflections on the Scientific Recruitment] *Finsk Tidskrift* 171 (1962): 1–10.

185. Naturen som ideal. [Nature as an Ideal] *Nya Argus* 55 (1962): 273–75. Items 185–88 were originally a lecture in the Tekniska Föreningen (Technical Society) i Finland. See also item 193.

186. Den detroniserade och den återupprättade naturen. [The Dethroned and the Rehabilitated Nature] Ibid., 283–85.

187. De två revolutionerna. [The two Revolutions] Ibid., 305–07.

188. Natura non vincitur nisi parendo. Ibid., 315–18.

189. Logikens modernisering. [On Nonclassical Logic in the 20th Century] *Dagens Nyheter* 11 October 1962.

190. *Norm and Action: A Logical Enquiry*. London: Routledge and Kegan Paul; New York: The Humanities Press, 1963. xviii & 214 pp. International Library of Philosophy and Scientific Method. Based on Gifford Lectures given at the University of St. Andrews in 1959.
 (a) *Norma y Acción: Una investigación lógica*. [Spanish translation of item 190 by Pedro Garcia Ferrero] Madrid: Editorial Tecnos, 1970. 216 pp. Estructura y funcion, 30.
 (b) *Norm und Handlung*. Königstein: Scriptor Verlag, 1979. 207 pp. Monograhien. Wissenschaftstheorie und Grundlagenforschung. 10. [German translation of 190 by Georg Meggle and Maria Ulkan].

(c) *Normă şi Acţiune. Studiu logic.* [Rumanian translation of item 190 by Dragan Stoianovici and Sorin Vieru]. Bucharest: Editura Ştiinţifică şi Enciclopedică, 1982.

191. *The Varieties of Goodness.* London: Routledge and Kegan Paul, New York: The Humanities Press, 1963. xiv & 222 pp. International Library of Philosophy and Scientific Method. Based on Gifford Lectures given at the University of St. Andrews in 1960.

192. *The Logic of Preference: An Essay.* Edinburgh: At the University Press, 1963. 68 pp. "This essay is an expanded version of one of a series of four lectures which I had the honour of giving in the University of Edinburgh in May 1962, under the auspices of the Northern Scholars Committee. The series was called 'Ethics and Logic'."
(a) *La Logica de la preferencia.* [Spanish translation of the preceding by Roberto J. Vernengo. Technical revisions by the translator and by E. Bulygin]. Buenos Aires: EUDEBA Editorial Universitaria de Buenos Aires, 1967. 80 pp. Colección ensayos.

193. *Essay om naturen, människan och den vetenskapligt-tekniska revolutionen.* Lund: Gleerups, 1963. 25 pp. Scripta Minora Regiae Societatis Humaniorum Litterarum Lundensis. 1961–1962. English Summary, pp. 24–25. 'An Essay on Nature, Man and the Scientific Revolution.' Originally given as a lecture in Lund, 24 September 1962. See also items 185–88. Reprinted, with revisions, in item 296.
(a) Luonto, ihminen ja tekninen vallankumous. [Finnish translation of item 193 by Tauno Nyberg] In *Saako ihminen vastauksen.* Edited by Lennart Pinomaa. Pp. 91–117. Helsinki: Werner Söderström, 1967.
(b) Essay om naturen, mennesket og den vitenskapelig-tekniske revolusjon. [Norwegian translation of item 193 by Olav Flo] *Naturen* 91 (1967): 155–180.

194. Remarks on the Paradox of the Liar. In *Philosophical Essays.* Dedicated to Gunnar Aspelin on the occasion of his sixty-fifth birthday, 23 September 1963. Edited by Helge Bratt et al. Pp. 295–306. Lund: Gleerups, 1963.

195. Practical Inference. *Philosophical Review* 72 (1963): 159–179.
(a) German translation in item 291, pp. 41–60.
(b) Praktinen Päättely. [Finnish translation of item 195 by Tauno Nyberg.] In *Ajatus ja Analyysi.* Edited by Tauno Nyberg. Pp. 167–189. Porvoo: Werner Söderström, 1977.

196. Den exakta vetenskapen och humanforskningen. [Exact Science and the Humanities]. *Matemaattisten aineiden aikakauskirja* 27 (1963): 135–149. Lecture given at the 5th Scandinavian Congress for Teachers of Mathematics, Physics and Chemistry, Helsingfors: 26–29 May 1963.

197. Självkarakteristik. [Brief Autobiographical Portrait] In *Filosofiskt lexikon.* Edited by Alf Ahlberg. 4th ed., pp. 203–04. Stockholm: Natur och Kultur, 1963.

198. A New System of Deontic Logic. *Danish Yearbook of Philosophy* 1 (1964): 173–182. See also items 203 and 203(a).

199. Normit ja Logiikka. [Norms and Logic] *Ajatus* 26 (1964): 255–276.

200. The Foundation of Norms and Normative Statements. In *The Foundations of Statements and Decisions, Proceedings of the International Colloquium on Meth-*

odology of Science, Warsaw, 1961. Edited by Kazimierz Ajdukiewicz, pp. 351–367. Warsaw: 1965.
(a) La Fondazione delle Norme e degli Asserti Normativi. In *L'Analisi del Ragionamento Giuridico.* Edited by P. Comanducci and R. Guastini. Pp. 53–80. Torino: G. Giappicelli Editore, 1987.

201. 'And Next'. In *Studia Logico-Mathematica et Philosophica in Honorem Rolf Nevanlinna,* pp. 293–304. Helsinki: 1965. Acta Philosophica Fennica, fasc. 18.

202. The Paradoxes of Confirmation. *Theoria* 31 (1965): 255–275.
(a) Reprinted with revisions in *Aspects of Inductive Logic.* Edited by Jaakko Hintikka and Patrick Suppes. Pp. 208–218. Amsterdam: North-Holland Publishing Co., 1966. Studies in Logic and the Foundations of Mathematics.

203. A Correction to a New System of Deontic Logic. *Danish Yearbook of Philosophy* 2 (1965): 103–07.
(a) A New System of Deontic Logic. [Item 198 and the preceding reprinted] In *Deontic Logic: Introductory and Systematic Readings.* Edited by Risto Hilpinen. Pp. 105–120. Dordrecht-Holland: D. Reidel, 1971. Synthese Library.

204. Edvard Westermarck och filosofiska föreningen. [Edward Westermarck and the Philosophical Society of Finland. Lecture given in the Society, 20 February 1963] *Ajatus* 27 (1965): 123–161.
(a) Piirteitä Edvard Westermarckin filosofisesta kehityksestä. [A revised version of item 204. Translated into Finnish by the editors] In *Aate ja maailmankuva,* edited by Simo Knuuttila, Juha Manninen, and Ilkka Niiniluoto. Pp. 279–319. Juva: Werner Söderström, 1979.
(b) The Origin and Development of Westermarck's Moral Philosophy. [A further revision of 204. Translated into English by Timothy Stroup] In *Edward Westermarck, Essays on His Life and Works.* Edited by Timothy Stroup. Pp. 25–61. Vammala. Societas Philosophica Fennica, 1983. Acta Philosophica Fennica, vol. 34.

205. Katsaus teon yleiseen teoriaan. [Outlines of a General Theory of Action] *Sosiologia* 2 (1965): 53–61.

206. Exakt vetenskap om människan. [Exact Science of Man] *Dagens Nyheter* 21 April 1965.

207. Människan i världsordningen. [Man in the World Order] *Dagens Nyheter* 24 April 1965.

208. 'And Then'. Societas Scientiarum Fennica. Commentationes Physico-Mathematicae. Vol. 32, no. 7. Helsingfors: 1966. 11 pp.

209. Den filosofiska situationen. [The Situation in Philosophy. Presidential Address given to the Finnish Society of Sciences 29 April 1966] Societas Scientiarum Fennica. Årsbok-Vuosikirja 44 (1965–66). Helsinki: 1966. 19 pp.
(a) Tilanne filosofiassa. [Finnish translation of the preceding by Kai Kaila, with a Postscript by the Author] In *Filosofian tila ja tulevaisuus.* Edited by Jaakko Hintikka and Lauri Routila. Pp. 9–29. Tapiola: Weilin & Göös, 1970.

210. Kazimierz Ajdukiewicz [in Memoriam]. In Societas Scientiarum Fennica. Arsbok-Vuosikirja 42 (1963–64): 20. Helsingfors: 1966.

211. Memorial Address [on E. W. Beth]. *Synthese* 16 (1966): 4. [Reprinted in *E. W. Beth Memorial Colloquium: Logic and Foundations of Science,* edited by Jean-Louis Destouches. p. 1. Synthese Library. Dordrecht-Holland: D. Reidel, 1967.

212. Om förklaring av beteende. [On the Explanation of Behavior. Lecture given at the 7th Scandinavian Meeting of Psychologists. Jyväskylä, 1 August 1965] *Nordisk Psykologi* 18 (1966): 16–29.
(a) Käyttäytymisen selittämisestä. [Finnish translation of the preceding by Tauno Nyberg] *Psykologia* 1 (1966): 11–23.

213. Teot ja käyttäytymisen selittäminen. [Action and the Explanation of Behavior. Reply to Professor Raimo Tuomela's discussion of 212(a). Ibid., 132–35] Ibid., 183–86.

214. The Logic of Action—A Sketch. In *The Logic of Decision and Action.* Edited by Nicholas Rescher. Pp. 121–136. Pittsburgh, Pa.: Pittsburgh University Press, 1967.
(a) Reply to Comments [made by R. M. Chisholm and J. Robison]. Ibid., pp. 144–46.
(b) German translation, discussion omitted, in item 291, pp. 83–103.

215. Deontic Logics. *American Philosophical Quarterly* 4 (1967): 136–143.

216. Quelques remarques sur la Logique du Temps et les Systèmes Modales. *Scientia* 102 (1967): 565–572.
(a) Qualche osservazione su logica del tempo e sistemi modali. [Italian translation of the preceding] In *La Logica del tempo.* Edited by Claudio Pizzi. Pp. 243–254. Turin: Boringhieri, 1974.

217. Vetenskapens villkor i dagens Finland. [The Conditions of Scientific Research in Finland today] *Hufvudstadsbladet* 15 January 1967: 9–10. Reprinted in *Finlandssvenskarna i 1970-talets utbildningssamhälle,* edited by Märta Tikkanen. Pp. 114–123. Ekenäs: Ekenäs Tryckeri Aktiebolags Förlag, 1967. Svenska Kulturfondens Skrifter. 2.
(a) Tieteen ehdot nykypäivän Suomessa. [Finnish translation of item 217 by Tauno Nyberg] In *Kertomus Suomen Akatemian toiminnasta vuonna 1966,* pp. 10–19. Helsinki: 1967.
(b) Vitenskapens vilkår i dagens Finland. [Norwegian translation of item 217 by Olav Flo] *Forskningsnytt* 12 (1967): 51–56.

218. Kriget mot Vietnam. [The War against Vietnam] *Hufvudstadsbladet* 28 November 1967. See also item 228.
(a) Also printed in *Dagens Nyheter* 28 and 30 November 1967. Later published as a pamphlet, Stockholm: Svenska kommittén för Vietnam, 1968.
(b) Vietnamin sota ja Yhdysvaltain pulma. [Finnish translation of item 218 by Pekka Tarkka. See also items 228(a) and (b)] *Helsingin Sanomat* 28 November 1967.
(c) USA i Vietnam. [Danish translation of item 218] *Information* 24 and 27 December 1967.

219. *An Essay in Deontic Logic and the General Theory of Action. With a Bibliography of Deontic and Imperative Logic.* Amsterdam: North-Holland Publishing Co., 1968. 110 pp. Acta Philosophica Fennica. Fasc. 21.

(a) *Un Ensayo de Logica Deóntica y la Teoría General de la Acción. Con una bilbliografía de lógica deóntica y de los imperativos.* [Spanish translation of item 219 by Ernesto Garzón Valdés] Mexico, D. F. Instituto de investigaciones filosóficas. Universidad Nacional Autónoma de México. Quaderno 33: 1976. 133 pp.

220. The Logic of Practical Discourse. In *Contemporary Philosophy, A Survey,* edited by Raymond Klibansky, vol. 1. Pp. 141–167. Florence: La Nuova Italia Editrice, 1968.

221. Deontic Logic and the Ontology of Norms. In *Akten des 14. Internationalen Kongresses für Philosophie.* Vol. 2, pp. 304–311. Vienna: Verlag Herder, 1968.

222. Deontic Logic and the Theory of Conditions. *Crítica* 2 (1968): 3–25. (Summary in Spanish, pp. 27–31).
(a) Reprinted with some revisions in *Deontic Logic: Introductory and Systematic Readings,* edited by Risto Hilpinen. Pp. 159–177. Dordrecht-Holland: D. Reidel, 1971.
(b) German translation of 222(a) in item 291, pp. 19–39.

223. 'Always'. *Theoria* 34 (1968): 208–221.

224. Suomen Akatemia katsoo tulevaisuuteen. [The Academy of Finland Looks toward the Future] In *Kertomus Suomen Akatemian toiminnasta vuonna 1967,* pp. 7–14. Helsinki: 1968.

225. Alkusanat. [Foreword to] *Suomen Akatemia Puhuu.* Pp. 7–9. Helsinki: Werner Söderström, 1968.

226. Om förklaringar i historievetenskapen. [On Explanations in History] *Historiallinen Arkisto* 63 (1968): 155–169. Lecture given to the Scandinavian Meeting of Historians. Helsingfors: 9 August 1967. Discussion, pp. 169–174. Also printed in *Historiska Förklaringar,* edited by Dag Lindberg, pp. 7–24. Oslo: Universitetsforlaget, 1969. Studier i historisk metode. 4.
(a) Historiallisista selityksistä. [Finnish translation of item 226 by Tauno Nyberg. Summary in English, pp. 327–28] *Historiallinen Aikakauskirja* 65 (1967): 311–327.
(b) Also published in *Suomen Akatemia Puhuu.* Pp. 178–201. Helsinki: Werner Söderström, 1968.

227. Alienering eller integration—den lilla enhetens livsfråga. [Alienation or Integration—a vital question for small ethnic groups] *Svensk-Finland* 28 (1968): 3–11. Also published in *Åbo Underrättelser* 20, 21, and 22 February 1968.

228. Försök till en efterskrift. *Hufvudstadsbladet* 11 September 1968. Attempt at a Postscript to item 218 after the invasion of Czechoslovakia.
(a) Elokuussa 1968: muutama sana jälkilauseeksi. [August 1968, a short Postscript. Finnish translation of the preceding by Tuomas Anhava. Published together with item 218(b)] In *Praha 21 August 1968.* Edited by Jaakko Okker. Pp. 68–80. Helsinki: Tammi, 1968.
(b) Sota Vietnamia vastaan. In *Asiatekstejä lukioon ja aikuiskasvatukseen.* Edited by Aila Harju et al. Pp. 90–102. Helsinki: Tammi, 1969.

229. *Time, Change and Contradiction.* London: Cambridge University Press, 1969.

32 pp. The twenty-second Arthur Stanley Eddington Memorial Lecture, delivered at Cambridge University, 1 November 1968.

(a) Tempo, cambiamento e contraddizione. [Italian translation of the preceding] In *La Logica del Tempo*. Edited by Claudio Pizzi. Pp. 255–279. Turin: Boringhieri 1974.

(b) Tid, forandring og kontradiksjon. [Norwegian translation of the preceding by Jorunn and Knut Björngaard. Dedicated to the Memory of A. N. Prior] Tilegnet A. N. Priors minne. *Norsk Filosofisk Tidsskrift* 5 (1970): 1–18.

230. On the Logic and Ontology of Norms. In *Philosophical Logic*. Edited by J. W. Davis et al. Pp. 89–107. Synthese Library 20. Dordrecht-Holland: D. Reidel, 1969.

231. Die Entstehung des *Tractatus Logico-philosophicus*. [Translation into German, by Walter Methlagl, of an earlier version of item 231(a)] In Ludwig Wittgenstein, *Briefe an Ludwig von Ficker*. Aus dem Englischen übersetzt von Walter Methlagl. Pp. 71–110. Salzburg: Otto Müller Verlag, 1969. For particulars, see also item 007.

(a) Historical Introduction: The Origin of Wittgenstein's *Tractatus*. In *Prototractatus*. An early version of *Tractatus Logico-philosophicus* by Ludwig Wittgenstein, edited by B. F. McGuinness, T. Nyberg, and G. H. von Wright. Pp. 1–34. London: Routledge and Kegan Paul, 1971.

(b) The Origin of Wittgenstein's *Tractatus*. In *Wittgenstein: Sources and Perspectives*, edited by C. G. Luckhardt. Pp. 99–137. Ithaca, NY: Cornell University Press, 1979. A re-issue of item 231(a) with some revisions.

(c) A revised and expanded version of 231(a) is printed in item 336.

232. (With G. E. M. Anscombe) Vorwort—Preface. In Ludwig Wittgenstein, *Über Gewissheit—On Certainty*, pp. vi–vii. Oxford: Basil Blackwell, 1969. See also item 006.

233. Wittgenstein's Views on Probability. *Revue Internationale de Philosophie* 23 (1969): 259–279. Followed by a Discussion, pp. 279–283. Contributors: A. R. Raggio, Max Black, B. F. McGuinness, G. G. Granger, J. Vuillemin, M. Rousseau. Replies by Professor von Wright.

(a) A revised version of item 233 is reprinted in item 336.

234. The Wittgenstein Papers. *Philosophical Review* 78 (1969): 483–501.

(a) A much revised version of item 234 is reprinted in item 336.

235. Ordförandens hälsningstal. Societas Scientiarum Fennica. Årsbok-Vuosikirja 45 (1966–67): 45–51. Helsingfors: 1969. Presidental address, given to the Finnish Society of Sciences, 29 April 1967.

236. Johannes Sundwall, Håkan Lindberg, Osvald Sirén [in Memoriam]. Ibid., 21–24.

237. Luitzen Egbertus Jan Brouwer [in Memoriam]. Ibid., 40–41.

238. Finlandssvensk högskoleplanering. [University Planning in Swedish-speaking Finland] *Hufvudstadsbladet* 17 August 1969.

239. A Note on Confirmation Theory and on the Concept of Evidence. *Scientia* 105 (1970): 595–606. Also published in *Logic and Value: Essays dedicated to Thorild Dahlquist on his fiftieth birthday*, edited by Tom Pauli. Pp. 36–51. Mimeographed

volume. Uppsala: 1970. Filosofiska studier utgivna av Filosofiska föreningen och Filosofiska institutionen vid Uppsala Universitet. No. 9.
(a) A revised version of item 239 is reprinted in item 345.

240. Suomen Akatemia—vanha ja uusi. [The Academy of Finland—the Old and the New One] In *Kertomus akatemian toiminnasta vuosina 1968–1969*, pp. 10–15. Helsinki: 1970.
(a) Also printed, with some abbreviations, in *Helsingin Sanomat* 2 January 1970.

241. Russellin oikeustaistelu haaste filosofikunnalle. [Russell's Fight for Justice, a Challenge to Philosophers. Finnish translation, by M. Niiniluoto, of part of an Address at the Opening-session of the 'Entretiens de Helsinki de l'Institut International de Philosophie', 25 August 1970] *Helsingin Sanomat* 26 August 1970.

242. *Explanation and Understanding*. xvii & 230 pp. Cornell Contemporary Philosophy Series/International Library of Philosophy and Scientific Method. Ithaca, N.Y.: Cornell University Press, and London: Routledge and Kegan Paul, 1971.
(a) *Erklären und Verstehen*. [German translation of the preceding by Günther Grewendorf and Georg Meggle] Aus dem Englishen von Günther Grewendorf und Georg Meggle.Fischer Athenäum Taschenbücher. Grundlagenforschung. Frankfurt: Athenäum Fischer Taschenbuch Verlag, 1974. 197 pp.
(b) *Objasnjenje i Razumevanje*. [Serbo-Croat translation of the preceding by Aleksandar Pavković. With an Introduction, pp. 9–48, by Mihailo Marković] Belgrade: Nolit, 1975.
(c) *Spiegazione e Comprensione*. [Italian translation of item 242 by Giuliano di Bernardo] Bologna: il Mulino, 197. Introduction, pp. 7–12, by Giuliano di Bernardo. Preface, pp. 15–16, for the Italian edition by G. H. von Wright. 233 pp.
(d) *Explicación y Comprensión*. [Spanish translation of item 242 by Luis Vega Reñón] Madrid: Alianza Editorial, 1979. 198 pp.
(e) Japanese translation of item 242 by Takashi Maruyama. Nobui Kioka, 1984. 306 pp.

243. Editor's Preface. In *Prototractatus*. An early version of *Tractatus Logico-philosophicus* by Ludwig Wittgenstein, pp. 35–37. London: Routledge and Kegan Paul, 1971. See also items 231(a) and 008.

244. Note on Variations between the different Editions of the *Tractatus*. Ibid., pp. 255–56.

245. Saatesanat. [Foreword to] Ludwig Wittgenstein, *Tractatus Logico-philosophicus*. Translated into Finnish by Heikki Nyman, pp. ix–xii. Helsinki: Werner Söderström, 1971.

246. Wittgenstein, Ludwig (1889–1951). In *The Dictionary of National Biography 1951–1960*.Edited by E. T. Williams and Helen M. Palmer. Pp. 1068–1071. London: Oxford University Press, 1971. This biography was written in the 1950s.

247. Katsaus logiikan kehitykseen. [A Survey of the Development of Logic] In *Logiikka ja matematiikka. Studia logica et mathematica*, p. 9–39. Helsinki: Werner Söderström, 1971.

248. Niin kutsutusta praktisesta päättelystä. [On so-called Practical Inference. Finnish

al inference. *Acta Sociologica* 15 (1972): 39–53. A re-
vised version of item 248. Reprinted in *Practical Reasoning,* edited by Joseph
Raz. Pp. 56–62. Oxford Readings in Philosophy. Oxford: Oxford University
Press, 1978.
(b) German translation of item 248(a) in item 291, pp. 61–81.
(c) A revised version of item 248(a) is reprinted in item 344.

249. Introduction. In *Contemporary Philosophy in Scandinavia.* Edited by Raymond
E. Olson and Anthony M. Paul. Pp. 1–12. Baltimore and London: The Johns Hop-
kins Press, 1972.

250. Some Observations on Modal Logic and Philosophical Systems. Ibid., pp. 17–
26. See also item 336.
(a) A preliminary version of the above paper was published in a volume in honor
of Professor Konrad Marc-Wogau: *Nio Filosofiska Studier Tillägnade Konrad
Marc-Wogau:* 30 June 1968. Edited by Hjalmar Wennerberg. Pp. 87–100.
Filosofiska studier utgivna av Filosofiska föreningen och Filosofiska instituti-
onen vid Uppsala Universitet. No. 6. Uppsala: 1968. Mimeographed.

251. Preface. In *Problems in the Theory of Knowledge.* Edited by G. H. von Wright.
Pp. vii–viii. The Hague: Martinus Nijhoff, 1972. See also item 009.

252. Wittgenstein on Certainty. Ibid., pp. 47–60.
(a) Wittgenstein varmuudesta. [A Finnish translation of the preceding] In Ludwig
Wittgenstein, *Varmuudesta.* Translated by Heikki Nyman. Pp. 11–30. Porvoo-
Helsinki: Werner Söderström, 1975.
(b) Item 252 reprinted with revisions in item 336.

253. Foreword. In Erik Stenius, *Critical Essays,* p. 5. Acta Philosophica Fennica.
Fasc. 25. Amsterdam: North-Holland Publishing Co., 1972.

254. The Logic of Preference Reconsidered. *Theory and Decision* 3 (1972): 140–169.
(a) Reprinted with revisions in item 345.

255. Människor, matematik och maskiner. [Men, Mathematics, and Machines. Lec-
ture given at the Opening Session of the Nord Data Conference, Helsinki: 14 June
1972] *Data* 2 (1972): 23–26. Reprinted with minor revisions in item 296.
(a) Tietokone mullistaa yhteiskunnan. [Abridged translation into Finnish of the
preceding] *Helsingin Sanomat* 14 June 1972.

256. Vietnam i slagrutan. [Letter to the Editor on Vietnam] *Hufvudstadsbladet* 26
March 1972.

257. Marxismen som en humanism. [Marxism as a Humanism. Review-discussion of
Mihailo Marković, *Att Utveckla Socialismen.* Stockholm: Prisma, 1972] *Dagens
Nyheter* 13 August 1972.
(a) Marxilaisuuden uudet tuulet. [Finnish translation of the preceding] *Suomen
Kuvalehti* 19 January 1973.

258. Truth as Modality. A Contribution to the Logic of Sense and Nonsense. In *Mo-
dality, Morality and Other Problems of Sense and Nonsense.* Essays dedicated to
Sören Halldén. Pp. 142–150. Lund: Gleerups, 1973.

259. Foreword. In Ludwig Wittgenstein, *Letters to C. K. Ogden with Comments on the English Translation of the 'Tractatus Logico-philosophicus'*, pp. vii–ix. Oxford: Basil Blackwell, and London: Routledge and Kegan Paul, 1973. See also item 010.

260. Introduction. Ibid., pp. 1–13.

261. On the Logic and Epistemology of the Causal Relation. In *Logic, Methodology and Philosophy of Science. IV*, edited by Patrick Suppes et al. Pp. 93–312. Studies in Logic and the Foundations of Mathematics. 74. Amsterdam: North-Holland Publishing Co., 1973. Reprinted in *Causation and Conditionals*, edited by Ernest Sosa. Pp. 95–113. Oxford Readings in Philosophy. London: Oxford University Press, 1975.

262. Charlie Dunbar Broad [in Memoriam]. Societas Scientiarum Fennica. *Årsbok-Vuosikirja* 50 (1971–1972): 25–26. Helsingfors: 1973.

263. Deontic Logic Revisited. *Rechtstheorie* 4 (1973): 37–46.
 (a) Reencuentro con la lógica deóntica. [Spanish translation of item 263 by Eugenio Bulygin] In *Derecho, Filosofía y Lenguaje*. Homenaje a Ambrosio L. Gioja. Edited by J. A. Bacque et al. Pp. 225–235. Collección mayor Filosofía y Derecho. Buenos Aires: Editorial Astreal, 1976.
 (b) Spanish translation, by Jesús Rodrigues Marín, in item 303, pp. 29–67.

264. Remarks on the Logic of Predication. *Ajatus* 35 (1973): 158–167.

265. Determinismi ja ihmistutkimus. [Determinism and the Study of Man. Summary in Finnish of a Paper in English read at the Jyväskylä Summer Festival, 3 July 1973] *Katsaus* 1 (1973): 3–7. Cf. item 281.

266. Aseet vaikenevat Vietnamissa. [Truce in Vietnam] *Yleisradion Julkaisusarja* 40 (1973): 5–9.

267. Brev till redaktören. [Letter to the Editor on the Philosophical Society of Finland] *Hufvudstadsbladet* 11 April 1973.

268. Klimatet hårdnar. [On Repressive Measures against Intellectuals in Yugoslavia] *Dagens Nyheter* 20 September 1973.

269. *Causality and Determinism*. New York and London: Columbia University Press, 1973. xxii & 143 pp. Woodbridge Lectures Delivered at Columbia University, October–November of 1972.
 (a) *Causalità e Determinismo*. [Italian translation of item 269 by Paolo Allegri. With an introductory essay by Stefano Besoli, pp. 1–40]

270. Handlungslogik. In *Normenlogik, Grundprobleme der deontischen Logik,* edited by Hans Lenk. Pp. 9–24. Uni-Taschenbücher. 414. Munich-Pullach: Verlag Dokumentation, 1974. Reprinted in item 291, pp. 105–118.
 (a) Reprinted, with minor changes, under the title 'Elemente der Handlungslogik', in *Handlungstheorien—Interdisziplinär*, vol. 1, edited by Hans Lenk, pp. 21–34. Kritische Information, 62. Munich: Wilhelm Fink Verlag, 1980.

271. Normenlogik. In *Normenlogik, Grundprobleme der deontischen Logik,* pp. 25–38. Reprinted in item 291, pp. 119–130.

272. Introduction. In Ludwig Wittgenstein, *Letters to Russell, Keynes and Moore,* pp. 1–5. Oxford: Basil Blackwell, 1974. See also item 011.

273. Determinismus, Wahrheit und Zeitlichkeit, ein Beitrag zum Problem der zukünftigen kontingenten Wahrheiten. *Studia Leibnitiana* 6 (1974): 161–178.
(a) Determinism, Istina i Vremennoi Parametr. [Russian translation of the above with an Introduction by I. S. Narski] *Filosofskie Nauki* 18 (1975): 106–119.

274. Letter to the Editors. [On Repression in Yugoslavia] *Journal of Philosophy* 71 (1974): 756–58.

275. Inledningsanförande. In *Från grundskola till vuxenutbildning i finlandssvenskt perspektiv.* Edited by H. Westerlund. Pp. 23–28. Helsingfors: Holger Schildts förlag, 1974. Inaugural Address delivered at a Conference on Education among the Swedish speaking population of Finland, held in Åbo (Turku), 18 January 1974.

276. Förtrycket ökar i Jugoslavien. [On Repressive Measures against Intellectuals in Yugoslavia] *Dagens Nyheter* 31 October 1974.
(a) Quo Vadis, Tito? [Identical with the preceding] *Hufvudstadsbladet* 31 October 1974.

277. Tal vid Fakultetens för Pedagogiska Vetenskaper vid Åbo Akademi invigning i Vasa, den 28 September 1974. [Address delivered on the occasion of the Inauguration of the Faculty of Education at Åbo Akademi in Vasa, 28 September 1974] *Åbo Akademi, Reports from the Faculty of Education* 1 (1975): 1–11.

278. Protest mot förtryck av jugoslaviska forskare. [Protest against Harassment of Yugoslav Scholars] *Hufvudstadsbladet* 3 January 1975.

279. Et brev til Tito. *Verdens Gang* 4 February 1975. A Letter to the President of Yugoslavia, dealing with the same problem as item 278.

280. Replies to Commentators. Second Thoughts on Explanation and Understanding. In *Essays on Explanation and Understanding: Studies in the Foundations of Humanities and Social Sciences,* Edited by Juha Manninen and Raimo Tuomela, pp. 371–413. Synthese Library. 72. Dordrecht-Holland: D. Reidel Publishing Co., 1976. Most of the papers in this collection were presented at an International Colloquium on Explanation and Understanding held in Helsingfors, Finland, January 24–26, 1974.
(a) Erwiderungen. [German translation, by G. Meggle and M. Ulkan, of a somewhat expanded version of item 280] In *Neue Versuche über Erklären und Verstehen.* Edited by Karl-Otto Apel et al. Pp. 264–302. Frankfurt: Suhrkamp Verlag, 1978.

281. Determinism and the Study of Man. In *Essays on Explanation and Understanding,* pp. 415–435.
(a) German translation in item 291, pp. 131–152.
(b) Determinismi ja ihmistutkimus. [Finnish translation of the preceding by Jyrki Uusitalo] In *Yhteiskuntatieteiden filosofiset perusteet. II.* Edited by R. Tuomela and I. Patoluoto. Pp. 114–138. Helsinki: Gaudeamus, 1976.
(c) Il determinismo e lo studio dell'uomo. In *La spiegazione storica.* Edited by Raffaella Simili. Pp. 233–262. Parma: Pratiche Editrice, 1984.

282. Det aristoteliska möjlighetsbegreppet och determinismen. [The Aristotelian Con-

cept of Possibility and Determinism. Paper read at the Scandinavian Symposium on Casuality in Oslo, 11–12 April 1975] In *Kausalitet*. Edited by Dagfinn Føllesdal et al. Pp. 1–15. Oslo: Universitetet i Oslo, Institutt for filosofi, 1976.

283. Kausalitet och handling. [Causality and Action. Paper read at the above Symposium] Ibid., pp. 121–131.

284. Kanslers hälsning till österbottniska nationen. [The Chancellor's Greeting to the Students Nation of Ostrobottnia] In *Österbottniska Nationen vid Åbo Akademi*. Edited by Chr. Carlsson. Pp. 6–7. Jakobstad: 1976.

285. Humanismi—taisteleva elämänasenne. [Humanism—a Fighting Attitude to Life. Based on a paper read at the Jyväskylä Summer Festival, 2 July 1976] *Kanava* 4 (1976): 453–461. Reprinted from 296(b) in *Aatevirtaukset*. Edited by H. Kirjavainen. Pp. 18–42. Helsinki: Yliopistopaino, 1985.

(a) *What Is Humanism?* The Lindley Lecture, University of Kansas, 19 October 1976. Lawrence, Kansas, 1977. 25 pp. A somewhat amended and expanded version of the preceding.

(b) *Humanismen som livshållning*. Lund: Tegnérsamfundet, 1977. 43 pp. A somewhat amended and expanded version of items 285 and 285(a), based on a paper read to the Tegnér Society, Lund, on 2 November 1976. Reprinted with minor revisions in item 296: pp. 157–184.

286. De intellektuellas svåra ställning i Jugoslavien. [The Plight of Intellectuals in Yugoslavia] *Dagens Nyheter* 28 March 1976.

287. Quo usque tandem—? [In Defense of Freedom of Research] *Hufvudstadsbladet* 24 November 1976.

(a) Quo usque tandem—? [A Finnish translation of item 287 by Pekka Tarkka] *Helsingin Sanomat* 24 November 1976. Reprinted in *Sosiologia* 13 (1976): 189–190.

288. 'Vetenskapsakademin belönar en mänsklighetens skadegörare'. *Dagens Nyheter* 7 December 1976. A protest against the awarding of the Nobel Prize in Economics to Milton Friedman.

289. Svar till Lundberg om ekonomipriset. *Dagens Nyheter* 7 December 1976. Reply to Professor Lundberg about the Nobel Prize in Economics.

290. Nobelpris, vetenskap och moral. [Nobel Prizes, Scholarship, and Morality. A Reply to Professor Nils Meinander] *Hufvudstadsbladet* 12 December 1976.

291. *Handlung, Norm und Intention: Untersuchungen zur deontischen Logik*. Introduction and edited by Hans Poser. De Gruyter Studienbuch: Grundlagen der Kommunikation. Berlin and New York: Walter de Gruyter, 1977. xxix & 158 pp. A collection of essays. Contains translations into German by D. Wengel and Hans Poser of items 123, 195, 214, 222(a), 248(a), 270, 271, and 281.

292. Modaljnaja logika mestopolosjenij. *Filosofskie Nauki* 20 (1977): 112–19.

(a) A Modal Logic of Place. [A slightly revised and abbreviated translation of item 292] In *The Philosophy of Nicholas Rescher*. Edited by Ernest Sosa, pp. 65–73. Philosophical Studies Series in Philosophy. 15. Dordrecht-Holland: D. Reidel, 1979.

(b) Paikan modaalilogiikka. [Finnish translation of item 292 by Heikki Nyman] In

Kosmologian naailmankuva. Edited by Chr. Gefwert, pp. 155–167. Helsinki: Werner Söderström, 1980.

(c) Item 292(a) reprinted with revisions in item 345.

293. Prefazione all'edizione italiana. In *Spiegazione e Comprensione,* pp. 15–16. Bologna: il Mulino, 1977. See also item 242(c).

294. Zur Einführung. In *Deontische Logik und Semantik.* Edited by Amadeo G. Conte et al. Pp. 7–8. Wiesbaden: Athenaion, 1977. See also item 013.

(a) Introduzione. In *Logica deontica e semantica.* Edited by Guiliano di Bernardo. Pp. 35–37. Bologna: il Mulino, 1977.

295. Vorwort. In Ludwig Wittgenstein, *Vermischte Bemerkungen.* Pp. 7–10. Frankfurt: Suhrkamp, 1977. See also item 012.

296. *Humanismen som livshållning och andra essayer.* [What Is Humanism? and Other Essays. Contains slightly revised versions of items 67, 179, 183, 193, 255, 285(b) plus 'Autobiographical Preface' and 'On Marx and Marxism'] Helsingfors: Söderströms, 1978. 185 pp.

(a) Reprint of item 296 with minor revisions. Helsingfors: Söderströms, 1979.

(b) *Humanismi elämänasenteena.* [Finnish translation, by Kai Kaila, of items 296 and 331] Helsinki: Otava, 1981.

297. En filosof ser på filosofien. [A Philosopher Looks at Philosophy. First published in a collection of essays dedicated to Anders Wedberg] In *En filosofibok.* Edited by Lars Bergström et al. Pp. 188–205. Stockholm: Bonniers, 1978. Reprinted in *Ajatus* 40 (1983): 49–67.

298. Wittgenstein in Relation to His Times. [Opening Address at the Second International Wittgenstein Symposium. Kirchberg, Austria, 29 August 1977] In *Wittgenstein and His Impact on Contemporary Thought.* Edited by Elisabeth Leinfellner et al. Pp. 73–78. Vienna: Hölder-Pichler-Tempsky, 1978.

(a) Wittgenstein suhteessa aikaansa. [Finnish translation of item 298 by Heikki Nyman] In Ludwig Wittgenstein, *Yleisiä humautuksia,* translated by Heikki Nyman. Pp. 13–27. Porvoo-Helsinki: Werner Söderström, 1979.

(b) Wittgenstein und seine Zeit. [German translation of item 298 by J. Schulte] In Ludwig Wittgenstein, *Schriften, Beiheft 3,* pp. 103–114. Frankfurt: Suhrkamp Verlag, 1979.

(c) Wittgenstein in Relation to his Times. [A reprint, with some changes, of 298] In *Wittgenstein and His Times,* edited by Brian McGuinness, pp. 108–120. Oxford: Basil Blackwell, 1982.

(d) Wittgenstein et son temps. [French translation of item 298 by J. P. Cometti.] *SUD.* Revue Litteraire Bimestrielle 16 (1986):173–188. (Hors série.)

299. Saatesanat. [Foreword to] Ludwig Wittgenstein, *Zettel.* Translated into Finnish by Heikki Nyman. Pp. 5–7. Helsinki: Werner Söderström, 1978.

300. (With Quentin Skinner and Ernest Nagel) Comment (on a paper by Mihailo Marković). In *Research in Sociology of Knowledge, Science and Art.* Vol. 1. Edited by R. A. Jones. Pp. 26–61. Greenwich, CT: The Jay Press, 1978.

301. Avslutande betraktelser om högskolor, forskning och kulturpolitik. [Concluding Reflections on Universities, Research, and Cultural Policies] *Finsk Tidskrift* 201–202 (1978): 1–26.

302. Vetenskapens historia i Finland under Autonomiens tid. *Historisk Tidskrift för Finland* 63 (1978): 501–03. A presentation of the series *The History of Learning and Science in Finland 1828–1918*. Professor von Wright, Chief Editor.

303. *Logica deóntica: Con una Introducción Critica del autor.* Cuadernos Teorema 28. Valencia: 1979. 67 pp. Contains a Spanish translation of items 123 and 263 by Jesús Rodriguez Marín and a critical introduction by the author.

304. The Origin and Composition of Wittgenstein's *Investigations.* In *Wittgenstein: Sources and Perspectives,* edited by C. G. Luckhardt. Pp. 138–160. Ithaca, NY: Cornell University Press, 1979.
(a) Reprinted with revisions in item 336.

305. Introduction. In *Eino Kaila, Reality and Experience,* edited by R. S. Cohen. Pp. ix–xlii. Vienna Circle Collection. 12. Dordrecht-Holland: D. Reidel, 1979.

306. The 'Master Argument' of Diodorus. In *Essays in Honour of Jaakko Hintikka.* Edited by Esa Saarinen et al. Pp. 297–307. Synthese Library. 124. Dordrecht-Holland: D. Reidel, 1979.

307. Time, Truth and Necessity. In *Intention & Intentionality: Essays in Honour of G. E. M. Anscombe.* Edited by Cora Diamond and Jenny Teichman. Pp. 237–250. Brighton, England: Harvester Press, 1979.

308. Diachronic and Synchronic Modalities. *Teorema* 9 (1979): 231–245.
(a) Modalidades diacrónicas y sincrónicas. [Spanish translation of item 308 by Ana Sánchez and Teresa Orduña] *Teorema* 9 (1979): 231–245.
(b) Diachronic and Synchronic Modalities. [A somewhat revised and abridged version of item 308] In *Intensional Logics: Theory and Applications.* Edited by Ilkka Niiniluoto and Esa Saarinen. Pp. 42–49. Acta Philosophica Fennica, vol. 35. Helsinki: Societas Philosophica Fennica, 1982.

309. Das menschliche Handeln im Lichte seiner Ursachen und Gründe. In *Handlungstheorien—Interdisziplinär,* vol. 2. Zweiter Halbband. Edited by Hans Lenk. Pp. 417–430. Kritische Information. 63. Munich: Wilhelm Fink Verlag, 1979.

310. The Determinants of Action. In *Reason, Action, and Experience.* Essays in honor of Raymond Klibansky. Edited by Helmut Kohlenberger. Pp. 107–119. Hamburg: Felix Meiner Verlag, 1979.

311. O Homem, a Natureza e o Futuro. *Encontros Internacionais da Universidade de Brásília.* 1979. 6 pp.

312. A Note on a Note on Practical Syllogisms. *Erkenntnis* 14 (1979): 355–57.

313. Hjalmar Magnus Eklund. Ett hundra års minne. [Hjalmar Magnus Eklund. A Centenary] *Finsk Tidskrift* 205–06 (1979): 479–495. Eklund (1880–1936) was the pioneer of the study of mathematical logic in Finland.
(a) Hjalmar Magnus Eklund—muuan satavuotismuisto. [Finnish translation of item 313 by Juha Manninen] *Tiede ja Edistys* 5 (1980): 3–12.

314. Filosofian tilasta ja tehtävästä. [On the State and Task of Philosophy. Answers, written by Professor von Wright, to interview questions] *Filosofinen Kulttuurilehti Genesis* 1 (1979): 11–13.

315. *Freedom and Determination*. Acta Philosophica Fennica, vol. 31, no. 1. Amsterdam: North-Holland Publishing Co., 1980. 88 pp.
 (a) *Libertà e Determinazione*. [Italian translation of item 315 by Raffaella Simili. With an Introduction, pp. 5–20, by Raffaella Simili, and a Preface for the Italian edition, pp. 21–27, by G. H. von Wright] Parma: Pratiche Editrice, 1984.

316. Modallogik. In *Handbuch Wissenschaftstheoretischer Begriffe*, vol. 2, pp. 433–37. Edited by Josef Speck. Göttingen: Vandenhoeck & Ruprecht, 1980.

317. Logik, deontische. In *Historisches Wörterbuch der Philosophie*, vol. 5, pp. 384–89. Basel-Stuttgart: Schwabe & Co. A. G. Verlag, 1980.

318. Totuus ja contingentia futura. [*Truth and Future Contingents*] In *Totuus*, Reports from the Department of Philosophy, University of Helsinki 9 (1980), pp. 101–110.

319. Humanism and the Humanities. [Address delivered in Uppsala 8 June 1977 in connection with the 500 years jubilee of the University] Kungl. Vetenskapssamhället s i Uppsala Årsbok 22 (1979): 32–47. Reprinted in *Philosophy and Grammar*, edited by Stig Kanger and Sven Öhman. Pp. 1–16. Dordrecht-Holland: D. Reidel, 1981.

320. Preface. In *Logic and Philosophy*, pp. vii–viii. The Hague: Martinus Nijhoff, 1980. See also item 014.

321. Zametjanija Professor von Raita k russkomy perevody logitjiskich sotjinenij Aristotelja. [Remarks by Professor von Wright to the Russian translation of the logical works of Aristotle] *Izvestija Akademii Nauk Gruzinskoj* SSR, Serija filosofii i psikologii (1980): 103–04.

322. Människan, tekniken, framtiden. [Man, Technics, and the Future. A Summary, written by Professor von Wright, of an address given at the Centenary Jubilee of Tekniska Föreningen i Finland, 29 March 1980] *Hufvudstadsbladet* 30 March 1980. Reprinted in *Insinööriuutiset—Ingenjörsnytt* 4 April 1980.
 (a) Ihminen, tekniikka, tulevaisuus. [Finnish translation of item 322 by Johan Ringbom] *Contactor* 16 (1980): 2.
 (b) Människan, tekniken och framtiden. [A somewhat revised and expanded version of item 322] *Forskning och framsteg* (1980): 45–48.

323. Mänsklighetens villkor—teknologi och filosofi, samhälle och engagemang i en hotad värld [The Condition of Man - Technology and Philosophy, Society and Engagement in a Troubled World. Answers, written by Professor von Wright, to interview questions by Thomas Wallgren] *Studentbladet* 18 April 1980.
 (a) Ihmisyyden ehdot. [Finnish translation of item 324 by Riitta Tamminen] *Näköpiiri* 3 (1980): 10–13.

324. Kasvun ideologia on sokaissut yhteiskunnan. [The Ideology of Growth Has Blinded Society. Answers, written by Professor von Wright, to interview questions by Harri Saukkomaa] *Helsingin Sanomat* 14 September 1980.

325. Problems and Prospects of Deontic Logic. A Survey. In *Modern Logic—A Survey*. Edited by Evandro Agazzi. Pp. 399–423. Dordrecht-Holland: D. Reidel, 1981.

326. Explanation and Understanding of Action. *Revue Internationale de Philosophie* 35 (1981): 127–142.

327. On the Logic of Norms and Actions. In *New Studies in Deontic Logic*. Edited by Risto Hilpinen. Pp. 3–35. Dordrecht-Holland: D. Reidel, 1981.
 (a) Reprinted, with revisions, in item 344.

328. Action Theory as a Basis for Deontic Logic. *Normative Structures of the Social World*, Preprint 1. Trento, Libera Università degli Studi, Dipartimento di Metodologia, Teoria e Storia Sociale, 1981.
 (a) Reprinted in *Normative Structures of the Social World*. Edited by Giuliano di Bernardo. Pp. 39–63. Amsterdam: Rodopi, 1988.

329. Introduction. [An Introduction on Philosophical Logic, written for the second part of the work] *Contemporary Philosophy, A New Survey*, vol. 1, pp. 227–233. Edited by G. Fløistad. The Hague: Martinus Nijhoff, 1981. See also item 018.

330. Saatesanat. Foreword to Ludwig Wittgenstein, *Philosophische Untersuchungen*. Translated into Finnish by Heikki Nyman. Pp. 7–12. Helsinki: Werner Söderström, 1981.

331. Människan, tekniken och framtiden. [Man, Technics, and the Future. Address given at the Centenary Jubilee of Tekniska Föreningen i Finland, 29th March 1980] In *Teknik, forskning, innovation, framtidsansvar*, pp. 81–88. Helsinki 1981. Also printed in *Datorerna och samhällsutvecklingen*, pp. 15–27. Stockholm: Tiden, 1981. Also in *Ny teknik* 8, 1982 and in *Dackekuriren* 3, 1982. See also items 296(b), 311, 322, and 340.

332. Inlägg i debatten. [A contribution to a symposium at Bomersvik, Sweden, May 1980 on the impact of electronics on social developments] In *Datorerna och samhällsutvecklingen*, pp. 115–121. Stockholm: Tiden, 1981.

333. Itsekkyys ja solidaarisuus. [Egoism and Solidarity. An appeal on the Finnish radio for global solidarity] *Näköpiiri* 4 (1981): 18–19.
 (a) What Do I Fear—What Are My Hopes? [English translation, by Greg Cogan, of item 333] *Blue Wings* 1981: 24–27.

334. Ajatuksia sodasta ja rauhasta. [Thoughts on War and Peace. A radio broadcast] *Suomen Kuvalehti* 1981: 15–17.
 (a) Tankar om krig och fred. In *Vår röst en makt*, pp. 96–104. Södertälje: Gidlunds, 1982.
 (b) Självbesinning eller självförintelse? [A much revised version of item 334(a)] *Fredsposten* 26 (1982): 3–6.

335. Rolf Nevanlinna. Tankar vid hans bortgång. [Rolf Nevanlinna. In Memoriam] In *Rolf Nevanlinna in Memoriam*, pp. 28–33. Helsinki: Otava, 1981.

336. *Wittgenstein*. Oxford: Basil Blackwell, 1982. vi & 218 pp. Contents: Revised versions of items 145, 234, 231(a), 304, 233, 252, and 298, and an essay 'Modal Logic and the *Tractatus*' partly based on item 250.
 (a) *Wittgenstein*. [Italian translation, by Alberto Emeliani, of item 336. With an introduction, pp. 7–19, by Jochim Schulte] Bologna: Mulino, 1983. 269 pp.
 (b) *Wittgenstein*. [German translation, by Joachim Schulte, of item 336 with some additions and corrections.] Frankfurt am Main: Suhrkamp, 1986. 226 pp.
 (c) *Wittgenstein*. [French translation, by Elisabeth Regal, of item 336 with the same additions and corrections as in 336(b).] Mauvezin: Trans-Europ-Repress, 1986. 229 pp.

337. Determinism and Knowledge of the Future. *Tulevaisuuden Tutkimuksen Seuran Julkaisu A4.* Turku 1982. 25 pp.
 (a) Determinismi ja tulevaisuuden tietäminen. [Finnish translation of item 337 by Heikki Nyman] In *Tulevaisuuden tutkimus Suomessa,* edited by P. Malaska and Mika Mannermaa. Pp. 2–41. Helsinki: Gaudeamus, 1985. See also item 356.

338. Norms, Truth, and Logic. In *Deontic Logic, Computational Linguistics and Legal Information Systems.* Edited by A. A. Martino. Pp. 3–20. Amsterdam: North-Holland Publishing Co., 1982.

339. Om behov. [On Needs] *Filosofisk Tidskrift* 3 (1982): 1–12.
 (a) Tarpeesta. [Finnish translation of item 339 by Heikki Nyman] *Ajatus* 41 (1984): 25–38.

340. Människan, naturen och tekniken. [Man, Nature, and Technics. An expanded, final version of item 331] In *Vårt Hotade Hem.* Edited by R. Edberg. Pp. 168–185. Höganäs: Bra böcker, 1982.

341. Hans Ruin (1891–1980). [Hans Ruin. In Memoriam] *Horisont* 29 (1982): 78–79.

342. Musil and Mach. In Robert Musil, *On Mach's Theories,* pp. 7–14. Munich: Philosophia Verlag. 1982.

343. Norms of Higher Order (A Summary). *Bulletin of the Section of Logic* Wrocław University 11 (1982): 89–94. See also item 346.

344. *Practical Reason. Philosophical Papers,* vol. 1. Oxford: Basil Blackwell, 1983. x & 214 pp. Contents: Revised versions of items 182, 194, 200, 248(a), 281, 326, 327, and an essay 'Norms, Truth, and Logic', ibid., pp. 130–209.

345. *Philosophical Logic. Philosophical Papers,* vol. 2. Oxford: Basil Blackwell, 1983. xiii & 143 pp. Contents: Revised versions of 177, 180, 193, 201, 202(a), 208, 229, 239, 254, and 292(a).

346. Normas de Orden Superior. In *El lenguaje del derecho, Homenaje a Genaro R. Carrio.* Edited by Eugenio Bulygin et al. Pp. 457–470. Buenos Aires: Abeledo-Perrot, 1983.
 (a) Norms of Higher Order. [A somewhat abridged version of item 346. Summarized in item 343.] *Studia Logica 42* (1983): 119–127.

347. Sodanuhka, kilpavarustelu ja rauhanliike—Krigshotet, kapprustningen och freds-rörelsen—The Threat of War, the Arms Race and the Peace Movement. A Pamphlet. Forssa, 1983.

348. Greetings from the International Institute of Philosophy. [The President's Opening Address at the Meeting of the International Institute of Philosophy in Jerusalem 6–9 September 1977] In *Spinoza—His Thought and Work.* Edited by Nathan Rotenstreich and Norma Schneider. Pp. 11–13. Jerusalem: The Israel Academy of Sciences and Humanities, 1983.

349. Mein Verhältnis zur deutschen Literatur. Selbstbiographisches Fragment. *Jahrbuch für finnisch-deutsche Literaturbeziehungen* 17 (1983): 15–17.

350. Technology and the Legitimation Crisis of Industrial Societies. *Epistemologia* 6 (1983), Special Issue: 17–27. Incorporates parts of items 311, 322, and 340 above.

351. Proposizioni normative conditionali. *Epistemologia* 6 (1983): 187–197. Abstract in English, 'Conditional Norms', ibid.: 198–200.

352. Norme, verità e logica. [Italian translation by G. Pezzini with technical revision by A. A. Martino of the essay 'Norms, Truth, and Logic' in item 344. With a preface for the Italian translation by Professor von Wright, Ibid.: 5–7] *Informatica e Diritto* 9 (1983), number 3: 5–87.

353. On Causal Knowledge. In *Knowledge and Mind,* edited by Carl Ginet and Sydney Shoemaker. Pp. 50–62. New York-Oxford: Oxford University Press, 1983.

354. Bedingungsnormen—ein Prüfstein für die Normenlogik. In *Theorie der Normen, Festgabe für Ota Weinberger zum 65. Geburtstag.* Edited by Werner Krawietz et al. Pp. 447–456. Berlin: Duncker & Humblot, 1984.

355. Onko ihminen oman onnensa seppä? [Is Man Master of His Destiny? Finnish translation of Opening Address at the Symposium 'The Coevolution of Man and the Biosphere', arranged by Institut de la Vie at Vuoranta, Helsinki, 5–10 September 1983] *Suomen Luonto* 1984: 58–59.

356. *Truth, Knowledge, and Modality. Philosophical Papers,* vol. 3. Oxford: Basil Blackwell, 1984. ix & 155 pp. Contents: Revised versions of 308, 337, 353, and the following new essays: 'Determinism and Future Truth', 'Demystifying Propositions', 'Truth and Logic', 'The Logic of Predication', 'Knowledge and Necessity', ' "Omne quod est quando est necesse est esse" ', 'Logical Modality', 'Natural Modality', and 'Laws of Nature'.

357. Inhimillisestä vapaudesta. [Of Human Freedom. Based on the Tanner Lectures on Human Values given by Professor von Wright at the University of Helsinki, May 1984. Translation by Heikki Nyman] *Kanava* 12 (1984): 326–334. See also item 363.

358. [Answer to a Questionnaire for *Doxa, Quadernos de Filosofia del Derecho* on the relevance of logic to legal philosophy. Spanish translation by J. A. Regla] In *Problemas abiertos en la filosofia del derecho.* Alicante: Departemento de Filosofia del Derecho de la Universidad de Alicante, 1984. Pp. 265–67.

359. A Pilgrim's Progress—Voyage d'un pélerin. In *Philosophes critiques d'eux-mêmes,* vol. 12. Edited by A. Mercier and M. Svilar. Pp. 257–294. Bern: Verlag Peter Lang, 1985.

360. Sulla verità delle 'spiegazioni comprendenti'. [Italian translation by M. Failla. A preliminary version for item 361] In *Dilthey e il Pensiero del Novecento.* Edited by Franco Bianco. Pp. 127–135. Milano: Franco Angeli, 1985.

361. Om förstående förklaringars sanning. [On the Truth of Understanding Explanations. An expanded version of item 360] In *Filosofi och kultur,* vol. 2. Edited by Arno Werner. Pp. 227–245. Lund: Filosoficirkeln, 1985.

362. Is and Ought. In *Man, Law, and Modern Forms of Life,* edited by E. Bulygin et al. Pp. 263–281. Dordrecht, Holland: D. Reidel Publishing Co., 1985.

363. Of Human Freedom. In *The Tanner Lectures on Human Values,* vol. VI. Edited by Sterling M. McMurrin. Pp. 107–170. Salt Lake City: University of Utah Press, 1985.

364. *Filosofisia tutkielmia.* [Philosophical Papers] Helsinki: Kirjayhtymä, 1985. 215 pp. Contains slightly revised versions of items 226(c), 281(b), 297, 318, 319, 357, 339(a), and 362, and a previously unpublished essay 'Keinojen ja päämäärien ratio-naalisuudesta' (The Rationality of Means and Ends). The essays 297, 319, 362, and the previously unpublished essay translated for this collection into Finnish by Heikki Nyman.

365. Tieteen maailmankuva ja ihmisjärki. [The Scientific View of the World and Human Reason. The 5th Pekka Kuusi Lecture, delivered by Professor von Wright on 23 September 1985.] *Sosiaalipolitiikka* 10 (1985): 93–107.

366. Egységes Logica. [Translation into Hungarian of a paper with the title 'The Unification of Logic' presented at a symposium in Vezprém, Hungary in August 1984.] *Doxa* 5 (1985): 7–32.

367. Truth, Negation, and Contradiction. *Synthese* 66 (1986): 3–14.

368. Comment (on a paper by Joseph Nyasani). In *The Cultural Dimension of Development.* Edited by A. Serkkola and Christine Mann. Pp. 21–24. Helsinki: Publications of the Finnish National Commission for UNESCO No. 33, 1986.

369. Muistoja Suomen Akatemian taipaleilta. [Recollections of the Academy of Finland. On the occasion of Professor von Wright's retirement, 14 June 1986.] *Suomen Akatemia tiedottaa* 5 (1986): 4–6.

370. Tahdommeko elää silmät ummessa? [Do We Wish to Live with Our Eyes Closed? Statement on a pamphlet by Pentti Linkola on the threats to the environment.] *Suomen Kuvalehti,* Nr. 38, 1986: 26–29.

371. Katsaus filosofian tilaan Suomessa. [Survey of the State of Philosophy in Finland.] In *Vuosisatamme filosofia.* Edited by I. Niiniluoto and E. Saarinen. Pp. 244–253. Helsinki: Werner Söderström, 1986.

372. Tekojen vapaus. [The Freedom of Actions. Based on an extract from item 363.] *Ajatus* 43 (1986): 6–23.

373. Rationality: Means and Ends. *Epistemologia* 9 (1986): 57–71.

374. *Vetenskapen och förnuftet. Ett Försök till orientering.* [Science and Reason, An Attempted Orientation.] Helsingfors: Söderströms, 1986. 154 pp.
 (a) *Tiede ja ihmisjärki. Suunnistusyritys.* [Finnish translation of item 374 by Anto Leikola.] Helsinki: Otava, 1987. 143 pp.

375. *Logiko-filosofskie Issledovanija, Izbrannye Trudy.* [Logico-Philosophical Investigations, Selected Works. Translations into Russian by A. S. Karpenko, E. I. Tarusino, et al. of items 242, 327, 254, 177, 202(a), 180, 367, 366, the essay 'Determinism and Future Truth' included in 356, and the essay 'Norms, Truth, and Logic' included in 344. Edited by G. A. Ruzavin and V. A. Smirnov, with Introductions by V. A. Smirnov (pp. 7–26) and G. H. von Wright (pp. 27–33.] Moscow: "Progress", 1986. 595 pp.

376. Den mångdimensionella verkligheten. [Multidimensional Reality.] *Sydsvenska Dagbladet* 28 December 1986.

377. Omständigheternas diktatur. [The Dictatorship of Circumstances.] *Sydsvenska Dagbladet* 29 December 1986.

378. Mot en ny helhetssyn på naturen. [Towards a Holistic View of Nature.] *Sydsvenska Dagbladet* 30 December 1986.

379. Den ofrånkomliga teknologiska kapprustningen. [The Inevitable Technological Arms Race.] *Sydsvenska Dagbladet* 31 December 1986.

380. Teknosysteemi ravistaa jo kansallisvaltioita. [The Technosystem is Shaking the National State.] *Helsingin Sanomat* 28 January 1987.
 (a) Teknosystemet, nasjionalstaten og naturen. [Norwegian translation of a somewhat expanded version of item 380.] *Samtiden*, Nr. 2, 1988. Pp. 11–19.

381. Humanististen tieteiden haasteet. [Challenges Facing the Humanities.] *Helsingin Sanomat* 7 March 1987.

382. Inaugural Address, in German and English, at the congress of the International Society for Dialectical Philosophy, Societas Hegeliana, in Helsinki, 4–8 September 1984. In *Vom Werden des Wissens: Philosophie—Wissenschaft—Dialektik*. Edited by H. H. Holz and J. Manninen, pp. 13–16. Oulu: Oulun Yliopiston Julkaisuja, 1987.

383. Georg Henrik von Wright svarar sina kritiker. [GHvW Answers His Critics. Reply to 17 critics of item 374 in the Swedish newspaper *Svenska Dagbladet*.] *Svenska Dagbladet* 14 June 1987.
 (a) Kirja ja sen vastaanotto. [The Book and Its Reception. A slightly expanded version in Finnish of item 383.] *Vartija*, nr 5–6, 1987. Pp. 3–9.

384. Wissenschaft und Vernunft. [Translation by Joachim Schulte from the English original. Cf. also item 365.] *Rechtstheorie 18* (1987); 15–33.
 (a) Wissenschaft und Vernunft. [A somewhat abridged version of item 384.] *Alexander-von-Humboldt-Stiftung, Mitteilungen*, Heft 49, July 1987. Pp. 1–11.

385. *Imagini della scienza e forme di razionalità*. [Italian translation by Rosaria Egidi of the English original of item 384. With an Introduction by the translator.] Rome: Editori Riuniti, 1987, 78 pp.

386. 'Se-Allora'. [Translation by Margherita Sani of the English original.] In *L'Epistemologia di Cambridge 1850–1950*. Edited by Raffaella Simili. Pp. 25–37. Bologna: Il Mulino, 1987.
 (a) If—then. In: *Intensional Logic, History of Philosophy, and Methodology. To Imre Ruzsa on the Occasion of his 65th Birthday*. Edited by I. M. Bodnár et al. Pp. 91–99. Budapest: Akadémiai Kiadó Idegennye, vú szerkesztóség, 1988.

387. Viekö konsensus lopulta ajopuutilanteeseen?. [Does the "consensus" lead to a future without alternatives?] *Turun Sanomat* 18 January 1988. Also published in *Futura* 7 (1988): 4–6.

388. Arvot ja tarpeet. [Values and Needs.] *Futura* 7 (1988): 8–15.

389. Dante mellan Odysseus och Faust. [Dante between Ulysses and Faust. Inaugural Address in English at the Eighth International Congress of Medieval Philosophy in Helsinki, August 1988. Swedish translation by Erik Carlquist.] *Horisont* 35 (1988): 7–15.

390. Välfärdsstaten och framtiden. [The Welfare State and the Future. An abridged version of 380 (a).] *Dagens Nyheter* 11 and 12 September 1988.

391. Tankar on vetenskapernas historiografi. [Thoughts on the Historiography of Science.] In: *Ährenprijs*. Pp. 19–30. Helsingfors: Sällskapet Bokvännerna i Finland, 1988.

392. Reflections on Psycho-Physical Parallelism. In *Perspectives on Human Conduct*. Edited by Lars Hertzberg and Juhani Pietarinen. Pp. 22–32. Leiden: E. J. Brill, 1988. (Philosophy of History and Culture. Vol. 1.)

393. An Essay on Door-Knocking. *Rechtstheorie 19* (1988): 275–288.

394. Marxist ja marksismist. [Translation from Swedish to Esthonian by Ann Saludäär of the essay 'Om Marx och marxismen' in item 296.] *Loomingu Raamatukogu 51/ 52 1988*: 58–76.

II. WORKS EDITED BY G. H. VON WRIGHT AND WORKS PUBLISHED WITH HIM AS CO-EDITOR.

001. Augustin Ehrensvärd som politiker. Av Carl Sanmark. Ur förfs efterlämnade manuskript. [Augustin Ehrensvärd as Politician. By Carl Sanmark. Excerpt from the author's posthumous papers, now deposited in the University Library, Helsingfors] In *Historiska och litteraturhistoriska studier*. 17. pp. 1–63. Skrifter utgivna av Svenska Litteratursällskapet i Finland. 289. Helsingfors: 1942. See also item 16.

002. (With Rush Rhees and G. E. M. Anscombe) Ludwig Wittgenstein, *Bemerkungen über die Grundlagen der Mathematik—Remarks on the Foundations of Mathematics*. German-English parallel text. Translated by G. E. M. Anscombe. Oxford: Basil Blackwell, 1956. xix & 204 pp. See also item 150(a).
 (a) *Bemerkungen über die Grundlagen der Mathematik*. Revidierte und erweiterte Ausgabe. Frankfurt: Suhrkamp Verlag, 1974. 446 pp.
 (b) *Remarks on the Foundations of Mathematics*. Translated by G. E. M. Anscombe. 3d rev. ed. Oxford: Basil Blackwell, 1978. 444 pp.

003. (With G. E. M. Anscombe) Ludwig Wittgenstein, *Notebooks 1914–1916*. German-English parallel text. English translation by G. E. M. Anscombe. Oxford: Basil Blackwell, 1961. vi & 131 pp.

004. Eino Kaila, *Die perzeptuellen und konzeptuellen Komponenten der Alltagserfahrung*. Acta Philosophica Fennica. Fasc. 13. Helsinki: 1962. See also item 181.

005. (With G. E. M. Anscombe) Ludwig Wittgenstein, *Zettel*. German-English parallel text. Translated by G. E. M. Anscombe. Oxford: Basil Blackwell, 1967. vii & 214 pp.

006. (With G. E. M. Anscombe) Ludwig Wittgenstein, *Über Gewissheit—On Certainty*. Translated by Denis Paul and G. E. M. Anscombe. Oxford: Basil Balckwell, 1969. vii & 90 pp. See also item 232.
 (a) With an index prepared by E. D. Klemke. Oxford: Basil Blackwell, 1979. 110 pp.

007. (With the assistance of Walter Methlagl) Ludwig Wittgenstein, *Briefe an Ludwig von Ficker*. Brenner-Studien. 1. Salzburg: Otto Müller Verlag, 1969. 110 pp. See also items 231 and 244.

008. (With B. F. McGuinness and Tauno Nyberg) *Prototractatus*. An early version of *Tractatus Logico-philosophicus* by Ludwig Wittgenstein. German-English parallel text. Translated by D. F. Pears and B. F. McGuinness. Historical Introduction by G. H. von Wright. Facsimile of the Author's Manuscript. London: Routledge and Kegan Paul, 1971. vi & 256 pp. See also items 231(a), 243, and 244.

009. *Problems in the Theory of Knowledge*. Symposium in Helsinki, 24–27 August 1970, International Institute of Philosophy. The Hague: Martinus Nijhoff, 1972. 70 pp. See also items 251 and 252.

010. Ludwig Wittgenstein, *Letters to C. K. Ogden with Comments on the English Translation of the 'Tractatus Logico-philosophicus'*. Edited with an Introduction by G. H. von Wright. Appendix of Letters by Frank Plumpton Ramsey. Oxford: Basil Blackwell, London and Boston: Routledge and Kegan Paul, 1973. ix & 90 pp. See also items 259 and 260.

011. (With the assistance of B. F. McGuinness) Ludwig Wittgenstein, *Letters to Russell, Keynes and Moore*. Edited, with an Introduction and Notes by G. H. von Wright. Oxford: Basil Blackwell, and Ithaca: Cornell University Press, 1974. 190 pp.
 (a) 2d ed. with revisions. Oxford: Basil Blackwell, 1977. iv & 197 pp.

012. (With the assistance of Heikki Nyman) Ludwig Wittgenstein, *Vermischte Bemerkungen*. Eine Auswahl aus dem Nachlass. Frankfurt: Suhrkamp Verlag, 1977. 168 pp. Bibliothek Suhrkamp. 535. See also item 295.
 (a) 2d ed. with additions and corrections. Frankfurt: Suhrkamp Verlag, 1978. 170 pp.
 (b) Ludwig Wittgenstein, *Vermischte Bemerkungen—Culture and Value*. English-German parallel text. Translated by Peter Winch. Oxford: Basil Blackwell, 1980. vi & 94 pp.

013. (With Amadeo Conte and Risto Hilpinen) *Deontische Logik und Semantik*. Linguistische Forschungen. 15. Wiesbaden: Athenaion, 1977. 215 pp. See also item 294.

014. *Logic and Philosophy*. Symposium in Düsseldorf, 27 August–1 September 1978. International Institute of Philosophy. The Hague: Martinus Nijhoff, 1980. 85 pp. See also item 320.

015. (With B. F. McGuinness) Ludwig Wittgenstein, *Briefwechsel mit B. Russell, G. E. Moore, J. M. Keynes, F. P. Ramsey, W. Eccles, P. Engelmann und L. von Ficker*. Frankfurt: Suhrkamp Verlag, 1980. 306 pp.

016. (With G. E. M. Anscombe) Ludwig Wittgenstein, *Bemerkungen über die Philosophie der Psychologie—Remarks on the Philosophy of Psychology.* Vol. 1. English-German parallel text. Translated by G. E. M. Anscombe. Oxford: Basil Blackwell, 1980. vi & 218 pp.

017. (With Heikki Nyman) Ludwig Wittgenstein, *Bemerkungen über die Philosophie der Psychologie—Remarks on the Philosophy of Psychology.* Vol. 2. English-German parallel text. Translated by C. G. Luckhardt and M. A. E. Aue. Oxford: Basil Blackwell, 1980. ii & 143 pp.

018. (With G. Fløistad) *Contemporary Philosophy. A New Survey,* vol. 1, part two (Philosophical Logic), pp. 225–386. The Hague: Martinus Nijhoff, 1981. See also item 329.

019. (With Heikki Nyman) Ludwig Wittgenstein, *Letzte Schriften über die Philosophie der Psychologie—Last Writings on the Philosophy of Psychology,* vol. 1. German-English parallel text. Translated by C. G. Luckhardt and M. A. E. Aue. Oxford: Basil Blackwell, 1982. 148 pp.

020. Letters from Ludwig Wittgenstein to Georg Henrik von Wright. Edited with comments by Professor von Wright. *Cambridge Review* 104 (1983): 56–64. With a correction, ibid.

(a) Briefe von Ludwig Wittgenstein an Georg Henrik von Wright. In *Weder-Noch, Tangenten zu den finnish-österreichischen Kulturbezeihungen.* Edited by Georg Gimpl. Pp. 339–356. Helsinki: Mitteilungen aus der deutschen Bibliothek, 1986. [Translation of item 020 by Saski Sössel.]

INDEX

The index material includes the bibliography. Numerals prefixed with a B refer to the chronological numbering of items in the bibliography. I have used 'f' when the item referred to occurs on two consecutive pages, 'ff' when it occurs on more than two, but not necessarily consecutive, pages, and page numbers separated by a dash when the topic referred to is being discussed over the whole stretch of pages even if not mentioned by name on every one of the pages. For kind assistance in making the index I am indebted to Olav Flo,* Heikki Nyman, and Erkki Kilpinen.

—G.H.v.W.

INDEX OF NAMES

*I have just learned of the death of Professor Flo in September 1989.

—L.E.H.
26 January 1990

Subject Index

Ability 271f, 323, 335, 458f, 666ff
Acceptance 89ff, 142
Action 36f, 38ff, 72, 76, 187f, 191–194, 205–207, 272ff, 283f, 288, 290–298, 305–332, 334, 336ff, 450ff, 499–501, 704, 723ff, 804–827, 868f
 agency theory of a. 305, 310ff, 319f, 326, 329
 basic a. 306, 321ff, 326f, 329, 337, 439f, 444, 724, 814
 and behaviour, *see* Behaviour
 causal theory of a. 305, 310, 319f, 324f, 365ff, 405, 815ff
 cause and a. 39f, 307, 329, 333ff, 419, 432ff, 439, 441f, 471ff, 723f, 768ff, 883f, 887
 cause of a. 307, 334ff, 405
 collective a. 41, 478ff, 500f, 513, 841f, 844f
 consequence(s) of a. 41, 290, 307, 310f, 330, 337f, 809f, 842
 counterfactual element of a. 307, 321ff, 434f, 808, 883f
 and description, *see also* Description, 187, 192, 206, 307, 321, 337ff, 347ff, 367ff, 378, 810ff
 end of a., *see* Teleology
 explanation of a. 38ff, 308, 310, 315, 324f, 839f
 General Theory of a. 36
 generic a. 330f, 647, 653ff, 868
 individual a. 41, 330, 478ff, 500, 505, 513
 inner and outer aspect of a. 336ff, 344f, 809f
 intentional a. *see also* Intention, 275, 306, 309, 312ff, 328, 330, 404ff, 805, 815f
 Kantian theory of a. 305, 326, 329, 805
 Logic of A. 30, 36f, 40f, 647, 658ff
 non-intentional a. 308
 prediction of a., *see also* Prediction, 821

 prolegomena to action theory 305ff,
 reason for a., *see* Reason
 result of a. 272f, 307, 310f, 330, 337, 466f, 805, 809
 social a. 842
 a.-type, *see* generic a.
Activity 190f, 193, 195, 199f, 272ff, 338, 459, 467
 muscular 338f
 neural 63, 338, 724f
 normative 871
Agapistic ethics, *see also* Love, 800
Agent (agency) 188f, 272, 276, 288, 291, 294ff, 300, 302, 310f, 329, 333, 335ff, 343ff, 349, 448, 450, 456ff, 464f, 500, 513, 658f
 cause and a., *see also* Cause and action, 311, 329, 340ff, 812f, 830f
Akrasia 258f, 276, 411, 775
Alethic modality, *see* Modality
Always 859ff
Analytical philosophy, *see* Philosophy
And Next 37, 859ff
And Then 37, 859ff
Antinomies 30, 51, 70
Aristotelian tradition 9, 305, 471, 805, 843
Asserting 593, 667f, 707ff, 881f
Authority, *see also* Moral, Norm 188, 191f, 205, 208,282, 295
Autonomy of morals, *see* Morality
Auxiliary construction 530, 532, 537, 847
Axiology (axiological), *see* Value

Bad for, *see* Harmful
Basic need, *see* Need
Bayes's Theorem 34, 111f, 149, 745f
Behaviour 308ff, 319ff, 328ff, 353ff, 448f, 455ff, 805ff
 and action 308ff, 805ff, 810f

DATE DUE

HIGHSMITH # 45220